THE PAUL HAMLYN LIBRARY

DONATED BY
THE PAUL HAMLYN
FOUNDATION
TOTHE
BRITISH MUSEUM

opened December 2000

· X					

History of Italian Renaissance Art

Painting / Sculpture / Architecture

PAINTING / SCULPTURE ARCHITECTURE

History Renaissance

Frederick Hartt / David G. Wilkins

ofItalian

Art

Fifth edition

PLEASE NOTE: In captions to the illustrations in this book, *in situ* works—artworks still in their original settings—are indicated by ...

For obvious reasons, the logo is not used in captions for façade sculpture, frescoes, mosaics, and architecture.

References to figure numbers 1–16 in the text and captions indicate that these illustrations appear in the "Portfolio of the Italian Renaissance" (see pp. 10–27).

Illustrations appearing in the endpapers, title page, part openers, and chapter openers are identified and credited on page 766.

Any copy of this book issued by the publisher as a paperback is sold subject to the condition that it shall not by way of trade or otherwise be lent, resold, hired out or otherwise circulated without the publisher's prior consent in any form of binding or cover other than that in which it is published and without a similar condition including these words being imposed on a subsequent purchaser.

First published in the United Kingdom in 1970 by Thames & Hudson Ltd, 181A High Holborn, London WCIV 7QX First revised edition 1980; new revised edition 1987 Fourth edition 1994, reprinted 1999, 2001 Fifth edition 2003

Text copyright © 1987 Frederick Hartt Copyright © 1994, 2003 Harry N.Abrams, Inc.

All Rights Reserved. No part of this publication may be reproduced or transmitted in any form or by any means, electronic or mechanical, including photocopy, recording or any other information storage and retrieval system, without prior permission in writing from the publisher.

British Library Cataloguing-in-Publication Data A catalogue record for this book is available from the British Library

ISBN 0-500-23803-0

Printed in Japan

WIELD RAWN

709 45 HAR

CONTENTS

Prefaces and Forewords	6				
A PORTFOLIO OF THE ITALIAN RENAISSANCE	10				
PRELUDE					
1. Italy and Italian Art	32				
PART ONE					
THE LATE MIDDLE AGES					
2. Duecento Art in Tuscany and Rome					
3. Florentine Art of the Early Trecento	92				
4. Sienese Art of the Early Trecento	124				
5. Later Gothic Art in Tuscany and Northern Italy	154				
DADT TWO					
PART TWO THE OHATTROCENITO					
THE QUATTROCENTO					
6. The Beginnings of Renaissance Architecture					
7. Gothic and Renaissance in Tuscan Sculpture					
8. Gothic and Renaissance in Florentine Painting					
9. The Heritage of Masaccio and the Second Renaissance Style					
0. The Second Renaissance Style in Architecture and Sculpture					
1. Absolute and Perfect Painting: The Second Renaissance Style					
2. Crisis and Crosscurrents					
3. Science, Poetry, and Prose 4. The Renaissance in Central Italy					
5. Gothic and Renaissance in Venice and Northern Italy					
Total relational vertice and relationship to the second se	424				
PART THREE					
THE CINQUECENTO					
6. The High Renaissance in Florence	476				
7. The High Renaissance in Rome					
8. High Renaissance and Mannerism					
9. High and Late Renaissance in Venice and on the Mainland					
). Michelangelo and the <i>Maniera</i>	690				
Classami					
Glossary Bibliography	724 732				
Index	746				
Credits	766				

hen Frederick Hartt's History of Italian Renaissance Art was first published, more than thirty years ago, it was an epoch-making achievement. This large volume with its dozens of color plates presented for the reader the story of Italian Renaissance art as it was loved, appreciated, and understood by one of the great scholars of the period. Before his death in 1991, Frederick Hartt was able to revise the book for two later editions. In 1994 a fourth edition offered minor revisions to Hartt's text and illustrations in the light of new discoveries and the restoration of the Sistine Chapel and other works. Now, at the beginning of the twenty-first century, this new edition has been undertaken to update and enhance Hartt's original vision. I think he would have been especially pleased with our ability to offer color illustrations throughout the book, uniting the images with the text in a manner not possible before.

As I set about updating Hartt's vision, my intent was to maintain the integrity of the story that he had first told so enthusiastically many years ago. The organization of the text as he planned it has been retained, and many of the works illustrated are the same. The new works added here were chosen to expand and enhance Hartt's original vision.

The history of Italian Renaissance art is a vast and complex subject that could be told in a number of ways. Frederick Hartt's view was a traditional one that had its roots in the first history of Renaissance art, written by Giorgio Vasari in the sixteenth century. Like Vasari, Hartt emphasized the art that was created in Florence, Rome, Siena, and Venice. While art historians have discovered much that is interesting and important in the art created in Naples, Milan, Ferrara, and other centers during the Renaissance, to include this material in extensive detail would have detracted from Hartt's thesis that Renaissance art evolved in Florence and had its most fulfilling later development in Rome, Siena, and Venice. His belief that each of these cities evolved a unique style was the basis for his organization; as such, chapters were devoted to the developments in each center. Such an approach remains appropriate, for the story of each city's art has an internal integrity that is based on its own independent political and social structure and development.

Hartt's model, Vasari's *Lives of the Artists*, was based on an interest in understanding each artist as a creative individual. While such a biographical and focused approach is still rewarding, it means that each artist is isolated and discussed independently. This organization provides readers with a strong sense of the personality and artistic development of each individual, while at the same time requiring

that they re-create the original, overlapping chronology of events and works.

While choosing to maintain Hartt's traditional framework, I have at the same time introduced a number of changes. Illustrations have been deleted to make way for other works that enrich our understanding of the diversity of the period. While Hartt emphasized religious art, I have added a number of secular works. Also new is a series of portraits of significant patrons and personalities of the period. Extracts from Renaissance texts have been added to enhance the historical context. The emphasis throughout, however, remains as Hartt envisioned it—on the work of art and on the individual creator rather than on the broader social and historical context within which these works were created.

One of Hartt's goals was to help the reader see the works of art as he saw them through the use of evocative and poetic language. As an example of his descriptive powers, note how quickly he captured the effect of Parmigianino's *Vision of St. Jerome* (see fig. 18.54): "In the darkness that veils any possibility of establishing spatial relationships, rays of light flash from the Madonna's head and shoulders like shards of ice." Again and again his words send the reader back for another, closer look at the work of art.

My own love for this period was established when I first visited Florence in 1963 in preparation for a position at the University of New Hampshire. Although at the time I thought of myself as a medievalist in training, my job required that I teach a full semester course on Italian Renaissance art. As a result I devoted extra time to Italy and Renaissance art; when I left Florence that summer, I knew that I would be going back. I owe a special debt to all my teachers at the University of Michigan: Ludovico Borgo, Eleanor Collins, Marvin Eisenberg, Ilene Forsyth, Oleg Grabar, Victor Meisel, Clifton Olds, James Snyder, Harold Wethey, and Nathan Whitman.

In preparing this edition I want to thank a number of individuals for their assistance, including my family—Ann Thomas Wilkins, Rebecca Wilkins, Katherine Wilkins, Chris Colborn, Tyler Jennings—and past and present students and colleagues at the University of Pittsburgh—Bonnie Apgar Bennett, Maria Carolina Carrasco, Jennifer Craven, Roger Crum, Holly Ginchereau, Ann Sutherland Harris, Ray Anne Lockard, Sarah Cameron Loyd, Erin Marr, Stacey Mitchell, Elizabeth Prince, Azar Rejaie, David Rigo, Jane Vadnal, and Jim Wilkinson. I profited, as always, from the thoughtful and enthusiastic assistance of the excellent staff at Harry N. Abrams, Inc., including Julia Moore, head of the textbooks division, my editor and project manager for this revision,

Cynthia Henthorn, and Julia Chmaj, Holly Jennings, and Sabine Rogers for editorial; John Crowley for picture research; and former publisher Mark Magowan for his inspired support. Much appreciation also goes to Diana Gongora, Alia Mansoori, Doria Romero, and David Savage for picture research and permissions; John McKenna for

illustration; Adrian Kitzinger for map design; and the staff of BTD, Inc., Beth Tondreau, Erica Harrison, Lorie Pagnozzi, and Mia Risberg for design. My hearty thanks to all. Errors and omissions are, as always, my responsibility alone.

DAVID G. WILKINS Silver Lake, New Hampshire, December 2001

PREFACE TO THE FOURTH EDITION

his revision of Frederick Hartt's magisterial History of **■** *Italian Renaissance Art* was scheduled at the time Professor Hartt died, unexpectedly, on October 31, 1991. It had already been decided that there would not be major changes to the text, and the revision maintains the canon of works selected by Hartt to characterize the development of Italian Renaissance art as well as the sequence in which he ordered them. New photographs have been substituted when works have been restored, and colorplate portfolios of Renaissance art in context and of Michelangelo's restored Sistine Ceiling have been added. The text has been somewhat tightened to conform to the book's new design, and new ideas and scholarship have been included where possible. It was agreed from the beginning that the inimitable voice of Frederick Hartt, discussing the works and landscape that he loved so much, should continue to speak clearly in this revision. I hope you will agree that this has been accomplished.

A few changes have been introduced to make the book more useful for today's students and general readers and to conform to new interests that are developing in art history. Because location was such an important consideration in the design of Renaissance works of art, paintings and sculptures that are still in their original settings—with the exception of obvious examples of frescoes, mosaics, and façade sculptures—are indicated by a in the captions. For works today in private collections or museums, the original locations, if known, have been added to the captions.

In addition, an effort has been made to include in each caption a reference to the patron, when the name of the particular individual, family, or commissioning body is known. Although some patrons are today no more than a name, even the name serves as a reminder of the formative and essential role that the patron so often played in the creation of a Renaissance work of art.

Earlier editions included occasional references to specific scholars, but as the increasing complexity and richness of Renaissance scholarship threatened to bury this revision under an avalanche of names, it was decided to eliminate this information. The revised glossary now keys terms to the illustrations, and an updated bibliography guides interested readers to the sources that support, critique, and expand upon the information presented in this book.

I owe special thanks to many colleagues in the Renaissance field who have advised me during this process, especially Bernard Schultz of West Virginia University and Roger Crum of the University of Dayton. Additional ideas for improvements were made by Ann Sutherland Harris and by many members of the Italian Art Society. For insight into the student's point of view and for research and editorial assistance I am indebted to Rebecca Wilkins, Chris Colborn, and Katherine Wilkins. The updated bibliography profited from the attention of Ray Anne Lockhard, Librarian at the Henry Clay Frick Fine Arts Library at the University of Pittsburgh. At Harry N. Abrams, Inc., I received good advice, encouragement, and direction from Julia Moore and Eve Sinaiko. Uta Hoffmann located the splendid new photographs, and I owe a special debt to Joanne Greenspun, whose subtle editorial skills have been crucial throughout this endeavor. The artists for the handsome new design were Lydia Gershey and Yonah Schurink. The fine jacket design is by Dirk Luykx.

It was my intention from the beginning that Frederick Hartt's personal and inspiring approach to the Renaissance remain intact. As I read his text again and again, I continued to be impressed by the breadth and depth of his knowledge, by the manner in which he encourages us to examine each work in detail, and how he tries to persuade us to experience each work as fully as he did. My hope is that this revision will demonstrate my respect for his authority and vision.

DAVID G. WILKINS University of Pittsburgh, August 1993 Reprinted here are excerpts from Frederick Hartt's Forewords and Prefaces to earlier editions. It is our belief that Professor Hartt's own words, both illuminating and instructive, will be of interest to the reader. They also provide a framework for and an important record of the changes that were made to this book over the course of three editions. For the full texts, the reader is referred to the original editions.

FOREWORD TO THE FIRST EDITION, 1969

A book in English dealing with the art of the Italian Renaissance—painting, sculpture, and architecture—needs no apology for its existence . . . all three were closely related in Renaissance Italy. Often the same master practiced two of the major arts with equal success; sometimes he achieved commanding stature in all of them. And, especially in the early Renaissance, architects, sculptors, and painters interchanged their ideas with the greatest freedom, often going so far as to borrow for exploitation in their own arts effects which seem more appropriate to other techniques and other media. . . .

The organization of the book has precipitated a series of difficult choices. A comprehensive treatment of all the gifted masters at work from the Alps to Sicily, during the period of roughly three centuries which can be embraced by the term Renaissance, the whole compressed between one pair of covers, might have produced a useful handbook but not a readable account. Worse, it would not have been possible to illustrate all the works of art mentioned in the text with photographs of legible scale and quality. I chose, instead, the twin principles of extended discussion and adequate illustration. In fact, no work of art treated in the book is left unillustrated.

In making my choices I have tried to leave some for other teachers. While my own undergraduate course in Italian Renaissance art covers many more works than can possibly be discussed or illustrated in a single book, I have never attempted to treat in my lectures all the masters who appear in the following pages. Individual teachers may wish to take up artists I omit, or vice versa, and the general reader—whose rights should be respected—ought also to be able, if he wishes, to get a wider view of the subject than can be fitted into any college course.

Reasons could be advanced for every inclusion, every omission; but equally persuasive arguments will doubtless be produced by critics who do not agree with my judgments. Neither they nor I can claim complete objectivity. First, for instance, I admit to a personal slant in favor of Tuscany, and especially Florence, which I would be willing to relinquish if it could be proved to me that the Renaissance originated anywhere else. Second, it has seemed to me more important to write at length about revolutionary figures and major movements than to include certain minor masters, no matter how delightful their works may be. I have tried to be fair, despite my Tuscan bias. . . .

My guiding principle of selection has meant that certain pictures have had to be reproduced here no matter how often the reader may have seen them elsewhere; otherwise I would have had to refer him to a library of other volumes. But even here, from time to time I have changed the traditional emphasis, and put in fresh works that I thought deserved to be better known, and left out some familiar warhorses. Sometimes it has been impossible to give a fair account of the work of an artist with so few examples. *Pazienza*, as the Italians would say; the works of art themselves are in the galleries and churches to be enjoyed and thought about, and the rich literature about them is on the shelves to be read. My goal will be attained if I have stimulated the reader's appetite to do both.

Throughout the book I have attempted, where possible, to present the individual work of art in its context of contemporary history, to show how it fulfilled specific needs on the part of artist and patron, and how its meaning was intended to be interpreted. Sometimes the texts I quote may seem abstruse and remote from our own experience; that is not their fault. An iconologist (one who interprets the meaning of works of art through texts) often meets with the objection, "But aren't you reading all this into the work of art?" If the iconologist has found the right texts, he has discovered only what was intended to be seen in the work of art, and what the forgetfulness of centuries has caused to be read out of it. Aesthetically, of course, a work of art is no less interesting if we do not know what it represented. But a knowledge of its meaning can admit us into realms of experience, in both the personality of the artist and the period to which he was speaking, that would otherwise have been inaccessible. Such knowledge can also open our eyes to previously unobserved qualities of form and color in the work of art. And it can tell us much about why the artist did certain things the way he did—and even, at times, give us a flash of insight into the forces which cause styles to change or disappear and new ones to take their places.

In quite a number of instances I have presented tentative ideas, labeled as such, which will eventually, I hope, be more completely expounded elsewhere, supported by all the necessary evidence. Would it have been better to leave them out? Rightly or wrongly, I have always felt that I owed the student in my courses the benefits of my thoughts even when not fully tested by proof, and I saw no reason why I should not follow the same principle in this book. . . .

FOREWORD TO THE SECOND EDITION, 1979

y generous publishers have permitted my considerable expansion in both text and illustrations in this Second Edition. As a result, I have been able to rectify to a considerable extent my Tuscan bias and to include a number of important Northern Italian painters, sculptors, and architects for the first time. I have also been able to extend the treatment of both the Trecento and the Cinquecento by the inclusion of more artists and of additional works by some masters already present. Alas, if all the artists I would like now to have included were to make their way into these pages, the Second Edition would require two volumes! . . .

There is little necessity to justify an attempt to bring a book such as this one abreast of recent literature. Bernard Berenson once quipped that his *Italian Painters of the Renaissance* was a literary classic and he had no right to touch it. No such claim can be made for this volume. . . . My professional colleagues

will be the first to recognize that this goal cannot be fully achieved. The outpouring of books and articles dealing with all aspects of Italian Renaissance art in the past ten years has been immense, and new discoveries have changed radically our ideas about many works of art treated in these pages. Inevitably, today's commonplace is tomorrow's antique. . . .

If I have learned one lesson in a long professional career, it is the danger of faith in one's own infallibility. Anyone can be proved wrong. Investigators who devote a disproportionate amount of their energy to pursuing the mistakes of others pay the penalty of slighting the larger issues of aesthetics, meaning, social relationships, and historical development that are the central mission of art history, and they also run the risk of slipping or being pushed, sometimes spectacularly, into the pit of error over which we must all thread our way along such slender bridges. . . .

PREFACE TO THE THIRD EDITION, 1986

orks of art, like all human productions and like ourselves, are bound in time. . . . Their history, therefore, is a part of their very nature, if by history we mean their place in the development of art, and their relation to the circumstances under which they were produced. The history of works of art after creation is another story. It should not be essential to their appearance, but it too often is, in the case of damage or other alteration, and that also must be at least mentioned.

In determining historical importance, paternalism again sets in. The writer of a general text has to make difficult choices, and must often leave out works of high quality in favor of others somewhat less attractive in order to provide a reasonable account of historical situations and their development. The reader, then, is asked to trust the writer's judgment based on experience, and to recognize that sometimes these choices were painful.

In the forewords to earlier editions I have admitted to a personal slant in favor of Tuscany and especially Florence, which I would be willing to relinquish if it would be proved to me that the Renaissance originated anywhere else. I must also confess to greater excitement in contemplating the beginning of an important cycle than its end, and thus, according to some colleagues with later interests, have slighted the Cinquecento. In the second edition I included for the first time a number of important North Italian painters, sculptors, and architects, and in this one I have brought into the fold several more painters and sculptors, all from the Cinquecento and mostly from the North. In order to include these masters without increasing the size of the book unreasonably I have been obliged to eliminate two or three earlier and lesser artists as well as some important works, such as Giotto's frescoes in the Peruzzi Chapel, which are in such poor condition that they cannot be appreciated in small reproductions. . . .

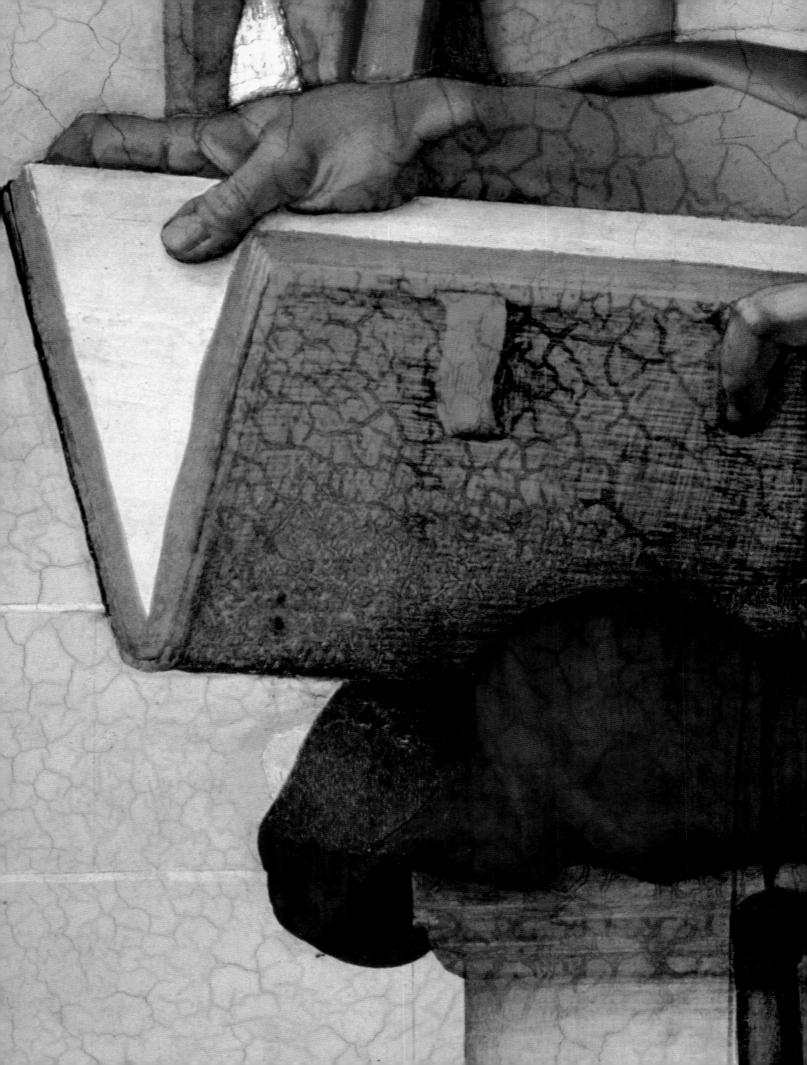

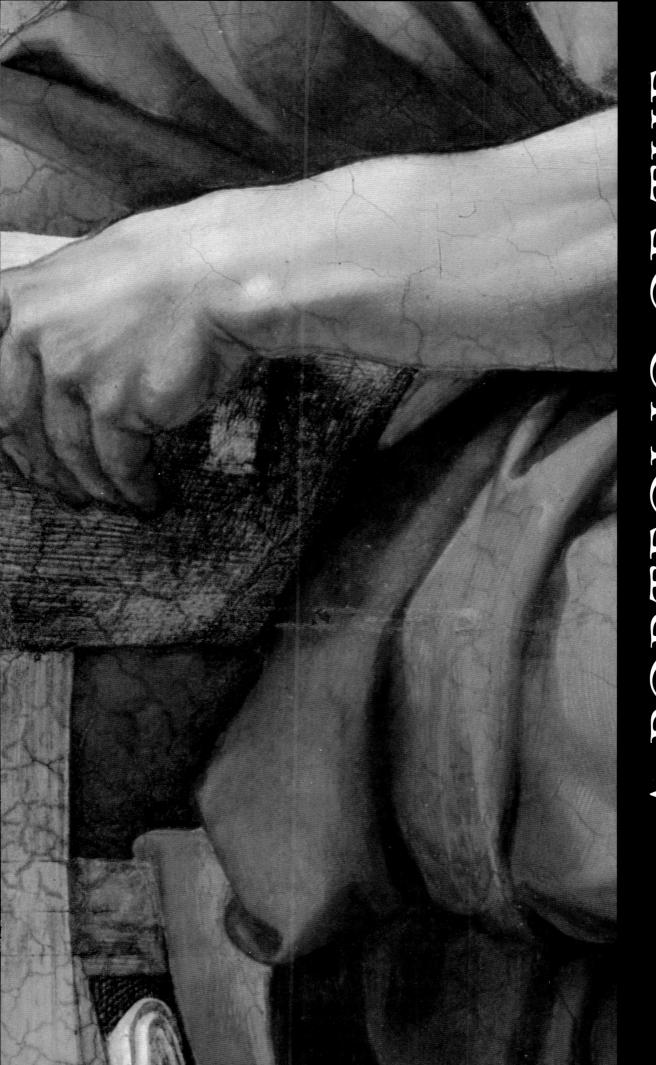

A PORTFOLIO OF THE

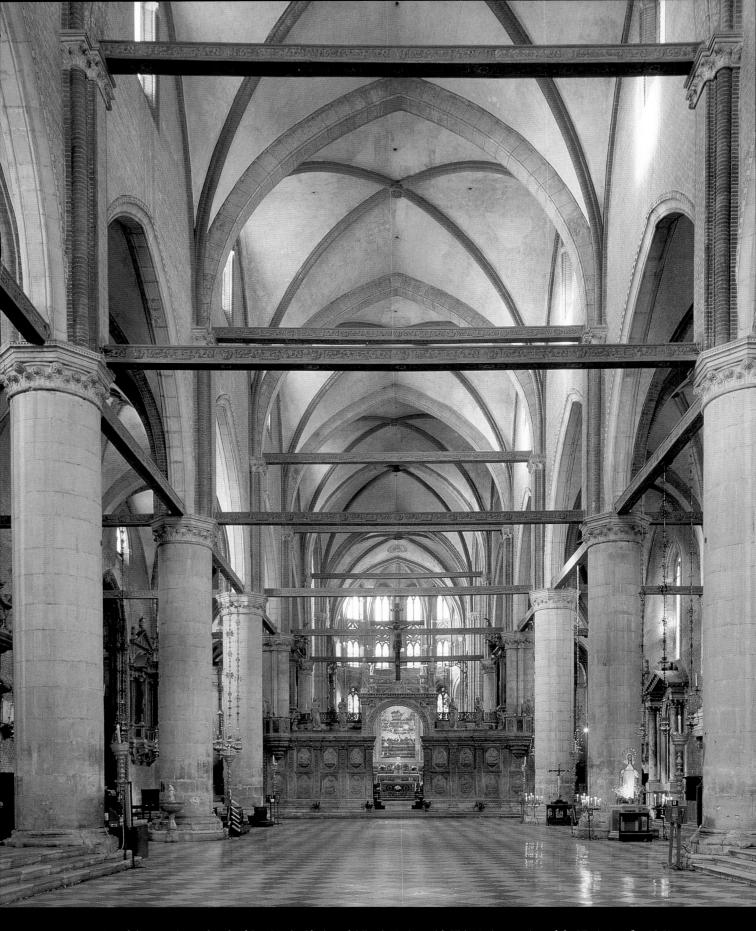

1. Interior of the Franciscan church of Sta. Maria Gloriosa dei Frari, Venice, with Titian's Assumption of the Virgin (see fig. 19.8) over the high altar. Begun c. 1330, finished after 1443.

Length of nave, 295' (90 m). Commissioned by the Franciscans. (see figs. 5.17, 5.18)

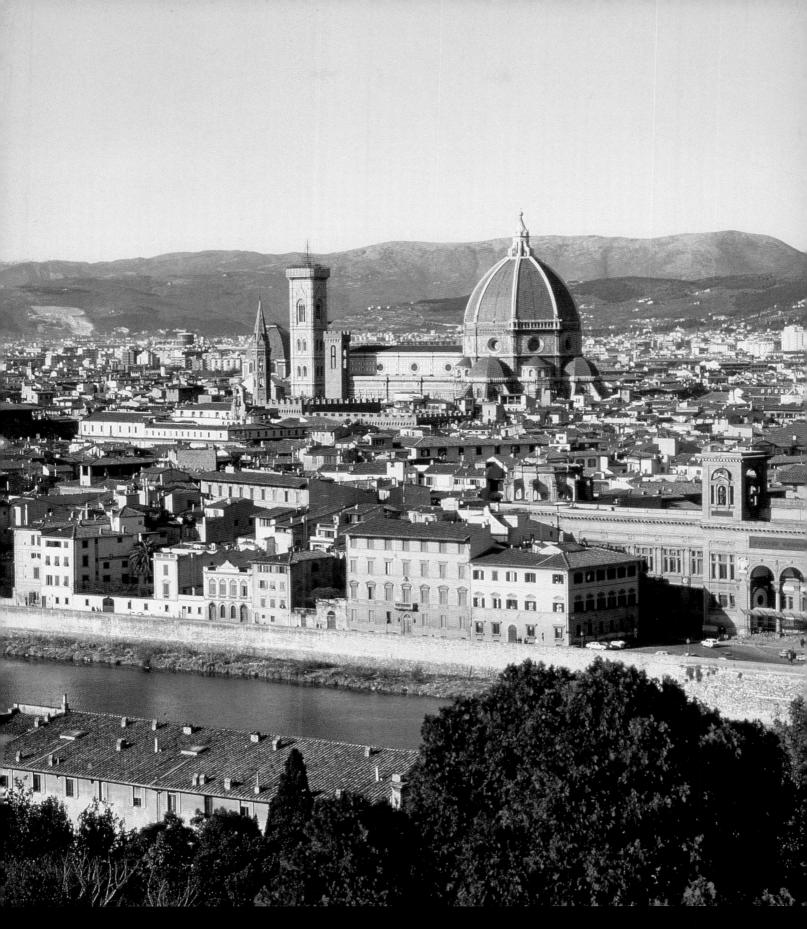

2. View of Florence with Arno River and Florence Cathedral and Campanile (see figs. 3.25, 3.26, 5.14, 5.15, 6.2, 6.5)

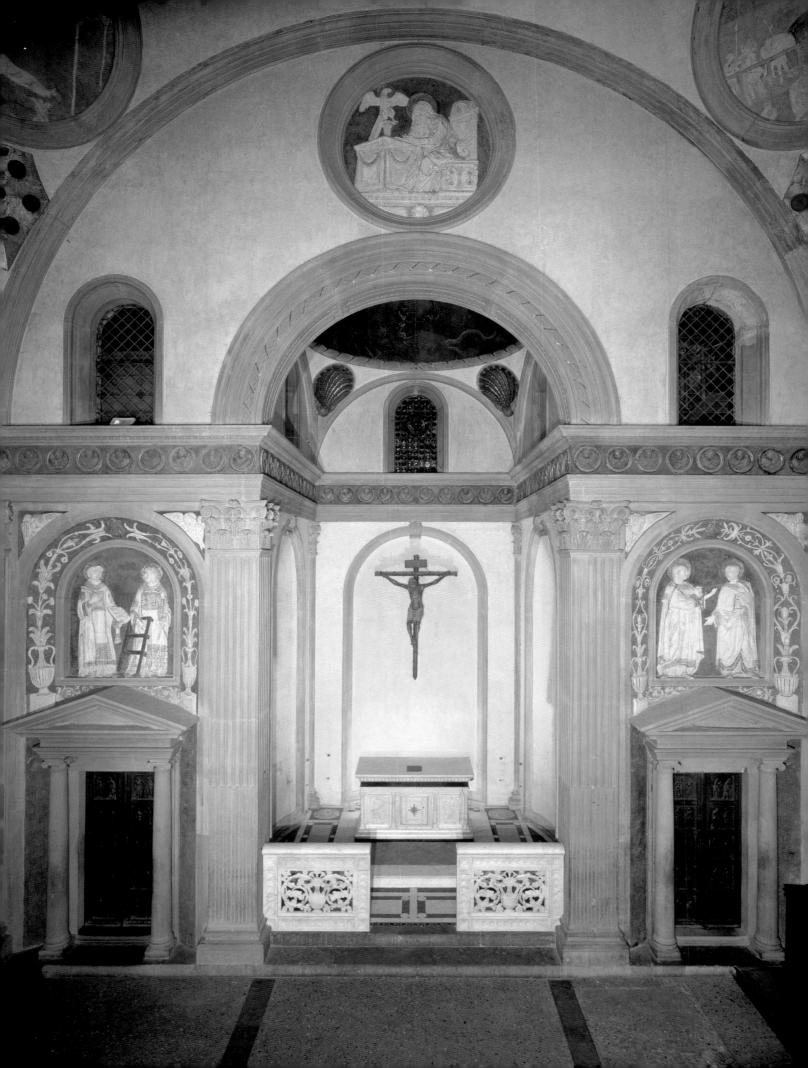

Opposite: 3. FILIPPO BRUNELLESCHI.
Sacristy, S. Lorenzo, Florence. 1421–28.
Stucco reliefs and bronze doors
by DONATELLO. After 1428–c. 1440.
(see figs. 6.7–6.9)

4. DONATELLO. *St. George.* c. 1415–17. Marble, height of figure 6'5" (1.95 m). The figure is now in the Bargello, Florence. Commissioned by the Arte dei Corazzai e Spadai for their niche on Orsanmichele, Florence. (see figs. 7.15–7.17)

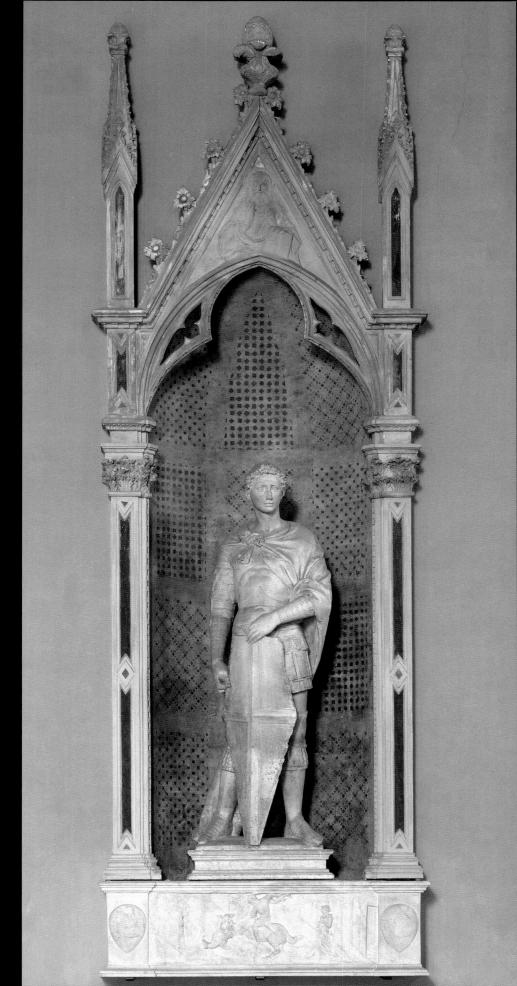

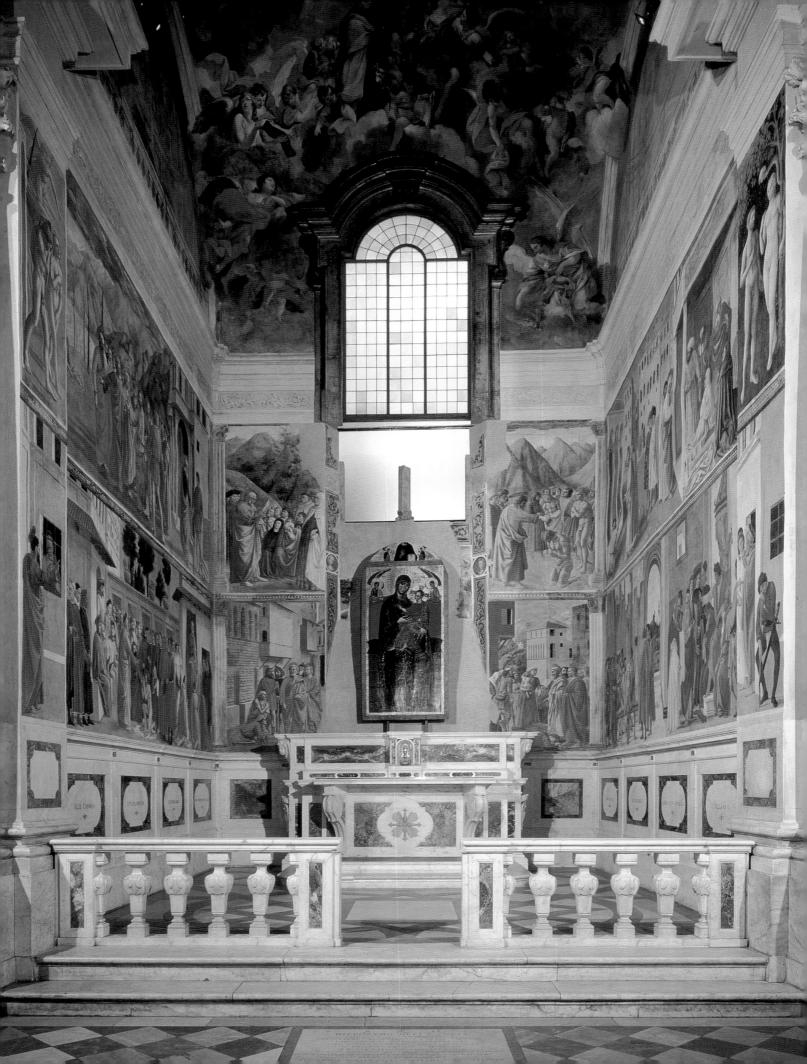

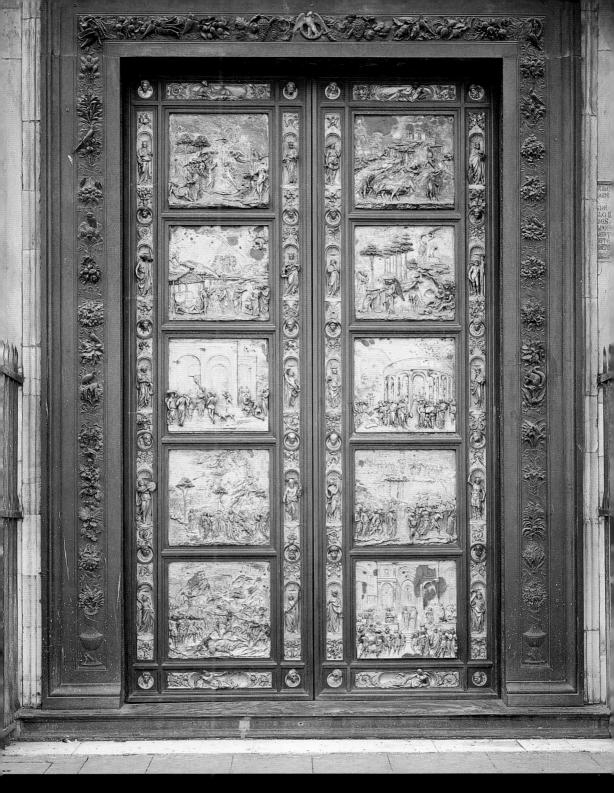

5. LORENZO GHIBERTI. *Gates of Paradise* (East Doors), Baptistery, Florence. 1425–52. Gilded bronze, height approx. 15' (4.6 m). Museo dell'Opera del Duomo, Florence. Commissioned by the Opera of the Baptistery and the Arte di Calimala for the Florentine Baptistery. (see figs. 10.15–10.20)

Opposite: 5. MASACCIO, MASOLINO, and FILIPPINO LIPPI.

Prancacci Chanal Sta Maria del Carmine Florence Lece fias & & &?

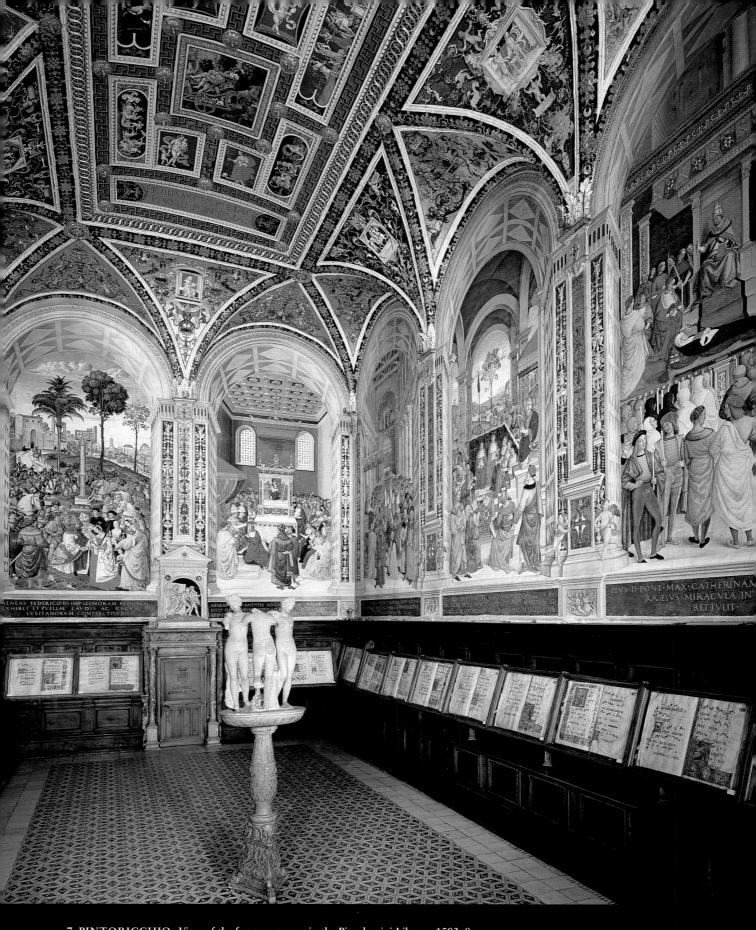

7. PINTORICCHIO. View of the fresco program in the Piccolomini Library. 1503–8.

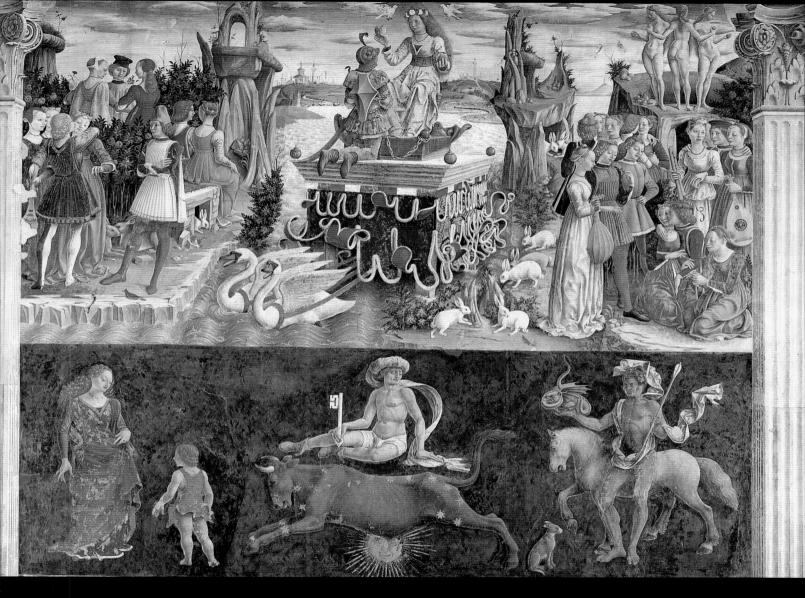

8. FRANCESCO DEL COSSA. April. 1469–70. Fresco, width 13'2" (4 m). Hall of the Months (portion), Palazzo Schifanoia, Ferrara. (see figs. 15.60–15.61)

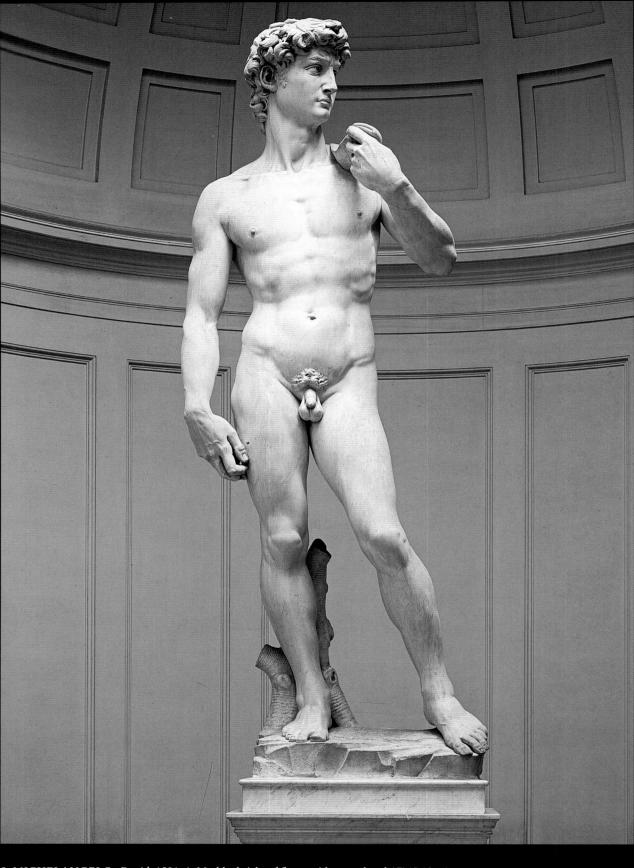

9. MICHELANGELO. *David.* 1501–4. Marble, height of figure without pedestal 17' (5.18 m); height of figure with pedestal 23' (7 m). Accademia, Florence. Commissioned by the Opera del Duomo, Florence. (see figs. 16.39, 16.40)

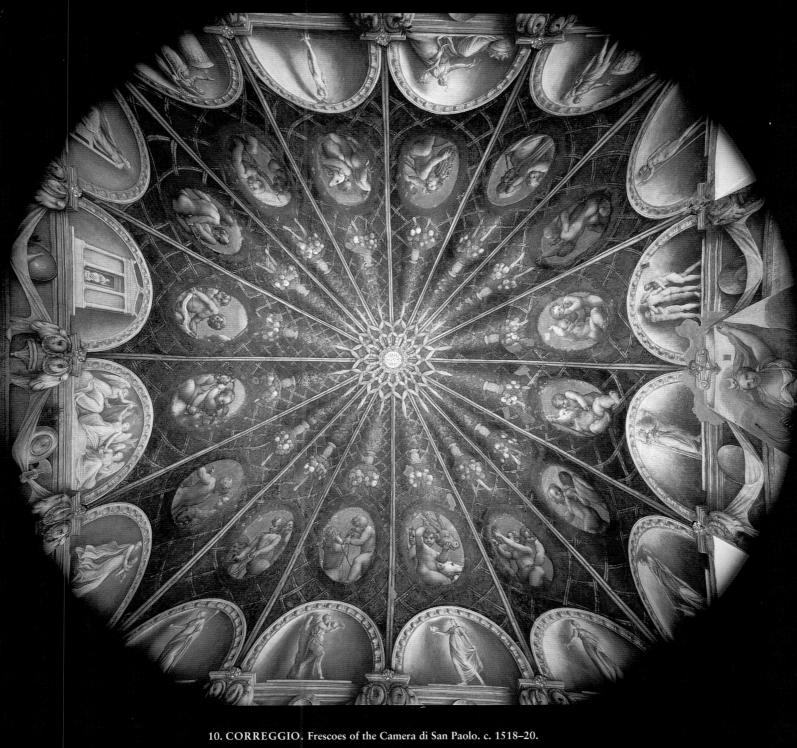

10. CORREGGIO. Frescoes of the Camera di San Paolo. c. 1518–20. Convent of San Paolo, Parma. Commissioned by Giovanna da Piacenza, Abbess of the Convent of San Paolo. (see fig. 18.43)

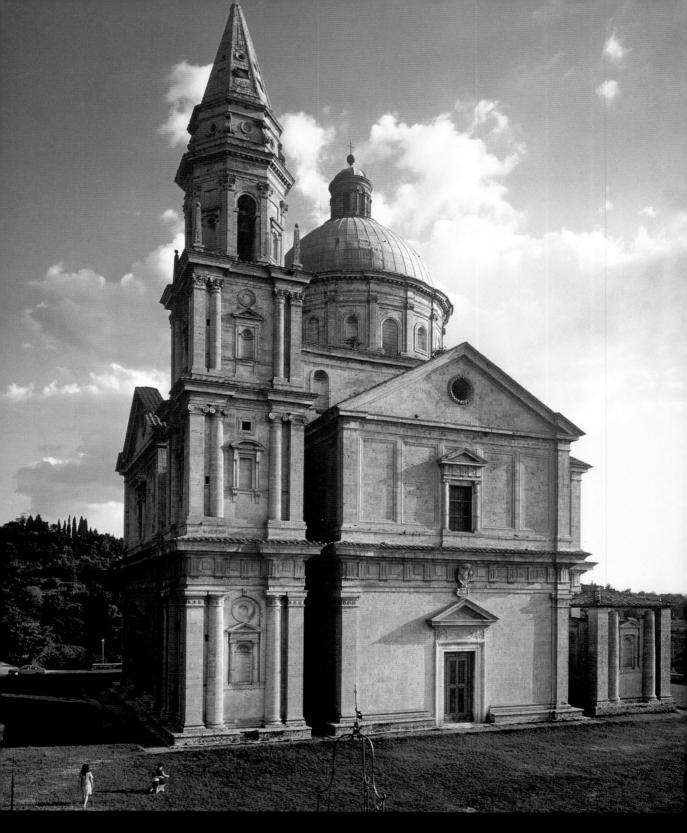

1. ANTONIO DA SANGALLO THE ELDER. Madonna di S. Biagio, Montepulciano. 1518-34. (see figs. 18.58-18.60)

Opposite: 12. TITIAN. Madonna of the Pesaro Family as seen in its original frame in the Church of Sta. Maria Gloriosa dei Frari,

Venice Commissioned by Jacopo Pesaro, Risbor of Paphos, and his brothers (see firs. 1914, 1915)

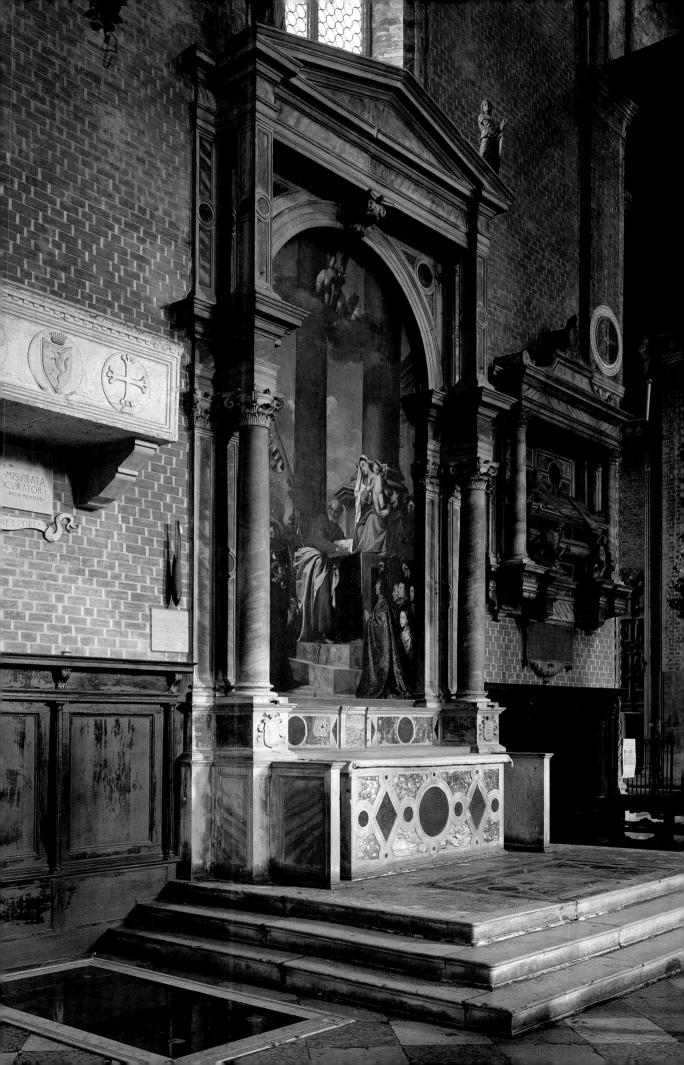

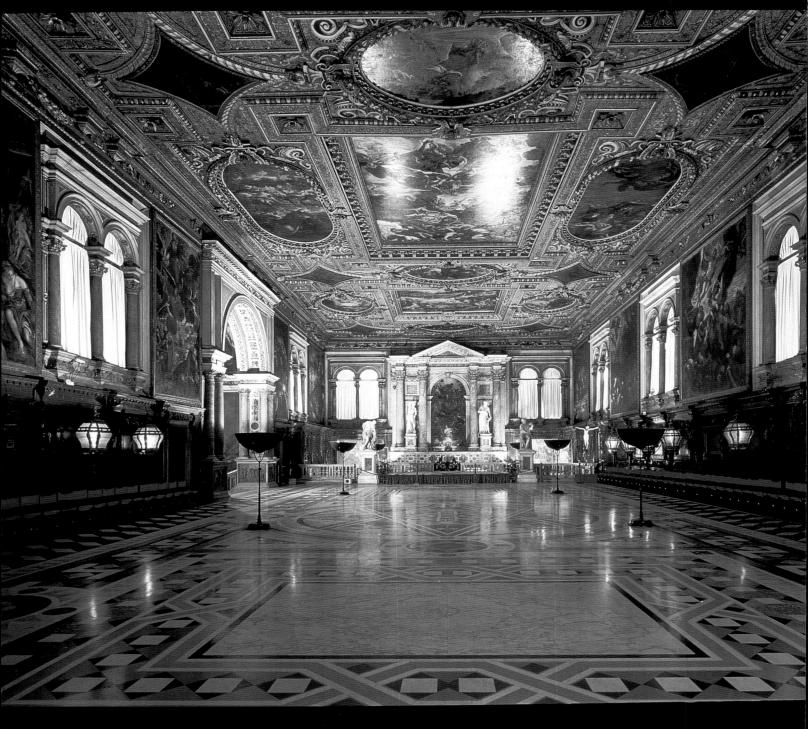

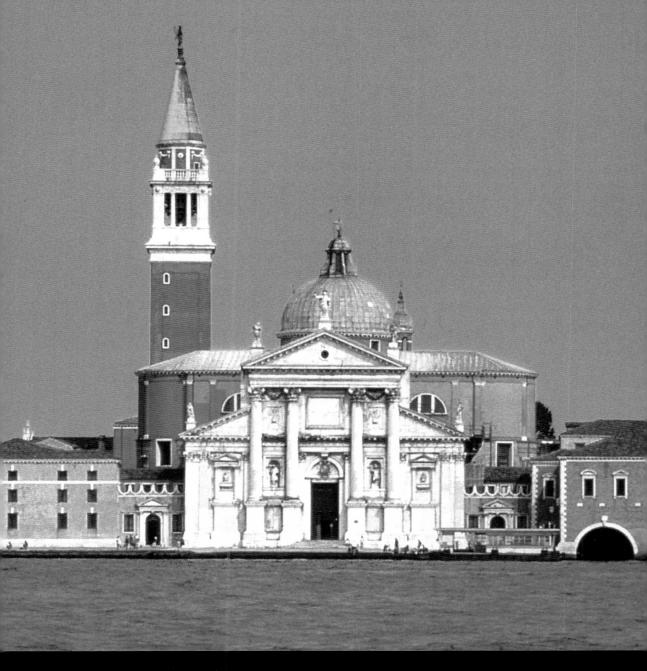

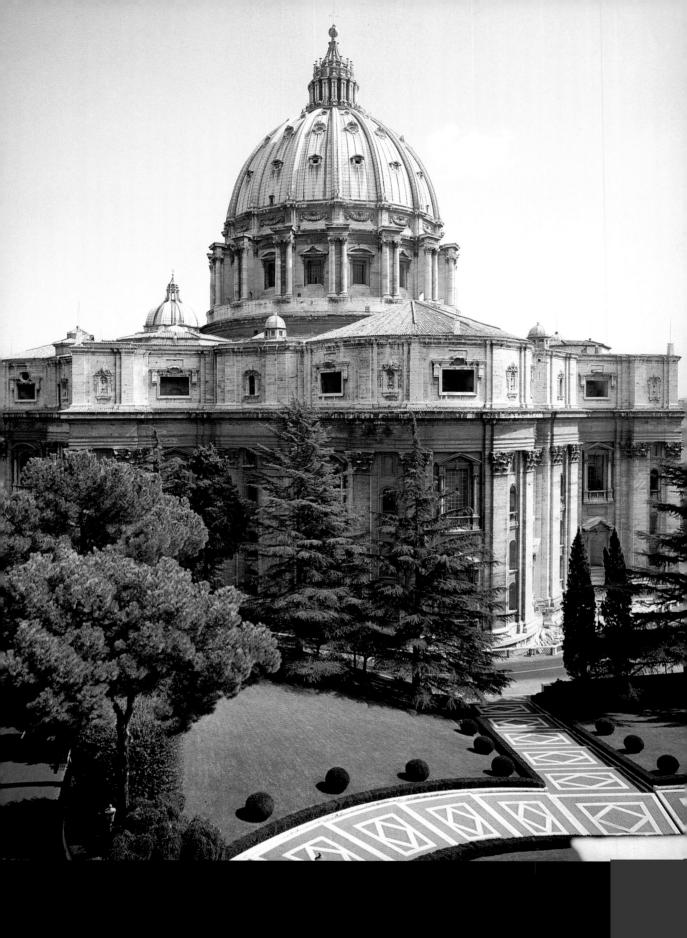

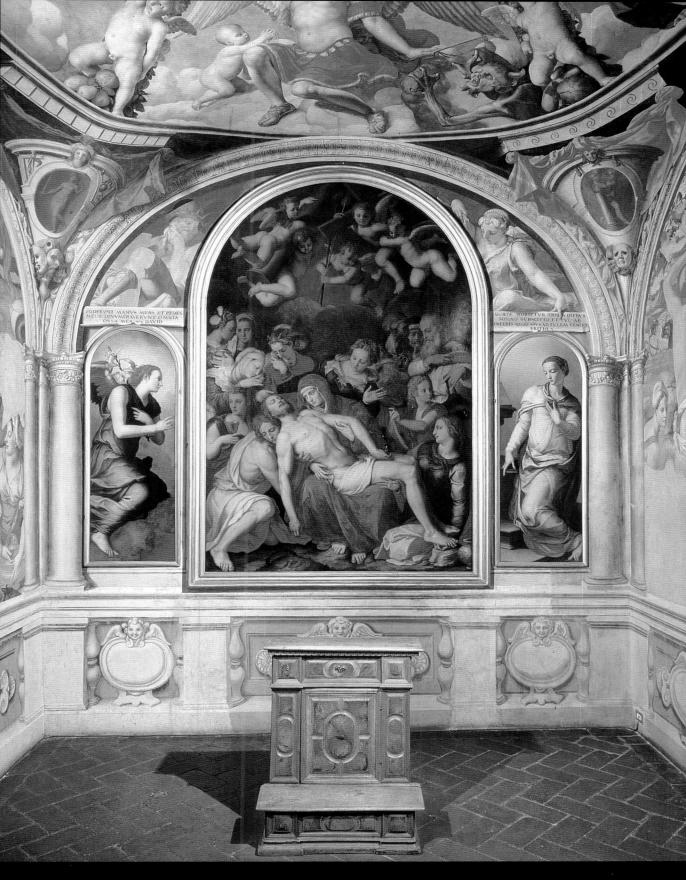

16. BRONZINO. Altarpiece and frescoes in the Chapel of Eleonora da Toledo, Palazzo Vecchio, Florence. c. 1540. Fresco and tempera, size of chapel 16'1" (4.9 m) deep x 12'7" (3.8 m) wide. (see figs. 20.35, 20.36)

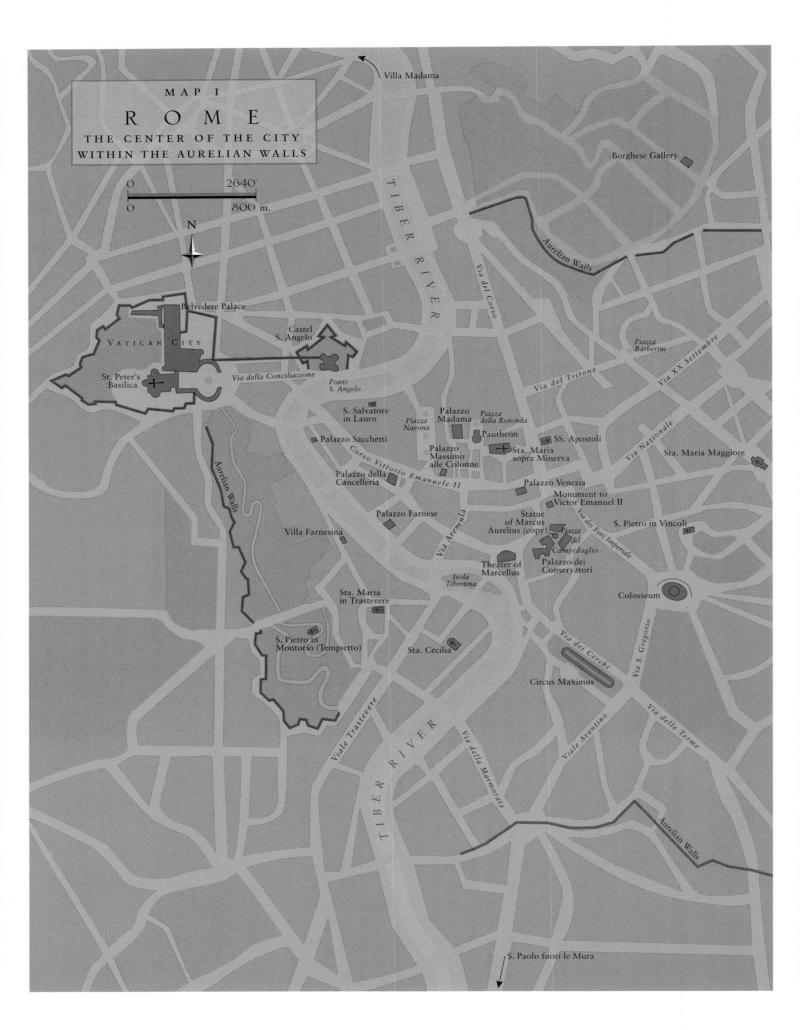

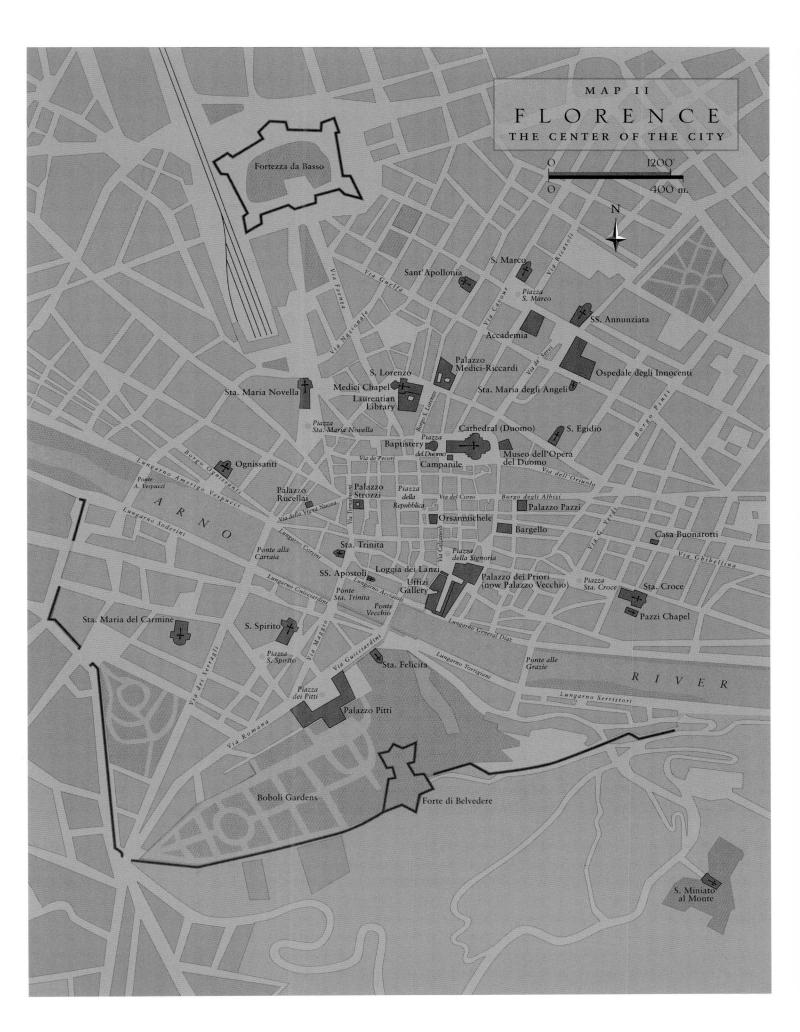

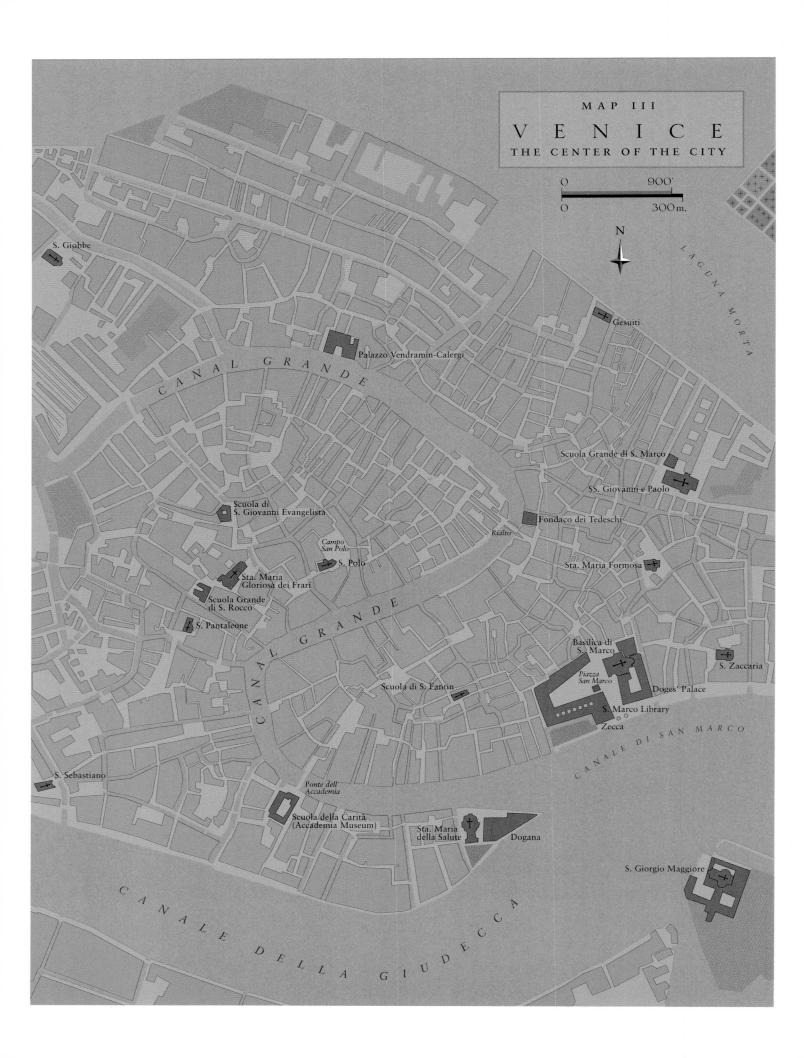

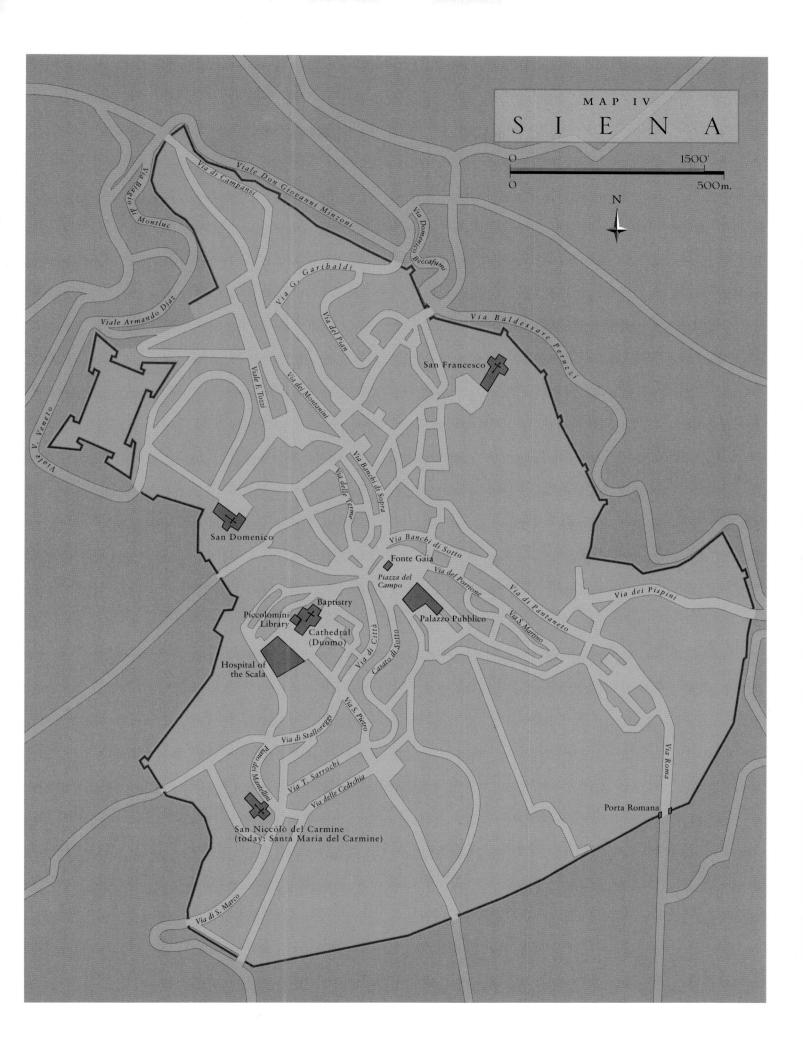

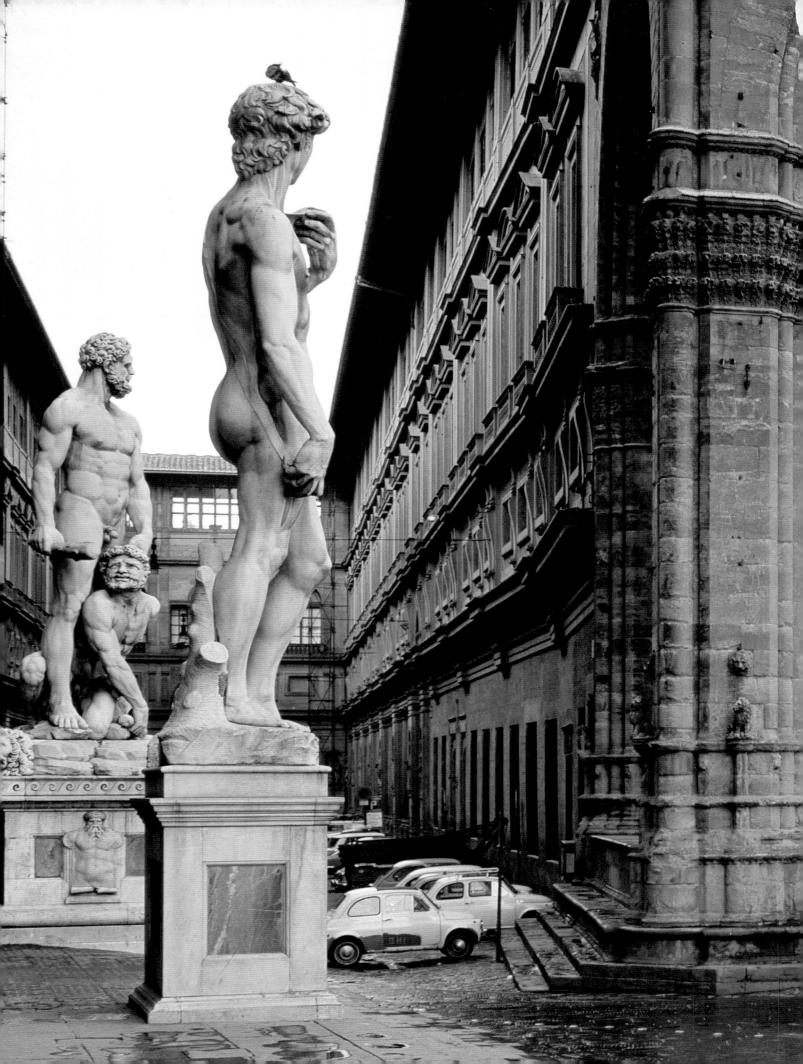

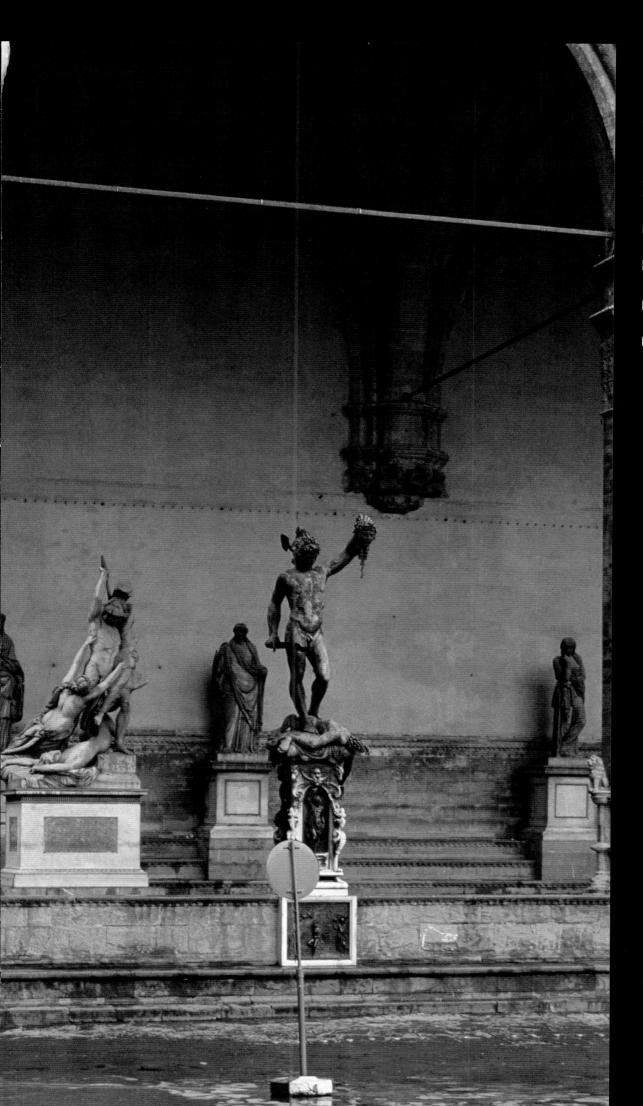

P R E L U D E

TALYAND

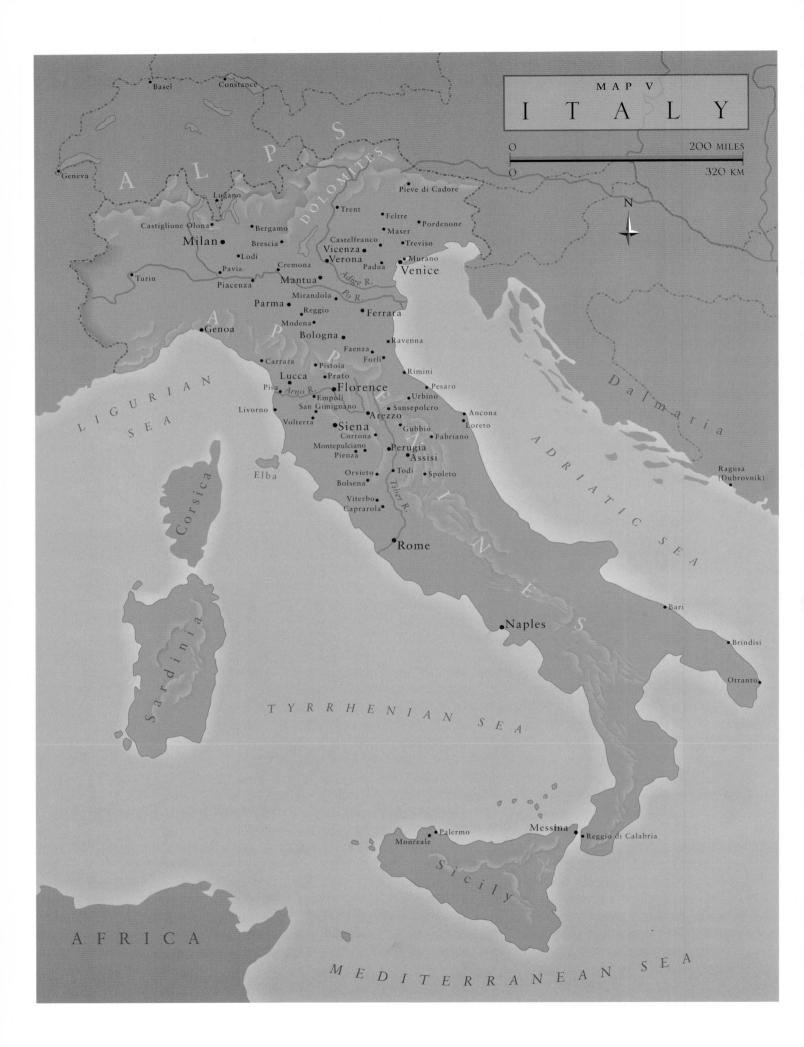

ITALY AND ITALIAN ART

he matrix of Italian art is Italy itself (map 5). The variety of the Italian landscape, even over short distances, transforms a country roughly the size of California into a subcontinent, harboring a seeming infinity of pictorial surprises. Alpine masses shining with snow in midsummer, fantastic Dolomitic crags, turquoise lakes reflecting sunlight onto cliffs, fertile plains, poplar-bordered rivers, sandy beaches, Apennine chains enclosing green valleys, vast pasture lands, glittering bays enclosed by mountains, volcanic islands, dark forests, eroded deserts, gentle hills—all these combine to make up the land of Italy.

But not all the beauty of Italy was provided by nature. The country and its people have made their peace in an extraordinary way. Many towns and even some large cities do not lie in the valleys but are perched on hilltops, sometimes at dizzying heights. The reason for such positions is not hard to discover, for most Italian towns were founded when defense was essential. At the same time the views from their ramparts offered the inhabitants not only a military but also an intellectual command of surrounding nature. Even the hills that are not crowned with cities, villages, castles, or villas-and most of those that are-have been turned into stepped gardens, terraces that hold, growing constantly and together, those essentials of Italian civilization—wheat, the olive, and the vine. Only here and there does one come across wild tracts whose rocks or sand have defied attempts at cultivation.

Agriculture and forests are submitted to the ordering intelligence of human activity. On the Lombard plains the plots of woodland are marshaled in battalions; like perfect sentinels, cypresses guard the Tuscan hills. Three-hundred-year-old olive trees shimmer in gray and silver, winter and summer alike. The gardens are not simple flowerbeds but hedged and terraced evidence of human planning, patience, and skill. The Italian climate is less gentle than its reputation; even in southern Italy and Sicily, winter is dark, wet, and inter-

minable, while throughout the peninsula, summer is hot, autumn rainy, and spring capricious. Yet in three millennia or so of stormy marriage with the land, the Italians have created a kind of harmony between human life and the natural world that is not found elsewhere.

In recent decades, the forces of industrialization have drained the historic hill farms of their population. Stone farmhouses stand abandoned among untended olive trees and crumbling terraces. Blocks of apartment houses and factories in modern suburbs mar the beauty of many valleys and plains. The modern highway, metastasizing through the peninsula and inevitably accompanied by factories and warehouses, has devoured many a beautiful vista. Automobile smog has fouled the once-clear skies over Florence, Rome, and Naples. The façades of many churches and palaces are blackened by exhaust fumes. But one can still experience the Italian concord with nature. Country roads are still traveled, and hill farms still worked by pairs of colossal long-horned oxen. The smoke still rises from the ancient towns on their hilltops, and views across lines of cypresses and up rocky ledges reveal what might be the background of a fresco by Benozzo Gozzoli. The vast Umbrian spaces are much as Perugino saw them, and the woods in the Venetian plain seem ready to disclose a nymph and satyr from the paintings of Giovanni Bellini.

The Role of Antiquity

While it is in part the harmony with nature that explains why Italian Renaissance art is distinctive, another factor is the survival of artistic and architectural monuments from the culture of ancient Rome. Though it is impossible to catalogue all ancient works known during the Renaissance, it is clear that ancient sarcophagi, sculptures, and coins were abundant, as were fragments of architectural structures, some of which had been reused as decoration and/or structure in medieval buildings. Entire ancient monuments

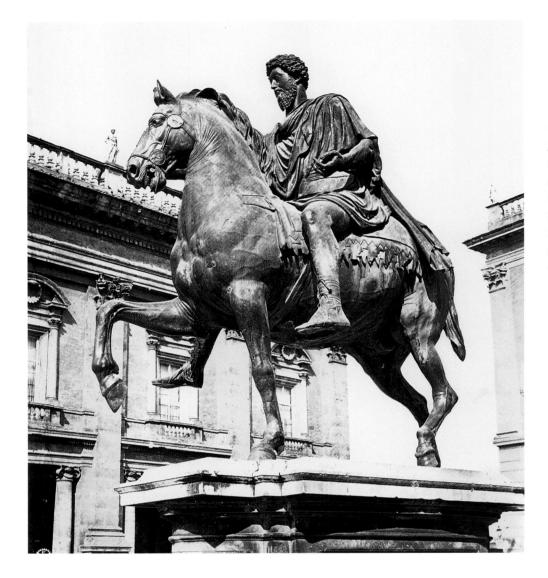

1.1. Equestrian Monument to Marcus Aurelius. 161–80 C.E. Bronze (originally gilded), over-life-size. Now in the Capitoline Museum, Rome. In the sixteenth century Michelangelo relocated this monument to the center of the Capitoline Hill (see fig. 20.15).

seldom survived; one influential exception is the Pantheon in Rome, the huge dome of which soars 144 feet above the floor. The domes of both Florence Cathedral and St. Peter's in Rome were intended to challenge the preeminence of the ancient dome of the Pantheon.

In several Italian cities, Roman theaters and arenas were evocative reminders of the glory of the ancient world, but even a coin or a fragmentary torso of a sculpted figure could provide inspiration to artists drawn to the antique. During the Renaissance, ancient works were presumed to be illustrations of ancient life; the humanist Manuel Chrysolorus wrote: "But these reliefs show how things were in past times and what the differences were between peoples. They therefore make our knowledge of history exact or, rather, they grant us eyewitness knowledge of everything that has happened, just as if it were present."

Ancient Roman sculpture and ruins were the subject of drawings by Renaissance artists and architects; Giuliano da Sangallo's drawing of the *Theater of Marcellus*, for example, preserves for us a building whose appearance would

otherwise be lost (see fig. 12.24). There was excitement in the Renaissance when new ancient monuments were found; in 1506 the heroic group of Laocoön and His Sons (see fig. 17.2) was discovered among the ruins of the Golden House of Nero in Rome. Another important discovery was the fragment of a figure that became known as the Belvedere Torso (see fig. 17.3) because it was installed and displayed in the new Belvedere Palace (see figs. 17.18, 17.19); it is still there today, for the sixteenth-century palace is now a part of the Vatican Museums. The ancient bronze equestrian monument of the Roman Emperor Marcus Aurelius (fig. 1.1) had been visible in Rome throughout the Middle Ages, when it was revered because it was presumed to be a portrait of the Emperor Constantine, who had accepted Christianity as the state religion of the ancient empire. During the Renaissance, the statue was appreciated as an impressive ancient work of art, and it played an important role in inspiring Donatello's and Verrocchio's equestrian monuments to the mercenary generals Gattamelata and Colleoni (see figs. 10.31, 13.16).

The impact of these and other ancient survivals and rediscoveries for Renaissance artists and architects is evident in the following chapters. Visual materials of all sorts from the antique world were supplemented by the knowledge available in ancient texts, which were studied and reconstructed by the scholar-teachers of this period, the famous Renaissance "humanists." The human dignity and critical reasoning that they found in ancient writings played an important role in the transformation of art and society that we now call the Italian Renaissance. While the humanists showed an interest in all areas of ancient learning, they were at the same time determined to reconcile their Christian beliefs with the ideas they found in the Greek and Roman authors.

The Cities

The art, culture, and history discussed in this volume were focused in the new, vital Italian cities. The growth of cities, the new wealth accumulated there, and the increasing sophistication of urban life are important foundations for the developments that became the Renaissance. To speak of Italian cities is in some ways incorrect, for these manifestations predate the establishment of the national state of Italy in the nineteenth century. The term "Italian cities" is correct only in the sense that these centers existed on the Italian peninsula, and their citizens were unified by a common language, albeit divided into many distinct dialects.

The Italian language uses the same word (paese) for village and country (in the sense of nation), and to the medieval Italian and to millions of Italian villagers today, the boundaries of "country" do not extend beyond what can be seen from a hilltop village. A map of Italy in the Late Middle Ages or Early Renaissance looks like a mosaic, the pieces representing separate political entities that were sometimes hardly larger than a village. These communes, which have often been compared to the city-states of ancient Greece, were all that remained of the Roman Empire, or of the kingdoms and dukedoms founded in the disruptive period following the barbarian invasions and the ensuing breakup of ancient Roman society. During the Late Middle Ages, from the eleventh through the fourteenth centuries, these city-states were quite independent of one another. Each had its own peculiar political organization, at least outside the fairly monolithic south, the so-called Kingdom of the Two Sicilies or Kingdom of Naples. Each ruled its surrounding area of farmland and villages from the central city. Each spoke a different, sometimes sharply individual, dialect, and not until the Renaissance did the modern Italian language begin to emerge, based on the Tuscan dialect. Although undermined by radio and television, many of these dialects are still spoken today.

At the outset of the Late Middle Ages, most city-states were republics, but in Lombardy, in the northwest, many were ruled by their bishops. In general, they were merchant cities, and the republican governments were dominated by manufacturers, traders, and bankers. These republics were in a state of endemic if sporadic war with each other, even with visible neighbors (Florence with Fiesole, Assisi with Perugia). Even fiercer than the intercommunal wars, however, were the civil eruptions of family against family and party against party within the communes. Under such conditions, it was easy for powerful individuals to undermine the independence of a city-state. Nobles in their castles, mercenary generals ostensibly hired to protect the republic, and powerful merchants struggled to gain control of the prosperous towns, and their success in the fourteenth and fifteenth centuries often led to the destruction of communal liberties. The most successful of these superpolities was the papacy, which maintained varying degrees of control over a wide belt of central Italian states from its center in Rome.

Some of the republics were destined for greatness. Venice, at the top of the Adriatic, had by the thirteenth century established an enormous empire, largely to maintain its commercial ties with the East. By the end of the thirteenth century, Florence in Tuscany was trading with northern Europe and Asia, and had so many branches of its banking firms in Europe that Pope Innocent III declared that there must be five elements, rather than four, because wherever Earth, Water, Fire, and Air were found in combination, one also saw Florentines. There were other important republics as well: Siena, Lucca, Pisa, Genoa—all separate, proud, independent states—and many that were smaller. Each state, whether a republic or ruled by a despot (duchy, marquisate, county, or merely signoria-lordship), tended to absorb its smaller neighbors by conquest or purchase. As a result, by the end of the fifteenth century the peninsula was divided into a decreasing number of polities, each dominating a considerable subject territory. Yet they were unable to unite against the menace of the increasingly centralized monarchies of the rest of Europe which, in the sixteenth century, were to submerge Italy almost entirely.

The most striking phenomenon apparent in these Italian city-states was the dense huddle of houses of almost uniform height—regulated by law—crowding up the slopes and toward the summits of the hills, often still surrounded by defensive city walls with gates and towers. The jumbled planes of the tiled roofs were punctuated here and there by the loftier walls and towers of churches and civic buildings. The town houses of the great noble and commercial families also generally culminated in towers, built to secure the fortunes—and sometimes the lives—of their owners. Only in a few isolated towns are some of these house-towers preserved to their full height; in the Late Renaissance, when the small republics had coalesced into a few larger princedoms, the owners were forced by decree to truncate these symbols of family power.

In or near the center of every town was the piazza, an open space that is even today the focus of civic life, just as it had

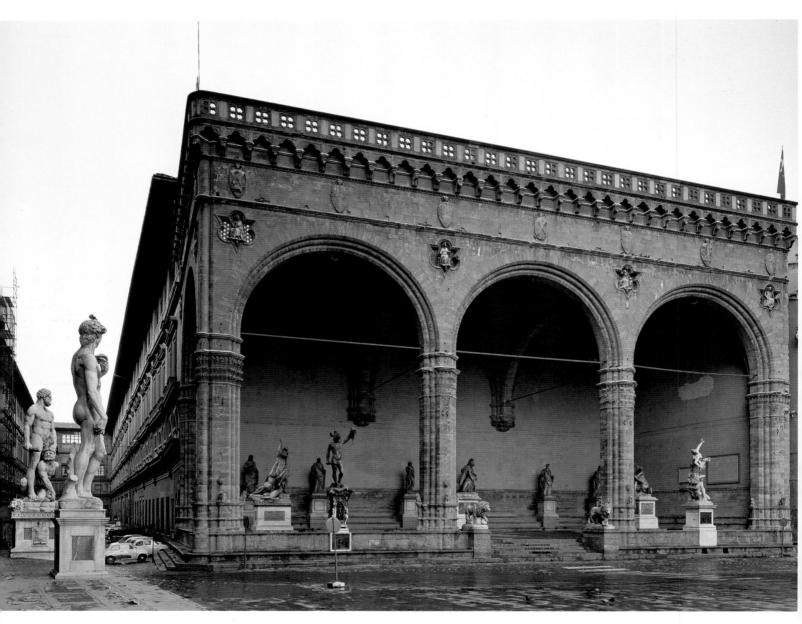

1.2. Piazza della Signoria, with a view of the Uffizi (see fig. 20.40) and the Loggia della Signoria (dei Lanzi). Built 1376–c. 1381 under the supervision of BENCI DI CIONE and SIMONE TALENTI. The loggia was originally built in Republican times as a speakers' platform but the sixteenth-century Medici transformed it into a guard station (hence the current popular name, Loggia of the Lances) and a place for the presentation of sculpture, some of it in support of the Medici regime. Underneath the left arch of the loggia: Perseus and Medusa, by BENVENUTO CELLINI (see fig. 20.25); under the right arch: Rape of the Sabine Woman, by GIOVANNI BOLOGNA (see figs. 20.30, 20.31); to the left is a copy of MICHELANGELO'S David (see figs. 9, 16.39), placed on the statue's original site.

been in ancient Roman times (fig. 1.2). Italian art was based in part on communication between people in the square and its adjoining streets, the sites where the life of the citizens took place. The strong sense of community and identity shared by citizens of these Italian cities is foreign to the isolation of the urban individual so often commented upon today.

In even the earliest Italian paintings, it is striking how the circumstances of life, the people, and the architecture have been transported into the works of art. Under the guise of religious or historical narrative, the paintings and sculptures

present an image of the reality experienced in everyday life—the contact, conversation, and conflict between people that constituted the drama of the piazza.

In its ground plan, Florence reveals the nature of the expansion of the Italian city-state (fig. 1.3). A bird's-eye view (fig. 1.4) shows the city in the fifteenth century, when it was the largest in Europe. A century earlier, when London and Paris were towns of twenty thousand or so and Bruges and Ghent, the trading cities of the north, did not surpass forty thousand, Florence had more than one hundred thousand

1.3. Plan of Florence. Crosshatched area, original Roman city; inner black line, thirteenth-century walls; outer black line, fourteenth-century walls and fortifications

1.4. FRANCESCO DI LORENZO ROSSELLI (attributed to).

Florence: View with the Chain. 1480s.

Woodcut, 23 x 51³/₄" (58.4 x 131.5 cm).

Every will drawn up in Florence was required to include a donation to the maintenance of the city walls.

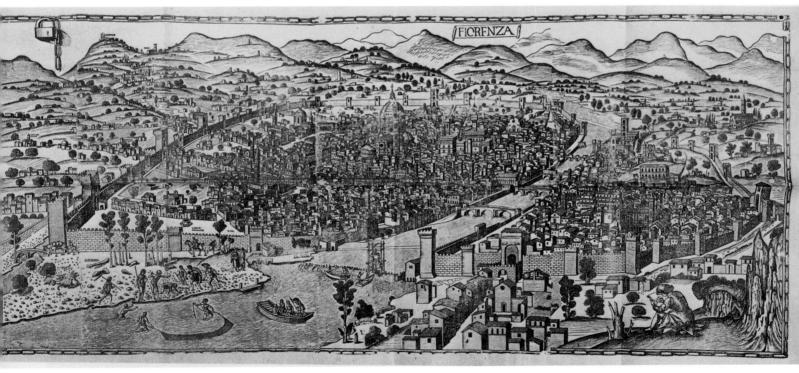

inhabitants. A colossal dome, whose construction we will presently follow, forms a focus for the city, which is surrounded by the circle of walls and then by the Tuscan hills. In the plan one can see how the metropolis grew. The original Roman city, indicated by crosshatched lines, was initially crisscrossed with straight streets intersecting at right angles. By the thirteenth century, there were more inhabitants in the suburbs clustering around the gates than inside the Roman walls, and during this period a second circle of fortifications, much less regular, was built. The third, fourteenth-century

circle of walls encompassed an area so large that the city had not filled it by the nineteenth century. Its towered gates were decorated with paintings and sculpture.

Even in today's Florence, which has grown to more than half a million, a few large gardens remain inside the boulevards that, except on the south bank, have largely replaced the walls. The narrow streets must have been overcrowded even during the Middle Ages and Renaissance. They are flanked by stone buildings that present a forbidding appearance in their present, largely stripped state. Such homes and

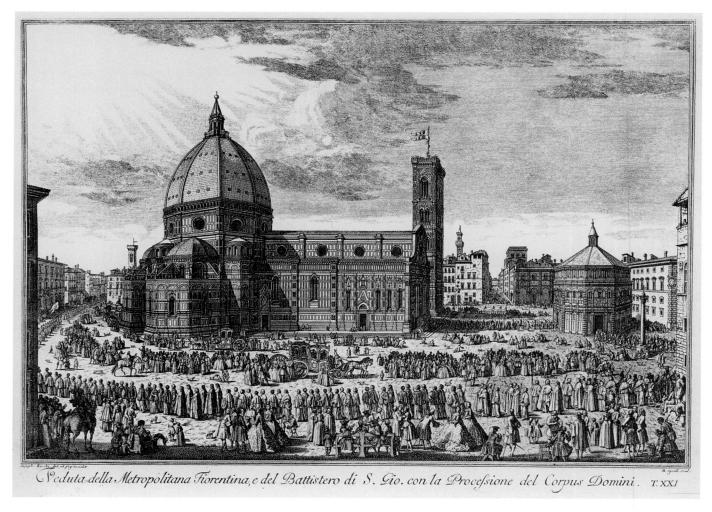

1.5. GIUSEPPE ZOCCHI. The Piazza of Florence Cathedral in 1754, with the Baptistery and Bell Tower. 1754. Etching

shops were originally coated with gray, white, or even brightly colored stucco, if we can believe the representations in old paintings. The more splendid houses were sometimes decorated with simulated architectural elements, ornament, and figures incised in the plaster in a technique known as *sgraffito*.

Although the print shown in figure 1.5 documents an eighteenth-century procession and festival, it reminds us that the great civic and religious spaces of the Italian Middle Ages and Renaissance were often used for such public festivities and ceremonies as fairs, theatrical productions, sporting events, weddings, funerals, and triumphal processions. While records survive that document the costumes, floats, music, temporary triumphal arches, dramatic productions, and other aspects of such events, the visual evidence is slim; only a later representation can suggest the drama of such an experience within its communal setting.

Siena (fig. 1.6), another important city we will examine, is some forty-five miles to the south of Florence over winding roads—in the Middle Ages probably a day's journey on horseback. A wealthy commercial and political rival of Florence, Siena would eventually succumb to her hated enemy in the middle of the sixteenth century. Siena is a hill town, with main thoroughfares in the shape of a Y along the crest of three hills in the midst of a magnificent landscape. Instead of the foursquare intersections and powerful cubic masses of Florence, Siena presents us with climbs and descents, winding streets and unexpected vistas. The Sienese were proud of their city and its reputation as a religious, charitable, and intellectual center; during the late Duecento and the Trecento, the city seems to have been governed fairly and justly by civic-minded citizens.

The last of the major cities that will concern us, Venice (fig. 1.7), is unique in its position. Supported by wooden piles set on hundreds of marshy islets in a sheltered lagoon along the Adriatic shore, Venice had no need of either city walls or the massive house construction of mainland towns. The result was an architecture whose freedom and openness come as a surprise after the fortresslike character of so many Italian cities.

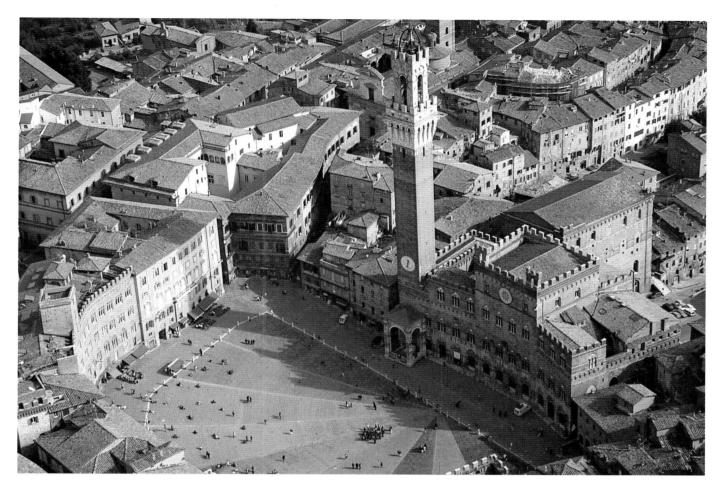

1.6. Aerial view of Siena from the west showing the Palazzo Pubblico (City Hall)

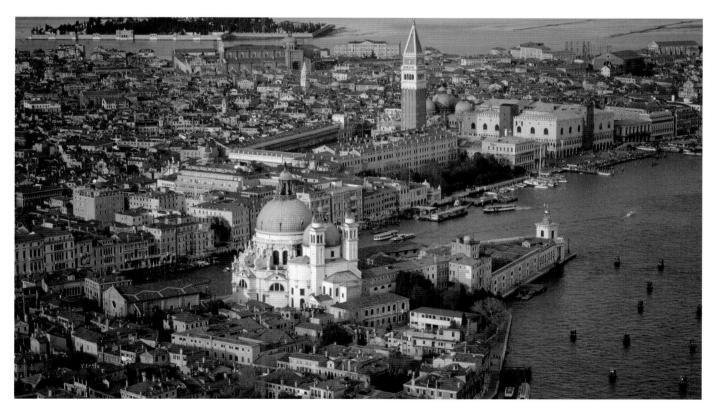

1.7. Aerial view of Venice

The Artist and the Guilds

The typical central and northern Italian city-state of the Late Middle Ages was dominated by guilds—independent associations of bankers and artisan-manufacturers—in virtually every phase of commercial and political life. Florence was a republic founded on commerce and ruled by an organization of guilds which were self-perpetuating and self-regulating. They were forced to accept the domination of the Parte Guelpha, the single political entity permitted in this protodemocracy that, however restrictive by modern standards, was in advance of anything conceived of in Western Europe since the days of Pericles and ancient Athens. In Florence the position of the guilds was symbolized by the niches reserved for them at Orsanmichele (fig. 1.8), a building that held the central food supply guaranteed by the Republic in an era threatened constantly with famine. The arches of this enor-

mous three-story structure in the center of the city were, in those days, still open to the streets, and between the arches were niches in which the principal guilds had the responsibility to place statues of their patron saints.

The seven major guilds (*Arti*, as they were called) included the Arte di Calimala, the refiners of imported woolen cloth; the Arte della Lana, the wool merchants who manufactured local cloth; the Arte dei Giudici e Notai, for judges and notaries; the Arte del Cambio, for bankers and money changers; the Arte della Seta, for silk weavers; the Arte dei Medici e Speziali, for doctors and pharmacists; and the Arte dei Vaiai e Pellicciai, for furriers. The painters, oddly enough, belonged to the guild of doctors and pharmacists, to which they were admitted in 1314, perhaps because they had to grind their colors just as pharmacists ground materials for medicines. In the 1340s the painters were classified as dependents of the physicians, perhaps because painters and doctors enjoyed the protection of the same patron, St. Luke,

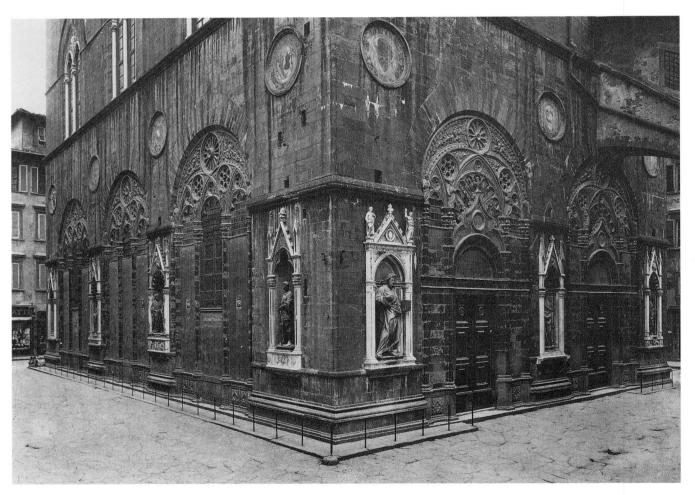

1.8. Orsanmichele, Florence, historical photograph of the southeast corner with guild patron saints and tabernacles, including NANNI DI BANCO'S Four Crowned Martyrs (third niche from left, see fig. 7.18), DONATELLO'S St. George (fourth from left, see figs. 4, 7.15), and GHIBERTI'S St. Matthew (fifth from left, see fig. 7.11). Rebuilt 1337; arches closed, later fourteenth century; niches and sculptures, fourteenth to sixteenth centuries. The sculptures from Orsanmichele are in the process of being removed for restoration and many are now on display in the Museo di Orsanmichele. (For a view of the interior, see fig. 5.2.)

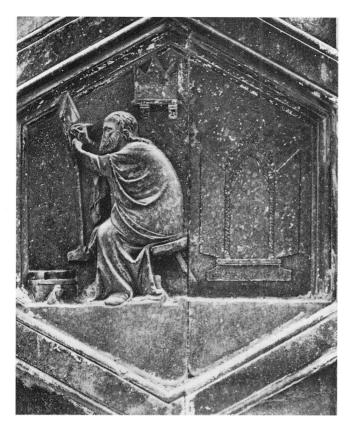

1.9. ANDREA PISANO (from designs by GIOTTO?). Art of Painting. c. 1334–37. Marble, $32\sqrt[3]{4} \times 27\sqrt[1]{4}$ " (83.2 x 69.2 cm). Removed from original location on the Campanile, Florence (see fig. 3.26). Museo dell'Opera del Duomo, Florence

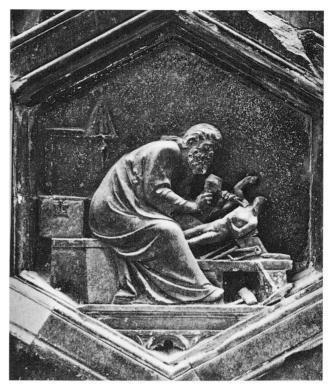

1.10. ANDREA PISANO (from designs by GIOTTO?). *Art of Sculpture.* c. 1334–37. Marble, 32³/₄ x 27¹/₄" (83.2 x 69.2 cm). Removed from original location on the Campanile, Florence (see fig. 3.26). Museo dell'Opera del Duomo, Florence

who was reputedly both artist and physician. In 1378 the painters finally became an independent branch within the Medici e Speziali.

There was a constantly shifting number of intermediate and minor guilds. Among the former, and never admitted to the rank of the major guilds, was the Arte di Pietra e Legname, artisans who worked in stone and wood. This included only those sculptors who specialized in these two materials, while a sculptor trained in metals, such as bronze (and there was a completely different attitude on the part of the citizens toward this material and those who knew how to manipulate it), was required to be a member of a major guild, the Arte della Seta.

At the bottom of the social structure, outside the guilds, were the wool carders, on whose labors much of the fortune of the city depended. Their situation in some ways was comparable to that of the slaves of ancient Athens, for although the Ciompi, as they were called, were permitted to leave their employment, their activities were strictly circumscribed by law. These workers, who constantly hovered on the brink of starvation, revolted in 1378 and founded a guild of their own, but this organization and its participation in govern-

ment were both short-lived. The oligarchy resumed control and put down the Ciompi by mass slaughter and individual execution, thus resuming control over the economy and political fortunes of the Republic.

An artist's social position, based on membership in the appropriate guild, was established in the Mechanical Arts, and not in the rigidly defined Liberal Arts—grammar, logic, rhetoric, arithmetic, geometry, astronomy, and musicwhich were considered the only arts suitable for a gentleman in antiquity and in medieval feudal societies. In the Italian city-states, however, classification among the Mechanical Arts represented a positive advantage to painters, sculptors, and architects. These arts professions were represented in a series of reliefs for the campanile (bell tower) of the Cathedral of Florence that were intended for the citizen in the street. The series begins with illustrations of the Creation of Adam (see fig. 3.32) and Creation of Eve, skips the episodes of the temptation and expulsion, and resumes with the first labors of Adam and Eve. Next, moving round the tower, the early activities of humanity are depicted, with the Mechanical Arts among them, including painting, sculpture, and architecture (figs. 1.9, 1.10, 1.11).

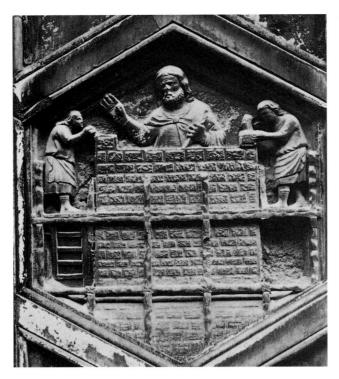

1.11. ANDREA PISANO (from designs by GIOTTO?). Art of Architecture. c. 1334–37. Marble, $32\sqrt[3]{4} \times 27\sqrt[1]{4}$ " (83.2 x 69.2 cm). Removed from original location on the Campanile, Florence (see fig. 3.26). Museo dell'Opera del Duomo, Florence

Late in the fourteenth century, the Florentine writer Filippo Villani devoted a chapter to the painters of his era, comparing them to those who practice the Liberal Arts. In 1404 the Paduan humanist Pier Paolo Vergerio claimed (erroneously) that painting had been one of the four Liberal Arts taught to ancient Greek boys. At the end of the fifteenth century, Leonardo da Vinci wrote eloquently about the importance of the Liberal Arts for artists (see p. 479). The stakes were economic as well as social. The fifteenth-century artist, with some outstanding exceptions, was not well paid and often complained of poverty, but in the sixteenth century Michelangelo (who claimed noble ancestry), Titian (who was actually ennobled), Raphael, and many other artists attained international fame, respect, and wealth. Artists who could attach themselves to a princely court—a list that included Andrea Mantegna and Leonardo da Vinci in the fifteenth century and Giorgio Vasari and Benvenuto Cellini in the sixteenth—occupied positions of prosperity and possessed the power to enforce their style on others. By the late sixteenth century, academies under princely patronage (see p. 691) began to replace the guilds.

Artists were an essential part of the era's closely knit society, and it is important to remember that they almost always worked on commission. It would hardly have occurred to an artist of the thirteenth or fourteenth century to paint a pic-

ture or carve a statue for any reason other than to satisfy a patron, and an artist who was a good manager would have a backlog of commissions awaiting execution. Artists did not work in the kind of studios that we associate with later centuries. The word itself, which means "study" in Italian, only came into use in the seventeenth century, when artists were members of academies. In the Late Middle Ages and throughout much of the Renaissance, an artist worked in a bottega (shop); this word is also used to signify the organized body of paid assistants and apprentices who labored under the direction of the master. Apprentices entering the system could be as young as seven or eight, and their instruction was paid for by their families. Until the late sixteenth century, women were excluded, in part because they were forbidden to join the appropriate guilds.

Sometimes the *bottega* was entered, like a shop, from the street and the artist at work might be viewed by passersby. Artists might even exhibit finished work to the public in their shops. Masaccio, Ghiberti, Castagno, and Antonio del Pollaiuolo, as well as other important artists, would accept commissions for jewelry, painted wooden trays (customarily given new mothers), painted shields for tournaments, processional banners, or designs for embroidered vestments or other garments. Artists were also employed to design triumphal arches, floats, and costumes for the festivals that

celebrated civic, religious, and private events. In his old age, in a period dominated by the new academic conception of the artist as well as by the new autocracies, Michelangelo protested that he "was never a painter or a sculptor like those who keep shops."

The principal object made by a painter in a bottega was the "movable picture"; the most common work in this category was the altarpiece. Such works functioned as public religious images set upon altars in churches. An altarpiece might represent the Virgin Mary or Christ or depict the saint to whom a particular church or altar was dedicated, together with scenes from his or her life. Up to the thirteenth century, with the exact date varying from place to place, the priest stood behind the altar, facing the congregation. With the celebrant in such a position, there was only room on the altar for the required crucifix, liturgical book, candles, and vessels of the Mass. Decoration—and this could include images and narrative scenes-was limited to the front of the altar and perhaps the sides and back. Sometimes the decoration was sculpted in stone or even precious metals. Often it was painted on wooden panels known as altar frontals.

In the thirteenth century, the ritual was moved in front of the altar, so that the priest had his back to the congregation except when he turned to face them for responses or readings. This change was a direct result of the growth of the city throughout Western Europe, and especially in Italy, which placed wealthy middle-class families in the position of donors to the new and often large church buildings. The belief in the efficacy of the Mass as an instrument for salvation gave rise to chapels in which Mass could be said daily, sometimes many times a day, for the souls of departed members of these families. Such chapels ranged from altars along the inner walls to structures like small churches in themselves. A few chapels were so small that barely enough space existed for the priest to stand behind the altar.

Sometimes chapter houses, intended for the meetings of a community of monks or nuns, and sacristies, where the vessels, books, and vestments of the liturgy were kept, were endowed as family chapels and provided with altars. Family chapels might outnumber by twenty or thirty to one the high altar at which Mass was said for the entire congregation.

The new position of the priest left the altar table open for large-scale religious images, and these developed rapidly in the thirteenth and fourteenth centuries. The crucifix, required for every altar, was the most logical theme (fig. 3.27, far left panel). The thirteenth century also saw tremendous growth in the veneration of the Virgin Mary. Patrons began to commission the images of the Madonna and Child, protectors of the Christian family, that play so large a part in Italian art. If the chapel were large, the side walls, the space above the altarpiece, and the vaulted ceiling might be painted in fresco with subjects related to that of the altarpiece, and by the same artist. Many of the paintings and sculptures

treated in this book come from such family chapels, and some are still in place.

Large churches were generally divided by a massive wood or stone screen into a choir, where the clergy, monks, or nuns celebrated the Divine Office (prayers and psalms sung seven times daily), and a nave for the public. This choir screen was treated as an important architectural element; if composed of a vaulted space rather than being just a surrounding wall, it could enclose a series of small family chapels. It was often surmounted by religious images, usually crucifixes, sometimes of great size, often tilted forward so that they could be seen more easily (see fig. 2.3 for example). After the destruction of most choir screens in the sixteenth century, the crucifixes were placed elsewhere in the church, or, eventually, on museum walls.

Altarpieces and the smaller devotional pictures intended for private homes as aids to devotions were almost always composed of wooden panels. Sometimes two panels were joined together, called a diptych. More common, however, were the triptychs (three panels) and polyptychs (many panels), whose architectural frames often suggest the façades of Gothic or Renaissance churches. An altarpiece on the main altar might have images and scenes painted on the back. The custom of painting the predella, or base of the altarpiece, with small narrative scenes, visible only at close range, began early in the fourteenth century. And at about the same time the Gothic pinnacles, set between or above the arches and their architectural gables, also began to provide fields for painting. The iconography of the altarpiece was determined by the clergy, or by the wealthy family who ordered it, and even its shape could be subject to the patron's tastes. The panels of the altarpiece, complete with frames, were sometimes manufactured outside the painter's studio by a carpenter who, on occasion, might also be a well-known architect; sometimes this occurred even before the painter had signed a contract to gild its background, frame, and ornaments and to paint pictures on its surfaces. Sometimes the painter was also an architect and would thus probably have provided the design no matter who carved and assembled the panels. Painters might even be confronted with ready-made panels in little harmony with their own style. One of the Giotto-Pisano reliefs (see fig. 1.9) shows the interior of a painter's bottega with an artist earnestly at work on a painting on an easel.

The Practice of Painting

The intricate procedures of the painter's craft, as practiced in Florence and northern Italy, are described in detail by Cennino Cennini in *Il libro dell'arte* (*The Book of Art*), written about 1400. Although he states that he studied with Agnolo Gaddi—the son and pupil of Taddeo Gaddi, who had been an assistant of Giotto—no evidence or paintings back up this claim. The book was written in Padua, in northern Italy,

1.12. Tempera panel dissected to show principal layers: *a.* wooden panel; *b.* gesso, sometimes reinforced with linen; *c.* underdrawing; *d.* gold leaf; *e.* underpainting; *f.* final layers of tempera

where Cennini had lived long enough to write in the local dialect rather than in Tuscan. All we know for certain is that the art of painting as described by Cennini is how things were done in his own Paduan *bottega*. Nonetheless, we have no other technical treatise from this period, and what Cennini says, although not necessarily relevant to earlier periods—and sometimes certainly in error—must be read critically.

The first step in making a tempera painting was the construction of the panels. Once joined and framed by the carpenter, the panels, of finely morticed and sanded poplar, linden, or willow wood, were taken to the painter's shop (fig. 1.12). They were then spread with gesso, a mixture of finely ground plaster and glue. Sometimes the gesso was covered with a surface of linen soaked in gesso and still more gesso was applied to the linen. When dry, the final gesso surface could be given a finish as smooth as ivory. Then came the procedure of drawing, whose exact role in the fourteenth and early fifteenth centuries is still debated among scholars.

1.13. Workshop of LORENZO MONACO. Six Kneeling Saints, study for Coronation of the Virgin. c. 1415. Silverpoint and pen on paper, 9^{5} /s x 6^{7} /s" (23.9 x 17.5 cm). Gabinetto Disegni e Stampe, Uffizi Gallery, Florence

Relatively few Italian drawings dating before the 1430s are preserved. Quite a number of these are apparently leaves from artists' pattern books that represent copies of works of art, models for standard compositions, and drawings of animals, birds, figures, and heads. Many, however, seem to be sketches for actual compositions, and some can be securely identified as such, although only one, by a member of Lorenzo Monaco's workshop (fig. 1.13), is for a section of an altarpiece. If these few drawings survive from a period when such preliminary studies were neither prized nor collected, there must have been many more.

Drawing is regarded as the foundation of art by Cennini, who devotes twenty-eight brief chapters to the subject, advising the painter to draw daily on paper, parchment, or panel with pen, charcoal, chalk, or brush (fig. 1.14). He urges the artist to draw from nature, from the paintings of the masters, or from the imagination. A generation later the architect and theorist Leonbattista Alberti, writing in Flo-

rence, speaks of "concepts" and "models" (doubtless sketches and detailed drawings) as customary preparations for painting and for *storie* (figural compositions). In the midsixteenth century, Giorgio Vasari described sketches as "a first sort of drawings that are made to find the poses and the first composition," dashed down in haste by the artist, from which drawings "in good form" will later be made.

The importance of preparatory drawings may well have varied considerably from bottega to bottega, but the evidence suggests that the fourteenth-century painter drew such standard subjects as Madonnas, saints, or crucifixes directly on the gessoed panel before beginning to paint. The painter must also have sketched complex figural compositions in small scale, on paper or parchment, to be kept next to the painting as a guide in the early stages. Dust, paint drippings, and the wear and tear of the bottega (Cennini warns painters to cover ornaments and gilding with a sheet while painting) would have rendered such sketches hardly worth preserving.

By the mid-fifteenth century, the *spolvero* (Italian for "dust off"), a new technique previously used for ornamental borders, came into broader usage. The *spolvero* was a full-scale drawing of a complex detail, such as the head of a main figure. The outlines of the drawing would be pricked with a

1.14. AGNOLO GADDI (attributed to). Life Studies of Five Heads. c. 1380. Pen and wash on parchment, $7^{3}/4 \times 6^{1}/4$ " (19.7 x 15.9 cm). Castello Sforzesco, Milan

sharp point and, after the drawing was placed on the painting's surface, it would be tapped with a sponge or a porous bag loaded with charcoal dust, thus transferring rows of dots outlining the design. Surprisingly, sometimes these dots can still be made out. In the early sixteenth century, the *spolvero* was replaced by the cartoon (from the Italian word *cartone*, a heavy paper), a drawing made on sheets of paper glued together, whose outlines were transferred by means of a metal point, or stylus, pressed against the cartoon. Several cartoons and fragments of cartoons remain, but they are few compared to the thousands that must have been executed.

Cennini is explicit on how to compose a single figure on a panel. The underdrawing began with a piece of charcoal tied to a reed or stick in order to gain distance from the panel, and thus enjoy greater ease in composing and a better ability to judge the whole composition as it was developed. Shading was done by means of light strokes, and erasures were made with a feather. When the design of the figure was determined, the feather could erase all but dim traces of the original strokes, and the drawing could then be reinforced with a pointed brush dipped in a wash of ink and water; the brush was made of hairs from the tail of a gray squirrel. After the panel was swept free of charcoal, the painter shaded in the drapery folds and some of the shadow on the face with a blunt brush loaded with the same wash, "and thus," Cennini says, "there will remain to you a drawing that will make everyone fall in love with your work."

In panel paintings of the thirteenth, fourteenth, and early fifteenth centuries, the background behind the figures and the haloes around the heads of saints were almost invariably gold leaf, applied in small sheets over a red sizing or glue called bole. Gold was used because of its precious and beautiful character and because its luminosity suggested the light of heaven. Lines incised around the contours of the figures and haloes guided the gilder. In many paintings, edges of the sheets can still be discerned. As the gold leaf tends to wear off with rubbing, backgrounds sometimes display passages of the red bole. In the thirteenth century, gold haloes, and sometimes parts of the background, were incised to make a pattern in relief, but by about 1330 these areas were decorated using low-relief punches shaped like flowers, stars, cusped Gothic arches, and other patterns to emboss such designs into the gold surface.

When the gilding of the background was complete, the painter could proceed with underpainting, usually in *terra verde* (green earth) for the flesh and, sometimes, the drapery. When the underpainting was completed, the artist would build up the actual painting in layer after thin layer of tempera-ground colors mixed with egg yolk. Because yolk dries rapidly and becomes extremely hard, the painter could not easily change a form or correct mistakes. The strokes, applied with a sharply pointed brush of gray squirrel hairs, had to be accurate, neat, and final. Although Cennini does not say so,

1.15. NARDO DI CIONE. *Madonna and Child with Sts. Peter and John the Evangelist*. Probably c. 1360. Panel, height 30" (76.2 cm) (see fig. 5.6). National Gallery of Art, Washington, D.C. (Kress Collection)

the brushstrokes are generally parallel and seldom overlap, following in concentric curves each form of flesh or drapery.

Cennini instructs the painter to make three dishes of each drapery color, the first full strength, the second mixed half-and-half with white, and the third an equal mixture of the first two, thus accounting for darks, lights, and intermediate tones. The highlights, brushed on last in white or near-white, or sometimes even yellow or gold, are inevitably the first to disappear in the rough cleaning to which almost all old pictures were subjected in the past. Cennini also instructs the painter how to achieve an effect of iridescent drapery by using a different color for highlights from that employed for darker areas. The methods he describes reveal the slow, painstaking approach required by the art of painting in tempera, and the Giotto-Pisano relief (see fig. 1.9) shows a painter working on a small panel as closely as if it were a miniature.

Blue was a special problem. The two available pigments were both imported and expensive: azurite came from Germany, and ultramarine, which was as costly as gold (sometimes more so), was produced by grinding lapis lazuli imported from Afghanistan. Both were customarily mixed with a little white. In the case of the Virgin's mantle, which was typically painted blue to represent her as Queen of Heaven, the white was usually omitted. In most early altarpieces her mantle has turned dark grayish green through the transformation of the egg medium over time. By the end of the Trecento, apparently, painters began to notice what was happening, and in most later paintings the Virgin's blue mantle is painted with materials that retain their intended hue.

The fresh bright colors and flashing gold of the altarpieces were slightly toned down by the application of varnish; varnish has even been found on thirteenth-century panels beneath a layer of fourteenth-century repaint. While a painting was displayed in a church or elsewhere for ritual, the colors would slowly be obscured by candle smoke. Only a few old pictures exist that have suffered hardly at all: one notable example is a *Madonna and Child with Sts. Peter and John the Evangelist* by Nardo di Cione (fig. 1.15). A domestic devotional image, this picture apparently remained closed for centuries, preserving the surface from dirt, fading, or other discoloration, as well as from rubbing or retouching. This is one of the best preserved of Italian fourteenth-century pictures, and it should be studied as a standard against which to measure the condition and original qualities of other tempera paintings of this period.

Altarpieces forced painters to work with meticulous care in tempera over months and even years, but in the medium of fresco they had a chance to express themselves more freely. According to Cennino Cennini, who described standard procedures probably also practiced by Giotto and his followers, fresco (the Italian word means "fresh") was the most delightful technique of all, probably because the painter could work fast, pouring out ideas with immediacy, vivacity, and intensity. A fresco may appear detailed when viewed from the floor, but when examined closely, it is apparent that it was executed at considerable speed. Most Italian fresco painters could manage an approximately life-sized figure in two days—one for the head and shoulders, the other for all the rest. Counting an additional day for the background architecture or landscape, one can devise a rule of thumb that arrives at the amount of time involved in painting a fresco by multiplying the number of foreground figures by three days.

Some painters, such as Masaccio, who finished the *Expulsion* in only four days, worked even faster (see figs. 8.15–8.17).

In creating a fresco (fig. 1.16), the thirteenth- or fourteenth-century painter seems to have painted directly on the wall without preparatory drawings on paper beyond the kind needed for painting on a panel. But if the subject were unusual, requiring new compositional inventions or perhaps prior approval of the patron, more detailed drawings may well have been made. The painter probably drew on the wall rapidly, standing on a scaffolding before a wall whose masonry had been covered with a rough coat of plaster called arriccio. On this surface the painter could lay out the principal divisions of the area to be painted with the aid of lines created by snapping a cord suffused with chalk against the wall; the same technique, using a string tied to a nail, would be applied by artists interested in establishing recession in perspective. Then, with or without the aid of preliminary sketches, the painter drew the composition rapidly, first with a brush dipped into pale, watery earth color that would leave only faint marks.

Over these first ocher indications, the painter could draw the rough outlines of the figures lightly with a stick of charcoal, further establishing the poses and principal masses of drapery. The third stage was a drawing in red earth called *sinopia* (pl. *sinopie*), after the name of the Greek city Sinope, in Asia Minor, from which the finest red-earth color originated. Mixed with water, the red earth made an excellent material to establish musculature, features, and ornament, sometimes with the broad strokes of a coarse-bristle brush, sometimes with shorter, finer strokes.

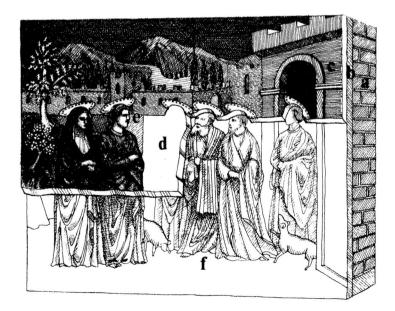

- 1.16. Partially finished fresco at beginning of a day's work. Joints between previous days' work indicated in heavy lines.
- a. masonry wall
- b. arriccio
- c. painted intonaco of upper tier
- d. giornata of new intonaco ready for color
- e. previous day's giornata
- f. underdrawing in sinopia on arriccio layer

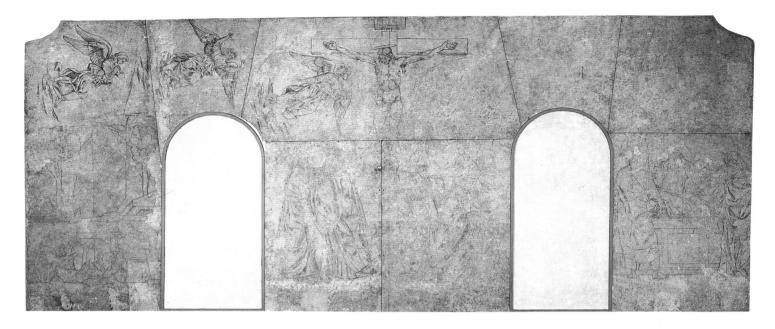

1.17. ANDREA DEL CASTAGNO. Resurrection, Crucifixion, Entombment. 1445–47. Sinopia drawing for fresco, width of wall 39'6" (10.25 m). Cenacolo of Sant'Apollonia, Florence (see fig. 11.11)

In the process of detaching threatened frescoes from the walls, many of these *sinopie* have been brought to light (fig. 1.17). In their freshness and freedom, *sinopie* are sometimes more attractive to modern eyes than are the finished frescoes that covered them. If a *sinopia* varies considerably from its fresco, this may be because the painter decided to change the position of a limb or a piece of drapery, or perhaps because the patron complained about some aspect, iconographic or compositional, of the original design. A letter survives in which Benozzo Gozzoli informed Piero de' Medici that he had just painted a cloud over an angel to which the patron had objected—presumably in the *sinopia*.

As the work progressed, the artist or an assistant covered a section of *sinopia* each morning (or the previous evening) with an area of fresh, smooth plaster called *intonaco*, covering the *sinopia* and leaving the painter with nothing but memory (or some good working drawings) as a guide to paint that area. Each new patch of *intonaco* is called a *giornata* (pl. *giornate*). On any given day, a fresco in progress would consist of an area of finished work, an area of *sinopia*, and one blank *giornata* of fresh *intonaco* that had to be painted before the plaster became too dry late in the afternoon. The joints between *giornate* are often visible because the painter removed with a knife whatever *intonaco* re-

mained unpainted when the light failed so as to have a clean edge on which to start the next day. To keep the edge from crumbling, it was beveled. When the new *giornata* was applied, it left a soft, rounded edge adjoining the bevel. One can therefore often determine not only the limits of each *giornata*, but also the order in which they were completed. Individual painters differed as to how much they could achieve in a day and in how they placed their joints. Sometimes the joints follow the contours of a head or figure, but more frequently the joints fall between two figures or heads. The nature of this process is illustrated in the diary of the sixteenth-century painter Pontormo, which lists briefly what he accomplished each day, what he ate, and, on occasion, the illnesses he may have endured:

30th Tuesday I started the figure

Wednesday as far as the leg

On the first of August I did the leg, and at night I had supper with Piero, a pair of boiled pigeons.

Friday I did the arm that leans

Saturday the head of the figure that's below that's like this [accompanied by a drawing]

Sunday I had supper at Daniello's with Bron, we had meatballs.

In the course of painting, the colors, which had been mixed with water, would sink into the fresh *intonaco*. At this point a chemical reaction took place: the carbon dioxide of the air combined with the calcium hydrate in the plaster, producing calcium carbonate as the plaster hardened. When dry, fresco colors no longer look the same as when they were first laid down on the wet plaster, and the quality and luminosity of color depend on exactly how dry the plaster was when the painter applied that color. The painter also had to consider the humidity of the interior of the church or palace; frescoes could not be painted in cold weather in unheated interiors. Not all colors were water soluble, and some had to be painted in *fresco a secco*—on the dry plaster. *Secco* areas were, sooner or later, in danger of peeling off.

Painters worked from the top down to keep from dripping paint on completed sections. The floorboards of the scaffolding would be lowered as successively lower levels were painted. The result was a tendency to compose in horizontal strips. The background landscape and architecture, sometimes including the haloes, would be painted before the heads of the foreground figures. Sometimes the painter started in the center and worked out, sometimes from the sides toward the center. The piecemeal nature with which a fresco had to be painted became a drawback during the fifteenth century, when visual unity, including light and atmosphere, was considered essential to good painting; perhaps it was this limitation that explains why Leonardo da Vinci's Last Supper (see figs. 16.22–16.25) is not painted in true fresco. The limits of the scaffolding prevented the painter from stepping back to get a view of the whole, and occasionally an impulsive painter went over the edge and was injured, as was Michelangelo when he was painting the Last Judgment. According to Vasari, a painter named Barna da Siena was killed in such a fall. When faced with a deadline, some masters did a great deal of secco painting over fresco underpainting. In the fifteenth century, painters carried out experiments, some of them ruinous, in attempts to discover a compromise between the demands of the new illusionism and the limitations of the old method. In this period, technical skill and experience were required at every stage. Planning ahead was crucial, and the kind of creative expression and invention that we have now come to expect from artists was possible only at the point of the preliminary sketches, the sinopie, and during the painting of faces and details.

Cennini's testimony suggested that before the fifteenth century painters used *sinopie* consistently, drawing directly on the *intonaco* without making preparatory drawings, but conservation work has shown that a number of fourteenth-century fresco cycles, including both cycles by Giotto in Santa Croce in Florence (see figs. 3.21–3.24), had no preparatory drawings on the wall under the *intonaco*. The frescoes by Nardo di Cione in Santa Maria Novella (see figs. 5.4, 5.5) have rough

indications on the intonaco that are insufficient to guide the artist. It was physically impossible to carry out sinopie for huge frescoes, such as those in figures 3.4, 4.27, 4.28, 4.29, 4.31, and 5.8, while running up and down the scaffolding because only a small portion of the wall could be seen through the scaffolding, whose beams and boards concealed any view of the whole from the floor. For such colossal paintings, detailed preparatory plans would have been indispensable. That Cennini does not mention them may indicate that at his modest artistic level in Padua, preparatory drawings were customarily skipped. It seems logical, however, that for the complex cycles mentioned above compositional drawings would have been prepared, while the interest in light shown by Giotto and his followers would also have required studies of the behavior of light on faces and drapery. A number of such drawings survive, including the sheet attributed to Giotto's pupil Maso di Banco (fig. 1.18). Any preparatory drawings actually used in painting a fresco would be exposed to damage on the scaffolding, and no preserved examples can be connected with known frescoes.

The use of the *sinopia* was gradually replaced by a new technique, the *spolvero*, although there was a period, in the middle of the Quattrocento, when both were used in the

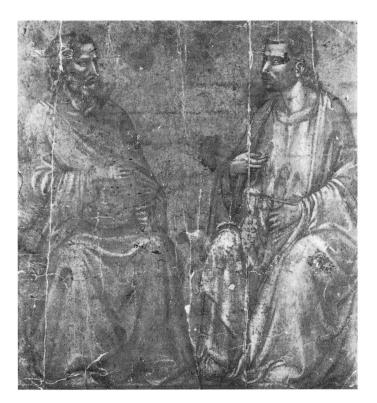

1.18. MASO DI BANCO (attributed to). Sts. Paul and Julian. c. 1340. Silverpoint, wash and white on green-tinted paper, $8\frac{1}{4} \times 7\frac{5}{16}$ " (21 x 18.6 cm). The Louvre, Paris

creation of a single fresco. The *spolvero*—and later the cartoon (perhaps cut into sections if too large to be easily manageable)—was brought onto the scaffolding and the outlines transferred by pouncing, or by incising with a stylus in the case of the cartoon, as each section of *intonaco* went on the wall. The painter was then free to lay on colors without having to remember the composition of a hidden section of *sinopia* under the *intonaco*, and with the *spolvero* or cartoon still at hand for guidance. Even with these techniques, however, it is fascinating to note how often painters varied from the contours they had pounced or incised when they actually applied paint.

The Practice of Sculpture

Giotto and Andrea Pisano depict a sculptor (see fig. 1.10) at work on a statue. The figure is not standing vertically, as it will when complete, but in the most convenient position for carving—reclining at a diagonal. Even as late as the sixteenth century, Michelangelo worked on some of his statues in this manner, a method that permitted the sculptor to approach every section easily without climbing and which also gave every hammer blow the benefit of gravity.

Sculptors, too, began a project by drawing. Before undertaking a statue in marble or any other material, a sculptor usually made a small model in clay, then sometimes a full-scale version in clay. A complex device composed of adjustable iron rods jointed together could be used to enlarge, in the case of a small model, or transfer, in the case of a full-scale model, the shape from the model to the block. The outlines of the subject were sketched in charcoal on the surfaces of the block, from which the sculptor then began to create the work by carving away, first with a pointed, then with a toothed, chisel. The parallel marks left by the latter were removed with files and the surface was then polished with pumice and straw. The word "sculptor," incidentally, did not come into common use until the late fifteenth century; older documents use the term *tagliapietra* (stonecutter).

A bronze sculpture was approximately ten times as expensive as one in marble. Sculptors were generally, but not always, their own bronze founders, carrying out in person every stage of the difficult operation (fig. 1.19). The initial step in casting began with the artist's production of a full-scale clay model, around which a plaster mold would be constructed that could be removed in sections. These sections were coated inside with a layer of wax. Separately, a core of clay and shavings was built on a framework of iron to provide support during the casting process; the core is necessary so that the bronze statue could be hollow, for otherwise both weight and cost would be prohibitive. The thin wax coating is then removed from the plaster mold and fixed to the core with wires to make a statue of wax around the core. This

wax statue was then brushed with a paste made of fine ash mixed with water, and around it was made an exterior mold of clay and shavings that was supported by an iron framework pinned and jointed to that of the core. When this construction was heated, the wax ran out, leaving the space between core and outer mold for the melted bronze, which passed through pipes from a furnace.

After the bronze had cooled, both core and mold could be chipped away, leaving a hollow bronze statue. In the Gothic and Early Renaissance periods, the rough surfaces of the bronze were filed away and polished by a process known as chasing, and details such as strands of hair and the decorative edging of garments would be refined by scratching into or incising the bronze. Fine detail could be added to the statue or relief by these laborious means. In the fourteenth and fifteenth centuries, the entire statue or relief, or selected details, was gilded. This was an elaborate process; details could be gilded by a means similar to that used for panels, but larger areas were usually fire-gilt. This technique required the application of an alloy of gold and mercury; when heated, the mercury ran out, leaving the sculpture covered with a thin but durable coating of gold.

The Practice of Architecture

For Italians during the Renaissance, architecture was the leading art. New buildings were erected and old ones remodeled. New city centers were constructed, and ideal cities—destined to remain dreams—reached fulfillment only when described in treatises. In these structures and groups of structures reference was consistently made to classical antiquity through the use of classical proportions and revived Roman orders, arches, and decoration. Squares that recall Roman forums were built, and direct imitations of Roman triumphal arches were created for the festivities of Renaissance sovereigns. Italian architects were inspired by the buildings of ancient Rome, many of which were visible in a more complete state during the Renaissance than they are today (see fig. 12.24). The new classicizing buildings of the Renaissance, based on drawings of Roman structures, could vary from exactly measured, archaeologically correct views to designs that added highly personal embellishments to the original model.

Yet, in the long view, it is remarkable how little Italian architects before the High Renaissance understood the fundamentals of Roman Imperial building, especially the system of vaulting used by the Romans to roof vast interior spaces. In comparison with the richly articulated architecture of masses and spaces developed during the Roman Empire, continued at Ravenna, and—technically at least—surpassed in the Gothic cathedrals of France and other countries in northern Europe, Italian architecture of the Late Middle Ages and the

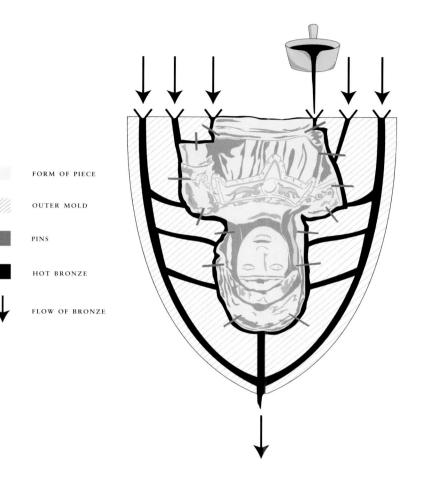

1.19. Conjectural reconstruction of a cross section of the bronze casting process for the head, bust, and upper arms of the figure of Judith from DONATELLO'S *Judith and Holofernes* (see figs. 12.5, 12.6). The beige areas in the center indicate the form of the piece to be cast. The hatched areas are the outer mold for the piece, and the red lines are the metal pins that hold the inner mold to the outer one after the wax has been melted out. The black arrows and black areas show how the hot bronze will flow through the piece and out the bottom.

Early Renaissance remained, essentially, an architecture of vast spaces enclosed by flat walls. In fact, the word used by Renaissance architects, patrons, and theorists for "to build" was *murare* (literally "to wall"), and in Italy a builder is still a *muratore*. Often these Italian structures are roofed by the same simple timber constructions used in Early Christian basilicas, with a flat, wooden ceiling suspended from the beams.

Even when constructing a vault, the Italian architect was averse to the rich system of supports—the so-called exo-skeleton—of a French Gothic church with its flying buttresses and pinnacles. The massive masonry vaults of the cathedrals of Florence and Siena would have collapsed without the iron tie-rods that helped to hold the structure together (see figs. 5.14, 5.17, and 1, where the tie-rods are visible in nave and side aisles).

It seems that the builders of Italian churches were often far from sure, when they laid out the foundations of their structures, exactly how high the walls and columns were to reach or how the interior spaces were to be vaulted. The calculation of spaces and forms was based on mathematical principles of sequence and proportion, rather than on any notion of the requirements of day-to-day living. Vast numbers of drawings of architectural plans, elevations, perspectives, and details (see figs. 16.7, 17.14, 18.1) survive and form one of the most striking categories of Renaissance artistic creation, especially when, as often happened, the building was never built. In addition, the backgrounds of paintings sometimes offer architectural backgrounds, some of which are clearly unbuildable (see figs. 14.14, 16.42, 16.53). Sadly, the dreams of most Renaissance architects for the rebuilding of Italian cities were prevented by circumstances—wars, internal conflict, lack of funds—from their realization (see figs. 14.28, 15.53).

Although work was sometimes carried out under the general direction of an architect, often the key figure was a mason or builder—a member of the Arte di Pietra e Legname. Rarely did such a technician, however, rise to the status of architect. There was, in fact, no word for architect in the fourteenth century, only *capomaestro* (literally "head-master"). Almost all the most inventive architects discussed here began as painters, sculptors, or, in the case of Michelangelo, both; some came to architecture late and—impressive as their architectural achievements were—they continued to paint or sculpt. Often they were appointed *capomaestro* without training or experience in building. The modern institution of

an architectural office was unknown in the Renaissance, and the principal method of communication between architect and builder was a detailed wooden model, a number of which survive (see fig. 18.2). Military architecture was given over to untrained builders, who made themselves into expert engineers. Unfortunately, there is no room in this volume to discuss Renaissance fortifications, whose beauty, brilliance, and practicality have attracted increasing notice.

Another relief from the Florence Campanile (see fig. 1.11) shows the construction of a building with the rough-cut blocks (known as rusticated masonry) characteristic of Florentine houses and Florentine military architecture of the Late Middle Ages and Early Renaissance. The architect, holding a scroll that might contain a plan or other calculations, directs the procedure; masons, shown in a smaller scale, stand on the scaffolding and lay the stones around its beams. As the wall rose in height, these beams would be raised, leaving holes in the structure. These square holes remained so that repairing the structure could be accomplished without rebuilding scaffolding from the ground; they are still visible in many medieval structures. The wall, freestanding with a minimum of external buttressing or none at all, was the basis of Italian architectural thinking until it was replaced in the High Renaissance by the development of the radial plan, with large interior spaces radiating out from a central, domed core (see, for example, figs. 17.13–17.16, 20.11).

The concept of the flat wall plane dominates the architecture of Italy to an extent inconceivable elsewhere. It is fascinating, for example, to note how often the facade of an Italian church or palace seems to have little to do with the building behind it. Although the façade of a church may alert the observer to the spaces and architectural motives of the interior, the delicate elements that comprise the facade often do very little by way of architectural support, and the abutting side walls stand without articulation, flat and untreated. The façade is not considered an essential part of the building but is, rather, a ceremonial decoration for the piazza before it, like the shrines still erected in south Italian streets to celebrate the festival of a saint. The façade sometimes does not even have the same number of stories as the building behind it, and it may tower far above and be supported from behind by iron rods fastened to the roof beams; sometimes it is even lower than the bulk of the actual building.

In a sense, the wall is the beginning and the end of Italian architecture, and it forms as well a broad field for fresco painting and a background for altarpieces and sculpture. The wall is the plane from which perspective thinking starts, when new, harmonious spaces are created in a world projected within and beyond its surface and into which the observer is visually invited to step. The wall is the screen on which, in a series of brilliant frescoes painted during this period, Italian civic life and the Italian landscape are preserved through the fertility of the Italian imagination.

The Practice of History and of Art History

Before proceeding with our examination of Renaissance art, another kind of practice needs to be discussed, that of history. The idea that history was worthy of study for its own sake was a new phenomenon in the Renaissance. While medieval theologians had defined the world of the past and the present solely within the context of Christian goals and institutions, Renaissance humanists defied these narrow parameters, analyzing and assessing historical evidence in search of answers that were not dependent on the traditional doctrines promulgated by the church. They were inspired in their research by the historical approach they noted in the ancient historians whose works they read.

When Lionardo Bruni (see figs. 10.36, 10.37), humanist chancellor of Florence, wrote his *History of the Florentine People*, he researched his subject, consulted historical documents, and developed theories that placed Florence's background within a larger historical context. He argued, for example, that Florence must have been founded during the Roman Republic, relating it to what he knew of Greek political practice and calling it "the new Athens on the Arno."

In recent decades scholars have grown increasingly interested in historiography, the history and analysis of writing history. No historian is a mere compiler of facts, and even one's choice of facts can be an indication of bias. The Renaissance was no exception. In a peninsula dominated by autocratic rulers in other centers, it was important for Bruni to place Florence's foundation in the ancient Roman republican period, just as it was important for Renaissance Florentines to believe that their Baptistery (see fig. 3.33) had been an ancient Roman Temple to Mars. Keeping this in mind, we can turn briefly to the first historian of Italian art, Giorgio Vasari.

The Practice of Art History: Giorgio Vasari

The name that will appear more often than any other in this book is that of Giorgio Vasari (1511–74), the first historian of Italian Renaissance art. Vasari, who came from a family of artisans (the name Vasari is derived from *vasaio*, "vase," suggesting that an ancestor had been a potter), had a distinguished career as a painter and an architect as well (see figs. 20.39–20.41), but it is for his work as an historian and a critic that he is best known. In 1550 Vasari published the first edition of his *Lives of the Best Architects, Painters, and Sculptors*... (*Le vite de più eccellenti architetti, pittori, et scultori*...). This two-volume work was more than one thousand pages long and featured biographies of 133 artists, as well as brief mentions of many others; the second, three-volume edition (1564–68) of *Lives* ran to about fifteen hun-

dred pages and was updated with new information that Vasari had collected through correspondence, research, and travel. There was also discussion of new categories of art, such as the temporary decorations for weddings, triumphal entries, funerals, and other pageants that played significant roles in Renaissance life. This edition also had woodcut portraits of many artists.

In *Lives* Vasari established a number of precedents that continue to influence the writing of art history, for better or—as some critics would argue—for worse. One of these is the emphasis on the individual artist in terms of biography, character, and style and, in many cases, a close identification between the person and the works. A second is the notion that scholars should evaluate the works they discuss, distinguishing some artists and works as superlative. At the same time, Vasari also recognized that artists must be understood in terms of the period in which they lived and worked. As an artist Vasari was well aware of the sometimes difficult and demanding role a patron could play in the creation of a work of art. The importance of the patron is a third aspect that surfaces significantly in *Lives*.

Perhaps the crucial contribution of Vasari's *Lives* is the trajectory that he established to explain the development of Renaissance art. The concept of historical development or progress that he presented was derived from the writings of ancient authors. While he found little of interest in earlier Italian medieval art, Vasari argued that a revival of art, based on a new interest in imitating nature, had emerged in Tuscany in the works of Giotto and other thirteenth- and fourteenth-century artists. This first phase was followed in the fifteenth century by Vasari's second phase in which, to quote the author, "all things are done better, with more invention and design, with a more beautiful style and greater industry." The third and final stage in Vasari's history was, he argued, made possible by the discovery and study of ancient sculptures (see figs. 17.2, 17.3). The perfection that Vasari identi-

fied in this final phase was exemplified, he wrote, in the works of Michelangelo.

In addition to his role as artist and author, Vasari was one of the first collectors of drawings. In *Lives* he pointed out that preliminary sketches were the initial expression of the artistic idea, and he cited drawings in his collection that demonstrated a specific artist's personal style and/or method. Vasari compiled his drawings into volumes, mounting them on large pieces of paper and enframing the earlier works with architectural motifs drawn in his own style. Sometimes he would incorporate into this elegant presentation the woodcut portrait of the artist taken from *Lives*.

The biases that Vasari brought to his task were many. While Florence was certainly the leader in many Renaissance developments and deserves a special role in any history of Italian Renaissance art, the preeminence that Vasari granted Florentine art and the amount of space he devoted to it in *Lives* is certainly exaggerated. Vasari dedicated his volumes to Cosimo I de' Medici, and throughout the biographies he privileged the role of the Medici in commissioning and collecting works of art.

Vasari's *Lives* was intended to inform a wide segment of the educated public about art. It had a wide and immediate circulation; responses to his comments on German art, for example, were being written by German writers as early as 1573. Several authors in Italy and other European countries were inspired to write their own versions of the *Lives*. It is not surprising that Vasari's version survives as a crucial source of information and ideas to the present day.

Vasari's comments and conclusions will often be mentioned or quoted in these pages. While his historic and personalized history of Italian Renaissance art must be read, like all histories, with an understanding of his cultural background and motivations in mind, there is no question that he is our earliest source on the development of a beloved tradition of art.

ATE M

DUECENȚO ART IN TUSCANY AND ROME

he first manifestations of an independent new style in painting and sculpture seem to have taken place in Tuscany, a region in central Italy between the Apennines and the Tyrrhenian Sea. The region corresponds roughly to the area inhabited in ancient times by the Etruscans, from whom the medieval Tuscans were in part descended. Shortly after the year 1000, this region became the scene of new political developments; one by one the cities of Pisa, Lucca, Pistoia, Prato, and Florence constituted themselves as free communes or republics. Liberated from domination by the counts of Tuscany after the death of Countess Matilda in 1115, they owed a somewhat shadowy allegiance to either the emperor or, in the case of Florence, the pope. Siena eventually established itself as an independent republic free from the domination of the bishop and neighboring feudal lords. Within these new Tuscan city-states there was a constant struggle for power between the merchant class and the old nobility, a struggle in which a premium was placed on the value and initiative of the individual. The new middle class that arose provided a rich market and a powerful incentive for the new art.

The term *Duecento* (in Italian literally "two hundred") is used to designate the thirteenth century (the 1200s), as Trecento is used for the fourteenth century, Quattrocento for the fifteenth, and Cinquecento for the sixteenth. The quality and quantity of panel painting (the frescoes have largely disappeared) in the Duecento have come to be appreciated only in the modern era; earlier this period was generally accepted as one of stagnation, under the influence of Byzantine art—the painting of the Eastern or Greek Empire, centering on Constantinople. According to Vasari, Greek (Byzantine) painters were even called to Florence, where Cimabue, whom Vasari considered the first of the truly Florentine painters, saw them at work and surpassed their "rude" manner. Vasari knew little, of course, about the intellectual and refined quality of later Byzantine painting, but there is a germ of truth in his story. Greek mosaicists were indeed called to the court of King Roger II of Sicily in the twelfth century (fig. 2.1) and founded a new school of Italo-Byzantine art. Byzantine influence in thirteenth-century Europe is in part explained by the sack of Constantinople in 1204 by the Crusaders, who devastated the churches and the Great Palace. The artistic works

2.1. ITALO-BYZANTINE. *Christ Pantocrator*, the *Virgin Mary, Angels, Saints*, and *Prophets*. 1148. Apse mosaic. Cathedral, Cefalù, Sicily

taken by the Crusaders—painted icons, manuscripts, ivory carvings, enamels, fabrics with woven pictures, liturgical vessels—were scattered throughout Europe.

Byzantine artistic ideas impressed the European imagination through the elegant sophistication of their style and the inherent visual richness of the materials used. Greek painters themselves, with few opportunities in ruined Constantinople, were probably attracted by the wealth of Venice and the Tuscan cities. They brought with them the newest Byzantine developments, the highly formalized and linear "Comnenian" style, which is named after the dynasty of Byzantine emperors that came to an end in 1204. But as we shall see, while the earliest Italo-Byzantine paintings show the Italian artists' initial reliance on Byzantine models in dividing the anatomy into clearly demarcated and delicately shaded portions and in rendering light on drapery by means of parallel striations of color or gold, at the same time they also demonstrate a vigor and tension that distinguish them from the Eastern examples that inspired them.

Painting in Pisa

So little is left of twelfth-century Tuscan painting that it is impossible to reconstruct its development and the complex problem of its origins, but the earliest surviving examples seem closer to the art of Romanesque Europe than to that of the Byzantine East. Probably as a result of the conquest of Constantinople, however, Byzantine influence in the Duecento rapidly became dominant. Pisa had been a rich, powerful seaport since Roman times, when it was the capital of the Province of Tuscany. In 1133, under Pope Innocent II, Pisa was briefly the seat of the papacy, and St. Bernard called it "a new Rome." The republic was in constant commercial competition and naval warfare with the rival ports of Genoa, to the northwest, and Amalfi, south of Naples.

One of the earliest surviving Italian panel pictures is probably the anonymous, undated Cross No. 15 which is still in Pisa, where it probably originated (fig. 2.2). This large work, perhaps intended for a choir screen, shows Christ alive on the cross. Scenes from the Passion and subsequent events are placed on the areas to either side of his body, known as the apron, and at the ends of the bars of the cross. This type of cross with a living Christ—the Christus triumphans (Christ triumphant)-appears in a number of examples. The purpose of these images, which avoid the agony of the Crucifixion, seems to have been to present a symbolic image that would express the doctrine of Christ's sacrifice and dramatize for the worshiper the significance of the Mass. In the backgrounds of these scenes, the arches and columns recall the Romanesque architecture of the Cathedral, Baptistery, and Bell Tower (Leaning Tower) of Pisa.

It was the necessity of viewing the painting from a distance that doubtless led the artist to consider carefully the archi-

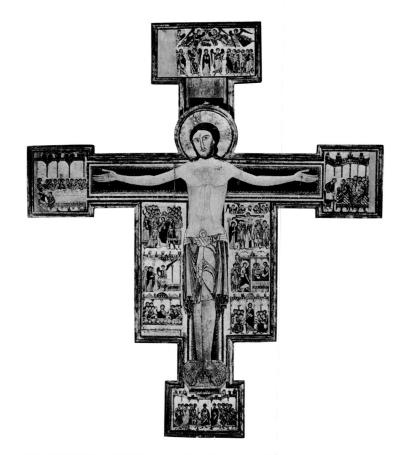

2.2. SCHOOL OF PISA. Cross No. 15. Late twelfth century. Panel, 9'3" x $7'9^3/4$ " (2.82 x 2.38 m). Pinacoteca, Pisa

tectural structure of the composition and also the colors, which are evenly spaced and repeated to achieve an all-over harmony among a few simple colors—blue, rose, white, tan, gold. Considering the potential drama of the subjects, the style is restrained. Clear contours outline major elements, and the linear drapery is related to that of contemporary Tuscan Romanesque sculpture. Christ's arms seem stretched voluntarily against the cross, while his body is modeled with delicacy, as though carved in low relief. The wide-open eyes, in their curious squared lids, stare impassively outward. Against the elaborate architectural structures, the scenes from the Passion are treated as if they were incidents from a codified ritual rather than events that happened to real people. All in all, the style recalls the manuscript painting of the Romanesque period in Italy more than anything Byzantine.

Against this static and largely symbolic painting, another example, *Cross No. 20*, also still in Pisa (figs. 2.3, 2.4), sets forth an unexpected range of emotional values. Christ is shown dead, hanging weightless upon the cross. It was perhaps the direct appeal to the personal feelings of the spectator of this type, known as the *Christus patiens* (suffering Christ), that explains why it so rapidly replaced the *Christus triumphans*. Again we know neither the date of the painting

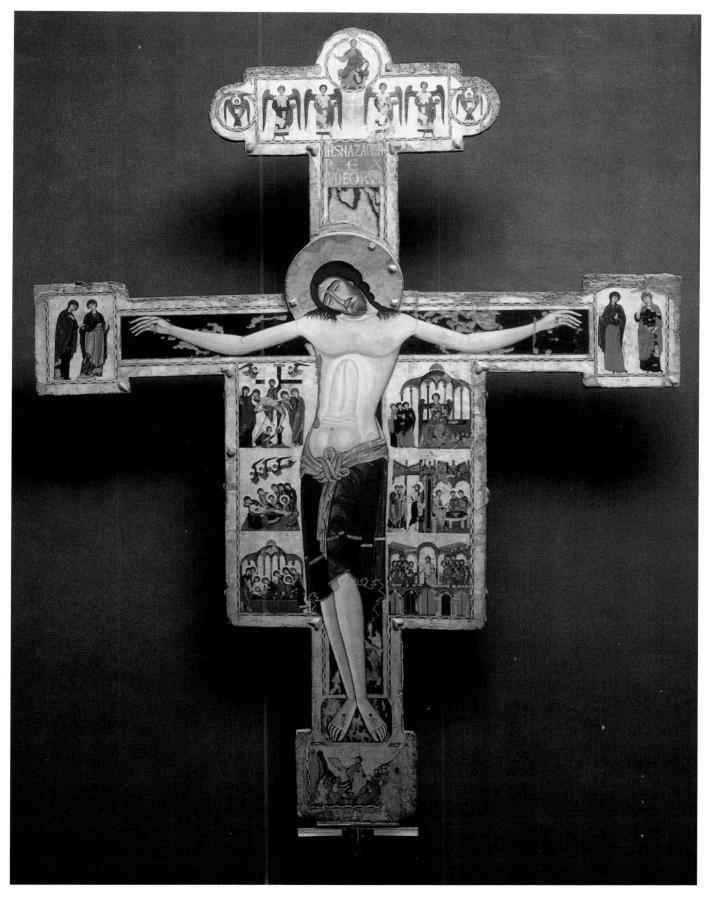

2.3. SCHOOL OF PISA. Cross No. 20. c. 1230. Parchment on panel, 9'9" x 7'8" (2.97 x 2.34 m). Pinacoteca, Pisa

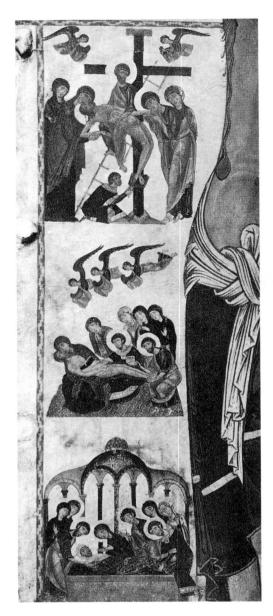

2.4. Deposition, Lamentation, and Entombment, details of fig. 2.3

nor the identity of the artist, but it is evident that this painter was strongly influenced by Byzantine art. The pose of the body, with the hips curving to our left, is common in Byzantine representations, such as the mosaic at Daphni in Greece (fig. 2.5) and examples in Serbia. By analogy with dated works, it is possible to suggest a date of about 1230. The change in content and style between the two Pisan crosses is probably at least in part explained by the rapid spread of the doctrine and devotional practices of St. Francis of Assisi (d. 1226). Francis preached and practiced a direct devotion to Christ, and in 1224 is said to have received the miracle of the stigmata, crucifixion wounds that paralleled those of Christ. Although it is difficult to make a direct connection, it seems likely that the emotionalism with which Francis and his fol-

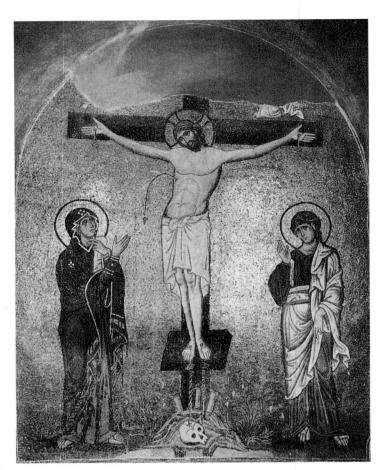

2.5. BYZANTINE. *Crucifixion*. Eleventh century. Mosaic. Monastery Church, Daphni, Greece

lowers approached religion would have had an impact on the interpretation and representation of religious subjects in art.

The new emotional content is evident throughout Cross No. 20: in Christ's sad expression and in the drama evoked in the scenes from the Passion, in which architectural backgrounds are now subordinated to human content. Everywhere the flow of line—in the hair and the delicately delineated features, in the long and slender fingers, and in the composition of the scenes silhouetted against gold—achieves an expressive and decorative effect. In the Lamentation (see fig. 2.4), long delicate lines move downward with increasing rapidity through the angels' wings to Mary and her son, whose dead body rests on her lap; this group was surely derived from Byzantine sources. The subject of Mary holding the dead Christ on her lap as she had held him as a child is not found in the Bible, and it was apparently the tenth-century theologian Simeon Metaphrastes who first described this theme; as early as the twelfth century it was already being represented in Byzantine art. A passionate fresco of about 1164 at Nerezi re-created this scene (fig. 2.6); an icon with a similar representation may have migrated to Pisa. Cross No. 20 is one of the earliest Italian examples of the representation of

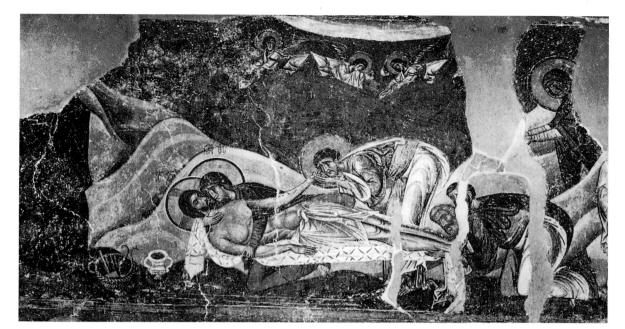

2.6. BYZANTINE. *Lamentation*. c. 1164.

Fresco. St. Pantaleimon,
Nerezi

the tragic relationship between the dead Christ and his mother that became an important subject for artists of the Renaissance. By the late years of the Trecento, this theme was called the Pietà (Italian for both "piety" and "pity").

Painting in Lucca

Similar stages may be discerned in the painting of Lucca, a rival republic about fifteen miles from Pisa. Separated from the sea by Monte San Giuliano, for centuries Lucca carried on a splendid existence through its banking activities. A group of crosses of the *Christus triumphans* type culminates in an example (fig. 2.7) by one of the earliest Italian artists known to us by name. Berlinghiero Berlinghieri, born in Milan, founded a family of painters active in Lucca in the Duecento. In his signed *Cross*, Christ looks out at the observer with wide-open eyes. The small figures of Mary and John on the apron replace the customary narrative scenes but the side terminals of the cross again culminate in the symbols of the four evangelists. The impact of Byzantine style is evident in the striated drapery and the division of Christ's body into separately modeled segments.

An altarpiece of *St. Francis with Scenes from His Life* (fig. 2.8) located in San Francesco at Pescia, a town about halfway between Lucca and Pistoia, is signed by Berlinghiero's son, Bonaventura, and dated 1235, only nine years after the death of St. Francis. Although it is the earliest known image of the saint, there is no evidence that Tuscans in the Duecento attached any importance to portrait likeness. We can, however, deduce from the intensity of the face, with its emaciated cheeks and piercing gaze, a great deal about the meaning of

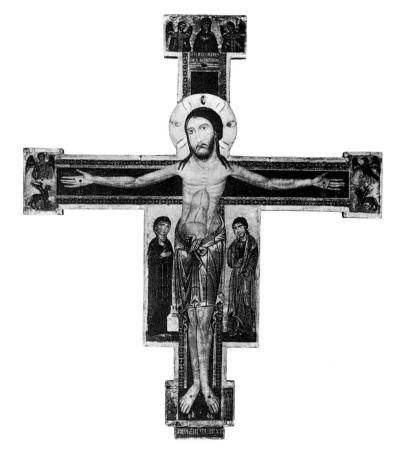

2.7. BERLINGHIERO BERLINGHIERI. *Cross.* Early thirteenth century. Panel, 5'8" x 4'7" (1.73 x 1.40 m). Pinacoteca, Lucca

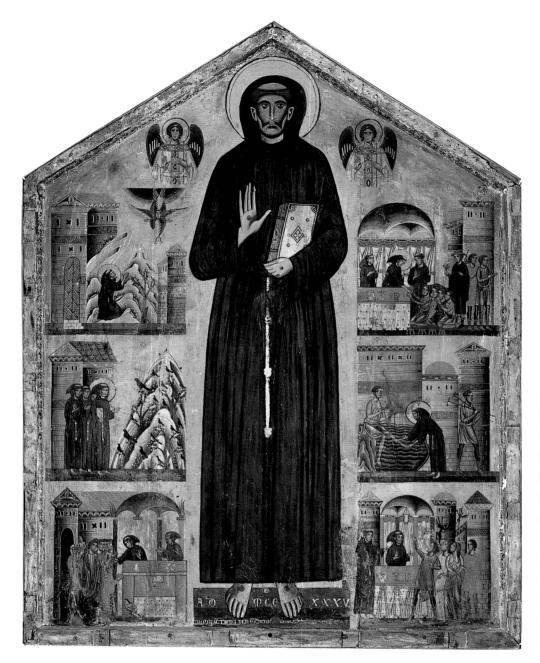

2.8. BONAVENTURA BERLINGHIERI. St. Francis with Scenes from His Life. 1235. Panel, $60 \times 45^{3}/4$ " (1.52 x 1.16 m). $\hat{\blacksquare}$ S. Francesco, Pescia

St. Francis's message to his contemporaries. Bonaventura has shown us the ascetic Francis of private meditations and ecstatic prayers. The harsh power of the forms and the solemnity of content come as a surprise if we know only the gentler representations of St. Francis and his life found in later Trecento and Quattrocento representations.

The placement of the lateral scenes from the life of the saint to either side of a large central figure is probably inspired by painted crosses. The triangular top, however, is like the gable of a church or a shrine; this shape will be followed in altarpieces of the enthroned Madonna and Child until the mid-Trecento, when it will be replaced by rich Gothic

pointed arches, often cusped and crocketed, imported from French art. Two of the narrative scenes have landscape backgrounds in which the Byzantine models for painting hills are schematized and reduced to repeated, superimposed formulae; at the same time, however, there is something about the color and shapes that suggests a new feeling for nature but no interest in representing natural space. The narratives demonstrate a new interest in human emotional reactions, yet the architectural settings, on the other hand, were adopted almost without change from Byzantine formulae and show no relation to the architecture of Lucca in Bonaventura's day.

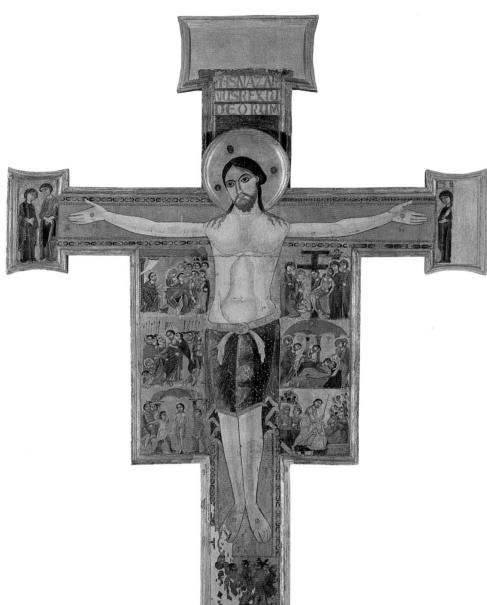

2.9. SCHOOL OF FLORENCE. Cross. Late twelfth century. Panel, $12'4\frac{3}{8}$ " x 7'7" (3.78 x 2.31 m). Uffizi Gallery, Florence

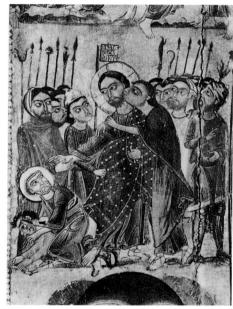

2.10. Betrayal, detail of fig. 2.9

Painting in Florence

Until the Duecento, Pisa and Lucca were more populous and powerful than Florence, and Florentine painting seems to have had a slightly later start. But even the earliest examples show a greater directness, power, and plasticity than is found in the works of the two rival schools. An impressive early work is a *Cross* of the *Christus triumphans* type (fig. 2.9) which has affinities with works located in or around Florence. In this example, the figure of Christ seems almost to be soaring, and there is no indication of the original wood of the cross, which is dissolved into a background field of flat gold. The firmly modeled and strongly constructed forms culminate in a somber head whose eyes gaze calmly outward. The

powerful shapes contrast with the delicacy of detail in the dotted loincloth and in the subdued colors. The narrative scenes make no effort to compete with the modeling of the central figure. Almost flat in their silhouetted shapes, they are, nonetheless, sharply alive, owing to the vivid contrasts in linear direction and to the flashing glances of their eyes (fig. 2.10). As in Romanesque painting elsewhere in Europe, the heads in the small dramatic scenes are enlarged so that the facial expressions will not be lost. Byzantine canons of proportion, inherited from the Hellenic and Roman world, did not permit such violations. This artist, like the master of *Cross No. 20*, appears to have asserted an independent personality; he is the first of the innovative Florentine artists we are to encounter.

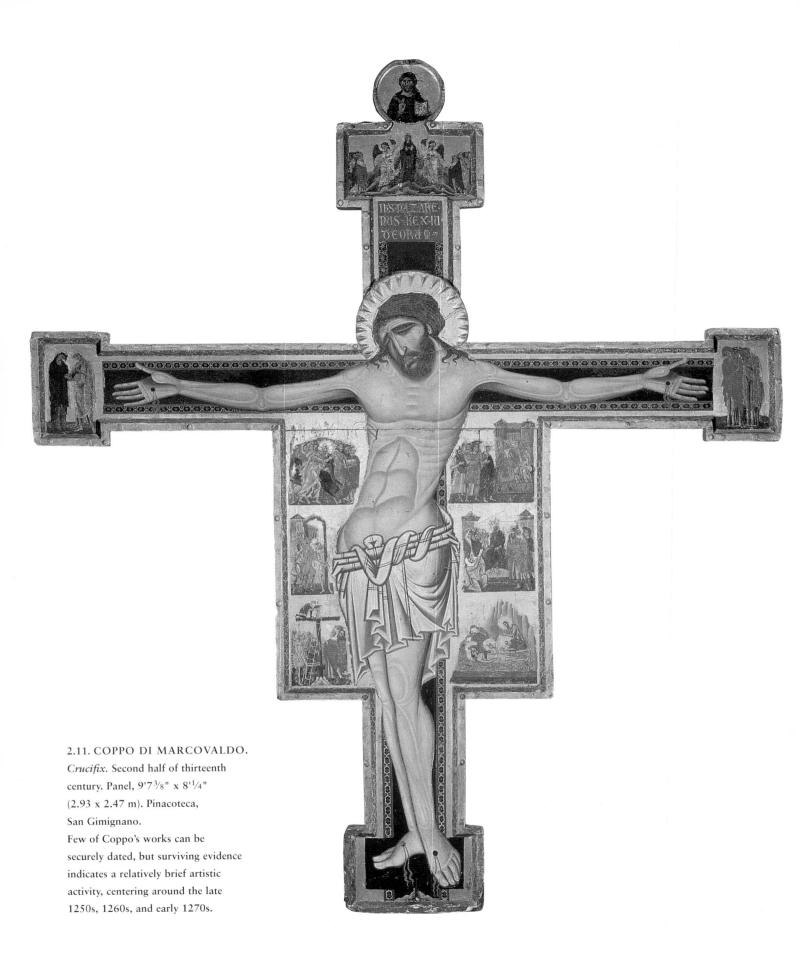

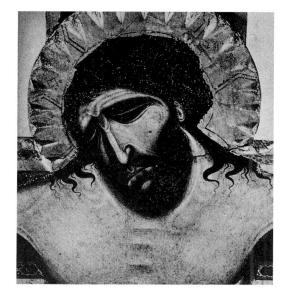

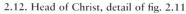

2.13. Lamentation, detail of fig. 2.11

Coppo di Marcovaldo (active 1260s-70s), a Florentine painter, is generally accepted as the artist of the harrowing Crucifix (fig. 2.11) in San Gimignano, which was then in Sienese territory. Coppo was evidently even more deeply influenced by the Byzantine style than the painter of Cross No. 20, but the former turns the linearity, compartmentalized forms, and striated drapery construction toward a different end. Coppo shows us a Christ whose sculptured body and face are convulsed and distorted with suffering, and whose loincloth, powerfully rendered, hangs low at the waist, broken into deep-set angles that are projected with a violence unusual in Italian art. The closed eyes are treated as two fierce, dark, hooked slashes (fig. 2.12), the pale mouth seems to quiver against the sweat-soaked locks of the beard, and the hair seems to writhe like snakes against the tormented body. Even the halo, carved into a raised disk that is broken by wedgelike indentations, plays a part in a total effect of thunderous expressive power. Because the edge of the head was painted over a layer of gold leaf, some of the hair has flaked off, spoiling the long curves of the contours.

Coppo fought as a Florentine soldier in the Battle of Montaperti in 1260 and was taken prisoner by the Sienese after the Florentine defeat; it has been suggested that the emotional content of his *Crucifix* reflects his wartime experiences. Compared with the Lamentation in *Cross No. 20* (see fig. 2.4), Coppo's scene suggests the immediacy of a sudden family tragedy (fig. 2.13). Christ lies rigid on the ground, his head held by his mother; the other figures use gesture and glance to suggest strong emotion and the landscape, with its dramatic verticals, adds further tension.

Among the other surviving works by Coppo is a *Madonna* and *Child* (fig. 2.14). The subject does not allow the emotive outbursts seen in the *Crucifix*, but Coppo's intensity of feeling is transferred to the form and design. As in many

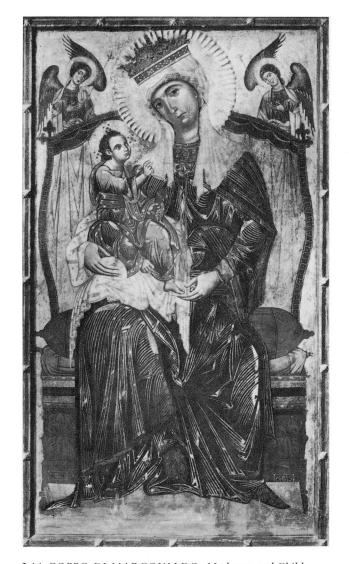

2.14. COPPO DI MARCOVALDO. Madonna and Child. c. 1265. Panel, $7'9^{3}/4$ " x $4'5^{1}/8$ " (2.38 x 1.35 m). S. Martino dei Servi, Orvieto

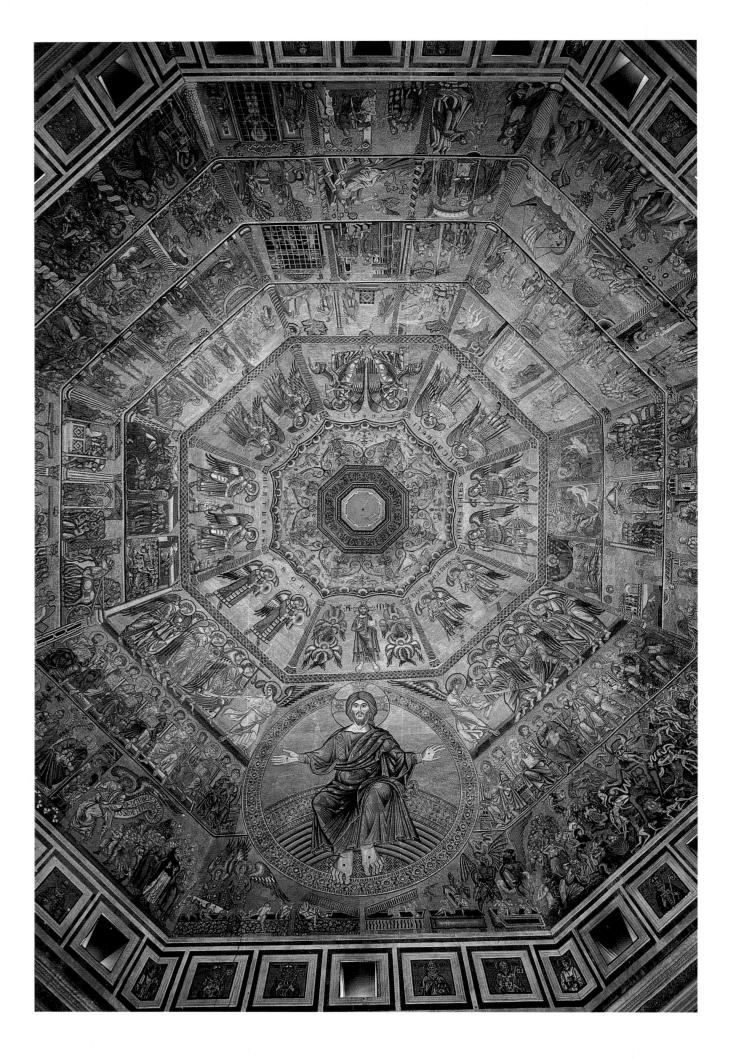

Byzantine representations, the Virgin is shown seated on a throne, crowned as Queen of Heaven and holding her son, his hand raised in blessing, upon her knee. The Virgin's sad expression reveals an emotional content that can be explained neither by the relationship of mother and child nor by the ritual purpose of the image; like many other Italian Madonna and Child compositions, her expression is a reference to the Passion and death of Christ. Coppo's Madonna is mournful because she has the ability to prophesy the tragic events to come.

As in the *Crucifix*, Coppo has divided the face into compartments by sharp, linear accents in the nose, lips, and eyes, and these divisions are strengthened by the modeling in light and dark. But every shape is treated as an abstracted form, severe and clear-cut—like elements of architecture. Here, too, Coppo has used wedge-shaped depressions in the halo, but they are smaller and more numerous than those in the *Crucifix*, creating a glitter of gold around the face. The energetic Christ Child, remarkably unchildlike in appearance and holding a scroll in his left hand, is represented as the Savior and teacher. Coppo's dramatic style is also evident in the drapery, which is cut up in folds that are outlined and patched by gold striations. These sharp, intense, and irregular sunburst shapes have little to do with the behavior of cloth.

The extensive cycle of mosaics in the octagonal vault of the Baptistery of Florence is the most important pictorial undertaking of the Florentine Duecento. On the west face is the Last Judgment (fig. 2.15), which is attributed to Coppo di Marcovaldo. The commission for a work of such prominence provided an opportunity for Coppo to display the vigor of his imagination and the power of his forms on an unprecedented scale. The colossal central figure, more than twenty-five feet in height, is designed with simplicity and clarity, and the anatomical masses are broken into segments that are richly modeled in color. Christ is enthroned in a glory whose border is adorned with foliate ornament that is easily visible from the floor. Gazing outward, Christ beckons with his right arm toward the blessed, while with his left he casts the damned into eternal fire. The athletic figures leaping from their tombs, on the right, can be attributed to Coppo, as can the terrifying hell scene, in which a few punishments and demons, decipherable from the floor, suffice for the whole. Around Satan, writhing serpents and monstrous toads devour the damned, which are rendered with the

Opposite: 2.15. Mosaics of the Last Judgment, Ranks of Angels, and Scenes from the Lives of Christ and St. John the Baptist; the central figure of Christ in the Last Judgment has been attributed to COPPO DI MARCOVALDO.

Second half of thirteenth century. Baptistery, Florence.

The other registers of the Baptistery vault feature scenes from the Old Testament, the life of Christ, and the life of John the Baptist. These same themes will later be represented on the bronze doors added to the Baptistery in the fourteenth and fifteenth centuries.

broad, clear, zigzag shapes characteristic of Coppo's style. Coppo's mosaic of Christ was the most awe-inspiring representation of divinity in Italian art until Michelangelo. Although his name, forgotten by tradition, was not even mentioned in later sources, Coppo's vision remained to inspire, directly or indirectly, generations of Florentine artists.

Painting in Siena

During his stay in Siena, Coppo had considerable influence, especially on Guido da Siena (active c. 1260), then the leading painter of the previously archaic Sienese School. For San Domenico, Guido painted a huge *Enthroned Madonna* (fig. 2.16). The face of the Madonna and the figure of the Christ

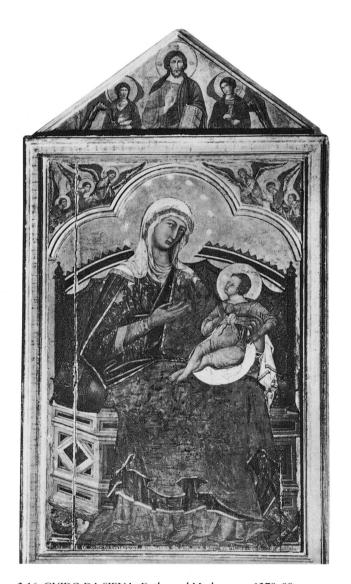

2.16. GUIDO DA SIENA. *Enthroned Madonna*. c. 1270–80 (Madonna's face and Child repainted, probably by DUCCIO, early fourteenth century). Panel, 9'4½" x 6'4" (2.86 x 1.93 m). Palazzo Pubblico, Siena. Commissioned for the high altar of S. Domenico, Siena. The date of 1221 on the painting has been interpreted as referring to the installation of the Dominican order in Siena that year.

Child were repainted in the early Trecento, but the original portions of the picture show the adaptation of Italo-Byzantine motifs to the Sienese style, which has often been described in general as being more refined and delicate than that of Florence. In other works, Guido appears to have been strongly influenced by the style of Bonaventura Berlinghieri. The Madonna has been the subject of a prolonged controversy because the painting bears an inscription declaring that Guido da Siena painted it in the "happy days" of 1221. This gave early Sienese scholars ammunition in their battle to assert the cultural priority of Siena over Florence. Although the inscription has been proved old and unaltered, most modern scholars are unable to date this accomplished painting at the same time as the crude efforts of the Sienese School in the early Duecento, about fifty years earlier than dated paintings that are almost identical with it in style. The inscription is lettered in a manner common in the early Trecento and was probably added for commemorative purposes when the faces were repainted, at a time when Guido's exact dates had long been forgotten.

Cimabue

The painter Cenni di Pepi (active c. 1272–1302) is better known by the nickname Cimabue, a name of difficult etymology that could be translated as "ox head" or "dehorner of oxen." The latter interpretation might refer to Cimabue's personality, which in an early source is described as proud and arrogant. In most introductions to the history of art, Cimabue appears as the earliest of Florentine—and therefore of Italian—painters. This is where Vasari, who considered everything before Cimabue's time to be clumsy, positioned him in his history. In reality, Cimabue belongs not at the beginning of a development but at its end. His altarpieces show him to be the last Italo-Byzantine painter. Cimabue sums up a tradition that had been pervasive for nearly a century in Tuscany, and elaborate and splendid though his creations are, he begins nothing essentially new.

The huge Enthroned Madonna and Child with Angels and Prophets (fig. 2.17), painted for Santa Trinita in Florence, has long been attributed to Cimabue; undated, it was probably done a few years before Duccio's Madonna of 1285 (see fig. 4.1). It is even larger than the Madonna by Guido, and by far the most ambitious panel painting attempted by any Italian artist up until that time. When seen by candlelight inside the dark and lofty church, it must have made an overwhelming impression. The enthroned Madonna, shown without a crown, presents her child to the viewer. The throne is held by eight angels, while in the arches below, Old Testament prophets display scrolls with prophecies of the Virgin

Birth. The throne's structure and its relationship to the surrounding angels defies reason; some figures appear from below, as if on elevators that have stopped midway in their ascent. Cimabue does not even seem to have mind whether the curves beneath the throne are arches in elevation, niches in depth, or both.

The Christ Child, seated on the Virgin's left, holds his scroll and looks directly at the observer. This is a ceremonial subject depicting a court ritual in which none of Coppo di Marcovaldo's emotional power could be tolerated. The gold striations of the drapery have proliferated, and hundreds of lines weave a shifting, glittering network of shapes, as if the artist were trying to overwhelm the faithful with this image of regal majesty. The Virgin's heavenly mantle was originally a brilliant blue, the customary color, as is the rose tone of her tunic. The coloristic effect when the painting was fresh must have been impressive, especially as the blue was brought into relief by the colors of the angels' wings.

Cimabue's drawing style is delicate, in contrast to the power suggested by Coppo's broad lines. The eye structure is characteristic of his style, with the lower lid almost level, the upper lid shaped like a circumflex, and the sidelong glance contrasting with the downward tilt of the head. Cimabue has a keen sense of modeling within definite limits, and he delicately shades the drapery save for the gold-striated garments of Christ and the Virgin. But no form seems to occupy space and no head is really three-dimensional. He wishes to show everything he knows to exist, making both ears appear even in a three-quarters view of the face, as though no solid mass of the head intervened to hide one of them. The idea that the image of an object was received by the human eye as a reflection of light had, at this time, occurred to no one. In his zeal to inform us, Cimabue gives us a kind of Mercator's projection of a global head on a flat surface. At the same time, however, Cimabue differentiates psychological types with considerable effect, as in the distinction between the youthful angels and the seriousness of the Old Testament prophets below, who, like their writings, form a foundation for the subject. Cimabue delights in complicated shapes, long slender fingers, and the complex ornament derived from classical sources. Even at the gold background, he does not stop inventing. This background, including the haloes, is enriched with shifting patterns of incised lines and a series of punched dots.

Cimabue's adherence to the Byzantine style is best demonstrated in a huge *Crucifix*, perhaps originally intended for the rood beam or choir screen of Santa Croce in Florence (figs. 2.18, 2.19). Cimabue bases his composition on the Byzantine-inspired *Christus patiens* (see figs. 2.3, 2.5, 2.11), but his version is both enormous in size and greatly simplified

Opposite: 2.17. CIMABUE. Enthroned Madonna and Child with Angels and Prophets. c. 1280. Panel, 11'7" x 7'4" (3.53 x 2.24 m). Uffizi Gallery, Florence. Commissioned for the high altar of Sta. Trinita, Florence

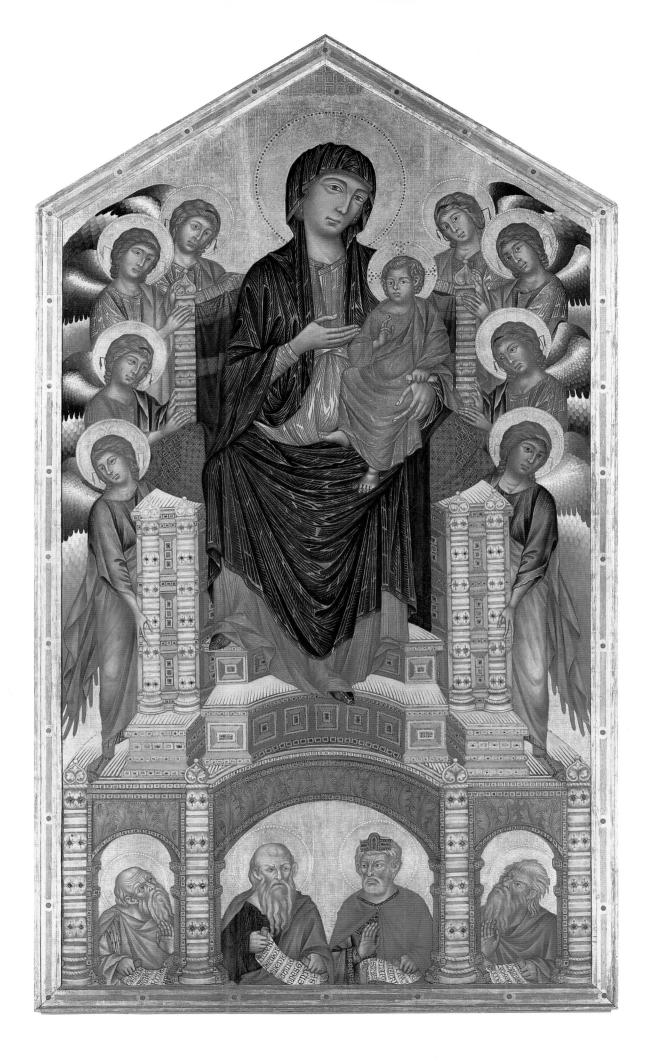

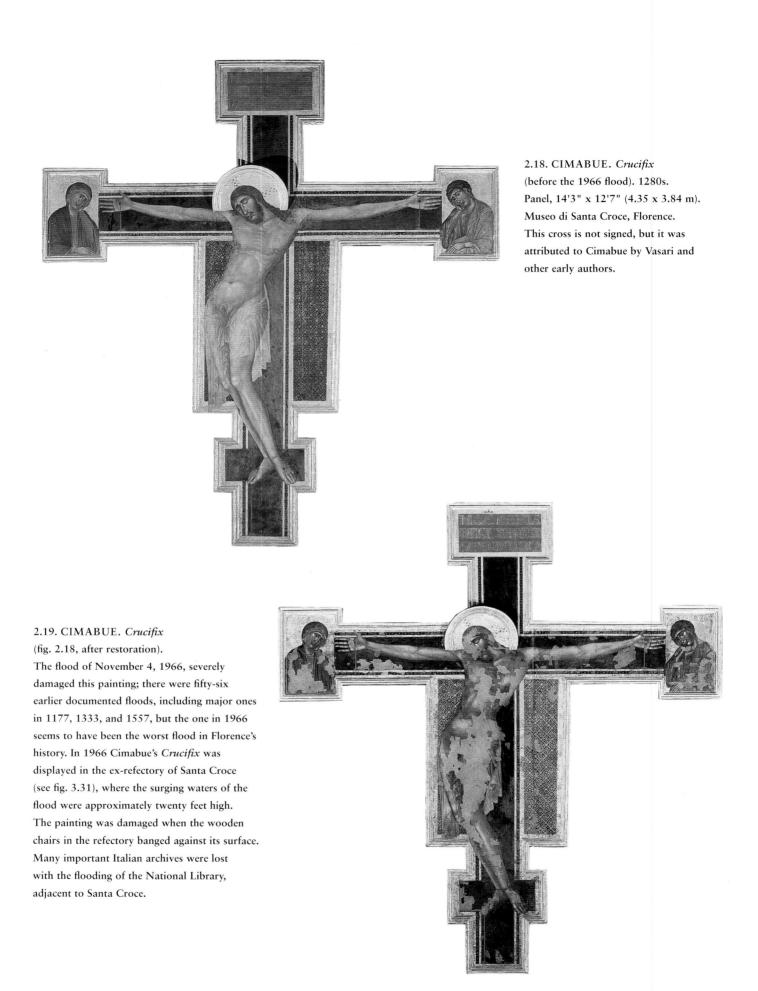

in subject and composition. The patterned apron and text at the top do not distract us from the body of Christ and the half-length figures of the Virgin and John the Evangelist in the side terminals, whose heads are inclined inward, directing us back to the suffering Christ. The heads and hands of the two subsidiary figures are stylized and segmented in the Byzantine manner, as is the huge body of Christ, which sways even more dramatically to our left than did the figure of Christ in the Crucifix by Coppo di Marcovaldo (see fig. 2.11). What is surprising here is the powerful expressiveness that Cimabue is able to create through subtle changes he makes in the basic Byzantine pattern. The transparent nature of the loincloth allows us to see and feel the full sweep of the sagging body, and Cimabue increases the sense of tension and pain by stretching the arms outward, rather than letting them sag as in the earlier Byzantine and Italian examples. The sense of suffering has increased in Cimabue's monumental Christ, yet the figure is still created within the elegant, two-dimensional Byzantine pattern. The abstraction with which Cimabue approached

his subject is evident in his treatment of the blood from the wounds in Christ's hands, which does not stick to his hands naturalistically, but falls straight downwards, pooling only when it hits the flat, decorative, gold border.

Cimabue was a monumental artist not just in tempera, but in fresco and mosaic as well, and he probably continued the Baptistery mosaics started by Coppo and others. His abilities as a fresco painter can be suggested by his poorly preserved cycle of frescoes in the apse and transept of the Upper Church of San Francesco at Assisi.

St. Francis, who was called the *Poverello* (little poor man) of Assisi and who married Lady Poverty by renouncing all possessions, is enshrined in a double church erected over his tomb. Probably built with the collaboration of French and German architects, the Upper Church is almost completely lined with frescoes, and its window openings are filled with stained glass. These cycles make it the most nearly complete large-scale cycle of religious imagery in Italy before the Sistine Chapel. Cimabue's *Crucifixion* (fig. 2.20) is difficult to

2.20. CIMABUE. *Crucifixion*. After 1279. Fresco, approx. 17 x 24' (5.18 x 7.32 m). Upper Church of S. Francesco, Assisi. Perhaps commissioned by Pope Nicholas III Orsini

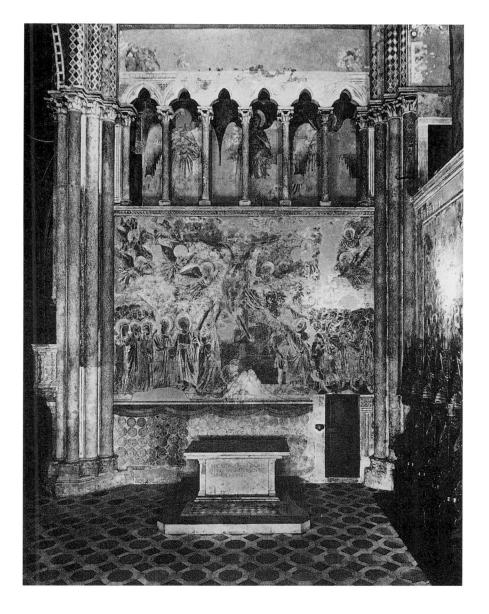

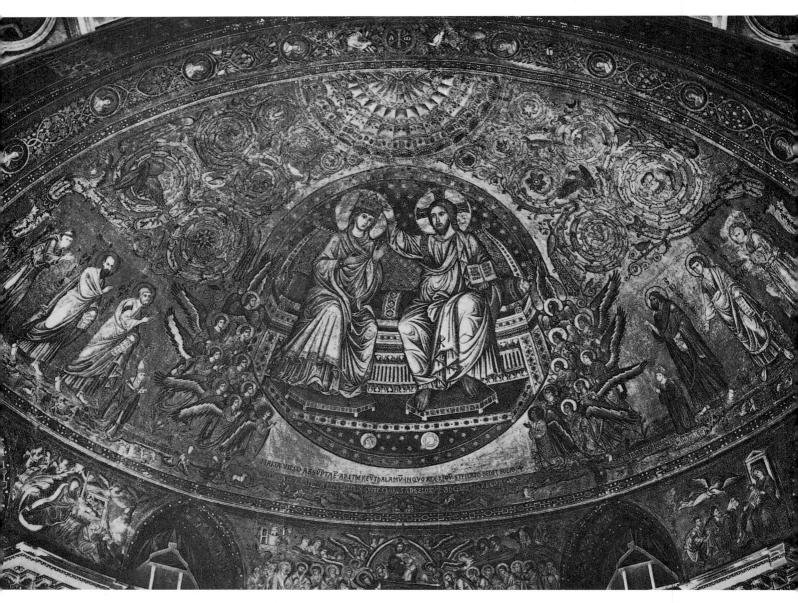

2.21. JACOPO TORRITI. Coronation of the Virgin. c. 1294. Apse mosaic. Sta. Maria Maggiore, Rome

decipher because the whites, painted with white lead, have oxidized and turned black with time. Later, Cennini would warn painters against using white lead on walls.

Cimabue has conceived the Crucifixion as a universal catastrophe. Christ writhes on the cross, his head bent in pain—perhaps already in death, although this is impossible to determine in the fresco's present state. A great wind seems to have broken loose, perhaps in reference to the sudden darkness that accompanied the Crucifixion. (When an eclipse of the sun takes place, a strong and unexpected wind will sweep across the landscape.) The air moves naturalistically here, as it never was allowed to do in Byzantine art. Angels hover in the air, their drapery blown by the fierce wind, and hands reach upward from the crowd below toward the crucified Christ. From his side pour blood and water—allusions to the sacraments of the Eucharist and baptism—into a cup held by a fly-

ing angel. On our left are Mary, the other holy women, and the apostles; on our right are the Romans and the chief priests and elders, including in the foreground the Roman centurion, who recognized Christ as the son of God. Even from this wrecked fresco we can understand that Cimabue was an artist of great dramatic capacity, endowed with the ability to grasp and project the intensity of a moment of revelation.

Painting in Rome

While Cimabue ruled the Florentine scene, a remarkable school of painters labored in Rome, where the practice of mural decoration in fresco and mosaic had continued in an unbroken tradition since the Early Christian period. The late thirteenth century saw an upsurge in pictorial activity in Rome that continued until 1305, when the seat of the papacy

was removed from Rome to Avignon in southern France. A certain impetus may have been given to Roman artists by the arrival of exiled Greek masters from Constantinople, and there are documents that Pope Honorius III imported mosaicists, probably either Greek or Greek-trained, from Venice.

The climax of Duecento monumental art in Rome is the apse mosaic of Santa Maria Maggiore (fig. 2.21), signed by Jacopo Torriti and executed during the pontificate of Nicholas IV (1285–94). Christ and the Virgin, robed in gold with blue shadows and seated on a rose-colored cushion with their feet on sky blue footstools, appear against a deep blue mandorla studded with gold stars and framed in sky blue, with silver stars that seem to float in the golden empyrean of the background.

As in certain earlier Roman apse mosaics, the gold ground is crowded with curling acanthus scrolls populated by ducks, doves, parrots, pheasants, cranes, and peacocks. The colors within the shell-niche at the crown of the apse move through a startling succession: gold, sky blue, rose, and green. The mosaic combines a subject popular in French Gothic cathedrals, the Coronation of the Virgin, with the linear style of

Byzantine mosaic art, while the acanthus scrolls are based on late classical originals, probably of the mid-fifth century. This work even embodies fragments of a fifth-century mosaic, including a river god and a sailing ship just barely visible below the angels at the left. More important than these diverse origins (including the pre-Christian) is the ease with which they are harmonized. The drapery motifs, for example, are at once Byzantine in their linearity, Gothic in their amplitude, and classical in their unity. A new style is emerging in Rome, in which the three currents most active in the formation of the Italian Renaissance are already approaching fusion.

Several Roman painters, including Torriti, were active in the nave of the Upper Church of San Francesco at Assisi, probably after Cimabue had finished his work in the transept and choir. One of these, the Isaac Master, painted two scenes from the story of Isaac and Jacob (fig. 2.22) in the upper level of frescoes, above the later series of the life of St. Francis. The flat ceiling with a diamond pattern in dark and light to indicate coffering, the elaborate hangings of the bed, and the little colonnade at its base are motifs often found in Roman

2.22. ISAAC MASTER. *Isaac and Esau*.1280s or early 1290s. Fresco, 10 x 10'(3 x 3 m). Upper Church of S. Francesco, Assisi

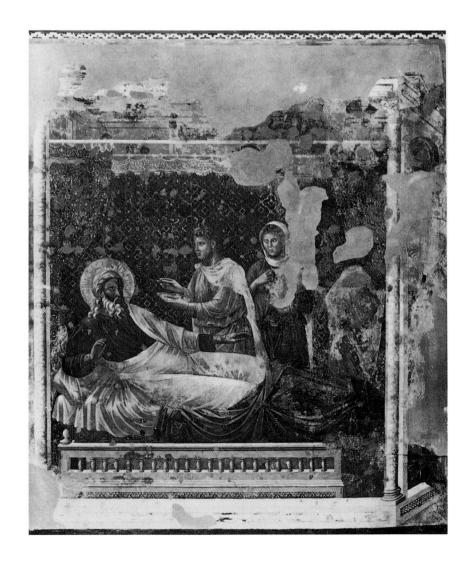

thirteenth-century art (see fig. 2.23), while the majestic drapery curves, at once classical, Byzantine, and Gothic, recall those of Torriti.

The scene is tense. In the adjoining fresco, Jacob, abetted by Rebecca, has received the blessing of the blind Isaac by fraudulent means, presenting a gift of venison. Here Esau, Isaac's favorite son, returns with the real gift, expecting the blessing; Isaac, realizing that he has been tricked, says to Esau, "Who art thou?" and "trembled very exceedingly" (Genesis 27:32-33). His right hand is raised, while his left captures his confusion at his father's unexpected response. The figure of Jacob is in poor condition, but he can be made out slinking away to the right. Stiff as the scene may be in poses and gestures, and imperfectly realized in the weightlessness of the bodies under their drapery, this unidentified painter was able to express psychological interaction and to capture the dramatic significance of a narrative with a subtlety not seen earlier. Also new here is the modeling of the faces and hands, which reveals the artist's close observation of light. A date in the 1280s or early 1290s seems likely, but the identity of this artist remains unknown.

Cavallini

Discovering the meaning and function of light to realize form transfigured Roman painting in the works of Pietro Cavallini (Pietro de' Cerroni, nicknamed Cavallino, "little horse"). Born sometime between 1240 and 1250, he was active until about 1330. A notation by his son tells us that he lived to a hundred and never covered his head, even in the worst days of winter. The Florentine sculptor Ghiberti, who knew frescoes and mosaics by Cavallini that are still preserved and others that have perished, including cycles in Old St. Peter's, San Paolo fuori le

Mura, San Francesco, and San Crisogono, called him a "most noble master" and praised his work for its "great relief."

The most important achievements by Cavallini still visible in Rome are the mosaics in the apse of Santa Maria in Trastevere (meaning, across the Tiber) and the fragmentary frescoes in Santa Cecilia in Trastevere, both of which Ghiberti mentions, but neither of which can be securely dated beyond the probability they were done in the 1290s. Ghiberti discerned in Cavallini's frescoes in Old St. Peter's "a little of the ancient manner, that is, Greek." The circumstances of Cavallini's lost work in the Early Christian basilica of San Paolo fuori le Mura explain Ghiberti's assessment. As Early Christian frescoes suffered from the passage of time, they were repainted again and again throughout the Middle Ages. When Cavallini was commissioned to do this, he tried to maintain the late classical qualities seen in the original compositions: rounded, weighty figures enveloped by softly folding draperies, modeled by light and standing in an illusionistic space. These qualities had little to do with the Byzantinizing style that we have seen flourishing elsewhere in Italy. When Cavallini had to substitute where little or nothing of the original was left, he clearly would have tried to mimic the style of the original.

The classic stylistic idioms inherent in the Early Christian models that Cavallini learned in this repainting process are evident in the *Birth of the Virgin* (fig. 2.23) from the series of the life of the Virgin in Santa Maria in Trastevere. The color emits a soft radiance that fills the whole apse with shifting, subtle variations of hue and value. The background appears like a simple stage set that is based on ancient Roman domestic architecture and shrines, while its inlaid ornament derives from Roman medieval sources. The women setting a table by the mother's couch and the two midwives about to

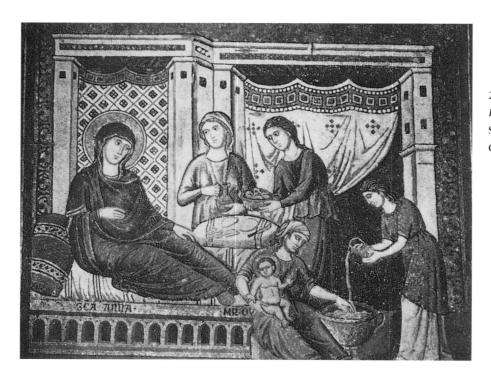

2.23. PIETRO CAVALLINI.Birth of the Virgin. 1290s. Mosaic.Sta. Maria in Trastevere, Rome.Commissioned by Bertoldo Stefaneschi

bathe the newborn Mary (a theme borrowed from representations of the birth of Christ; see p. 80) carry their bread, wine, and water with the solemnity of a ritual. The figures are imbued with classical grace and simplicity, and though Byzantine gold striations persist in the mantle about St. Anne's legs, the other drapery masses recall Greek and Roman sculpture in the breadth of their forms and the ease with which the folds fall, in sharp contrast to the tense com-

plexity of the drapery of Torriti or the Isaac Master. Most importantly, the three-dimensional heads and cylindrical bodies seem to depend largely on the play of light.

This is a fundamental revolution in artistic vision, and it is clear that it came about through an intimate acquaintance with Early Christian models. An even sharper transformation is visible in Cavallini's fragmentary fresco of the *Last Judgment* in Santa Cecilia in Trastevere (fig. 2.24), which is

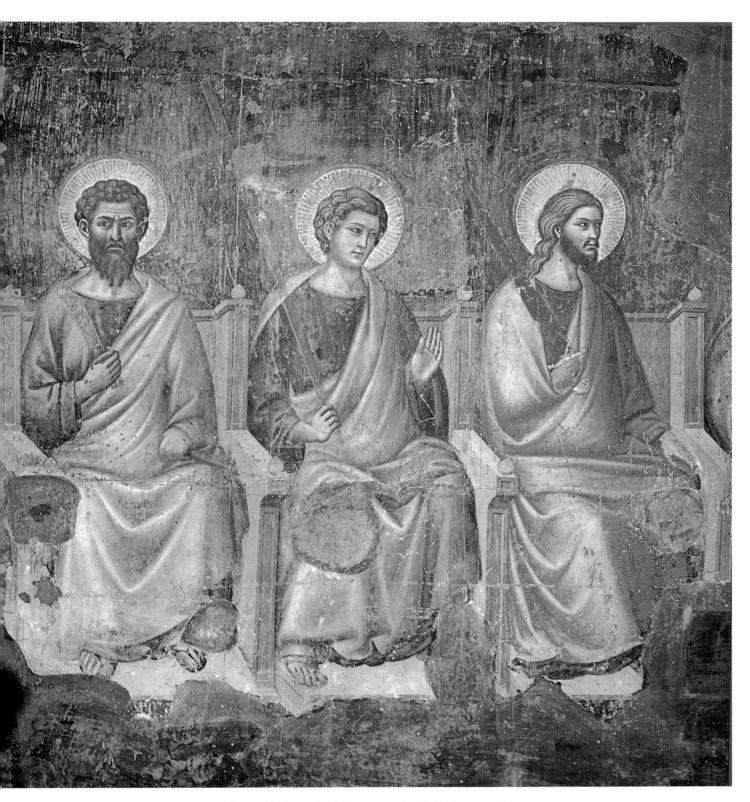

2.24. PIETRO CAVALLINI. Last Judgment (detail). c. 1290. Fresco. Sta. Cecilia in Trastevere, Rome

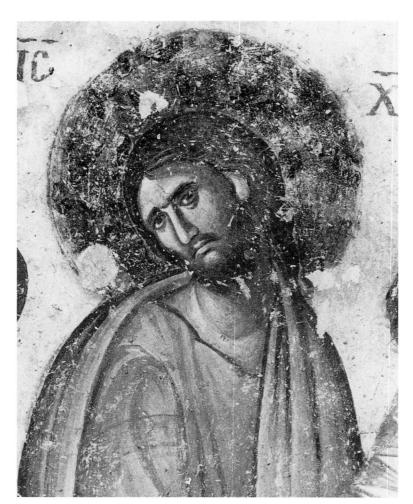

2.25. BYZANTINE. Head of Christ, detail of *Dormition of the Virgin*. Probably 1263–68. Fresco. Church of the Trinity, Sopoćani

all that remains of a cycle that once covered the entrance and nave walls of the church. In the enthroned Christ and apostles, whose rich coloristic harmonies are dominated by soft orange and green, and in the angels with feathers in graduated colors (not illustrated here), there is a wholly new sense of real rather than schematic volumes, of surfaces, and of textures in light. Cavallini's illumination still does not originate from one identifiable source, but it plays richly on the drapery of the seated apostles and the faces. Forms seem to have roundness in depth through the action of light. A columnar roundness makes the anatomical structure of the neck palpable in a manner not found in art since ancient times. Although the locks of hair are still somewhat patterned, the beards are naturalistic in texture and the mantles have a soft and silky sheen, no doubt due in part to Cavallini's adoption of the Roman use of marble dust in his intonaco. The naturalism of the seated apostles, whose facial expressions betray deep and subtle states of feeling, owes little to antiquity and nothing to Tuscany, but much to a new stylistic current that made its appearance during the 1260s under the Byzantinized Palaeologan dynasty. There is a striking relationship between Cavallini's style at Santa Cecilia and that of the Palaeologan-style frescoes in the Church of the Trinity at Sopoćani, Serbia, built in the early thirteenth century and decorated at the order of King Uroš I, probably between 1263 and 1268, by Greek painters (fig. 2.25).

Cavallini may have seen Palaeologan icons in Italy, but it is perfectly possible, considering the migrations of artists in the Middle Ages and Renaissance, that he went to Sopoćani to absorb the new style in its full measure. There were rich and continuous relations between Serbia and Western Europe. Uroš had a French wife and his Venetian mother, Queen Anna Dandolo, daughter of a doge, was buried at Sopoćani, which was built by Italian architects. Although there are many differences as well, Cavallini's apostles resemble the Christ in the Sopoćani *Dormition of the Virgin* in facial type, handling of beard and hair, expression, drapery masses, and above all in the manner in which form is created by light.

The innovations of Cavallini provided a strong incentive, perhaps even inspiration, for the Florentine master Giotto, who must have seen and studied Cavallini's work in Rome. In spite of his longevity, Cavallini was not able to keep pace with the rapid changes in style he had been instrumental in launching; his later works, in Rome and Naples, show only occasional flashes of the old fire.

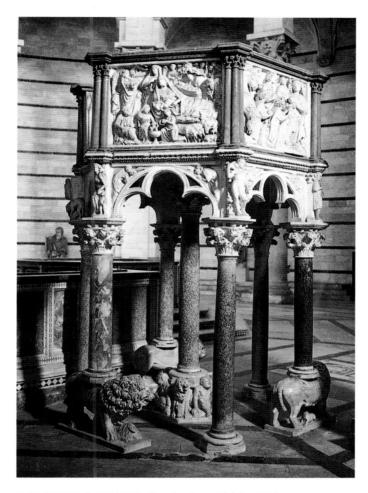

2.26. NICOLA PISANO. Pisa Baptistery Pulpit. 1260. Height approx. 15' (4.6 m).

Baptistery, Pisa. Commissioned by Archbishop Federigo Visconti. The inscription on the pulpit reads:
"In the year 1260 Nicola Pisano carved this noble work.
May so greatly gifted a hand be praised as it deserves."

Sculpture

Sometime during the decade of the 1250s, the sculptor Nicola d'Apulia arrived in Pisa; he is known today as Nicola Pisano (active 1258–78). He was the first of many sculptural innovators, and his unexpected classicism has often been attributed to a connection with the classicizing culture of the court of Emperor Frederick II, who ruled in Nicola's native Apulia. But Pisa, with its Roman history and pretensions, had a strong classical tradition of its own, and its ancient monuments had been copied by Nicola's sculptural predecessors earlier in the century. His first known work, a marble pulpit for the Baptistery of the Cathedral of Pisa (fig. 2.26), was signed with an inscription in which the artist proclaimed himself the greatest sculptor of his day, in keeping with the self-laudatory inscriptions common in medieval Tuscany. Busketus, the architect of the Cathedral of Pisa, had even compared himself to Ulysses and Daedalus.

The presence of a pulpit in a baptistery can be understood through the latter's special importance in the Italian city-states: it was the only place to celebrate baptism, the sacrament that brought a child into the Christian community and into citizenship in the Commune. The baptistery, usually a separate building, thus had a civic as well as religious importance. Sermons by Archbishop Federigo Visconti, who commissioned Nicola's pulpit, contain vivid symbolism of water as a vehicle for divine grace. Nicola's hexagonal pulpit is a magnificent construction of white marble from the quarries at nearby Carrara, with columns and colonnettes of polished granite and variegated red marble. Every other column is supported on the back of a marble lion, while the central column stands on a base enriched by seated sculptural figures.

Nicola's study of the ancient Roman Corinthian capitals found in abundance in Pisa gives his capitals classical firmness and precision, but their acanthus leaves resemble the more naturalistic ornament on French Gothic cathedrals.

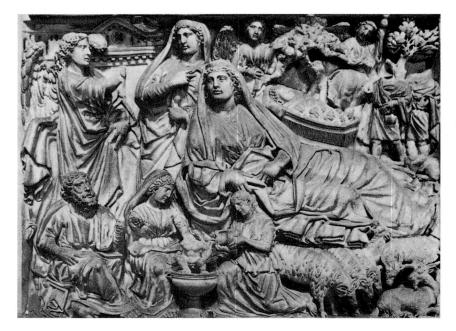

2.27. NICOLA PISANO. Annunciation, Nativity, and Annunciation to the Shepherds, panel on the Pisa Baptistery Pulpit (see fig. 2.26). $\stackrel{\triangle}{=} 33^{1/2} \times 44^{1/2}$ " (85 x 113 cm)

While Nicola's arches are rounded rather than pointed in the Gothic manner, they are enriched with the scalloped decoration known as cusping developed in French cathedral architecture. The hexagonal parapet behind which the speaker would stand provides fields for five high-relief panels (the sixth being used for the opening from the staircase); the spandrels, filled with reliefs of Old Testament prophets, are separated by figures in high relief standing over the capitals. The pupils of the eyes were inset with stone in some cases and painted in others, and the backgrounds of the scenes were decorated with patterned glazes on a gesso foundation, creating an effect not unlike the patterns that decorate the backgrounds of French Gothic manuscript paintings.

Nicola was apparently required by his archepiscopal patron to compress separate incidents into the same frame: the initial panel includes the Annunciation, the Nativity, and the Annunciation to the Shepherds (fig. 2.27). The Annunciation is one of the most important events in the Christian cycle, when the Angel Gabriel announced to the Virgin Mary that she would be the mother of the son of God. According to theologians, it was when Gabriel's words struck her ear that the human body of Christ was conceived in Mary's womb. The Annunciation is celebrated on March 25, which was also the first day of the Roman year; this also helps to explain the choice of December 25, nine months later, for the Nativity of Christ. Until the Gregorian calendar was adopted in the late sixteenth century, the new year in Tuscany began on March 25. Florence adhered to the tradition of celebrating the new year on the feast of the Annunciation until 1750.

In the *Nativity*, Mary reclines upon a mattress before the cave common in Byzantine representations of this event, a reference to the cave still shown to visitors in Bethlehem. The

two midwives who test the temperature of the child's bath are derived from a tradition preserved in an apocryphal gospel, but here on a baptismal font this scene is doubtless also connected with the sacrament of baptism. At the lower left, Joseph sits as a silent spectator. The representation of the shepherds, although damaged, can be seen at the upper righthand corner. These peripheral scenes act as a kind of frame for the enormous figure of the reclining Virgin. The style suggests that Nicola drew his figures on the marble slab and then cut in to free heads, arms, and trees from the background or from each other. No attempt was made to suggest distant space, and all the heads lie on the surface plane no matter how much the figures may overlap. Yet this also means that the forms of the crowded relief are related to the surrounding frame, a feature impossible to observe in photographs but effective when facing the actual pulpit.

The dense packing of the figures and the rendering of their heads can be traced to classical models, especially to figures on Roman sarcophagi, of which a number had remained in Pisa since antiquity or been brought there more recently to be reutilized as Christian tombs. These provided Nicola with authoritative models. His Virgin has often been characterized as a Roman Juno, and the straight nose, full lips, broad cheeks, and hair waving back from a low forehead come directly from classical art. But for all these specific references to antiquity, and the figures' classical weight and dignity, the whole is strangely unclassical. The drapery breaks into sharp angles, creating an all-over network reminiscent of the Italo-Byzantine forms in contemporary Duecento painting. The general compositional principles in the Baptistery pulpit reliefs are not far from those of Coppo di Marcovaldo and Cimabue. Classical and Gothic details alike seem intrusions at this stage.

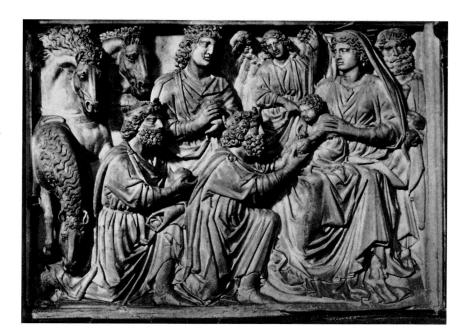

2.28. NICOLA PISANO. Adoration of the Magi, panel on the Pisa Baptistery Pulpit (see fig. 2.26). $\stackrel{\triangle}{=} 33^{1/2} \times 44^{1/2}$ " (85 x 113 cm)

In the Adoration of the Magi (fig. 2.28), the seated Virgin is imitated, almost line for line, from the seated Phaedra on a Roman sarcophagus representing the legend of Hippolytus; in Nicola's day this sarcophagus was on the façade of the Cathedral—today it is in the Camposanto. The borrowing was first mentioned by Vasari. The three kings look like Roman bearded figures, but again the drapery shows the staccato breaks of Italo-Byzantine style rather than the fluidity of the mass-produced Roman sculpture available to Nicola. Most striking of all is the nude male figure, below the left-hand corner of the Adoration, who is now identified as Daniel (fig. 2.29). He was imitated from a figure on a Roman Hercules sarcophagus, but his large head is probably in compensation for the low viewpoint of the spectator. In spite of the Christian horror of nudity, naked figures do appear in medieval art, especially in scenes of the Last Judgment, where all are naked before God. In the Trecento, in fact, nude figures are more common than one might realize. Andrea Pisano's sculptor (see fig. 1.10) is carving a male nude, and Cennino Cennini describes the proportions and construction of the male nude in detail. But this classically inspired Daniel is the first nude in Italian art who might be described as heroic.

Nicola's interest in the classical may be the result of a number of factors. Even at this early date Pisans traditionally thought of their city as a new Rome, and classical sarcophagi were used for burials in churches throughout the city. In addition, Nicola's use of the classical gives his scenes a majesty and dignity not seen in earlier Italian reliefs; his motivation in looking to the antique may have been based on a desire to find sculptural models that offered a mood and character that he deemed appropriate for the profundity of his Christian subject matter.

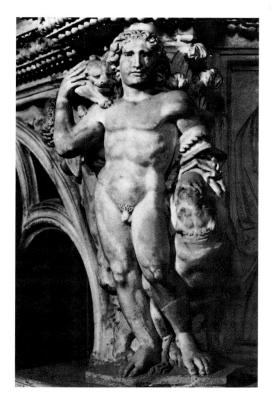

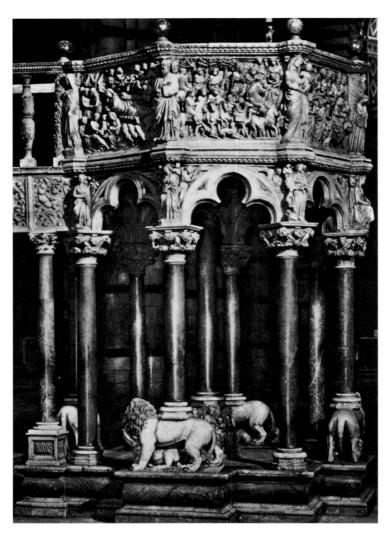

There is no inscription on this pulpit, but the documents mention four assistants: Arnolfo di Cambio, Lapo, Donato, and a special junior assistant, Nicola's son Giovanni Pisano. Giovanni also worked with Nicola on a fountain for the town of Perugia, as is revealed in its inscription: "The names of the worthy sculptors of the fountain are these: Nicola honored in his art and respected on all sides. He is the finest flower of honest sculptors. First comes the father, next the most dear son, whose name is Giovanni. May the Pisans be for long preserved on their course."

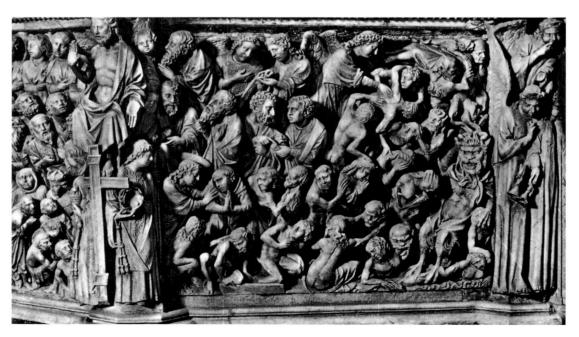

2.31. NICOLA PISANO. *Last Judgment* (portion), panel on the Siena Cathedral Pulpit (see fig. 2.30). $\stackrel{\triangle}{\mathbb{Z}}$ Each panel, $33^{1/2}$ x $38^{1/4}$ " (85 x 97 cm)

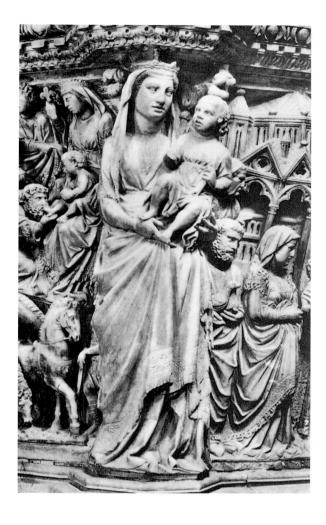

Five years after he completed the Pisa pulpit, Nicola was called to Siena, where he executed an even more ambitious pulpit for the Cathedral (fig. 2.30). In this octagonal, more richly decorated work, Gothic and classical elements blend effortlessly. Nicola worked on this immense undertaking from 1265 to 1268 with the assistance of a group of pupils that included his son Giovanni and three other sculptors who would later become well known, including Arnolfo di Cambio. These assistants were necessary to complete such an elaborate project in so short a time, but the general style of the work and probably even the execution of most of the principal sculptural portions indicate the hand of Nicola himself. Here the abrupt compositions and technique of the Pisa Baptistery pulpit have given way to a broader, smoother, and more unified treatment of shapes and surfaces. Standing statues separate curved reliefs, making the flow of sculpted forms appear continuous. Nine columns of granite and porphyry support the pulpit; the four shorter ones rest on the backs of lions or lionesses who stand over animals they have struck down. Around the base of the central column sit the Liberal Arts, their number here augmented to eight. The pulpit was at one time dismantled, and the statues are no longer in their proper positions; furthermore not all the figures have been clearly identified.

Nicola, like so many artists from the Middle Ages to the Baroque, must have had pattern books for stock scenes, and some of the compositions here are similar to those in the Pisa Baptistery pulpit. The most spectacular of the scenes is the Last Judgment (fig. 2.31), which comprises two relief panels flanking the central sculptural group of the enthroned Christ with angels. The richness of the panoramic composition depends on a new, vivid conception of the musculature of the human figure, especially in the relief that shows the damned about to be dragged to hell-figures whose freedom of pose and action gave inspiration to later artists, particularly the Sienese painter Duccio. All traces of the Italo-Byzantine compartmentalization of form have been swept away by the vigor of Nicola's surface. Now drapery flows as easily as in the classical originals he admired, and a new softness of flesh and a grace of expression are evident, particularly in the Madonna (fig. 2.32), who has a new physicality. Her breasts are visible through the drapery, as in the French Gothic statues of Reims Cathedral. The question of French influence is still open, but Nicola's art is full of premonitions of the Renaissance and runs parallel to the innovations of Cavallini in painting.

Nicola's son Giovanni inherited the shop after his father's death, sometime between 1278 and 1287. Giovanni Pisano

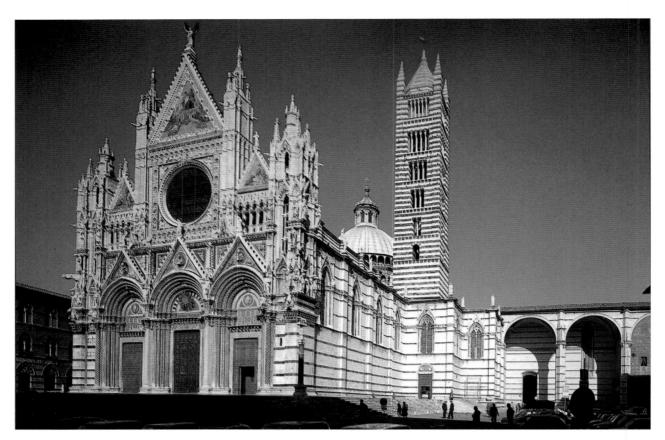

2.33. GIOVANNI PISANO. Lower half of façade, including statuary. 1284–99. Cathedral, Siena. Most of the sculptures are copies; originals now in the Museo dell'Opera del Duomo, Siena (see fig. 2.34)

(c. 1250–c. 1314) designed the lower half of the façade of Siena Cathedral (fig. 2.33) and carried out some of its finest sculpture before returning to Pisa. In contrast to Nicola, Giovanni's style is determinedly Gothic, but it is closer to the expressionistic Gothic found in German sculpture than to the courtly style of France. The statues of prophets and saints on the Siena façade twist and turn as if to declare their independence from the confining rules of architecture, even though it was Giovanni himself who laid out the arches, gables, and pinnacles that surround and enframe them. The statues recall figures from the pinnacles of Reims Cathedral, carved only a few years earlier, but Giovanni's figures express a more powerful sense of movement that is most evident in his figure of *Mary, Sister of Moses* (fig. 2.34).

The abrupt tension of her pose—especially the neck projecting sharply from the torso and then twisted to one side—can be explained in part by a sensitivity to the spectator's viewpoint. Giovanni was well aware that unsatisfactory

2.34. GIOVANNI PISANO. *Mary, Sister of Moses.* 1284–99. Marble, height $74^{3}/8$ " (1.89 m). Removed from original location on the façade of the Duomo, Siena (see fig. 2.33). Museo dell'Opera del Duomo, Siena

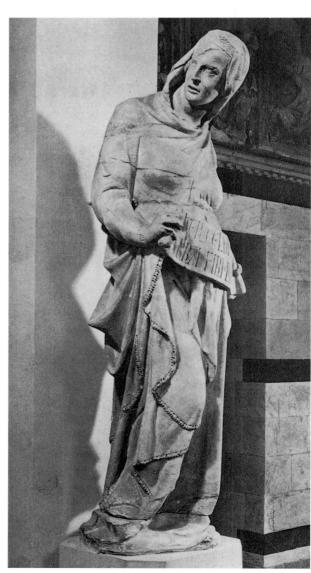

2.35. GIOVANNI PISANO.

Pistoia Pulpit. 1298-1301.

Height 12'9" (3.89 m). 🟛 Sant'Andrea, Pistoia.

Commissioned by Canon Arnoldus.

The inscription on the pulpit reads:

"In praise of the triune God I link the beginning with the end of this task in thirteen hundred and one. The originator and donor of the work is the canon Arnoldus, may he be ever blessed. Andrea, [son?] of Vitello, and Tino, son of Vitale, well known under such a name, are the best of treasurers. Giovanni carved it, who performed no empty work. The son of Nicola and blessed with higher skill, Pisa gave him birth, endowed with mastery greater than any seen before."

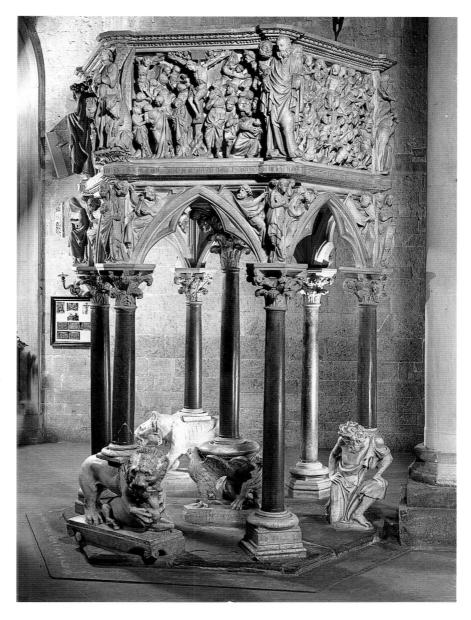

effects would result if a sculptor did not take the viewer's position into account when planning statues intended for a lofty position. He therefore brought the neck outward so that when the figure was seen from the piazza below, the face would not be hidden by the breasts and knees. Mary's dramatic pose may also be related to her original position on the side of the façade; she leans aggressively forward as if to communicate with her fellow prophets and sibyls. Giovanni also-and this is common in Italian sculpture designed for distant viewing—reduced the figure and its features to their essentials, because from a distance fine detail would be lost and only the most powerful masses and movements would register on the eye. Today the badly eroded originals, taken down for safekeeping, have been replaced by copies on the façade. In their present setting in the Museo dell'Opera del Duomo, near or in some cases even below eye level from the entrance, the rationale for their extraordinary appearance has evaporated.

The self-laudatory inscription placed by his father on the Pisa Baptistery pulpit is exceeded by the inscription Giovanni carved on the pulpit he created between 1298 and 1301 for the Romanesque church of Sant'Andrea in Pistoia (fig. 2.35). Although hexagonal, the Pistoia pulpit gives a totally different impression from the Pisa Baptistery pulpit. The cusped arches are sharply pointed and the leaves of the capitals more richly three-dimensional, while the classical elements so important in Nicola's art have been submerged by a rising tide of emotionalism. The projections are stronger, the undercuttings of heads, arms, and other projecting elements deeper. The free, zigzag movement of the drapery has little in common with Nicola's carefully balanced folds. Even when the arrangement of figures and scenes appears to be derived from Nicola's pattern book, the effect is one of deep hollows enclosed by fluid shapes in continuous motion.

A scene especially suited to Giovanni's new style is the *Massacre of the Innocents*, those children under the age of

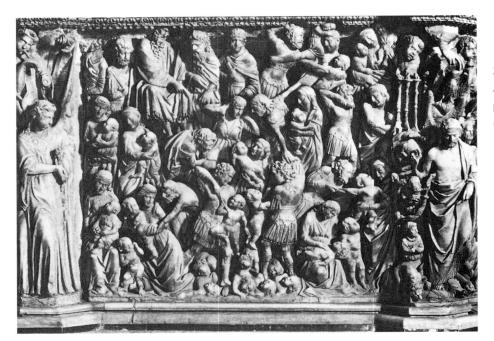

2.36. NICOLA PISANO.

Massacre of the Innocents,
panel on the Siena Cathedral Pulpit
(see fig. 2.30).

33¹/2 x 38¹/4" (85 x 97 cm)

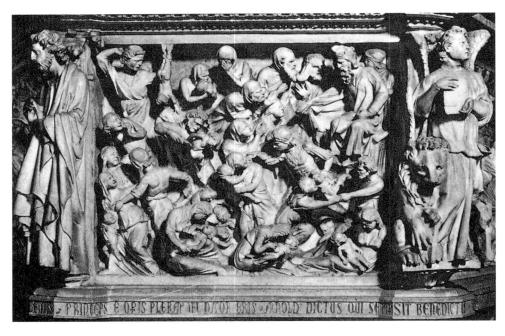

2.37. GIOVANNI PISANO. *Massacre of the Innocents*, panel on the Pistoia Pulpit (see fig. 2.35). $\widehat{\mathbb{m}}$ 33 x 40¹/s" (83 x 102 cm)

two who were slain at the command of King Herod to destroy the infant he feared would usurp his power. Represented in a restrained way by Nicola, this scene becomes an orgy of sadism in Giovanni's relief (figs. 2.36, 2.37). On the upper right, Herod gives the order; the stage is filled with wailing mothers, screaming children, and soldiers raising children and stabbing them with swords; below, mothers cradle their dead children and weep over them. Even the lesser figures—the prophets in the spandrels and sibyls between the capitals and the parapet—share in the general agitation. The sibyls, Greek and Roman prophetesses who were believed to have foretold the coming of Christ, can be seen again and again in Italian art, culminating in their representation by Michelangelo on the Sistine Ceiling. One dramatic figure (fig.

2.38), inspired by an angel who appears over her shoulder, can be compared to Michelangelo's much later *Libyan Sibyl* (see fig. 17.39). Her excitement is communicated by the turn of her head, the zigzag movement of the figure, and the flow and flicker of the drapery. Giovanni's most unexpected figure supports a column on the nape of his neck (fig. 2.39); his struggle is evident in his pose and the tortured expression on his face.

It is perhaps characteristic of the mélange of styles that coexisted in Duecento Tuscany that the Pistoia pulpit should be roughly contemporary with the last manifestations of the Italo-Byzantine style in painting. But we have seen that Cimabue was, at Assisi, capable of projecting emotional dramas on a large scale in fresco compositions. At this particular

Opposite: 2.38. GIOVANNI PISANO. Sibyl, figure on the Pistoia Pulpit (see fig. 2.35). $\stackrel{\triangle}{\mathbb{D}}$ Height $24^{3}/8^{\circ}$ (62 cm)

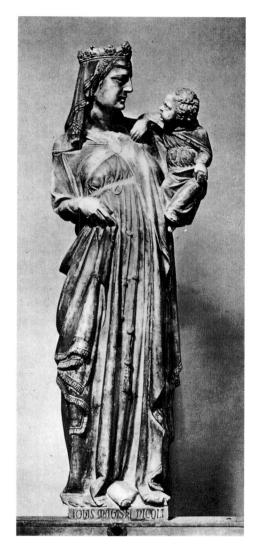

Above: 2.40. GIOVANNI PISANO.

Madonna and Child. c. 1305–6. Marble,
height 50¾" (129 cm). Arena Chapel, Padua.
Commissioned by Enrico Scrovegni

2.39. GIOVANNI PISANO.

Supporting Figure, on the base of the Pistoia

Pulpit (see fig. 2.35).

Height 34³/₄" (88 cm)

moment in Italian art, Gothic sculpture and Italo-Byzantine painting are allies. The last manifestations of Giovanni Pisano's art, however, really belong to the next chapter. The grand simplicity of his *Madonna and Child* on the altar of the Arena Chapel in Padua (fig. 2.40), her clear-cut profile so different from the Romanizing profiles by Nicola, the broad

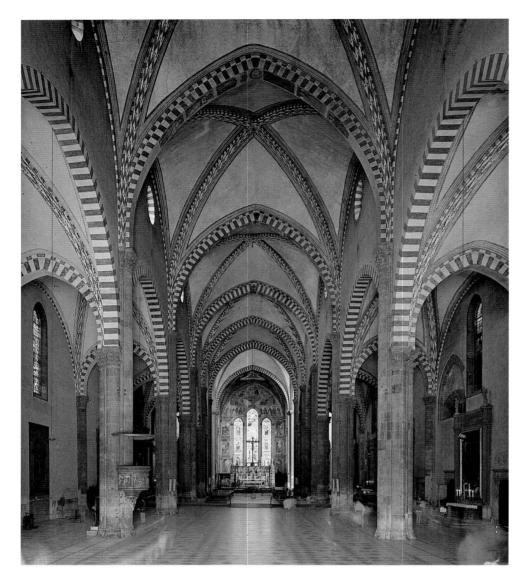

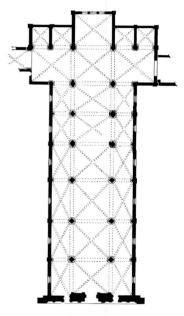

2.41. Nave and choir, Sta. Maria Novella, Florence. Begun 1246

2.42. Plan of Sta. Maria Novella

sweep of the drapery masses enhancing the volume of the figure beneath them, the geniality and human directness of the expressions—all suggest a close familiarity with the art of Giotto, the master whose frescoes fill the walls and ceiling of the same chapel.

Architecture

At this point we face a dilemma. It is logical enough to consider the great painters and sculptors of the Duecento and the Trecento as precursors of the Renaissance and, in their own right, as leaders of an artistic revival that is not directly comparable with the Gothic style that prevailed elsewhere in Europe. Despite their ties with the Middle Ages, their work, as will be seen, is inseparable from that of the Renaissance masters of the Quattrocento and Cinquecento. The same cannot be said of Duecento architecture—an Italian version of the

Gothic without the organic complexity of French Gothic, to be sure, but Gothic nonetheless. Yet the figurative artists of the period worked within this architectural context, and many of its preconceptions governed their frescoes, statues, and reliefs. In fact, they sometimes took part in the construction of Duecento buildings.

The two new thirteenth-century religious movements, Dominican and Franciscan, required ecclesiastical buildings on a huge, unprecedented scale to accommodate their large congregations. The Florentine churches of Santa Maria Novella and Santa Croce owe their existence to the preaching orders that still occupy them. Santa Maria Novella (figs. 2.41, 2.42), founded by the Dominicans before 1246 and constructed between 1246 and the early Trecento, is perhaps the supreme example of the simplicity of plan, organization, and detail that characterizes Italian Gothic architecture. The plan is derived from those developed for churches of the Cister-

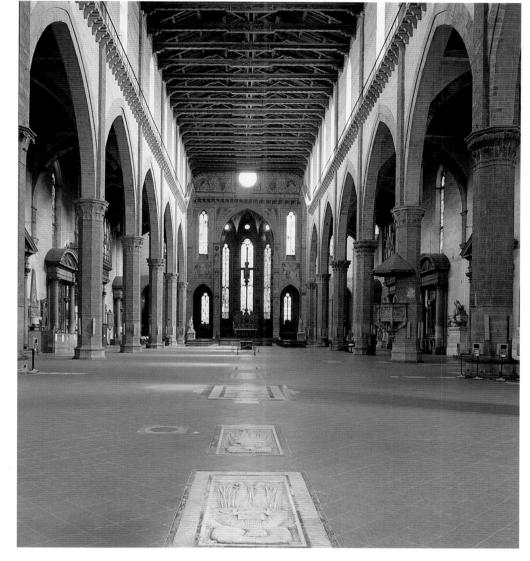

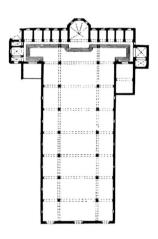

2.43. ARNOLFO DI CAMBIO (attributed to). Nave and choir, Sta. Croce, Florence. Begun 1294

2.44. Plan of Sta. Croce

cian Order; in the order's monasteries in France, England, and Italy, a flat east end was substituted for the rounded or polygonal apse generally used in cathedral churches. But the relatively high side aisles, leaving little room for a clerestory and none for a triforium, are typically Italian. So is the contrast of the stone of the supports and arches with the *intonaco* that covers the walls and vaulting. These plastered surfaces create a membrane that encloses and harmonizes with the forms of the pointed arches, which are striped in stone like the lower, Gothic part of the façade (see fig. 10.5). Arches and vault ribs are flat, wall ribs are almost nonexistent, and compound piers are as simple as those of Romanesque buildings in France.

There is, moreover, no formal separation between the nave arcade and the wall above, which is pierced by simple oculi instead of the usual pointed Gothic windows. As a result, nothing interrupts the unifying membrane of the wall, which

creates a feeling of calm repose. This is in striking contrast to the energetic pictorial art and rich sculpture of the period. However different the architectural forms of Santa Maria Novella may be from the later, classically derived elements of the Renaissance, the harmony of its lines and spaces renders it a fitting precursor of such Quattrocento churches as San Lorenzo and Santo Spirito (see figs. 6.10, 6.11). At a moment when French architects had dissolved the wall entirely, converting whole churches into elaborate stone cages to enclose surfaces of colored glass, the unknown—possibly monastic—builders of Santa Maria Novella proclaimed the quintessentially Italian supremacy of the wall.

So did the architect of Santa Croce (figs. 2.43, 2.44), the Franciscan church on the opposite side of the city, but in a very different way. In all probability this master was Arnolfo di Cambio, who was also important as a sculptor, as a pupil and coworker of Nicola Pisano, and as the first architect of

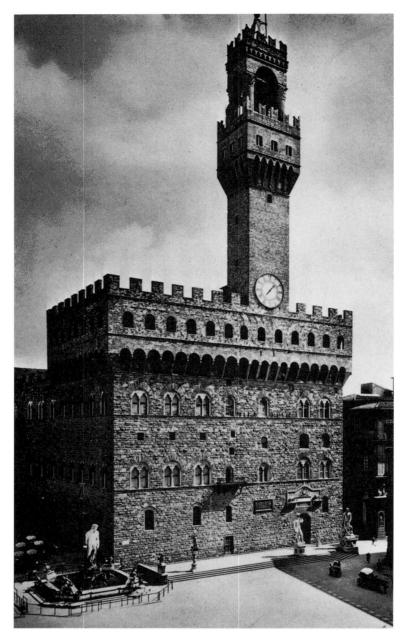

2.45. ARNOLFO DI CAMBIO (attributed to). Palazzo dei Priori (now known as Palazzo Vecchio), Florence. 1299–1310

the new Cathedral of Florence (see fig. 5.14). The construction of Santa Croce, founded in 1294, continued well into the Trecento. The plan combines a long, timber-roofed nave of seven bays with a lower, vaulted polygonal apse that is separated from the nave by a triumphal arch somewhat like those of the Early Christian basilicas in Rome but with pointed arches and windows. A choir screen containing chapels once separated the crossing from the nave. Octagonal columns replace the compound piers used in Santa Maria Novella, which are needless here since there is no vaulting. A catwalk carried on corbels separates the small clerestory

from the nave arcade, and carries the eye down the nave and up over the crossing to the triumphal arch.

Santa Croce's loftiness and the openness of its arches make it seem almost endless. From the very start, the wall surfaces were intended for painting, as were the windows for stained glass. In fact, the nave was still being built when Giotto and his followers were at work painting frescoes on the walls of some of the transept chapels. The early Trecento painted decoration of the ceiling beams is still largely intact. The splendor of Santa Croce, of which this brightly painted roofing is an essential part, gives us some insight into how the nave of

the Duomo of Florence (*duomo* is Italian for "cathedral") might have looked had Arnolfo's plan been followed.

In the Italian city-states the building that housed the government competed in physical bulk and artistic magnificence with the principal churches, and Florence was no exception. Also attributed to Arnolfo is the Palazzo dei Priori, or Palace of the Priors, as the principal governing body of Florence was called (fig. 2.45); it is now popularly (and inappropriately) known as the Palazzo Vecchio, a name it was given in the sixteenth century when the Medici family, who had lived in the republican city hall for a period, moved across the river to their "new" palace, the Palazzo Pitti.

The Palazzo dei Priori dominates a whole section of the city and in popular imagination its tower is grouped with the dome of the cathedral as a symbol of the city. It is not only the largest, but also one of the last built of the Italian medieval communal palaces. It was erected in an astonishingly short space of time, only eleven years from the laying of its foundations in 1299 to the completion of the bell tower in 1310. From the start, the building was intended to help define the piazza produced by the destruction, in 1258, of the houses of the traitorous Uberti family, who had fled Florence and later fought with the Sienese at the Battle of Montaperti. The Priori had declared that no buildings would ever stand

on their property, which was confiscated by the Commune. The new communal palace was built of *pietra forte*, a tancolored local stone. It appears as a gigantic block, divided by stringcourses into a ground floor and two main stories, each of colossal proportions, and crowned by powerfully projecting machicolations carried on corbels and culminating in a crenellated parapet. The great tower is placed off-center, perhaps to make use of the foundations of earlier house towers. It is thrust aggressively forward, out over the corbelled arcade, and terminates in more corbelled machicolations, another crenellated parapet, and a baldacchinolike bell chamber supported on four huge columns.

The brutal power of the building mass is accentuated by the roughness of the blocks, which are rusticated as in Roman military architecture. And the building seems even more impregnable by virtue of the relative delicacy of the mullioned windows with their trefoil arches, in imitation of French Gothic models. Its simplicity and force, its triumphant assertion of the noble human capacity to govern, were intended to symbolize the victory of civic harmony over the internal strife that tore the Republic apart in the late Duecento. The building may also serve as an introduction to the artistic ideals of one of the greatest periods in Florentine art, the Trecento, and to the style of Giotto, its leading master.

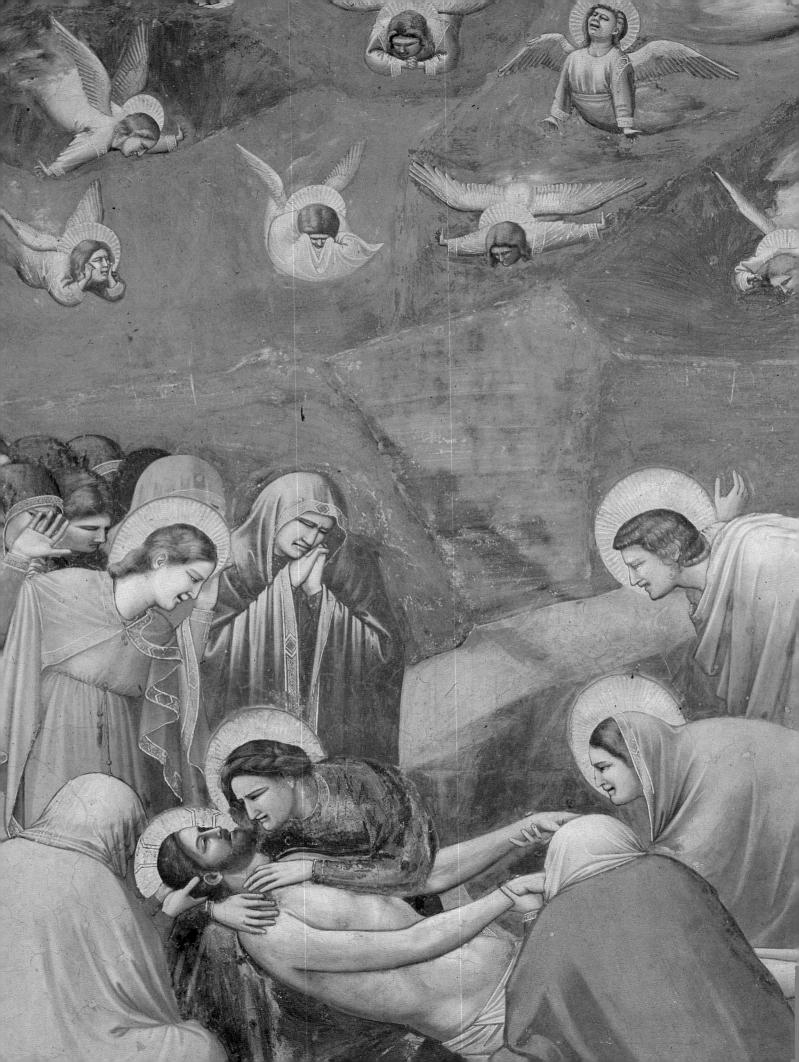

FLORENTINE ART THE EARLY TRECENTO

n the early Trecento, a new style of painting emerged that revolutionized the art of Florence, Tuscany, Italy, and eventually the entire Western world. This new style achieved a broad importance that made its initiator one of the most influential artists of the Western tradition.

Giotto

The significance of Giotto di Bondone (c. 1277-1337) was not lost on his contemporaries. The Chronicle of Giovanni Villani, written a few years after Giotto's death, rated him among the great personalities of the day. Boccaccio claimed that Giotto had "brought back to light" the art of painting "that for many centuries had been buried under the errors of some who painted more to delight the eyes of the ignorant than to please the intellect of the wise" (Decameron, VI, 5). Later, in his treatise On Poetry, Boccaccio compared Giotto to the ancient painter Apelles, about whose works he had learned by reading the ancient author Pliny.

In a famous passage from the Divine Comedy (XI, 94-96), Dante relates his encounter in purgatory with the miniaturist Oderisi da Gubbio, who bewails his own fall from popularity, comparing it with that of Cimabue as an example of the transience of worldly fame. As Dante makes clear, it was Giotto who stole Cimabue's fame: "O empty glory of human powers! . . . Cimabue thought to hold the field in painting, and now Giotto has the cry, so that the other's fame is dim." Giotto's success was similar, according to Dante, to that of the poet Guido Cavalcanti, inventor of the dolce stil nuovo (sweet or beautiful new style), whose revolutionary use of the Tuscan language chased his competitors from the field.

Dante's statement is literally true. Within a few years after Giotto's art made its appearance, the Byzantinizing style of Cimabue virtually disappeared in Florence. Most Florentine painters began to imitate Giotto's new style, which spread to

other centers in Tuscany, including Siena, and then up and down the Adriatic coast, capturing one provincial school after another. It met resistance only in Venice, which was strongly tied to the Greek East, and in Piedmont and Lombardy, where the Northern Gothic was deeply influential. Basic conceptions behind Giotto's new direction remained dominant into the Quattrocento when Renaissance artists and writers emphatically insisted that Giotto was their true artistic ancestor. At few other moments in the history of painting has a single idea undergone so rapid, widespread, and complete a change.

What was this new style? Cennino Cennini, a late-fourteenth-century painter who claimed to have been the pupil of Agnolo Gaddi (himself the son and pupil of Taddeo Gaddi, one of Giotto's closest followers), declared that Giotto had translated painting from Greek (by which he meant Byzantine) into Latin. In the sixteenth century, Vasari would write that Giotto had revived painting after it had languished in Italy since ancient times. Giotto, he said, had abandoned the "rude manner" of the Greeks and, since he continued to "derive from Nature, he deserves to be called the pupil of Nature and no other." In his exaltation of Giotto, Vasari ignored the transformations of the Byzantine style evident in the works of Cimabue and Duccio, both of whom exerted a powerful impact on Giotto's innovations. No one at the time was in a position to realize what Italian painting had gained from Byzantine examples and, perhaps, from actual Byzantine artists working on Italian soil. To all Trecento commentators, naturalness was equated with Latinity, which meant ancient Roman culture, in the larger sense—Italy, and, as we shall see, France. The virtue of Giotto's style for his contemporaries and successors lay in its fidelity to the human, natural, Italian world they knew, as against the artificial manner imported from the Byzantine East. Although Cennini never wrote that Giotto drew from posed models, Villani suggested as much when he referred to Giotto as "he who drew every figure and action from nature," depending on the precise significance

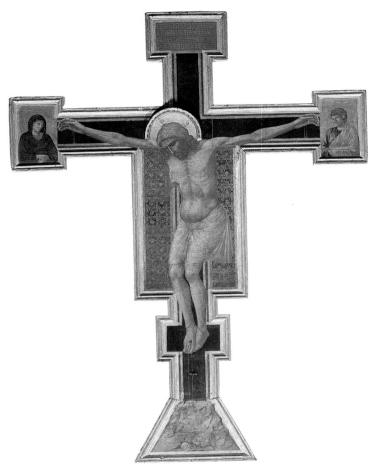

3.1. GIOTTO. Crucifix. c. 1295. Panel,
19' x 13'4" (5.8 x 4 m). Santa Maria Novella, Florence.
In 1568 Vasari wrote that Giotto "became so good an imitator of nature that he banished completely the rude Greek [i.e., Byzantine] manner and revived the modern and good art of painting, introducing the portraying well from nature of living people, which had not been used for more than two hundred years."

one attaches to his verb *trasse*, which can mean "drew" in two different senses, to take from or to make a drawing.

The surviving work of Italy's early Trecento painters represents a mere fraction of what they must actually have painted; in most cases the majority of works created by any given artist does not survive. As we read Vasari's accounts of Giotto's output—even remembering that some of the paintings he mentions may have been by other artists—we realize how little remains of what Giotto produced in the course of a long and honored lifetime. He was reported to have worked throughout Tuscany, northern Italy, and the Kingdom of Naples, including its capital, then ruled by a French

dynasty. He was said to have traveled to France to work in Avignon, the new seat of the papacy after 1305, and elsewhere, a record supported by the French contacts abundantly visible in Giotto's style. Commercial relations between Florence and all parts of Europe were so routine during the Trecento that we cannot deny the possibility, even the ease, of a trip to France for so prosperous and universally desired an artist as Giotto. Whether or not Giotto studied with Cimabue in Florence, as Vasari said he did, the older painter played little part in the formation of the artist's style as we know it. The dominant influences were several: the sculpture of the Pisano family, the paintings of Cavallini, French sculpture seen either in France or through small, imported works, and, perhaps most importantly, a new interest in the study of nature.

During most of the Duecento, Florence and its territory had been the scene of warfare between opposing factions: the Guelphs, who favored the pope, and the Ghibellines, who were attached to the Holy Roman Emperor. In reality, this was a class conflict, because the Ghibellines were the feudal nobility, and they and their supporters looked to the emperor to maintain them in their fiefs. The Guelphs, on the other hand, comprised the bulk of the city dwellers—artisans and merchants for the most part—who succeeded in establishing their guilds by the Ordinances of Justice in 1293; these regulations disenfranchised the nobles unless they were willing to adopt a trade and join a guild. An attempt by the nobles to regain power was put down in 1302, and hundreds of Ghibellines, including Dante, were exiled from the city. It is within the historical context of the triumph of the prosperous commercial and artisan class that the art of Giotto emerged with its emphasis on clarity, measure, balance, order, and on the carefully observed drama that develops between human beings who live and work at close quarters.

THE CRUCIFIX IN SANTA MARIA NOVELLA.

The earliest works of Giotto are still debated, but a newly restored Crucifix has recently gained acceptance (fig. 3.1). A comparison with Cimabue's Crucifix at Santa Croce (see figs. 2.18, 2.19) is instructive. The basic design of the two works is the same, with the body of Christ isolated against the decorated, traditional frame, and half-length figures of the Virgin and John the Evangelist in the side terminals. But Giotto has replaced the abstracted Byzantine segmentation of bodies, heads, and hands with three-dimensional forms modeled in light. While the flowing, two-dimensional pattern of Cimabue's Christ was locked into a composition of horizontals, verticals, and decorative patterns, the body of Giotto's Christ, profoundly three-dimensional, thrusts itself forward into space, forcing the cross and its patterns to become background. Christ's head moves forward, while his buttocks seem to fall back against the cross. His mouth falls open, exposing his lower teeth, his hair falls naturally to the side of

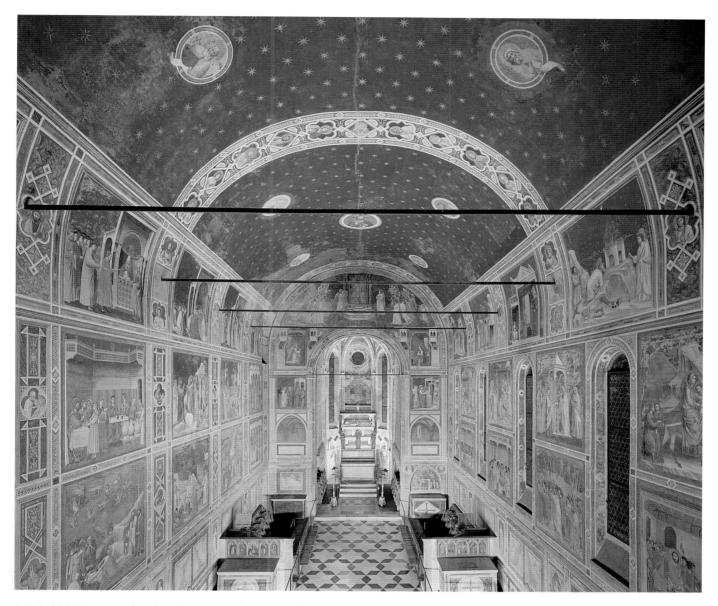

3.2. GIOTTO. Arena Chapel, Padua. Interior, facing altar. Consecrated 1305. Commissioned by Enrico Scrovegni

his face, and his hands cup the surrounding space. The physicality of Giotto's very human Christ draws an empathetic response from the viewer.

THE ARENA CHAPEL. During this same period Padua, a university city not far from Venice, had regained its republican independence and created a considerable state on the flat Venetian plain. In 1300 a wealthy Paduan merchant, Enrico Scrovegni, acquired the ruins of an ancient Roman arena, where a chapel dedicated to the Virgin Annunciate was located. Three years after acquiring the site for his palace, Scrovegni began building a new chapel, probably in the hope of atoning for the sins of usury committed by himself and his deceased father, Reginaldo. In 1305 the chapel was consecrated, and manuscript copies of the chapel's frescoes can be dated to 1306. From the very start, apparently, Scrovegni thought of commissioning Giotto, who according to one account was satis iuvenis (fairly young), to paint the interior. Whether Giotto planned the fresco cycle by himself or with the aid of Scrovegni and theological advisers is unknown. Although he undoubtedly had assistants working with him, Giotto certainly painted the principal figures of each scene.

The Arena Chapel frescoes represent Giotto's greatest preserved achievement (figs. 3.2, 3.3, 3.4). They are astonishing in their completeness and state of preservation, especially given that the chapel was narrowly missed by an Allied bomb during World War II. Since the chapel was attached to the palace on the north side, there are windows on the south only. These were kept small to provide as much wall space as possible for the frescoes, which are designed in three superimposed

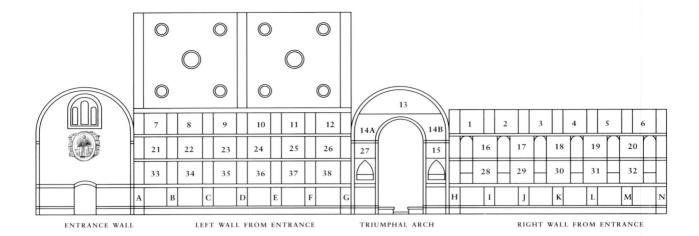

3.3. Diagram of Arena Chapel iconography. Computerized reconstruction by Sarah Loyd, after Flores d'Arcais.

LIVES OF JOACHIM AND ANNA: 1. Joachim Expelled from the Temple; 2. Joachim Takes Refuge in the Wilderness (see fig. 3.6);

3. Annunciation to Anna; 4. Sacrifice of Joachim; 5. Dream of Joachim; 6. Meeting at the Golden Gate (see fig. 3.7).

EARLY LIFE OF THE VIRGIN MARY: 7. Birth of the Virgin; 8. Presentation of the Virgin in the Temple; 9. Suitors Presenting the Rods;

10. Prayer before the Rods; 11. Marriage of Mary and Joseph; 12. Wedding Procession; 13. God's Mission to Gabriel;

14A. & 14B. Annunciation (see figs. 3.8, 3.9); 15. Visitation.

LIFE OF CHRIST: 16. Nativity and Apparition to the Shepherds (see fig. 3.10); 17. Adoration of the Magi; 18. Presentation of Christ in the Temple; 19. Flight into Egypt; 20. Massacre of the Innocents; 21. Christ Disputing with the Doctors in the Temple; 22. Baptism of Christ;

23. Marriage Feast at Cana; 24. Raising of Lazarus (see fig. 3.11); 25. Entry into Jerusalem; 26. Christ Driving the Money Changers from the Temple; 27. Judas Receiving the Blood Money from the High Priests of the Temple; 28. Last Supper; 29. Washing of the Feet;

30. Kiss of Judas (see fig. 3.13); 31. Jesus before Caiaphas; 32. Crowning with Thorns; 33. Christ Carrying the Cross; 34. Crucifixion (see fig. 3.14); 35. Lamentation (see fig. 3.15); 36. Noli Me Tangere; 37. Ascension of Christ; 38. Pentecost.

SEVEN VICES: A. Despair; B. Envy; C. Infidelity; D. Injustice (see fig. 3.17); L. Faith; M. Charity; N. Hope.

ENTRANCE WALL: Last Judgment; Enrico Scrovegni Offering the Model of the Chapel to the Virgin Mary (see figs. 3.4, 3.16)

rows. To separate each scene, Giotto designed frames that form a continuous structure of simulated architecture. On the north wall, French Gothic quatrefoils enframe smaller scenes that act as commentaries on the scenes of the main narrative of the life of Christ (fig. 3.5; see fig. 3.15). The vault is painted the same bright unifying blue as the background color in all the frescoes—naturally enough, since vaults and domes were traditionally held to be symbolic of heaven, and Italian documents show that an interior vault was often referred to as *il cielo* (the sky). The chapel's vault is covered with gold stars, while figures of Christ, the Virgin, the four evangelists, and four prophets appear in circular frames that seem to pierce the sky, revealing the golden glory of heaven beyond.

The chapel is dedicated to the Virgin of Charity. The wall surfaces are so divided to illustrate the lives of the Virgin and Christ in thirty-eight scenes. The chosen episodes emphasize the life of the Virgin as told in the *Golden Legend*, a book written by the thirteenth-century Genoese bishop Ja-

cobus de Voragine. In Giotto's cycle, the scenes of Christ's life where the Virgin plays no role are generally omitted. Narration begins on the upper level, to the right of the chancel arch, with the events of the lives of Joachim and Anna, Mary's parents, on the right-hand wall (as seen from the entrance). The life of the Virgin on the left ends with God the Father enthroned in the center over the arch, sending the Archangel Gabriel on his mission, and the Annunciation with Gabriel and Mary on either side of the sanctuary. On the second level, the infancy of Christ begins on the righthand wall, culminating in his adult mission, on the left. On the lowest tier, the passion of Christ on the right is followed on the left by his Crucifixion and Resurrection. The level below is treated like wainscoting, with panels painted in imitation of marble alternating with images of the Seven Virtues (on the right) and the Seven Vices (on the left) painted in grisaille as if they were stone sculptures. This drama of human salvation comes to its climax in the Last

Opposite: 3.4. GIOTTO. Arena Chapel, Padua, looking toward the fresco of the Last Judgment over the entrance door

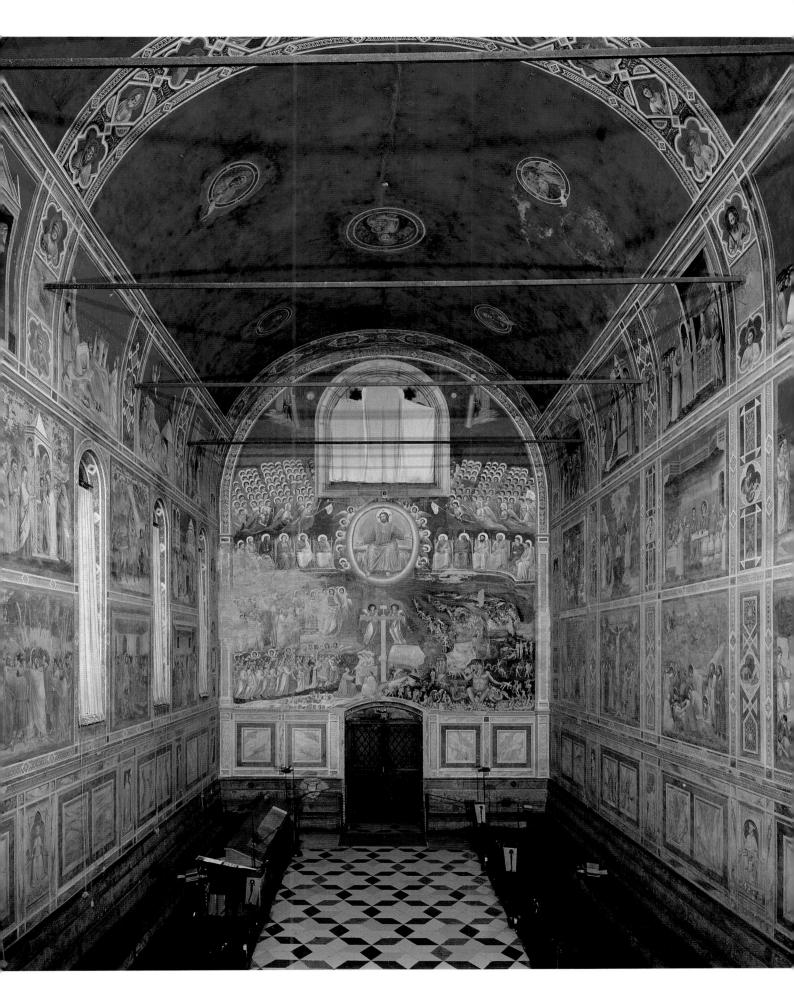

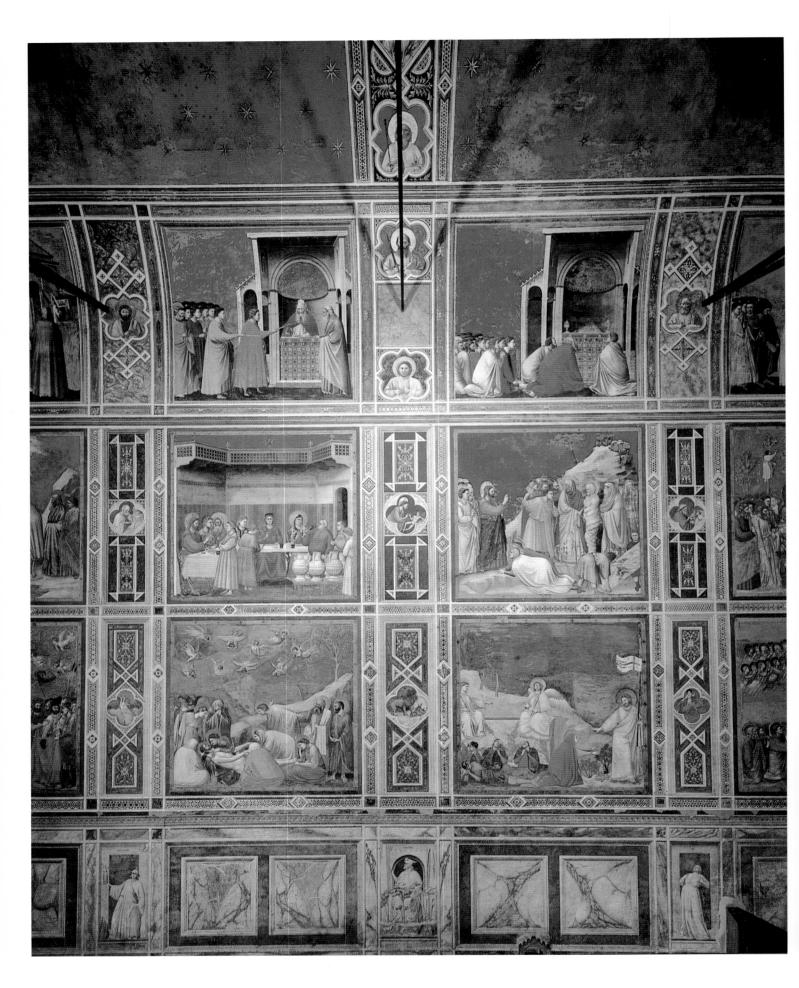

98 • THE LATE MIDDLE AGES

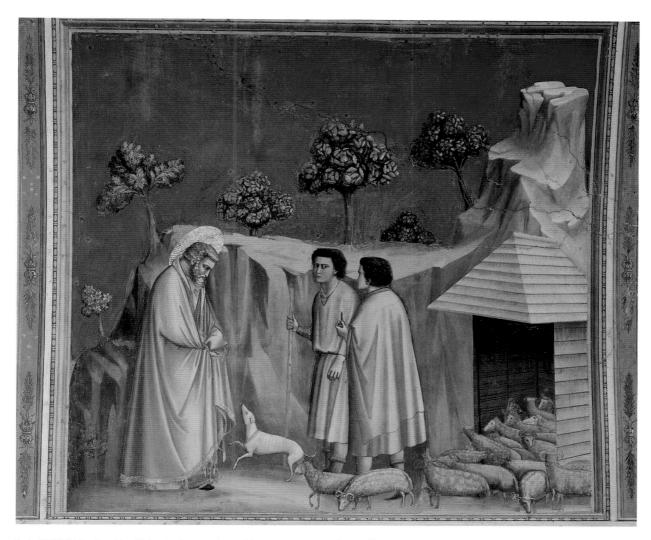

3.6. GIOTTO. Joachim Takes Refuge in the Wilderness. Fresco, 78 3/4 x 727/8" (2 x 1.85 m). Arena Chapel, Padua

Judgment, which covers the entrance wall (see fig. 3.4). Unfortunately, in a book of this scope all the scenes cannot be illustrated or discussed.

Giotto's narration has been compared to that of the traditional cinema, because of his sense of timing in successive dramatic incidents. Most observers entering the chapel probably do not immediately recognize the element of time, but they are at once aware that they have stepped into a world of order and balance. The Byzantine fabric of compartmentalized figures and gold-striated drapery has vanished. All is clear light, definite statement, strong form, firm ground, simply defined masses, and beautiful glowing color. In the nineteenth century, critic and design reformer John Ruskin described this color as "the April freshness of Giotto."

In many scenes, Giotto's balanced, dignified narration recalls the philosophy of Sophocles, who, it was said, "saw life steadily and saw it whole." Italian documents and sources contain no word for our "scene": scenes are invariably called *storie* (stories). We can follow the plot in each *storia*, generally accompanied by one or two subplots, in great or delicate, but seldom excessive, detail as we move through the series. In an incident from the life of the Virgin, for example (fig. 3.6), the aged Joachim, who will later become her father, has been expelled from the temple because of his childlessness and is taking refuge with shepherds in the wilderness. The composition is based on the human relationships between the figures. Joachim looks downward, overcome by humiliation, while the youthful shepherds accept him only with reluctance; one looks

Opposite: 3.5. GIOTTO. Arena Chapel, Padua. Portion of the wall. Frescoes in the top register: Suitors Presenting the Rods and the Prayer Before the Rods; middle register: Marriage Feast at Cana and Raising of Lazarus; lower register: Lamentation and Noli Me Tangere; bottom: figures of the vices of Infidelity, Injustice, and Anger. After 1305

toward the other, attempting to gauge his friend's response and judge whether it is safe to take in this outcast. The landscape frames and accentuates this tense moment. Then comes the subplot; the sheep, symbols of the Christian flock (priests and ministers are still called pastors, "shepherds"), pour out of their fold, and the dog, an age-old symbol of fidelity in Christian art, leaps upward in joyful recognition of Joachim's sacred role.

The landscape, the most advanced known at that time, is powerfully projected but deliberately restricted in scope. Writing in the Late Trecento, Cennini instructed his readers that, to paint a landscape, it is necessary only to set up some rocks in the studio to stand for mountains and a few branches for a forest. Yet Giotto's rocky backgrounds form an effective stage setting for his dramas, and in successive scenes that take place in the same spot, he does not hesitate to rearrange the rocks a bit to bring out the inner meaning of the particular moment of action. The rocks enclose a distinct space that is limited, as in all the scenes, by the continuous blue background. There are no clouds or suggestions of other atmospheric phenomena, except where they are needed to indicate the celestial origin of the angels.

Within this shallow box of space, the figures stand forth in three dimensions like so many columns. Giotto's drapery masses are simplified to bring out the cylindrical masses of the figures, who reveal profile, one-quarter, and even back views instead of the customary three-quarter profile of figures in Duecento painting. The head of the shepherd to the right is foreshortened as a powerful volume in space. Vasari waxed eloquently on the subject of Giotto's foreshortenings; he is probably right in claiming that Giotto was the first to render them.

Cennini taught that distant objects should always be painted darker than those in the foreground. This must have been another convention derived from Giotto; the foremost leaves on Giotto's trees are lighter than those farther away. In delicate gradations, Giotto's light models faces, drapery, rocks, and trees with a delicacy that establishes their existence in space. But—and this is of prime importance— Giotto's light is not derived from a single source. A uniform illumination bathes all scenes alike, regardless of the time of day, and this, of course, helps maintain the unity of the chapel. As a whole, Giotto's light, having no specific origin, casts no shadows. With few exceptions, cast shadows do not appear in painting until the Quattrocento, yet we can hardly imagine that Trecento painters were unaware of them. In a famous passage in the *Inferno* one of the damned asked who Dante is, since he—unlike the dead—casts a shadow; this is only one example from a rich medieval tradition of literature on light and its behavior. But for some reason, painters did not consider natural light effects suitable for representation. Although Giotto's settings are limited by convention, he often suggests a broader or more distant space; trees are shown cut off by rocks, so that we read them as growing on the other side of the hill, and his figures sometimes appear or disappear behind the frame at the sides of his scenes. There is no limitation whatsoever to his subtle observation of the human reactions of his figures.

The final scene of this first group is the Meeting at the Golden Gate (fig. 3.7). Joachim has received a revelation from an angel and returns to Jerusalem to tell Anna, just as she rushes out to break her identical news to him. Their encounter occurs on a bridge outside the Golden Gate of Jerusalem. Like the rocks in Giotto's landscapes, a few simple architectural elements symbolize a complex reality. The shrunken scale of the architecture as compared to the figures is explained by another Trecento convention. Architecture is relatively large and people, small; to apply the same scale to both would mean reducing the figures to a point where the story could be read only from close up, or omitting all but the lower portions of the buildings. Giotto and his followers—in fact all artists well into the Quattrocento-were content with rendering a double scale that presented the story within reduced architectural settings.

In this case the architecture reflects the emotions of the figures. In this joyous reunion of husband and wife, Anna puts one hand around Joachim's head, drawing his face toward her for a long embrace. As always, Giotto's draftsmanship is broad

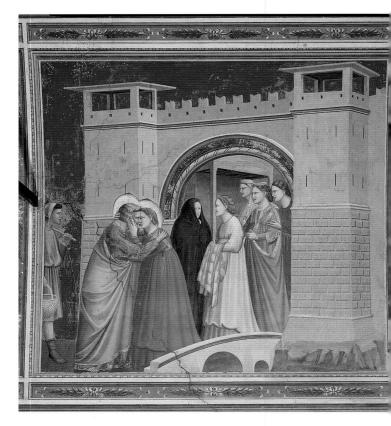

3.7. GIOTTO. Meeting at the Golden Gate. Fresco, $78^{3}/4$ x $72^{7}/8$ " (2 x 1.85 m). Arena Chapel, Padua

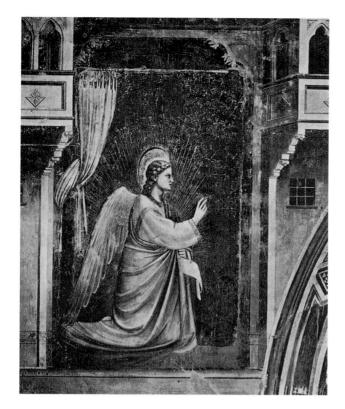

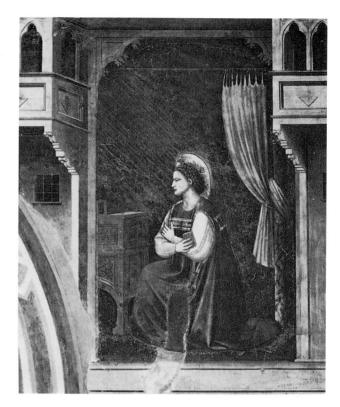

3.8., 3.9. GIOTTO. Annunciation. Fresco; each scene $76^{3}/4 \times 59$ " (1.95 x 1.5 m). Arena Chapel, Padua

and simple, leaving out details that might interrupt his message of human feeling or the powerful clarity of his form. One subplot, of course, can be sensed in the happy neighbors; another appears in the shepherd who carries Joachim's belongings.

Turning to the events directly connected with the life of Christ, we find the Annunciation (figs. 3.8, 3.9) in the spandrels flanking the sanctuary arch. This position was designated for this event in Mary's life by a Byzantine tradition based on Ezekiel's vision of the temple's sanctuary with its gate shut: "And no man shall enter in by it; because the Lord, the God of Israel, hath entered in by it, therefore it shall be shut. It is for the prince; the prince, he shall sit in it to eat bread before the Lord; he shall enter by way of the porch of that gate, and shall go out by the way of the same" (Ezekiel 44:2-3). To Christian theologians, the closed gate (porta clausa) of the sanctuary, which only the Lord both entered and left, stood for Mary's virginity; the prince was Christ and the bread, the Eucharist. The use of cusped Gothic arches for the balconies to either side is important, for throughout the chapel Giotto uses the round arch to refer to the Old Law and the pointed arch as a symbol for the New Testament; here, at the moment of the conception of Christ, we see the first Gothic arches in the cycle.

Giotto has represented the Annunciation, the moment of Christ's incarnation in human form, in a new and intimate way that is in keeping with his understanding of the human heart. He has stressed the moment in which Mary accepts her responsibility, when she says: "Be it done to me according to thy will." In a token of resignation, she crosses her hands upon her chest and kneels, as does the angel. A flood of light, painted in clustering rays with a soft orange-yellow pigment, descends on the figure of the Virgin. This suggests actual light, not golden rays (even though the haloes are still rendered as gold disks). Yet since there are no sources of natural light in Giotto's art, this must be the light of heaven. Light was (and is) identified mystically with Christ: "In him was life; and the life was the light of men. . . . That is the true Light which lights every man who comes into the world."

The two stages on which Giotto has placed the Annunciation's participants were probably derived from constructions used in the Paduan dramatizations of the Annunciation that took place during the Trecento. Such reenactments started at the local Cathedral and culminated in performances in the Arena Chapel. Following convention, the front walls have been removed to show the interiors. But Giotto has filled his spaces with a radiance that seems to emanate from the throne of God in the arch above. In Giotto's *Annunciation* we have emerged from a world where every scene is bathed in the same dispassionate light into a world of mysticism and revelation.

Before Giotto, Italian artists had always placed the Nativity in a cave, a Byzantine tradition (now less familiar than

the stable of European tradition). The Gospel account, however, specifies no precise setting. Giotto, perhaps after visiting France, adopted the shed usually depicted in Gothic art (fig. 3.10). He also eliminated the apocryphal account of the baby's bath. The midwives are still there, however; one is handing the Christ Child, already washed and wrapped, to Mary, while the ox and ass, who almost invariably appear in Western Nativities, look on. They are a fulfillment of the Old Testament prophecy: "The ox knoweth his owner, and the ass his master's crib" (Isaiah 1:3). Joseph sleeps in the foreground, while angels announce Jesus' birth. The rejoicing angels seem to emerge at the waist from trailing clouds. They are scattered in a variety of positions against the blue, and one leans down to give the tidings to two shepherds. One shepherd has turned his back to us—a simple device, yet it is impossible to overestimate what this reveals about Giotto's attitude toward space; he can turn and move his figures in any direction. Giotto's backs, moreover, can be expressive: the shepherd's astonishment seems evident in the set of his shoulders, the way his head is tilted back, and even in the manner in which he pulls his garment more tightly around him.

The adult Christ in the *Raising of Lazarus* (fig. 3.11) is the short-bearded Christ of French Gothic tradition, as at

Amiens Cathedral (fig. 3.12). He appears more natural than the Byzantine type favored by Coppo and Cimabue. Lazarus's sisters, Mary and Martha, prostrate themselves before Christ in supplication, while he calls their brother from the dead with a simple gesture. Giotto includes the traditional figures who cover their noses ("by this time he stinketh." John 11:39), yet such details never seem out of the ordinary. The scene is simply composed: divided into blocks of figures by broad diagonals, verticals, and rhythmic curves.

In the workman on the right, Giotto has again used a figure's back as an expressive device. The vivid color includes iridescent passages (the bending workman is dressed in pale pea green with rust-colored shadows), the formula for which was recorded in Cennini's handbook. A striking bit of colorizing freedom appears in the veined marble of the tomb slab. Christ's blue garment is rendered in one of the pigments that, Cennini said, could not be painted in true fresco and therefore had to be added *a secco*. As a result of peeling, the underlying drawing has been revealed. In a striking balancing of New Testament events with those from the Old that were believed to foreshadow them, the quatrefoil in the border frames the *Creation of Adam*; God raises Adam from the dust as Christ raises Lazarus.

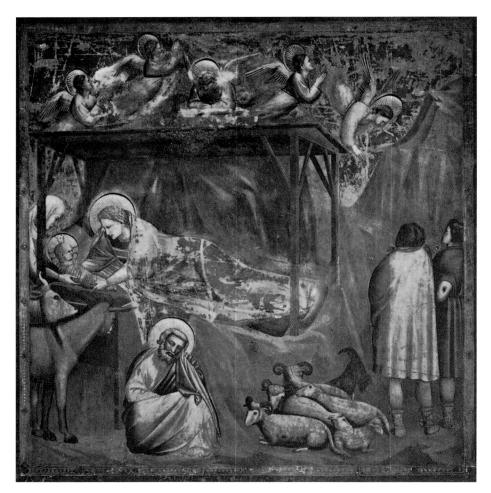

3.10. GIOTTO. *Nativity and Apparition to the Shepherds*. Fresco, 78³/₄ x 72⁷/₈" (2 x 1.85 m). Arena Chapel, Padua

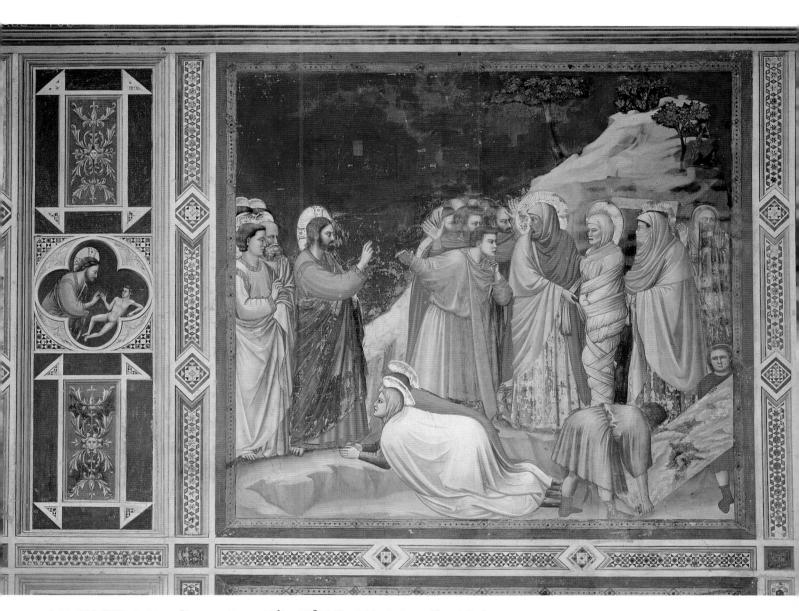

3.11. GIOTTO. Raising of Lazarus. Fresco, $78^3/4 \times 72^7/8$ " (2 x 1.85 m). Arena Chapel, Padua. The small scene in the quatrefoil to the left is the *Creation of Adam*.

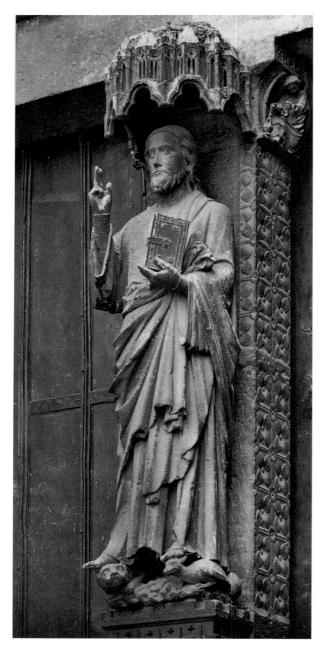

3.12. French Gothic.Christ Treading on the Lion and the Basilisk.c. 1220. Cathedral of Notre Dame, Amiens, France.This figure is popularly known as the "handsome" or "beautiful God" (beau dieu).

In the Kiss of Judas (fig. 3.13), Giotto follows the conventional composition of the narrative as it appears in the Uffizi Cross (see fig. 2.10). The nucleus of the drama is Christ and Judas. Even though his body almost disappears in the sweep of Judas's cloak, Christ stands firmly, as he did in the Raising of Lazarus, and with the same calm gaze. Giotto exploits the contrast between Christ's stoic profile and the bestial features of Judas, whose lips are pursed for the treacherous kiss. These small details symbolize the age-old confrontation between good and evil. The contrast is made even more striking since, in the preceding scene of the Last Supper, Judas had the same handsome, youthful face as many of the other apostles. But the Gospel account tells us that the devil entered into Judas when he dipped his bread in the wine at the Last Supper (John 13:27; see p. 304). Giotto has heightened the drama by inserting the faces of two Roman soldiers between the profiles of Judas and Christ.

The main group is flanked by two sharply different subplots. The episode of Peter cutting off the ear of Malchus, the high priest's servant, was required by iconographic tradition. Giotto has virtually concealed it behind another of his expressive backs, that of a hooded attendant on the left who tries to restrain one of the fleeing apostles. The high priest at the right points toward the treacherous embrace in the center, yet vacillates as he does so, as if unable to face the wickedness of Judas's betrayal. Note that Christ's halo, modeled in plaster, is designed so that it is foreshortened and seems to recede into space. Some of the composition's original effect is dissipated by the loss of swords, halberds, and torches that, painted a *secco*, have largely peeled off.

In the *Crucifixion* (fig. 3.14), Giotto shows the *Christus mortuus*, not the triumphant Christ found on liturgical crosses of earlier centuries, nor the agonized victim in Italo-Byzantine representations. Here he is dead, quietly and absolutely, just as in his earlier *Crucifix* (see fig. 3.1). No one screams and there are few gestures, but Mary collapses, losing the columnar firmness with which Giotto endowed humanity.

Mary Magdalen kneels before the cross, her long, golden hair unbound, gazing at the feet she once washed with her tears and dried with her hair. At the right, the Roman soldiers dispute over Christ's seamless robe, mentioned in the Gospels (John 19:23–24). One soldier, dressed in a gilded cuirass, argues with a companion, who is about to cut the robe with a knife. Above, the grieving angels recall their rejoicing counterparts in the Nativity. Some hold chalices to catch Christ's blood, while others rend their garments or wring their hands. Directly above the cross, two angels fly toward the observer so that their heads are foreshortened from above. Even this tragic scene is presented with the same quiet firmness of composition—two blocks of figures, at once divided and united by the cross—and the same fresh beauty of color we find throughout the cycle.

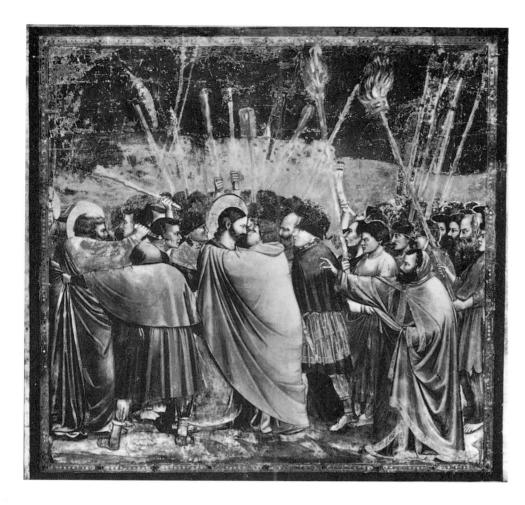

3.13. GIOTTO. Kiss of Judas. Fresco, $78^{3}/4 \times 72^{7}/8$ " (2 x 1.85 m). Arena Chapel, Padua

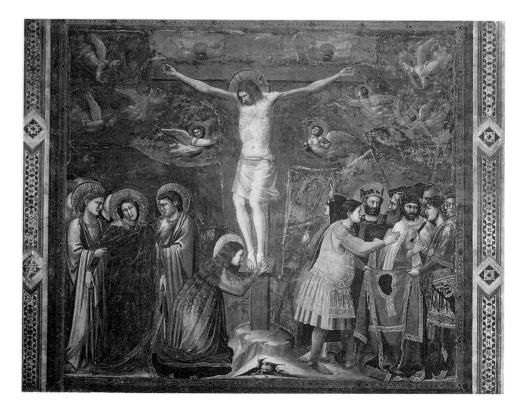

The famous *Lamentation* (fig. 3.15; see fig. 3.5), like the *Kiss of Judas*, follows the traditional Byzantine type (see fig. 2.6) that was common in Duecento Italy (see figs. 2.4, 2.13). The dead Christ is stretched across the lap of Mary, his head upheld by a mourning figure seen only from the back, while another holds up one of his hands; Mary Magdalen gazes down at his feet. John stands with arms outstretched, and the long line of the barren rock behind him leads the eye back to the intimate interchange between Mary and Christ. The angels here move discordantly, twisting and turning first toward us, then away, while the drapery lines of all the main figures point sharply down toward the earth. Here and there some startling bits of Giotto's colorizing freedom are visible, especially the apostle to the far right, whose gray-blue cloak has plum-colored shadows.

The Last Judgment (see fig. 3.4) fills the entire entrance wall, except for the window, around which Giotto deployed ranks of angels. On either side of the window, archangels roll away the sun, the moon, and the heavens like a scroll (Isaiah 34:4; Revelation 6:14), revealing the

golden gates of Paradise. The Divine Comedy, begun by Dante at about this same time, would provide later painters with an inexhaustible supply of details about the torments of hell, but Giotto has selected a limited number of punishments. The explicit physical torment suffered by some of the sinners is unforgettable. A monk is hung by his tongue, for example, while the woman next to him is suspended by her hair. One figure is being turned on a spit, while a trussed woman has hot lead poured into her mouth. A devil uses large tongs to squeeze the penis of one sinner. Although these figures are small, their individual suffering is clearly visible to the observer in the chapel. The physical nature of many of the punishments seems consistent with Giotto's interest in naturalism and human experience. Rivers of red and orange fire flow from the throne of Christ to engulf the damned.

In the center of the wall, Christ, wearing his seamless robe, appears as judge. His rainbow throne and the rainbow glory around him are made up of colored feathers graduated in tone like those in the wings of Duccento angels. The seat is

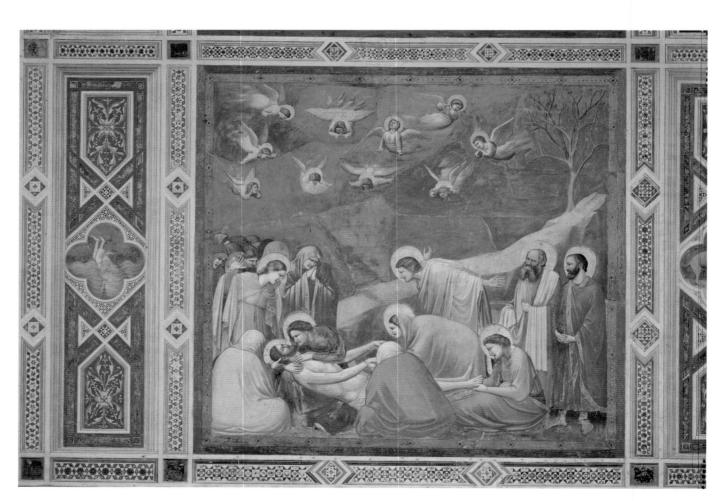

3.15. GIOTTO. Lamentation (see also fig. 3.5). Fresco, $78^{3}/4 \times 72^{7}/8$ " (2 x 1.85 m). Arena Chapel, Padua. The small scene in the quatrefoil to the left is *Jonah Being Swallowed by the Whale*.

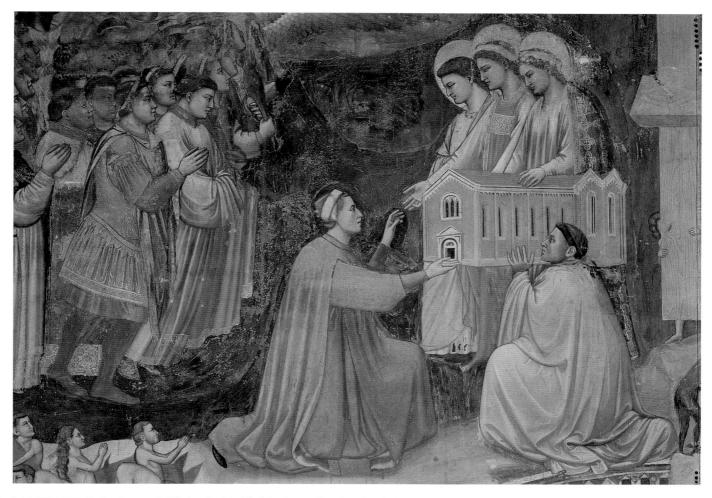

3.16. GIOTTO. Enrico Scrovegni Offering the Model of the Arena Chapel to the Virgin Mary, detail of *Last Judgment* (see fig. 3.4). Arena Chapel, Padua

upheld by the beasts symbolic of the four evangelists. Whereas Coppo's terrifying judge (see fig. 2.15) stares impassively, Giotto's compassionate Christ averts his face from the damned and seems to betray grief over their fate. The apostles are enthroned to the sides. Below, the dead rise from their graves and are welcomed into heaven or consigned to hell; among the blessed can be seen the soldier who saved the seamless robe.

Directly over the door of the chapel, the cross of Christ is upheld by angels, and directly below the cross kneels Enrico Scrovegni and an Augustinian monk (fig. 3.16), who hold a model of the Arena Chapel as Scrovegni's offering. These two portraits and others found within the ranks of

the blessed are important as early examples of the new interest in portraiture that develops during the Renaissance; perhaps self-portraits of Giotto and his assistants are included among the blessed. In any case, one senses that Enrico Scrovegni would have been recognizable to contemporary Paduans; one wonders what their reactions were to the placement of this notorious usurer on the side of the blessed in the Last Judgment. The identity of the figures who stand behind the model of the chapel has been a matter of controversy, but the central one is certainly the Virgin Mary, to whom the chapel was dedicated; her acceptance of Scrovegni's offering seems assured by her extended hand.

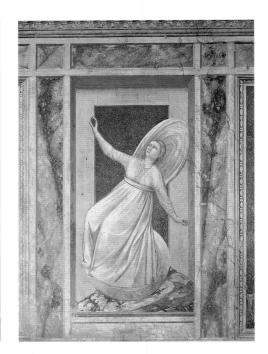

3.17., 3.18., 3.19. GIOTTO. Justice, Injustice (see fig. 3.5), and Inconstancy. Fresco; each figure 47 1/4 x 215/8" (120 x 55 cm). Arena Chapel, Padua

The virtues and vices on the lower sections of the walls recall a tradition common in French Gothic portal sculpture. *Justice* (fig. 3.17) is a regal female figure before whom commerce, agriculture, and travel proceed undisturbed. Her male counterpart, *Injustice* (fig. 3.18), is a robber baron (reminding us that Padua and Florence were both merchant republics organized against the nobility) who, from his castle gates surrounded by rocks and forests, presides over rape and murder. The vice of *Inconstancy* (fig. 3.19) tilts on a precarious wheel, losing the very balance that for Giotto was an essential aspect of human existence.

THE OGNISSANTI MADONNA. Although not dated precisely, the *Enthroned Madonna with Saints* (fig. 3.20), painted for the Church of Ognissanti (All Saints), is believed to have been executed between 1305 and 1310, not long after the completion of the Arena Chapel. The gabled shape is similar to that of Duccio's *Madonna* for the Laudesi (see fig. 4.1), Cimabue's *Enthroned Madonna and Child* (see fig. 2.17), and other Duccento altarpieces. Giotto has placed the Virgin on a Gothic throne, like that of *Justice* in the Arena Chapel—another instance of his interest in French idioms. This throne, with its pointed vault, delicate gable ornamented with crockets, and open arched wings, provides a cubic space for the Madonna that is utterly different from the

elaborate Byzantine thrones of the Duecento. Access to the throne is provided by a marble step. Narrow panels are filled with delicate ornament that contrasts with the free forms of the marble veining, which are surprisingly fluid and brilliant in color.

The Virgin gazes outward with the calm dignity we expect from Giotto, but her lips are parted to give the effect of the natural passage of breath. When compared to earlier Duecento Madonnas, Giotto's Madonna seems the quintessence of stability, harmony, and warm humanity. Christ lifts his right hand in a gesture of teaching, holds the scroll lightly in his left, and opens his mouth as if speaking. As in the frescoes, Giotto has abandoned the anatomical compartmentalization of the Italo-Byzantine style. The existence of the massive bodies in depth is enhanced by the delicate forms of the stone throne. The robust Christ Child is lightly but firmly held by his mother, whose fingertips press against his waist. Her right hand is truly sculptural in its apparent roundness, and her neck's cylindrical shape is enhanced by the clean, round neckline of the tunic. His massive head turns in space, completely hiding the right ear from sight.

On each side of the throne saints are grouped with angels, but all of these figures are smaller in scale than Mary, Queen of Heaven. The two foremost standing angels offer Mary a crown and a box. They are in profile, as are the kneeling

Opposite: 3.20. GIOTTO. Enthroned Madonna with Saints (Ognissanti Madonna). c. 1305–10. Panel, 10'8" x 6'8¹/₄" (3.25 x 2 m). Uffizi Gallery, Florence. Commissioned for the high altar of the Church of Ognissanti in Florence

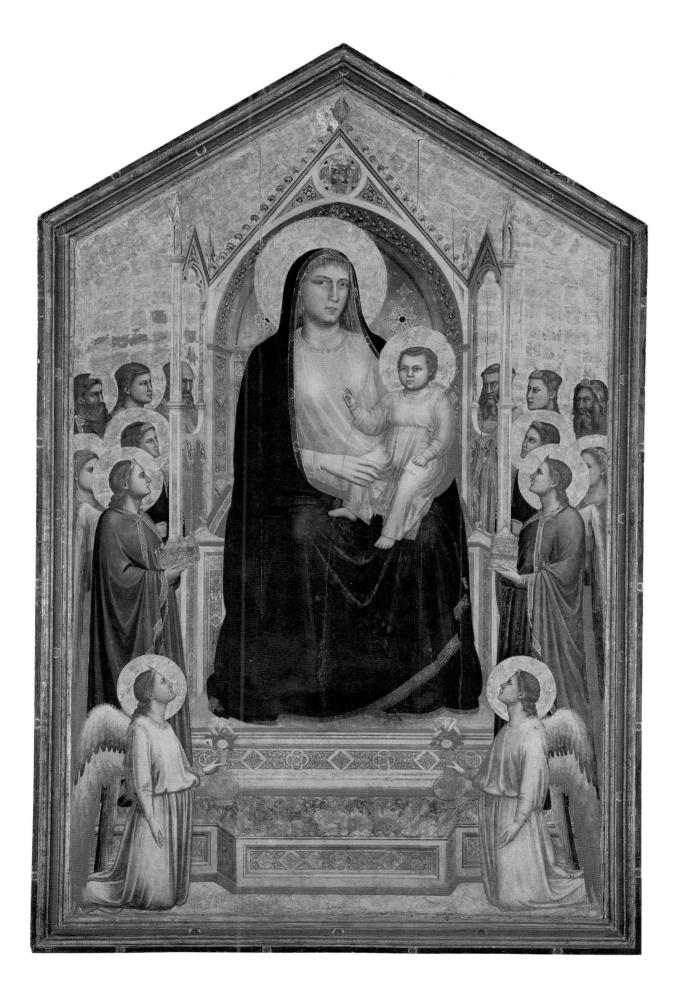

angels before the throne who present vases of lilies and roses, symbols of the Virgin. The clarity of their profiles is strikingly similar to that of Giovanni Pisano's *Madonna* made for the Arena Chapel (see fig. 2.40). Their tunics are glowing white, with shadows of soft lavender-gray. They have an awestruck quality, suggesting that they are participants in a heavenly scene.

THE BARDI AND PERUZZI CHAPELS. After the fresco cycle in Padua and the *Ognissanti Madonna*, Giotto's style underwent a change. Of the four fresco cycles he and his workshop painted in the Franciscan Church of Santa Croce in Florence, only the chapels of the Bardi and the Peruzzi families, who controlled the two greatest banking houses in Italy, survive. The dates of the frescoes are as controversial as the order in which the two chapels were painted. Both would appear to date from the 1320s, a period of turmoil and difficulty during which the popular government was threatened from within and the Republic's territory diminished by attacks from the Ghibelline forces of Pisa and

Lucca. Under such circumstances, perhaps the heroic harmonies of the Arena Chapel could not be recaptured.

Both chapels were whitewashed in the eighteenth century and cleaned and overpainted in the nineteenth, but a twentieth-century restoration has removed all or most of the repaint, revealing a different situation in each chapel. The Bardi Chapel, frescoed with scenes from the life of St. Francis, reappeared in good condition, except for gaps left by earlier mutilations. But the Peruzzi Chapel is a ghost of its former self and no scenes from this chapel are illustrated or discussed here; apparently it was painted largely a secco. In all his fresco cycles, Giotto must have had assistance in laying out the surface and in the actual painting, especially when rendering the background figures and less important details. Conservation work in both chapels has shown that there were no underdrawings on the wall, so preparatory drawings on paper or parchment were probably used to transfer the ideas from the mind of the painter to the pictorial surface.

St. Francis Undergoing the Test by Fire Before the Sultan (fig. 3.21) in the Bardi Chapel shows some renunciation of

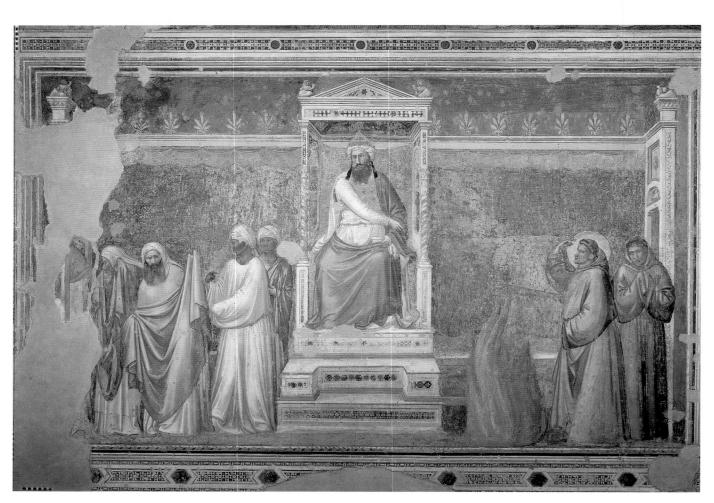

3.21. GIOTTO. St. Francis Undergoing the Test by Fire Before the Sultan. Probably 1320s. Fresco, 9'2" x 14'9" (2.8 x 4.5 m). Bardi Chapel, Sta. Croce, Florence. Commissioned by a member of the Bardi family

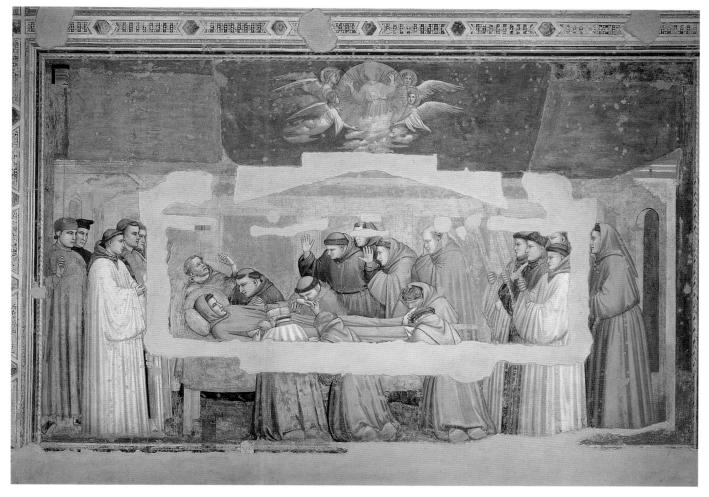

3.22. GIOTTO. Funeral of St. Francis (see also fig. 3.23). Probably 1320s. Fresco, 9'2" x 14'9" (2.8 x 4.5 m). Bardi Chapel, Sta. Croce, Florence

the controlled dramatic intensity that made the Arena Chapel frescoes so powerful. At first sight, little appears to be going on in the Bardi frescoes, but a closer look discloses that Giotto modified his dramatic and human style in his later years. The sultan in the center is seated on his throne, while on the right St. Francis calmly prepares to undergo the test by fire. He will, of course, emerge unharmed, to the discomfiture of the Muslim priests who are creeping away on the left, their fright indicated by their expressions and the agitated patterns of their drapery folds. The two servants beside them, who are among the earliest known representations of black people in Western art, are sensitively rendered not only in their rich coloring, set off by the luminous white and soft gray of their garments, but also in the naturalistic analysis of their facial structure. In this fresco,

Giotto overrides Western biases toward outsiders such as blacks and Muslims by depicting them as human, instead of caricatures of evil.

The Funeral of St. Francis (fig. 3.22) was mutilated when the frescoes were whitewashed and a tomb, now removed, was added. The saint lies upon a simple bier; the other friars crowd around him, weeping, kissing his hands and feet, or gazing into his face. Priests and monks at the saint's head intone the service for the dead. A richly dressed knight of Assisi, his back to the spectator, kneels beside Francis and, like a new St. Thomas, thrusts his hand into the wound in the saint's side. Above, angels bear the released soul heavenward, his drab Franciscan habit now transformed into a celestial amethyst shade. The composition is static, symmetrical, and carefully balanced, but a closer view shows that the

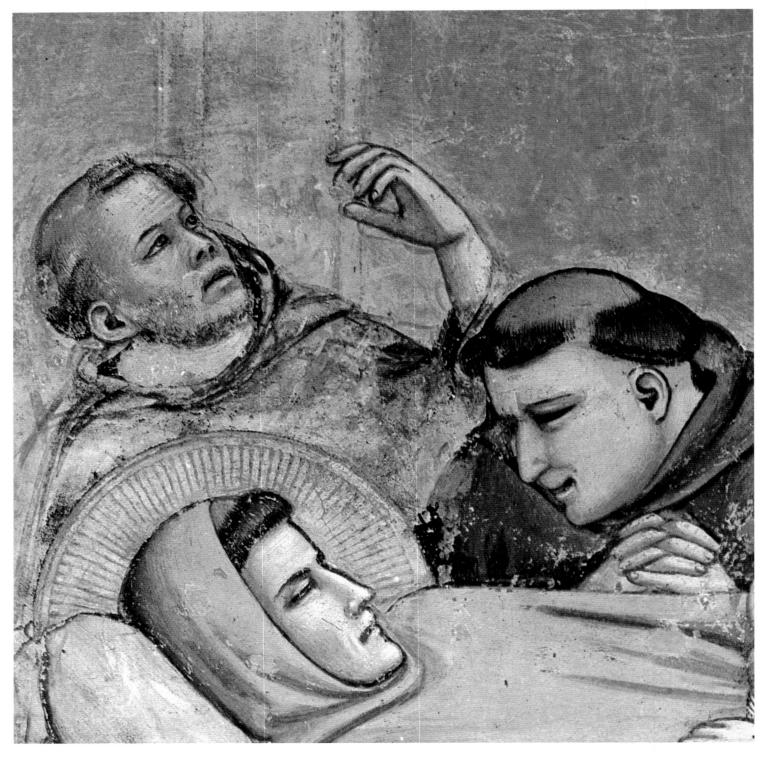

3.23. St. Francis, detail of fig. 3.22

drama still proceeds (fig. 3.23). The face of the saint and those of the mourners—even the characteristic Giotto backs—express a powerful emotion. In this fresco the late style of Giotto reaches a new stage of calm, purity, and breadth. The latter aspect is especially evident in the head of the brother looking upward in wonder at the soul being car-

ried to heaven, which seems to have been painted quickly, capturing the figure's astonishment.

Above the entrance to the chapel is Giotto's *Stigmatization* of *St. Francis* (fig. 3.24), which is visible in the view of Santa Croce (see fig. 2.43) to the right of the chancel opening. This subject had been represented many times since its earliest

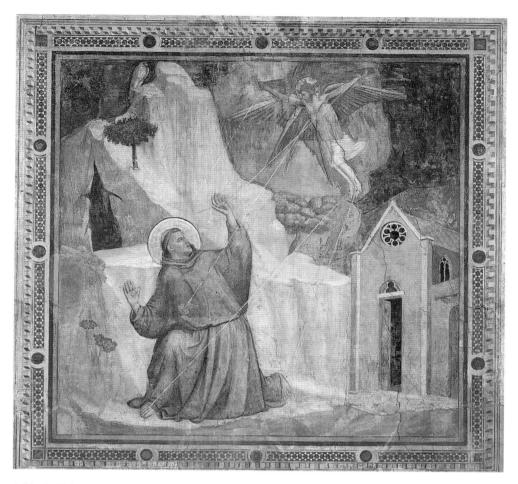

3.24. GIOTTO. Stigmatization of St. Francis. Probably 1320s. Fresco, 12'9" x 12'2" (3.9 x 3.7 m). Bardi Chapel, Sta. Croce, Florence

known depiction by Bonaventura Berlinghieri (see fig. 2.8, upper left-hand corner). Two altarpieces on the subject from Giotto's studio (but not by his own hand) also survive, as well as a fresco at San Francesco in Assisi. According to the Legenda Maior, the official life of St. Francis written by St. Bonaventura (see p. 116), Francis was meditating on the lofty peak of La Verna when he asked a follower to bring him the Gospels from the chapel altar and open them at random. Three times the book opened to the sufferings of Christ. At that moment Francis knew he had been chosen to endure great trials similar to those of Christ. Suddenly, a six-winged flaming seraph came toward him through the heavens, and in the midst of the wings appeared a crucified figure. Christ's Crucifixion pierced St. Francis's soul "with a sword of compassionate grief," and when the vision disappeared, the marks of the nails began to appear in his hands and feet, turning rapidly into the nails themselves, the heads on one side, the bent-down points on the other, and his right side was marked with a scar that often bled.

A later version of the life of St. Francis, the anonymous *Fioretti* (little flowers), speaks of a light that illuminated the

surrounding mountains. Berlinghieri does not depict this light in any way, but other Duecento painters represent it as stripes of gold descending toward the kneeling saint. In the two works from Giotto's shop and in this fresco, gold rays project from the five wounds of Christ to the corresponding spots on Francis's body, forming, as it were, a network of taut, golden wires. In earlier representations, St. Francis kneels before the vision on one knee or both; here he turns away and then, raising his right knee, turns back toward the vision in combined surprise, pain, and acceptance. Not until Michelangelo will we find a colossal figure of such complexity or of so rich an interrelation of changing spiritual states and dynamic physical movement.

The light described by the *Fioretti* radiates from the figure of Christ, whose loincloth streams behind him against what was once a soft, blue cloud, now eroded. This spiritual light is the sole source of illumination. A tree to the right bends as if swayed by the storm of the apparition. On the left is the saint's cave, and the falcon who awakened Francis each morning is perched on a ledge just below the summit of the peak.

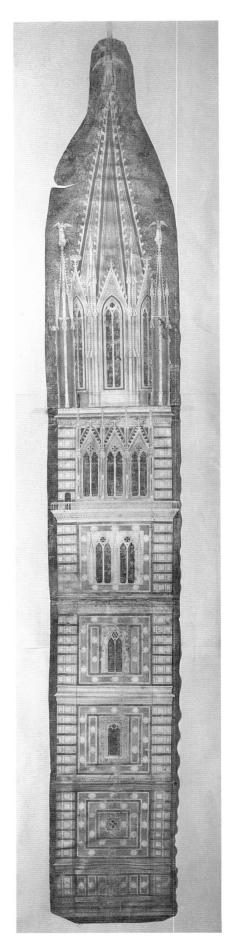

THE DESIGN FOR THE CAMPANILE OF FLORENCE CATHEDRAL. The principal surviving achievement of Giotto's last years is his design for the Campanile of the Cathedral of Florence (fig. 3.25). In January 1334, the Commune appointed Giotto capomaestro of the Cathedral in an extraordinary document that extols his fame as a painter but mentions no architectural training or experience; by this time the only parts of the Cathedral that had been built were the partially completed façade and south wall, which had reached the level of the side-aisle roof. In April 1334, a document again mentions the Campanile, the only portion of the Cathedral with which the aging artist was involved. By January 1337, Giotto had died, but in the brief intervening period, work had proceeded at a rapid pace. A massive foundation was laid, and the first story constructed in correspondence with that of a large, tinted drawing on parchment. The drawing itself involved a mechanical repetition of identical elements; it was probably carried out by assistants under Giotto's direction. We would be foolish to suggest that his hand can be detected in any part of it, but it is his creation nonetheless, in the same sense as is the decorative framework of the Arena Chapel.

In the tradition of Tuscan campaniles, the windows multiply as the stories rise. The final story is an octagonal bell chamber flanked by cylindrical pinnacles on the corners that are set on octagonal buttresses that rise from the ground. Giotto's solution corresponds to that of a slightly earlier tower found at the Cathedral of Freiburg im Breisgau, Germany, although how Giotto might have known this tower is uncertain. In any case, the appearance of the two buildings is entirely different; Giotto's spire and pinnacles are solid, while those at Freiburg, as in other German cathedrals, are open tracery. Actually, both the pitch of Giotto's spire and the character of its crockets correspond to those of the solid spires begun, but never carried out, on the towers of Reims Cathedral, a work that greatly influenced Italian artists. Moreover, the tracery of Giotto's windows, with their beautiful pointed arches and crocketed gables, is also close to that at Reims.

3.25. GIOTTO (attributed to). Design for the Campanile of the Cathedral, Florence.c. 1334. Tinted drawing on parchment, height of image 6'10" (2.08 m).Museo dell'Opera del Duomo, Siena. Commissioned by the Arte della Lana

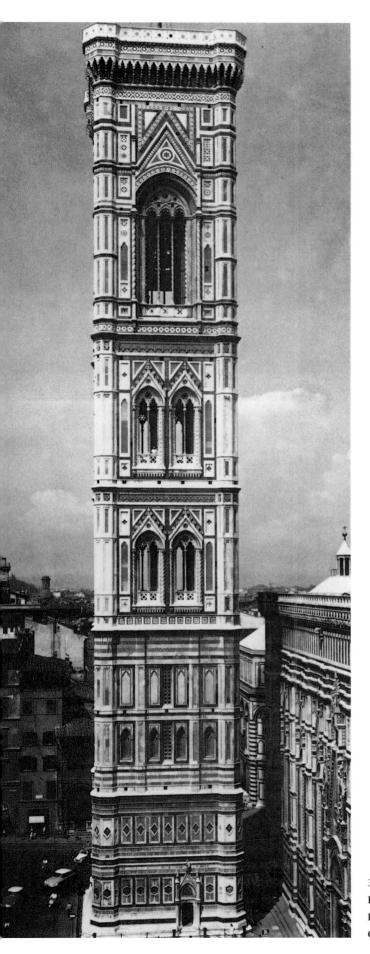

The lower story of the Campanile as actually built (fig. 3.26) relates closely to Giotto's design, in which hexagons of white marble are placed within vertical pink marble panels (it is unclear whether or not at this stage of Giotto's design reliefs were intended). These hexagons would have been repeated in the second story in a staccato pattern within bands enframing a quatrefoil window. In the design, two such bands appear on the third and fourth stories, one on the fifth, and none thereafter. The effect looking up would have been an oscillation of white hexagons against pink to the height of about two hundred feet. There would have been seventy-five hexagons on each face of the Campanile, or three hundred for the entire structure, which tells us something about Giotto's desire for mathematical balance. But there may be much more. In a medieval structure it is difficult to overlook the fact that Giotto's tower has seven stories, the number of the Gifts of the Holy Spirit and of the Joys and Sorrows of the Virgin. In addition, the hexagons are grouped in sevens, fours, eights (the numbers of the Resurrection), and twelves (the number of the apostles and of the gates of the New Jerusalem); and the perfect number one hundred is multiplied in their total by the number of the Trinity. Such number symbolism was widespread in the later Middle Ages.

Giotto, aware of the force of wind pressure on such a lofty bell chamber, draws iron tie-rods running from the pinnacles through the oculi of the corner windows, possibly to some stabilizing framework inside. Given this caution, it is surprising that he places enormous marble baskets of fruit on the three gables of his sixth story, crowns his slender pinnacles with marble angels-their wings widespread—and poises a colossal Archangel Michael holding a banner on the tip of his spire, some three hundred feet above the ground; all of these would have been exposed to the wind, rain, ice, and snow of Florentine weather. His design was not followed by his successors, only plundered (see fig. 3.26 and p. 168). After his death it was discovered that the walls of his first story were insubstantial and their thickness had to be doubled. After all, Giotto was a painter, and his tower was a painter's tribute to the glory of his beloved Florence.

3.26. Campanile of the Cathedral, Florence. Lowest story by GIOTTO, 1334-37; next three stories by ANDREA PISANO, c. 1337-43; remainder by FRANCESCO TALENTI, 1350s. Commissioned by the Arte della Lana. (see figs. 1.4, 1.5)

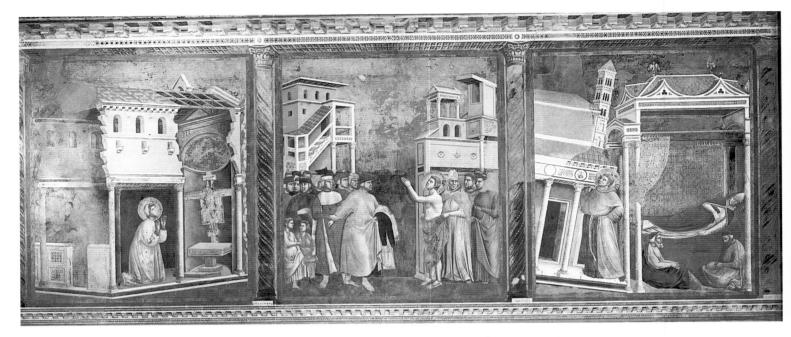

3.27. MASTER OF THE ST. FRANCIS CYCLE. St. Francis Praying Before the Crucifix at San Damiano; St. Francis Renouncing His Worldly Goods; Dream of Innocent III. Early fourteenth century. Fresco; each scene 8'10" x 7'7" (2.7 x 2.3 m). Upper Church of S. Francesco, Assisi

THE UPPER CHURCH OF SAN FRANCESCO,

ASSISI. The matter of Giotto's early style has been left until this point because it is a vexing question and there is still no general agreement. The crucial problem revolves around the twenty-eight scenes of the life of St. Francis in the Upper Church of San Francesco at Assisi. In each bay the wall is divided into three or four scenes by painted spiral colonnettes resting on a corbel table (fig. 3.27). The painted colonnettes appear to support a characteristic Roman architrave, which is ornamented with simulated inlaid mosaic and surmounted by a cornice on painted consoles (not visible here). The soffit of the entablature is coffered in two parallel strips so that it looks quite deep. The effect of three-dimensionality in these elements is enhanced by a sharp light focused on what seem to be projections, contrasted by soft shadow on the undersurfaces. By simulating architectural space, the artist responsible for the general layout has established an illusion of a continuous portico as deep as the real catwalk above it. Through this portico we read the vivid scenes that record, with brusque naturalism and intense conviction, the life of St. Francis, largely according to the Legenda Maior of St. Bonaventura.

In general, Italian scholars regard all but four of the scenes as early works of Giotto, painted before the Arena Chapel, though with a large amount of student participation in some scenes. Many other scholars reject attributing the scenes to Giotto, and date them somewhat later. The series itself is one of the most extensive and largest (the figures, for the most part, are approximately life-size) Italian fresco cycles. A few contemporaneous models existed for some scenes (see fig. 2.8), but none for most of them, and the artists' solutions to these new narrative problems often display striking originality, conceived in terms of a fresh, new naturalism.

There are no documents regarding the series. A chronicler named Riccobaldo wrote about 1313 (the passage is reconstructed, since the original manuscript is lost) that the quality of Giotto's art is witnessed by "the works made by him in the churches of the Franciscans at Assisi, Rimini, and Padua, and in the church of the Arena." Since the Arena Chapel frescoes are preserved, and since we know that paintings by Giotto once decorated the Franciscan churches of San Francesco at Rimini and Sant'Antonio in Padua, it is argued that Riccobaldo, writing while Giotto was still alive, was correct about Assisi as well, and that his remarks could only

refer to the St. Francis cycle. In the fifteenth century, Ghiberti wrote that at Assisi Giotto "painted almost all the lower part," and in his *Lives* Vasari assigned the St. Francis series to Giotto. A document shows that in 1309 Giotto repaid in Assisi a debt he had contracted there, but it does not mention the frescoes.

Neither Riccobaldo, Ghiberti, nor Vasari provides any solid evidence. Riccobaldo's proponents do not mention that he may have been referring to the paintings in the Magdalen Chapel in the Lower Church, quite possibly commissioned from Giotto, executed partly by him, but largely completed by pupils. Nor has the question been examined of an altarpiece for the Upper Church, whose absence is one of the strangest phenomena at Assisi; such an altarpiece, presumably a polyptych, might have been by Giotto. Ghiberti's ambiguous remark might also refer to the paintings in the Magdalen Chapel or to other frescoes in the Lower Church painted by followers of Giotto. As for Vasari, the extent of his information regarding works painted nearly three hundred years earlier at Assisi may be measured by the fact that he assigned Pietro Lorenzetti's Crucifixion there to Cavallini.

In the St. Francis cycle, each bay is organized as a triptych, as in Scenes IV-VI (see fig. 3.27), in which two incidents involving collapsing churches flank a central event taking place in an open piazza. The actual sequence of incidents in the Legenda Maior was sometimes altered in the Assisi cycle to bring out an underlying spiritual structure through arrangements of paralleled scenes across the nave. In Scene IV, St. Francis Praying Before the Crucifix at San Damiano, the jagged masses of fragmentary walls quickly attract our attention. In the second, St. Francis Renouncing His Worldly Goods, the piazza is split vertically, leaving on one side the raging father, on the other the naked saint cloaked by an embarrassed bishop; Francis stretches out his hands in prayer to the hand of God, which can be seen above, at the left. The setting is delightful, with its delicate color and the charm of an Italian cityscape, but in its complexity it is also a far cry from Giotto's rudimentary architectural forms. The Dream of Innocent III shows the pope reclining in a sumptuous interior framed by typically Roman architecture and ornament, while a serene Francis upholds the collapsing Basilica of San Giovanni in Laterano, identifiable with the appearance of this church at that time. Throughout the cycle, the color is crisp, clear, and decorative.

Throughout the series, however, despite the originality of the conceptions and often brilliant bits of observation, the compositions are staccato and abrupt, in contrast to the balance characteristic of Giotto. Facial expressions are uncommunicative and often inert, while the figures themselves are often not convincing in their structure. Neither the impact nor the force of Giotto's figures can be felt. Profiles, so characteristic of Giotto, are rare in the St. Francis cycle. When Giotto's eloquent backs are imitated, the artist also tries to

make sure the faces are visible. Giotto's one-quarter views of faces rarely appear, and then awkwardly. Most of the faces are in Byzantine three-quarter view. Eyes are shown full-face, whatever the angle of the head; in faces seen in three-quarter view at Assisi, the distant eye remains flat, while at Padua Giotto shows his distinct awareness of three-dimensionality by cutting them into the profile. The settings in both the city and the country are distinct from Giotto's practice, as already suggested above. The landscape scenes have a kind of complexity alien not only to Giotto's landscape as we know it, but also to the directions that Cennino Cennini said were derived from Giotto. To many critics, the differences in style and quality between the St. Francis cycle and the known works of Giotto are too great to be embraced by the style of a single artist.

The need to demonstrate that the St. Francis cycle at Assisi is not by Giotto has unfortunately had a negative impact on its reputation, preventing us from recognizing its unique and important qualities. This cycle is revolutionary in ways that reveal an alternative direction to that taken by Giotto; for whatever reasons, this ultimately was to have less influence on later developments. Many of the scenes at Assisi offer a vivid, naturalistic effect that indicates an interest in capturing everyday life. In several of the frescoes the artist squeezes in the crowds that must have accompanied Francis, while in others we have glimpses of authentic, albeit miniaturized, architecture from the period: note the convincing nature of the ruined Church of San Damiano in figure 3.27. In a scene not illustrated here that is set in Assisi, the artist represented an ancient Roman temple façade that still survives in the center of town; the immediacy of recognition supports the suggestion that the miracles represented here were vivid and real. At the same time, however, the artist has chosen to Gothicize the temple, probably to make it more fashionable, by reducing the massive ancient columns to elegant Gothic colonnettes. The life and character of Francis of Assisi, who lived, died, and was canonized less than a century before the frescoes were painted, are rendered accessible and immediate in this daring cycle.

Scholars agree that Scene I and Scenes XXVI–XXVIII were painted by a Florentine painter known as the St. Cecilia Master. Who, then, painted the other twenty-four? The consistency of the compositions throughout the entire cycle, including those by the St. Cecilia Master, has suggested to many authors that one artist made designs for all twenty-eight, to be approved by the superior general of the Franciscan Order, and that these were followed in general and in most details. Probably these designs were on parchment or paper, since no *sinopie* have come to light. Two major painters have been distinguished in addition to the St. Cecilia Master: one was active from Scene II through Scene XIX; the second, less experienced in fresco, from Scene XX through Scene XXV, accompanied by a host of assistants. The two

masters used white lead for highlights, with the same disastrous results that Cimabue encountered. Neither the St. Cecilia Master nor Giotto in his disputed works ever used this pigment, which, as we have seen, Cennini would later condemn. The connections with ancient Roman architecture and painting are so strong that the first and second masters may well have been from Rome, of a generation following Torriti and Cavallini, and left unemployed in Rome by the move of the papacy to Avignon in 1305.

Florentine Painters after Giotto

The authority of Giotto's style in Florence may well have impeded the emergence of other innovative artists. Nonetheless, three of Giotto's Florentine assistants became important painters in their own right. Closest to the master, perhaps, is Maso di Banco (active 1330s and 1340s), whose work has been convincingly reconstructed. Although, for whatever reason, Maso did not approach Giotto's breadth and harmony, he did achieve a handsome narrative and decorative style, especially in the frescoes of the Bardi-Bardi di Vernio Chapel in Santa Croce. The chapel is decorated with scenes from the lives of the Emperor Constantine and of St.

Sylvester, the pope who was believed to have baptized the emperor. One miracle of St. Sylvester was the sealing of the mouth of a dragon whose breath had killed two pagan magicians in the Roman Forum, and their subsequent resuscitation (fig. 3.28). The pagan magicians lie dead amid Roman ruins and are then shown alive again and kneeling in thankfulness. This before-and-after representation is typical of Trecento miracle paintings. The massive figures and the unified space and lighting are all learned from Giotto, but Maso has gone further in the spatial complexity of the background and the evocative quality of the Roman ruins, with their flat wall planes and empty arches, enhanced by the plants that grow in the cracks.

A study of *Sts. Paul and Julian* (see fig. 1.18) has been attributed to Maso on the basis of the facial types and expressions and the style of the hands and the drapery. The two saints are shown seated, apparently on a bench. Each holds a sword, but for opposite reasons; St. Paul, who is called the sword of the Church, grasps his weapon with both hands, but Julian, who committed parricide, holds the instrument of his crime downward with his left while with his right he strikes his breast in repentance. Except for the deep, yet wordless, communication between them, the two saints

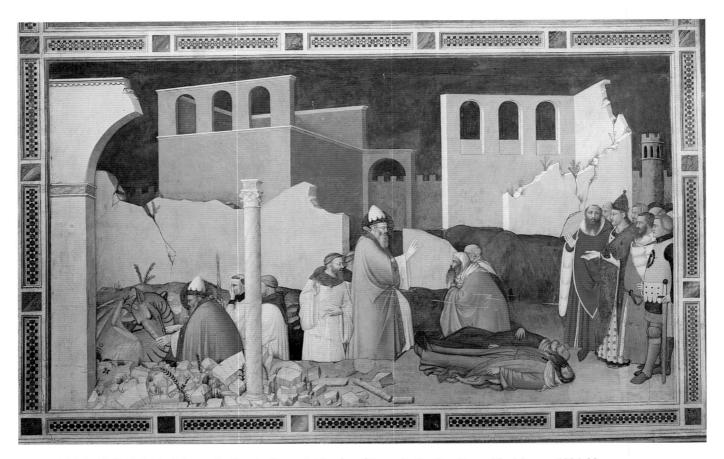

3.28. MASO DI BANCO. St. Sylvester Sealing the Dragon's Mouth and Resuscitating Two Pagan Magicians. c. 1336–39. Fresco, width 17'6" (5.34 m). Bardi-Bardi di Vernio Chapel, Sta. Croce, Florence

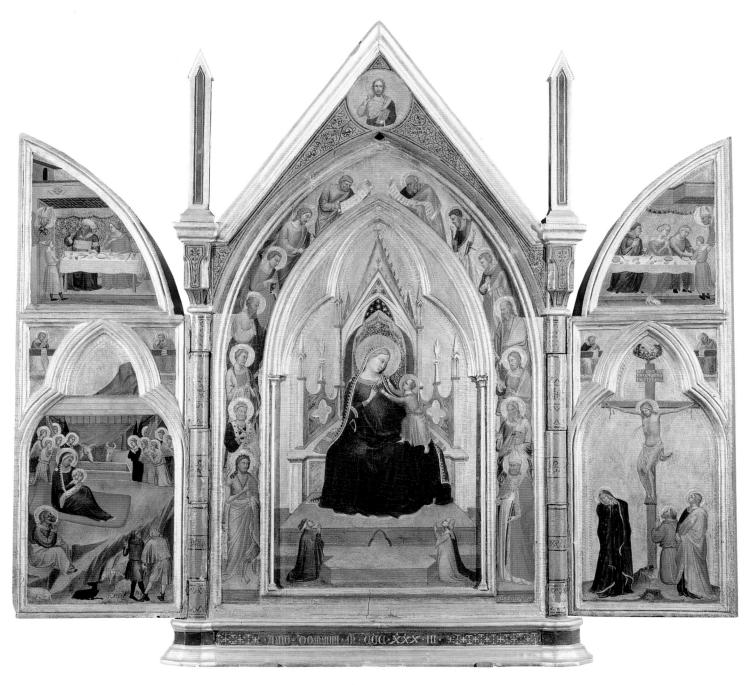

3.29. BERNARDO DADDI. Triptych. 1333(?). Central panel, 353/8 x 381/8" (89 x 97 cm). Loggia del Bigallo, Florence

recall their direct ancestors in the *Last Judgments* by Cavallini and Giotto (see figs. 2.24, 3.4).

Like many such detailed studies from the Trecento and later, the drawing is done with wash over underdrawings in silverpoint on tinted paper, and the lights are picked out with white, thus approximating the three gradations of value Cennini described in his directions for painting a fresco. Since no figure drawings attributable to Giotto are known, this carefully rendered work is witness to the probable role of drawing in Giotto's art, as well as the procedures of draw-

ing common at the time. Intense psychological interchange, the basic principle of Giotto's compositions, is established from the start. Then, after the general proportions and contours were fixed by line, light, gliding across faces and drapery masses with silken grace, projects the larger volumes and smaller forms in depth.

Giotto's follower, Bernardo Daddi (active c. 1312–48), is a painter whose sensitivity was more suited to panel paintings than to frescoes, which in fact he rarely painted. The triptych intended for personal devotion (fig. 3.29) is typical;

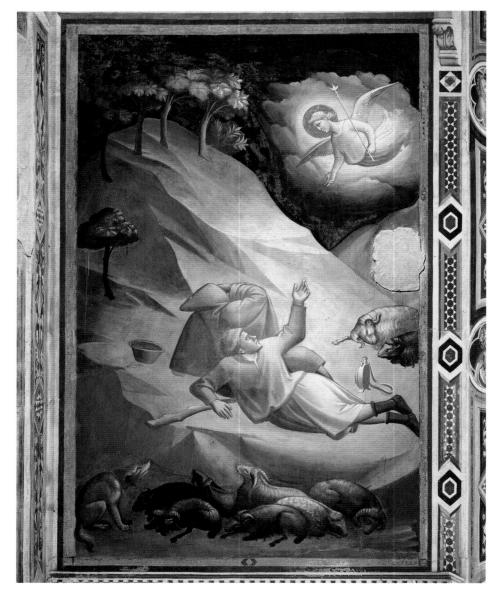

3.30. TADDEO GADDI.
Annunciation to the Shepherds.
c. 1328–30. Fresco. Baroncelli Chapel,
Sta. Croce, Florence. Commissioned
by Bivigliano, Bartolo, and Salvestro
Manetti and Vanni and Piero Bandini
de' Baroncelli

his pictures are intimate, even those intended for important public places, and show a different approach to the Virgin and Child from the majestic images in the tradition that runs from Coppo di Marcovaldo to Giotto. Daddi's Virgin smiles gently as she admonishes the playful Christ Child. The delicate Gothic forms of the throne provide ample space for her, yet diminish her monumental size. The two donors (made small for the sake of convention) appear even more minute. In a space seemingly outside that of the inner image, the surrounding saints and prophets rise like a rose trellis.

Intimacy extends to the side wings. In the *Nativity* to the left, Mary has taken Christ out of the manger and cradled him on her lap. Even the Crucifixion on the right is relatively calm and restrained.

Daddi's lyric intimacies have been traced to the influence of Sienese art, but this is difficult to justify; most likely it is a happy conjunction between his own temperament, the rather relaxed taste of the 1340s, and the example of Gothic ivory carvings brought from France, which often show a similar sweetness and playfulness. But Daddi is never sentimental: his forms are as round and firm as one could wish from a protégé of Giotto's, his drawing is precise, his modeling clear, and his color resonant. The facial types, with their short noses and round cheeks, are his own, and his drapery folds flow easily while also emphasizing the three-dimensional bodies of his figures.

The principal achievement of Taddeo Gaddi (active c. 1328–c. 1366), another faithful follower of Giotto and father of Agnolo Gaddi, is the fresco cycle in the Baroncelli Chapel, one of the larger chapels in Santa Croce. As much of the work was done during Giotto's last years, it may reflect his ideas. Giotto even "signed" the chapel's altarpiece,

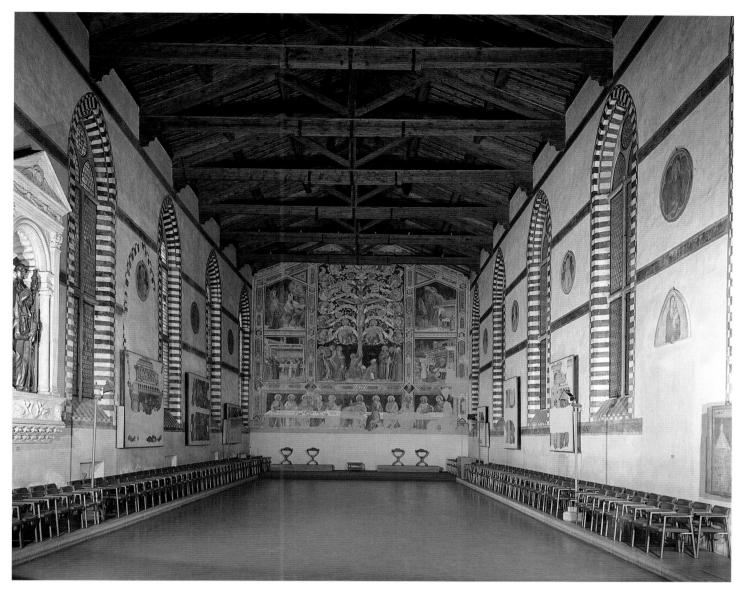

3.31. TADDEO GADDI. Refectory, Sta. Croce, Florence. Frescoes of the Last Supper with the Tree of Life and Other Scenes. c. 1360. Width 39' (12 m). Commissioned by the woman in the garments of a Franciscan tertiary kneeling at the foot of the cross, behind St. Francis

though few believe he painted much of it. The *Annunciation to the Shepherds* (fig. 3.30) is notable for its dramatic effect of night light, an important forerunner of later efforts in this direction, including Correggio's Cinquecento *Adoration of the Shepherds* (fig. 18.45), and all its Baroque descendants. The angel casts a strong light onto the dark hillside, where the shepherds are guarding their sheep.

Taddeo's enormous Last Supper with the Tree of Life in the refectory of Santa Croce shows the robust vigor of this painter, as well as a fascinating display of iconographic richness (fig. 3.31). The fresco illustrates one of the major works of St. Bonaventura. Christ hangs not upon the conventional cross but upon the symbolic Tree of Life, which

grew alongside the Tree of Knowledge in the Garden of Eden (Genesis 2:9). The medallions hanging from it, the fruits of this marvelous tree, contain bust portraits of the four evangelists and twelve prophets. At the right are the *Priest at His Easter Meal Receiving Word of St. Benedict's Hunger in the Wilderness* and the *Magdalen Washing the Feet of Christ*, at the left the *Stigmatization of St. Francis* and *St. Louis of Toulouse Feeding the Poor and Sick of Toulouse*. The *Last Supper*, below, is the earliest survivor of the many that still decorate the refectories of Florentine monasteries and convents. The strong, simple figures, with their harsh expressions, provide a strong contrast to the refinements of Bernardo Daddi.

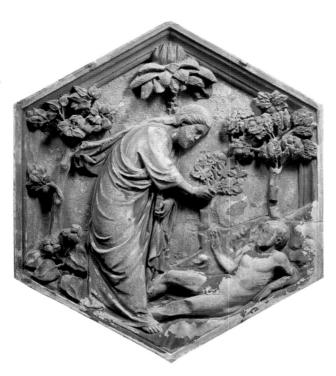

3.32. ANDREA PISANO (from designs by GIOTTO?). *Creation of Adam.* c. 1334–37. Marble, 32³/₄ x 27¹/₄" (83 x 69 cm). Removed from original location on the Campanile, Florence (see fig. 3.26), and now in the Museo dell'Opera del Duomo, Florence. Commissioned by the Arte della Lana

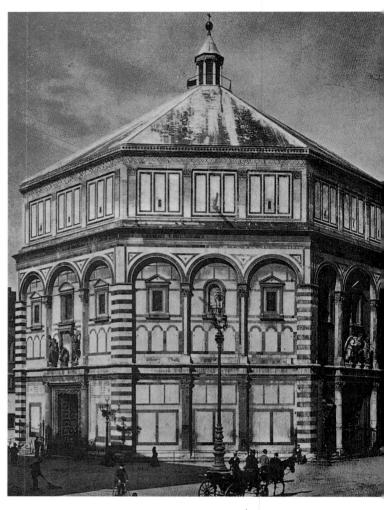

Sculpture

Giotto's style dominates the art of the Trecento, including sculpture. The work of Andrea Pisano has a special relationship to Giotto's shop. Andrea Pisano (c. 1290–1348) is no relation to Nicola and Giovanni Pisano, but acquired his name through the fact that he came from a town then in Pisan territory. We have already noted the reliefs representing painting, sculpture, and architecture (see figs. 1.9, 1.10, 1.11) with which Andrea ornamented Giotto's Campanile. Ghiberti claimed to have seen Giotto's designs for these reliefs, which he says were "most exceptionally

drawn." The *Creation of Adam* (fig. 3.32), which begins the series, obviously comes straight from Giotto's quatrefoil representing the same subject in the decorative framework of the Arena Chapel (see figs. 3.5, 3.11). The figures and their poses are almost identical, although the increased size of the image permits the figure of God the Creator to be shown in its entirety, as well as allowing the addition of a splendid array of trees, including both the Tree of Knowledge and the Tree of Life.

Andrea had been brought to Florence as a specialist in bronze casting to help make a set of bronze doors for one of the portals of the Florentine Baptistery (fig. 3.33). These

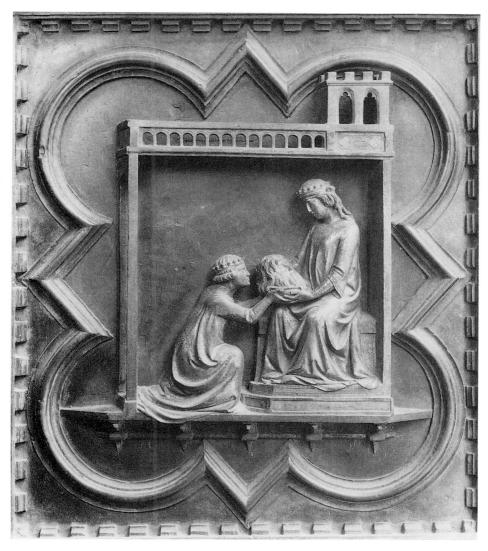

doors include twenty scenes from the life of St. John the Baptist with figures of eight virtues below. Like Ghiberti's two sets of doors that followed in the Quattrocento, they consist of bronze panels set in a bronze frame. The figures and many of the raised elements of ornament, architecture, and land-scape were originally covered with gold leaf and burnished. The individual compositions of the scenes from the Baptist's life are, with one exception, derived from either the Baptistery mosaics (see fig. 2.15) or Giotto's fresco cycle in the Peruzzi Chapel at Santa Croce; perhaps as an outsider Andrea's contract required him to employ these Florentine models in representing the life of the city's patron saint. Or, since

Giotto was the *capomaestro* of the Cathedral complex at this time, it is possible that he provided drawings from these sources for Andrea to follow. The limited depth, well-spaced compositions, and simple stagelike sets are directly related to Giotto's vision of form and space, and especially to his economy of statement. The delicate and lucid scene of *Salome Presenting the Baptist's Head to Herodias* (fig. 3.34) is neatly balanced inside the fashionable quatrefoil form imported from Gothic France; note especially how the drapery of the kneeling Salome mirrors the curved corner of the quatrefoil frame. The composition is derived directly from Giotto's Peruzzi fresco.

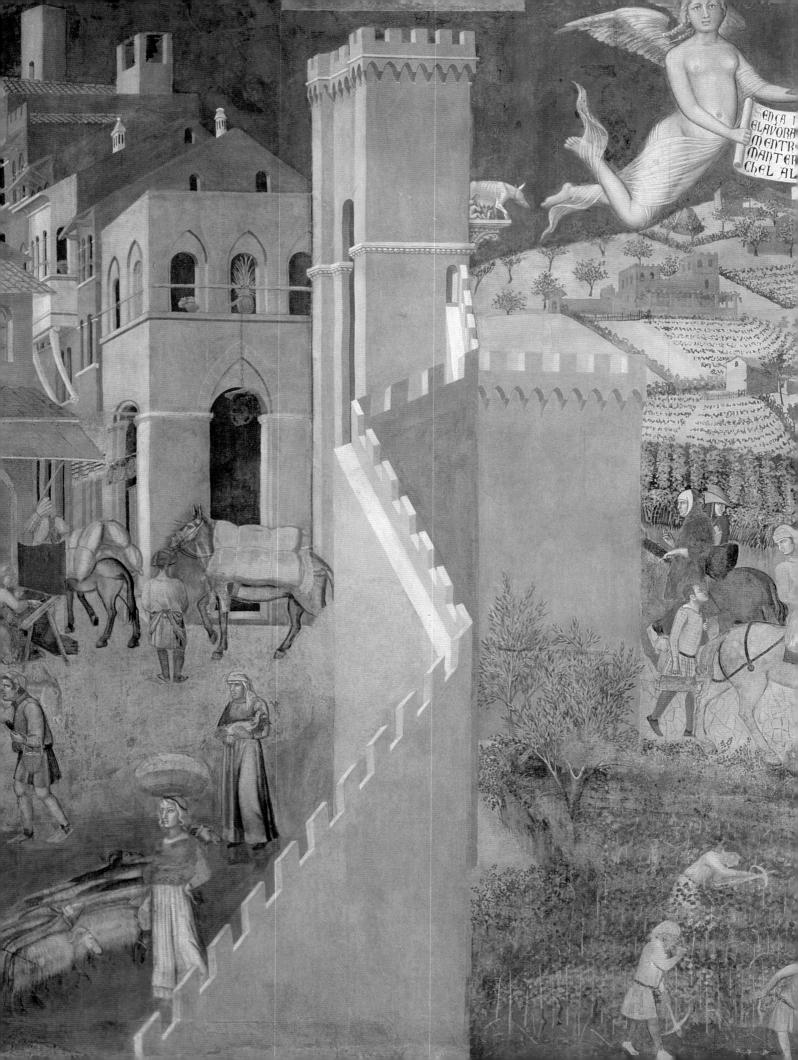

SIENESE ART OF The early trecento

s in Florence, Sienese painters moved decisively away from the Byzantine style. During the late Duccento and early Trecento in Siena, it was Duccio di Buoninsegna (active 1278–1318) who was in the forefront of the new developments.

Duccio

The documents that survive from Duccio's life include ones that levy fines against the painter for breaking the curfew, for such offenses as not swearing allegiance to an important official, and for an unwillingness to fulfill military service. He did not pay some of the fines for years, and when he died his children renounced his will, possibly because it consisted mostly of debts. In Siena, Duccio may well have witnessed the carving of the Cathedral pulpit by Nicola Pisano and his assistants, including his son Giovanni (see fig. 2.30). In Florence, Cimabue's *Enthroned Madonna and Child* in Santa Trinita (see fig. 2.17) must have excited the young painter.

The earliest major work we know by Duccio is, surprisingly, a Florentine commission, the huge *Madonna and Child* (fig. 4.1) known today as the *Rucellai Madonna* because it once stood in the Rucellai family chapel in Santa Maria Novella. It has been identified with a Madonna commissioned in 1285 by the Society of the Virgin Mary, known as the Laudesi.

In the Uffizi today, Cimabue's and Duccio's *Madonnas* are displayed in the same room, enabling us to contrast the differences in style between them. Duccio's Virgin is seated sideways on an elegant wooden throne seen slightly from the right. The surrounding angels kneel naturally on one knee, and their placement against the gold ground suggests that they physically support the throne. Except for the cloth around the legs of the Christ Child, Duccio has abandoned the Byzantine gold drapery striations still used by Cimabue; Duccio's drapery is composed and modeled to suggest the manner in which cloth wraps around and over three-dimensional bodies. The border

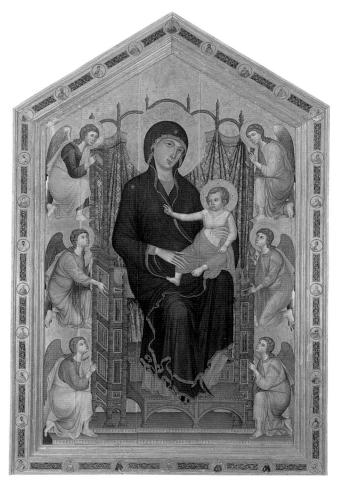

4.1. DUCCIO. *Madonna and Child (Rucellai Madonna)*. Commissioned 1285. Panel, 14'9¹/8" x 9'6¹/8" (4.5 x 2.9 m). Uffizi Gallery, Florence. Commissioned by the Società della Vergine. The contract for this work clarifies the role of the patrons in directing an artist's production, for it states that Duccio should "paint the said panel and adorn it with the image of the Blessed Virgin Mary and her omnipotent Son and other figures, in accordance with the wishes and pleasure of the said commissioners, and to gild it, and to do each and every thing which will contribute to the beauty of said panel, all at his own expense."

of the Virgin's cloak, embellished with a delicate golden fringe, assumes an important role as a carrier of energy. The colors of the angels' robes offer a refinement new to Italian panel painting; their flowerlike tones include lavender, yellow, rose, and luminous gray-blues and gray-lavenders.

Refinement of surface is here pushed to a new extreme. The arches on the Virgin's throne are hung with a splendid patterned silk, its folds indicated by strokes of wash over the design. The same pattern reappears in the fragmentary frescoes in the chapel used by the Laudesi at Santa Maria Novella, suggesting that Duccio's *Madonna* may have been part of a wider decorative program. These fragmentary frescoes have been attributed to both Duccio and Cimabue.

The ovoid shapes in the Virgin's face are derived from those of Coppo di Marcovaldo (see fig. 2.14), but they are more organic, in keeping with Duccio's undulating line and more naturalistic form. Curving contours outline the eyes and unite the brow with the long, slender nose. The upper lip protrudes slightly and the chin recedes to blend with the slender neck. The angels, whose faces are similarly constructed, gaze in reverence toward the Christ Child, who extends a blessing with his outstretched hand.

The gold of the haloes is tooled in a pattern of interlocking circles and foliate designs derived, like the patterns of the silk, from French Gothic sources, while tiny Gothic arches decorate the spindles of the throne. The frame is painted with a series of bust portraits of saints in medallions alternating with ornamented bands. Despite the subtle color and the elegance of the

line, it is also clear that Duccio's picture offers a revolutionary exploration of space with its side view of the throne and the clear articulation of its support at the hands of the surrounding angels. Duccio's redefinition of the Italo-Byzantine style in terms of both space and decoration surely had an effect on contemporary Florentine painters, including the young Giotto.

For Sienese citizens, the Virgin Mary was the mother of God, the Queen of Heaven, and the patron saint of the Republic; modern skeptics may have trouble understanding how fully Sienese citizens were convinced that the Virgin, accompanied by saints, protected their city. Siena's title, in fact, was vetusta civitas virginis (ancient city of the Virgin). In 1308 Duccio was commissioned to create a high altarpiece for the Cathedral, a striped marble structure at the apex of the city's highest hill (see fig. 2.33). Three years later the colossal altarpiece was finished and a contemporary description relates how it was carried in triumphal procession to the Cathedral: "accompanied by the members of the government, the clergy, and the people, carrying lighted candles and torches, to the sound of all the bells of the city, and the music of trumpets and bagpipes." The altarpiece was not only a religious triumph for the city, but also an artistic one for the painter. In 1506, however, it was replaced by a fashionable new ciborium, statues, and candlesticks, and when Vasari wrote his *Lives* in 1550, he was not even able to discover its location.

Originally the *Virgin in Majesty*—or simply the *Maestà*, to give the work its Italian title—was an enormous, Gothic-pinnacled, double-sided work (figs. 4.2–4.6). The central panel

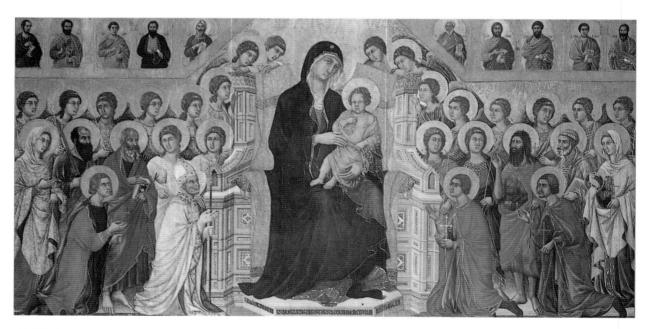

4.2. DUCCIO. *Maestà*. 1308–11. Central front panel, 7 x 13' (2.13 x 3.96 m). Museo dell'Opera del Duomo, Siena. Commissioned by the Opera del Duomo for the high altar of Siena Cathedral.

The inscription includes Duccio's only known signature: "Holy Mother of God be thou the cause of peace for Siena and, because he painted thee thus, of life for Duccio."

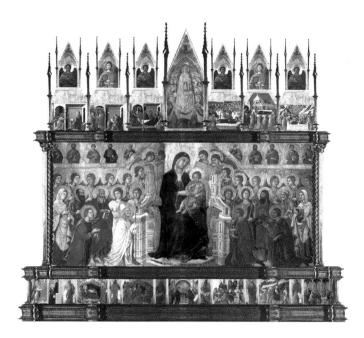

4.3. DUCCIO. Maestà. Conjectural reconstruction of the front, with predella, pinnacles, and framing elements.

Computerized reconstruction by Sarah Loyd.

It is also possible that the predella, to hold up such a huge altarpiece, was quite deep, making it possible for each end to be decorated with a narrative scene, in which case the predella reconstruction shown here and in the next reconstructions would take a different form.

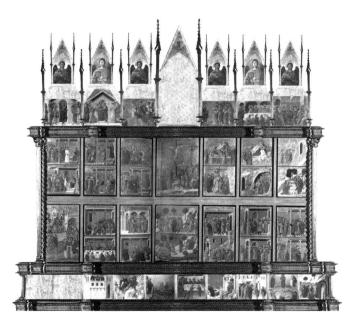

4.4. DUCCIO. *Maestà*. Conjectural reconstruction of the back, with predella, pinnacles, and framing elements. Computerized reconstruction by Sarah Loyd

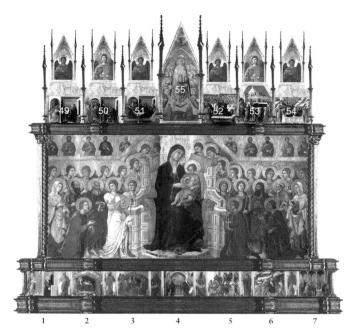

4.5. DUCCIO. Maestà. Diagram of the conjectural reconstruction of the iconography of the narrative scenes on the front. Computerized reconstruction by Sarah Loyd. CENTRAL PANEL: Madonna and Child with Saints and Angels. FRONT PREDELLA (conjectural), with narrative scenes flanked by prophets: 1. Annunciation; 2. Nativity and Apparition to the Shepherds; 3. Adoration of the Magi; 4. Presentation of Christ in the Temple; 5. Massacre of the Innocents; 6. Flight into Egypt; 7. Christ Disputing with the Doctors in the Temple. FRONT NARRATIVE PINNACLES (Later Life of the Virgin Mary): 49. Annunciation of the Death of the Virgin; 50. Arrival of John the Evangelist; 51. Farewell of the Apostles; 52. Death of the Virgin; 53. Funeral of the Virgin; 54. Entombment of the Virgin; 55. Assumption and Coronation of the Virgin Mary (lost; reconstruction based on later Sienese version) Angel pinnacles (largely lost, but several examples survive)

(see fig. 4.2) is dominated by the enthroned Virgin, who is adored by saints and angels; above is a row of bust-length prophets. Most of the parts of Duccio's altarpiece remain in Siena, but some of the predella panels are scattered to other collections. The central pinnacles, front and back, have never been found, and their subjects are unknown. On the predella at the base, a sequence of panels originally illustrated scenes from the infancy of Christ, while the later life of the Virgin was related on the pinnacles at the top, surmounted by bust-length angels. Since the high altar stood under the dome of the Cathedral, the back of the altarpiece was covered with scenes depicting the Passion of Christ. This altar was central in a cluster of works dedicated to the

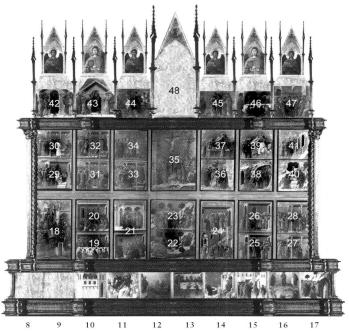

4.6. DUCCIO. Maestà. Diagram of the conjectural reconstruction of the iconography of the narrative scenes on the back. Computerized reconstruction by Sarah Loyd. BACK PREDELLA (conjectural), with narrative scenes: 8. Baptism of Christ (conjectural, lost); 9. First Temptation of Christ (conjectural, lost); 10. Temptation of Christ in the Temple; 11. Temptation of Christ on the Mountain; 12. Calling of Peter and Andrew; 13. Marriage Feast at Cana; 14. Christ and the Woman of Samaria at the Well; 15. Christ Heals the Blind Man; 16. Transfiguration; 17. Raising of Lazarus. CENTER BACK, LOWER REGISTER: 18. Entry into Jerusalem; 19. Last Supper; 20. Washing of the Feet; 21. Sermon to the Apostles and Judas Receiving the Blood Money from the High Priests of the Temple, occurring simultaneously; 22. Agony in the Garden; 23. Kiss of Judas; 24. Christ Before Annas and First Denial of Peter, occurring simultaneously; 25. Christ Before Caiaphas and Second Denial of Peter, occurring simultaneously;

26. Mocking of Christ and Third Denial of Peter,

occurring simultaneously; 27. Christ Before Pilate; 28. Pilate Declaring Christ's Innocence to the Pharisees.

CENTER BACK, UPPER REGISTER: 29. Christ before Herod;

30. Christ in the Robe Before Pilate; 31. Flagellation;

32. Mocking of Christ; 33. Pilate Washing His Hands,

34. Christ Carrying the Cross; 35. Crucifixion; 36. Descent from the Cross; 37. Entombment of Christ; 38. Descent into Limbo;

39. Three Marys at the Tomb; 40. Noli Me Tangere;

41. Journey to Emmaus.

BACK PINNACLES: 42. Christ Appears Behind Closed Doors; 43. Incredulity of Thomas; 44. Apparition to the Apostles at the Sea of Tiberias; 45. Apparition to the Apostles on a Mountain in Galilee; 46. Apparition at Supper; 47. Pentecost; 48. Ascension of Christ (lost, subject conjectural)

Virgin: the pulpit by Nicola Pisano and later narrative altarpieces by Simone Martini (see fig. 4.15), Pietro Lorenzetti (see fig. 4.24), Ambrogio Lorenzetti (see fig. 4.25), and Bartolommeo Bulgarini.

In the *Maestà* as we know it today, Sienese saints kneel in the front row of the central panel (see fig. 4.2); more saints and four archangels stand in a row behind them. Four angels rest their hands and chins on Mary's inlaid marble throne. In the resulting interlace of figures, heads, and haloes-all united by the flow of drapery lines, ornamental patterns, and brilliant color—separate elements do not stand out as they would in Giotto's compositions. Rather, the panel takes on the appearance of a rich and splendid fabric. The Christ Child, who gazes directly outward at the observer, is a more natural, human baby than in earlier Sienese altarpieces. In line with the artist's decreasing reliance on Byzantine motifs, gold striations appear only here and there in the richly modeled drapery that courses over somewhat attenuated bodies.

The head of St. Catherine of Alexandria (fig. 4.7), at the extreme left, demonstrates how the Byzantine demarcation of forms, including all but a hint of the characteristic forma-

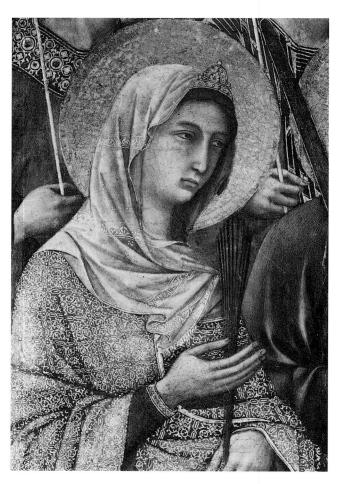

4.7. Head of St. Catherine, detail of the front of fig. 4.2

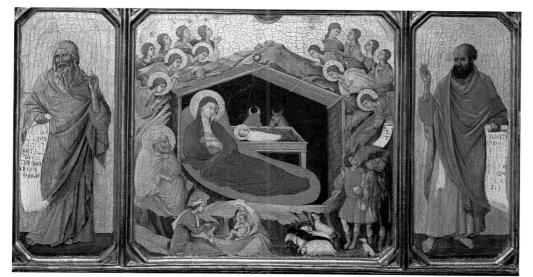

4.8. DUCCIO.

Nativity and Prophets Isaiah
and Ezekiel, from the front
predella of Maestà (see figs. 4.3,
4.5). Panels: Nativity, 17 ½ x
17 ½ (44 x 45 cm); Prophets,
each 17 ¼ x 6 ½ (44 x 16.5 cm). National Gallery
of Art, Washington, D.C.
(Mellon Collection)

tion at the juncture of the eyebrows, is swept away in a new, unified sense of surface. Catherine's mournful gaze is characteristic of Duccio's figures, as is the Byzantine treatment of the eye so that the white continues below the iris. His treatment of the fabrics of her garments is refined; the gold-embroidered scarf seems translucent, and we sense the shape of her head and see her hair through its flowing folds. Her mantle is painted over gold, and the paint has been tooled away to suggest the sparkle of a gold-thread damask cloth.

The Nativity flanked by the prophets Isaiah (on the left) and Ezekiel (on the right) from the front predella (fig. 4.8) preserves its original, simple framing. Duccio keeps the Byzantine cave, but inserts the French Gothic shed, a compromise symptomatic of his artistic position, which draws upon both these traditions. Mary, enveloped in her bright blue mantle, reclines on a scarlet mattress; following Byzantine tradition, she pays no attention to the Christ Child in the manger. In the bath scene, below the reclining Mary, the Christ Child is plunged by midwives into a chalicelike tub, as in Nicola Pisano's Pisa Baptistery pulpit (see fig. 2.27). Some of the angels behind the cave look up toward heaven, while others bend over like the angels behind Mary's throne in the central panel. One angel waves a scroll announcing the event to shepherds, whose sheep have already arrived upon the scene. The brilliant colors of Mary's cloak and mattress are in contrast with softer colors, such as the rose of Joseph's cloak. Isaiah's lavender mantle covers a tunic of an entirely different rose, and the powdery blue of the angels' garments contrasts with the stronger blue of Ezekiel's cloak.

A panel from the back predella (fig. 4.9) shows how Satan tempted Christ by leading him up a high mountain and offering him all the kingdoms of the world. Duccio represents the kingdoms as Italian city-states with walls, gates, streets,

and public and religious buildings with towers, domes, roof tiles, and battlements. The colorful architecture of those in the foreground is picked out delicately in light, while the distant cities are darker, as if lost in shadow. The illusion is limited, but a sense of vast space is created by the cities' tiny scale. While we may feel that we can enter the reasonable, tangible environment Giotto created for his narratives (see fig. 3.6), we cannot penetrate the complex, elusive world of Duccio's creation. Duccio's rocks, for example, seem almost fluid when compared with Giotto's mountains: their surfaces seem to twist and ripple, and they break upward toward the

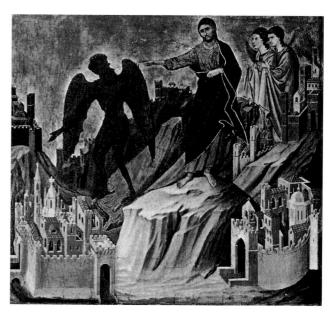

4.9. DUCCIO. *Temptation of Christ on the Mountain*, from the back predella of *Maestà* (see figs. 4.4, 4.6). Panel, $17 \times 18^{1/8}$ " (43 x 46 cm). Copyright The Frick Collection, New York

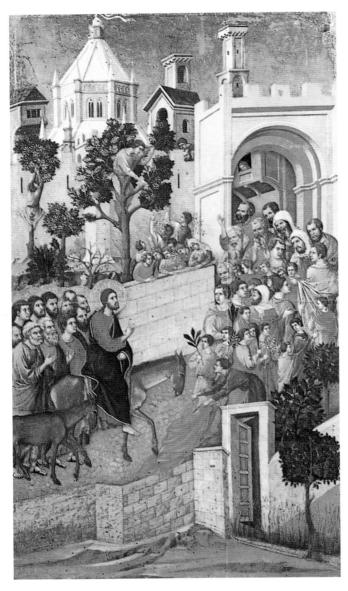

4.10. DUCCIO. Entry into Jerusalem, from the back of Maestà (see figs. 4.4, 4.6). Panel, $40\frac{1}{8} \times 21\frac{1}{8}$ " (102 x 56.5 cm). Museo dell'Opera del Duomo, Siena

standing figures. On this moving ground the figures cannot stand with the firmness and decision of Giotto's people; they maintain an uncertain footing, as if walking on waves. In the drapery of Christ, Duccio's flowing line is transformed into straight lines and sharp points that reinforce Christ's gesture and words: "Get thee behind me, Satan" (Luke 4:8). Even in this scene, however, Duccio's slender, sad Christ is utterly different from the majestic, forthright Christ of Giotto.

On the main panel on the back of the *Maestà*, the story of the Passion is told in twenty-four scenes, beginning with the *Entry into Jerusalem* (fig. 4.10). The hilltop setting, similar to that of Siena itself, reflects a Sienese Palm Sunday

procession in which the bishop led a throng to one of the city gates to meet an actor garbed as Christ. Duccio has placed us in a field that is separated from the highway by a wall with an open gate, over which we watch the procession winding up along the highway to the towering city gate. We can see over the wall on the other side of the road into an orchard where people climb trees, as in Byzantine representations of the scene. As the text of the Gospel requires, some onlookers remove their mantles and spread them on the road. Christ rides on a donkey, fulfilling the prophecy of Zachariah: "Behold, thy King cometh . . . lowly, and riding upon an ass" (9:9). The crowd surges out of the gate chattering and gesticulating while the apostles follow Christ up the road. In these two human rivers about to meet we get all the feeling of a crowded medieval city. We can look through the gate into the main street; there is even a balcony with a head protruding through a window. What seems to be a Tuscan Gothic baptistery rises in the distance over trees and rooftops.

In the Crucifixion (fig. 4.11), Duccio reveals his ability to create a scene of mass violence and tragedy. All three crosses are shown and, following the Gospels, the legs of the thieves have been broken to ease their agony, while Christ's legs were left intact, fulfilling a prophecy that "a bone of him shall not be broken" (John 19:36). The lofty, slender crosses soar against the gold background, which shimmers with an effect that is airy and atmospheric. Duccio distinguishes the penitent thief, who is turned toward Christ, from the unremorseful one, who faces away and is represented in a darker color. Below, the crowds are separated into two waves, like the Red Sea parting before the Israelites. As in the Meditations on the Life of Christ, a text written by a Franciscan mystic living in Tuscany about 1300, Mary swoons below the cross, sinking powerless into the arms of the holy women as she looks upward toward Christ, from whose side blood and water gush in powerful streams. Duccio's mastery of crowds and his ability to project naturalistic human feeling are effectively shown in this scene, with its flashing eyes and reaching hands. Duccio is, in the final analysis, no less dramatic a narrative artist than is Giotto.

Simone Martini

Like Giotto in Florence, Duccio had a number of pupils and close imitators in Siena. Their works suggest that he was a liberating teacher, for each pupil developed a style independent of both the master and one another. One of the most original was Simone Martini (active 1315–44), who most likely worked on Duccio's later commissions, including the *Maestà*, and later achieved fame and influence far beyond the borders of Siena. Shortly after Duccio's *Maestà* was completed, Simone was commissioned to paint a *Maestà* of his

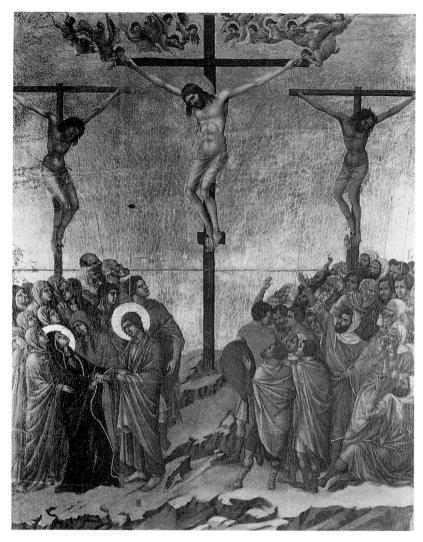

4.11. DUCCIO. *Crucifixion*, from the back of *Maestà* (see figs. 4.4, 4.6). Panel, $40^{1}/8 \times 29^{7}/8$ " (102 x 76 cm). Museo dell'Opera del Duomo, Siena

own (fig. 4.12), a large fresco on the end wall of the Council Chamber in Siena's Palazzo Pubblico. From this vantage point, the Virgin could watch over the deliberations of the Council of the Sienese Republic or, to put it another way, the councillors would have the Virgin Mary and other saints constantly before them to guide their behavior. The kneeling saints in the foreground reveal the influence of Duccio, but the kneeling angels follow the innovations of Giotto. The throne is intensely Gothic; its delicate tracery recalls the windows of French cathedrals.

Simone has unified the throng of saints and angels under a spacious cloth canopy similar to the ones that shelter the Eucharist today when it is carried in procession in churches or through the streets. Simone's canopy is upheld by saints, who turn to gaze toward the observer. Some portions of the work were painted *a secco* and have peeled off, showing the underdrawing on the *intonaco*. It is documented that in 1321 Simone repaired certain sections of the fresco; these repairs may explain the different head styles evident in the fresco. In the rear ranks of the Virgin's attendants some Duccio-inspired heads are still to be seen, their eyes almond-shaped and their hair covered with mantles. The heads of the Virgin and Child and of the two female saints that flank them show the more Gothic type characteristic of Simone's later works; they have broad full cheeks, pursed mouths, and wavy or curly blond hair.

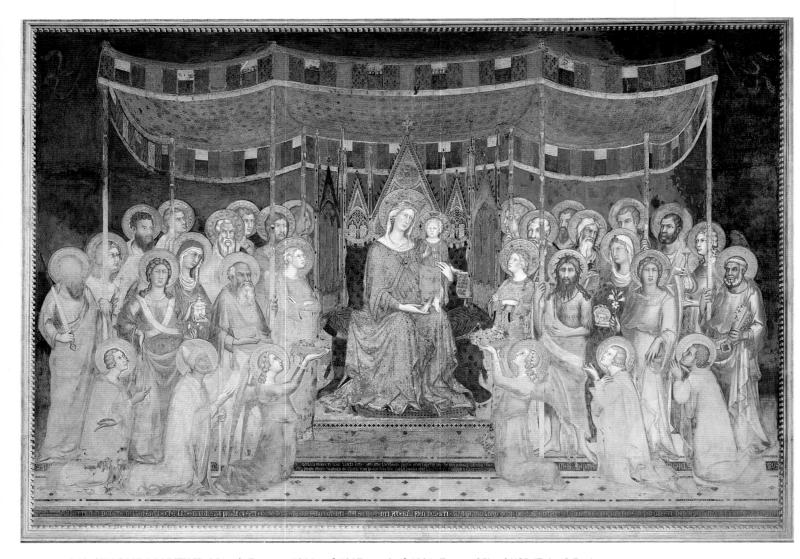

4.12. SIMONE MARTINI. *Maestà*. Between 1311 and 1317; repaired 1321. Fresco, 25' x 31'9" (7.6 x 9.7 m).

Council Chamber, Palazzo Pubblico, Siena. Commissioned by the Commune of Siena.

The inscriptions on the steps of the throne urge the use of wisdom and justice, and in one case the Virgin speaks directly to the Sienese public and the city's rulers: "The angels' flowers . . . which adorn the heavenly meadow, delight me no more than good counsel. . . ." From the beam in front of the *Maestà* hang two sculpted, polychromed arms, with openings in the hands; these arms, identified as those of angels descending from heaven, must have held ropes that supported lamps that hung in front of the fresco. The lamps could thus be raised or lowered as needed. Also in this room was a circular world map (*mappamondo*) painted by Ambrogio Lorenzetti; almost sixteen feet (approx. 5 m) across, it had Siena at its center and could be rotated on a central pivot to bring areas closer to the viewer.

Between the two campaigns of work on the *Maestà*, Simone was invited to Naples by the French king, Robert of Anjou. While there he painted a large dynastic icon depicting the king kneeling, about to receive the crown from his older brother, St. Louis of Toulouse (fig. 4.13), who was canonized in 1317; motifs from the family's coat of arms decorate the frame, the background, and the garments. The artist has minimized the conflict between the vertical, frontal image of the saint and the kneeling king, who is placed to one side to counterbalance the shift of the saint to the left. Simone unites the composition through interweaving diagonals and diagonally directed curves. In this

original, and at times almost abstract, composition Simone displays his ingenuity in handling boldly silhouetted areas and in creating surface patterns that are even richer and more delicate than those of Duccio. The large round pin or morse that holds together the saint's cape is made of glass decorated with paint and gold leaf; it is attached to the surface of the panel; the original decoration also included the application of precious gems, now lost. The richly embossed surface patterns are never permitted to compete with the basic element in Simone's maturing style—a taut, linear contour, almost as if the shapes were cut from sheet metal.

4.13. SIMONE MARTINI.

St. Louis of Toulouse Crowning Robert of Anjou, King of Naples, and Scenes from the Life of St. Louis of Toulouse. c. 1317. Panel with gold and silver leaf, originally embellished with gold work and precious stones, 78¾ x 54¼" (2 x 1.38 m). Museo di Capodimonte, Naples. Commissioned by Robert of Anjou

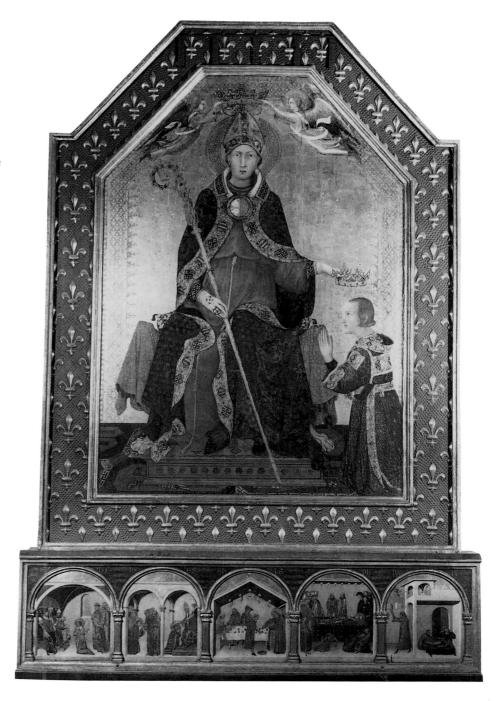

While the face of St. Louis resembles the standardized head type used by Simone in other works, King Robert's features are an early example of what will become an important new Renaissance development: portraiture. The silhouette is perhaps the simplest way to capture an individual, and the contrast between the face of the placid, enthroned saint and the vigorous, individualized physiognomy of his brother is startling. Simone has clearly fulfilled the need of his royal patron that he be recognizable, a goal that is also evident in the flamboyant repetition of the family's coat of arms within the painting and its frame. But portraiture is only one of the elements of naturalism evident in Simone's style.

Simone's frescoes in the St. Martin Chapel in San Francesco in Assisi have been assigned to the period between 1312 and 1319. Here Simone showed his narrative ability, sophisticated use of color, and decorative talents. In the *Dream of St. Martin* (fig. 4.14), an aloof and princely Christ appears to the saint, who sleeps under a rose and blue plaid silk coverlet heightened by gold threads. The simple architectural construction effectively isolates the sleeping saint, while the precise details of bed hangings and chest add an element of authenticity. The linear organization and expressiveness of the faces are typical of Simone's style.

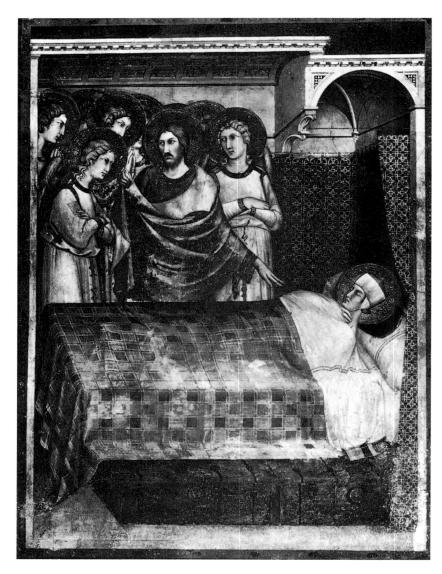

4.14. SIMONE MARTINI.

Dream of St. Martin. Between
1312 and 1319(?). Fresco, 8'8" x 6'7"
(2.65 x 2 m). St. Martin Chapel,
Lower Church of S. Francesco, Assisi.

Commissioned by Cardinal Gentile Partino da Montefiore dell'Aso

The most famous of Simone's surviving works is the *Annunciation* (fig. 4.15) painted for Siena Cathedral in 1333. He signed it jointly with his brother-in-law Lippo Memmi; this signature and the joint payments for the work attest to their collaboration, but it is not clear what role Lippo played in the execution of the work. This is the earliest known example in which the Annunciation was the subject of an entire altarpiece. The elaborate frame is not the original, and the different floor design and angle of view between side panels and center suggest that the side saints were not attached in this manner to the Annunciation panel. The blank gold background is traversed by raised gesso words that stretch from Gabriel's mouth to Mary's ear: *Ave gratia plena dominus tecum*, "Hail, thou that art highly favored, the Lord is with thee" (Luke 1:28).

As in Giotto's fresco the heavenly messenger kneels, but here the suddenness of his arrival is indicated by the cloak that still floats in the breeze. The Virgin shrinks back

sharply at the news, following the Gospel account that says she was disturbed by the angel's appearance and salutation. The violence of her movement increases the explosive immediacy of the scene. The sharp, taut curves of her body are contrasted to the masses of the angel, who is crowned with olive leaves and bears an olive branch, symbol of peace, in his hand. In the center of a richly veined marble floor stands a vase of lilies, symbol of Mary's purity. The lilies, the olive leaves, the curves of the drapery, and even the features of Mary and Gabriel display the same sharp, metallic quality seen in Simone's St. Louis of Toulouse. The hard, crisp lines of Simone's faces emphasize the suspicious expression of Mary, with her puckered brows and pursed lips. Glittering sunburst shapes incised in the gold background burst out around the tooled haloes, adding to the bristling tension of the scene.

Simone reveals his skill as a narrator in the altarpiece representing the Blessed Agostino Novello with scenes of his miracles (fig. 4.16). That the altarpiece follows the pattern of Bonaventura Berlinghieri's *St. Francis* (see fig. 2.8) and other Duecento images may have been requested by the unknown patron, but Simone has transformed the stiffness of his prototypes into the saint's gentle, swaying pose. He is seen among the trees of a forest, lost in meditation, while an angel whispers in his ear. The subtlety of Simone's sense of line and space is evident in the flattened curves and the suggestion of diagonal motion into depth. The stubble on the monk's face is a rare naturalistic detail at this time, while the book he holds may be symbolic of the legal learning for which Novello, briefly prior general of the Augustinian Order, was respected. The lateral scenes represent Agostino Novello's posthumous

miraculous appearances, in which he heals a boy attacked by a wolf and restores to life a traveler thrown from his horse and a baby fallen from a broken hammock. In the lower left scene, the monk intervenes to grab a board dislodged from a balcony and to revive a child who had fallen. Wood-grained balconies, nail-studded doors, and views into staircase halls recapture the Siena of Simone's day. Agostino Novella was beatified but never made it to sainthood; perhaps this altarpiece, with its four required miracles, was part of an effort to convince the authorities that he deserved canonization.

Simone's last years were spent in Avignon, a Provençal city then the seat of the papacy. Simone's followers left a number of works from this period, but only a few by Simone remain,

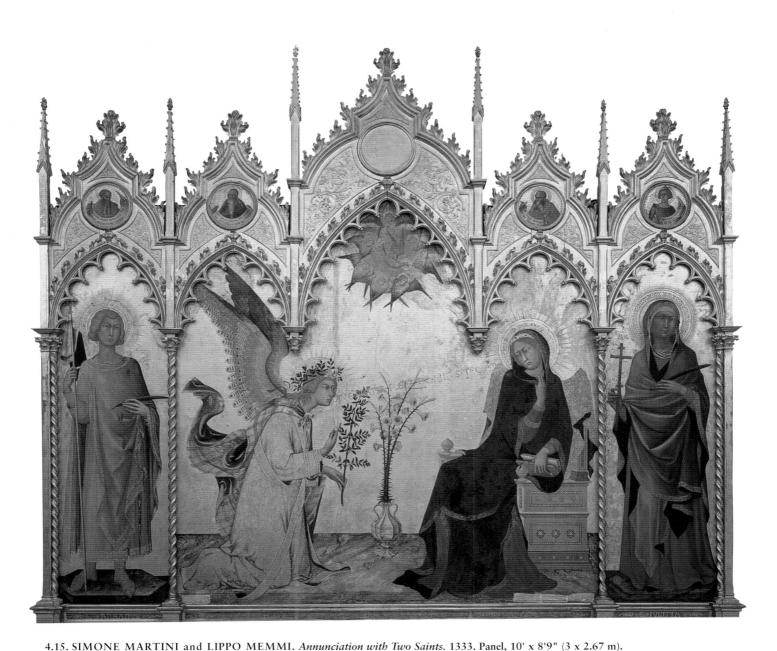

Uffizi Gallery, Florence. Commissioned by the Opera del Duomo for the Cathedral of Siena.

An analysis of prices undertaken by the scholar Hayden Maginnis has revealed that the cost of this altarpiece was about equal to that of a fine house.

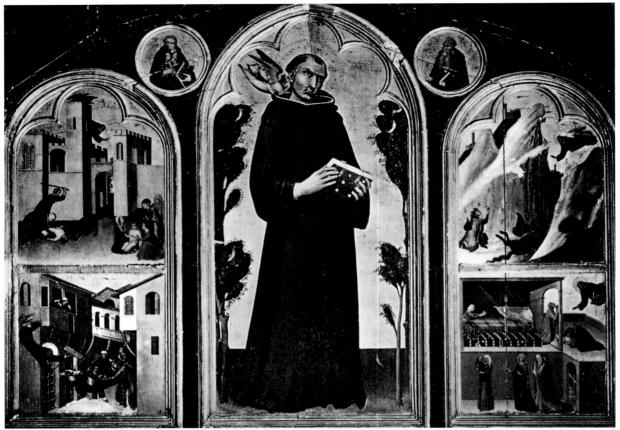

4.16. SIMONE MARTINI. *The Blessed Agostino Novello and Four of His Miracles*. c. 1324. Panel, 6'6" x 8'5" (2 x 2.7 m). Pinacoteca, Siena

4.17. SIMONE MARTINI. Way to Calvary. c. 1340–44. Panel, $9^{7}/8 \times 6^{3}/4$ " (25 x 17 cm). The Louvre, Paris. Originally part of a small folding devotional work commissioned by an Orsini cardinal

including a series of panels from a small folding devotional work representing the Passion; the most dramatic of these is the *Way to Calvary* (fig. 4.17). In these works painted in France, where we might expect a renewed influence of the French Gothic style, Simone's Francophile elegance is replaced by an interest in immediate, naturalistic, and even violent action. Christ is led forth from a very Sienese Jerusalem, seen from below, but he is almost overwhelmed by the mob of loving, grieving apostles and friends and by mocking Romans and Hebrews, including two irreverent children. In the new interest in passionate drama, even Simone's delicate color has given way to a fierce brilliance centering on the scarlet robe of Christ. Simone's late style had no immediate issue in Italy, but it must have been a revelation to Northern European painters; certainly his art and that of his compatriots

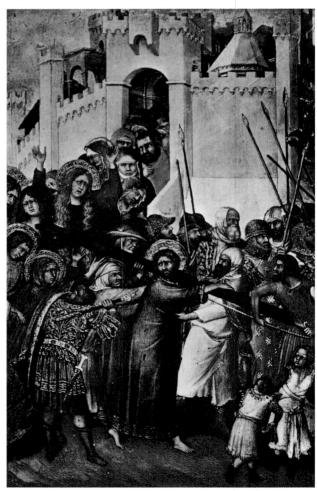

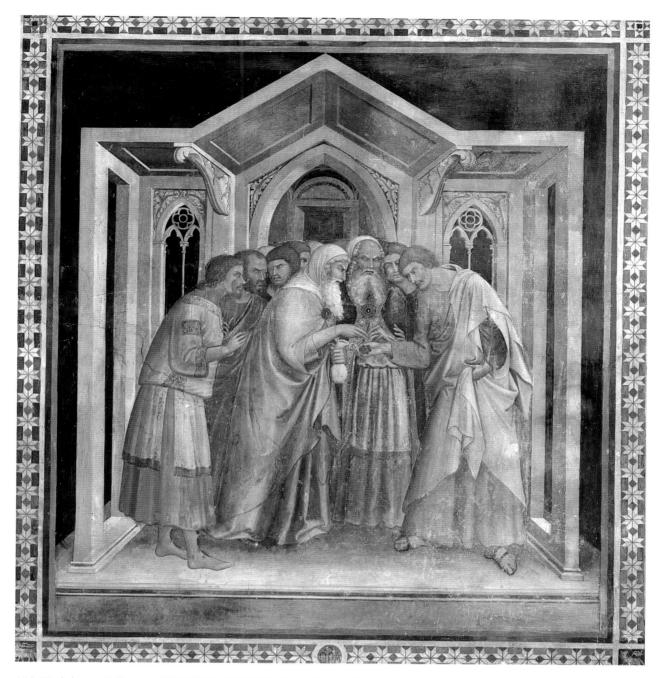

4.18. Workshop or Followers of SIMONE MARTINI. *Pact of Judas*. 1330s or 1340s. Fresco, 8'6" x 7'9" (2.6 x 2.4 m). Collegiate Church, San Gimignano. The frescoes of the New Testament cycle here were attributed by Vasari to Barna da Siena, but current opinion finds the hands of three or four distinct painters in the cycle working as collaborators. Scholarship in the twentieth century placed these works in the 1350s, after the 1348 Black Plague, but new evidence suggests a date in the 1330s or 1340s.

working in Avignon played a role in the development of the new naturalism with which Netherlandish painters under Jan van Eyck and Robert Campin (the Master of Flemalle) transformed Northern painting in the opening decades of the fifteenth century.

The dramatic intensity seen in Simone's later work had an impact on his followers, as is evident in the New Testament cycle painted on one side aisle wall of the Collegiata in San Gimignano, a hill town near Siena. Among the scenes is a

frightening representation of the *Pact of Judas* (fig. 4.18), the moment when the high priests give Judas thirty pieces of silver to betray Christ. While the composition recalls earlier renderings of this subject, including Duccio's on the *Maestà*, here the incident is converted into a transaction between sinister characters drawn together so that their heads form a human arch. The perspective of the architecture seems intended to pull us into the scene, forcing us to become witnesses to the betrayal.

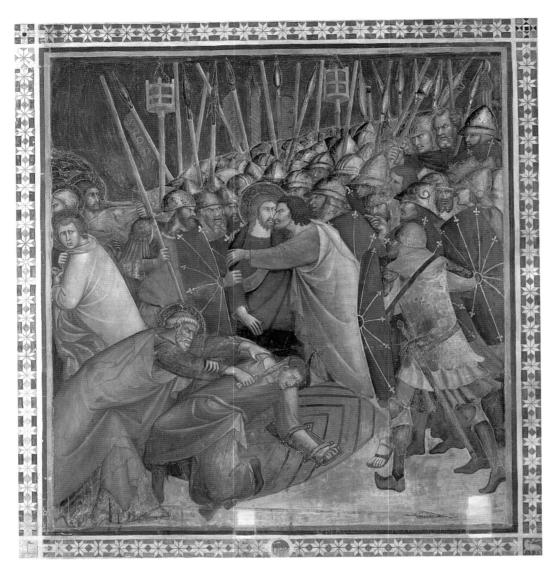

4.19. Workshop or Followers of SIMONE MARTINI. *Betrayal*. 1330s or 1340s. Fresco, 8'6" x 7'9" (2.6 x 2.4 m). Collegiate Church, San Gimignano

In all the Passion scenes Christ is alone, but never more so than in the *Betrayal* (fig. 4.19). Peter's attack on the Roman soldier Malchus in the foreground, which fills one-third of the scene, is rife with violence. The artist also convincingly represents the cowardice of the other apostles, who leave Christ to his fate. Even St. John gathers his cloak about him and darts a look of terror over his shoulder as he scurries away. Christ is abandoned to an avalanche of steel. His quiet face resists Judas's glare even as he is cut off from the rest of the world by helmets, spears, and shields. Although the derivation from Simone is evident, this painter, or group of painters, offer an individualized and pessimistic view of human behavior that is unforgettable.

Pietro Lorenzetti

Simone's chief competitors in Siena were the brothers Pietro and Ambrogio Lorenzetti. That two brothers would be successful painters might seem contrary to our notions of the artist as individual genius, but in Siena (and elsewhere) during the later Middle Ages and the Renaissance a trade would often be practiced by whole families, who would pass their workshop, tools, and expertise down to their children and grandchildren. The two Lorenzetti brothers exercised undisputed domination over Sienese style after Simone's departure (Pietro, c. 1290-1348?; Ambrogio, d. 1348?). Although the brothers almost always worked and signed their paintings independently, they show an affinity of style that is distinct from both the lingering Byzantinizing of the Duccio School and the Francophile elegance of Simone. Pietro's earliest known work, the polyptych still on the high altar of the Romanesque Pieve di Santa Maria in Arezzo (fig. 4.20), reveals a mature artist in control of a new style. Pietro must have visited Florence, for the Gothicism and humanity of his art, not to mention the clear-cut features, strong hands, and ample proportions of his figures, reveal an acquaintance with the art of Giotto and his followers. In the central panel the Christ Child looks upward at his mother with a gaze whose happiness is answered by a look of foreboding, typical of the intensity that characterizes Pietro's art. The saints in the lateral panels turn toward each other as if in conversation even as they look out questioningly toward the observer; in the upper register, just to the left of the *Annunciation*, St. Luke, closing his book, looks upward at the event about which he had written so beautifully—perhaps also to remind us that he, too, was a painter and, according to tradition, painted the Virgin's portrait.

Compared with the monumental figures in the Giottesque tradition, however, Pietro's personages are less massive and there is an emphasis on the richness of patterned fabrics. Instead of her customary blue mantle, the Virgin wears a tunic and cloak of white patterned silk, the latter lined with ermine. In this work there is little to suggest that Duccio's *Maestà* was finished only nine years before and that Simone had still to complete his own version of that subject.

The extent of Pietro's participation in the Passion cycle in the Lower Church of San Francesco at Assisi, as well as the

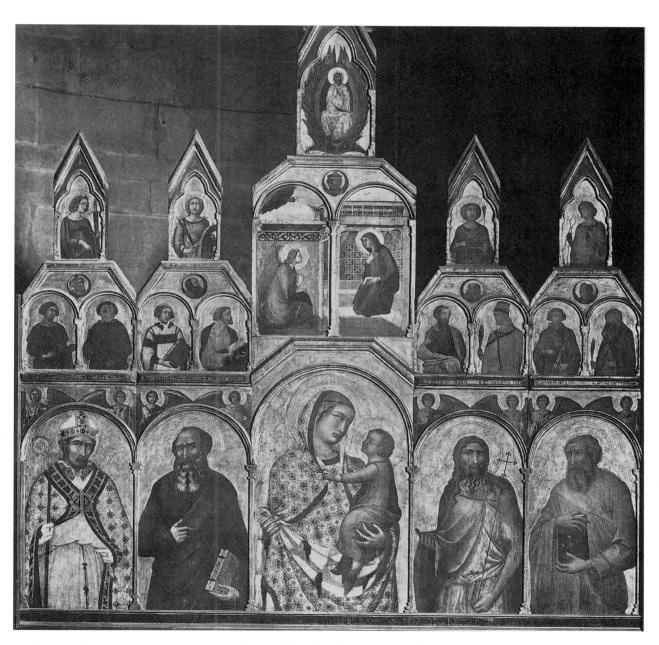

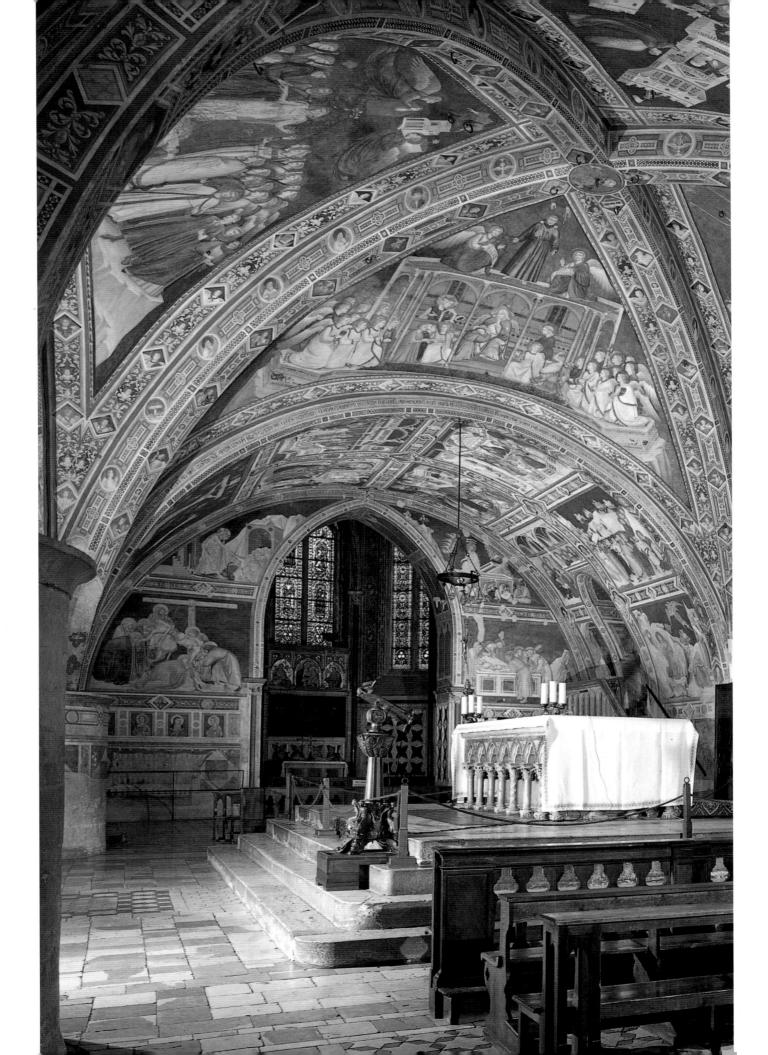

date of the series, remains in doubt. His authorship of the *Descent from the Cross* (figs. 4.21, 4.22), however, is beyond question, as are its dramatic power and bold originality of composition. The upper portion of the cross is cut off by the fresco's border, leaving the long horizontal of the crossbar against a background that, on the right, is completely vacant. The gaunt body of Christ, the effects of rigor mortis indicated in its harsh lines and angles, is lowered by his friends: Joseph of Arimathea holds the torso; St. John embraces the legs, pressing his cheek to one thigh; and Nicodemus, holding an immense pair of tongs, attempts to withdraw the spike from one pierced foot while Mary Magdalen prostrates herself to kiss the other. Another Mary holds Christ's right hand, and—most shattering of all—the Virgin presses the head of her Son to her cheek in a way that unites the two heads, one right side up, the

other upside down. The broad, columnar masses of Giotto's figures, which undoubtedly influenced Pietro's repertory of forms, are simplified into vertical drapery lines that suggest little or no volume beneath them, yet they bind the fabric of the composition into a unity of almost unbearable tension.

Lorenzetti's *Last Supper* (fig. 4.23) in the same church demonstrates how carefully he had studied light effects. Christ and the apostles are gathered in a hexagonal upper loggia that is almost filled by the table. The rich ornament of this structure includes nude baby angels inspired by the putti that often appear in ancient Roman works; these may have been intended to suggest the historical setting of the event in ancient times. Judas at the left reaches greedily for the bread in wine that Christ hands to him, but the reactions of the other apostles to Christ's revelation contrast with the disinterest of the

4.22. PIETRO LORENZETTI and assistants. Lower Church of S. Francesco, Assisi. Frescoes of the Descent into Limbo and Descent from the Cross. 1320s–30s. Width at base 12'4" (3.76 m). That Pietro worked quickly is revealed by the giornata; the eight figures of the Descent from the Cross shown here, for example, were painted in only six days.

Opposite: 4.21. PIETRO LORENZETTI and assistants. Lower Church of S. Francesco, Assisi. Frescoes in the transept arm: Descent from the Cross, the Lamentation, and other scenes from Christ's Passion. 1320s–30s. (The allegorical Franciscan frescoes over the altar, which are by an unknown Trecento painter, are not discussed in this book.)

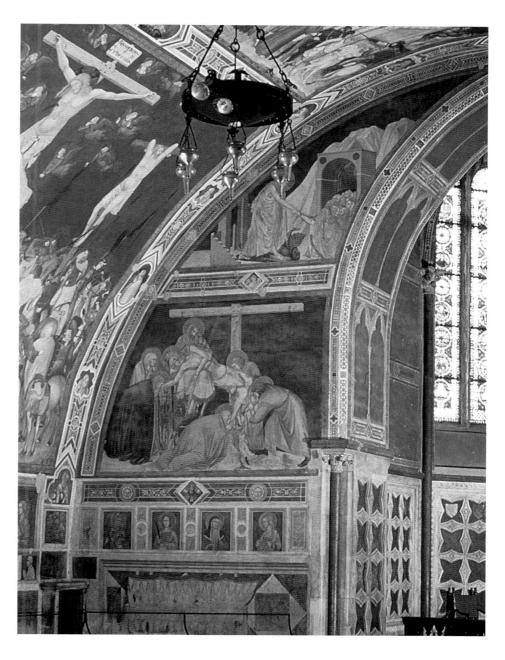

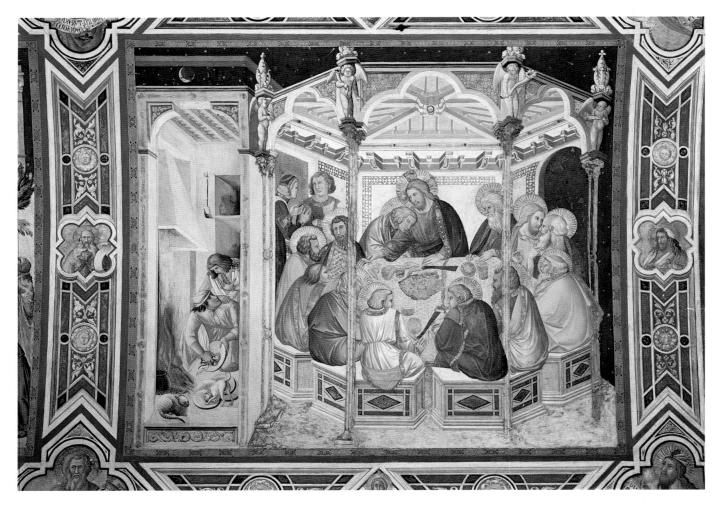

4.23. PIETRO LORENZETTI (design; executed by a pupil). Last Supper. 1320s-30s. Fresco, 8' x 10'2" (2.4 x 3.1 m). Lower Church of S. Francesco, Assisi

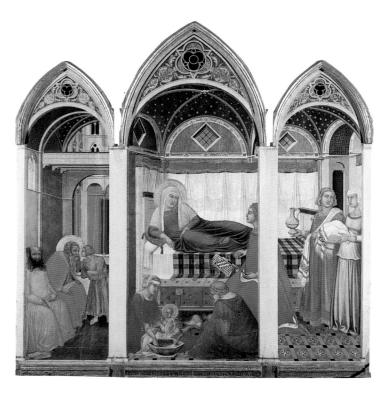

4.24. PIETRO LORENZETTI. Birth of the Virgin. 1335–42. Panel, $73\frac{1}{2} \times 71\frac{1}{2}$ " (1.87 x 1.82 m). Museo dell'Opera del Duomo, Siena. Commissioned by the Opera del Duomo for the Cathedral of Siena. The documented pair of saints that flanked this altarpiece is lost.

servants conversing in the doorway, just as the spiritual food of the Last Supper contrasts with the greedy dog licking the plates being scraped in the kitchen. Even more striking is the contrast of material and spiritual light. The kitchen is illuminated by the fire in the fireplace, and the moon and stars are shown in a naturalistic sky outside, a detail that will not reappear until the 1420s (see fig. 8.4). But what source lights the ceiling of the loggia from below when there is neither candle nor lamp? It can only be the light from the haloes of Christ and the apostles.

In 1342 Pietro completed the Birth of the Virgin (fig. 4.24) as his contribution to the cycle of altarpieces devoted to narrative scenes from the life of the Virgin Mary for the Cathedral of Siena; this triptych, perhaps in competition with one by his brother Ambrogio (fig. 4.25), established a new standard in the definition of space. The altarpiece is treated as if it were a stage or even an actual building, with the colonnettes, pointed arches, and pinnacles of the frame becoming the outwardmost projection of the painted architecture (the present Italian policy of removing all restorations has left us with no outer edges, no pinnacles, and no colonnettes to support the arches). Or, conversely, we can view each arch of the frame as the foremost arch of the vault beyond it. It is an astonishing bit of illusion that gives us the feeling that we could enter the room where St. Anne lies on her bed with its checkered Sienese spread, while the baby Virgin is being bathed and neighbors arrive bearing gifts. One woman holds a striped fan to cool St. Anne (the Virgin's birthday was traditionally set on September 8, still the hot season in Tuscany). In the antechamber on the left, St. Joachim receives the good news. Behind him we look into a space that might belong to some ecclesiastical building-a towering Gothic structure of at least three stories, the upper one cut off by the vault of the antechamber. This tall structure must be a reference to the temple in which Mary would be presented three years later.

Pietro's triptych is the first of a series of Italian paintings that presents the illusionistic space of the picture as an inward extension of the frame. In his perspective formulation Pietro at times comes close to the one-point perspective system that will rule pictorial art during the following century, but analysis shows that the floors in the side panels have separate vanishing points that do not correspond to the single vanishing point used for the three vaults. Nonetheless, the works of the Sienese Trecento painters reveal an interest in exploring how space can be rationally analyzed and represented, an investigation that will culminate in the Quattrocento.

Ambrogio Lorenzetti

Ambrogio Lorenzetti, like his brother, exhibits the impact of Florentine art: he seems to have visited Florence on at least two occasions—in 1319, when he painted a *Madonna* for a church outside Florence, and in 1332–34, when he painted a

polyptych for the Church of San Procolo. During the later visit he joined the Florentine branch of the Arte dei Medici e Speziali, possibly because this was a requirement in order to work in Florence.

In 1342, both Pietro and Ambrogio completed altarpieces for the narrative series on the life of the Virgin for the Sienese Duomo. The space in Ambrogio's Presentation in the Temple (fig. 4.25) is even more revolutionary than that seen in Pietro's Birth of the Virgin. Space is here penetrated in a manner unprecedented since Roman antiquity. The complex Gothic frame, now shorn of its superstructure, is not an integral part of the architecture, but the frame establishes the impression of a lofty gateway. Within and beyond the frame we gaze into an interior where the light is dimmed by a stained-glass window. While Ambrogio still maintains the double scale of medieval art—one scale for figures, another for setting—he has reduced the figures so as to make the architecture more credible. Slender columns uphold the blue, gold-starred, ribbed vaults of the nave. Behind the altar we look into the dimness of the sanctuary, with its black marble columns and gilded capitals, and for the first time in any Italian painting we sense the immensity of a cathedral interior.

The architecture is a strange amalgam of Romanesque and Gothic. In the Late Middle Ages, Romanesque architecture was considered to be of Eastern origin, so that the Temple in Jerusalem was generally represented with Romanesque round arches rather than Gothic pointed ones. Also, the polygonal building we see in the backgrounds of such Trecento paintings as Duccio's *Entry into Jerusalem* (see fig. 4.10) is always the Temple, since the Crusaders had brought back descriptions of the Dome of the Rock in Jerusalem, the central-plan mosque built on the site of Solomon's Temple. In Ambrogio's picture, we also see beyond the roof of the building to a great polygonal dome with Gothic windows, despite the Romanesque arches of the interior.

Ambrogio has precisely illustrated the Gospel text (Luke 2:22–38), which includes a reference to the gift of two turtle doves seen here upon the altar. The aged Simeon, who had been told that he would not die until he had seen the Messiah, holds the Christ Child in his arms and murmurs the words of the *Nunc Dimittis:* "Lord, now lettest thou thy servant depart in peace, according to thy word: For mine eyes have seen thy salvation, Which thou hast prepared before the face of all people; A light to lighten the Gentiles, and the glory of thy people Israel" (Luke 2:29–32).

At the left stand Joseph, Mary, and two attendants; on the right the eighty-four-year-old prophetess, Anna, holds a scroll with the last verse of the passage from St. Luke: "And she coming in that instant gave thanks likewise unto the Lord, and spake of him to all them that looked for redemption in Jerusalem" (Luke 2:38). Ambrogio has depicted the differences in age and feelings, from the tiny Christ Child blissfully sucking his thumb and the gentle pride of his mother to

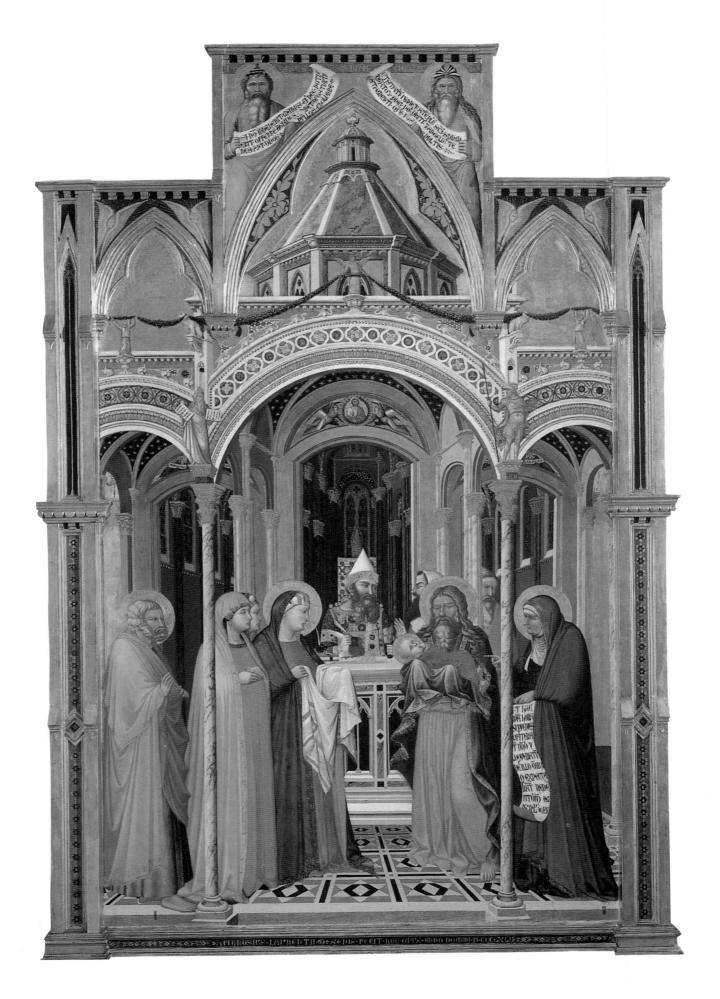

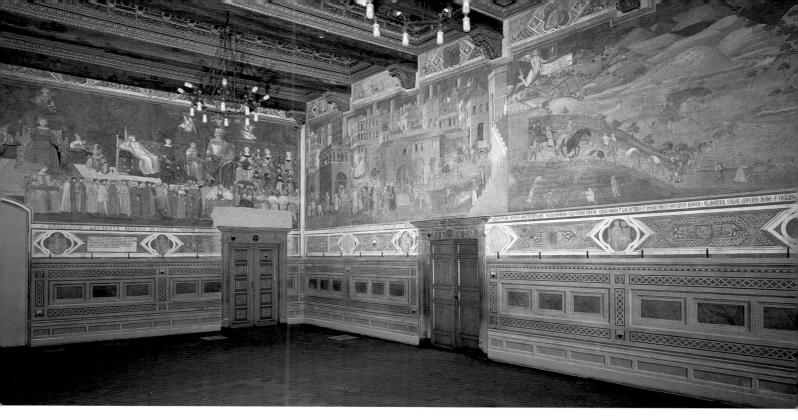

4.26. AMBROGIO LORENZETTI. Allegory of Good Government: Effects of Good Government in the City and the Country (portion). 1338–39. Fresco; size of the room, approx. 46' x 25'3" (14 x 7.7 m). Sala della Pace, Palazzo Pubblico, Siena. Presumably commissioned by the Commune of Siena. This room is also sometimes called the Sala dei Nove (Room of the Nine) because this was the council room for the Nine.

Opposite: 4.25. AMBROGIO LORENZETTI. Presentation in the Temple. 1342. Panel, 8'5 1/8" x 5'6 1/8" (2.6 x 1.7 m). Uffizi Gallery, Florence. Commissioned by the Opera del Duomo for the Cathedral of Siena. The documented pair of saints that flanked this altarpiece is lost.

the wrinkled age of the prophetess Anna and the weariness of Simeon, now to be released from the burden of life. The brilliant colors—crisp whites against clear primary tones—compete with the splendor of Duccio and Simone.

Ambrogio's most revolutionary achievement—one of the most remarkable accomplishments of the Renaissance—is the fresco series that lines three walls of the room in the Palazzo Pubblico where Siena's chief magistrates, the Nine, held their meetings (fig. 4.26). Ambrogio's task was unprecedented, for he was apparently called upon to paint allegorical depictions of good and bad government—subjects of intense significance to medieval Italian communes—and to represent the effects such regimes would have in the town and the country. The result is the first panoramic city/countryscape since antiquity, and the first expansive portrait that we have of an actual city and landscape. Faced with two long walls, Ambrogio composed freely, following a panoramic principle that he seems to have invented. Today, the cycle is usually identified simply as Good and Bad Government, but in 1427 St. Bernardino of Siena referred to it as War and Peace, perhaps in part because of its location in the Room of Peace. Ambrogio chose the most

strongly illuminated walls for *Good Government* and its effects, leaving *Bad Government* in the shadows on a wall that has also suffered considerable damage; the difference in condition between the two subjects suggests that perhaps some of the damage to *Bad Government* was caused by individuals who attacked the representation because of its subject.

The compositions flow in a relaxed manner, without set geometric relationships, much like the spontaneous city plan of Siena itself. On one wall Ambrogio has enthroned the majestic figure of the Commune of Siena, who holds the orb and scepter and is dressed in the communal colors of black and white. He is guided by Faith, Hope, and Charity, who soar above his head (fig. 4.27). On either side are other Virtues, chosen for their civic significance, who sit or lounge on a decorated bench. To the left, Justice, above whose head floats Wisdom, dispenses rewards and punishments through winged figures that represent Commutative Justice, who gives arms to a noble and money to a merchant, and Distributive Justice, who crowns a kneeling figure with her left hand as she lops off the head of another with her right. Below the throne of Justice, a figure representing Concord presides over the twenty-four

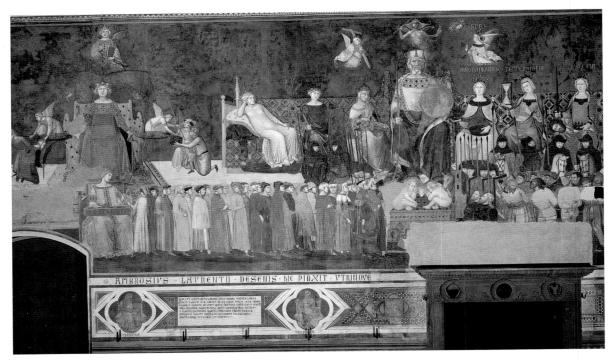

4.27. AMBROGIO LORENZETTI. Allegory of Good Government: Commune of Siena (see fig. 4.26)

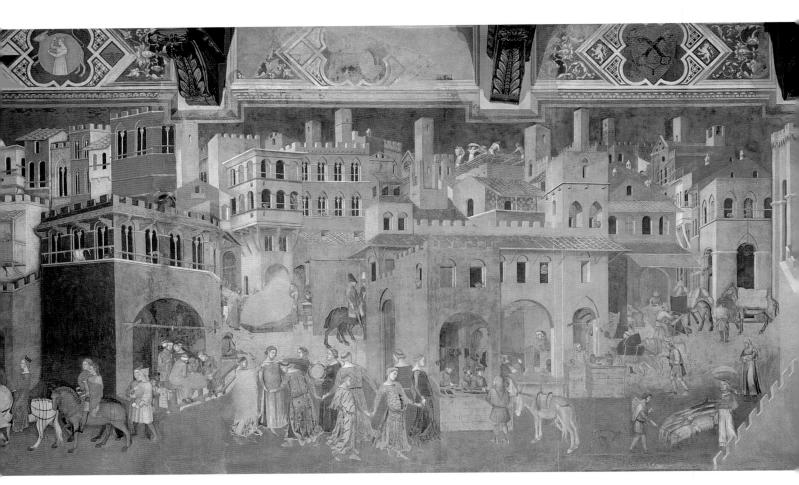

4.28., 4.29. AMBROGIO LORENZETTI. Allegory of Good Government in the City and the Country (see fig. 4.26)

magistrates of the Sienese Republic, one of whom grips a cord that extends from Justice and Concord back to the scepter held by the personification of the Commune. The reclining figure of Peace is taken from a Roman sarcophagus fragment still in Siena, but if the original were not preserved, Ambrogio's drapery is so medieval in style that one would scarcely suspect a classical prototype. Peace reclines on armor, indicating that she has overcome war.

The amazing panorama of *Good Government* in town and country (figs. 4.28, 4.29) is a delightful, continuous vista so wide that no photograph can contain it all. We are taken through the streets, alleys, and squares of Siena (much as it still stands), over the city walls, and out into the Tuscan countryside. To show us as much as possible of town and country and of what goes on in every corner, Ambrogio, still a medieval painter, constantly shifts his viewpoint. His world is complete with buildings, people, trees, hills, farms, waterways, animals, and birds.

Since the subject is life in the city and the country, Ambrogio is almost able to abandon the medieval double scale discussed previously (see p. 100). Actually, the buildings are

smaller than they would be in relation to people, but if Ambrogio had painted the people and animals in scale to the architecture, they could hardly have been made out in so vast a worldscape. He has boldly represented the entire city of Siena, with its towers, parapets, and windows both simple and mullioned. He shows us the beams outside the windows for hanging clothing or providing leverage to haul things up from the street; he includes people conversing, entering houses, or cut off from our view as they pass behind buildings. Through the open arches of the large building in the foreground, we gain access to the interior of an elegant shop displaying shoes and hosiery, a school where a master teaches attentive pupils from a raised desk, and a tavern with flasks of wine set on an outdoor bar. We can also see a house in the process of construction; the workmen, standing on scaffolding they had probably put in place the day before, are carrying building materials in baskets on their heads and laying new courses of masonry. A young woman plays a tambourine and sings while her elegantly dressed companions dance a kind of figure eight in the street. Nearby farmers arrive from the prosperous countryside, leading donkeys, driving herds of sheep, and carrying

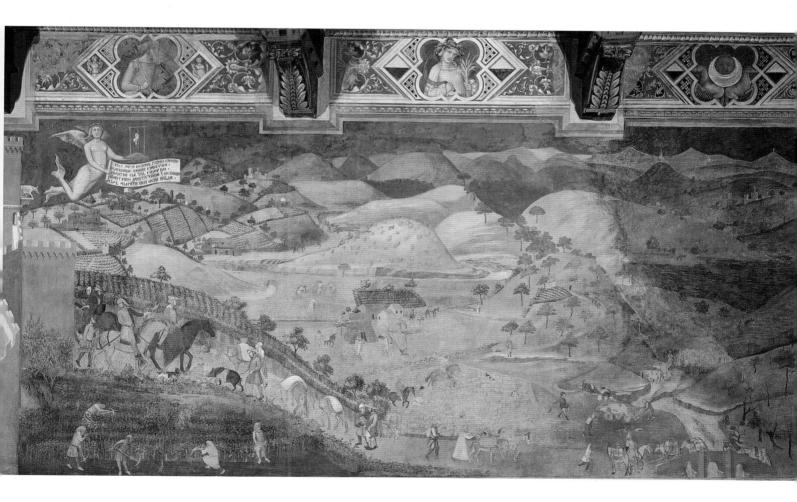

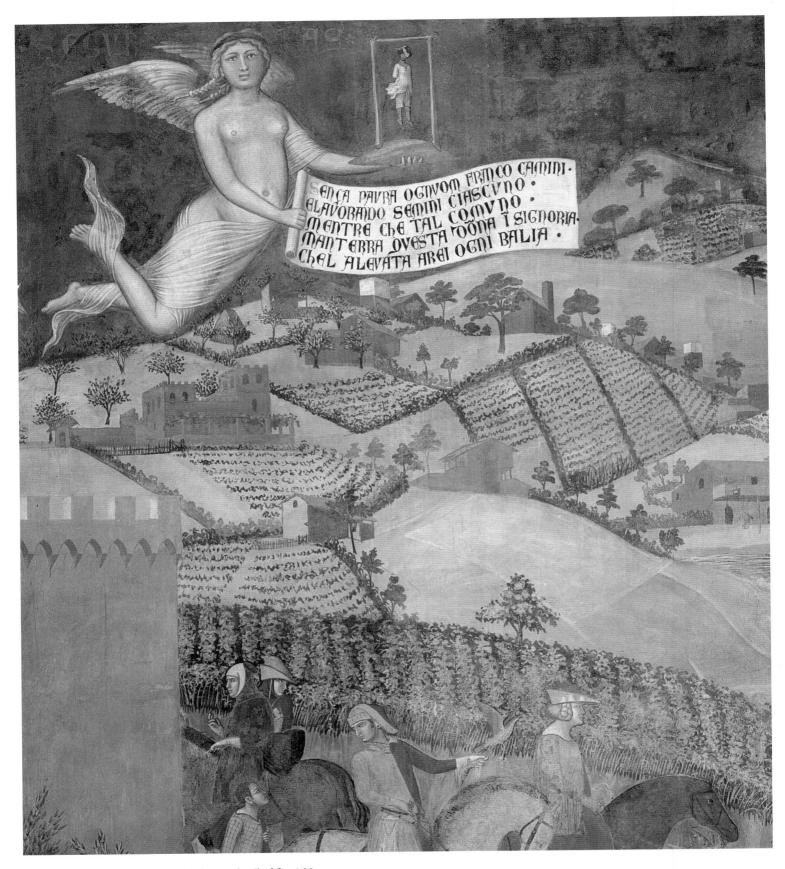

4.30. Securitas and Sienese landscape, detail of fig. 4.29

produce in baskets on their heads. All have come through the city gate—probably the recently completed Porta Romana in the walls of Siena. This wall zigzags freely from the lower border to the gate, which is surmounted by a representation of the mythical wolf with Romulus and Remus, a Sienese symbol because the citizens believed Remus had founded Siena.

The pastoral view shown in figure 4.29 is perhaps the most daring of all. Ambrogio seems to have included Sienese territory as far as the sea at Talamone, Siena's ambitious new port, in order to display the prosperity of the Republic. Vines are tended; grain is harvested and threshed. As the peasants, conversing happily, bring their produce and their animals (including a saddlebacked, black-and-white hog) up the incline into the city, men and women descend into the country to go hawking. These aristocrats indulge in this sport only where the fields have already been harvested, so as not to damage the crops.

The apparently random activities depicted in city and country correspond to the seven Mechanical Arts, according to Hugh of St. Victor. For example, dancing in the street is related to the art of Music. Medicine, another Mechanical Art, includes both shopkeeping and spice selling and is personified by the teacher visible in the central arch, who wears a doctor's red gown. Presiding over these activities is a virtually nude figure of Securitas (fig. 4.30), who floats through the air holding a gallows and a scroll: "Without fear, let each man freely walk, and working let everyone sow, while such a commune this personage will keep under her rule because she has removed all power from the guilty." Her hideous counterpart on the opposite wall is Fear, who can only be banished by Good Government.

Our eye follows the vista off over hill after towered hill, farm after farm, but this spectacle terminates against the traditional unmodulated blue of the wall itself at the horizon. It is too early, apparently, for the artist to want to paint the sky with clouds. But as the landscape moves into the distance, it is clear that Gothic linear techniques no longer suffice for Ambrogio. He now represents details of plants and stubble with a few quick, sketchy strokes, a kind of shorthand that will only be more fully explored in the Quattrocento.

The Master of the Triumph of Death

Another work to be included at this point, even if its author is probably not Sienese, is the panoramic series of frescoes on the theme of the Last Judgment and the Triumph of Death in the Camposanto in Pisa. In previous editions of this book these works were dated after the outbreak of the plague in 1348. Recent scholarship has demonstrated, however, that these works are from the 1330s. The artist, once

identified as the Pisan Francesco Traini, is now known simply as the Master of the Triumph of Death. Although the artist has not been identified, these works reveal an understanding of Florentine and Sienese innovations of the early Trecento.

The enclosed cemetery next to Pisa Cathedral is known as the Camposanto (holy field) because it contained earth brought from the Holy Land. The long rectangular building is enclosed by an outer wall, while the interior, rather like an elongated cloister, is lined with Gothic arches that open out onto an inner courtyard. The inside surfaces of the enclosing walls were once frescoed with vast panoramas from the Old and New Testament, the lives of saints, and sacred history, but most of these were lost when an Allied incendiary bomb burned the roof during World War II. The cycle by the Master of the Triumph of Death survived largely intact, along with its *sinopie*, which have been detached and are now displayed at the nearby Museo delle Sinopie.

The most dramatic of the series is the *Triumph* of *Death* (fig. 4.31). At the lower left, we see the medieval scene known as "The Three Living and the Three Dead." While hunting, three splendidly dressed noblemen, accompanied by friends and attendants, come upon three open coffins, each occupied by a corpse; one is still bloated, the next is half-rotted, the third is reduced to a skeleton. Worms and serpents play over all three; one of the noblemen holds his nose at the stench, while the horses and hunting dogs draw back in disgust. No obscure text is needed to explain the meaning of this scene, and its placement in the context of a cemetery adds to its immediate impact. The same point is made again to the right, where young men and women sit in a garden playing music, caressing pets and each other, oblivious in their pleasure of the approach of Death. This terrifying white-haired hag flies toward them on bat wings brandishing the huge scythe with which she will cut them

In the center is a heap of Death's recent victims, all richly dressed, while above demons carry off their souls or angels protect them, with at least one case, a monk, still in doubt as his soul is pulled in opposite directions by an angel and a demon. Perhaps the most poignant detail in the fresco is the pathetic band of cripples next to the pile of corpses, who hold a scroll on which they beg Death to turn and take them instead of the elegant pleasure-seekers who are so able to enjoy life. The escape from this horror, apparently, is to be sought in the scene above the three coffins, where hermits in the wilderness read, work, and contemplate, fed by milk furnished by a doe.

The accompanying *Last Judgment* shows a regally crowned Christ acting as the condemning judge, with no concern for salvation. Christ, seated in a mandorla, uses his left hand to display the wound in his side; Mary, raised to

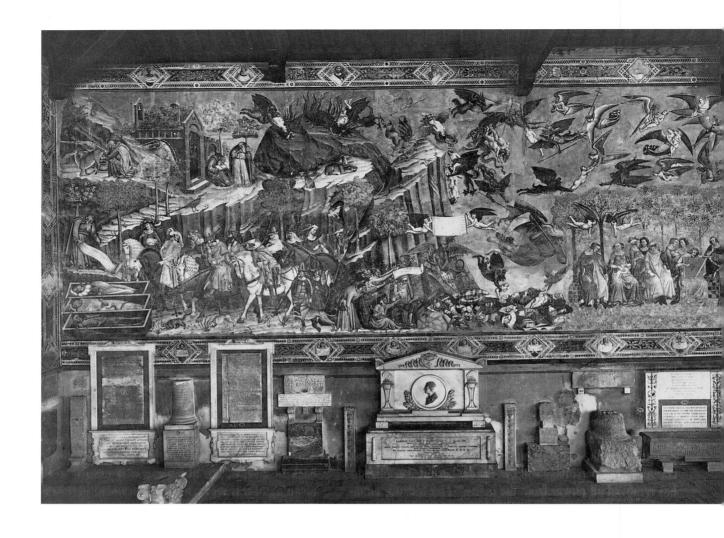

new preeminence in a twin mandorla, puts her hand to her chest and shrinks back in fear. A tempest of emotion sweeps both the terrified damned, expelled by archangels armed with huge swords, and the blessed, even the apostles. Earth is reduced to a great tomb of square holes from which the dead arise, while an expansive representation of hell to the right completes the program. We must be careful not to credit the unknown artist with the evolution of this didactic, moralizing program, which was almost certainly designed by a theologian. At the same time, the ability of the artist to visualize and represent the concept is impressive. And the fresco as a whole reminds us of how art functioned in a culture and society distinctly different from our own.

Lorenzo Maitani

At the end of the Duecento and in the early Trecento, Sienese sculpture was still dominated by Nicola and Giovanni Pisano. Although some local sculptors managed to free themselves from the Pisani tradition, the appearance of Lorenzo Maitani in Siena in the first third of the Trecento comes as a surprise. This extraordinary man was responsible for the finest carving on the four marble panels on the façade of Orvieto Cathedral, and he probably also created the general design of all four. In 1263, a bloodstained cloth, the relic of the miraculous Mass of Bolsena (see p. 559), was carried to Orvieto for presentation to Pope Urban IV. In 1264, the pope proclaimed the Feast of Corpus Christi from Orvieto. A vast

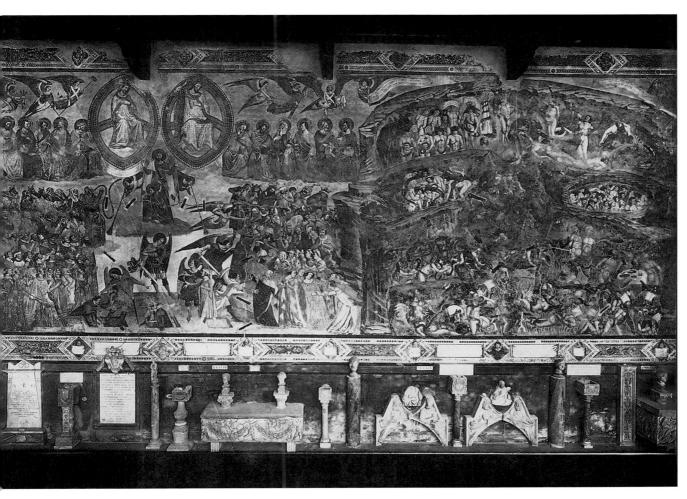

4.31. MASTER OF THE TRIUMPH OF DEATH. The Three Living and the Three Dead, The Triumph of Death, The Last Judgment, and Hell. 1330s(?). Fresco, 18'6" x 49'2" (5.6 x 15 m). Camposanto, Pisa. These frescoes have been attributed to Buffalmacco, a documented painter by whom no certain works survive.

cathedral was built to enshrine the relic, and in 1310 the Sienese architect and sculptor Lorenzo Maitani, about whom we know little except the dates of his marriage in 1302 and death in 1330, was named *capomaestro*. One of his responsibilities was the "wall figured with beauty, which wall must be made on the front part," clearly the four reliefs, each over thirty feet high. One of Maitani's drawings for the façade survives. The leading position he holds in the documents has caused him to be identified with the most gifted of the sculptors at work on the panels, the upper portions of which, here and there, are still unfinished.

The reliefs represent the story of Adam and Eve (figs. 4.32, 4.33), the life of Christ, the Tree of Jesse, and the Last Judgment (fig. 4.34). The first and last reliefs display the vi-

sion of an artist who could create images of exquisite poetry and utmost horror. Unlike fresco, the work proceeded from the bottom up. From the start, Maitani and his collaborators dispensed with the customary enframements and composed the scenes in continuous strips, like those on the ancient Roman columns of Trajan and Marcus Aurelius, and with figures as closely packed as in the work of the Pisani. But in the second row a change takes place: in the center of each relief sprouts an immense vine, whose branches and tendrils form frames for the scenes. In the two central panels the vine is an acanthus, as in Roman medieval apse mosaics, and the scrolls curl tightly. But the branches of the vines in the right and left panels are more widely separated, leaving airy spaces above and around the figures. On

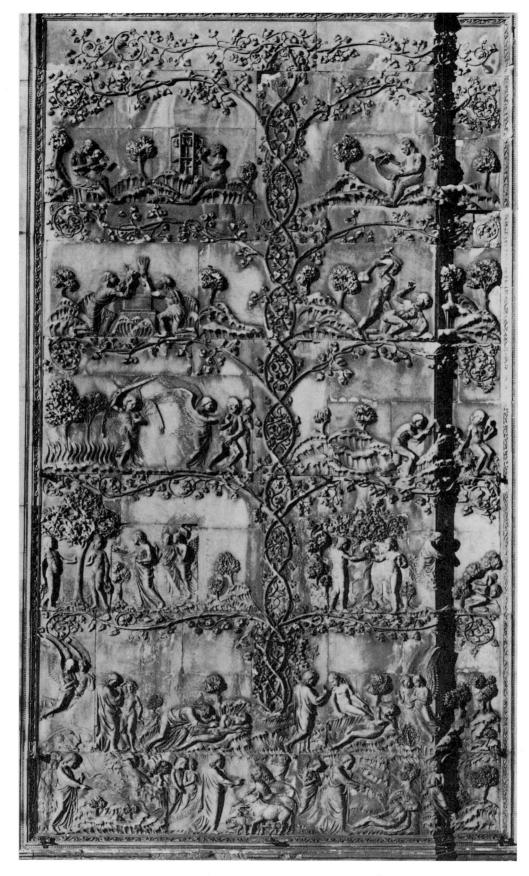

4.32. LORENZO MAITANI. Scenes from Genesis. c. 1310–before 1316. $\hat{\underline{m}}$ Marble. Façade, Cathedral, Orvieto

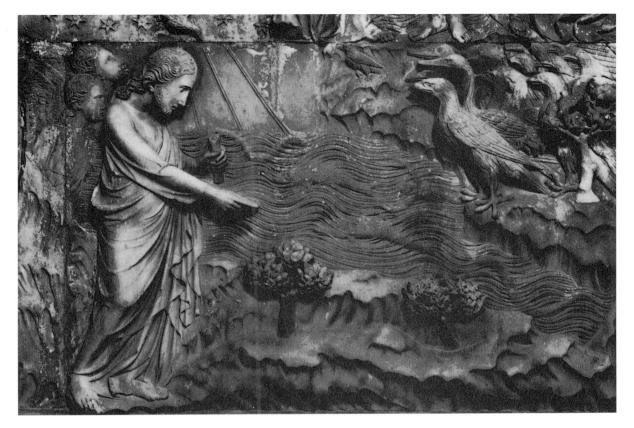

4.33. Creation of the Birds and Fishes, detail of fig. 4.32

the left, the vine is ivy, while on the right it is the grapevine, recalling the Eucharistic miracle of Bolsena celebrated at Orvieto Cathedral.

The Creation scenes are imaginative (see fig. 4.33). God moves with grace across the primal rocks, calling the fish to life in swirls of marble water and the birds to attention in miniature forests. Maitani—if indeed this is he—has taken a tremendous step, in a direction not to be fully exploited until Donatello and Ghiberti. By lowering the projection of distant figures and birds to a fraction of an inch above the background elements, in contrast to the almost freestanding, heavily undercut foreground figures, he is able to suggest effects of distance within the limited field of relief sculpture.

The airy movements and diaphanous mantle of God the Creator, moving among his works, hardly prepare us for the shock of Maitani's view of hell. Here, barely above eye level (see fig. 4.34), the tormented figure of one of the damned hangs by his arm from the jaws of a demon. This figure reveals the dramatic imagery and expressive power that characterizes the best of Trecento art.

4.34. LORENZO MAITANI. Detail of the Damned in Hell from the *Last Judgment*. c. 1310–30.

Marble. Façade, Cathedral, Orvieto

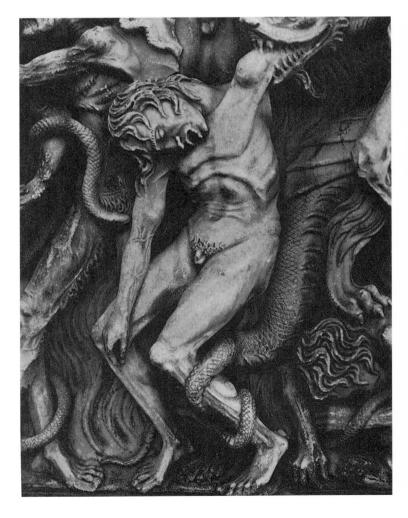

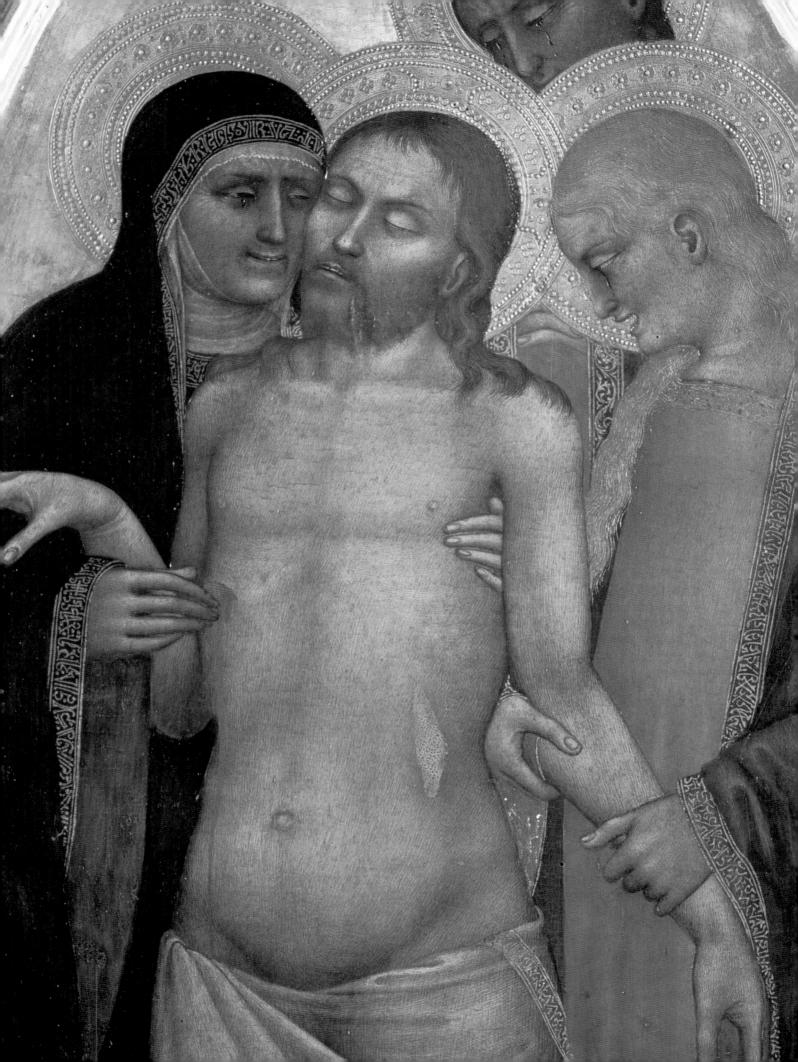

LATER GOTHIC ART IN TUSCANY AND NORTHERN ITALY

n the first half of the Trecento, the artists of Florence and Siena, especially the painters, created a new art that revolutionized the mode of representation in Western Europe. Trecento artists made discoveries that anticipated the Early Renaissance, and without Giotto, Nicola and Giovanni Pisano, and Ambrogio Lorenzetti, the work of such leaders of the Early Renaissance as Donatello, Ghiberti, and Masaccio would be hard to imagine. Yet the history of art, like that of humanity itself, does not follow a single development and is seldom predictable. In some ways, the art of the second half of the Trecento seems to have little to do with the Renaissance that followed, and thus it is sometimes passed over with a few perfunctory phrases. Nonetheless, during this period artists produced works of striking originality and expressive depth.

For both Florence and Siena, the 1330s and 1340s were decades marred by a sequence of escalating calamities. In Florence the flood of 1333, exceeded in height only by that of 1966, struck the city with such violence that it tore down six hundred feet of city walls and towers along the Arno and brought havoc to commerce, buildings, and, doubtless, works of art. Costly and frustrating military activities and a succession of political and economic crises were followed in the mid-1340s by the failures of the Peruzzi and Bardi banks, chiefly due to the bankruptcy of their English branches, which had been involved in the military adventures of King Edward III. Soon every major banking house in Florence and Siena was drawn into ruin, with serious consequences for economic and cultural life. A brief experiment with dictatorship under an outsider known as the Duke of Athens in 1342-43 did little to help, and agricultural disasters during 1346 and 1347 brought widespread famine.

The weakened and demoralized populations of Florence and Siena were in no position to resist when in 1348 the bubonic plague—the so-called Black Death, which had already attacked in 1340—struck again with dire intensity. The estimates vary from a 40 percent mortality rate in both

cities to 75 or even 80 percent—all swept away in one hot, terrible summer. Chronicles written by the survivors present a picture of streets piled high with rotting corpses, bodies stacked in immense ditches, economic stasis, runaway inflation, and general terror. The workforce was decimated, and the effects on every aspect of culture were devastating.

The artists suffered like everyone else. Bernardo Daddi, Andrea Pisano, and probably Pietro and Ambrogio Lorenzetti died in the plague. Only Taddeo Gaddi survived to carry the tradition of Giotto into the second half of the century. The demand for works of art seems also to have changed; in the wave of self-castigation that follows catastrophe, religion offered an explanation in terms of divine wrath, as well as a refuge from the consequences of that wrath. The new style that developed at this time has been interpreted in a variety of ways. One interpretation is that there was a turn toward the supernatural and the Italo-Byzantine past that rejected as perilous the humanity and naturalism of the early Trecento. An alternate new interpretation by Hayden Maginnis sees the new art not as a denial of the old, but as a development from it that heightens or transforms certain aspects; he refers to it as a "mannered" style.

Mid-Trecento Painting in Florence

An altarpiece painted by Andrea Orcagna (active c. 1343–68) for the Strozzi Chapel in the Dominican Church of Santa Maria Novella in Florence (fig. 5.1) reveals the new style. At first glance the elements of Giotto's style seem to be present, but an examination reveals that the figural composition within the elaborate frame is locked in a rigid and formal pattern. In the center Christ is frontally enthroned but no throne is visible; he appears as an apparition within a mandorla framed by seraphim. Fixing the viewer with an hypnotic gaze, but without looking at either of the kneeling saints, Christ hands the keys to St. Peter, the "rock" on whom the Church was founded, and presents a book to St. Thomas Aquinas, one of

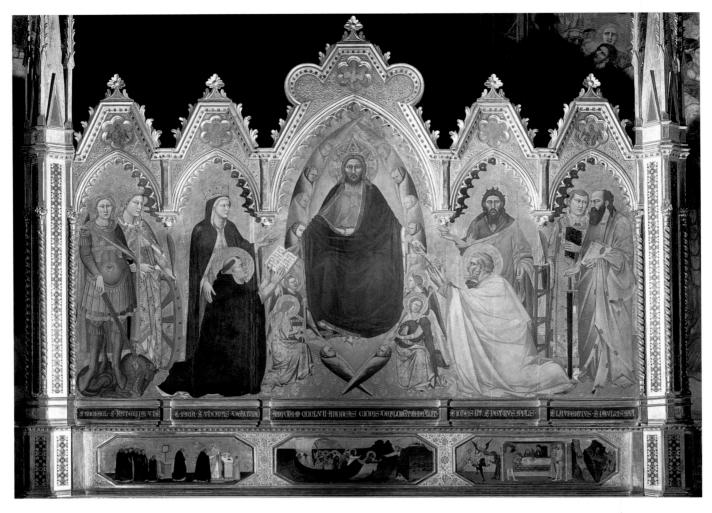

5.1. ANDREA ORCAGNA. Enthroned Christ with Madonna and Saints. 1354–57. Panel, approx. 9' x 9'8" (2.74 x 2.95 m). 🗈 Strozzi Chapel, Sta. Maria Novella, Florence. Commissioned by Tommaso di Rossello Strozzi. The frame is original.

the most important Dominican saints and patron saint of the donor, Tommaso Strozzi. The equation of Thomas with Peter suggests the importance of the role of theology in the ideology of the Dominicans, whose church this altarpiece decorates. Behind these paired symbols of ecclesiastical authority (historic and intellectual, papal and Dominican) stand Mary, patron of the church, and John the Baptist, patron of Florence. This clear expression of the authority of doctrine is not surprising in the Dominican context at Santa Maria Novella. Space is ambiguous because the gold-figured carpet refuses to recede back from the picture plane. The arrangement is ostensibly symmetrical: saints holding swords (Michael and Paul) guard the flanks; those with instruments of martyrdom (Catherine and Lawrence) stand next to them. But asymmetries appear: on the right side, the saints turn their heads toward each other in conversation; on the left, Catherine looks inward, Michael out toward the spectator. The concentration on the linear definition of form is a change from the soft roundness suggested in Giotto's works. In the head of St. Peter, there is an insistence on every line of the intricately curled beard and waved, crisply

cut hair. Even the complex shapes of the drapery are sharply delineated. St. John the Baptist, his locks of hair writhing like flames, looks outward with an expression of mystic exaltation. Only the female or youthful faces are calm. Thomas Aquinas's face is so distinctive that it seems to be a portrait of a living individual.

Two predella scenes are directly related to the saints above. They depict St. Thomas Aquinas in ecstasy during the celebration of Mass and Christ walking on the water to save Peter. The third scene, the saving of the soul of the Emperor Henry II, is unexpected and unrelated to any figure above. According to the story preserved in the *Golden Legend*, Henry's soul hung in the balance until he made a gift of a golden chalice to the Cathedral of Bamberg. Perhaps Tommaso Strozzi expected his gift of this altarpiece to determine matters in his own favor at a similar moment, which occurred a few years later.

Orcagna joined the Arte di Pietra e Legname in 1352 and in 1355 was made *capomaestro* of Orsanmichele. Probably in that very year he began a fantastic tabernacle (fig. 5.2) to enshrine Daddi's huge *Madonna and Child Enthroned*, for

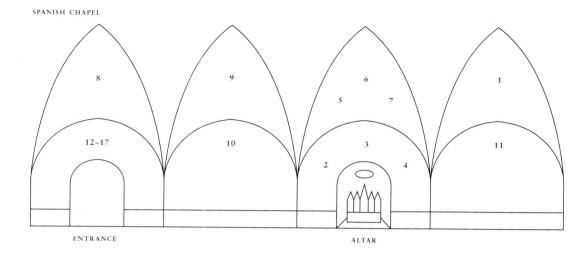

chapter house at Santa Maria Novella (fig. 5.7). Andrea converted the interior into an allegorical diorama surpassing in scale even the *Government* frescoes by Ambrogio Lorenzetti (see figs. 4.26–4.30). Now, however, the theme is ecclesiastical rather than secular government, and it was clearly the intent of the patron, a wealthy merchant, and of the Dominican monks to emphasize the role of the Dominican Order in establishing a new ecclesiastical orthodoxy. All the frescoes make reference to the sacred origins and supreme power of the Roman Church in general, and the importance of the Dominican Order in particular. Perhaps the most unusual is the scene known as the *Triumph of the Church* (fig. 5.8).

This fresco covers one wall of the chapel. The lower part is concerned with religious life on earth, the upper part with heaven, and the area between seems to be controlled by the Dominican Order. In the lower left a detailed representation of the Duomo of Florence, then incomplete and never to be finished according to this plan, refers to the Church on earth—a reminder, perhaps, that when money was donated for the frescoes the archbishop of Florence was a Dominican and that Andrea da Firenze himself was one of the consulting architects for the Duomo. The reigning pope, Urban V, is enthroned in the center of this section, with a cardinal and a bishop on his right, Emperor Charles IV and the king of Cyprus on his left. The sheep at his feet, symbolizing the Christian flock, are guarded by black-and-white dogs—the domini canes (a play on the word Dominicans that translates as "dogs of the Lord")-and a crowd of ecclesiastical and secular figures gathers before the thrones.

On the right-hand side is the world outside the fortress of the Church, where black-and-white dogs attack wolves and Dominican saints admonish heretics and refute pagans. Above these groups, worldly figures dance in the fields, make music, and embrace in the bushes. From this blind alley, humanity can be rescued only by the sacrament of penance, administered by a Dominican, while another Dominican saint then shows humanity the way to heaven. In front of the 5.7. Iconographic diagram of the Spanish Chapel. Computerized diagram by Sarah Loyd.

- 1. Navicella (see fig. 5.8)
- 2. Christ Carrying the Cross
- 3. Crucifixion
- 4. Harrowing of Hell
- 5. Three Marys at the Tomb
- 6. Resurrection
- 7. Noli Me Tangere
- 8. Ascension
- 9. Pentecost
- 10. Allegory of St. Thomas Aquinas
- 11. Triumph of the Church (see fig. 5.8)
- 12.-17. Scenes of the Life of St. Peter Martyr

splendid gates, opened by St. Peter, angels crown the little souls who then move sedately into heaven, the exclusive province of rejoicing saints, all drawn in a much larger scale. Only the saints in heaven can behold Christ who, with book and key as in Orcagna's Strozzi altarpiece, floats far above in his mandorla-shaped glory; below him the apocalyptic lamb on his altar-throne is guarded by symbols of the four evangelists, while angelic attendants praise God. The details, the general composition, and the symbolism all support the didactic mode of this expansive mural.

While Andrea da Firenze seems disinterested in the naturalism of Ambrogio Lorenzetti's frescoes, he relies on the same vast visual sweep as did Ambrogio. His detailed landscape moves past distant ranges to culminate in castles and a little chapel. The foliage, however, is represented according to formula, without the delicate observation and sketchy brushwork of Ambrogio. The space represented in the landscape is curiously negated by the composition and the coloring, which produce an effect of all-over patterning.

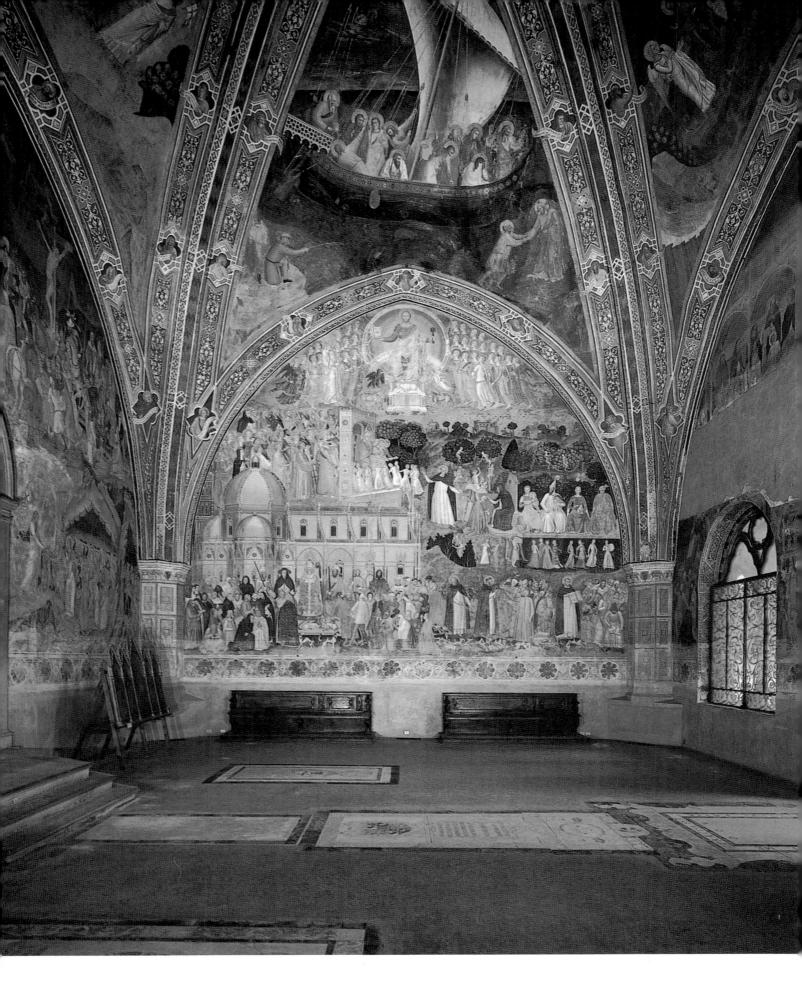

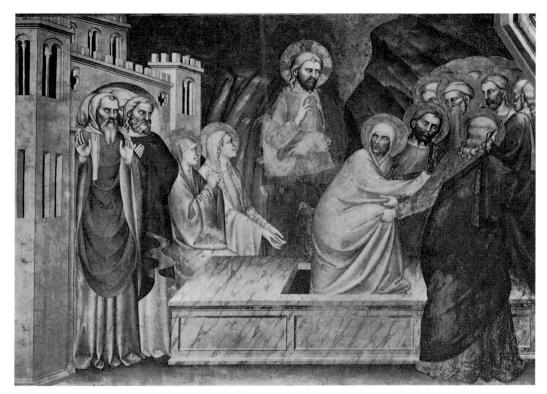

5.9. GIOVANNI DA
MILANO. Resurrection
of Lazarus. 1365. Fresco.
Rinuccini Chapel,
Sta. Croce, Florence.
Probably commissioned by
Lapo di Lizio Guidalotti

Giovanni da Milano (active 1346–66), an outsider from Lombardy working in Florence at the same time, began a series of frescoes in the Rinuccini Chapel in the sacristy of Santa Croce in 1365. In the *Resurrection of Lazarus* (fig. 5.9), Giottoesque space is compressed. Scowling bystanders emerge from a city gate that is tiny even by Trecento pictorial standards, while Lazarus seems to be hustled out of the tomb. Giovanni da Milano's *Pietà* (fig. 5.10), which shows the dead Christ upheld by the Virgin, Magdalen, and St. John, is one of the earliest representations of this subject painted in Florence. Its expressive depth is typical of the contemporary interest in a harrowing representation of Christ's sacrifice. The face of the dead Christ is haunting in its intensity. His body is raised by the grieving figures to remind the observer of the suffering Christ endured for humanity.

Right: 5.10. GIOVANNI DA MILANO. *Pietà*. 1365. Panel, 43¹/₄ x 18¹/₈" (110 x 46 cm). Accademia, Florence

Opposite: 5.8. ANDREA DA FIRENZE. Triumph of the Church (below) and the Navicella (above). c. 1366–68. Fresco, width of wall 31'6" (9.6 m). Chapter House (now known as the Spanish Chapel), Sta. Maria Novella, Florence. Commissioned by Buonamico Guidalotti. The chapter house at Santa Maria Novella is now misleadingly known as the Spanish Chapel because of its use in the sixteenth century by the Spanish community in Florence.

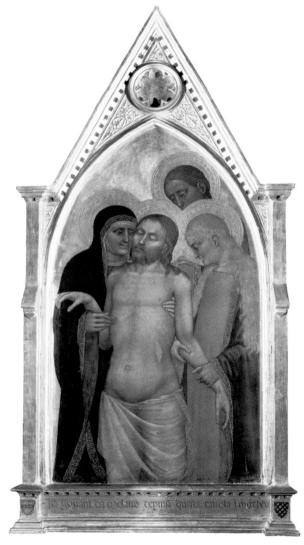

Late Gothic Painting: Agnolo Gaddi and Lorenzo Monaco

The last quarter of the Trecento is marked by a continuation of the styles seen earlier; revolutionary developments in art only resume in the early years of the Quattrocento. Government by committee was the order of the day in both Florence and Siena in order to forestall either dictatorship or revolution, though the personnel of any given committee might often rotate. Applied to artistic projects, the result of this patronage seems to have been a leveling process that stressed conformity at the expense of individuality. In this bureaucratic society, which held oligarchical control over all state activities, the most representative painter in Florence was Agnolo Gaddi (active c. 1369-96), the son of Taddeo Gaddi and the artist whose precepts appear to be recorded in Cennino Cennini's book. Agnolo was far from being a revolutionary artist, but he had at his fingertips the resources of the Trecento tradition, and at his best he fused his Giottoesque inheritance with the compositional and expressive devices of the midcentury artists.

Agnolo's principal work, for which he must have needed a number of assistants, is a vast fresco cycle of the Legend of the True Cross for the Church of Santa Croce in Florence. On the walls of the huge choir (see figs. 2.43, 2.44), Agnolo composed and narrated on a gigantic scale. The story is told in four superimposed registers, and within each composition two or three separate episodes may take place side by side, sometimes almost overlapping. Landscape or architectural elements serve as dividers, in a manner reminiscent of the crowded compositions of Nicola and Giovanni Pisano a century or so earlier. Juxtaposing large and small, near and distant, in tightly knit scenes such as the Triumph of Heraclius over Chosroes (fig. 5.11), enables him to narrate all parts of the complex story with equal visibility and, at the same time, to preserve the decorative unity of the wall. (For a discussion of the rather complex legend underlying this fresco and the others in Agnolo's choir, see the discussion of Piero della Francesca's cycle of the same theme, also in the choir of a Franciscan church, this one in Arezzo, pp. 313-21.)

An observer in the choir of Santa Croce must acknowledge the brilliance and variety of Agnolo's color and the manner in which his surfaces, treated almost like tapestry, maintain the integrity of the building. In those scenes that contain no more than one incident, Agnolo showed his mastery of spatial recession, and even in the landscape dividers of the *Chosroes* scene, he demonstrates many different ways to suggest depth. Agnolo's landscape devices, drapery forms, and compositional methods seem to have determined the representation of such elements in Floren-

tine painting until the works of Gentile da Fabriano and Masaccio. A lively pen-and-wash drawing attributed to Agnolo is probably the earliest Italian drawing from life preserved to us (see fig. 1.14), and it seems to have been made in preparation for some of the many heads that crowd the frescoes in this series. The bareheaded young man in the upper left is shown slightly foreshortened from below as he looks upward. The others wear the customary Florentine headdress known as a cappuccio; one bends over as he writes or perhaps draws; the other three are seen from variant profile angles, including the one-quarter view (lower right) that appears often in Giotto's frescoes. At the top of the drawing, a lamb's head is provided with the word agnolo, which can mean "angel" or "lamb," but in this context could also be a signature or a notation of Agnolo's authorship by a later owner.

The Late Gothic style of Agnolo, his contemporaries and followers, remained, at least in quantity of production, the dominant pictorial style in Florence well into the Quattrocento: it was what patrons wanted, and what the painters gave them for an industrious half century or so. Among the host of competent practitioners in this final phase of Gothic-style painting in Florence, a single artist stands out; he is known today as Lorenzo Monaco (Lawrence the Monk). Lorenzo was probably born in the mid-1370s and he died (or ceased working) in 1423 or 1424. His early works are influenced by Agnolo Gaddi in their color, drapery rhythms, and landscape motifs.

The sudden burst of linear patterning in the attenuated poses and sweeping curves of drapery in Lorenzo Monaco's figures (fig. 5.12) betrays the arrival on the scene of a new style from the north. Because it flourished across northern Europe, from London to Prague, it is known to scholars as the International Gothic. As far as Tuscan art is concerned, the term "international" is somewhat of a misnomer. In northern Europe it is often difficult to tell in what center or even in what country a picture originated. This is not the case with Tuscan paintings, for the clarity and firmness of Tuscan forms always prevail over the most exuberant Gothic movement.

We are somewhat out of chronology here, for the International Gothic Style seen in Lorenzo Monaco's paintings reveals that the dominant influence in his mature style was the works of the sculptor Lorenzo Ghiberti. This helps explain the vigorous sculptural quality of the flowing drapery folds. They resemble the drapery folds in Ghiberti's contemporary sculpture (see figs. 7.5, 7.8, 7.11) and those in some works by Ghiberti's rival, Nanni di Banco (see fig. 7.19), and are also related to certain aspects of the art of the most revolutionary artist of the Quattrocento, Donatello (see fig. 7.12). But to place Lorenzo Monaco in one of the later chapters, where he belongs chronologically, would ignore one factor: the first practitioners of the new style of the Early

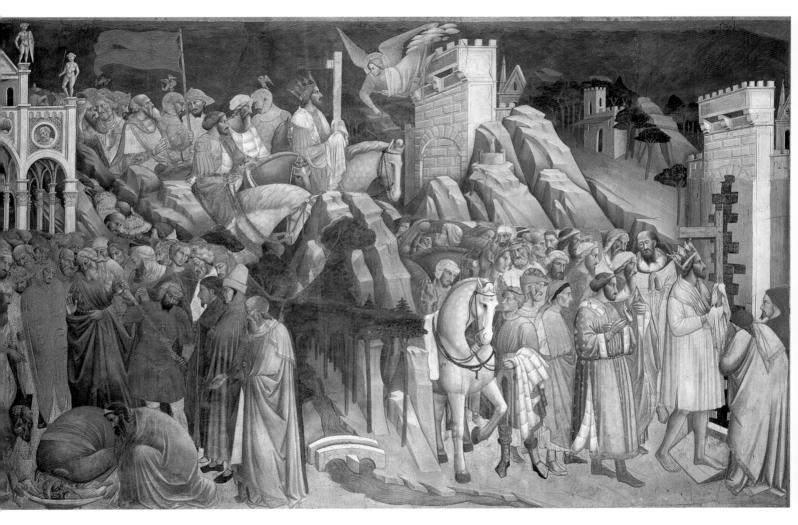

5.11. AGNOLO GADDI. *Triumph of Heraclius over Chosroes*, from the Legend of the True Cross. 1388–93. Fresco. Sta. Croce, Florence. Commissioned by Benedetto di Nerozzo degli Alberti

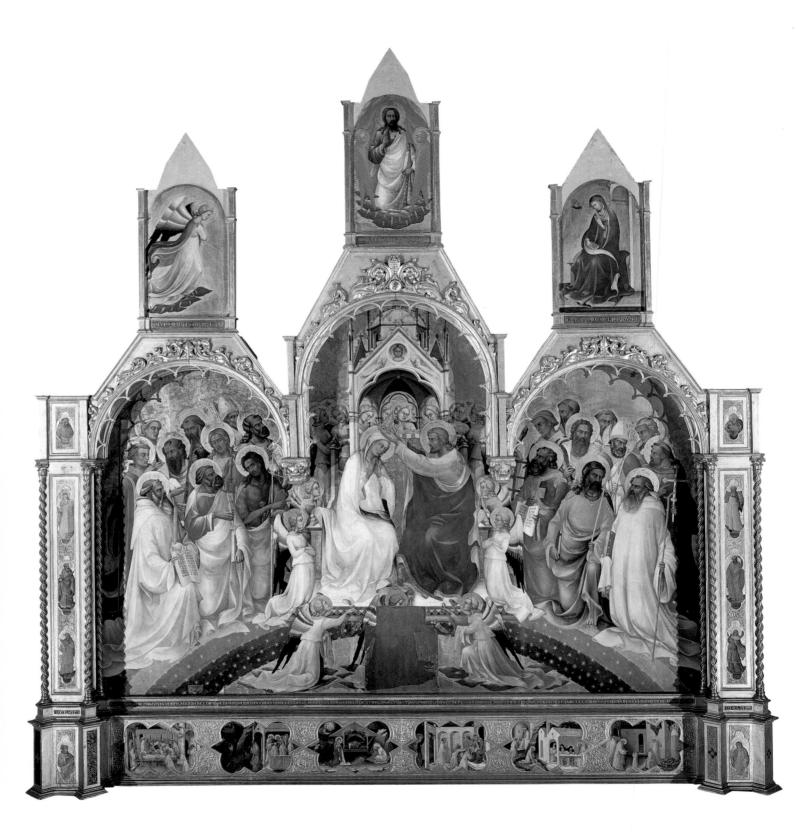

5.12. LORENZO MONACO. Coronation of the Virgin. Dated February 1414 (actually 1413).

Panel, 16'9" x 14'9" (5.12 x 4.5 m). Uffizi Gallery, Florence. Commissioned for the high altar of Sta. Maria degli Angeli, Florence. The inscription provides a date of February 1414, but it is unlikely that such an inclusion refers to the completion of the painting, which would hardly have been something worth noting at the time. Dates on works of art more likely refer to a date of dedication of the chapel or altar, or to the event that inspired the work of art. February 1414 in the Florentine calendar refers to February 1413 in modern dating since the Florentines began their year on March 25, the day celebrating the Annunciation to the Virgin Mary (and therefore the date of Christ's conception).

Renaissance were concerned with naturalism, basing their art on observation, and this to Lorenzo Monaco meant little.

It is not easy to reconstruct his environment. We know that he joined the Camaldolite Order at Santa Maria degli Angeli in Florence in 1390, rising to the rank of deacon in 1396. By 1402 he was enrolled in the Arte dei Medici e Speziali under his lay name, Piero di Giovanni, and was living outside the monastery. Apparently he retained his habit and monastic status while painting a splendid array of altarpieces, frescoes, and illuminated manuscripts.

The Camaldolite Order was the most mystical of the Tuscan religious communities, and this mysticism was expressed in Lorenzo's altarpiece, the Coronation of the Virgin, for the high altar of his own monastery, Santa Maria degli Angeli (fig. 5.12). In the central panel all divisions are swept aside by the tide of colors and forms. We are lifted into the empyrean, above the dome of heaven, which we see in cross section, its arches shaded in blue and studded with golden stars. At the apex of the heavenly vault stands a Gothic tabernacle culminating in a dome on a drum that is reminiscent of Orcagna's shrine at Orsanmichele (see fig. 5.2). On a double throne in front of-not within-the tabernacle, Christ turns to place a crown on the head of his mother. In the central gable, directly above the tabernacle, God the Father floats on clouds flanked by seraphim, conferring his blessing on the scene, while in the side gables, Gabriel, flying against a gold background and trailing clouds, makes his announcement to the seated Mary.

For all their solidity, the figures seem essentially bodiless; it is the crispness of the metallic contours and the power of line and shading that achieve the strong, sculptural effect. The dazzling color composition is based on a splendid bouquet of blues—the dome of the heavens, the blue clouds, the blue shadows, Christ's azure mantle-in combination with the gold background and the dazzling whites of the mantles. The figures in white robes at the far left and right are St. Benedict, of whose order the Camaldolites were a branch, and St. Romuald, founder of the Camaldolite community. In honor of the Benedictine Order, Mary is garbed in a white mantle instead of the traditional blue. These white garments are anything but inert: a rainbow of colors from the surrounding saints and angels is reflected into their shadows, and even the lightest areas are often picked out in glowing yellow. Rainbow-winged angels swing censers below the throne. How the composition of such altarpieces as this took shape can be followed in a vivid pen sketch (see fig. 1.13) probably done in preparation for a similar altarpiece. The rhythmic surge from figure to figure takes shape with the first rapid strokes of the quill pen, breaking into ripples as the folds and borders of individual tunics and mantles are defined.

The exalted mood in the central panel of the *Coronation* continues in the predellas below, especially the *Nativity* (fig. 5.13). Here Lorenzo elongated the French Gothic quatrefoil shape used by Giotto and Andrea Pisano (see figs. 3.5, 3.34). His *Nativity* is based partly on the writings of Bridget, a fourteenth-century Swedish princess who would later be

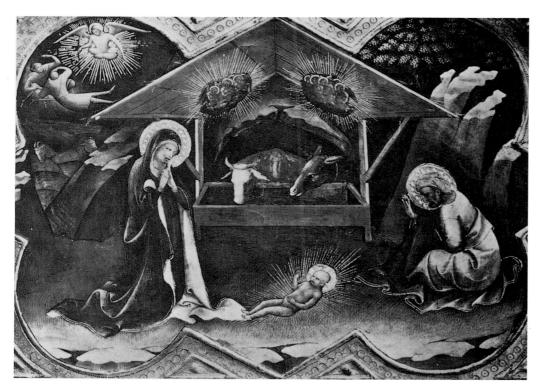

5.13. LORENZO MONACO. *Nativity*, on the predella of the *Coronation of the Virgin* (see fig. 5.12). 1414. Panel, 12½ x 21" (32 x 53 cm)

canonized by Pope Martin V while he was resident in Florence. During a visit to Bethlehem, Bridget had a vision of the Nativity while in the cave that traditionally marks the site. Not everything in her vision is represented by Lorenzo, but the principal elements that he includes led to a new version of the Nativity that became popular in the art of Quattrocento Florence—the Adoration of the Child (see figs. 9.20, 11.36, 12.33, 15.9). In Lorenzo's scene Mary kneels to worship her new born child, who lies naked before her on the floor of the cave, shining with golden rays; Bridget commented on the shining light that radiated from the newborn child. Lorenzo has added to the cave of Bridget's vision the shed from the Western tradition, matching its shape to the angles of the quatrefoil. The curves of the frame are reflected in other parts of Lorenzo's composition, but nowhere more exquisitely than in the robes of St. Joseph, which unfold below his body like the petals of a rose. In the dark night outside, a luminous angel awakens the shepherds.

When Lorenzo died, he had already started painting a large altarpiece for the Strozzi family; apparently he had only finished the pinnacles. The altarpiece was completed a decade later by another monastic painter, Fra Angelico, who was already working in the new, more naturalistic style (see fig. 9.1). The contrast between Lorenzo's curvilinear figures, silhouetted against their luminous gold backgrounds, and Fra Angelico's sturdy individuals, standing in a landscape filled with natural light, eloquently demonstrates how quickly style could be transformed during the Renaissance.

This and Lorenzo Monaco's other works represent a final flowering of the Gothic style in Florence. His display of light in the predella panel differs dramatically from the treatment of the same scene by Gentile da Fabriano nine years later (see fig. 8.4), and it seems much less real than the rendering of supernatural light by Giotto in the Arena Chapel (see figs. 3.8, 3.9). Lorenzo Monaco's visual poetry might be described as imaginative and unreal. The crucial developments of the early Quattrocento, on the other hand, were based on a new interest in the realities of daily human experience.

Architecture

The major architectural monument of the period, the Cathedral (or Duomo) of Florence (figs. 5.14, 5.15), had been commenced in 1296 under the direction of Arnolfo di Cambio to replace the Church of Santa Reparata, but work came practically to a standstill after Arnolfo's death in 1302. It continued sporadically under Giotto, who began the Campanile, and Andrea Pisano, who designed its second and third stories (see fig. 3.26). After the Black Death, however, the project for the Cathedral underwent modification. During the 1350s, Francesco Talenti completed the Campanile, changing the design yet again. A comparison with Giotto's

design (see fig. 3.25) will show how Talenti adapted Giotto's French Gothic windows to the more elaborate taste of the late Trecento. Talenti is only one of the personalities involved in the complex group activity at the Cathedral. In 1355 a commission was appointed; its personnel was to change, but it included the painters Taddeo Gaddi, Orcagna, and Andrea da Firenze, as well as well-known sculptors and prominent citizens. Model after model for the church and its details was submitted to the commission and accepted or rejected; somehow the work went on, although rejected ideas were often resubmitted.

One of these may be the design recorded in Andrea da Firenze's fresco of the Triumph of the Church (see fig. 5.8). It is not clear how much, if any, of Arnolfo's original design was kept and how much of the present Duomo can be attributed to the documented activity there of Francesco Talenti, Fra Jacopo Talenti (no relation), Simone Talenti (Francesco's son), and the painters. A definitive project embodying the piers and cornice designed by Francesco Talenti was adopted by the commission in 1364 and embodied in a model constructed after the final decisions of 1367 on the designs of Neri di Fioravante. The commission ordered the destruction of all competing designs and models and absolute adherence to the official project. For example, they required that the bracketed cornice above the nave arcade be kept as close as possible to the arches and that the vault rise directly from this cornice, effectively eliminating a pointed clerestory (common in the French Gothic) for which oculi were substituted. The final result was a striking compromise between a central plan and a Latin cross. Three polygonal apses, each with five radiating chapels, surround the octagonal dome, under which the high altar was placed. On the outside, these tribunes culminate in semidomes intended to buttress the central dome, but at the time no one had the faintest notion how a dome of this scale could be engineered and constructed. How close the basic shape of this plan is to the original conception of Arnolfo di Cambio in the 1290s is uncertain. It has been argued, however, that this later Trecento development follows his basic plan, but on a much larger scale.

The interior of the Cathedral consists of a majestic nave composed of four huge bays, its lofty arches opening onto side aisles half the width of the nave. The nave leads to the octagon of the dome and provides the principal entrance to this majestic, centralized space. The building was planned so that vast crowds could move from one area to the next without disturbing ceremonies at the high altar or in the fifteen surrounding chapels. The interior's imposing simplicity is enhanced by the warm brown stone used for the piers, capitals, and other details. The Florentine duomo was not consecrated until 1436, when the dome, apparently first envisioned by Arnolfo di Cambio, was near completion under Filippo Brunelleschi (see figs. 6.2–6.4).

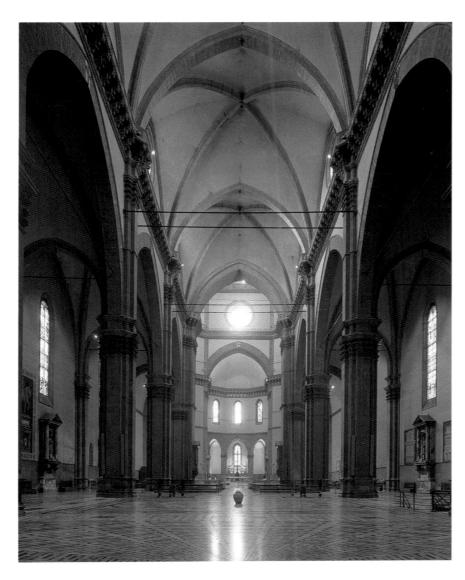

5.14. Nave and choir, Cathedral, Florence. Begun by ARNOLFO DI CAMBIO, 1296; present appearance due to FRANCESCO TALENTI and others

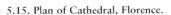

The overlaid plans are an attempt to demonstrate the various stages in the construction of the Florentine Duomo. Included are the partly conjectural plans of the earlier churches of Santa Reparata and of Arnolfo di Cambio in relation to the final plan that evolved in the 1350s and 1360s.

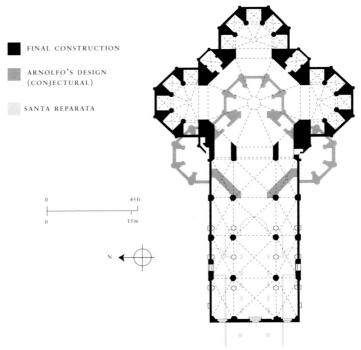

Painting and Sculpture in Northern Italy

In the Late Middle Ages and Early Renaissance, the political life of northern Italy was dominated by relations between the two most important city-states of Venice and Milan and such smaller centers as Mantua, Ferrara, Padua, and Brescia, whose communal governments had, at varying moments, been taken over by princes who had founded hereditary dynasties. Milan, near the northern edge of the Lombard plain, controlled trade routes to northern Europe. Once the capital of the Western Roman Empire, it became a flourishing commercial center. Its territory, however, was landlocked until the expansionist attempts of Duke Giangaleazzo Visconti gained temporary control of Pisa in the opening years of the Quattrocento. The opposition to this Milanese imperialism, which had aimed at domination of the Italian peninsula, came from Florence and was eventually successful. Florence found its only ally in republican Venice, whose outburst of independent artistic activity began in the middle of the Quattrocento and continued throughout the Cinquecento.

THE VENETIAN REPUBLIC. The existence of Venice is one of the miracles of history. The city was founded in the fifth and sixth centuries on marshy islets of the Adriatic by refugees from the Roman cities of the Po Valley who were fleeing barbarian invaders. Deprived of their territory and homes, these remnants of a former imperial culture learned to think of the sea as their sole resource and protection and of continental Italy, at their backs, as essentially hostile. The Venetian Republic-actually an oligarchy of aristocratic families with an elected duke (doge in Venetian dialect)—became the only state in Western Europe that survived from antiquity into modern times without revolution, invasion, or conquest. It endured from the last years of the Roman Empire until Napoleon abolished it in 1792 when he burned one of Venice's great symbols, an extravagant vessel from which the Doge conducted an annual ceremony marrying Venice to the sea. Venice was the only Italian state to achieve an empire. For many centuries the Venetians disliked and distrusted land power; their interest was in commerce and their riches were fantastic—both had to be protected. The security of the city was not hard to maintain; its lagoons were superior to any fortifications devised by land-based states, while the Venetian navy was the equal, at times the superior, of that supported by Genoa, its only serious maritime rival. But sea commerce needed bases, and the Venetians developed these throughout the Adriatic, Ionian, and Aegean seas, which became, to all intents and purposes, Venetian lakes. The Most Serene Republic of St. Mark, to give the Venetian state its full title, took over ports down the eastern Adriatic coast and throughout the Greek islands, and, after the capture of Constantinople by the Crusaders in 1204, Venice enjoyed extraterritorial possession of one-quarter of that imperial city.

In its initial stages, the Venetian Renaissance was nourished by contacts with Florence. But before Florentine artists arrived in Venice in the first half of the Quattrocento, Venetian art had turned toward the East. In Greece and in the churches and palaces of Constantinople, the Venetians witnessed Byzantine mosaics at their grandest, and in the Duecento the Venetians set to work covering the interior of the Ducal Basilica of San Marco with glittering mosaics, relying more on Byzantine examples and training, and even on actual Greek mosaicists, than on the Early Christian prototypes still visible in Venetian-controlled or -dominated areas. The lower walls are sheathed in slabs of veined marble and the total effect is one of sumptuous richness.

It has been asserted that Venice's situation on the water gave the inhabitants a predisposition toward placing higher value on color and light rather than on form and mass; such a notion is hard to disprove, especially given the role of light and color in Venetian art. At all times in its history the city has presented itself as an amazing and unique spectacle (see fig. 1.7). From the start, water formed the thoroughfares for the inhabitants. Larger passages became major canals, while the others made up a labyrinth of small canals and basins. These at first were bridged by wooden structures, but gradually wood gave place to stone, which also came into use for the canal embankments. Land space was at a premium, so few open squares were left, while narrow alleys separated houses and provided passage for pedestrians. The houses of the great families, who alone were allowed to participate in the government, faced the major canals and were approached by water, thus rendering unnecessary the massive walls of the Florentine palaces, which were built for defense against civil unrest. Construction was based on wooden piles driven into muddy islets or the underwater subsoil. The canals, basins, alleys, and squares must have overflowed with continuous and colorful pageantry. Ships, flags, exotic garments, and wares of many nations mingled here, and the palaces of brick, limestone, or marble were (and still are) illuminated by reflections from the water as well as by the direct light of the sun.

In the Duecento, a lively school of panel painting arose in Venice, but Venetian painting found its first authoritative voice in Paolo Veneziano, whose signed works can be dated from the 1320s to the 1360s. Paolo was certainly aware of Giotto's frescoes in nearby Padua, but there is no indication, if he saw them, how much they meant to his work. His pictures exemplify the high refinement of Italo-Byzantine style. In Paolo's earliest dated work, the *Coronation of the Virgin*

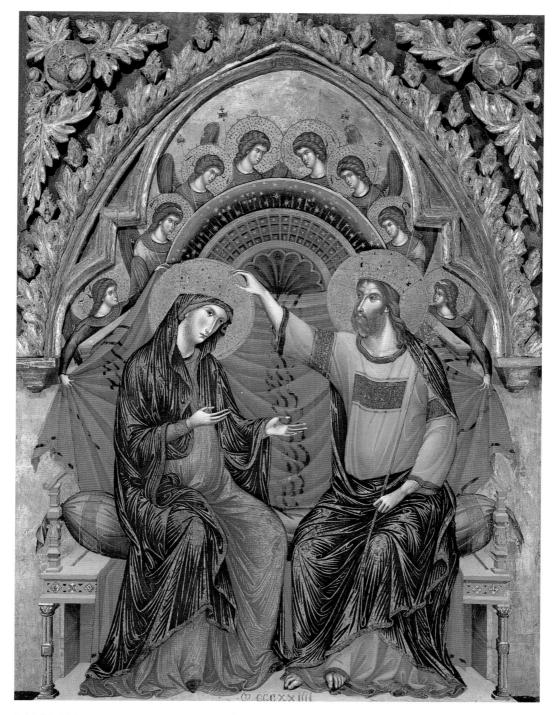

5.16. PAOLO VENEZIANO. Coronation of the Virgin. 1324. Panel, $39 \times 30^{1}/2$ " (100×78 cm). National Gallery of Art, Washington, D.C. (Kress Collection)

(fig. 5.16), the freedom, freshness, and brilliance of Paolo's color epitomize Venetian taste. The whole picture is organized in terms of waves of different colors and patterns. Unlike Tuscan painting, no clear-cut forms emerge; the picture is a web of color and lines, like a luxurious fabric. It is perhaps not irrelevant to the splendid surfaces of Venetian art

that, while the Florentines based their fortunes on banking and woolen cloth, the Venetians dealt principally in spices and silks.

As in many other cities, the new Franciscan and Dominican churches in Venice were among the largest religious structures. There are interesting similarities between the

Franciscan church of Santa Maria Gloriosa dei Frari (figs. 5.17, 5.18; see fig. 1) and the Dominican Church of Santi Giovanni e Paolo. Both are built of brick, which is lighter than stone and more appropriate for construction in Venice, and their plans follow the cruciform type, with single side aisles and an apse flanked by multiple chapels. On the interior the nave piers consist of enormous and impressive cylinders. Their spacious naves have Gothic ribbed cross vaults, with wooden tie-rods to constrain the outward

thrust of the Gothic vaulting, thus avoiding the need for heavy buttressing on the exterior. The huge scale satisfies the two rival orders' need for a large preaching space, while the austerity of design and lack of decoration are intended to communicate the simplicity the orders avowed. The similarity between the two churches and their dissimilarity to Gothic architecture elsewhere suggests that there was a determined attempt to invent a distinctive Venetian variation on the Gothic style.

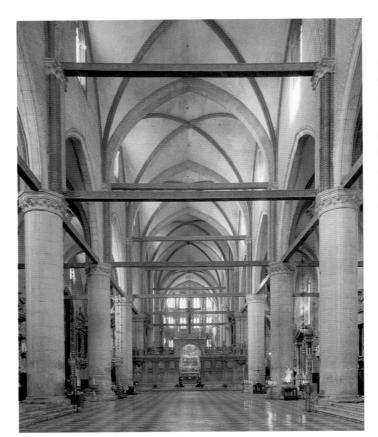

5.17. Santa Maria Gloriosa dei Frari, interior, Venice.
Begun c. 1330, finished after 1443. Length of nave, 295¹ (90 m).
Commissioned by the Franciscans (see fig. 1).
Visible on the high altar is Titian's Assumption of the Virgin of 1518 (see fig. 19.8). The monk's choir, which has been destroyed in so many Italian Gothic churches, including Santa Maria Novella and Santa Croce in Florence (see figs. 2.41, 2.43), remarkably survives here. The marble screen dates from 1475 and was carved by Bartolomeo Bon and Pietro Lombardo.

5.18. Santa Maria Gloriosa dei Frari, plan, Venice.
Plan from Dehio and von Bezold.
The numbers indicate the following monuments, added later by Renaissance artists to this Gothic church:
1. Giovanni Bellini's Frari Altarpiece of 1488 (see fig. 15.39)
2. Titian's Assumption of the Virgin of 1518 (see fig. 19.8)
3. Titian's Madonna of the Pesaro Family of 1526 (see fig. 19.30)

Giovanni Bellini's Frari Altarpiece of 1488 (see fig. 15.39)
 Titian's Assumption of the Virgin of 1518 (see fig. 19.8)
 Titian's Madonna of the Pesaro Family of 1526 (see fig. 19.14).
 Titian's Pietà of c. 1576 (see fig. 19.30)
 was originally intended to be placed over the artist's tomb in this church.

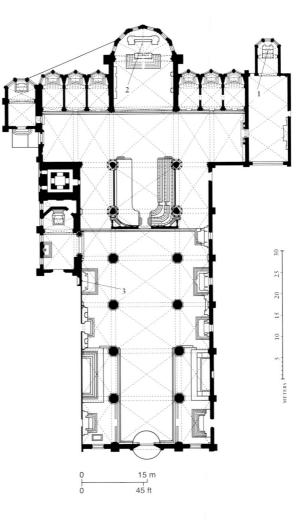

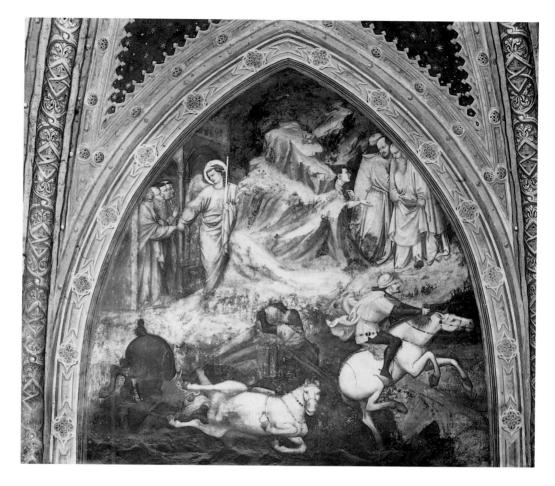

5.19. JACOPO AVANZI.

Liberation of the Companions
of St. James. c. 1374. Fresco.
Chapel of St. Felix (formerly
St. James), Sant'Antonio, Padua

PADUA. Independent of the immediate sphere of Venetian influence in the late Trecento, the school of Padua can be ranked as the most vigorous of northern Italian schools. The painters of Padua built upon Giotto's achievements; indeed their art may in some aspects be considered a Giottoesque revival. Not only Giotto but also his followers, and especially Maso, may be sensed in the prolific Paduan fresco painters, who added striking naturalistic observations of their own in landscape, in the painting of animals, and in portraiture. The most successful painters of the period came to Padua from outside—Altichiero from Verona and Jacopo Avanzi from Bologna. To Avanzi have been attributed most of the lunettes of the life of St. James, painted about 1374 in the Chapel of St. James (now St. Felix) in Sant'Antonio, while to Altichiero has been assigned the huge Crucifixion in the same chapel, some of the other lunettes, and all of the frescoes in the nearby Oratory of San Giorgio.

Avanzi's Liberation of the Companions of St. James (fig. 5.19) shows some of the qualities of the Paduan style. Ambrogio Lorenzetti and the Master of the Triumph of Death had, of course, developed the panoramic background (see figs. 4.29, 4.31), but no Tuscan painter presents us with this kind of nature—impassable, impenetrable, indecipherable. The human figures, many showing traits of physiognomy and drapery that remind us of Giotto and Maso, are domi-

nated by a central mass of rocks. The foreground is even more hostile. A bridge has collapsed, and the persecutors following the saint's companions fall into a stream. The floundering horses and humans are represented with striking fidelity. It seems unlikely that a Tuscan painter in the Trecento would have put a horse, seen from below, in the most prominent spot in the painting. In the Quattrocento, however, Paolo Uccello did exactly that in his *Battle of San Romano* (see fig. 11.5); considering the time he spent in Padua, it is possible that Avanzi's fresco put the idea in his mind.

In its density and richness Altichiero's *Martyrdom of St. George* (fig. 5.20) is equally non-Tuscan, despite echoes of Giotto in the faces. An impressive palace with loggias and Late Gothic parapets fills the scene and provides stages for episodes of the saint's life. The attempt to break him on the wheel fills the center foreground. The crowds of executioners and townspeople are terrified at the intervention of angels, who smash the wheel with their swords. As in Avanzi's frescoes, the complexity of the background, this time architectural rather than natural, envelops and dominates the figures. Altichiero's color, gorgeous in its muted tones of rose, green, and gold, is as foreign to Tuscan art as is the extreme naturalism of the portrait types that emerge from the crowd. Especially striking is the almost nude body of the saint on the wheel, which is painfully real in its anatomical modeling.

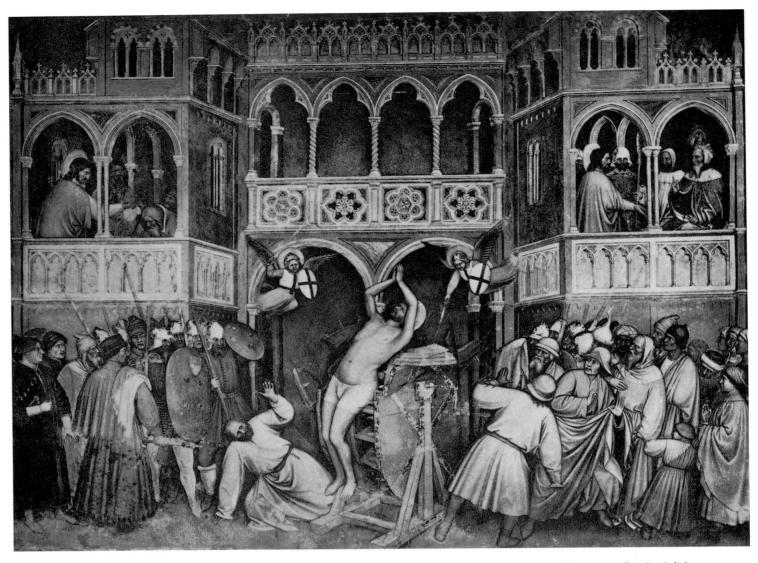

5.20. ALTICHIERO. Martyrdom of St. George. 1380-84. Fresco. Oratory of S. Giorgio, Padua. Commissioned by Raimondino Lupi di Soragna

MILAN. In 1387 Milan lost its communal liberties to the Visconti family, and for the next two centuries the Visconti, succeeded by their relatives the Sforza, held sovereignty over a fluctuating territory including, at times, all of Lombardy and much of central Italy. At Milan and Pavia these rulers held courts whose magnificence was rivaled in Italy only by those of the Vatican and the Kingdom of Naples. Bernabò Visconti, count of Milan, commissioned a remarkable monument (fig. 5.21) probably from the Lombard sculptor Bonino da Campione (active 1357-85). The base of the monument is a sarcophagus, carved in a style derived from that of Nicola Pisano. On the sarcophagus stands a colossal statue of Bernabò on horseback, the ancestor of the famous Ouattrocento equestrian monuments by Donatello and Verrocchio (see figs. 10.31, 13.16), which also commemorated northern Italian leaders. But in contrast to these dynamic Renaissance successors, imbued with the influence of ancient Rome, the equestrian statue by Bonino remains absolutely immobile. The steed plants all four feet firmly on the base, and the rider, who stands boldly up in his stirrups, stares grimly ahead. It is impressive through the power of its presence and the typical northern Italian attention paid to the anatomy of the horse and to naturalistic detail. According to Trecento sources, the statue was covered with silver and gold decoration and the figure held a flag or pennant; such a mixture of color and media in Italian sculpture is not uncommon; in general, sculpture during this period was almost certainly more colorful than is generally recognized today.

In 1385 Bernabò was imprisoned by his nephew Giangaleazzo Visconti, who assumed total power and in 1395 bought from the impoverished Holy Roman Emperor Wenceslas the title of hereditary duke of Milan. Aspiring to

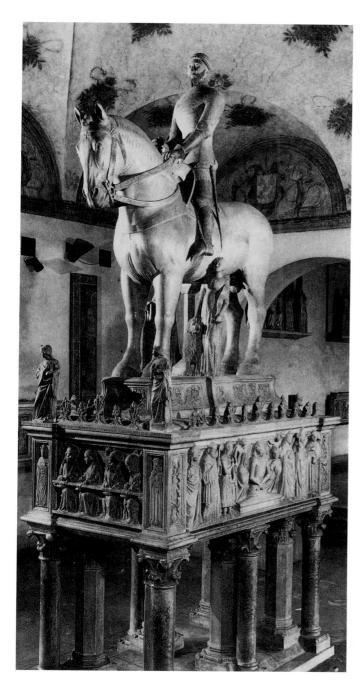

5.21. BONINO DA CAMPIONE (attributed to).

Equestrian Monument to Bernabò Visconti. Before 1363.

Workshop of BONINO DA CAMPIONE, Sarcophagus of Bernabò Visconti. c. 1385. Marble, originally with polychromy, gilding, silver decoration, and a cloth flag or pennant; overall height 19'8" (6 m). Museo del Castello Sforzesco, Milan.

Equestrian monument commissioned by Bernabò Visconti for the high altar of S. Giovanni in Conca, Milan

5.22. GIOVANNINO DE' GRASSI. Psalm 118:81. Page from Visconti Hours. Before 1395. Tempura and gold on parchment, approx. $9\sqrt[3]{4} \times 6\sqrt[7]{8}$ " (25 x 18 cm). Biblioteca Nazionale, Florence. Commissioned by Giangaleazzo Visconti, whose profile portrait is shown in the bottom margin

rule over all of Italy, Giangaleazzo became, as we shall see in the next chapter, a threat to the Florentine Republic. The duke gathered about himself a talented and original group of artists from Lombardy, France, Germany, and the Netherlands to build the Visconti funeral monastery, the Certosa of Pavia, and the ambitious Cathedral of Milan, which was still far from completion when Leonardo da Vinci worked in that city a century later.

Animals constituted one of the favorite delights of northern Italian courts. The pleasures of the chase and the joys of collecting rare animals and birds from as far away as Africa and the Near East enliven the art of northern Italy at this time. Giovannino de' Grassi (active 1380s, d. 1398) was architect, sculptor, and painter to Giangaleazzo, and for a while capomaestro over the host of artists working on the Cathedral of Milan. He was also responsible for a book of animal studies and for the first half of a magnificent Book of Hours. The pages decorated by Giovannino in the Visconti Hours are among the many alluring products of Italian manuscript art. In the middle of the huge initial "D" on the page with Psalm 118 (fig. 5.22) is shown King David enthroned, clothed in red, blue, and gold, in a gorgeous Gothic interior. He reaches out his left hand while God, a bit hard to find among the ornament at the right, extends to David the orb of power.

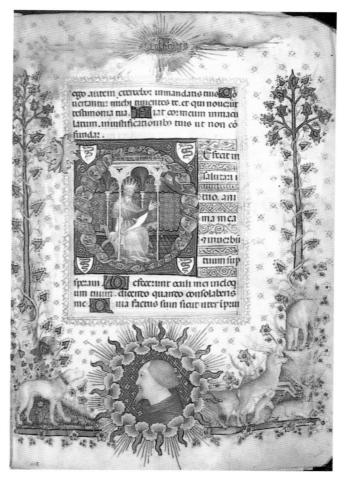

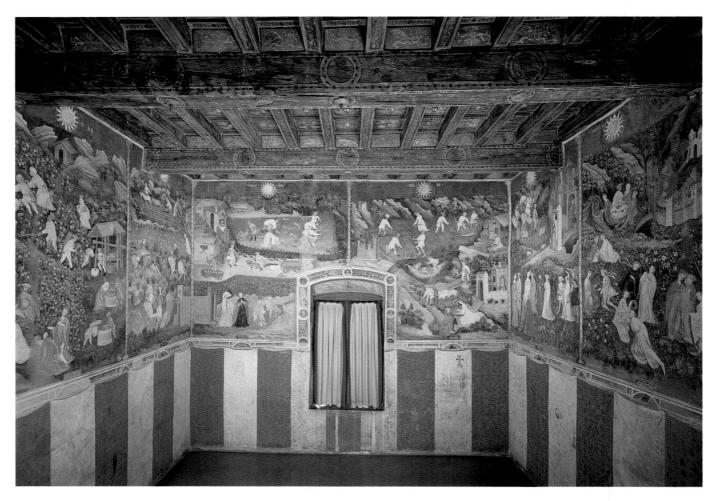

5.23. The Months. Scenes shown here: months of April through September. Before 1407; restored in 1535.

Fresco; scenes, 10' high (3 m); dimensions of room 19'8" x 19'1" (6 x 5.8 m). Eagle's Tower, Castello del Buonconsiglio, Trent.

Commissioned by Georg von Lichtenstein, Bishop of Trent. Only eleven of the months survive. The draped fabric painted below replaces the original wainscoting, which was painted with a sequence of niches.

The border ornaments are schematic trees entwined with gold that grow from green grass and rocky slopes sparkling with wildflowers. Giangaleazzo's hunting dogs already sniff their prey: three handsome stags and a doe, crouching, climbing, grazing, and even represented foreshortened from the rear. The animals and flowers are painted with a freedom distinct from the stiffness characteristic of earlier Milanese art. Between the hunters and the hunted is a beautifully enframed portrait of Giangaleazzo. The naturalism of Giovannino and other Lombard illuminators, known to contemporary French artists as the *ouvraige de Lombardie*, appears to have inspired the art of the Limbourg brothers in Burgundy, and in Italy it exercised an incalculable influence on Gentile da Fabriano (see pp. 223–27).

TRENT. An exceptional secular fresco cycle of the Months draws our attention northward to Trent, in the foothills of the Alps (fig. 5.23). The theme of the months is not, however,

purely secular, for at the time the cycles of nature were a revelation of the divine order that orchestrates all life, including human life. The repeated patterns of flowery meadows, leafy forests, and fields with haystacks here are surely meant to suggest the design motifs common in French Gothic tapestries, and are a reminder that during the Gothic period, a secular ruler would have preferred to have his residence decorated with tapestries rather than frescoes. While tapestries could provide desirable insulation during the winter months, more important was the impact they made because of their value. Because tapestries were much more expensive than frescoes, they could convey to guests the wealth, and therefore power, of their host; by suggesting the style of elite foreign tapestries here, the Trent frescoes at the very least must have signified the sophisticated taste of their patron. In addition, their subject matter captures indications of how a ruler from this period chose to represent episodes in the lives of both aristocrats and peasants. While we must be careful

not to interpret the seemingly everyday scenes here as a mirror of reality, the social hierarchy represented was, indeed, quite real: a bishop has commissioned an artist to depict aristocrats at play and peasants at work, indicating their separate roles while reinforcing the social fact that leisure belongs to those in power. The difference in scale between the toiling peasants and the wealthy underscores this intentional social gulf pictorially by symbolizing worldly status—or lack thereof.

VERONA. The equestrian monument Bonino da Campione had produced for Count Bernabò Visconti of Milan (see fig. 5.21) was originally placed behind the high altar of a church. Though grand in its construction, its placement in the church signified Bernabò's divine right to rule, but also his subordinate position to God. The monument to Cansignorio della Scala, ruler of Verona (fig. 5.24), which Bonino

signed, was placed in a piazza. The public presence of this monument reveals its distinct purpose from Bernabò's; Cansignorio's authority is absolute and answers to no higher power than himself. It was the last, as it turned out, in a series of monumental equestrian tomb monuments erected by the Scala family as hereditary rulers of the city. In a desire to outdo his predecessors, Cansignorio commissioned the largest monument and had it decorated in a rich Gothic style. Figures of soldiers in tabernacles surround the bier/sarcophagus in the middle, while virtues and angels lead our eyes upward to the triumphant equestrian figure of Cansignorio at the top. The metal wings of the angels were probably originally gilded and the monument had added color details when completed. The imposing force of Cansignorio's personality is still evident when viewed today, but during the Late Middle Ages, such a presence presaged the rise of a secularized worldview that placed greater value on the individual.

5.24. BONINO DA CAMPIONE.

Funerary Monument of Cansignorio della Scala. Completed 1376. n Piazza next to Santa Maria Antica, Verona. Probably commissioned by Cansignorio. Although the work is signed by Bonino da Campione and one Gaspare (the builder?), it has little in common with the other works by Bonino and is probably a composite work hurriedly designed and erected at the request of a youthful ruler during his final illness. Cansignorio, who was only thirty-six when he died in 1375, had requested that his tomb be the work of "the most excellent sculptors and architects to be found in Italy at the time." He was more interested in art and architecture than in military affairs, and he is reported to have said that "building was a sweet way to become poor." Cansignorio became ruler of Verona at the age of twenty-one when he assassinated his older brother, Cangrande II.

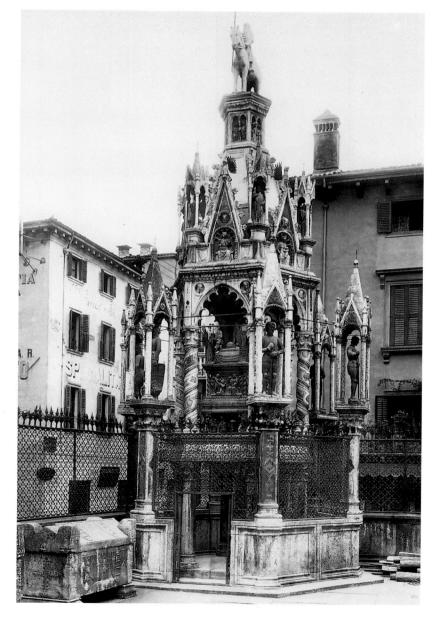

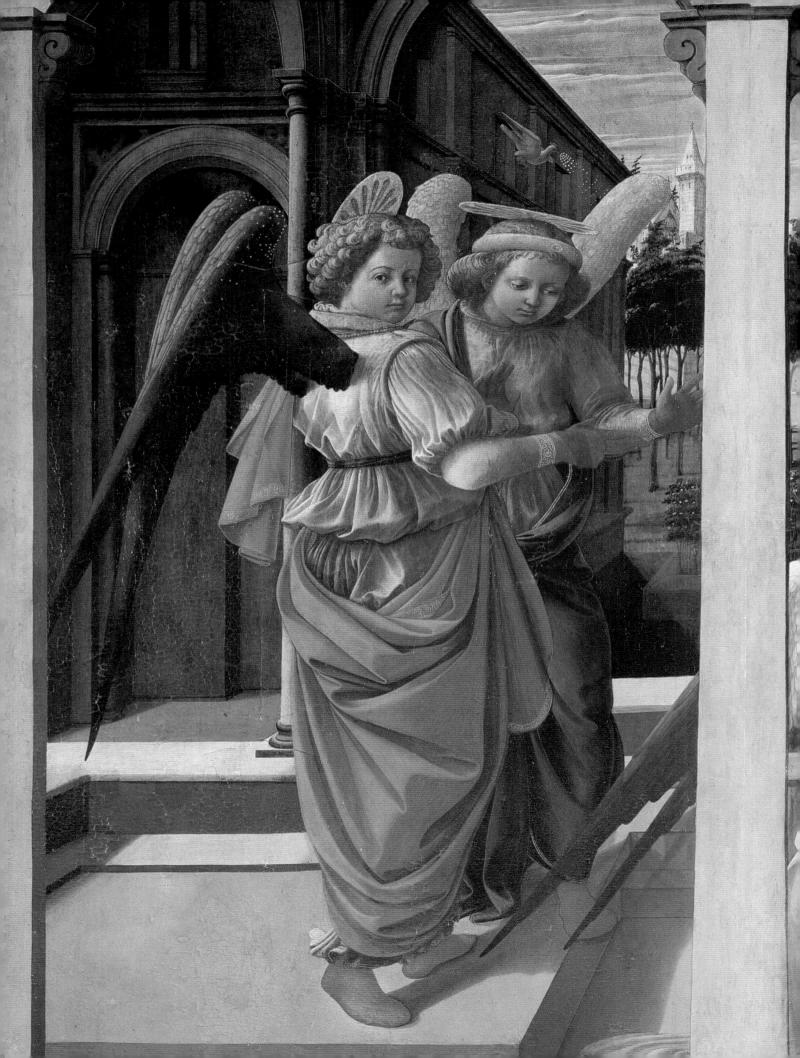

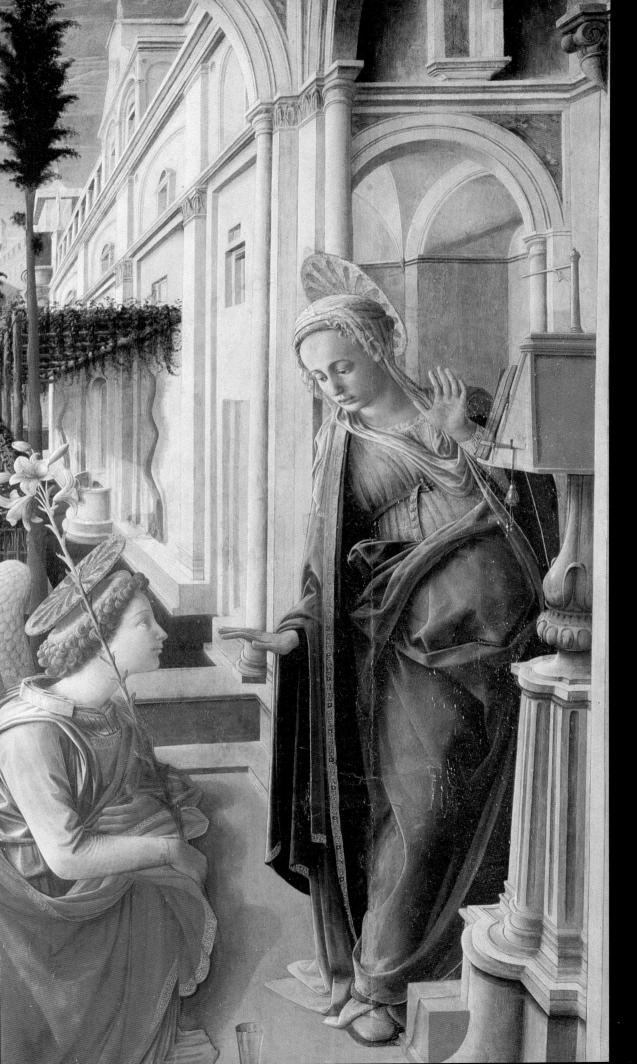

P A R T W C

THE OUATTROO

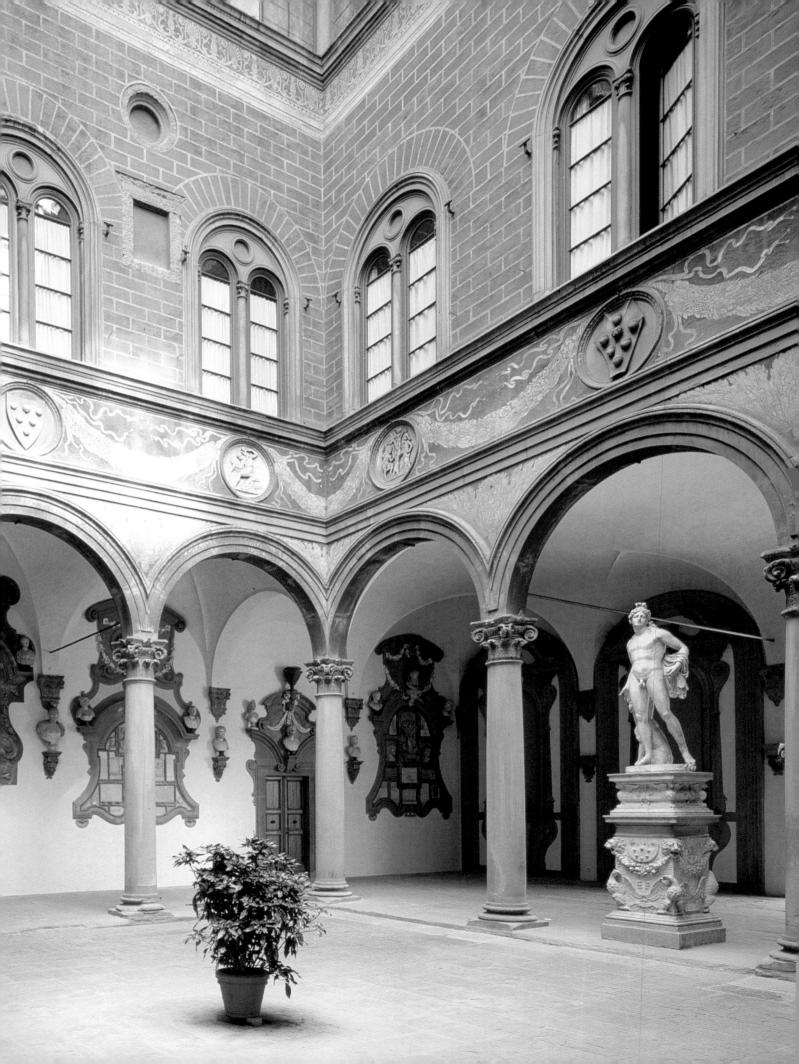

THE BEGINNINGS OF RENAISSANCE ARCHITECTURE

p to this point we have been considering what might be referred to as premonitions of the Renaissance, including the occasional imitation of and inspiration from ancient art. Architecture remained Gothic. although a Gothic modified by Italian ideas of clarity and simplicity. In the early Quattrocento in Florence, we can trace the development of a new art dedicated to what we might call human potential and human standards, one inspired by forms and ideas drawn from the civilizations of Greek and Roman antiquity. Leonbattista Alberti, an important humanist, formulated the theoretical principles of the new style in a series of books written some twenty years after the first new stylistic statements of the Renaissance; he referred to antiquity at almost every point. At the same time, he proudly articulated the new ideas of his own period. In his 1435 treatise On Painting, written in Latin and translated into Italian as Della pittura, he claimed that "it was less difficult for the Ancients—because they had models to imitate and from which they could learn—to come to a knowledge of those supreme arts which today are most difficult for us. Our fame ought to be much greater, then, if we discover unheard-of and never-before-seen arts and sciences without teachers or without any model whatsoever."

As a supreme example of the new art, Alberti points to the dome of the Cathedral of Florence (see figs. 2, 6.2), then being completed by Filippo Brunelleschi (1377–1446), to whom the prologue of his treatise was addressed:

Who could be hard or envious enough to fail to praise [Filippo] the architect on seeing here such a large structure, rising above the skies, ample to cover with its shadow all the Tuscan people, and constructed without the aid of centering or great quantity of wood? Since this work seems impossible of execution in our time, if I judge rightly, it was probably unknown and unthought of among the Ancients.

As we look at this dome, whose shape and proportions vie in grandeur with the hills surrounding Florence, it seems the product of a harmonious period consecrated to the kind of intellectual activities that Alberti and his fellow humanists extol, but nothing could be further from the truth. Like so many creative periods, the Early Renaissance (which covered roughly the fifteenth century in most major centers) was an era of bitter conflict and of challenges never more than partly met; seldom, however, in history is the gap between human problems and their solutions more evident. Florence in particular, whose role in the modern world has often been compared with that of Athens in antiquity, resembled Athens in this respect as well. Only on an ideal plane, in their monuments and works of art, did the Florentines achieve the harmony, dignity, and balance denied them by the turbulent realities of their epoch.

During the formative period of the Early Renaissance, in the first third of the Quattrocento, the continued existence of the Florentine Republic and even of Florence as an independent state was in doubt. In 1378 the guild system had come under attack in the short-lived revolt of the Ciompi—the impoverished wool carders who occupied the bottom rung of the social and economic ladder. After ruthless suppression of the Ciompi, the oligarchy reestablished its domination through the major guilds and the Guelph party. The next threats originated outside the city, from the rapidly expanding duchy of Milan, which, under the Visconti family, seemed ready to engulf most of the Italian peninsula. By a system of alliances, threats, and intimidations, as well as by conquest, Duke Giangaleazzo Visconti gained control over all northern Italy, except for the republics of Genoa and Venice, and much of central Italy, including Siena, the ancient rival of Florence; Florence thus was surrounded on three sides. Eventually Giangaleazzo succeeded in cutting Florence off from the sea, and in the summer of 1402 he was poised in the Apennines, ready to descend on Florence and wipe out that hotbed of bourgeois liberty. At that moment the plague, always smoldering, erupted among

his armies and by September, Giangaleazzo was dead and his jerry-built empire fell apart. The Florentines rejoiced at their deliverance and returned to their commercial and intellectual activities.

And then another threatening tyrant emerged. King Ladislaus of Naples, having conquered Rome three times (on the third he put the city to fire and sword), threatened Florence from the south. Again disease came to the aid of the Florentines when Ladislaus died in 1414. It is important to remember that despite these two deliverances, which many Florentines ascribed to divine intervention, the city had been ready to defend itself against these tyrants. With no alliances save an uncertain one with Venice, modest resources, and no standing army, the Florentines, armed, we might say, with only their commercial power and their courage, prepared for the onslaught.

In the 1420s arose the third danger, and this time no fortuitous disease saved the Florentines. Filippo Maria, the son of Giangaleazzo Visconti, undertook to finish off his father's work. The Florentines suffered one defeat after another before they managed to pull together all the resources of their Republic. In 1427, to obtain the necessary sums for the war, the Florentines instituted the *catasto*, the first graduated tax in history. The catasto was a tax on wealth, but it was also the ancestor of the modern income tax in the sense that it was calculated according to the productivity of property, including artists' tools and materials; it had a system of exemptions and deductions and required a personal, written declaration. Large numbers of these survive from 1427 and later assessments, and they form an invaluable source of information (although often deliberately misstated by the taxpayers) about Florentine citizens of all ranks. The new system replaced the capricious levies of earlier tax collectors with a workable, if far from watertight, mechanism for defining the financial responsibilities of every citizen to the threatened Florentine Republic.

The war dragged on; Filippo Maria did not descend on Florence, but neither did the Florentines defeat him. The situation that developed was a prolonged stalemate; nobody really won, yet danger overshadowed the people of Florence for years. It was in this atmosphere of crisis that some of the important works of Early Renaissance art were created. Military expenditures notwithstanding, the Florentines were able and willing to pay for costly structures and large works of sculpture in marble or bronze. One reason for this seeming extravagance was the civic orientation of the new commissions. Writing in the 1960s, Frederick Hartt argued that these works of art could function as soldiers in the struggle against absorption and dictatorship by galvanizing popular support for the lifeand-death struggle of Florence through their profoundly felt, yet easily recognizable, symbolic content. In any case, these new public works were unusual in that they were meant for the person in the street, not for the pious in the churches. This appeal to the individual citizen can be related to the civic ideals promulgated by contemporary humanists.

The Role of the Medici Family

The story of Florentine Quattrocento art is inseparable from the history of the Medici family. While the family's fortunes were founded by earlier members, Giovanni di Bicci de' Medici (1360–1429) greatly expanded the family's resources by becoming banker to the papacy, probably the wealthiest institution in Europe. Giovanni commissioned Brunelleschi to design a new sacristy for the Church of San Lorenzo (now known as the Old Sacristy; see figs. 6.7, 6.8; see also fig. 3), which is one of the earliest examples of a Renaissance interior. But it was Giovanni's son Cosimo (1389-1464) who used the resources of the family's great wealth to become a catalyst for developments in Florentine art. Cosimo played an important role in commissioning the first Renaissance church, San Lorenzo (see figs. 6.7-6.10); the first Renaissance palace, also, at the time, the largest (see figs. 6.17–6.19); the first Renaissance monastery, San Marco, which was rededicated in 1443 to St. Mark and the Medici family patrons, Sts. Cosmas and Damian (see figs. 6.20, 9.5-9.12); two Medici villas; and many other significant works of art, including works by Ghiberti, Uccello, Desiderio da Settignano, and, most likely, Antonio Pollaiuolo, Fra Filippo Lippi, Domenico Veneziano, and the Flemish painter Rogier van der Weyden. He may have been the patron of Donatello's revolutionary Bronze David, the first large-scale nude sculpture since antiquity, which is first documented in the Medici Palace courtyard (see figs. 6.19, 10.29). Cosimo was also, of course, a powerful businessman, a subtle and cautious politician, a book collector, the founder of the first public library, and an important intellectual. There is no question that much of his artistic patronage had implications in the political sphere.

Politically, Cosimo was nothing more than a private citizen, but he was recognized by many as the man who controlled Florentine politics. After he returned from exile in 1433–34, he transformed the ostensibly republican system so that only Medici partisans could be selected for office.

Cosimo's low personal profile was evident in the fact that the only known portrait painted during his lifetime is found in Benozzo Gozzoli's *Procession of the Magi*, in the private chapel Cosimo had built as part of the Palazzo Medici (see fig. 12.30). After he died, the commune recognized his contribution to the city's political and cultural life by coining a medal in his honor, on which he is identified as the *Pater Patriae*, "Father of the Country" (fig. 6.1). In the sixteenth century, however, Machiavelli would more truly express Cosimo's role by calling him "The Prince of the Republic." Because some of the later Medici rulers were named Cosimo, the Quattrocento patron who played such an important role in Florentine life and art became known as Cosimo il Vecchio, "Cosimo the Elder."

Cosimo was succeeded by his son, Piero the Gouty (1416–69), who was in turn succeeded by his son, Lorenzo the Magnificent (1449–92). Lorenzo's son Piero the Unlucky

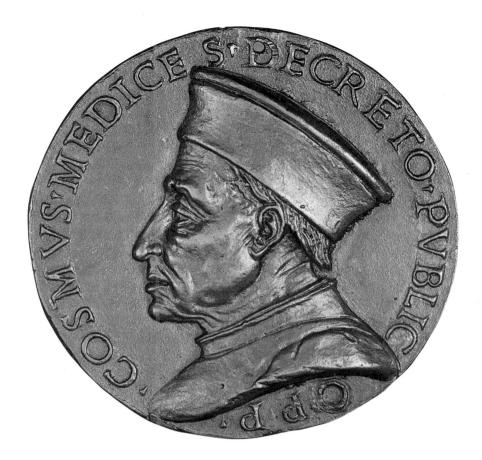

6.1. Portrait Medal of Cosimo de' Medici, Pater Patriae. c. 1465. Bronze, 3½16" (7.8 cm). Washington D.C., National Gallery of Art (Kress Collection). Coined by the Commune of Florence, presumably in the year after Cosimo's death. The reverse of the medal features an allegorical figure of Florence holding an orb and triple olive-branch and an inscription that reads, in part, "Pax et Libertas" (Peace and Liberty).

(1471–1503) was driven from Florence by Savonarola and his followers in 1494. The Medici returned in 1512, and ruled Florence until the family line died out with Anna Maria Louisa, the childless daughter of Cosimo III, in 1743; she left the family collections to the city of Florence.

Filippo Brunelleschi and Scientific Perspective

In 1403, after Brunelleschi lost the competition for a set of bronze doors for the Florentine Baptistery to Lorenzo Ghiberti (see figs. 7.2, 7.4), he largely abandoned the art of sculpture, at which he had been proficient, and dedicated himself to architecture. Vasari wrote that Brunelleschi went to Rome to study and measure the remains of ancient architecture. He came back to Florence with ideas on how ancient

elements could be utilized in the new art of the day. It is most likely that he also brought back with him measured drawings and views of the great Roman monuments.

It was probably this interest in ancient monuments that led to his work in perspective. Using the perspective scheme that he developed in Rome, he could make a drawing that captured both the appearance of an ancient ruin and, by including a figure or another indication of scale, its exact measurements. The utility of such a drawing scheme to an architect is obvious, but its usefulness to painters and sculptors working in relief was incalculable at that time. Brunelleschi executed two paintings to demonstrate the verisimilitude made possible by the technique of scientific perspective (see pp. 215–16). Exactly when Brunelleschi created these works is unknown, but it is interesting that his friend the sculptor Donatello was among the first to take advantage of Brunelleschi's scheme (see figs. 7.17, 7.23).

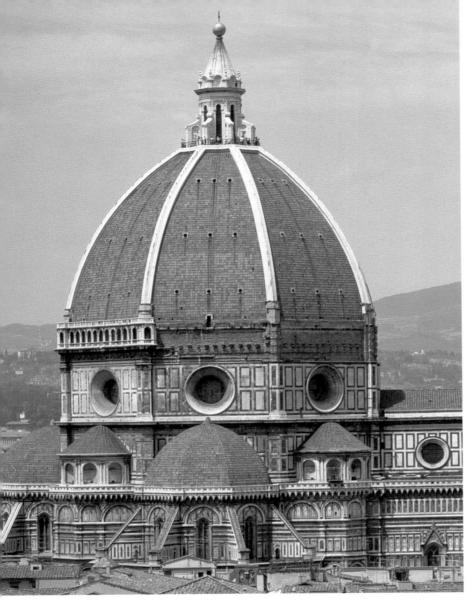

6.2. FILIPPO BRUNELLESCHI.

Cathedral Dome, Florence. 1420–36; lantern completed second half of fifteenth century; dome commissioned by the Arte della Lana and the Opera del Duomo (see fig. 2). The copper ball made in the workshop of Verrocchio was raised into place, accompanied by the singing of a hymn in honor of the Virgin Mary, in May 1471. Every will drawn up in Florence included a donation to the construction of the cathedral. For the plan and a view of the interior of the Gothic cathedral, see figs. 5.14 and 5.15 (see also figs. 1.4, 1.5).

The Dome of the Florence Cathedral

Brunelleschi's dome for the Cathedral (fig. 6.2; see fig. 2) addresses not only the citizens of Florence, but also the inhabitants of the Arno Valley from which its shape was visible. We do not know when Brunelleschi designed the dome, but his father had served on the Duomo committee of 1367. Brunelleschi must have been brought up with the model of 1367, and both he and Ghiberti took part in the committee of 1404, which obliged the architect Giovanni d'Ambrogio to lower his projected semidomes to their present level. Vasari says that it was Brunelleschi who, in 1407, advised the Opera del Duomo (Board of Works of the Cathedral) to "lift the weight off the shoulders of the semidomes," in other words to insert a drum between the central dome and the surrounding semidomes. In 1410 the Opera authorized just

such a drum. A wooden model, still in the Opera Museum, seems to represent this stage. The Opera hired Brunelleschi as an adviser in 1417, and three years later a masonry model of the dome was accepted.

Brunelleschi was limited by the nature of the existing structure, for the plan of the Cathedral, commenced by Arnolfo di Cambio and expanded in the Trecento by his successors, could not be changed (see fig. 5.15). The octagonal base for the crowning dome was already established; the nave, choir, and transepts had been built; and the decorative marble surfacing of the exterior, with its intricate Gothic ornamental shapes, was largely complete. The idea of oculi (round windows) instead of Gothic pointed ones had been adopted in 1367, and the construction of this clerestory area was apparently completed by 1390. But the exterior decoration of the clerestory as we see it today and of the finished portions of the dome present a consistent appearance whose harmony, clarity, and simplicity are strikingly different from

the complex Gothic shapes of the lower areas. The marble incrustation around the dome was carried out during 1452–59, after Brunelleschi's death, but incrustations on the clerestory and drum probably reflect his designs.

In both the clerestory and the drum, the bays are decorated with rows of rectangular panels over which the oculi windows seem superimposed. Rectangles and circles are elements of architectural draftsmanship created with the compass and square: Brunelleschi's architecture has been called "paper architecture," and to some degree it does preserve in stone the procedures of laying out architectural shapes on paper. Indeed, this basic partitioning conveys the principles and the message behind Brunelleschi's architecture, with its simplicity and order, clear-cut proportions, and carefully balanced relationships.

The shape of Brunelleschi's dome has an inherent tension that relates it more to a Gothic vault than to the hemispherical dome of the Pantheon, which Brunelleschi had studied and measured in Rome. The eight massive ribs seem held together at the top by the marble lantern, designed to admit light into the interior. In the taut curves of its profile, the scope of its volume, and the dynamism of its upward leap, Brunelleschi's dome could even be compared to the Early Renaissance idea of the indomitable individual will promoted by the humanists.

The construction, started in 1420, was completed in 1436 with a temporary octagonal oculus at the summit until the lantern could be built. It was under this dome that, three years later, the Roman pope and Greek patriarch signed a treaty designed—uselessly, as it soon appeared—to end the centuries-old schism between the two branches of Christianity. The dome's symbolic value continues till today. The Florentine equivalent to a London cockney's declaration of having been born within the sound of Bow bells is *Io son fiorentino di Cupolone* (I am a Florentine from the great dome).

The crowning lantern and the four semicylindrical exedrae that function as buttresses (figs. 6.3, 6.4) represent another period in Brunelleschi's development and are executed in a different style. The exedrae recall circular temples Brunelleschi had seen in and near Rome, but instead the columns are paired

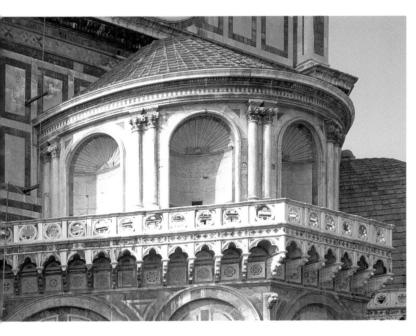

6.3. FILIPPO BRUNELLESCHI. Buttress in the shape of an exedra, Cathedral, Florence. 1440s

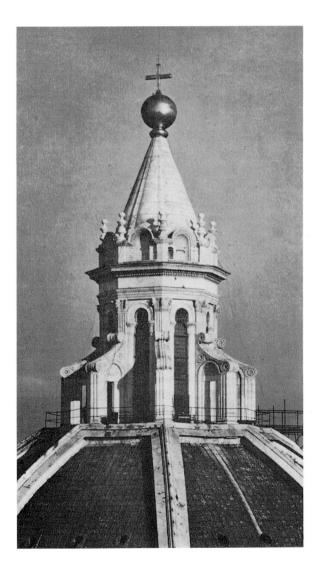

6.4. FILIPPO BRUNELLESCHI and MICHELOZZO DI BARTOLOMMEO. Lantern, Cathedral, Florence. After 1446 (a favorite Brunelleschian motif) and alternate with shell-headed niches. No longer is there any trace of Gothicism; there is a sense of ancient harmony in the relationships of capital to shaft, base, and entablature. But Brunelleschi has introduced an unexpected variant. Between the capitals and the entablature he inserted rectangular boxes, known as impost blocks, that give an extra visual lift to the structure at this point.

The lantern (fig. 6.4) brings the shapes and forces of the building to a climax and abounds in variations on classical vocabulary. The eight ribs of the dome culminate in eight buttresses, each surmounted by a volute. Each angle is decorated with a Corinthian pilaster, while the window arches between them rest on capitals of a design unique to Brunelleschi. Each buttress is pierced by a portal-like opening surmounted by a classicizing shell form. Brunelleschi died before the lantern was begun, and some details not seen in the model may be due to Michelozzo di Bartolommeo, who finished the work. The lantern as built by Michelozzo culminates in a burst of delightful forms: the attic, composed of alternating niches and balusters surmounted by balls, supports a fluted cone, a gold orb, and a cross.

No one knows how Brunelleschi intended to complete the section separating the drum and the dome, which is now a stretch of rough masonry except for a later gallery on one face (see fig. 6.2). A Cinquecento competition for this area was won by Baccio d'Agnolo, but after one section of his design was carried out, Michelangelo reportedly compared it to a cricket cage, and work came to a stop. The bare masonry is perhaps preferable, for Baccio's gallery, despite its handsome classical forms, is out of scale to Brunelleschi's design.

Brunelleschi's fame among his contemporaries was largely based on his ability to solve the constructional problems of so great a dome—the largest since the Roman Pantheon and the highest ever built until that time. The officials of the Opera del Duomo were especially concerned about the colossal expense of erecting the temporary centering of timber that was the traditional means of supporting a dome's masonry as it went up. Centering for a dome of this scale would have required an entire forest (remember Alberti's emphasis on the fact that the dome was "constructed without the aid of centering or great quantity of wood"). To resolve this difficulty, one of Brunelleschi's competitors suggested building the dome over a core of earth sown with silver and gold coins; when the dome was finished and the doors opened, it was argued that the Florentines would rapidly remove the dirt to search for the coins.

Brunelleschi's scheme, however, made it possible to construct the dome without centering. The masons worked from a scaffolding that could be suspended from recently completed sections of the dome; beams supporting narrow platforms would be lifted as the work progressed. Traditionally, masons would have to carry all the building materials on their shoulders to great heights. But Brunelleschi invented a hoisting machine that was such a success that the Opera del

Duomo had to publish an order forbidding adventurous Florentines from riding it just for fun.

For the dome, Brunelleschi designed a method of laying brickwork in rings of horizontal masonry, but with each ring cut occasionally with a vertical brick; these were laid in staggered vertical rows to produce a diagonal whorl that converged on the keystone. He used this method for his other domical constructions, but here, for an octagonal dome, he employed a strong, interlocking herringbone pattern. The lower levels of the dome were laid in *pietra forte*, the traditional stone of the Florentine builders, the higher in brick.

The dome is composed of an inner and an outer shell (fig. 6.5), both of which are anchored to the eight ribs; between the shells are sixteen smaller ribs visible only to those who climb up, between the inner and outer domes. They are connected to one another and to the main ribs by arc-shaped bands of stone; the strength of this interlocking grid was reinforced at the springing of the dome by an encircling chain of gigantic oak beams held together by iron links.

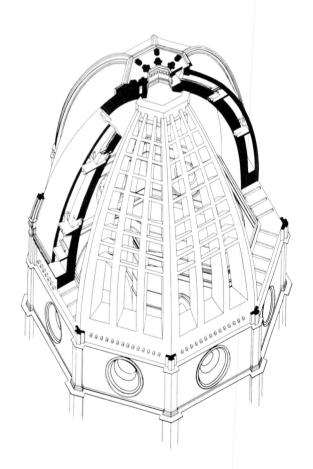

6.5. Diagram showing construction of Brunelleschi's Cathedral Dome, Florence.

Writing in the sixteenth century, Francesco Bocchi stated: "In truth, knowledgeable artists cannot well decide whether this sovereign building is more beautiful or more strong, for joined together, these two things compete with each other for first place, and yet are at the same time in harmony in generating wonder and amazement."

Originally there were seventy-two oculi in three superimposed tiers in both shells of the dome. The ones in the outer shell are still visible, but those in the inner shell were closed in the sixteenth century so that the inner surface could be frescoed. Originally these dazzling crowns of light must have transformed the now rather dark interior. It has been suggested that the Florentines may have entertained the idea of leaving the dome without a lantern, lighting the interior by the pinpoints of light from the oculi and the shaft of light that would have come from the octagonal oculus at the summit, as in the ancient Roman Pantheon.

In all the buildings that he designed from the outset, Brunelleschi abandoned the Gothic compound pier and Gothic pointed arch, substituting a vocabulary imitated—but simplified—from classical antiquity and from the Baptistery of Florence (see fig. 3.33) and the Church of San Miniato, two classicizing Romanesque buildings that in his day were thought to be Roman. These two medieval sources explain one of the main differences between Brunelleschi's building and his ancient models. In ancient structures, rows of columns carry flat lintels, while in Brunelleschi's buildings columns are often used to support round arches (see figs. 6.6, 6.10, 6.11), a motif found at both the Baptistery and San Miniato.

The Ospedale degli Innocenti

The most striking embodiment of Brunelleschi's style in the crucial years around 1420 was the Ospedale degli Innocenti, the foundling hospital for orphans and abandoned children (fig. 6.6). These orphans were given the last name Innocenti, and the role of this hospital in the evolution of the Florentine citizenry is evinced by the numbers of persons bearing this name in recent telephone directories. Although orphanages had existed previously, the Innocenti was dedicated to caring for an increasing number of foundlings, including providing for their education and vocational training until they reached the age of eighteen. The Innocenti was built on one side of a piazza at the end of Via dei Servi, a street that led from the Duomo to the Church of the Santissima Annunziata.

Brunelleschi's science of measure and proportion dominates the apparent simplicity of his design, in which Corinthian columns support round arches and an entablature. The cornice above the frieze serves as the base for a row of pedimented windows, one above the keystone of each arch. Since he was obliged to be absent from Florence during a crucial phase of construction, Brunelleschi provided the builders with something they had never seen, a measured

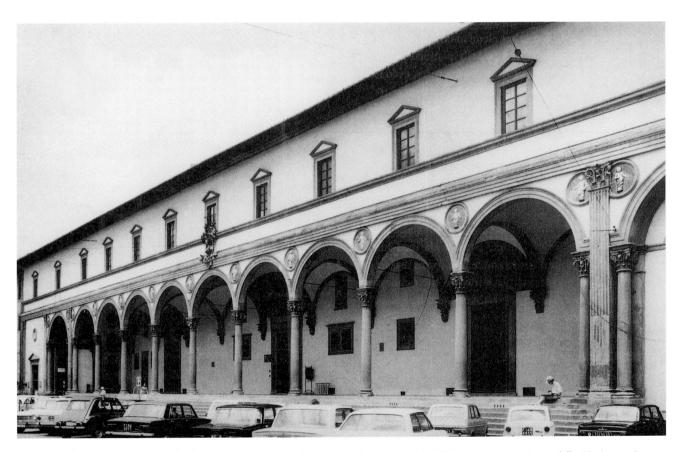

6.6. FILIPPO BRUNELLESCHI. Ospedale degli Innocenti. Begun 1419; completed mid-fifteenth century. Piazza della SS. Annunziata, Florence. Enameled terra-cotta medallions with "Innocents" by Andrea della Robbia, 1487. Building commissioned by the Arte della Seta

scale drawing, and, according to his biography, they had difficulty with the measurements and deplored the absence of the customary wooden model. Worse, Brunelleschi's name eventually disappears from the documents concerning the hospital's erection, and the new supervisor eliminated from his design roundels in the frieze and pilasters between the windows of the second story. Only the arcade and the Corinthian pilasters embracing the terminal arches are as Brunelleschi planned them.

In both plan and elevation, the structure is founded on modules. The system of proportions used by Brunelleschi is based on the sixth century B.C.E. writings of Pythagoras. Pythagoras noted that when plucked a stretched string produces by vibration a note, and that when the string is measured and plucked at points which correspond to exact divisions by whole numbers—1/2, 1/3, 1/4, etc.—the vibrations will produce a harmonious chord.

Brunelleschi's modular system starts with equivalencies. The distance between the centers of the columns, for example, equals the distance between the center of a column and the back wall of the loggia; this means that each bay of the structure is a perfect square. Other modules related to this one—in the relationships of one to two, one to five, and two to five—control the height of the loggia, the width of the principal doors, the height of the second-story windows, the width of the smaller doors and windows, the height of the architrave, the proportions of capitals and bases, the proportions of the interior rooms, and other elements of the design.

The appearance of Brunelleschi's rationally planned buildings is different from that of ancient Roman structures, even if these provided many of the elements from which his new architecture was derived. Characteristically, Brunelleschi preferred the smooth shafts of Florentine Romanesque columns to the fluted ones he must have seen in Rome, although it should be noted here that the great monolithic columns of the Pantheon are unusual in not being fluted. Brunelleschi reserved fluting for pilasters, such as the ones that enframe the outer arches of the Innocenti loggia; it is no surprise to discover that the columns are three-fifths the height of these pilasters. Brunelleschi consistently simplified and clarified his Roman models; in his capitals, for example, the forms are set separately against a plain ground, in contrast to the richness and technical virtuosity of Roman Corinthian capitals.

Brunelleschi's Sacristy for San Lorenzo

The sacristy that Brunelleschi designed for San Lorenzo is now called the Old Sacristy to distinguish it from its later counterpart at the other end of the transept, the New Sacristy, designed by Michelangelo (also known as the Medici Chapel, see fig. 18.3). Brunelleschi's sacristy was commis-

sioned by Giovanni di Bicci de' Medici, founder of the family fortunes, as an addition to the medieval Basilica of San Lorenzo. With Giovanni's fortune supporting the work, it proceeded with rapidity, and when completed in 1428 or 1429, the sacristy was the first Renaissance architectural space that could actually be entered and experienced. In plan (fig. 6.7), the interior is an exact square, extended on one side by a square altar space flanked by two chambers. This principal side of the room (fig. 6.8; see fig. 3) is articulated by fluted Corinthian pilasters, an entablature, and an arch framing the altar space. Pendentives lead our eyes upward to the ribbed dome (fig. 6.9). The ribs divide the drum into twelve round-arched compartments, each containing an oculus.

Here again Brunelleschi maintained a simple system of proportions: the height of the lower story to the top of the architrave equals the distance from the architrave to the circular base of the dome, and the distance from the dome to the base of the lantern. Each story is, then, related to the height of the entire building as one to three.

The lightness and clarity of Brunelleschi's design are challenged by the powerful sculptures added by Donatello—bronze doors, reliefs filling the niches over the doorways, and medallions. Brunelleschi protested, and this is one of many occasions when artists of the Renaissance did not see eye to eye. Considering the gulf between the serenity of Brunelleschi's ideas and the violence of Donatello's temperament, a clash between the two is hardly surprising.

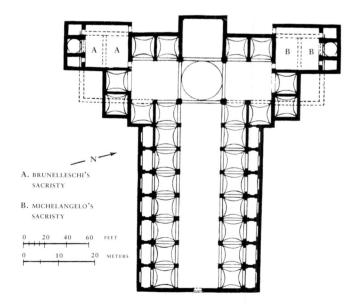

6.7. FILIPPO BRUNELLESCHI.

Plan of S. Lorenzo, including First Sacristy (Old) (see figs. 3, 6.8, 6.9) and New Sacristy or Medici Chapel by Michelangelo (see figs. 18.3–18.10). Commissioned by Giovanni di Bicci de' Medici and Cosimo de' Medici

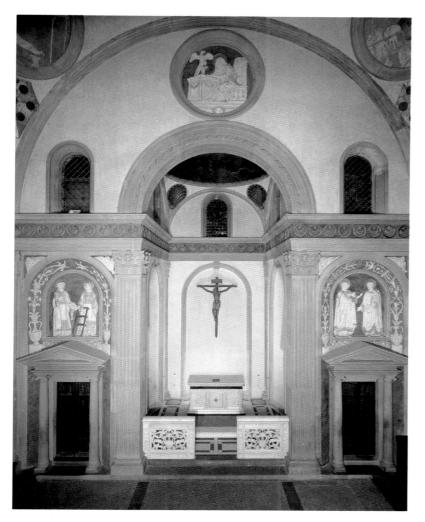

6.8. FILIPPO BRUNELLESCHI. Sacristy, S. Lorenzo, Florence. 1421-28. 38 x 38' (11.6 x 11.6 m) Commissioned by Giovanni di Bicci de' Medici. Architectural sculpture by Donatello. After 1428-c. 1440. Probably commissioned by Cosimo de' Medici. (see fig. 3)

6.9. FILIPPO BRUNELLESCHI. Dome, Sacristy, S. Lorenzo, Florence. 1421–28. Stucco reliefs by Donatello. After 1428-c. 1440

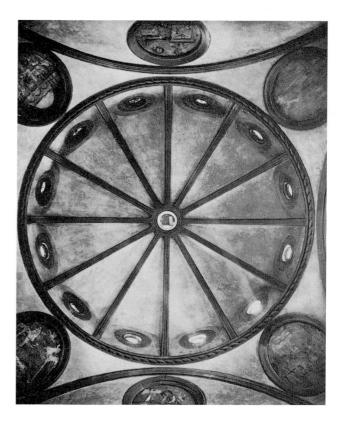

San Lorenzo and Santo Spirito

Brunelleschi was also responsible for a revolution in the plan of church interiors and in the relation between church buildings and the urban complexes surrounding them. He was commissioned to build two of the major churches of Florence, San Lorenzo and Santo Spirito, and in each case he also submitted a design for an adjacent *piazza*. He never saw either church completed, and the projects for their *piazze* (pl.) were altered, retaining nothing of his original plans. Nonetheless, Brunelleschi's new ideas for church interiors and his vision of harmonious urban design remained influential for centuries.

The building history of neither church is clear, especially at the planning stage, but it seems that both took shape in Brunelleschi's mind at about the same time. San Lorenzo had the advantage of Medici patronage, and consequently benefited by more expensive materials and elaborate detailing, but it was erected piecemeal and its architect had to struggle with preexistent buildings, including his own sacristy. Santo Spirito, on the other hand, is evidence of what Brunelleschi could do when given a free hand. In planning both churches he swept away the whole history of late medieval architec-

ture—its complex vaulting systems, compound piers, and radiating chapels—and he even abandoned the openwork timber ceilings characteristic of Dominican and Franciscan churches in the Duecento and Trecento (see fig. 2.43). Clearly he wanted to return to the simple, three-aisled plan of Early Christian basilicas in Rome, which he probably thought was also exemplified in the Romanesque Church of Santi Apostoli in Florence.

The lower stories of San Lorenzo (fig. 6.10) and Santo Spirito (figs. 6.11, 6.12) are nave arcades supported on monolithic Corinthian columns of great height, simplicity, and beauty. To achieve greater height, Brunelleschi added impost blocks above the capitals composed of squared sections of Corinthian entablature, including the cornice, between the capital and the arch. The flat ceilings are supported on a clerestory wall that is unbroken save for round-arched windows. The interior details are simple and light, with delicate projections; the flat surfaces of the masonry are covered with stucco and painted white, while the supporting elements and trim, including the columns, arches, and entablature, are made of a gray stone the Florentines call, appropriately, pietra serena. The result is a cool, harmonious, and austere

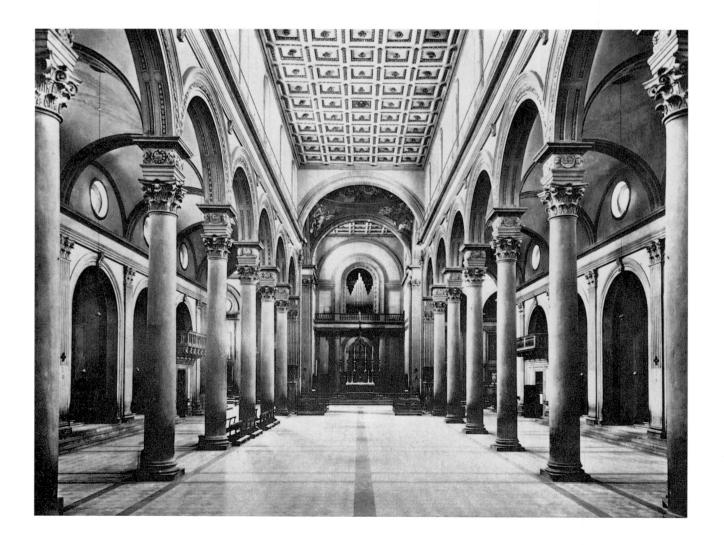

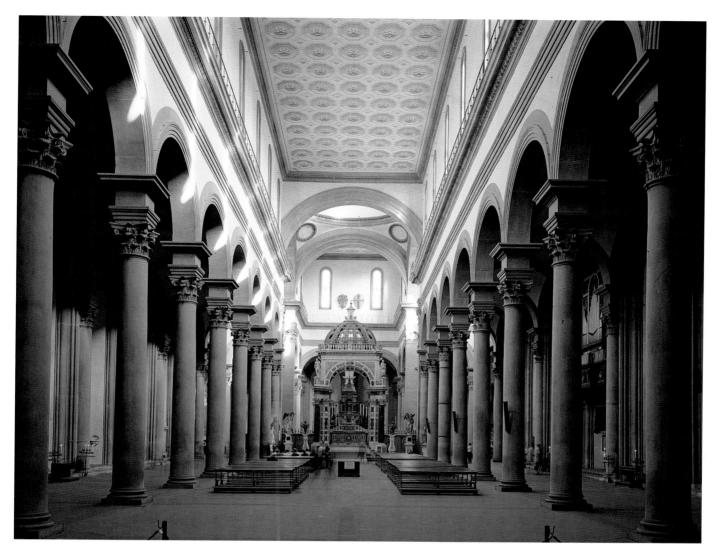

6.11. FILIPPO BRUNELLESCHI.

Nave and choir, Sto. Spirito, Florence. Model submitted 1434–36(?); construction 1446 to late fifteenth century

Right: 6.12. FILIPPO BRUNELLESCHI.

Plan of Sto. Spirito as originally intended; dotted lines indicate present exterior walls

Opposite: 6.10. FILIPPO BRUNELLESCHI.

Nave and choir, S. Lorenzo, Florence. Choir and transept begun c. 1425; nave designed 1434(?); construction 1442 to 1470s.

Commissioned by Giovanni di Bicci de' Medici and Cosimo de' Medici. The building of the church was funded by a gift of 40,000 florins from Cosimo, in exchange for an agreement that he could be buried in front of the high altar and that the Medici arms would be the only arms to appear in the transept or choir. Later, Cosimo's grandson Lorenzo il Magnifico would write in his *Ricordi* (diary) that between 1434, the year Cosimo returned from exile, and 1471, seven years after Cosimo's death, the Medici family had spent the enormous sum of 663,755 gold florins for alms, taxes, and public buildings.

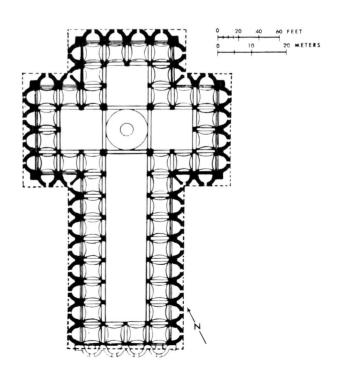

alternation of gray and white that emphasizes the relationships between the parts of the structure. This new two-tone system, devised by Brunelleschi, would be used to decorate the interiors of Florentine churches and dwellings into the eighteenth and nineteenth centuries. The vaults of the side aisles have the pendentive domes of the Innocenti loggia, while the ceilings of the nave are coffered with carved and gilded moldings and rosettes at San Lorenzo and painted decoration in the cheaper ceiling at Santo Spirito.

If each square side-aisle bay is the module, then each nave bay is two modules wide and the crossing is four modules square (see figs. 6.7, 6.10-6.12). The bays of the aisles and ambulatory are four times as tall as they are wide, and the nave is twice as tall as the aisles and ambulatory. The width of the nave equals the height of the nave arcade. These relationships are emphasized in the floor pattern at San Lorenzo (never, unfortunately, carried out at Santo Spirito). Its double lines indicate the width of the plinths as well, establishing that the width of a plinth is one-fifth the distance between the plinths. The visitor is everywhere made aware of the geometric grace of the individual shapes and of their function in the harmonic, Pythagorean structure of the church. Brunelleschi's rows of columns and arches also emphasize the systematic diminution as the eye is led down the interior. No wonder Brunelleschi has been traditionally credited with the invention of one-point perspective—a system that, as we have seen, was developing long before his day, but for which he seems to have provided the first mathematical formula.

A summary of the building history of both churches helps explain their differences. In 1418 it was decided to extend the medieval Church of San Lorenzo with a new choir and transept. Construction was started in 1421, but all the houses on the site were not demolished for two or three years. Only about 1425, when the foundations of the new choir and transept were already laid, was Brunelleschi, who had already designed the neighboring sacristy, called on the scene. He replaced the original plan for octagonal Gothic piers with square Renaissance piers faced by Corinthian pilasters, but it was no longer possible to make any changes in the basic plan. There was still no talk of tearing down the nave, for which the new constructions were still intended as an addition. It is not clear how much was completed before the expenses of the war with Milan forced abandonment of the work, but in 1434 houses flanking the church were torn down with the idea of creating a large piazza facing the Medici Palace. At this moment Brunelleschi seems to have conceived a plan for replacing the medieval sections of the church. This plan did not include the chapels that line the side aisles; they were added after 1470 and fit the structure poorly.

At the same time, Brunelleschi was involved in the project to build a new and grandiose basilica to replace a small thirteenth-century structure at Santo Spirito. Here lateral chapels were planned from the first, and Brunelleschi's design, probably datable to 1434–36, integrates semicircular chapels, thus creating a succession of interrelated circles and squares. Brunelleschi made the arms of the transepts and choir of equal length, and ran the semicircular chapels continuously around the exterior, even intending originally to continue them across the façade. Brunelleschi intended that the apsidal shape of these chapels be visible on the exterior, establishing a play of curved forms against flat clerestory walls and roof lines that would demonstrate great sculptural richness. There could scarcely have been a stronger departure from the "paper architecture" of Brunelleschi's early work. Unfortunately, the apses are now subsumed within the flat exterior walls, and the four chapels along the façade, which would have served as entrance porches, were never built.

As compared with the flatness, lightness, and grace of San Lorenzo, the interior of Santo Spirito produces an impression of mass, space, and majesty. The apsidal chapels in Santo Spirito are separated not by pilasters, as at San Lorenzo, but by half columns. Except for the long arched window, each apsidal chapel is smooth and unbroken and thus seems related to the pendentive vault above. Throughout the church, we are presented with an alternation between massive, convex gray forms and elusive, concave white forms; this effect corresponds to the continuous shifting of spatial views through ever-changing relations of columns and arches. Unfortunately, the body of citizens responsible for carrying out the construction of the church from public funds after the Florentine victory at Anghiari in 1440 (see p. 499) did not accept the architect's idea of rotating the plan so that the church would face the Arno across a wide piazza.

San Lorenzo did not enjoy a state subsidy, and not until 1442 did Cosimo de' Medici agree to finance the continuation of the long-delayed building. Brunelleschi was destined to see his great architectural vistas only in imagination; when he died in February 1446, not one column for either of his basilicas had even been quarried. Under the supervision of Michelozzo di Bartolommeo, work dragged on at San Lorenzo (with many errors of judgment) until after 1470; at Santo Spirito it was even longer, and under a variety of architects. We have no idea how Brunelleschi intended either of the façades to appear; he seems to have been commissioned only to provide models for the body of each church. Santo Spirito has a simple plastered façade, while that of San Lorenzo, in spite of Michelangelo's dream of completing it (see pp. 582–83 and fig. 18.2), remains unfinished to this day. Despite these vicissitudes, San Lorenzo and Santo Spirito remain two of the most serene of Renaissance interiors.

Santa Maria degli Angeli

A little building that might have been one of Brunelleschi's masterpieces was the chapel of the Monastery of Santa Maria degli Angeli, the Florentine seat of the Camaldolite

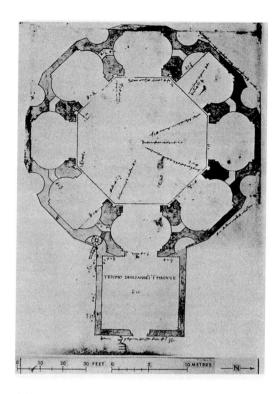

6.13. FILIPPO BRUNELLESCHI. Plan of Sta. Maria degli Angeli, Florence. Anonymous drawing after Brunelleschi's design. Construction begun 1434. Commissioned by the Arte di Calimala, executor for the heirs of Pippo Spano

Order (see pp. 167, 261–63), whose prior was then the celebrated and widely traveled scholar Ambrogio Traversari. The foundations were started in 1434, but the current structure dates almost entirely from 1937 and only the ground plan gives any hint of how Brunelleschi's building would have looked. It was intended for the community of about forty monks and would have had no space for public worship. Insofar as can be determined from early drawings (fig. 6.13), the plan was octagonal with each of the eight sides opening into a rectangular chapel. The exterior, with sixteen sides, would certainly have been roofed by a dome—one is even shown in a fifteenth-century topographical map of the city. In this project we have the first step in the direction of the central plan, which was to reach its culmination later in the High Renaissance projects for the new St. Peter's in Rome.

The Pazzi Chapel

Brunelleschi's chapter house of Santa Croce was commissioned by the powerful Pazzi family and is known as the Pazzi Chapel (fig. 6.14). Although the structure may have been designed c. 1423–24, construction did not start until 1442 and it was only finished c. 1465. The portico itself is awkward, but the latest suggestion is that it follows Brunelleschi's design with the substitution of dome over the entrance, the raised height of which led to the awkward, unfinished roof.

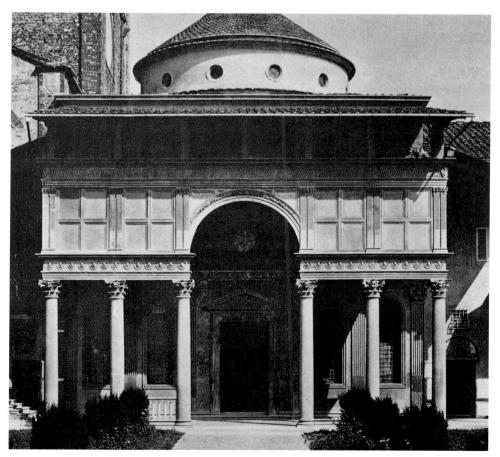

6.14. FILIPPO BRUNELLESCHI.
Pazzi Chapel, Sta. Croce, Florence.
Perhaps designed c. 1423–24;
built 1442–c. 1465. Commissioned
by Andrea di Guglielmo Pazzi.
After the death of Brunelleschi, the
construction was probably supervised by
the workshop of Bernardo Rossellino.

The plan and interior (fig. 6.15, 6.16) represent an amplification and consolidation of the principles announced earlier in Brunelleschi's Sacristy of San Lorenzo (see figs. 6.7, 6.8 see also fig. 3); it is a rectangular structure of three stories, the second containing the arches and pendentives that support the third, a star-vaulted dome culminating in a lantern. Here the resemblance ceases. Probably because the Franciscan chapter of Santa Croce required a large meeting space, the central square is extended on either side by half a square. As a result, the building is twice as wide as it is deep; the center is roofed by the twelve-ribbed dome, the sides by barrel vaults.

The side walls are articulated by Corinthian pilasters upholding a decorative arch and embraced by the barrel vault; this, in turn, is supported by quarter-width pilasters, the remainder of which is folded onto the adjoining wall. The arched panels on the back and side walls match the size and shape of the windows on the entrance wall. The distance between the outer edge of a quarter-width pilaster and the inner edge of the next pilaster on the side walls is the basic module for the interior articulation—but not for the total proportions—of the chapel. The module is clearly indicated by the architect's use of corbels, and thus the space between the

inner edges of the central pilasters is two modules wide. The area of the altar space is an exact square, two modules wide and two deep. The height of the order from its base (above the bench) to the top of the cornice is four modules; from above the bench to the bottom of the architrave, three and one-half. Each shaft is three modules high and one-third module wide, each capital one-third module high and one-half module wide at the abacus.

The proportions of the three stories—architectural order, arches, and dome—are not identical, as they were in the San Lorenzo Sacristy. Here they diminish as they rise. The amount by which these stories are decreased is in each case one-half module. The result of this controlled diminution is that the Corinthian order, used throughout the chapel, gains in importance and dominates the interior to an extent impossible in the San Lorenzo Sacristy. As in Brunelleschi's other works, the clear-cut decorative details are set out in *pietra serena* against white stucco walls, vaults, and dome. The only color is provided by the stained-glass window over the altar and the glazed terra-cotta reliefs in the medallions—predominantly the sky blue of their backgrounds—and by the Pazzi coats of arms in the pendentives.

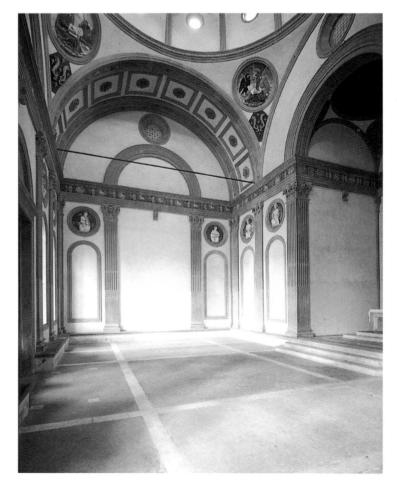

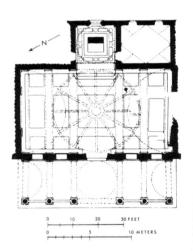

6.16. FILIPPO BRUNELLESCHI. Plan of Pazzi Chapel

6.15. FILIPPO BRUNELLESCHI.
Interior of fig. 6.14. Twelve enameled terra-cotta medallions of apostles by Luca della Robbia.
Enameled terra-cotta medallions of the four evangelists attributed to Brunelleschi.

At this juncture one might bear in mind the admonition of the contemporary Florentine humanist Giannozzo Manetti, who stated in his book On the Dignity and Excellency of Man that the truths of the Christian religion are as clear and self-evident as the axioms of mathematics. The rational, ordered clarity of Brunelleschi's religious buildings may disappoint those who, like Ruskin, the nineteenth-century British critic, are fascinated by Gothic architectural idioms, which still epitomize the sacred among Christian building types. Yet Brunelleschi's churches are religious structures of the highest order. The Florentine humanists thought that geometric principles could unlock mysteries at the heart of the universe and reveal the intentions of a God who was, if one only knew how to go about it, eminently understandable and had created the universe for human enjoyment. Alas, Brunelleschi's vision of architectural harmony and perfection, reflecting the order of the cosmos, was doomed to incompletion. The only work Brunelleschi ever saw finished, the Sacristy at San Lorenzo, was spoiled in his estimation by the encroachments of others. Despite the incomprehension of those who continued it, his truncated lifework remained to inspire the architects of the Renaissance.

The Medici Palace

According to Vasari and other sources, Brunelleschi submitted a model for a new house to Cosimo de' Medici. It has been suggested that this house would have been situated on

the Piazza San Lorenzo, its portal opposite that of the church, and that they would have faced each other across a large piazza. This location was within the third circle of walls, but outside the area of Florence where the older families lived. Vasari reports that Cosimo rejected Brunelleschi's proposal as too sumptuous and that Brunelleschi then smashed the model. The story suggests that Cosimo did not wish his residence to be so splendid that it would make him appear what, in fact, he was—the ruler of Florence. Cosimo had been exiled in 1433–34, but by 1446, when the palace was begun, Cosimo had reinforced his power by political maneuvers; although the machinery of the Republic remained superficially intact, it was directed by Cosimo.

The designation of the Medici house as a palace does not indicate any special status, for the Italian word *palazzo* (palace) is used to refer to any large building, and town houses of Florentine merchants, even modest ones, are called *palazzi*. But the dimensions of the Medici Palace (fig. 6.17) are by no means modest. Each story is more than twenty feet high, and the entire structure, to the top of the cornice, rises more than seventy feet above the street.

It is usually presumed that the architect of this palace was Michelozzo di Bartolommeo (1396–1472), but at least one scholar has reattributed it to Brunelleschi based on the originality of the structure; the exceptional nature of the palace makes it difficult to identify the architect. After the palace was bought by the Riccardi family in the mid-seventeenth century, it was extended; these later additions must be disregarded

6.17. MICHELOZZO DI BARTOLOMMEO

(attributed to). Palazzo Medici
(now known as the Palazzo Medici-Riccardi),
Florence, as seen in an early print.
Begun 1446. Commissioned by
Cosimo de' Medici. Ground-floor
pedimented windows by Michelangelo.
c. 1517. Commissioned by Pope Leo X.
A diplomat from Milan wrote in 1459 that
the palace was "embellished on every side
with gold and fine marbles, with carvings
and sculptures in relief, with pictures and
inlays done in perspective, by the most
accomplished and perfect masters."

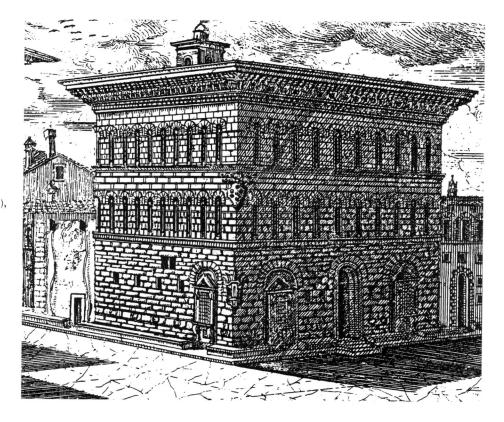

to understand the original proportions. We must also imagine the building without the pedimented windows of the ground floor, which were added in the Cinquecento by Michelangelo; originally the arches were open and the corner was an open loggia.

To modern eyes perhaps the most striking aspect of the Medici Palace is its unpalatial appearance. The rough-cut stones of the ground floor seem more appropriate for a fortress, and something of the grimness of Florentine medieval house-towers seems to linger in this design. It is not that the rustication looks like that of medieval buildings; these blocks, haphazardly projecting, were imitated from the rustication of such ancient Roman monuments as the Forum of Augustus, which in the Renaissance was believed to have been the Palace of Caesar. Even in the turbulent civil existence of Florence, such rustication can have had no defensive nature. The rustication may have been intended to convey to the Florentine passerby a moral quality—the Tuscan dignity and antique fortitude of the House of Medici. The lucidity of the plan and the regularity of the basic shape of the palace were new to Florentine palace architecture and may have been inspired by the description of ancient Roman houses given by Vitruvius, the first century B.C.E. architect and theorist. The interior has been so remodeled that it is hard to reconstruct its original nature and decoration; today we miss especially the inlaid wooden wainscoting of the bedroom with the battle scenes by Paolo Uccello (see figs. 11.5, 11.6), and Piero de' Medici's study, which had an enameled terra-cotta ceiling with representations of the months by Luca della Robbia which survive today at the Victoria and Albert Museum in London. An inventory made after the death of Lorenzo the Magnificent in 1492 shows that the palace housed a treasury of Quattrocento painting, sculpture, and decorative arts, as well as a collection of ancient coins and gems.

Narrow horizontal moldings called stringcourses separate the three stories, and the progressive diminution in height from the lower to the upper story is accompanied by correspondingly smoother surface treatments. The powerful blocks of the ground story are replaced on the second by trimmed blocks with deep joints, while the joints between the blocks of the third story are almost invisible. The windows of the upper story are mullioned, as is characteristic of Florentine Quattrocento palaces. These windows, derived from such Gothic structures as the Palazzo dei Priori (see fig. 2.45), utilize round arches supported on slender Corinthian colonnettes; the lunettes are decorated with Medici arms and symbols, and there is a large Medici coat of arms on the corner. The cornice (fig. 6.18), although its many elements are directly imitated from Roman models, echoes the sharply projecting eaves that give Florence and its subject towns so distinctive an appearance.

Like large medieval palaces, the Medici Palace was built around a central courtyard (fig. 6.19). Its lower story is a

continuous arcade, the second has mullioned windows resembling those of the exterior, and the third was originally an open loggia. The columns of the ground story resemble those of Brunelleschi's buildings, but they are heavier in their proportions, as is appropriate for columns that functionally and visually must support an enclosed second story. The Medici Palace served as the model for Florentine palazzi for almost a century.

Among all the churches, chapels, palaces, villas, and monasteries carried out by Michelozzo, either alone or in collaboration with other architects, one of his most elegant and appealing creations is the Library of the Monastery of San Marco (fig. 6.20; for a plan of the monastery, see fig. 9.8), part of an extensive rebuilding project supervised by Michelozzo and financed by Cosimo de' Medici in the years following 1436. The library has three aisles of equal height, the outer ones groin-vaulted, the central one roofed by a barrel vault and supported on an airy arcade of Ionic columns. The long, narrow design with windows on both sides is intended to maximize the availability of natural light. The slenderness of the elements gives a lightness to the interior, an effect that reappears in the architectural backgrounds of paintings by Fra Angelico (see fig. 9.9), who lived and worked in this monastery. The impressive collection housed here was consistently enriched by donations from Cosimo de' Medici; since books could be circulated for a period of six months to applicants who had been approved by the trustees, the Library at San Marco can be described as the first public library since antiquity.

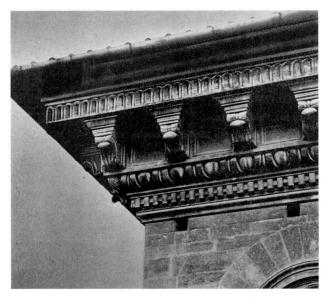

6.18. MICHELOZZO DI BARTOLOMMEO. Detail of cornice, Palazzo Medici, Florence

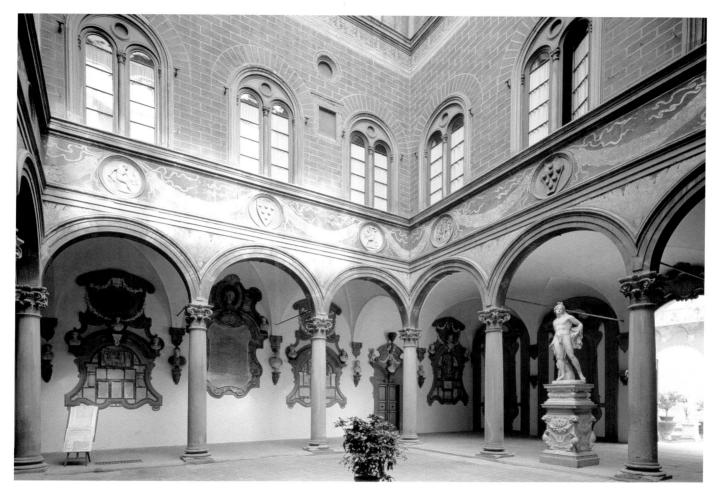

6.19. MICHELOZZO DI BARTOLOMMEO (attributed to). Courtyard with *sgraffito* decoration, Palazzo Medici, Florence. Begun 1446

6.20. MICHELOZZO DI BARTOLOMMEO. Library, Monastery of S. Marco, Florence. 1442–44. Commissioned by Cosimo de' Medici

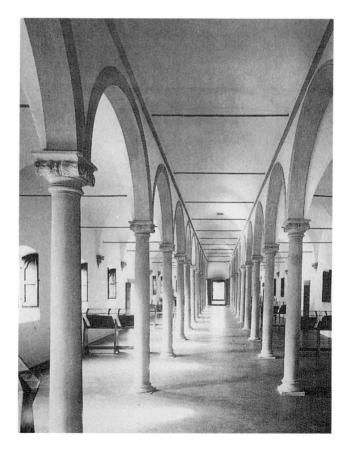

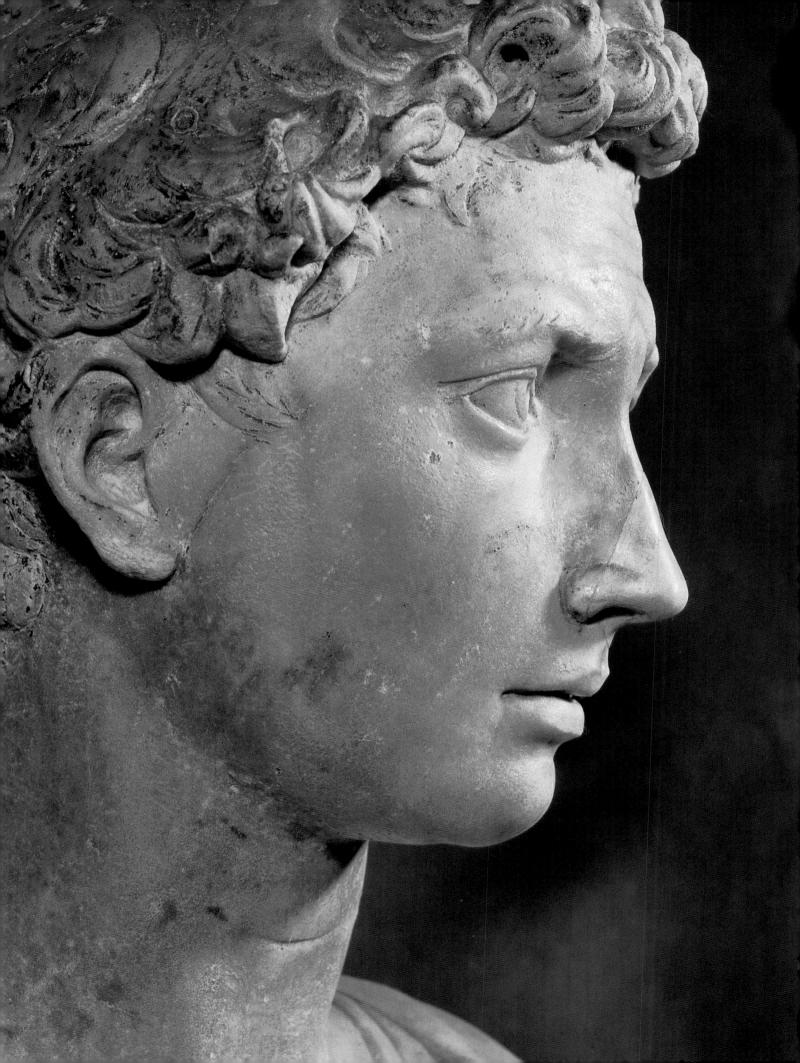

GOTHIC AND RENAISSANCE IN TUSCAN SCULPTURE

n its use and transformation of classical elements and the evolution of a mathematical proportion system, architecture is the art in which the new principles of the Renaissance are most clearly evident. At the same time, sculptors were creating a remarkable group of works that expressed the new concepts of the dignity and autonomy of the individual.

The Competition Panels

Among the most ambitious sculptural projects of the Early Renaissance was the continuation of the series of doors for the Florentine Baptistery, one pair of which, showing the life of John the Baptist, had been made by Andrea Pisano in the 1330s (see fig. 3.34). Two more sets, to illustrate the Old and New Testaments, were needed. In 1401 the Opera of the Baptistery announced a competition for the second set of doors. The competition was under the supervision of the Arte di Calimala, the refiners of imported woolen cloth and the oldest of Florentine guilds. All seven sculptors who are reported to have competed were Tuscans, including the Sienese Jacopo della Quercia (c. 1380–1438), Filippo Brunelleschi, and Lorenzo Ghiberti (1381?–1455). The victor was Ghiberti, who was scarcely more than twenty at the time and trained as a painter.

The subject selected for competition was the story of how God tested the faith of Abraham by commanding him to sacrifice Isaac, his only son, born to him and his wife Sarah in their extreme old age. According to the story, Abraham, accompanied by two servants and a donkey, took Isaac into the wilderness to enact the sacrifice. But just before Abraham's knife was to slit his son's throat, God sent an angel who told Abraham that the Lord was pleased by Abraham's faith and would be satisfied with the offering of a ram caught in a nearby thicket. The story was interpreted as foreshadowing the sacrifice of Christ, God's son, but the Opera, as we shall see, may have had a more immediate reason for selecting it.

The two preserved competition panels (figs. 7.1 and 7.2), by Brunelleschi and Ghiberti, represent the same moments in the story: the angel intervenes as the boy kneels on the altar, his father about to put a knife to his throat (fig. 7.3). The two servants, the ram caught in the thicket, and the donkey drinking from a stream are all represented. Perhaps the inclusion of these elements, as exhibited in both panels, was required by the competition.

The competition's theme is divine intervention, delivering the chosen people from impending doom. We must remember that the Florentines credited the unexpected death of Giangaleazzo in September 1402 to divine intervention. The date of the announcement of the competition is not known; it may have been after September, or the choice of subject may have mirrored Florentine hopes for a solution.

Brunelleschi's relief (fig. 7.1) is an original creation, full of daring poses and observation of natural movement, mass, and weight. Surprisingly, the harmony and balance that we sense in Brunelleschi's later architecture are absent from this dramatic interpretation. Abraham twists Isaac's head to expose his neck, while the angel rushes in to physically restrain him, thus preventing the sacrifice. Brunelleschi's interpretation is profoundly human. Abraham's brutal treatment of Isaac suggests that he has blocked out the knowledge that it is his only child that he has to sacrifice to please God. The body of the boy is scrawny, the poses of each figure tense, the rhythms of both drapery and figures sharp and broken—all rendered in a naturalistic way.

The young Ghiberti, who was trained as a painter but had not yet matriculated in any guild, least of all the Arte della Seta to which metalworkers belonged, nonetheless displays extraordinary accomplishment in handling bronze (fig. 7.2). In his interpretation the boy looks upward for deliverance from death. Abraham, his arm embracing the boy, is poised with his knife pointed toward—but, unlike Brunelleschi, not touching—his son. With a gesture the floating, foreshortened angel is able to stop the sacrifice. The ram rests

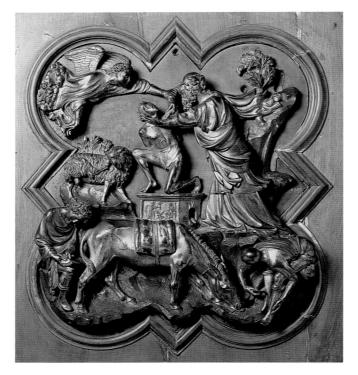

7.1. FILIPPO BRUNELLESCHI. Sacrifice of Isaac. 1402–3. Bronze with gilding, $21 \times 17^{1/2}$ " (53 x 44 cm) inside molding. Museo Nazionale del Bargello, Florence. Competition panel for the second set of bronze doors for the Florentine Baptistery, sponsored by the Opera of the Baptistery and the Arte di Calimala

7.2. LORENZO GHIBERTI. Sacrifice of Isaac. 1402–3. Bronze with gilding, $21 \times 17^{1/2}$ " (53 x 44 cm) inside molding. Museo Nazionale del Bargello, Florence. Competition panel for the second set of bronze doors for the Florentine Baptistery, sponsored by the Opera of the Baptistery and the Arte di Calimala

quietly before his thicket, while the servants converse gently. There is none of the physical contact and physical strain of Brunelleschi's relief, and his jagged movements are replaced in Ghiberti's work by poses as graceful as those of dancers. Throughout Ghiberti's composition—in every figure and drapery fold and even in the rocks—curving rhythms create a continuous melody.

Ghiberti's melody comes to its climax in the body of Isaac (fig. 7.3). While Brunelleschi had analyzed the human body with an unprecedented understanding of naturalistic detail, his end result is ungraceful, albeit expressive. Ghiberti's is the first truly Renaissance nude; here naturalism and classicism are blended and sublimated by a new vision of what a human being can be. The body displays the strength and resiliency of a perfectly proportioned youth, overflowing with energy yet

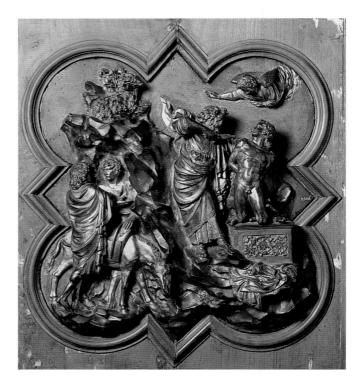

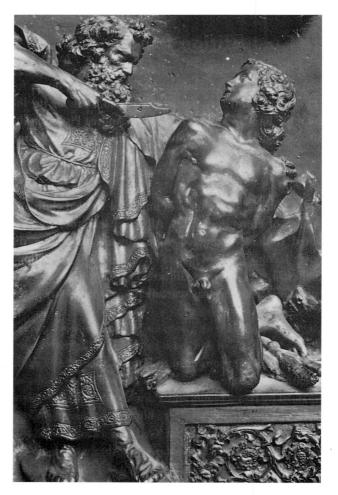

7.3. Isaac, detail of fig. 7.2

remarkably graceful. Not since the last Roman sculptor capable of imitating a Greek or Hellenistic original had such a nude been created. Ghiberti, without special study of anatomy as far as we know, understood how to represent the difference between bony and muscular tissue, the dynamic possibilities of muscles, and the softening quality of skin. Most natural of all, perhaps, is the expression of the boy—not only his face but the spring and lightness of his pose.

Ghiberti's Isaac was certainly inspired by a study of ancient Roman nude figures, and other references to classical antiquity are evident in both reliefs. The head of Abraham in both reliefs shows the inspiration of ancient Roman heads of Jupiter. The servant plucking a thorn from his foot in Brunelleschi's panel is based on a popular Roman sculpture (many copies are known to exist) called the Spinario; the second servant is also taken from an ancient model. The relief on the front of Brunelleschi's altar features figures enacting what seems to be a scene of religious offering. The style is simple and might even be described as explicitly crude; whatever model may have inspired Brunelleschi in this case, the style suggests that he is intentionally setting the event in the very distant past. In Ghiberti's relief the altar is decorated with an ancient Roman rinceau or vine pattern, and antique models have been found for both his servants and the ram. These two reliefs are so replete with classical quotations—yet so few surface in Ghiberti's subsequent first set of Baptistery doors—that one wonders if allusions to ancient art were a requirement for the competition.

Some important technical differences between the two reliefs should be noted. Brunelleschi's is composed of a bronze sheet to which the individually cast figures are attached, while Ghiberti's background and figures are cast in a single, continuous piece, with the exception of the figure of Isaac, which was attached. Ghiberti's relief is, therefore, stronger and, because his figures are hollow, his relief is only about two-thirds as heavy as Brunelleschi's. The judges of the competition would surely have realized that doors made following Ghiberti's technique would endure better and require less bronze. For the practically minded members of the Arte di Calimala, such differences may have helped make Ghiberti the obvious winner in the competition.

Ghiberti was the author of a lengthy work titled, in classical style, the *Commentaries*. Much of the text deals with the relative merits of artists of classical antiquity whose works were known to Ghiberti from literary sources. One *Commentary* discusses many scientific subjects and is especially devoted to an analysis of the eye, its structure and its functions, and the relation of sight to the behavior of light. Given this study, it seems appropriate to note how Ghiberti treats the eye in his sculpture. Before his time the eye was generally modeled as a blank surface, whether or not the cornea was painted on later (as in the case of a marble

statue) or sculpted away so that colored inlay of ivory or glass paste could be inserted. Ghiberti makes Isaac's gaze infinitely more expressive by delicately incising the line of the cornea and dot of the pupil. This treatment of the eye underscores other new optical qualities evident in Ghiberti's sculpture. Near the beginning of the second *Commentary* he says, "Nessuna cosa si vede senza la luce" ("Nothing can be seen without light"), and in his relief gilded surfaces send light flowing across delicate textures or reflect it into shadows. In almost all of Ghiberti's sculpture the eye is delineated in this new way, conferring a vivid individuality to human expression.

Ghiberti to 1425

The Opera acquired the competition relief in 1403 and paid Ghiberti a sizable sum for gilding the figures and landscape. He and the members of his workshop worked on the set of doors (which are today known as the North Doors) for twenty-one years, until 1424. The scale of the project demanded such a lengthy commitment; the project consisted of a range of complex techniques: modeling in wax, casting in bronze, then chasing, gilding, and burnishing, all guided by Ghiberti's meticulous execution.

Between the competition and the commission, the subject for the doors was changed, and Ghiberti was confronted with illustrating the New Testament instead of the Old. His panel of Abraham was thus set aside for use in the third set of doors. The second doors (fig. 7.4) were designed to match the Trecento doors of Andrea Pisano, which were organized in twenty-eight quatrefoils arranged in seven rows of four (see fig. 3.34). The borders that define Ghiberti's quatrefoils, however, provide a richer enframement than Andrea's relatively austere design of alternating diamonds and stylized flowers. Through Ghiberti's margins flows a tide of vegetable and animal life-branches, foliage, fruit, birds, lizards, and even insects-and there is a head in a quatrefoil at each intersection. These heads, with the exception of Ghiberti's selfportrait, apparently represent Old Testament prophets and prophetesses, all uniquely different: young, old, male, female, calm, agitated. Several reveal the influence of Ghiberti's study of antique sculpture.

The lowest two rows of reliefs represent the four evangelists and the four Early Christian theologians known as the Fathers of the Church. Above these begin the New Testament scenes; the first is the *Annunciation* (fig. 7.5). Ghiberti's version is related to a number of Late Gothic Annunciations in Florentine art, particularly those by Lorenzo Monaco. In these, Gabriel flies into the scene—a visionary angel with clouds streaming from his feet, his wings beating, still airborne at the command of God the Father, who sends down the dove of the Holy Spirit.

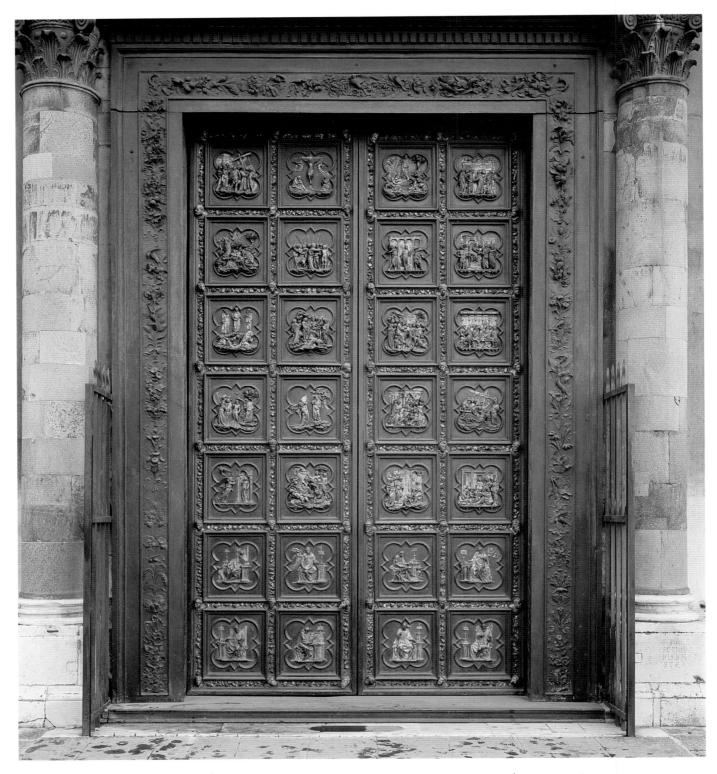

7.4. LORENZO GHIBERTI. North Doors. 1403–24. Bronze with gilding, height approx. 15' (4.6 m). 🖺 Baptistery, Florence. Commissioned by the Opera of the Baptistery and the Arte di Calimala

Ghiberti's composition exudes grace, elegance of line, and economy of detail. Throughout the doors, Ghiberti is both attracted to the compelling rhythms of the quatrefoil format established by Pisano's doors and frustrated by its emphasis on surface patterning. He keeps the flat bronze

background, but rotates the portico before which the Virgin stands and deploys the pier to indicate depth, penetrating the flatness of the plaque. The foreshortened figure of God seems to emerge through the background rather than being placed against it, as were Andrea's figures. Here

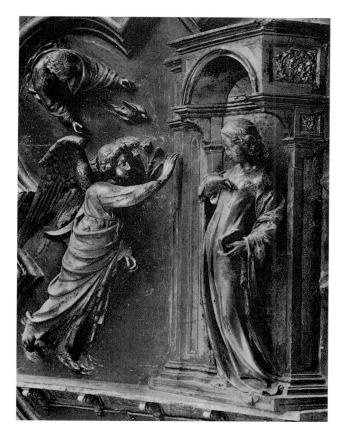

7.5. LORENZO GHIBERTI. Annunciation, panel on the \hat{m} North Doors, Baptistery, Florence. Before 1407. Bronze with gilding, $20^{1/2}$ x $17^{3/4}$ " (52 x 45 cm) inside molding

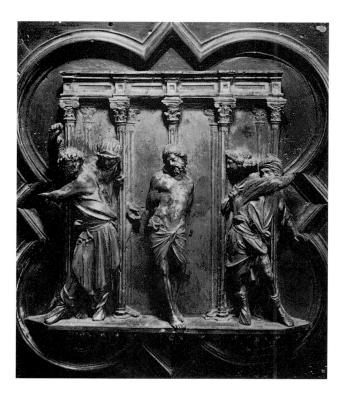

7.6. LORENZO GHIBERTI. Flagellation, panel on the $\widehat{\mathbb{D}}$ North Doors, Baptistery, Florence. c. 1416–19. Bronze with gilding, $20^{1/2}$ x $17^{3/4}$ " (52 x 45 cm) inside molding

7.7. LORENZO GHIBERTI. Flagellation. c. 1416–19(?). Pen and bister, $8^{1}/8 \times 6^{1}/2$ " (21 x 17 cm). Albertina, Vienna

Ghiberti struggles against the limitations of the frame, trying to suggest the illusion of a deeper space. The drapery forms contribute to this illusion; Gabriel's cloak envelops his body in drapery that enhances his body's mass, and Mary's beltless tunic flows about her limbs, revealing their fullness and grace.

A partly classical portico sets the stage for the Flagellation (fig. 7.6). One would like to know more about the chronology in which these reliefs were made: presumably this is among the later ones, for it seems to have been designed near the time when Brunelleschi was meditating on his new classical architecture for the Ospedale degli Innocenti and San Lorenzo (see figs. 6.6, 6.10), or perhaps the relief precedes these buildings. A search of the backgrounds in Florentine art of the early 1400s discloses symptoms of the oncoming Renaissance, and Ghiberti's Roman composite capitals in the Flagellation take an important place among these. The colonnade, however, is only a background for the interaction of the figures. Christ's supple body continues the new classical tradition Ghiberti had established in his Isaac. With twisting movements the men whipping Christ raise their now-missing weapons and carry the eye up into the lobes of the quatrefoil. In a sketch (fig. 7.7), Ghiberti worked out possibilities for the figures whipping Christ before he arrived at the final solution.

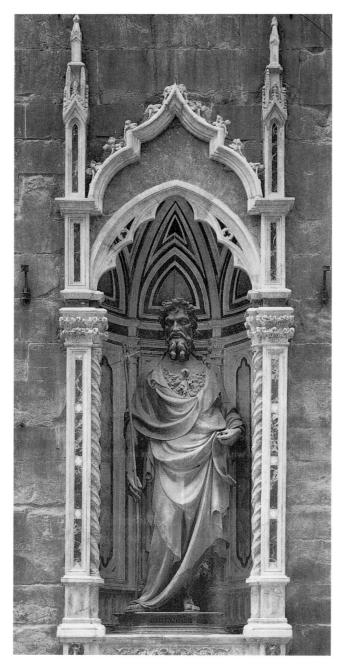

7.8. LORENZO GHIBERTI. St. John the Baptist and tabernacle. 1405–17. Bronze figure, originally with gilded decoration, and marble and mosaic niche; height of figure 8'4" (2.55 m). Orsanmichele, Florence. Commissioned by the Arte di Calimala

While he was working on the doors, the Calimala guild commissioned Ghiberti to execute a bronze statue of St. John the Baptist (fig. 7.8) for their niche at Orsanmichele (see fig. 1.8). This structure, originally a loggia, was rebuilt by the Commune in 1337 as a combined shrine, wheat exchange, and granary; its enormous size may have been intended to convince citizens of the vast amounts of grain the Commune kept available in case of siege or famine. In 1339 the fourteen niches on the ground floor level were assigned to the

leading guilds of Florence which were obligated to fill them with statues of their patron saints. By 1400 only three of these statues had been made and installed. In the first decade of the Quattrocento, pressure on the guilds was revived, and they were given a brief period to fulfill their obligations. All the statues were completed by 1429, and were easily visible from the street, their feet barely above eye level of any passerby. Once begun, the march of monumental Florentine statues did not stop for twenty years or so. At Orsanmichele

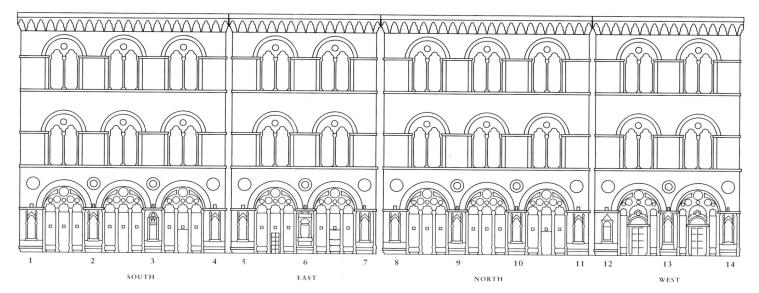

7.9. Iconographic diagram of the sculptural program at Orsanmichele, Florence. Computerized diagram by Sarah Loyd

- 1. Tabernacle of the Arte dei Linaioli e Rigattieri, with marble statue of *St. Mark* by Donatello, 1411–16 (see figs. 7.13, 7.14)
- Tabernacle of the Arte dei Vaiai e Pellicciai, with marble statue of St. James attributed to Niccolò di Pietro Lamberti, c. 1420
- Tabernacle of the Arte dei Medici e Speziali (1399), with marble figure of the Madonna and Child attributed to Niccolò di Pietro Lamberti, before 1399
- 4. Tabernacle of the Arte della Seta (c. 1340), with bronze figure of St. John the Evangelist by Baccio di Montelupo, 1515, replacing a figure of the saint by an unknown artist, c. 1377
- Tabernacle of the Arte di Calimala, with bronze statue of
 St. John the Baptist by Ghiberti, 1405–17 (see figs. 7.8, 7.10)
- 6. Tabernacle of the Mercanzia (1425), with bronze group of *Christ and St. Thomas* by Verrocchio, 1467–83 (see figs. 13.12, 13.13). Niche originally made for the Parte Guelfa by Donatello, who also made a gilded bronze figure of *St. Louis of Toulouse* for this niche, c. 1422–25
- 7. Tabernacle of the Arte dei Giudici e Notai (1406), with bronze figure of St. Luke the Evangelist by Giambologna, 1601, replacing an earlier marble figure of the saint by Niccolò di Pietro Lamberti, 1404–6

- Tabernacle of the Arte dei Beccai, with marble figure of St. Peter attributed to Bernardo Ciuffagni, c. 1412
- Tabernacle of the Arte dei Calzolai, with marble figure of St. Philip by Nanni di Banco, 1410
- Tabernacle of the Arte di Pietra e Legname,
 with marble group of the Four Crowned Martyrs by
 Nanni di Banco, c. 1409–16/17 (see fig. 7.18)
- Tabernacle of the Arte dei Corazzai e Spadai, with bronze copy after original marble figure of *St. George* by Donatello now in Bargello,
 t. 1415–17 (see figs. 7.15, 7.16; see also fig. 4)
- 12. Tabernacle of the Arte del Cambio, with bronze figure of *St. Matthew* by Ghiberti, 1419–23 (see fig. 7.11)
- 13. Tabernacle of the Arte della Lana (c. 1341), with bronze figure of *St. Stephen* by Ghiberti, 1429, replacing the original marble figure of the saint attributed to Andrea Pisano, c. 1339–40
- 14. Tabernacle of the Arte dei Fabbri, with marble figure of *St. Eligius* by Nanni di Banco, c. 1417–21

and at the Cathedral, two centers of civic and spiritual life in the Florentine Republic, no fewer than thirty-four largerthan-life statues were set up; still more were planned (fig. 7.9).

Ghiberti's monumental bronze *St. John* (fig. 7.10; see fig. 7.8) was an ambitious undertaking. No bronze figure on this scale—more than eight feet tall—had been cast for centuries in Italy, and it seems clear that the idea of the statue must have come from the self-confident Ghiberti. The guild's uncertainty about his ability to complete a bronze

figure on this scale is clear, for the contract states that the guild would owe him nothing if he did not succeed. But he did, successfully casting this monumental figure in a single piece.

Although patterns of Ghiberti's drapery also appear in Lorenzo Monaco's paintings, there is a naturalism about *St. John* that is missing from Lorenzo's painted fantasies. The statue represents a saint who has lived long in the wilderness; his hair and beard fall in disordered locks, while his

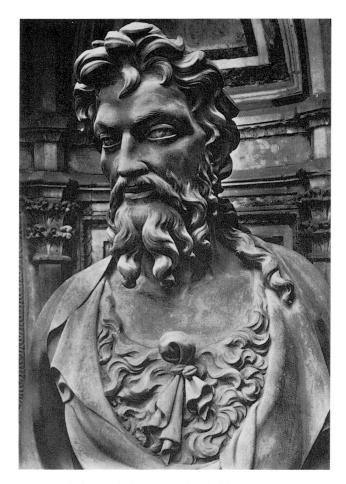

7.10. Head of St. John the Baptist, detail of fig. 7.8

eyes sink deep into their sockets. The curves of hair and beard contrast elegantly with the bold folds of the saint's cloak. Yet, all vestiges of the wildness are governed by Ghiberti's ability to create unity through linear movement.

The St. John, with its bursting curves and exaggerated shapes, is still imbued with the ideas of the International Gothic, as indeed are the earlier panels from the North Doors. Ghiberti's bronze St. Matthew (fig. 7.11), however, commissioned for Orsanmichele in 1419 by the Arte del Cambio, the guild of bankers, represents the culmination of the new classical style. The only Gothic elements are the pointed arch and florid gable of the tabernacle. Otherwise, the grand figure, poised and balanced before its semicircle of Corinthian pilasters, recalls the dignity and ease of a classical philosopher portrait. In accord with ancient artistic precepts, St. Matthew places his weight on one leg, leaving the other relaxed, suggesting the figure's potential for movement. His right hand points toward his breast, his left holds an open book in which the opening chapter of his Gospel is set in an early example of the ancient Roman let-

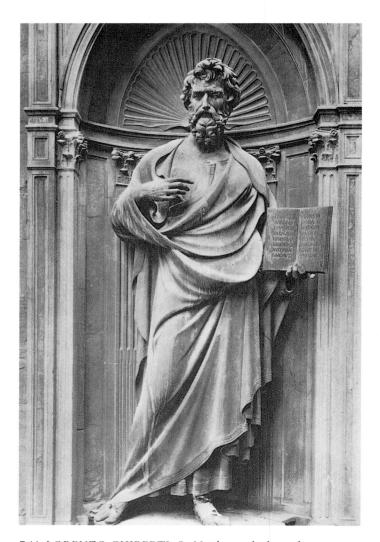

7.11. LORENZO GHIBERTI. St. Matthew and tabernacle. 1419–23. Bronze figure, originally with gilded decoration, and marble and mosaic niche; height of figure 8'10" (2.7 m).

© Orsanmichele, Florence. Commissioned by the Arte del Cambio

ter forms that will soon become fashionable, thus replacing Gothic-style calligraphy. Such a figure is unthinkable without the intervening statues for Orsanmichele by Donatello and Nanni di Banco (see figs. 7.15, 7.18; see also fig. 4), in which, as we shall see, manifestos of a new classicism were launched. But Ghiberti's version of the classical style is his own; flowing through it are the same linear ease and harmony visible in his most "Gothic" works.

Donatello to 1417

Ghiberti's contemporary Donato di Niccolo Bardi (c. 1386/90–1466), known as Donatello, seems to have been as tense and impulsive as Ghiberti was serene and shrewd.

Donatello was a member of the Arte di Pietra e Legname, the guild of workers in stone and wood, and although he made many sculptures in bronze, he certainly did not think like a metalworker. Neither can it be said that he was bound by the conventions of stoneworkers. He shared neither Brunelleschi's concern for strict proportional relationships nor Ghiberti's interest in graceful line. More than any of his contemporary innovators, he was fascinated by the inner life of his subjects and the naturalistic effects he observed in the world around him. The result is an art striking in its im-

mediacy and careless of surface refinements, but able to reach a high level of force and drama.

One of Donatello's earliest known works is the marble *David* (fig. 7.12), originally commissioned to be placed on a buttress of Florence Cathedral. Its fate was, in some respects, similar to that of another statue carved for this same position and also not put in place, the *David* created almost a century later by Michelangelo (see fig. 16.39; see also fig. 9). In 1416, the Priori of the Republic called for Donatello's statue to be set up in the Palazzo dei Priori as a symbol of the Florentine

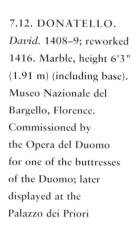

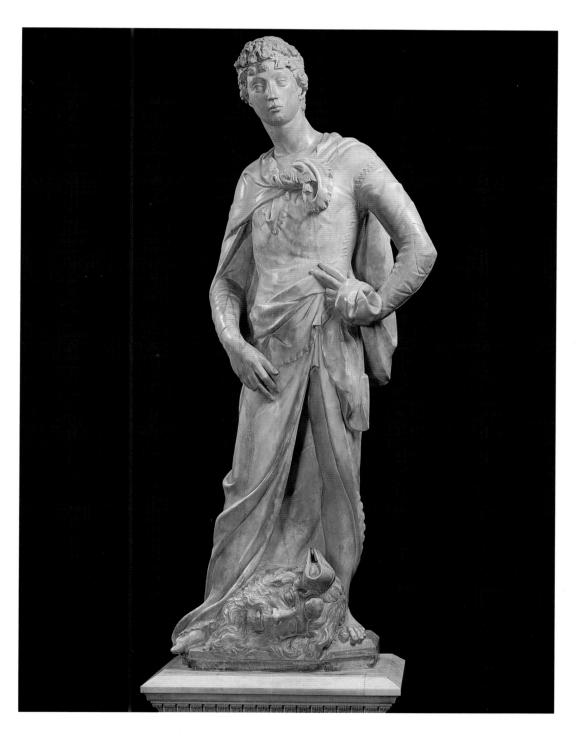

Republic. The statue was inscribed: "To those who bravely fight for the fatherland, the gods will lend aid even against the most terrible foes." David wears a crown of amaranth, a plant that in classical antiquity symbolized the undying fame of heroes. The right hand originally held a leather or bronze strap for the slingshot (only the marble portion enclosing the stone now remains, on Goliath's brow).

In the pose and drapery, echoes of the Late Gothic may be discerned, but the folds do not flow easily as in the work of Ghiberti. Nothing flows smoothly in Donatello—his work is often tense and sometimes deliberately harsh. The boy stands proudly yet awkwardly, with his left hand bent upward on his hip and his head tilted. The youth's elevated chin and self-confident posing assert his awareness of his triumph.

The sculptor is fascinated by textures; although a hint of Late Gothic serpentine line flows through the hair and beard, they also form unkempt masses that contrast with David's smooth cloak and smoother neck and cheeks. Even at this early stage in Donatello's style, curious sculptural effects appear. Projections and hollows in the marble no longer correspond to projections and hollows in the represented object. Donatello has begun to reduce contrasts in levels and to utilize projections and hollows to attract light and cast shadows. These tendencies toward suggestion rather than description will gradually increase in Donatello's work over time.

Donatello's earliest contribution to fill the niches of Orsanmichele was probably a marble *St. Mark* (fig. 7.13) for the Arte dei Linaioli e Rigattieri, the linen weavers and peddlers. Shortly after the statue was commissioned from Donatello, the guild approved the drawing submitted by two stone carvers for the figure's elaborate inlaid marble tabernacle. Donatello, then, neither designed nor executed the niche in which his figure of Mark would be displayed. The contract set the tabernacle's price at 200 florins, but Donatello's statue was only to be appraised at the completion of his work, revealing that whereas the ornamental niche could be evaluated in advance, the cost for a sculpted figure could only be judged upon completion. Since Donatello was usually paid between 90 and 100 florins for a figure like *St. Mark*, it is clear that the tabernacle would cost approximately twice as much as the figure.

A greater contrast could hardly be imagined than that between this statue and Ghiberti's *St. John the Baptist* (see fig. 7.8). In Donatello's *St. Mark*, Late Gothic patterns have completely disappeared. The figure's feet seem to sink into his cushion (a product sold by the Rigattieri), heightening the effect of reality, while the drapery pulsates over the underlying torso and limbs. Donatello seems to be demonstrating how cloth, the product of the patron guild, behaves. Why, one wonders, had the Florentines, whose fortunes were largely founded on the manufacture, processing, and sale of cloth, not paid more attention to its properties before, instead of being seduced by abstract formulas, whether Byzantine, Giottoesque, or Late Gothic?

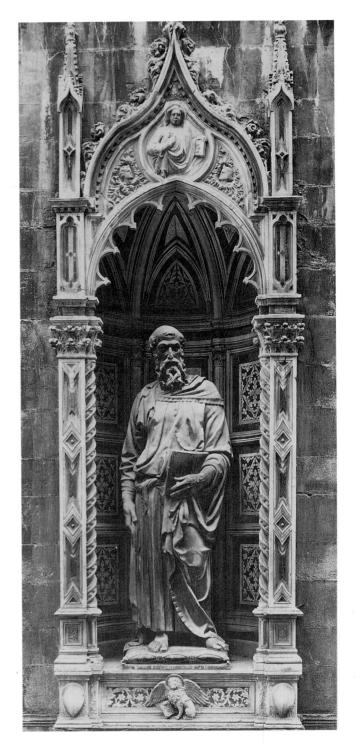

7.13. DONATELLO. St. Mark. 1411–16. Marble figure, originally with gilded decoration and metal additions; height 7'10" (2.39 m). Historical photograph taken before the figure was removed from its niche. Orsanmichele, Florence. Commissioned by the Arte dei Linaioli e Rigattieri for their niche on Orsanmichele, Florence. Niche by Perfetto di Giovanni and Albizzi di Pietro

St. Mark's mantle, like David's, is tied about the shoulders, and folds of cloth fall around the hips without concealing their structure. The figure stands in the *contrapposto* pose derived from antiquity: the left knee comes forward against

the cloth to emphasize that this is the relaxed leg, while the straight folds over the weight-bearing leg reinforce its role in the figure's pose. In these areas the *Mark* bears a striking resemblance to the caryatids from the ancient Greek Erechtheum in Athens, a monument Donatello could not have seen; he may have known a copy or heard a description from a traveler who had visited the Acropolis. Donatello's figure, however, suggests the potential for movement more strongly than the Greek caryatids because of the way the axes of his body twist subtly in space.

It has been claimed that this statue represents so abrupt a break with tradition that it should be considered a mutation-a fundamental declaration of the new Renaissance position with respect to the visible world. Yet it has not been emphasized how much this new position is stated with simple, practical means. Vasari explained that a sculptor should first model a clay figure in the nude. The next step was to dip sheets of cloth in what potters today call "slip" (a very thin paste of water and clay), hang these masses of cloth on the clay figure until the drapery falls in a naturalistic manner, and let them harden. Then a full-scale statue in marble or bronze could be made on the basis of this draped model. In one of Donatello's later works, Judith and Holofernes (see figs. 12.5, 12.6), we can see in the cloth over the forehead where the slip broke away during casting and the cloth itself was cast into the bronze.

According to Vasari, the officials of the guild objected to the figure of St. Mark when they saw it in Donatello's studio and refused to allow it to be installed in their tabernacle. The sculptor asked them to let him work on it in its final position and, after it was placed on Orsanmichele, he pretended to continue carving behind a screen. He then called in the officials, who enthusiastically approved of the work they had previously rejected. Presumably, Donatello had from the beginning calculated that he should lengthen the torso and shorten the legs to make the figure seem naturalistic when seen from street level.

Donatello's statue is formidable not only in the conviction and naturalism of its rendering, but also in the concentrated power of the face. St. Mark seems, on the one hand, to assess the outer world and its dangers and, on the other, to summon up the inner resources of the self, which must be marshaled against them. This noble face with its expression of severe determination—the Italian term terribile is how the Renaissance would describe it—has been described as a symbolic portrait of the ideal Florentine under stress as identified at the time by the humanist propagandists for the Republic. It is a summation of the virtues demanded in a crisis: the eyes flare, the brow knits, the head lifts, the figure draws back in pride and a new moral grandeur. At this same time, the styles of Florence's opponents, Milan and Naples, remained flamboyantly Gothic, and the sculpted figures created there maintained a courtly, arrogant expression.

In the details of the *St. Mark*, Donatello's optical suggestions show an important increase (fig. 7.14). Curls of hair and beard are not modeled in the round as the Pisano family or Ghiberti would have done; grooves and scratches suggest reality as it is revealed in light and shade. Donatello's interest in optical effects leads him to abandon Ghiberti's incised cornea edge and drilled pupil, which set out to preserve the external shape of the eyeball; in Donatello's *St. Mark* the pupil is dilated, becoming a deep hole, so that shadows, equated to the tonal values within the transparent cornea, substitute for the external shape.

Donatello's new style is celebrated in his *St. George* (fig. 7.15; see fig. 4), also for Orsanmichele. Like the *St. Mark*, this statue was made for a medium-sized guild that could not afford bronze. The marble figure, removed from its niche at the end of the nineteenth century for protection, was replaced, ironically, by a cast in bronze. St. George was the patron saint of the Arte dei Corazzai e Spadai, the guild of armorers and sword makers, whose stock must have jumped sharply in the days when Florence was threatened by Ladislaus. But we can no longer see the *St. George* as Donatello intended: a socket hole in his right hand, still bearing traces of corroded metal, and drill holes at various points indicate that the figure once sported the products of the guild—a helmet, a jutting sword or spear, and a belt and sheath. These have long since disappeared. The helmet

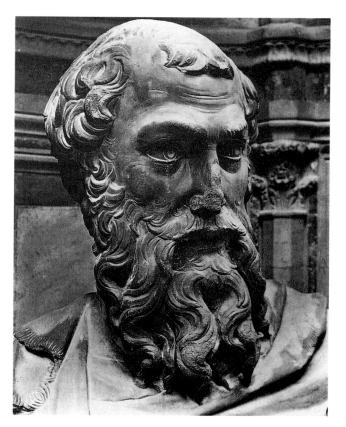

7.14. Head of St. Mark, detail of fig. 7.13

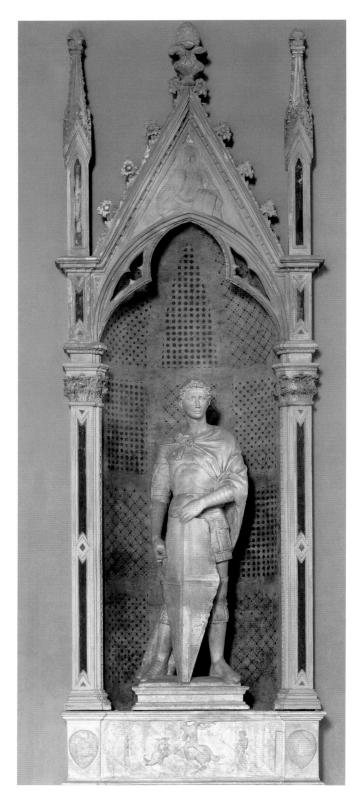

7.15. DONATELLO. St. George. c. 1415–17. Marble, height 6'5" (1.95 m). The figure is now in the Bargello, Florence. Commissioned by the Arte dei Corazzai e Spadai for their niche on Orsanmichele, Florence (see fig. 4). Writing about this figure in the sixteenth century, Francesco Bocchi said: "The legs move, the arms are ready, the head alert, and the whole figure acts; by virtue of the character, the manner and form of the action presents to our eyes a valiant, invincible, and magnanimous soul."

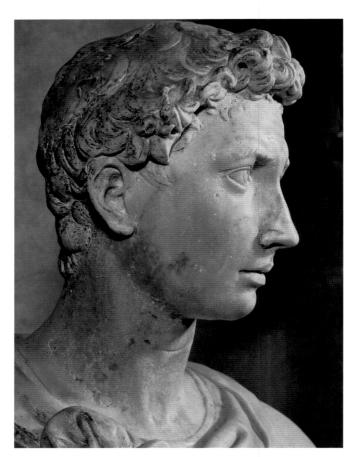

7.16. Head of St. George, detail of fig. 7.15. The figure's nose has been damaged and restored.

would probably have covered most of the curly locks, and the sword or spear would have protruded menacingly into the street. The taut lines of Donatello's figures, already evident in the marble *David*, are clarified here in the shield poised on its pointed tip, in the pointed shapes of the drapery, and in the sharply pointed, steel-clad feet.

The face comes as a surprise (fig. 7.16). It is not the countenance of an ideal hero, but of an individual who has experienced fear. The history of human crises is studded with individuals who never did a brave thing until an emergency called forth a burst of action. Donatello's St. George shows us a sensitive, reflective face with delicate features—a slightly receding chin, dilated eyes looking outward as if dreading the approaching combat, and a brow puckered with nervous tension. His stance, balanced on both feet, expresses resilient preparedness. His entire being seems to be marshaling resources against danger from without. "In times of safety anyone can behave well," said Niccolò da Uzzano, one of the humanist leaders of the Florentine Republic, "it is in adversity that real courage is shown." This passage and others written by the humanists reveal the same qualities seen in the St. George and in other monumental statues of the new age.

The most startling innovation of the St. George tabernacle at Orsanmichele is the marble relief on the base (fig. 7.17) representing the story of the young hero's victory over a dragon. The marble for this relief, an especially fine piece, was ordered in 1417, a year that should be regarded as a crucial date in the history of sculpture. Until this moment, sculptors had conceived of the background of a relief sculpture as a plane in front of which the figures were placed or from which they seemed to emerge. Even Ghiberti, although apparently wanting to penetrate the inert background, did so only by means of spatial implication. In traditional relief sculpture, figures were carved almost in the round, barely adhering to the background slab, or in a kind of half-round; only rarely were they systematically reduced in projection in the manner of low relief. A cross section of an ancient or medieval relief would show the background slab as a straight line and rising from it would be projections corresponding to cross sections of the figures. But a cross section of Donatello's St. George and the Dragon would be illegible, a series of bumps and hollows. These projections and depressions are subtly manipulated in the relief to attract light and cast shadow.

Donatello's relief sculpture no longer corresponds to the idea of the object, nor to the object as we know it, but to the image of that object which light casts upon the retina. This is a crucial distinction that marks an end to medieval art. The eye is now supreme. The new technique is so subtle that Donatello dissolves the barrier between represented object and background. He turns the marble into air, showing us distant hills, trees, and even convincingly naturalistic clouds. The little arcade to the right comes remarkably close to one-point perspective, and the forms are progressively altered in their precision of statement by an intervening veil of atmosphere. While the horse rears as George's

lance plunges into the dragon's breast, the princess clasps her hands, the arcade and rocky ground carry the eye back into misty distance, and the intervening air seems stirred by a natural breeze. All this is done in a sketchy, remarkably unsculptural manner, with Donatello employing the chisel as if it were a drawing instrument. The Italian expression for Donatello's innovation is *rilievo schiacciato* (flattened relief). This term is useful but inaccurate, for the forms are not created by flattening. Here Donatello has abandoned the traditional notion of relief in favor of optical suggestion.

Clearly, Donatello's effects were calculated for the position of the relief on the north side of the building, where it was exposed to a soft, diffused light reflected from the buildings across the street. The relief depends on the autonomy of a single pair of eyes at a defined point in space. Implicit in this approach is a concept of the individual that is wholly alien to the medieval notion of corporate society. Is it coincidental that the new idea should first appear in a relief of the victory of St. George, which can be seen as symbolically reenacting the triumph of Florence against Ladislaus? There were imperfections in Florentine democracy, but the declarations of her humanists and, from the other side, the denunciations of liberty by apologists for the dictators leave no doubt that to contemporaries the freedom of the individual was at stake. This concept of freedom is often posed as one of the wellsprings of the new style.

In northern Europe a similar interest in naturalism was taking place in the art of the Netherlandish miniaturists and panel painters; their enthusiasm for the visible world and every object it contained resulted in a technique of breathtaking accuracy of representation. But the illustrations of the *Turin-Milan Hours*, the earliest works by Jan van Eyck that show a stage comparable to the new point of view revealed in Donatello's

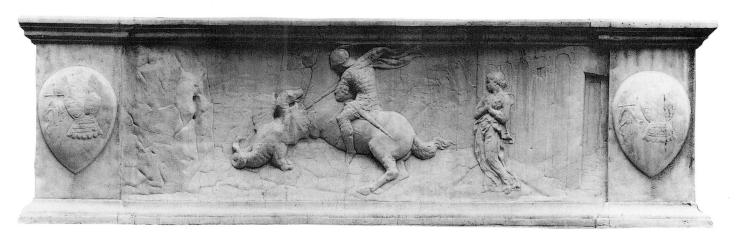

7.17. DONATELLO. *St. George and the Dragon*, relief now removed from the St. George tabernacle, Orsanmichele, Florence. c. 1417. Marble, 15³/₈ x 47 ¹/₄" (39 x 120 cm). Museo Nazionale del Bargello, Florence

relief, are datable probably in the 1420s. Paradoxically, then, Donatello's sculptural relief could be called the most advanced pictorial composition of its time. Lorenzo Monaco and his Late Gothic contemporaries give no hint that they knew what Donatello was about.

Nanni di Banco

Nanni di Banco (c. 1374–1421), a contemporary of Ghiberti and Donatello, was brought up by a sculptor father who worked in the Cathedral workshop. Nanni was responsible for important Cathedral sculptures and for statues in three niches at Orsanmichele. The most striking of these is the Four Crowned Martyrs (fig. 7.18). According to legend, these Christian martyrs were ancient Roman sculptors who were executed for refusing to carve a statue of a pagan god for the emperor Diocletian. The niche retains some Gothic details, but the togalike cloaks of the two figures on the right could hardly look more Roman, and their grand bearing is also inspired by Roman statuary. The heads are strikingly reminiscent of Roman portraiture, and it is possible that one is a portrait of Nanni's sculptor brother Antonio, who died while the group was being created.

Nanni's reliance on and quotation of Roman sources was not unique at the time. The propagandists for the Milanese and Neapolitan autocrats had recourse to examples drawn from Imperial Rome; the apologists for the Florentine Republic cited the virtues of Republican Rome and the Roman people, whose heirs they felt themselves to be. And it is Republican models that these statues call to mind. Even the Tuscan version of the Italian language, known as the volgare (common), was defended by the humanists as the true successor to ancient Latin. The determinedly Roman nature of Nanni's Four Crowned Martyrs may in part be the sculptor's attempt to be historically accurate—to represent these sculptors as a part of the ancient Roman world in which they lived, worked, and died. Such an attitude would coincide with the new interest in accurate, researched history evident in the work of contemporary humanists.

There is something conspiratorial about these four men who are united in a resolve to die for their principles. The patrons were the Arte di Pietra e Legname—the guild of workers in stone and wood—in which Nanni had been inscribed since 1405. By depicting the guild's patrons in this manner, Nanni has apotheosized the guild, as Donatello was shortly to do for the armorers in the *St. George*. The four figures grouped in a semicircle are an unprecedented composition in Italian sculpture, and they were to exercise a profound effect on the art of the Quattrocento, especially on the painters Masaccio and Andrea del Castagno, and are even echoed in Raphael's frescoes in the Stanza della Segnatura.

Nanni's figure to the right, derived from a figure of an ancient Roman orator, seems to speak while the others listen,

contemplating their decision and assessing the consequences of their resolution. The debate that we sense is taking place here has recently been interpreted by Mary Bergstein as related to the corporate republican ideals of the members of the merchant-class and artisan-class guilds in Florence. Nanni, his father, his uncle, and his brother were all engaged in various guild and civic responsibilities.

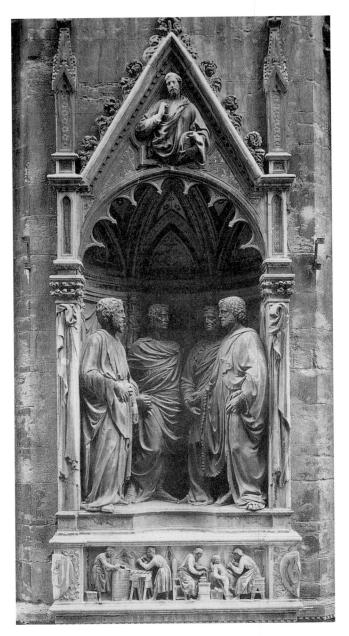

7.18. NANNI DI BANCO. Four Crowned Martyrs (Quattro Santi Coronati) and tabernacle. c. 1409–16/17. White marble figures and polychrome niche of white, green, and gray marble with additions in blue faience; height of figures approx. 6' (1.83 m). ① Orsanmichele, Florence. Commissioned by the Arte di Pietra e Legname.

The two figures on the right are carved from a single block.

7.19. NANNI DI BANCO.

Assumption of the Virgin, gable on the n Porta della Mandorla, Cathedral, Florence. 1414-22. White marble with frame of red and green-black marble and green granite, originally with a painted blue background and gold leaf decoration on details of the figures. a painted metal lily in one of the hands of the Virgin Mary, and a silk sash with gold borders or tassels. The latter was replaced with a copper sash in 1435. The spikes that held the sash in place can still be seen in Mary's hands. Commissioned by the Opera del Duomo. The main relief is composed of eleven sections of white marble. Notice the elaborate border of inlaid marble in a design of hanging lamps shown in perspective; lamps are a traditional symbol of the Virgin Mary, but the specific nature of these examples may reflect the use of hanging lamps in Florentine ritual in honor of the Virgin.

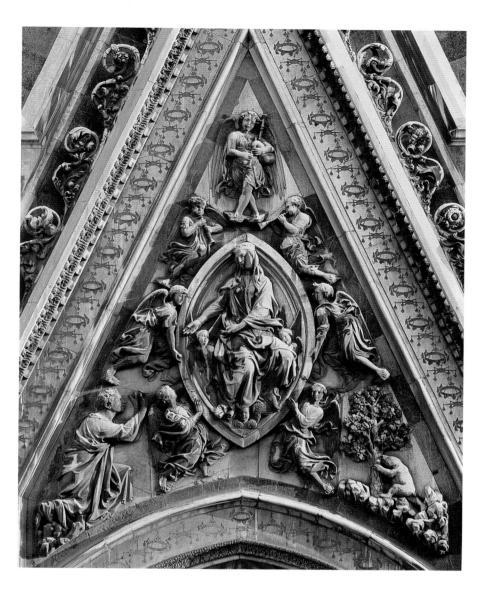

The movements of the drapery folds seem in some cases to sweep the four together, in others to hold them hesitantly apart. But the figures are united by two simple devices. First, the pedestal is carved in an arc that roughly follows the placement of the feet. Second, the tabernacle is draped in broad folds, a motif taken from ancient sarcophagi that reinforces the semicircular grouping. Details of features, hair, and beards either long or stubbly (the decision not to shave was, in certain periods of Roman history, a penitential resolve) demonstrate both a strong Latinism and many survivals of the Gothic, natural enough in a sculptor educated in a fairly conservative tradition. Nanni is apparently not interested in the optical suggestions of Donatello; his drapery masses, locks of hair and beard, stubble, wrinkles, and veins are fully modeled, not flattened or sketched as in Donatello's illusionistic method.

To enhance the naturalism of the group, the feet of the two outer figures overlap the base, extending into the viewer's space. The molding on which the white marble figures stand is a distinctive gray-veined marble, suggesting that there is no base. Like the malleable pillow below the feet of Donatello's *St. Mark*, which heightens the sense of reality, Nanni proposes that these figures could step out of their tabernacle. In the relief below, four stoneworkers in contemporary dress representing the guild build a wall, carve a column, measure a capital, and finish a statue of a nude putto.

It is, of course, idle to speculate on what might have been the achievements of Nanni di Banco had he not died young, but the single-minded force of his art makes us wonder whether the course of the Quattrocento might not have been different had he lived to midcentury or even beyond, as did Donatello and Ghiberti. The culminating work of Nanni's brief career is his *Assumption of the Virgin* (fig. 7.19) above the Porta della Mandorla, a doorway of the Florence Cathedral that takes its name from the mandorla (almond-shaped glory) surrounding

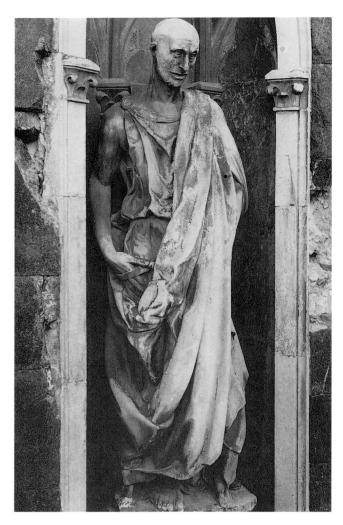

7.20. DONATELLO. *Zuccone* (*Habakkuk*), seen here on the Campanile, Florence fi (now in Museo dell'Opera del Duomo, Florence). c. 1427–36. Marble, height 6'5" (1.95 m). Commissioned by the Opera del Duomo

the Virgin. The work, commissioned in 1414, was listed as incomplete in a document at Nanni's death in 1421, but this may refer only to the setting up of the ensemble.

In contrast to the gravity of Nanni's work at Orsanmichele, his Assumption is turbulent; this huge relief over a side portal of the Duomo is part of a decorative scheme in sculpture and stained glass encompassing the events of the Virgin's life. Four angels lift the mandorla, from within which the Virgin, supported by seraphim, hands her belt to the kneeling St. Thomas as proof of her assumption (it was believed that this belt was preserved as a relic in the nearby Tuscan town of Prato). The darkened and streaked relief today has lost much of its original character and even its most important attribute, for the original belt was a length of golden-edged silk that would have moved with the wind (later replaced with a metal version, this too lost). The fig-

ures had gold leaf on selected details, and a painted blue background clarified the crowded composition. Given the limited space available and the need for a clear narrative when seen from below, the usual witnesses are absent and the scene acquires the character of a private revelation to St. Thomas, the most famous of doubters. The only other being who is present, except for the angels (three more, making music, fill the point of the gable), is a bear who seems to be trying to shake acorns from an oak tree; the meaning of this unusual addition to the Assumption scene has been difficult to unravel, but a recent analysis emphasizes that the bear can be connected both to the notion of the wilderness into which the original sinners, Adam and Eve, were exiled and to the sin of physical gratification or lust. In this light, Frederick Hartt's original suggestion is not far off the mark: "Perhaps Nanni intended to contrast the impossibility of gaining bounty through force, exemplified by the animal's greed and rage, with the golden gift received by St. Thomas through divine grace." It has recently been suggested that the bear may have played a role in inspiring Alberti when he wrote that the "copiousness and variety" of a good istoria (narrative scene) would be well served by adding animals.

The effect of the narrative event is dramatic and instantaneous. The flying folds, agitated by the upward movement of Mary's mandorla, envelop figures of an insistent corporeality. The faces are full of individuality, energy, and beauty—all hallmarks of Renaissance style. Here Nanni was in the forefront of the Florentine Renaissance, in full control of its naturalism and classical resources.

Donatello (c. 1417 to c. 1435)

Donatello was involved repeatedly in work for the Cathedral of Florence, even contributing two small heads to the Porta della Mandorla after Nanni's death. During the twenty years from 1415 to 1435, the sculptor, sometimes in partnership with Nanni di Bartolo, carved seven marble prophets for the Campanile (see fig. 3.26), completing the series of sixteen begun in the Trecento. These statues have now been transferred to the Museo dell'Opera del Duomo, where they have lost an essential element of their former effect—the tension between statue and niche so important in works by Donatello, Ghiberti, and Jacopo della Quercia. At Orsanmichele the statues addressed the citizen from slightly above eye level, but the Campanile niches are so high that the figures can only be viewed from a distance of about sixty feet. Donatello, who had been relatively conservative in his treatment of the earlier statues in the cycle, began to realize as they were installed that he would have to adopt more drastic methods. The most dramatic of the group are certainly the so-called Zuccone (Big Squash, or Baldy), now often identified as Habakkuk, and the Jeremiah (see figs. 7.20, 7.22).

The psychological intensity expressed by these figures surpasses anything Donatello had previously created. The boldness that we sense today is related to the fact that Donatello has calculated the effect of the statue on an observer standing at least sixty feet below. In Gothic cathedrals and throughout Italian Trecento art, Old Testament prophets and New Testament saints—with the exception of John the Baptist, who lived in the wilderness—are dignified characters with flowing robes and well-combed hair. Not so these emaciated creatures, who seem to throb with the import of their divinely inspired messages and the devastation of their rejection. Their stances and expressions convey the fiery intensity of the prophetic books of the Old Testament. They are far from handsome, but in their ugliness Donatello's conviction has found a strange beauty. The Zuccone (fig. 7.20) draws his chin in, gazes bitterly down, and seems to open his mouth in condemnation of humanity's iniquities. The figure is skin and bone under the rough cloth that suggests a toga. The hand clutches convulsively at the strap and the rolled top of a scroll. The bald head is carved with brutal strokes, left intentionally rough (fig. 7.21), and the few marks that represent stubble on the chin, the flare of the lips, and the eyebrows have been exaggerated by the effects of weathering.

Jeremiah (fig. 7.22) is equally terrifying, and one wonders where Donatello found the models for these statues. Denunciatory types still roam the streets of Florence; perhaps in Donatello's day there were even more. Certain features in Donatello's heads suggest that he was inspired by the realism found in Roman portrait busts, but these sources have been transfigured by Donatello's imaginative

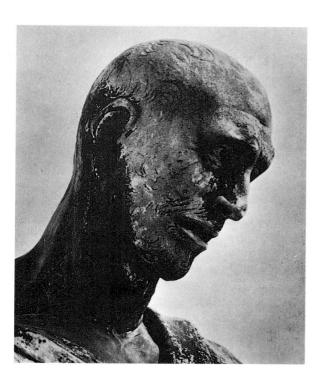

7.21. Head of Zuccone, detail of fig. 7.20

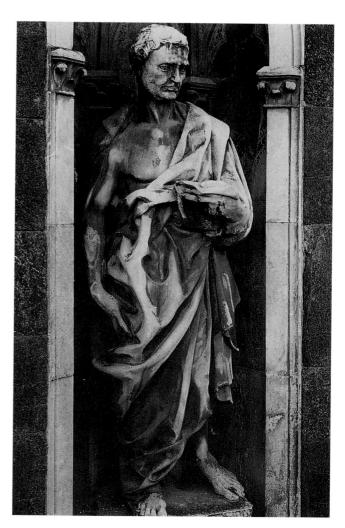

7.22. DONATELLO. *Jeremiah*, seen here on the Campanile, Florence â (now in Museo dell'Opera del Duomo, Florence). c. 1423–25. Marble, height 6'3" (1.91 m)

powers. The pulsating structure of folds, disordered locks, tense poses, and searing glances all express the difficult task facing the prophet, who must communicate to an unwilling people the inspiration received from God.

Donatello's optical interests and the vitality of his dramatic style reach a climax in the *Feast of Herod* (fig. 7.23) for the baptismal font of the Cathedral of Siena, a project in which he was involved with other sculptors, including Ghiberti and the Sienese Jacopo della Quercia. Donatello's contribution, executed between 1423 and 1427, is certainly closer to a consistent statement of one-point perspective than any earlier work in Western art. The invention of perspective was credited to Brunelleschi by his anonymous biographer and Vasari, although the authenticity of this claim remains vexing. The biographer described in detail two paintings by Brunelleschi, one of which represented the Baptistery of Florence and the

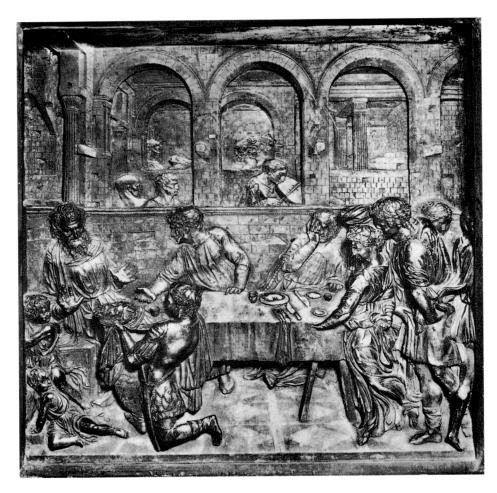

7.23. DONATELLO.

Feast of Herod,
panel on the

Baptismal Font,
Baptistery, Siena. 1423–27.

Gilded bronze, 23½"

(60 cm) square

surrounding buildings as seen from just inside the Cathedral's door. The sky was rendered in burnished silver, to reflect the real sky and passing clouds and thus to complete the sense of reality. The observer was required to look through a peephole in the back of the painting that was coordinated with the vanishing point of Brunelleschi's perspective view on the front; through this hole the observer saw the scene reflected in a mirror that was held an exact cubit (the distance from the elbow to the end of the middle finger, approximately eighteen inches) in front of the painted surface. The observer was thus assumed to be standing about three cubits inside the Cathedral door and sixty cubits from the front of the Baptistery. Measurements taken of the buildings were reduced in a 1:60 proportion and set forth on a plan that was then projected onto the panel.

Such a graph of space was derived from Brunelleschi's technique of producing measured drawings of architecture, for which the individual observer's actual position in space was a prime determinant. By forcing the observer to view the painting in the mirror, Brunelleschi was also able to guarantee that the observer's eye was exactly opposite the vanishing point. The device of the mirror also meant that the observer could see only the illusion and none of the distracting reality that sur-

rounds a painting and reduces its illusionistic effect. Brunelleschi's perspective method seems to have been used in the early Quattrocento, in a somewhat reduced form, by a few adventurous souls, notably Donatello and, as we shall see, the painter Masaccio.

Donatello's Feast of Herod is not a painting, of course, but a three-dimensional relief that was to be placed on the base of a baptismal font and would, therefore, be seen from above at a rather sharp angle. To use a perspective scheme that coordinated with the observer's high viewpoint would have demanded architecture that was sharply distorted. Instead, Donatello has placed his vanishing point, established by floor lines, moldings, and the recession of capitals and lintels, in the center of the relief. But Donatello, always an enemy of regularity, has introduced so many different levels and architectural features that do not correspond from one side to the other that it is impossible to trace all the recessions into deep space accurately. He also created two curious recesses in the wall behind the figures that recede at angles counter to that of the perspective scheme and that do not even coordinate with one another. But he has interrelated the square slabs of the inlaid floor diagonally, so that the extended diagonal of one becomes the diagonal of the square in

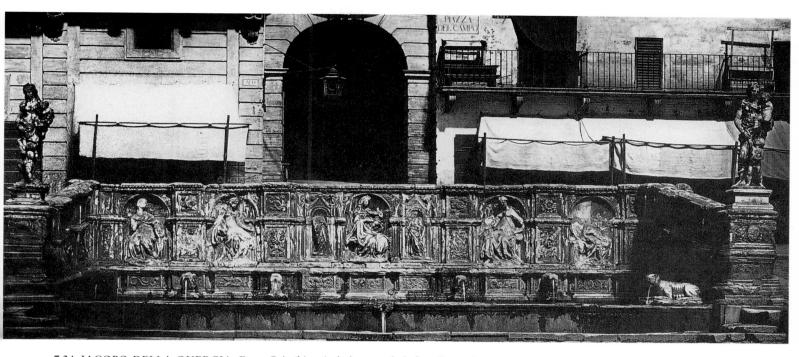

7.24. JACOPO DELLA QUERCIA. Fonte Gaia (historical photograph, before dismantling in 1860), Piazza del Campo, Siena. Commissioned 1409; executed 1414–19. Marble, overall 4'8" x 33'4" x 18'3" (1.42 x 10.17 x 5.57 m). 🗈 Fragments now in the museum at the former Hospital of Sta. Maria della Scala, Siena. Commissioned by the Commune of Siena.

The poor condition of the fountain is largely the result of the use of an inferior-quality local stone, rather than marble from Carrara. The heavy usage of the fountain and its placement in a much-used piazza, as well as vandalism, contributed to the damage; one of the female figures to the sides, for example, was broken during a horse race (the famous Sienese Palio) in 1743, when it fell because spectators had climbed on it in order to get a better view of the race. As a result of his work on the Fonte Gaia, Jacopo gained the nickname "Jacopo della Fonte." Drawings of portions of the fountain's design survive and have been attributed to Jacopo (Metropolitan Museum of Art, New York; Victoria and Albert Museum, London).

the next row, and so on. As a result, he imposes on the basic system of orthogonals, which meet at a vanishing point within the frame, secondary systems of diagonals that meet at other vanishing points to either side, outside the frame. This produces an external control for establishing a systematic diminution of the distance between the transversals in depth. This secondary system is also a part of Alberti's perspective theory. (For Alberti's later formulation of perspective, see pp. 275–76.) Whether this was an original part of Brunelleschi's perspective demonstrations or Donatello hit on it ten years or so before Alberti published its formulation, is uncertain.

Nothing in Donatello's architectural perspective, with its views through three successive levels separated by arches and piers, prepares us for what is happening in the foreground space. There the scheme is disrupted by the event—the presentation of St. John's severed head on a platter to Herod. The moment Donatello has chosen is the explosion of an emotional grenade that produces a wave of shock among the spectators. Herod shrinks back; a guest expostulates; another recoils, covering his face with his hand; two children scramble away only to stop short and look back. At the right Salome continues her dance, but two attendants stare, one

with his arm about another's shoulder. Donatello incorporates us and our position into his work, for when viewed from above it becomes clear that the figures are grouped in a semicircle, with the center left open to express the explosive drama of the event. The perspective network of interlocking grids is half submerged in the rush of conflicting drapery folds. Donatello's dramatic scene was to influence later artists, including Leonardo da Vinci, whose *Last Supper* (see fig. 16.24) adopts and refines the dramatic principle on which this history-making relief was based.

Jacopo della Quercia

A fourth decisive sculptor of the Early Renaissance was a Sienese—Jacopo della Quercia (c. 1371/4?–1438), son of a goldsmith and wood engraver. If Vasari's accounts of Jacopo's early life are accurate, he must already have enjoyed a considerable career as a sculptor before taking part in the competition for the doors of the Florentine Baptistery in 1401, but little is preserved that can be attributed with certainty to Jacopo's early period. The major sculptural cycle dating from Jacopo's middle period is the Fonte Gaia in Siena (fig. 7.24), a

7.25. JACOPO DELLA QUERCIA. *Rea Silvia* or *Public Charity*, from the Fonte Gaia. 1418–19. Marble, 5'4" (1.63 m). Museum at the former Hospital of Sta. Maria della Scala, Siena

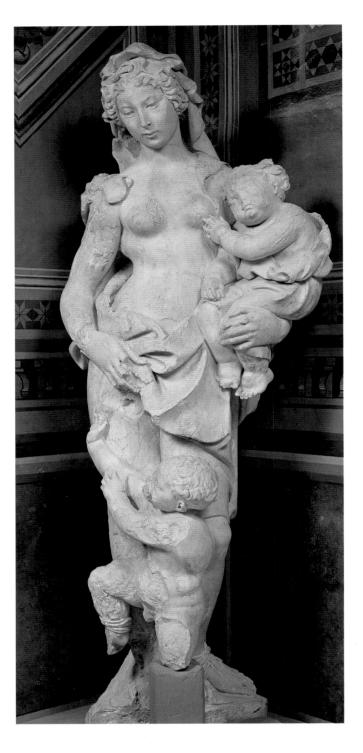

public fountain supplying water to the people in Siena's central square, the Piazza del Campo. The name "gay," which had been in use for an earlier fountain on the same site, suggests the importance of a reliable water supply at the center of the hilly city.

The water poured into a central rectangular basin from multiple spigots in a surrounding wall decorated with high relief sculptures. The central niche contained the Virgin and Child, the Virgin being the patron saint of Siena. The civic virtues of Wisdom, Hope, Fortitude, Prudence, Justice, Humility, Temperance, and Faith are represented in niches on either side of the Virgin. Reliefs at either end represent the *Creation of Adam* and the *Expulsion from Eden*, references to the "original sin" from which Mary and Christ redeemed humankind and from which believers are liberated through baptism, the sacrament of water.

The most surprising element on the fountain are the two standing female figures, each with two children, who stood at the sides on high bases. Their identity is not certain. One theory is that they represent Rea Silvia, the mother of Ro-

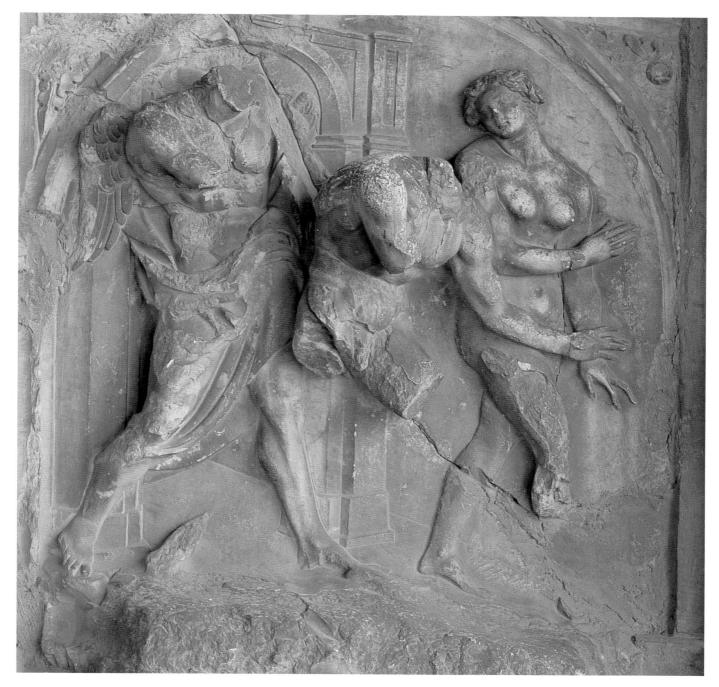

7.26. JACOPO DELLA QUERCIA. *Expulsion*, relief from the Fonte Gaia. 1418–19. Marble, $45^{11}/16 \times 39^{3}/4$ " (1.16 x 1 m). Museum at the former Hospital of Sta. Maria della Scala, Siena

mulus and Remus (fig. 7.25), and Acca Larenzia, the wet nurse of the twins. (Remus was considered to be the father of Senus, founder of the city of Siena.) More recently the women have been identified as Divine and Public Charity. Whatever their iconographic meaning, these maternal figures with babies must be seen as representations of fertility, especially when understood in the context of the life-giving nature of water at a public fountain. In these figures Jacopo builds upon his knowledge of the Renaissance movement in Florence, adding a new sensuous treatment of the female

body not yet seen in Florentine art. The sense of organic life is conveyed not just by the subtle *contrapposto* and the lively movement of the babies, but also by the swelling contours of the group as a whole. With a surprisingly meditative expression, the figure of Rea Silvia/Public Charity looks sharply downward, making eye contact with the Sienese citizens who would come here daily to gather water.

The battered *Expulsion* (fig. 7.26) remains powerful despite its ruinous condition. Adam and Eve, their muscular bodies strongly projected, are expelled from the gate of Eden

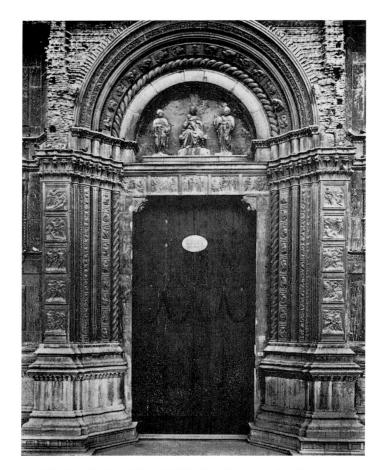

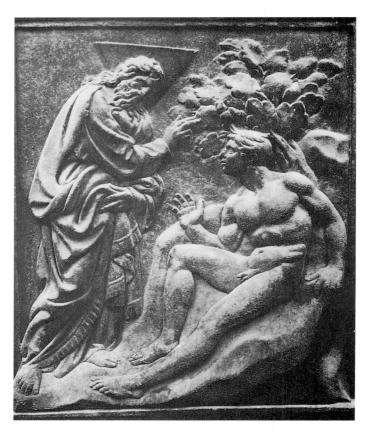

7.28. JACOPO DELLA QUERCIA. *Creation of Adam*, panel on

Main Portal, S. Petronio, Bologna. c. 1429–34. Marble, 39 x 36¹/4" (99 x 92 cm) with frame

by an athletic angel. The spiritual conflict of Donatello's art is translated by Jacopo into physical action.

In many respects the art of Jacopo della Quercia is a curious phenomenon. He had little interest in the architectural achievements of the Florentine Renaissance, paid no attention to its spatial harmonies, and his rare landscape elements remained Giottoesque to the end of his days. Yet in his reliefs for the portal of San Petronio at Bologna (fig. 7.27), he projected a world of action in which figures of superhuman strength struggle and collide. Despite distortions (heads, hands, and feet are sometimes too large) and occasionally crude execution, his reliefs at San Petronio are impressive. Fortunately, the projections are not high, and the

panels have survived in better condition than the Fonte Gaia fragments.

In the *Creation of Adam* (fig. 7.28), a solemn, long-bearded Creator with a triangular halo gathers about him a mantle whose sweeping folds offer the power of Donatello's and Nanni's drapery yet none of their feeling for real cloth; with his right hand he confers on Adam a living soul. The figure of Adam, whose name in Hebrew means "earth," is understood as part of the ground from which he is about to rise. Unlike Ghiberti's delicately constructed nudes (see fig. 10.16), this husky figure is broadly built and smoothly modeled. Jacopo may have patterned the pose and treatment of the figure after the classical Adam in a Byzantine

ivory relief now in the Bargello in Florence. Jacopo's noble figure, in turn, exercised a strong influence on the pose used by Michelangelo in the *Creation of Adam* on the Sistine Ceiling (see fig. 17.35). Of the garden itself, only the Tree of Knowledge, represented as a fig tree, is visible.

The evil effects of this tree are conveyed in the *Temptation* (fig. 7.29), a generally static scene that Jacopo has turned into a tense, even sexual, drama. To demonstrate supernatural qualities, the serpent slides through the tree trunk, emerging on the other side. With one hand, a sensuous Eve repulses the serpent's advance while with the other she already holds the fruit. Eve's body, one of the first voluptuous female nudes since classical antiquity, must have been influenced by an ancient statute of Venus. With a gesture of fury Adam turns away from Eve, expostulating with his head turned back toward his

right shoulder, his eyes glaring. It is not hard to see why this heroic style appealed to Michelangelo, who must have studied Jacopo's works during his two visits to Bologna.

Most intense of all is Jacopo's *Expulsion* (fig. 7.30), its composition roughly the same as that of the relief on the Fonte Gaia. At San Petronio, however, the figures are well enough preserved to exhibit the interplay of muscular forces. Adam attempts to resist, but is powerless against the angel's touch. Eve's pose is based on that of a *Venus pudica*, the modest Venus type favored by Greek sculptors and their Roman copyists. Although occasionally there are resemblances between Jacopo and Nanni, especially in facial types, the world inhabited by Jacopo's figures was, at least in the Quattrocento, available only to his own tormented imagination.

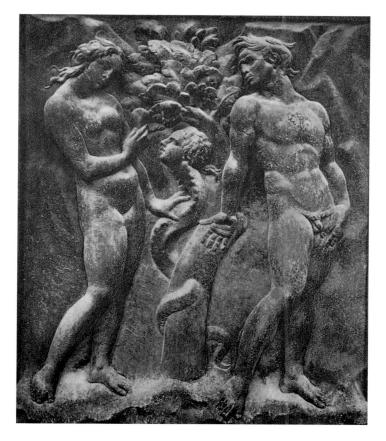

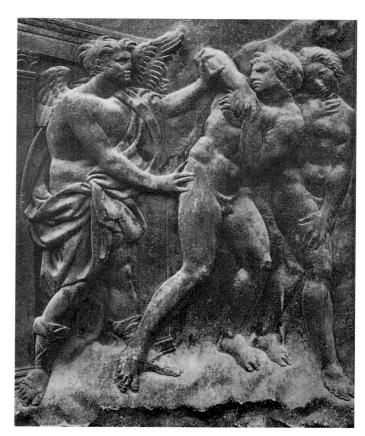

7.29., 7.30. JACOPO DELLA QUERCIA. *Temptation* (left) and *Expulsion* (right), panels on fine Main Portal, S. Petronio, Bologna. c. 1429–34. Marble, each 39 x 36 ½ (99 x 92 cm) with frame

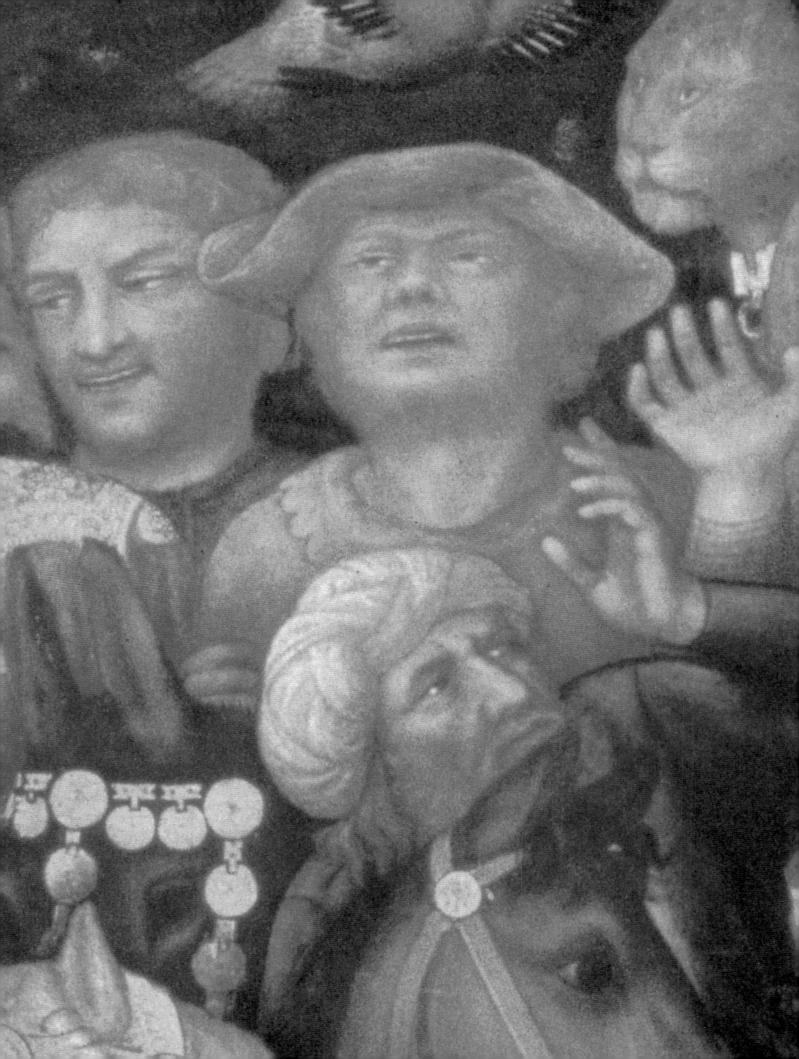

GOTHIC AND RENAISSANCE IN FLORENTINE PAINTING

t is noteworthy that the new figurative style of the Renaissance is seen first in sculpture and only later in painting. During the first two decades of the Quattrocento, the sculptors created the new Renaissance style in the figurative arts in Florence. The painters active during those years were painting altarpieces and an occasional fresco cycle, all in variants of the Gothic style. They were not concerned with the problems that inspired the sculptors, and today their works seem to belong to another era. In their midst there emerged, about 1420 or 1421, a non-Tuscan artist of extraordinary originality, who, judging from the importance of his commissions, must have created a sensation.

Gentile da Fabriano

Gentile da Fabriano (c. 1385?–1427) has suffered at the hands of art historians from two contradictory misconceptions. First, it was thought that he was born about 1370 and his undated works were therefore placed too early in time; second, he was thought to have been a conservative artist, an assessment belied by his works. Our earliest documentary reference concerning Gentile shows him living in Venice in 1408, far from his native town of Fabriano in the Marches. In the Doge's Palace, Gentile painted a fresco, now lost, of a naval battle between the Venetians and Emperor Otto III that took place in the midst of a great storm. Gentile's depiction of the storm clouds, the waves, and the battle was said to have been so realistic that those who saw it were filled with terror.

From 1414 to 1419 Gentile was in Brescia, painting a now-lost chapel at the command of Pandolfo Malatesta. There he met Pope Martin V, who in 1417 had been elected at the Council of Constance to end the Great Schism dividing the Church. Gentile followed the pope to Rome, but he

did not arrive until 1426, after stopping to work in Florence, Siena, and Orvieto. In Rome he began a now-lost series of frescoes in San Giovanni in Laterano for the pope, but this work was interrupted by his death, perhaps as a consequence of the malaria that felled many visitors to the Eternal City.

Gentile's Coronation of the Virgin (fig. 8.1) from the Valle Romita altarpiece (c. 1410–14) is in some ways more naturalistic and less schematic than Lorenzo Monaco's representation of this same subject (see fig. 5.12). Christ and Mary sit suspended in the light of the gold background, the dove of the Holy Spirit floats between them, and God the Father above, surrounded by seraphim, extends his arms. From this height we look down on the top of the dome of heaven, presented as if it were an architectural model bisected to show the interior, studded with stars, and hung with sun and moon. Music-making angels kneel on the outer surface of the dome, which is paved with gold and marble tiles.

The heavy-lidded eyes, languorous expressions, gentle flow of silky drapery, and soft modeling of the faces are typical of Gentile's style; the rich coloring and minute details suggest his knowledge of Venetian painting. Mary's blond hair can be seen beneath her veil, and Christ's reddish brown locks stream over his neck. Mary's azure mantle is lined with muted crimson lighted with tiny strokes of gold, while the mantles of God the Father and God the Son are vermilion. A brighter blue, starred with gold, lines Christ's mantle and contrasts with the vermilion of the seraphim. The gold background is tooled in conventionalized flames around the sacred pair, and incised rays surround the group. The effect is that of some natural celestial apparition, like the Aurora Borealis. Although the draperies are related to the International Gothic Style, their surface has a softness that is Gentile's own.

Palla Strozzi, perhaps the richest man in Florence, commissioned Gentile to paint the Adoration of the Magi

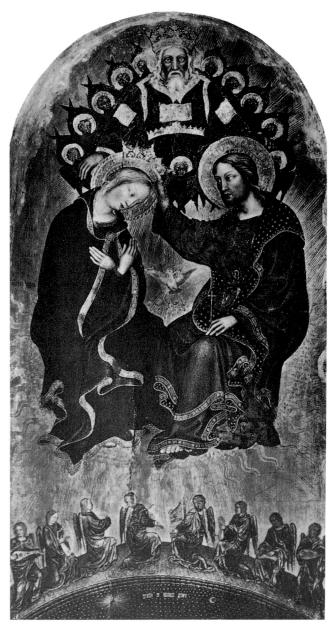

8.1. GENTILE DA FABRIANO. Coronation of the Virgin, from the Valle Romita polyptych. c. 1410–14. Panel, 70½ x 31½ " (178 x 79 cm). Brera Gallery, Milan. Commissioned as the high altarpiece for Sta. Maria di Valdisasso outside Fabriano, probably by Chiavello Chiavelli, Lord of Fabriano

(fig. 8.2) for his chapel in the Sacristy of Santa Trinita. This narrative subject was unusual for a Florentine altarpiece and the splendor of its treatment unprecedented: both were justified by the destined location of the panel, for the Adoration of the Magi marks the moment when the infant Christ was first shown to the Gentiles. The theme and gorgeous garments were thus appropriate to a sacristy where the clergy dressed themselves and prepared for saying the Mass. The

frame recalls earlier Gothic examples (see fig. 5.1), but the forms are now swept together by an exuberant vitality accompanied by greater depth and naturalism. The left and right gables feature roundels of the Annunciation, while in the central gable a youthful God blesses the scene and prophets recline in the spandrels. In the predella, the *Nativity*, the *Flight into Egypt*, and the *Presentation in the Temple* appear almost as one continuous strip. The life that proliferates in the ornamentation comes to a climax in the painted flowers and fruits in the frames as they burst from their Gothic openings to grow out over the gold itself.

Three small scenes in the arches of the main panel narrate moments in the journey of the Magi to Bethlehem. In the left arch the Magi gaze at the star from the top of a mountain, while before them stretches a wavy sea, with ships waiting at the shore. In the center the kings ride up a curving road toward the open gate of Jerusalem. To the right they are about to enter the walled town of Bethlehem; only in the foreground do they arrive at their destination—the cave of Bethlehem, with ox, ass, and manger, the ruined shed, and the modest family. Dressed in splendid garments, the oldest Magus prostrates himself before the Christ Child, his crown beside him on the ground; the second kneels and lifts his crown; the youngest, waiting his turn, still wears his. Attendants crowd the stage: some restrain horses (the animals are shown from both the front and back, a compositional motif that will later become common in Italian art); others toy with monkeys and leopards, or release falcons.

The panoramic views and the rendering of farms, distant houses, and vineyards suggest that Gentile had seen Ambrogio Lorenzetti's *Good Government* series in Siena (see figs. 4.29, 4.30). He was also deeply influenced by the art of northern Italy, both the wild landscape backgrounds and the wonderful animals so typical of Lombard painting (see pp. 176, 425). Gentile has been classified as an exponent of the International Gothic, but his art is a phase remote from that of the Late Gothic painters in Florence. Gentile is uninterested in profiles, for example, and throughout his work, line is understood as part of a directional flow within the tissue of matter and space, whether this flow be the processions in the background, the fluid curves of a horse's proud body, or the undulating drape of silks, velvets, and brocades.

The birds and animals are represented with scrupulous delicacy and also with a new psychological realism. Irreverent attendants exchange glances and, it seems, jokes as their royal masters are caught up in worship, or they look upward in suspense at a pair of fighting birds (fig. 8.3). The two midwives, like guests at a bridal shower, examine one of the gifts as if to assess its value. While chained monkeys chatter happily, the ox looks patiently down toward the Christ Child, and over the rim of a king's halo the ass stares with enormous eyes, his ears lifted, catching unaccustomed sounds. The carefully observed hound in the right foreground, who wears

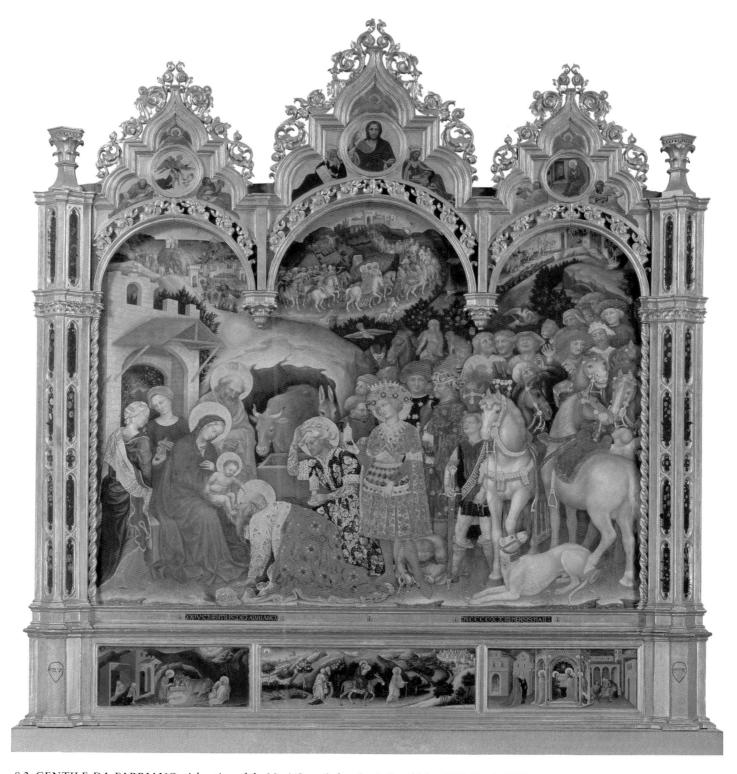

8.2. GENTILE DA FABRIANO. *Adoration of the Magi* (Strozzi altarpiece). Dated May 1423. Panel, 9'10" x 9'3" (3 x 2.82 m). Uffizi Gallery, Florence. Commissioned by Palla Strozzi for his burial chapel in the Sacristy of Sta. Trinita, Florence (the right predella, the *Presentation in the Temple*, is a copy; the original is in the Louvre, Paris)

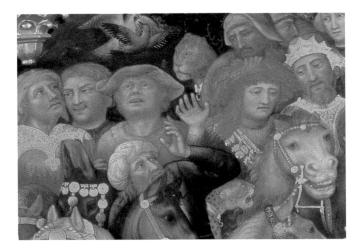

8.3. Attendants, detail of fig. 8.2

a bejeweled collar, seems to be following the clues of the Magi and adopting a position of reverence toward the Christ Child—until the horse steps on him. In the background, dogs chase hares, horses prance and rear, one horse kicks another who then complains, and two soldiers seem to be mugging a wayfarer.

Gentile seems intent on re-creating the whole fabric of the visible world. His rendering, however, is not merely encyclopedic, for he is satisfied only with surfaces whose vibrancy is achieved by a careful study of color. As compared to the brilliance of Lorenzo Monaco, Gentile's color is subdued and rich, full of subtle hints and reflections. There may even be signs that Gentile had studied Florentine sculpture and Masaccio's paintings; the modeling of some of the heads and

the sharply foreshortened figure who is removing the spurs from the youngest king evince this possibility. Nonetheless, with this display of visual richness and naturalism, certain basic archaisms remain. In the main panel of the altarpiece, Gentile seems unaware of the new investigations of space and illusionism: his double scale for figures and setting is still Trecentesque, gold leaf over molded gesso is used for the gold damasks and gilded ornaments, and the landscape carries us to the distant horizons only to end in a gold background.

In the predella scenes, however, Gentile abandons, for the first time as far as we know in Italian painting, the flat gold or undifferentiated blue background in favor of representing a sky with atmospheric and luminary effects. Gentile's Nativity (fig. 8.4), like that of Lorenzo Monaco (see fig. 5.13), is founded on the vision of St. Bridget, but now the light effects are more natural rather than conventional. Although the pool of light emanating from the Christ Child is still a surface of gold leaf with incised rays, Gentile has painted a believable light that shines upon the ceiling of the cave and the faces of the kneeling ox and ass. Illuminating the Virgin, this light casts her shadow on the shed and then casts the shadow of the shed itself upon the underside of the lean-to where the midwives have taken shelter—one curious, the other napping. This light even picks out the branches of the tree under which Joseph sleeps, making a tracery of light against the dark hills. While one portion of the hills is illuminated by a flood of gold from the angel who descends to bring the glad tidings to the shepherds, the remainder billows softly against a night sky dotted with shining stars.

The exquisite attention to nature in this scene is, to be sure, still partly Trecentesque, for it is miraculous rather than

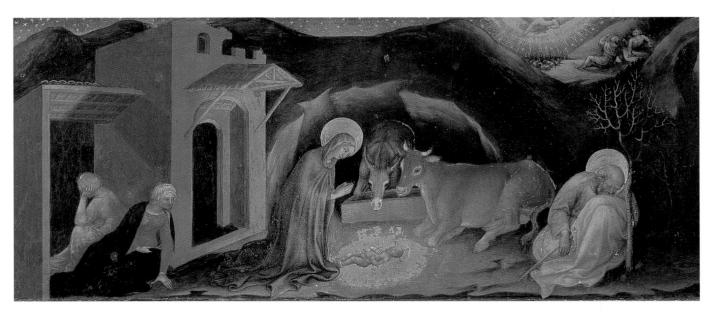

8.4. GENTILE DA FABRIANO. Nativity, on the predella of the Strozzi altarpiece (fig. 8.2). Panel, 12¹/₄ x 29¹/₂" (32 x 75 cm)

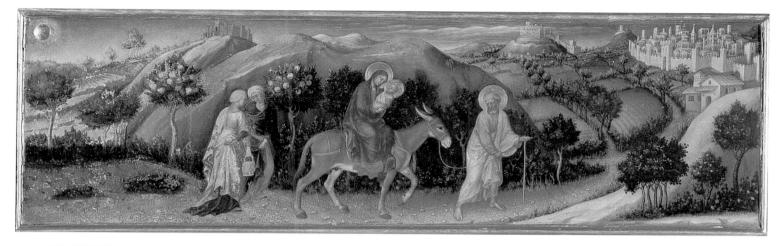

8.5. GENTILE DA FABRIANO. Flight into Egypt, on the predella of the Strozzi altarpiece (fig. 8.2). Panel, 12½ x 43½ (32 x 110 cm)

natural light that illuminates the scene and casts the shadows. Yet this is the first painting we know that contains the source of illumination within the picture and maintains its effect consistently on the represented objects. The supernatural is treated as if it were natural—so natural that one wonders if Gentile made a model of a stage set with figures and put a candle inside it before painting the scene. The little ruined structure is, of course, the same one he painted in the principal panel above; the only difference is that between December 25 (the birth of Jesus), in the predella, and January 6 (the arrival of the Magi), in the main panel, the barren ground has brought forth flowering and fruit-laden trees. Apart from the religious meaning of the scene, the effect is naturalistic and yet deeply poetic—especially the dark, distant hills and starry sky.

Equally convincing is the *Flight into Egypt* (fig. 8.5). The little family, still attended by the midwives, moves along a pebbly road that curves through a rich Tuscan landscape toward a distant city. The farms and hillsides are lighted by a sun raised in relief in the gesso and gilded, and the natural light that washes over the fields, giving the effect of grain ripe for harvesting, is also created through the use of gold leaf. The distant hills and towers rise against a soft, blue sky, the first natural daytime sky we know in Italian art. Darker toward the zenith, lighter toward the horizon, it is clearly represented with atmospheric perspective. One fortified villa is partly hidden by drifting clouds. So velvety is the landscape and so subtle does the light dance across rocks, pebbles, foliage, and people that we easily accept the scene as natural, in spite of the persisting medieval double scale.

Gentile's stay in Florence was short, but his influence there was incalculable. As far as can be determined, he was the first Italian painter to carry out the atmospheric discoveries Donatello had made and those realized in northern Europe in the miniatures of the Limbourg brothers. He is also, as far as we

now know, the first Italian painter to depict shadows cast consistently by light from an identifiable source, and the originator of an almost endless series of night scenes, a rarity in the Quattrocento but later a commonplace. Gentile put into practice Ghiberti's maxim "Nothing can be seen without light."

Masolino and Masaccio

No artists in Florence in the early 1420s understood more clearly Gentile's innovations than two painters who, strangely opposite, not only collaborated on several works but also shared the name Tommaso. One, however, was known as Masolino (Little Tom), the other as Masaccio (the suffix "accio" in Italian usually means "ugly" or "bad" but it can also mean something big and impressive). Perhaps these nicknames were coined to distinguish them according to appearance, character, or style. Masolino, little concerned with the problems and ideals that inspired the sculptors of the time, created an artificial world of refined shapes and elegant manners, flowerlike colors, and unreal distances. But Masaccio, on the other hand, was one of the revolutionary painters of the Western tradition, and as careless of "beauty" in his works as he was, apparently, neglectful of appearances in real life; he was profoundly influenced by the world of space, emotion, and action that the sculptors had discovered. Yet the two managed to work together.

Tommaso di Cristofano Fini—Masolino—was probably born about 1400 in Panicale in the upper Valdarno (Arno Valley). He joined the Arte dei Medici e Speziali in 1423. Much of his life was spent away from Florence; his most adventurous trip took him to Hungary in the service of the Florentine *condottiere* Pippo Spano, from September 1425 to July 1427. Later he worked in Rome and then, about 1435, in the Lombard village of Castiglione Olona, where he probably died in 1436.

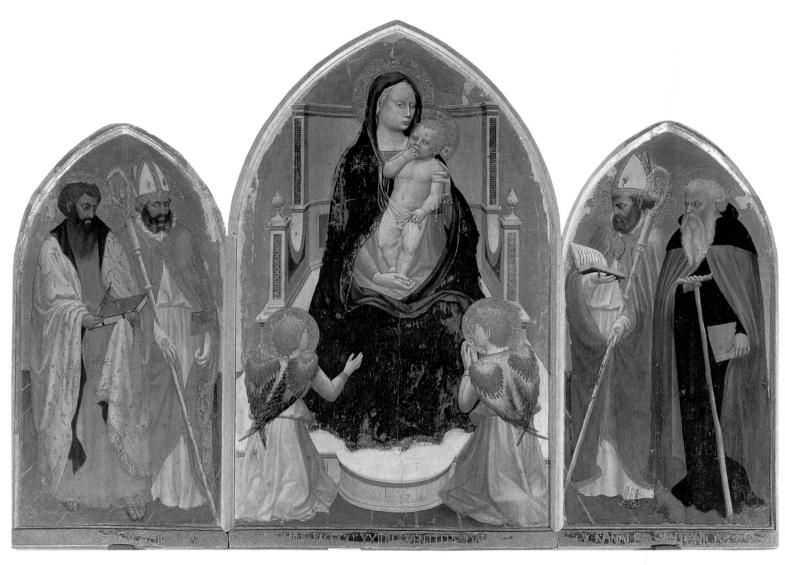

8.6. MASACCIO. Madonna and Child with Saints. Dated April 1422. Panel, 42½ x 60½" (1 x 1.5 m). 🗓 S. Giovenale, Cascia di Reggello

Masaccio—Tommaso di Ser Giovanni di Mone Cassai—was born December 21, 1401, in what is today San Giovanni Valdarno, not far from Panicale. He joined the guild in Florence in January 1422 and worked there and, in 1426, in Pisa. In the summer or autumn of 1428 he went to Rome, where he died either later that year or in 1429.

The tradition that Masolino was Masaccio's teacher was laid to rest by the discovery of an early work by Masaccio, a *Madonna and Child with Saints* (fig. 8.6) in a small church at Cascia di Reggello, on the slopes of the mountain mass that dominates Masaccio's native town. The roughness, impulsiveness, and freedom exhibited in this triptych, dated April 23, 1422, justify Vasari's account of Masaccio as an artist who cared nothing about material considerations, neither the clothes he wore, the food he ate, the lodgings he inhabited, nor the money he received, so completely was he on

fire with "le cose dell'arte" (literally, "the things of art"). The twenty-year-old artist painted a rather stiff Madonna, with a high forehead, staring eyes, and a weak chin, on a traditional inlaid marble throne. The Christ Child, homely and stiff-limbed, holds a bunch of grapes and a veil and, like a real baby, stuffs two fingers into his mouth. Two angels kneel before the throne, and while their wings preserve the traditional rainbow gradations, the feathers are as disheveled as those of street sparrows. On either side stand pairs of morose saints. But under the guise of this naturalism, the triptych still discloses its religious content, for the grapes Christ holds are those of the Eucharist.

In the triptych, little trace remains of the Gothic or of Ghiberti's mellifluous folds (see fig. 7.8), and at first sight there appears no influence of Gentile either. But Gentile must already have been in Florence for several months at the time

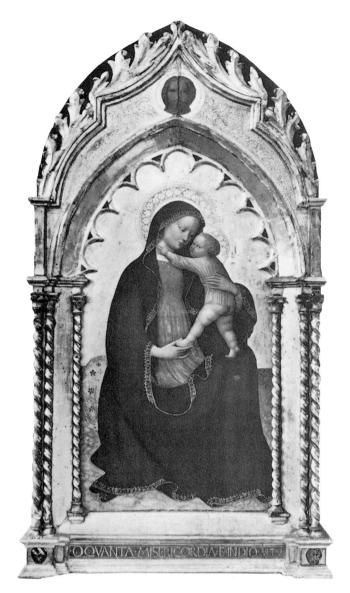

8.7. MASOLINO. *Madonna and Child*. 1423. Panel, $37^{3}/4 \times 20^{1}/2$ " (96 x 52 cm). Kunsthalle, Bremen

Masaccio's triptych was completed, and it may have been his style that suggested to the young painter the free sketchiness of, for example, the wings of the angels and the hair and beards of the saints. But already Masaccio has gone farther than Gentile. Here the hands and limbs and, above all, the folds of the angels' tunics exist as ordinary daylight reveals them. At twenty, Masaccio has assimilated the lesson of Donatello's *St. George and the Dragon* (see fig. 7.17), carved scarcely five years before.

One year later, in 1423, Masolino signed a dainty *Madonna and Child* (fig. 8.7) whose style, closely related to those of Lorenzo Monaco and Ghiberti, shows not a trace of Masaccio's brutal naturalism. The delicately modeled head of the Virgin is typical of Masolino's female faces throughout his career, while the sweetness of the Christ Child, the tenderness with which he touches the Virgin's neck, and the easy

curvilinear flow of the drapery are all within the conventions of conservative Florentine style. Only the roundness of the modeling in light and shade betrays that Masolino, too, was attempting to learn some new lessons.

THE BRANCACCI CHAPEL. The most important manifesto of the new pictorial style was the decoration of the Brancacci family chapel in the Carmelite Church of Santa Maria del Carmine in Florence—a cycle by Masaccio and Masolino that would become a model for Florentine artists, including Michelangelo.

In the cloister alongside the church, Masaccio had painted a celebrated fresco of the new church's consecration in which he represented a procession of contemporary, recognizable Florentines. This influential work was destroyed; only a few drawings survive—some by Michelangelo—

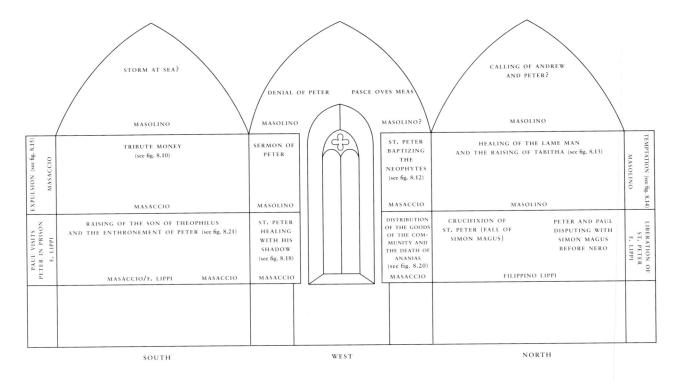

8.8. Iconographic diagram of the Brancacci Chapel. Diagram by Sarah Loyd

showing certain figures. The Brancacci Chapel also suffered losses over time. In the mid-eighteenth century the frescoes of the vault and lunettes were destroyed and replaced with a dome frescoed in that era's style. Later, in 1771, when a fire devastated much of the church, the Brancacci Chapel suffered only small areas of loss.

Because evidence suggests that the lost vault and lunette frescoes were by Masolino, it has been proposed that he alone received the original commission and was later joined by Masaccio, but this is by no means certain, especially given the manner in which they rather consistently worked together on other projects. The dating of the chapel frescoes is uncertain, with some scholars placing the frescoes in 1424-25, before Masolino's trip to Hungary and Masaccio's stay in Pisa in 1426, and others suggesting that work continued in 1427-28. Perhaps the simplest explanation is that the frescoes were accomplished by the two painters working together at some time during the fall of 1427 and the spring of 1428. Whether Brunelleschi also played a role in the design of the chapel is uncertain, but the frescoes are enframed with pilasters and entablatures in the new, Brunelleschian style. It is also unclear how much of the cycle was left unfinished when the two painters departed for Rome in the spring of 1428; physical evidence suggests that portraits of the Brancacci may have been destroyed after the family was exiled in 1435. In any case, Filippino Lippi finished the frescoes in the chapel in the early 1480s. A restoration during the 1980s removed layers of grime, revealing color that represents a return to Giotto and subtle atmospheric and landscape detail.

The chapel frescoes, with two exceptions, represent scenes from the life of St. Peter, the first pope (fig. 8.8). Exactly why this subject was chosen at this time and for this Florentine chapel has been a matter of lengthy debate, and there is no agreement among scholars. Since the founding patron of the chapel was named Pietro, the choice of his patron saint for the fresco cycle is not unexpected. At the same time certain aspects of the cycle can be related to the history of the Carmelite Order, suggesting that the clergy at the church may also have played a role in the choice and interpretation of the theme.

The most problematic of the frescoes in terms of theme is the one that is probably most famous: Masaccio's Tribute Money (figs. 8.9, 8.10; see fig. 5), a subject (Matthew 17:24-27) that was seldom represented. When Christ and the apostles arrived at Capernaum, Peter was confronted by a Roman tax-gatherer who demanded the usual halfdrachma tribute. Peter, returning to Christ for instructions, was told that he would find the money in the mouth of a fish near the shore of Lake Galilee. He caught the fish, collected the money, and paid the tax-gatherer, who then departed. Out of this episode, Masaccio has built a scene of great solemnity. He has also revised the story. In the middle of the fresco the tax-gatherer comes directly before Christ and the apostles, who are not represented "at home," as in the text, but standing in a semicircle before a wide Arno Valley landscape. Peter points to the left, indicating that Christ has directed him to Lake Galilee. There, in the background, Peter finds the fish in shallow water, and on the far right, in the

8.9. MASACCIO, MASOLINO, and FILIPPINO LIPPI.

Brancacci Chapel, Sta. Maria del Carmine, Florence (see fig. 5). The miraculous icon on the altar of the Brancacci Chapel is known as St. Mary of the People (Santa Maria del Popolo); it was in Sta. Maria del Carmine by 1315, but was probably only moved into the chapel in 1422. Between 1422 and 1434 the chapel was owned by Felice Brancacci, the nephew of Pietro di Piuvichese Brancacci (died 1366/67), who founded the chapel. The money to pay for the frescoes may have been the two hundred florins left to the monks of the Carmine by Pietro's son Antonio when he died c. 1383/90. Another possible source for funds was Pietro's widow, Mona Ghetta, who died c. 1414. If these earlier legacies were depleted, it is possible that Felice, as owner of the chapel, also participated in funding this Brancacci family burial chapel. Felice, who served as the Florentine ambassador to Cairo in the early 1420s, fled Florence when Cosimo de' Medici returned from exile in 1434, never to return. His property was confiscated.

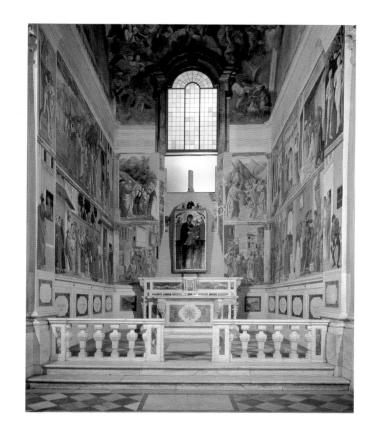

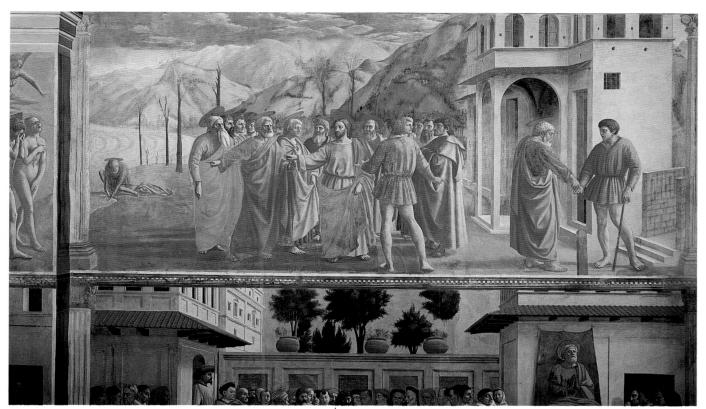

8.10. MASACCIO. *Tribute Money.* 1420s. Fresco, 8'1" x 19'7" (2.47 x 5.97 m). Brancacci Chapel, Sta. Maria del Carmine, Florence. Perhaps commissioned by Felice Brancacci.

The head of Christ is painted on one of the last *giornate* of the fresco, probably because this is where the nail was driven in the plaster to which the string was attached that was used to determine the perspective recession of the building to the right. The head of Christ is in the style of Masolino and may have been painted by him. This fresco was painted in thirty-one days.

foreground, he pays off the tax-gatherer. But center stage is, therefore, occupied by the confrontation of temporal and spiritual power. Christ gives his instructions to the apostles, whose faces betray surprise, indignation, and concern.

The assessment and payment of taxes has a long complex social and political history, but whether Masaccio's *Tribute Money* reflects the debate about taxes in Florence during the 1420s is still uncertain. In order to distribute equitably the financial burden of the war with Filippo Maria Visconti, duke of Milan, in 1427 the Florentines instituted a new tax called the *catasto*, based on ability to pay and provided with a system of exemptions and deductions (see p. 182). One aspect of the Florentine debate was whether the clergy could be taxed, a problem for which the story of the Tribute Money provides a biblical precedent.

Whether or not there is an explicit Florentine reference here, Masaccio has chosen to place the scene on the banks of the Arno. His semicircular arrangement of heavily cloaked figures in depth had a precedent in Nanni di Banco's *Four Crowned Martyrs* (see fig. 7.18); the young Masaccio may even have been watching when the group was installed in its niche at Orsanmichele. Certainly he studied the behavior of light on the figures, faces, and drapery masses of the powerful figures created by contemporary Florentine sculptors.

In his landscape, however, he has surpassed sculptors and painters alike. The vast distances of Ambrogio Lorenzetti and Andrea da Firenze had been depicted partly from above and always ended in a flat, abstract background, as if the mountains and trees were extensions before an impenetrable wall. Masaccio, adopting Donatello's low point of view and atmospheric distance and Gentile's complexity of construction, has produced a landscape of a grandeur unknown before his time. The wide plane of the impenetrable wall is dissolved, as it was in the tiny predella panel in Gentile's Strozzi altarpiece (see fig. 8.5). The eye is taken inward harmoniously, with none of Gentile's medieval leaps in scale, past the plain and the riverbanks, over ridges and distant mountains, some snowcapped, to the sky and the clouds. In this landscape, Masaccio's rugged figures stand and move at their ease. They and the landscape are represented with the full power of the new style that Masaccio had developed. Objects, forms, faces, figures, and masses of heavy drapery all exist in light that models them and sets them forth in space.

The background is filled with atmosphere. Misty patches of woodland are sketched near the banks. Masaccio's brush moves with a new ease and freedom, representing not hairs but hair, not leaves but foliage, not waves but water, not physical entities but optical impressions. At times the brush must even have administered jabs at the moist plaster surface in a manner suggesting the touch of a nineteenth-century Impressionist such as Manet or Monet.

Masaccio depicts the apostles not as the officials of the Florentine oligarchy but as "men in the street," like the artisans

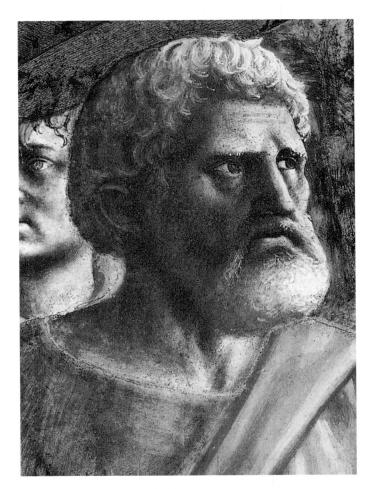

8.11. Head of St. Peter, detail of fig. 8.10

and peasants on whose support the Republic depended (fig. 8.11). They are painted with conviction and sympathy—sturdy youths and bearded older men, rough-featured, each an induplicable human personality, each endowed with the fortitude that can still be counted on when the Florentine people face adversity, as modern events like the bombing of the city's bridges in World War II and the 1966 Arno flood have shown. As if to symbolize both the spatial existence of the figures and the individuality of the personalities, the haloes are projected in perspective and touch or overlap at random angles. The tax-gatherer, seen from the rear in *contrapposto*, is as astonished as the apostles at the message of Christ.

On the same upper tier, just to the right of the altar, Masaccio painted *St. Peter Baptizing the Neophytes* (fig. 8.12), the scene set at a cold spring high in the headwaters of the Arno. Here the artist shows himself the equal of Ghiberti and Jacopo della Quercia (see figs. 7.6, 7.28) in the representation of the nude figure; subsequent generations were impressed by the realism of the shivering figure awaiting his turn, the man drying himself with a towel, and the muscular youth kneeling in the foreground, over whose head St. Peter pours the cold water. The nude, painted with broad strokes, conveys a sense of what it would be like to be cold and almost naked in the presence of

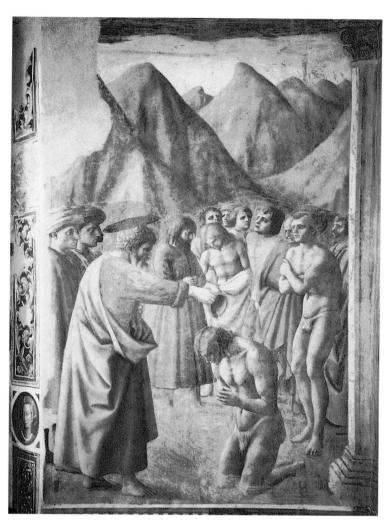

8.12. MASACCIO. St. Peter Baptizing the Neophytes. 1420s. Fresco, 8'1" x 5'8" (2.47 x 1.7 m). Brancacci Chapel. It has been suggested that the landscape in this scene was painted by Masolino.

This fresco was painted in ten days.

inhospitable nature. The volumes of the figures are defined by Masaccio's new *chiaroscuro* technique—smooth and consistent in the surfaces of legs, chests, and shoulders, strikingly sketchy in the heads in the background. The two young men at the extreme left, wearing the Florentine *cappuccio* wrapped around an underlying framework, *mazzocchio* (see p. 295 and figs. 11.3, 11.4), appear to be portraits.

Masolino's principal contribution to the upper tier is the fresco opposite the *Tribute Money*—the *Healing of the Lame Man and the Raising of Tabitha* (fig. 8.13), miracles performed by St. Peter in Lydda and Joppa. Although it would have been difficult for Masolino, given his dual subject, to create a composition as close-knit and unified as that of Masaccio's *Tribute Money*, the two frescoes were constructed using the same perspective scheme, with the vanishing point at the same height within the fresco; perhaps the two painters were working on the two opposing scenes simultaneously. Masolino had to depict two separate scenes, telescoping the space between them with a continuous Florentine city background whose simple houses, projected

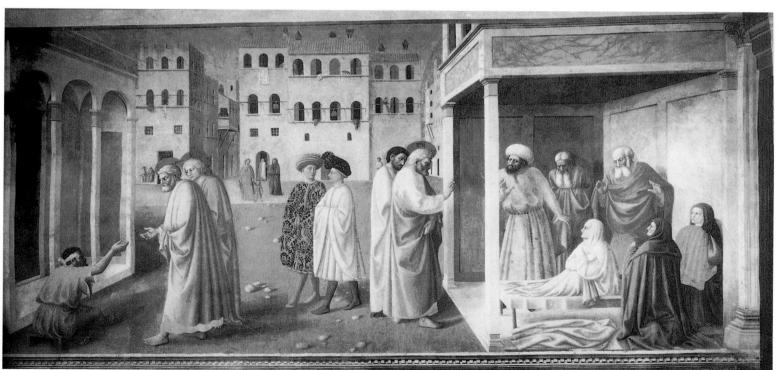

8.13. MASOLINO. Healing of the Lame Man and the Raising of Tabitha.

1420s. Fresco, 8'1" x 19'3" (2.47 x 5.9 m). Brancacci Chapel. This fresco was painted in thirty days.

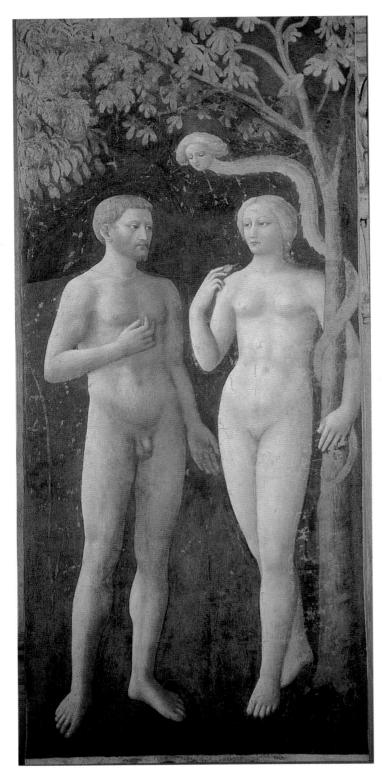

8.14. MASOLINO. *Temptation*. 1420s. Fresco, 7' x 2'11" (214 x 89 cm). Brancacci Chapel. This fresco was painted in six days.

in perspective, are now sometimes attributed to Masaccio. On the left St. Peter and St. John, with typical Masolino faces and haloes still parallel to the picture plane, command the lame man to rise and walk; on the right they appear in the home of Tabitha (on the ground floor, not the upper story

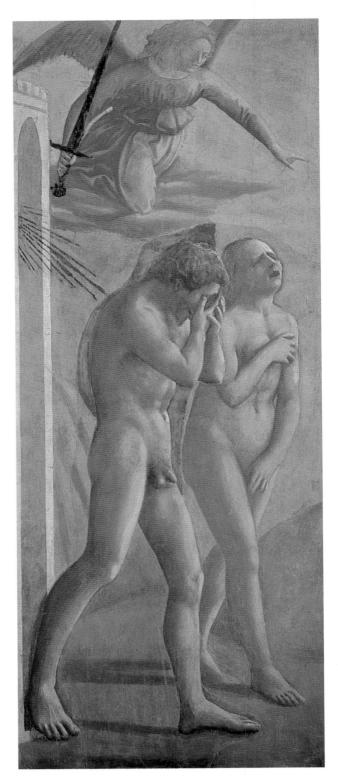

8.15. MASACCIO. *Expulsion*. 1420s. 7' x 2'11" (214 x 89 cm). Brancacci Chapel. This fresco was painted in four days.

mentioned in the text) and raise her from the dead. The two elegantly dressed young men in the center are the messengers sent from Joppa to fetch St. Peter and St. John with the greatest speed, although their doll-like faces betray little sense of urgency.

Masolino's drapery lacks the fullness and suppleness of Masaccio's, and there is little sense of the underlying figure. Expressions seem forced, and the drama unconvincing. The sense of the light here is sophisticated; rocks scattered on the ground cast shadows that are directly related to the placement of the window within the chapel. In addition to emphasizing the consistent light source and adding another measurable element to the spatial recession, they may also be a reference to St. Peter, whose name is the same as "stone" in Latin and Italian and who is symbolically recognized as the "rock" on which the Roman Church was founded.

To modern eyes the styles of the two friends collide abruptly in the scenes representing the *Temptation* (fig. 8.14) and *Expulsion* (fig. 8.15) that face each other on the entrance arch. Masolino and Masaccio may well have found the division of labor reasonable—to Masolino the less dramatic scene, to Masaccio a moment of personal and universal tragedy. How these scenes are related to the main cycle has been much debated, but perhaps the reason for their inclusion was based on the idea that the Church, under Peter and the papacy, is the institution that helps humanity overcome the sin of Adam and Eve. Whatever the theological or historical basis for their inclusion, these paired nude figures are not usually a part of the Peter legend. Restoration has removed leaves that were added to cover the figures' genitals; now they are completely and, in this context, unexpectedly naked.

Masolino painted a gentle Adam and an equally mild Eve, undisturbed by the trouble that is about to ensue. She throws one arm lightly around the tree trunk while, from the bough above, the serpent's human head tries to attract her attention. The nude flesh appears naturally soft, but the feet hang instead of support, and the masses are so elegantly silhouetted against the dark background that the figures seem like cutouts.

Masaccio's *Expulsion* was perhaps influenced by Jacopo della Quercia's relief on the Fonte Gaia (see fig. 7.26), but the painter infused the scene with even greater intensity. He abandoned the physical contest between the angel and Adam; a calm, celestial messenger hovers above the gate, holding a sword in one hand and pointing with the other to the barren world outside Eden. Adam moves forth at the angel's bidding as if driven by his shame. He ignores his nakedness, burying his face in his hands (fig. 8.16). His mouth contorts in anguish and the muscles of his abdomen convulse. Eve remembers to cover her nakedness, but she throws her head back, her mouth open in a cry of despair (fig. 8.17). The drama has been reduced to its essential elements—two naked, suffering humans pushed out into the cold unknown and forced to face work and death.

Above right: 8.16. Head of Adam, detail of fig. 8.15 Below right: 8.17. Head of Eve, detail of fig. 8.15

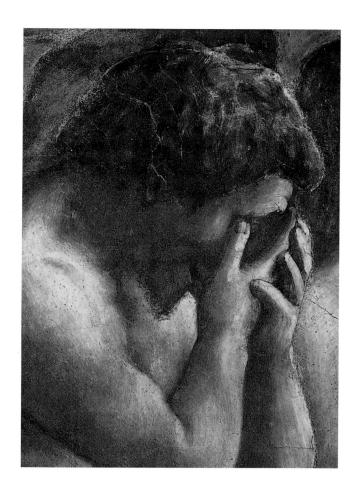

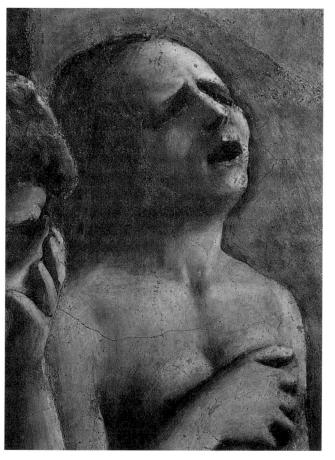

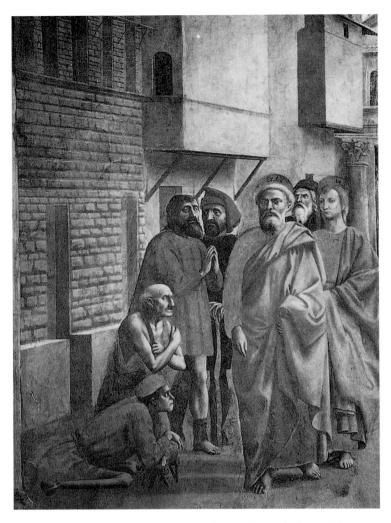

8.18. MASACCIO. St. Peter Healing with His Shadow. 1420s. Fresco, 7'7" x 5'4" (2.3 x 1.6 m). Brancacci Chapel. This fresco was painted in ten days.

On the right-hand side of the altar, the *Distribution of the Goods of the Community and the Death of Ananias* (fig. 8.20) seems to be set in the middle of a village in the Florentine countryside. The houses frame a view over a freely painted Tuscan landscape. St. Peter and four other apostles,

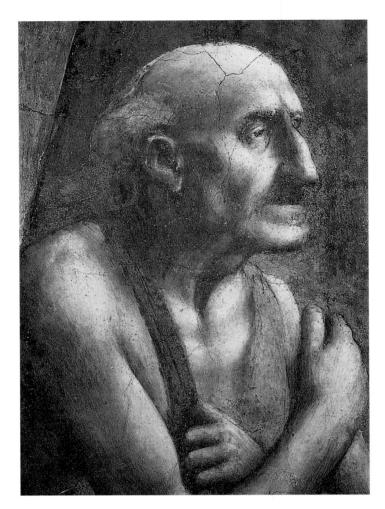

8.19. Lame man, detail of fig. 8.18

enveloped in majestic cloaks, distribute alms to the poor, who are as rough and as noble as they; the peasant woman holding her child comes from the same stock as any of Masaccio's Madonnas. In the immediate foreground stretches the corpse of Ananias, who lied about the full value of a farm to his fellow Christians and who was, therefore, struck down at Peter's feet—a grim reminder of the fate of a tax delinquent. (Masaccio's tax declaration of 1427, written in his own hand, is still preserved, and the words and phrases are set forth with a simple dignity.)

In Masaccio's Raising of the Son of Theophilus and the Enthronement of St. Peter (fig. 8.21), the artist has adopted an S-shaped plan in depth, with one center revolving around the miracle performed at the left, the other curving around St. Peter being adored by Carmelites at the right. These curves, one moving toward us, the other away, are locked in a rectilinear architectural enclosure, formed partly by the palace of Theophilus, partly by the austere architectural block before which St. Peter is enthroned. The presence of

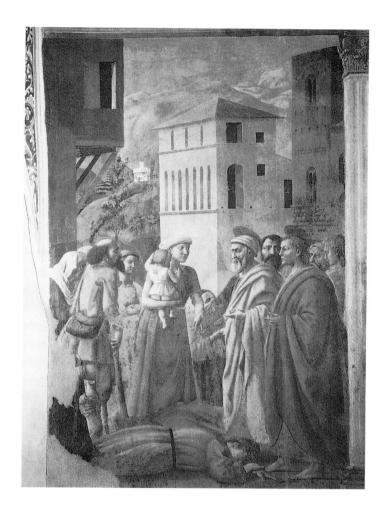

8.20. MASACCIO. *Distribution of the Goods of the Community and the Death of Ananias*. 1420s. Fresco, 7'7" x 5'2" (2.3 x 1.6 m). Brancacci Chapel. This fresco was painted in twelve days.

the Carmelites in the same scene with Peter would seem to be a reference to a contemporary debate about the origin of the Carmelites; while members of the order argued that it was founded by the prophet Elijah and that some members were baptized by Peter himself, others maintained that they had been founded in the twelfth century in the Holy Land. To represent Carmelites, even contemporary portraits of Carmelites, worshipping St. Peter is to support the Carmelite argument about their ancient origins.

The architectural setting is by Masaccio, as are most of the figures except for the five at the extreme left, eight in the central section, and the delicate kneeling boy, all of which were finished by Filippino Lippi. The palace of Theophilus has Brunelleschian Corinthian pilasters and pedimented windows that resemble those of the Ospedale degli Innocenti (see fig. 6.6). A wall divided into panels of inlaid colored marble runs across the back of the scene, and freely painted trees and potted plants are placed in an asymmetrical sequence against the sky.

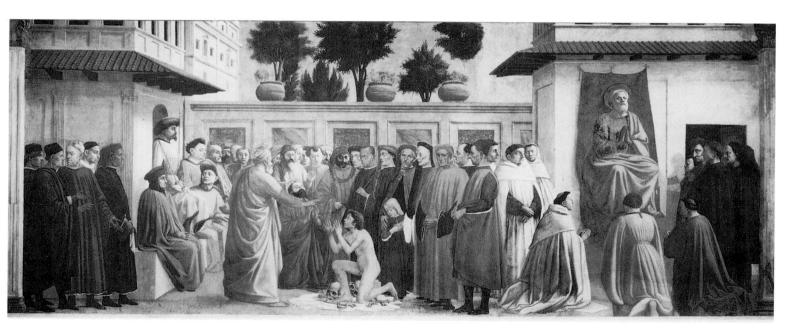

8.21. MASACCIO (some areas painted by FILIPPINO LIPPI). Raising of the Son of Theophilus and the Enthronement of St. Peter. 1420s; completed early 1480s. Fresco, 7'7" x 19'7" (2.3 x 6 m). Brancacci Chapel. The third figure from the right, who is staring out at us, is presumed to be a portrait of Masaccio's part in this fresco was completed in thirty-two days. Filippino, who usually spent a full day painting one of the portraits, spent another twenty-two days completing it.

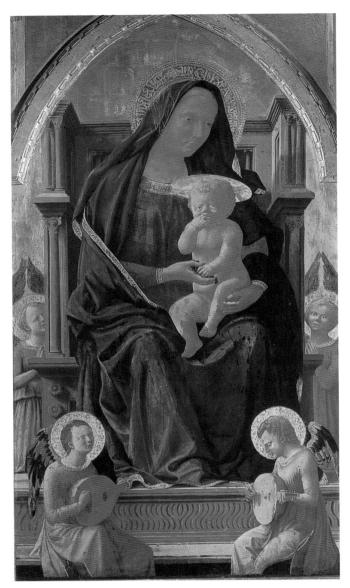

8.22. MASACCIO. Enthroned Madonna and Child, fragment from the Pisa polyptych. 1426. Panel, 53¹/₄ x 28³/₄" (135 x 73 cm). National Gallery, London. Commissioned by Giuliano di Ser Colino degli Scarsi, a notary, for Sta. Maria del Carmine, Pisa

One senses in this fresco a strict adherence to an abstracted, geometric composition. The masses of the figures, projected so convincingly in depth and light, adhere to the patterns of the embracing curvilinear and rectilinear ground plans within which they are set. Only the central St. Peter (by Masaccio, with the exception of the outstretched hand) is free to act and move. The meaning of the fresco is reduced to simple and compelling terms in its composition: St. Peter appears twice, at the two foci of the S-plan; other mortals, including Theophilus, are only incidental elements in the structures that revolve around the Church.

THE PISA POLYPTYCH. Masaccio worked in Pisa from February to December of 1426 on a polyptych for a Pisan church. At an unknown date it was dismembered, the panels scattered and some lost. The effect of the surviving central panel, the *Enthroned Madonna and Child* (fig. 8.22), is so overwhelming that it is a surprise to discover its modest dimensions. The looming monumentality of the Virgin reveals Masaccio's ability to elevate human figures, with all their physical defects, to a level of grandeur and power.

Some of the majesty of the figure doubtless derives from the fact that we read the two-story throne with its Corinthian columns as a work of architecture, imagining gigantic proportions for its occupant by analogy. She towers above the cornice, her blue cloak falling in heavy folds about the masses of her shoulders and knees. It is possible that Masaccio made a model throne and a clay figure with cloth arranged over it to chart the behavior of light and shade, as Verrocchio and his pupils would do later. This could explain how Masaccio produced with such accuracy the shadows cast on the throne by its projecting wings or by the Virgin herself. The plain faces conform to a type seen over and over again in Masaccio's work. The Christ Child, now totally nude, is again behaving like a baby, eating the Eucharistic grapes offered him by his mother (see fig. 8.6).

The panel is damaged; here and there passages of paint have broken away, but worse is the overcleaning, which has reduced the face of the Virgin to its underpaint. The architectural details of the *pietra serena* throne, including the rosettes and the S-shaped strigil ornament (imitated from ancient and medieval sarcophagi still in Pisa; see Nicola Pisano's manger, fig. 2.27), are strongly projected, as are the lutes in the hands of the two little angels. Here the haloes are still set parallel to the picture plane with the exception of that of the Christ Child, which is foreshortened in depth.

In the *Crucifixion* (fig. 8.23) intended for the summit of the altarpiece, Masaccio has determined the spot where the observer must stand to see all the forms correctly. The cross, for example, is seen from below, and the body of Christ is foreshortened upward, with the collarbones projecting in silhouette. The face inclines forward, looking down into the upturned face of the spectator, as does the figure of God the Father above Donatello's *St. George* niche (see figs. 4, 7.15). The gold background may have been specified by the patron, but so convincing is the sense of mass and space created by Masaccio that the gold no longer seems completely flat; it sinks into the distance to become an illusion of golden air behind the figures on Calvary. The bush that grows from the top of the cross once contained the pelican striking her breast to feed her young, a medieval symbol for the sacrifice of Christ.

The sacrifice is Masaccio's theme, rather than the historical incident, which is here reduced to four figures. The Magdalen prostrates herself before the cross, her arms thrown wide so that the cross seems to rise upward from her gesture

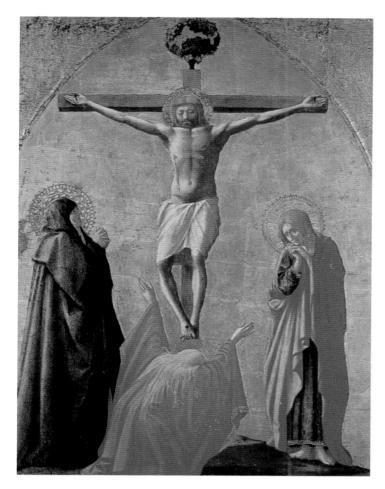

8.23. MASACCIO. *Crucifixion*, from the summit of the Pisa polyptych. 1426. Panel, $30^{1/4}$ x $25^{1/4}$ " (77 x 64 cm). Museo di Capodimonte, Naples. Commissioned by Giuliano di Ser Colino degli Scarsi for Sta. Maria del Carmine, Pisa

of despairing guilt to culminate in the arms of Christ stretched in pitying self-immolation. The yellow hair and red mantle of the Magdalen are in jarring contrast with the soft rose tone of the evangelist's cloak. St. John, wrapped in his own grief, seems to shrink into himself under the cross. Mary expands, a noble presence in her blue mantle, whose voluminous folds are set forth with all the conviction of Masaccio's style at its best. No longer is she the swooning Virgin common in Trecento art. At the Crucifixion, St. Antonine writes, the Virgin Mary is "erect, not fainting on the ground . . . afflicted, but not tearing her hair or scratching her cheeks or complaining to the Lord." She stands with dignity under the cross, her hands folded in prayer. Christ, pale in death, his eyes closed and the crown of thorns low upon his brow, seems to be suffering still. The Christus triumphans of the twelfth century, the Christus patiens of the Duecento, and the Christus mortuus of Giotto and his followers are fused and transfigured by Masaccio's new humanity. And in these four small figures, Masaccio achieved a drama of Aeschylean simplicity and power. All the grandeur of the Brancacci frescoes is here in miniature—all the beauty of light on the gradations of the fold structures revolving in space, all the consistency and breadth of anatomical masses, all the strength and sweetness of color. And nowhere more than in this panel did Masaccio's style deserve the characterization given it in the later Quattrocento: "puro, senza ornato" (pure, without ornament).

The epic breadth of Masaccio's art is maintained even in the predellas. The central *Adoration of the Magi* (fig. 8.24) may represent Masaccio's comment on the profusion of Gentile's Strozzi altarpiece (see fig. 8.2), painted only three years before, although the interval seems more like fifty. Masaccio has adopted an eye-level point of view. He fills the foreground with figures and then discloses, between or just above them, a landscape of simple masses that recedes with more

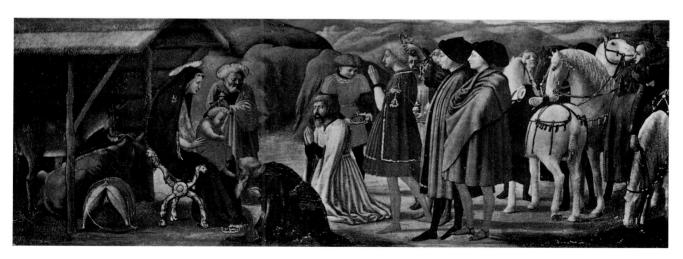

8.24. MASACCIO. Adoration of the Magi, from the predella of the Pisa polyptych. 1426. Panel, 81/4 x 24" (21 x 61 cm). Gemäldegalerie, Berlin

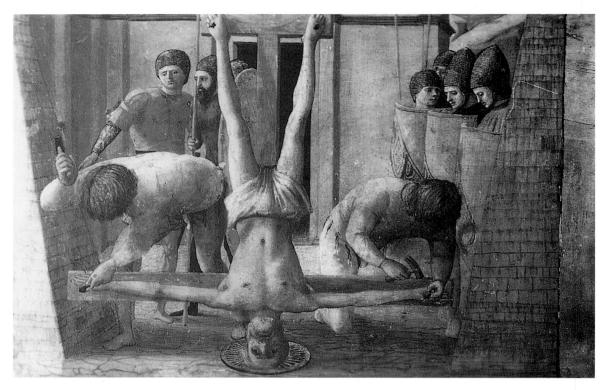

8.25. MASACCIO. *Crucifixion of St. Peter*, from the predella of the Pisa polyptych. 1426. Panel, $8^{1/2}$ x 12" (22 x 31 cm). Gemäldegalerie, Berlin

spatial conviction than the splendid miscellany in Gentile's world. The distant bay and promontories suggest the seacoast near Pisa; the barren land masses may be based on the eroded region called Le Balze, near the Pisan fortress-city of Volterra. His low viewpoint allows him to compose a magnificent pattern of masses and spaces using legs, both human and equine, and the flat shadows cast by these legs on the ground. Masaccio's soberly clad kings enjoy the services of only six attendants as they arrive before the humble shed. The vividly portrayed patron, Giuliano di Ser Colino, and his son stand in contemporary costume just behind the kings, the patterns of their cloaks worked into the structure of the composition. Everywhere one finds new delicacies of foreshortening. Note for example, the ox, ass, and saddle, all turned at various angles to the eye and therefore differently foreshortened, or the white horse who lifts one hind hoof gently and turns his head so that we can just discern his beautiful right eye. Another example is the groom at the extreme right who leans over toward us.

The same spatial principle compressed into minuscular scope is turned to dramatic effect in the *Crucifixion of St. Peter* (fig. 8.25). This subject had presented difficulties for artists because St. Peter had insisted that, to avoid irreverent comparison with Christ, he be crucified upside down. Masaccio meets the problem by underscoring it; the diagonals of Peter's legs are repeated in the shapes of the two py-

lons, which are based on the ancient Pyramid of Gaius Cestius still to be found in the city of Rome. Between the pyramids, the cross is locked into the composition. Within the small remaining space the executioners loom toward us with tremendous force as they hammer in the nails. Peter's halo, upside down, is shown in perfect foreshortening.

THE TRINITY FRESCO. What may be Masaccio's most mature work is the fresco representing the central mystery of Christian doctrine, the Trinity (fig. 8.26), in Santa Maria Novella in Florence. Below the illusionistic chapel that encloses the main scene is a skeleton bearing the epitaph: "Io fu gia quel che voi siete e quel chio son voi anco sarete" ("I was once what you are, and what I am, you also will be"). The configuration of the skeleton, the text, and the religious imagery above is obviously related to tomb iconography; beneath the floor in front of the fresco there was once a tomb for Domenico Lenzi and his family. Domenico died in January of 1426 (Florentine style; new style 1427) and is the probable man, depicted with his wife, in Masaccio's Trinity. The tomb would have been related to an altar where Mass could be said for the deceased, and perhaps the altar table of the Lenzi family chapel was installed in the space between the skeleton and the Trinity.

The skeleton is not a representation of Domenico Lenzi but rather of Adam, over whose tomb it was believed Christ

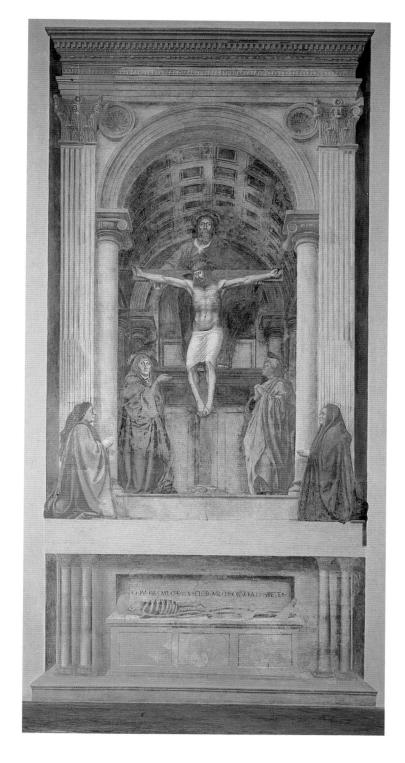

8.26. MASACCIO. *Trinity with Mary, John the Evangelist, and Two Donors.* c. 1426–27. Fresco, 21' x 10'5" (6.4 x 3.17 m) (including base). Sta. Maria Novella, Florence. The two donors painted here are probably Domenico Lenzi and his wife.

had been crucified. Thus the fresco refers to both the original sin of Adam and Eve and the redemptive power of the Crucifixion of Christ.

The setting of the *Trinity* is a magnificent Renaissance chapel. Its Corinthian pilasters and Ionic half-columns flanking a coffered barrel vault conform so closely to the architecture of Brunelleschi and are projected so accurately in terms of his perspective principles that he almost certainly

must be credited with the design of this architectural illusion. Vasari commented eloquently upon how the illusionistic architecture dissolves the wall here to suggest an apparently real chapel.

In the narrow space before the chapel kneel a man and a woman; their portraits seem so specific that they must have been easily identifiable when painted. While they are decisively placed in front of the enframing architecture to

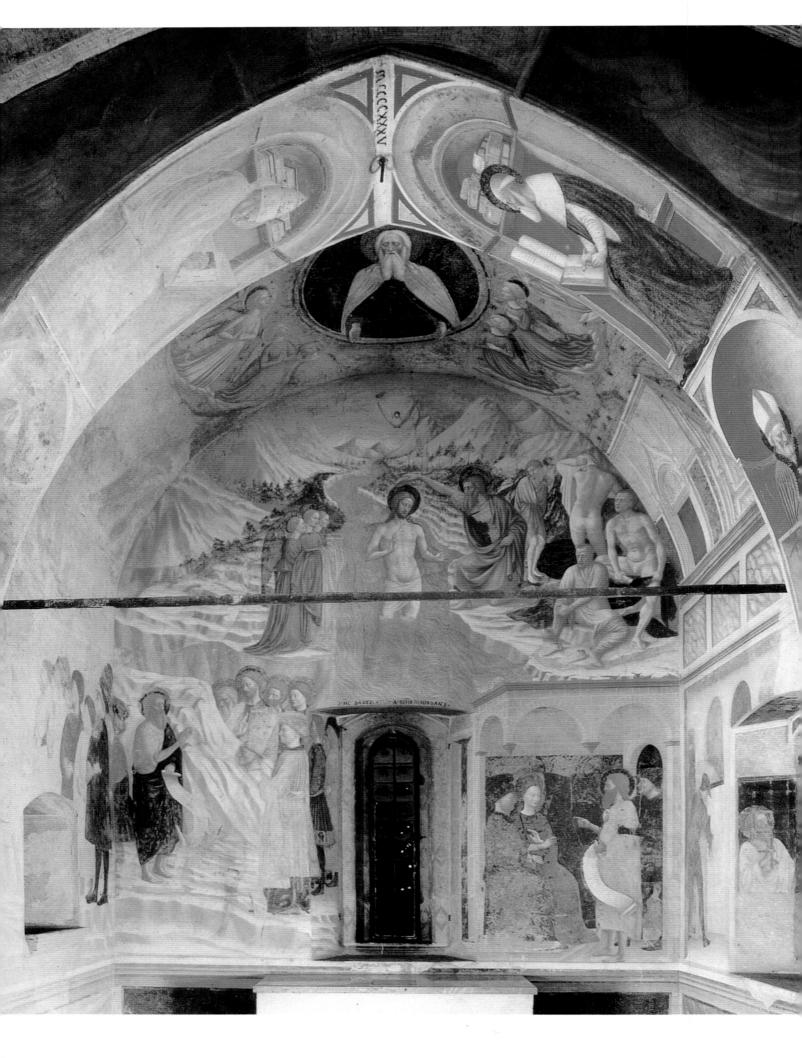

suggest that they exist within our space, the illusion of the tomb enclosing the skeleton is painted to suggest that it exists partly in our space and is partly recessed into the wall; that the skeleton occupies both realms is clearly a spatial equivalent for its inscription.

Within the illusionistic chapel, Masaccio has shown Golgotha reduced to symbolic terms—the sacrifice of Christ through the will of the Father, who stands on a kind of shelf toward the back of the chapel, gazing fixedly outward and steadying the cross with his hands. The figure of Christ is a Christus mortuus who seems to have endured pain and is no longer suffering. The dove of the Holy Spirit flies between the heads of Father and Son. Below the cross, Mary does not look at her Son but raises her hand to recommend him to us; she is somber and determined, with no hint of the elegant beauty with which she is sometimes endowed. St. John seems lost in adoration before the mystery. The portraits of the kneeling man and woman are stoically calm. Here Calvary has been stripped of its terrors. The kneeling Florentines pray to Mary and John, who in turn intercede with Christ, who, in terms of his sacrifice, atones with God the Father for the sins of all humanity.

The pyramidal composition of figures ascends from the mortals in our sphere, outside the arch, to God at its apex. The perspective, on the other hand, converges behind the lightly painted mound of Golgotha—at exactly eye level. The ascending and descending pyramids thus created intersect in the body of Christ. In its reduction to geometric essentials that unite figures and architecture, forms and spaces, the composition could hardly be more closely knit. Its power embodies Giannozzo Manetti's contention that the truths of the Christian religion are as clear as the axioms of mathematics. The composition suggests that the Trinity is the root of all being.

Within the imposing structure, the individual parts are powerfully projected to suggest three-dimensionality and a sense of mass. Details of arms, hands, and architecture reveal startling effects of three-dimensionality. Even the nails that hold Christ's hands are set forth in accordance with the perspective scheme. The surface is rendered with remarkable breadth and freedom. We can only speculate what Masaccio might have accomplished had he lived longer. When informed of his death, Brunelleschi is reported to have said, "Noi abbiamo fatto una gran perdita" ("We have had a great loss").

THE CASTIGLIONE OLONA FRESCOES. Masolino also came to Rome, and for a brief time the two friends collaborated there, although there is little trace of Masaccio's style in the surviving frescoes in San Clemente. A few years later, Masolino was working in the Lombard village of Castiglione Olona, where he carried out two series of frescoes for Cardinal Branda Castiglione. The Baptism of Christ (fig. 8.27) emphasizes grace and charm, but it also contains an echo of Masaccio (see fig. 8.12) in the figures undressing or drying themselves at the right. Yet Masolino apparently was not interested in re-creating Masaccio's rugged heroes, and his dainty Christ seems almost to dance in the ornamental patterns of the water. Masolino has learned how to construct one-point perspective, with strings and a nail, but he clearly delights more in the fantastic nature of his landscape, in which hills, rocks, water, and drapery flow delicately together. What is new here is Masolino's delight in the broad and luminous extent of the earth; in this fresco the painter offers a new, more expansive vision of landscape on a large scale. This landscape is an extension of what Masaccio had accomplished in the Tribute Money, the most influential single painting of the 1420s.

Opposite: 8.27. MASOLINO. Baptistery. Castiglione Olona. Fresco in the lunette: Baptism of Christ; lower register: St. John the Baptist Preaching (left) and St. John the Baptist Brought Before Herod (right). c. 1435–36. Width of back wall 15'6" (4.7 m). Commissioned by Cardinal Branda Castiglione

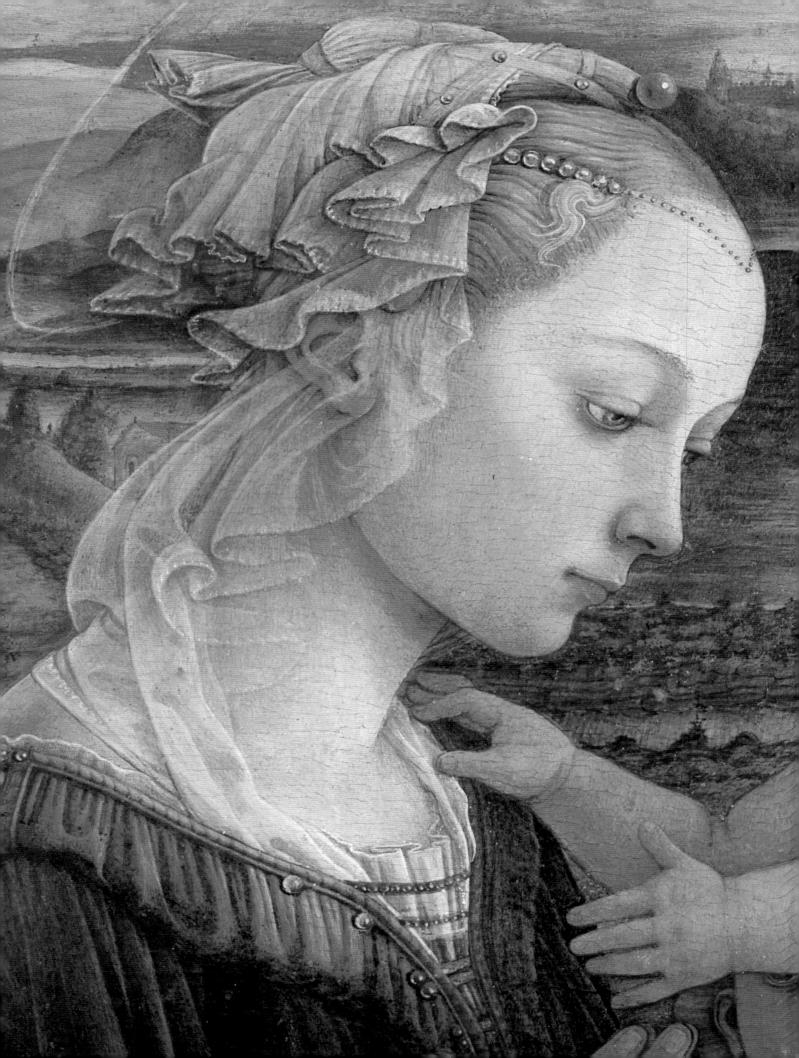

THE HERITAGE OF MASACCIO AND THE SECOND RENAISSANCE STYLE

rom our present vantage point, Florence at the time of Masaccio's death seems the undisputed leader of the new style in painting. But in 1428 Masaccio's influence was neither as immediate nor as far-reaching as that of Masaccio's sculptural contemporaries. The Florentine situation was unlike today's, where artists must compete for timeliness in a market that has no mercy for yesterday's ideas. It would be more fitting to compare Florence with Paris of the 1880s, when the paintings by the Impressionists were bought by a few, and historical, classicistic, and genre painters still ran the Salons and captured popular taste. The Gothic, for example, continued in Florentine painting through the 1430s and into the 1440s and 1450s. Altarpieces with gold backgrounds, pointed arches, tracery, and pinnacles continued to be commissioned and executed in quantity, as if Masaccio had never lived. He had no close followers, but his ideas bore fruit in the work of two painters who seem younger only because they survived him by decades—Fra Angelico and Fra Filippo Lippi-and in the work of other artists born before Masaccio or a decade or so later. In the work of these painters, and in the mature creations of Ghiberti and Donatello, we can watch the early Quattrocento stylistic heritage being transformed into something approaching a common style.

The artists of this second Renaissance style, which flourished in the 1430s, 1440s, and 1450s, lived in and worked for a society that was changing from the defensively republican Florence of the first third of the Quattrocento. Although threats from outside continued until 1454, when the Peace of Lodi put an end to external warfare for forty years, the political and territorial independence of Florence was no longer threatened. But its republican integrity was, and by midcentury the oligarchic state, in whose government the artisan class was permitted at least token participation, persisted in name only. Political and economic rivalry had led to the expulsion of Cosimo de' Medici from Florence in 1433. He left as a private citizen, but he returned in 1434 as, to all intents

and purposes, lord of Florence. Cosimo and his descendants seldom held office, but they maintained themselves in power by manipulating the lotteries that governed the "election" of officials. Until the second expulsion of the Medici, in 1494, the Florentine Republic was in effect a Medici principality, and the Medici related to foreign sovereigns as equals.

Paradoxically, this period comprised the decline of the Florentine banking houses, including that of the Medici, but it also saw the establishment of a new social and intellectual aristocracy among the Medici and their supporters. These humanistically oriented patrons commissioned buildings, statues, portraits, and altarpieces in the new classicizing style: the elegance of ancient Augustan Rome replaced the rougher republican virtues predominant in the art of Masaccio, Nanni di Banco, and the early Donatello. Although sumptuary laws still forbade luxury and display in personal adornment, the palace and villas of the Medici set the tone for a new existence of ease and grace.

At this juncture, it is convenient to examine Fra Filippo Lippi (c. 1406–69) and Fra Angelico (late 1390s–1455) together. Their names were mentioned in a letter written from Perugia in 1438 to Piero the Gouty, son and eventual successor of Cosimo de' Medici, by the painter Domenico Veneziano. Trying to obtain a commission in Florence, Domenico listed Fra Filippo and Fra Angelico as the most important painters of the day and reported that both were overwhelmed with commissions. In their roughly parallel development we can see the emergence of the new Renaissance style. One must remember, however, that both were, by and large, contemporaries of the artists we shall explore in Chapter 10 and absorbed in solving many of the same artistic problems.

Fra Giovanni da Fiesole, born Guido di Pietro and known to us as Fra Angelico, has long been called *Beato* (Blessed) Angelico by the Italians, though he was not actually beatified until 1983. Fra Filippo Lippi, on the other hand, was a monk who fathered two children by a nun. Although Fra Filippo had a personal and visible connection with Masaccio, we

know nothing for certain about his early style. We discuss Fra Angelico first because he was, according to all surviving evidence, the leading painter of Florence in the 1430s, and it was he who interpreted Masaccio's art in a form that exercised a profound and lasting influence on Renaissance art.

Fra Angelico

In 1417 the artist we know as Fra Angelico was a painter named Guido di Pietro. In 1423 he is first mentioned as Fra Giovanni da Fiesole. Depending on his age at the time he entered the monastery, he was probably born in the late 1390s and was in his fifties when he died in 1455. For the span of

more than a generation, he worked as an artist in the service of the Dominican Order, first at San Domenico in Fiesole and then at San Marco in Florence under the priorate of Antonino Pierozzi, who later became archbishop of Florence and was canonized in the sixteenth century as St. Antonine of Florence. Eventually, Fra Angelico succeeded St. Antonine as prior of San Marco. Even before his death, Fra Giovanni was extolled as "the angelic painter."

The earliest fully Renaissance painting by Fra Angelico is his *Descent from the Cross* (fig. 9.1). This work had originally been commissioned by Palla Strozzi from Lorenzo Monaco; it was intended for the Sacristy of the Church of Santa Trinita, where its subject would complement Gentile's

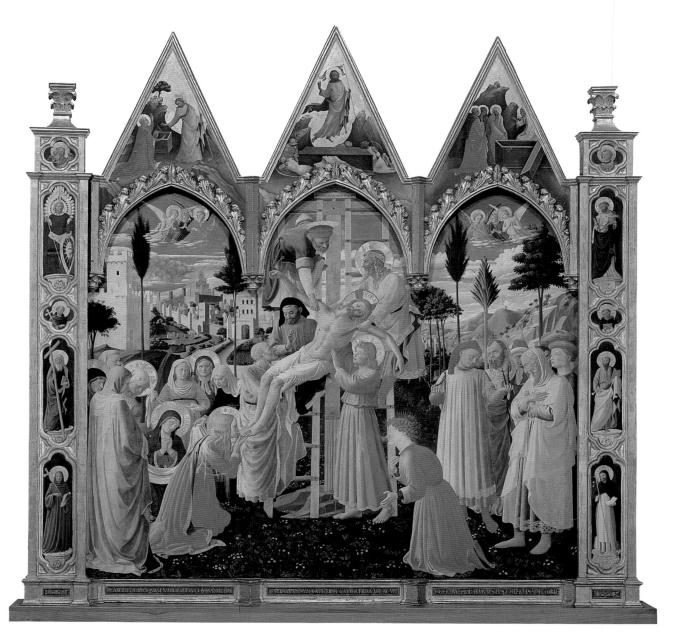

9.1. FRA ANGELICO. *Descent from the Cross*. Probably completed 1434. Panel, 9' x 9'4" (2.75 x 2.85 m). Museum of S. Marco, Florence. Frame and pinnacles by LORENZO MONACO. c. 1420–22. Commissioned by Palla Strozzi for his burial chapel in the Sacristy of Sta. Trinita, Florence

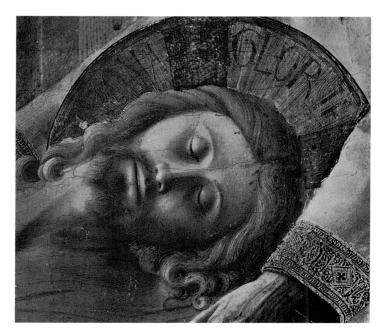

9.2. Head of Christ, detail of fig. 9.1

Adoration of the Magi (see fig. 8.2) in the same chapel. Lorenzo completed only the pinnacles before his death in 1425, and at some later date the unfinished work was given over to Fra Angelico. The painting of the central panel may have been started in the late 1420s or early 1430s and was almost certainly finished by November 1434, when Cosimo de' Medici returned to Florence and members of the opposition party, including Palla Strozzi, were exiled.

At first sight, the artist seems hampered by the preexistent frame, but then we realize that Fra Angelico has exploited the Gothic arches, utilizing the central panel for the cross and ladders and anchoring the bases of the arches to the gates of Jerusalem on one side and to a grove of trees on the other. This monastic painter presents us with a world in which every shape is clear, every color bright and sparkling. Christ, gently lowered from the cross, is received by John, Mary Magdalen, and others and mourned by the kneeling Virgin and the Marys. On the right stand a group of men in contemporary Florentine dress. The young man kneeling in adoration and the older man wearing a red *cappuccio* and exhibiting the crown of thorns and the nails are characterized as *beati* (blessed) by gold rays emanating from their heads.

The figures, grouped on a flowering lawn, are united by their adoration of the sacred body, which is depicted with Fra Angelico's characteristic reticence and grace. His superior, St. Antonine, was to preach and write in horrifying detail about the agony of Christ, but in Fra Angelico's rendering, one barely notices the bruises on Christ's torso or the blood on his forehead. Instead, attention is concentrated on the quiet

face (fig. 9.2) and on the light that dwells on the lips, eyelids, arching brows, and silky surfaces of hair and beard.

Fra Angelico's method of stylization presents the distant Jerusalem as an array of multicolored geometric shapes. The storm cloud that darkened the sky during the Crucifixion still casts a shadow over some of the city. On the right side, a palm, a cypress, and other trees provide a loose screen through which one looks into a hilly Tuscan landscape punctuated by towns, villages, farmhouses, castles, and villas under a sky filled with soft clouds. Fra Angelico's *Descent from the Cross* was a milestone; at this time, no painter in Europe, except Jan van Eyck, could surpass his control of the resources of the new naturalism, and none could match his harmony of figures and landscape.

Fra Angelico's splendid *Annunciation* (fig. 9.3) was painted for Cortona, a Tuscan town on a promontory above the Chiana Valley. Fra Angelico's setting is a portico of Corinthian columns that divide his panel into thirds—two occupied by the arches of his portico, the third by three receding arches and a garden. The angel enters the portico, bowing and genuflecting before Mary as he delivers his greeting. Mary,

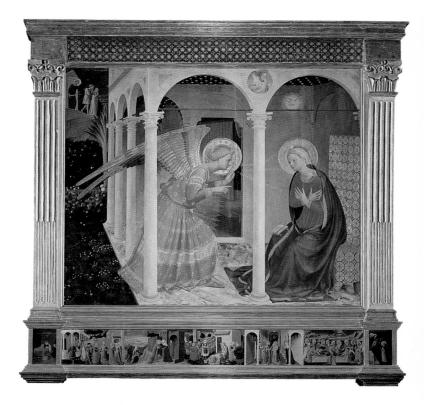

9.3. FRA ANGELICO.

Annunciation and Scenes from the Life of the Virgin. c. 1432–34. Panel, 63 x 71" (1.6 x 1.8 m). Museo Diocesano, Cortona. The frame, with its fluted Corinthian pilasters, is original.

seated on a chair draped with gold brocade, abandons her book to cross her hands on her breast in acceptance of her destiny. Gabriel's words run from left to right, but Mary's reply, "Behold the handmaid of the Lord; be it unto me according to thy word" (Luke 1:38), must be read from Mary to the angel and is written upside down and in reverse. The angel replies: "The Holy Ghost shall come upon thee, and the power of the Highest shall overshadow thee" (Luke 1:35), and directly above Mary's head, in the shadow under the star-studded ceiling, the dove of the Holy Spirit emits golden light. A sculpted representation of the prophet Isaiah looks down from the spandrel. Behind the angel's head, through a doorway and past a partially drawn curtain, we can see Mary's bedchamber.

The garden at the left, a symbol of Mary's virginity that will reappear in many Quattrocento Annunciations, illustrates the words of the Song of Songs, "A garden enclosed is my sister, my spouse" (Song of Songs 4:12). St. Antonine had been connected with the Dominican community in Cortona, and here Fra Angelico follows Antonine's doctrine of the "garden of the soul," a set of meditations for penitents written in Italian. Fra Angelico also identifies the garden with Eden, for at the upper left the weeping Adam and Eve are being gently but firmly expelled. This association is natural since, according to St. Paul, Christ is the second Adam, Mary the second Eve. Angelico avoids the drama seen in Masaccio's *Expulsion* in the Brancacci Chapel (see fig. 8.15), and also the nudity, instead clothing Adam and Eve in the coats of skins God made for them, according to Genesis.

Fra Angelico is aware of Masaccio's method of constructing forms and spaces, but he restrains *chiaroscuro* as firmly as he does emotion. His figures seem barely corporeal—slender and refined; their limbs are only just discernible under their garments. Their faces are drawn with simplicity and purity, and they have exquisitely tended blond hair. The poised shapes, the

subtle rhythms of contour, and the harmonies of space and light are enhanced by the freshness of Fra Angelico's color. The angel, with wings that seem made of beaten gold, is dressed in a tunic of clear, bright vermilion with bands of golden embroidery. Mary's blue mantle contrasts with the sparkling folds of the cloth of honor that hangs behind her, as do the snowy columns with the richly veined marble of the floor, or the white steps with the flowered lawn. As remote from the world as the imagination of a sensitive child, Fra Angelico's altarpiece admits us to a realm of unmarred celestial beauty.

In the predella scenes, however, the real world reappears. In the Visitation (fig. 9.4), we look past Mary and her cousin to where an old woman labors up the hill toward us and then beyond her to a broad landscape, its distance enhanced by shadows of clouds. Mary "went into the hill country with haste," wrote Luke in his Gospel (1:39), and St. Antonine's Summa stressed that a hilly background was important for this first recognition of the divinity of Christ—the joy of John the Baptist while still in the womb of Elizabeth. The background elements are identifiable as the town of Castiglione Fiorentino, the tower of Montecchi (still visible to travelers between Florence and Rome), and the wide lake (see fig. 16.3) that then filled the Chiana Valley. This may well be the earliest recognizable portrait of a known place in the Renaissance. Beyond the sun-drenched town, the plain fuses with the sky in imperceptible gradations of summer sunlight and dusty haze. The spatial experience of landscape is realized more fully in this tiny panel than in any previous Italian work.

In 1436 the decaying buildings of San Marco in Florence were transferred to the Dominicans of Fiesole. Beginning in 1438, the Dominicans, supported by contributions from Cosimo de' Medici, employed Michelozzo to build a new church and monastery on the site (see fig. 6.20). Pope Eugenius IV was present at the consecration of the church on January 6, 1443, under its new prior, St. Antonine. Fra Angelico

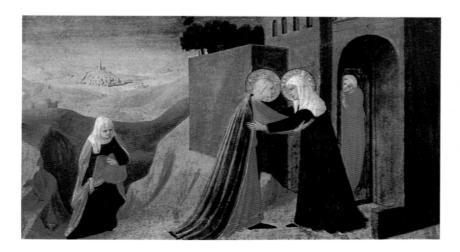

9.4. FRA ANGELICO.
Visitation, from the predella of the Annunciation altarpiece (see fig. 9.3).
c. 1434. Panel, approx. 9 x 15" (23 x 38 cm).
Museo Diocesano, Cortona

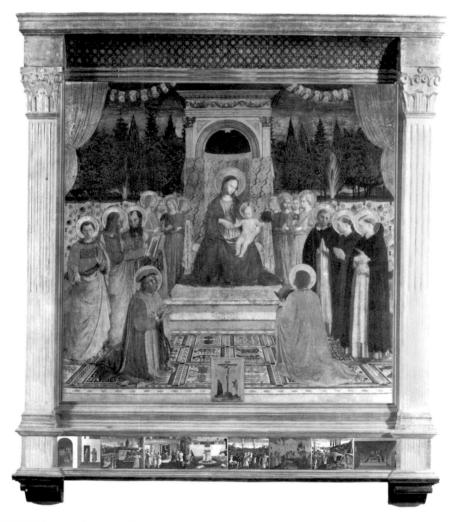

9.5. FRA ANGELICO. *Madonna and Saints* (S. Marco altarpiece), in a conjectural reconstruction. c. 1438–40. Computerized reconstruction by Sarah Loyd.

Central panel, 865/8 x 893/8" (2.2 x 2.27 m). Museum of S. Marco, Florence.

Commissioned by Cosimo de' Medici for the high altar of S. Marco, Florence.

Because the frame of this altarpiece is lost, this illustration uses computerized photomontage in an attempt to re-create the effect of the original altarpiece in a Quattrocento frame. The frame added here is from Fra Angelico's Cortona *Annunciation* (see fig. 9.3). With this frame in place, the illusionism of the gathered curtains to the sides and garland swags across the top take on a new effectiveness.

painted the high altarpiece, which was probably installed by 1440 (fig. 9.5). In this work the artist showed himself to be abreast of the latest artistic developments.

In spite of overcleaning, the principal panel is still impressive. Gold curtains, their loops continued across the top of the picture by festoons of pink and white roses, are parted to show the court of heaven. At the center, where the perspective lines converge, the Virgin is enthroned in a Renaissance niche whose Corinthian order is so closely related to Brunelleschi's new style (and to Michelozzo's adaptation of that style at San Marco) that he himself may have shown Fra Angelico how such things should be designed. The Christ Child is seated as the Divine Ruler, holding a prominent orb

painted with a world map that has the Holy Land at its center, marked by a gold star. Gold brocades decorate the throne and create a wall over which one looks into an "enclosed garden" of fruit trees, cedars and cypresses, palms and roses; these choices are not merely decorative, for Christ is the fruit of the Tree of Life, and Mary, according to symbolism derived from the apocryphal Book of Wisdom, is a cedar of Lebanon, a cypress on Zion, a palm in Cades, and a rose tree in Jericho. The texts inscribed on the Virgin's mantle are: "I am the mother of beautiful love . . . and of holy hope" and "Like a vine I caused loveliness to bud, and my blossoms became glorious and abundant fruit." The garden in the background is both the representation and the symbol of these

words. A circle of angels and saints gathers on the steps and on an Anatolian animal carpet which provides the converging orthogonals of the perspective construction; the rendering of this now-rare kind of carpet seems precise, but it has been noted that its border features the red palle, or balls, of the Medici coat of arms. In the foreground, the circle is continued by the kneeling Medici patron saints, Cosmas and Damian, and completed by what seems to be a small panel of the Crucifixion, a picture within a picture. This illusionistic device is based on the practice that an image of the Crucifixion or the dead Christ was required to say Mass at an altar. A small panel like the one painted within Fra Angelico's altarpiece would be brought from the sacristy in cases where no such image appeared in the altarpiece. One wonders if a visiting priest ever tried to grab the illusion, in order to return it to the sacristy whence he would presume it had come.

This unified composition of figures within an integrated, continuous, illusionistic space is a new development in Renaissance painting. Although we cannot determine who the innovator was, there is no question that Fra Angelico and his Medici patrons were in the forefront of the changes occurring at this time. With its perspective construction, lofty central arch, and pyramidal grouping of figures within a circle in depth, the altarpiece establishes a precedent that may well have influenced other centralized, multifigural compositions.

More completely than any work of Fra Filippo Lippi, Fra Angelico's San Marco altarpiece embodies the ideals of the new phase of the Florentine Renaissance. The pictorial space, measured by systematic perspective from the foreground plane to the horizon beyond the trees, provides place and scale for every figure and thing. The space is projected by dividing the lower edge using the squares in the carpet, then drawing orthogonals from these segments to the vanishing point. One of the kneeling saints turns and looks outward as he points with his right hand, directing our attention to the center of the picture. These devices correspond, as we shall see, to the doctrines of Leonbattista Alberti, who had arrived in Florence a few years earlier, and who, only two or three years before this picture was painted, had circulated *Della pittura*, the Italian version of his treatise *De pictura* (*On Painting*).

Fra Angelico displayed his versatility in handling both figures and the natural world, with its luminous and atmospheric effects, in the predella panels of the legend of Sts. Cosmas and Damian; Dominican high altarpieces rarely have predellas, and the inclusion here of a cycle that would have been instantly recognizable as Medician reveals the influence of the patron in determining iconography, even in public religious works. At first sight the interiors seem to be standard Trecento boxes. The *Miracle of the Deacon Justinian* (fig. 9.6) shows the two saints, who float in trailing soft clouds, exchanging the deacon's gangrenous leg for a healthy

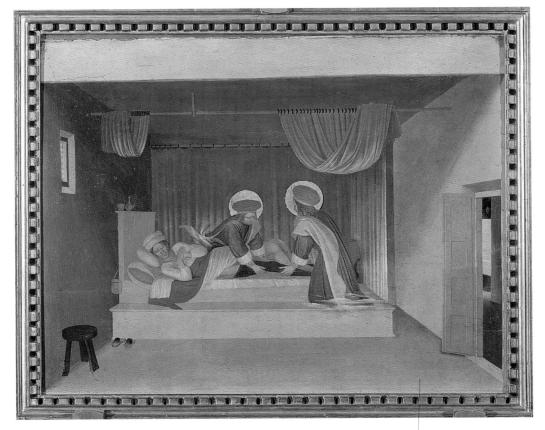

9.6. FRA ANGELICO.

Miracle of the Deacon Justinian, from the predella of the S. Marco altarpiece (see fig. 9.5).

Panel, 14¹/₂ x 18³/₄" (37 x 48 cm).

Museum of S. Marco, Florence

one amputated from a Moor. The space is illuminated naturally by light coming in from the front and slightly left, so that a shadow is cast across the right wall. A second source of light is the tiny window on the left wall, through whose panes light filters onto the embrasure. A third is the light reflected upward from the floor, and there is a fourth source in the corridor visible through the open door at the right. In the separate effects of light from four different sources, in their interplay on walls, furniture, curtains, figures, and still life, and in the delicacy with which light suffuses the shadows, Fra Angelico has produced a triumph of observation.

Fra Angelico's landscapes are even more original than his interiors. The predella panels include scenes where attempts are made to martyr Cosmas and Damian, culminating in their beheading (fig. 9.7). In the foreground, on a road bordering a flowery meadow, the bodies of the two saints and their severed heads, still bearing haloes, tumble on the ground. One of their three younger brothers still kneels, his neck spouting blood, his head rolling beside the others. The other two, blindfolded, await the executioner's sword. The poses of the figures and their facial expressions, which range from the remorse of the officer to the calm brutality of the soldiers, display the artist's interest in physical and psychological activity. The execution, the likes of which could doubtless have been witnessed in the Florence of Fra Angelico's day, takes place among the sunlit spaces and cubic or curving forms of the walled city. The Tuscan hills, crowned by castles and villas, rise in the distance, while the cypresses mark the extent of the landscape.

Between the end of 1438 and late 1445, when he left for Rome, Fra Angelico and his assistants, probably also monks, provided paintings for the Monastery of San Marco's chapter house, corridors, overdoors, and for forty-four individual monks' cells (fig. 9.8). The painters were certainly under the direction of the prior, St. Antonine. The style of their paintings

9.8. MICHELOZZO DI BARTOLOMMEO.

Plan of the second floor of the Monastery of S. Marco, Florence.

- 1. The Library, by Michelozzo (see fig. 6.20)
- 2. Location of fresco of the *Annunciation* in the hallway, at the top of the entrance stairs (see fig. 9.9)
- 3. Location of monk's cell with fresco of the *Annunciation* (see fig. 9.10)
- 4. Location of monk's cell with fresco of the *Coronation of the Virgin* (see fig. 9.11)
- 5. Location of monk's cell with fresco of the *Transfiguration* (see fig. 9.12)
- 6. Location of the double cell reserved for Cosimo de' Medici, with fresco of the *Procession* and *Adoration of the Magi* by the workshop of Fra Angelico
- Location of the double cell used by Savonarola when he was the prior of San Marco

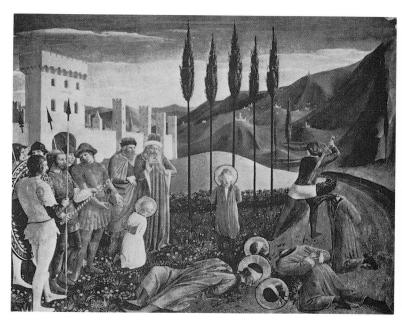

9.7. FRA ANGELICO.

Beheading of Sts. Cosmas and Damian, from the predella of the S. Marco altarpiece (see fig. 9.5). Panel, $14^3/4$ x 18" (38 x 46 cm). The Louvre, Paris

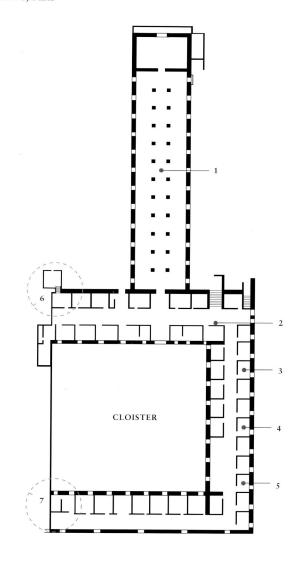

differs sharply from that of Angelico's altarpieces for public view, and there is even a distinction between the frescoes destined for the monastic community as a whole and those in the individual cells. At the head of the staircase into the dormitory, which every monk must have used several times a day, Fra Angelico painted an Annunciation (fig. 9.9) that is supplied with the inscription, "As you venerate, while passing before it, this figure of the intact Virgin, beware lest you omit to say a Hail Mary." The date of the inscription is uncertain, but it is an important indication of practices within the monastery and the role of images in those rituals. Other clues to monastic behavior are evident in the San Marco frescoes; in the fresco of St. Peter Martyr over the door to the adjoining church, for example, the saint has his finger raised in the traditional gesture of silence; clearly monks could speak in the cloister but should fall silent upon entering the church.

As for the *Annunciation*, when seen in its original setting, after making a turn in the staircase, light floods in from the left, conforming to the painted light within Fra Angelico's illusion. As befitting not only the fresco medium but also the monastic setting, the bright colors and gold of the Cortona altarpiece give way to pale tints. Moreover, the architecture is now seen directly from the front, so that the lateral columns recede toward the center of the composition, draw-

ing the viewer's eye from left to right. The greater weight of the columns and the care with which the capitals are rendered probably reveal the painter's interest in Michelozzo's architecture, then in construction all about him. It is doubtful, however, that an architect would have approved of the use of Corinthian and Ionic capitals in the same portico.

The mood here is more contemplative than in the ecstatic Cortona Annunciation (see fig. 9.3). Mary holds no book and she sits on a rough-hewn, three-legged wooden stool. The fence around her Antonine "garden of the soul" is higher and stronger. Her chamber, stripped of furniture, looks on the world through a barred window, and one is reminded of St. Antonine's admonition to sweep clean the room of one's mind and to distrust the eye, the window of the soul. "The death of sin comes in at the windows, if they are not closed as they ought to be," said Antonine in analyzing the theme of the Annunciation. Fra Angelico has made the window the eye of his fresco, the center of his perspective lines.

Within the monks' cells, the observer penetrates into deeper regions of the soul. Each arched fresco is about six feet high and seems to float on the wall under the vault. Everything in these images is pure, clean, and disembodied. The world seems to retreat, leaving the meditative subject suspended in the cell. The *Annunciation* (fig. 9.10) shows a

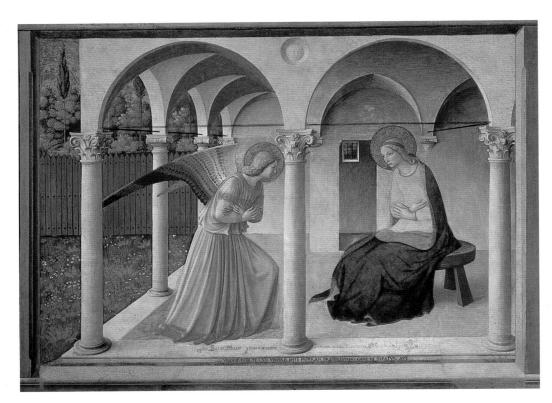

9.9. FRA ANGELICO.

Annunciation. 1438–45.

Fresco, 7'1" x 10'6"
(2.2 x 3.2 m).

Hallway, Monastery
of S. Marco, Florence.

Probably commissioned by
Cosimo de' Medici

Opposite: 9.10. FRA ANGELICO. *Annunciation*. 1438–45. Fresco, 6'1½" x 5'2" (1.87 x 1.58 m). Monk's cell, Monastery of S. Marco, Florence. Probably commissioned by Cosimo de' Medici

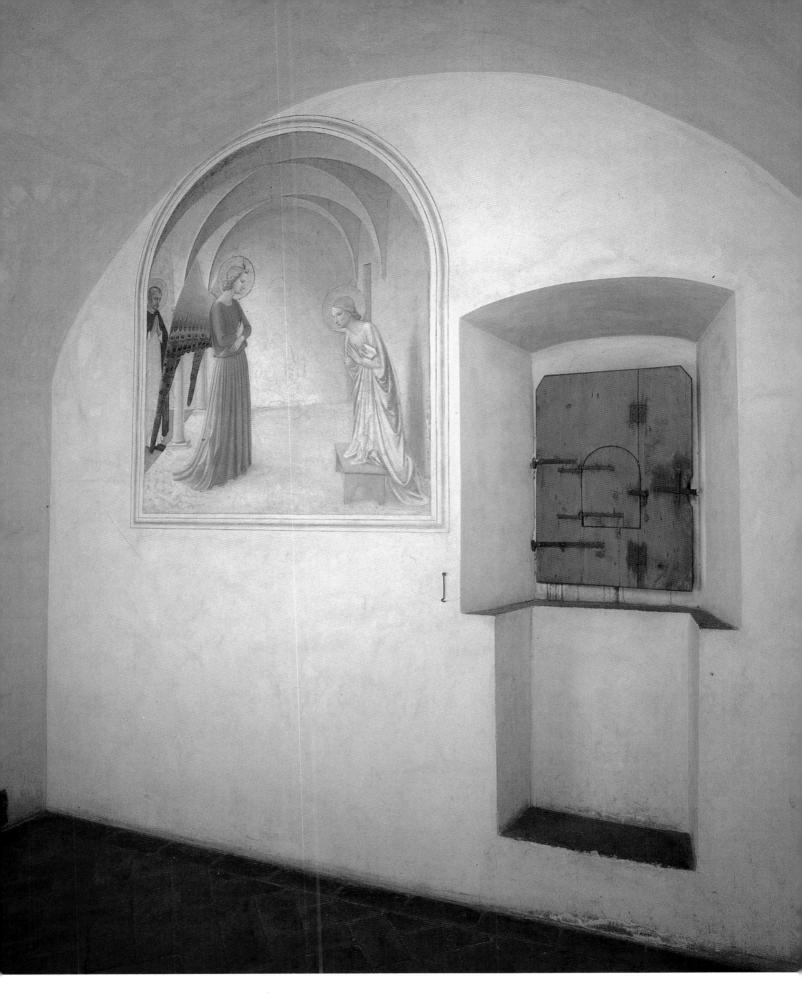

THE HERITAGE OF MASACCIO AND THE SECOND RENAISSANCE STYLE • 253

standing angel and a kneeling Virgin, slight and frail, who holds her open book to her breast. The angel has entered with the light, which falls on the Virgin; they are united by the simple rhythms of the plain architecture, which is arched like the cell. There is no garden, and outside the arcade St. Peter Martyr meditates on the event; he serves as an example for the monk, who, under the hypnotic influence of the luminous colors, clear shapes, and harmonious spaces, is expected to experience mystically the miracle of the Incarnation.

The Coronation of the Virgin (fig. 9.11) glitters with the lilacs and greens of snow-reflected light that vibrate throughout the cloudy throne and the white of the garments. Christ places a crown on the head of the Virgin while Franciscan and Dominican saints, knowing the miracle without having to see it, kneel in an arc on clouds. The Transfiguration (fig. 9.12) becomes at once a revelation of Christ's divinity and a prophecy of his crucifixion and resurrection. He stands, arms spread, enveloped by raiment "shining, exceeding white as snow" (Mark 9:3). He is surrounded by a mandorla composed of the unpainted white intonaco. The apostles below are represented in smaller scale and the figures of Moses and Elijah, who appeared in

the sky with him, are reduced to disembodied heads. Here the Virgin Mary and St. Dominic, identifiable by the red star in front of his halo, serve as mentors for the monk praying under the painting in his cell.

In the San Marco cells, through austere color and purified shape, no worldly concerns trouble the spirit. In each painting, however, Fra Angelico also probes the sensibilities of the individual observer, as Donatello had done in his sculpture (see figs. 7.13, 7.20); in these frescoes the individual is the center, as is also true in the Renaissance perspective system. In this sense these paintings are fully Renaissance works.

Fra Filippo Lippi

Filippo was born about 1406 into the large family of an impoverished butcher in the poor quarter that surrounded the Monastery of the Carmine in Florence. Together with a brother, he entered that monastery at an early age and took his vows in 1421. Vasari reported that he decided to become a painter while watching Masaccio at work in the Brancacci Chapel. The mistake of Filippo becoming a monk was compounded by his appointment to the chaplaincy of a convent

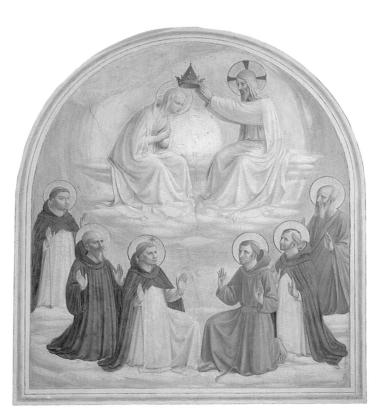

9.11. FRA ANGELICO. Coronation of the Virgin. 1438–45. Fresco, 6'2¹/₂" x 5'2¹/₂" (1.9 x 1.6 m). Monk's cell, Monastery of S. Marco, Florence. Probably commissioned by Cosimo de' Medici

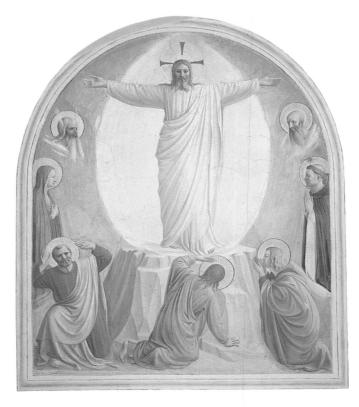

9.12. FRA ANGELICO. *Transfiguration*. 1438–45. Fresco, 6'2¹/₂" x 5'2¹/₂" (1.9 x 1.6 m). Monk's cell, Monastery of S. Marco, Florence. Probably commissioned by Cosimo de' Medici

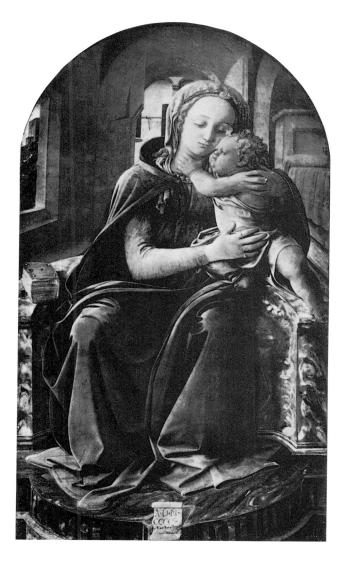

9.13. FRA FILIPPO LIPPI.

Madonna and Child
(Tarquinia Madonna). 1437.

Panel, 45 x 25¹/₂" (114 x 65 cm)
(cut down at the sides and bottom).
National Gallery, Rome.
Perhaps commissioned by Giovanni
Vitelleschi, Archbishop of Florence,
for his palace in Corneto Tarquinia

in Prato where, according to Vasari, his attention was deflected while he was saying Mass by a young nun named Lucrezia Buti. We know from an anonymous denunciation, made to the Office of the Monasteries and of the Night, that from 1456 to 1458 Lucrezia, her sister Spinetta, and five other nuns were living in Filippo's house. During this period a son, who became the painter Filippino Lippi, was born to Lucrezia; later a daughter was born. There was other trouble: patrons claimed that Filippo did not fulfill his contracts; an assistant claimed he was not paid; Filippo found himself in difficulty with ecclesiastical and secular authorities and was tried and tortured on the rack. It is said that Cosimo de' Medici persuaded Pope Pius II to release Filippo and Lucrezia from their vows. They allegedly married and their children were legitimized.

The first dated painting by Filippo that we know, a *Madonna and Child* (Tarquinia *Madonna*) (fig. 9.13), shows the influence of Masaccio. The heavy-featured type chosen

for the Madonna and the simplicity of the domestic interior, complete with a bed and a view into a courtyard, are as reminiscent of Masaccio as are the heavy shadows. Only the marble throne and pearled diadem seem out of place. The absence of a halo for either of the sacred figures underscores their naturalism. But a closer look reveals that Filippo is not interested in the consistency of Masaccio's style. The powerfully lit drapery masses in the foreground project erratically, and the interior space seems throttled around the center, although perhaps this effect is the result of the panel having been reduced in size sometime in the past. The homely gestures and natural attitudes of Masaccio here seem somewhat forced. The most striking feature of the style, however, is the reappearance of contour. Apparently, Masaccio's chiaroscuro did not seem sufficient to Filippo, for around every form he supplied hard, drawn edges, accenting them by gradation of tone to give them the look of sharp lines. An expression of wistful melancholy is often seen on the faces of Filippo's Madonnas.

Also in 1437, Filippo began a large altarpiece for the Barbadori family (fig. 9.14). It is this work that Domenico Veneziano, in his letter of 1438, predicted would take Filippo at least five years to complete. The panel shows the Virgin standing before her throne in a kind of courtyard beyond which blue sky is visible. The architecture is Renaissance, with the pointed arches of a Gothic triptych discarded in favor of round ones. The Virgin uses a sling to hold Christ on one hip, as some mothers still do. Sts. Fredianus and Augustine kneel before her and youthful, blond angels gather about

them. The picture is suffused with shadows, inspired by those of Masaccio, that are softer and richer than those of the Tarquinia *Madonna*. The coloring, smoldering and subdued, is typical of Filippo's early work: soft deep greens, sonorous metallic reds, and smoky plum tones predominate. Here and there a clear yellow or a surprising orange-red enlivens this chromatic scheme, as do occasional touches of gold. While Trecento artists seemed content with the traditional metallic halo, Quattrocento artists began to search for new, more naturalistic devices to suggest the glowing light of

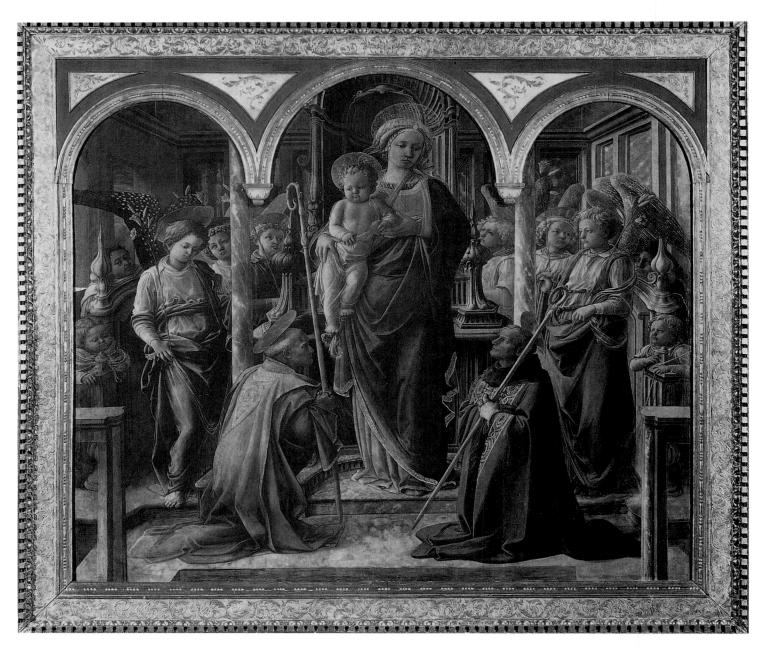

9.14. FRA FILIPPO LIPPI. Madonna and Child with Saints and Angels (Barbadori altarpiece). Begun 1437. Panel, 7'1¹/₂" x 8' (2.17 x 2.44 m). The Louvre, Paris. Commissioned with funds left by Gherardo di Bartolomeo Barbadori (died 1429) as part of the establishment of a burial chapel in the Sacristy at Sto. Spirito, Florence (see fig. 6.11). The frame shown in this illustration is not original.

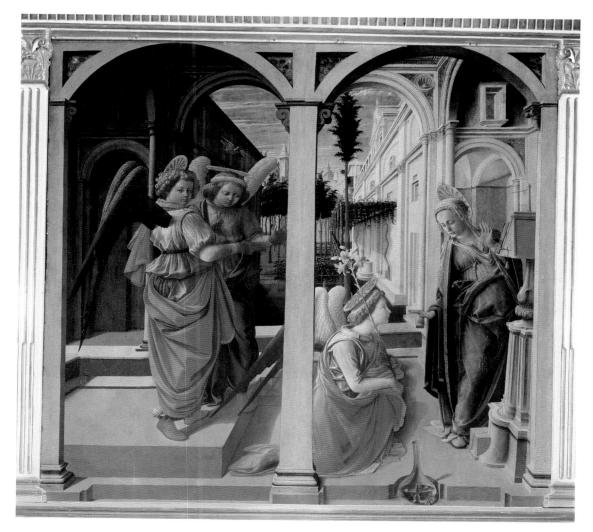

9.15. FRA FILIPPO LIPPI. Annunciation. c. 1440. Panel, 69 x 72" (1.75 x 1.83 m).

S. Lorenzo, Florence. Probably commissioned by a member of the Martelli family for their family chapel in San Lorenzo. Physical evidence and the unusual composition, with the scene of the Annunciation squeezed into one-half of the available space, suggest that the work may have been created as two hinged panels, to function as a kind of diptych.

divinity. Here, apparently for the first time in Italian painting, the haloes of Mother and Child appear to be made of transparent crystal flecked with gold.

As in the Tarquinia *Madonna*, the proportions of figures and faces are full and heavy, and the masses are projected by means of *chiaroscuro*. The pyramidal composition of the central figures is imposing, but we are distracted by the angels, who look like neighborhood youngsters dressed up with wings and lilies, as we know they were for festival occasions. At the Carmine each year, for example, Filippo could witness the Ascension of Christ reenacted for the pleasure of the local population: a hole cut in the ceiling made it possible for the actor who played Christ to sail up through the crossing vault in front of the Brancacci Chapel. And the nearby Church of San Felice put on a similar annual show, designed by

Brunelleschi himself, dramatizing the Annunciation. The angel Gabriel, lowered in a copper mandorla in the midst of the church, ran across a stage in front of the altar and delivered the salutation to Mary, waiting in her little habitation. After listening to her reply, he ascended in a blue dome lined with lighted lamps for stars and with child-angels standing on clouds of carded wool and held in by iron bars so that they could not fall "even if they wanted to," according to Vasari. The flavor of these popular festivals seems to animate Filippo's paintings. Even small details reflect a festive nature, for at the extreme left, chin on balustrade, we see Filippo himself, in Carmelite habit, looking out at the observer.

In Filippo's early *Annunciation* (fig. 9.15) he establishes a deep perspective into a monastery garden, at once the garden of the Temple of Solomon with which Mary was connected

and the symbolic closed garden of the Song of Songs. Mary's agitated pose is probably derived from Donatello's *Annunciation* (see fig. 10.27), but the mood of the picture has little to do with that monument to classicism. The two curly-haired, puffy-faced angels to the left may function as witnesses to this moment of Christ's incarnation. One looks downward; the other gazes out at the observer and points to the Annunciation—a device to lead the observer's eye into the painting that was authorized by the theorist Leonbattista Alberti, who had recently arrived in Florence.

The tones of the drapery of the foreground figures contrast surprisingly with the brilliant orange building at the end of the garden. A captivating feature of the picture is the glass vase in the foreground, from which Gabriel has apparently just plucked the lily he holds. Filippo has even painted a niche to suggest that the vase rests on the frame—or perhaps on the altar itself—thereby uniting the real space of the chapel with his splendid illusion. With its shining water and soft shadow, the vase contrasts with the expanse of the softly painted garden, with its flowers, trees, arbor, and blue sky beyond. It is the kind of effect one would expect from a Netherlandish rather than an Italian artist.

Fra Filippo's Madonna and Child with Two Angels (fig. 9.16) is in keeping with the taste of the new age. Mary, more fashionable than Filippo's earlier Madonnas, is seated at an opening that affords a view over a landscape of plains, distant mountains, a city, and a bay. With eyes downcast, she lifts her hands in prayer before the Christ Child, who is held

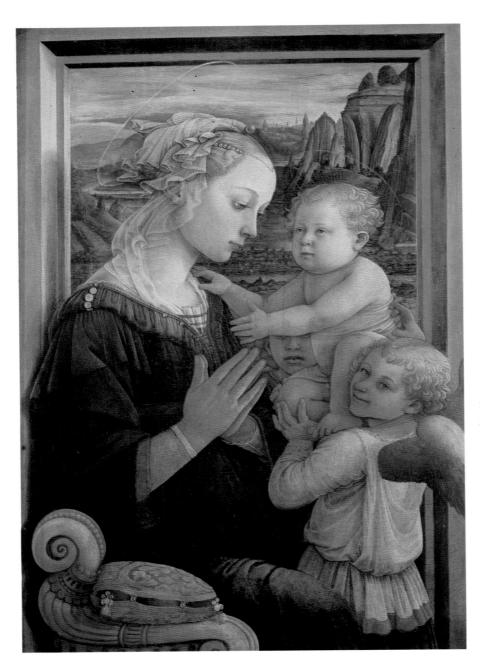

9.16. FRA FILIPPO LIPPI.

Madonna and Child with Two Angels.
c. 1455 or mid-to-late 1460s(?).

Panel, 35½ x 24" (90 x 61 cm).

Uffizi Gallery, Florence

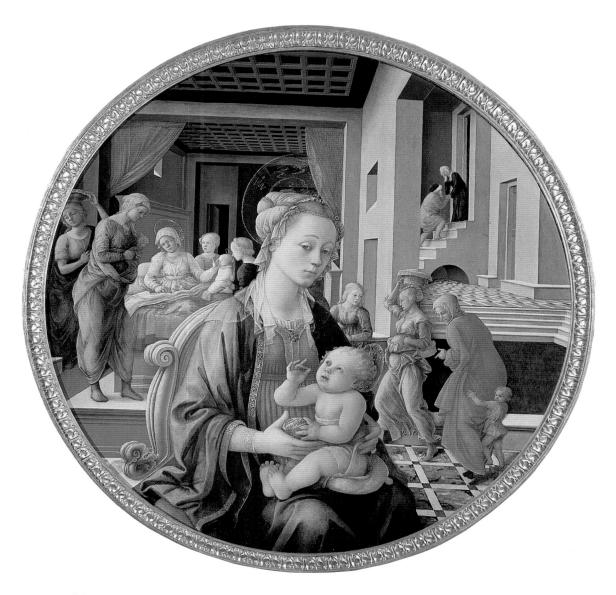

9.17. FRA FILIPPO LIPPI. Madonna and Child with the Birth of the Virgin and the Meeting of Joachim and Anna. c. 1452(?) or mid-to-late 1460s(?).

Panel, diameter 53" (1.35 m). Pitti Gallery, Florence. Perhaps commissioned by Lionardo Bartolini

up by two angels, one of whom, far from angelic in appearance, grins charmingly out at the spectator. The elegance of mid-Quattrocento taste is seen in the new delicacy of figural proportion and in refinement of costume, especially the headdress with its artfully pleated design and gigantic pearl. The blond hair, combed tightly back, is partially covered by a transparent linen veil, while a string of graduated pearls makes a peak on the forehead. In Renaissance fashion, a high forehead was an object of special beauty, to be achieved, if necessary, by plucking or even shaving, in extreme cases, as far back as the top of the skull.

Filippo's enthusiasm for the beauties of light and atmosphere, rocks and fruitful plains, cities and soft cloud masses, lovely young women and healthy babies, tasteful garments and splendid furnishings, is well demonstrated in this popu-

lar image. Masaccio's *chiaroscuro* has vanished and the figures are illuminated by a soft, all-over glow without harsh shadows, while the sense of mass evident in Filippo's earlier works is reduced.

The delightful tondo (circular picture) of the Madonna and Child with the Birth of the Virgin and the Meeting of Joachim and Anna may be the one on which Filippo was working in 1452 for the prosperous merchant Lionardo Bartolini; other scholars date it later, in the 1460s (fig. 9.17). The tondo, which became a popular shape for domestic religious images in the late Florentine Quattrocento, is derived in part from the Florentine tradition of painted wooden trays presented to women as marriage gifts or when they gave birth to a child.

In Filippo's tondo, the architectural background consists of a Quattrocento interior, and the subject emphasizes

genealogy. On the left side the birth of the Virgin is depicted as if it had occurred in the Renaissance house of a well-todo Florentine family, attended by maidservants carrying gifts. At the upper right there is a staircase on which St. Anne, mother of the Virgin Mary, receives the returning Joachim, perhaps a reference to the kiss that, some theologians argued, marked the moment the Virgin was conceived. The planes of the walls, the inlaid marble squares of the floor, the coffered ceilings, and the steps of varying breadth and pitch create a complex spatial composition. The Virgin and Child sit at the focal point of the perspective but offcenter in the tondo. The Virgin, a delicate creature who looks shyly out at the observer, was drawn from the same model as the Madonna and Child with Two Angels (see fig. 9.16). The Christ Child holds a pomegranate and is about to pop a seed into his mouth. Like Masaccio's grapes (see figs. 8.6, 8.22), this realistic motif has a religious meaning; the pomegranate is red, like the blood of Christ, and its multiple seeds made it a symbol of the Resurrection.

Fra Filippo's frescoes in the chancel of Prato Cathedral were executed over a period of time, from their inception in 1452, through the date of 1460 found on one fresco, into 1464 when officials complained to Carlo de' Medici that Filippo had not completed the job, and up to at least 1466 when the painter left for Spoleto. Much of the work was done from Filippo's designs by his pupil, Fra Diamante, but everywhere the cycle overflows with details that show the human sweetness and warmth of Filippo's art.

The Feast of Herod (fig. 9.18) is a work of great originality. A garden courtyard, floored with inlaid marble in a strong perspective pattern, is the setting for the celebration. The perspective lines shoot inward past the central table of Herod himself, seated directly below the arms of the patron, to windows opening onto a landscape. On this stage the action

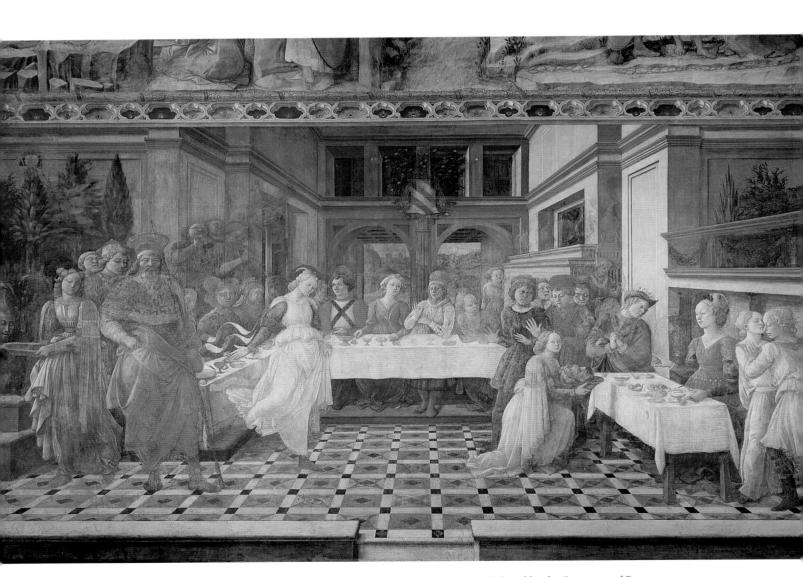

9.18. FRA FILIPPO LIPPI. Feast of Herod. 1452/3-66. Fresco. Cathedral, Prato. Commissioned by the Commune of Prato

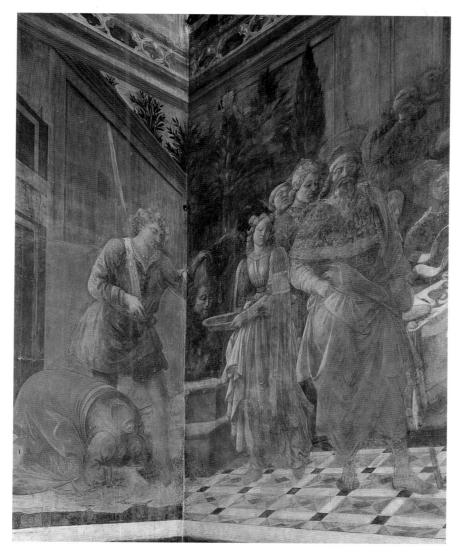

9.19. FRA FILIPPO LIPPI. *The Head of St. John the Baptist Handed to Salome*. 1452/3–66. Fresco, Cathedral, Prato

moves in three episodes. At the left, cut off from the festivities by a gigantic, armed guard, Salome receives on a platter the head of St. John the Baptist, from which she looks away. The decapitation itself is painted on the adjoining wall, and the executioner has to reach around the corner to place the head on her platter; his elbow is bent at ninety degrees to conform to the angle at which the walls meet (fig. 9.19). In the center Salome does her dance, poised on her left foot, while her right foot, hand, and assorted ribbons fly in the air. This figure is the ancestor, so to speak, of the figures in motion painted by Fra Filippo's pupil Botticelli (see fig. 13.25). At the right Salome kneels, still not looking at the head she presents to Herodias, but at the extreme right two servants clutch each other as one surreptitiously captures a glimpse of the grisly trophy.

Fra Filippo was scarcely the artist for the Medici to select to paint a series of penitential pictures, but possibly in the late 1450s he was in no position to refuse. The flourishing world of the Renaissance had taken, at this time, a disagreeable turn. In 1448 the Black Death struck again, and it returned annually for three summers; thousands of Florentines succumbed, and the pilgrims passing through Tuscany on their way to the papal jubilee of 1450 in Rome carried the plague with them and died miserably in the streets there. The archbishop of Florence at this time was St. Antonine, who had been prior of San Marco when Fra Angelico lived and worked there. A man of blameless personal life, Antonine allowed the revenues of his archdiocese to accumulate and lived in a simplicity unexpected in the mid-Quattrocento. Except on ceremonial occasions, he wore a threadbare

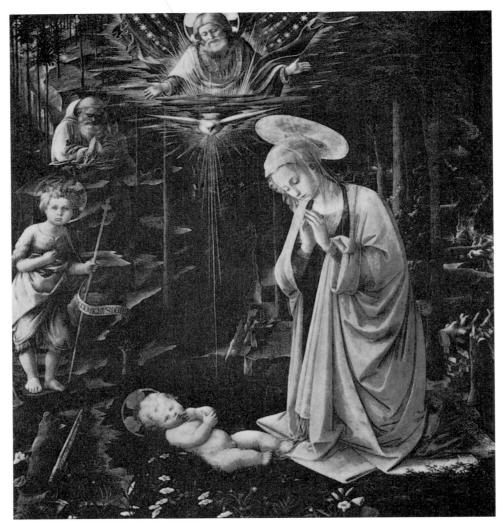

9.20. FRA FILIPPO LIPPI. *The Adoration of the Infant Jesus*.

Late 1450s. Panel, 50 x 45⁵/s" (1.27 x 1.16 m). Gemäldegalerie, Berlin.

Commissioned by a member of the Medici family (Cosimo or Piero de' Medici or perhaps Lucrezia Tornabuoni) for the chapel in the Medici Palace (see fig. 6.17).

The painting is signed "Frater Philippus P[inxit]" along the handle of St. John the Baptist's ax in the left foreground.

Dominican habit. He may well have been responsible for the content of two similar works painted by Fra Filippo for Lucrezia Tornabuoni, wife of Piero de' Medici—one was for her penitential cell at the Monastery of Camaldoli in the Apennines, the other for the altar of the chapel in the Medici Palace (fig. 9.20). St. Antonine originally wrote his moral treatise "on the art of living well" for Lucrezia's sister, and he made a copy of it in his own hand for Lucrezia.

In Filippo's painting for the Medici Palace, the Virgin kneels and adores the naked Christ Child, following, in part, the description by St. Bridget of Sweden of her vision of the Nativity (see pp. 167–68); this suggests that images like Filippo's represent Nativities even if iconographic de-

tails, like the cave, shed, Joseph, angels, ox, or ass are missing. The setting is the middle of a forest in which many felled trees can be seen. God the Father and the dove of the Holy Spirit join the Christ Child in forming the Trinity. Nearby stands St. John the Baptist as a boy of five or six although, according to tradition, he was only six months older than his cousin Jesus. In the lower left-hand corner an ax jammed into a tree trunk has "Frater Philippus P" (for *pinxit*, meaning painted) on its handle. This is a penitential image derived from the Baptist's own words: "And now also the axe is laid unto the root of the trees: therefore every tree which bringeth not forth good fruit is hewn down, and cast into the fire" (Matthew 3:10).

Since the painting seems to date about the time of the Lucrezia Buti scandal, Filippo's signature on the ax handle may record his penance. But logging was also an essential daily activity of the monks at Camaldoli, who lived a rigorous existence in clearings they made in the forest. Each monk resided in a separate hut, where he celebrated solitary Mass and lived on what he could raise in his garden plot. Taking the Camaldolites as his theme, St. Antonine's writings recommended to penitents a life of religious meditation in what he called "the little garden of the soul," very like the garden plot in which we see Mary kneeling to adore Christ. First one should cut down the trees, he wrote, then uproot the stumps and brambles, then fence in the garden and appoint a guardian for the gate, and only then will the flowers of a good life spring. He also suggested admiring St. John the Baptist—the last of the prophets and the first of the martyrs—who went into the wilderness before the age of seven. Most important, Antonine quoted Christ's saying: "For whosoever shall do the will of

my Father which is in heaven, the same is my brother, and sister, and mother" (Matthew 12:50).

St. Antonine claimed that the true penitent will identify with the Virgin, and that through creating the "garden of the soul," the Christ Child can be born again in one's heart. Antonine had derived this doctrine from the teaching of his mentor and predecessor as prior of San Domenico in Fiesole, Giovanni Dominici. Filippo's painting is replete with Antonine's dictums. Around Christ, flowers spring up to form a garden protected by saints, while felled and uprooted trees fill the background. Fire comes down from heaven—the fire of the Holy Spirit with which St. John said Christ would baptize (Matthew 3:11). In the deep blue-green gloom of the forest, Mary and the praying saint-Romuald, founder of the Camaldolite Order-adore Christ. At this same time, other painters were exploring Masaccio's style and investigating new aspects of the natural world, as we shall see in Chapter 11.

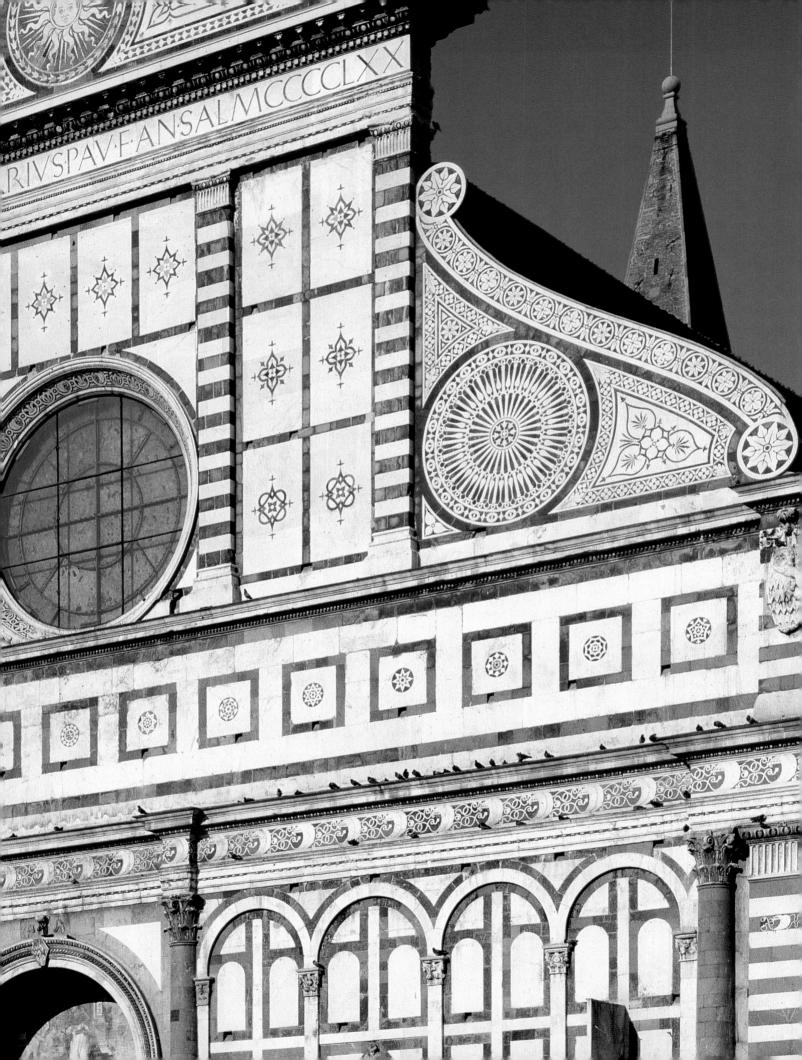

THE SECOND RENAISSANCE STYLE IN ARCHITECTURE AND SCULPTURE

he new stylistic concerns of the mid-Quattrocento are rooted in the life, thought, and artistic activity of Leonbattista Alberti (1404–72), whose influence has been mentioned so many times in preceding chapters. Alberti was especially interested in writing about the theories behind architecture, sculpture, and painting, and on each of these disciplines he made a lasting impact.

Alberti

Latin was still almost exclusively the language of intellectual discourse, and it was in Latin that Alberti authored a series of works ranging from poems and comedies to treatises on law, the horse, the family, and the tranquillity of the soul. In 1435 he circulated in manuscript form his Latin treatise De pictura (On Painting), following in 1436 with Della pittura, an abridged and less erudite version in Italian. He knew the treatise De architectura by the ancient Roman architect and engineer Vitruvius and before 1450 produced his own counterpart, De re aedificatoria libri X (Ten Books on Architecture). It is now thought that he wrote De statua (On the Statue) in the 1440s. His writings express the doctrine that virtus is the most important quality to be sought in human life; by this he meant not "virtue" in the Christian sense, but a combination of ideal human traits: intelligence, reason, knowledge, control, balance, perception, harmony, and dignity. Alberti's was not a democratic theory, and it was intended for the same elite who, in the Florence of the mid-1430s, were gaining the political and economic power they would hold until nearly the end of the century.

Without exception, the Florentine humanists came from the upper class, and Alberti was a member of one of the grand Florentine families. But the Alberti had been expelled

from the Republic in 1402 and Leonbattista was born in exile, in Genoa, in 1404. He received a humanistic education at the University of Bologna, where he took his doctorate in canon law at the age of twenty-four and became acquainted with the humanist scholar Tommaso Parentucelli, who later became Pope Nicholas V. He derived no steady income from family sources and was dependent on stipends from his patrons, who included both secular and ecclesiastical princes—the Este of Ferrara, the Malatesta of Rimini, the Gonzaga of Mantua, several cardinals, and at least two popes, as well as the Florentine merchant prince Giovanni Rucellai. As a young man Alberti traveled widely in Germany and the Low Countries, eventually became a writer of papal briefs, and for more than thirty years enjoyed the revenue (benefice) of the Church of San Martino a Gangalandi in the Arno Valley. He seems to have made up for his habitual absence from San Martino by a bequest to build a handsome Renaissance apse (still standing) apparently from his own design. Alberti's role at the courts of his princely patrons was that of adviser, and his artistic influence, especially in the realm of architecture and city planning, extended far beyond the buildings he designed.

Alberti's first appearance in Florence was in 1434, the year of Cosimo de' Medici's return from exile. But, in his own words, he "went to Florence seldom and remained there little." Neither of his two architectural creations there were imitated by Florentine patrons or architects, although his architectural ideas had an enormous effect on other Italian centers, and the Roman High Renaissance is inconceivable without his innovations. His notions about the construction and organization of pictorial space and the compositional and narrative methods that painters should follow help explain the developments we have already observed in the works of Fra Angelico and Fra Filippo Lippi. Such ideas also clarify the new, more pictorial sculpture developed by

Ghiberti and Donatello and the pictorial styles of Paolo Uccello, Domenico Veneziano, Andrea del Castagno, and Piero della Francesca.

THE MALATESTA TEMPLE. At midcentury Alberti was given an opportunity to put his classical ideas into visible form in an ambitious structure that, although still unfinished today, endures as an elegant fragment (fig. 10.1). The Adriatic city of Rimini was at that time under the rule of one of the least scrupulous yet most erudite of Renaissance tyrants, Sigismondo Malatesta, beside whose crimes the excesses of modern gangsters pale. Sigismondo enjoys, in fact, the distinction of being the only person in history publicly consigned to hell while still alive; the ceremony was performed with due solemnity by the humanist pope Pius II in front of St. Peter's. One of Sigismondo's offenses was the conversion of the Church of San Francesco at Rimini into a sort of temple to Sigismondo and Isotta degli Atti, the mistress for whom he had caused his wife to be suffocated. The desecration had started unobtrusively. In the original Gothic church, funerary chapels were erected for Sigismondo and Isotta that were decorated by the sculptor Agostino di Duccio and the painter Piero della Francesca (see p. 310). Matteo de' Pasti, the Veronese architect responsible for the remodeling, continued to clothe the arches of the interior in Renaissance dress, destroying earlier works, including frescoes by Giotto. At the jubilee of Pope Nicholas V in Rome in 1450, Sigismondo seems to have made the acquaintance of Alberti, who was then advising the pope on redesigning the papal city. For Sigismondo, Alberti envisioned a splendid exterior that would enclose and conceal the work of Matteo de' Pasti, which Alberti sharply criticized in a letter dated 1454.

Only the exterior of Alberti's plan was brought anywhere near completion, and the elegance of the lower story of the façade makes one doubly regret the mutilated, unfinished upper story. The dominant motif of the façade was to have been a triple arch, the shapes and proportions of which were borrowed from the ancient Roman Arch of Augustus only a few hundred yards from the Malatesta Temple. Early in the construction, Alberti was forced to convert the lateral arches into shallow niches and to continue the plinth underneath them. In other respects the lower story was carried out substantially as he desired. On the façade, four fluted, engaged

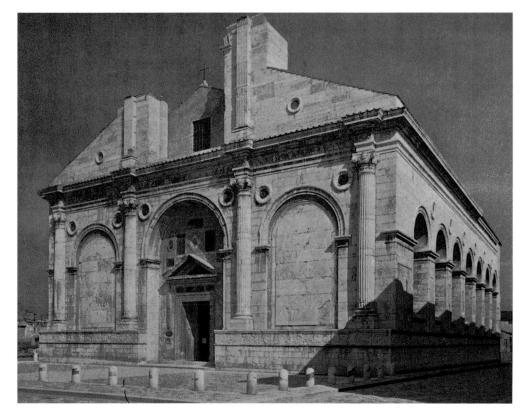

10.1. LEONBATTISTA
ALBERTI. Malatesta Temple
(S. Francesco), Rimini.
Exterior designed 1450.
Commissioned by
Sigismondo Malatesta

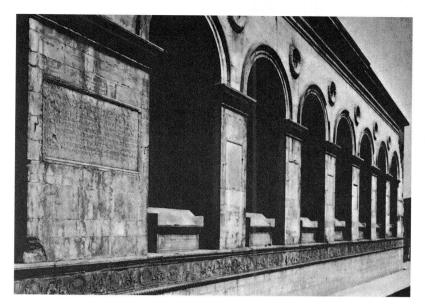

10.2. West flank of Malatesta Temple (see fig.10.1)

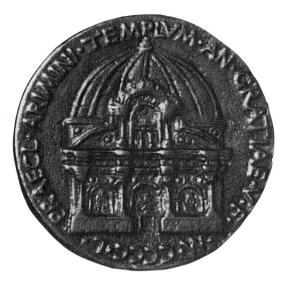

10.3. LEONBATTISTA ALBERTI.

Malatesta Temple. Design for exterior, on a
bronze medal after MATTEO DE' PASTI. 1450.
Diameter 1%16" (4 cm). National Gallery of Art,
Washington, D.C. (Kress Collection).
Commissioned by Sigismondo Malatesta

columns uphold the entablature, and on the flanks (fig. 10.2) arches enframe sarcophagi for the humanists of Sigismondo's court. The three arches between the columns and the seven deep arches—Alberti preferred an uneven number of openings—on the flanks are supported not by columns, as in a Brunelleschian building, but by piers.

Alberti once defined beauty as "the harmony and concord of all the parts, achieved in such a manner that nothing could be added, taken away, or altered." In keeping with this basic statement, he explained that arches, as openings in a wall, should be sustained by sections of the wall; columns, in contrast, belong not to beauty but to decoration and should be treated as applied elements, not supporting members. The resultant emphasis on the block of the building itself is alien to Brunelleschi's more linear, planar architecture and represents a fundamental change in the conception of a Renaissance structure. The effect of massive grandeur is enhanced by the projection of arches, cornices, triumphal wreaths (enclosing slices of porphyry columns taken from the sixth-century Church of Sant'Apollinare Nuovo in Ravenna), and capitals. The capitals, which at first glance seem to be ancient Roman in derivation, have in actuality been invented by Alberti out of volutes, egg-and-dart moldings, acanthus leaves, and winged cherub heads. Matteo de' Pasti described Alberti's extraordinary designs for the capitals as "bellissimi" (most beautiful).

Matteo's medal (fig. 10.3), struck for the laying of the cornerstone in 1450, shows a façade that culminates above in a

bay with a triple mullioned window enclosed by an arch supported on two columns. Pilasters were substituted for columns in the execution, and only one was completed. According to the medal and to a number of buildings in Venice and Dalmatia that reflect Alberti's design, the sloping roofs were to have been half-arches. The central arch and flanking quarter-circles were intended as external reflections of a wooden barrel vault to be built over the nave and half-barrel vaults in wood over the side aisles. These vaults were to have been decorated to look like stone in order to confer an effect of simple grandeur onto a structure cluttered by Matteo's revetment. Alberti demolished the Gothic sanctuary to make way for the crowning feature of the building, the never-constructed dome visible in the medal.

Alberti's own words lend substance to conjectures about the appearance of the dome, which the medal shows as a hemisphere divided by ribs that spring from a cylindrical drum. Although Alberti admired Brunelleschi's dome for the Cathedral of Florence (see fig. 6.2), he insisted that its proportions were incorrect because they did not correspond to those invented by the Romans and demonstrated in the Pantheon. In all probability, therefore, we must imagine at Rimini a rotunda surmounted by a hemisphere, as in the Pantheon, where the total height is equal to the diameter. If Sigismondo's own disastrous fortunes had not prevented completion of the Malatesta Temple, the subsequent history of ecclesiastical architecture might well have been different.

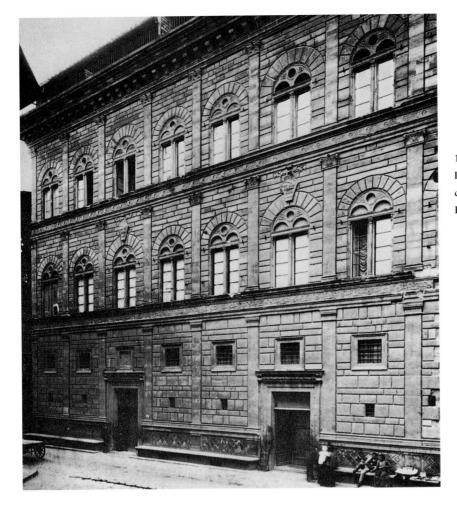

10.4. LEONBATTISTA ALBERTI(?).Palazzo Rucellai, Florence. Façade (left five bays).c. 1452–58. Later extended by BERNARDO ROSSELLINO. Commissioned by Giovanni Rucellai

THE PALAZZO RUCELLAI. A strikingly original contribution to the history of Renaissance palace design was the façade of the Palazzo Rucellai in Florence (fig. 10.4), which Vasari attributed to Alberti. The palace belonged to a wealthy Florentine merchant, Giovanni Rucellai, who in 1457 wrote the kind of personal journal known in the Renaissance as a *Zibaldone*. The façade's general principles were followed in many other buildings, some actually built, others merely designed (see figs. 10.10, 14.28).

The harmonious and classical design of the façade of the Palazzo Rucellai may be taken as an answer to the Palazzo Medici (see fig. 6.17), started less than a decade earlier. The basic elements of the Palazzo Rucellai are similar to those used at the Medici Palace—a rusticated three-story building with an entrance portal and high, square windows on the ground floor, mullioned windows on the second and third, and a massive cornice. But in the Palazzo Rucellai these features have been absorbed into a new system of proportions. The three stories are of equal height, and the rustication, consisting of smooth pseudoblocks of stone (the real joints do not always correspond to the apparent ones), is identical in all three stories. Most important of all, the rustication is

held in check by a grid of pilasters supporting entablatures, an idea probably inspired by the engaged columns and pilasters of the Colosseum in Rome. The main purpose of this classical screen architecture is to convey the humanist erudition of architect and patron.

In the Palazzo Rucellai, details are articulated with the utmost elegance. Alberti maintained that if one knew the grammar of ancient architecture well enough, one could at times devise one's own vocabulary. According to ancient Roman practice, Ionic was placed above Doric or Tuscan, and Corinthian above Ionic; thus the ground story of the Palazzo Rucellai is Tuscan and the third Corinthian. But the second story displays graceful capitals of new invention composed of a single layer of acanthus leaves grouped about a central palmette—a fitting intermediate stage between the Tuscan and the Corinthian. The rectangular portals and square windows are bordered by frames scaled to harmonize with their respective dimensions. Within this tightly knit structure the only random elements are the joints in the rustication, and even here the intersections are delicate and austere. Against this rectilinear system, projecting so slightly that the pilasters are nearly flush with the masonry, are the modeled ornament of the portal cornices and the friezes containing Rucellai family symbols, including the motif of a billowing sail.

The foregoing indicates a designer of brilliant originality, supporting Vasari's attribution of the façade to Alberti, which is sustained by at least two other sources. But others mention a "model" of the building made by the architect and sculptor Bernardo Rossellino (see pp. 273, 289–91), and some later scholars have contended that it was he, not Alberti, who designed and built the façade. Giovanni Rucellai, writing about 1464, mentions the palace as his chief achievement in building but does not identify the architect or the builder. Neither does Filarete (see p. 466), who was in Florence in 1461 and described the façade of the Palazzo Rucellai as "all made in the antique style."

One solution is that the design by Alberti consisted of only five bays, reading from the left, and would therefore have been centralized. A five-bay façade would agree with the design principles stated by Alberti in his *De re aedificatoria*, where he recommended that, as a reflection of the natural bodies of humans and animals, a building should be central-

ized and have an equal number of supports. This should be combined with an odd number of openings, an idea based on the eyes, ears, nostrils, and mouth of the head. It follows that a five-bay design should have six pilasters combined with four windows and a central doorway. In fact, documents indicate that just such a five-bay façade was actually built, starting about 1455 and completed in 1458, over a core of remodeled earlier structures, to which the portal does not exactly correspond. Later, the sixth and seventh bays were added, as Giovanni Rucellai acquired more land, and the eighth bay remains fragmentary because the owner of the next house refused to sell. Moreover, the quality of the carving in the sixth and seventh bays is not up to the level of that in the first five. Perhaps Giovanni called in Bernardo to extend his palace, and Alberti deserves credit for the original design.

SANTA MARIA NOVELLA. Alberti also furnished the designs for other projects commissioned by Giovanni Rucellai, including the façade for the Church of Santa Maria Novella (fig. 10.5), which has little in common with the

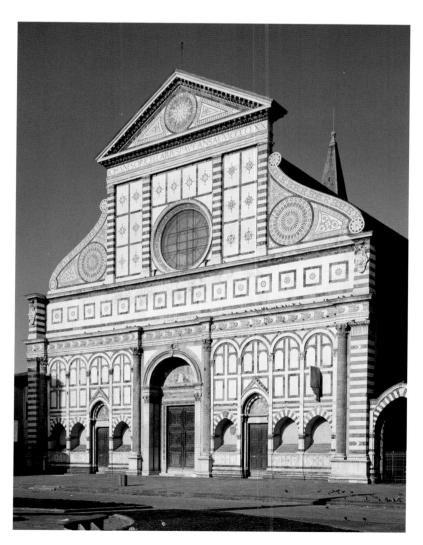

10.5. LEONBATTISTA ALBERTI.

Façade, Sta. Maria Novella, Florence. c. 1461–70. Completion of the façade commissioned by Giovanni Rucellai.

The base of both sides of the façade, each with three Gothic niches and a portal had been built earlier and Alberti had to incorporate these elements into his façade design. Trecento church that it fronts (see fig. 2.41). The white-andgreen marble structure is the only Florentine church façade on a grand scale to be built during the Renaissance. In its design Alberti followed the Romanesque but classicizing façade of San Miniato al Monte, a church overlooking Florence, and divided the structure into an arcade below a secondstory temple crowned by a pediment. Between the two stories he inserted a handsome mezzanine that serves as an attic for one floor and a base for the other. It is here that we see the name of the patron in huge Roman capitals and his motif of the billowing sail. Alberti framed the second-story temple on either side by large volutes, an ingenious solution to a problem that had perplexed designers of basilica façades for a millennium: how to unite a narrow upper story with a wider lower story and at the same time mask the sloping roofs of the side aisles. In France and England the roofs were hidden behind towers; in medieval Italy, massive screens were commonly used. But Alberti's volutes make a virtue of necessity by turning the straight slopes of the roof lines into a double curve.

Alberti's solution is so successful that we hardly notice how easily he integrated the Gothic tomb niches (*avelli*) and side portals of the unfinished Gothic façade. He absorbed these into his Renaissance design by enclosing them within a round-arched blind arcade and by repeating their horizontal green-and-white banding in the pilasters on both levels. The result is one of the most impressive church façades in the history of Renaissance architecture.

SANT'ANDREA. Alberti's triumph as a church architect was his design for Sant'Andrea at Mantua (fig. 10.6), although it was only built after his death, and the dome, added in the eighteenth century, has nothing to do with his intentions. Christian priest or no, Alberti never abandoned his humanist attitude long enough to write the word "church"; one always reads "temple." His innovations at Sant'Andrea are, in part, based on his criticism of the use of the ancient Roman basilican plan for church architecture. For the ancient Romans the basilica was used for courts of law, with proceedings taking place in twin apses, one at

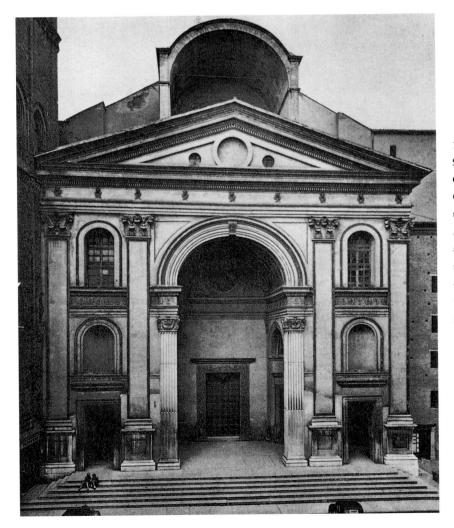

10.6. LEONBATTISTA ALBERTI.
Sant'Andrea, Mantua. Designed 1470.
Commissioned by Ludovico Gonzaga.
Of all Alberti's buildings, perhaps Sant'Andrea is the one that best fulfills the following statement by Alberti on the desirable balance between decoration and structure: "One thing above all which a temple should have, in my opinion, is that all its visible qualities should be of such a kind that it is difficult to judge whether . . . they contribute more to its grace and aptness or to its stability."

each end, while the nave accommodated litigants and spectators. Clients conferred with their attorneys in the side aisles. The basilica's three-aisled plan had been adopted for Early Christian churches by changing the axis and focusing on a single apse, and this plan remained standard for church design throughout the Middle Ages. But Alberti maintained that the three-aisled plan was unsuited for the worship of "the gods" (never "God"), because the columns could conceal the ceremonies at the altar. So, eleven hundred years of Christian architecture were irreverently dismissed.

Ludovico Gonzaga, marquis of Mantua (see figs. 15.22, 15.23), had commissioned Sant'Andrea in order to exhibit to pilgrims a relic of Christ's blood which St. Longinus was supposed to have brought to Mantua. In fact, at least nine major churches owe their existence to the wave of popular religiosity that, in the late Quattrocento and early Cinquecento, took the form of the adoration of relics; five are covered in this book (see figs. 12.27–12.29, 14.11–14.13, 17.17, 18.58–18.60), and none utilized the basilican plan. For Sant'Andrea, Alberti invented a new plan (fig. 10.7) based on the barrel-vaulted chambers of the ancient temple dedicated to Venus and Rome in the city of Rome. The gigantic barrel vault of Sant'Andrea (fig. 10.8) produces a unified spatial effect concentrating on the high altar. Nothing

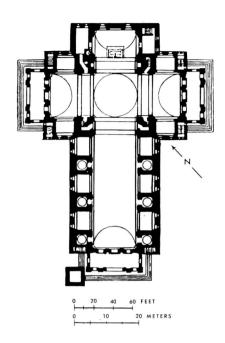

10.7. Plan of Sant'Andrea, Mantua, as built

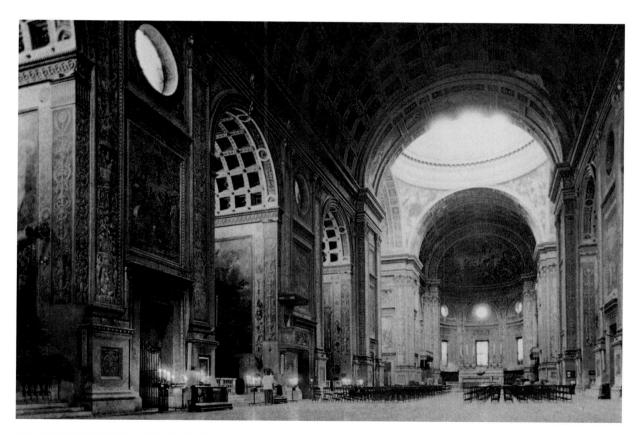

10.8. LEONBATTISTA ALBERTI. Nave, Sant'Andrea, Mantua. Designed 1470

hides the ceremony. The lateral arches admit worshipers not to side aisles but to secluded chapels, each crowned with a barrel vault at right angles to the nave. The single-aisle plan is matched by a single-story elevation, for the barrel vault rests, without clerestory, on the nave entablature; this in turn rests upon piers articulated by pilasters on tall bases that frame the arched entrances to the chapels.

Alberti's new barrel-vaulted church interior was repeated throughout Europe, from the St. Peter's of Bramante and Michelangelo to the churches of the Baroque. For illumination Alberti depended on the dome, the huge oculus of the façade, and the smaller oculi in the chapels; all of these showed only the sky, wherein dwell "the gods." In the façade, Alberti establishes the motif of coupled giant pilasters that flank arches and are interlocked with a smaller order of pilasters supporting transverse barrel vaults. This motif is repeated throughout the interior of the church.

ARCHITECTURE AFTER ALBERTI. All over Italy the influence of Alberti's ideas was felt. Pope Nicholas V's plans for a new papal Rome, centered for the first time

on St. Peter's and the Vatican, were developed by Alberti. Many Roman buildings are derived from his innovations and link him with the more grandiose Rome of the High Renaissance and the Baroque. Interestingly enough, none of the architects of these Roman buildings has been securely identified. The courtyard of the Palazzo Venezia in Rome (fig. 10.9), built after 1455, at a time when Alberti was still connected with the papal court, imitates the arcades and engaged columns of such nearby Roman buildings as the Colosseum and the Theater of Marcellus (see fig. 12.24). Several church façades built in the 1470s and 1480s are variants of Santa Maria Novella. It seems unlikely, however, that Alberti would have approved the colossal Cancelleria (fig. 10.10)—its principal façade is nearly 300 feet long which dilutes the scheme of the Palazzo Rucellai over vast areas of masonry, intermingled with single-arch windows, heavy cornices, and ornamental motifs. The use of pilasters as a screen architecture here suggests the ideal cities of Luciano Laurana's panels (see fig. 14.28) and reappears in several other Roman palaces. Originally designed for Cardinal Raffaello Riario before 1489 (he is seen at the right hand of

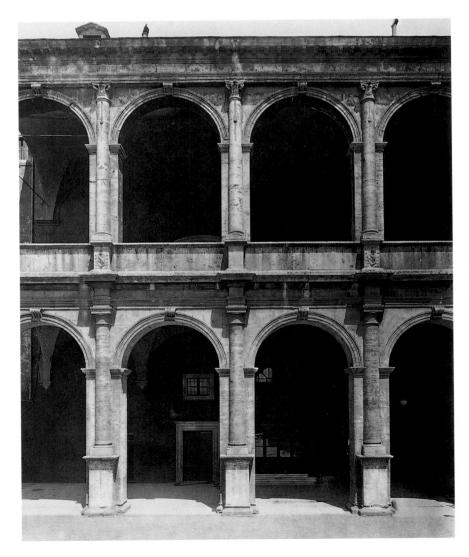

10.9. Circle of LEONBATTISTA ALBERTI. Courtyard, Palazzo Venezia, Rome. After 1455. Commissioned by Pietro and Marco Barbo

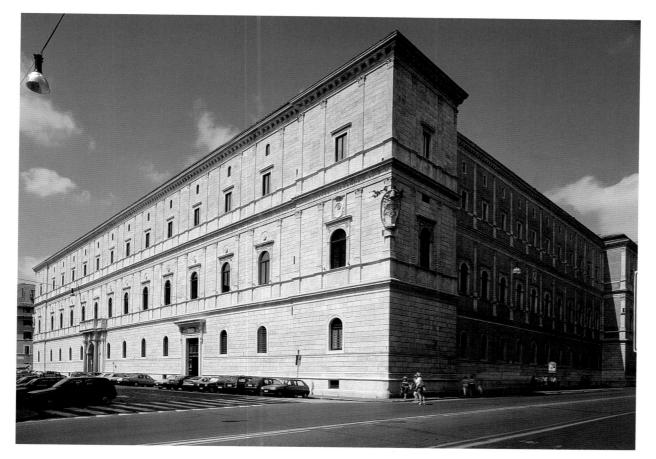

10.10. Palazzo della Cancelleria, Rome. Designed before 1489. Commissioned by Cardinal Raffaello Riario

his uncle Sixtus IV in the fresco by Melozzo da Forlì; see fig. 14.22), the building is impressive enough to have been attributed to Bramante—who did not arrive in Rome until ten years after it was started.

Pius II's conversion of his native village of Corsignano into the papal city of Pienza (figs. 10.11, 10.12) was carried out by Bernardo Rossellino, the same architect who probably extended the Palazzo Rucellai and who commenced, under Pope Nicholas V, the projected reconstruction of St. Peter's in Rome, doubtless under the supervision of Alberti. At Pienza he imitated the façade articulation of the Palazzo Rucellai in the Palazzo Piccolomini. The piazza at Pienza is the first of the new Renaissance town designs that was actually built. Although details such as the irrational superimposition of arcade on colonnade in the façade of the cathedral might have offended Alberti, the supremacy of the bold blocks of the confronting church and palaces, to which pilasters, columns, and arches are added as decoration, conforms to Alberti's notions.

Plans and façades of churches built in Florence in the midand late Quattrocento show strong Albertian influences.

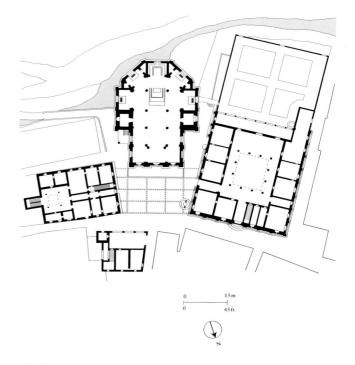

10.11. BERNARDO ROSSELLINO.
Plan of Piazza Pio II, Pienza. 1459–62. Commissioned by Pope Pius II

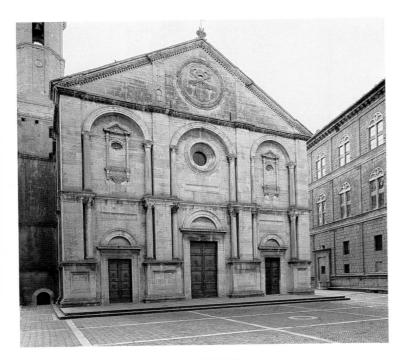

10.12. BERNARDO ROSSELLINO. Papal Palace and Cathedral, Pienza. 1459-62. Commissioned by Pope Pius II

The Palazzo Pitti in Florence (fig. 10.13), commenced for Luca Pitti, a wealthy merchant, was attributed to Brunelleschi until the discovery that construction did not begin until 1458, twelve years after his death. Later, as the official residence of the Medici grand dukes, it was extended during the late sixteenth (see fig. 20.28) and seventeenth centuries; in the nineteenth century it served briefly as the residence of the Italian monarchy. The Quattrocento structure was originally limited to the central seven bays, as shown here, and it is not known whether there was to have been a courtyard. The powerful rustication and the grandeur of the superimposed arcades, obviously based on the ancient aqueducts (the ruins of which can still be found in the countryside around Rome) are alien to the taste of Brunelleschi, but attractive to a follower of Alberti. The most likely candidate seems to be the Florentine architect Luca Fancelli, who was deeply imbued with Albertian ideas, was in Florence at the time, and built much of Sant'Andrea in Mantua after Alberti's designs.

Most important of all, Alberti's ideas on city planning, expounded in De re aedificatoria, were read and pondered by other architects and resulted in projects far more ambitious and comprehensive than Brunelleschi's piazze, such as the dreams of Filarete for Sforzinda (see fig. 15.53) and the urbanistic harmonies of Luciano Laurana (see fig. 14.28).

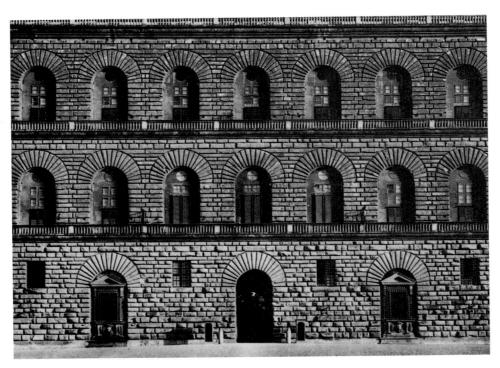

10.13. LUCA FANCELLI(?). Façade, central portion, Palazzo Pitti, Florence. Begun 1458. Commissioned by Luca Pitti. Because the Pitti Palace was much expanded in the sixteenth and nineteenth centuries (see fig. 20.28), this view shows only the central area planned in 1458.

ALBERTI AND THE ART OF PAINTING. Alberti's relation to the pictorial art of his time is striking, but difficult to assess. It is still a moot point among scholars whether some of his ideas on perspective are a systemization of what the painters and sculptors about him had been doing on their own. Alberti's perspective theory was derived in great part from medieval studies on optics in the Aristotelian tradition. In any case, his Latin treatise on painting, *De pictura*, of 1435 (and its Italian version, *Della pittura*, of 1436), is the first known treatise on painting, as distinguished from handbooks of shop practice, such as Cennino Cennini's *Libro dell'arte*.

We do not know if Brunelleschi's perspective theory provided a system for projecting imaginary spaces and their contents within a pictorial field. It is clear, however, that Alberti's formula produced a result that was aesthetically attractive and visually convincing (fig. 10.14). Alberti required the artist first to establish the height of a human being in the foreground of the field (a in fig. 10.14), then to divide the base line (b) of the field into segments corresponding to one-third of this height, each segment called a *braccio* (or cubit). At the height of the figure above the base line (a), the artist was to set the vanishing point (c) and connect it with diagonal lines to the divisions of the base line. These lines are called orthogonals (d).

Then the question arose as to how the parallel horizontal lines crossing the ground plane—the transversals (h)—would be established. A passage missing in the Italian text, but present in some of the Latin manuscripts, including one annotated by Alberti himself, shows that on a separate surface (e, called "little space" by Alberti), which could be another piece of paper or another part of the wall surface, the artist was to draw another horizontal base line divided into segments in the manner of the original line, and to set the distance point (f) perpendicularly above it at the same height as the vanishing point in the first construction, again drawing a set of diagonal lines from point to base. The viewer's distance from the picture was then expressed in terms of a vertical line (g), intersecting

the new diagonals at whatever point the artist wished. Then, setting the two constructions on the same level at any convenient distance, the artist could draw horizontal lines from these intersections in the second construction across to the first. These horizontal lines would become the transversals (h) in the first construction and, in conjunction with its orthogonals, would form trapezoids. The results could be easily counterproved by making sure that diagonals drawn through the corners of the trapezoids in the foreground squares always passed through the centers and corners of all diagonally related trapezoids in the first construction. Alberti's perspective was, quite simply, a graph of space. It provided a single, harmonious system for calculating the relative proportions of every figure, object, and spatial division within a pictorial field.

The remainder of Alberti's treatise is devoted to what he calls istoria—which can be translated as history, story, or narrative—and how it should be represented, and to a discussion of the education of the painter. His three principles of pictorial art consisted of circumscription, composition, and reception of light. These included his notions on drawing, division of the pictorial surface, light and shade, and color. His recommendations for naturally balanced color constituted a direct attack on the often aggressive arrangements of the Trecento. Alberti was concerned with consistency and propriety in the representation of persons of various ages and various physical and social types, with their reactions to the dramatic situations in which the istoria placed them, and with the delicacies of anatomical rendering of bodies and features. He wished the narrative to unfold with copiousness and with a variety of humans and animals in poses and movements full of grace and beauty, a goal that was in opposition not only to the figural alignments common in the Trecento, but also to those in the compositions of Masaccio.

Above all, Alberti was well aware of the magical qualities in pictorial art, which he said were the foundation of religion and the noblest gift of "the gods." "Painting," he said, "contains

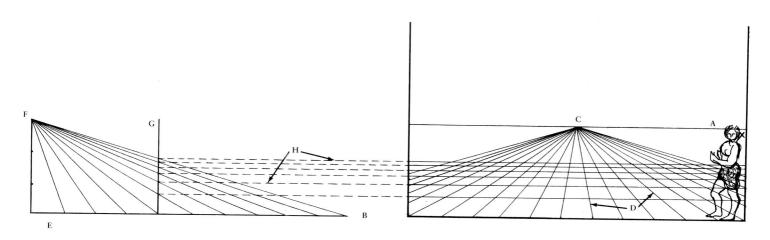

10.14. Design of Alberti's Perspective Construction. a. height of human being; b. base line; c. vanishing point; d. orthogonals; e. "little space"; f. distance point; g. vertical intersection; h. transversals

a divine force that not only makes absent men present, as friendship is said to do, but moreover makes the dead seem almost alive." Alberti viewed the artist as a person whose education demanded the intellectual activity of the Liberal Arts, as well as technical training. *Della pittura* established a new dignity for the art of painting and for the artist and laid a foundation that changed our understanding of the visual arts. The last words of *Della pittura* sum up what Alberti desired: "absolute and perfect painting."

In many respects Alberti's ideals harmonize with the art of Masaccio, the only painter he mentions in the preface to *Della pittura*, but they are even closer to the painting of Fra Filippo Lippi and Fra Angelico, whom Alberti must have known personally. The new perspective governs Fra Angelico's *Annunciation* in the San Marco corridor (see fig. 9.9)—as distinguished from his pre-Albertian treatment of this subject at Cortona (see fig. 9.3)—and his San Marco altarpiece (see fig. 9.5). Fra Filippo's and Fra Angelico's frequent use of a foreground figure who looks out at the spectator, the copiousness and variety of their compositions, and their analysis of the reception of light all correspond to Alberti's principles. By the end of the century some of the classical subjects he recommended were re-created by such painters as Botticelli and Mantegna.

In the 1430s and 1440s the two surviving giants of early Quattrocento Florentine sculpture, Ghiberti and Donatello, underwent changes of style that are in keeping with Alberti's new doctrine, if not always in accordance with its details. Both sculptors may have become acquainted with Alberti during visits to Rome prior to Alberti's return to Florence in 1434, for the tone of the dedication in his *Della pittura* of 1436 suggests long friendship. These relationships must have become close once Alberti was established in Florence.

Ghiberti after 1425

Ghiberti's Gates of Paradise (fig. 10.15; see fig. 6) were so profoundly influenced by Alberti's ideas that they constitute, in a sense, a programmatic exposition of his theory. When given the commission for the third and final set of doors for the Florentine Baptistery in 1425, Ghiberti was in his late forties. The humanist chancellor of Florence, Lionardo Bruni, proposed a scheme of twenty-eight scenes that would have matched the two previous sets (see figs. 3.34, 7.4). A second proposal reduced the number of scenes to twenty-four, but the final scheme has only ten square fields. This meant, of course, that Ghiberti's competition panel, with its Gothic frame (see fig. 7.2), could not be incorporated into the final set. In these doors the constricting quatrefoils are abandoned, and so is the notion of gilded figures and forms set against a bronze background; now each square is totally gilded, background and all. Donatello had pioneered this idea in his marble St. George relief (see fig. 7.17), in which he created a unified sense of space without resorting to contrasts of color or medium.

The present title of the doors derives from the fact that they open on the *paradiso*, the Italian term for the area between a baptistery and the entrance to its cathedral. Michelangelo, playing on this word, is reported to have said that the doors were worthy to be the "Gates of Paradise," and the nickname stuck. The modeling, in wax, of all ten scenes and the friezes of the frame has been dated between 1429 and 1437, when all were cast in bronze. Finishing, gilding, and other time-consuming processes meant that the doors were not set in place until 1452.

Each panel deals with one or more incidents from the Old Testament arranged within a consistent space that stretches from the foreground into the remote distance. Although the individual scenes were each cast in a single piece, the foreground figures are so highly projected that they are almost in the round. The projection gradually decreases as the figures diminish in size and recede into the background. The most remote are scarcely raised above the surface. The illusion of continuous space is enhanced by the use of gold over the

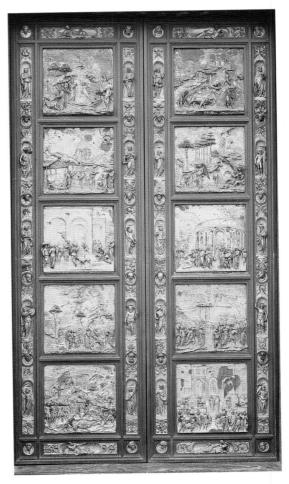

10.15. LORENZO GHIBERTI. *Gates of Paradise* (East Doors), Baptistery, Florence (now removed). 1425–52. Gilded bronze, height approx. 15' (4.6 m). Museo dell'Opera del Duomo, Florence. Commissioned by the Opera of the Baptistery and the Arte di Calimala for the Florentine Baptistery. (see fig. 6)

entire relief, giving the feeling that the space is united by a golden atmosphere.

The first scene, the story of Adam and Eve (fig. 10.16), shows the Creation of Adam at the lower left, that of Eve in the center, the Temptation in the distance at the extreme left, and the Expulsion from the Garden at the extreme right. Emphasis is placed on the Creation of Eve in the center of the panel; the reason lies in the doctrine that her birth from the side of Adam foretold the creation of the Church. This parallel, represented in medieval manuscripts and stained glass, was also set forth in a chapter of the Summa of St. Antonine. It is possible that Antonine was responsible for the programs of numerous important works of art in Florence (see pp. 248, 251). At the time the program for the Gates of Paradise was under discussion in 1424–25, he was nearby at San Domenico in Fiesole. When the doors were installed, he was archbishop of Florence, and in a sense it was his Baptistery. The chapter from the Summa noted above is a sermon on St. John the Baptist, to whom the Baptistery is dedicated, and St. Antonine compared the Baptist to a lantern whose light, thrown upon the Old Testament, brings forth the New. The ten specific stories discussed by St. Antonine are contained in nine of the ten panels of the doors, which vary only occasionally from Antonine's text.

Ghiberti represented the ideal male nude in the competition relief (see fig. 7.2) and in the North Doors of the Baptistery (see fig. 7.6); the female nudes in the *Creation* (fig. 10.16) relief are noteworthy as the first sensuous female nudes of the

Renaissance. Although they are not classical in their proportions, they are nonetheless akin to the frank voluptuousness of the ancient nude sculptures Ghiberti must have seen in Rome. In this relief, the nude male and female figures contrast gracefully with the long, parallel folds of drapery and with the airy wedge-shaped striations of the clouds that create a shimmer of golden light around the angels and the crowned figure of God. Still, Ghiberti has pierced the background only to the extent necessary to stage the Temptation a few yards off, and there is no distant view or horizon line.

By the time he made the *Abraham* scene in the second row, however (fig. 10.17), Ghiberti had dissolved the background to permit the eye to see beyond the slender trunks of trees to the profiles of distant hills against the sky, as Fra Angelico had done in his contemporary *Descent from the Cross* (see fig. 9.1). Here again the Old Testament scene prefigures the New, for the sacrifice of Isaac, the subject of the 1402 competition, reappears in the background as a foreshadowing of the sacrifice of Christ. The three angels appearing to Abraham are a revelation of the Trinity, and the meal prepared for them by Sarah prophesies the perpetual banquet of the Eucharist; all are expounded in the same text by St. Antonine. The prominence given to the fountain flowing from a spring in the side of the cliff is in accordance with St. Antonine's emphasis on the water of baptism.

In the *Jacob and Esau* relief in the third row (fig. 10.18), Ghiberti has adopted the perspective construction formulated

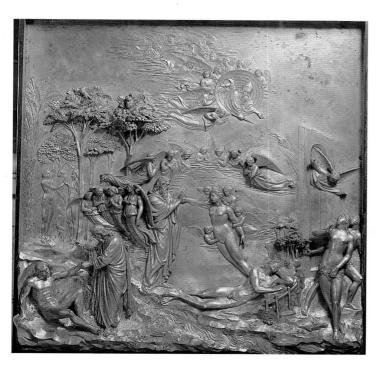

10.16. LORENZO GHIBERTI. *The Creation*, panel from the *Gates of Paradise* formerly on the Baptistery, Florence. 1425–37. Gilded bronze, 31¹/₄" (79 cm) square. Museo dell'Opera del Duomo, Florence

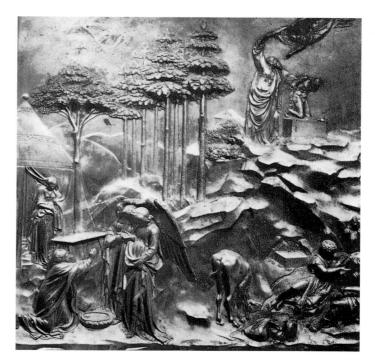

10.17. LORENZO GHIBERTI. Story of Abraham, panel from the Gates of Paradise formerly on the Baptistery, Florence. 1425–37. Gilded bronze, 31¹/₄" (79 cm) square. Museo dell'Opera del Duomo, Florence.

by Alberti in *De pictura*. Presumably the relief was composed shortly after Alberti's arrival in Florence in 1434. The protruding apron that Ghiberti had used in the North Doors here becomes a base line, divided into cubits as Alberti indicated, and from these divisions he projected his receding or-

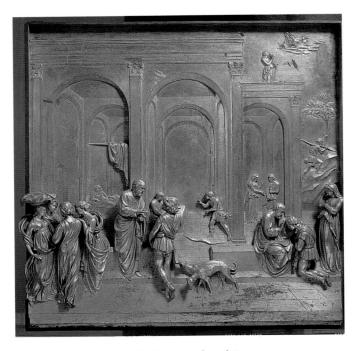

10.18. LORENZO GHIBERTI. *Jacob and Esau*, panel from the *Gates of Paradise*, formerly on the Baptistery, Florence. c. 1435. Gilded bronze, 31¹/₄" square (79 cm). Museo dell'Opera del Duomo, Florence

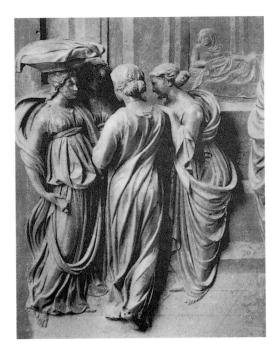

10.19. Detail of *Jacob and Esau*, panel (see fig. 10.18) from the *Gates of Paradise*

thogonals to the central vanishing point that also defines the recession of the loggia. The pavement squares in the patch of terrace at the extreme right do not recede to this vanishing point, and therefore apparently do not correspond to the Albertian construction. But Ghiberti must have realized that these squares, if drawn in rigid conformity to Alberti's scheme, would have been compressed into absurdly distorted shapes, as the reader can easily verify by drawing out the construction. This Achilles's heel of one-point perspective becomes evident at the sides of an extended view, which expose the necessity, avoided by Alberti, of making the transversals curve away from the picture plane.

The narrative unfolds from the background to the foreground. On the rooftop, to the right, Rebecca, feeling her twins struggling within her, receives God's explanation of the two hostile peoples who will spring from her womb. Under the left arch she appears in childbed; in the center, partly concealed by the foreground figures, Esau sells his birthright. On the right, "taught by God" according to St. Antonine, Rebecca rehearses Jacob in his "pious fraud," which will be accomplished by the meat and skin of the kid he holds. Esau is seen at the far right going hunting. St. Antonine's interpretation culminates in the foreground, where Jacob, symbolizing the Christians, receives the blessing on the step which foretells his approaching vision of a ladder to heaven. The disappointed Esau who confronts Isaac in the center signifies the Jews.

The architecture of the scene is Albertian. First of all, the arches are supported by piers, not columns, and the Corinthian order, in the form of applied pilasters, is used as decoration (see p. 267); presumably Alberti entertained such ideas long before he wrote them down in De re aedificatoria. But the architecture is Albertian in a deeper sense, for Jacob and Esau is an early example of a space construction that abandons the double scale of the Middle Ages in favor of Alberti's doctrine of visual unity. A single scale for figures and architecture that could still preserve the legibility of the narrative is achieved by setting the buildings a measurable distance behind the foreground figures and allowing some of the incidents to move back into it. The figures, too, demonstrate Alberti's contention that the artist should represent bodies in such a way that the drapery should move around them to reveal the beauty of the limbs beneath. Ghiberti has done this with matchless grace in the four figures at the extreme left (fig. 10.19). Every motion is harmonious, whether within each figure, between one figure and the next, or among groups of figures within the perfectly coordinated space. Running across both doors just above eye level, Ghiberti's conspicuous signature reminds us who was responsible for this "marvelous art" (partially visible at the bottom of fig. 10.18). Nearby is his self-portrait in a medallion of the frame (fig. 10.20); wise, cultivated, shrewd, sensitive, it is an unforgettable self-assessment. In Alberti's phrase, Ghiberti has made "the dead seem almost alive."

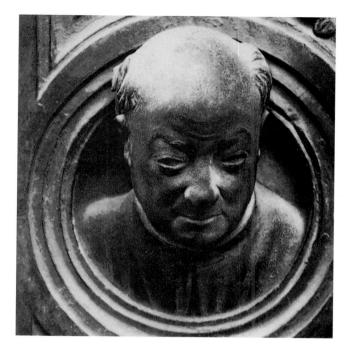

10.20. LORENZO GHIBERTI.Self-Portrait in frame of the Gates of Paradise.Museo dell'Opera del Duomo, Florence

Luca della Robbia (1399 or 1400-82)

Alberti's introductory note to *Della pittura* contains one name that is surprising, since Luca della Robbia does not seem to belong in the same league as Brunelleschi, Ghiberti, Donatello, and Masaccio, the other artists mentioned. Alberti's confidence in the 1430s was doubtless based on the splendid marble *Cantoria* (choir gallery) being carved by Luca in 1431–38 to be placed over the door of the left sacristy of Florence Cathedral. Luca's gallery (fig. 10.21), as well as that by Donatello over the door of the right sacristy (see fig. 10.24), was removed when the musical requirements for a grand-ducal wedding in the seventeenth century rendered them obsolete. In the historical documents, Luca's *Cantoria* is described as an organ loft, but that by no means excludes singers and perhaps other instrumentalists as well, given the small choirs and portable organs of the period.

Luca's gallery, supported on acanthus consoles, consists of a parapet divided by paired pilasters. The marble panels are carved with music-making children and adolescents illustrating Psalm 150, which is inscribed in its entirety on the

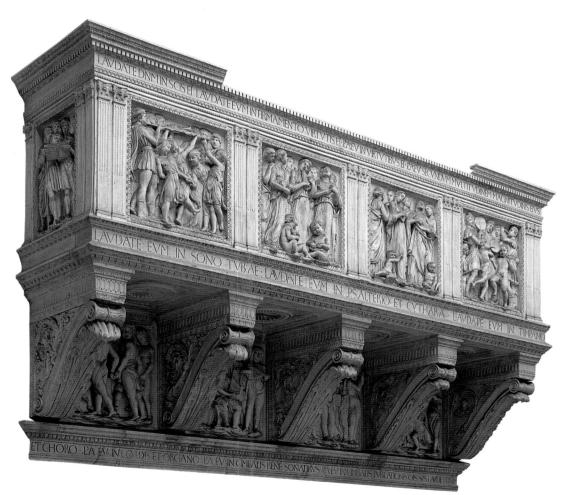

10.21. LUCA
DELLA ROBBIA.
Cantoria. 1431–38.
Marble, length 17'
(5.18 m).
Removed from
the Duomo; now in the
Museo dell'Opera
del Duomo, Florence.
Commissioned by
the Opera del Duomo

Cantoria. The children praise the Lord "with the sound of the trumpet . . . with the psaltery and harp . . . with the timbrel and dance . . . with stringed instruments and organs . . . upon the high sounding cymbals." They are beautifully grouped in compositions that are centralized or balanced—moving, playing, singing in relaxed happiness, yet so arranged and projected as to recall the frieze on the Ara Pacis, that elegant Roman monument to early Imperial taste. Luca's young people who stand so harmoniously, whose clothing falls so naturally into shapes reminiscent of Roman togas, nevertheless have youthful faces as winsome as those by Fra Filippo Lippi (see fig. 9.16). Luca's youths and maidens, especially the famous singing boys—some treble, some bass (fig. 10.22)—retain a high place in popular imagination.

To posterity, however, the name Della Robbia has more commonly been associated with works in enameled terracotta with white figures against a blue relief background that were made according to a technical formula invented by Luca. These durable and colorful works could be placed both

inside and outside. The style was continued by Luca's nephew and successor, Andrea della Robbia, and by a host of assistants who prolonged the activities of the workshop well into the sixteenth century.

Luca's earliest large enameled terra cotta was the commission in 1442 for the *Resurrection* relief (fig. 10.23) over the door of the left sacristy of the Florentine Duomo and, therefore, directly under his own *Cantoria*. As Brunelleschi's dome was nearing completion, it must have been evident that the high altar area would be dark; the blue and white enameled terra-cotta technique that Luca had been developing in the course of the 1430s was a good solution to the problem of how to enliven this area. The gold highlighting of certain details, now largely lost, would have given additional interest to the relief. The stable, symmetrical composition is typical of Luca's works, while the body of Christ, the togalike drapery, and the armor of the soldiers reveal how fully he absorbed the classicism already demonstrated in the work of his fellow scuptors.

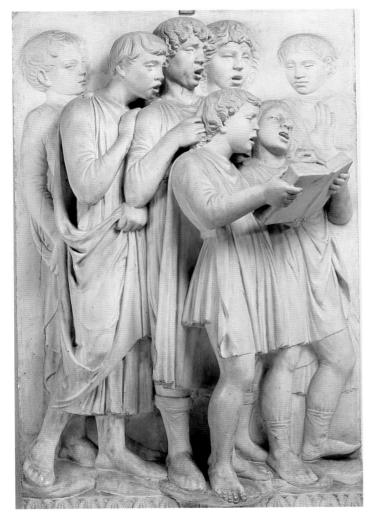

10.22. *Singing Boys*, end panel on the *Cantoria* (see fig. 10.21). Marble, 38 x 24" (96 x 61 cm)

Opposite: 10.23. LUCA DELLA ROBBIA. Resurrection.

1442–45. Blue and white enameled terra cotta with surface gilding of some details in the halo of Christ, the hair and wings of the angels, the armor, and elsewhere: 6'7" x 8'8" (2 x 2.65 m).

North Sacristy Doors. 1446–75. Bronze, 13'8" x 6'7" (4.2 x 2 m); each panel 20⁷/8 x 20⁷/8" (53 x 53 cm).

Duomo, Florence. Both commissioned by the Opera del Duomo. The seated figures flanked by angels on the doors include the Madonna and Child, the four evangelists, and five other saints, including the patron of Florence, St. John the Baptist.

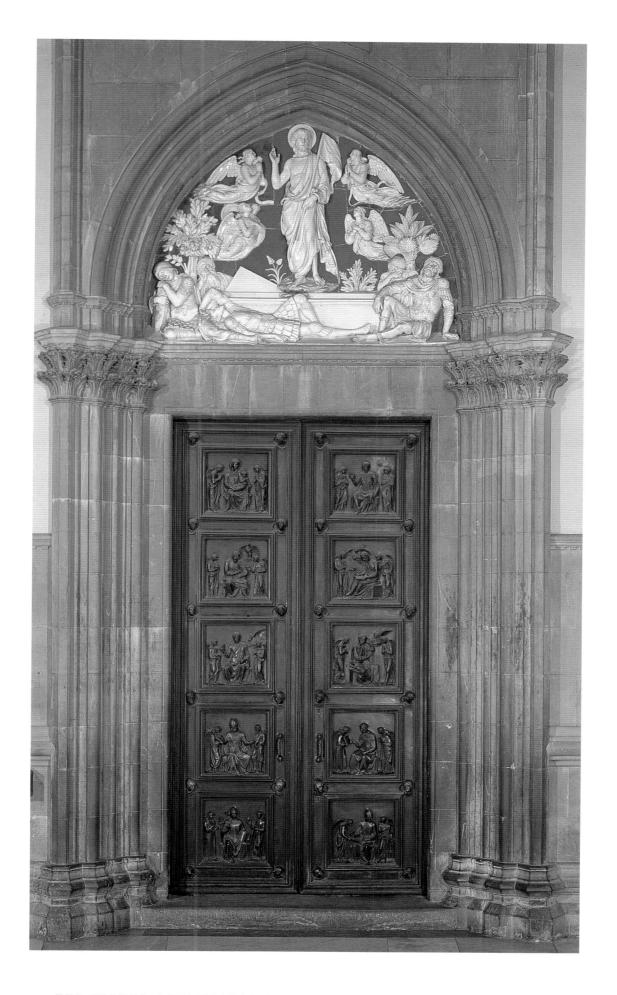

Two sets of bronze doors for the paired sacristies of Florence Cathedral were commissioned from Donatello in 1437, but because he made little progress, the commission for one set was canceled and in 1446 awarded to Luca della Robbia, Michelozzo, and Maso di Bartolommeo; the final payment for these doors was not made until 1475, when the doors were put into place. While the model for the panel of St. Gregory the Great on the lower left has been attributed to Maso di Bartolommeo, the other nine models were designed by Luca. It was these doors that would save the life of Lorenzo de' Medici at the time of the Pazzi Conspiracy of 1478 (see pp. 330–31).

Donatello (c. 1433 to c. 1455)

What a contrast there is between Luca's serenity and the energy of Donatello's *Cantoria!* Donatello seems to have sacked ancient art during his stay in Rome in 1432–33 so that he could creatively reassemble his loot upon returning to Florence. All the elements of his *Cantoria* (fig. 10.24) are

found in classical art—the egg-and-dart molding, the acanthus, the palmetto, the shell, the urn, and the mask—but they never appear in such combinations or with such proportions. Even the most basic architectural elements are unconventional and unexpected. Donatello's consoles, for example, have double volutes, one horizontal and the other vertical, in near collision. Every surface is heavily ornamented, and the substance of the colonnettes and backgrounds is disintegrated by rows of inlaid, colored marble disks.

Behind the colonnade, and completely disregarding it, surges a torrent of energetic activity (fig. 10.25). Donatello's children refuse to be constricted by the neat frames of Luca della Robbia and seem to rush wildly through space in a paean of jubilation. Transparent tunics cling to their chubby limbs, and feathery wings erupt from their shoulders. The result is a work of intense dynamism. Subsequent generations ranked Donatello's *Cantoria* higher than Luca's smooth and somewhat static work; Vasari, for example, wrote with enthusiasm of the sketchy freedom of Donatello's

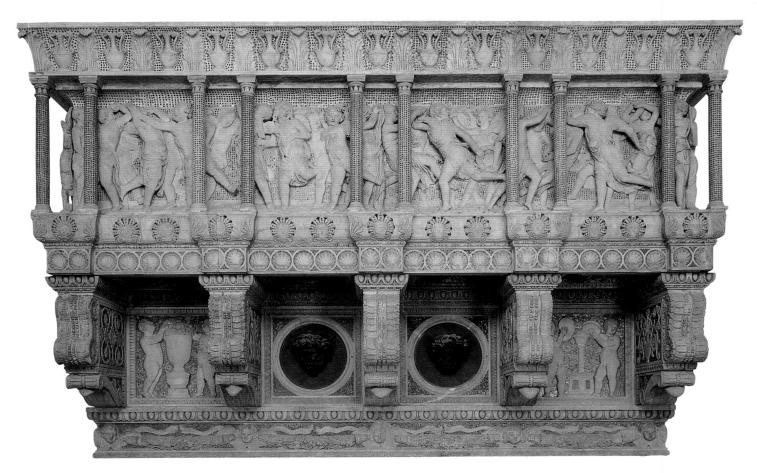

10.24. DONATELLO. *Cantoria*. 1433–39. Marble and mosaic, length 18'8" (5.7 m). Removed from the Duomo; now in the Museo dell'Opera del Duomo, Florence. Commissioned by the Opera del Duomo

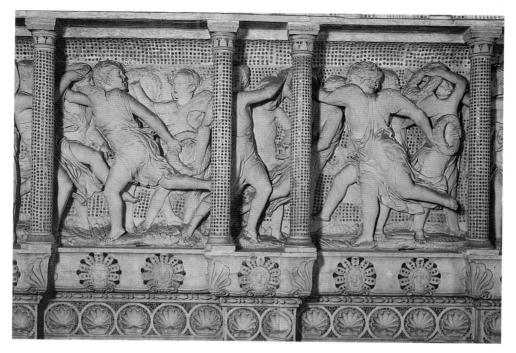

10.25. Putti, detail of fig. 10.24. Marble and mosaic, height $38^{1}/2$ " (98 cm)

surfaces, which from a distance produces an effect of far greater vigor.

Perhaps produced at about this same time is one of Donatello's most delightful works, the so-called Atys-Amorino (fig. 10.26). While the boy's happy, carefree air suggests an antique subject, no one has been able to convincingly identify which Greek or Roman figure he might have been intended to represent. If this work does indeed date from the 1430s and if the subject is antique, then this would represent one of the earliest Renaissance works on an ancient theme. There are a number of explicit attributes—his youthful age, the exposure of his genitals by unusual leggings, the wings on his shoulders and sandals, the little satyr tail, the snake that coils around his feet, the poppy heads decorating his belt, the cord tied around his head and decorated with a poppy—but they do not point to any single classical deity. In addition, it seems likely that this joyful figure, his face lifted, was once holding something in his raised hands that might have provided the clue that could explain such a disparate group of attributes. Perhaps this is a construct designed by a Renaissance humanist, who synthesized several antique themes into this single figure.

The figure is almost certainly intended for a domestic setting, but where it might have been placed in a Renaissance home or garden is unknown. Despite these uncertainties, the mood created by the figure's carefree expression and relaxed contrapposto stance is infectious—yet another example of both the revival of an antique spirit in the Renaissance and the diversity that characterizes Donatello's style.

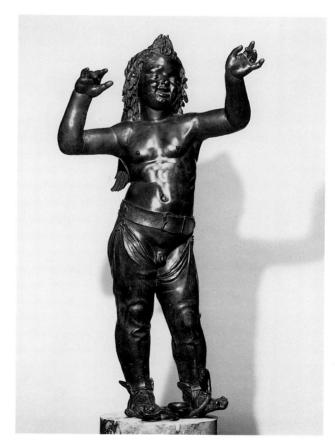

10.26. DONATELLO. "Atys-Amorino." c. 1435–40(?)
Bronze, with traces of original gilding on the belt, hair, and wings, height 41" (1.04 m). Museo Nazionale del Bargello, Florence.
By 1677 this sculpture was being identified as an ancient work.

The undated but probably almost contemporary *Annunciation* (fig. 10.27) shows another aspect of Donatello's new classicism. The enframing architecture is as unconventional as that of the *Cantoria*. A colossal egg-and-dart molding invades the frieze, and masks form the capitals. The terracotta putti above the arched pediment may be a reference to Vitruvius's report that Etruscan temples had terra-cotta figures decorating their roofs. Mary is shown gently recoiling in fear from the message of the kneeling angel and then, in the same moment, turning toward him with her hand on her heart to indicate her acceptance of his message.

The faces of Mary and the angel, with their straight Greek noses, low foreheads, and hair drawn rippling back from a central part, are among Donatello's most classicist passages (fig. 10.28). But neither these nor the evident classicism of the drapery can submerge the emotional tension evident in the momentary poses and the complexity of the surfaces. The ornamented panels of the background suggest the *porta*

clausa (closed door) of Ezekiel's vision, the prophecy of Mary's virginity.

The least expected work of this period in any medium is Donatello's nude David in bronze (10.29), the earliest known nude freestanding statue in the round since antiquity. (It is noteworthy that when Andrea Pisano and Nanni di Banco represented a sculptor, they showed him carving a male nude—see figs. 1.10, 7.18.) After Donatello's heroic marble David of 1408-9 (see fig. 7.12), the bronze David is a surprise. A slight boy of twelve or thirteen, clothed only in ornamented leather boots and a hat crowned with laurel, stands with one hand on his hip and a great sword in the other. His right foot rests upon a wreath, while his left foot toys idly with the severed head of Goliath, one huge wing of whose helmet seems to be caressing the boy's thigh. David's face, which seems to express a cold detachment, is largely shaded by the hat (fig. 10.30). In the Speculum humanae salvationis (a fourteenth-century compendium of imagery

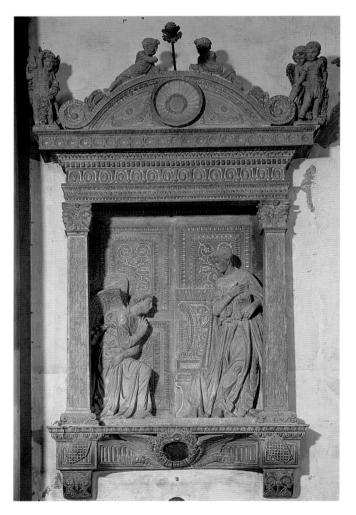

10.27. DONATELLO. *Annunciation*. 1430s. Limestone and terra cotta with gilding, 13'9" x 9' (4.20 x 2.75 m).

☐ Sta. Croce, Florence.

Commissioned by a member of the Cavalcanti family

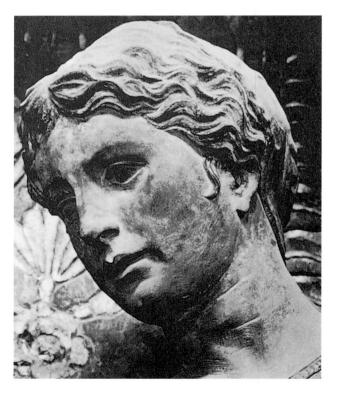

10.28. Head of the Virgin, detail of fig. 10.27

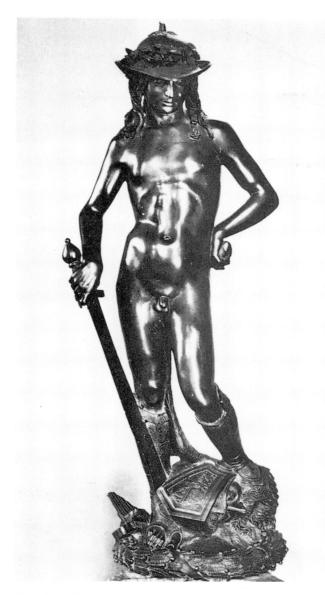

10.29. DONATELLO. *David.* c. 1446–60(?). Bronze, height 62¹/₄" (1.58 m). Museo Nazionale del Bargello, Florence. Perhaps commissioned by Cosimo de' Medici for the courtyard of the Palazzo Medici (see fig. 6.19). While the figure was still in the Medici courtyard it bore this civic patriotic inscription: "The victor is whoever defends the fatherland. All-powerful God crushes the angry enemy. Behold,

a boy overcame the great tyrant. Conquer, O citizens!"

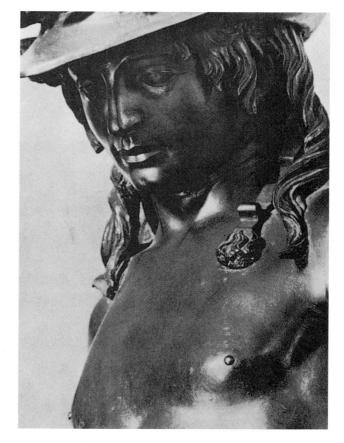

10.30. Head of David, detail of fig. 10.29

connecting personages and events of the Old and New Testaments, widely reprinted in the fifteenth), David's victory over Goliath symbolizes Christ's triumph over Satan. The laurel crown on the hat and the laurel wreath on which David stands are probably allusions to the Medici family, in whose palace the work was first documented in 1469.

Donatello's sculptural activity in Florence was interrupted by his departure for Padua in the early 1440s. He remained there for more than a decade, a fact that changed the entire course of sculpture and painting in northern Italy. A whole school of painting grew up in Padua around the personality of Donatello—during his presence, as he himself put it, among the Paduan "fogs and frogs." Vasari explained that Donatello disliked the adulation he received in Padua and was relieved to return to Florence, where he knew he would receive from the carping Florentines nothing but criticism, which would spur him on to greater achievements. Whether or not Vasari recorded Donatello's actual words, his comment

admits us to an essential aspect of the Florentine Renaissance, in which conflict of wills was a determinant of style.

The Florentine sculptor was probably called to Padua to execute the colossal equestrian statue in bronze of the Venetian condottiere Erasmo da Narni, whose nickname was Gattamelata (Honeyed Cat or Calico Cat). The monument still stands in the square in front of the Basilica of Sant'Antonio where Donatello placed it after its completion in 1453 (fig. 10.31), although the other tomb monuments that must have surrounded it have disappeared. Although the funds were provided by the dead general's family according to a stipulation in his will, this kind of monument, previously reserved for rulers, must have been authorized by a decree of the Venetian Senate. The Gattamelata is by no means the first equestrian monument of the Late Middle Ages and Renaissance in Italy. In Florence Donatello had an immediate pictorial forerunner in Paolo Uccello's Sir John Hawkwood (see fig. 11.2). The Tuscan examples, however,

had been intended for interiors. In the Trecento, the ruling Scala family of Verona built outdoor tombs surmounted by equestrian statues, and Bonino da Campione had created an amazing monument to Bernabò Visconti (see fig. 5.21). In 1441 Niccolò d'Este was commemorated by an equestrian statue by two otherwise unknown Florentine sculptors, which stood in front of the Cathedral of Ferrara until it was destroyed in 1796.

Donatello was influenced somewhat by ancient Roman examples, two of which were extant in Italy in his day: the *Marcus Aurelius* in Rome (see fig. 1.1), then thought to represent Constantine, and the so-called *Regisole* in Pavia, an Imperial statue now lost. But Donatello's sculpture rivals the *Marcus Aurelius* in majesty and surpasses it in determination. Realizing the effect of the high base and the vast space in which the *Gattamelata* was to be placed, Donatello restricted his design to bold masses and powerful tensions. Any minor shapes that might compete with the broad curves of the battle charger's

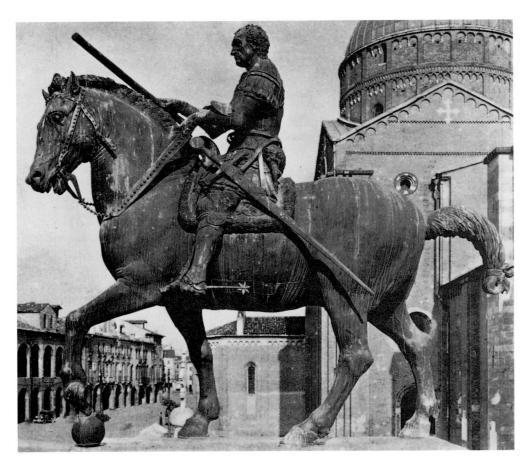

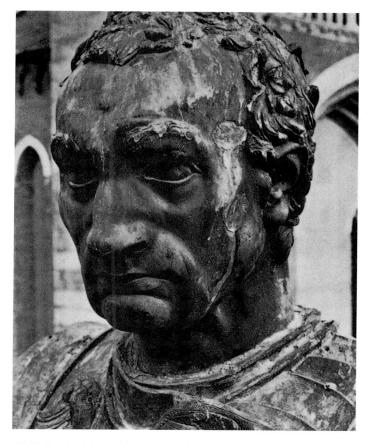

10.32. Head of Gattamelata, detail of fig. 10.31

anatomy are suppressed. The horse's tail, tied at the end, is held to form a taut arc, while his left forehoof, poised on a cannonball, forms another. A powerful diagonal formed by the general's baton and sword ties the composition together from above the horse's head down to his hind leg. Donatello may well have seen the famous general in Florence or in Rome, and it is likely that the head reproduces his features. The compressed lips, the firmly set jaw, the heavy, arched brows, and the wide eyes used to gazing into distances all suggest a powerful personality in the prime of life (fig. 10.32). The horse, with his swelling veins, open jaws, and flaring eyes and nostrils, is under the general's control. Seldom in the history of portraiture can one point to so majestic an image of command. The Renaissance humanist Vespasiano da Bisticci was so devoted to the contemporary cult of personality that he wrote a book on the "singular men" of the fifteenth century, but never set before his public a character more imposing than Gattamelata.

The details play their part in the total picture. The general is dressed in fifteenth-century armor, complete with giant broadsword and greaves, but there are also references in the costume to the grandeur of antiquity. Donatello borrowed

the kilt and short sleeves made of leather thongs from ancient Roman military costume. Victory masks and winged genii, flying or on horseback, decorate the armor and saddle. On the breastplate, a winged victory crying out in fury enhances, by contrast, the composure of the general. Virtually every element contributes to the impression of emotional and physical forces held under stern control. This is the ideal man of the Renaissance, the exemplar of Albertian *virtus*.

While he was at work on the equestrian statue, dealing in absolutes on a colossal scale, Donatello was concerned with another major commission, the high altar of Sant'Antonio; this grand architectural construction was decorated with four large narrative reliefs, a number of smaller ones, and seven life-sized statues in bronze. The altar, repeatedly remodeled in the sixteenth and seventeenth centuries and erroneously restored at the end of the nineteenth, no longer looks at all as Donatello intended. The individual reliefs and statues are unchanged, but their ambience is lost.

In Florence, Donatello had experimented with relief narration and illusionistic space in his stucco medallions for the spandrels of the Old Sacristy of San Lorenzo (see fig. 6.9), but the stories that unfold in the bronze reliefs of the Padua

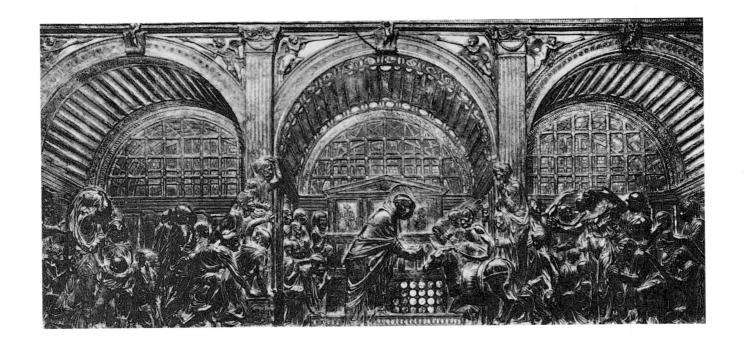

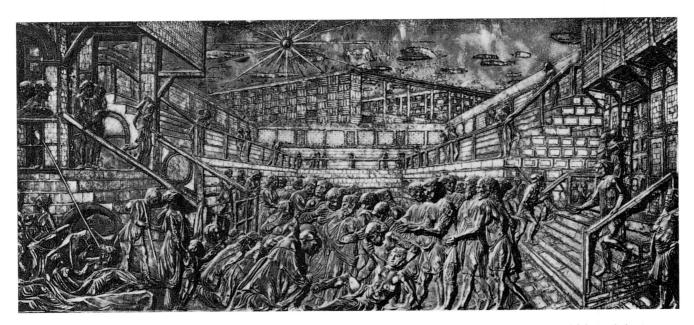

10.33., 10.34. DONATELLO. Miracle of the Believing Donkey (above) and St. Anthony of Padua Healing the Wrathful Son (below). Reliefs on the high altar, \hat{m} Sant'Antonio, Padua. 1444–49. Bronze, each $22^{1/2}$ x $48^{1/2}$ " (57 x 123 cm). Commissioned by the Arca del Santo for Sant'Antonio, Padua

altar (figs. 10.33, 10.34) are so much more elaborate in their representation of architectural backgrounds that they seem Donatello's answer to Ghiberti's *Gates of Paradise* (see figs. 6, 10.15). Not only are they, as we might expect, deliberately less harmonious than the compositions of Ghiberti, but they also present an explosive new conception of space as an alternative to Ghiberti's adherence to Albertian principles.

In the *Miracle of the Believing Donkey* (fig. 10.33), Donatello illustrates a tale from the legend of St. Anthony of Padua that tells how a skeptic refused to believe in the presence of the body of Christ in the Eucharist unless his donkey would kneel down and worship it, which the animal promptly did. Donatello shows the saint turning from the altar with the consecrated bread in his hands as the beast kneels on the top step. The excited crowds of the faithful,

peering out from behind the altar and around columns and piers, are swept by a wave of astonishment. The energetic poses and agitated drapery create a vigorous surface pattern. The low viewpoint excludes any Albertian floor construction, and the figures are dwarfed by a vast construction with barrel vaults recalling those of the ancient Roman Basilica of Maxentius and Constantine. Donatello has substituted horizontal moldings for the original octagonal coffering of the barrel vaults and filled the windows with metal grilles through which one sees other barrel vaults and grilles. Between the arches, pilasters with modified Corinthian capitals support an entablature. The resultant spatial formulation tends to break forward and outward rather than recede smoothly into the distance, as in the *Gates of Paradise*.

St. Anthony of Padua Healing the Wrathful Son (fig. 10.34) is even more surprising. Here St. Anthony heals the leg of a young man who had cut off his foot in remorse for kicking his mother. The setting is a stadiumlike structure that has been identified as an outdoor ball court. While most of the elements recede according to the new perspectival convention, a fantastic building in the background and a structure with a flight of steps in the right foreground are set at angles to the main axis and refuse to conform, as if to provide a spatial fracturing appropriate to the theme. Clouds float in Donatello's sculptured sky, and a great sun throws out clustered sword-shaped rays. Donatello's dramatic compositions must have been a revelation for the north Italian painters of his day, and their influence continued to make an impact for the next century and a half.

FLORENTINE TOMB SCULPTURE. Throughout the Late Middle Ages and the Renaissance a major field for sculpture in Italy was the funerary monument, from simple floor slabs, carved or cast, to splendid sepulchers displaying the effigy of the deceased in a magnificent nichelike setting. Donatello and Michelozzo together made such a tomb for Cardinal Baldassare Cossa in the Baptistery in Florence, and Michelozzo made one, now dismembered, for the Aragazzi family in the Tuscan hill town of Montepulciano. The vigor of Michelozzo's sculptural style (fig. 10.35), as well as its strong classicism, place him in the second Renaissance style, and especially close to Luca della Robbia.

Another master of tomb sculpture was Bernardo Rossellino (1409–64), the fourth of five brothers who were all stonecutters from Settignano (Antonio, the youngest, will be discussed later). As an architect Bernardo had worked at the Palazzo Rucellai (see p. 269), and he also remodeled the papal city of Pienza for Pius II (see p. 273). His most conspicuous sculptural work was the tomb of Lionardo Bruni, the chancellor of the Florentine Republic and an eminent humanist scholar (fig. 10.36). Bruni died in 1444, and his tomb, paid for by the Republic, must have been built and carved shortly thereafter.

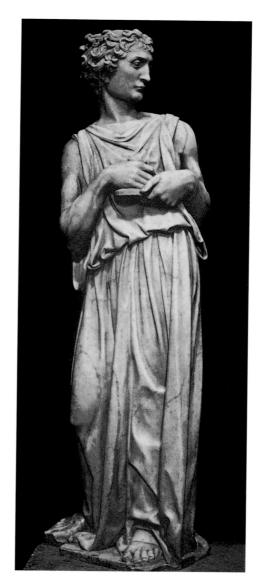

10.35. MICHELOZZO DI BARTOLOMMEO. Faith from the Tomb of Bartolommeo Aragazzi,

☐ Cathedral, Montepulciano. c. 1427–37. Marble.
Commissioned by Bartolommeo Aragazzi

Bernardo, possibly under Albertian direction, devised a background of colored marble paneling that was mimicked in other tombs and imitated by painters of the second Renaissance style. In front of the white and deep red marble panels lies the effigy of the chancellor, holding one of his own books, on a bier upheld by eagles. Angels in low relief, posed like winged victories, support a tablet with a Latin inscription: "After Lionardo departed from life, history is in mourning and eloquence is dumb, and it is said that the Muses, Greek and Latin alike, cannot restrain their tears." Above, the Virgin and Child are flanked by praying angels while at the top angels steady a shield with the *marzocco* (lion) of the Florentine Republic. With forthright realism

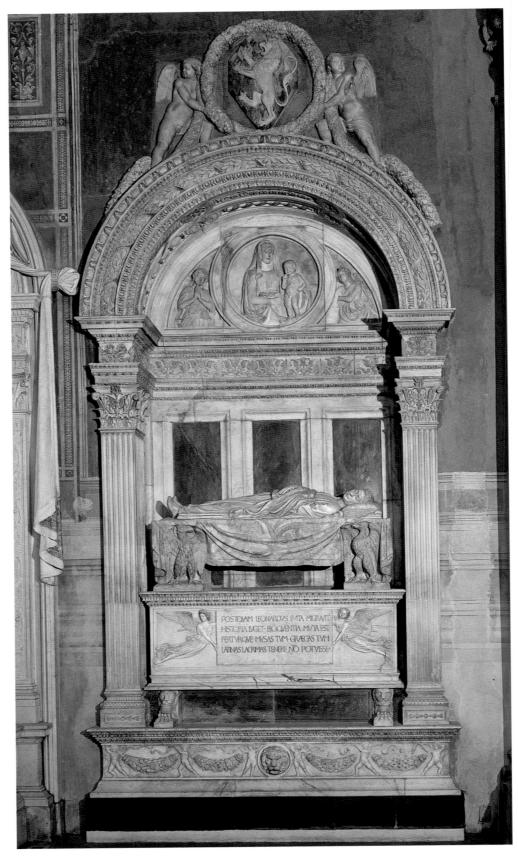

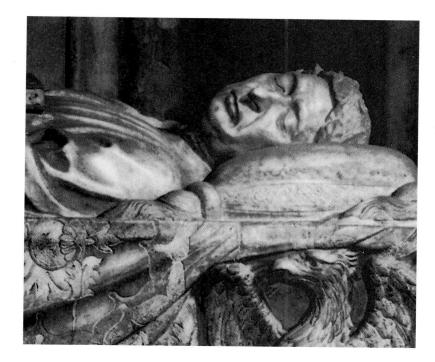

10.37. Head of Lionardo Bruni, detail of fig. 10.36

Bernardo shows the rugged features of the old statesman turned toward us, his brow crowned with laurel (fig. 10.37). In the clear-cut, simple arrangement and the emphasis on the dignity of the individual, Bernardo established the standard type of Florentine wall tomb.

THE PORTRAIT BUST. The first dated Renaissance portrait bust is one of a pair of portraits of the Medici brothers, Piero (fig. 10.38) and Giovanni. These were sculpted by Mino da Fiesole (1429–84) and underneath each bust is a full identification: name and age of sitter, year of bust, name of sculptor. These mark a distinct change from the patronage of Cosimo il Vecchio, their father, who had avoided the kind of personal ostentation and commemoration suggested by these works. In the next decades such portraiture would not be limited to the Medici family.

Although we prize such portraits for the glimpse they give us into new Renaissance attitudes toward the significance of the individual, their function as objects in Renaissance society is far from clear. We know that such busts were sometimes placed over the exterior and interior doorways of Renaissance palaces, but whether they played any particular role in family ritual is uncertain. Although the commemoration of the individual is an idea derived from Greek and Roman writings, ancient Roman portrait busts do not seem to have been a visual source for Mino's portraits; the form of Mino's busts, with the figure cut off at chest level, is not related to ancient prototypes.

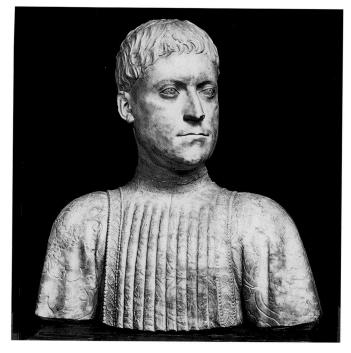

10.38. MINO DA FIESOLE.

Portrait of Piero de' Medici. 1453. Marble, height 18" (46 cm).

Museo Nazionale del Bargello, Florence.

Commissioned by Piero de' Medici.

The fabric of the garments, which is exquisitely executed to suggest sumptuous brocade, contains emblems of the sitter and his family, including a diamond ring intertwined

with a ribbon and the word SEMPER (always).

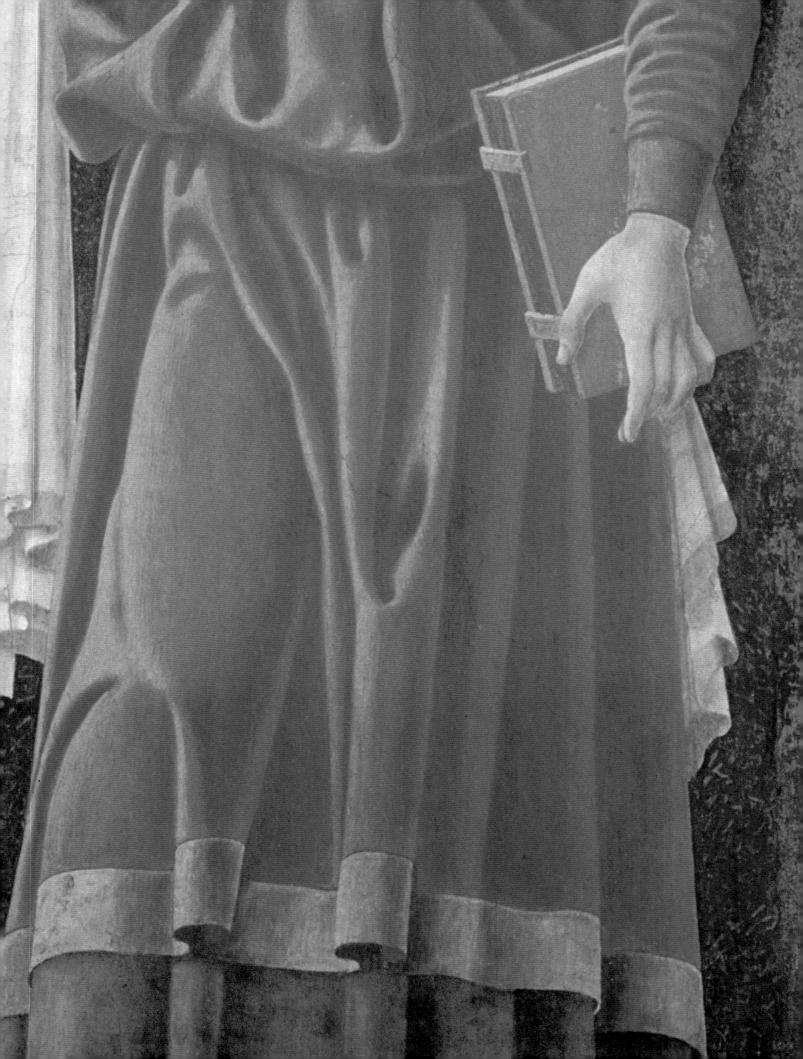

ABSOLUTE AND PERFECT PAINTING: THE SECOND RENAISSANCE STYLE

our painters closely associated with one another and with Alberti embody the ideals of the second Renaissance style: Paolo Uccello, Domenico Veneziano, Andrea del Castagno, and Piero della Francesca. We must bear in mind that, while these four were painting, Fra Angelico and Fra Filippo Lippi were still at work, that the age gap between these artists was insignificant, and that there must have been considerable interchange among them. In the works of their imitators, after midcentury, the styles of all six tend to fuse.

Paolo Uccello

Paolo di Dono, known as Paolo Uccello (Paul "Bird," c. 1397–1475), had a long life, but seems to have painted little, and although he occasionally received an important commission, he was never responsible for a major altarpiece or large fresco cycle. At least twice his patrons complained of the unconventionality of his work. In his tax declaration of 1469, he lamented that he was old and infirm, had no means of livelihood, and that his wife was sick.

Some scholars have complained that he chose to spend too much time studying perspective (fig. 11.1). Vasari wrote that Uccello could use perspective to represent a polyhedron with seventy-two sides projected in space; while this would be impressive in and of itself, Vasari stated that Uccello also projected a stick bearing a scroll from each of the seventy-two sides, all executed in perfect recession. It is also due to Vasari that we have the delightful tale that Uccello once refused to leave his work to follow his wife into the bedchamber with the rejoinder, "What a sweet mistress is this perspective." He viewed perspective as a challenge and probably also as a game; he certainly did not approach it with the solemnity recommended by Alberti.

Little remains of Uccello's artistic achievements before his fortieth year. Unless certain decorative mosaic designs in San Marco in Venice can be attributed to him, the work he did

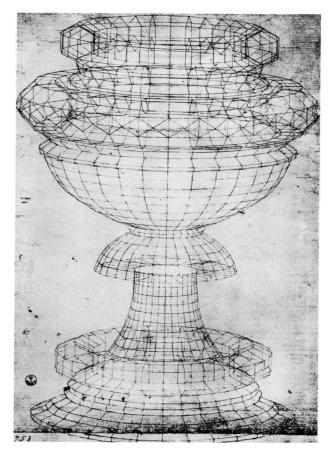

11.1. PAOLO UCCELLO. *Perspective Study.* 1430–40. Pen and ink, 11⁷/₁₆ x 9 ¹/₂" (29 x 24.1 cm). Gabinetto dei Disegni e Stampe, Uffizi Gallery, Florence. This is only one of several drawings of objects in perspective by Uccello.

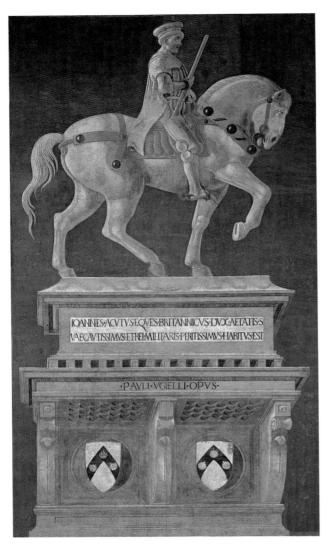

11.2. PAOLO UCCELLO. *Sir John Hawkwood*. 1436. Fresco, transferred to canvas; 24' x 13'3" (7.32 x 4.04 m). Cathedral, Florence. Commissioned by the Opera del Duomo, Florence.Hawkwood was born c. 1320 in Essex; he died in 1394 and received a grand funeral from the Florentine state; his remains were buried in England, thus Uccello's fresco functions more as a memorial than as a tomb marker.

there in 1425–27 is lost. His earliest dated painting is a fresco in the Cathedral of Florence, an equestrian monument to the English *condottiere* Sir John Hawkwood (fig. 11.2), who was known to the Italians as Giovanni Acuto. Before his death in 1394, Hawkwood had been promised a monument sculpted in marble, an obligation that the city fulfilled with a reduction in medium to fresco, painted in 1395 by Agnolo Gaddi and Giuliano Pesello. This fresco was later replaced with Uccello's version, which gives the illusion that the monument is bronze, thus offering an elevation in medium from the promised marble. Donatello had seven years to assess the painting before departing for Padua in 1443. There are nu-

merous points of resemblance between Uccello's *Hawkwood* and Donatello's later *Gattamelata* (see fig. 10.31), including the pose of the rider's legs, the raised baton, and, of course, the horse's stride, with both legs on one side advanced, both on the other retracted. Although both works emphasize the rider's control of the horse, the *Hawkwood* monument is less tense: the baton is lifted lightly, the forehoof paws the air, the tail flows free. And, unlike the Roman trappings of *Gattamelata*, Uccello's general wears contemporary armor, cloak, and cap.

The pedestal rests on a base supported by three consoles, not unlike those of Luca della Robbia's Cantoria, also designed for the cathedral (see fig. 10.21). The fresco has been detached from the wall and, unfortunately, is now hung lower on the wall than its original placement; this means that the consoles and base no longer have their full illusionistic effect. The original vanishing point had been established by Uccello to coincide with the eye level of a person standing in the side aisle; now the vanishing point is below the level of the cathedral pavement. The lowering of the fresco does not matter for the horse and rider, who are seen as if they are on the same level as the viewer. The disjunction between the two viewpoints is disturbing once it is noted, and it is surprising given Uccello's interest in perspective. It is documented that Uccello's patrons objected to his first horse and rider, and he was forced to repaint them. Perhaps Uccello, who seems to have been a lifelong practical joker, originally represented horse and rider in conformity with the pedestal, showing a worm's-eye view that would have emphasized the horse's belly and little of the rider except for the bottoms of his feet and the underside of his chin and nose. The accuracy of such a representation would surely not have mollified his patrons. In any case, the discrepancies in the finished fresco are only noticed after a careful analysis, and Uccello's monument may well have tricked Quattrocento viewers into believing that Hawkwood had been granted a bronze monument and thus received even more than he had been promised. Today the illusion is further reduced because the background color surrounding Uccello's fresco no longer matches the Duomo walls and, to make matters worse, the monument is enclosed in a later, frescoed frame (not shown here). Rather than creating the illusion of a three-dimensional bronze monument, it reads like a painting hung on the Duomo wall.

Uccello's fresco representing the *Deluge* in the Chiostro Verde (Green Cloister) of Santa Maria Novella (fig. 11.3) is part of a cycle started earlier by various painters, including Uccello himself; the cycle was damaged (ironically enough, considering Uccello's subject) by floods over the centuries. The cloister acquired its name because the frescoes were largely painted in a *terra verde* (green earth) monochrome. The *Deluge* also employs ocher, but no other color. The style of the painting, with its emphasis on monumentality and spatial unity, is consistent with what other Florentine painters

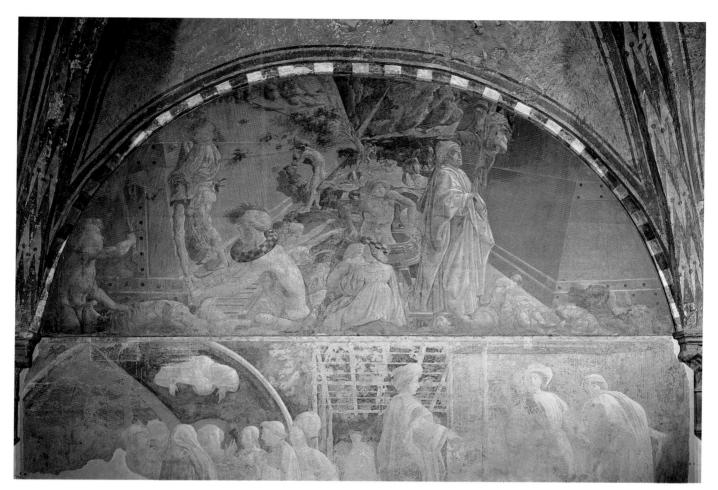

11.3. PAOLO UCCELLO. *Deluge*. c. 1445–55(?) Fresco, 7' x 16'9" (2.15 x 5.1 m). Chiostro Verde, Sta. Maria Novella, Florence

Right: 11.4. Detail of fig. 11.3

were doing in the years around 1450. Despite the damage, the work is still impressive. Uccello has shown us two scenes within the same lunette, thus giving two views of Noah's pyramidal ark, side by side, and creating a strong perspective recession in the center. As no border divides the episodes, the figures in one scene tend to overlap those in the other. On the left the ark is afloat, beset by thunder, lightning, wind, and rain. A streak of light, representing a lightning bolt, strikes in the distance, casting the shadow of a tree being blown away by a little wind god, whose inclusion was recommended by Alberti. Doomed humans attack the ark. One brandishes a sword as he rides a swimming horse, another threatens him with a club, a third clutches at the ark with his fingers (fig. 11.4). Others attempt to stay afloat on wreckage or in barrels. The club-bearer wears around his neck one of the favorite subjects of Uccello's perspective investigations, the mazzocchio, a faceted construction of wire or wicker around which the turban-shaped headdress of the Florentine citizen was draped. The hair on one side of his head remains

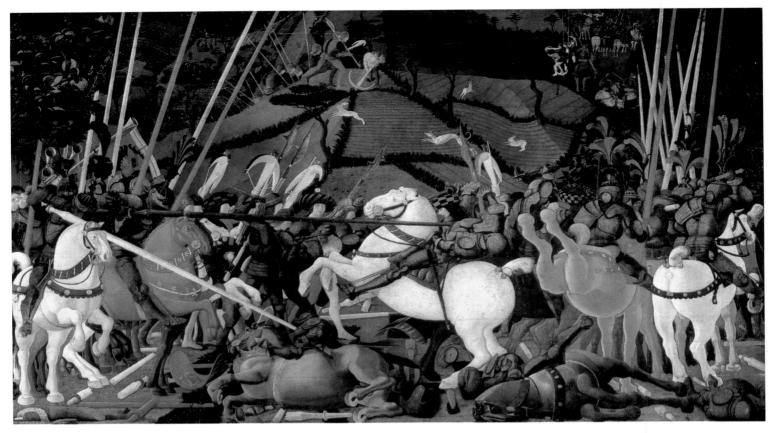

11.5. PAOLO UCCELLO. *Battle of San Romano*. 1430s or 1450s(?). Panel, 6' x 10'5" (1.82 x 3.23 m). Uffizi Gallery, Florence. Commissioned by a member of the Medici family, perhaps Cosimo de' Medici. Uccello's signature is included as part of the decoration on the fallen shield in the lower left corner. The signature and the central position of Niccolò da Tolentino in this panel suggest that it may have been the center one in the series of three, only two of which are reproduced here.

neatly combed, the other side disheveled by the wind. A ladder floats parallel to the ark, providing two more Albertian orthogonals.

On the right the ark has come to rest, and Noah leans from its window as the dove, sent forth to discover dry land, returns. Below the ark is the corpse of a drowned child, and a raven picks out the eyes of another. The cloaked man standing in the right foreground with one hand raised, while two hands clutch his ankles from the water below, has been difficult to identify. The powerful drapery masses, the intensity of the faces, the sense of tragedy in the individual figures and groups, and the overall cataclysm are compelling enough to make us overlook the riddles Uccello seems to pose.

Uccello's panels of the *Battle of San Romano* (figs. 11.5, 11.6) recall a Florentine victory over the Sienese in 1432. The panels once decorated a bedchamber in the Medici Palace that was later occupied by Lorenzo the Magnificent; Niccolò da Tolentino, who died in the battle, was an ally of Cosimo, and the subject may have been chosen to exalt his memory. The three panels are now divided among London, Florence, and Paris, and recent scholarship has argued, partly on the

basis of differences in the style of armor, that the London and Florence panels were executed for an earlier Medici residence and that the Paris panel was added when a larger space became available in the new Medici Palace (see fig. 6.17). The panels were originally arched to fit into a vaulted chamber but the tops have been cut off, explaining why no horizon line or sky is visible today. End to end, the series measures more than thirty feet. The panels form a continuing interlace of horses, horsemen, and weapons on a narrow foreground stage that is separated from the landscape background by a screen of fantastic fruit trees that creates a tapestrylike effect. United with the architecture of a vaulted room, the panels must have combined to create a brilliantly colored effect that would have been enhanced by the silver armor (now tarnished and apparently unrestorable).

As a whole the battle panels lack the intensity felt in the *Deluge*. The rearing horses seem wooden (not unlike those of a later carousel). The impression is one of a tournament rather than a military engagement. This is partly due, of course, to Uccello's geometricization of the forms and his emphasis on ornament rather than grim reality. The unreality

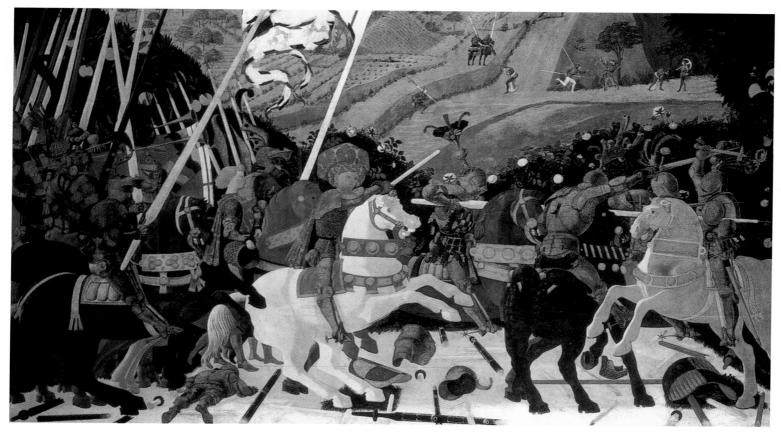

11.6. PAOLO UCCELLO. *Battle of San Romano*. 1430s or 1450s(?). Panel, 6' x 10'5" (1.86 x 3.23 m). National Gallery, London. Commissioned by a member of the Medici family, perhaps Cosimo de' Medici. The 1492 inventory that includes this and the other two panels of the *Battle of San Romano* in the bedroom that had belonged to Lorenzo il Magnifico also lists the other contents of the room, including a bed with *intarsia* decoration, seven brass candelabra, and a number of other paintings, including animal scenes, a large *tondo* of the Adoration of the Magi, and portraits.

of the scene also derives, in part, from the perspective construction. Most of the broken lances, like the floating ladder in the *Deluge*, have fallen in conformity with Albertian orthogonals. So have pieces of armor including, in the lower left-hand corner of the Florence panel (see fig. 11.5), a shield around which is wrapped a scroll bearing Uccello's signature in perspective. Horses and horsemen are seen in profile or in foreshortening so that they recede into depth or plunge toward the spectator, often at right angles to the orthogonals formed by the lances. In one instance, at the lower left of the London panel (see fig. 11.6), a soldier has managed to fall in perspective. It is as if perspective were not a phenomenon of vision, but a magical process, implicit in the air, able to force its will on persons and objects.

In the midst of this web of geometric compulsions, practical jokes, and abstract beauty, the humanity of certain faces comes as a surprise, especially the portrait in the London panel of Niccolò da Tolentino, captain of the Florentine forces, who wears a red and gold hat. The landscape looks stylized, but resembles the rippling hills divided into fields of narrow strips still visible in the Arno Valley. All sorts of

things go on in this background: hand-to-hand combat, soldiers in pursuit of the enemy, a dog in equally hot pursuit of a rabbit, and unconcerned peasants serenely bringing baskets of grapes to the wine press—all in the midst of trees and hedgerows.

Domenico Veneziano

Domenico Veneziano (c. 1410–61), as his name discloses, came from Venice. His artistic origins and the dates of many of his works are as uncertain as the date of his birth. Presumably he was influenced in his early paintings by the legacy of Gentile da Fabriano in Venice and by the early Quattrocento art of Lombardy, especially by Pisanello (see pp. 425–28), with whose paintings Domenico's have sometimes been confused. He may even have studied the manuscript paintings of the Franco-Flemish school, such as the works of the Limbourg brothers. It has been suggested that he visited Rome and assisted Gentile da Fabriano and Pisanello. Domenico may have worked in Florence before he came there to stay in 1439.

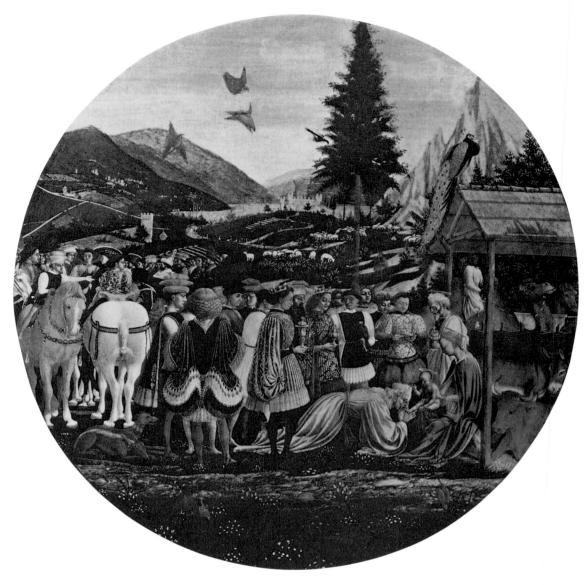

11.7. DOMENICO VENEZIANO. *Adoration of the Magi.* c. 1439–41. Panel, diameter 33" (84 cm). Gemäldegalerie, Berlin. Perhaps commissioned by Piero de' Medici for the Medici Palace

A large tondo of the Adoration of the Magi (fig. 11.7) reveals that Domenico was familiar with the works of Masaccio and Fra Angelico. Like Fra Angelico's Descent from the Cross (see fig. 9.1), the painting sets a many-figured composition deep in a naturalistic space. The tondo shape itself, an innovation rapidly being taken up by Quattrocento artists, poses particular compositional problems as we shall see (see figs. 13.22, 16.37). The arrangement of Mary, the Christ Child, and the first Magus is similar to that in Masaccio's Adoration of the Magi (see fig. 8.24), but in reverse. The costumes, like those of Gentile da Fabriano's Magi and their retinue (see fig. 8.2), would apparently have been illegal in Florence because of sumptuary laws, but that did not prevent the Florentines from enjoying the representation of forbidden fruits. After all, the Magi came from afar and were there-

fore not subject to Florentine law. Foreigners in Florence must have looked strange in this respect, as witness the two messengers in Masolino's *Raising of Tabitha* (see fig. 8.13). Domenico has endowed two of his figures with the towering hats of Greek courtiers, others with costumes bearing French and Italian mottoes inscribed in Gothic letters.

The forms are projected in space and light in a manner that reveals Domenico's study of Masaccio and Fra Angelico. The heads and headgear, the masses of curled hair, the stockinged legs, the swinging sleeves of velvet, brocade, and fur—all are painted flawlessly in light and shade, and they overlap and diminish as they recede into the distance. But no one in Florence could have taught Domenico to paint the landscape background, a memory of northern Italy that is reminiscent of the shores and sub-Alpine surroundings of Lake Garda,

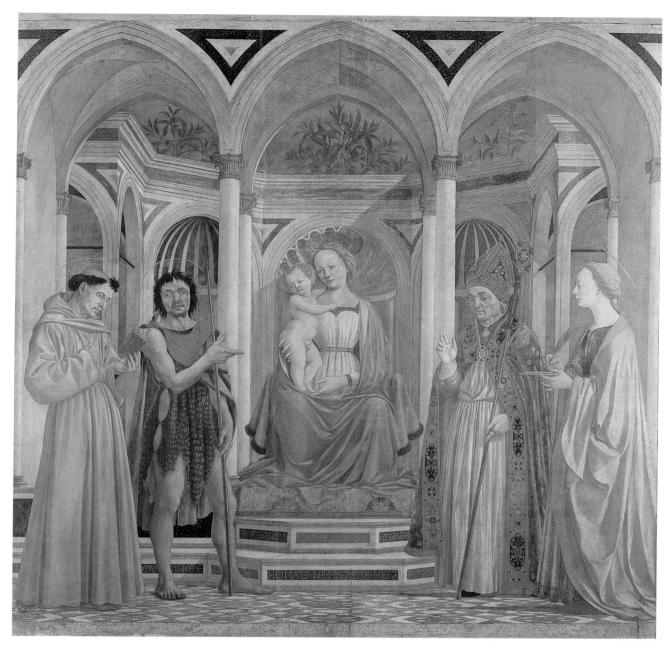

11.8. DOMENICO VENEZIANO. *Madonna and Child with Sts. Francis, John the Baptist, Zenobius, and Lucy* (St. Lucy altarpiece). c. 1445–47. Panel, 82 x 84" (2.09 x 2.16 m). Uffizi Gallery, Florence. Commissioned for the high altar of Sta. Lucia de' Magnoli, Florence

with sailboats, castles, a road, travelers, and even a corpse swinging on a roadside gibbet. It may have been familiarity with works by Netherlandish painters that prompted such attention to nature and the details of daily life. The rocky promontory at the right is inherited from traditional medieval landscape forms. Masaccio had developed a loose, suggestive brushwork in his landscape backgrounds, and Domenico has developed this even further in the little touches that represent foliage or people in his expansive countryside.

In 1438 (see p. 245), Domenico wrote from Perugia to Piero the Gouty, son and heir of Cosimo de' Medici: "I have hope in God to be able to show you marvelous things." Per-

haps this *tondo* was one of them, as it was in the Medici Palace in 1492. The mottoes have been identified as Medicean, and it has been suggested that the standing figure to the right of the second Magus is a portrait of Piero de' Medici; the sumptuousness of the textiles would have appealed to Piero's taste for luxurious fabrics. By 1439 Domenico was at work in Florence on a cycle of frescoes, now lost except for a few fragments, for the Church of Sant'Egidio in the Hospital of Santa Maria Nuova. He was assisted by the youthful Piero della Francesca, Baldovinetti, and others.

Probably about 1445–47, Domenico painted his principal surviving work, the St. Lucy altarpiece (fig. 11.8). The

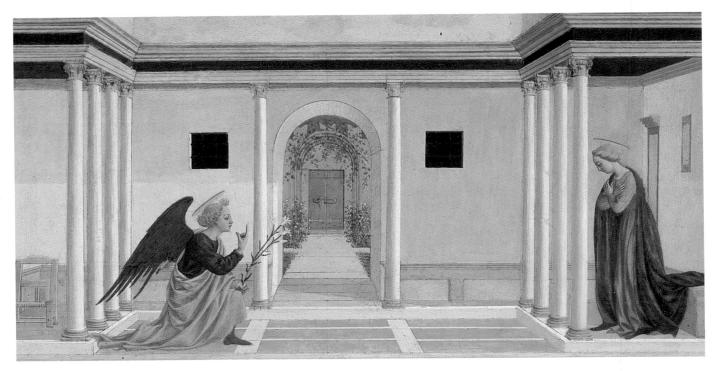

11.9. DOMENICO VENEZIANO. *Annunciation*, from the predella of the St. Lucy altarpiece (see fig. 11.8). c. 1445-47. Panel, $10^{5}/8 \times 21^{1}/4$ " (27 x 54 cm). Fitzwilliam Museum, Cambridge, England

central panel admits us to a courtyard in which the enthroned Virgin and Child are flanked by Sts. Francis, John the Baptist, Zenobius, and Lucy. The triptych format, which survived in the three-arched frame of Filippo Lippi's Barbadori altarpiece (see fig. 9.14), is still echoed in the pointed arches of the loggia.

Color seems to be the artist's major concern. The entire panel glows with a kind of color so foreign to Florentine experience as to account for Vasari's belief that Domenico painted in oil. The architecture itself—its arches, spandrels, steps, and elaborate pavement inlaid in rose, white, and green marbles like the Florentine campanile—is conceived in color, and all its shadows are illuminated by reflections from the sunbathed surfaces. Some of the "marvelous things" that Domenico promised in his letter are suggested by the softly colored shadows of the shell niches and the fabrics—the gold damask below the Virgin's feet, the blue cloth of her cloak, the green velvet of the sable-trimmed mantle thrown over her chair, the vestments of St. Zenobius, the rose-colored cloak of St. Lucy, and the pearls that shine at the neckline of her tunic and that of the Virgin. In St. Zenobius's miter, Domenico has even distinguished between the dull tone of seed pearls in the embroidery and the luster of larger pearls. This does not mean that the Venetian was unaware of Florentine developments in the realm of form. The wrinkled faces of the male saints indicate that Domenico had studied the works of Donatello and Ghiberti. The firm muscular forms of St. John's limbs follow Florentine practice, and the easy flow of the drapery folds is in harmony with passages in the Gates of Paradise (see figs. 6, 10.15). Yet these forms have been created less by the traditional Florentine means of drawing in line, followed by shading, than by the changing play of color in light. Nowhere is Domenico's interest in color more apparent than in the figure of St. Lucy, who extends the palm of martyrdom and the platter holding her eyes, which she plucked out and sent to a young man who had admired them excessively. (The Virgin rewarded her with a new pair.) The legend suggests that light is especially appropriate to Lucy, patron saint of vision. Domenico's light penetrates the shadows of Lucy's cloak and gives threedimensionality to the folds, all in tones of glowing rose. This calm, poised figure seems to typify the new aristocratic ideal of the Florentine upper middle class. St. Lucy's blond hair, its swept-back masses contrasting with wispy locks that have escaped, brings out the pallor of the face and forehead. The head is like one of Domenico's giant pearls, so gently does the light glide across it and across the silken surface of the neck. The haloes—such an impediment to the increasing illusionism of the period-are here successfully transformed into disks of crystal rimmed with gold.

The setting of the *Annunciation* (fig. 11.9), the altarpiece's central predella, is a court whose elegant forms contrast with Mary's rough bench and the simple rush chair, which is almost identical with those still used in Italian farmhouses. The angel kneels while Mary crosses her hands upon her chest. We look through an arch into the closed garden, symbol of

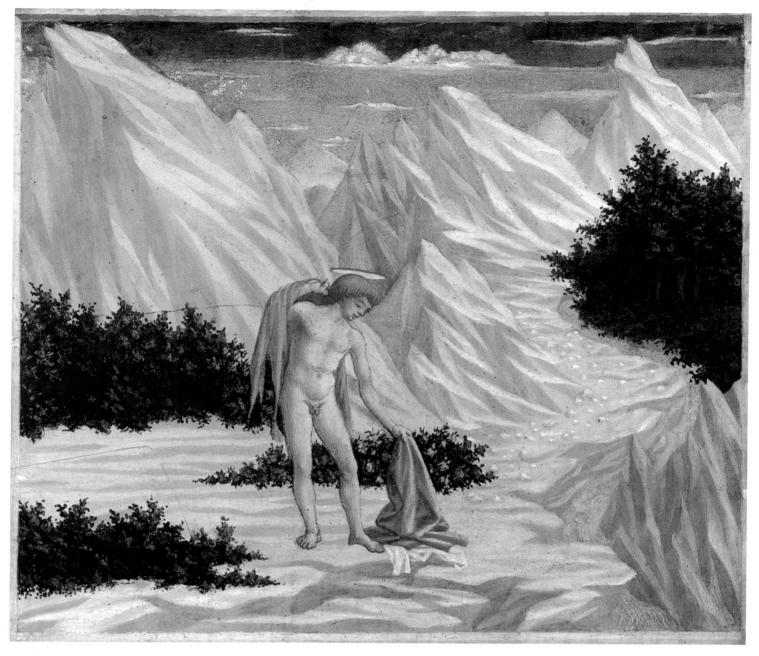

11.10. DOMENICO VENEZIANO. *St. John the Baptist in the Desert*, from the predella of the St. Lucy altarpiece (see fig. 11.8). c. 1445–47. Panel, 11³/₁₆ x 12¹/₂" (28.4 x 31.8 cm). National Gallery of Art, Washington, D.C. (Kress Collection)

Mary's virginity, as already seen in the *Annunciations* of Fra Angelico (see figs. 9.3, 9.9). The garden walk ends in a *porta clausa*, a gateway studded with nails and secured with a huge wooden bolt. The rose beds and the vine clambering over the trellis are painted in small, separate touches of the brush in a manner recalling the foliage in Masaccio's frescoes (see p. 232), but more striking here since it was intended to be seen at close range. Here Domenico uses an isolated touch of the brush to represent an individual ray of sunlight reflected from a leaf or petal. An even more intense rendering of sunlight is given in the predella representing the youthful *St. John the Baptist in the Desert* (fig. 11.10). In the Trecento,

St. John had been shown trudging cheerfully off, cross-staff in hand. Domenico's picture depicts the boy dropping his clothes on the rocky ground as he prepares to don the camel's skin he will wear in the desert. With a sensuous grace typical of the new Renaissance delight in the body, the youth is exposed to the glare of the sun. The almost Greek rendering of the nude figure is in keeping with Ghiberti's Isaac of the competition relief and the Christ of the *Flagellation* (see figs. 7.2, 7.6). The fierce sunlight changes the facets of the still somewhat Byzantine forms of the mountains to blue-white and yellow-white. The same light reflects from the rounded forms of the boy's body and dwells on every pearly stone.

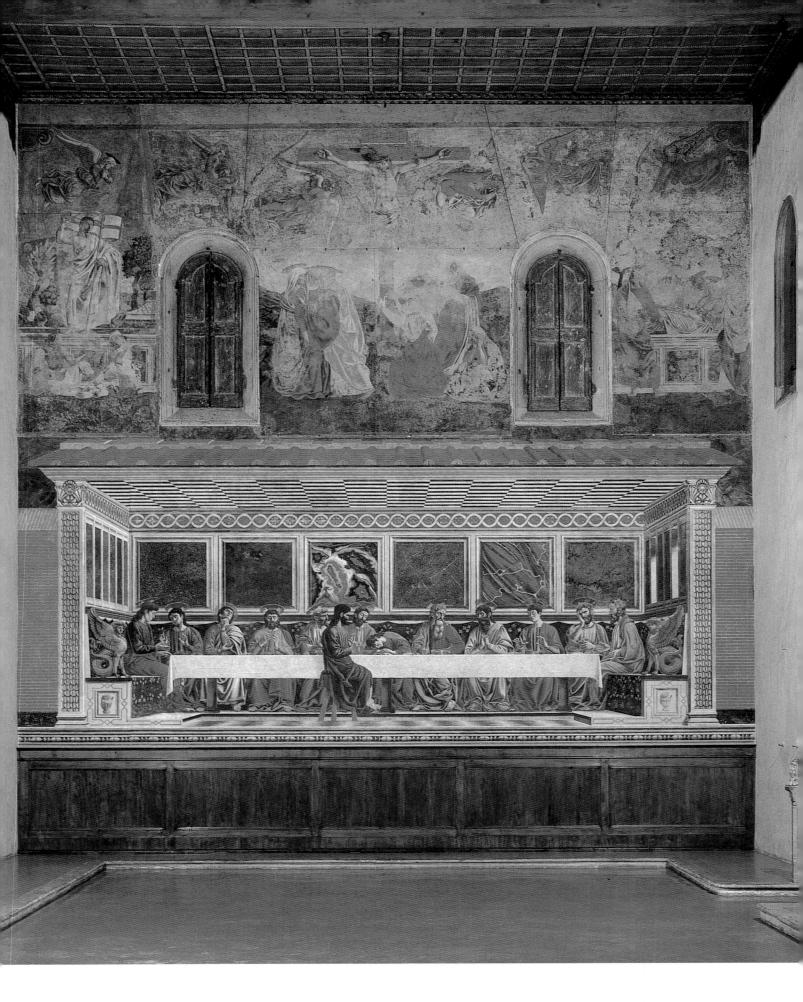

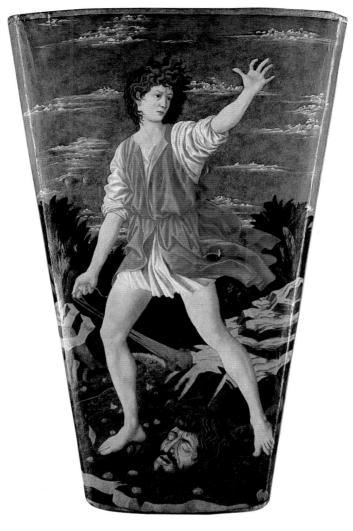

11.17. ANDREA DEL CASTAGNO. *David.* c. 1451. Tempera on leather on wood, height 45½" (1.155 m). National Gallery of Art, Washington, D.C. (Widener Collection)

While Castagno's figures here are still strong and wiry, like those in the *Last Supper*, more diffused lighting now replaces the strong shadows and harsh modeling, and a system of minute lines indicates contours, details of garments and ornament, locks of hair, and even individual hairs in the beard and eyelashes. Doubtless the new style was to please a different patron and, perhaps, to harmonize with the villa setting. The perspective could not possibly be unified, any more than that of the *Last Supper*, and for the same reason. A consistent one-point perspective would have looked incorrect except from a single spot in the loggia. But Castagno made every effort to make his figures and scene palpable. The feet, for example, overlap the ledge on which the figures stand and seem to project into the space of the room, while the folds of the skirts, seen from below, recede convincingly into depth.

Castagno's *David* (fig. 11.17) owes its shape to its purpose as a shield, presumably for ceremonial use in pageants. As contrasted to Donatello's two static figures of *David*, Castagno's wiry youth runs, swinging his sling in one hand and extending his other to help guide the trajectory of the stone, despite the fact that Goliath's decapitated head is at his feet. The movement causes his garments to flutter in the air above the tense muscles of his legs. This is one of the first great action figures of the Renaissance, and so impressive is its naturalism that it may come as a surprise to learn that the stance was probably suggested by an ancient Greek statue, part of a group representing Niobe and her dying children now in the Uffizi. The sculptors of the early decades of the Quattrocento had turned to classical antiquity for their philosopher-saints and for their relatively quiet male and female nudes. Castagno

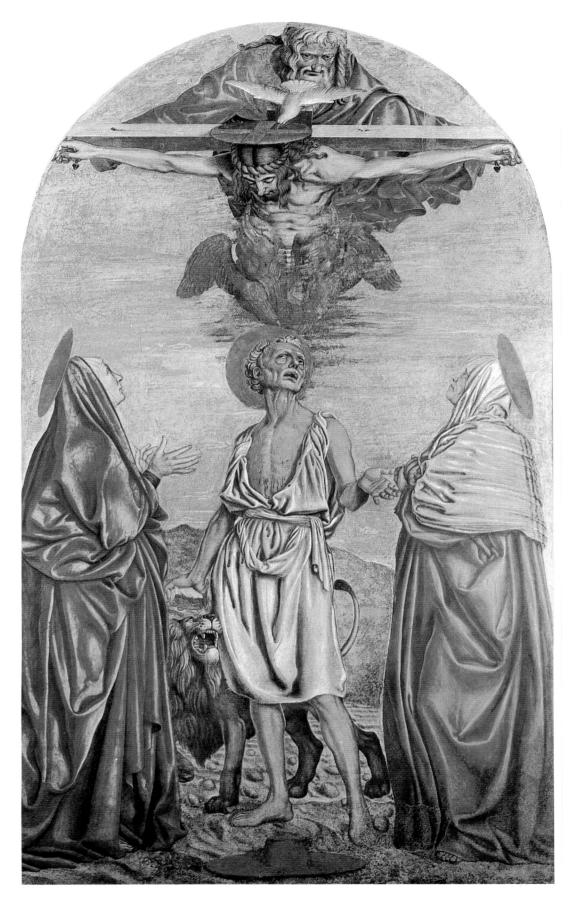

11.18. ANDREA DEL CASTAGNO (and DOMENICO VENEZIANO?). Vision of St. Jerome. c. 1454–55. Fresco, 9'9" x 5'10" (3 x 1.8 m). SS. Annunziata, Florence. Commissioned by Girolamo dei Corboli

11.19. St. Jerome, detail of fig. 11.18

now finds inspiration in ancient art for a pose that demands the total resources of the body. Despite the deliberate archaisms of the linear shapes, the patterned hair, the stylized clouds, and the still-Gothic landscape forms, Castagno has taken a giant step along the road later taken by Antonio del Pollaiuolo, Leonardo, Michelangelo, and, eventually, the sculptors and painters of the Baroque. At the same time, however, it is clear that he has not forgotten Donatello, whose works provided models for Goliath's severed head.

Castagno's Vision of St. Jerome (fig. 11.18) was created as an altar fresco. Jerome was often represented as a theologian in a study, at work on his translation of the Scriptures, but here Castagno places him among the rocks of the Egyptian desert—looking like any barren hill to the north of Florence-where, stripped to his undergarment, he has been beating his breast with a rock. His cardinal's hat rests at his feet. Flanking Jerome are St. Paola and her daughter St. Eustochium, followers of Jerome. The Trinity above the Father holding the Son, and the Holy Ghost in the form of a dove-are so sharply foreshortened that they seem about to glide out of the picture. The seraphim that cover the lower part of Christ's body were added later a secco and have partially peeled away. Perhaps the clergy or the patron were offended by Castagno's foreshortened Trinity and demanded this correction. Yet we still look down on the top of the crossbar, down on Christ's head (crowned with the

rope of flagellation, rather than with thorns), down even on his gold halo. The rope may have been included because the patron, Girolamo (Jerome) dei Corboli, was a member of the Girolamite community of flagellants. One hardly knows whether to be more astonished by the tortured face of the saint, his features and neck muscles twisted like a rope (fig. 11.19), by the intensity of his inner convulsion, or by the gloomy figure of God the Father, staring over pendulous lower lids as if despairing of the fate of his own creation. Blood runs from the gashes in St. Jerome's bony chest, drips from the rock he holds, and oozes from the pierced side of Christ.

Castagno's equestrian *Niccolò da Tolentino* (fig. 11.20) was commissioned as a pendant to Uccello's *Hawkwood* (see fig. 11.2); it too was detached and is now hung too

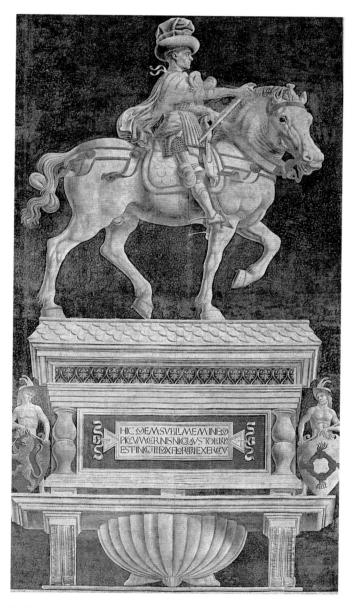

11.20. ANDREA DEL CASTAGNO. *Niccolò da Tolentino*. 1455–56. Fresco transferred to canvas; 27'4" x 16'9" (8.3 x 5.1 m). Cathedral, Florence. Commissioned by the Opera del Duomo, Florence.

low and with a later frame. Uccello had already painted Niccolò in the Battle of San Romano (see fig. 11.6), and it is not clear why he was not chosen to paint the second simulated statue for the cathedral. In any case, a comparison between the two is inevitable. The simple harmony of Uccello's earlier image is gone; perhaps such qualities were no longer possible in the 1450s, not even for Uccello. Characteristically for Castagno, the perspective scheme has no single point of view. Harsh contrasts between light and shadow throw into relief the simulated marble of the tomb, its giant balusters, inscriptions, and shell, and the nude youths who hold shields bearing the devices of Niccolò and the Florentine Republic. The convoluted shapes of the horse's muscles, head, and tail and of the rider's cloak produce an effect of movement utterly different from the geometry of Uccello's work. Castagno's illusion of marble means that he has substituted earth tones and black for the violet and green used by Uccello to simulate bronze.

Castagno's wife died in one of the recurrent plagues in August 1457 and the artist himself died eleven days later. They were buried, apparently in a mass grave, at Santa Maria Nuova. Castagno, who was ranked by his contemporaries among the leading artists of the period, created works that probed humanity's dilemmas and tragic destiny.

Piero della Francesca

The artist who seems to us today to fulfill the Albertian ideal of absolute and perfect painting in nearly every respect is Piero della Francesca (c. 1415–92). He was not a Florentine, and except for occasional visits there, he lived in Borgo Sansepolcro, a Tuscan market town then still a possession of the Papal States. Apart from recent construction outside its walls, the town seems to have changed little since Piero's day. The name della Francesca, formerly believed to refer in some way to Piero's mother, is a feminine variant of the family name dei Franceschi; both versions appear in early documents, which reveal the family as the owners of a wholesale leather business, a dyeing establishment, houses, and farms.

In the nineteenth century, Piero's art was treated as an oddity, of interest only to a few scholars who found in it little merit and saw the artist as standing apart from the mainstream of the Renaissance. Only a new appreciation of form for form's sake, aroused by the art of Cézanne and the Cubists, led to an acceptance of the exceptional qualities of Piero's art.

The first reference to Piero is in 1439, when he was a modestly paid assistant of Domenico Veneziano working on now-lost frescoes in Florence. In 1442 Piero became a member of the *Priori* (town council) of Borgo Sansepolcro, an office he retained for the rest of his life. This rustic town, set in the upper Tiber Valley among the barren foothills of the Apennines, may have offered the atmosphere of simple dignity and

calm that is so evident in Piero's art. His three years or so in Florence provided him with the technical resources, the knowledge of perspective theory, and the form, light, and color so evident in his work. He certainly studied the paintings of Masaccio, and he may have returned to Florence from time to time and become acquainted with the art of Castagno. He may also have worked with Domenico again, at Loreto. But in the isolation of Borgo Sansepolcro, he posed a series of problems on the subject that seems to have concerned him most—the visual unity of the picture.

Piero's earliest known work is a polyptych commissioned for a group to which members of his family had long belonged, the Compagnia della Misericordia (Company of Mercy) (fig. 11.21). The Misericordia, which still flourishes in Tuscan towns, is an organization of volunteers similar to American rescue squads; individual members dedicate a portion of their time to works of mercy, especially bringing the sick to hospitals and the dead to burial. When volunteering for the Misericordia's works, members wear hoods so that their service to their fellow citizens remains anonymous.

In order to replace an earlier polyptych, the Misericordia must have required the old-fashioned gold background and complex Gothic format of Piero's altarpiece. With its several stories and standing saints in three different sizes, it reflects the towering Sienese altarpieces that would have been familiar to the members (see fig. 4.3). Unfortunately the altarpiece has been damaged by fire and its elaborate Gothic frame is lost. The result is a harsh contrast between the proliferation of panels and Piero's emphasis on simple compositions and powerfully modeled figures.

The central panel represents the Madonna of Mercy, patroness of the Misericordia and a familiar figure in Tuscan art; the flanking saints are Sebastian, John the Baptist, John the Evangelist, and Bernardino of Siena. The Madonna towers grandly, like a temple column, stretching out her mantle-symbol of heaven-over the kneeling townspeople shown in a smaller scale. One man, second from the left, wears the black Misericordia hood pulled over his face so that his eves look out through slits. The Virgin's columnar form, its vertical folds interrupted only slightly by her extended knee, is the central axis of the domelike space created by her mantle. Vasari wrote that Piero generally made models, clothed them in drapery, and studied the behavior of light on their folds for hours. Here he seems to have done exactly that, setting a strong side light on the hanging or bunched folds of cloth and on the smoothly sculptured faces. Yet this light avoids the deep shadows of Masaccio. The soft variations in Piero's direct and reflected light suffuse his shadows with color in the manner invented by Fra Angelico and developed by Domenico Veneziano. Here line is almost absent, and it is light that creates form. The glances of the figures are calm, and their lips are closed. Piero permits himself to represent only an occasional

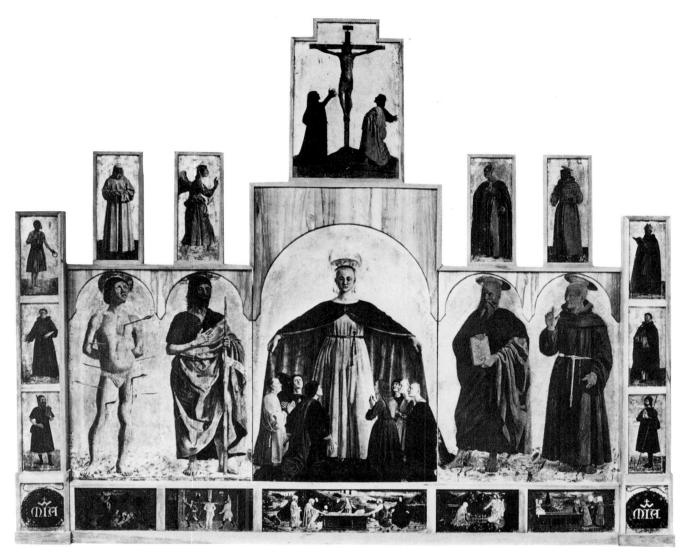

11.21. PIERO DELLA FRANCESCA and others. Misericordia altarpiece. Commissioned 1445; finished c. 1460. Panel, 8'8" x 10'6" (2.73 x 3.3 m). Museo Civico, Sansepolcro. Commissioned by the Compagnia della Misericordia in Borgo Sansepolcro. The original contract for the painting stipulated it be completed within three years, suggesting that this was a normal time span for a work of this scale and complexity. In 1455, after ten years, the patrons complained that the work was still not finished. A close examination reveals that some of the final painting was executed by assistants. There is evidence that Piero was already using some oil glazes in this painting.

gesture of deep emotion, only an infrequent dalliance with a delicately waved mass of blond hair, a sparkling jewel, or a gold-embroidered sleeve.

The *Crucifixion* at the apex of the altarpiece is a commentary on Masaccio's Pisan *Crucifixion* (see fig. 8.23). Piero, however, shows Christ as unresponsive to the grief expressed

in the gestures of Mary and John. Such passionate demonstrations of emotion are rare in Piero's art. The sharply foreshortened left arm of St. John (which adds to the sense of vivid bereavement) is one of the most impressive demonstrations of this sort before Michelangelo's drastic foreshortenings on the ceiling of the Sistine Chapel (see fig. 17.37).

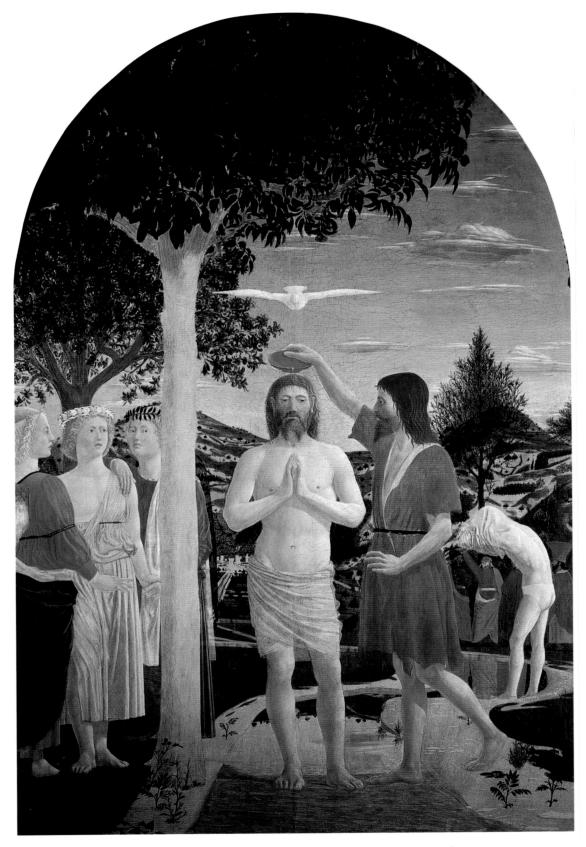

11.22. PIERO DELLA FRANCESCA. *Baptism of Christ*. Late 1440s–50s. Panel, 66 x 45 ³/₄" (1.67 x 1.16 m). National Gallery, London. Commissioned by a member of the Graziani family and by the Opera of the Pieve of San Giovanni, Borgo Sansepolcro.

This was the central panel of an altarpiece, the side panels and predella of which were painted later by the Sienese artist Matteo di Giovanni.

In Piero's Baptism of Christ (fig. 11.22), the beauty of the landscape setting reveals his command of the developments in naturalism of the second Renaissance style; one is reminded of Fra Angelico's Descent from the Cross (see fig. 9.1). Christ stands in a glassy stream under a well-pruned tree in a Tuscan landscape; he is up to his ankles in water so clear that we can see stones on the bottom. Holding a simple earthenware bowl, St. John steps from the bank to pour water over Christ's head. The three angels who attend the ceremony recall the classicism and naturalism of the singing boys on Luca della Robbia's Cantoria (see fig. 10.21). The homely face of Piero's Christ is unprecedented in the Italian tradition; Piero seems to have painted a Tuscan farmer, with heavy cheekbones, thick lips, large ears, lank hair, and wiry beard. The mood of suspenseful anticipation is in part the result of the stillness of all the figures and the balanced, flanking profiles of the Baptist and the angel on the left.

Piero develops a visual relationship between Christ's legs and the cylindrical white trunk of the tree; both seem equally rooted in the earth, equally responsive to the light of the sky. In the same way the foreshortened dove (symbol of the Holy Spirit) and the white clouds are so similar in shape that we have to look a second time to distinguish them. There is no representation of God the Father, not even the hand of God; apparently the blue sky will do. Piero is a nature poet who sees revelations or relationships in the simplest things—the Son in a tree, the Holy Spirit in a cloud, the Father in the sky. Piero's color is slightly bleached, similar to the color in his own countryside, where intense light will not permit bright colors to survive. Shadowless, this white glare models the smooth forms of Christ's torso, revealing the thighs through the translucent loincloth, and models the figure of a man in the middle distance. Pulling his garment over his head as he prepares for Baptism, his arms are visible through the white linen.

Beyond the second curve of the stream stand bearded figures wearing bright robes and towering headdresses; they and the terraced hill behind them are reflected in the water, which is as clear as it is bright. Piero seems to have painted slowly, and neither his analysis of nature, as seen here, nor his vision of humanity could be set down at Castagno's impulsive speed. To our surprise, for example, between Christ's hip and the tree trunk we are offered a detailed glimpse of Sansepolcro, its towers touched by light, and of the straight road that runs toward the town of Anghiari, site of the famous battle later to be painted by Leonardo (see fig. 16.28). Background details are painted more freely and without line, for Piero has mastered Domenico Veneziano's doctrine of light, with its equation of a single brushstroke with the separate sparkle of light on an object.

Piero's *Resurrection* (fig. 11.23) was painted for the Town Hall of Borgo Sansepolcro and moved from an adjoining room to its present position in the early sixteenth century; the *di sotto in sù* (looking up from below) viewpoint of the

enframing columns suggests that it was originally painted rather high on the wall. The theme was appropriate because the tomb of Christ was the symbol of Sansepolcro (which means, Holy Sepulchre) and appeared on its coat of arms. Piero compressed the scene to its essentials and represented the Resurrection not as a historical event—it is nowhere described in the Gospels—but as a timeless truth upon which one can meditate on any rocky hillside above Sansepolcro.

Christ stands with one foot in the sarcophagus, the other on its edge. One hand rests on his knee while the other grasps the red-cross banner of triumph. A pinkish red cloak with majestic folds leaves his right side bare to reveal the spear wound. The classical muscular torso is modeled by the dawn light coming from the left. Above the pillarlike throat, the face, as frontal as that of the Virgin in the Misericordia altarpiece, is firmly projected. The curving lips seem to have been carved in pale stone, and his wide-open eyes engage ours, challenging us to return his stare. In front of the tomb, the watchers sleep fitfully; according to Vasari, the second from the left is Piero's self-portrait. The large eye sockets, broad cheekbones, square jaws, and firm chin recall those seen in Etruscan sculpture—features still visible in the inhabitants of Tuscan villages.

The fact that the trees on the left are barren while those on the right are in full leaf can hardly be devoid of meaning. On his way to Calvary, Christ had said, "If they do these things in a green tree, what shall be done in the dry?" (Luke 23:31), meaning, "If they do this to me while I am still alive, what will they do when I am dead?" Christ's analogy between green and withered trees was also a reference to the Tree of the Knowledge of Good and Evil and the Tree of Life, standing together in the Garden of Eden as told in Genesis.

SAN FRANCESCO, AREZZO. The Resurrection contains evidence of Piero's slow technical procedures. Unlike Castagno, he took a working day for each face and a day for the torso, neck, and right arm of Christ. He seems to have spent more than a decade on his only major fresco cycle, at San Francesco in Arezzo (figs. 11.24-11.31), although most of the painting is now assigned to the early to mid-1450s. The commission had originally been given to one of the last surviving painters in the Gothic tradition, Bicci di Lorenzo, but he left Arezzo around 1447 after completing the Four Evangelists in the vault and the Last Judgment on the Triumphal Arch. Piero often applied wet cloths to the plaster at night so that he could work two days on a single section, and a study of the giornate in the chancel indicates that the actual painting could have been completed in no more than two years. The preliminary calculations and working drawings and cartoons, however, may have required more time than the actual painting. Piero had at least two assistants, but the designs and the principal figures are from his own hand. Exactly why the cycle took so many years to finish is uncertain.

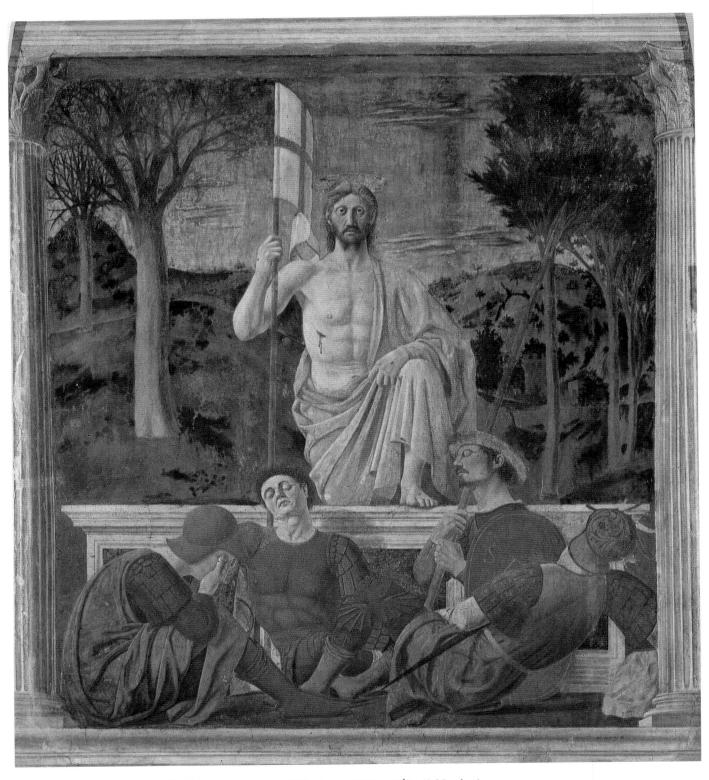

11.23. PIERO DELLA FRANCESCA. *Resurrection.* c. 1458. Fresco, 7'5" x 6'6½" (2.25 x 2 m). Museo Civico (originally the Town Hall), Sansepolcro. Commissioned by the chief magistrates of Sansepolcro for their state chamber

Opposite: 11.24. PIERO DELLA FRANCESCA. Chapel, S. Francesco, Arezzo. Frescoes of the Legend of the True Cross. c. 1450s. Commissioned by members of the Bacci family.

The cycle was begun in the late 1440s and completed by 1465. Most of the paintings were probably executed in the early to mid-1450s. The *Crucifix* seen hanging here is from the thirteenth century.

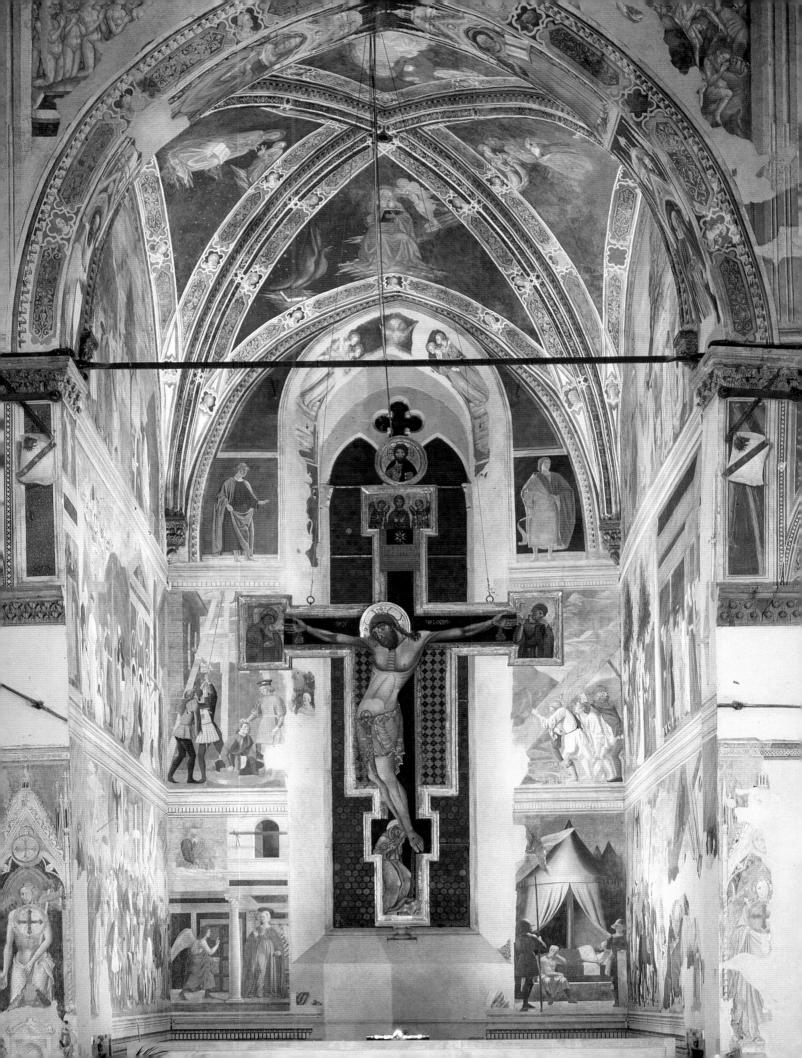

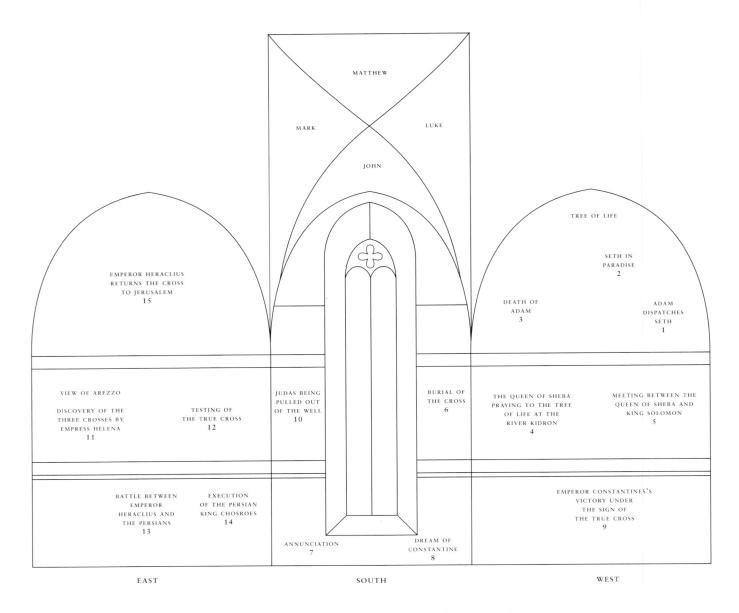

11.25. Diagram of the program of the frescoes of the Legend of the True Cross. Diagram by Sarah Loyd

The subject, the Legend of the True Cross, was a medieval fabrication of fantastic complexity, and Piero was certainly familiar with the cycle on the same theme frescoed by Agnolo Gaddi at Santa Croce in Florence (see fig. 5.11). The tale begins with the final illness of Adam, who, an angel tells his son Seth, can be cured only by a branch from the Tree of the Knowledge of Good and Evil from which Eve took the apple. Seth returns from Eden to find Adam already dead, but the branch is planted on his grave, where it takes root and flourishes. Later, King Solomon desires to use a beam from this tree in the construction of his palace, but it proves too large and is placed bridging a brook. The queen of Sheba, gifted with prophecy, discovers it on her trip to Solomon's court and recognizes that it will serve to produce a cross on which the greatest of kings will hang; kneeling, she worships it before proceeding onward to tell King Solomon, who has it buried deep in the earth.

Piero's depiction of the legend then shifts to the period after the Crucifixion, to the struggle between the rival emperors Constantine and Maxentius. An angel appears to Constantine in a dream, saying, "In this sign thou shalt conquer." Protected by his faith in the cross, Constantine vanquishes Maxentius at the Milvian Bridge. Helena, Constantine's mother, sets out to find the True Cross which, along with those of the two thieves, was buried after the Crucifixion. The person who knows the location reveals it only after he has been lowered into a dry well and starved. When the three crosses are dug up, they show no external differences and the True Cross cannot be identified. Luckily a funeral procession is passing by, and when the crosses are held over the corpse, the True Cross revives him. Later, the True Cross falls into the hands of the Persian emperor Chosroes, who attaches it to his throne, but the Byzantine emperor Heraclius defeats Chosroes in battle and brings the cross in triumph back to Jerusalem.

Piero's sense of order was equal to the challenges of this complex program, and he rearranged episodes to make analogous scenes face each other (fig. 11.25). The final structure forms a visual harmony rather than a temporal sequence, although the order of the scenes has also been related to the demands of Franciscan liturgy. Among the six scenes illustrated here, for example, he paired the scenes dominated by women (the queen of Sheba and the empress Helena) (figs. 11.26, 11.28) and those of battles won by emperors on facing walls (figs. 11.27, 11.29), while on either side of the window he placed visions of the cross (figs. 11.30, 11.31).

The story of the queen of Sheba (fig. 11.26) is divided into two episodes: at the left, the queen worships the wood of the cross, and at the right she is received at Solomon's palace. In the first episode horses are shown foreshortened from front and rear in the manner of Gentile da Fabriano and Masaccio (see figs. 8.2, 8.24). In the foreground the giant beam is placed across a tiny brook that runs past the bases of the palace columns. The shadow of the kneeling queen falls across the beam in accordance with the light from the actual window of the chancel. The garments of the queen and her ladies-in-waiting are not elaborate compared, for example, with those of Fra Filippo's Madonnas (see figs. 9.16, 9.17); their hair is simply dressed and they wear few jewels. Yet these stately women make their Florentine contemporaries look overdressed. This is due partly to the carriage of their heads, the coolness of their gaze, and the authority of their gestures, but even more to the simplicity of Piero's forms and

lines. The heads with their plucked foreheads and the long necks resemble perfect geometric forms, while the grand folds of the cloaks descend in parabolic curves.

The second episode takes place in the classical architecture of Solomon's palace, and here we are faced for the first time with the relation of Piero della Francesca to Leonbattista Alberti. The massive proportions of the composite order of Piero's portico recall those of Alberti's Malatesta Temple at Rimini (see fig. 10.1), and it is no surprise to discover that in 1451 Piero had been in Rimini, where he painted a portrait of Sigismondo Malatesta in a fresco in Alberti's temple. He may also have absorbed Alberti's perspective doctrine in Florence, and many years later Piero himself wrote the first Renaissance treatise on perspective (see p. 327).

Piero's ceiling is composed of veined marble slabs laid on white marble beams that run from column to column; the scheme is beautiful but would be unbuildable, given the weight of the marble. The cool white columns and green and red marble panels make a splendid enclosure for the meeting of the two monarchs. Piero has set his vanishing point low, on a level with the eyes of the kneeling queen; it is centered just outside the portico, so that some of the capitals are visible along the profile of the first column. Within the portico, we see the same queen and ladies, their heads drawn from the same cartoons reversed, a technique employed by Piero to achieve an effect of balance and regularity. They are received by a sumptuously dressed Solomon, whose gold-brocaded ceremonial robe was painted *a secco* and has largely peeled away.

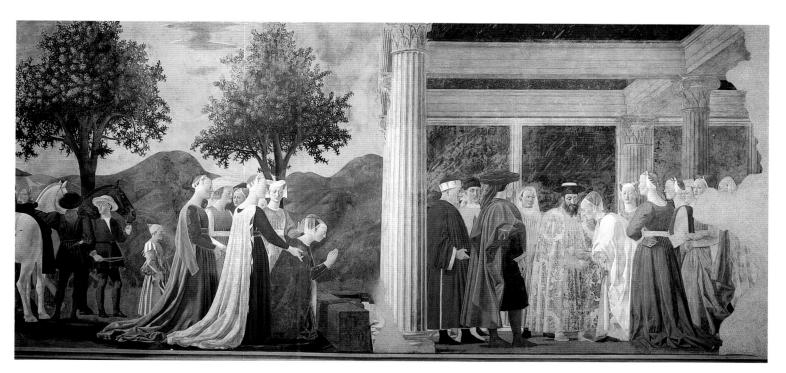

11.26. PIERO DELLA FRANCESCA. Discovery of the Wood of the True Cross and Meeting of Solomon and the Queen of Sheba, from the Legend of the True Cross. Fresco, $11'8" \times 24'6" (3.56 \times 7.47 \text{ m})$.

The second face from the left in the scene of the Meeting, who stares directly at the spectator, is probably Piero's self-portrait.

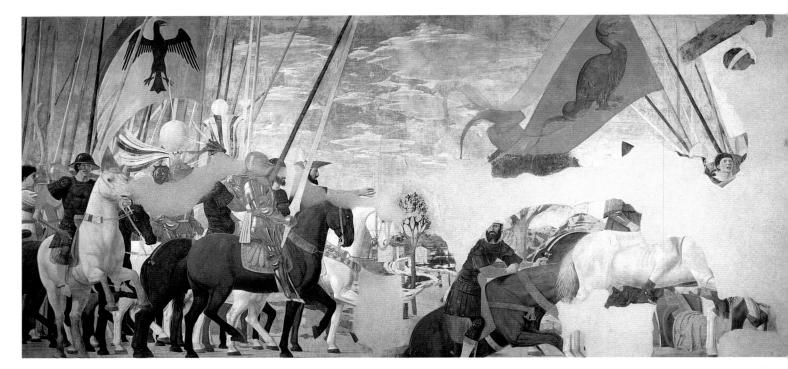

11.27. PIERO DELLA FRANCESCA. *Battle of Constantine and Maxentius*, from the Legend of the True Cross. Fresco, 10'9" x 25'1" (3.29 x 7.64 m)

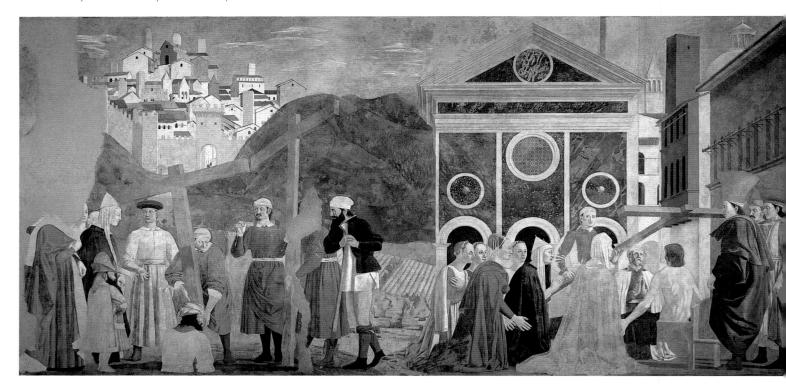

11.28. PIERO DELLA FRANCESCA. *Invention of the True Cross* and *Recognition of the True Cross*, from the Legend of the True Cross. Fresco, 11'8" x 24'6" (3.56 x 7.47 m)

In the companion piece on the opposite wall (fig. 11.28), there are again two episodes: at the left is the *Invention of the True Cross* (as the cross's actual discovery is generally entitled), in which Empress Helena—her face line for line the same as that of the queen of Sheba—directs the excavation of the crosses. This takes place outside the gates of Jerusalem,

which is still recognizable as a portrait of Arezzo; the cathedral can be distinguished and, at the extreme right, the side of San Francesco itself. The simplification of the cubic architectural masses recalls Fra Angelico's treatment of the same subject in his *Descent from the Cross* (see fig. 9.1), which Piero may well have studied.

The episode at the right, the Recognition of the True Cross, is dominated by one of the most memorable façades in Renaissance architecture. What makes this so surprising is the realization that at this time Piero could not have seen a single Renaissance church façade, for none had yet been built. Nonetheless, Alberti's ideas are evident in the simple masses of Piero's structure, which are divided into balanced rectangular, circular, and semicircular areas, with the arches supported on piers. There is a clear-cut dichotomy between the simplicity of the design and the veined marbles that form the ornamentation. Piero is also aware of the distinctions between historical styles, for above a street bordered with Tuscan houses are a Romanesque campanile, two medieval house-towers, and a dome culminating in a circular templelantern based on Brunelleschi's lantern for his Sacristy at San Lorenzo in Florence. In front of these disparate yet harmonious architectural forms, Piero has placed his kneeling figures, while the True Cross, its planes clearly defined in light. is projected toward us above the brilliantly lit torso of the man brought back to life by its power.

Piero's two battle scenes face each other across the chancel. Many scholars feel that Piero must have seen Uccello's battles (see figs. 11.5, 11.6), but they seem toylike compared with Piero's solemn depictions, in which the realities of conflict, defeat, and death are deeply felt. Piero has contrasted the two battle scenes more sharply than the two scenes just discussed. This was inevitable because Constantine defeated Maxentius through the cross alone, while Heraclius defeated Chosroes in massive, hand-to-hand combat. In the damaged Battle of Constantine and Maxentius (fig. 11.27), Piero depicted the army of Constantine advancing from the left. At the right Maxentius and his troops are in rout. If Piero had

painted the Tiber at its proper scale, he would have had to reduce the figures to miniature size. Piero inserted a symbolic Tiber, painting it as the narrow upper Tiber that flows by Sansepolcro, mirroring trees and farmhouses and providing a haven for three white ducks. His horses approach the edge, stare at the water, and paw the air, while against the blue morning sky Constantine holds a tiny white cross. Patterns are created by the cylindrical forms of the horses' legs and by the lances against the sky. While the dragon and Moor's-head banners of the defeated army are in disarray, the black Imperial eagle on its yellow banner floats triumphantly over Constantine's army.

Constantine wears a sharp-visored hat and bears the features of the Byzantine emperor John Palaeologus, the penultimate successor of Constantine, whom Piero must have seen in Florence in 1439. The emperor on his white horse is overlapped by a figure in armor so that we see only his head in profile and his outstretched hand. But seldom has armor been painted so magnificently. To Uccello, armor presented a series of forms that he could fit into ingenious patterns, while to Piero these surfaces of polished steel are forms that capture the morning light.

For the battle scenes Piero chose a point of view level with the riders' feet, so that we look slightly upward to the belly of the rearing horse at the left. The horse is foreshortened toward us and seems to look at us as his rider tries to control him. This device, coupled with the roundness of the modeling throughout, creates an illusion of depth that helps break up the procession of equestrian figures across the foreground.

The Battle of Heraclius and Chosroes (fig. 11.29) has little of the luminary magic of the Battle of Constantine and Maxentius, for such a display would have been lost because of its

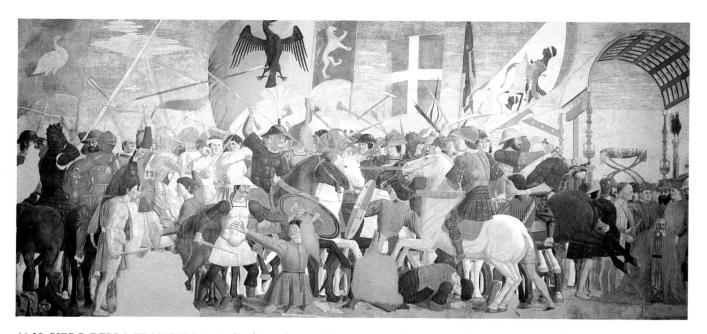

11.29. PIERO DELLA FRANCESCA. Battle of Heraclius and Chosroes, from the Legend of the True Cross (see fig. 11.24). Fresco, $10'9" \times 24'6" (3.29 \times 7.47 \text{ m})$

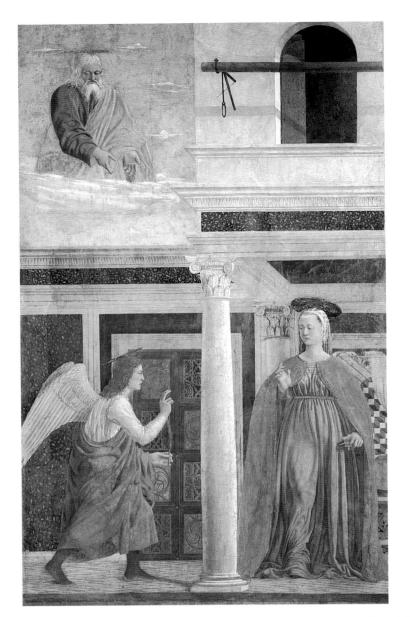

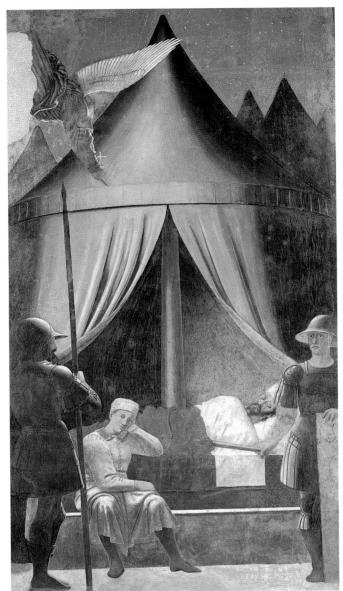

11.30, 11.31. PIERO DELLA FRANCESCA. *Annunciation* (left) and *Vision of Constantine* (right), from the Legend of the True Cross. Frescoes, 10'9" x 6'4" (3.29 x 1.93 m) and 10'9" x 6'3" (3.29 x 1.9 m)

situation on a wall which never receives direct light. Piero includes no landscape, concentrating instead on the battle. He was guided in part by Roman battle sarcophagi, which he could have seen in Florence and Pisa. The manner in which the composition is arranged close to the picture plane and motifs such as the horse rearing over a fallen enemy recall Roman sculptures. One of the most celebrated military encounters of Piero's day, the Battle of Anghiari (see p. 499), took place within sight of Borgo Sansepolcro in 1440. By that year Piero may have returned to his birthplace, and he could hardly have avoided hearing eyewitness accounts of the struggle.

His battlefield is a stretch of ground on which the two forces have gathered. Piero has chosen here to represent the grim mechanics of the slaughter: there are no beautiful patterns here, no lovely light, and the shining armor has little allure. The legs of horses and people fill the lower part of the composition, while masses of steel and flesh collide. Occasionally, one makes out an incident of utter brutality, as when a soldier near the throne jabs his dagger into the throat of another, or one of pathos, as we watch the dying figure below the rearing horse or look into the eyes of the severed head at the extreme left. The dethroned monarch on the far right awaits the executioner's sword. Above him the True Cross is seen, blasphemously incorporated into his throne.

Some scholars have tried to show that the *Annunciation* (fig. 11.30), at the lower left of the chancel window, is not an Annunciation at all but a vision of Empress Helena; others

have claimed that the scene is out of place in the Legend of the True Cross and was inserted later. It can be argued, however, that certain aspects of the subject, as well as its relevance to the legend, are clarified by St. Antonine. The Virgin looks down toward Gabriel, while God the Father appears above, his hands outstretched as if releasing the dove of the Holy Spirit. If so, it must have been painted a secco and since peeled off, for no trace of a dove remains. The loggia is formed by splendid columns similar to those of Solomon's palace. To the right is the open door of Mary's bedchamber, complete with a bed decorated with complex intarsia; the left has been identified as the porta clausa, the closed door of her virginity. St. Antonine declared that the porta clausa was the way to salvation and that when Christ said, "Narrow is the gate and straight the way that leads unto salvation," he meant the cross. Antonine suggested that the cross was mystically identified with the porta clausa, and that it was therefore already symbolically present at the Annunciation. Of this Piero has given a strong hint, for the picture seems to be based on a cruciform scheme.

Instead of the customary lily, Gabriel holds a palm, symbol of eternal life. As the conception takes place within Mary, the light from the real window of the chancel falls upon her. Light also pierces the open window above her, a symbol of divine revelation, and throws the shadow of the portico upon the *porta clausa*. In this simple composition—all rose, blue, white with the rich colors of the veined marble—Piero has expressed the mystery of Christianity as revealed by the miracle of light.

To the right of the window the same cross makes Constantine emperor, also through light. The Vision of Constantine (fig. 11.31) has its ancestry in the luminary revelations of Taddeo Gaddi, Pietro Lorenzetti, and Gentile da Fabriano (see figs. 3.30, 4.23, 8.4). Constantine's tent fills the scene, and behind it stand other tents, two of which are touched by moonlight. The parted curtains show the emperor asleep in bed, on the base of which sits a sleepy servant. A guard armed with a lance looks toward Constantine, another looks outward. No waking figure is aware that an angel has appeared over the group, flying downward into the picture. The right shoulder of the angel obscures his head, and the extended right arm holds a tiny golden cross. This must be the source for the light that illuminates the figures and the tent and even shines through the feathers of the angel's wing. No one seems to notice this miraculous radiance. As in the Annunciation, the cross is implicit in the picture's construction, and the shapes of the two scenes subtly correspond, pillar for pillar, horizontal for horizontal. Male and female, day and night, the cycle comes in these last two scenes to its fulfillment.

URBINO. Evidence suggests that Piero traveled widely. He seems to have worked in Ferrara at the court of the Este dukes, and he certainly left a mark on the Ferrarese school.

In 1459 he painted a fresco, now lost, in the Vatican. He may have visited Rome earlier, for there is some suggestion that he studied Fra Angelico's frescoes in the Chapel of Nicholas V. But Piero's strongest ties outside Sansepolcro were with the neighboring mountain principality of Urbino, then ruled by Count Federico da Montefeltro, who was elevated to duke in 1474. Urbino's territory was not rich in resources and the count's revenues were small, but he came from a family of long military traditions. His talents were valued by the popes, who made him captain general of the Roman Church and relied on his aid in warfare against rebels, including Sigismondo Malatesta. Young men came from as far away as England to Federico's palace to study the art of war and to acquaint themselves with the principles of noble conduct and gentlemanly behavior. Under his rule, Urbino became less a second Sparta, as might have been expected, than a tiny Athens. Federico was a learned man, scholar, and bibliophile who surrounded himself with humanists, philosophers, poets, and artists, and under his successors the cultural preeminence of Urbino lasted well into the seventeenth century. Federico's palace, a brilliant example of Renaissance architecture (see fig. 14.27), contained many important works of art. His studiolo (study; see figs. 14.29, 14.30), center of his intellectual life, may have been the original location for Piero's Flagellation of Christ (fig. 11.32). It is by no means certain that Federico was the patron of this painting, however, and there is little scholarly agreement on its date or even upon its subject. One interpretation suggests that the scene is actually St. Jerome's vision of the Flagellation.

The setting is the portico of Pontius Pilate's palace in Jerusalem, and scholarship suggests that Piero based details of the setting on descriptions of the palace and surrounding structures in Jerusalem. What has perplexed all observers is the placing of Christ and his tormentors deep at the left of the picture, while in the right foreground stand three figures who seem to have no involvement with what is going on in the other half of the picture. There have been many interpretations of this work, but none have been wholly convincing to a majority of scholars.

Crucial is the vanished inscription Convenerunt in unum (They came together as one), which was recorded in the early nineteenth century as being near the group of three figures or on the frame. The words appear in Psalms 2:2 and are quoted in a slight variation in Acts 4:26: "The kings of the earth stood up, and the rulers were gathered together against the Lord, and against his Christ." In fifteenth-century breviaries this verse appears in the Antiphon for the First Nocturn of Good Friday; it is followed by a passage from Acts 4:27 that refers to the trial of Jesus and names both Herod and Pilate. It has often been suggested that Piero's picture refers allegorically to the capture of Constantinople by the Turks in 1453 or to the threat of that capture in the years preceding the fall of the city; torments then inflicted on the

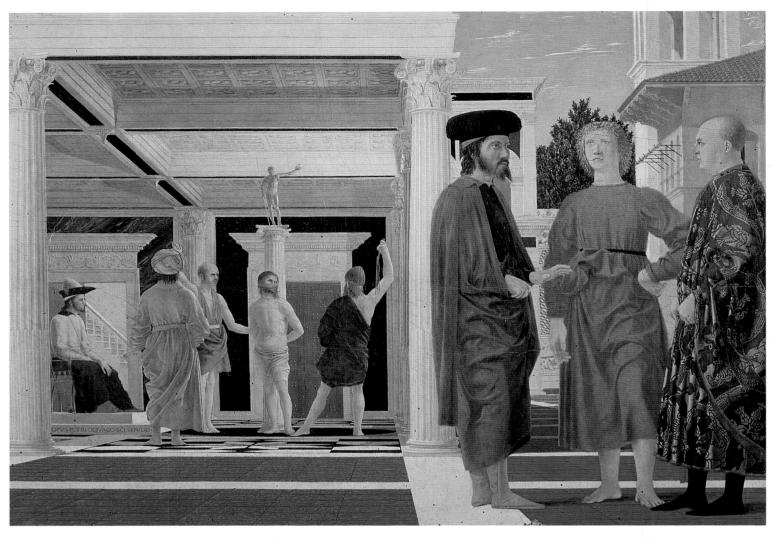

11.32. PIERO DELLA FRANCESCA. Flagellation of Christ. 1450s(?). Panel, 23½ x 32" (60 x 80 cm). Galleria Nazionale delle Marche, Palazzo Ducale, Urbino

Church, which is still known today as the mystical body of Christ, could easily be symbolized by the Flagellation.

An old tradition in Urbino identified the youthful, barefoot figure in the group on the right, clothed only in a plain red garment, as Duke Oddantonio, Federico's half-brother who was murdered in his nightshirt. (Federico, though older, was illegitimate.) More recently the figure has been identified as a wingless angel (see fig. 11.36). The figure at the right has the red mantle of a nobleman thrown over his right shoulder and may be a portrait of Duke Guidantonio, father of both Federico and Oddantonio; a more recent interpretation identifies him as Francesco Sforza. Pilate, who observes the torture from a throne, is thought to be a portrait of Mahomet II, who conquered Constantinople (see fig. 15.29). In all likelihood, then, the remaining man in the foreground is a por-

trait as well. Bearded in the Byzantine fashion, he also wears a Byzantine hat. He gazes earnestly outward, and his mouth is open in speech as he gestures to his two companions. We are led to conclude that the suffering of Christ, placed deep in space as the Flagellation is remote in time, and the contemporary events it symbolizes are the subject of his discourse. Perhaps the speaker is a Greek scholar at the court of Urbino who expounds the meaning of the event taking place behind him.

Deep in the portico Christ stands calmly, awaiting the blows about to fall upon him from men in Turkish dress. He is bound to a column surmounted by a golden sculpture of a nude man which has been identified as a statue of the Sun that was a principal monument of Constantinople; if correct, it would indicate the idolatry of those who are persecuting

Christ. In his left hand the figure holds what seems to be a colossal pearl; it is this form that seems to be providing the strong light illuminating the ceiling panel above Christ. If Federico was the patron, the picture may have been intended to embody Federico's own ideals for his mission as captain general of the Church involving the liberation of the Holy Land and Constantinople, the holy city of the East, and his own eventual reward, the ducal mantle of his predecessors.

The architectural setting has been constructed with such accuracy that modern scholars have been able to play Piero's perspective backward, so to speak, and reconstruct the plan of the inlaid marble floor. This turns out to have been, not surprisingly, put together according to precise mathematical principles. The orthogonals are projected from divisions in the base line, as Alberti says they should be, but Piero has intentionally placed the point of view slightly below the figures' hips rather than at eye level, as Alberti recommended. In consequence, the foreground figures loom grandly and their dialogue becomes all the more important. The architectural details are studied with even greater refinement than at Arezzo, and the ceiling is coffered rather than filled with marble panels. The steps visible behind Pilate surely represent the staircase used by Christ in Pilate's palace. Later what was believed to be this staircase was brought to Rome for veneration; it is now known as the Scala Santa.

Outside and inside the portico Piero's sunlight reflects from the snowy marbles, penetrates the deep-toned slabs of onyx and porphyry, and creates tones of blue and rose, red and gold, that suffuse the whites in the indirect illumination of the portico. Lavenders and blues make up the shadows in the white garments of the turbaned man who stands with his back to us. All in all, the interlocking web of form, space, light, and color represents Piero's most nearly perfect single achievement. If the Albertian ideal of absolute and perfect painting could be embodied in a single picture, this is it. Piero seems to have thought so too, for he signed the panel conspicuously. Why he chose the lowest step of Pilate's throne for the signature, however, is uncertain. The enigma of this unusual painting, with its combination of a subordinate narrative scene with a dialogue in the foreground, will undoubtedly continue to perplex scholars.

In July 1472, Federico's wife Battista Sforza, who had governed Urbino capably during his frequent absences, died in her twenty-sixth year, six months after the birth of her ninth child and first son, Federico's long-expected heir, Guidobaldo. Federico stopped all work on his palace and began the construction of a new church of San Bernardino across the valley from Urbino that is visible in the background of Raphael's *Small Cowper Madonna* (see fig. 16.46). For this church he commissioned Piero to paint the *Madonna and Child with Saints* (fig. 11.33). The Albertian setting is brilliantly projected, and the picture was probably intended to have a mar-

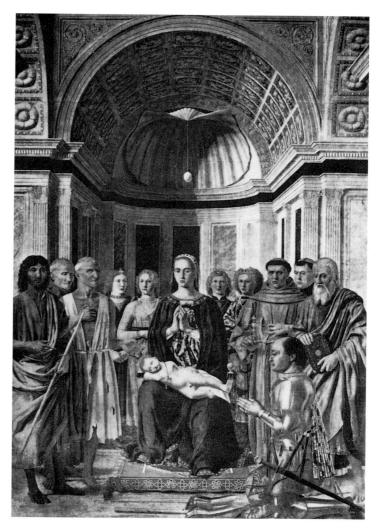

11.33. PIERO DELLA FRANCESCA. *Madonna and Child with Saints*. Mid-1470s. Panel, 98 x 67" (2.48 x 1.7 m). Brera Gallery, Milan. Commissioned by Federico da Montefeltro for S. Bernardino, Urbino

ble frame with matching architectural membering. The Virgin sits with her hands folded in prayer, and on her lap sleeps the Christ Child. Grouped around them are saints and angels. On the right kneels Federico, wearing a suit of shining armor from which he has removed helmet and gauntlets. Behind Federico stands his patron saint, John the Evangelist, but the spot before St. John the Baptist (on the left), where Battista Sforza should be kneeling, is vacant. The rose and gold brocade of the Virgin's tunic is repeated in Federico's cape, and her blue mantle is decorated with pearls that are painted with almost Flemish detail. From the shell of the apse, divided half in shadow and half in light, hangs an egg suspended by a silver cord. Throughout the picture stillness reigns.

So exact is Piero's perspective that the size of the egg can be measured, revealing that it is an ostrich egg. Such eggs

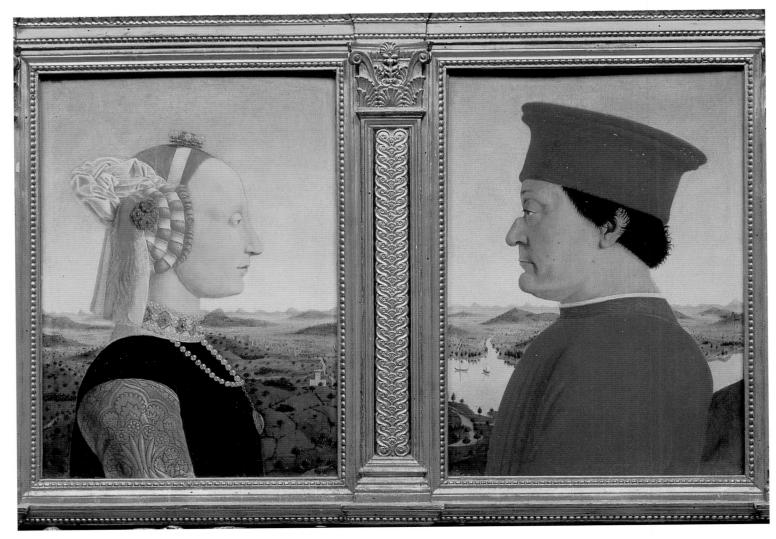

11.34. PIERO DELLA FRANCESCA. *Battista Sforza* and *Federico da Montefeltro*. c. 1474. Panel, each 18½ x 13" (47 x 33 cm). Uffizi Gallery, Florence. Probably commissioned by Federico da Montefeltro. Federico would later be immortalized in Baldassare Castiglione's 1528 *Book of the Courtier*.

often hung over altars dedicated to the Virgin—one still hangs in the Baptistery of Florence, and others appear in works by Mantegna and Giovanni Bellini (see figs. 15.16, 15.43)—for it was believed that the ostrich let her egg hatch in the sunlight without the intervention of the bird itself and thus, following medieval logic, the ostrich egg became a symbol of the Virgin Birth. It was also believed that the ostrich subsisted on a diet of nails, nuts, bolts, screws, and other hardware appropriate for a soldier, and it therefore appeared on Federico's coat of arms. Finally, the ostrich was an absent mother, and therefore a symbol of the deceased Battista.

The backs of Piero's portraits of Federico and Battista (fig. 11.34) are painted with allegories of their triumphs (fig. 11.35) and humanist texts that extol their virtues, but unfor-

tunately no evidence survives to suggest how double-sided portraits such as these might have been displayed. The ducal mantle worn by Federico in the triumph scene seems to date the panels after September 1474, when he was elevated to his long-desired rank (he does not wear the mantle in the *Madonna and Child with Saints*), but by that date Battista had been dead for more than two years. Piero must have worked from the still-extant death mask, and the features also correspond to those shown in Francesco Laurana's bust of Battista (see fig. 14.26). Federico's profile, disfigured by a sword blow in a tournament that cost him his right eye and the bridge of his nose, was done from the same cartoon as the portrait in the *Madonna*. Both figures are in absolute profile, set against continuous land-scapes that surely refer to the extent of their realm. The city in

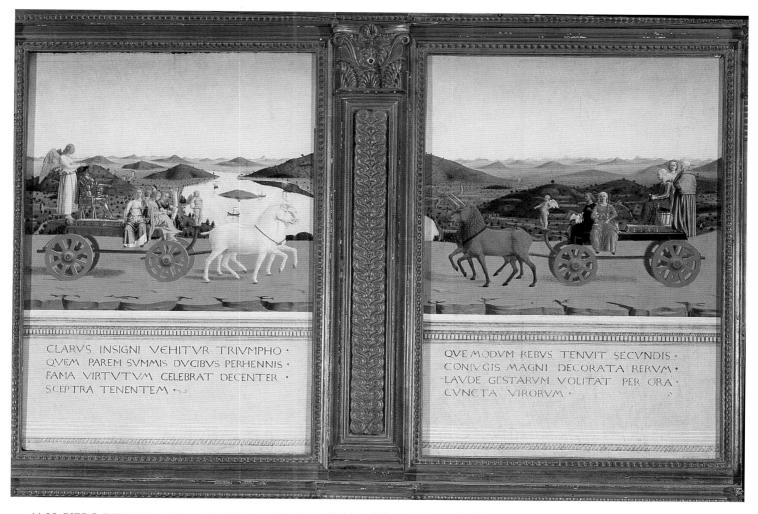

11.35. PIERO DELLA FRANCESCA. Triumph of Federico da Montefeltro and Triumph of Battista Sforza (reverse of fig. 11.34)

Battista's portrait is probably Gubbio, the second city of the Montefeltro domain, where Battista had taken her children during the construction of the palace in Urbino, where she gave birth to Guidobaldo, and where she died.

The portraits (see fig. 11.34) are typical of Piero in their combination of unsparing realism with inner nobility. Motionless and with chins silhouetted against the sky just barely above the horizon, these heads create an effect of grandeur. Piero's cool light plays full on the pale skin of Battista, leaving that of Federico somewhat in shadow. His olive skin is set against her pallor, his low-set red hat and tunic against her fashionably high forehead, blond hair, and jewels. The headdress conforms to the shape of the head, and the pearl-studded jewels against the sky seem almost like a lantern

crowning a great dome. The pearls concentrate the radiance of the landscape and sky in a chain of lucent globes that deliberately contrast with the chain of square, gray towers of Gubbio. Every element of luxury in the veil and jewels has been subordinated to the sense of order that dominates both portraits and Piero's work in general.

In the landscapes behind the portraits, Piero has set himself new problems—first, that of atmospheric perspective. He makes us aware of the veil of atmosphere, which even in a Tuscan summer contains some moisture, softening the contours of forms as they recede. But these hills, so strangely formed, have a second, more important, purpose. Piero was in touch with the major scientific currents of his time and must have known his Tuscan contemporary Paolo del Pozzo Toscanelli, who

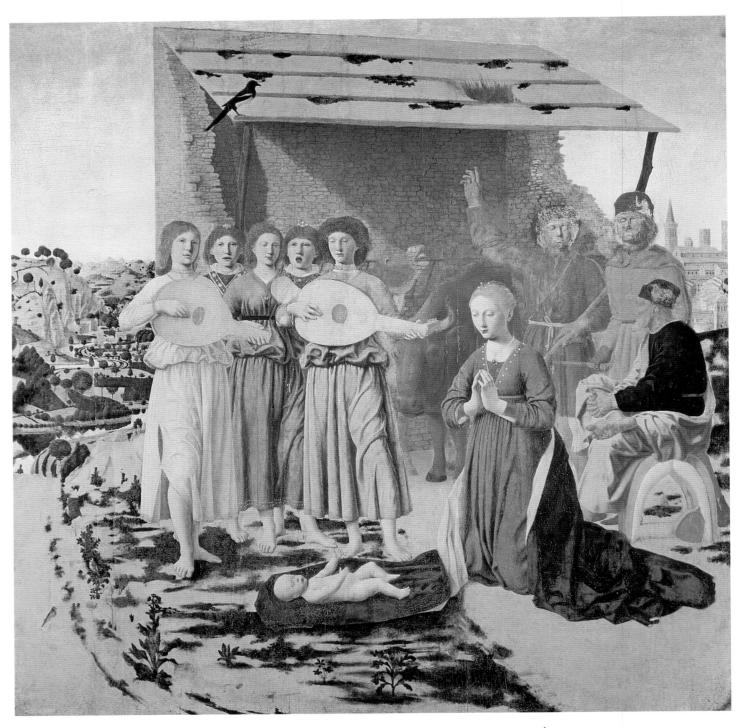

11.36. PIERO DELLA FRANCESCA. Adoration of the Child. 1470s or 1480s. Panel, 49 x $48^{1/2}$ " (1.24 x 1.23 m). National Gallery, London. Perhaps painted by Piero as a wedding gift for his nephew Francesco when he married Madonna Laudomia. The painting may have been cut at the top.

believed the world was round and made the map that started Columbus on his voyage. Piero has set out to prove this proposition visually, by establishing a continuous plain of a kind rarely to be found in central Italy. He then studded the plain at recurrent intervals with conical hills that have the texture and atmosphere of Tuscan hills but are not connected in ranges.

Below the allegorical triumphs on the reverse (see fig. 11.35) are Latin inscriptions in Roman capitals. Federico's refers to the "fame of his virtues" and asserts that he is the equal of the greatest leaders. In the inscription below Battista's triumph she is mentioned in the past tense; her personal fame and leadership are never acknowledged, but she is "honored by the praise of the accomplishments of her great husband." In the allegories, triumphal cars driven by putti approach each other before the landscape, the car of Federico drawn by horses, that of Battista by unicorns, symbols of chastity and fidelity. Fortune crowns Federico. On his car sit Justice, Prudence, Fortitude, and Temperance. Standing by Battista, who is shown reading a prayerbook, are Chastity and Modesty; seated on the front of the car are Charity and Faith. The colors of the costumes and armor resonate against the landscape, where a lake amid olive-colored hills and valleys reflects the sky. The luminous atmosphere and soft colors are similar to effects found in the art of Jan van Eyck and Rogier van der Weyden, whose works were known in Italy at this time. It seems likely that some of Piero's luminary effects were created using oil glazes in Netherlandish style, a technique he used elsewhere.

In Piero's later work, his interest in subtle manifestations of color and light—and correspondingly in the art of the Netherlands (see fig. 13.34)—deepens and intensifies. The Adoration of the Child (fig. 11.36) takes place on a sunny day in the Tiber Valley. Before a ruined wall, converted into a shed by means of a lean-to roof, Mary kneels to adore Christ, who stretches out his arms to her. Behind Mary a weary Joseph sits on a saddle, not even looking at the two shepherds who point upward. Behind the child stand five angels. Three of them (dressed in tunics and playing lutes and a viol) could have stepped out of Luca della Robbia's Cantoria (see fig. 10.21); the other two (vested as deacon and subdeacon at the first Mass) sing joyously.

Piero's careful balancing of color is evident in the garments of the foreground figures, which range through deep blue, light blue, blue-gray, and violet-blue, to blue-white.

Notice especially the subtlety with which the Virgin, with her pearl-studded hair and tunic, is painted. In the distance the Tiber Valley opens to the left; the river reflects the sky and the bordering rocky bluffs and scattered trees. On the right the principal church of Borgo Sansepolcro, which then contained Piero's *Baptism*, can be seen above the roofs and streets of the town, its campanile competing with the neighboring house-towers. The figures of the shepherds were apparently never finished; the linear underdrawing in perspective is clearly visible.

Piero lived on for about a decade more but seems to have abandoned painting for his studies on perspective and mathematics. His principal theoretical works are preserved in his own handwriting and include De prospectiva pingendi (On Painting in Perspective), in which he treats a series of problems in perspective as propositions in Euclidean style, and De quinque corporibus regolaribus (On the Five Regular Bodies), a study of geometry. According to Vasari, the aged Piero was blind, and in the mid-sixteenth century a man still lived who claimed that, as a boy, he had led Piero about Borgo Sansepolcro by the hand. This story's validity has been doubted, but it may well contain more than a grain of truth even though in 1490, two years before his death, Piero still wrote in a clear and beautiful hand. Writing with the aid of a magnifying glass might have been possible for an artist who could not see well enough to paint panels and frescoes.

The second Renaissance style thus ends in the contemplation of mathematical harmonies that, for the Quattrocento humanists, contained the secrets of the universe and served to admit humanity, at least in part, to the perfect mysteries that emanate from the mind of God.

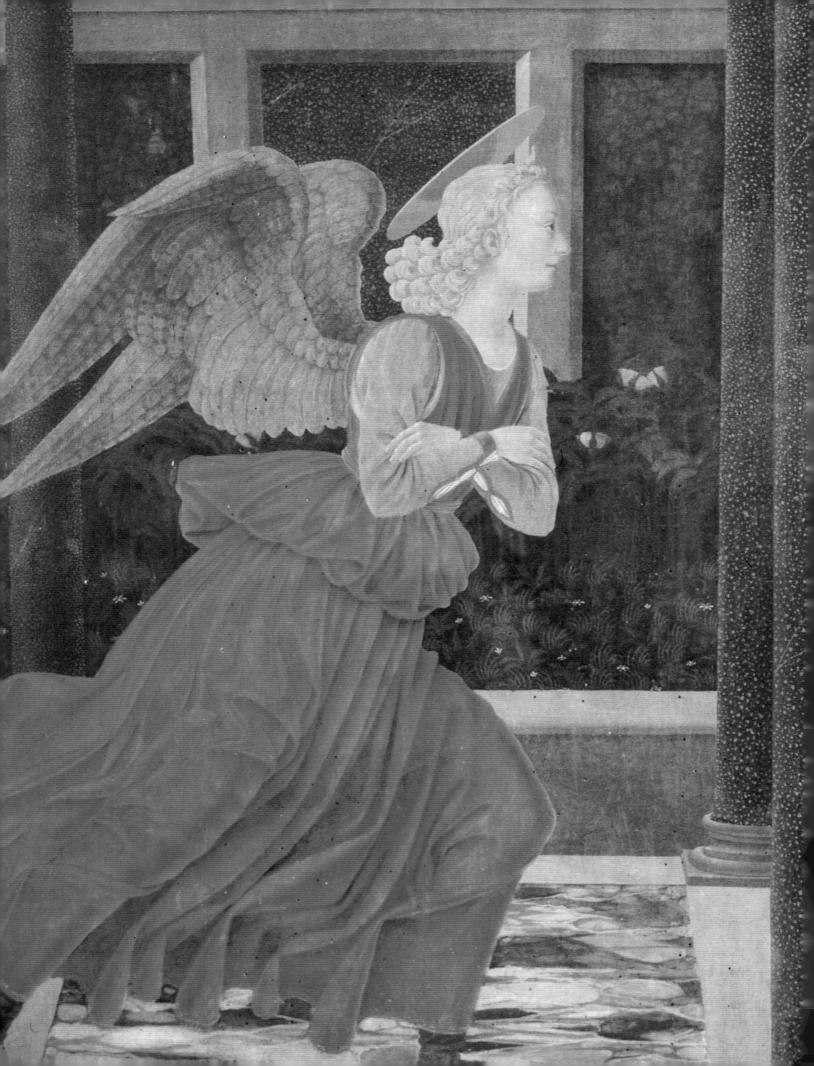

CRISIS AND CROSSCURRENTS

uring the first half of the Quattrocento, there were variations of manner, taste, and content, but no basic stylistic conflicts among the revolutionary Florentine artists. We might imagine these architects, sculptors, and painters as a band of hardy conspirators—let us say the heroic artists of Nanni di Banco's Four Crowned Martyrs (see fig. 7.18)—united against the entrenched Gothic style. By the 1430s the outcome of the struggle was no longer in doubt. The major commissions were awarded to the innovators, and artists who still adhered to the Gothic style were banished to the villages or forced to seek commissions in such still-Gothic centers as Milan or Venice. The triumph of the Renaissance artists was virtually absolute, and by the middle of the Quattrocento, furniture, textiles, metalwork, and ceramics had all been transformed by Renaissance taste. Florentine workshops turned out birth salvers, painted chests, processional banners, shields, and bridles in the new taste. They also painted reliefs made by sculptors and produced outdoor tabernacles and altarpieces for village churches, using ideas and motifs—sometimes even by means of stencils—borrowed from the revolutionary painters.

In the 1450s, just when the Renaissance style was beginning to seem as standard as had Giotto's in the 1320s, there appeared a rift that widened within a few years. Soon there was no longer a single dominant style but several, almost equally important, in sharp contrast to each other and, in general, to the previously dominant second Renaissance style (see pp. 245, 293). For the next fifty years these contrasting and sometimes conflicting currents characterized Florentine art.

By 1450, Brunelleschi, Masaccio, Nanni di Banco, and Jacopo della Quercia were all dead. After the installation of the *Gates of Paradise* in 1452, Ghiberti retired to his farm to live the life of a country squire. Fra Angelico was at work on a series of small panels that emphasized personal religious and artistic introspection. Alberti, Fra Filippo Lippi, and Piero della Francesca were largely or entirely active outside Flo-

rence and so, until 1454, was Donatello. We do not know much about Domenico Veneziano in the 1450s, but he seems to have fallen under the spell of Castagno, whose style had taken a strange and, we might say, shocking turn. The same could be said of Donatello's style on his return to Florence. But while these two artists seem to have been deeply affected by the terrible events of the time, another group of artists working during this period chose to depict scenes full of pleasure and delight.

We have already seen that the plague of 1448, a century after the Black Death, had serious consequences for Florence and Rome (see p. 261); moreover, it kept returning. The humanist pope Nicholas V, who once had been a university companion of Alberti, fled the Eternal City to the remote safety of Fabriano, to which papal soldiers then forbade further access. In Florence, St. Antonine, the ascetic archbishop, remained in the city and organized house-to-house efforts to aid the sick, bring the last comforts of the Church to the dying, and bury the dead. Events succeeded each other with frightening rapidity. Stefano Porcari, a Roman noble, led a conspiracy to assassinate the pope at High Mass on Easter Sunday. Halley's comet, considered a harbinger of disaster, hung over Europe in the summer of 1453. Repeated earthquakes shook central Italy, especially Florence, many of whose inhabitants slept outdoors for a month. And frightening news hit Western Europe in 1453, when the last citadel of the Greek Orthodox Church, Constantinople, fell to the Turks.

In due time Florence recovered, and in 1454 the Peace of Lodi put an end to most armed conflict in northern Italy and brought the illusion of restored tranquillity. But something seems to have happened to the Florentines. On the surface, the government of Cosimo de' Medici, although it suffered some serious challenges, continued to work well enough. He and his sons controlled politics from behind the scenes by ensuring that only the names of citizens approved by the Medici party went into the leather purses from which those

who held public office were to be drawn. Cosimo also tried to guarantee that his chief enemies, or individuals of whom he disapproved for one reason or another, were so heavily taxed that they fled the Florentine state; one conspicuous victim of this practice was the humanist Giannozzo Manetti.

Under such circumstances it might be assumed that the Medici bank and allied commercial establishments would flourish, but the opposite was the case. Cosimo gave less attention to banking, his sons Piero and Giovanni received little training in finance, and Piero's sons Lorenzo and Giuliano even less. Perhaps as a result—and perhaps as part of a Europe-wide business decline in the second half of the fifteenth century—the Medici bank closed one after another of its European branches, and the volume of its transactions declined precipitously. The fiscal corrosion was contagious, and by 1495 almost every bank in Florence had closed its doors.

Yet the splendor of the Medici family, emulated by those who sought their favor, took little account of the weakening of its financial base. Florentine architects, sculptors, painters, and artisans were kept busy designing, building, and decorating family palaces and the villas (often converted farmhouses) that rose in the countryside.

Cosimo, an amateur architect in his own right, was succeeded in 1464 by his sickly son, Piero the Gouty, whose tastes for refinement and luxury were, it seems, rapidly satisfied by artists. Piero's successor in 1469 was his son Lorenzo, who was nicknamed "the Magnificent." At the time magnificence was seen as a virtue because it implied liberal support, intellectual and financial, for one's city and its institutions. This was certainly the case for Lorenzo de' Medici. In addition, the term may also refer to the high level of culture that he supported and in which he participated; one of the humanists of the time, Marsilio Ficino, went so far as to compare Lorenzo's musical abilities to those of Apollo. With his pro-Medicean bias, Vasari wrote later that the period of Lorenzo in Florence was "truly a golden age for men of talent." Lorenzo managed adroitly to keep up the fiction of republican liberties at home while freely relating as an equal with kings and princes abroad.

In 1478, however, Lorenzo and his brother Giuliano were attacked and Giuliano was killed. The attackers had been encouraged by Pope Sixtus IV and members of the papal curia to overthrow the Medici, but local leaders included members of the Pazzi family, and thus this event became known as the Pazzi Conspiracy. The plot necessitated attacking Lorenzo and Giuliano when they would be without bodyguards: this was possible in the Duomo on Easter Sunday. The attack apparently took place at the moment when a bell was rung during Mass, indicating that the officiating priest would be receiving communion. Giuliano died, stabbed nineteen times, but Lorenzo received only a light

wound in the neck and escaped by fleeing into the Sacristy (see fig. 12.20) and slamming Luca della Robbia's bronze doors behind him (see fig. 10.23). The perpetrators were captured and more than seventy were hanged from the windows of the Palazzo dei Priori and the Bargello. Botticelli and Leonardo da Vinci were commissioned that same year, perhaps by Lorenzo dei' Medici, to paint portraits of some of these men, including the archbishop of Pisa, on the exterior walls of the Florentine Customs House. These portraits showed the men hanging by the neck, with one conspirator still at large shown hanging by one foot. The political message of such imagery would surely have been obvious to any citizen as he passed in the street. One result of the Pazzi Conspiracy was a war that broke out between Florence and Rome because of the papal court's involvement; peace negotiations were not concluded until 1480, and only after the Medici agreed to have Botticelli's portrait of the hanging archbishop of Pisa eradicated. After the expulsion of the Medici from Florence in 1494, the other portraits were also removed.

Giuliano's death and Lorenzo's survival are commemorated in a medal commissioned by the latter immediately after the Pazzi Conspiracy (figs. 12.1, 12.2). On the side commemorating Giuliano as a Florentine political martyr, the attack is shown in front of the polygonal enclosure that surrounded the Duomo's high altar. The emphasis on the setting suggests the sacrilegious nature and timing of the attack. Giuliano's gigantic head soars over the scene; he is identified by name, and the phrase *LUCTUS PUBLICUS* (Public Mourning) below his profile suggests the appropriate public response to his murder. The phrase *SALUS PUBLICA* (Public Safety) appears below Lorenzo's head, implying that Lorenzo's salvation was crucial for the good of the city.

Another commemoration of the event was a life-sized figure of Lorenzo with cloth garments and a naturalistic wax head and hands commissioned by the Bandini-Baroncelli family to be set up in front of a miracle-working crucifix in their family church. One family member had been part of the conspiracy, and the figure of Lorenzo was probably made to reassure the surviving Medici of the continuing allegiance of the other family members. The figure wore the bloodstained garments Lorenzo had been wearing on that fatal Easter Sunday, donated by him for this commemoration. This kind of figure, which must have been similar to those seen in today's "wax museums," was a widespread phenomenon during the Trecento and Quattrocento. Such mannequins, often shown praying in thanksgiving, were commonplace in the Renaissance, but unfortunately no single early example survives; examples of this wax technique from the eighteenth and nineteenth centuries, however, demonstrate the vivacity of this medium.

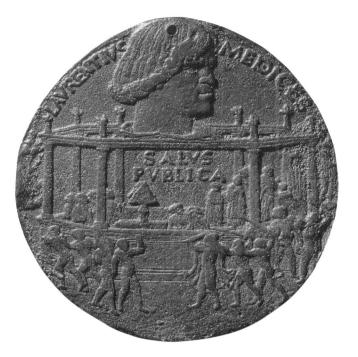

12.1. BERTOLDO DI GIOVANNI, cast by ANDREA GUACIALOTI. Commemorative Medal of the Pazzi Conspiracy with the Portrait of Lorenzo il Magnifico. 1478. Bronze, diameter 2¹/₂" (6.4 cm). The Metropolitan Museum of Art, Bequest of Anne D. Thomson, 1923. Commissioned by Lorenzo de' Medici. Bertoldo di Giovanni, a pupil of Donatello, was a member of Lorenzo's intimate circle. The many surviving copies of this medal indicate that it was widely circulated.

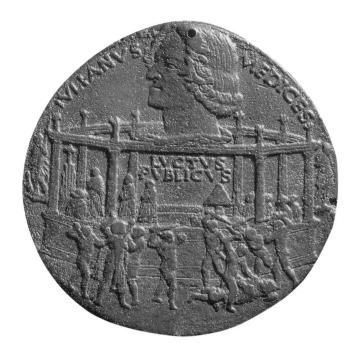

12.2. BERTOLDO DI GIOVANNI.

Commemorative Medal of the Pazzi Conspiracy
with the Portrait of Giuliano de' Medici. (reverse of fig. 12.1)

These clothed figures with wax heads and hands represent only one of many genres of Renaissance art that are documented but for which we have no visual record; such gaps remind us how limited our knowledge is of the visual culture of this period.

Despite attempts to suppress it, the anti-Medicean party continued to grow during the last years of what should perhaps be known as Lorenzo's reign. The flames of their anger and discontent were fanned by the sermons of Girolamo Savonarola, a Ferrarese monk who succeeded St. Antonine and Fra Angelico as prior of San Marco.

After Lorenzo's death in 1492, his son Piero, nicknamed the Unlucky, failed to continue the family's control of the city. In 1494 Piero and his brothers—Cardinal Giovanni, later Pope Leo X, and Giuliano, later duke of Nemours—were forced to flee the city. Some works of art from the Medici Palace were moved to the Palazzo dei Priori; the rest of the contents were sold at auction. Small wonder that the humanistic precepts of the second Renaissance style—intellectualism, order, harmony—had lost their relevance.

Donatello after 1453

Donatello's harrowing figure of the *Penitent Magdalen* (fig. 12.3), carved in poplar wood, polychromed, and gilded, is often dated after his return to Florence from Padua in the early 1450s; this is, however, rendered uncertain by the date of 1438 discovered recently on a similar statue. The Magdalen's original location and patronage are likewise unknown. What is not in question is its strong expressive power.

Emaciated from thirty years of penitence in the wilderness and clothed only in her own hair, this skeletal, even spectral, figure with shrunken cheeks and almost toothless mouth seems the antithesis of the noble Early Renaissance figures that we have discussed previously. But this figure is no return to the Middle Ages, and the new developments that were so important for the first Renaissance sculptures by Donatello, Nanni, and Ghiberti are also found here. An examination of the pose of the figure, for example, reveals that she stands in a beautiful and subtle *contrapposto*. This pose, in combination with the refined bone structure of her cheeks,

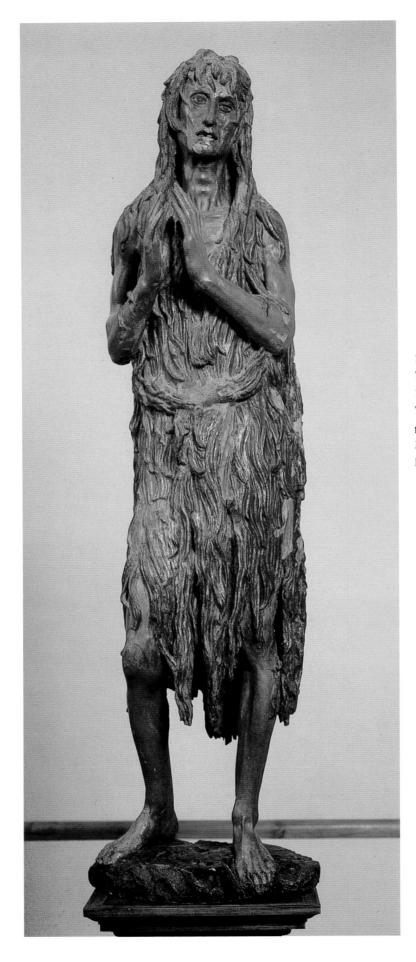

12.3. DONATELLO.

The Penitent Magdalen.
1430s–50s(?).

Wood with polychromy and gold, height 6'2" (1.88 m).

Museo dell'Opera del
Duomo, Florence

eye sockets, and nose and the elegance of her long fingers and delicately formed ankles and feet, reminds us that the Magdalen was traditionally known for her great beauty; it is clear that Donatello is interested here in developing character, just as he had earlier in the *Sts. Mark* and *George* and the *Zuccone* (see figs. 7.13–7.16, 7.20). Of utmost importance in this case is the Magdalen's spiritual presence: her eyes are focused on an inner vision (fig. 12.4), and her mouth seems to be murmuring a prayer as she raises her hands and asks for forgiveness.

The flood of 1966 immersed the lower part of the statue in water mixed with mud and oil and necessitated a cleaning of the surface. A coat of brown paint, apparently added in the seventeenth century, was removed to disclose that Donatello had originally painted the flesh to suggest the leathery tan produced by years of exposure to the sun, and had used streaks of gilded highlights to create the Mag-

dalen's traditional red hair. Wooden figures like this one were sometimes carried through the streets in popular processions, and the effect of the shimmering streaks of gold on her long hair would have been impressive in the open air. Like the late works of Castagno (see fig. 11.18), those of Donatello admit us to an inner world of emotional stress, and to a merciless examination of the ravages of time and decay on the human body.

Donatello's bronze group of Judith cutting off the head of Holofernes (fig. 12.5) was most likely originally commissioned for the garden of the Medici Palace, where it is first documented. After the expulsion of the Medici, in 1494, it was situated in front of the Palazzo dei Priori to symbolize revolt against tyranny. But when it belonged to the Medici, the group had another meaning, indicated by an inscription describing how the head of Pride was cut off by the hand of

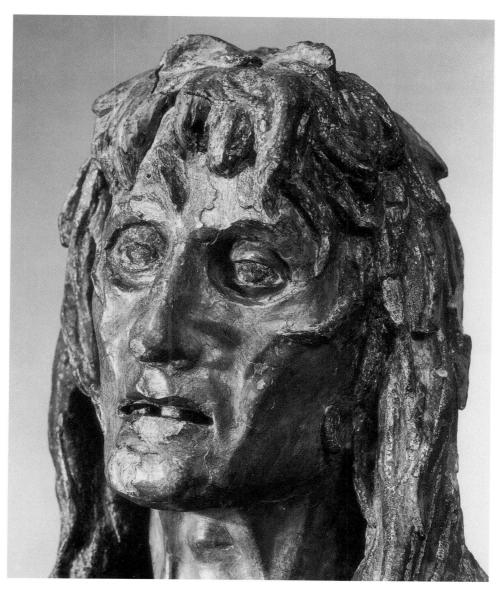

12.4. Detail of fig. 12.3

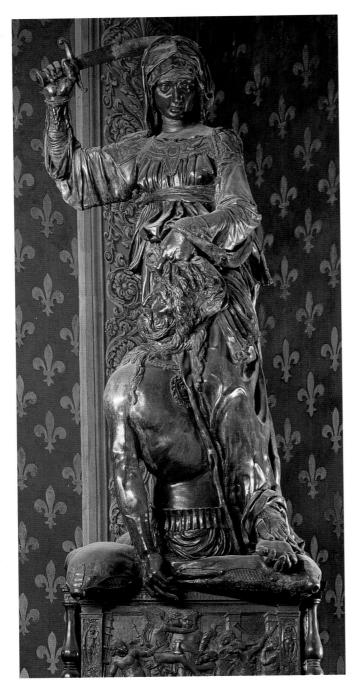

12.5. DONATELLO. Judith and Holofernes. c. 1446-60. Bronze, height 7'9" (2.36 m) (including base). Palazzo Vecchio, Florence. Perhaps commissioned by a member of the Medici family for the garden of the Medici Palace. For a diagram of the casting of the upper portion of Judith, see fig. 1.19.

12.6. Judith, detail of fig. 12.5

Humility. Judith's victory over Holofernes was compared with that of Mary over sensuality (luxuria), which is thought to derive from pride (superbia), the first sin and source of all others. Judith's purity in the face of Holofernes's flattery as he tried to seduce her is compared to the virginity of Mary; she, like Mary (in a simile borrowed from the Song of Songs), is a camp of armed steel, an army terrible with banners.

Donatello's Judith stands transfixed at the moment of victory. She has already struck Holofernes once and cut deeply into his neck. The sword is raised for the second blow that will decapitate him as she gazes outward with unfocused eyes (fig. 12.6). One foot is planted on Holofernes's hand, the other on his genitals. The rather awkward shapes and halting movements of the Judith are intensified by the convulsed masses of cloth that cover the figure. In making the mold, Donatello apparently applied cloth soaked in a thin paste of clay to the clay figure, modeling it in place. In the band over Judith's forehead some of the clay broke off before the figure was cast in bronze, revealing the underlying cloth and thus also his method. Donatello chose not to repair the break.

Even more startling than the Magdalen and Judith are the reliefs by Donatello-finished in part by his students-that

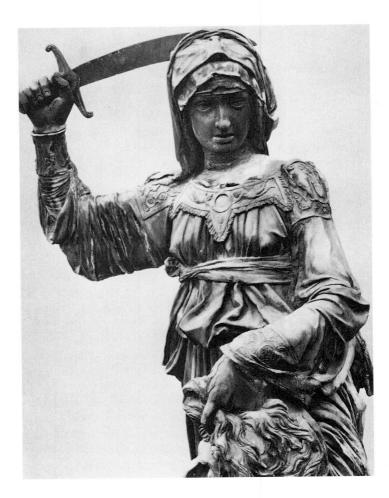

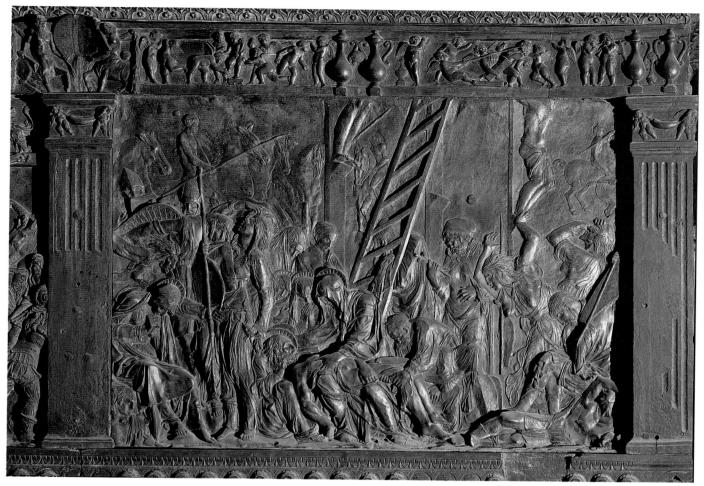

12.7. DONATELLO. Lamentation. 1460s; completed by students of Donatello at a later date.

Bronze, height approx. 40" (1 m). S. Lorenzo, Florence. Commissioned by a member of the Medici family.

In 1547 the Renaissance sculptor Baccio Bandinelli explained the rough finish of these works as the result of the aging Donatello's failing eyesight: "When he did the pulpits and doors of bronze in San Lorenzo for Cosimo il Vecchio, Donatello was so old that his eyesight no longer permitted him to judge them properly and to give them a beautiful finish; although their conception is good, Donatello never did coarser work."

Portraits of Cosimo de' Medici and his wife Contessina have been identified in the two figures at the foot of the left-hand cross.

are now on two pulpits in San Lorenzo. The reliefs were not installed on these pulpits during Donatello's lifetime and their original purpose is uncertain; it has been proposed that they were originally intended for three distinct monuments: a pulpit, an altar table, and a tomb monument for Cosimo de' Medici. Whatever their original purpose, the themes of the reliefs focus on the passion of Christ and the martyrdom of St. Lawrence.

The reliefs are rendered in a style characterized by freedom, sketchiness, and even brutality at times; they are extraordinary even for Donatello, and it could be argued that some of the technical and expressive devices used here do not recur until the early twentieth century. The scenes on one of the pulpits are flanked by fluted pilasters in the Renaissance fashion, but figures overlap these frames, as if moving out into

the space of the spectator. The *Lamentation* (fig. 12.7) takes place below the three crosses, which are placed diagonally in the pictorial space and cut off by the upper frame. The thieves still hang on their crosses, but we see only the knees, calves, and feet of the penitent thief; a ladder leaning against the central cross recedes diagonally in the opposite direction. Christ, at the foot of the ladder, his flowing hair and beard mingling in a torrent, lies across the knees of his mother. She holds his head, assisted by a figure whose head is concealed behind that of Christ in a manner unexpected at this time. Mary's face is recessed under her veil in such a way that the light coming through the high windows of the church shadows her expression; Donatello thus guarantees the grieving mother the dignity of privacy. Some of the surface finish—particularly the hammering of the bronze—is the work of

assistants, but they have left Donatello's angular draperies, especially the sleeve of the apostle holding Christ's legs, intact. The *Lamentation* poses insoluble mysteries: four screaming, maenadlike women rush about, but which one is the Magdalen? Who is the seminude figure reclining in anguish at the lower right corner? Why are the soldiers on horseback nude? Such iconographic uncertainties, uncommon in Renaissance art, add to the fascination of the relief.

The panels on the second pulpit are framed in an unprecedented illusionistic configuration: low brick walls roofed with tiles project outward with what seems to be surprising speed and as a result the figures seem thrust forward, out into the space of the church where we are standing. The *Martyrdom of St. Lawrence* (fig. 12.8), inscribed 1465, is Donatello's last dated work. The explosive architectural setting enhances the frightful event; with a huge, forked stick executioners force the saint not onto the traditional grill but directly onto blazing logs. One man blows the flames with bellows, another is felled by the intense heat, a third rushes away; at the same time an angel floats in to receive the soul of the dying martyr. The deep architectural setting, with its emphatic geometric elements, is in sharp contrast to the horrific drama of the foreground.

In his last works the aged sculptor—one of the founders of the Renaissance and a prime mover of every change in its evolution—abandoned the Renaissance notion of the ideal in order to emphasize drama and emotion and to involve the observer in his work. In the 1450s, both Donatello and Castagno possessed an insight into suffering that enabled them to explore the darker regions of human experience.

Desiderio da Settignano

Desiderio da Settignano (c. 1429/32–64) chose a different direction and style. The son of a stone-carver, he was born and trained in Settignano, a village of stonecutters. Few sculptors have understood the possibilities and limitations of marble with such intimacy as Desiderio.

Desiderio designed the tomb of the Florentine humanistchancellor Carlo Marsuppini (fig. 12.9) as a pendant to Lionardo Bruni's tomb by Bernardo Rossellino (see fig. 10.36), which lies directly across the church. The general layout and proportions of the monuments are similar and may even have been required by the commission, but the Marsuppini tomb produces an impression of greater lightness and grace. The sarcophagus and bier are lower, the moldings narrower, and Desiderio has divided the paneling into four narrower, taller slabs that accent verticality and openness. Desiderio crowns his design with a lampstand and frame imitated from Roman art, elements in keeping with the classical nature of the epitaph: "Stay and see the marbles which enshrine a great sage, one for whose mind there was not world enough.

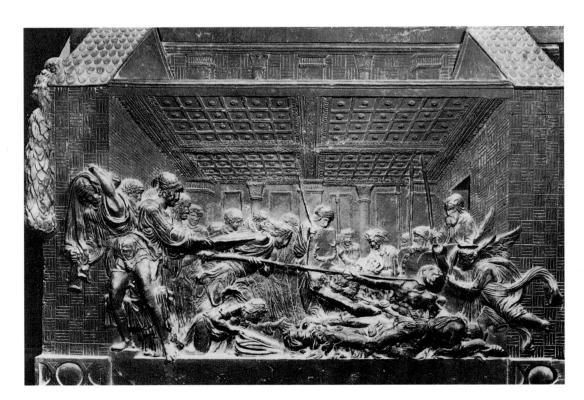

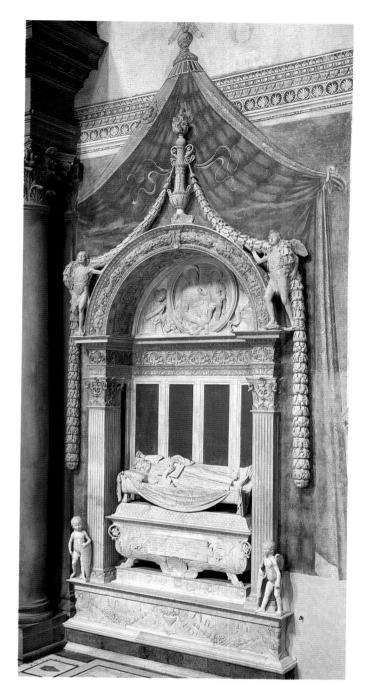

12.9. DESIDERIO DA SETTIGNANO.

Tomb of Carlo Marsuppini. c. 1453–60.

White and colored marbles, originally with gilding and green and red paint; 20′ x 11′9″ (6.1 x 3.6 m).

Sta. Croce, Florence

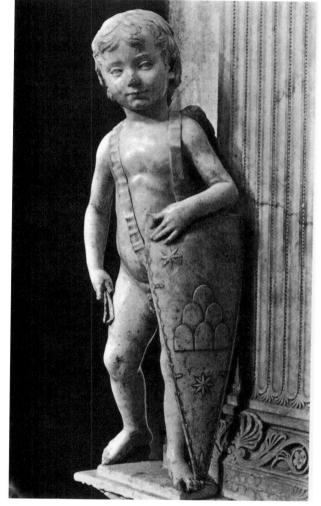

12.10. Putto, detail of fig. 12.9

Carlo, the great glory of his age, knew all that nature, the heavens and human conduct have to tell. O Roman and Greek muses, now unloose your hair. Alas, the fame and splendor of your choir is dead." Above, wingless angels seem to be striding around the top of the cornice to lift loose garlands that further enframe the tomb to either side. At the base of the pilasters, standing as if in our space, are putti who hold shields with the Marsuppini arms (fig. 12.10). Rather

than being rectangular, Marsuppini's sarcophagus has the curving forms of an ancient Roman funerary urn. Ancient vine-scroll ornament animates its surfaces and dissolves its angles; the openwork scrolls at the upper corners and the thin winged shell at the base are frank demonstrations of Desiderio's remarkable skill in carving. The angels in the arch above bend forward as they pray while the smiling Virgin leans back slightly, the better to contemplate her child as

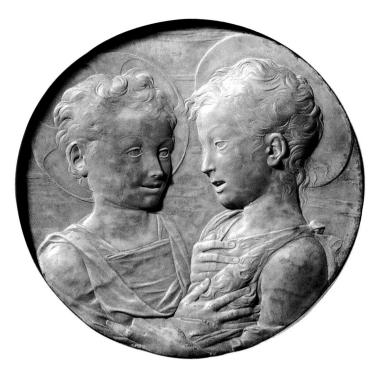

12.11. DESIDERIO DA SETTIGNANO. Meeting of Christ and John the Baptist as Youths (Arconati-Visconti Tondo). c. 1453-64. Marble relief, diameter 20" (50 cm). The Louvre, Paris. Vasari described a tondo of this subject, perhaps this same one, in the collection of Cosimo I de' Medici, but no such work is listed in the 1492 inventory of the Medici Palace.

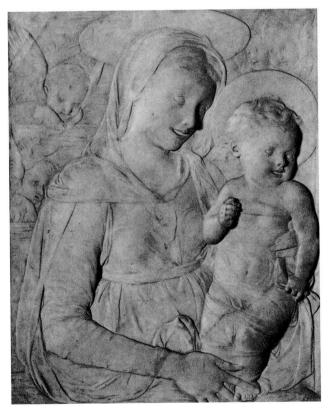

he blesses. Her halo overlaps the frame and her drapery spills over the lower edge.

Desiderio's rilievo schiacciato tondo of the Meeting of Christ and John the Baptist as Youths (Arconati-Visconti Tondo) (fig. 12.11) can be related to a passage written by Giovanni Dominici in 1403 in his Regola del governo di cura familiare:

Have pictures of saintly children or young virgins in the home, in which your child, still in swaddling clothes, may take delight and thereby may be gladdened by acts and signs pleasing to childhood. And what I say of pictures applies also to statues. It is well to have the Virgin Mary with the Child in her arms, with a little bird or apple in His hand. There should be a good representation of Jesus nursing, sleeping in His Mother's lap or standing courteously before Her while they look at each other. So let the child see himself mirrored in the Holy Baptist clothed in camel's skin, a little child who enters the desert, plays with the birds, sucks the honeyed flowers and sleeps on the ground. It will not be amiss if he should see Jesus and the Baptist, Jesus and the boy Evangelist pictured together; [or] the slaughtered Innocents, so that he may learn the fear of weapons and of armed men. Thus it is desirable to bring up little girls in the contemplation of the eleven thousand Virgins as they discourse, pray, and suffer. I should like them to see Agnes with her little fat lamb, Cecilia crowned with roses, Elizabeth with roses on her cloak, Catherine and her wheel with other such representations as may give them, with their milk, love of virginity.

This passage clarifies that on at least one level images in the home were intended to teach even very young children the identity of figures in the Christian pantheon, an understanding of basic Christian beliefs, and an incipient knowledge of moral behavior.

In Desiderio's relief, the boy Christ is clearly distinguished by the cross in his halo, the youthful Baptist by the animal skin he wears. The vivacity of their meeting and interaction is convincingly expressed by Desiderio. The happy expressions reveal a delight in their relationship that would indeed provide an appropriate model for children to follow. The lively interaction suggested in Desiderio's tondo is also found in his low-relief Madonnas, such as the one in Philadelphia (fig. 12.12). Desiderio employed techniques to take advantage of the luminosity in marble. Aware of how light sinks into the marble crystals, is held there, and then is transmitted back to the eye, Desiderio seems to have set out to

12.12. DESIDERIO DA SETTIGNANO. Madonna and Child. c. 1455-60.

Marble relief, 233/4 x 18" (59 x 45 cm).

Philadelphia Museum of Art (Wilstach Collection).

This Madonna was originally at S. Maria Nuova in Florence.

achieve in marble some of the effects of light created in paint by Fra Angelico and Domenico Veneziano and in gilded bronze by Ghiberti. He knew that the crystalline structure and brilliant whiteness of marble meant that any shadow would be partly dissolved by the light from the crystals, partly radiated by reflections from surrounding illuminated surfaces. Donatello's rilievo schiacciato technique, which he had employed to establish form, space, and atmosphere, was refined by Desiderio to suggest how light is diffused through the atmosphere. In the figures on the Marsuppini tomb these effects are obtained by broad surfaces, subtle cutting, and a delicate polish. But at the end of his brief career, in the Madonnas and in Head of a Child attributed to Desiderio (fig. 12.13), Desiderio renounces polish and lets the marble crystals speak for themselves by suppressing any sharp linear surface definition; he apparently filed the surface to blur lines and soften the junction of shape with shape, as if all were seen through a luminous haze. Perhaps Bernini in the seventeenth century and Rodin in the nineteenth studied Desiderio's sculptures to achieve similar transitory effects of expression and subtle luminosity. Desiderio's works embody the ideals of elegance and refinement characteristic of the new Florentine aristocracy at midcentury.

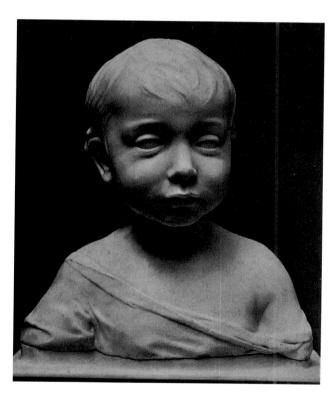

12.13. DESIDERIO DA SETTIGNANO (attributed to). Head of a Child. c. 1460. Marble, height 12" (30.5 cm). National Gallery of Art, Washington, D.C. (Mellon Collection). The exact subject here is difficult to pin down; this might be a representation of the Christ Child, the youthful John the Baptist, or a portrait of a contemporary boy.

Antonio Rossellino and the Chapel of the Cardinal Prince of Portugal

Antonio Rossellino (1427–79) was the youngest of five artist brothers, and his nickname (Rossellino means little redhead) became the name by which the whole family was known.

Antonio and his workshop played an important role in the creation of the burial Chapel of the Cardinal Prince of Portugal (figs. 12.14–12.17; see also figs. 12.34, 12.35). This elaborate undertaking was the result of the collaboration of an architect, four sculptors (Antonio Rossellino, his brothers Bernardo and Giovanni, and Luca della Robbia), three painters (Alesso Baldovinetti, Antonio and Piero Pollaiuolo), their workshops, and other craftsmen as well, and yet the chapel today—which looks exactly as it must have looked in the 1470s—is a stylistically unified totality rather than a demonstration of the diverse talents of a number of individual Florentine artists.

James, a prince of the Portuguese royal family who had been made a cardinal at the age of twenty-two, died of tuberculosis in Florence when he was only twenty-five. He expressed a desire to be buried at San Miniato, and immense sums poured in for his funerary chapel. After all, one of his cousins was king of Portugal, another was Holy Roman Empress, and his aunt was duchess of Burgundy, the richest state in Europe. The chapel was designed by Antonio Manetti, a pupil of Brunelleschi, and the architectural detail was carved by Giovanni Rossellino, third of the five Rossellino brothers. Work started in 1460 and was carried out with rapidity, as is shown in documents that clock the work on the chapel almost from day to day.

The ground plan of the chapel is a perfect square, with inset arches on three walls and a matching open arch for the entrance on the fourth wall; coffers decorated with floral patterns highlighted in gold fill each arch. Classicizing pilasters define the corners and frame each wall. Even a glance reveals how the chapel's unity is accomplished. On the back and left walls, for example, there is a round window; on the tomb wall this is matched by the appearance of the Madonna and Child in a windowlike form of the same dimensions. The pattern of the metal gate that closes off the chapel resembles twisted rope; the same design decorates the railing painted in the background of the altarpiece by the Pollaiuolo brothers (now replaced with a copy). The view behind the painted railing looks like the view over the Arno Valley that would be visible if the altar wall were dissolved, while the cypress trees above the Annunciation on the left wall (see fig. 12.34) are like those in the cemetery of San Miniato outside, next to this chapel. The floor is executed in the traditional inlaid stone pattern of circles that dates back to the Romanesque period; this pattern-with

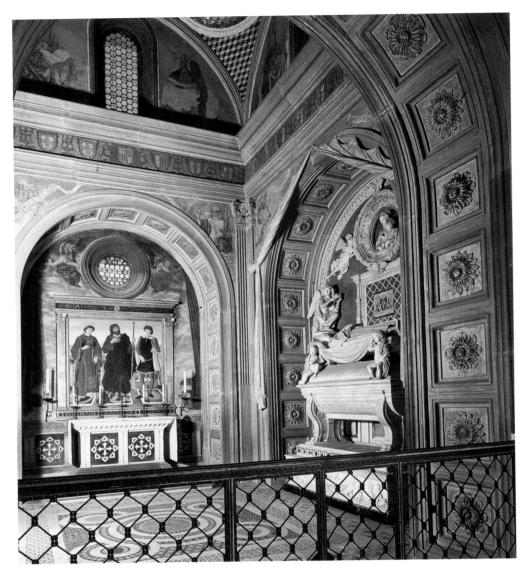

one circle in the middle and one in each corner—is echoed in the circular composition of Luca della Robbia's enameled terra-cotta dome above, which has five medallions representing the Cardinal Virtues and the Descent of the Holy Ghost. On the altar wall Antonio Pollaiuolo's angels pull back curtains that can be related to the curtains that surround Rossellino's tomb on the right wall.

Documents reveal that in executing the tomb Antonio Rossellino was helped by several assistants and his brother Bernardo, but there is no doubt that he was the designer and leading master. As compared with earlier, static tombs, Antonio's tomb is dynamic. The traditional marble curtains

seem to have been momentarily drawn aside to reveal the tomb monument. The cardinal lies on a bier above a marble coffin that Antonio imitated—at the cardinal's request—from an ancient Roman porphyry sarcophagus which then stood in the portico of the Pantheon. The two kneeling angels to the sides seem to have just alighted; one bears the crown of eternal life, the other once held the palm of victory. Except for an ornamental structure in the center, the background is red marble that was once covered with gilded designs to resemble a brocaded cloth of honor. Against this background two angels seem to fly in, holding a circular marble wreath. Here, against a ground of blue with gold

Opposite: 12.15. ANTONIO ROSSELLINO. Tomb of the Cardinal Prince of Portugal. 1460–66. White and colored marbles with traces of polychromy and gold, width of chapel wall 15'9" (4.8 m).

The Chapel of the Cardinal of Portugal, S. Miniato, Florence (see also fig. 12.34). Commissioned by the executors of the will of the Cardinal of Portugal

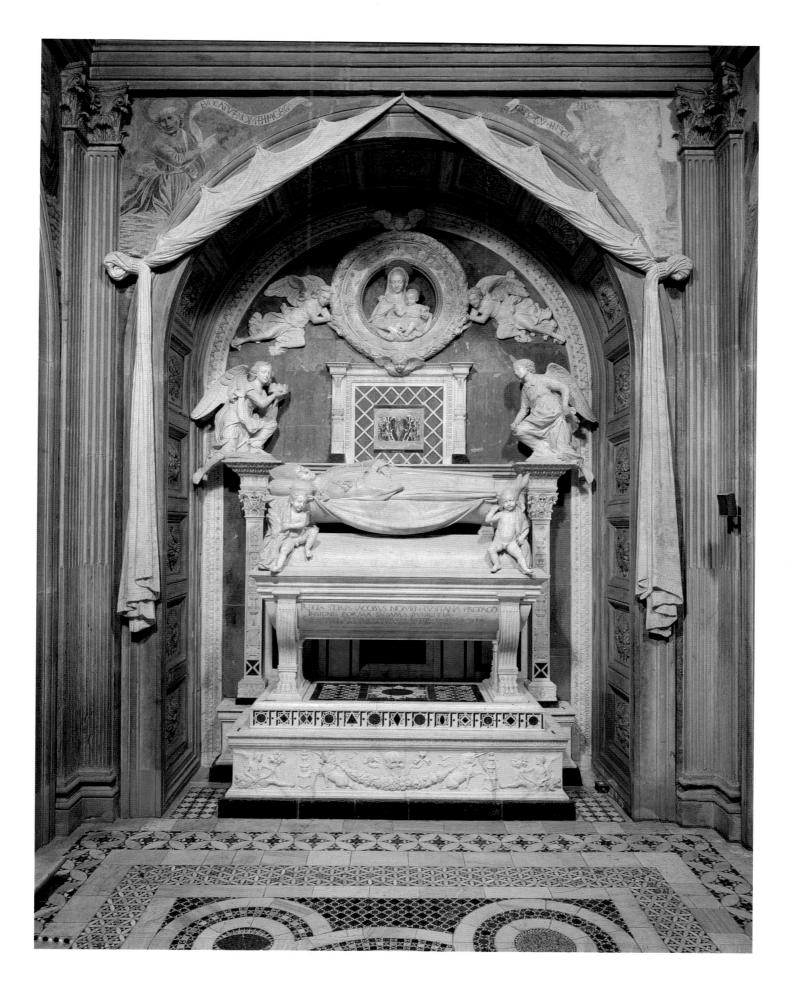

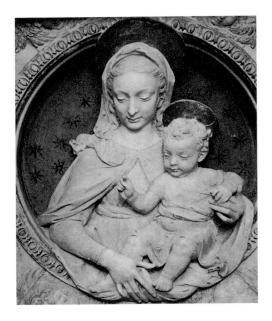

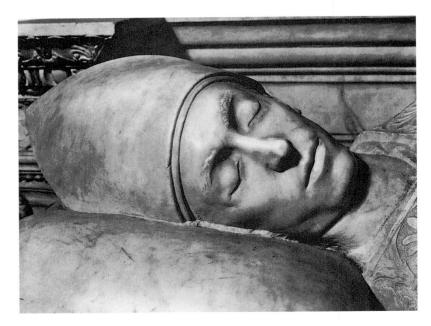

12.16. 12.17. Head of the Cardinal Prince of Portugal, detail of fig. 12.15

Virgin and Child, detail of fig. 12.15

stars, the Virgin and Child bless the cardinal (fig. 12.16). This heavenly vision seems to be resting here, poised against the architecture by the efforts of the winged cherub heads, as if in a moment it might move on.

The angel with the crown can be attributed to the more conservative Bernardo, but the angel who once held the palm shows the lightness and dynamism of Antonio's style. Antonio was as aware as Desiderio of the luminous possibilities of marble, but he found other means of exploiting it. The Madonna and Child, who are placed so that the light in the chapel never leaves their features, show how Antonio unified his sculpture through light that flows over the surfaces of flesh and drapery.

The handsome young cardinal seems to be dreaming of the paradise to which the sacred figures promise him entrance—although one could almost say that it lies around us as we stand in this most perfect of Quattrocento chapels. Documents suggest that Desiderio supplied a death mask of the cardinal, from which Antonio created a portrait that is persuasive in its reality (fig. 12.17). The plinth, which was designed by Antonio and executed by him and his brother Bernardo, features youthful genii, cornucopias, and garlands, held by unicorns, that enframe a skull which seems to be smiling.

Another work by Antonio that reveals the liveliness which marks his style is his portrait of the humanist Matteo Palmieri (fig. 12.18). Despite wear to the surface, Antonio's representation is indeed a "speaking likeness." Yet beyond this realism lies Antonio's instinctive sense of composition, of how to control the masses so that they harmonize, fold against fold, wrinkle against wrinkle. A surprising nobility of form emerges from what could have been a caricature in the hands of another artist.

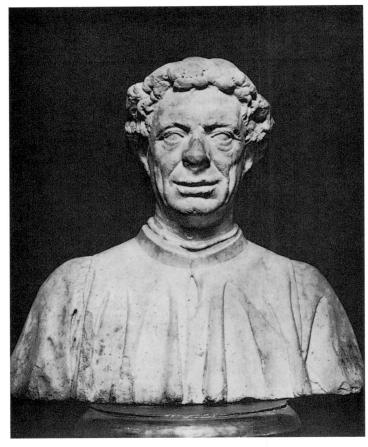

12.18. ANTONIO ROSSELLINO.

Bust of Matteo Palmieri. 1468. Marble, height 21" (53.3 cm).

Museo Nazionale del Bargello, Florence.

Probably commissioned by Matteo Palmieri.

The worn surface of the bust was apparently caused when it was displayed for centuries over the Palmieri Palace door.

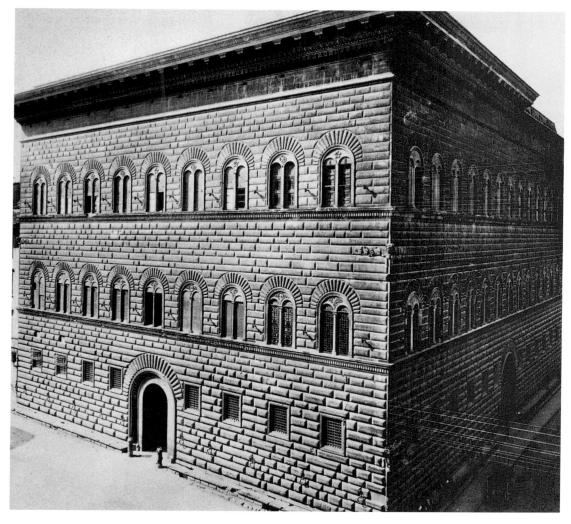

12.21. BENEDETTO DA MAIANO. Palazzo Strozzi, Florence. 1489-1507.

Commissioned by Filippo Strozzi. Cornice added by SIMONE DEL POLLAIUOLO, called IL CRONACA. When Filippo Strozzi died in 1494, the palace had reached only partway up the lowest story, to the height of the great iron rings to which the reins of horses were to be tied. The surviving wooden model of the Palazzo Strozzi should perhaps be related to Alberti's advice: "I always recommend the ancient builders' practice by which not only drawings and pictures but also wooden models are made, so that the projected work can be considered and reconsidered, with the counsel of experts, in its whole and all its parts."

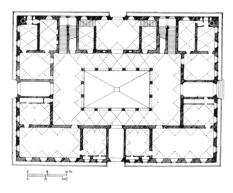

12.22. Plan of Palazzo Strozzi, Florence

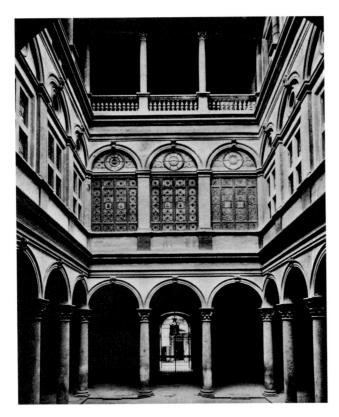

12.23. BENEDETTO DA MAIANO. Courtyard, Palazzo Strozzi, Florence

means of a rustication whose projection is so slightly graduated from one story to the next as to at first seem uniform throughout. Within the limits of the three-story type, Benedetto has harmonized all the parts in a manner that fulfills Albertian ideals.

The oblong courtyard (fig. 12.23) is, in the opinion of many scholars, the finest Quattrocento courtyard in Florence, partly because of the larger space at Benedetto's command and the greater height of his columns and arches, as compared with those at the Medici Palace (see fig. 6.19). But there are further refinements. Mullioned windows on the center story are here replaced with arches supported on piers; those on one side of the court were open (later filled with glass), and on the other sides the arches enclose cruciform windows with oculi in the lunettes. The third story is a loggia of delicate Corinthian columns on bases, the whole united by a balustrade. Thus the courtyard opens not only outward in its expanded plan but also upward through the use of superimposed verticals.

Giuliano da Sangallo

Giuliano da Sangallo (1443?–1516) was the first eminent member of a dynasty of architects that included Giuliano's brother Antonio the Elder (see figs. 18.58–18.61) and

their nephew Antonio the Younger (see figs. 18.62–18.64). Giuliano, perhaps the most imaginative Florentine architect of the later Quattrocento, was imbued with the refined classicism of the age, and his buildings provide a setting for the cultivated life we know from the writings of contemporary historians and philosophers. His knowledge of Roman antiquity was derived from study of the original monuments, and because his drawings often document buildings that no longer exist (fig. 12.24), they provide important information for archaeologists. At the same time, however, Giuliano never forgot his Brunelleschian heritage. Although he was probably only a year older than Bramante, founder of High Renaissance architecture, Giuliano did not produce any work in that new, grand style.

Giuliano's Florentine buildings of the 1480s are delightful, especially the villa at Poggio a Caiano (fig. 12.25), which was built for Lorenzo de' Medici on a small hill (poggio is Italian for hill) near the edge of the plain of Prato. The site was chosen to command views of the plain and the Apennines to the north and Monte Albano to the south. The simple block of Giuliano's structure, with its plain walls and sharply projecting eaves, is interrupted by the temple portico (fig. 12.26), apparently the first in a long line of such temple porticoes

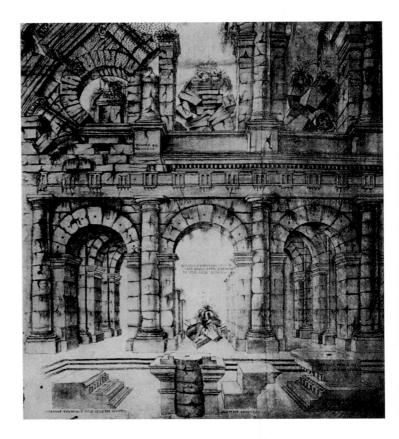

12.24. GIULIANO DA SANGALLO. Ruins of the Ancient Roman Theater of Marcellus, Rome. 1480s. Drawing, $18^{1/4}$ x $15^{1/2}$ " (46 x 37.82 cm). Biblioteca Apostolica Vaticana, Vatican, Rome

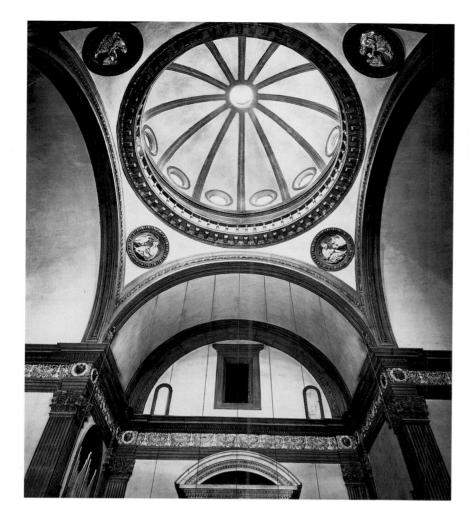

12.29. GIULIANO DA SANGALLO.
Dome, Sta. Maria delle Carceri, Prato. 1485–92

Benozzo Gozzoli

The painter who seems to typify the luxurious proclivities of the 1450s was Benozzo Gozzoli (c. 1420–97). His long artistic activity commenced in the studio of Fra Angelico. Later he worked in Umbria and in Rome where, with a collaborator, he was commissioned to paint mantles and banners used in the celebration of the crowning of Aeneas Sylvius Piccolomini as Pope Pius II; unfortunately none of these survive. He returned to Florence to paint the frescoes in the chapel in the Palazzo Medici in Florence (fig. 12.30; for the palace see figs. 6.17–6.19).

The Medici belonged to the Company of the Magi, an important religious organization that flourished in Renaissance Florence; their participation in this confraternity almost certainly explains the choice of the Journey of the Magi as the subject for their chapel decorations. Certainly, Benozzo's frescoes had nothing to do with the rather penitential mood of the *Madonna Adoring Her Child* painted by Fra Filippo Lippi for the altar of the chapel only a few years earlier (see fig. 9.20).

The Journey of the Magi is the same theme that fills the background of Gentile da Fabriano's Strozzi altarpiece (see fig. 8.2), but Benozzo's version is updated, and the landscape

is derived from the surroundings of Florence, including castles and villas in Medici possession. The retinue includes a number of contemporary personages, several of whom seem to be trying to catch the eye of the spectator. The man on the white horse leading the cavalcade at the left has been identified as Piero the Gouty, while behind him is Cosimo riding on a donkey. Portraits of Piero's children Giuliano and Lorenzo appear in the group to the left, right below Benozzo's selfportrait, which is identified by the Latin signature OPUS BENOTII ("the work of Benozzo") on his hat. The array of ceremonial costumes and horse trappings, studded with gold and blazing with red, blue, and yellow against the green of the foliage and the blue-green of the distance, is further strengthened by the red of the Florentine costumes worn by all but foreigners. The composition is unified by the repetitive landscape, with its vertical trees and curving roads. The walls of the small chapel seem to have been painted away by Benozzo's continuous panorama. The result is not dissimilar to the tapestrylike effect noted earlier in the Gothic frescoes in the Castello del Buonconsiglio in Trent (see fig. 5.23), which is probably no accident. Cosimo de' Medici would have been as aware of the prestige value of Northern tapestries as was Georg von Lichtenstein, patron of the earlier

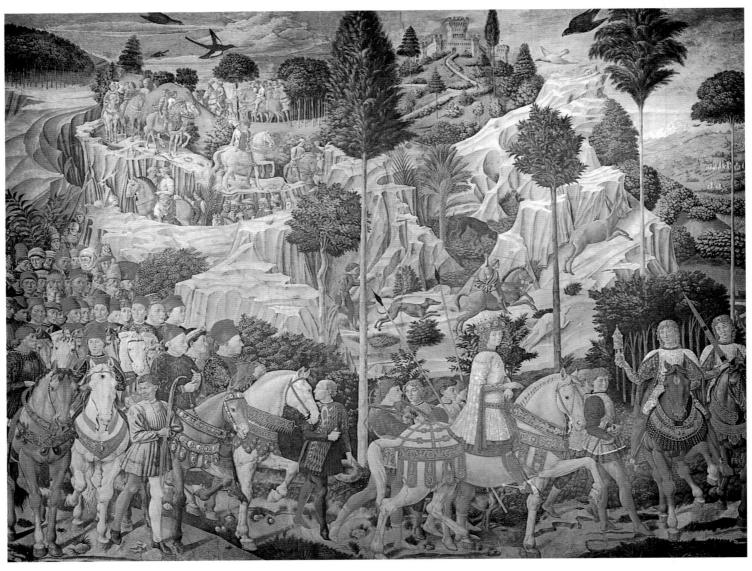

12.30. BENOZZO GOZZOLI. *Procession of the Magi*. c. 1459. Fresco. Chapel, Palazzo Medici-Riccardi, Florence. Probably commissioned by Piero de' Medici.

In the fifteenth century the chapel was described by Filarete as "most nobly painted by the hand of a good and excellent Florentine master named Benozzo." The ceiling of the chapel is elaborately carved and gilded and the floor is inlaid with red and green marbles. Many of the figures here have been identified as portraits.

frescoes. Benozzo, however, combines the decorative patterning of tapestries with a Florentine interest in a deep and broad landscape panorama, strongly modeled figures, animals seen in convincing recession, careful observation of detail, and incisive portraits of the prominent Florentines who were his patrons and his patron's friends.

Alesso Baldovinetti

Among the artists of the Florentine Renaissance, Alesso Baldovinetti (1425–99) was the only one to have been brought up in comfortable, patrician surroundings. The Baldovinetti were among the oldest families in Florence, and their house-tower is still visible from the Ponte Vecchio. Alesso was apprenticed

to Domenico Veneziano at Sant'Egidio, but he soon came under the influence of Andrea del Castagno, and in his journal, records having painted—more or less from Castagno's dictation when the latter was ill—a hell scene "with many infernal furies." But the gentleness of Alesso's art had little in common with that of Castagno, from whom he seems to have absorbed chiefly a devotion to line and pattern. Alesso's patterns, however, are filled with the soft light that he learned from Domenico Veneziano. Baldovinetti's art can be whimsical, witty, charming, and refined. At the same time, he must be appreciated as a conservative artist rather than an innovator.

In Baldovinetti's *Annunciation* (fig. 12.31), Mary receives Gabriel in a delicate loggia whose colonnettes recall those of Domenico Veneziano in the St. Lucy altarpiece (see fig. 11.8).

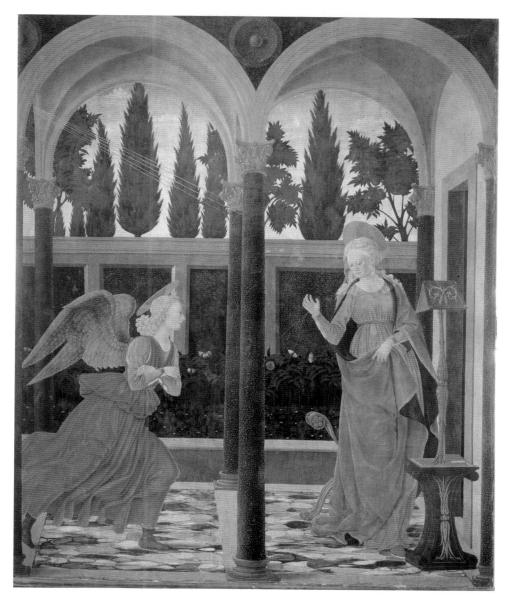

12.31. ALESSO BALDOVINETTI. Annunciation. Before 1460. Panel, $65\frac{3}{4} \times 54$ " (1.67 x 1.37 m). Uffizi Gallery, Florence. Commissioned by the Salvestrini Fathers, perhaps with the intervention of the Medici, for S. Giorgio alla Costa, Florence

Beyond a low parapet one looks into Mary's closed garden, with its fruit trees (perhaps the *cedro*, the huge Italian lemon) and cypresses. According to the Old Testament *Book of Wisdom*, Mary is a cedar of Lebanon (also *cedro* in Italian) and a cypress on Mount Zion. Mary and Gabriel, with their small heads and tall, slender bodies, represent patrician refinement. Gabriel, his blond tresses as elegantly curled as those of the pages in Gozzoli's frescoes, glides in to bear the news to Mary. In a pose derived from Donatello's *Annunciation* (see fig. 10.27), she turns from her reading, draws her cloak about her, and lifts her right hand in a gesture of combined wonder and demure acceptance.

The color is as refined as the content and form, and as unexpected, especially in the dull red of the arches. The rose and powder blue of Mary's tunic and mantle are reversed in the garments of the angel. Brighter tones, including pinks and yellows, are picked up in the flowers and in the haphazard pattern of marble scraps that compose the pavement. Capitals, ornament, and haloes are painted gold (not gold leaf), to show Alesso's ability to render subtle light. Although some colors are highly saturated, the effect is delicate and restrained.

The same grace is visible in Baldovinetti's *Madonna and Child* (fig. 12.32). The Virgin is seated above a vista of the Arno Valley—a winding stream, farms, roads, cypresses, and the hills under a few summer clouds. She folds her hands in adoration of the Christ Child, who appeals to her to finish swaddling his body. Baldovinetti records the subtle gradations of tone (learned from Domenico Veneziano) that

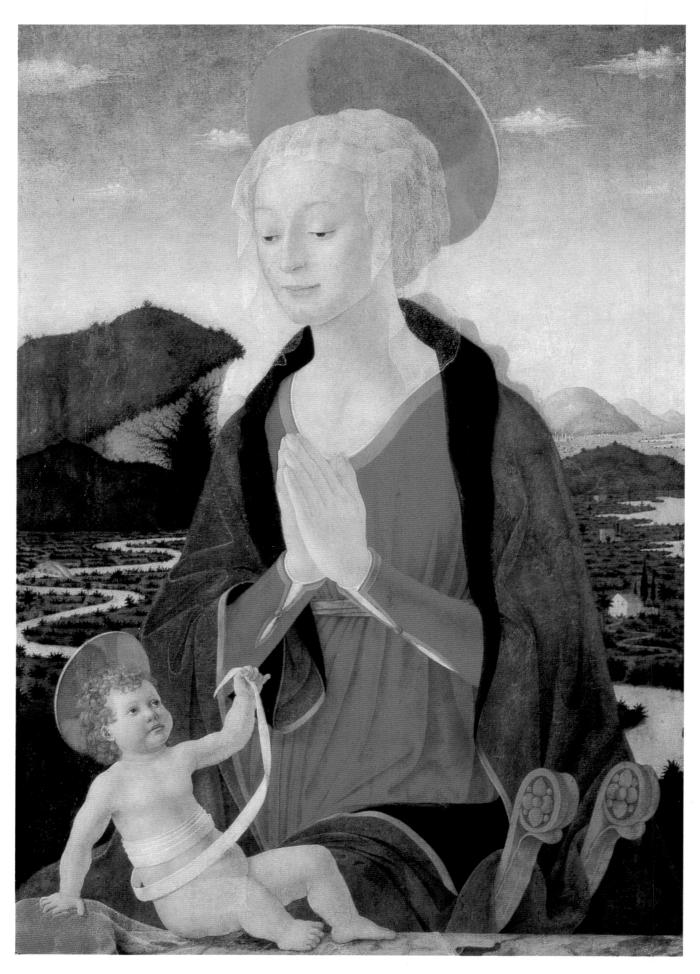

352 • THE QUATTROCENTO

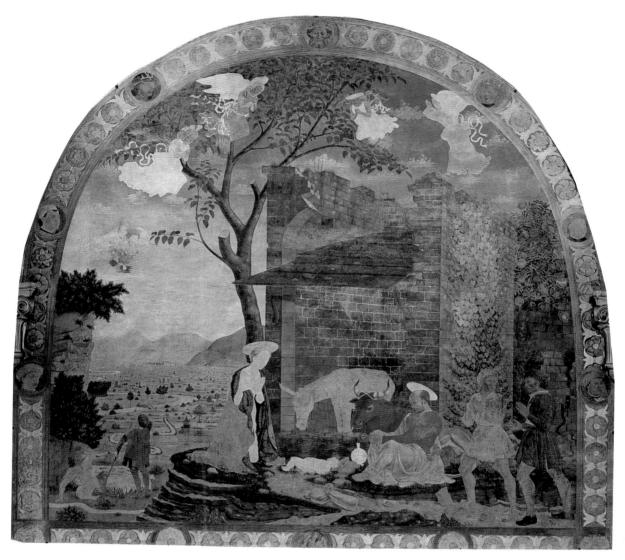

12.33. ALESSO BALDOVINETTI. *Nativity*. 1460-62. Fresco, 13'4" x 14' (4 x 4.3 m). Atrium, SS. Annunziata, Florence. Commissioned by Arrigo Arrigucci, whose portrait may appear in one of the medallions in the frame

illuminate the face of his youthful Mary. Some of the blond hair seen through Mary's veil escapes down her back, and the shadow of her head on the golden disk of her halo is a delightful touch.

The delicacies of Alesso's Arno Valley landscape should be kept in mind as we examine a mural at the Annunziata (fig. 12.33) that occupied him off and on from 1460 to 1462. The length of time should indicate that he did not follow the traditional piecemeal method used by Andrea del Castagno for example, who could have completed a fresco this size in a month. But Castagno cared little about the subtleties of diffused light or Alberti's total visual unity, while Baldovinetti seems to have concluded that he could not obtain such unity, and more especially the subtleties of light gradations, by tra-

ditional means. He therefore painted only a few portions of the picture in true fresco, and then waited until the plaster had dried so that he could paint *a secco*, as if working on an altarpiece. Such a procedure would have been dangerous even in an interior, but in the atrium of the church Baldovinetti's *Nativity* was exposed to winter fogs and even rain; in time the *a secco* faces, hands, and drapery peeled off, and Alesso's underdrawing is now visible. Even so, the painting is impressive in the airy openness of its setting and the view over the expansive Tuscan plain, which is filled with the light of a clear winter day.

Baldovinetti was the choice when, in 1466, the executors of the Cardinal Prince of Portugal wanted a painter to decorate the walls, lunettes, and spandrels of the Chapel of the

Opposite: 12.32. ALESSO BALDOVINETTI. Madonna and Child. c. 1460. Canvas, 411/2 x 291/2" (106 x 75 cm). The Louvre, Paris

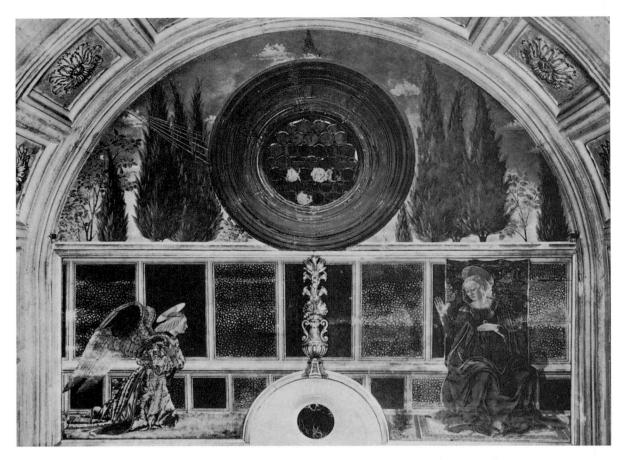

12.34. ALESSO BALDOVINETTI. Annunciation. 1466-67. Fresco and panel, width of chapel wall 15'9" (4.8 m). â Chapel of the Cardinal of Portugal, S. Miniato, Florence. Commissioned by the executors of the will of the Cardinal Prince of Portugal. (For a view of the chapel, see fig. 12.14)

Cardinal Prince of Portugal in San Miniato (see figs. 12.14-12.17). Baldovinetti's Annunciation (fig. 12.34) is placed over the empty cardinal's throne that faces the Rossellino tomb. Again Baldovinetti had to experiment, possibly because of pressure to finish the paintings rapidly. While the background of cypresses and cedars is painted in fresco, the wall, bench, and figures are painted on an unprimed oak panel, probably in the artist's studio in the winter months of 1466-67. Here and there the color has peeled away to show the grain.

Baldovinetti's work here has a new solemnity. The model for the Virgin (fig. 12.35) also posed for the Louvre Madonna and Child (see fig. 12.32), but here the mood is serious, and the Virgin lifts her right hand in greeting and places her left on her body, as if feeling the conception taking place. The angel who kneels before her is dressed in the dalmatic worn by a deacon, as is the cardinal on his tomb; a circle of coral beads crowns the angel's head, a ruby carved into the shape of a strawberry rests on his brow, and peacock eyes flash from his wings. The lily in the center, which in the Rossellino tomb symbolizes the cardinal's purity, is here carved and gilded.

Baldovinetti's profile portrait of an unknown Florentine woman (fig. 12.36) represents the ultimate in patrician Florentine Quattrocento elegance. She is posed in the conventional profile view that is used almost without exception for female portraits until the end of the century, long after male sitters are shown turned toward the observer (see fig. 13.28). Such a pose, with its inability to make eye contact, is surely related to social practices; Alberti's advice to women in his book on the family cautions humility lest one risk divine wrath:

A beautiful face is praised, but unchaste eyes make it ugly through men's scorn. . . . A handsome person is pleasing to see, but a shameless gesture or an act of incontinence in an instant renders her appearance vile. Unchastity angers God, and you know that God punishes nothing so severely in women as he does this lack.

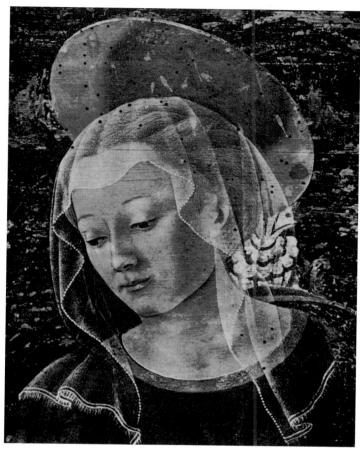

12.35. Head of the Virgin, detail of fig. 12.34

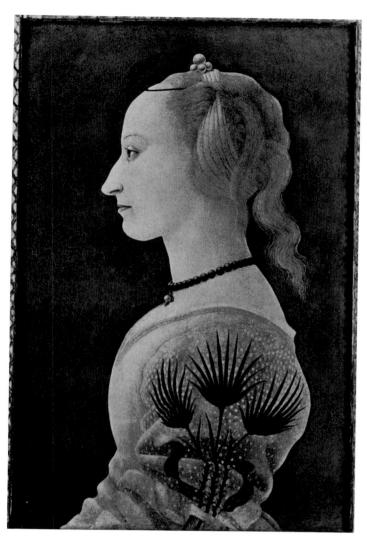

12.36. ALESSO BALDOVINETTI. *Portrait of a Young Woman.* c. 1465. Panel, 25 x 16" (62.9 x 40.6 cm). National Gallery, London

The three palm leaves that decorate her sleeve are probably a reference either to her paternal family or, were she married, to that of her husband. The portrait, in light of these various social conventions—including those expressed by Alberti—identifies less an individual and more an emblem of male property. The fact that she remains anonymous may underscore her role in that respect as well. The Renaissance humanism that opened opportunities for expression, self-discovery, and innovation to men were not, as this picture attests, equally available to women.

Francesco Pesellino

Francesco di Stefano (c. 1422–57), known as Francesco Pesellino, was probably a pupil of Fra Filippo Lippi. He is not

an innovator, but his style represents a synthesis of the developments we have been studying, and his surviving works—despite his death at the age of about thirty-five—indicate he had many patrons. His panel of *The Triumphs of Love, Chastity, and Death* (fig. 12.37) and its companion, *The Triumphs of Fame, Time, and Eternity,* originally decorated the fronts of a pair of large chests known as *cassoni*; their themes are derived from Petrarch's poem "The Triumphs," written c. 1360–70. Pesellino's panels should probably be connected to a pair of chests identified as *The Triumphs of Petrarch* that are listed, without the name of the painter, in a 1492 inventory of the Medici Palace. In the palace they were located in the bedchamber occupied by Lorenzo il Magnifico. In Florence during the fourteenth, fifteenth, and sixteenth centuries, such chests were commissioned to

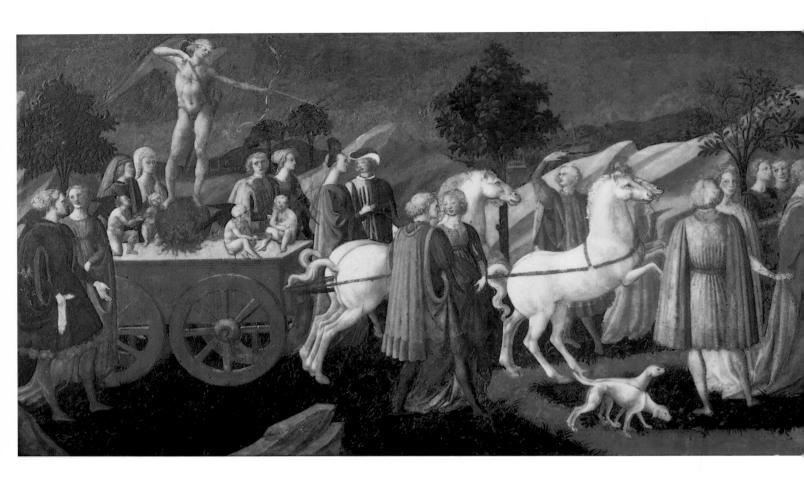

celebrate a betrothal, and they would be carried through the streets as a demonstration of the wealth of the families. It is possible that the chests listed in the Medici inventory were made for the wedding of Piero de' Medici to Lucrezia Tornabuoni. As the main storage areas for clothing, such chests were heavily used, and as a result their lavish framework, with classicizing pilasters and pawed feet, is usually lost; the paintings survive, inappropriately framed, as Renaissance works of art hanging on museum walls. Pesellino's two panels still show the damage from the heavy keys that were used to lock the chests.

Petrarch's Triumphs were a popular subject for *cassoni* and other decorations in Quattrocento Florence, in part because they provided a decorative way to enforce the notion of virtuous behavior. Pesellino's panels are among the earliest known representations of the theme, and one of the few that includes all six triumphs. In the grouping depicted here, three carts topped by allegorical figures are shown being pulled by vari-

ous animals. Standing atop the cart of Love at the left is a graceful figure of blindfolded Cupid, who has pulled back his bow to let an arrow fly at an unexpected victim; his cart is pulled by four white horses. On Chastity's cart Cupid is shown bound and submissive below the allegorical figure of the virtue; unicorns, symbols of virginity, pull this cart, which is surrounded by delicate maidens. The cart surmounted by the haggard figure of Death comes from the opposite direction. Pulled by two black buffaloes, this cart is shaped like a coffin; the victims of Death's scythe lie on the ground around the cart. The season that accompanies Death is winter. Petrarch's poem emphasized a sequence of conquests, with Love conquered by Chastity, Chastity defeated by Death, Death by Fame, Fame by Time, and Time, in the end, conquered by Eternity; this sequence helps to explain the positions of carts in Pesellino's series, for while Love's cart moves from left to right, it is headed off by Chastity's cart, which moves forward, only to be cut off by Death's cart, moving in from the right.

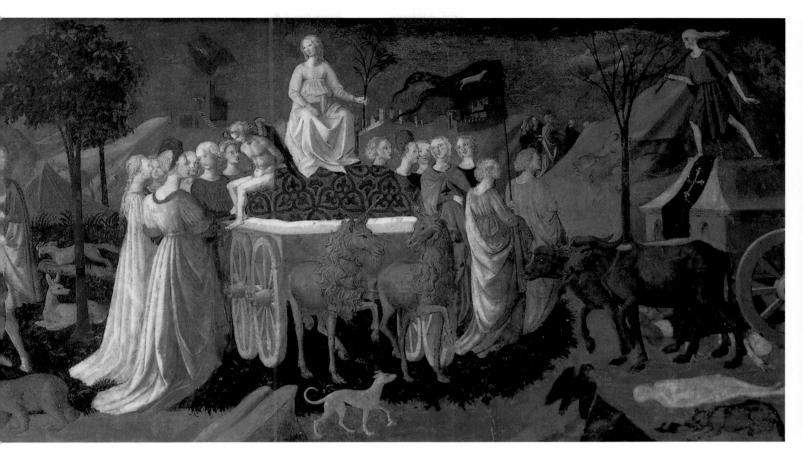

12.37. FRANCESCO PESELLINO. The Triumphs of Love, Chastity, and Death. c. 1448. Cassone panel, $1'4^{1}/2" \times 5'1^{1}/4"$ (42 x 154 cm). Isabella Stewart Gardner Museum, Boston.

Pesellino, who was in partnership for a period with two other painters, had a workshop on the Corso degli Adimari, a street heavily populated with painters' workshops. It was to this street that a potential patron might gravitate when looking for an artist.

Quattrocento paintings of the Triumphs, such as this one and other representations of this popular theme, are especially valuable because they give us some idea of the appearance of the ornamented carts that are documented as appearing in Florentine Renaissance civic pageants and processions. It is not hard to imagine carts like those represented by Pesellino, decorated with figures and passing through the streets of Florence; the visual, moral, and educational impact of such festival carts on the populace of the city should not be underestimated. Such works were probably more noticed and discussed than many an altarpiece, masterpiece or not, tucked away in a private family chapel.

Other subjects that were popular for *cassoni* were the Garden of Love, tales by Boccaccio, the Seven Virtues and the Seven Arts, scenes of battle or justice, and themes from Homer, Livy, and Virgil. Whatever the subject, the intent was usually didactic, and often directed specifically toward

the female members of the household. The insides of the lids, which would be seen only by the members of the household and servants, were sometimes painted with a nude female figure in one chest and an almost nude male figure in the pendant; these are probably representations of classical figures such as Paris and Venus. Many workshops of the mid-Quattrocento specialized in the production of *cassoni*, and because they were largely painted by assistants, many of the surviving examples are difficult to attribute to any particular painter or even to a specific workshop; that Pesellino can be identified as the painter of this pair supports the idea that these were a luxury product made for a Medici wedding.

Pesellino's style demonstrates a mastery of the techniques that the artists of the earlier decades of the Quattrocento had developed. Later Florentine artists will use the techniques and style established by their predecessors as a foundation for new developments, as we shall see.

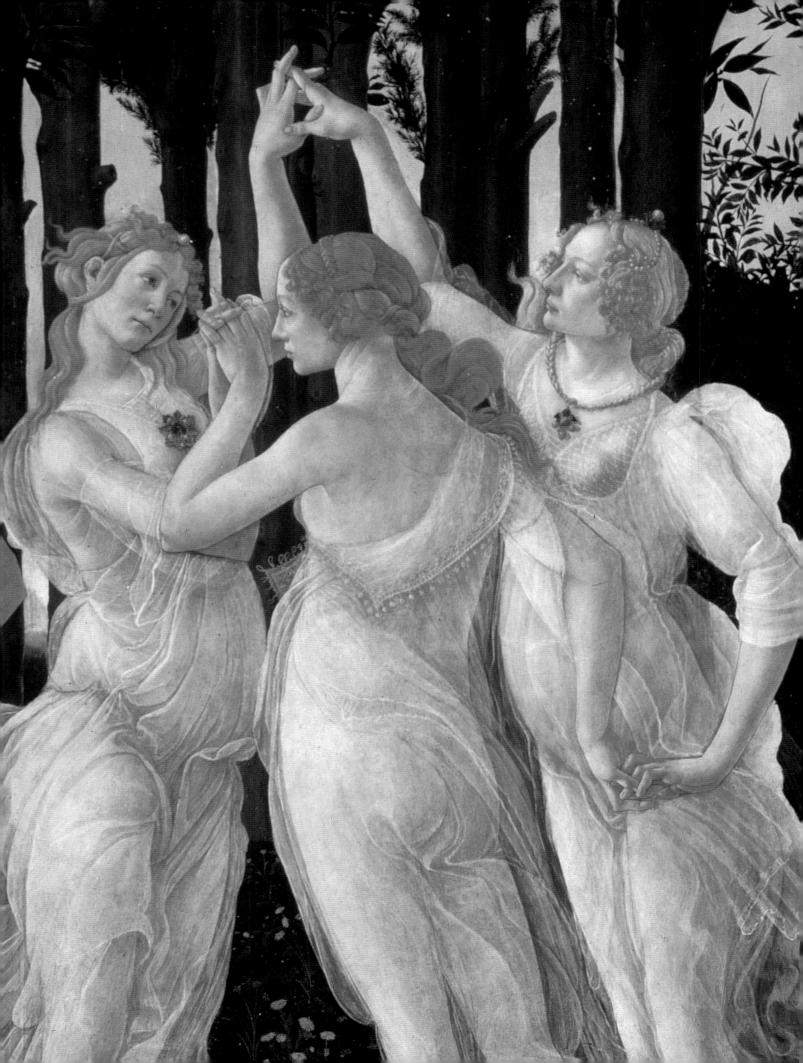

SCIENCE, POETRY, AND PROSE

t the beginning of the final third of the Quattrocento, few of the innovators who had founded Renaissance art were still alive. Uccello was not working at all, and Luca della Robbia was old and his style had become repetitive. Piero della Francesca was painting in Urbino and Borgo Sansepolcro, and Alberti was designing buildings for Florence and Mantua. The new generation of painters and painter-sculptors was encouraged by what appears, in view of the general economic decline, to be extravagant patronage on the part of the great Florentine families. In retrospect, the period was dominated by five artists-Antonio del Pollaiuolo, Andrea del Verrocchio, Sandro Botticelli, Filippino Lippi, and Domenico del Ghirlandaio. Toward the middle of the period, new directions for art were laid out by Leonardo da Vinci and by two visitors to Florence, Luca Signorelli and Pietro Perugino. Because none of the three was in Florence for long at this time, their activity, like that of the Florentine Piero di Cosimo, belongs to later chapters.

Despite their relative freedom, our five artists were to a certain extent limited by the discoveries of their predecessors. The methods of depicting space, form, and light were well known, and there seemed little point in merely repeating them. But many new fields remained for exploration, and the five leading artists set out to investigate them in three different directions. Doubtless each direction appealed to a somewhat different sector of Florentine society. None of the three can be labeled conservative. All were basically new, and all were destined to have a strong influence on future developments.

The first of these later Quattrocento tendencies begins with the premise that all nature is one: that there is no essential difference between humans and other animals; that plant, animal, and human physiology are as worthy of study as the principles of form, space, and light; and that motion, growth, decay, and dissolution are more characteristic of our world than are mathematical relationships or, indeed, any other apparently enduring verity. The greatest exponent of this vitalistic, animistic, dynamic, and scientific trend (these are epithets, not names) is Pollaiuolo, but similar concerns motivated Verrocchio as well, if to a less marked degree. These two artists are the only two painter-sculptors of the period; they are also the most original sculptors. Pollaiuolo seems to have appealed especially to the elite of the circle of Lorenzo de' Medici.

The second current in this period of the Quattrocento is concerned less with the outer world than with the life of the spirit. This lyrical, poetic, and romantic current (again these are mere characterizations) often ignores tangible reality in favor of the abstract values of line and tone and prefers subjects that express emotional yearnings. The unchallenged leader in this movement is Botticelli, but Filippino Lippi at times keeps pace with him and at times goes beyond him into the realms of the unreal. This second current seems to have pleased the Medici less than those in their circle, especially the Neoplatonic philosophers.

The third trend emphasizes the here and now. The fore-grounds of their scriptural narratives and scenes from saints' legends are filled with contemporary Florentines, while the backgrounds show how Florence looked or how the painters thought it should look. Prose, not poetry, is the aim of these artists; their representations are not only exact and descriptive, but also well balanced, measured, composed, and intelligible. Underneath an exterior of admirable craftsmanship, this naturalistic current (again, not a title) can also on occasion express an interest in psychological relationships. Ghirlandaio was the leader of this style, which appealed especially to the well-to-do citizen without intellectual pretenses, the successful merchant or banker.

Antonio del Pollaiuolo

Antonio del Pollaiuolo (1431/32–98) excels in subjects of action, especially themes from mythology, in which his naturalism can be allowed free rein. When he treats scriptural themes, they sometimes take on a fierce air that seems to have

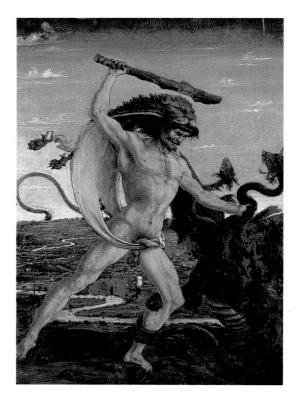

13.1. ANTONIO DEL POLLAIUOLO.

Hercules and the Hydra. c. 1460. Panel, 6³/₄ x 4³/₄"

(17.5 x 12 cm). Uffizi Gallery, Florence.

Probably commissioned for the Medici Palace

little to do with any religious purpose. His name means "poultry-keeper," apparently a reference to his father's occupation. Piero, Antonio's older brother and assistant, was a painter—a dull one, judging from his one signed work. Antonio began as a goldsmith and designer of embroideries with gold and silver thread. One would expect to find him highly adept at linear precision, and so he is, but his fascination with the human figure in motion is a surprise. No artist in any medium since Hellenistic times had treated this theme with anything approaching his ability. Castagno, who greatly influenced Pollaiuolo, had tried, in his *David* shield (see fig. 11.17), but his attempt seems stiff when compared with the strong movement of Pollaiuolo's figures.

About 1460 Antonio painted three large pictures representing the Labors of Hercules that are later listed in the 1492 inventory of the Medici Palace. Hercules, a favorite Florentine hero, appeared on the seal of the Republic in the late Duecento and was represented in monumental art as early as the reliefs by Andrea Pisano on the Campanile. Pollaiuolo's three paintings were among the works moved to the Palazzo dei Priori after the expulsion of the Medici, which suggests that these works probably had a political content when displayed at the palace. The paintings are among the first large-scale mythological works known to us; because they were painted on canvas, it is possible that their original

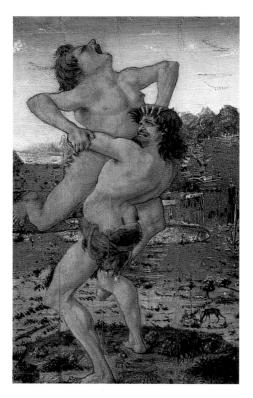

13.2. ANTONIO DEL POLLAIUOLO. Hercules and Antaeus. c. 1460. Panel, $6\frac{1}{4} \times 3\frac{3}{4}$ " (16 x 9 cm). Uffizi Gallery, Florence. Probably commissioned for the Medici Palace

function was as banners for a festival or tournament. The originals are lost, but Pollaiuolo's tiny panels of *Hercules and the Hydra* and *Hercules and Antaeus* (figs. 13.1, 13.2) probably preserve two of the larger compositions.

As in Piero della Francesca's Montefeltro portraits (see fig. 11.34), the figures are silhouetted against earth and sky. But while Piero's figures project a serene control over nature, Pollaiuolo's seem to erupt from nature and to be pitted against it in mortal combat. Compositionally, the necks and tail of the hydra are counterparts of the winding river. Hercules seems almost as feral as the lion whose skin he wears and no less cruel than Antaeus, whose strength derives from his mother, the Earth. Pollaiuolo chooses not to represent Hercules as a glorious hero, easily superior to the forces of evil that he is vanquishing. In rendering the human figure, he avoids its potential nobility or the play of light upon its surfaces, emphasizing instead the strain imposed on muscles and even bones by its activity. His bodies seem pushed to the limits of their capability. He must have studied carefully the behavior of bodies in motion, and evidence suggests that he dissected corpses to understand how muscles, tendons, and bones are interrelated. Like Baldovinetti, Pollajuolo lets our eyes wander over the rich tapestry of the earth in the backgrounds: the Arno Valley in Hercules and the Hydra, with a microscopic Florence at the extreme left, and the seacoast in

Hercules and Antaeus, with a little city at the right and the Apuan Alps above.

Probably during the 1470s, Pollaiuolo repeated the Antaeus composition in a small bronze group (fig. 13.3) that broke the rules followed by earlier sculptors. The contours of medieval and previous Renaissance statues and groups had been limited by the ideal contours imposed upon the composition, even when the bronze medium theoretically allowed a free rein. In Pollaiuolo's revolution, figures can move in any direction necessitated by their actions. To be sure, Antonio Rossellino had led the way, in the dynamism of the soaring angels and floating Madonna tondo above the tomb of the Cardinal Prince of Portugal. But his figures were still constrained by the overall composition of the monument. Pollaiuolo's figures do not seem to be posed; the composition is determined by their actions, and its contours are defined by flying legs and arms, clutching toes, noses, open mouths, even unruly curls. For one of the first times since antiquity, the space surrounding a sculptural group is electrified by the energies developed within the group.

In his engraved *Battle of the Nudes* (fig. 13.4), the largest Florentine print of the fifteenth century, Pollaiuolo sets out to demonstrate his impressive understanding of human anatomy. This print was widely circulated (more than forty copies survive, as well as a German woodcut version), and it probably

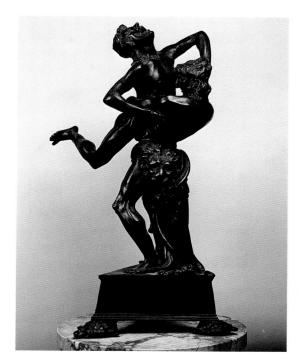

13.3. ANTONIO DEL POLLAIUOLO. Hercules and Antaeus. Probably 1470s. Bronze, height 18" (46 cm) (including base). Museo Nazionale del Bargello, Florence. Probably commissioned by a member of the Medici family for the Medici Palace

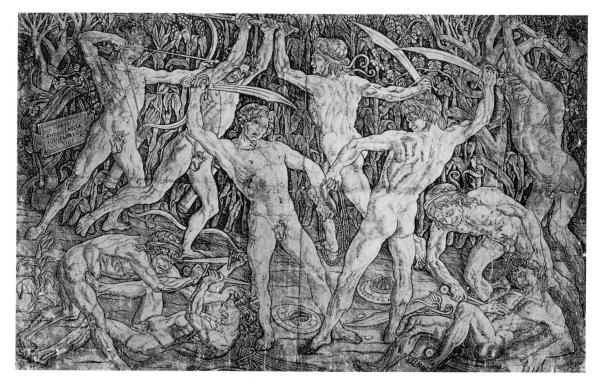

13.4. ANTONIO DEL POLLAIUOLO. *Battle of the Nudes.* c. 1470. Engraving, 15 ½ x 23 ½ " (38.4 x 59.1 cm). The Metropolitan Museum of Art, New York (Joseph Pulitzer Bequest, 1917). This work is Antonio's only known engraving, but his interest and skill in the technique are not surprising, given his training as a goldsmith. The Latin signature, *OPUS ANTONII POLLAIOLI FLORENTINI*, guaranteed that Pollaiuolo would receive credit for this work.

had a greater influence on later artists than any of Pollaiuolo's other works. The unifying themes appear to be struggle and death, but no specific narrative subject has been determined by scholars and perhaps none was intended; this may be an early example of a work created as a demonstration of artistic skill. At the lower left a nude is about to dispatch a prostrate foe, but his intended victim plants a foot in his groin and aims a dagger at his eyes. Two swordsmen in the foreground are equally matched and may well dispose of each other, as will the figures just behind them, armed with swords and axes. At the right a man withdraws his sword from the side of his dying enemy, unaware that he is about to be slaughtered by the uplifted ax of a man behind him, who in turn does not notice the arrow aimed at him by the archer at the upper left. The composition of intertwined figures in superimposed registers to indicate depth may have been suggested by ancient Roman sarcophagi widely available in Tuscany and Rome. Pollaiuolo sets his figures against a dense background of corn, olive trees, and grapevines. As much as the actions, the expressions of pain or cruelty on the faces of Antonio's figures convey a horror that has its only medieval counterpart in the torments of

hell seen in representations of the Last Judgment (see fig. 5.5).

Equally unrestrained but of a completely different character is the dance of nude figures painted by Pollaiuolo to decorate a room in the Villa La Gallina, near Florence (fig. 13.5). Their present appearance is deceptively like the red figures of Greek vase painting, since the painted surface is lost and the surviving underdrawing has been enhanced by a repainted dark background. Originally, the figures must have been carefully modeled. One figure, at the extreme left, moves in a pose frequently seen in ancient sculpture or cameos, but the other poses seem derived from direct observation. The subject of the *Dance of the Nudes* is no more easily resolved than that of the *Battle of the Nudes*, but the theme of exuberant dance is certainly appropriate for a country villa.

Christian subjects seem to have interested Pollaiuolo little, and he generally turned over such commissions in whole or part to his brother. But the order for a monumental altarpiece of St. Sebastian for Santissima Annunziata, where it would be seen in competition with frescoes by Andrea del Castagno (see fig. 11.18), apparently could not be resisted. The painting (fig. 13.6), Antonio's most ambitious extant work, is a

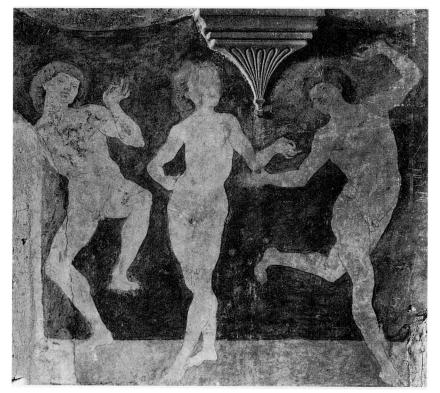

13.5. ANTONIO DEL POLLAIUOLO.

Dance of the Nudes (portion). 1470s.

Fresco underdrawing. Villa La Gallina, Florence.

Probably commissioned by Jacopo and Giovanni di Orsino Lanfredini

Opposite: 13.6. ANTONIO DEL POLLAIUOLO (and PIERO DEL POLLAIUOLO?). St. Sebastian. 1474–75. Panel, 9'7" x 6'8" (2.92 x 2.03 m).

National Gallery, London. Commissioned by the Pucci family for the Oratory of S. Sebastiano (the Pucci family burial chapel) at SS. Annunziata, Florence. The Pucci arms, which consist of Moors's heads, appear on the triumphal arch in the background. The patron may have been Antonio Pucci, who built the Oratory in the early 1450s. The church of the Annunziata possessed a relic presumed to be the arm bone of St. Sebastian; by devoting the altarpiece in their family burial chapel to St. Sebastian, the Pucci were allowed to house this relic in their chapel. It has been argued that Piero painted the body and head of the saint.

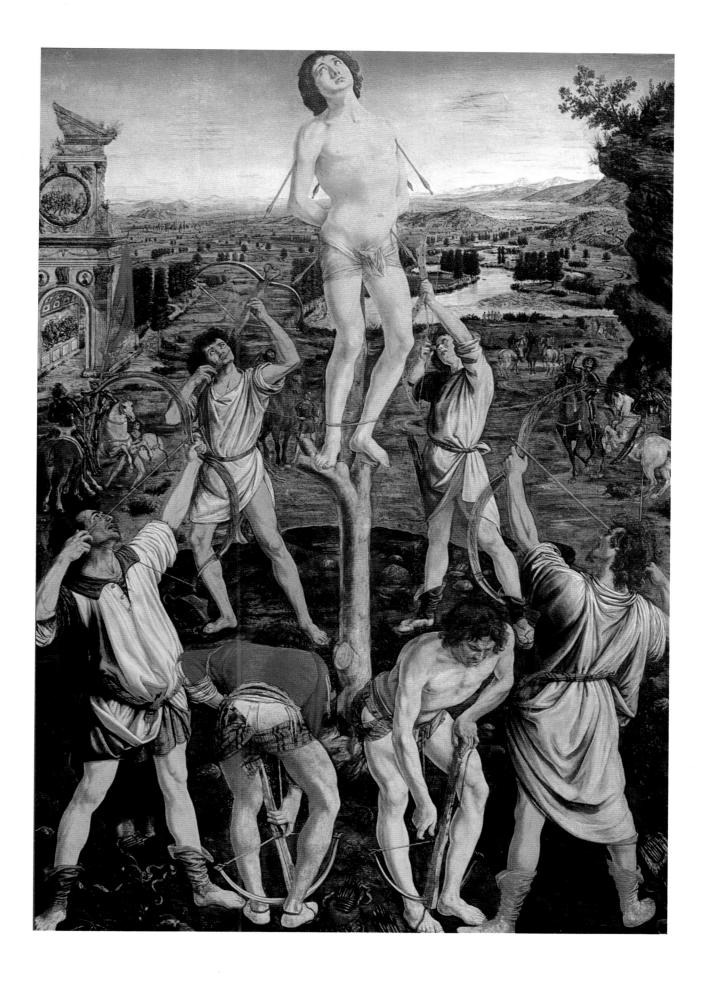

milestone in Renaissance art. The use of the triangle as a basis for a composition is not a new idea (see Masaccio's Trinity, fig. 8.26, for example), but Antonio's triangle is not imposed on the figures but is rather the product of their movements: the minute the last arrow is discharged and the bowmen leave, the triangle will dissolve. The painting was still the object of admiration in Vasari's time, even after all that Leonardo and Michelangelo had achieved in the intervening period. Antonio may have left the painting of the saint to Piero, but the longbowmen and crossbowmen became a showcase to demonstrate Antonio's skill. The positions of strain seen in the two crossbowmen who wind their bows seem to display everything Antonio knew about muscular tension, while the foreshortening demonstrated here reveals Antonio's mastery in this area. Passages of underdrawing visible through the thin paint layer show that Antonio at first drew the figures nude, only clothing them after the exact positions of their limbs was determined.

In reality there are only three poses among the six archers. Pollaiuolo has reversed each figure, as if he had turned around a clay model rather than following the common painter's practice of reversing the cartoon. Sculptor that he was, he may have done exactly that, although the surfaces of the bodies are so convincing that it looks as if living men posed for them while he was doing the actual painting. The effect of vivacity is increased by the scale, for the figures in the foreground are nearly life-sized. Michelangelo used the pose of the nude crossbowman for one of the nude youths on the Sistine Ceiling and, much later, for an angel hauling two souls into heaven in his *Last Judgment* (see fig. 20.1). Antonio's incisive contour, a kind of analytic line that describes shapes in such a way that helps us to understand how they revolve in depth, leads directly to Michelangelo.

The Arno Valley landscape in the background gave Pollaiuolo an opportunity to exercise his skill in the rendering of nature. But he must have done this to please himself, because at a height of eight feet above the altar, this landscape would have been virtually invisible. Even in the National Gallery today much of the delicacy of observation is imperceptible. The triumphal arch, included to suggest the historic period when Sebastian was martyred, is adorned with battle reliefs and looks more like a ruined Renaissance façade than anything in ancient Rome. In the distance, enveloped in nature, should lie Rome-which Antonio had not yet visited. He substituted Florence, with an occasional hint of a Roman theater, dome, or obelisk. The shapes of the hills are taken from those near Florence; to study this landscape Antonio may have stood on Monte Albano near Carmignano; from here the city becomes a speck in the luminous, blue-green valley. Antonio was interested not in the abstract shapes that Baldovinetti found in nature, but in the spontaneity of growth and the sense of atmosphere over hills and farms and

among the trees. The Arno sweeps into view, moving too rapidly to offer reflections in the manner of Piero della Francesca's still waters. Then the water hits a dam and a shoal, and the surface breaks into rapids. As in his altarpiece for the Chapel of the Cardinal Prince of Portugal in San Miniato (see fig. 12.14), Piero has used oil glazes to convey the soft effects of light, distant haze, soft foliage, and rushing water. The freedom of his brushstroke is unexpected at this early date and is an important indication of how quickly Italian painters moved away from the precise, controlled brushstrokes of the Flemish contemporaries.

Pollaiuolo's ability to render the transitory effects of nature is also displayed in his *Apollo and Daphne* (fig. 13.7), a tiny, exquisitely painted mythological subject probably created for a connoisseur. Before the shimmering curves of the Arno, suggested by soft brushwork, the god, a long-haired adolescent in a short tunic, rushes across the meadow in pursuit of the unwilling Daphne. At the point of embracing her, he finds only defeat; her father, a river-god, has answered her prayer for salvation. Daphne's left leg has

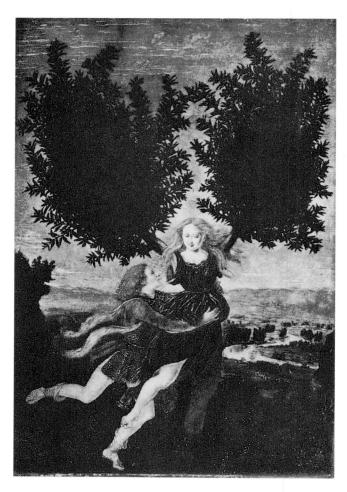

13.7. ANTONIO DEL POLLAIUOLO. Apollo and Daphne c. 1470–80. Panel, $11^{5}/8 \times 7^{7}/8$ " (29.5 x 20 cm). National Gallery, London

taken root, her arms have become branches, and in another minute she will be fully transformed into a laurel tree. Perhaps this tiny picture was created as an allegory of the invincibility of Lorenzo de' Medici's government, for the laurel was his symbol and also that of his second cousin and neighbor, Lorenzo di Pierfrancesco de' Medici.

Pollaiuolo's *Portrait of a Young Woman* (fig. 13.8) is one of the last profile portraits of a woman, for the type would soon give way to the three-quarter or full-face view already commonly in use for male portraits. But Antonio seems to delight in the profile, whose rigidity yields to vibrant life in his hands. His analytic line responds to every nuance of shape in the face of this young woman. We can follow the line as it models her delicate features almost without the aid of variations of light.

By the last decade of the Quattrocento, Pollaiuolo's influence in Florence and elsewhere was enormous. In 1489 Lorenzo de' Medici described him as the leading master of

the city: "Perhaps, by the opinion of every intelligent person, there was never a better one." Antonio's final commissions were the papal tombs of Sixtus IV and his successor Innocent VIII. The huge bronze tomb of Sixtus IV (fig. 13.9) occupied the artist and his shop for nine years after the pope's death in 1484. The recumbent pope, wearing tiara and pontifical vestments, is surrounded by reliefs representing the seven Virtues (Charity, Hope, Prudence, Fortitude, Faith, Temperance, and Justice). Below these, on the sides of the tomb, separated by acanthus consoles, are ten Liberal Arts: Philosophy, Theology, Rhetoric, Grammar, Arithmetic, Astrology, Dialectic, Geometry, Music, and Perspective. It is noteworthy that Perspective has entered this august company (fig. 13.10); she holds a book with a quotation paraphrased from the medieval philosopher Peckham, an astrolabe, and an oak branch (the pope came from the Della Rovere family, whose name means oak). The astrolabe suggests that during the Renaissance navigation

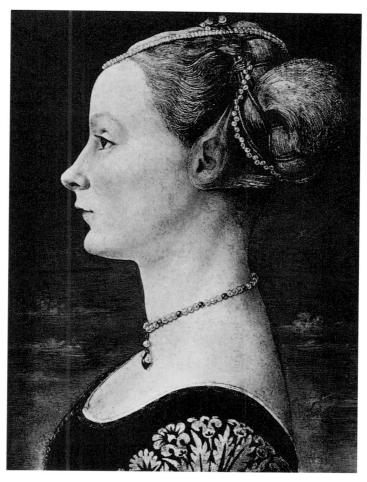

13.8. ANTONIO DEL POLLAIUOLO. *Portrait of a Young Woman*. 1467–70. Panel, $18\frac{1}{8}$ x $13\frac{3}{8}$ " (46 x 34 cm). Museo Poldi Pezzoli, Milan

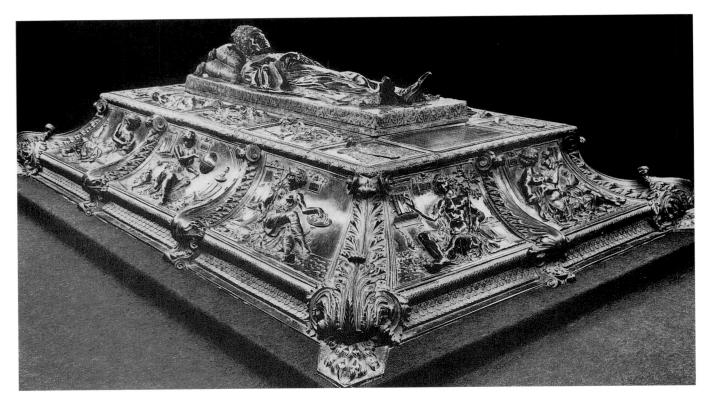

13.9. ANTONIO DEL POLLAIUOLO. Tomb of Pope Sixtus IV della Rovere. 1484–93. Bronze, length 14'7" (4.45 m). Museo Storico Artistico, St. Peter's, Rome. Commissioned by Cardinal Giuliano della Rovere for Sixtus IV della Rovere's burial chapel in Old St. Peter's, Rome

and exploration were considered part of the discipline of Perspective.

The portrait of Sixtus dwells with what seems to be fascination on the pope's hawklike features and sagging flesh. The crumpled folds of the pope's vestments and the drapery of the allegorical figures suggest the latest style of Do-

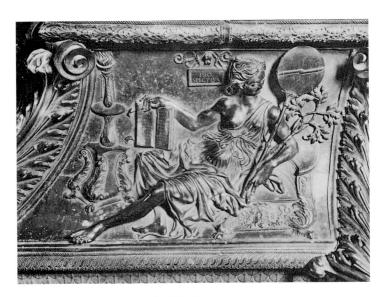

13.10. Perspective, detail of fig. 13.9

natello, but they are, in actuality, the sculptural counterpart of the drapery shown in the paintings of Antonio and Piero del Pollaiuolo.

Andrea del Verrocchio

Although Verrocchio, the nickname of Andrea di Michele Cioni (1435-88), means "true eye," it refers not to any exceptional powers of vision but to a Florentine family who were his early patrons. His most notable painting is the Baptism of Christ (fig. 13.11). During the creation of this work, Verrocchio's young pupil Leonardo da Vinci painted some remarkable passages that are distinctive of his new style, but his contributions will be discussed later (see p. 484). Verrocchio's composition in itself is simple and grand. The figures are loosely aligned across the foreground to afford wide views into a distant landscape. Between the palm tree on one side—its fronds studied in perspective in the manner of Uccello-and the pine-crowned bluff on the other, the figures are spread out almost like anatomical charts. The bony forms, the emphasis on muscles and tendons, and the play of light over torsos, limbs, and hands are analyzed with the care of Pollaiuolo but without his interest in movement. The Baptist looks at Christ with intense devotion, while Christ looks downward and, it seems, inward.

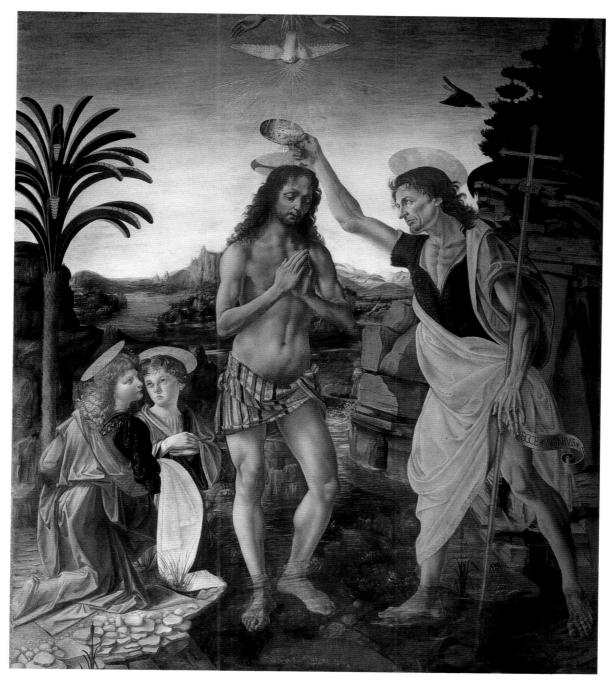

13.11. ANDREA DEL VERROCCHIO and LEONARDO DA VINCI. Baptism of Christ. 1470s(?). Panel, $69^{1/2} \times 59^{1/2}$ " (1.8 x 1.52 m). Uffizi Gallery, Florence. Commissioned for S. Salvi, Florence

The *Baptism* is closely related to Verrocchio's *Christ and St. Thomas* at Orsanmichele (fig. 13.12), an impressive demonstration of his skill in composition, knowledge of anatomy, and depth of feeling. The group is enclosed in an earlier marble tabernacle that had been commissioned in the early 1420s by the Parte Guelfa, then the dominant force in Florentine political and economic life; it was designed by Donatello to enclose his gilded bronze statue of St. Louis of Toulouse. With the rise of the Medici, the Parte Guelfa was eclipsed, and in 1463 their niche was sold to the magistrates

of the Mercanzia, which acted as a tribunal to adjudicate disputes between merchants; Donatello's statue was moved to Santa Croce. The subject of the new group may have been chosen because of the insistence of the Mercanzia that in all their deliberations they were engaged in a search for truth, and that they required, as had Thomas, tangible evidence.

Verrocchio could have squeezed two figures into Donatello's niche, but the principles of composition prevailing in the later Quattrocento suggested another solution. Verrocchio clearly wanted to bring out the emotional intensity

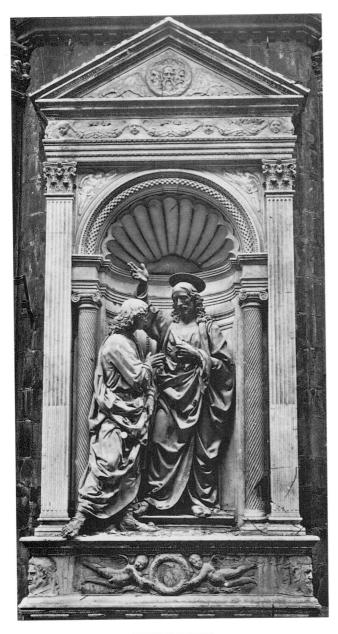

13.12. ANDREA DEL VERROCCHIO. Christ and St. Thomas. 1467-83. Bronze, height of Christ 7'61/2" (2.3 m). Orsanmichele, Florence. (Marble niche by DONATELLO, c. 1422-25; commissioned by the Parte Guelfa.) Verrocchio's group was commissioned by the Mercanzia

of the moment when, to prove his identity, Christ invites the apostle to touch the wound in his side. The composition overflows the niche, and Thomas stands on the ledge below. The figures had to be smaller in scale than Donatello's St. Louis, and when the group was removed for safekeeping during World War II, it was discovered that the statues have no backs. Seen from behind they are hollow shells of bronze.

Drama is centered less in the individuals (both faces are quiet, even reserved) than in the carefully calculated space between them-the wound revealed by one hand, approached by another (fig. 13.13). The drapery patterns are not used by Verrocchio to unite the figure and indicate the pose, as they had in earlier Quattrocento sculptures. Rather, the drapery's countless pockets shatter the forms into facets of light and dark, the sculptural counterpart of Pollaiuolo's free brushwork, within which the rhythm of the figures is conveyed but not their mass. According to sources, Donatello's device of using cloth soaked in hardened slip was emulated by Verrocchio, who substituted plaster for clay. Here, however, it is employed for different ends: the restless patterns of the drapery and the rippling descent of the curls help to communicate emotion. The Christ here has the same haunting expression that he has in the Baptism. On the border of his mantle appear Christ's words, "Because thou hast seen me, thou hast believed: blessed are they that have not seen, and yet have believed" (John 20:29). The work is so impressive and its content so profound that the question of the participation of the young Leonardo has been raised, but perhaps this is only because Verrocchio has been persistently underrated. When the group was placed in its niche in 1483, the diarist Landucci described the head of Christ as "the most beautiful head of the Savior that has yet been made."

Verrocchio's Portrait of a Lady with Flowers (fig. 13.14), the first three-quarter-length sculpted portrait since antiquity, demonstrates a new simplicity compared to the elegance noted in works by Filippo Lippi and Piero della Francesca.

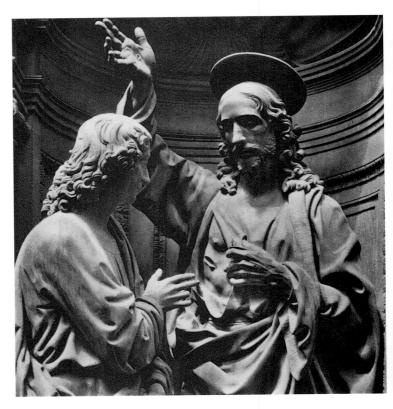

13.13. Christ and St. Thomas, detail of fig. 13.12

Here the woman's brow is not shaved; her hair, parted in the middle to reveal a natural brow, is drawn to the sides and then allowed to escape in clustered curls. The eyebrows are broad and full, the costume an unadorned tunic. With graceful hands the woman holds to her chest a bouquet of flowers; the inclusion of her sensitive hands allows Verrocchio to comment more fully on her personality. This is the new naturalism of the later 1480s, and Verrocchio has carried it out in every detail, suggesting in marble the nature of flesh even where it is covered by what seems to be a translucent garment.

Verrocchio's bronze *David*, commissioned by Lorenzo de' Medici, is an angular boy (fig. 13.15). In contrast to the nudity of Donatello's earlier figure (see fig. 10.29), he is clothed in leather jerkin and skirt and armed with a dagger suitable to his stature rather than with the enormous sword of Go-

liath grasped by Donatello's *David*. His expression is pensive and gentle in the moment of victory.

Verrocchio's final work is also his grandest. The condottiere Bartolommeo Colleoni (d. 1475) left a considerable sum of money to the Venetian Republic for a bronze equestrian monument to himself to be set up in Piazza San Marco, center of Venetian life. The authorities relegated the statue to a less important square, in front of the Scuola di San Marco, a clever solution that conformed to the letter of Colleoni's stipulation, if not the spirit. When and how Verrocchio received the commission is not clear, but in 1483 a monk recorded seeing on exhibition in Venice three colossal horses by three competing masters. Verrocchio died before he could cast his clay model, and the bronze version was carried out by a Venetian founder, Alessandro

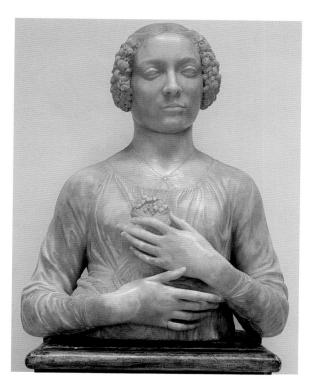

13.14. ANDREA DEL VERROCCHIO.

Portrait of a Lady with Flowers. c. 1475.

Marble, height 23⁵/8" (61 cm). Museo Nazionale del Bargello, Florence. The sitter has often been identified, but without proof, as Lucrezia Donati, mistress of Lorenzo de' Medici.

13.15. ANDREA DEL VERROCCHIO.

David. Probably early 1470s.

Bronze, height 49⁵/₈" (1.26 m). Museo Nazionale del Bargello, Florence. Commissioned by Lorenzo de' Medici for the Medici Palace. Sold to the Signoria of the city in 1476 for 145 florins, a price that surely was lower than the original paid to Verrocchio by the Medici.

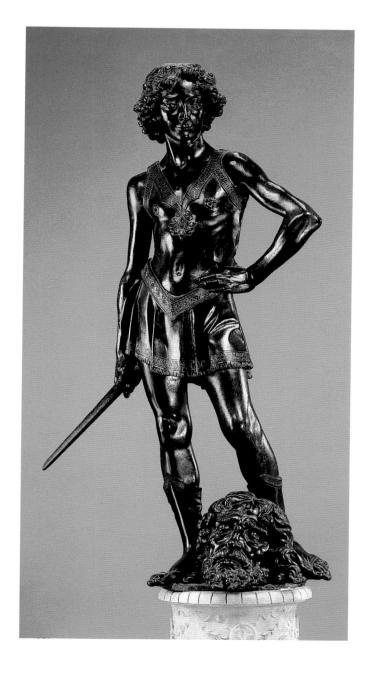

Leopardi, who also designed the base (fig. 13.16). The visual evidence suggests that Leopardi deprived many details of the vitality that Verrocchio would probably have given them had he been able to do the chasing himself; this is particularly true of the ornament and the mane and tail. The total effect of the statue as one comes upon it while crossing the little bridge into the Campo San Zanipolo is, however, stupendous.

In keeping with the new interests of his period and the stylistic current to which he belonged, Verrocchio abandoned Donatello's static concept of the equestrian monument (see fig. 10.31). Now the general, helmeted and armed with a mace, seems to be riding his charger into battle. In mass and silhouette the group commands the surrounding space. The horse's left foreleg steps freely, his veins and muscles swell, his head is turned, and his muzzle is drawn in.

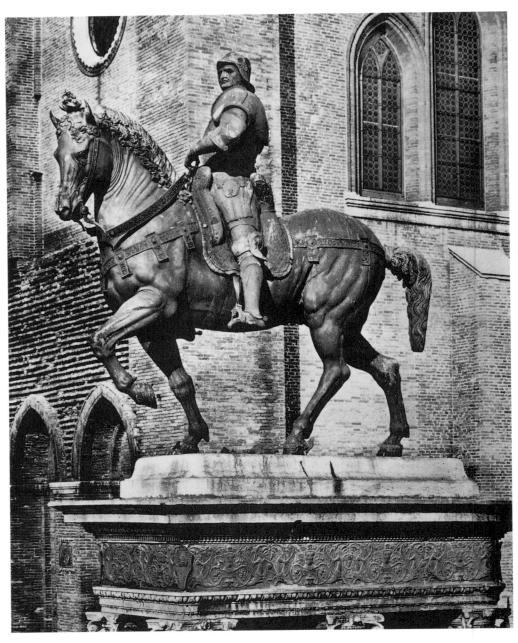

13.16. ANDREA DEL VERROCCHIO (completed by ALESSANDRO LEOPARDI). *Equestrian Monument of Bartolommeo Colleoni*. c. 1481–96. Bronze, height approx. 13' (4 m) without the base. É Campo SS. Giovanni e Paolo (Zanipolo), Venice. Commissioned by the Venetian Republic with funds left by Bartolommeo Colleoni

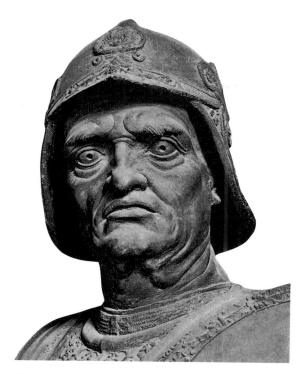

13.17. Head of Colleoni, detail of fig. 13.16

The rider stands in the stirrups, his torso twisted against the movement of the horse's head, dilated eyes staring, jaw clenched (fig. 13.17). Seldom has concern with the moment of drama been expressed more powerfully in sculpture than in Verrocchio's last work.

Alessandro Botticelli

The leader of our second, or poetic, current in later Quattrocento Florentine art is Alessandro (or Sandro) Botticelli (1445-1510). In his art he withdrew from the world around him and—unlike his contemporaries—he moved away from the sense of a forceful physical presence that characterizes the works of Pollaiuolo and Verrocchio. His style emphasized line, weaving complex and beautiful linear compositions with such subtlety that the many layers of sixteenth-century polyphonic music come to mind as a parallel. At the same time, however, he was recognized by Fra Luca Pacioli, assistant and follower of Piero della Francesca, as one of the great experts of perspective. Although his work is often praised for its gentleness, an Old Testament scene featuring the fate of Korah, Dathan, and Abiram (see fig. 13.20) reveals the dramatic intensity of which he was capable. In his later works, with their barren backgrounds, he often achieved an unforgettable sense of fatality.

Botticelli had his start as an assistant to Fra Filippo Lippi. They became so close that before Filippo died he entrusted Botticelli with the guidance of his son Filippino, who at the time was only twelve years younger. Later, Botticelli was active in the shop of Verrocchio, along with the young Leonardo da Vinci. Almost from the start, however, his own style is antiatmospheric, antioptical, and antiscientific.

Botticelli's Adoration of the Magi in the Uffizi (fig. 13.18) was painted for an altar in Santa Maria Novella. The subject is common in the later Quattrocento, and Botticelli painted it at least seven times. As has been mentioned in connection with Benozzo Gozzoli's frescoes (see p. 349), the Medici belonged to a Company of the Magi; traditionally members of the family are represented as the Magi in this panel. The aged Cosimo, who had died in 1464, before the picture was painted, is the oldest Magus, kneeling before the Christ Child. This figure holds the child's feet, which he covers with a veil that drapes over his shoulders. This action is similar to that of the priest at the benediction of the sacrament, when he covers his hands with the humeral veil to hold the foot of the monstrance-containing the Eucharist, the body of Christ-for the adoration of the faithful. The Adoration of the Magi was the first occasion when Christ was shown to the gentiles. At the feast of Corpus Christi, the sacrament was carried in solemn procession from Santa Maria Novella, past the very altar on which Botticelli's painting was placed, to the Duomo. Botticelli's picture can thus be interpreted as a perpetuation of this annual event in which the Medici took part, and to its religious significance a certain political ingredient must be added.

The star of Bethlehem hovers over the Virgin and Child, who are enthroned upon a rock that hints at Calvary. A gentle Joseph stands behind and slightly above them. Below the first Magus the two other Magi kneel in intense conversation-apparently portraits of Giovanni (d. 1463) and Piero the Gouty (d. 1469), Cosimo's sons. The youth at the extreme left, embraced by a friend as he listens to the words of a somewhat older mentor, may be Lorenzo. At the right, a dark-haired youth in profile, gazing downward, resembles surviving portraits of Giuliano, Lorenzo's brother (see fig. 12.2). The faces, delicately illuminated, are foreshortened from above, below, and behind. All are projected with equal sharpness by means of sculptural contours and incisive light. The portrait of the young man in the gold-colored cloak at the right (fig. 13.19), who gazes rather arrogantly at the spectator, has generally been accepted as a self-portrait.

Botticelli's first monumental fresco commission was to depict rebels of the Pazzi conspiracy on the walls of the Florentine Customs House (see pp. 330–31). These frescoes were destroyed after the expulsion of the Medici in 1494, but possibly their success (certainly not their subject, as Pope Sixtus IV was implicated in the conspiracy) suggested that Botticelli be called to Rome in 1481, together with his fellow

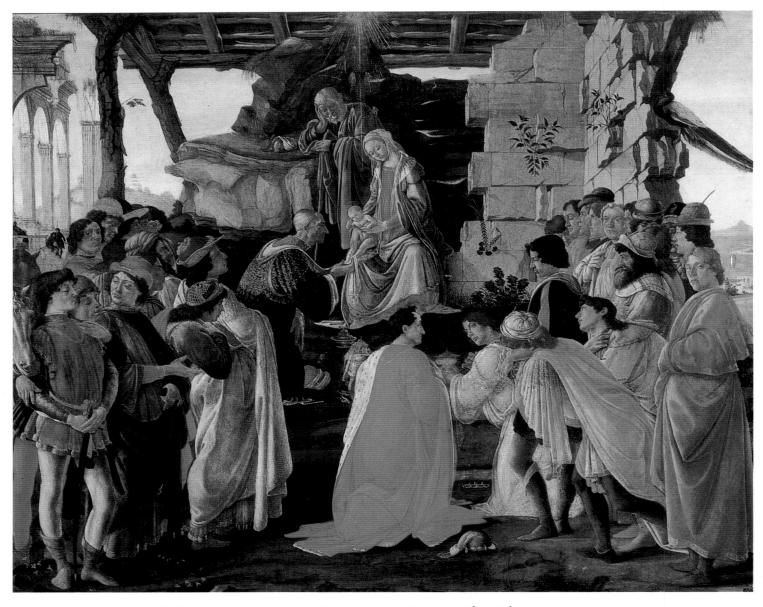

13.18. SANDRO BOTTICELLI. Adoration of the Magi. Probably early 1470s. Panel, 43³/₄ x 52³/₄" (1.1 x 1.34 m). Uffizi Gallery, Florence. Commissioned by the merchant Guasparre dal Lama for his funerary chapel at Sta. Maria Novella, Florence. The altar here was dedicated on January 6, the feast day of the Three Kings. The painting features several portraits of members of the Medici family, and of the painting Vasari wrote "the beauty of the heads that Sandro painted in this picture defies description." Botticelli, whose given name was Alessandro di Mariano Filipepi, had an older brother who was a successful broker and who was nicknamed "il Botticello" (the keg). Sandro appears to have been cared for by this brother, and it was therefore natural to call him "del Botticello," which in time became Botticelli.

Florentines Cosimo Rosselli and Domenico del Ghirlandaio as well as Perugino, from Perugia. The commission was to participate in the decoration of a chapel constructed by Pope Sixtus IV della Rovere. This is known today as the Sistine Chapel; Sixtus is Sisto in Italian, and in Italy the chapel is still called the Cappella Sistina.

The Sistine Chapel was intended to accommodate not only the Masses and other services of the papal court, but also the meetings of cardinals. Today only tourists with an interest in Quattrocento painting manage to detach themselves from Michelangelo's later frescoes on the ceiling to contemplate the works on the walls (see fig. 17.22). These scenes from the lives of Moses (fig. 13.20) and Christ were chosen, at least in part, to represent crucial episodes in the history of spiritual leadership in the Old and New Testaments that prefigured and justified the claims of the papacy to universality; like Roman cycles in general, there may well be additional layers of meaning, including references to the particular papal patron. Vasari argued that Botticelli was in charge of the decorative program; an attempt has also been made to place Perugino in this role.

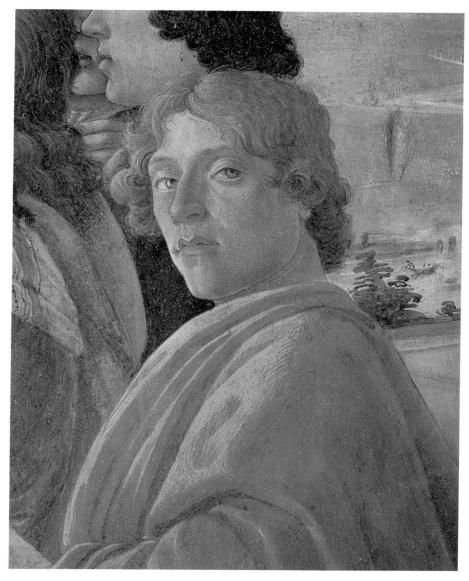

13.19. Self-Portrait, detail of fig. 13.18

If anyone exercised a commanding position, it must have been the pope. Moreover, some credit ought to be given to the common sense of the artists, none of whom were likely to want their paintings to appear out of harmony with the others. In the Chapel of the Cardinal Prince of Portugal, for example (see fig. 12.14), every visitor is struck by the decorative beauty of the ensemble, yet the architect died before the work was begun, the sculptors and painters represented conflicting tendencies, the paintings were an afterthought, and no one artist stayed on the job from beginning to end. In the case of the Sistine Chapel, it is probably safe to suppose that the pope and his advisers determined the subjects and gave the artists guidelines as to unity, and that they left the artists to work out among themselves consistency of scale, horizon line, palette, and the like. On closer examination, however, it becomes evident that none of the original four artists-or Pintoricchio or Signorelli, who were

later brought into the project—was willing to sacrifice his artistic identity. Sharp discrepancies of expression and even of compositional principles are found in the series, and none of the artists left Rome with a trace of any of the others in his style.

In each of the surviving frescoes of the Quattrocento cycle, the foreground is almost filled with figures that narrate the principal incidents and are scaled at roughly two-fifths the height of the scene. The vanishing point for the landscape—which should govern the recession of the architecture as well, but does not always do so—is placed one-fifth above their heads. This two-fifths, one-fifth, two-fifths horizontal division of the scenes, crossed by a vertical division into thirds, is respected throughout the series. With typical Florentine rigor, Botticelli treats each scene as a triptych, grouping the figures and vertical masses such as architecture and trees into a central block flanked by two wings.

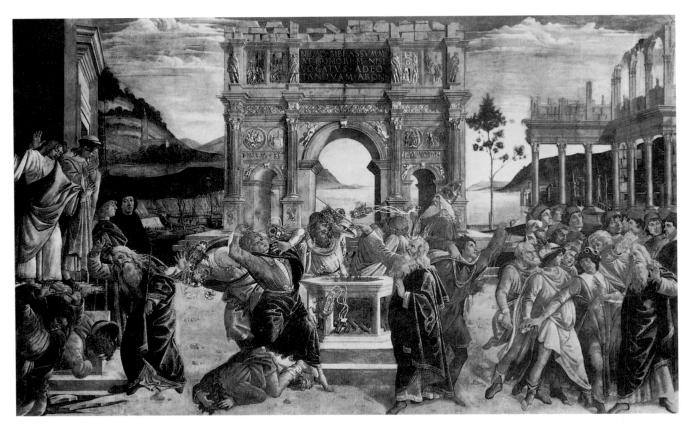

13.20. SANDRO BOTTICELLI. *Punishment of Korah, Dathan, and Abiram.* 1481–82. Fresco, 11'5 ¹/₂" x 18'8 ¹/₂" (3.5 x 5.7 m). Sistine Chapel, Vatican, Rome. (For a diagram of the chapel see fig. 17.24). Commissioned by Pope Sixtus IV della Rovere. Botticelli had to lodge a complaint against the pope in order to be fully paid for his work in the chapel.

Botticelli's Punishment of Korah, Dathan, and Abiram (fig. 13.20) narrates how these three men challenged Aaron's right to the high priesthood. When they inappropriately assumed his role by offering incense to the Lord, they were swallowed up by the earth (Numbers 16:1-40); this unusual subject would clearly appeal to a patron interested in asserting his authority. In Botticelli's fresco, the story, narrated from left to right, is fused with other incidents concerning Moses. At the left the earth opens up; only two figures are shown—one must already have vanished into hell—and flames arise to consume them. In the center, six figures who are offering false fire to the Lord are consumed by fire from heaven. On the right Moses seeks refuge from the seditious Israelites who tried to stone him. Botticelli has added an inscription from St. Paul to his representation of the Arch of Constantine in Rome: "And no man taketh this honor unto himself, but he that is called of God, as was Aaron" (Hebrews 5:4). Read together with the altar and punishment, the arch prefigures the mission of the Roman Church, especially as Aaron wears a papal tiara and has been recognized as a

reference to the patron. Botticelli's linear patterns, sharply lighted forms, and densely packed groups are evident. Moses has a long white hair and beard, and his countenance has an intensity that prefigures the *Moses* of Michelangelo (see fig. 17.43).

The rays issuing from Moses' forehead have a curious history. When Moses came down from Mount Sinai the second time, the biblical text says that rays of light shone from his face. In translating this into Latin, St. Jerome balked at attributing light to anyone who antedated Christ. The Hebrew word could also be rendered "horns," the translation chosen by Jerome, and so Moses is often represented with horns. In St. Paul's Epistle, however, the word "rays" was allowed to stand. Botticelli's Moses is a compromise: two horns made up of rays.

The Adoration of the Magi in Washington, D.C. (fig. 13.21) is more formal and classical than the Uffizi version (see fig. 13.18), and may reflect Botticelli's stay in Rome. The looser figural arrangements of the earlier picture have given way to a circle in depth that is open in the foreground to give

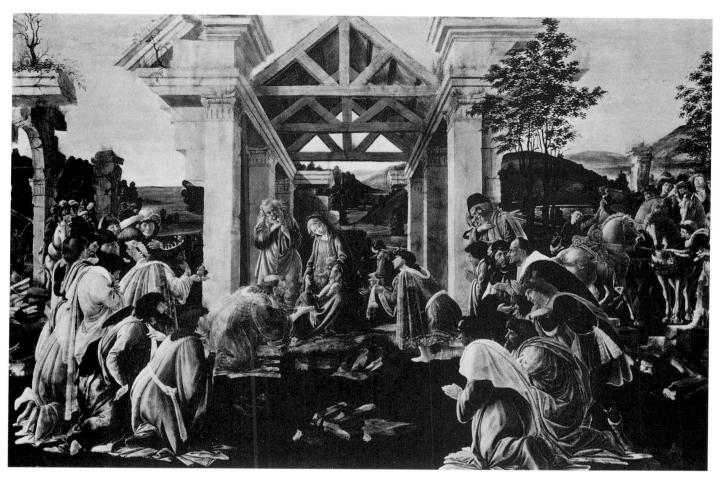

13.21. SANDRO BOTTICELLI. *Adoration of the Magi.* Probably 1481–82. Panel, 27 ⁵/8 x 41" (70 x 103 cm). National Gallery of Art, Washington, D.C. (Mellon Collection)

a view of the Virgin and Child. Now the ruins suggest a once imposing Roman monument, with a new roof replacing the entablature stone that is about to topple at the left. The shed's beams recall the open timber ceilings of the Early Christian basilicas Botticelli saw in Rome, particularly Old St. Peter's.

Botticelli has chosen the point of view of a hypothetical spectator standing at the center and well within the picture, on a line with the two Magi nearest the Madonna. All the other worshipers, therefore, and we along with them, are excluded from the scene by the entire width of the grassy lawn, which we instinctively attempt to traverse in order to bring the architectural perspective to a resolution. We are caught up involuntarily in the worshipers' movement toward the sacred figures. Botticelli must have been aware of the teachings of the Platonic Academy formed within the court of Lorenzo de' Medici. One of these doctrines was the principle of *desío* (desire, longing, yearning), by which the soul, in its earthly exile, could mystically traverse the gulf separating it from its home in God. In the Washington painting, such *desío*, al-

ready nascent in the Uffizi picture, assumes the power of a natural force, activating the figures in the composition.

Although in this case none of the faces can be identified as portraits, many demonstrate subtle psychological expressions. Because of the difficulty in dating most of Botticelli's works, it is unclear whether the picture was conceived before or after the unfinished Adoration of the Magi by Leonardo (see fig. 16.15). In any event, the two paintings cannot be separated by more than months, and the two Verrocchio pupils almost certainly knew each other's compositions. They may even have quarreled about them, as we know they did over perspective and landscape. In the upper right background grooms are having difficulty restraining unruly horses, a theme common to both pictures, although it is more tempestuous in Leonardo's. Leonardo wrote that Botticelli claimed it was possible to paint a landscape by throwing a sponge filled with paint at the panel and turning the smears into landscape forms. From Leonardo's scientific, or quasiscientific, point of view, these would be poor landscapes but to our eyes they are still completely acceptable. In its

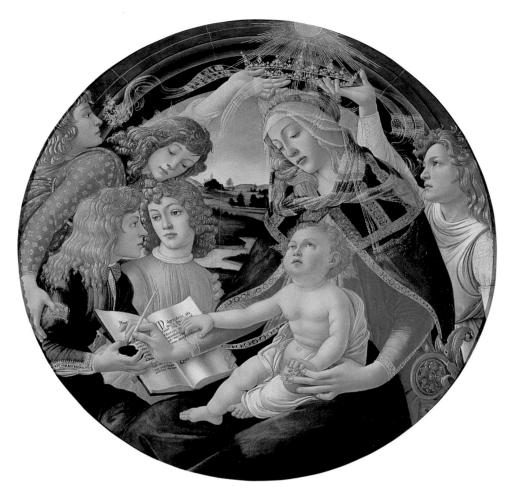

13.22. SANDRO BOTTICELLI. *Madonna of the Magnificat.* c. 1480. Panel, diameter 3'10" (1.2 m). Uffizi Gallery, Florence

broad contours the landscape here enhances the movement of the figures, while its blue-green color provides a foil for the strong reds, blues, and yellows of the costumes.

Botticelli's *Madonna of the Magnificat* (fig. 13.22) was, like the earlier *tondo* by Domenico Veneziano (see fig. 11.7), probably a wedding present or a gift made at the time of the birth of a child. The change in diameter from thirty-three to forty-six inches is typical of the increasing size of domestic objects during the second half of the Quattrocento when Florentine patrons demanded larger and more sumptuous objects for their palaces.

Botticelli's abilities in the realm of composition play an important role in the evolution of this elegant picture. Using the circular format as a base, he curves his figures around the periphery, leaving the center open for a view into a delicate landscape. The two sides are joined by the angels who reach up to place an exquisite filigree crown on the Virgin's head—crowning her as the queen of heaven—and by the flying folds of the transparent silk scarf that flutters to either side. The name of the picture is derived from the hymn that the Virgin has just written in a book held open by angels: "Behold my

soul doth magnify the Lord," words that she announced to Gabriel at the time of her acceptance of the Annunciation. To explain the moment, Botticelli represents her dipping her pen again in an inkpot.

Like Pollaiuolo, Botticelli was called upon to paint the mythological subjects fashionable at the court of Lorenzo and in the elegant society of the Florentine patriciate. In these paintings the graceful figures, nude or draped and always in the foreground, fill the frame from top to bottom with the gravity and dignity of the figures Botticelli had seen in ancient marble reliefs in Rome. Botticelli's mythologies have been explained through the writings of the Florentine Neoplatonists, notably Marsilio Ficino, but the interpretations are complicated by the kaleidoscopic nature of the Neoplatonic writings, which often demonstrate how humanists can derive a host of different meanings from the same ancient legend. In the following discussions, some persuasive elements have been selected from still-controversial interpretations, and new elements added; some day perhaps a "lucky find," as the art historian Ernst Gombrich put it, will reveal exactly what these images were intended to communicate.

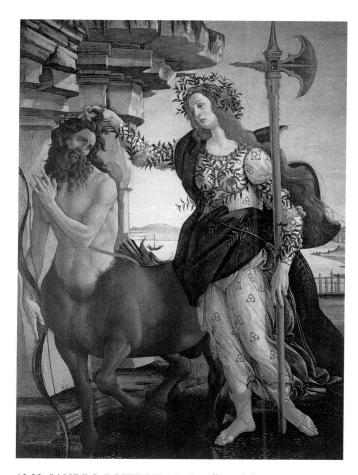

13.23. SANDRO BOTTICELLI. Camilla and the Centaur. After 1482. Canvas, 81½ x 58¾ (2.1 x 1.5 m). Uffizi Gallery, Florence. Probably commissioned by Lorenzo di Pierfrancesco de' Medici for his Florentine palace at the time of his wedding

Let us start with Camilla and the Centaur (fig. 13.23). The subject has been identified from a 1499 inventory, which lists a painting of Camilla hanging outside the bedchamber of Lorenzo di Pierfrancesco de' Medici in his Florentine palace. Camilla, who appears in Virgil's Aeneid, is a princess from Latium and a chaste huntress dedicated to the service of Minerva, whose olive branches she wears. Her tunic is also ornamented with the Medici symbol of three interlocked rings. She holds a halberd, the weapon of guards, and grasps a cringing centaur, a traditional personification of lust, by the hair. The representation suggests that Camilla is preventing him from breaking into the fence. Semiramide d'Appiano, Lorenzo di Pierfrancesco's bride, was herself a princess from Latium, and the picture should probably be read as an allegory of marital chastity, an appropriate subject for its placement outside Lorenzo's bedchamber. Behind Camilla lies an open landscape with a tranquil sea and a ship full of people, while jagged rocks form the realm of the centaur. Botticelli's figures here have assumed the proportions characteristic of his mature style, with elongated necks, torsos, arms, and legs.

The gods of ancient Greece and Rome had survived in one form or another throughout the Middle Ages, especially as personifications of the planets able to exercise power over human destiny, but in the meantime they had lost their ancient appearance. In Botticelli's works they reenter Quattrocento life on a grand scale, without much visual resemblance to ancient forms or representations, and with an allegorical meaning paralleling that of Christian subjects. Botticelli's *Venus and Mars* (fig. 13.24), for example, has little in common with the nude Venuses of antiquity. Here we behold a lovely young woman, barefoot but clothed in a garment

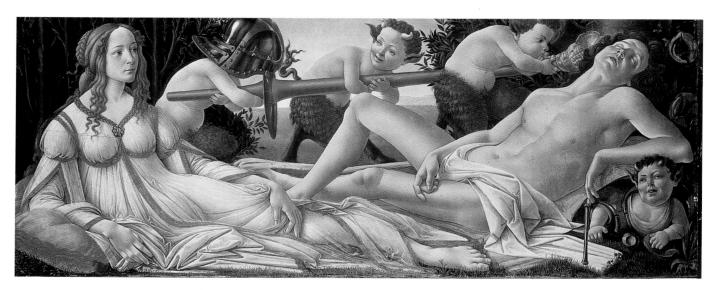

13.24. SANDRO BOTTICELLI. *Venus and Mars*. c. 1483. Panel, 27 ¹/₄ x 68 ¹/₄" (69 x 173.5 cm). National Gallery, London. Perhaps commissioned by a member of the Vespucci family.

The size and the shape suggest that this was a *spalliera* panel, painted to be placed over a chest, a bench, or some other piece of household furniture. The languor expressed here is induced as much by the painting's long, low shape as by the sleep of Mars.

with double sleeves and voluminous folds that conceal her waist. Mars, a slender youth, lies on the ground, naked except for a strip of white cloth. While he sleeps, four impudent baby satyrs—among the first, if not *the* first, satyrs to make an appearance in Renaissance painting—make sport with his armor and spear, and one of them blows through a conch shell into his ear, demonstrating how soundly he is sleeping.

The painting has been connected with a tournament of 1475, celebrated in Poliziano's poem La giostra, in which Giuliano de' Medici received the victor's crown from Simonetta Vespucci. It seems, however, to have had some connection with the Vespucci family, Botticelli's neighbors, for the wasps buzzing about the head of Mars come from the Vespucci coat of arms (vespucci in Italian means little wasps). Several passages from classical literature were probably used by the humanist who devised the painting's iconography. Especially relevant is Marsilio Ficino's astrological characterization of Mars as "outstanding in strength among the planets because he makes men stronger, but Venus masters him. . . . Venus . . . often checks his malignance . . . she seems to master Mars, but Mars never masters Venus." Part of the picture's meaning was surely the conquering power of love, even over war, and the subjugation of violence by the powers of culture and the intellect. This is a lofty message, of course, but Mars's deep sleep can also refer to another, less profound theme common in ancient and medieval writings: the ability of Venus—or of any woman—to defeat the male as a result of strenuous sexual activity. Although it is difficult to re-create the sense of humor that prevailed in earlier periods (we can only wonder what jokes might have amused patricians during the Renaissance), there are suggestions within this painting that humor may have been a part of the artist's and/or patron's original intent.

It might be said that with the Primavera (fig. 13.25), Botticelli moves from painting sleep to representing the dream itself. The scene is a grove of dark orange trees, whose intertwined branches and golden fruit fill the upper portion of the picture. Between the trunks one glimpses the sky and, at one point, a hint of a distant landscape. Just off center stands a maidenly figure, one hand raised as if in benediction. At the right Zephyrus, the wind god, enters the scene in pursuit of the virgin nymph Chloris, from whose mouth flowers seem to issue; in the legend Zephyrus rapes Chloris and then he marries her. At this point Chloris is transformed into Flora, goddess of Spring, who scatters blossoms from her flower-embroidered garment. Because the picture represents the eternal spring that flourished in Venus's garden, Flora is one of the key figures in decoding the meaning. On the left Mercury raises his caduceus to catch and dispel the storm clouds trying to enter the garden. The three figures dancing in a ring are the Graces; above, the blindfolded Cupid shoots a blazing golden arrow in their direction. The figure in the center, so much like one of Botticelli's Madonnas, is Venus, goddess of Love and Beauty and also, in this context, of Marriage.

The picture, like *Camilla and the Centaur*, is probably the painting documented in the town house of Lorenzo di Pierfrancesco de' Medici; when Vasari saw it half a century later, it was in Lorenzo di Pierfrancesco's villa at Castello. Probably in 1478, Marsilio Ficino wrote a letter to the youthful Lorenzo di Pierfrancesco, then only fourteen or fifteen years old, in which he described the virtues of Venus:

Venus, that is to say, Humanitas, . . . is a nymph of excellent comeliness, born of heaven and more than others beloved by God all highest. Her soul and mind are Love and Charity, her eyes Dignity and Magnanimity, the hands Liberality and Magnificence, the feet Comeliness and Modesty. The whole, then, is Temperance and Honesty, Charm and Splendor. Oh, what exquisite beauty! . . . My dear Lorenzo, a nymph of such nobility has been wholly given into your hands! If you were to unite with her in wedlock and claim her as yours, she would make all your years sweet.

To Ficino, then, Venus represented the moral qualities that a cultivated Florentine patrician woman should possess. Ficino's passage may help to explain the restraint that characterizes Botticelli's elegant interpretation of Venus.

The Graces are symbols of the beauty and grace that Venus offers to the world. In addition, it should be noted that Alberti had recommended that painters try to re-create a work described by the ancient author Seneca in which the Graces were shown nude or in transparent garments, dancing together with intertwined hands. Botticelli may also have been inspired by a surviving sculptural composition from antiquity that shows three nude Graces, their hands joined; in one view, one of the figures is seen from the rear and the other two from the front, as in his painting. Their long, loose, flowing hair indicates that they are unmarried virgins.

Scholars have posed various explanations for aspects of the painting based on the writings of Horace, Ovid, Lucretius, and Columella, but there are also noteworthy Florentine elements. The Roman poet Claudian, who in the Renaissance was believed to have been a Florentine, wrote that all clouds were excluded from Venus's Garden of the Hesperides, where her "golden apples" (i.e., oranges) grew. Botticelli's garden boasts no fewer than forty-two varieties of plants common to Tuscany in the spring. Mercury, armed and helmeted, stands guard in a pose derived from the *Davids* by Donatello and Verrocchio (see figs. 10.29, 13.15). Venus, moreover, is decorously clothed and wears the headdress of a Florentine married woman. A cleaning of the painting revealed the delicate lines of breath from Zephyrus's mouth that instilled new life in the nymph Chloris, so that

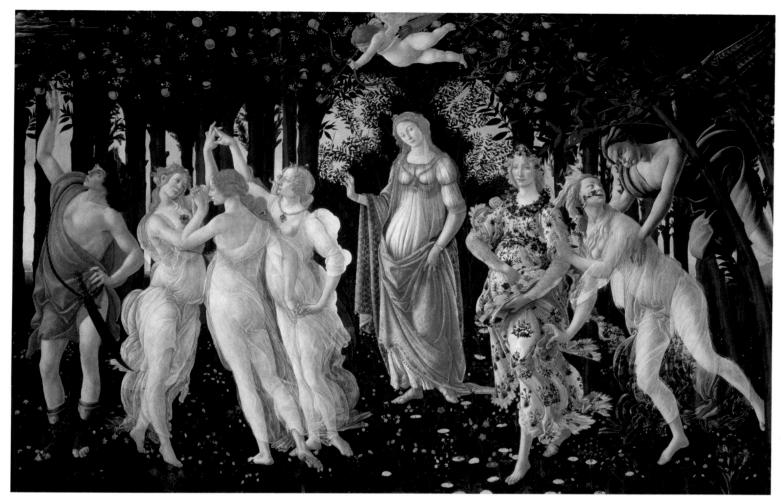

13.25. SANDRO BOTTICELLI. *Primavera*. c. 1482(?). Panel, 6'8" x 10'4" (2 x 3.1 m). Uffizi Gallery, Florence. Probably commissioned by Lorenzo di Pierfrancesco de' Medici for his Florentine palace at the time of his wedding

her mouth in turn may sprout flowers and that she may be reborn as Flora. This painting was appropriately placed outside the nuptial chamber of Lorenzo di Pierfrancesco, whose wedding was planned for May 1482.

Scholarship has raised new issues about the painting, particularly in reference to the intended meaning that the imagery may have had for Lorenzo di Pierfrancesco's bride, Semiramide d'Appiano. It has been suggested that Botticelli's chaste, modest, and submissive Venus may have been meant as a behavioral model for the new bride. These qualities are emphasized in humanist writings by Alberti and Bruni as appropriate for the ideal woman and the perfect wife. Bruni wrote that women should especially study the Roman poets, for "in no other writers can be found so many examples of womanly modesty and goodness . . . the finest pattern of the wifely arts."

The last word about this perpetually alluring allegory has yet to be written. For example, the orange grove, so similar to the one that separates foreground from background in Uccello's *San Romano* panels (see fig. 11.6), may have other

connotations. Oranges cannot be raised outdoors in the Arno Valley, and to a Florentine Quattrocento eye these golden orbs could hardly have failed to suggest the Medici coat of arms. Also, Mercury's beautiful rose-colored chlamys is strewn with golden flames, a proper attribute of the god but one that also belongs to St. Lawrence (Lorenzo). They decorate his vestments in Fra Angelico's San Marco altarpiece (see fig. 9.5), made for Cosimo de' Medici, and many other representations; the meteor showers that descend on the earth in August each year are known in Italy as "fires of St. Lawrence" because they occur at the time of his feast. This attribute shared by the two Lorenzos also decorates Venus's white gown, which is bordered at the neckline with a continuous row of golden flames, while loops of these flames encircle her breasts. Finally, Mercury also bore the responsibility for doctors, whose symbol, the caduceus, he bears. Medici means "doctors," and the Medici patron saints were the doctors Cosmas and Damian. The metaphor was standard in any eulogy of the Medici family.

Botticelli's mythologies typify the learning and social graces of a society intent on reviving antiquity on a new scale, but now less for the moral lessons that interested Alberti than for private delight. Botticelli's painting has given this rarefied ideal a perfect embodiment, and at the same time raised it to the level of poetry. In front of the dark green leaves and golden fruit of the grove that shuts out the world, the pale, long-limbed figures move with a melodious grace, their golden tresses and diaphanous garments rippling about them. These lovely creatures seem almost weightless, and the composition wavers as the spring winds blow through it.

Yet there is nothing weak or hesitant about Botticelli's style. In his hands moving and often energetic patterns of line are united with lighting from the side that emphasizes the sculptural relief of every feature, every long lock of hair, every jewel. All surfaces are smooth, all masses firm, no edge is veiled in atmosphere, no brushwork visible.

Slightly smaller than the Primavera, painted on canvas (a surface usually reserved for ceremonial banners), and recorded in no Quattrocento inventory, the Birth of Venus (figs. 13.26, 13.27) was seen, together with the *Primavera*, in Lorenzo di Pierfrancesco's villa at Castello by Vasari in the mid-sixteenth century. The suggestion that the painting might originally have served a function different from that of the Primavera is supported not only by the unusual use of canvas but also by the simplified composition and iconography. Whether it might have been a banner for a procession or festival is uncertain, but we know that Botticelli painted such works because he is documented in 1475 as painting a now-lost standard for a joust. Although the Birth of Venus corresponds to a passage in Poliziano's La giostra, Ernst Gombrich related it to Ficino's interpretation of the mythical birth of the full-grown Venus from the sea, who had been fertilized by the severed genitals of her father Uranus. Ficino interpreted this birth as an allegory of the

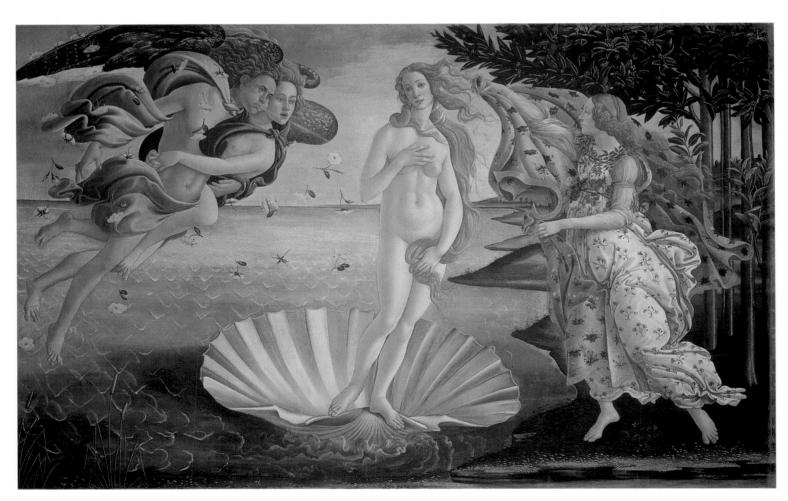

13.26. SANDRO BOTTICELLI. *Birth of Venus*. c. 1484–86. Canvas, 5'9" x 9'2" (1.75 x 2.8 m). Uffizi Gallery, Florence. Probably commissioned by a member of the Medici family

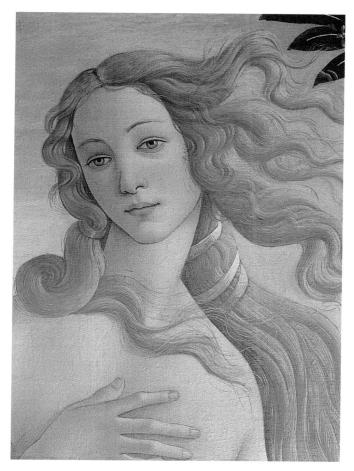

13.27. Head of Venus, detail of fig. 13.26

birth of beauty in the mind of humanity. Botticelli has created from the myth an image of grace and beauty which in composition can be likened to the traditional format of the scene of St. John baptizing Christ. Venus, arisen from the sea, stands on the front edge of a shell, while the Zephyr and a nymph waft her to shore, where she will be robed by a waiting Hour, one of the traditional attendants of Venus. Although Venus is nude here, she is derived from ancient statues of the Venus pudica (modest Venus) type and hides her nakedness with her hands and with her long golden hair, which sweeps about her. The waiting Hour has her neckline wreathed in laurel. The sea itself is simply rendered, with Vshapes that suggest waves. Flowers drift through the air, and Venus's unearthly beauty is heightened by the use of gold pigment to highlight her hair. The atmospheric and voluminous qualities that so interested Renaissance artists are ruled out in this picture, which is dependent on the delicacy of Botticelli's line. His proportions show here their greatest exaggeration, yet despite this, the long neck and the torrent of honeyed hair are entrancing.

The sitter in Botticelli's *Portrait of a Man with a Medal of Cosimo de' Medici* (fig. 13.28) may be Lorenzo di Pierfrancesco since the features resemble a profile portrait of him on a medal; whoever the sitter may have been, he clearly felt a need, for whatever reason, to demonstrate his allegiance to the Medici in this unusual portrait. The placing of the head in three-quarter view against the sky is unexpected in a portrait painted at this time, and Botticelli's interest in emphatic modeling in light and shadow produces a powerful and strongly individualized presence. This is a surprise after the idealized, quintessentially Botticellian character of the figures in his mythological pictures. The sculptural modeling of the hands and face contrasts with the flattened landscape and its maplike riverbank.

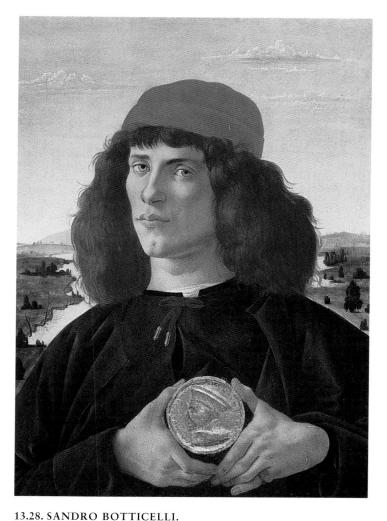

Portrait of a Man with a Medal of Cosimo de' Medici. c. 1475. Panel, 22 5/8 x 17 3/8" (57.5 x 44 cm). Uffizi Gallery, Florence. The medal that he is shown holding, which is executed in raised, gilded gesso, seems to be a cast of the medal shown in figure 6.1.

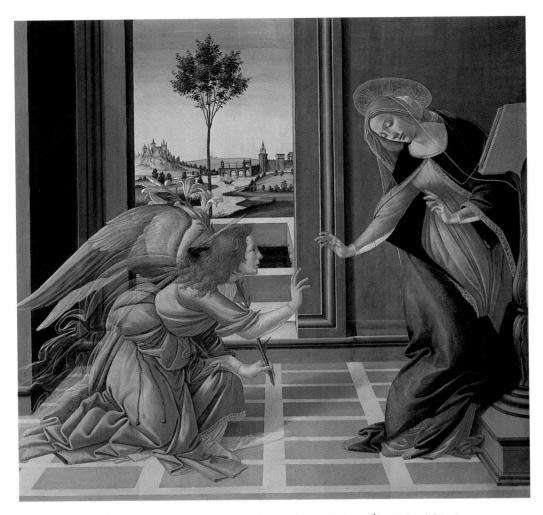

13.29. SANDRO BOTTICELLI. *Annunciation*. 1489–90. Panel, 59 x 61³/4" (1.5 x 1.56 m). Uffizi Gallery, Florence. Commissioned by Benedetto di Ser Francesco Guardi del Cane for Sta. Maria Maddalena dei Pazzi, Florence

The Annunciation for Santa Maria Maddalena dei Pazzi (fig. 13.29) shows the increasing intensity that will be evident in Botticelli's religious paintings. The event takes place in a spare room furnished only with Mary's reading desk, but through the open door we can look into her closed garden. The barrenness of the architecture provides a foil for the emotional figures. Mary, whose pose is ultimately derived from Donatello's Annunciation (see fig. 10.27), sways as if caught in a rushing wind. The biblical text says only that "her heart was disturbed within her," but here she seems about to swoon. Her eyes are almost closed, her features pale. Here Botticelli's flowing line becomes the vehicle of a new and passionate emotional expression.

The strong emotions, severe architectural forms, and strong, clashing colors of Botticelli's late style suggest that he may have been a willing listener to the fiery sermons of a monk from Ferrara named Girolamo Savonarola, who ar-

rived at San Marco in 1482. He remained until 1487, returned in 1490, and was appointed vicar general of the Tuscan congregations of Dominicans in 1493. There is no evidence that Botticelli, unlike his younger brother Simone, ever became a partisan of the political movement Savonarola set in motion. The adherents of the Dominican preacher known as piagnoni (weepers, from piangere, to weep)—mobilized popular resentment against the Medici supporters, or palleschi. Savonarola preached sermons in the Duomo, the only building in Florence large enough to hold his audiences; in this setting he denounced the sins of Florence and the worldliness of the Renaissance with such force that his listeners wept openly. Although many of his sermons are recorded, sometimes we are in doubt as to exactly what he said, because the piagnoni were weeping so fitfully they could not take accurate notes. His prophecies of the destruction to be visited on Florence seemed to come true when the

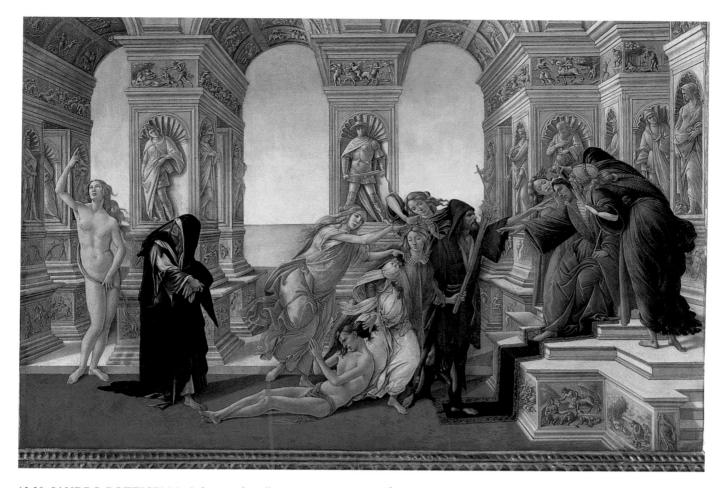

13.30. SANDRO BOTTICELLI. Calumny of Apelles. 1497–98(?). Panel, 24⁵/8 x 36" (62 x 91 cm). Uffizi Gallery, Florence. The iconography of Apelles's lost painting was known to Renaissance humanists through a description by the ancient author Lucian. A more descriptive title, such as Botticelli's Re-creation of The Allegory of Slander Painted by the Ancient Greek Artist Apelles, although awkward, would better convey to modern viewers the difficult subject of Botticelli's painting. It has been suggested that Botticelli created this work without a commission, for his own satisfaction. If this was the case, a major question would be whether the main intent was to re-create an ancient work or to comment on the Savonarola episode.

armies of King Charles VIII of France entered the city in 1494, after the expulsion of Piero the Unlucky. The peace that had reigned with few interruptions in central and northern Italy for forty years was over, and it became evident that the Italian states could not stave off domination by the rising centralized monarchies of France and Spain, not to mention the Holy Roman Empire. Eventually, Savonarola took over the government of the Republic, but problems in Florence and his attacks on Pope Alexander VI eventually turned both the Florentines and the papacy against him. In 1498 Savonarola was tortured and admitted the charges of heresy leveled against him. He and two of his monastic assistants were hanged in front of the Palazzo dei Priori and their bodies burned; the ashes were thrown in the Arno.

Botticelli's moralistic fervor during this period is illustrated by a painting of a difficult subject known rather enigmatically as the *Calumny of Apelles* (fig. 13.30) because it

attempts to re-create a lost painting of allegorical figures on the theme of slander (calumny) by the ancient Greek painter Apelles; whether Botticelli's painting has any connection with the Savonarola episode in Florentine history is uncertain, and who the humanistically minded patron may have been is also unknown. It was Alberti who suggested that artists attempt to re-create this painting. The complex iconography, enacted by allegorical figures, is based on the ancient description. Standing beside the throne of Midas, the unjust judge, are Ignorance and Suspicion, who lift his donkey ears to whisper their advice. Slander's victim, a nearly naked youth, is dragged forward to face the judgment of Midas. Slander is led by the hooded, bearded Hatred, and attended by Deceit and Fraud, who is adjusting her jewels. Penitence, an old woman, looks away from the main scene toward the nude figure of Truth, who points upward, to heaven.

The oppressive effect of the *Calumny* is in part produced by its illogical space. Most of the perspective lines vanish toward a common point behind the head of Fraud, but the central pier of the hall supports a cornice and two barrel vaults that recess toward a lower vanishing point. The composition is further complicated by the placing of the throne at the right, which creates an axis of interest that conflicts with the visual axis of the perspective.

The architecture presents a series of animated surfaces. Sculptural friezes representing classical subjects dwarf the piers, which are pierced by transverse passages and decorated with niches. From these niches protrude statues, a Judith with the head of Holofernes at the extreme right, for example, and at the center a warrior in the pose of Castagno's *Pippo Spano* (see fig. 11.15). More reliefs adorn the bases of the piers, and even the coffers of the vault are filled with reliefs.

Within this active architecture, whose windows look out on a simple marine horizon, the frenzied figural composition is rendered in Botticelli's characteristic linear style. Echoes of earlier graceful figures occur here and there. Truth is an obvious reference to the *Birth of Venus* (see fig. 13.26). But the dreamlike quality of Botticelli's painted mythologies has turned into a kind of nightmare. It has been proposed that the iconography was prompted by a desire to defend the memory of Savonarola by suggesting that his accusers were wicked and his judge weak, a suggestion rendered plausible by the tattered Dominican habit in which Penitence is dressed.

The crowded and dramatic style of the *Calumny* reappears in contemporary religious works by Botticelli, such as the harrowing *Lamentation over the Dead Christ with Sts. Jerome*, *Paul*, and *Peter* (fig. 13.31). The painting is pervaded by the self-flagellating gloom of Savonarola's doctrines. Jagged rocks form the entrance to the tomb and enclose the mourning figures. Within lies the sarcophagus—and utter blackness. The pose of Christ, with his long, hanging arm, seems to have been in part inspired by a window designed by Castagno for the dome of Florence Cathedral, and Botticelli seems also to have been impressed by Pietro Lorenzetti's *Descent from the Cross* (see fig. 4.22), from which he adopted not only the appearance of rigor mortis but also the upsidedown confrontation of the Magdalen's face (in Lorenzetti's fresco, it is the Virgin's) with that of Christ.

Botticelli's painting of 1500 now known as the *Mystic Nativity* was probably painted for the artist's personal satisfaction, as is suggested by the cryptic inscription, in Greek, across the top (fig. 13.32). In spite of this text, the picture has been difficult to interpret: while a few elements are drawn from Chapters 11 and 12 of the Book of Revelation, some of the figures are not, and there are also references to specific sermons by Savonarola. The second woe of the Apocalypse, describing the fiery prophecies of two "witnesses" and their death at the hands of the Antichrist, almost surely refers to the deaths of Savonarola and his principal follower, Fra Domenico da Pescia. And the "half time after the time" in the inscription can only refer to the year 1500, the half millennium after the millennium of the Nativity of Christ.

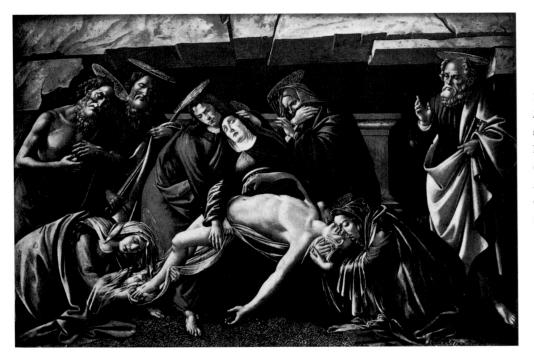

13.31. SANDRO BOTTICELLI.

Lamentation over the Dead Christ
with Sts. Jerome, Paul, and Peter.

Late 1490s(?). Panel, 54³/8 x 82"
(1.4 x 2.07 m).

Alte Pinakothek, Munich.

Commissioned for
S. Paolino, Florence

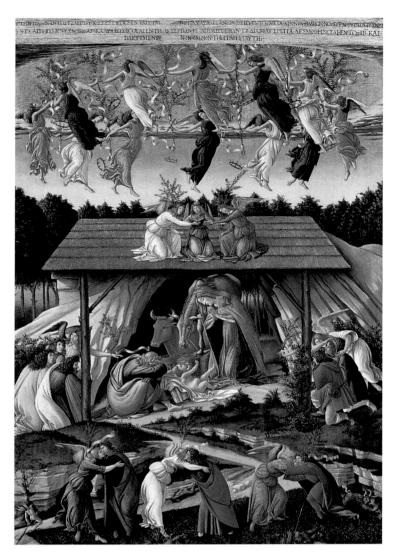

13.32. SANDRO BOTTICELLI. *Mystic Nativity.* 1500. Canvas, $42^{1/4}$ x $29^{1/2}$ " (108.6 x 74.9 cm). National Gallery, London.

At the top of the painting is this inscription, in Greek:

"This picture I, Alessandro, painted at the end of the year 1500, during the trouble in Italy in the half time after the time which was prophesied in the eleventh [chapter] of John and the second woe of the Apocalypse when the Devil was loosed upon the earth for three years and a half. Afterward he shall be put in chains according to the twelfth woe, and we shall see [word missing] as in this picture." The missing word may be "heaven."

The "trouble in Italy," to which the inscription refers, is not hard to identify, considering that the armies of Cesare Borgia were then loose in Tuscany. Botticelli suggests that after all this passes we will be brought to the place where the mystic woman of Revelation 12 has found refuge with her child in the wilderness; then all devils will be chained under the rocks (we see this in the lowest foreground), angels will embrace us, and we may dwell in safety. Angels with olive branches draw shepherds forward to adore the Christ Child. In the heavens above, angels dance in a ring and crowns swing from the olive branches they carry. The embrace of peace, the circling patterns, the sheltering wood, and the protecting mother offer an atmosphere of calm missing in most of Botticelli's later pictures. Even the color is transformed: the jewel-like blues, yellows, and reds are a release from the harsh tones that characterized the immediately preceding period of Botticelli's art.

During the last ten years of his life, Botticelli seems to have painted little. Although he was consulted along with other artists about the placing of Michelangelo's *David* in 1504, the Florence of Leonardo, Michelangelo, and the young

Raphael apparently had little or no work for him. Commissions went to artists who could emulate the new style of the High Renaissance. Vasari, who would have us believe that Botticelli's patronage declined when he was under the influence of Savonarola, wrote that Botticelli became prematurely old and walked with two canes.

Filippino Lippi

The fourth important Florentine painter of the end of the Quattrocento, Filippino Lippi (1457/58–1504), received his early training from his father, Fra Filippo Lippi, accompanied him to Spoleto in 1466, and remained there until Fra Filippo's death in 1469. Filippino's association with Botticelli lasted for a number of years, perhaps until the latter was called to Rome in 1481. In 1484 Filippino was asked to complete the frescoes by Masaccio and Masolino in the Brancacci Chapel (see figs. 5, 8.9).

Filippino's style is demonstrated in the *Vision of St. Bernard* (fig. 13.33). Jacobus de Voragine's thirteenth-century *Golden Legend* explained that one day when St.

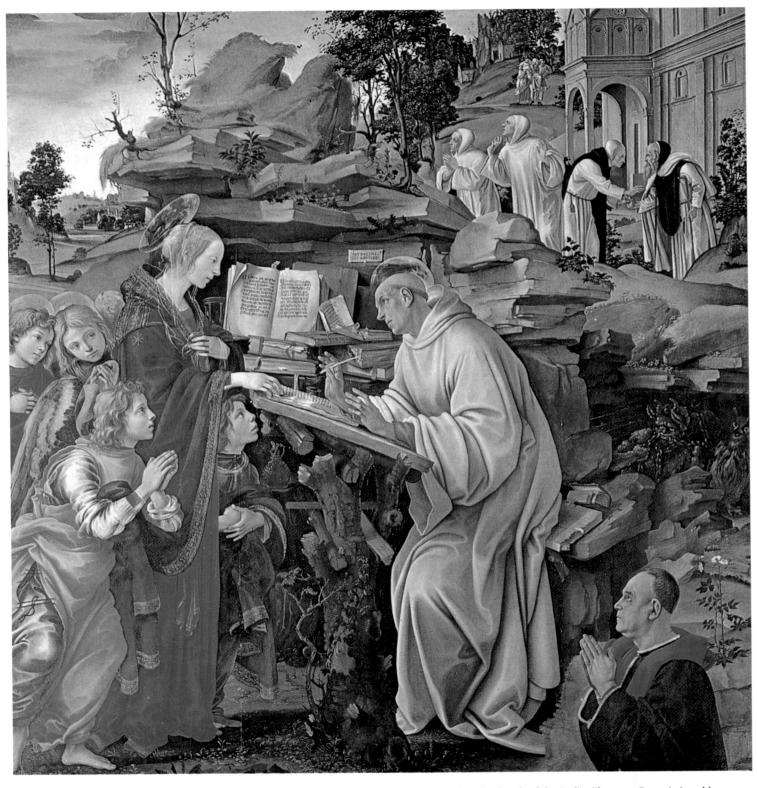

13.33. FILIPPINO LIPPI. Vision of St. Bernard. c. 1485–90. Panel, 82 x 77" (2.08 x 1.96 m). Church of the Badia, Florence. Commissioned by Francesco del Pugliese, a wealthy cloth merchant, for the monastic Church of Le Campora at Marignolle, near Florence

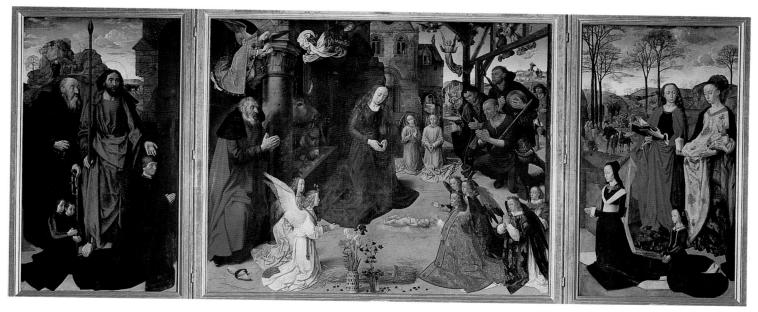

13.34. HUGO VAN DER GOES. *Adoration of the Shepherds* (Portinari altarpiece). Late 1470s. Panels: center, 8'4" x 10' (2.54 x 5.86 m); laterals, each 8'4" x 4'8" (2.54 x 1.42 m). Uffizi Gallery, Florence. Commissioned by Tommaso Portinari for Sant'Egidio, Florence. Hugo's altarpiece was placed on the high altar of Sant'Egidio between the now-vanished frescoes of Domenico Veneziano, his young assistant Piero della Francesca, and, later, Castagno and Baldovinetti.

Bernard was feeling so tired and ill that he could scarcely hold his pen, the blessed Virgin, about whom he had written so much, appeared to strengthen him. In later, Cinquecento representations of the vision, Mary and her accompanying angels float as a heavenly apparition (see fig. 16.49). Here she stands quietly before Bernard's outdoor desk, attended by wide-eyed child-angels who watch in wonder or genuflect and pray, as she lays a slender hand on Bernard's rumpled page. He stops writing to look up in adoration, and between the profile of Mary and the face of the monk a Trecento manuscript stands open so that one can read St. Luke's account of the Annunciation. Filippino must have meant us to feel that Mary came to St. Bernard as the angel Gabriel had come to her, and that in this vision the Christ Child is born a second time—as St. Antonine would have put it-in St. Bernard's heart. On the hillside monks look upward, astonished, at the golden glow through which Mary and her angels have descended. In the lower righthand corner the donor folds his hands in prayer; a demon, gnawing his chains in defeat, can be seen in a hole in the rocks above his head.

The naturalism of faces and hands, rocks and trees, even the appearance of the angels recalls an important artistic event. Florentine painters were profoundly impressed when a large altarpiece representing the *Adoration of the Shepherds* by the Netherlandish painter Hugo van der Goes (fig. 13.34) arrived in Florence, probably in 1483; it had been commissioned by Tommaso Portinari, a Florentine who worked in Flanders. The Florentines had certainly seen small examples of Netherlandish painting, and a tiny oil on panel painting of *St. Jerome* attributed to Jan van Eyck and Petrus Christus had belonged to Cosimo de' Medici (now in the Detroit Institute of Arts). The Portinari altarpiece, however, offered the Florentines the extensive realism of Northern painters on a huge scale and in a public setting where it could be readily examined. This work's arrival in Florence was a revelation, and Filippino must have studied the melancholy faces of the Portinari children with care, as there is clearly a reflection of them in his angels.

In his composition Filippino has achieved something similar to the broken quality of Verrocchio's sculptured drapery surfaces (see fig. 13.12). The forms seem to move restlessly, shimmering in small facets and pervaded by movement but with little sense of overall mass. In Filippino's Strozzi Chapel frescoes of the legends of Sts. Philip and John the Evangelist, this antimonumental style comes to its climax (fig. 13.35). The frescoes were commissioned in 1487 by Filippo Strozzi, builder of the Strozzi Palace (see fig. 12.21), who first gave Filippino permission to go to Rome for an important commission in Santa Maria sopra Minerva. Strozzi died in 1494 without seeing the frescoes, which were completed only in 1502.

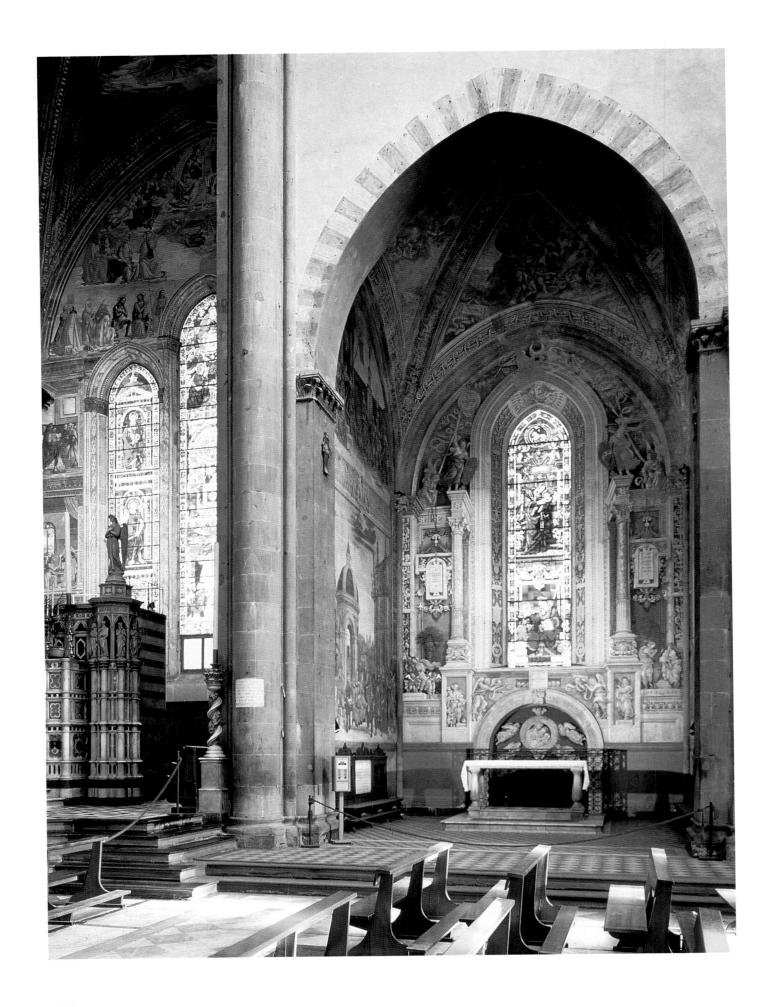

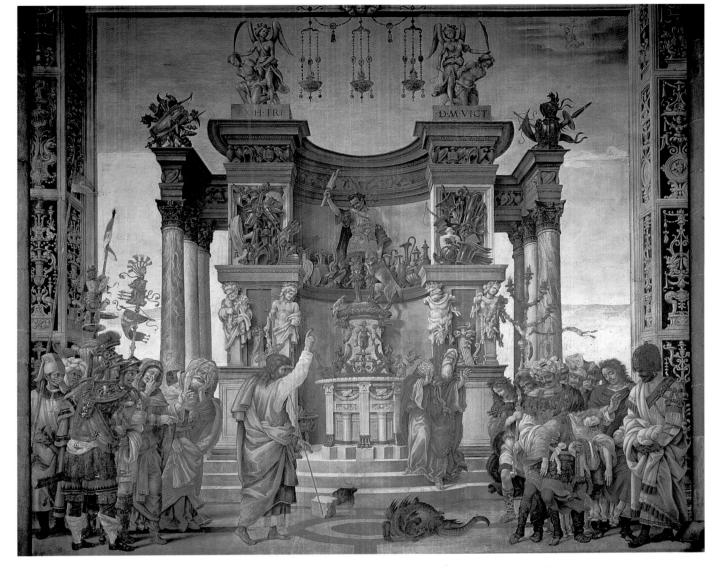

13.36. FILIPPINO LIPPI. St. Philip Exorcising the Demon in the Temple of Mars. 1487–1502. Fresco. Strozzi Chapel, Sta. Maria Novella, Florence

St. Philip Exorcising the Demon in the Temple of Mars (fig. 13.36) is one of the most unexpected pictures of the Florentine Renaissance. Apocryphal sources relate that when St. Philip entered the Temple of Mars in Hierapolis in Asia Minor, a demon in the shape of a dragon Burst from the base of the statue of the god and emitted such poisonous

fumes that the king's son fell dead. St. Philip's exorcism of the dragon greatly displeased the priest of Mars and led to the saint's crucifixion, which Filippino represents in the fresco above this one. At the upper right-hand corner of the scene of exorcism, so small that one hardly notices him, Christ appears in a rift in the clouds, carrying his cross and

Opposite: 13.35. FILIPPINO LIPPI. View of frescoes in the Strozzi Chapel. 1487–1502. Frescoes and stained glass. Strozzi Chapel, Sta. Maria Novella, Florence. Commissioned by Filippo Strozzi. The Tomb of Filippo Strozzi behind the altar is by BENEDETTO DA MAIANO. The tomb is placed in relation to the altar table so that it seems to lie underneath the table, while the Madonna and Child sculpture that surmounts the tomb becomes a sculpted altarpiece for the chapel itself. Filippino's frescoes on the back wall illusionistically suggest sculpture, integrating the tomb into the total decoration of the chapel.

offering his blessing. For these frescoes Filippino has transformed the Strozzi's Gothic chapel with elaborate painted frames featuring details borrowed from motifs found in Rome in the Golden House of the Emperor Nero. Since these decorations were found in what seemed to be a grotto, they became known as *grotteschi*, the origin of our word "grotesque." They consist of lamps, urns, consoles, masks, harpies, lions' feet, and other decorative elements that can be combined vertically on pilasters or woven into fantastic webs covering walls or vaults. Filippino's enframement is one of the first examples of *grotteschi* to reach Florence.

The pagan altar is a huge exedra that encloses a statue of Mars, while below, to either side, herms, supposedly marble sculptures, twist as if alive. The ledges above are crowded with trophies and, behind Mars, amphorae of various sizes and shapes. On the cornice, statues of kneeling, bound captives below winged Victories seem to mesh with the painted lamps that hang into the scene on chains from the mouths of three putti whose bodies are outside the frame. The illusion becomes even more contradictory through Filippino's placement of some figures in front of the frame at the sides. Filippino and Botticelli were classified as experts of perspective by Fra Luca Pacioli in 1494, but here Filippino demonstrates how a late Quattrocento artist could manipulate the hard-won perspective space of the earlier decades for his own experimentation and delight.

Mars, looking more like a living person than a statue, brandishes a shattered lance with one hand, while with the other he caresses what is supposedly a wolf, however much it may look like a hyena. The priest cringes in terror at the power of St. Philip. On either side stand priests, courtiers, and soldiers wearing exotic costumes apparently meant to suggest the Near East. The organic consistency of the body and its pose that was so carefully studied and mastered by earlier Quattrocento artists such as Donatello and Masaccio is understood by Filippino but is not an important part of his style. Instead he swaths his figures in voluminous and complex robes that enliven the composition and add to the expressive power of his narrative. Despite differences of costume, age, hair, beards, and skin color, the faces are essentially the same; individuality was less important here than conveying the incipient nausea caused by the deadly fumes. It was hardly necessary for Filippino to show three of the bystanders holding their noses, for the emanations from the monster in the center seem to have attacked figures and setting. What a distance we have come since Masaccio's Tribute Money! One might even say that Filippino's fresco is, in the last analysis, the painting of a foul smell.

Filippino died in 1504 at the age of forty-six, only three months after having submitted his judgment on the placing of Michelangelo's *David* (see figs. 9, 16.39). We are told that all the workshops of Via dei Servi closed in respect as

his body was carried from the Church of San Michele Visdomini to its final resting place in Santissima Annunziata. Ironically, it was for San Michele Visdomini that Jacopo Pontormo, only thirteen years later, was to paint an altarpiece that has been regarded as one of the first manifestations of Mannerism, a style that owes much to Filippino's introspection and interest in personal expression.

Domenico del Ghirlandaio

Our account of the Florentine Quattrocento ends with Domenico del Ghirlandaio (1449-94), who, despite a career even briefer than that of Filippino, became a leading personality in the Florentine School. Domenico, together with his brother Davide, their brother-in-law Bastiano Mainardi, and an army of assistants, captured many major commissions for public painting in Florence—frescoes and altarpieces—and a number of portrait commissions as well. Like Agnolo Gaddi at the end of the Trecento (see p. 164) and Giorgio Vasari in the third quarter of the Cinquecento (see p. 714–16), Ghirlandaio and his school represented the official taste of the period. The scientific pursuits of Pollaiuolo and Verrocchio might appeal to Lorenzo the Magnificent, the arcane researches of Botticelli to Lorenzo di Pierfrancesco and his friends, but the ordinary Florentine businessman knew what he liked and may even have been irritated by so much fierce knowledge on the one hand and so much wild imagination on the other. Ghirlandaio's prosaic style suited the successful merchant perfectly.

The fate of Ghirlandaio's reputation is instructive. When Quattrocento art was rediscovered by nineteenth-century critics, Ghirlandaio's meticulous view of life about him impressed a generation that never quite understood Masaccio and were little interested in the art of Uccello and Piero della Francesca. Then, in the wake of the late-nineteenthcentury Symbolist and Art Nouveau emphasis on emotive form as opposed to naturalism—which gave rise to the abstract forms and perspectives of the early twentieth century—Ghirlandaio fell from grace a second time. After all, he had made no discoveries about form or space, and he had little interest in drama. So Ghirlandaio-who to the nineteenth-century English critic John Ruskin was the master of painting in Quattrocento Florence-dwindled to minor significance in twentieth-century eyes. Gradually, however, his merits have become appreciated again. His art shows at least three important qualities: he had the freshest and most consistent color sense of any Florentine painter of his day, he was familiar with the achievements of contemporary architecture and was thus able to compose figures and architectural spaces into a complex unity, and, finally, in his rendering of human beings, his reserve sometimes veils his interest in representing character.

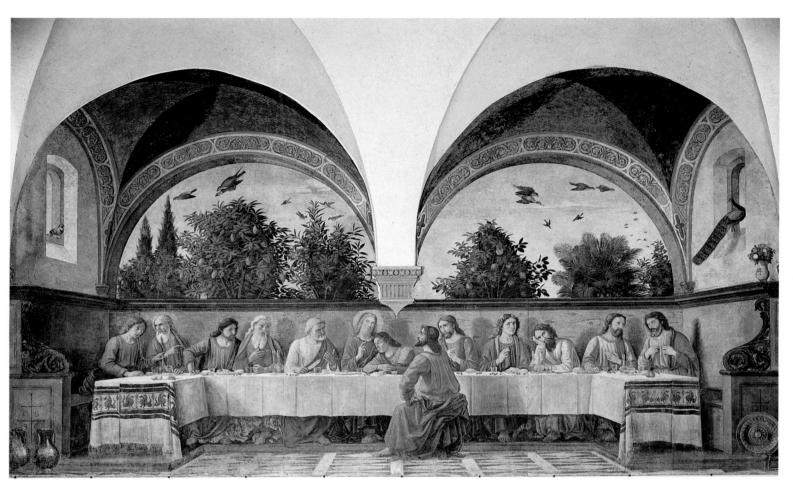

13.37. DOMENICO DEL GHIRLANDAIO. *Last Supper.* 1480. Fresco, 13 x 26 '6" (4 x 8.1 m). Refectory, Ognissanti, Florence. The face of Christ was repainted on a new patch of plaster by Carlo Dolci in the seventeenth century.

Born Domenico Bigordi, the son of a dealer in the golden garlands worn by wealthy women, our painter acquired his father's nickname, Ghirlandaio (garland maker). He was trained as a metalworker, and we are not sure just how or when he turned to painting. He was soon so popular that he could not work fast enough to satisfy the demand for his works. His *Last Supper* for the refectory of the monastery of Ognissanti (fig. 13.37) was dependent on Castagno—probably not the work at Sant'Apollonia (see fig. 11.11), which Ghirlandaio most likely never saw, but on Castagno's lost *Last Supper* for Santa Maria Nuova. Ghirlandaio's table is situated in an upper room with a view over citron trees and cypresses extending into a sky with soaring fal-

cons and pheasants. Nowhere is there a face as intense as those in Castagno's fresco, yet the subtle analysis of the inner life of the apostles is not to be underrated and it is clear from their reactions that Christ has announced the betrayal. The individualization of their responses may have inspired Leonardo's famous fresco of this same scene. The freshness of the color, the balance of the composition, and the naturalistic handling of the faces and drapery demonstrate Ghirlandaio's style.

Ghirlandaio's interest in including contemporary Florentine citizens is evident in his decorations for the Sassetti Chapel in Santa Trinita in Florence, dedicated by the wealthy banker Francesco Sassetti to the life of his patron,

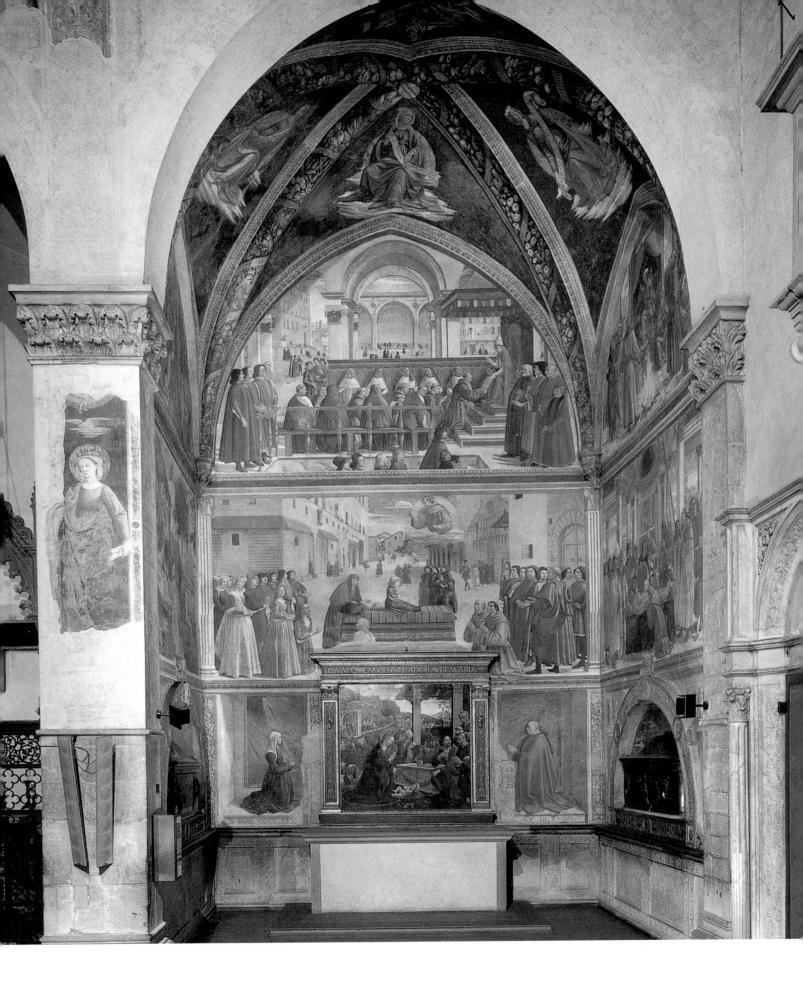

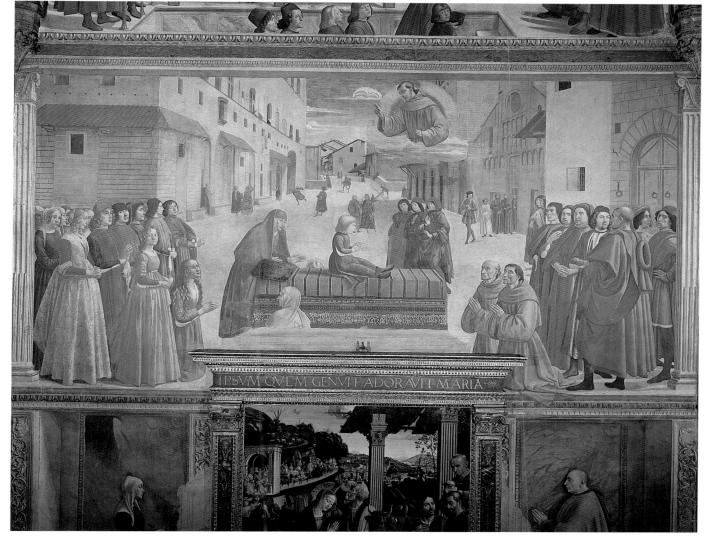

13.39. DOMENICO DEL GHIRLANDAIO. Resurrection of the Notary's Son (see fig. 13.38). 1483–86. Fresco, width 17'2" (5.25 m). Sassetti Chapel, Sta. Trinita, Florence.

The figure to the far right, looking out at us, is Ghirlandaio's self-portrait.

St. Francis (fig. 13.38). In the *Resurrection of the Notary's Son* (fig. 13.39), Sassetti's five daughters with their spouses can be seen to the left; the one looking out at the viewer is perhaps the youngest, Maddalena. In the group of male portraits to the right, Ghirlandaio is the figure who looks out toward us; next to him is probably his brother Davide. In the background of the scene, the boy who is the subject of the miracle can be seen falling out of a window in a large palace. In the center St. Francis blesses the child, who sits upright on his bier. The clarity of the narrative is reminiscent of the sim-

ple ex-voto scenes still painted today for Italian village churches to record the miraculous intervention of saints in the lives of the faithful. The choice of this unusual scene may be related to the death of Teodoro, the son of Francesco Sassetti and his wife, Nora Corsi Sassetti, in 1478 or 1479; shortly thereafter Nora Sassetti gave birth to a son who, in memory of his deceased brother, was also named Teodoro. Ghirlandaio sets this scene in the Piazza Santa Trinita, right outside the church where the chapel is situated. On the left rises the Palazzo Spini, on the right the Romanesque façade

Opposite: 13.38. DOMENICO DEL GHIRLANDAIO. Sassetti Chapel, Sta. Trinita, Florence. Frescoes of scenes from the legend of St. Francis; four sibyls in the vault; altarpiece with *Nativity and Adoration of the Shepherds* (see fig. 13.41). 1483–86. Size of chapel: 12'2" deep x 17'2" wide (3.7 x 5.25 m). Commissioned by Francesco Sassetti. The basalt tombs at the sides are attributed to GIULIANO DA SANGALLO

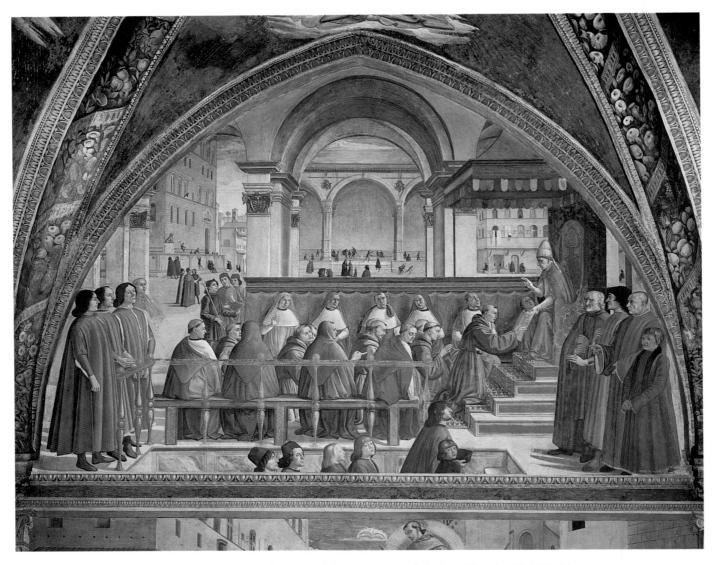

13.40. DOMENICO DEL GHIRLANDAIO. Confirmation of the Franciscan Rule by Pope Honorius III. 1483–86. Fresco, width at base 17'2" (5.25 m). Sassetti Chapel, Sta. Trinita, Florence

of Santa Trinita (later to be replaced with a Mannerist structure by Bernardo Buontalenti in the late Cinquecento), and in the distance is the old Ponte Santa Trinita, lined with houses (this was replaced, after the flood of 1555, with the monumental bridge designed by Bartolommeo Ammanati with Michelangelo's intervention; see fig. 20.29).

In the Confirmation of the Franciscan Rule (fig. 13.40), Ghirlandaio's determination to paint Florence into the background is even more obvious. The scene of the pope's approval of the order is eclipsed in the front by a grouping of Florentines and in the back by a view of the city's most important public square, the Piazza della Signoria. The four portraits to the right are Antonio Pucci, Lorenzo the Magnificent, and Francesco and Federigo Sassetti. The figures coming up the steps in the foreground are led by the humanist Angelo Poliziano, accompanied by Lorenzo's three sons: Giuliano is beside Poliziano, with Piero and Giovanni following behind.

In the background we see the Palazzo dei Priori (fig. 2.45) to the left and, full front in the background, the covered speakers' platform now known as the Loggia dei Lanzi (see fig. 1.2). Looking carefully, we can still make out a nail hole in the middle of the central opening. This reveals where Ghirlandaio's workshop attached the nail to hold strings to mark the orthogonals of the perspective scheme and swing some of the semicircular arches of the setting. Ghirlandaio's use of a Florentine setting has recently been related to the idea that republican Florence represented the idea of a "new Rome."

In the chapel's altarpiece, the *Nativity and Adoration of the Shepherds* (fig. 13.41), the Virgin adores the Christ Child, who is pillowed by a bundle of hay. Classical elements witness Ghirlandaio's fascination with antiquity. Two elegant square Corinthian piers, one bearing the date 1485, support the roof of the shed. The ox and ass look earnestly out and down over the manger, here a Roman sarcophagus whose inscription

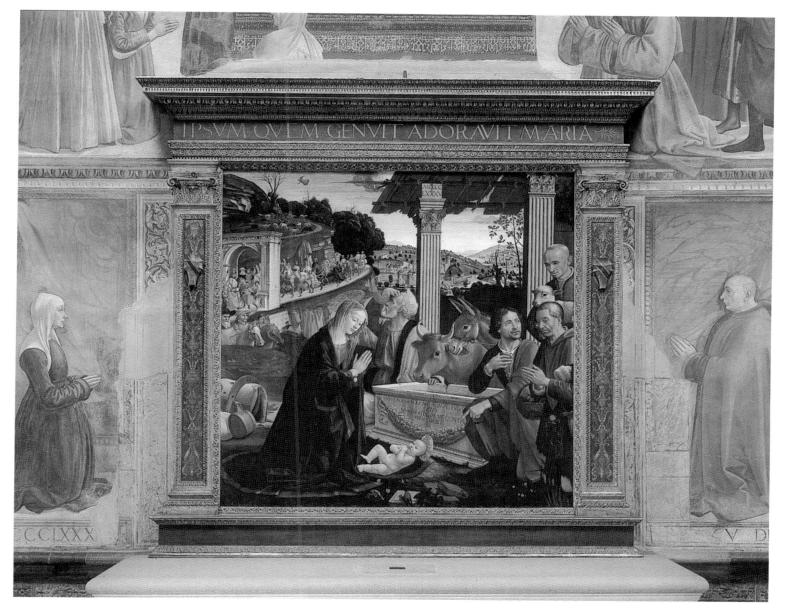

13.41. DOMENICO DEL GHIRLANDAIO. *Nativity and Adoration of the Shepherds*. 1485. Panel, 65³/₄" (1.67 m) square. Sassetti Chapel, Sta. Trinita, Florence. The frame is original. The donors to the sides are painted in fresco.

records a divine promise of resurrection for the former occupant. The Roman triumphal arch in the background bears an inscription of Pompey the Great.

The train of the Magi passes through the triumphal arch and moves toward the foreground. The naturalism of the ox and ass, of Mary, and above all of the three shepherds shows Ghirlandaio's study of Van der Goes's Portinari altarpiece (see fig. 13.34). Ghirlandaio must have admired this work for the honesty and completeness with which the tiniest detail was rendered. Following Van der Goes, he incorporates a vase of flowers into his foreground, complete with the Florentine iris. Although the types and poses of his shepherds come straight out of the Portinari altarpiece, the differences

are instructive. For all his absorption in Netherlandish naturalism, the artist is a Florentine, and he has chosen to assimilate the new detail into the overall monumentality, compositional harmony, and tonal balance of an Italian Renaissance altarpiece.

One of Ghirlandaio's major commissions was the series of almost twenty frescoes of the lives of Mary and John the Baptist that fills the Gothic chancel of Santa Maria Novella (see fig. 2.41); Ghirlandaio also designed the chapel's stained-glass windows. The patron was the wealthy Giovanni Tornabuoni, a relative by marriage of the Medici, and Ghirlandaio was under such pressure that he enlisted his whole shop in the undertaking, including possibly a thirteen-

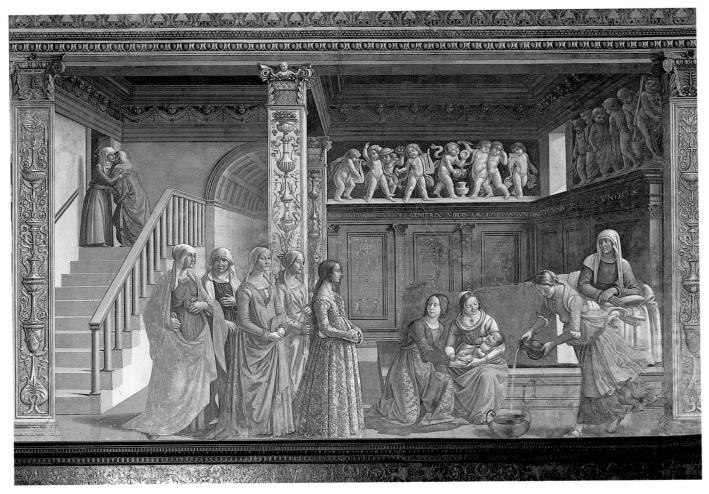

13.42. DOMENICO DEL GHIRLANDAIO. *Birth of the Virgin*. 1485–90. Fresco; width approximately 14'9" (4.5 m). Cappella Maggiore, Sta. Maria Novella, Florence. Commissioned by Giovanni Tornabuoni

year-old apprentice named Michelangelo Buonarroti. Although the execution, especially in some of the uppermost scenes, is occasionally hasty, the compositions are framed by a highly decorative Renaissance architecture closely connected, like that in the Sassetti Chapel, with the ideas of the architect Giuliano da Sangallo (see pp.346–49) and full of elaborate detail.

The *Birth of the Virgin* (fig. 13.42) takes place in a Giuliano da Sangallo interior. St. Anne reclines on a bed that is surrounded by paneling inlaid with ancient Roman designs, within which one can read both Ghirlandaio's family name and his nickname. The child is held by attendants, while another pours water for her bath. Giovanni Tornabuoni's daughter Ludovica stands dispassionately with four attendants, dressed in splendor that surely violated the Florentine sumptuary laws. The details, including the frieze of putti, are painted with Ghirlandaio's precision of observation, smoothness of surface, and perspective consistency.

Our farewell to Ghirlandaio might best be made with the portrait of an old man with a child, possibly his grandson (fig. 13.43). The subject has never been identified, although the deformed nose would seem to be easily traceable. A drawing by Ghirlandaio showing the old man on his deathbed was almost certainly a study for the painting. All the best qualities of his art appear here—the honesty of detail, studied with such respect that the deformity loses its ugliness; the inner gentleness of expression; the delicate light on the smooth surfaces; the brilliance of the color; the beauty of the landscape; and the strange rigidity of composition.

Botticelli, Pollaiuolo, Verrocchio, Ghirlandaio, and Filippino Lippi, together with innumerable imitators, bring to its close a century of great artistic fertility. As we will see, the new century found it necessary to make a new beginning and to move in a sharply different direction.

Opposite: 13.43. DOMENICO DEL GHIRLANDAIO. Old Man with a Young Boy. c. 1490. Panel, 24\sqrt{8} x 18\sqrt{8}" (62.7 x 46.3 cm). The Louvre, Paris. The disease that disfigured the old man's nose is rhinophyma.

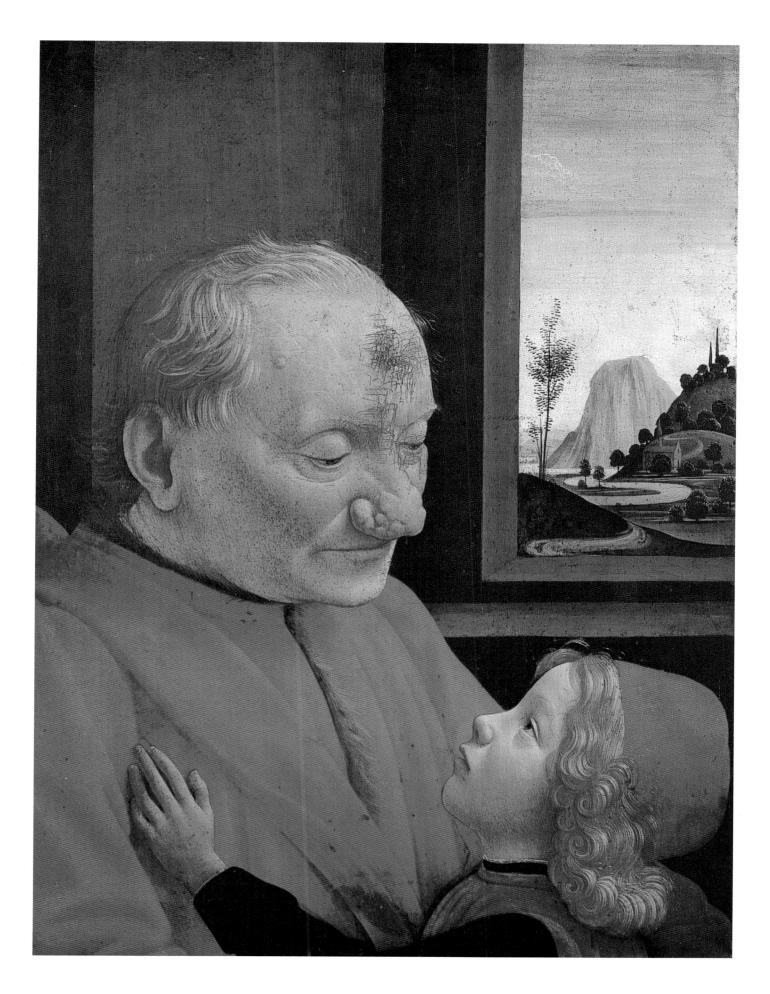

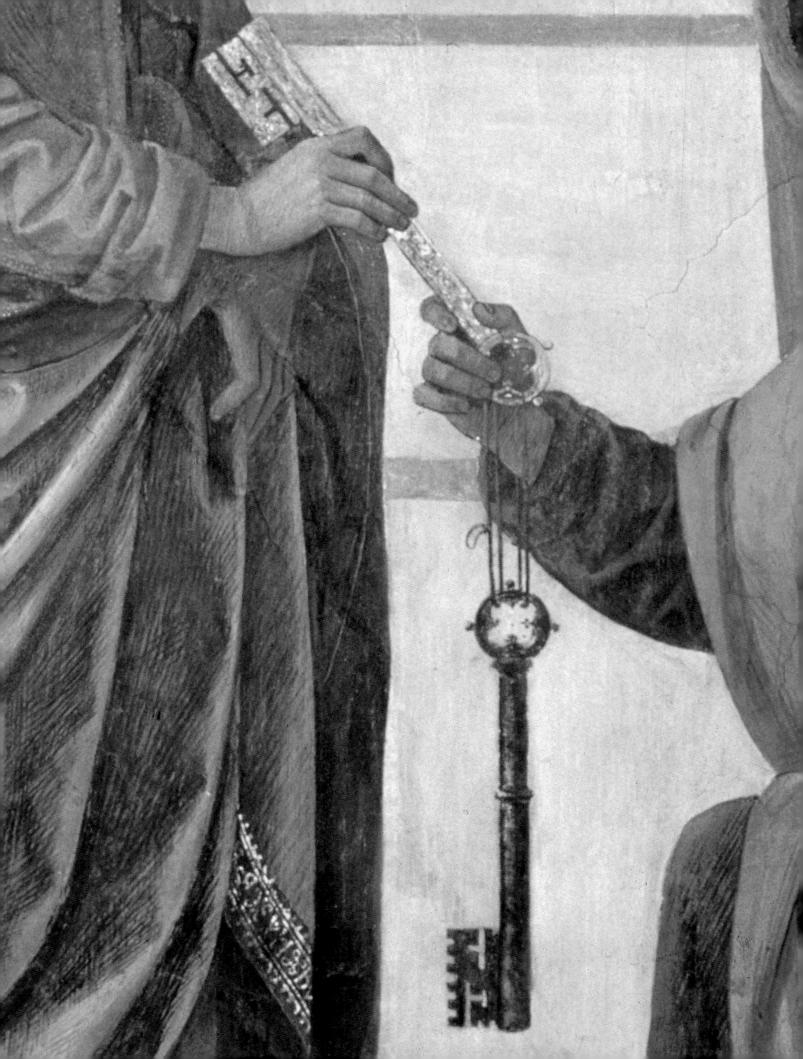

14.

THE RENAISSANCE IN CENTRAL ITALY

espite the impact of Florentine artistic innovations, central Italian cities outside of Florence's political control felt no obligation to imitate the artistic ideals of the Florentine Renaissance. The problems faced by most central Italian towns had little in common with the civic responsibilities considered important by the Florentines. If these states escaped absorption by Florence—whose territorial ambitions were aimed largely at protecting the Arno Valley—they fell under the control of other powers, chief of which, in the second half of the century, was the papacy. While the old communal form of government might linger on, most towns owed their allegiance to the pope. This was true to a lesser extent of some of the independent sovereigns of the region, such as the counts (later dukes) of Urbino and the lords of Rimini. A number of local schools flourished in the southern portion of Tuscany and in the regions now known as Umbria, Latium, and the Marches. The most important schools developed in the two most populous centers, Siena and Perugia.

Siena

By the early Quattrocento the bonds that formerly linked Siena with Florence had almost dissolved. Siena submitted to the temporary overlordship of Giangaleazzo Visconti of Milan, thereby outflanking Florence from the south. Against Guelph Florence, Siena supported the Holy Roman Empire and received visits from the emperors Sigismund and Frederick III. At the end of the Quattrocento, the city was under the rule of a dictator, Pandolfo Petrucci. Whether it was related to Siena's political affiliations or to other factors is uncertain, but Siena had no Masaccio or Brunelleschi. For Siena's artists perspective was a plaything rather than an instrument, they demonstrated little interest in the Early Renaissance and less in the High Renaissance, and antiquity made only a tardy and fragmentary appearance in their art.

One exception to this is the sculptor Jacopo della Quercia (see pp. 217–21), but even Jacopo worked as much in Lucca and Bologna as in his native city and, in the 1402 competition for the Baptistery doors, made an attempt to enter the world of Florentine art (see p. 199). We may wonder what the Florentine artists thought of Siena when, occasionally, one went there. The reliefs contributed by Donatello and Ghiberti to the baptismal font in the Cathedral of Siena (see fig. 7.23) were soon imitated by Sienese artists. Donatello returned in the 1450s, and a spark of his late style caught fire in the minds of local sculptors. In 1458, when the Sienese humanist Aeneas Silvius Piccolomini became Pope Pius II, he called Bernardo Rossellino to Siena for architectural projects there and in the Piccolomini village of Corsignano, rechristened by the pope with the name Pienza (see figs. 10.11, 10.12).

There are other contacts as well, but Siena in the Quattrocento went in its own, still largely Gothic direction, with the patrons or painters—or both—continuing to prefer pointed arches and gold backgrounds. There was a clear demand for copies of works by the leading Sienese Trecento artists or for variations on their much earlier works. One distinction was the Sienese painters' interest in nature. In Siena the open country began at the city walls, where one can still find vistas out over low ranges of hills to spacious views. Without the aid of Florentine science, the Sienese painters made discoveries about landscape that were denied to the more systematic Florentines. In his country town of Borgo Sansepolcro in southern Tuscany, even Piero della Francesca found much to learn from the Sienese.

Sassetta

Before he left Sansepolcro for Florence, Piero may have met Sassetta, who came there in 1437 to produce an altarpiece for San Francesco. Sassetta's painting was in position by 1444, a year before Piero accepted the commission for his own early work, the Misericordia altarpiece (see fig. 11.21).

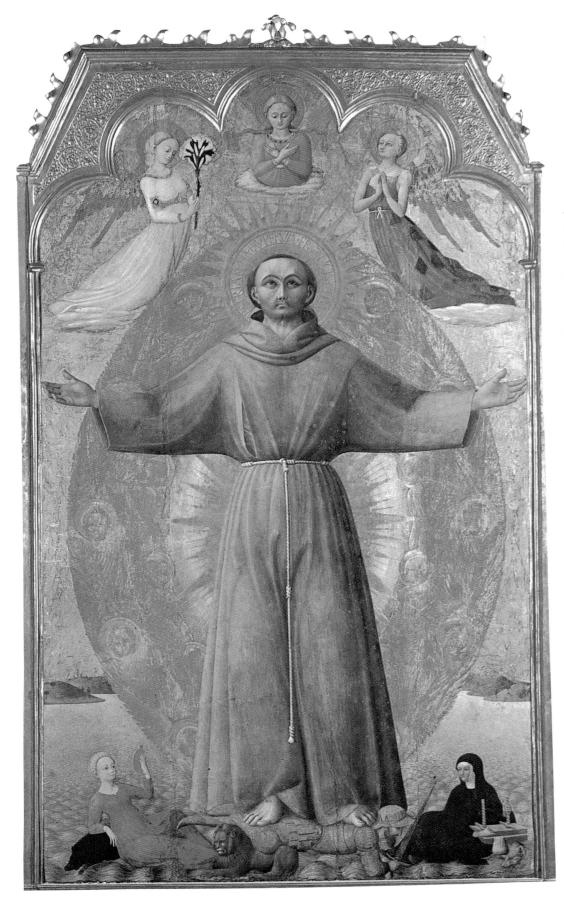

14.1. SASSETTA. St. Francis in Ecstasy, from the back of the Sansepolcro altarpiece. 1437–44. Panel, 80³/₄ x 48" (2 x 1.2 m). Berenson Collection, Villa I Tatti, Florence (reproduced by permission of the President and Fellows of Harvard College). Commissioned by the Franciscan Community in Sansepolcro for the high altar of S. Francesco, Sansepolcro. St. Francis stands triumphant over three vices: Lust, Wrath, and Avarice.

Stefano di Giovanni (c. 1400–50), called Sassetta for unknown reasons, may have come from Cortona. His double-sided Sansepolcro altarpiece, its elements now scattered, is his major work (figs. 14.1, 14.2); the front showed the *Enthroned Madonna and Child* between four saints in separate panels. Eight panels illustrating the life of St. Francis originally accompanied the *St. Francis in Ecstasy* on the back.

Seen in its original position in the restricted space of a monks' choir, the *St. Francis in Ecstasy* must have been impressive. St. Francis, extending his arms as he glides miraculously over the sea, stands upon Wrath, a crowned and bearded figure attended by a lion. To the left, an elegantly dressed woman leaning on a boar and looking in a mirror personifies Lust. On the right, Avarice, a shriveled old woman dressed in black and accompanied by a wolf, keeps her money bag in a rectangular press. Above the saint soar three dainty blond maidens who represent the Franciscan Virtues: Chastity with her lily, Poverty dressed in rags, and, in the center, Obedience with her yoke. The inscription on St. Francis's halo identifies him as the patriarch of the poor.

The saint's pose and expression convey both rapture and calm. The figure is modeled in broad, clear-cut masses by a high light source, creating an effect of weight and thickness, which leads to the suspicion that Sassetta must have studied the works of Giotto and Masaccio. The features are equally sculptural, but the head is curiously constructed. Following Byzantine tradition, Sassetta has used the bridge of the nose for the center of the face, drawing a circle described from this point to create the circles of the halo. The forehead and hair fall short, apparently to indicate that they are tilted back. The old Sienese linearism reappears in the wrinkles in the saint's forehead, temples, and cheeks, which are drawn as parallel curves, moving in elliptical, parabolic, or figure-eight patterns with dizzying effect.

Around the saint blazes a mandorla composed of red seraphim with interlocked wings, a traditional Trecento device. These have largely peeled away from the gold background, but their original effect must have been striking. That the gold represents the sky is suggested by the distant shore, with its bare hills and towers. There are echoes of Simone Martini and the Lorenzetti, but this should not blind us to the essential: that without applying Florentine perspective, Sassetta has established a convincing distant landscape and has set a solid, well-modeled figure within this space. These are Renaissance elements, and they place Sassetta in harmony with what was then going on in Florence.

In the smaller scenes Sassetta gives free rein to his imagination and interest in space. The *Marriage of St. Francis to Lady Poverty* (fig. 14.2) shows the saint stepping forward to place a ring on the finger of Poverty, who stands between Chastity and Obedience; as the three float off for celestial regions, Poverty glances back sweetly toward her bride-

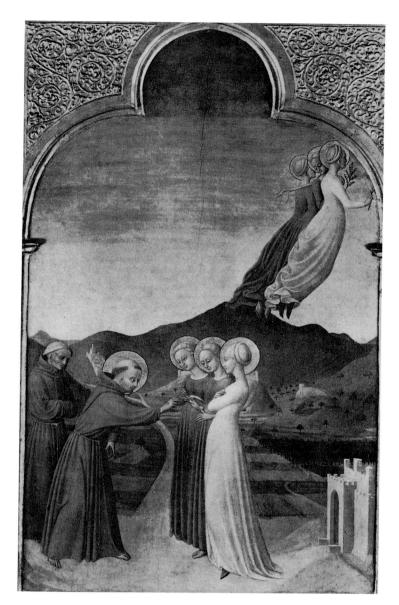

14.2. SASSETTA. Marriage of St. Francis to Lady Poverty, from the back of the Sansepolcro altarpiece. 1437–44. Panel, $34\frac{5}{8} \times 20\frac{1}{2}$ " (88 x 52 cm). Musée Conde, Chantilly

groom. The curves of the Virtues harmonize with the shapes of the cusped frame. At the lower right, Sassetta makes reference to Duccio in the tiny city that might have come out of a panel of the *Maestà* (see fig. 4.9). Between Francis and the Virtues a white road runs across the valley floor to branch into curves among distant ranges that are not just a backdrop; these mountains loom before us, their contours rippling in the evening air. Sassetta here has achieved a compelling sense of natural space.

Giovanni di Paolo

The slender bodies, delicate features, and small eyes of Sassetta's figures are further exaggerated in the works of his prolific contemporary Giovanni di Paolo (1403?-83). We do not know which of the two was the older. A baby named Giovanni di Paolo was born in Siena in 1403, but the name is a common one that translates literally as John, the son of Paul. Our artist was painting in 1420-not uncommon for a seventeen-year-old in the Renaissance, but unlikely. In the course of his long life he painted enough to fill two galleries in the Pinacoteca at Siena, as well as altarpieces scattered throughout the town and the contado (countryside) and many works found in collections throughout the world. Giovanni copied Ambrogio Lorenzetti and Gentile da Fabriano and purloined from Ghiberti, Donatello, Lorenzo Monaco, and Fra Angelico-perhaps at the request of patrons-but in the end his style is uniquely his own. In the Madonna and Child in a Landscape (fig. 14.3), Mary sits on a cushion in a flowered clearing surrounded by an orange grove. In the background a landscape, whose orthogonals refuse to converge, stretches off into the distance. Its rippling waters and checkered fields alternate at intervals with soft hills.

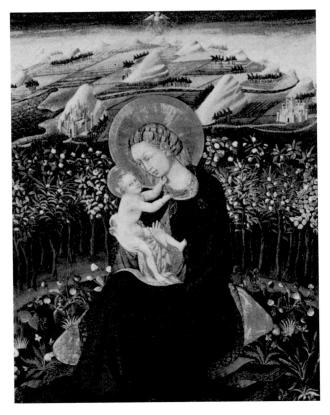

14.3. GIOVANNI DI PAOLO. Madonna and Child in a Landscape (Madonna of Humility). c. 1460s. Panel, 22 x 17" (56 x 43 cm). Museum of Fine Arts, Boston (Marie Antoinette Evans Fund)

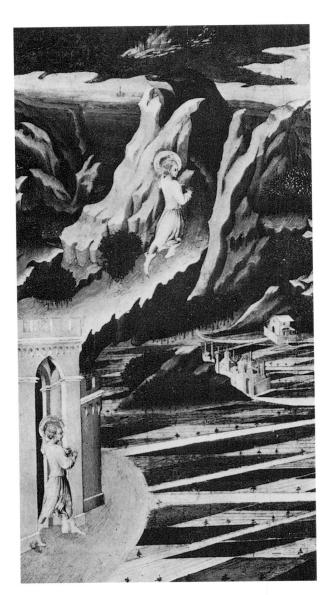

14.4. GIOVANNI DI PAOLO. St. John Entering the Wilderness, perhaps part of a reliquary cupboard (custodia). 1455–60. Panel, 27 x $14^{1}/4^{\circ}$ (68 x 36 cm). The Art Institute of Chicago (Mr. and Mrs. Martin A. Ryerson Collection)

Both the archaistic charm of Giovanni di Paolo and his magpie borrowings are evident in a series of panels of the life of John the Baptist. In the scene showing *St. John Entering the Wilderness* (fig. 14.4), two episodes are superimposed. First we see John stepping bravely out of a Sienese city gate that recalls Duccio and Simone Martini in the details of architecture and rendering. He gazes out on a cultivated plain made endless by Giovanni's characteristic use of orthogonals that never meet. Above, the world bursts into wild, flamelike mountains that are imitated from those depicted with vivid effect by Lorenzo Monaco (see fig. 5.13). The two episodes are separated by a tiny grove of distant trees, producing the effect of a sudden and disconcerting change in scale and in landscape character as the eye moves up the panel.

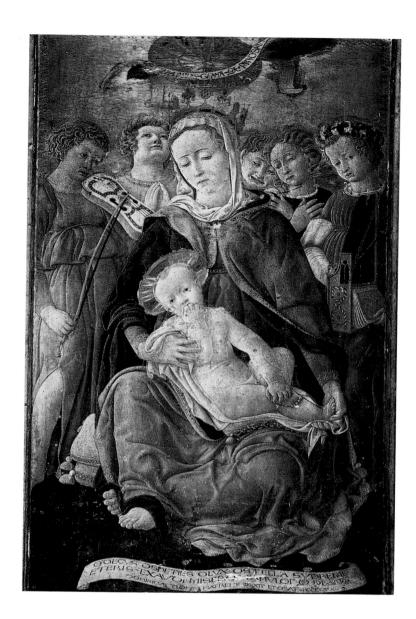

14.5. DOMENICO DI BARTOLO. *Madonna of Humility*. 1433.

Panel, 36⁵/₈ x 23¹/₄" (93 x 59 cm). Pinacoteca, Siena

Domenico di Bartolo

The first Sienese painter to capture some of the gravity and weight of the Florentine Renaissance is Domenico di Bartolo (c. 1400-47). The influence of Masaccio is apparent in his Madonna of Humility (fig. 14.5), which, judging by its modest size, was probably painted for a private patron. The representation of the Madonna seated low upon a cushion was first developed by Simone Martini in the 1330s; by the early Quattrocento it was widespread. Domenico has packed his picture with bulky, Masaccioesque figures that are firmly placed in space. But Domenico's Sienese linearism requires that every shape be surrounded by a sharp contour that negates the modeling that was so important in the Florentine Early Renaissance. The Christ Child stuffs fingers into his mouth, instead of grapes, and the angels, with their elaborate curls and solemn faces, have nothing to do with Masaccio's ragamuffins. The scroll (cartellino) in the foreground, which antedates examples by Paolo Uccello (see fig. 11.5), tells us that Domenico "painted and prayed to" this Madonna. This unexpected inscription suggests that the painting may have been intended for the artist's private use or, alternatively, that a patron or purchaser would not have been unhappy with the painter's devotions to the Madonna while he was painting her.

Domenico's major surviving achievement is his participation in a series of frescoes in the Pellegrinaio, a receiving ward in the Sienese Hospital of Santa Maria della Scala that was in use as a ward until recently (fig. 14.6). Our interest in Domenico's series is heightened by their unusual secular subjects, which deal with the charitable, civic, and medical activities of the hospital. The Gothic vaulting of the room determined the arched openings, through which we look, as if through windows, into the fifteenth century. The viewpoints are sometimes taken from within the rooms of the hospital and show decorations that are still in place today or even, in the case of the three-legged basin in figure 14.6, objects that still survive.

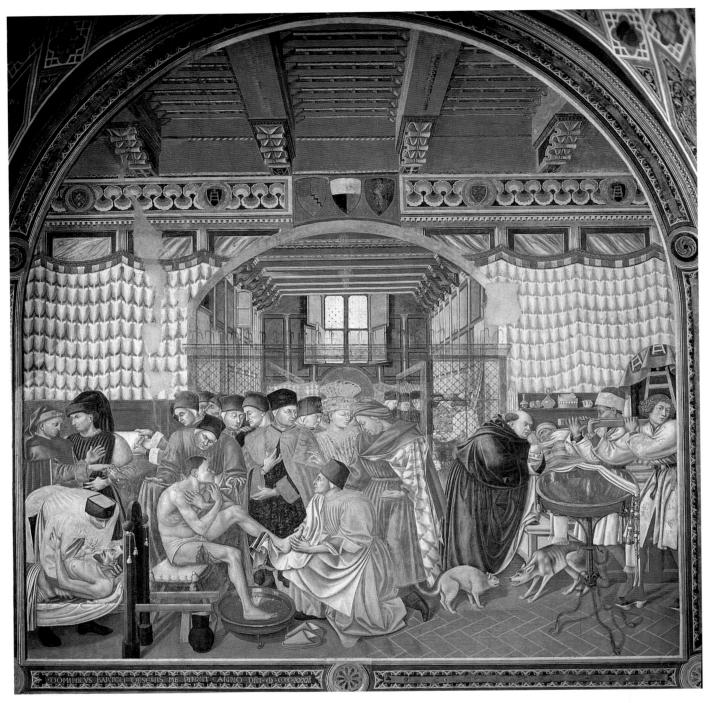

14.6. DOMENICO DI BARTOLO. Care of the Sick. 1440-47. Fresco. Pellegrinaio, Hospital of Sta. Maria della Scala, Siena

In their naturalism, the frescoes recall less the formally organized compositions of the Florentine Renaissance than the more freely arranged paintings of the Netherlands, with their wealth of imagery drawn from contemporary life. In the *Care of the Sick* (see fig. 14.6), Domenico displays both an interest in specific portraiture and a sensitive treatment of the nude figure. The unidealized bodies of the sick man being placed in bed and the wounded man being washed make them among the most naturalistic figures in Quattrocento painting.

Matteo di Giovanni

The Sienese painters of the second half of the Quattrocento absorbed the details of Renaissance architecture while ignoring its simple harmony and dignified proportions, and they transformed the linear grace of Botticelli to their own ends. In their isolation, they inverted Florentine inventions to achieve personal poetic and expressive effects. One of the most subjective of the late Quattrocento artists working in Siena is Matteo di Giovanni (1435?–95). He is best known for four

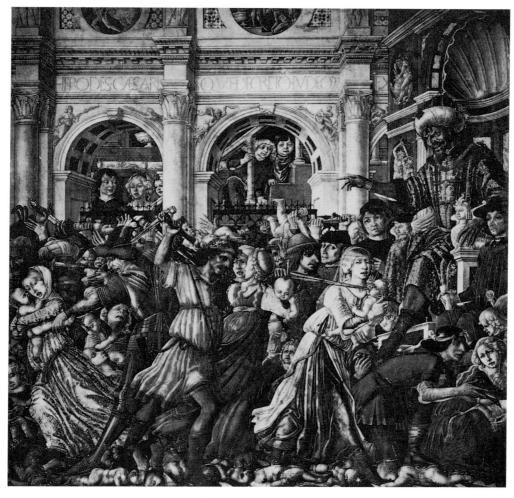

14.7. MATTEO DI GIOVANNI. Massacre of the Innocents. 1482. Panel, 95 x $94\frac{1}{2}$ " (2.4 x 2.4 m). Sant'Agostino, Siena

monumental compositions of the Massacre of the Innocents, three made for Sienese churches and one executed in inlaid stone for the pavement of the Duomo. It is possible that the popularity of this horrific subject at this time is due to the massacre of Christian children by the Saracens at Otranto in southern Italy in 1480. In Matteo's Massacre of the Innocents of 1482 (fig. 14.7), the arches and columns of Herod's palace suggest that the artist had visited Rome. He has left no foreground space, and every inch of Herod's hall is occupied by screaming mothers, dead or dying babies, and bloodthirsty soldiers. The marble pavement is covered with infant corpses. Impassive courtiers flank Herod's throne, but the gloating king is portrayed as a monster: one hand is outstretched to order the butchery; the other, like a claw, clutches the marble sphinx on the arm of his throne. Matteo draws our attention to the soldier near the right-hand column, who pauses in his bloody task to look straight at the spectator. Can this be Matteo himself, trapped within this holocaust of his own creation?

Vecchietta

The visits of the Florentine sculptors Donatello and Ghiberti and the intermittent presence of the Sienese Jacopo della Quercia provided the impetus for Renaissance developments on the part of Sienese sculptors. One of the most memorable of these, Lorenzo di Pietro, called Vecchietta (1412-80), was also active as a painter. He was involved at an early age in the work on Masolino's frescoes at Castiglione Olona (see fig. 8.27), picked up elements from the Florentine painters at midcentury, and executed one of the frescoes in the Hospital of Santa Maria della Scala. However, his most remarkable work is a Risen Christ (fig. 14.8) made for his own tomb chapel at Santa Maria della Scala. The bronze figure is harrowing in its insistence on such realistic details as the veins on the legs, arms, and torso; it betrays in exaggerated form the influence of the sinuous grace of Ghiberti and the dramatic expressiveness of the late Donatello. The artist's

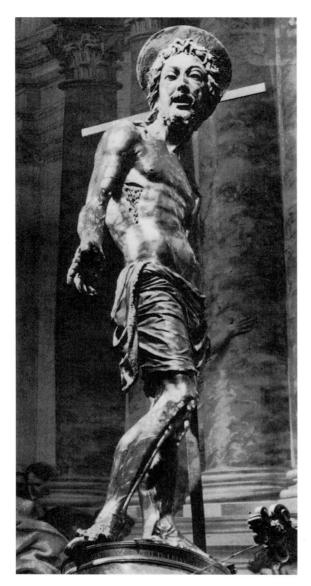

personal involvement is evident in the touching petition he addressed to the hospital officials asking that he be permitted to place this statue in his chapel. Perhaps this explains why in this case he rejected the stylistic archaisms and borrowings that generally restrained him in order to produce for his tomb a compelling witness of late Quattrocento religiosity.

Francesco di Giorgio

Francesco di Giorgio (1439–1502)—architect, sculptor, and painter—was the only Sienese Quattrocento artist except for Jacopo della Quercia to acquire a reputation outside of Siena; he worked at the courts of Urbino, Naples, and even Milan, where he became acquainted with and was influenced by Leonardo da Vinci. His huge *Coronation of the Virgin*

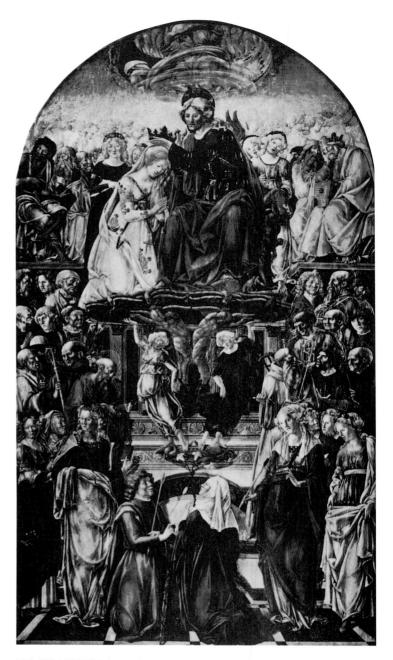

14.9. FRANCESCO DI GIORGIO. Coronation of the Virgin. 1471. Panel, 11' x 6'6" (3.4 x 2 m). Pinacoteca, Siena. Probably commissioned for the high altar of the Benedictine Monastery of Monte Oliveto Maggiore, near Siena

(fig. 14.9) has a spatial composition that is at first difficult to unravel. A marble floor recedes to steps that end at a wall articulated by pilasters and paneled in veined marble. The floor and the steps are crowded with saints, and prophets sit atop the wall. Angels and cherubs support a platform of cherub wings and heads that floats in midair, and on this platform Mary kneels to receive her crown from Christ. At the top, one sees a foreshortened figure of God the Father, feet first, surrounded by a spinning cloud based on Dante's description: the concentric circles around God represent the seven heavens; each has a planetary sign from the zodiac. At the

apex of the altarpiece, inside the highest circle, is a voluptuous array of female nudes based on Dante's statement that the final heaven, or empyrean, was *pieno d'amore* (full of love).

Francesco was a master of perspective, but he chooses to renounce it in this complex composition that represents a synopsis of the Christian universe, including nine hierarchies of angels and eight of souls. In spite of the Renaissance treatment of figures and drapery, the effect is that of an abstract schema, like Duccio's *Maestà*, which nobody in Siena was ever quite able to forget (see fig. 4.2). The mournful faces and staring eyes are as characteristic of Francesco's paintings as are the treatment of the drapery and hair and the poses of the figures. The dramatic and unexpected color scheme is dominated by reds, orange-reds, and several shades of bright blue.

Francesco's sculpture demonstrates a close acquaintance with the works of Donatello, Ghiberti, and Antonio del Pollaiuolo. His *Flagellation* relief (fig. 14.10), which was probably modeled and cast in bronze during Francesco's stay in Urbino in the late 1470s, provides a striking contrast to the quiet *Flagellation* by Piero della Francesca (see fig. 11.32),

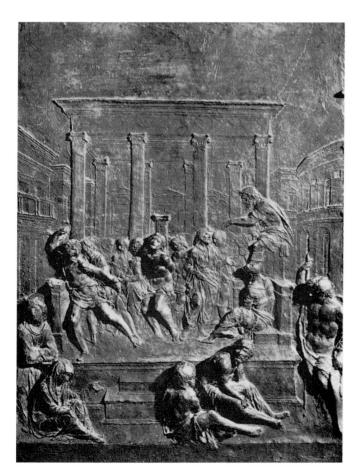

14.10. FRANCESCO DI GIORGIO. *Flagellation*. Late 1470s. Bronze, 22 x 16" (55.9 x 40.6 cm). Galleria Nazionale dell'Umbria, Perugia

also for Urbino. The spatial impression created by the central portico and flanking architectural masses goes back to Ghiberti's reliefs on the *Gates of Paradise* (see figs. 6, 10.15, 10.18). But the handling of the clay, left rough and sketchy after being cast in bronze, is derived from Donatello's late style. The tormented pose of Christ, with his head thrown back, and the wild movement of the yelling man who beats him suggest the poses and expressions of Pollaiuolo.

The buildings Francesco portrays are new in style, and so were those he designed and built. The palaces in the background of the Flagellation are conceived as single-story structures, raised on ground stories treated like gigantic podia and crowned by deep entablatures. Francesco has emphasized what is later to be known as the piano nobile (the second story, where the nobles lived), and on the left he has provided it with balconies. These two-story palaces, which contrast with the three-story palaces common in Florence and other Italian cities, seem to have been Francesco's invention. Bramante, the most important architect of the High Renaissance, was a citizen of Urbino and may have received the idea from Francesco. Second in importance is the emphasis given to the windows. No longer are they merely openings in a rusticated wall-in fact, rustication itself is abandoned. Now the windows are independent tabernacles with sharply projecting frames; some are composed of pilasters supporting a pediment and resting upon a continuous cornice. These, too, were taken up by Bramante, Raphael, Antonio da Sangallo the Younger, and Michelangelo, and they become a constant feature of monumental architecture through the Baroque period.

Some of the grandest constructions of the late Quattrocento and early Cinquecento were sanctuaries built to enshrine miracle-working images of the Virgin. Giuliano da Sangallo's Santa Maria delle Carceri in Prato (see figs. 12.27–12.29) was such a sanctuary, and so was Francesco di Giorgio's Santa Maria del Calcinaio (fig. 14.11), on a slope below Cortona. A miraculous image was found there in 1484, and the influx of pilgrims became so great that Francesco was commissioned to design a church to contain them. It was only completed in 1515, long after the architect's death, but the initial phases of construction seem to have proceeded rapidly, and there was already enough built to dedicate the building in 1485. The plan is a Latin cross (fig. 14.12) whose nave has three bays of diminishing depth to increase the apparent length of the church as seen from the entrance. This flexibility of proportions is made possible by Francesco's abandonment of the usual articulation of a church in terms of vaulted bays. His lofty two-storied hall is roofed by a barrel vault (fig. 14.13) and articulated by pilasters; the Corinthian order of the second floor, which is visually supported by flat unmolded strips on the lower floor, supports the same kind of heavy entablature and cornice seen in the sculptured palaces of his Flagellation.

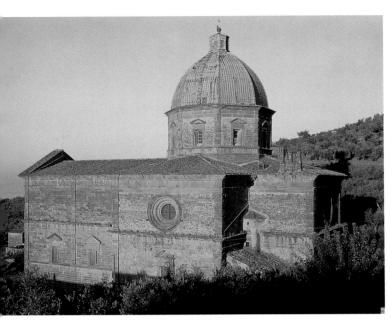

14.11. FRANCESCO DI GIORGIO. Sta. Maria del Calcinaio, Cortona. Begun 1484–85; completed 1515, by ANTONIO DA SANGALLO THE ELDER

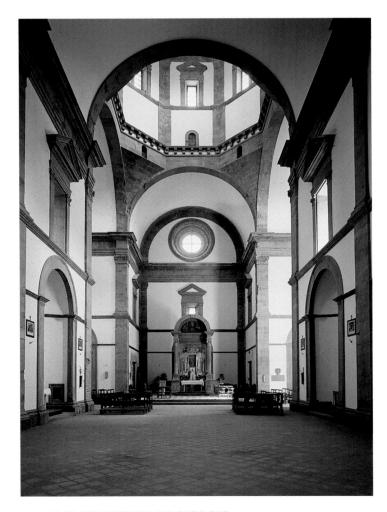

14.13. FRANCESCO DI GIORGIO. Interior, Sta. Maria del Calcinaio, Cortona

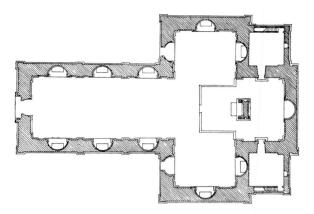

14.12. Plan of Sta. Maria del Calcinaio, Cortona

Although the ground-story niches suggest the arches of the characteristic nave arcade, their function seems to be to support the *piano nobile*, to which attention is directed. The tabernacle windows, with their sharply projecting pediments, are identical inside and out; they are the direct ancestors of the tabernacles that play so important a role in the architecture of Michelangelo (see fig. 18.11). All four ends of the cross are flat, the entablature runs unbroken around the church, and the plain white plaster walls and barrel vaults suggest a space larger than the one they actually enclose. The tabernacles in *pietra serena*, therefore, seem to be independent sculptural entities within the broad expanses of white wall.

In his paintings, more in his sculpture, and most of all in his archaeological drawings, theoretical investigations, and architectural creations, Francesco di Giorgio emerges from Siena into an all-Italian arena. A similar course, leading from provincial isolation to strong influence upon other centers, is followed by the Quattrocento School of Perugia.

Perugia

Since 1701 Perugia has been the capital of the region known as Umbria, but in the Middle Ages and Renaissance the name "Umbria" was little known, having lapsed with the dissolution of the Roman Empire. During ancient times Perugia had been an important Etruscan center. In the Middle Ages the communal government asserted itself against the duchy of Spoleto, and in the Renaissance Perugia came under the control of the Baglioni family while owing ultimate allegiance to the papacy. In a chronicle of 1478 by Giovanni Santi, the father of Raphael, Perugia is said to be in Etruria (Tuscany). The designation "Umbria" for the area of Perugia is therefore avoided in this book.

Perugia stands on top of a high hill, dominating a considerable section of modern Umbria and southern Tuscany. Although the city embellished itself with a number of splendid

buildings, and a number of Roman, Florentine, and Sienese painters worked at nearby Assisi, Perugia did not produce an important school of painting in the Duecento or Trecento. Its finest work of sculpture before the Quattrocento was the Fontana Maggiore, a fountain carved by Nicola Pisano and his assistants. But in the 1430s the presence of Domenico Veneziano in person and of a notable altarpiece by Fra Angelico (who may well have visited the town)—as well as the activity of Benozzo Gozzoli at nearby Montefalco in the early 1450s—seems to have awakened local artists to the achievements of Florentine art.

Perugino

The leading painter of the Perugian School was Pietro Vannucci (c. 1445–1523), who may have been born in Città della Pieve but is known today simply as Perugino (the Perugian). He brought the city from artistic obscurity to considerable influence and, as the teacher of Raphael, may be said to have had a hand in shaping the High Renaissance. Where Perugino received his training is not known, but in 1472 he is listed as a member of the Company of St. Luke in Florence. He may have worked with Verrocchio for a period, and he certainly ab-

sorbed Florentine notions of perspective and figure drawing, but he rapidly developed a distinctive style. He had little or no feeling for religious subjects—Vasari said he was an atheist—and often reduced his figures to routine patterns. Nonetheless, Perugino became the expert of a kind of spatial composition unknown before his day.

The principles of Perugino's spatial composition are evident in his first major work, Christ Giving the Keys to St. Peter (fig. 14.14), in the Sistine Chapel, part of the program commissioned by Pope Sixtus IV. Perugino has been credited with the supervision of the entire cycle because he painted not only this subject, which is of primary importance to papal claims, but other crucial scenes in the chapel and the frescoed altarpiece of the Assumption of the Virgin Mary, which would later be destroyed when Michelangelo painted his Last Judgment on the altar wall (see fig. 20.1). However, none of the painters called to Rome had had much experience with monumental frescoes and all were relatively young; the impression of consistency among the frescoes may result partly from supervision by the papal court and partly from the taste and common sense of the artists, who seem to have been willing to work together to assure the success of this pictorial undertaking in the pope's private chapel.

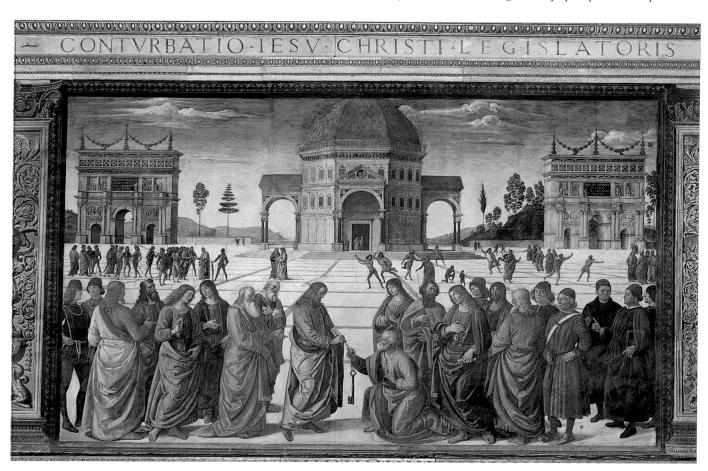

14.14. PERUGINO. Christ Giving the Keys to St. Peter. 1481. Fresco, 11'5½" x 18'8½" (3.5 x 5.7 m). Sistine Chapel, Vatican, Rome. Commissioned by Pope Sixtus IV della Rovere. Like Botticelli, Perugino had to lodge a complaint against the pope in order to be paid for his work in the chapel.

Perugino represents the moment when Christ gives Peter the keys to heaven and earth, and the structure in the center of the piazza is doubtless intended to represent the Church, founded on the "rock" of St. Peter. It is telling that this theme establishing the authority of the pope is opposite Botticelli's fresco showing the punishment of usurpers who tried to assume the role of Moses (see fig. 13.20). Notice too that the structures in Perugino's painting are in pristine condition, in opposition to the decayed structures painted by Botticelli. Perugino's fresco is flanked by triumphal arches, modeled on Constantine's arch in Rome, that bear inscriptions comparing the building achievements of Sixtus to those of Solomon. In the middle ground the scene in which Christ says "render therefore unto Caesar the things which are Caesar's" (Matthew 22:21) is shown to the left; to the right is the stoning of Christ, who, according to the Gospel of St. John, hid himself, then passed through the midst of his assailants.

The perspective of the piazza is constructed according to Alberti's system, although with larger squares than Alberti recommended, probably to avoid the visual complexity that would have resulted from using Alberti's squares for such a huge piazza. The figures and drapery masses are deeply indebted to Florentine practice, with echoes of painters and sculptors from Masaccio to Verrocchio, and the ideal church blends elements drawn from Brunelleschi's dome and the Florentine Baptistery (see figs. 3.33, 6.2). The cool precision of the contemporary portraits (fig. 14.15) is not excelled, even by Ghirlandaio.

Yet the fresco's effect of openness is strikingly un-Florentine and, for that matter, un-Sienese. Florentine spatial compositions are usually enclosed by the frame, by figures, or by architecture. Perugino allows the eye to wander freely through his piazza, which is filled with little but sunlight and air and which is open at the sides so that we can imagine its continued indefinite extension. No such immense urban piazza was ever built in the Renaissance; it would have been impractical and in bad weather intolerable. But in Perugino's painting it provides a sense of liberation, as if the spectator could move freely in any direction. The perspective is truncated by the distant building and the eye moves to the hills on the horizon, which substitute their gentle curves for the severe orthogonals of the piazza. The hills diminish and form what has been called the "bowl landscape" characteristic of the paintings of Perugino and his followers.

Perugino's figures are only superficially Florentine, for they stand with ease and an absence of the tension notable in the figures of Florentine painters. The weight is generally placed on one foot, the hip slightly moved to the side, one knee bent, and the head tilted—the figure as a whole seems to unfold gently upward, perhaps like the growth of a plant. Raphael was to adopt this S-shaped pose from Perugino, and it survived, in altered and spatially enriched form, to the final phases of his

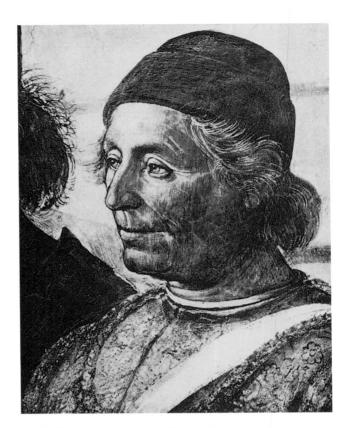

14.15. Head of a Man, detail of fig. 14.14

art. Perugino's main figures, like those of the other collaborators in the Sistine frescoes, occupy a shallow foreground plane, and the grace of their stance, united with flowing drapery and a looping motion, carries the eye almost effortlessly across the foreground from one figure to the next.

Perugino's Crucifixion with Saints (fig. 14.16), which probably dates from before his activity in Rome, shows influence from the Netherlands and, in particular, the style of Hans Memling. The triptych differs from Florentine representations of this scene in the absence of any strong emotion. Christ hangs calmly on the cross; Mary looks downward, St. John looks upward, and neither seems to betray a trace of grief, any more than does St. Jerome in the left panel or Mary Magdalen in the right. We are surprised, moreover, to notice that Mary Magdalen's pose is almost a carbon copy of John's-there is no difference between them, save for a slight change in the position of the clasped hands. Perugino seems to have made a pattern book of stock poses and to have repeated them even within the same picture, but this repetition of poses helps create the calm, lucid quality of Perugino's works. In the final analysis, the color of the painting is so cool and silvery, the finish so sensitive and exact, and the pervasive mood so poetic that we can accept the absence of emotion.

The fantastic rocks crowding the sky are characteristic of an eroded plateau in the upper Arno Valley, and Perugino must have studied these rock formations and the roads winding through them, one of which led from Florence toward Arezzo

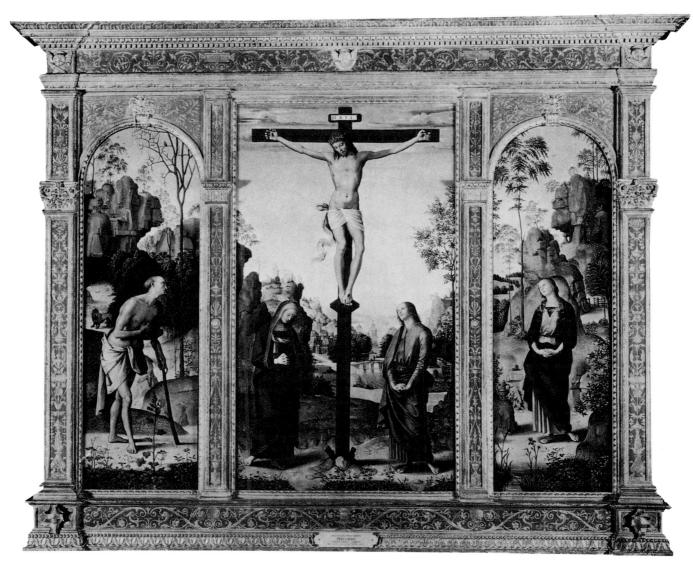

14.16. PERUGINO. *Crucifixion with Saints*. Before 1481. Panel, transferred to canvas: center, 40 x 22½ (101 x 56 cm); laterals, each 37½ x 12" (95 x 30 cm). National Gallery of Art, Washington, D.C. (Mellon Collection). Commissioned by Bartolommeo Bartoli, Bishop of Cagli and Confessor of Pope Alexander VI, and presented to S. Domenico, San Gimignano

and Perugia. The jagged profiles and sparse foliage against the sky are exploited for sheer artistic effect, as are the floating Scurves of Christ's loincloth, a motif probably borrowed from the Flemish painter Rogier van der Weyden. Much of the picture's effect is gained from the precision of detail—leaves, twigs, wildflowers, a castle or two—against the backgrounds of earth or sky.

As a portraitist Perugino also seems to have been influenced by Memling. His portrait of *Francesco delle Opere* (fig. 14.17) is the direct ancestor of portraits by his pupil Raphael, such as those of *Angelo Doni* and *Maddalena Strozzi Doni* (see figs. 16.47, 16.48). The subject is placed behind a ledge—a typical Netherlandish device—on which he rests his hands, one of which holds a scroll bearing the motto *TIMETE DEUM* (Fear God). The landscape is half-filled with an expanse of sea forming a distant horizon, over which rises the carefully observed

head, the hair streaming out naturally against the sky. This is a typical Perugino sky, graduated in aerial perspective from milky blue at the horizon to a clear, deep blue at the zenith. The balancing of mass and void, the harmonizing of the contours of the sitter with those of the sloping hills and feathery trees, and the sense of quiet and easy control that seems to emanate from Francesco delle Opere all mark a new stage in the development of portraiture.

Like all central Italian painters who made their reputations in the 1470s—save only Leonardo da Vinci—Perugino arrived at the threshold of the High Renaissance but did not cross it. The grand style emerged in Florence and developed in Rome, while in Perugia Perugino continued to paint his oval-faced Madonnas and serene landscapes. Ironically, Perugino outlived his pupil Raphael, one of the leading artists of the High Renaissance, by three years.

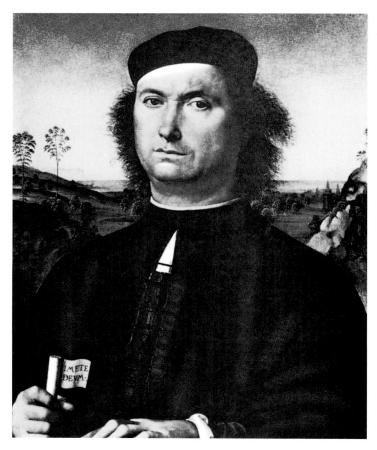

14.17. PERUGINO. Francesco delle Opere. 1494. Panel, 20^{1} /s x 16^{7} /s" (51 x 42 cm). Uffizi Gallery, Florence

Pintoricchio

The works of the Perugian painter Bernardino di Betto (c. 1454-1513), who is known by the nickname Pintoricchio, are impressive summaries of all the Quattrocento accomplishments in pictorial representation, combined with an interest in clear narrative and sumptuous decorative detail. The success of his work cannot be gauged by reproductions, even in color, because so much of their appeal depends on their large scale and the relation of the paintings to the spaces for which they were painted. Pintoricchio was Perugino's coworker in the Sistine Chapel frescoes, and he returned to paint an apartment in the Vatican for Pope Alexander VI, as well as chapels and ceilings in Roman churches. His largest work is the fresco cycle in the Piccolomini Library of the Cathedral of Siena (figs. 14.18–14.20; see also fig. 7), commissioned in 1502 by Cardinal Francesco Piccolomini to celebrate the life of his uncle, Pope Pius II. After the death of Alexander VI in 1503, Cardinal Piccolomini succeeded him as Pope Pius III, but lived to reign only ten days. Nevertheless, the fresco series financed by the Piccolomini heirs kept Pintoricchio busy until 1508.

The library was built to house the manuscripts assembled by Pius II (Aeneas Silvius Piccolomini), one of the most learned humanists of his age. After his election as pope, he poured the revenues of the papacy into this library. The frescoes narrate an embellished version of the career of Aeneas Silvius before and after his election. Their flattery contrasts with the salty memoirs of the pope, which, though long suppressed except in an expurgated version, furnish us with a vivid account of mid-Quattrocento events. The ten compartments are separated by painted pilasters with grotteschi decoration, while each individual scene is framed by illusionistic jambs and arches decorated with what seems to be red and white marble paneling. We seem to be looking through the arches of a gigantic loggia into scenes

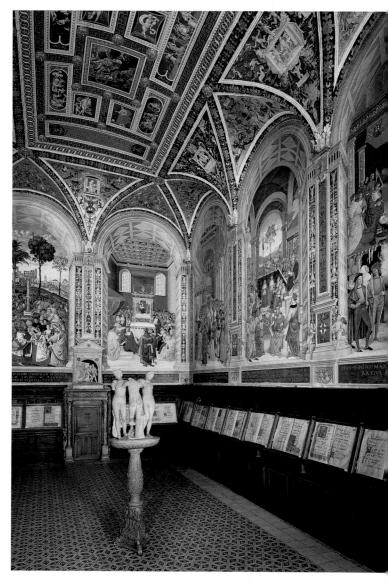

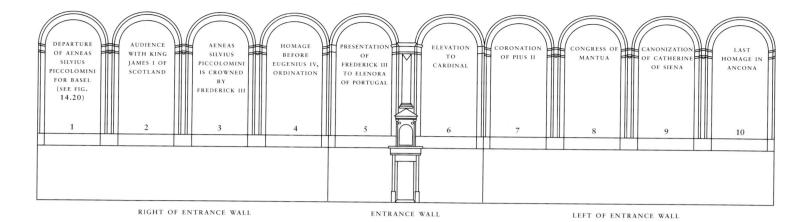

14.19. Iconographic diagram of the fresco program of the Piccolomini Library. Diagram by Sarah Loyd, after Roettgen

from Aeneas Silvius's life. The pageantlike incidents display a panoply of colorful costumes against fanciful architectural or landscape backgrounds, except when a recognizable setting was required by the narrative.

In one scene (fig. 14.20) Aeneas Silvius, as secretary to a cardinal, starts off from Genoa to the Council of Basel, at which his performance was so disloyal to the papacy that he had to do penance before Pope Eugenius IV. To the right we see ships at anchor in port, while at sea the cardinal's galleys are lashed by a storm. Genoa, of course, never looked like this; Pintoricchio has represented an Italian hill town, with a Romanesque church and a castle on top of the hill. But if his Genoa is derived from local experience, so is his storm. One of the earliest naturalistic storm scenes preserved to us, it is made convincing by the dark veils of rain, bent by the force of the wind, and the dramatic color of the thunderclouds.

While Pintoricchio was working on the library frescoes, he also designed a panel for the inlaid marble floor of the Duomo. The paving of the Duomo with narratives and allegories, including even an enormous Massacre of the Innocents by Matteo di Giovanni (see pp. 404-5), took more than a century and involved many artists and craftspeople. Because the Sienese had been unsuccessful in expanding their cathedral in size, they apparently decided to ornament it as richly as possible, and this unique floor is one of the results; while other cathedrals and churches might have floors with a few figures and many panels of abstract patterning made largely of marble fragments, the Sienese floor is almost completely filled with narratives and figures. Unfortunately, over the centuries many of the scenes have been worn away by the worshippers and visitors to the church. The theme Pintoricchio was assigned was The Allegory of

Fortune (fig. 14.21), a subject laden with the complex symbolism so popular with the humanists of the period. Who designed the program is unknown, but it meant that Pintoricchio had to combine a number of diverse allegorical figures, all executed in a naturalistic, Quattrocento manner, into a rather uncomfortable whole.

Melozzo da Forlì

Every now and then in Italian art, an innovative painter arises in a center that lacks a local school of painting. Gentile da Fabriano was such a case, as was Piero della Francesca and, a little later, Melozzo da Forlì (1438-94). Perhaps their isolation helped to make them among the most original and self-reliant of Renaissance artists. Forlì, the city of Melozzo's birth and early activity, is in the Romagna, a string of papal-dominated communes along and near the Adriatic, and not far from Ravenna, whose mosaics may have inspired the young Melozzo in the use of color and the combination of figures with architecture. His work was praised by Giovanni Santi, father of Raphael, before Melozzo's thirtieth year, as well as by other Quattrocento writers, but by the time Vasari published the first edition of his Lives in 1550, Melozzo had been so far forgotten that Vasari credited his Santi Apostoli frescoes to Benozzo Gozzoli. Today, Melozzo's detachment from the creative centers of Tuscany and central Italy and the limited number of his surviving works mean that he is often overlooked.

He began visiting Rome as early as 1460, and a few years later was active at the court of Urbino, where he worked for Federico da Montefeltro and must have come into contact with Piero della Francesca. Although Piero was certainly the dominant influence on his art, Melozzo's perspective interests seem to have been well established even earlier. Melozzo probably

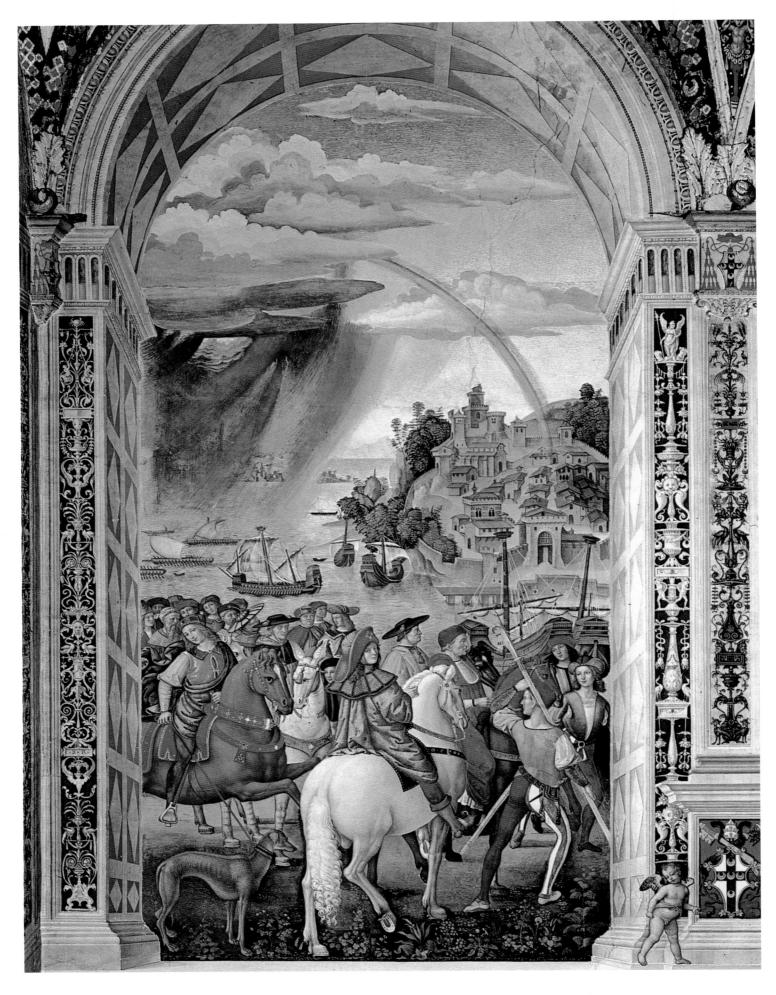

14.21. PINTORICCHIO. The Allegory of Fortune.
1505–6. Inlaid marble in diverse
colors; partially reworked by LEOPOLDO
MACCARI in 1859. ⚠ Cathedral, Siena.
Commissioned by Alberto Aringhieri,
Rector of the Cathedral.
This panel is in the nave, fourth from the entrance.
Vasari wrote that the inlaid marble floor of Siena
Cathedral was "the most beautiful... great and magnificent pavement ever made." To prevent
further damage, most of the inlaid marble floor panels
of Siena Cathedral are only visible for a
brief period of time each August.

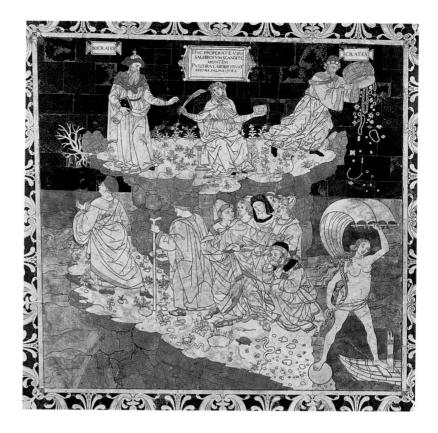

14.22. MELOZZO DA FORLÌ.

Sixtus IV della Rovere, His Nephews, and Platina, His Librarian. 1480–81. Detached fresco from the Vatican Library; transferred to canvas and now in the Pinacoteca, Vatican, Rome. 13'1" x 10'4" (4 x 3 m). Commissioned by Pope Sixtus IV della Rovere

encountered Alberti in Rome, and it is certain that he was familiar with his teachings. He must also have been impressed by Netherlandish art, particularly that of the Fleming Justus of Ghent, who was active at Federico's court. There is no record that Melozzo went to Florence or Siena—or even Mantua, where Mantegna was working—save for brief intervals. But Melozzo may have known about Mantegna's work through Ansuino da Forlì, who worked for a while with Mantegna in Padua.

In 1480–81, Melozzo was at work in the Vatican Library, which had been newly rebuilt and reorganized by Pope Sixtus IV. Most of his frescoes there have perished, but Melozzo's fresco of *Sixtus IV della Rovere*, *His Nephews*, *and Platina*, *His Librarian* was removed and transferred to canvas (fig. 14.22).

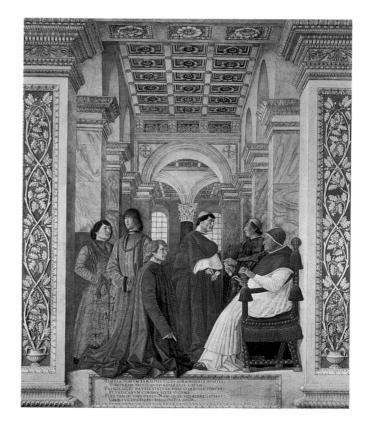

Opposite: 14.20. PINTORICCHIO. Departure of Aeneas Silvius Piccolomini for Basel. 1503−8. Fresco.

Piccolomini Library, Cathedral, Siena

It is the first surviving papal ceremonial portrait of the Renaissance (as distinguished from tomb effigies or from the portraits of popes disguised as their Early Christian predecessors in the paintings of Masaccio, Masolino, and Fra Angelico). The fresco once adorned the end wall of the library and was undoubtedly integrated with the decoration carried out by Domenico del Ghirlandaio and his brother Davide. Two painted piers that cast shadows admit us to an audience chamber in the Vatican, one no longer extant-if, indeed, it was not invented by Melozzo as a background for this painting. At the right sits the pope in a Renaissance armchair upholstered in velvet and studded with brassheaded nails. The four standing figures are portraits of his four nephews, including Cardinal Giuliano della Rovere, later to become Pope Julius II, in the center. Before him kneels the humanist Platina, the library's director, who points downward to a Latin inscription he composed to extol the pope's building achievements, including the library. To heighten the illusion, Melozzo allows the folds of Platina's cloak to overlap the frame.

The architecture is projected in perspective as if the eye of the observer were level with the pope's knee. The room, not large by Renaissance standards, is impressive in its simple masses and clear ornamentation. Square, marble-encrusted piers, culminating in heavily ornamented entablatures, support arches. Immediately above the arches rests the coffered ceiling. Through an arch at the end of the room we see a transverse chamber with an arcade and a similarly coffered ceiling. Rosettes, palmettes, acanthus, bead-and-reel, and other ornaments from ancient Roman architecture are picked out in gold. The entwined oak branches silhouetted against blue on the foremost piers refer to the coat of arms of the Della Rovere family, to which Sixtus IV and Cardinal Giuliano both belonged.

Melozzo avoids a ceremonial grouping, yet each person is motionless, each face firmly composed and staring directly ahead. Melozzo's substances are solid, his line definitive, his drapery forms crisp. These portraits relax only through the lyric beauty of Melozzo's color. The crimson of the papal cope, biretta, and chair contrasts with the vermilion of the cardinal's habit and with the violet, ultramarine, and blue-green in the other costumes. This colorful display is intensified by the coolness of the pearly marble piers and the sparkle of the gilded ornament.

Melozzo's grandest commission was an apse fresco of the Ascension for the Early Christian Basilica of Santi Apostoli in Rome. The commission may have been given to him by Cardinal Giuliano della Rovere, whose titular church, San Pietro in Vincoli, was not far away, but it has also been suggested that the project was paid for by Pope Sixtus IV. The remodeled basilica was consecrated by the pope in 1480, but there is no certainty that the decorations were complete

at that time. In the early eighteenth century the church was remodeled again, and Melozzo's fresco was destroyed, save for the central section and a dozen or so fragments. From these it is possible to gain some notion of how the composition must have looked. At the base of the apse stood a row of apostles, looking up. Above, a semicircle of angels playing musical instruments surrounded the central figure of the ascending Christ (fig. 14.23), who appeared in the middle of clouds and putti, his arms extended, his hair and beard floating in the breeze, his eyes gazing calmly downward. All the figures were painted as if seen from below, in the sharp foreshortening painters had been using since the days of Castagno and Uccello. But, as far as we know, this is the first time that a large-scale, monumental composition was seen from below in such a way that the mass of the building seemed to dissolve, creating the illusion that the figures exist in the air outside. Melozzo's composition inspired many ceiling painters, from Michelangelo, Raphael, and Correggio in the sixteenth century to the later painters of the Roman Baroque and Venetian Rococo.

Melozzo's idea was not wholly original. A vault is often termed *il cielo* (the sky) in Italian documents, and the association of the dome with heaven is the subject of an immense literature. The small dome over the altar of Brunelleschi's Sacristy of San Lorenzo in Florence is frescoed with the constellations at a specific moment, somewhat on the order of today's planetarium. Moreover, the Early Christian apse mosaic of Sts. Cosmas and Damian in Rome shows Christ walking toward us on sunrise-tinted clouds through an azure heaven, and it is even possible that a similar mosaic originally decorated the apse of Santi Apostoli. But the crucial step—the treatment of the dome or half-dome as a vision into space—was taken by Melozzo alone.

The central figure of Christ hints at the openness of Melozzo's lost composition, but the full effect of even this fragment cannot be experienced unless you hold the illustration about thirty degrees above your head and tilt it slightly toward you. Then the figure will appear to float on the clouds, as Melozzo intended. His insistence on solid form is as strong here as in the *Sixtus IV*, yet the winds of heaven themselves seem to blow through the composition.

As usual, the color is brilliant. The putti boast red and green wings, the white cloak and violet tunic of Christ glow against the sky, and the haloes are dotted with gold, achieving in fresco something of the sparkle of mosaic. As the official artist to Sixtus IV, Melozzo enjoyed the title of *pictor apostolicus* (apostolic painter). After his success as a painter of monumental frescoes, one wonders why his work is not to be found in the Sistine Chapel; none of the artists the pope called to Rome for that commission had as much experience.

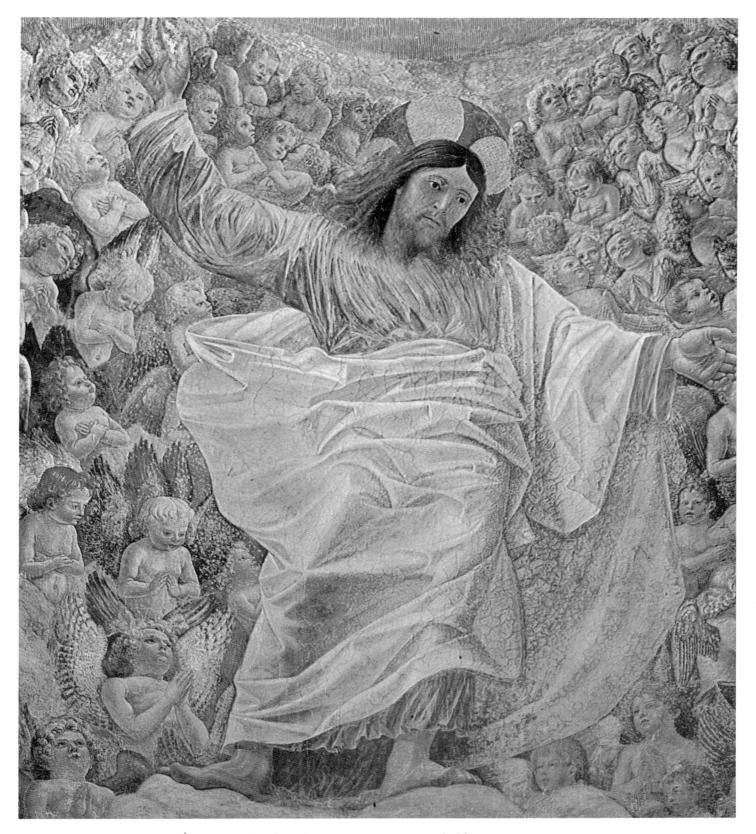

14.23. MELOZZO DA FORLÌ. *Christ in Glory,* from the *Ascension.* 1481–83. Detached fresco from the Church of SS. Apostoli in Rome; now in the Quirinal Palace, Rome. The patron may have been Cardinal Giuliano della Rovere or Pope Sixtus IV della Rovere

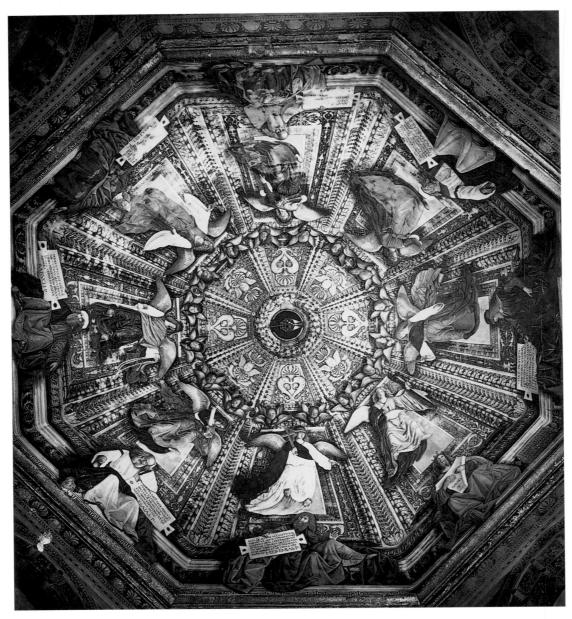

14.24. MELOZZO DA FORLÌ. Dome, Sacristy of St. Mark, Basilica of the Sta. Casa, Loreto. 1477–80(?). Fresco. Commissioned by Cardinal Girolamo Basso della Rovere

In any event, Cardinal Girolamo Basso della Rovere, one of Sixtus's nephews who appears in the group portrait, called Melozzo to Loreto, on the Adriatic coast, to decorate the sacristy of the Basilica of the Santa Casa (fig. 14.24). This remarkable building, a favorite project of the Della Rovere family, was being constructed by Giuliano da Sangallo to enshrine the holy house (Santa Casa) of the Virgin Mary, which tradition held had been brought from the Holy Land to Loreto by angels in the thirteenth century. Although Melozzo never completed the commission, which involved wall paintings as well, it is his only cycle that survives in its original spot unaltered, since a bomb in World War II obliterated his ceiling decorations for San Biagio in Forlì.

Melozzo has painted each face of the dome with ornamental paneling composed of his favorite elements—guilloches, acanthus, bead-and-reel, palmettes, and dolphins—converging on a central garland of Della Rovere oak leaves that embraces the cardinal's coat of arms. In front of this illusionistic structure Melozzo painted figures that seem to sit or float in the actual space of the sacristy. The painted cornice framing the dome is treated as a parapet, and on each segment sits a prophet holding a tablet with his name and a passage from his writings prophesying the Passion; the one exception is David, who holds his harp while his tablet is propped beside him on the ledge. Above each prophet hovers an angel holding one of

the instruments of the Passion; above the angels, as a kind of repetition of the garland of oak leaves, is a circle of sixwinged seraph heads. Melozzo even exploits such details as the soles of the angels' feet, shod or unshod, seen from below, and makes the angels' wings cast shadows on the painted architecture of the dome (fig. 14.25). As a result, it is easy to believe that Melozzo's figures are sitting or floating above your head. The drapery glows with Melozzo's usual brilliance of color, and every face and lock of hair are painted with his customary firmness. In 1484 Melozzo returned to Forlì, possibly because of the death of Sixtus IV. His connection with Rome and with monumental painting on a grand scale was never resumed.

The Laurana Brothers

In the late Quattrocento, Urbino was an important cultural center; this chapter closes with the work of two Slavic brothers whose sculpture and architecture played an important role in establishing the city's artistic significance. Both were born in Dalmatia, an area along the Adriatic coast that had been colonized by Venetians and was open to the influences of Italian culture.

Francesco Laurana (c. 1420–1503), the sculptor, moved from one dynastic court to another and was responsible for

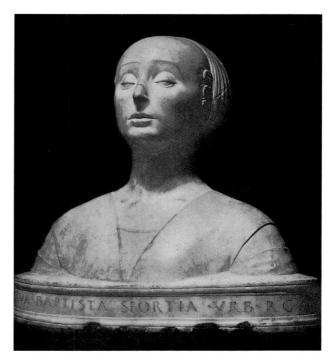

14.26. FRANCESCO LAURANA.
Battista Sforza. c. 1473. Marble, height approx.
20" (51 cm). Museo Nazionale del Bargello, Florence.
Perhaps commissioned by Federico da Montefeltro

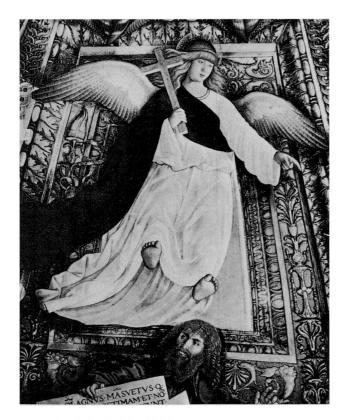

14.25. Angel, detail of fig. 14.24

the only surviving Quattrocento triumphal arch—that of Ferdinand of Aragon in Naples. His portrait bust of Battista Sforza, countess of Urbino (fig. 14.26), whom we have already met in Piero della Francesca's profile portrait (see fig. 11.34), may serve as typical of Francesco's ideals of elegance. This serene head has much in common with the heads in Piero's Arezzo frescoes (see figs. 11.26, 11.28) in Francesco's insistence on geometric or quasi-geometric volumes and clear contours. It owes little to Florentine sculpture of the period (see fig. 12.19). The transitions from shape to shape seem sharply simplified but are, in reality, rich and subtle.

After an extended search for an artist "learned in the mysteries" of classical architecture, in 1468 Federico da Montefeltro announced that he could find no one in Tuscany, "fountainhead of architects," and appointed Francesco Laurana's brother Luciano (d. 1479) as chief architect of his enormous unfinished palace. Luciano had probably already been at work on the project for two years, for he had sent a model for the building from Mantua in 1466. Luciano is only one of several architects listed in the Urbino records as working for Federico, however, and it is hard to distinguish who might have designed what. One of the most impressive spaces of the Palazzo Ducale is its

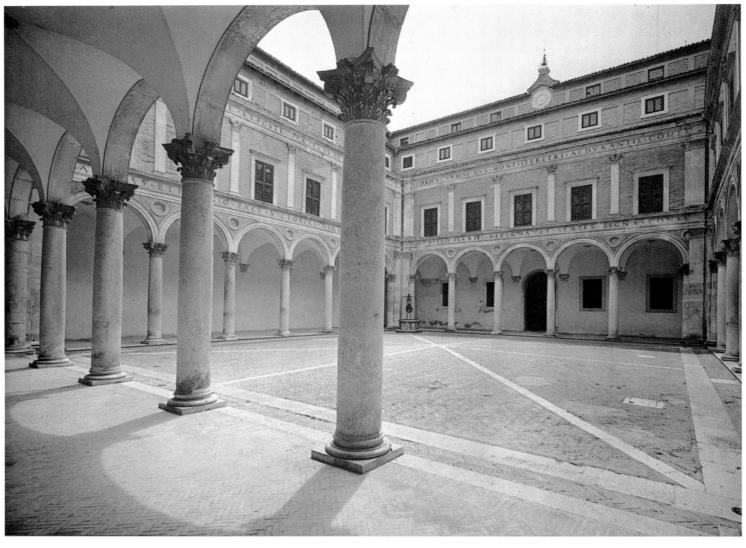

14.27. LUCIANO LAURANA. Courtyard, Palazzo Ducale, Urbino. c. 1467–72 and later completed by FRANCESCO DI GIORGIO. Commissioned by Federico da Montefeltro. What we are unable to show you here are the interior rooms (with the exception of the *studiolo*, fig. 14.29), which have fine examples of doors, windows, consoles, and fireplaces decorated with exquisite carvings in the Renaissance style.

courtyard (fig. 14.27), the construction of which can be dated during the years of Luciano's activity; it is therefore generally assumed that he was its architect.

In contemplating the design of the courtyard, we must mentally strip away the two upper stories, added later, and imagine that the structure ends with the cornice of the second story. Thus reduced, the courtyard emerges as among the most harmonious constructions of the Renaissance. Luciano has adopted the proportional scheme of Brunelleschi, for each bay of the lower floor is an exact square articulated by semicircular arches. The second-story windows are two-thirds the height and one-third the width of each bay. But Luciano avoided some major Florentine difficulties. First,

he managed to unite both stories with a single scheme, rather than allowing a solid second story to weigh down upon an open arcade. Second, he turned each corner in a way that completes both corner arches instead of having them come to rest on the same capital, in the uncomfortable way we find in Florentine courtyards (see figs. 6.19, 12.23). He solved the first problem by giving the second story an order of Corinthian pilasters that harmonize with the Composite columns of the arcade and by setting these stone pilasters against a wall of tan brick that is continued in the spandrels of the arcade. The columns, pilasters, entablatures, and windows are set off against brick to give the Palazzo Ducale the appearance of an open framework, an

effect unprecedented in Renaissance architecture. The second problem necessitated even greater ingenuity. Luciano decided to treat each face of the courtyard as if it were a separate façade, complete in itself. He therefore terminated each side of the arcade and *piano nobile* with superimposed pilasters.

Whether or not Luciano's solutions are fully consistent with the doctrines of Alberti, they would probably have pleased him. Certainly he would have enjoyed—and possibly did-the two friezes ornamented with inscriptions extolling Federico's virtues in handsome capital letters in a style derived from ancient Roman monuments. As compared with the verticality and density of Florentine Renaissance architecture, the columns, pilasters, windows, and even the letters of the inscriptions are widely spaced, emphasizing that the dominant direction of the courtyard is horizontal. The skill with which the intricate problems of form and space are solved, and the consequent effect of harmonious calm, mark a determined step in the direction of High Renaissance architecture. Bramante, born in Urbino in 1444 and therefore twenty-four years old at the time Luciano was appointed to his historic task, found his own artistic origins in this building, and the young Raphael also walked through these perfect arcades.

In all probability we should look to Urbino for the origin of two panels, in Urbino (fig. 14.28) and Baltimore (not illustrated), that show piazze bordered by palaces and centering around monuments of a more-or-less classical nature. A number of ingenious solutions, none wholly convincing, have been suggested to explain the purpose of these panels. While the execution of the Urbino panel has been attributed to Piero della Francesca or a close fol-

lower, the designs of both panels have been assigned to Luciano Laurana. The architecture resembles that of the Palazzo Ducale at Urbino, but the best support for the theory is the characters in the ruined inscriptions at the upper left and right in the Urbino panel, which are Slavic, and probably Old Church Slavonic, written in Cyrillic character. They are, therefore, doubtless by a Slav and not an Italian.

The three-story palaces are built on the same principle of open framework filled in by screen walls as the Palazzo Ducale, and the arcaded façades of both palaces at the right terminate, as in the courtyard of the Palazzo Ducale, before reaching the corner in order to avoid corner columns. The general feeling of openness in the proportions and spacing is like what we find in the Palazzo Ducale and quite opposed to the tensions of Florentine architecture in general and Giuliano da Sangallo's in particular. Some of the ideas are unprecedented, such as the rows of pediments crowning some of the palaces, and the entire cityscape clearly represents the kind of civic center that the Early Renaissance wanted to build but could never achieve save on the small scale of Pienza (see fig. 10.11).

The round building in the center is more perfect in its simplicity than most of the centralized structures built during the Renaissance. The small upper-story windows correspond perfectly to Alberti's desired "temple" illumination (see p. 272). The lantern is capped by a crystal orb surmounted by a faint cross. The building was surely intended to represent an Albertian "temple," which at the center of a city always dominates the law court, the three-aisled basilica with no religious insignia visible at the right. This ideal temple may have inspired the Tempietto by Bramante (see fig. 17.9).

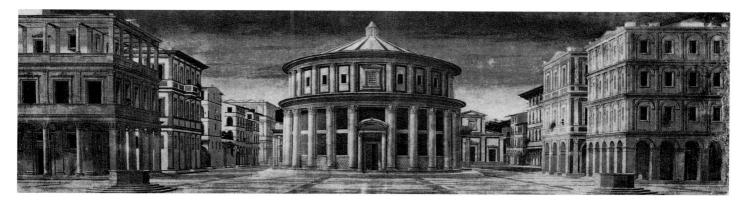

14.28. LUCIANO LAURANA (design attributed to; perhaps painted by PIERO DELLA FRANCESCA). *View of an Ideal City*. Third quarter of fifteenth century. Panel, 23 5/8 x 78 3/4" (60 x 200 cm). Galleria Nazionale delle Marche, Palazzo Ducale, Urbino

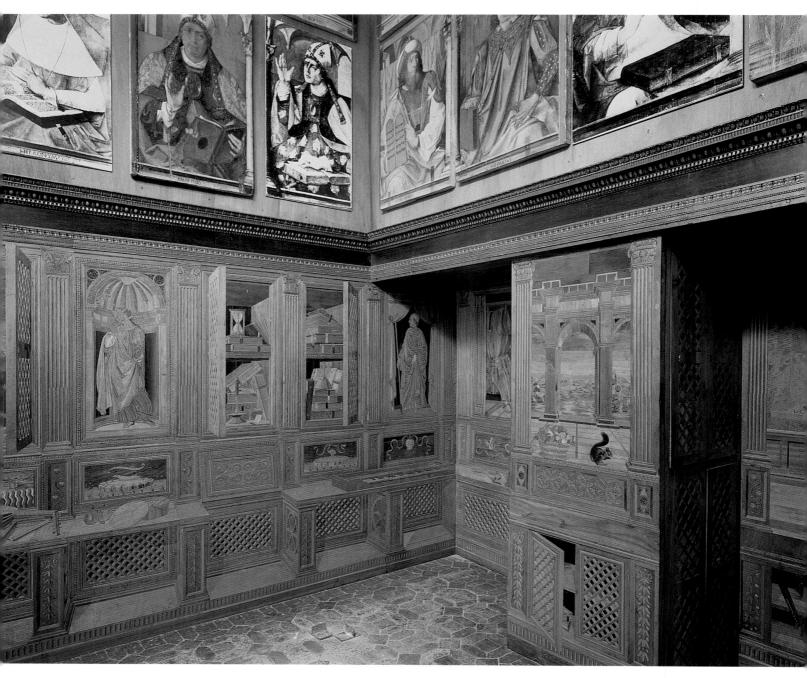

14.29. GIULIANO DA MAIANO. Studiolo of Federico da Montefeltro,

Palazzo Ducale, Urbino. 1470s.

Intarsia, height of intarsia 7'3" (2.2 m). Federico had a library of ancient, medieval, and Renaissance texts that numbered over one thousand volumes. The upper portion of this room was hung with twenty-eight paintings of famous learned men painted by Justus of Ghent and Pedro Berruguete, seen here in reproductions mounted in the *studiolo*. Federico's *studiolo* from his palace at Gubbio is now displayed at the Metropolitan Museum of Art in New York City.

A more stable society under autocratic rule was required for the realization of the kind of ideal city shown in the Urbino panel, which had to await the later sixteenth century and found its full fruition only in the Baroque. Architectural perspectives, however, were also characteristic of *intarsie*, the panels of inlaid wood used in the Quattrocento and Cinquecento to decorate small rooms and choir

stalls. This chapter concludes with the *intarsia* decoration of Federico da Montefeltro's study in Urbino (figs. 14.29, 14.30), where his manuscripts were kept and where he read—standing—at a desk from which he could look out through marble arches to the blue mountains of his domain. The unknown designer of the *intarsie* certainly worked in harmony with Luciano's architecture and possibly in part

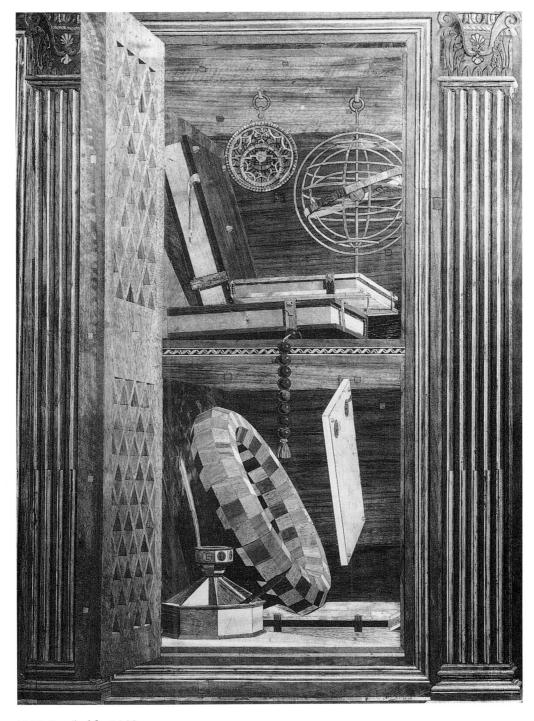

14.30. Detail of fig. 14.29

from his designs or suggestions. As in many *intarsia* schemes (see fig. 12.20), the decoration simulates cabinets and niches; on the lower level, with its latticed compartments, one door appears to be open to show the contents. Then comes a zone of ornaments, including the symbols of the duke, then a framework of pilasters, between which one looks into niches with statues, into cabinets with books,

candle, and hourglass, into a cupboard filled with the duke's armor, and into an architectural perspective with a distant view of mountains and lakes. This decoration offers a glimpse of how the intellectual refinements of an ideal life were concentrated within the confines of a tiny chamber, in an exquisite decoration executed with consummate illusionistic skill to please a Renaissance prince.

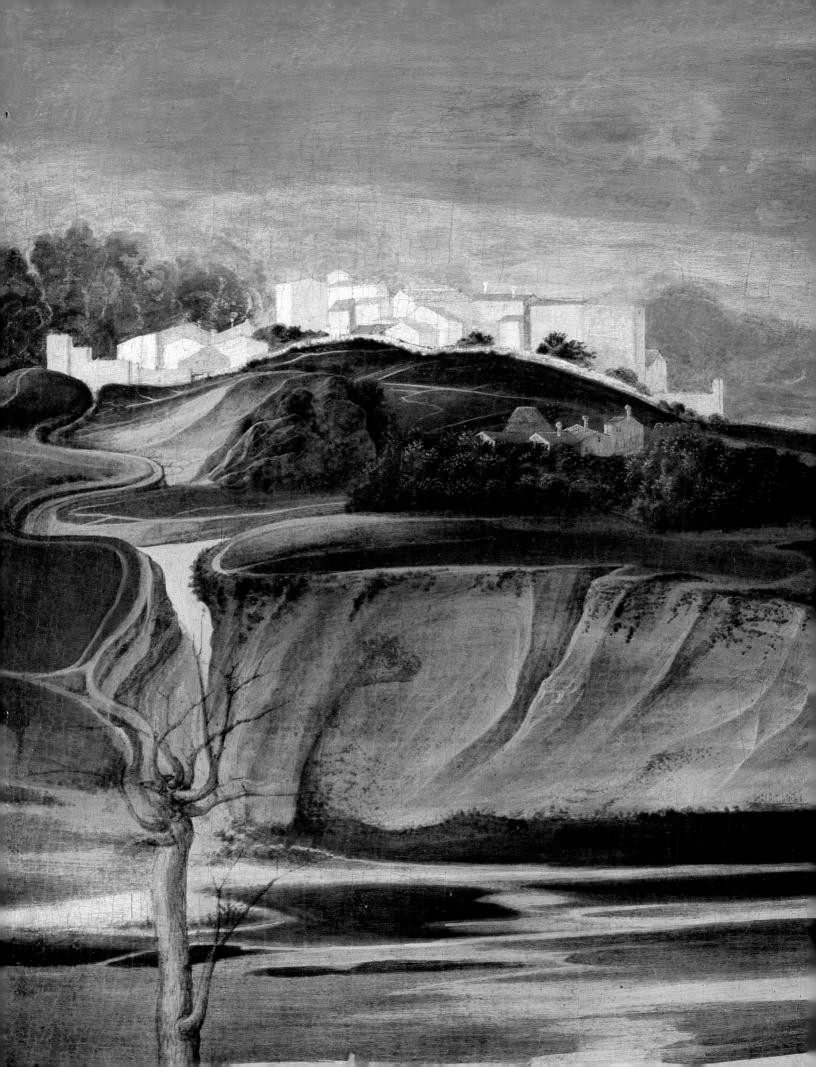

15.

GOTHIC AND RENAISSANCE IN VENICE AND NORTHERN ITALY

he Po Valley—an area that includes the cities of Bergamo, Verona, Vicenza, Cremona, and Pavia, among others-had been transformed politically and socially during the Trecento by the rise of tyrannies (see p. 170). During the Quattrocento these centers were often the scene of flourishing court life and artistic activity. The most splendid of the smaller courts was at Mantua, under the Gonzaga family, and at Ferrara, ruled by the Este. Milan, under the Visconti dukes and later under their relatives the Sforza, became one of the richest and most powerful principalities in Europe, able to attract important and well-known artists. At the other side of the northern Italian triangle, Venice was beginning to turn its attention to the Italian mainland, largely because the loss of its outposts and commerce to the Ottoman Empire forced the city to look toward Europe for trade. At this point it began to take control of inland bases, in part to protect new trade routes over the Alps. Padua, Treviso, Vicenza, and Verona all became subject cities, and in 1498 the Lion of St. Mark—symbol of Venetian authority—appeared on the ramparts of Bergamo, from which, on clear days, soldiers could glimpse the distant Cathedral of Milan. There were conflicts with the French conquerors of Milan at the end of the Quattrocento, and in the early Cinquecento the League of Cambrai, which included every major power in Western Europe, arrayed itself against Venice, but the city survived, maintaining its land power and much of its maritime empire until Napoleon finally disbanded the Republic in 1794. Among the smaller northern Italian states, only Mantua and Ferrara were able to keep their independence throughout the Renaissance, probably because they were buffer states for both Milan and Venice. The flowering of Venetian Renaissance art dates from the period of Venetian continental expansion.

In the early Quattrocento, Lombard naturalism had an electric effect when imported to Florence by Gentile da Fabriano (see p. 223–27). But in general it was Florentine artists

who migrated northward. Padua and Venice were visited by Paolo Uccello in 1421, Fra Filippo Lippi in 1433–34, Andrea del Castagno in 1442–43, Donatello from the early 1440s to the 1450s, and others. During the Quattrocento, the Renaissance was still largely a Florentine import, and only in the works of Domenico Veneziano did Venetian ideas and inventions have any lasting impact on Florentine art. But before the end of the Quattrocento, Venetian painters would begin to develop a style that would gain for Venice a special importance in the history of painting.

Pisanello

The tradition of northern Italian naturalism continued, after Gentile's death, in the work of his associate and follower Antonio Pisanello (before 1395–1455). Although from a Pisan family, Pisanello was born in Verona. As a young man, he worked with Gentile on frescoes, now lost, in the Doge's Palace in Venice, and after the latter's death he continued Gentile's work in Rome. Pisanello seems never to have painted in Florence. He made medals for several northern Italian princes and seems to have had a close relationship to the Este family, dukes of Ferrara.

Compared with contemporary Florentine art, or even with Pisanello's northern Italian Trecento predecessors, the fresco of *St. George and the Princess* (fig. 15.1) seems static; people and animals do not even look at each other. But the fresco—or what is left of it, since much of the ornament was painted *a secco* and has peeled away—is a tour de force of naturalism. Pisanello's animals come out of the Lombard tradition; his sketchbooks record the textures of fur and feathers and the details of animal structure (fig. 15.2). In *St. George and the Princess*, the hunting dogs and the horses pawing the earth are more compelling than the human figures. From Gentile, Pisanello takes the combination of front and back views of horses (see fig. 8.2), but his more powerful horses are in the tradition of Avanzi (see fig. 5.19).

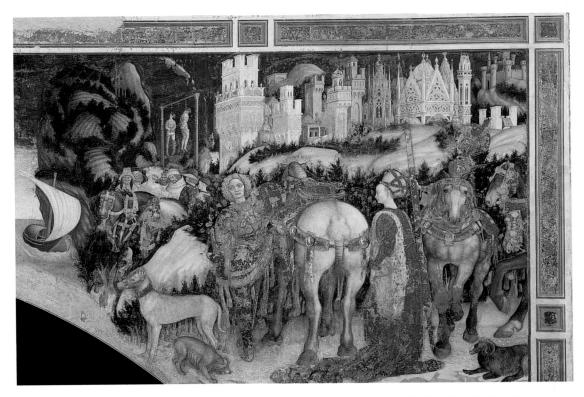

15.1. ANTONIO PISANELLO. St. George and the Princess. c. 1437–38. Fresco, $7'4" \times 20'4" (2.23 \times 6.2 \text{ m})$. Pellegrini Chapel, Sant'Anastasia, Verona

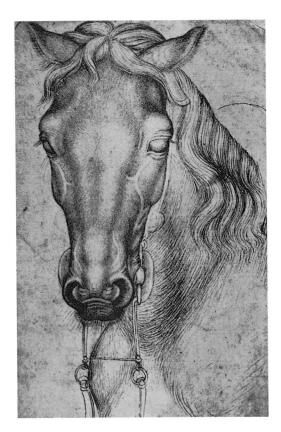

15.2. ANTONIO PISANELLO. Study of the Head of a Horse. c. 1437–38. Pen, $10^{7/8}$ x $7^{3/4}$ " (27.6 x 19.7 cm). Cabinet des Dessins, The Louvre, Paris

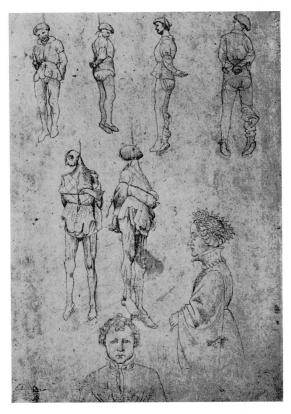

15.3. ANTONIO PISANELLO. Study of Hanged Men. c. 1433. Pen over metalpoint, $11\frac{1}{8} \times 7\frac{5}{8}$ " (28.3 x 19.4 cm). British Museum, London

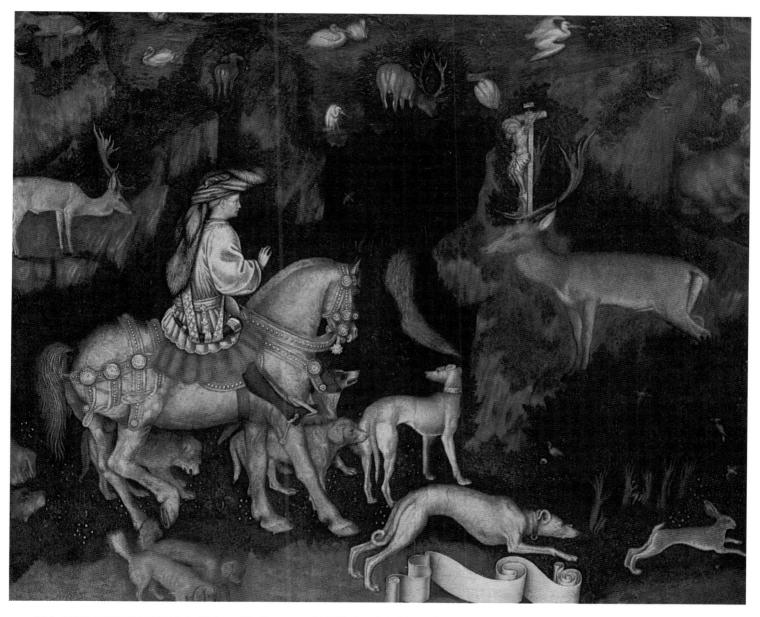

15.4. ANTONIO PISANELLO. Vision of St. Eustace. c. 1440(?). Panel, 21½ x 25¾ (54.5 x 65.5 cm). National Gallery, London. Incised gold leaf is used for the saint's garments, and raised plaster covered with gold decorates the horse's harness, the hunting horn, and the saint's spurs.

Pisanello's elegantly dressed people—especially the princess with her towering headdress and sleeves sweeping the ground—are reminiscent of his watercolor designs for costumes, while beyond stretch low hills and the towers, domes, and spires of a northern Italian city. At the left are uplands divided into fields and farms, then the sea with a ship under sail; before the city gates two partially decomposed corpses hang from a gallows, probably an indication of justice in practice. The soldiers in the middle distance show Asian facial types that may have been observed from the Mongol or Tartar slaves that were not uncommon in Italy at that time. Many of Pisanello's drawings for the fresco survive, including animal studies and renderings of the corpses (fig. 15.3). When the fresco was in good condition, the effect of animals and figures

must have been impressive, for the drawings suggest that they were precisely drawn, beautifully shaded, and convincingly projected in depth. Pisanello seems to show no interest in Florentine perspective, and in this case he seems to have made no effort to achieve a unified space. Yet a perspective drawing by Pisanello survives that demonstrates his control of the Florentine formula for spatial recession. It seems that he is more interested in filling his fresco with the variety of the natural world. Perhaps the only real difference between Pisanello and his Florentine contemporary Paolo Uccello is the former's unwillingness to make the world conform to patterns imposed upon it. In detail, their paintings are sometimes strikingly similar.

Pisanello's animals take over the panel (fig. 15.4) that probably represents the *Vision of St. Eustace* (or the similar

legend about the less well-known St. Hubert). While hunting, Eustace was converted to Christianity when a stag appeared with the crucified Christ between his antlers. The legend refers to Psalm 42, "As the hart panteth after the water brooks, so panteth my soul after thee, O God." Eustace, dressed in courtly fashion, lifts one hand in mild astonishment, but his horse snorts, rears back, and paws the ground. The forest setting provides a background against which the artist silhouettes the animals and birds that he apparently found more interesting than the miracle that was his subject. There is a second stag at the left, while a third drinks from a stream enjoyed by swans, cranes, and pelicans, one of whom is in flight. A bear inhabits the shadows toward the upper right, and at least three varieties of hunting dogs crowd around the saint's horse. One hound sniffs at an offended greyhound, while a second greyhound gives chase to a hare. The text planned for the scroll in the foreground was apparently never added; whatever Pisanello intended—his signature, a religious text, a dedication from a patron—is unknown today.

Early Quattrocento Painting in Venice

One of the first important Venetian painters of the early Quattrocento is Jacobello del Fiore (d. 1439), who signed the huge triptych representing *Justice with Sts. Michael and Gabriel* (fig. 15.5) for the Doge's Palace in Venice in 1421. A rich Gothic frame encloses an enthroned Justice holding a sword and balanced and flanked by Venetian lions. In the left wing St. Michael slays a rather inoffensive dragon; to the right Gabriel bears a lily, as if on his way to the Annuncia-

tion. This unusual surviving example of a civic picture would almost certainly have been located in a chamber where judgments and prison sentences would have been determined and/or announced. There are lingering elements of Gentile's art, especially in the raised stucco modeling of the gilded portions, but Jacobello here demonstrates little interest in Gentile's naturalism.

In 1444 Antonio Vivarini (c. 1418-76/84), together with his brother-in-law Giovanni d'Alemagna ("from Germany," d. 1450), both from the island-city of Murano near Venice, signed and dated a large altarpiece of the Coronation of the Virgin (fig. 15.6); such collaborations are not unusual in the Renaissance. Here Gothic, Byzantine, and Renaissance elements blend in a strange amalgam. Saints and prophets are seated in tiers like choir stalls, as if heaven were the apse of a gigantic church. Rows of angels bring the altarpiece to a domelike top. The entire center of the structure, from the checkered marble pavement to the apex of the animated dome, is filled with a fantastic throne containing Late Gothic motifs and vaguely Byzantine columns with foliated capitals. Between the columns and around them, infants (probably the Holy Innocents, the babies killed at the command of Herod) carry the symbols of Christ's Passion. Between the spiral columns of the upper stories of the throne, the back of which is also formed by angels, God the Father blesses Christ, who crowns his mother, while the dove of the Holy Spirit hovers between them. At the bottom right, St. Luke's doglike bull cuddles beside his master, who exhibits with pride his "portrait" of the Virgin Mary in a Venetian Gothic frame. Such examples provide us with rare evidence about how paintings of the time were framed. The painting of the faces and the handling of light and shade suggest that Antonio and Giovanni had studied the works made by Florentine visitors to

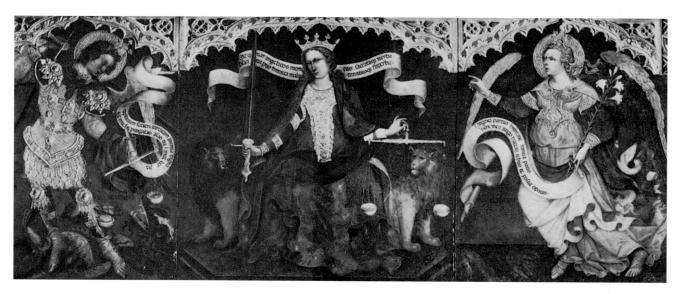

15.5. JACOBELLO DEL FIORE. Justice with Sts. Michael and Gabriel. 1421. Panels: center, $82 \times 76^{1/2}$ " (2.1 x 1.9 m); left, $82 \times 52^{1/2}$ " (2 x 1.3 m); right, 82×64 " (2 x 1.6 m). Accademia, Venice

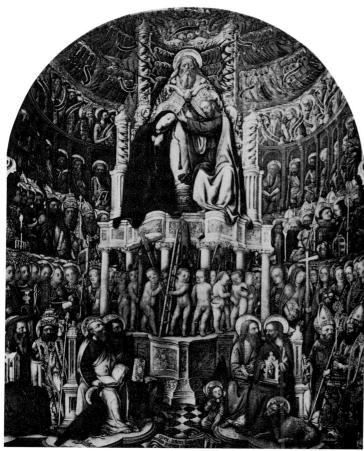

15.6. ANTONIO VIVARINI and GIOVANNI D'ALEMAGNA. Coronation of the Virgin. 1444.
Panel, 90 x 69¹/₂" (2.3 x 1.8 m), S. Pantaleone, Venice

Venice. The Vivarini family and its pupils remain a conservative current in Venetian painting through two generations and even into the sixteenth century.

Jacopo Bellini

The sequence of great northern Italian artists starts with Jacopo Bellini (c. 1400-70/71) and continues with his two sons, Gentile (1429-1507) and Giovanni Bellini (c. 1430-1516), and his son-in-law Andrea Mantegna (1431-1506). Jacopo got his start under Gentile da Fabriano, which is probably why he named his oldest son Gentile. At first sight Jacopo's work may seem uninteresting. His Madonna of the Cherubim (fig. 15.7) shows a lingering trace of Byzantine remoteness and rigidity, but a closer look discloses that Jacopo understood certain Renaissance principles. The parapet on which he has placed the Christ Child's cushion, Mary's elbow, and a book is convincingly projected in space, as is the book. There are Byzantine echoes in the gold pigment used for highlights-a last remnant of the old gold striations-but these do not obscure the artist's firm control of form. The draped bodies turn in space, and light

shimmers on the folds which behave like cloth. The short curls on the Christ Child's head are delicately rendered.

Highly regarded by northern Italian poets and writers of his time, Jacopo was in Ferrara in 1441 working for Lionello d'Este, but the Madonna of Humility with Donor (Lionello d'Este?) (fig. 15.8) has been dated somewhat earlier. The Gentilesque elements in the picture are evident, if softened by Jacopo's interest in painting silky drapery folds. This Virgin of Humility, seated low on a cushion, rises grandly against the sky, and the words on her halo, "Hail Mother, Queen of the World," help explain her dominance of the landscape and may also hint at the donor's political aspirations. The tiny scale of the kneeling donor is an archaism that recurs even in the Cinquecento. A semicircle of trees, in whose shadow a deer grazes, separates the sacred figures from what is perhaps the most ambitious landscape view of the decade. Jacopo's vision takes in farms, castles, cities, and the Magi on horseback riding toward a shed in which the Holy Family may be dimly seen. The distant mountains were probably not done after drawings from nature because they are conventionalized in shape, but the manner in which their summits are touched with light renders them convincing. Even more

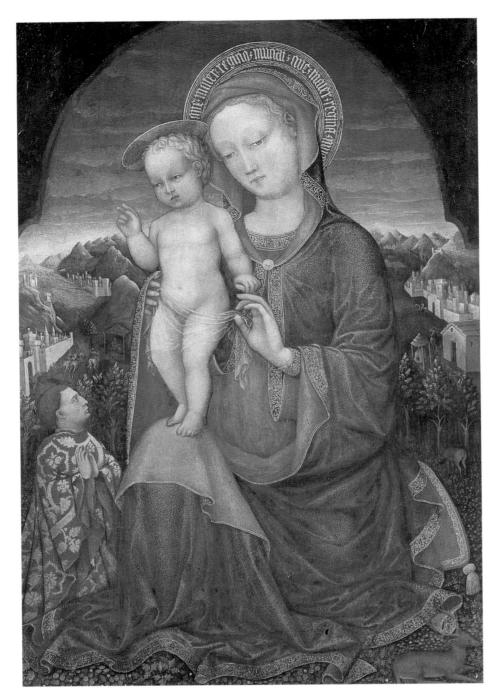

15.8. JACOPO BELLINI. Madonna of Humility with Donor (Lionello d'Este?). c. 1430. Panel, 23 x 16" (58.4 x 40.6 cm). The Louvre, Paris. Perhaps commissioned by Lionello d'Este

persuasive is the sky, with its low banks of clouds illuminated from below by this same light, apparently the last glow of afternoon. The soft, heavy atmosphere common in northern Italy appears here for the first time in painting. These clouds with gently glowing undersides will reappear again and again as a standard motif in the art of Jacopo's son, Giovanni. Despite the fact that Jacopo has attempted no perspective unity in the Florentine sense, his figures are convincingly projected in space, as is the Christ Child's halo.

Jacopo's extraordinary compositional imagination is seen in his surviving drawings, which were made on sheets of parchment or paper that were then bound into drawing books. They were probably intended to be model books that could be used in his workshop and by his descendants—as indeed they were—and also as a record of his style and attainments. Two such books survive, one of drawings on paper in the British Museum, the other, on parchment, in the Louvre. Both are datable close to 1450 and both include an

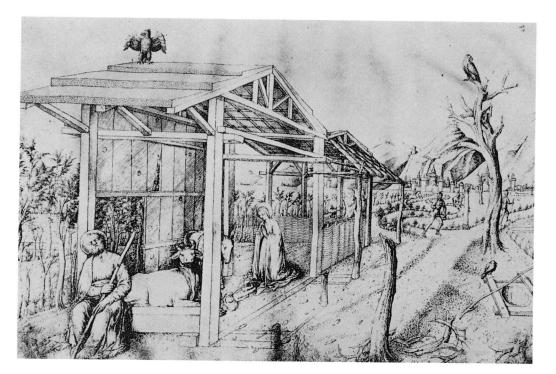

15.9. JACOPO BELLINI. *Nativity*, from a model book. 1440s. Leadpoint, $13^{1/4} \times 16^{1/4}$ " (33.7 x 41.3 cm). British Museum, London

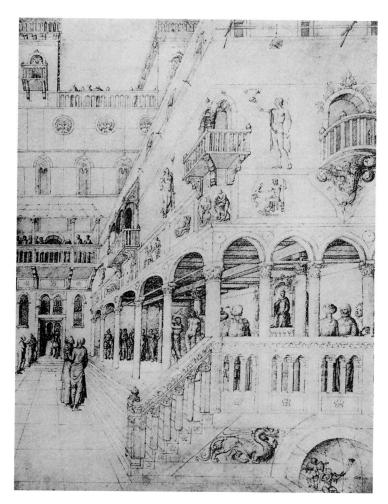

15.10. JACOPO BELLINI. *Flagellation*, from a model book. c. 1450. Leadpoint on parchment, with later pen retouching, $16\frac{3}{4} \times 11^{1/4}$ " (42.6 x 28.6 cm). The Louvre, Paris

extraordinary array of subjects-scriptural, mythological, archaeological, and purely fantastic. The books were inherited by Gentile Bellini, who had his father's rubbed and faded leadpoint drawings in the Paris volume retouched in pen; those in London remain in leadpoint. The books appear to have been consulted as compositional models by Venetian painters, including Mantegna and Giovanni Bellini, until well into the sixteenth century. They show that Jacopo learned the principles of Albertian perspective without losing his northern Italian interest in a broad, panoramic conception of nature. His strict adherence to perspective occasionally results in absurdly rapid perspective recessions. But his adoption of the system's single point of view enables him to keep the horizon in its proper place, to exploit glimpses between foreground objects, and to dissolve the last vestiges of medieval double scale in favor of a single scale that places human figures in a reasonable relationship to architectural and natural space.

In his *Nativity* (fig. 15.9), for example, Joseph sleeps in the foreground. Mary is reduced to two-thirds his size because she kneels a little deeper into the space, while shepherds and way-farers continue the diminution systematically to the point where distant Bethlehem, like a city on the Po River, rises with its walls and towers at the base of the mountains. While still betraying some Byzantine mannerisms of landscape construction, these masses recede into even smaller hills, castles, and cities visible between the uprights of the shed. Renaissance order has been imposed on the miscellaneous world of northern Italian art without weakening the dominance of nature.

The same principle is exploited to a greater degree in Jacopo's *Flagellation* (fig. 15.10). We see an enormous Gothic

palace, vaguely like the Doge's Palace in Venice, with an open loggia, balconies, classical reliefs, and statues adorning its walls, and an even larger distant building that culminates in two towers. In the foreground, a marble bridge arches over a waterway. Tiny figures appear here and there on the steps, on the balconies, and in distant courtyards. Only after examining the drawing for a while do we notice Christ, tied to a column in the loggia, and Pilate, who sits in a niche while bystanders look on idly. Those nearest us are, of course, represented as larger than Christ. In these drawings, Jacopo shows that this is the way even important events happen, not neatly centered and aggrandized, but as part of a universal texture of experience in which many of the characters simply go about their daily lives. Jacopo's adoption of Albertian perspective gave him a powerful instrument to demonstrate his views and to assert, moreover, the basic contention of northern Italian (as distinguished from Florentine) art: that nature is dominant over humanity. Venetian painting would never surpass the spatial daring of Jacopo's perspective compositions.

Andrea Mantegna

Andrea Mantegna, who married Jacopo Bellini's daughter Nicolosia in 1453, was the leading Quattrocento painter of the northern Italian mainland. Born in 1430 or 1431 near Padua, as a boy he was adopted and trained by Francesco Squarcione—part painter, part collector, part dealer in works of art, part entrepreneur-who seems to have employed several talented apprentices whose services he farmed out to prospective patrons. Eventually, Mantegna freed himself from Squarcione, but not without legal difficulties. When the artist was eighteen, so young that his contract had to be signed for him by his older brother, he was already engaged in a series of frescoes in the Ovetari Chapel in the Eremitani Church in Padua, together with such established artists as the Venetian team of Antonio Vivarini and Giovanni d'Alemagna and the Paduan painter Niccolò Pizzolo. Giovanni died in 1450, Vivarini withdrew in 1451, and in 1453 Pizzolo was killed in a quarrel. A new contract in 1454 assigned some of the subjects to Mantegna and others to such minor artists as Bono da Ferrara and Ansuino da Forlì. Eventually both withdrew, leaving the field to Mantegna, who finished the cycle before February 1457, when he was only twenty-six years old. The Ovetari frescoes demonstrate that Mantegna's remarkable new style was already formed at this time.

In the second register above the floor, Mantegna painted two scenes from the life of St. James, the *Baptism of Hermogenes* (fig. 15.11) and *St. James Before Herod Agrippa* (fig. 15.12). The two scenes are united by a common perspective scheme with a vanishing point centered on the frame between them. To enhance the illusionism, putti seem to be hanging garlands of fruits and flowers around the Ovetari and Capodilista arms in front of the narratives, as if in the

actual space of the chapel. In his first mature works, Mantegna shows his Squarcionesque training and also his interest in the compositional designs of his father-in-law, his absorption of the principles of Albertian perspective (which were to fascinate him for the rest of his life), and above all the impression made by Donatello's reliefs for Sant'Antonio (see figs. 10.33, 10.34). The marble pavement on which Hermogenes kneels, and which seems continuous with that of the square before the throne of Herod Agrippa, forms an Albertian perspective grid whose orthogonals and transversals establish the relative sizes of the figures. At this moment not even Piero della Francesca could produce so doctrinaire an exposition of perspective; Mantegna has even marked off the foreground slabs in cubits.

But this Tuscan rationalism and order is still joined with northern Italian realism. The architecture of classicizing piers and arches, decorated with an apparently invented "classical" relief with the familiar Renaissance detail of the horse seen from the rear, leads up to a potter's shop in which Mantegna painted a variety of jars and cups and even the wood grain of the rough counter. He shows how the water striking Hermogenes's bald cranium splashes outward into a fountain of separate drops, like pellets of quicksilver. A typical detail of Mantegna's naturalism is the infant at the left, who wants to take part in the ceremony but is restrained by the older boy who leans against the pier.

On the right, St. James is brought before Herod Agrippa in front of a Roman triumphal arch that is not an imitation of a specific Roman example but something even more impressive, a re-creation of Roman art in an Albertian manner. Mantegna belonged to a group of humanists in Verona who constituted themselves into an academy; they went for boat rides on Lake Garda, enlivening the trips with readings from classical authors, and also made some archaeological investigations on their own. Mantegna must have made a repertory of drawings from classical remains that he could use whenever he needed a specific detail.

The atmosphere is so clear that every element is visible with biting clarity, to the last tree and castle on the farthest hill. The experience of Donatello's sculpture, and perhaps even his personal influence, seem to have made Mantegna more sculptural in his paintings than was Donatello in his highly pictorial reliefs. The figures are so sharply modeled by the light, which is painted to match the actual light entering the chapel from the windows, that they almost seem carved in stone. Cloth does not fall over the limbs in masses, as in the paintings of Masaccio and his followers, but clings like the clay-soaked cloth of Donatello's figures (see fig. 7.13). The soldier leaning against the frame at the left, whose expression suggests that he is ravaged by inner torment, has long been thought to be a self-portrait (fig. 15.13). This face has been interpreted as corresponding to the difficult, domineering character we know Mantegna to have had from

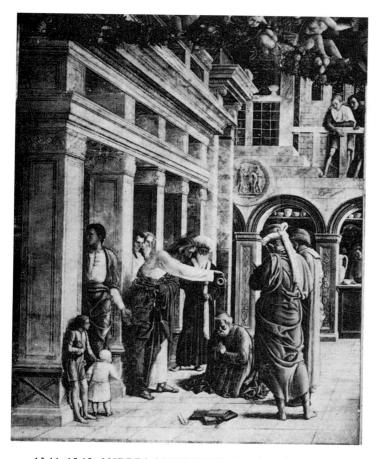

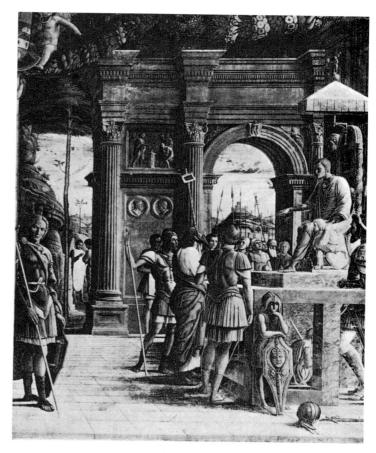

15.11, 15.12. ANDREA MANTEGNA. Baptism of Hermogenes (left) and St. James Before Herod Agrippa (right). 1454–57 (destroyed 1944). Frescoes, width of each 10'9" (3.3 m). Ovetari Chapel, Eremitani Church, Padua.

All our illustrations of Mantegna's Ovetari frescoes are made from photographs taken prior to the chapel's destruction by Allied bombing during World War II. Commissioned with monies from the will of Antonio di Biagio degli Ovetari; the patron of the frescoes was his wife, Imperatrice Capodilista, and members of her family.

Right: 15.13. Self-portrait of Mantegna, detail of fig. 15.12

documents, and it resembles the bust in his tomb chapel in Mantua. But in the midst of the solemnity of St. James's judgment, Mantegna still found room for naturalistic byplay. The boy who holds the soldier's shield and wears his enormous helmet looks right, while the eyes of the mask on the shield look just as sharply to the left. And the sword has been neatly placed parallel to the transversals of the pavement.

The lowest register of frescoes of the life of St. James begins just above the eye level of a person of average height during the Renaissance; the scenes are planned as if we were seated before a stage, and the figures seem to move downward as they recede from us. Only the feet of the figures nearest to the picture plane appear (some even seem to break through the picture plane), while others are cut off by the

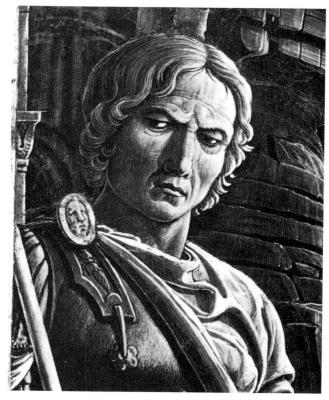

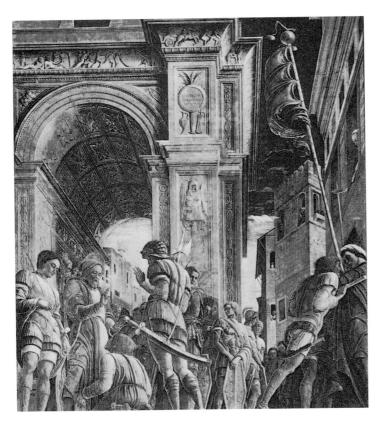

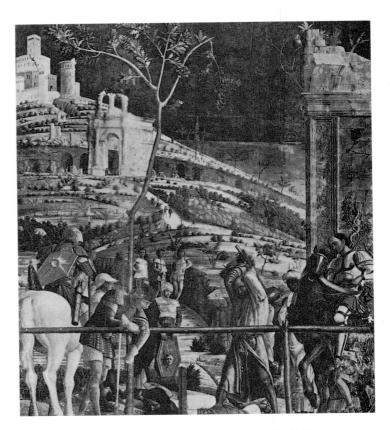

15.14, 15.15. ANDREA MANTEGNA. St. James Led to Execution (left) and Martyrdom of St. James (right). 1454-57 (destroyed 1944). Frescoes, width of each 10'9" (3.3 m). Ovetari Chapel, Eremitani Church, Padua

edge of the stage. In St. James Led to Execution (fig. 15.14), we look up at heads popping out of windows in the buildings above us, while the realistic effect is further enhanced by the random placing of medieval structures in a curving streettheir arches and battlements rendered with the same scrupulous attention to detail as the classical elements. The coffering of the arched gateway is also seen from below. But a moment's reflection will disclose that if Mantegna had been consistent, he would also have made the verticals converge as they rise, in conformity to our viewpoint below. That he did not do this is doubtless due to his unwillingness to violate the verticality of the wall on which he was painting and, in consequence, the architectural structure of the chapel itself.

Again Mantegna records and analyzes many facets of human experience, setting each into its correct relationship in space. A penitent breaks from the crowd to receive the blessing of the saint, for example, while a soldier uses a staff to hold back a woman who wishes to follow. Mantegna's sense of form invests humble faces with an unexpected majesty. The sad countenance of the saint is carved and compartmentalized with the same lapidary clarity as the masonry blocks in the buildings.

The final fresco, the Martyrdom of St. James (fig. 15.15), depicts the saint's beheading. Mantegna has developed a method of execution which requires that the saint lie prone, foreshortened in depth, under a blade that will slide in channels between two posts. An executioner is about to strike the blade with a gigantic mallet; when the blow falls, it seems that the severed head will roll out into the chapel. Although this is difficult to see in photographs, the illusion is increased by the rail of the sapling fence, which is painted so that it seems to overlap the painted frame, and by having a soldier lean forward over the fence. A powerful tension in depth is established by the rise of the hill-its ancient ruins illuminated against the sky-to a castle on the hilltop. As we wait for the blow to fall, we note that a bough has snapped at the top of the tree in the foreground, that the executioner's sleeve is ripping with the strain, and that a gigantic crack cuts through the keep of the castle from the top almost to the foundation. The contrast between this tension and the calm of the soldiers idly watching the execution encourages the observer to identify with the event through suspense and apprehension. That we look up into the saint's face renders the tension almost unbearable.

American bombs intended for nearby railway yards fell wide of their mark and demolished much of the east end of the church. The fragments of Mantegna's frescoes that survived are mounted in the rebuilt chapel on photographs of the lost frescoes, together with a scene from the life of St. Christopher that had been removed earlier for safekeeping.

Mantegna's first major altarpiece is still in its original position on the high altar of the huge Romanesque Church of San Zeno in Verona (figs. 15.16, 15.17). The altarpiece has often been characterized as a pictorial version of Donatello's

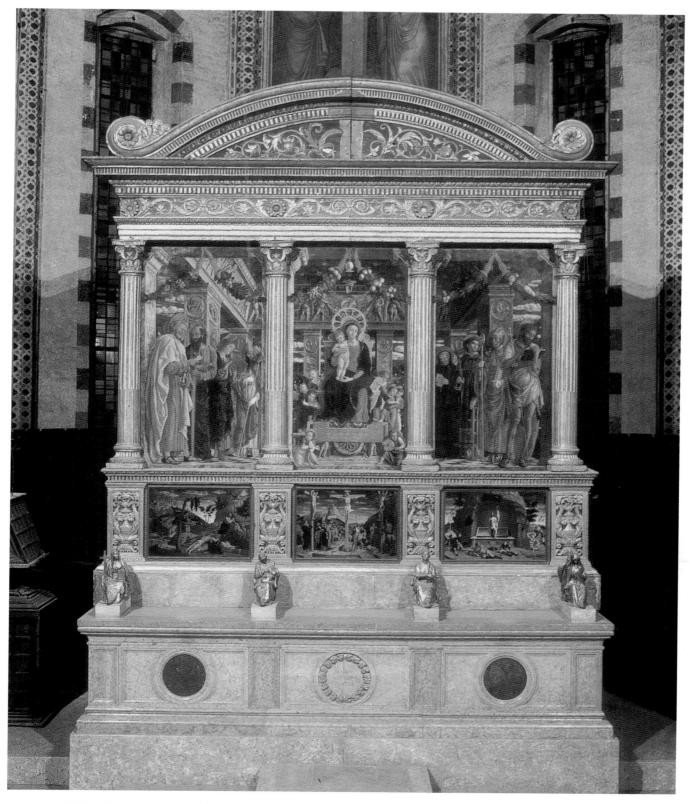

15.16. ANDREA MANTEGNA. Enthroned Madonna and Child with Saints (San Zeno altarpiece). 1456–59. Panel, height 86 ½ " (2.2 m).

® San Zeno, Verona. Commissioned by Gregorio Correr.

The frame is original, but it has lost whatever decoration was placed in the center of the pediment. The predella panels shown here are copies; the originals were taken by Napoleon and are now in French museums (see fig. 15.19).

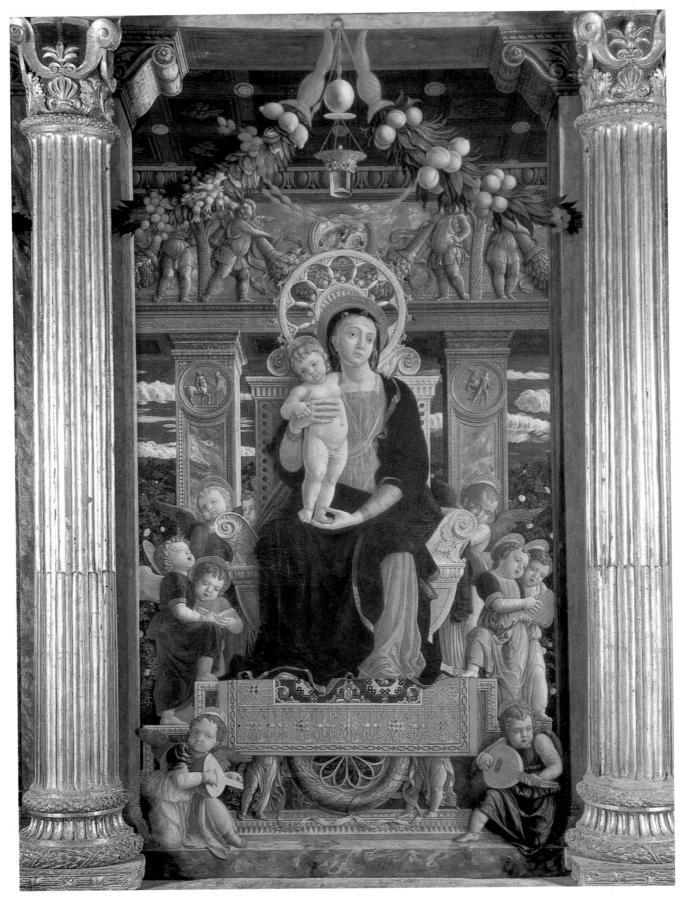

15.17. Enthroned Madonna, detail of fig. 15.16 🏛

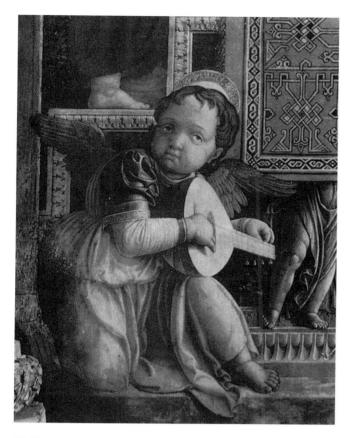

15.18. Putto strumming a lute, detail of fig. 15.17

sculptural altarpiece for Sant'Antonio in Padua, and it may well reflect some of the sculptor's architectural and figural arrangements. The wooden frame becomes a carved and gilded façade whose pediment and entablature are supported by four columns that seem to be attached to painted piers. Together the real half-columns and painted piers seem to form one side of a square loggia that is completed by the piers within the picture. In the center of this loggia, the Virgin sits on a classicizing marble throne, terminating in a large circle that enhances her halo. In the side panels eight saints, meditating or conversing, diminish in size as they recede from us. The brilliant colors of their costumes stand out against the veined marble of the painted architecture, the blue sky, and Mantegna's icy white clouds. Garlands of fruits and flowers hang between the gilded columns and the painted piers. From the same ring hangs an egg symbolizing the Virgin Birth, as in Piero's Madonna and Child (see fig. 11.33); from the egg is suspended a burning oil lamp. A rosary is draped between the garlands. Around and below the throne, putti sing or strum on lutes (fig. 15.18). The manner in which the Asian rug under the Virgin's feet naturalistically conceals the putti sculpted on the pedestal of the throne is a surprisingly witty touch.

Considering the brightness of the colors and the gold, the power of the architectural masses, the sharp definition of the forms, and the consistency of the spatial formulation, the illusion of reality—a higher reality—is overpowering. It is, of course, the sort of thing that had been initiated by Pietro Lorenzetti in his *Birth of the Virgin* (see fig. 4.24), although Mantegna most likely had no knowledge of that picture. The illusionistic altarpieces of northern Italy start from Mantegna's grand formulation at San Zeno and continue in a rich series well into the Cinquecento, as we shall see.

The Crucifixion from the predella (fig. 15.19) is so intense in its tragic emotion that in reproduction it could be a monumental fresco rather than a small panel. The three crosses on Golgotha-the place of the skull-are set in holes made in a rounded, skull-shaped stone outcropping and held in place by wedges and rocks. In the foreground two soldiers emerge from steps cut into the rock. Behind the cross of Christ a road leads toward Jerusalem. Beside the ascending road, filled with the crowds returning from the spectacle of the Crucifixion, towers a gigantic crag. The crosses of the thieves are turned inward and, following northern Italian tradition, they are not nailed to their crosses but tied. The cross of Christ is placed so that his toes, deprived of the usual footrest, match the junction point between two distant hills and his body is silhouetted against the sky. His arms are thrown wide in a gesture of suffering; the lines of the arms and turn of the head are related to the horizontal clouds in the cold sky. The tragic contrasts of the scene—the suffering women, whose haloes dissolve into soft-edged, gold clouds, the indifferent soldiers, and the beauty of the landscape and cityscape—make this small picture one of the memorable Crucifixions in Italian art.

Closely related to the San Zeno altarpiece is the Agony in the Garden (fig. 15.20). Here Mantegna repeats the sharply defined sculptured forms, the enameled brilliance of color, and the clarity of atmosphere of the San Zeno altarpiece. And, as in all his early works, the last stone, the last mountain, and the last rabbit in the road are projected with flawless precision. The composition derives from a Jacopo Bellini drawing, even to the ominous bird perched on a dead branch, but the rock masses and human forms have been subjected to Mantegna's passion for definition and organization. His Jerusalem is a mixture of the northern Italian cities, which Mantegna had seen, and Rome, which he knew only from drawings and descriptions. Mantegna's Christ kneels, contemplating not the chalice usually presented to him by an angel ("Father, . . . let this cup pass from me: nevertheless not as I will, but as thou wilt"; Matthew 26:39) but a row of child-angels bearing symbols of the Passion. Particularly striking is the foreshortening of one of the sleeping apostles, which may have been suggested by some vanished work of Paolo Uccello in Padua or Venice. Down the road, in the middle distance, Judas is bringing the Roman soldiers to arrest Christ.

After years of negotiation, in 1459 Mantegna went to Mantua as official painter to the court of Marquis Ludovico

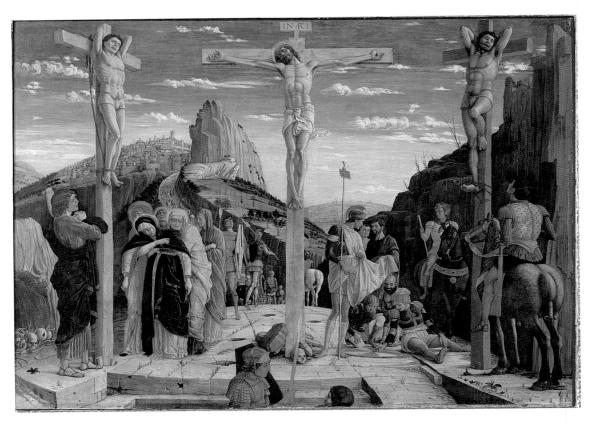

15.19. ANDREA MANTEGNA. *Crucifixion*, from the predella of the S. Zeno altarpiece (see fig. 15.16). 1456–59. Panel, $26 \times 35^{1/8}$ " (66×89.2 cm). The Louvre, Paris

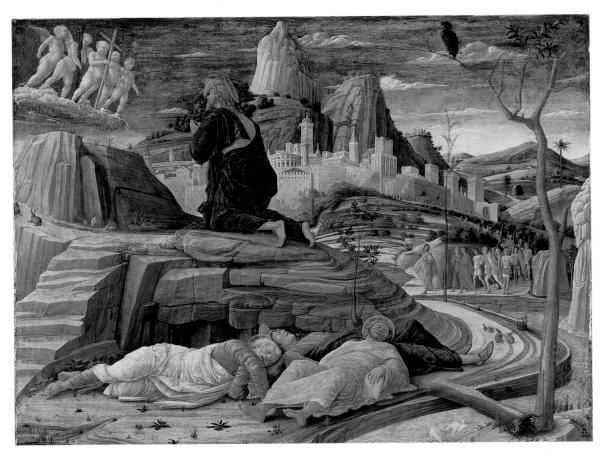

15.20. ANDREA MANTEGNA. Agony in the Garden. c. 1460. Panel, $24^{3}/_{4} \times 31^{1}/_{2}$ " (62.9 x 80 cm). National Gallery, London.

This painting may have been made for private devotional use, a function for which this iconography is appropriate. Mantegna's signature is inscribed, in Latin, on the rocks.

Gonzaga. He worked there for nearly half a century, becoming one of the first princely artists of the Renaissance. He painted altarpieces and frescoes for churches, chapels, and palaces, designed pageants, painted allegorical pictures, and performed the many official tasks required of a court artist.

Mantegna's Cristo in Scurto, or Foreshortened Christ (fig. 15.21), shows an interest in foreshortening that should be directly related to the artist's two trips to Florence in 1466 and 1467. These visits were probably the painter's initial contact with large numbers of Florentine works of art. He must have been impressed by the art of Castagno (whose earlier works he had been able to study in Venice), especially the Vision of St. Jerome in the Santissima Annunziata (see fig. 11.18) and the Death of the Virgin, destroyed in the seventeenth century but in Mantegna's time in Sant'Egidio; in the latter painting the dead Virgin was seen feet foremost. Mantegna emulated the sharp foreshortening of these pictures in his Foreshortened Christ, the name by which it was listed in Mantegna's house at the time of his death. The Foreshortened Christ is painted on canvas, and it may therefore have been intended as a processional banner for a society or confraternity dedicated to the Corpus Christi (the mystical adoration of the body of Christ). Alternatively, it may have been painted as a private devotional image, perhaps for Mantegna himself, given that it was in his possession when he died.

The picture shows the body of Christ lying on a marble slab with a white cloth over his legs and his head raised on a pillow. In the Quattrocento the death of Christ was frequently a focus for personal meditation, and in his *Imitation of Christ*, the fifteenth-century German mystic Thomas à Kempis exhorted readers to "dwell in the wounds of Christ." This is exactly what Mantegna asks his observers to do. His sculptural style gives the body and its open wounds convincing three-dimensionality. The perspective recession seems to catapult the body, wounds and all, out of the frame and even, we might say, into a willing observer's inner life. Nor can the viewer escape, for the feet, projected from our point of view, follow us wherever we stand in the gallery, and the wounds always lie open to our gaze.

If you compare the painting with a real figure seen in this position, you will note that the head of Mantegna's Christ is unnaturalistically large and his feet unrealistically small, but you will also immediately understand that a naturalistic painting of a figure in such a position would make the figure look ludicrous—gigantic feet would overwhelm the miniature head. Mantegna has painted a Christ that we recognize immediately and in which we do not sense any inherent disproportion, at least at first glance. The dramatic foreshortening of the figure is a vehicle for emotional expression.

Mantegna's Camera picta (painted chamber) was painted for Ludovico Gonzaga and his family in one of the towers of their castle (figs. 15.22, 15.23). Over the fireplace Mantegna painted the marquis and marchioness, Barbara von Hohen-

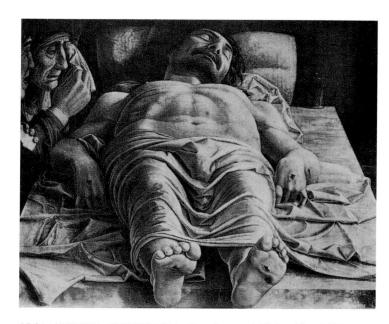

15.21. ANDREA MANTEGNA. Foreshortened Christ. After 1466. Canvas, $26\frac{3}{4} \times 31\frac{7}{8}$ " (68 x 81 cm). Brera Gallery, Milan

zollern, together with their children, courtiers, and favorite dwarf. They are gathered on a terrace enclosed by a parapet formed by linked circles of white marble filled with disks of veined marble and crowned with the stylized palm fronds known as palmettes; this parapet motif is used as a unifying factor in the frescoes of the room. The actual mantelpiece in the room, seen at the bottom, becomes a platform for the figures. At the left a messenger, who has just brought the marquis a letter, listens intently to his instructions.

Mantegna has designed the figures and their grouping to create an effect of natural spontaneity. The portraits are rendered with Mantegna's customary precision, but his style has changed since his early work. Now the forms are less sculptural, and the color is gentler and softer, without the harshness of the Eremitani frescoes or the brilliant contrasts of the San Zeno altarpiece.

The paintings are continuous on two of the four walls and over the vaulted ceiling. The main scene on the adjoining wall (fig. 15.22) takes place in the right section of the fresco; it has eluded identification with any known event and may be symbolic. At the left stands Ludovico, at the right his older son and successor, Federico, and in the center his second son, Cardinal Francesco, who in 1472 was made titular head of the Church of Sant'Andrea in Mantua (see figs. 10.6–10.8). The background, possibly symbolic of Rome, has Roman ruins and statues outside its walls and a castle above. In spite of losses in some areas, the glowing color is one of the chief delights of Mantegna's painted room. There is, however, a considerable difference in terms of color between the ceiling, painted in fresco, and the walls, which Mantegna carried out with a vehicle of walnut oil.

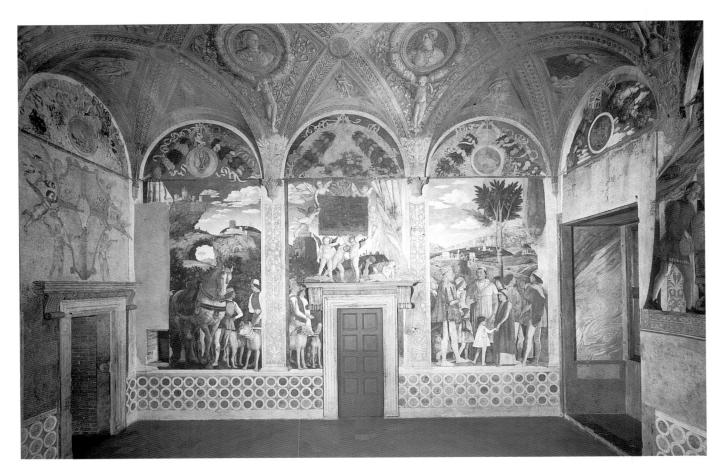

15.22. ANDREA MANTEGNA. Camera picta, Palazzo Ducale, Mantua. Arrival of Cardinal Francesco Gonzaga

15.23. ANDREA MANTEGNA.

View of the frescoes in the Camera picta, Palazzo Ducale, Mantua, with Ludovico Gonzaga, his family, and court visible at the right. Completed 1465-74. Walnut oil on plaster; size of room 26'6" x 26'6" (8 x 8 m). Commissioned by Ludovico Gonzaga. The date 1465 that marks the beginning of work on the room looks as though it is scratched into the plaster, and thus it makes a clever trompe l'oeil effect. Mantegna's self-portrait, perhaps functioning as a kind of signature, is hidden in the foliate decoration on the painted pilasters. In 1475 an ambassador wrote to Milan calling the Camera picta "the most beautiful room in the world."

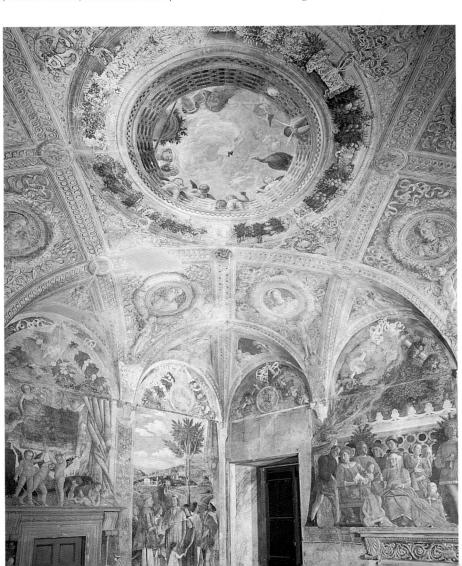

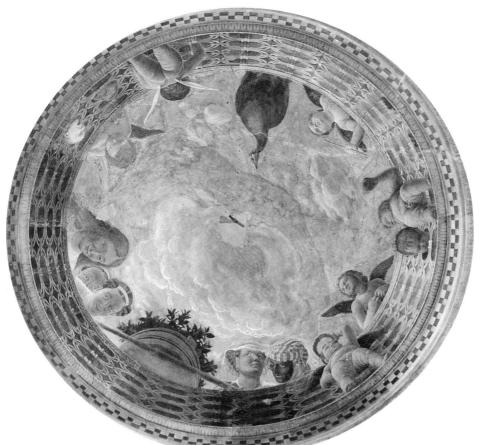

15.24. ANDREA MANTEGNA. Ceiling fresco, diameter 8'9" (2.7 m). 1465–74. Camera picta, Palazzo Ducale, Mantua

Below: 15.25. ANDREA MANTEGNA.

Madonna of the Victory. 1493–96. Tempera on canvas, 9'2" x 5'10" (2.8 x 1.8 m). The Louvre, Paris. Commissioned by Marquis Gianfrancesco Gonzaga of Mantua. The picture was paid for with a penalty of 110 ducats extracted from a Jewish banker; he had removed a fresco of the Madonna and Child from the wall of a house he had bought. The fine was levied despite the fact that the banker had received the bishop's permission to remove the fresco.

Mantegna painted the vaults of the ceiling to resemble marble relief sculpture and gold mosaic. Then in the center, unexpectedly, we seem to be looking straight up through a cylindrical opening out to the sky above (fig. 15.24). The opening seems to be framed by a parapet—also painted, and designed to match the one in the group portrait. Putti, foreshortened from below, stand inside the rim, others poke their faces through what appear to be empty circles in the parapet, and laughing servants look over the edge at us. As a final prank, Mantegna has perched a heavy tub of plants on the rim of the parapet, propped only by a pole that seems about to roll away at any moment.

In 1488 Mantegna made his first trip to Rome, where he was able to study classical antiquities in large numbers, as well as the frescoes recently painted for Sixtus IV in the Sistine Chapel (see figs. 13.20, 14.14). From 1489 to 1490 he painted a chapel for Pope Innocent VIII, but this was destroyed in 1780 to make way for a new wing of the Vatican Museums.

Mantegna's late style, after his return from Rome, is represented by the *Madonna of the Victory* (fig. 15.25). When it

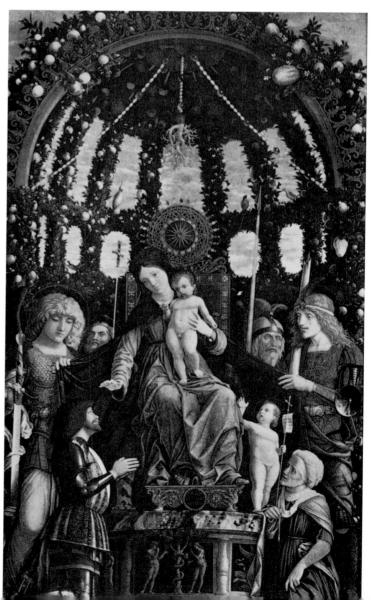

was completed it was carried through the streets in triumph, which explains why it was painted on canvas instead of wood, the medium used consistently for paintings at this time. Two military saints, Michael and George, and Andrew and Longinus, patron saints of Sant'Andrea in Mantua, accompany the armored marquis. The infant John the Baptist appears at the right, and kneeling next to him is an old woman, in all probability his mother, Elizabeth. On the pedestal a simulated relief shows the Temptation of Adam and Eve, from whose sin Christ and the Virgin have redeemed humanity. The figures are enclosed in a bower of orange trees enframed by a carved wooden arch with palmette decoration. From the apex of the bower an elaborate branch of rosecolored coral—efficacious in warding off demons and the evil eye-hangs from an early form of the rosary composed of coral and crystal beads. In the openings of the bower, parrots and cockatoos add more brilliant touches of color.

Mantegna and Isabella d'Este

Mantegna's classical proclivities endeared him to Isabella d'Este, who was married to Francesco Gonzaga in 1490; she commissioned the artist to paint a scene of *Parnassus* for her *studiolo* (fig. 15.26). Before discussing the painting, however, an examination of this famous patron is in order. Isabella's portrait is known in several examples, including a drawing by Leonardo da Vinci and a painting by Titian, but here we reproduce the portrait medal that she had made to present to important individuals (fig. 15.27). Approximately twenty thousand of Isabella's letters have been preserved, as well as sixty thousand letters she received, and such voluminous documentation grants us a rich record of her life, her collections, and her patronage of scholars and artists. The latter included Giovanni Bellini, Mantegna, Lorenzo Costa, Leonardo, Perugino, Francesco Francia, and Correggio, among others.

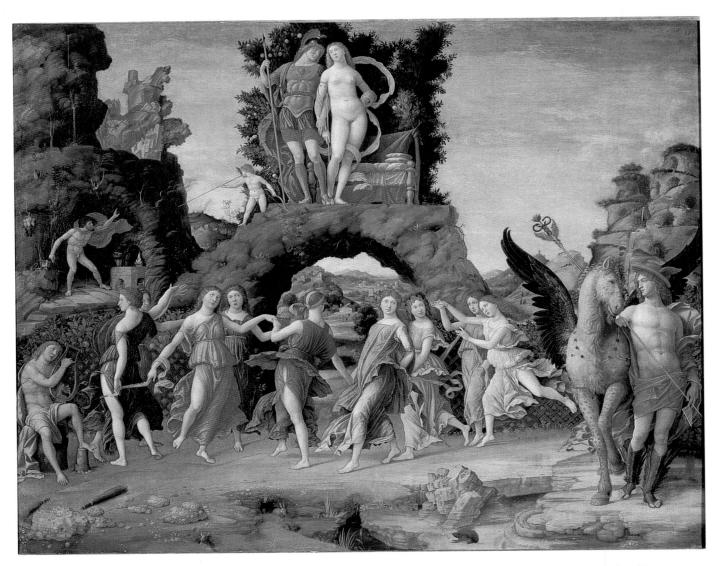

15.26. ANDREA MANTEGNA. *Parnassus*. c. 1495–97. Canvas, $63^{1}/2 \times 75^{5}/8$ " (1.59 x 1.92 m). The Louvre, Paris. Commissioned by Isabella d'Este for her *studiolo* in the Gonzaga castle, Mantua

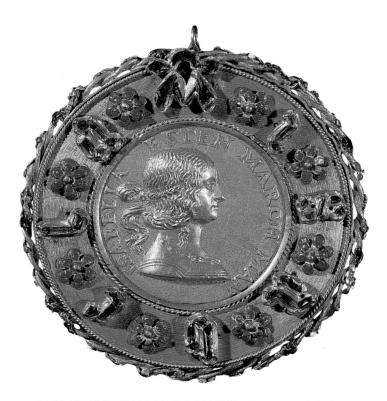

15.27. GIANCRISTOFORO ROMANO. *Portrait Medal of Isabella d'Este*. 1495–98. Gold, with diamonds and enamel, diameter 2⁵/8" (6.7 cm). Vienna, Kunsthistorisches Museum, Münzkabinett. Medals such as this one were commissioned by Renaissance rulers and others to be given as tokens of honor and respect. Isabella presented bronze versions of this medal to poets, and the text on the back reads "For Those Who Serve Her." She had the medal made as a modern version of the profile portraits found on ancient coins and cameos in her collection; this bejeweled example is the one she exhibited, paired with an ancient cameo with profile portraits, in the room she called her *grotta*.

While many patrons developed a preference for a single artist or a single style, Isabella's artistic taste evolved over time, from the Quattrocento styles of Costa and Perugino to the High Renaissance styles of Leonardo and Correggio. One of the humanists at her court called her "The Tenth Muse." Many Renaissance women were accomplished musicians, but Isabella was unusual in that she learned to play both plucked and bowed instruments; documents reveal that she commissioned new instruments for the musicians who played at the Mantuan court. In addition she raised seven children and frequently had to run the Mantuan state when her husband was away or in prison; after his death in 1519 she remained active in affairs of the state until her own death, twenty years later.

Isabella came from an art-loving family, and her sister and brother were both patrons as well (see figs. 19.11–19.13), but Isabella is exceptional in the sixteenth century as a

woman who was active not only as a patron, but also as a collector, an activity almost exclusively limited to men during this period. Isabella wrote that she had an "insatiable desire for antiquities," and one contemporary collector, after visiting her collection, wrote that in the area of antiquities she had "many beautiful and rare objects." She owned a Sleeping Cupid said to be by the famous ancient Greek sculptor Praxiteles which she paired with a sculpture of the same subject by Michelangelo. When she could not obtain the original, she would commission a reproduction; one of her treasures was a small bronze version of the Apollo Belvedere in the papal collection (see fig. 17.50). She also collected, or tried to collect, paintings by the leading masters of the period. The Gonzaga inventories disclose that her collection included paintings, classical gems, coins, medals, precious and semiprecious stones, vases, manuscripts, gold and silver work, and other rarities. In addition, she had an important library. She did all this, and commissioned paintings from major artists, on a limited budget.

Isabella was a demanding patron, but probably no more so than many male patrons of this period. In commissioning a painting from Perugino she dictated the subject and the complex symbolism and provided him with a small drawing to follow as he evolved the composition.

Isabella took great pleasure in her studiolo and grotta, the two chambers in the Gonzaga castle at Mantua that she had had decorated; they were not far from Mantegna's paintings in the Camera picta, which had been commissioned by her husband's grandfather Ludovico. In the studiolo she kept her library and her many collections, all stored and displayed in carved and gilded wooden cabinets. The ceiling was gilded and decorated with Isabella's private mottoes and emblems, and the walls were eventually filled with paintings, including two by Mantegna. The themes for the *studiolo* paintings were probably devised by two humanists, the Mantuan poet Paride da Ceresara and the Venetian humanist Pietro Bembo; their controlling role here is a reminder that many of the works created in this period should be seen as collaborations between enlightened patron, humanist iconographer(s), and creative artist(s).

In Mantegna's *Parnassus* (see fig. 15.26), Mars embraces Venus in front of a bed perched on a kind of natural bridge. Cupid blows a dart toward the genitals of Vulcan, Venus's deceived husband, who menaces the happy couple from a cavern illuminated by the soft glow from his forge. In front of the bridge, Apollo plays music on his lyre for a dance performed by the Muses, while Mercury at the right leans gently against Pegasus, the winged horse. It is a classicizing fantasy, full of complex patterns of line and form and the muted colors of Mantegna's late style.

This painting, replete with references to ancient sculpture that Mantegna had studied, probably celebrates the wedding of Francesco and Isabella on February 11, 1490, when the planets Mercury, Mars, and Venus all stood within the sign of Aquarius, as did the westernmost bright star of the constellation Pegasus. The figures of Mars and Venus have been interpreted as references to Francesco and Isabella, and such self-referencing was to be expected in the rarified secular setting of the Italian courts. Also in Isabella's *studiolo* was Lorenzo Costa's *Garden of the Peaceful Arts* (now in the Louvre in Paris), an allegory of the court of Isabella, with Isabella herself being crowned by Cupid. In another of the *studiolo*'s paintings, Mantegna's *Pallas Expelling the Vices from the Garden of Virtue* (also in the Louvre), Pallas is an allegorical representation of Isabella.

The colors of Mars's garments, Venus's scarf, and the coverings of the bed in the *Parnassus* are the mingled colors of the Este and Gonzaga families. The painting, whose elements were doubtless specified by Isabella, was clearly an allegory of marital harmony, under which the arts, led by music, would flourish. Mantegna's death in 1506 was felt as a personal tragedy by the Gonzaga family, for whom he had worked for nearly half a century. His fame was international, and the German artist Albrecht Dürer, on his second visit to Italy, was on his way to visit Mantegna, to whom he owed so much, when death intervened.

Gentile Bellini

In Venice, meanwhile, the Bellini family was creating a new style. The older brother Gentile, who won a number of large, official commissions, painted for the same kind of public as Ghirlandaio, recording the Venetian scene as faithfully as Ghirlandaio did that of Florence. His Procession of the Relic of the True Cross (fig. 15.28) was painted in 1496 for the Scuola di San Giovanni Evangelista. The scuole (schools) of Venice were not educational institutions as the name might suggest, but confraternities on the order of the Misericordia in Florence and elsewhere (see p. 310). The members, who tended to come from the middle class, gathered for religious ceremonies and to do good works within the city. Needless to say, there was a certain amount of competition among the guilds. Their headquarters always included a large hall, used as a combined hospice for the poor and hospital ward, a chapel, and often a meeting room as well. In a damp climate which is not conducive to fresco paintings, works on canvas formed suitable decorations for these public rooms, and series of huge framed narrative scenes for the various scuole make up a large part of the production of some of the leading Venetian artists. While the

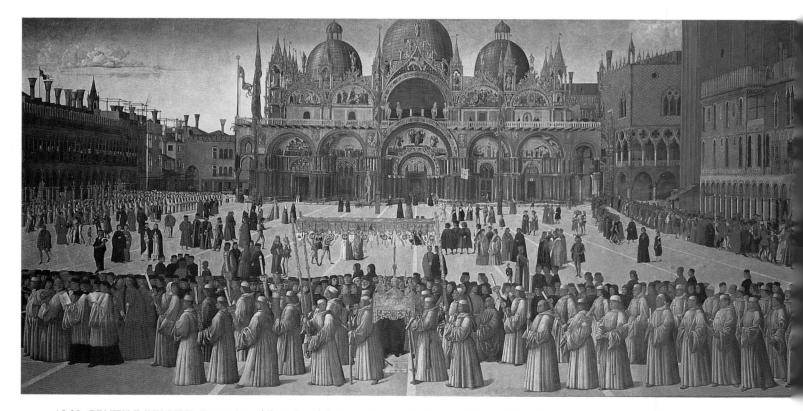

15.28. GENTILE BELLINI. *Procession of the Relic of the True Cross.* 1496. Canvas, 12' x 24'5" (3.67 x 7.45 m). Accademia, Venice. Commissioned by the Scuola di San Giovanni Evangelista for its confraternity headquarters. Gentile and his brother Giovanni Bellini were both members of this *scuola*.

narrative series were usually dedicated to events from the life of the scuola's patron saint, details of Venetian life are often included, and in some cases, as we shall see, events in the life of the scuola are also depicted. The relic of the True Cross, the pride of the Scuola di San Giovanni Evangelista, is shown as it was carried in solemn procession on the feast day of St. Mark through the Piazza San Marco. The painting records the procession of 1444, when a miraculous healing demonstrated the relic's power. The brothers of the order, dressed in white robes, are portraits of Bellini's contemporaries, as are many spectators, while the setting documents contemporary Venetian life and buildings. The Basilica of San Marco and the Doge's Palace are now much as they were then, although most of the original mosaics of San Marco's façade and Uccello's St. Peter, under the first pinnacle at the left, have long since been replaced; we gain an idea of their original appearance only from Gentile's painting.

The most colorful episode in the artist's otherwise routine life was his stay at the court of Sultan Mahomet II in Con-

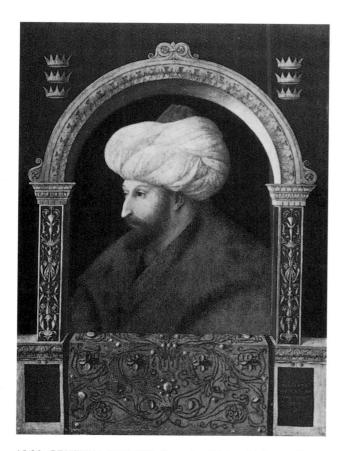

15.29. GENTILE BELLINI. Portrait of Sultan Mahomet II the Conqueror. 1480. Canvas, $27^{3/4}$ x $20^{5/8}$ " (69.9 x 52.1 cm). National Gallery, London.

It was Mahomet who masterminded the three-month siege that led to the fall of Constantinople to the Ottoman Turks on May 29, 1453, thereby ending the Byzantine Empire. The walls of Constantinople proved vulnerable to the large guns that Mahomet had commissioned from a Hungarian gun-founder.

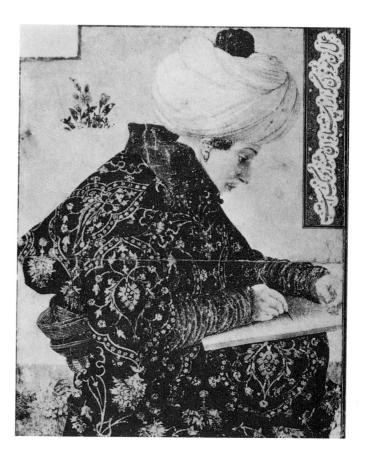

15.30. GENTILE BELLINI (attributed to). *Portrait of a Turkish Boy.* 1479–80. Pen and gouache on parchment, $7\frac{1}{4} \times 5\frac{1}{2}$ " (18 x 14 cm). Isabella Stewart Gardner Museum, Boston

stantinople in 1479-80. Most of the paintings he did for the sultan are lost, including, unfortunately, his decorations for the imperial harem in the Topkapi Palace. Despite its abraded surface, his Portrait of Sultan Mahomet II the Conqueror (fig. 15.29) reveals a combination of Eastern and Renaissance elements. The portrait is treated naturalistically in the Renaissance tradition, but this effect is muted by the scale of the surrounding decoration; the enframing arch seems too small for the figure, while the pattern of the sumptuous Turkish cloth thrown over the sill of the opening is, in contrast, too large. His Portrait of a Turkish Boy (fig. 15.30) reveals that, at least for a Turkish public, Gentile showed an interest in the kind of patterned surface composition that does not emerge in Western art until the late nineteenth century. Gentile's life in Constantinople provided material for many anecdotes; one tells how he showed the sultan a painting of the severed head of St. John the Baptist, a subject intended for personal contemplation. The sultan considered the picture quite unnaturalistic, and to prove his point called up two slaves, one with a sword. "This," said the sultan to Gentile, after the headsman had given one expert blow, "is how a freshly severed head should look!" Gentile soon left for home.

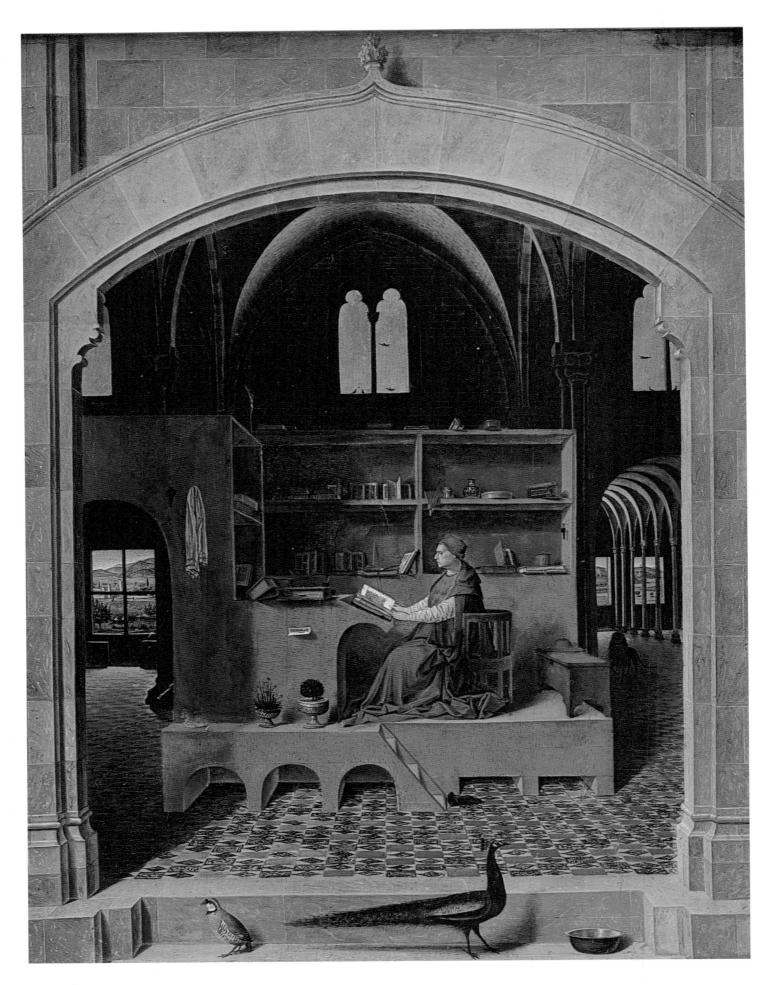

446 • THE QUATTROCENTO

Antonello da Messina

At this juncture the history of Venetian art is interrupted by the appearance of Antonello da Messina (c. 1430–79). Antonello came from the Sicilian city of Messina, where there had been no artistic tradition since the days of the twelfth-century mosaicists. Active as master of his own shop in Messina in 1456, he traveled widely but always returned to his native city. He arrived in Venice in 1475, stayed a year and a half, and, it appears, changed the course of Venetian painting. It seems to have been Antonello who showed Venetian painters how oil paint and color could be used to give previously unknown atmospheric and luminary effects to landscapes, interiors, and figures. Venetian painting before and after Antonello is radically different, and it is difficult to avoid the assumption that he was responsible for the change.

Antonello may have learned to paint in oil from a Flemish-influenced painter named Colantonio, with whom he could have been apprenticed in Naples. But as early as 1456 his presence was recorded at the court of Galeazzo Maria Sforza in Milan, where he was paid on the same basis as Petrus Christus, a pupil of Jan van Eyck. He certainly studied Jan van Eyck's paintings in Naples.

Antonello was the son of a stonecutter and he had a sculptor's sense of form. One scholar has even suggested that Antonello studied the Archaic or Severe Style Greek sculpture available in his native Sicily. Certainly he was able to blend a Netherlandish passion for the details of visual reality and the definition of form by subtle transitions of light and shadow with a quintessentially Mediterranean purity and clarity of form. But neither these disparate influences nor their unexpected combination in a single artistic personality fully explains Antonello's innovative style.

One of Antonello's earliest pictures, *St. Jerome in His Study* (fig. 15.31), is so Netherlandish in style that in 1529 there was a debate over whether it was by Antonello, Hans Memling, or possibly Jan van Eyck himself. St. Jerome reads quietly in a fantastic alcove set within a monastic library. We are admitted to his study through an illusionistic arch similar to those used by the Flemish painter Rogier van der Weyden, albeit simpler and less Gothic in form. On the step, lighted from the window through which we are looking, are a brass bowl, a peacock, and a partridge. The same light throws the shadow of the arch on the interior and competes with the light from the distant windows. St. Jerome's desk and shelves are mounted in the brightest section, just below a clerestory window. In the shadows behind him, his lion strolls across the

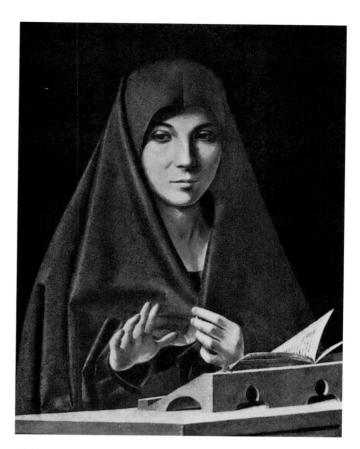

15.32. ANTONELLO DA MESSINA. Virgin Annunciate. c. 1465. Panel, $17\sqrt[3]{4} \times 13\sqrt[3]{8}$ " (45 x 34 cm). Museo Nazionale, Palermo

elaborate majolica floor and seems to come to an alert stop when he notices us looking in through the window. In true Van Eyck tradition, the picture is complete down to the tiniest detail of architecture and still life, including the characteristic Netherlandish motif of a towel hanging on a nail. The light effects, the atmosphere of the room, and the landscape visible through the windows all suggest Van Eyck's techniques of oil painting and glazes. Like many Netherlandish paintings, this little picture is a microcosm of its own at the same time that it reveals the vastness of the outside world.

In his Virgin Annunciate (fig. 15.32), Antonello has not represented the event of the Annunciation but rather the half-length figure of the Annunciate Virgin as a devotional image, timeless and removed from the traditional narrative. A book—probably of the prophet Isaiah—is open on a lectern before her, while her right hand is lifted as if in surprise and her left draws her blue veil closer over her chest. Light models the sculptural forms of her face while the shadow plays softly over her neck. In the manner of Jan van Eyck's

Opposite: 15.31. ANTONELLO DA MESSINA. St. Jerome in His Study. 1470s(?). Panel, $18 \times 14^{1}/8$ " (45.7 x 36.2 cm). National Gallery, London.

Small paintings of the scholar saint in his study were apparently popular devotional items for Italian Renaissance humanists.

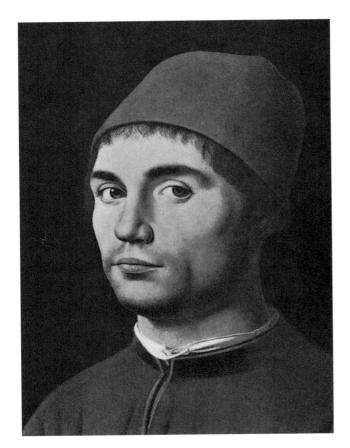

15.33. ANTONELLO DA MESSINA. Portrait of a Man. c. 1465. Panel, 14 x 10" (35.6 x 25.4 cm). National Gallery, London

portraits, the background is black, imparting greater intensity to the blue veil and removing the image from any connection with the surrounding world.

The serious face, with its grave, composed features, is the face of a young Sicilian, with the Greek nose still common there. Under the arched brows, the brown eyes suggest that she realizes the meaning of the Incarnation. In the smooth and simple masses of the head, the influence of Greek sculpture seems probable. At the same time, the clarity of form, the brilliant illumination, the emphasis on inner psychological experience, and the absence of a background point ahead more than a century to the revolutionary works of Caravaggio.

Antonello da Messina's *Portrait of a Man* (fig. 15.33) had an inscription at the bottom that is believed to have identified it as a self-portrait, but this was cut off in the eighteenth century and may have been merely a signature. It is a portrait of impressive psychological depth and great simplicity and dignity of form, a painting in which Antonello exemplifies the two major tendencies blended in his style. He rivals Netherlandish painters in his observation of the play of light across the textures of the skin, the faint stubble of the beard, the luminous eyes, and the dark hairs that escape from the red cap or compose the eyebrows.

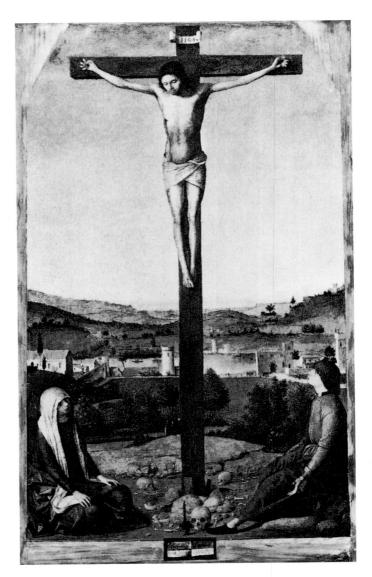

15.34. ANTONELLO DA MESSINA. Crucifixion. 1475. Panel, $16^{1/2}$ x 10" (41.9 x 25.4 cm). National Gallery, London

The *Crucifixion* (fig. 15.34) exhibits, just below the cross, the illusionistic piece of paper or *cartellino* that appears in many northern Italian paintings of the Quattrocento; here it bears Antonello's signature and the date 1475, and in all probability the picture was painted after his arrival in Venice. The illusion is enhanced by the way Antonello suggests that this paper has been folded up and only recently unfolded to be stuck on the painting. The restrained gestures of Mary and St. John are typical of Antonello's interpretation of narrative subjects.

A final work by Antonello, dating probably from the end of his stay in Venice, is the *St. Sebastian* (fig. 15.35), which is almost contemporary with Pollaiuolo's altarpiece on the same subject (see fig. 13.6), but as different as possible within the requirements of the subject. Antonello has chosen a late moment in the story: the attack is over and the soldiers have left. One sleeps in the sun, projected feet first, Mantegna-

15.35. ANTONELLO DA MESSINA. St. Sebastian. c. 1475. Canvas, transferred from panel, $67^{1/4} \times 33^{7/8}$ " (171 x 86 cm). Gemäldegalerie, Dresden. Commissioned for the Scuola dei SS. Rocco e Nicolò, Venice

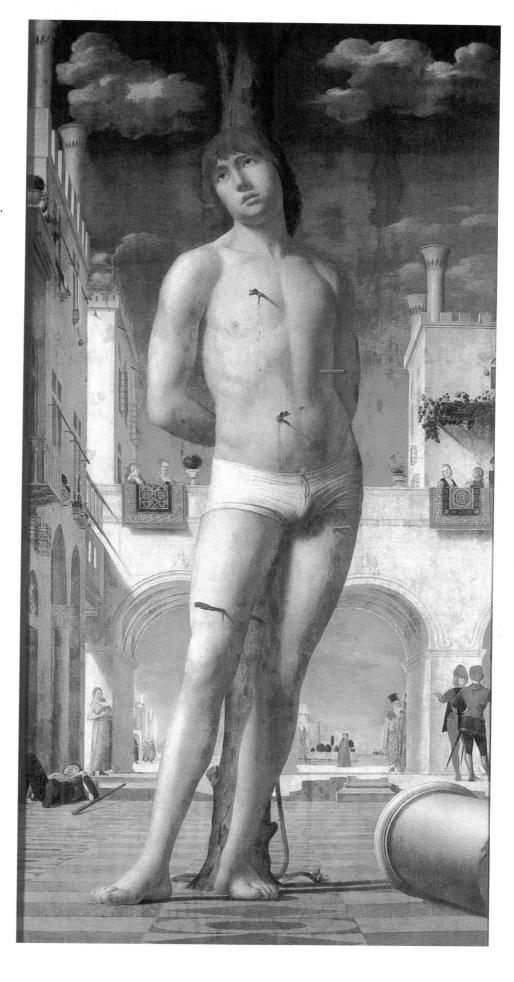

style, and two more chat before an arcade in the middle distance. The saint, pierced by arrows and tied to a tree, looks upward with calm trust. There is as yet no sign of St. Irene, the woman who will remove his arrows and nurse him back to health; she becomes a standard figure only later, in Baroque representations of the saint. Antonello's figure is both commonplace and ideal. In the reciprocal rhythms of the harmonious stance and the low viewpoint of the perspective construction, set just below the knees of the saint, Antonello shows his understanding of Mantegna's style. Figure and architecture tower above us as in the St. James Led to Execution (see fig. 15.14), but the only vestige of Mantegna's archaeological interests is the broken column lying to the right of the saint. Instead of the usual loincloth, the saint wears fifteenth-century undershorts, and the buildings are contemporary Venetian houses, even to the flaring cylindrical chimneys. Afternoon sunlight unites the scene-the buildings, the people watching from carpethung balconies, the flowers in the window boxes, the Greek priests in the middle distance, the landscape beyond, the glowing skin of the nude figure, and the carefully observed clouds in the sky.

Giovanni Bellini

It was Giovanni Bellini, or in Venetian dialect Giambellino, who brought Venetian painting to the threshold of the High Renaissance. His evolution is incomprehensible without Antonello for whom, in fact, Bellini had the deepest admiration and from whom he must have learned the new possibilities of oil painting. We know little about Bellini's character, and most of his paintings, especially the early ones, are undated. We have no evidence for the date of his birth save that he signed a document as a witness in 1459, when he was already living away from his father and brother, and that in 1506, when Albrecht Dürer visited Venice for the second time, he wrote that Bellini was very old but still the best painter in the city. Taken together, these would seem to place Bellini's birth in the early 1430s, fairly close to the birth date of his brother-in-law, Andrea Mantegna. He is recorded as a painter before 1460, and he was painting up to the time of his death in 1516. Although a similar poetic temperament can be felt in all Bellini's paintings, the difference in style between the earliest and latest is so great as to make it hard at first to believe they were done by the same artist (compare fig. 15.36 with fig. 15.43, for example).

Bellini's early works show a strong affinity with Mantegna's style, but while the sculptural hardness of the masses, the firmness of contour, the crispness of detail, and the careful construction of the picture may suggest Mantegna, Bellini never presents us with the same consistency, the same rigor of organization, the same finality. While

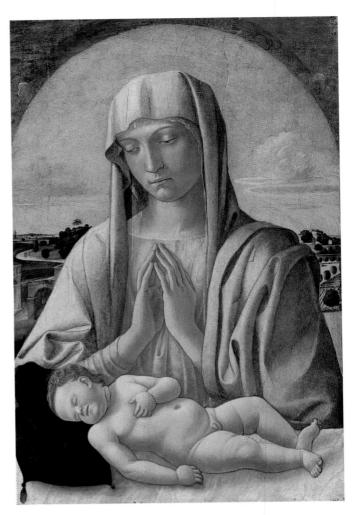

15.36. GIOVANNI BELLINI. Madonna and Child. c. 1455. Panel, $28^{1}/2 \times 18^{1}/4$ " (72 x 46 cm). The Metropolitan Museum of Art, New York

Mantegna's world seems absolute and unchanging, Bellini's works convey an interest in emotion and human experience, and his figures suggest a community of feeling.

A grave, pensive *Madonna and Child* (fig. 15.36) is typical of Bellini's early half-length Madonnas. Lifting her hands in prayer, Mary looks sadly down toward the sleeping Christ, whose slumber is meant to remind the observer of his death on the cross. Mary's face is suffused by light from below—the sea light of Venice reflected from canals and palaces and which Bellini used even for Madonnas set in landscapes. In the early works, these landscape views provide a background of easy roads and gentle slopes, but as Bellini's work develops they will grow to envelop the figures. Bellini is not interested in the enameled brilliance of color seen in the contemporary works of his brother-in-law Mantegna. In his early works, he prefers a harmonious combination of pearly pale flesh tones, soft gray-blues, and shades of rose as seen here; later with the use of oil, his color warms and deepens,

and the effect of the sea light so important for Venetian painting is strengthened.

Bellini's Agony in the Garden (fig. 15.37) is near Mantegna's (see fig. 15.20) in date and the two works offer a revealing comparison. Both derive from the compositions of Jacopo Bellini, but Giovanni's reveals his awareness of Mantegna's painting as well. Yet Giovanni ignores the grandeur of the landscape and the classical reminiscences characteristic of Mantegna's style, choosing instead to represent a simple northern Italian landscape where the Venetian plain meets the hills near Padua: a hill town on one side, a clustered village on the other, and in between a badly eroded valley. The rosy dawn light of Good Friday has started to color the undersides of the clouds, as it does in Jacopo Bellini's Madonna of Humility with Donor (see fig. 15.8). The color scheme is dominated not by the reds, yellows, and blues of the garments, as in Mantegna's painting, but by the tones of the still-shadowed earth and the delicate sky; there is an expressive poetry in the landscape here that is not found in Mantegna's work. Bellini's Christ lifts his head just above the horizon as he contemplates a single transparent angel holding the chalice. Instead of Mantegna's Roman platoon, Bellini's Judas leads a ragtag

band of sleepy soldiers, and in the foreground Bellini is less interested in perspective projection than in the fitful and exhausted slumber of the apostles. Bellini's sympathy to nature and his understanding of how landscape and light help to create a mood are important aspects of his style.

Of all the early works, perhaps the most moving is the Pietà (fig. 15.38), which is again closely related to compositions originated by Jacopo Bellini. The tomb ledge suggests the parapet of Jacopo's Madonna compositions, while behind the ledge Mary and John the Evangelist hold up the dead Christ for meditation. His head, still crowned with thorns, falls toward that of the ashen, worn Mary, who brings her cheek almost to his and searches the pale face and sunken eyes. Her eyes, and those of John, are red from weeping, and the inscription at the bottom reads, "When these swelling eyes evoke groans, this work of Giovanni Bellini could shed tears." The streams of blood that have congealed below the lance wound and along the left forearm are the warmest tones in the picture. The cold clear sky complements the subdued colors of the drapery, and the atmosphere suggests the clarity of a winter day. The colors of the flesh of Mary and John are a subtle contrast to the greenish tones of

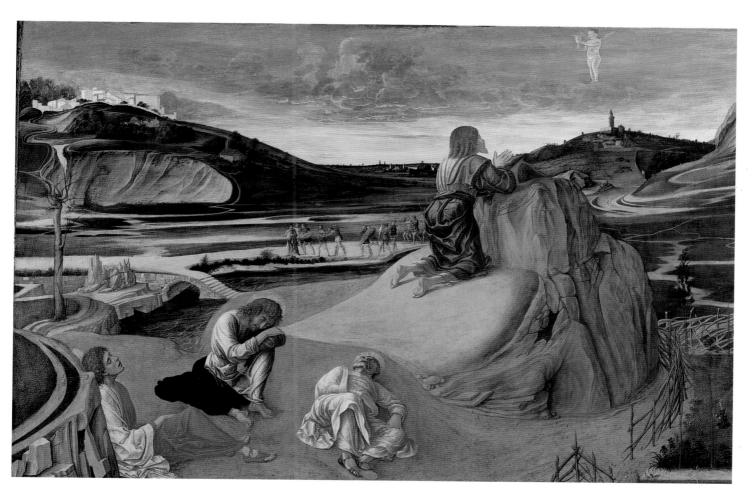

15.37. GIOVANNI BELLINI. Agony in the Garden. c. 1465. Panel, 32 x 50" (81.3 x 127 cm). National Gallery, London

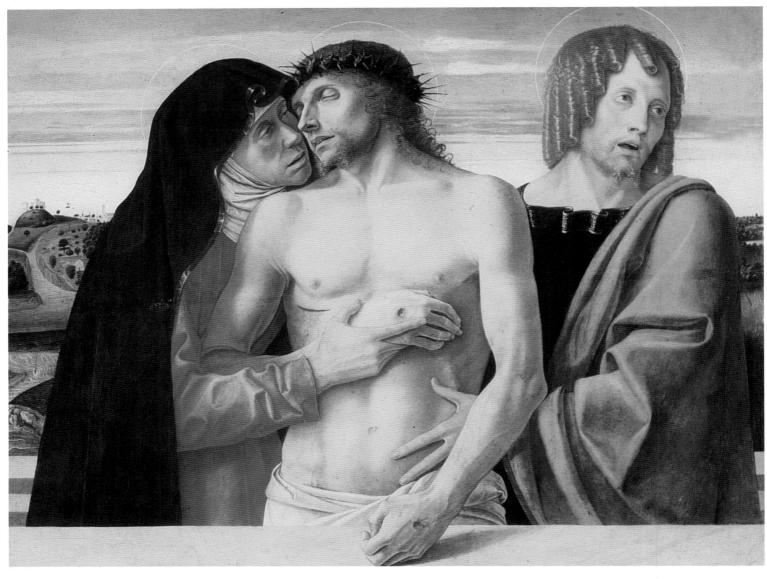

15.38. GIOVANNI BELLINI. Pietà. c. 1468-71. Panel, 331/4 x 42" (84.5 x 106.7 cm). Brera Gallery, Milan

Christ's gently illuminated body, and the figures and the tan and olive landscape seem locked between the horizontals at bottom and top of marble and cloud. Never again are Giovanni's dramas so intense or his appeal to emotion so explicit. As his style matures, the content of his pictures becomes warmer and richer as does his sun-drenched color.

Although nature is reduced to two brief echoes in the background, one at either side, Bellini's *Enthroned Madonna* and *Child with Sts. Peter, Nicholas, Benedict, and Mark* (fig. 15.39) shows a steady increase in the artist's interest in studying natural light. The altarpiece has its original frame, complete with dolphins and winged tritons, and is still in the position for which it was painted. The painting was commissioned in memory of Franceschina Tron, who is buried in a tomb in front of the altar that became the burial place of her descendants. Giovanni has borrowed his brother-in-law

Mantegna's device of the architectural frame into which one looks as if into a shrine (see fig. 15.16). In this case the illusion of reality is greater because the capitals inside the picture are identical with those of the frame and because the picture is painted in oil, which enables the artist to develop a continuous atmosphere, into whose shadows light is gradually dissolved. It is as if the gilded Renaissance frame were casting a golden light into Mary's shrine, to be given back out in softer keys by the painted gold mosaic of the apse, a typical Venetian reference to the Church of San Marco. The forms themselves are no longer so clearly defined; the contours of faces and figures and the boundaries between figures subtly merge with the atmosphere. Only oil medium and oil glaze can account for this transformation, and certainly it was prompted by Bellini's wonderrecorded by the sources-at Antonello's work. Now he

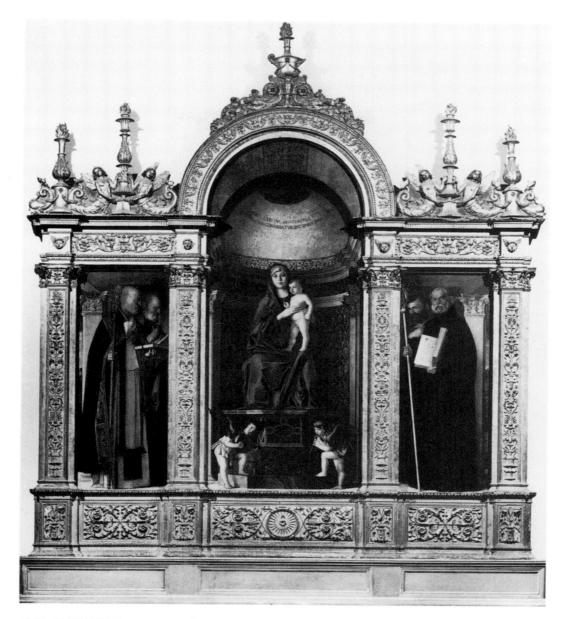

15.39. GIOVANNI BELLINI. Enthroned Madonna and Child with Sts. Peter, Nicholas, Benedict, and Mark (Frari altarpiece). 1488. Central panel $72\frac{7}{16}$ x $30\frac{3}{4}$ " (184 x78 cm); side panels each $45\frac{1}{4}$ x $18\frac{1}{16}$ " (115 x 46 cm). 🛍 Sacristy, Sta. Maria Gloriosa dei Frari, Venice. Commissioned by the sons of Pietro Pesaro and Franceschina Tron in memory of their mother

understands how to present the fluid fabric of light and atmosphere that surrounds us. In this new delight in optical beauty, however, some may think that certain qualities of Bellini's early works have been lost. The poignancy and, at times, somber drama of those pictures are different from the world of easy opulence that Bellini depicts in his years of success. His Madonnas now seem untroubled by any premonition of the Passion.

Giovanni's huge Enthroned Madonna and Child with Sts. Peter, Nicholas, Benedict, and Mark, known as the San Giobbe altarpiece (fig. 15.40), is related to a Madonna Enthroned with Saints painted by Antonello in 1476, which is now lost except for fragments, and also to the Madonna and Child with Saints by Piero (see fig. 11.33). Bellini has given the

figures not only reasonable proportions in comparison with the architecture—Piero had already done that—but also reasonable positions within the illusionistic space instead of before it; this effect is much clearer when the painting is seen reunited with its original frame, as shown here. The monumentality of the painting lies not just in its scale, but in the manner in which the figures relate to Giovanni's illusionistic space. The standing figures are less than one-third the height of the barrel vault above them, and even the Virgin's towering throne does not elevate her head as high as the mathematical center of the picture, which is marked by the golden cross that tops her throne.

These proportions show that Bellini was accustomed to composing on a grand scale, placing life-sized figures in vast

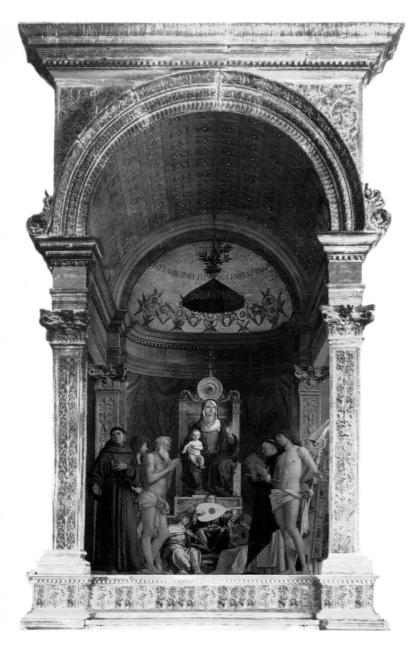

15.40. GIOVANNI BELLINI. Enthroned Madonna and Child with Sts. Francis, John the Baptist, Job, Dominic, Sebastian, and Louis of Toulouse (S. Giobbe altarpiece). Computerized reconstruction by Sarah Loyd. Late 1470s. Panel, 15'4" x 8'4" (4.7 x 2.5 m). Accademia, Venice. Commissioned for the chapel in the Hospital of S. Giobbe, Venice; perhaps the patron was the Scuola di S. Giobbe.

Christian churches are seldom dedicated to Old Testament figures, but in Venice Job and Moses each have their own church. This computerized reconstruction shows the painting in its original frame, which still survives in the original location while the painting has been moved to a museum. Unfortunately it is only in such a reconstruction that we can get a reasonable idea of the effect of the original altarpiece.

surroundings. We tend to forget this fact because almost all of his historical compositions were destroyed in the fire that gutted the Doge's Palace in 1577. If the compositions painted by Giovanni to fulfill commissions originally given to Gentile—left incomplete when the older brother went to Constantinople in 1479—were extant, we would have a more balanced picture of Giovanni's capabilities.

At any rate, the spatial effect of the shadowy Venetian Renaissance church interior that the softly lighted figures occupy is an essential element in the composition. The illusion that the apse behind the Madonna is decorated with a shimmering Byzantine mosaic has already been pointed out as a common reference to San Marco and Venetian tradition. On Mary's left, the idealized figure of St. Sebastian, more classical in feeling than Antonello's representation of the same saint (see fig. 15.35), is here as protector of the sick. The old man with long white beard at Mary's right is Job, patron saint of the hospital because of his physical and mental sufferings. The lofty space of the picture creates an effect of grandeur, and the details show Giovanni's ability to represent textures and the sweetness of expression characteristic of his mature pictures. Here he also demonstrates a new freedom in the use of the brush.

Two sublime examples of Bellini's pantheistic view of nature seem to date from this period. The Transfiguration of Christ (fig. 15.41) differs from an earlier rendering of the same subject by the artist. Now the event is shorn of its supernatural character, and Mount Tabor, traditionally represented as quite an eminence, is reduced to a slight rise. Broad meadows are interlocked along low, projecting escarpments. The afternoon is well advanced. At the left a farmer leads an ox and a goat past a monastery on a crag that is already darkening in the evening shadows; at the right, churches with cylindrical towers and partially ruined city walls still catch the light, which also dwells on the lower slopes of nearby mountain masses. Christ stands in the center of this chilly landscape, his hands and head silhouetted against the shining white clouds. The text says that "his raiment became shining, exceeding white as snow" (Mark 9:3), and Bellini has shown him in a color that grows out of the land and unites it with the sky, for the shadows are tinged with tan and green, and the whites are those of the lower layer of clouds shining against the darker masses above. The flanking figures of Moses and Elijah have all the majesty of the Old Testament. Before this group the three apostles have fallen to the ground. If Bellini's Transfiguration is a revelation of God in nature, he has cut us off from this revelation. A sapling fence moves diagonally across the foreground, and immediately behind it opens a rocky chasm, creating an explicit separation between the observer and the holy event.

Even more explicit is the *St. Francis in Ecstasy* (fig. 15.42). It is not certain exactly what moment in the saint's life is represented in this unusually large narrative painting; it has been

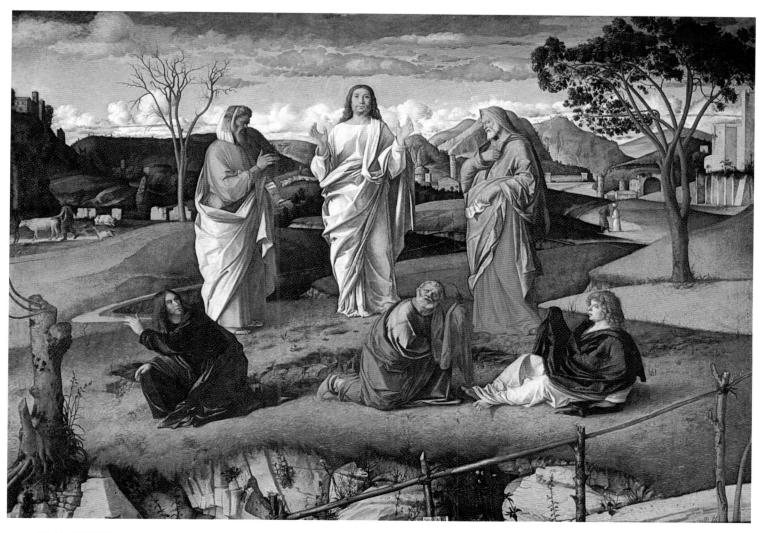

15.41. GIOVANNI BELLINI.

Transfiguration of Christ.
c. 1475–80. Panel, 45 x 59"
(114 x 150 cm). Museo di
Capodimonte, Naples.
Probably commissioned for the
funerary chapel of Archdeacon
Alberto Fioccardo in the
Cathedral of Vicenza

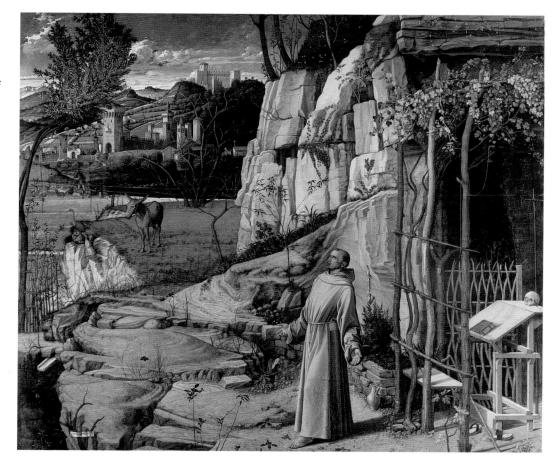

15.42. GIOVANNI BELLINI. *St. Francis in Ecstasy.* 1470s. Oil and tempera on panel, 49 x 55 7/8" (124.4 x 141.9 cm). The Frick Collection, New York

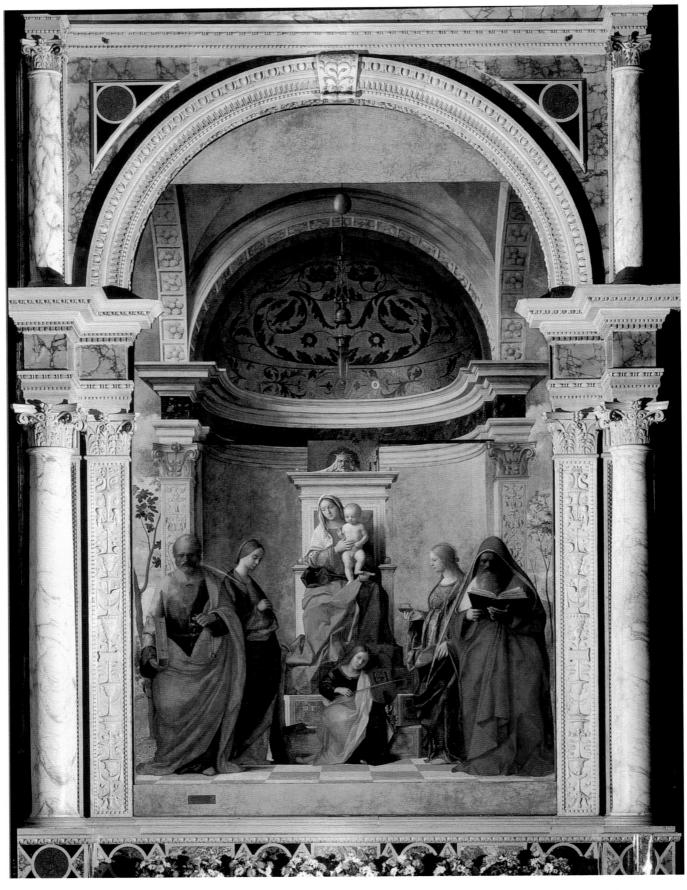

argued that this is not the stigmatization because we already see the wounds in the saint's hands. Whatever the exact moment, what we see here is the ecstatic communion of St. Francis in a verdant natural setting. He stands before a cave supplied with a grape arbor (an obviously Christian symbol) that shades his rough desk, on which only a book and skull appear. With hands outstretched, he looks upward toward a burst of golden light in the upper left corner. The slender sapling seems to bend toward him, and water flows from a stone spout attached to a little spring below. Both water and sapling are references to Moses-the burning bush and the water struck from the rock-in line with the attempts of Francis's followers to depict him as a second Moses. Beyond a standing crane and a motionless donkey, exemplar of patience, a shepherd watches over his flock. The sunlight seems to pour down on the fertile valley, the rich hillsides, the outcroppings of rock, the tranquil city, the humans, animals, and plants, and, above all, the saint. The clear deep blue of the sky helps to explain the crystalline nature of the detail throughout. Every object is represented with a Netherlandish fidelity to fact worthy of Antonello.

As the Quattrocento ended and the new century began, Bellini's art grew even stronger and more expressive. Despite his advancing age in a period when the average male lived to be only forty-four, Bellini in his seventies seems to have experienced no slackening of observation or imagination, no dulling of sensitivity, no loss of skill.

If he was not already a High Renaissance painter in the late altarpieces—such as the Enthroned Madonna with Saints (fig. 15.43)—it is hard to say why not. Certainly this was the kind of painting that impressed Fra Bartolommeo when he visited Venice in 1507, that he emulated on his return to Florence, and that Raphael in turn derived from him. At first sight the general formulation seems almost identical with that of the San Giobbe altarpiece (see fig. 15.40), but there is a profound difference. The painted architecture is not related to our position as spectators nor to our angle of vision. The viewpoint proposed by the perspective scheme, as in Leonardo's Last Supper (see fig. 16.23), is level with the heads of the saints, nine or ten feet above the floor. And of the seven figures in the painting, not one looks at another. As a result, the immediacy and intimacy of the altarpieces of Bellini's maturity are replaced by a mood of meditative calm. Each of the saints is wrapped in a voluminous mantle, and separated from the next by the enveloping light and atmosphere. The outlines, vaguer than ever, are almost completely dissolved in light or in shadow, but Bellini's control of form remains absolute. The figures stand out against the creamy marble and blue-green-gold mosaic of the shrine by the brilliance of their garments—the Virgin in bright blue, St. Peter in russet and gold, the angel in yellow with orange shadows, and St. Jerome in a deep red enlivened by crisp white. Even this altarpiece is not Giovanni Bellini's swan song, but for the

last eleven years of his life he had to compete with, and was eventually influenced by, his gifted pupils and successors: Giorgione, whom he outlived, and Titian, who was to live almost beyond the chronological limits of the Renaissance.

To complete his innumerable commissions, Giovanni maintained a large staff of assistants, who painted, following the master's sketches and directions, many Madonna compositions that bear the Bellini signature. His followers and imitators popularized the Bellini manner in Venice and its subject cities, where it became the dominant style. But Giovanni Bellini's style was not the only one available for patrons; even at the moment of his triumph, Gentile Bellini's narrative style continued, as did the Mantegnesque manner of the Vivarini family.

Vittore Carpaccio

Vittore Carpaccio (c. 1460/66–1525/26) owes almost nothing to Giovanni Bellini and only the idea of the crowded, anecdotal narrative to Gentile. His style is his own, and it is a fanciful one, full of witty observation embodied in a new kind of narrative composition.

Carpaccio was the perfect painter for the scuole, and he spent most of his artistic career decorating them with canvases of considerable size; we have little evidence that he received commissions for altarpieces and Madonnas. Most of his time in the 1490s was spent in carrying out an extensive cycle for the Scuola di Sant'Orsola. The legend of Ursula (Orsola in Italian) tells how Etherius, the pagan son of the king of Britain, sought the hand of the Christian Ursula, daughter of the king of Brittany. As a condition for her acceptance Ursula demanded that Etherius convert to Christianity and that they have a three-year cooling-off period, during which Ursula and her ten maids of honor, each accompanied by a thousand virgins, would make a pilgrimage to Rome. On the way back the 11,011 virgins were waylaid by the Huns at Cologne and slaughtered. Carpaccio divided the story into eight large paintings that originally lined the chapel of the scuola.

One canvas shows the departure of the young prince from Britain, his arrival in Brittany, and the departure of the betrothed couple for Rome (fig. 15.44). Although Britain at the left and Brittany at the right are separated by a flagpole, the same sunny Venetian sky with big, floating clouds unites them. For Carpaccio they are merely two sides of the same ideal harbor, a background for a narrative sequence that allows a celebration of the naval power and palatial splendor of imperial Venice. Britain could be any Venetian port along the Dalmatian coast or in the Aegean islands, with a castle rising above the fortifications of a seaside city. The two fortresses by the water have been identified as the Venetian strongholds at Rhodes and Candia. Whether or not Carpaccio had seen these buildings is unknown, but he had certainly

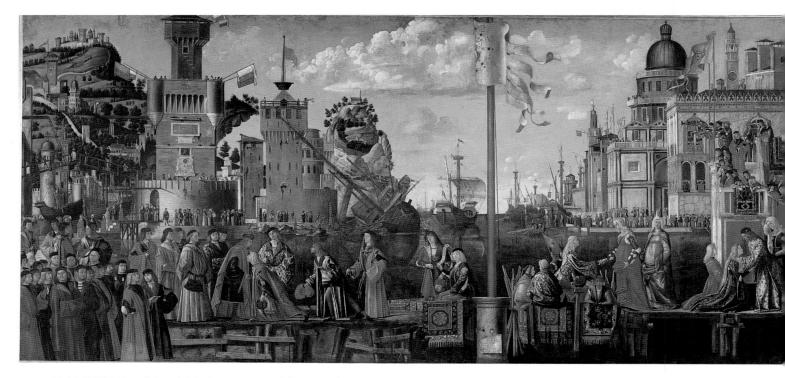

15.44. VITTORE CARPACCIO. Departure of the Prince from Britain, His Arrival in Brittany, and Departure of the Betrothed Couple for Rome. 1495. Canvas, 9'20" x 20' (2.8 x 6.1 m). Accademia, Venice. Commissioned by the Scuola di Sant'Orsola for the confraternity headquarters, perhaps with the financial assistance of the Loredan family

watched the careening of ships in the naval arsenal of Venice, and he represents this essential repair procedure of the predrydock era with concentration. Brittany is Carpaccio's fantasy on the theme of Quattrocento Venice, with marble-clad palaces, domes, and towers crowding to the sea. The verticals of towers, flagpoles, and masts and the diagonal of the careened galleon give him straight lines with which to bind the diffuse composition together—motifs that traverse, organize, and contain the space and the figures.

The narrative moves gently from left to right. First, the young prince kneels to take leave of his father; next we see him in a gorgeous brocaded costume meeting his bride; then, prince and princess kneel before the king of Brittany; finally, to the sound of trumpets, the young couple and the first contingent of virgins move in the distance toward the longboat that will take them to waiting ships. Carpaccio's colors are generally subdued by a rich, all-over golden tonality so that even the occasional strong reds, blues, and greens are never obtrusive. The shapes are controlled by his preference for triangular areas, often balanced on their points-people, costumes, drapery passages, sails, banners, architectural shapes. The result is a Venetian web of space and tone in which the triangles are embedded almost like fragments of glass in a kaleidoscope. The subtly observed, delicately lighted, strongly individual faces seldom betray emotion. Many are surely contemporary portraits; perhaps the artist himself peers at us from the worldly crowds who throng his docksides and piazze. The figures and the details of the contemporary setting are rendered in a series of sure, parallel touches that owe nothing to the styles of Giovanni Bellini and Andrea Mantegna. In fact, Carpaccio abandons traditional linear drawing and shaded modeling in favor of definition by pure brushwork.

The Arrival of the Ambassadors of Britain at the Court of Brittany (fig. 15.45) depicts an earlier episode in the legend. In the center the ambassadors kneel before the enthroned monarch, flanked by four of his councilors. On the right, the king is seated at the edge of a bed, his crowned head propped on one hand, as he listens wearily while his daughter ticks off on her fingers the conditions she intends to impose for the marriage.

The painting offers many delightful details, including the shrewd portraiture, the wittily drawn distant figures, and the intimate scene in the king's bedchamber, on whose wall hangs what appears to be an early Madonna by Giovanni Bellini. A flight of steps arches over a grated aperture, as if to afford us a special entry into the king's privacy, and at the foot of the steps sits an old woman with a cane, paying no attention to us or her sovereign. Carpaccio's rich golden tonality saturates the marble slabs and splendid fabrics with the glow of afternoon.

Carpaccio's poetic style is evident in the *Dream of St. Ursula* (fig. 15.46). The saint is sleeping in a high-ceilinged bedroom when a golden-haired angel enters to bring her the

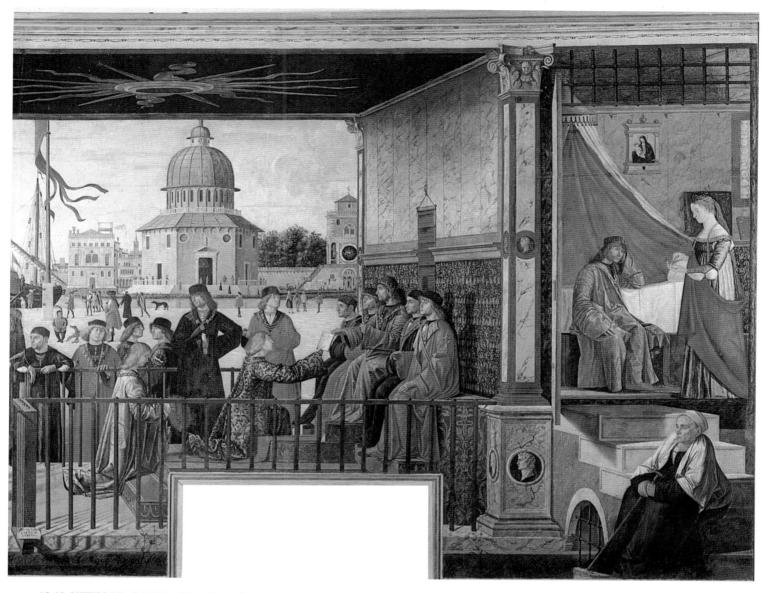

15.45. VITTORE CARPACCIO. Arrival of the Ambassadors of Britain at the Court of Brittany. c. 1495–96. Canvas, 9' x 19'4" (2.74 x 5.89 m). Accademia, Venice. Commissioned by the Scuola di Sant'Orsola for the confraternity headquarters, perhaps with the financial assistance of the Loredan family

palm that signals her approaching martyrdom. The angel is accompanied by a burst of powerful light that is based on Carpaccio's study of morning sunlight effects. Here it may be intended to represent a burst of divine light accompanying a revelation in the deep of night. Every detail is observed with almost Antonellesque fidelity, down to the three-legged stool, the reading table with lectern and portable library that accompanied the saint on her trip, the wooden clogs before her bed, and the crown carefully laid on the bench at its foot. The light effects range from the flood of light accompanying the angel and the sharp ray running along the ceiling from the oculus window at the right to the softer effects in the anteroom and the diffused sparkle of the bottle-bottom windows. All are unified by the softened red and greenish-gray tones that predominate in the room, and they become part of

the cubes of space created by the contours of the room and the delicate spindles of the bedposts and the lines of the canopy. Someday perhaps iconographers will discover why over one door there is a beautifully painted nude statue of a water carrier and over the other a provocative Venus on her shell. Neither seems to have much to do with the chaste saint sleeping so peacefully in her bed.

Probably in the late 1490s Carpaccio painted his *Meditation on the Passion* (fig. 15.47). The body of the dead Christ is displayed on a ruined throne between two bearded hermitsaints. St. Jerome, on the left, is recognized by his lion in the background; his companion is Job, an identification based in part on his similarity to Job as he appears in Bellini's San Giobbe altarpiece (see fig. 15.40). Reminders of death appear everywhere: a skull rests on the ground under Job's knees, the

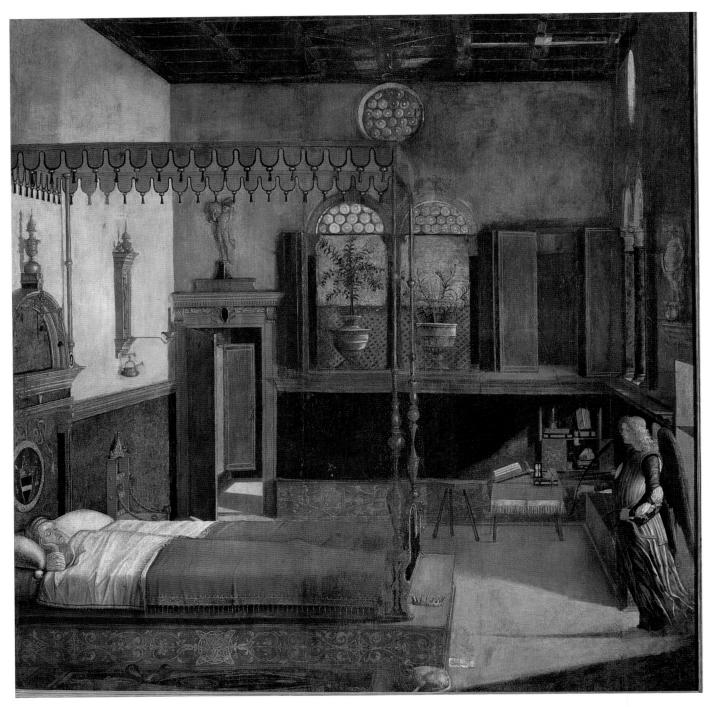

15.46. VITTORE CARPACCIO. *Dream of St. Ursula.* 1495. Canvas, 9' x 8'9" (2.74 x 2.7 m). Accademia, Venice. Commissioned by the Scuola di Sant'Orsola for the confraternity headquarters, perhaps with the financial assistance of the Loredan family

top of Jerome's staff is carved with a hand clutching a bone, and his rosary is a threaded set of vertebrae. Yet the dead Christ almost seems to be dreaming, and the warm afternoon sunlight that glows on the scene is reflected upward onto his features and closed eyes. St. Jerome wrote a commentary on the Book of Job in which he interpreted Job's words, "I know that my redeemer liveth, and that he shall stand at the latter day upon the earth" (19:25), as a prophecy of Christ's Resurrection. In the preceding verse Job had asked that his words be "graven with

an iron pen and lead in the rock," and this is just what Carpaccio has done. Among the generally meaningless tracks on the block on which Job sits can be read, "My redeemer liveth. 19," a clear reference to the passage from Job just cited.

The landscape is doubtless symbolic. As in Piero della Francesca's *Resurrection* (see fig. 11.23), it is sharply divided. On the left, dominated by a withered tree, is a wild and rocky mountainside where a doe grazes, oblivious of the fate that has befallen her mate, who is borne to earth by a

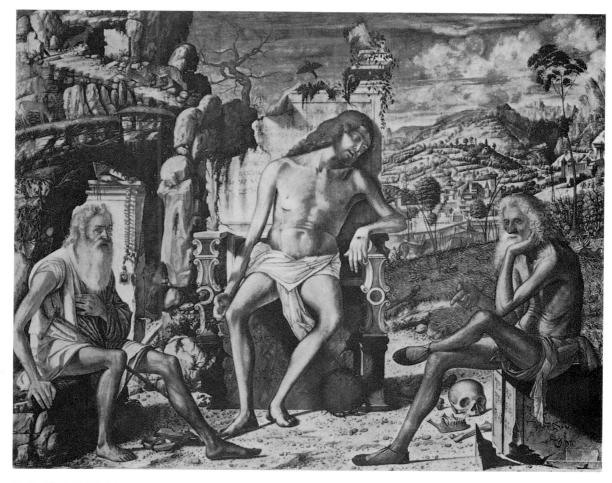

15.47. VITTORE CARPACCIO. Meditation on the Passion. Late 1490s. Panel, $27\frac{3}{4}$ x $34\frac{1}{8}$ " (70.5 x 86.7 cm). The Metropolitan Museum of Art, New York

leopard. On the right, where another stag runs from a pursuing leopard, there is a rich landscape of farms, orchards, castles, a peaceful town, and green trees. The stag, symbolic of the human soul (Psalm 42: "As the hart [deer] panteth after the water brooks, so panteth my soul after thee, O God"), is torn by the leopard on one side and escapes on the other, just as Job, once tormented, was later blessed by God. A bird, symbolizing the Resurrection, flies up from behind Christ's throne. This unusual picture must have been made for a patron who outlined for the painter the specific iconography and who may even have explained to Carpaccio how he or she planned to use this private devotional work.

In his later works Carpaccio never surpassed the glowing landscape and the pearly clouds of this painting, nor did he equal the personal religious poetry that makes it so intriguing. His late work has been interpreted as a decline and, after 1510, he could not compete with the High Renaissance style of Titian; he obtained commissions only in such places as the fishing town of Chioggia or the provincial centers of Istria and the Dalmatian coast.

Carlo Crivelli

Carlo Crivelli (c. 1435–c. 1495) is even harder to place than Carpaccio. Although a Venetian by birth, he spent almost all his active life far from Venetian territory. He might logically be considered a central Italian painter if it were not for the fact that his early style was formed by the Paduan school. Our first information about him is a court judgment against him in 1457 for having "kept hidden for many months" the wife of an absent sailor, "knowing her carnally in contempt of God and of Holy Matrimony." Sentenced to six months in prison and a heavy fine, he is presumed to have left Venice soon after his release. Still signing himself proudly "Carolus Crivellus Venetus," he spent the rest of his life in the Marches, where his sharply individual style had considerable influence on local artists.

Throughout Crivelli's known activity of about thirty years, his style developed little. He left Venice before the flowering of Giovanni Bellini's atmospheric art, taking with him his own linear version of the Paduan manner. Hair, veins, and

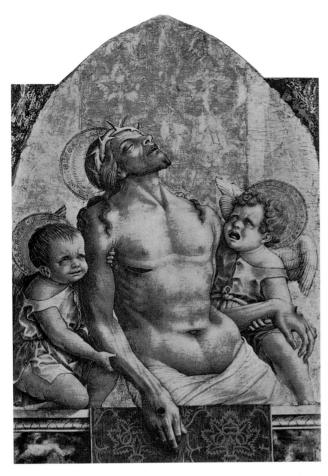

15.48. CARLO CRIVELLI. *Pietà*. c. 1470. Panel, $28 \times 18^{1/2}$ " (71 x 47 cm). John G. Johnson Collection, Philadelphia Mueseum of Art. Probably this panel was part of a polyptych with other, still-unidentified panels.

muscles are carefully outlined, and forms are sharply projected. Sometimes the drops of Christ's blood, the tears of his mourners, and the selected attributes of the saints are modeled in low relief in gesso so they stand out from the painting's surface before being painted or gilded. His color and form are dominated by metal and stone, which appear in profusion. In 1492 he was still using a gold background, although it is possible that this may have been required by some of his provincial patrons. Yet, paradoxically enough, the effect of a Crivelli painting is not hard. The stone he paints is colored marble that contains rich fluctuations of tone, while the metal is gold, silver, or both. The result is something like a tapestry with gold threads—sumptuous, russet, deeply glowing but subdued. This is Crivelli's own version of the Venetian web (see p. 171).

Right: 15.49. CARLO CRIVELLI. *Madonna della Candeletta*. Early 1490s. Panel, 86 x $29^{1/2}$ " (218 x 75 cm). Brera Gallery, Milan

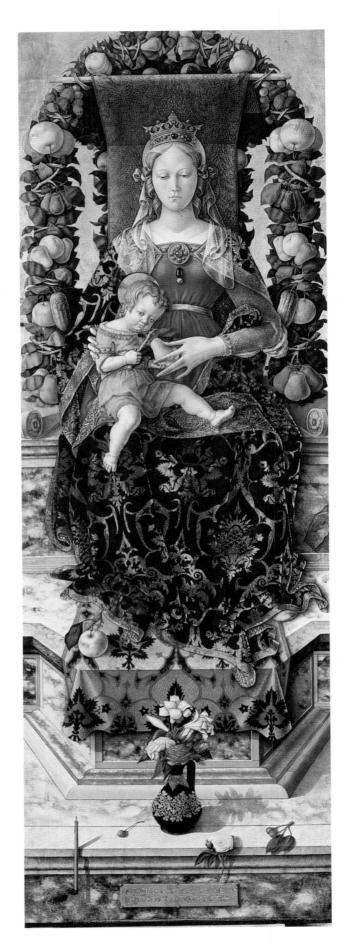

A typical work, the *Pietà* (fig. 15.48), reveals the intensity of Crivelli's rendering of the scenes of the Passion. Before a gold background and a cloth of honor made by tooling the gold surface, lamenting angels hold up the dead Christ. Christ's head is thrown back, his mouth hangs open. A gigantic spear wound yawns in his side, and one huge nail wound in his left hand is shown in profile so that its depth may be assessed. The taut veins, tendons, and wrinkles are projected by Crivelli's sharp surface hatching to an almost unbearable degree. Yet his sense of pattern is so strong and his golden tonality so insistent that there is no sense of disunity between the painted forms and the relief.

In his later works Crivelli achieved a harmony of form, color, and surface. In the Madonna della Candeletta (fig. 15.49), Crivelli signed himself as "eques" (knight), a slight inflation of the rank of "miles" (soldier) conferred upon him in 1490 by Prince Ferdinand of Capua, later King Ferdinand of Naples. The picture's title derives from the thin candle that burns at the lower left. The crowned Virgin sits upon a veined marble throne whose bench, pedestal, and base seem to continue out of the frame at either side. The garlands of fruit and leaves, which Crivelli had brought with him as part of his standard repertory from Padua and Venice, are here gathered to form a little bower. Not even the dark blue and gold velvet brocade of Mary's mantle or the red and gold of her sleeves can compete with the magnificence of the apples, cucumbers, and pears. These great, rounded shapes, with their metallic colors and rippling leaves, dominate the picture with a kind of magical intensity. Even Mary's face, with its downcast eyes and solemn frontality, is likened in shape to the apples and pears and shines as softly as they do. Again, Crivelli projects his forms sharply and lets the light cast shadows on the painted marble, and the effect, as usual, is that of a precious Renaissance textile. Crivelli's was a strongly personal style of refinement and brilliance, hermetically sealed from the developments of his Venetian contemporaries, from whom the artist exiled himself. Yet his work was certainly one of the major achievements of northern Italian art of the Quattrocento.

Late Quattrocento Architecture in Venice

In the course of its thousand-year history, Venice produced few architects of importance; most of the builders who worked there came from other regions. But once in the city, they fell heir to both the splendors of the Byzantine tradition—inevitable, with the Basilica of San Marco in their midst—and the rich linear complexities of the Flamboyant Gothic style brought from France and Germany. In Carpaccio's backgrounds (see figs. 15.44, 15.45), the Byzantine and

Gothic currents blend, clothed with the same rich marble paneling and highlighted by the same Venetian sunlight they seem created to exploit. Only here and there are Carpaccio's hybrid buildings punctuated by windows or pilasters borrowed from the Florentine Renaissance. These painted structures reflect the first timid appearance of the Renaissance in Venetian architecture, which occurred in structures built almost exclusively by artists from Lombardy. During the last third of the Quattrocento in Venice, a family of builders, stone carvers, and sculptors named Lombardo (they were from Carona, near Lugano, which is today in Switzerland but was then in Lombardy) competed for dominance with Mauro Codussi (c. 1440-1504), another Lombard, from Bergamo. Codussi was in closer touch with the ideas of the central Italian Renaissance than were the Lombardo family, and by the end of the century he had led the way to a truly Venetian Renaissance style in architecture.

The towering façade of San Zaccaria in Venice was almost exclusively the creation of Codussi (fig. 15.50). The interior of the church was still Gothic in design, and the preexisting lowest story of the façade, a sort of pedestal with rectangular paneling, established a complexity from which Codussi could hardly vary. On this he superimposed stories in the new classical style, exploiting by their projections and recessions the play of light one expects from Venetian paintings of

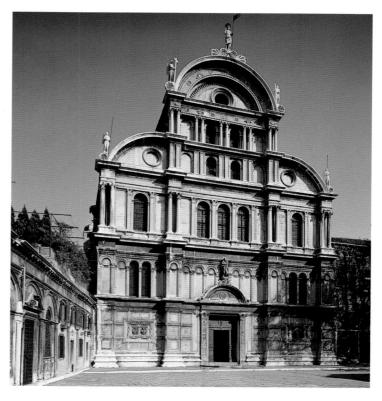

15.50. ANTONIO GAMBELLO and MAURO CODUSSI. Façade, S. Zaccaria, Venice. Second half of fifteenth century

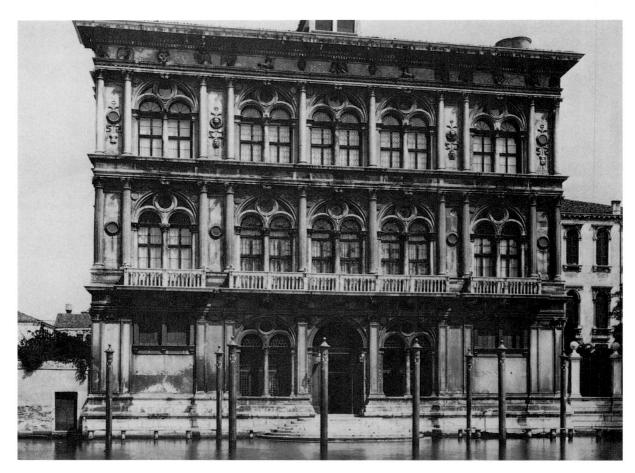

15.51. MAURO CODUSSI; completed by the LOMBARDO family. Façade, Palazzo Loredan (now known as the Palazzo Vendramin-Calergi), Venice. Begun c. 1500; completed 1509. Commissioned by the Loredan family

the period. Codussi continues the buttresses upward, using them to divide the arcade that decorates the second story into three segments. On the third and fifth stories the buttresses are articulated by paired, freestanding Corinthian columns. The proliferation of windows of differing sizes and proportions, the superimposition of orders utilizing different numerical systems between the second and third floors, and the stumpy proportions of the Corinthian colonnade on the fifth floor produce an effect of irregularity and improvisation alien to the Albertian tradition. Yet it is from Alberti's idea for the Malatesta Temple (see fig. 10.3) that Codussi derived the lofty central arched pediment at the top and the quartercircles that mask the roof line on either side. Imagine being an architect facing the problem of this commission—how to complete this tall façade with its lowest story already in place. Codussi's solution is profoundly Venetian and yet at the same time it asserts that classicizing columns and entablatures are the only proper architectural vocabulary. After passing through Codussi's Renaissance resolution, it is a surprise to enter the unified Gothic space of the interior, but the presence of Bellini's late altarpiece (see fig. 15.43) returns us to the world of Renaissance classicism.

Protected by their canals, Venetian palaces did not require the fortresslike construction we have seen in even the most princely dwellings in other central Italian cities. Throughout the Late Middle Ages and into the Quattrocento, Venetian builders constructed the façades of palaces along the main thoroughfare, the Grand Canal, according to a system that had been devised as early as the eleventh century. Long rows of arches and windows opened onto the canal, while on the lowest story a triple-arched entrance provided admission from the gondola landing to a courtyard and stairways. This entrance was flanked by service rooms lighted by relatively small windows, but this tripartite division was maintained in the second and third stories, where enormous windows filled the façade.

The marble façade designed and built by Codussi for the powerful Loredan family (fig. 15.51) was the culmination of the palace type of the Venetian Quattrocento and the bridge to the High Renaissance in Venice. Ironically enough, the work was completed, after Codussi's death, by the Lombardo family. But the design is Codussi's, and in the relationship between columns and windows he achieves a balance and maturity of proportions that had eluded him when he

had to complete the façade at San Zaccaria. He derived the double-light windows from the Florentine Renaissance (see fig. 6.17), but here they are enlarged and joined to the embracing Corinthian columns so that the wall-always so prominent in Florentine palace design—disappears. Even the tympanum above the paired windows is pierced by an open oculus, an echo of the lingering tradition of Gothic tracery. The façade seems to consist of a framework around openings, a succession of clusters of columns and colonnettes, with brief intervening spaces of veined marble that are enlivened by sculptured ornament and porphyry disks. The stories are separated by balconies and rich entablatures, and the whole is crowned by an impressive cornice. The pictorial effects of this Venetian palazzo are in strong contrast to the effect of the roughly contemporary Palazzo Strozzi in Florence (see fig. 12.21), where every effort seems to have been made to enhance the forbidding density of the masonry. Yet in harmony and balance, they are surprisingly similar. Like the other palace façades along the Grand Canal, the Palazzo Loredan (now known as the Vendramin-Calergi) enjoys the advantage of being reflected in the water, from which glittering light reflects back to soften the building's shadows and dematerialize its forms.

Late Quattrocento Art in Milan

Francesco I, the founder of the Sforza dynasty in Milan, was of low birth but a successful general. He married the illegitimate daughter of Filippo Maria Visconti; three years after the latter's death without male issue in 1447, Francesco managed to abolish the revived Milanese Republic and assume the hereditary dukedom. His son, Galeazzo Maria, duke from 1466 to 1476, was tyrannical and cruel-and an insatiable patron of the arts. After his murder in 1476, when he left a son too young to govern, the reins of government were taken over by his brother, Ludovico il Moro, who was declared duke in 1494. Ludovico became one of the most enlightened of Renaissance rulers and patrons of art, but unfortunately the magnificent structures he built are now largely transformed or destroyed and his art collections almost entirely dispersed. His expulsion from the dukedom by the French in 1499 and his death in a French prison marked the end of a brilliant era.

Vincenzo Foppa

Perhaps the most original Lombard painter of the Quattrocento was Vincenzo Foppa (c. 1428–1515) from Brescia. The relation of his earliest dated work, the *Crucifixion* of 1456 (fig. 15.52), to Quattrocento art elsewhere is clear. The embracing arch and imperial profile portraits in the spandrels show his adaptation of the classicized architecture and motifs that were transforming Quattrocento art. The pose of the

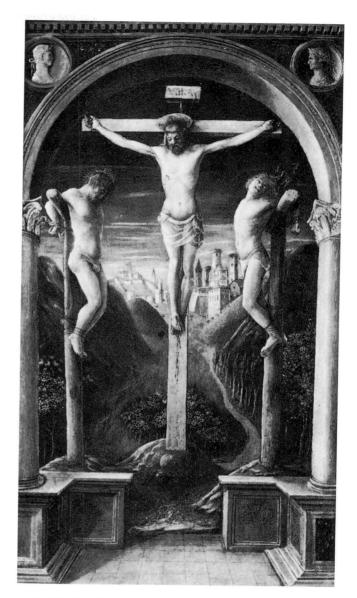

15.52. VINCENZO FOPPA. *Crucifixion*. 1456. Panel, 26³/₄ x 15" (68 x 38 cm). Galleria dell'Accademia Carrara, Bergamo

bad thief and the treatment of the background landscape betray a knowledge of Jacopo Bellini (see fig. 15.8) and there is even the possibility of influence from the predella of Mantegna's San Zeno altarpiece (see fig. 15.19). The muscular vigor of the bodies and the violence of the expressions and poses are typical of Foppa's interests. The expressive impact of the scene evolves from the manner in which Foppa contrasts the suffering of the two thieves with the calm serenity of the figure of Christ, which itself seems related to the quiet architectural frame that surrounds the scene. The painting demonstrates how quickly Renaissance innovations infiltrated Lombardy, and how profoundly an artist outside the centers of Renaissance developments could adapt its possibilities to his own expressive needs.

Filarete

Antonio Averlino (c. 1400–after 1465) was a Florentine sculptor and architect who adopted the name Filarete (from the Greek, "love of virtue"). In 1445 his set of bronze and silver doors commissioned by Pope Eugenius IV were installed at Old St. Peter's; they are in use today on the new building. Filarete left Rome and sought employment in Milan where, in the early 1450s, he began working for Francesco Sforza. His ideas, founded on what he could glean from Alberti in Rome, came into conflict with the entrenched conservatism of such local Gothic builders as the Solari family (see below), which doomed most of his projects from the start.

His fascinating treatise on architecture, under strong Albertian influence, laid out many ambitious and expensive Renaissance schemes. The only major project from the treatise that was undertaken was the Ospedale Maggiore (Main Hospital) for Milan, the practical and theoretical aspects of which Filarete described in detail. The basic plan of two enormous cross-squared structures united on either side of a central piazza was followed and the building, in spite of later alterations and damage from aerial bombardments, still exists. Even more fascinating was Filarete's proposal for an island city named Sforzinda after the ruling family of Milan

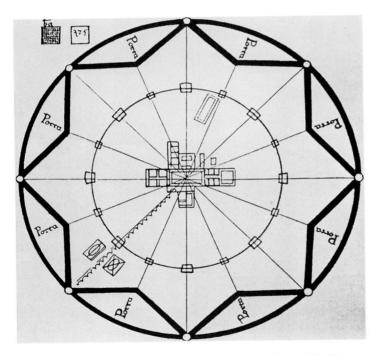

15.53. ANTONIO FILARETE. Plan of Sforzinda. c. 1457–64. Biblioteca Nazionale, Florence. Commissioned by Francesco Sforza. Filarete presented his treatise on architecture and city planning, in which this plan was illustrated and described, to both Piero de' Medici in Florence and Duke Galeazzo Maria Sforza of Milan. Where Filarete expected that Sforzinda would be built is unknown.

(fig. 15.53). The exterior walls were to be shaped like an eight-pointed star, with the palace of the prince and a nucleus of public buildings in the center, in true Albertian style. Such a centralized city, impossible even for despots such as the Sforza, was eventually carried out, but only at the close of the sixteenth century in the pentagonal plan for Livorno, designed by Bernardo Buontalenti for Grand Duke Ferdinand I de' Medici, and in the web of canals built in Amsterdam. Nevertheless, the imprint of Filarete's ideas is evident in some of the vast projects commissioned by Ludovico il Moro, including the villa, castle, scientific farms, and central square of Vigevano, built by Bramante, and in the system of canals—some still in use—in Milan.

The Certosa di Pavia

The vast Certosa (Carthusian monastery) at Pavia was, aside from the Cathedral of Milan itself, the major architectural undertaking of the Visconti and Sforza dukes. The church, where the dukes planned to be buried, was begun in 1396 under Giangaleazzo Visconti; in an attempt to assert their legitimacy, the Sforza enthusiastically continued this grand project. Eventually the Gothic architect Giovanni Solari was made head of the project; his son Guiniforte was associated with him in 1459. From the exterior (fig. 15.54), the church is a picturesque agglomeration of superimposed arcades of stone, set in the brick walls used so often in Lombard architecture. While the effect of the whole is Gothic, the details of capitals and arches conform to the new Renaissance style.

Some of the sculptural decoration from the original façade of the Certosa, begun in 1473, survives, including some dramatic reliefs attributed to the Milanese sculptor Cristoforo Mantegazza (d. 1482). His violent *Expulsion from the Garden* (fig. 15.55) shows Adam and Eve being driven from paradise not by the usual angel, but by an angry God, who lunges forward in a gesture of powerful condemnation. The tense poses and the angular treatment of God's drapery and the anatomy of Adam are striking, but whether this is Mantegazza's own interpretation or the impact of the late style of Donatello is uncertain.

The original design for the façade of Certosa was abandoned, and a new façade of overwhelming richness and splendor was commissioned by Ludovico il Moro beginning in 1492 (fig. 15.56). Designed and constructed under the supervision of the Pavian architect and sculptor Giovanni Antonio Amadeo (1447–1522), it was built of marble from the quarries at Carrara, near Pisa, brought over the mountains at staggering cost. The façade is divided and subdivided into windows and other openings—rectangular, arched or round, and single, double, quadruple, and quintuple—and enriched with sculptural reliefs (some from the 1473 façade) and carved ornament that at first seem to offer only a bewildering complexity. But a certain logic runs through it all; the

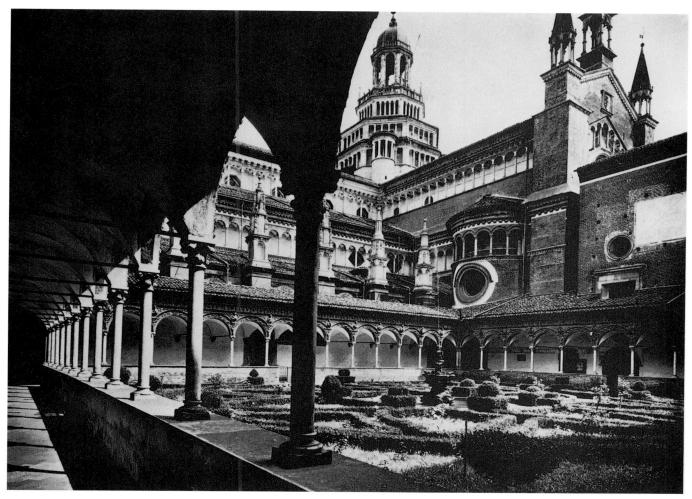

15.54. GIOVANNI and GUINIFORTE SOLARI. Certosa, Pavia. Begun 1396; finished after 1492. View from the cloister. Commissioned by Giangaleazzo Visconti. Pavia served as the capital of Lombardy before Milan.

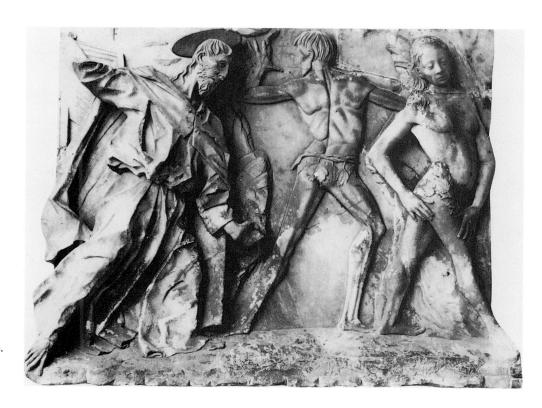

15.55. CRISTOFORO MANTEGAZZA. Expulsion from the Garden. c. 1480. Marble. Certosa, Pavia. Commissioned by Galeazzo Maria Sforza

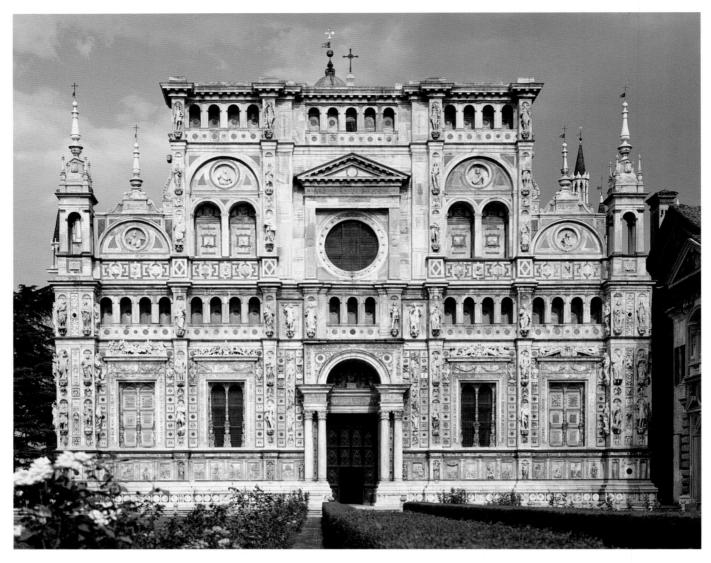

15.56. GIOVANNI ANTONIO AMADEO. Façade, Certosa, Pavia. 1492-first half of sixteenth century. Marble. Commissioned by Ludovico il Moro.

Amadeo's façade incorporates reliefs commissioned by Galeazzo Maria Sforza in 1473, including fig. 15.55.

elements are largely of classical derivation and the simplicity of the organization of the major areas, with an emphasis on horizontality and with the central axis flanked by symmetrical wings, offers a sense of Renaissance order despite the richness of the decoration.

Quattrocento Painting in Ferrara

We cannot leave the northern Italian Quattrocento without discussing the school of painting that flourished at Ferrara, an important Renaissance center in the lowlands south of the Po River, with which it is connected by waterways. In the thirteenth century the city and surrounding area came under the control of the Este family, who became dukes of Ferrara and ruled there until 1598. During this period of prosperity, the Este dukes, especially Niccolò III (1384–1441) and Lionello

(1404–50), commissioned works from important foreign artists, including Antonio Pisanello, Jacopo Bellini, Leonbattista Alberti, Piero della Francesca, Andrea Mantegna, and the Fleming Rogier van der Weyden. The local school that began to emerge about 1450 was influenced by these visitors from abroad, but the Ferrarese artists seem determined to distinguish their works, and a distinctive Ferrarese style soon developed.

The oldest of the three most important Ferrarese painters was Cosmè Tura (c. 1430–95), an artist in whose style sculptural elements are twisted into shapes of tension and torment. The central panel of his Roverella altarpiece, a towering *Enthroned Madonna and Child with Angels* (fig. 15.57), is startling in its combination of sculptural intensity with unexpected color combinations. The usually neutral Renaissance architectural elements, for example, here alternate between green and pink, while the shell above the

15.57. COSMÈ TURA. Enthroned Madonna and Child with Angels, from the Roverella altarpiece. c. 1475-76. Panel, 94 x 40" (2.39 x 1 m). National Gallery, London. Commissioned by members of the Roverella family, perhaps Niccolò and Filiasio, for their family chapel for S. Giorgio Fuori le Mura, Ferrara. The media used by Tura for this altarpiece included a sophisticated application of oil over an egg tempera underpainting. This dismembered altarpiece (see fig. 15.58) was partially destroyed by mortar fire in 1709. Originally it must have been more than thirteen feet high and would have had a predella with round paintings depicting scenes from the life of Christ. The only surviving side panel features a portrait that has been identified as Cardinal Bartolommeo Roverella being introduced to the Virgin by Sts. Paul and Maurelius. The inscription on the organ in the foreground is damaged, but a chronicler writing after 1709 related it to a couplet that reads: "Arise boy [Christ], the Roverella family are knocking outside. Let entry be given them. The Law says 'knock, you shall be admitted." An early description states that a figure in the lost left panel was shown knocking; perhaps this was Lorenzo Roverella, who died in 1474 and is buried at S. Giorgio in a tomb dated 1476.

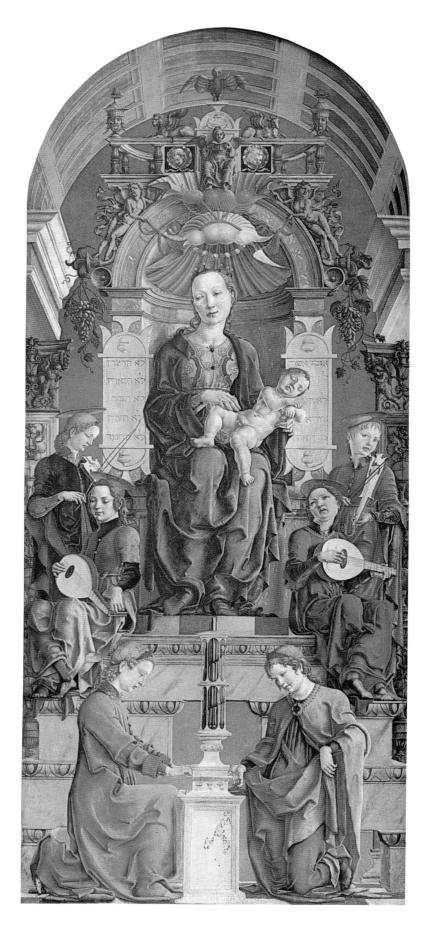

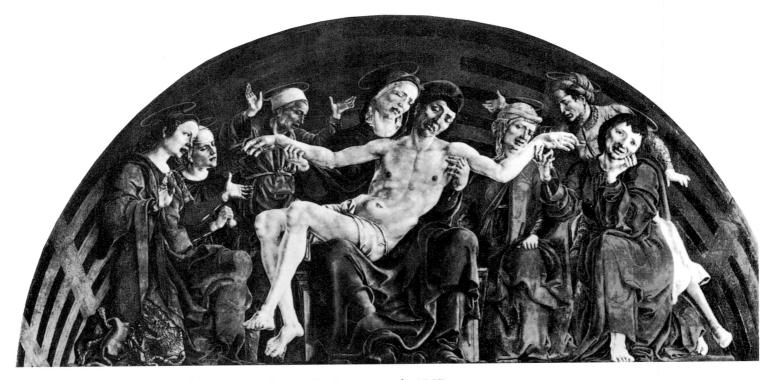

15.58. COSMÈ TURA. *Pietà*, from summit of the Roverella altarpiece (see fig. 15.57). c. 1475–76. Panel, 4'4" x 8'9" (1.3 x 2.7 m). The Louvre, Paris

Virgin's tall throne is surprisingly fluid in design. At the top of the throne, statues of the symbols of the four evangelists join winged putti and cornucopias from which dangle bunches of grapes. The capitals to the sides are original inventions by Tura, and incised lines reveal that he used the same cartoon, reversed, to create their decoration. On the open steps of this fantastic structure angels play viols and strum lutes. Below, an angel plays an organ with spirally arranged pipes while another works its bellows. The crowded space is characteristic of Tura's work, as are the contorted, strangely mesmerizing shapes. Instead of pilasters at the sides, the throne has the tablets of the Ten Commandments in abbreviated Hebrew. The inclusion of the commandments in Hebrew is an unusual touch, and a recent analysis of the painting, too complex to be fully summarized here, proposes that the Roverella altarpiece is best understood in the context of certain conflicts between Iews and Christians in late Quattrocento Italy.

Northern Italian painters and sculptors were often unrestrained in expressing grief, as in Tura's large *Pietà* from the summit of this same altarpiece (fig. 15.58). We look upward into a barrel vault that repeats the one seen in the Madonna panel below. The awkward body of the dead Christ is spread across the Virgin's knees, his arms held out by lamenting figures; the emotional impact of this crowded grouping is in-

escapable. The parallel between the image of the sleeping baby Jesus in the Madonna and Child panel below and the dead Christ, again on his mother's lap above, gives an added meaning to each scene.

Tura was appointed court artist for the Este family in 1458 and in that capacity he also produced secular decorations. In 1481, for example, he painted what the document calls four "naked women" to decorate the *studio* (study) of Duke Ercole d'Este. In 1490 Tura wrote a famous letter to his patron in which he complained that he had not been paid for certain works and asked the duke to intervene on his behalf:

Truly, Illustrious Prince and my Most Excellent Lord, my industry does not support me. I do not know how I shall be able to live and survive in this manner since I do not have the occupation or resources to sustain myself along with my household, apart from what I have earned from my daily labor and skill in painting. I find myself gravely ill with a sickness from which I cannot recover without considerable time and expense, as perhaps Your Excellency knows. I tell you this having six years ago made an altarpiece at my own expense in gold, colors, and painting for Francesco Nasello, secretary to Your Excellency, . . . and from which sixty ducats is owing to me; and having similarly painted for the most Reverend and

Illustrious Monsignor of Adria a Saint Anthony of Padua and certain other things for which remains a debt to me of twenty-five ducats. I cannot receive satisfaction, which is certainly neither honest nor fair, all the more so because they are powerful and very well have the means to settle and I am poor and helpless and cannot afford to lose the reward of my labor. For this reason I . . . implore you, as that one who has graciously deigned to give me satisfaction for the works I did for him, to deign in whatever honorable and appropriate way you see fit to have the aforementioned instructed to give me full satisfaction without more words and delays. . . . Ferrara, 9 January 1490.

Your excellency's most faithful servant, Cosmus Pictor

A second leading Ferrarese painter was Francesco del Cossa (c. 1435–c. 1477), whose John the Baptist (fig. 15.59) from the Griffoni altarpiece exemplifies the style of this artist, who was the son of a stonemason. In his paintings Cossa shows a special interest in rocky landscapes and in the stones, carved and otherwise, of which architecture is built. This affinity emerges behind the standing figure of John in a landscape of rocky pinnacles, vast open arcades, and natural bridges supporting turreted castles and domed churches stacked in impossible positions. Cossa's cloudless blue sky and brilliant light expose this stony world and all the objects in it, whether carved by nature or human fantasy, with relentless clarity. Cossa's magical intensity seeps into every detail—note the rosaries hanging from rings around a pole, the crumpled scroll bearing John's words, "Behold, a voice crying in the wilderness," and patterns of the saint's voluminous drapery-explaining why his paintings served as models for certain Surrealists during the 1930s.

The most remarkable surviving project of the Ferrarese artists is the fresco cycle lining the Sala dei Mesi (Hall of the Months), the main hall in the Palazzo Schifanoia at Ferrara, a hunting lodge enlarged by Duke Borso d'Este beginning around 1465 (figs. 15.60, 15.61; see also fig. 8). The frescoes are related to the calendar illustrations that appear frequently in Northern European manuscripts, but here there is a special emphasis, as we might expect, on Borso d'Este as a wise ruler. The program, devised by a stillunidentified humanist, is complex. Each month is represented in the top register by the triumphal cart of the ancient deity who presided over that month, with the signs of the related zodiac in the middle zone and the courtly activities and practical labors appropriate for that month on the bottom. Portraits of Borso and his courtiers appear in various scenes on the lower level. The frescoes demonstrate the brilliance of Ferrarese coloring and the inventiveness of the Ferrarese painters in their interpretation of the subjects. The leading master was apparently Cossa, with limited participation by Ercole de' Roberti and other anonymous artists.

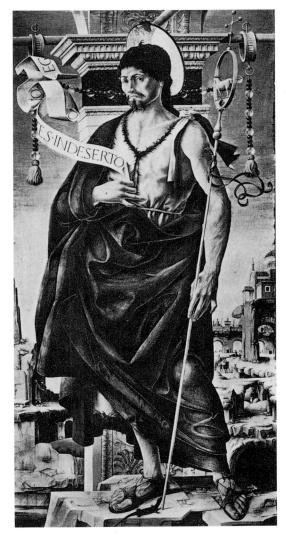

15.59. FRANCESCO DEL COSSA.

St. John the Baptist, from the Griffoni altarpiece.
1473. Panel, 44½ x 21½ (112.1 x 54.9 cm).
Brera Gallery, Milan. Commissioned by
Floriano Griffoni for S. Petronio, Bologna

In Cossa's *April* (fig. 15.61; see also fig. 8), the triumphal vehicle of Venus is a kind of barge drawn by swans. On either bank of this inlet elegantly dressed ladies and gentlemen in pleasant gardens indulge in amorous courtship that is parodied by white rabbits. Presiding over the couples are the Three Graces at the upper right; like Botticelli's Graces in the *Primavera*, their composition reveals that an ancient source, written or visual, was the model. Like the other frescoes, this scene resembles a continuous tapestry replete with fascinating details and an occasional penetration into depth.

Ercole de' Roberti (1456–96) is the youngest of the three painters of Quattrocento Ferrara discussed here. Roberti's

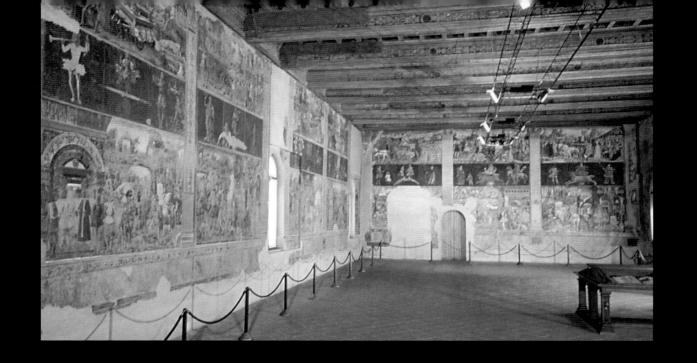

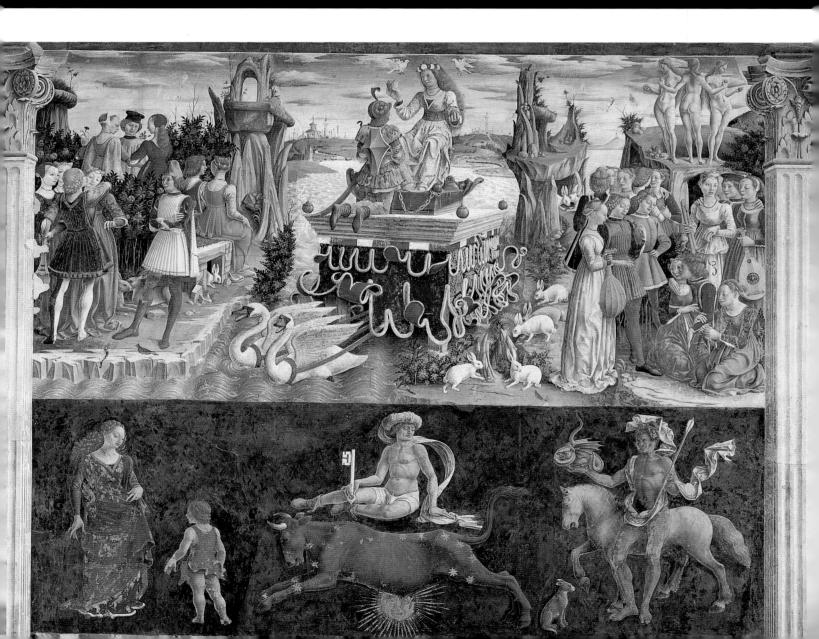

Opposite above: 15.60. FRANCESCO DEL COSSA, ERCOLE DE' ROBERTI, COSMÈ TURA, and others. Hall of the Months, Palazzo Schifanoia, Ferrara.

View showing, from left to right, frescoes of the months of September, August, July, June, May, April, and March respectively. Late 1460s–early 1470s. Fresco, size of room approx. 40' x 80' (12 x 24 m), width of each month approx. 13' (4 m). Commissioned by Duke Borso d'Este. The name Borso gave to this pleasure palace means "away with boredom."

emaciated and mystical St. John the Baptist (fig. 15.62) rises in skeletal gauntness above a distant horizon. The rocks are similar to those of Tura and Cossa, but their scale and substance are here reduced. The ledge on which John stands seems to melt away as we watch, and the sea mists that rise around the promontory, the port, and the ship are suffused with a rosy Bellinesque glow. The anguished head of the saint recalls that of John the Evangelist in Bellini's Pietà (see fig. 15.38). The foreground and background are separated by a line that makes the latter look almost like a backdrop. Perhaps Roberti intended to leave this relationship unresolved: the resulting ambiguity is part of the mystery of this haunting image. The figure, with its subtle contrapposto, and the landscape, here dissolved by atmosphere, reveal Roberti's understanding of earlier Renaissance developments at the same time that he subverts the naturalistic impulses of the earlier period to focus on expressing intense emotion and psychological character. A similar development was seen in the later paintings of Botticelli (see figs. 13.29-13.32). This approach to art will be challenged by the serenity and order established in the High Renaissance.

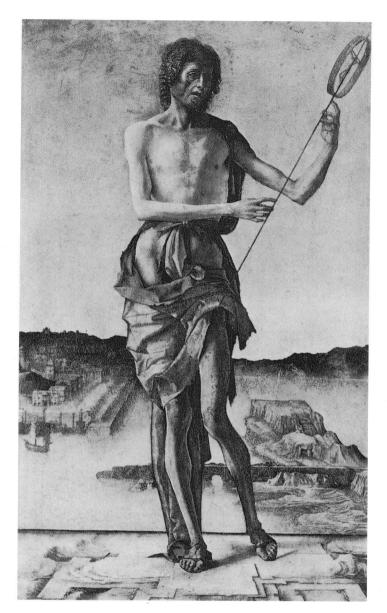

15.62. ERCOLE DE' ROBERTI. St. John the Baptist. c. 1478–80. Panel, $21\frac{1}{4} \times 12\frac{1}{4}$ " (54 x 31 cm). Gemäldegalerie, Berlin

Opposite below: 15.61. FRANCESCO DEL COSSA. April. 1469–70. Fresco, width 13'2" (4 m). Hall of the Months, Palazzo Schifanoia, Ferrara (see figs. 8, 15.60). The iconography of the months here might be compared with the early Quattrocento cycle from the Castello del Buonconsiglio in Trent (see fig. 5.23).

Z E(THE CINOU

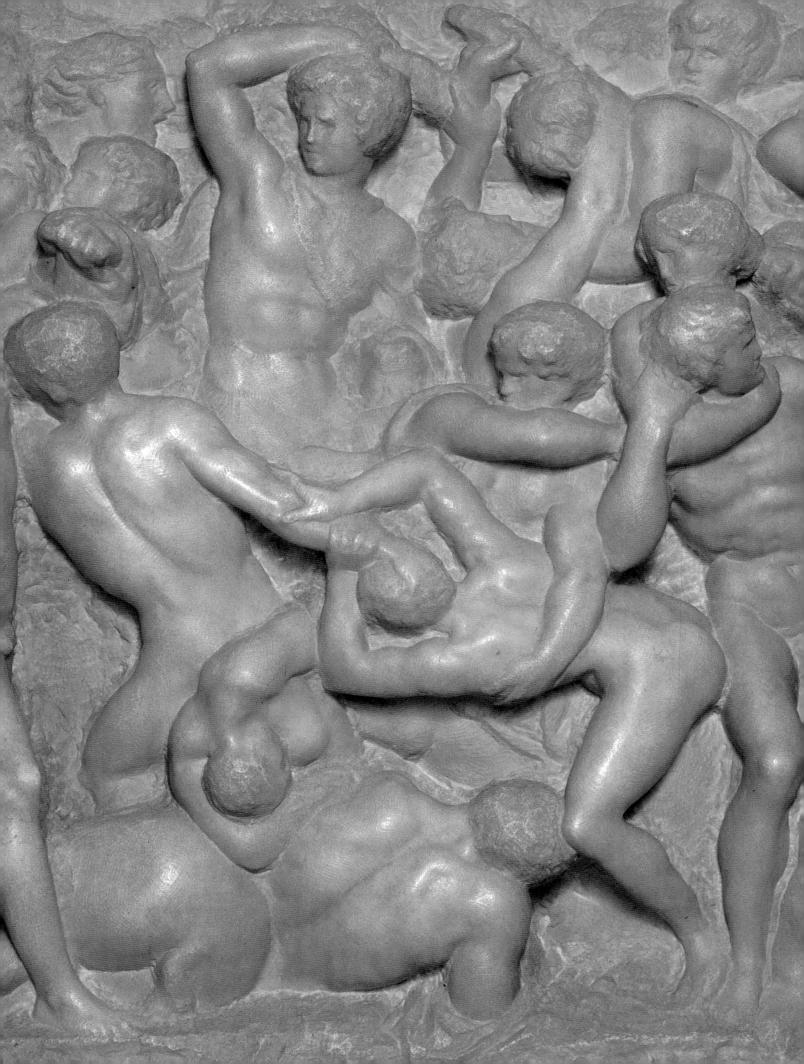

THE HIGH RENAISSANCE IN FLORENCE

he period that we now call the High Renaissance has its origins in the works of Leonardo da Vinci (1452–1519). He was born seven years after Botticelli and Perugino, and five years before Filippino Lippi, all of whose styles belong indisputably to the Quattrocento. Moreover, all of Leonardo's most important artistic achievements were completed or well under way before the death of Filippino, the first of the three to die, in 1504. The fact that we tend to think of Leonardo as a Cinquecento artist, and to speak of him together with Michelangelo, born twenty-three years later in 1475, or with Raphael, born thirty-one years later in 1483, indicates his revolutionary importance as the creator of the Florentine phase of the High Renaissance.

Leonardo da Vinci

The shopworn remark about persons who seem to be "ahead of their time" can be taken as a statement of fact in the case of Leonardo. He was ahead of his time not only in painting, sculpture, and architecture, but also in engineering, military science, botany, anatomy, geology, geography, hydraulics, aerodynamics, and optics, to mention only some of the branches of knowledge in which he made crucial discoveries and, in some cases, original contributions. Leonardo was able to make innovations in both art and science by virtue of his conviction that the two were intimately interrelated. He did not consider them interchangeable, for science seems to have been for him a pragmatic investigation of nature while art was an expression of beauty. In both his artistic and scientific activities he rejected authority and explored the natural world independently, without traditional prejudices or the restrictions put on investigations by religious belief. In an era when the revived authority of antiquity competed with that of Christianity, he had little respect for either source. It seems that for Leonardo final

authority emanated from a single source: the human eye. He maintained that no activity was nobler than that of sight. No text, no matter what its pretensions to divine revelation or philosophical authority, could block the evidence of sight or impede the process of induction based on sight. As he wrote in his notebooks:

Now do you not see that the eye embraces the beauty of the whole world? It is the lord of astronomy and the maker of cosmography; it counsels and corrects all the arts of humanity; it moves men to the different parts of the world; it is the prince of mathematics, its sciences are certain; it has measured the heights and sizes of the stars, it has found the elements and their locations . . . has generated architecture, perspective, and the divine art of painting. Oh most excellent thing above all others created, what peoples, what tongues shall be those that can fully describe your true operation? This is the window of the human body, through which it mirrors its way and brings to fruition the beauty of the world, by which the soul is content to stay in its human prison.

We know a great deal about what Leonardo thought from his writings. The thousands of pages that survive range from quick jottings to careful, extended analyses. Although he never assembled them into any sort of order, Leonardo's notes crackle with ideas and observations. Some of his observations were not to be made again by others, much less systematized into a coherent body of theory, for decades or even centuries. Seldom in his pages do we encounter a classical name—in contrast to Alberti and Ghiberti, for example, who are always citing classical authors or artists. Only infrequently do we find references to God, and occasionally we meet with caustic comments on organized Christianity (e.g., "Why are we supposed to worship the Son when all the churches are dedicated to the Mother?"), but nature is mentioned again and again, and

16.1. LEONARDO DA VINCI. Storm Breaking over a Valley.
c. 1500. Red chalk on white paper, 8 x 6" (20.3 x 15.2 cm).
Royal Library, Windsor

his sketchy views of mountains (fig. 16.1) are among the earliest mountain studies known.

Leonardo's notebooks reveal his detachment from human beings and their ways. As greatly as he admired the human body as a work of nature, he felt that humans did not deserve so fine an instrument, and he called them "sacks for food" and "fillers-up of privies." In spite of Leonardo's conversational gifts, in thousands of pages there is no hint that he ever cared deeply for another human being. Florentine though he was, he could detach himself sufficiently from the concerns of his native republic to work for Ludovico Sforza, duke of Milan, or even for Cesare Borgia, son of Pope Alexander VI, against whose armies the Florentines were trying to preserve their liberties.

Leonardo may have derived some of his aloofness from the circumstances of his birth. He was born the illegitimate child

of a notary named Piero in the little town of Vinci, about twenty miles west of Florence. At an early age the child was taken from his peasant mother, Caterina, about whom we know next to nothing, and brought up by his father and his father's wife. A notary in Italy verifies the legality of contracts, takes a percentage from both contracting parties, and can make himself prosperous, and this Piero seems to have done. But Leonardo's life was clouded by his illegitimacy, which brought with it legal disabilities. In addition, Leonardo was left-handed, which had a distinctly unfavorable connotation (although the Italian expression for "lefthanded" is the mild word mancino, the term for "left" in Italian is sinistro). Leonardo drew and wrote with his left hand-from right to left, for his own benefit. To read his writings, in addition to the usual linguistic and paleographic training, scholars must use a mirror.

Over and over in Leonardo's writings one encounters the lament, "Who will tell me if anything was ever finished?" and it is true that his pursuit of the mysterious and elusive aspects of nature was never finished; neither were a number of his works. Few of the finished ones survive in anything like what Leonardo intended. Some of Leonardo's contemporaries complained that his scientific and mechanical interests kept him from his activities as an artist. A fuller picture of his interests and style can be gained from his drawings, both the studies intended for specific paintings and sculptures and the sketches that illustrate almost every page of his notes.

Not the smallest of living things is neglected in these drawings. A cat, an insect, a flower-each is worthy of prolonged study. In a drawing of plants including a star-of-Bethlehem (fig. 16.2), for instance, Leonardo renders the shapes of the leaves with accuracy, but is also concerned with the rhythm of the plant's growth and the elusive qualities of natural life and motion: the leaves seem to unfold before us, like timelapse photographs of plants growing and blossoming. At the same time Leonardo could move from his interest in the microcosm—the smallest detail—to the macrocosm—the universal-with the ease of Netherlandish masters such as Jan van Eyck, whose work he may have studied. During his stay in Milan, he climbed the slopes of the nearby Alps and recorded what he saw. He noticed, for example, fossilized shells embedded in sedimentary rocks; calculating the time required for nature to produce such a phenomenon and carry the shells to such heights, he concluded that the world could not have been created in 4004 B.C.E., as theologians at the time maintained. Leonardo conveyed in his mountain drawings the elation of the climber on reaching a summit and beholding a view over mountains and plains. And he described the painter's power to reproduce this:

If the painter wishes to see beauties that charm him, it lies in his power to create them, and if he wishes to see monstrosities that are frightful, ridiculous, or truly pitiable, he is lord and God thereof; and if he wishes to generate sites and deserts, shady and cool places in hot weather he can do so, and also warm places in cold weather. If he wishes from the high summits of the mountains to uncover the great countrysides, and if he wishes after them to see the horizon of the sea, he is lord of it, and if from the low valleys he wishes to see the high mountains, or from the high mountains the low valleys and beaches, and in effect that which is in the universe for essence, presence, or imagination, he has it first in his mind and then in his hands, and these are of such excellence that in equal time they generate a proportionate harmony in a single glance, as does nature.

This is what Leonardo has done in a red chalk drawing (see fig. 16.1) depicting a landscape that stretches into a cloudy Alpine valley and then above storms to snowcapped summits.

16.2. LEONARDO DA VINCI. Star-of-Bethlehem and Other Plants. c. 1505–8. Pen and red pencil, $7\frac{3}{4} \times 6\frac{1}{4}$ " (19.8 x 16 cm). Royal Library, Windsor

Aside from the satisfaction that such studies gave him, they assisted Leonardo in promoting one of his favorite causes—the superiority of the painter. God has often been called an artist and the process of creation compared to artistic activity. Leonardo reversed the metaphor and saw the artist's creativity as analogous to that of God: "The deity that invests the science of the painter functions in such a way that the mind of the painter is transformed into a copy of the divine mind, since it operates freely in creating many kinds of animals, plants, fruits, landscapes, countrysides, ruins, and awe-inspiring places."

In Leonardo's day, the discipline of the Liberal Arts still rejected painting in spite of earlier efforts to include it (see p. 44). In the material for his *Treatise on Painting* (compiled after his death by his pupil Francesco Melzi), Leonardo argued at length not only for the inclusion of painting among the Liberal Arts but also for its precedence over poetry or music, since these depend on the ear, and the eye is the superior organ. He had little trouble arguing that it is better to be deaf than blind, and he pointed out that when the last note of a song has died away, the music is over and must be played again to exist, while a picture is constantly there. He asked if anyone ever traveled a great distance to read a poem, while pictures are the goal of many pilgrimages.

After many similar arguments, Leonardo turned to sculpture, which he was bent on excluding from the Liberal Arts,

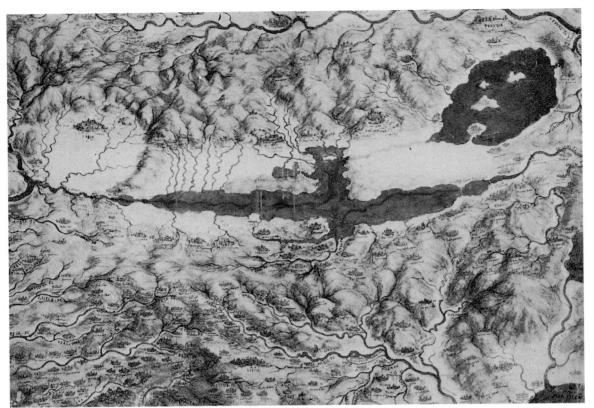

16.3. LEONARDO
DA VINCI.
Bird's-eye View of
the Chiana Valley,
Showing Arezzo,
Cortona, Perugia,
and Siena. c. 1502–3.
Pen and ink and color,
13¹/₄ x 19¹/₈"
(33.8 x 48.8 cm).
Royal Library, Windsor

Below: 16.4.
LEONARDO
DA VINCI.
Vitruvian Man: Study
of the Human Body
(Le Proporzione del
Corpo Umano). c. 1490.
Pen and ink, 13½ x 95/8"
(34.3 x 24.5 cm). Galleria
dell'Accademia, Venice

or at least on maintaining in a rank below that of painting. The elegantly dressed painter can sit in a pleasant studio, with soft breezes entering from the gardens through the open windows, and listen to music while working without physical strain. The sculptor must attack the stone with hammer and chisel, sweating, being covered with marble dust that mingled with sweat to form a gritty paste. The sculptor also had to endure being deafened by the noise of hammer and chisel on stone.

Leonardo's interests were also practical; many of his landscape drawings are studies of drainage, irrigation, water transportation, and military campaigns. He made a number of bird's-eye views showing a considerable area of central Italy. One maplike vista (fig. 16.3) stretches from Arezzo at the left to Perugia at the extreme upper right, with Siena just to the left of lower center. This drawing was apparently made as part of a project to divert water into the Arno from a lake in the central Chiana Valley, but it might also have had some purpose in Cesare Borgia's military campaigns. Leonardo also drew relief maps in the modern sense, in which the forms are shaded according to their altitude, and this he accomplished without the benefit of surveying instruments.

In his treatise *On Architecture*, the ancient Roman architect Vitruvius had described how an ideally proportioned human figure would fit within a circle, the navel at the center, and within a square. Earlier architects had tried unconvincingly to fit a human figure into such a geometric scheme, but it was Leonardo who created the most convincing visual representation of Vitruvius's theories (fig. 16.4). These ideas

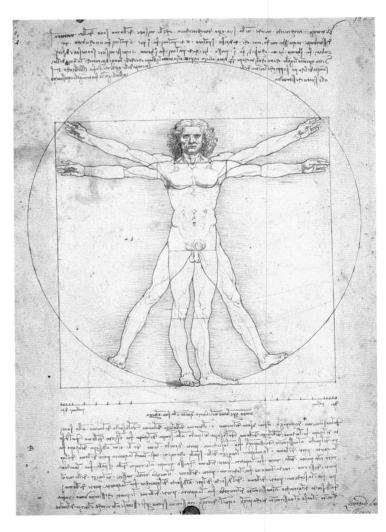

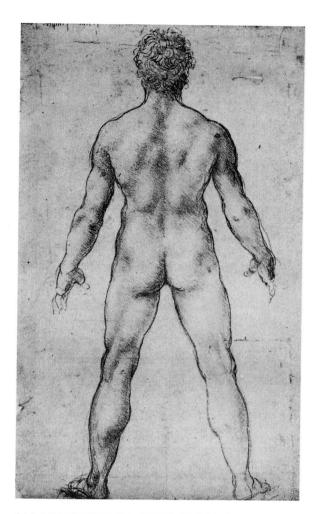

16.5. LEONARDO DA VINCI. *Male Nude*. c. 1503–7. Red chalk, $10^{3}/4 \times 6^{1}/4$ " (27 x 16 cm). Royal Library, Windsor

on proportion expressed in *On Architecture* were accepted by Renaissance architects, and Vitruvius's assertion that the circle was the ideal universal form led to a number of domed, centrally planned churches during this period (see figs. 12.27–12.29, 17.9–17.11, 18.58–18.60; see also fig. 11), the most important of which is New St. Peter's in Rome, by Bramante (see figs. 17.12–17.16) and Michelangelo (see figs. 20.11–20.14). For some of these buildings Leonardo's own architectural plans, such as the one seen in figure 16.7, may have played an influential role.

Leonardo studied the human body as it had never been studied before. His drawings from the nude model—such as one done (fig. 16.5) in red chalk, a medium that Leonardo was one of the first to use—show a new attentiveness to the structure of the body as light plays across it. In his writings he admonished artists not to exaggerate the musculature, like those who mistakenly made their figures look like "sacks of nuts" (he was most likely referring to Michelangelo), and in his drawings he emphasized the grace of the figure as a whole. Beginning with his initial anatomical studies in Milan in the

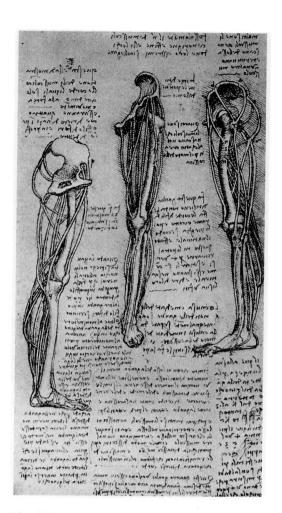

16.6. LEONARDO DA VINCI. Studies of a Left Leg, Showing Bones and Tendons. c. 1508. Pen and ink, $8^{1/2} \times 4^{1/4}$ " (21.5 x 11 cm). Royal Library, Windsor

mid-1480s, Leonardo carried anatomical dissection to remarkable lengths; it is recorded that he dissected more than thirty bodies. His anatomical drawings, made for purposes of scientific investigation and demonstration, are usually accompanied by a commentary written as he worked. A drawing that shows how he compared the behavior of the muscles of the human leg to that of cords (fig. 16.6) demonstrates how Leonardo sought to understand and record the complexity of human anatomy in a lucid manner. All these drawings are part of Leonardo's exploration of the natural world; only occasionally are they influenced by tradition at the expense of observation. His analyses of how muscles and tendons are connected to bones and how joints and muscles worked in unison had an immediate bearing on the art of the High and Late Renaissance—but they had little effect on Leonardo's own, which had come almost to a stop at the time he embarked on his most extensive series of detailed anatomical studies.

Although they have little importance for his artistic work, Leonardo's drawings for machines are so accurate and the principles involved so well understood that it has been possible for modern engineers to build a number of them. His machines include refinements on all sorts of known mechanical principles and improvements of pumps, dredges, pulleys, and tackles. His designs for weapons range from crossbows to chariots equipped with rotating scythe blades for dismembering the enemy and improvements to artillery as well as, ironically, defenses against his own innovations. Among his inventions are an automotive machine equipped with a differential transmission, a mobile fortress somewhat like a modern tank, and a flying machine—all of which, however, lacked an adequate source of power. Leonardo's optical studies and his invention of machines for grinding concave mirrors resulted in a telescope that was in existence by 1509, a century before Galileo.

Although as far as we know Leonardo never built a building, his architectural drawings promulgated new principles of design that had a far-reaching effect on buildings built by others. Leonardo, it may be said, founded the High Renaissance style in architecture just as he did in painting. For Leonbattista Alberti, whom the youthful Leonardo may have met and whose ideas he must have known, the best form of building was a centralized structure because, according to Alberti's theories, architecture is founded on nature, and nature, in plants and in the structure of animals, is centralized. Vasari argued that Leonardo had wasted time covering sheets of paper with meaningless squares, triangles, circles, and so forth; what he was probably doing, however, was exploring permutations and combinations of geometric figures as he developed ground plans for buildings.

Being left-handed, he starts his drawings at the right of the sheet. In a number of architectural drawings he begins with plans composed of geometric elements, and then proceeds, as he moves to the left, to erect churches in perspective upon these plans. The drawing in figure 16.7 shows an octagonal church surrounded by eight domed circular chapels, each with eight niches; a diamond plan with apses on the sides and towers on the points; and sketches for two more plans. But if these centralized plans follow Alberti's principles, the details recall Brunelleschi's dome for Santa Maria del Fiore and his plan for Santo Spirito (see figs. 6.2, 6.12). The end result, however, is something entirely new. The buildings are not juxtapositions of flat planes, as in Brunelleschi, or inert masses, as in Alberti. They are similar to living organisms that radiate outward from a central core, like the petals of a flower or the rays of a snow crystal. What Leonardo discovered-and this is the basis of High Renaissance composition in any artistic field—is a unified totality that is the product of the dynamic interrelationship of its components. Antonio del Pollaiuolo had hit on something similar in the triangular composition of the archers in his St. Sebastian (see fig. 13.6)—or perhaps the youthful Leonardo had already suggested the notion to him. In any case, Leonardo did not stop at individual buildings or parts of buildings, such as the turret for the Sforza Castle that he drew on the same page as a study for the Last Supper (fig. 16.8). He

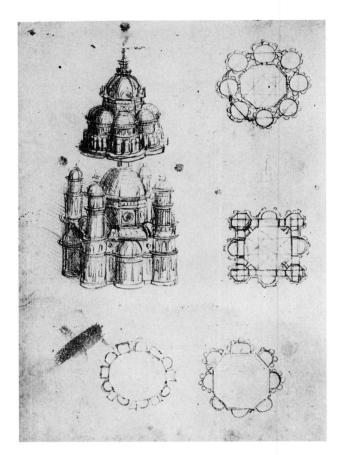

16.7. LEONARDO DA VINCI. Plans and Perspective Views of Domed Churches. c. 1490. Pen and ink, 9 x $6^{1/4}$ " (23 x 16 cm). Institut de France, Paris

also designed solutions for the urban problems of his day, including underground canals for the removal of refuse and streets for horsedrawn traffic below elevated walkways and pedestrian malls designed for human enjoyment. None of these were realized at the time, but the ideas are typical of Leonardo's concern with discovering principles of order in the apparent disorder of life.

What fascinated him perhaps more consistently than any other natural phenomenon was the behavior of water. His notebooks abound with schemes for providing it in abundance to cities, rendering it useful and free of obstruction in harbors, making it a safe means of transportation in rivers and canals. Leonardo must have sat hour after hour studying the patterns produced by a stream striking a body of water (fig. 16.9), penetrating it in spiral eddies, emerging again on the surface in bubbling circles. Drawings reveal that he sometimes examined the configurations formed when a board was thrust at various angles into a rushing stream. He notes that such shapes resemble curls of hair (fig. 16.10), and shows how the principles of spiral growth in the leaves of plants are found in water as well.

On a page where Leonardo drew the valves of the human heart, he wrote, "Let no one who is not a mathematician read my principles." For Leonardo the perception of mathematical structures underlying nature was the wellspring of his scien-

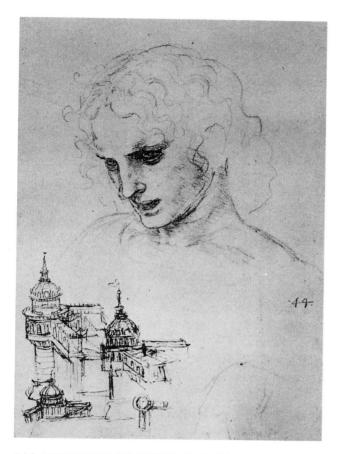

16.8. LEONARDO DA VINCI. Head of the Apostle Matthew for Last Supper; Architectural Studies for Sforza Castle. c. 1495. Red chalk, pen and ink, $9^{3}/4 \times 6^{3}/4$ " (25.2 x 17.2 cm). Royal Library, Windsor

Right, above: 16.9. LEONARDO DA VINCI. Studies of Water Movements. c. 1505. Pen and ink, $11\frac{1}{2} \times 8$ " (29 x 20 cm). Royal Library, Windsor

Right, below: 16.10. LEONARDO DA VINCI. Studies of Water (portion of drawing). 1490–95. Pen and ink; area shown, $6 \times 8^{1/2}$ " (15.2 x 21.6 cm). Royal Library, Windsor

tific investigation and creative imagination. Faith in the certainty of mathematical principles gave Leonardo the ability to correlate a broad yet diverse range of studies. The unified, pyramidal composition of the figures in his *Madonna of the Rocks* (see fig. 16.17), for example, and the pyramidal form of the parachute he designed are both related to his understanding of the efficiency demonstrated in a tri-cusped heart valve or an arrangement that used three ball bearings. Leonardo's use of the geometry of the triangle in painting is thus related to his investigations of nature and mechanics, demonstrating that art, as he wrote, "truly is a science."

Most of the problems connected with the interrelationship of Leonardo and his master, Andrea del Verrocchio—with whom he worked as an apprentice for several years around 1470 in Florence—are unresolved; we shall limit ourselves to a few

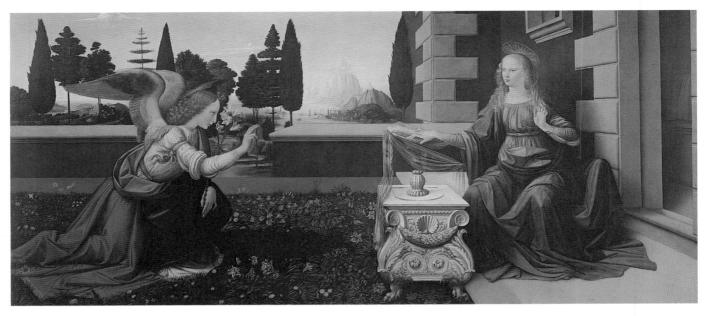

16.11. LEONARDO DA VINCI. *Annunciation*. 1472–75. Panel, 38³/₄ x 85 ¹/₂" (98 x 217 cm). Uffizi Gallery, Florence. Commissioned by the monks of the Monastery of Monte Oliveto, outside Florence

words about his participation in Verrocchio's *Baptism of Christ* (see fig. 13.11). About most of the painting there can be little doubt, for Verrocchio's hand is everywhere apparent. But of the two kneeling angels, the curly headed boy at the right, who still belongs to the world of Fra Filippo Lippi, is in sharp contrast to his companion at the left, who looks out from deep, luminous eyes and whose hair streams from his forehead to his shoulders with the mysterious patterns of Leonardo's water patterns. The water behind him, whose shimmering surface breaks into rapids over underlying shoals and whose juncture with the surrounding rocks is masked by mists, is by the artist who was to later paint the watercourses in the landscape of the *Mona Lisa* (see fig. 16.27). Possibly the clear and pristine water in the foreground is another passage that can be attributed to the youthful Leonardo.

Another of Leonardo's few remaining works from this Florentine period is the *Annunciation* (fig. 16.11). The Virgin is seated on the threshold of a villa with granite walls and perfectly projected corner quoins of *pietra serena*. Her book rests on a lectern made from a Roman sepulchral urn that is rendered with remarkable fidelity. Mary acknowledges the angel's message by lifting her hand in a gesture of restrained surprise, but not a trace of emotion disturbs her features. Gabriel kneels before her on a carpet of grass and flowers, each of which is rendered with Leonardo's botanical accuracy and sense of rhythmic growth. Over the garden wall, past cypresses and topiary cedars, is a distant port, with towers, lighthouses, and ships.

The picture seems decades later than Ghirlandaio's *Nativity and Adoration of the Shepherds* (see fig. 13.41) rather than several years earlier. The atmospheric veil that Leonardo interposes between the object and our eye—and about which he discourses at length in his writings—is

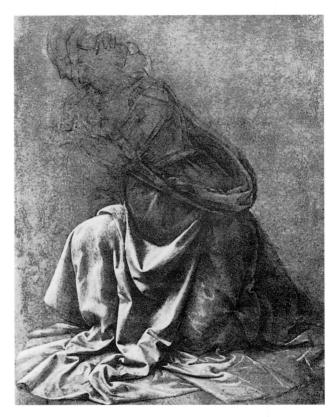

16.12. LEONARDO DA VINCI. Study of Drapery. 1470s. Silverpoint, ink, wash, and white on red prepared paper, $10 \times 7^{3}/4$ " (25.8 x 19.5 cm). National Gallery, Rome

completely new. The blue air becomes denser as we look toward the shimmering mountains, which resemble the Apuan Alps seen from Monte Oliveto. The figures' drapery, solid and sculptural, reveals Leonardo's method as recorded by Vasari (fig. 16.12): after soaking a piece of soft

linen in gesso Leonardo would arrange it over a small figure and allow it to harden. He would then move this model into a satisfactory illumination and draw it with a brush on linen canvas before starting to paint the final picture.

The two faces are without shadow and show an unearthly softness and lightness, even though the light that has entered the picture with the angel casts a dark shadow on the grass and creates a strong play of shadows in the drapery over Mary's knees. At the same time, every nuance of shape in the faces is clear and firm.

Leonardo wrote in his notebooks of how to use light in painting faces. He warned against drawing or painting faces in the direct light of the sun, reminding us of the beauty of faces passed in the street in the morning before sunlight has appeared, or in the early evening when the sun has just gone down. At that time, he noted, you see soft and mysterious expressions, forms that you cannot quite grasp, and the faces take on an inexplicable loveliness and grace. To produce such effects in the studio, he recommended painting all four walls of a courtyard black, stretching a sheet of linen over the courtyard, and then placing the model under this linen so that the diffused light would radiate the face without sharp reflections or shadows to break up the forms. This is exactly the effect he achieved in his *Annunciation* (see fig. 16.11).

These procedures for studying and rendering light reveal that darkness precedes light in his thought. In Leonardo's paintings, form and color must compete for their existence against the surrounding dark and against the overlying bluish atmosphere. As a result of this effort, color enjoys a new and deeper resonance, form has a more convincing three-dimensional existence, and the darkest shadows unite to give the picture a new kind of unity. This is in sharp contrast to the artificially bright world rendered by most of Leonardo's Florentine contemporaries.

Leonardo's early style is well represented by his revolutionary portrait of Ginevra de' Benci, which has an emblem of the sitter painted on the back (figs. 16.13, 16.14). This is the earliest known painted female portrait in which the sitter turns toward the viewer and the first to include her hands. Unfortunately, nearly eight inches were cut off the bottom of the painting when it was apparently damaged sometime before 1780; although that part of the painting is lost, a drawing of these hands survives, and a reconstruction of the front based on the drawing helps us to appreciate exactly how unconventional this portrait must have been when it was created. The costume, the hairstyle, and the placement of the hands holding a nosegay of flowers are all similar to those in *Portrait of a Lady with Flowers* (see fig. 13.14), a sculpture

16.13. LEONARDO DA VINCI.

Portrait of Ginevra de' Benci (obverse). c. 1474.

Oil on panel; size without reconstruction, 15 x 14 % x 7/16" (38.1 x 37 x 1.1 cm). Ailsa Mellon Bruce Fund. Digital reconstruction includes missing lower third (approximate).

Digital reconstruction © 2002 Board of Trustees,

National Gallery of Art, Washington, D.C. The lighter portion of the illustration indicates the area that has been reconstructed. Leonardo's technique combined oil glazes with tempera.

Probably commissioned by Bernardo Bembo, the Venetian ambassador to Florence. Ginevra, the daughter of a Florentine banker, married in 1474. The placement of her hands in this reconstruction is based on a drawing by Leonardo that is thought to be a study for her hands. The juniper branches in the background are a visual reference to Ginevra's name, which means juniper.

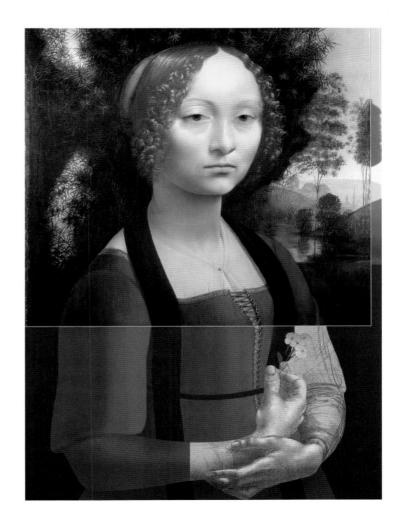

16.14. LEONARDO DA VINCI.

Portrait of Ginevra de' Benci (reverse of 16.13). c. 1474. Tempera on panel; size without reconstruction, 15 x 14⁹/₁₆ x ⁷/₁₆" (38.1 x 37 x 1.1 cm). Ailsa Mellon Bruce Fund. Digital reconstruction includes missing lower third (approximate). Digital reconstruction © 2002 Board of Trustees, National Gallery of Art, Washington, D.C. The lighter portion of the illustration indicates the area that has been reconstructed. The motto on the scroll reads "Beauty Adorns Virtue." In the Medicean circle in Florence, the expression in sonnets and portraiture of one's love for an unattainable ideal beauty was a common and accepted courtly activity; Florentine humanists wrote a number of poems celebrating Ginevra's beauty. The sonnets were based on a tradition begun by Petrarch in the fourteenth century in the poems he wrote to his beloved Laura.

created in Verrocchio's workshop at about the same time. Ginevra's long fingers, delicately holding the small bouquet, remind us that hands such as these were prescribed as one of the attributes of the perfect Renaissance woman. Ginevra discreetly avoids our glance, another indication that she fulfills the social mandates of a refined woman during this period. The play of light and shadow on the figure of Ginevra is restrained, with oil paint making possible the delicate transitions from light to very limited effects of shadow. The head stands out in relief, but the lack of strong contrast in the modeling is typical of Leonardo's earliest works.

Leonardo's Adoration of the Magi (fig. 16.15), commissioned in March 1481, was left unfinished when he departed for Milan sometime late in 1481 or early in 1482. But unfinished is hardly the proper word for a picture in which there is not a touch of color. What we see is an incomplete underdrawing that has been reinforced with a dark wash used to establish the unifying structure of shadows. While the methods used by the young artist in his underdrawing are revealing in themselves and offer visual proof of the attitudes toward light found in his writings, his style at this time would have demanded the same kind of finish and detail that we see in the *Annunciation* (see fig. 16.11).

It is difficult to accept Leonardo's chronological position as a contemporary of the artists discussed in Chapter 13. This revolutionary picture comes only a few years after Botticelli's altarpiece on the same subject for Santa Maria Novella (see fig. 13.18), and probably before his Adoration now in Washington, D.C. (see fig. 13.21). A perspective study for Leonardo's Adoration (fig. 16.16) shows that he originally intended to include the ruins and shed of the Botticelli tradition. The drawing is a celebrated example of Albertian one-point perspective. In the perspective study, the principal groups of figures do not appear-Leonardo studied them separately in other drawings—but on the steps and ruins are the followers of the Magi. A camel crouches in front of the steps, and in the background, at the vanishing point, a man tries to maintain his balance on a rearing horse, while another horse kicks backward with both legs. Leonardo may have observed these motifs in Uccello's Battle of San Romano (see fig. 11.6), but these are far from Uccello's geometricized horses; they are as full of uncontrollable energy as the water that fascinated Leonardo, and, like the rushing water, they reappear often in his imagination as symbols of the forces of nature.

In the painting Leonardo omits the shed and, therefore, its elaborate perspective construction. The ruins remain,

16.15. LEONARDO DA VINCI. Adoration of the Magi. Begun 1481. Panel, 8' x 8'1" (2.43 x 2.46 m). Uffizi Gallery, Florence. Commissioned by the monks of S. Donato a Scopeto for their monastery. This unfinished painting provides valuable information about Leonardo's technique. It is clear that he was more interested in working out the structure of the lights and darks in the work as a whole than in defining the exact perimeters of each figure in a linear fashion.

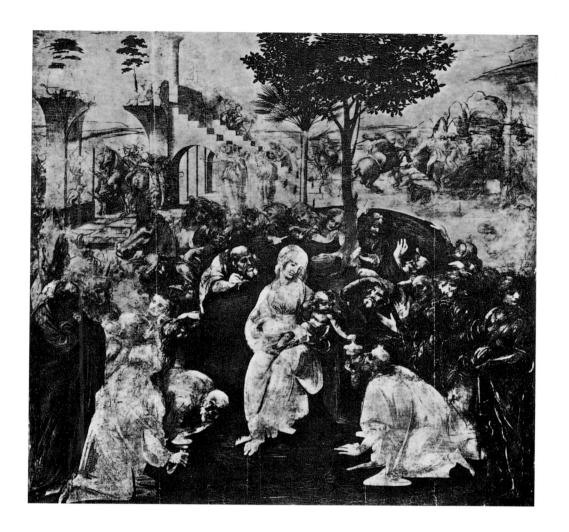

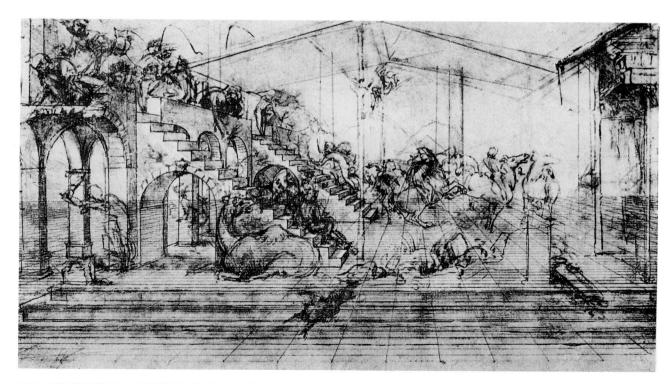

16.16. LEONARDO DA VINCI. Architectural Perspective and Background Figures, for the Adoration of the Magi. c. 1481. Pen and ink, wash, and white, $6\frac{1}{2} \times 11\frac{1}{2}$ " (16.5 x 29 cm). Gabinetto dei Disegni e Stampe, Uffizi Gallery, Florence

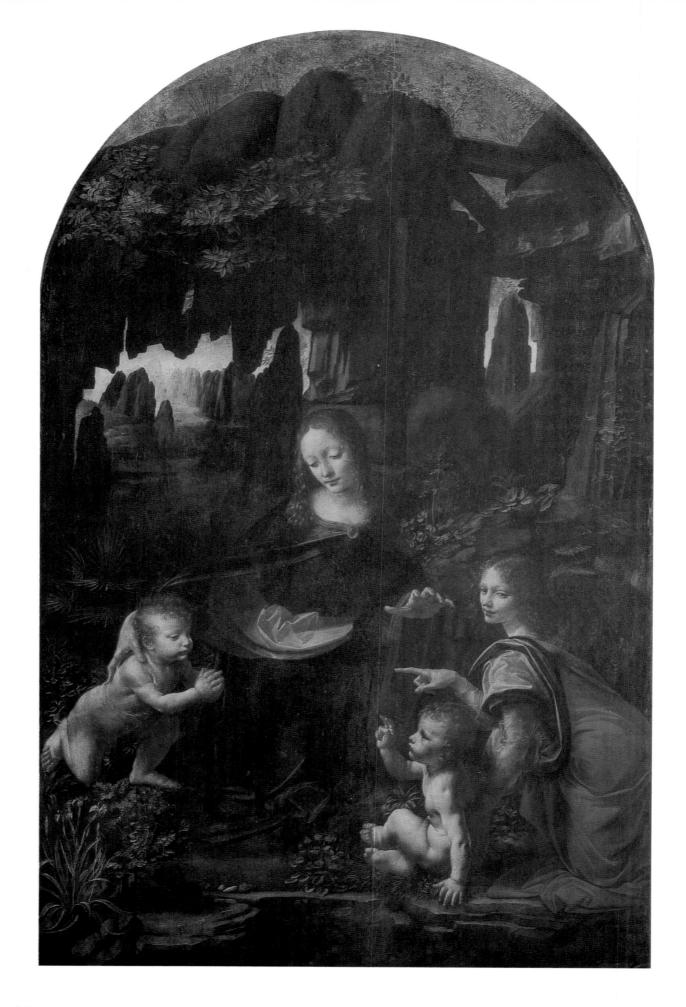

abbreviated somewhat—and still in flawless perspective—but now they are relegated to a background position. The arches are broken and the figures and horses surge beneath them. The camel has vanished, and both horses rear on their hind legs, as if their riders were in combat.

In the Adoration of the Magi, Leonardo demonstrates his interest in studying the group psychology that results when crowds are drawn together by the electric excitement of an event. Whatever their ostensible subject, in fact, Leonardo's compositions always seem to be expositions of his psychological interests. The yearning that sends the Magi to their knees runs like a storm through the crowd of attendants—young and old—building up a pyramid with the Virgin's head as its apex.

When we are able to observe the technical procedures of earlier painters from unfinished or damaged works or deduce them from pictorial surfaces, we see that they drew contours on white priming and applied color between these outlines. Leonardo inundates his surface with a dark wash that creates the areas of shadow so apparent in the Annunciation. The light areas-the figures-are the residue, but the darkness has invaded many of them. He then begins to define their edges with the brush. To Leonardo, therefore, the traditional roles of light and darkness are reversed. Darkness is universal, and light must struggle against it. Light fascinated him, and his notes record luminary experiments and analyses, including even a projector powered by a candle. Once the basic light areas received definition, Leonardo sharpened the details, always as a movement of dark against light. With a few touches he could make a beautiful young head or a ravaged old one spring into being, full of life and emotion. At times ghostly in its softness, at times volcanic in its power, the fluid dark pours over figures, horses, and vegetation. The tree in the upper left corner shows the method clearly. A few horizontal strokes of the brush represent the foliage; later he would have united these masses with a trunk and branches.

When Leonardo left Florence in 1481 or 1482 for a stay of nearly twenty years in Milan, he left the picture in its present state, and the monks eventually ordered another one, from Filippino Lippi. In his letter of application to Duke Ludovico Sforza, Leonardo speaks eloquently about his abilities as a civil and military engineer, emphasizing how his inventions could further the duke's conquests and render life more agreeable in his capital. He suggests a sculptural project for an equestrian monument to the duke's late father, and only at the end does he mention his skills as a painter. Soon after he arrived, however, he demonstrated his artistic talent in the *Madonna of the Rocks*. Two versions survive, an earlier one, begun 1483, in the Louvre (fig. 16.17) and a later one of

c. 1508 in the National Gallery in London (not illustrated). One or both were painted for the Confraternity of the Immaculate Conception, which had a chapel in San Francesco Grande in Milan; according to a document of 1483, the painting was part of an elaborate altarpiece by Leonardo, two of his pupils, and an independent sculptor. The history of the London version can be traced continuously from the original altar until its sale to an English collector in 1785. Could it have been substituted at some time and for some unknown reason for the Paris version? There is no general agreement, but the majority of scholars concede that the Louvre panel is earlier and entirely by Leonardo, whereas the London panel, even if designed by the master, shows passages of pupils' work consistent with the date of 1506, when there was a controversy between the artists and the confraternity.

The patron confraternity was devoted to the Immaculate Conception, the doctrine that Mary was conceived without sex and free from all stain of original sin. This belief, promulgated in papal bulls written by Pope Sixtus IV close to the date when Leonardo painted the picture, was represented in a sculptured image at the same altar (above or below the painting) and has infiltrated the meaning of Leonardo's painting. The artist has shown the youthful Virgin kneeling on the ground, her arm around the kneeling John the Baptist and her left hand extended protectively over the seated Christ Child, who is worshiped by John. A kneeling angel steadies the Christ Child and looks outward toward (but not directly at) the spectator (fig. 16.18), while pointing at John. The composition of the figures creates the unified pyramid that will be the basis of High Renaissance compositional practice.

The most extraordinary aspect of the painting is its dark and gloomy background, a wilderness of jagged rocks rising almost to the apex of the arch. Through this arch, as through the mouths of caverns, we look into mysterious vistas flanked by rocky pinnacles that rise from dim watercourses until we lose sight of them in the half-light of misty distances. According to tradition, the cave associated with the Nativity was mystically identified with the cave of the Sepulcher, and St. Antonine claimed that both are foretold in the Song of Songs: "O my dove, that art in the clefts of the rock, in the secret places [caverna] of the stairs, let me see thy countenance" (2:14). The dove may be interpreted as a reference to the Virgin Mary, and perhaps the shadowy caves are intended to suggest humanity's dark mortality, which needs the divine light that enters through Mary as the immaculate vessel of God's purpose. Leonardo interpreted the Annunciation as a romantic vision, painting shadows of unprecedented depth and poetic beauty, within which the light picks out sweet faces and delicate hands, warm flesh and

Opposite: 16.17. LEONARDO DA VINCI. Madonna of the Rocks. Begun 1483. Panel, transferred to canvas, $78\frac{1}{2}$ x 48" (2 x 1.2 m). The Louvre, Paris. Commissioned by the Confraternity of the Immaculate Conception for its chapel in S. Francesco Grande, Milan

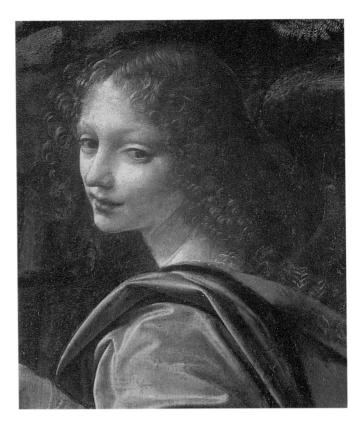

16.18. Head of Angel, detail of fig. 16.17

exquisite curls, while hinting at the shapes of geological formations and wild vegetation. This is the fulfillment of the new kind of light that Leonardo created in the underdrawing of the *Adoration of the Magi*. To emphasize the light Leonardo chooses muted tones for his colors, uniting them within his geometric composition by the black shadows that ultimately envelop each form.

One of the most exquisite and subtle drawings for the picture is the silverpoint study for the head of the angel (fig. 16.19), made on rose-colored paper and delicately heightened with white. In order to make this drawing Leonardo may well have used the method recommended in his note-books—setting the model in a black courtyard beneath a linen sheet—and he has reproduced the effect of this illumination with separate strokes of silverpoint that are so sensitive and close to each other that they almost blend into a gliding, all-over tone. The light that gives "a grace to faces," as Leonardo put it, strikes the luminous eyes, while the hair is suggested by a few simple lines.

Leonardo's projects for the duke of Milan ranged from military and civil engineering to costumed pageants enlivened by mechanical devices, but we know too little about the monument that was his major artistic undertaking for the duke. Judging from a fiery preparatory drawing (fig. 16.20), Francesco Sforza was to have been reining in a rearing horse

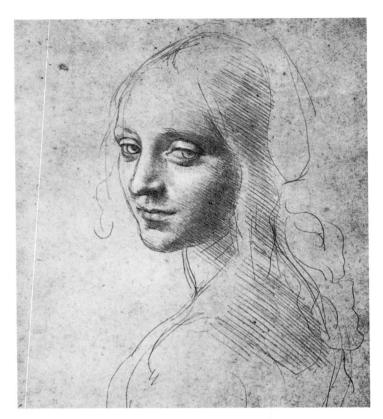

16.19. LEONARDO DA VINCI. Study of the Head of the Angel, for the Madonna of the Rocks. c. 1483. Silverpoint and white on rose-colored prepared paper, $7^{1/4}$ x $6^{1/4}$ " (18.4 x 15.9 cm). Royal Library, Turin

while an enemy cowered below. The representation of the military leader who restrains a rearing steed has a long history in ancient art, not as an independent statue but in historical reliefs, many of them accessible to Leonardo. Piero della Francesca had used the motif in the *Battle of Heraclius and Chosroes* (see fig. 11.29), but it remained for Leonardo to translate the notion into a project for a colossal statue in the round.

The first example of such a statue to be actually erected was Bernini's Louis XIV in 1669, and we have no way of knowing why Leonardo ultimately renounced the dramatic idea in favor of a striding pose, in the tradition of Donatello and Verrocchio (see figs. 10.31, 13.16). Drawings show he developed both ideas simultaneously, and it is possible that the duke objected to the unconventional idea, or perhaps Leonardo became discouraged by the technical problems of casting and raising such a large and precariously balanced group in bronze. For a while the duke considered taking on some other artist for the project, but in 1490 Leonardo set to work. Based on his exhaustive anatomical studies of horses, he produced a full-scale model some twenty-four feet high in clay or plaster, as well as complete plans for casting it in bronze. Unhappily, the drawings are our only evidence for the monument. After Louis XII ascended the French throne, he laid claim, as a descendant of the expelled Visconti, to the

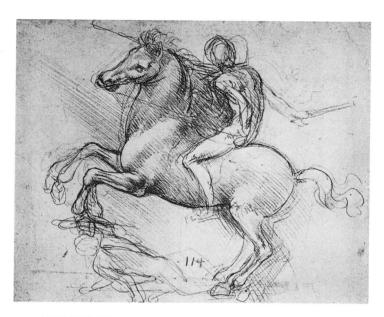

16.20. LEONARDO DA VINCI. Horseman Trampling on Foe, study for an Equestrian Monument to Francesco Sforza. c. 1485. Silverpoint on greenish ground, 6 x $7^{1/4}$ " (15.2 x 18.4 cm). Royal Library, Windsor. Commissioned by Ludovico Sforza

duchy of Milan, and the duke found himself in a military crisis that made it impossible for Leonardo to obtain the necessary metal. The French invaders who chased out Ludovico Sforza in 1499 used Leonardo's colossus for target practice. What was left of it soon fell to pieces.

The recently completed cleaning of Leonardo's *Last Sup*per (see figs. 16.22–16.25) has revealed its relatively poor condition, which is due to a disastrous technical experiment on Leonardo's part. An artist as sensitive as Leonardo to the slightest throb of light in atmosphere was bound to be impatient with the fresco method, which could not allow the time needed to establish his customary shadowy unity to the painting and his perfect luminous finish to the details. As previously mentioned, for similar reasons, Baldovinetti had combined underpaint in fresco with a finish in tempera at the Santissima Annunziata (see fig. 12.33). After preparing the wall with a base layer covered with a thin layer of lead white, Leonardo built up his composition and colors using layers in a manner resembling tempera painting on panel; dampness between the layers prevented them from drying properly and the paint eventually began to flake off the wall.

According to literary accounts, Leonardo would sometimes stand on the scaffolding all morning without picking up the brush, studying the relationships of tone. When completed, the painting inspired extravagant praise, but by 1517, while the artist was still alive, it had started to deteriorate. When Vasari saw it a generation or so later, he found it almost indecipherable. It was repainted twice in the eighteenth century, it suffered from the brutality of Napoleonic soldiers and from the monks, who cut a door through it, and it was again repainted in the nineteenth century. In 1943 Allied bombs destroyed much of the refectory but the painting, protected by sandbags supported on steel tubing, survived. Extensive conservation efforts after World War II disclosed more of the original under the repaint, and the recent scientific restoration revealed Leonardo's delicacy of touch and luminosity of color in the better-preserved areas.

The numerous reproductions of the *Last Supper* (figs. 16.21–16.24) have numbed us to this powerful composition. In preliminary drawings (fig. 16.21), Leonardo toyed with the idea of placing Judas on our side of the table, as had Taddeo

16.21. LEONARDO DA
VINCI. Study of composition of
Last Supper (see fig. 16.23).
c. 1495. Red chalk, 10½ x 15½"
(26 x 39.4 cm). Accademia, Venice

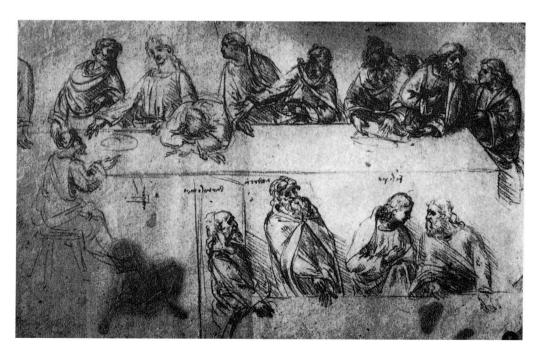

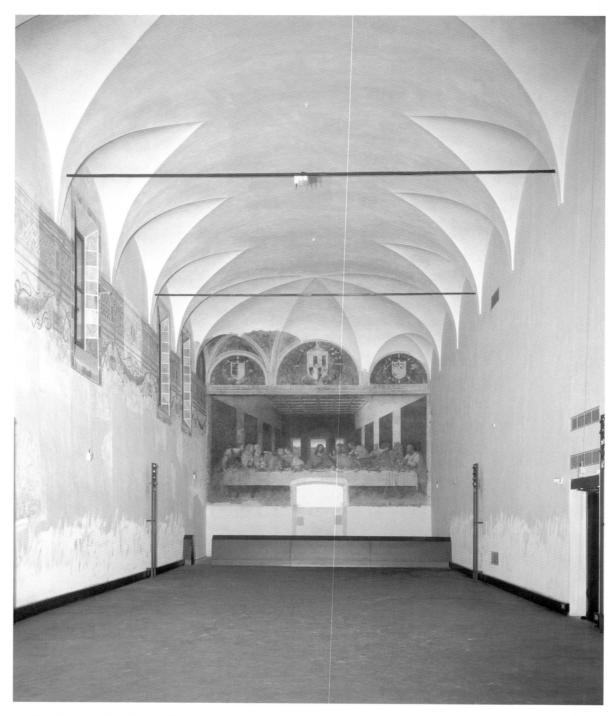

16.22. Refectory of Sta. Maria delle Grazie, Milan, with a view of Leonardo's *Last Supper.* 1495–97/98. Commissioned by Ludovico Sforza

Gaddi, Castagno, and Ghirlandaio (see figs. 3.31, 11.11, 13.37). The Gospel of St. John (13:26) states that Christ indicated Judas as the betrayer by handing him a piece of bread dipped in wine, while in the Gospels of Matthew and Mark, Christ says, "He who dippeth with me in the dish," and in Luke, "He whose hand is with me on the table." Leonardo refers to the text from Luke, for Judas's hand is on the table,

stretching after the bread. Because Christ's hands gesture toward the bread and the wine, the picture also refers to the institution of the Eucharist. Leonardo has fused this episode with yet another moment—never before represented—as recounted by Matthew, Mark, and Luke: "Verily I say unto you, that one of you shall betray me. And they were exceeding sorrowful, and began every one to say unto him, Lord, is

it I?" Instead of designating the betrayer, Leonardo has shown how the announcement sparked astonishment on the part of the apostles and the searching of their own souls.

Donatello represented a similar effect in his *Feast of Herod* (see fig. 7.23), but Leonardo has gone further. He has, in fact, composed the apostles' reactions in accordance with his own view of psychology, thus revealing the underlying mathematical unity of all life. As if by inexorable law, the revelation of betrayal factors the number twelve into four groups of three each. This grouping about the axial figure of Christ establishes a symmetrical order that subsumes the figurative variety of the individual apostles. In addition, Leonardo was certainly aware of the symbolic meaning of these numbers in Christian and human tradition. Three, the number of the

Trinity, is the most sacred, while four conveys the essence of matter in the elements of earth, air, fire, and water. Leonardo thus joins the components of creation, spirit, and matter. More complex numerical symbolism has also been seen here, for there are three Theological Virtues and four is the number of the Gospels, the Cardinal Virtues, the Rivers of Paradise, the seasons of the year, and the times of day. Three plus four make seven, the number of the Gifts of the Holy Spirit, the Joys of the Virgin, and the Sorrows of the Virgin. Three times four make twelve, not only the number of the apostles in the picture, but also of the gates of the New Jerusalem, the months of the year, the hours of the day, and the hours of the night. Christ, the divider, appears at the center of both light and space, the vanishing point of the perspective and the

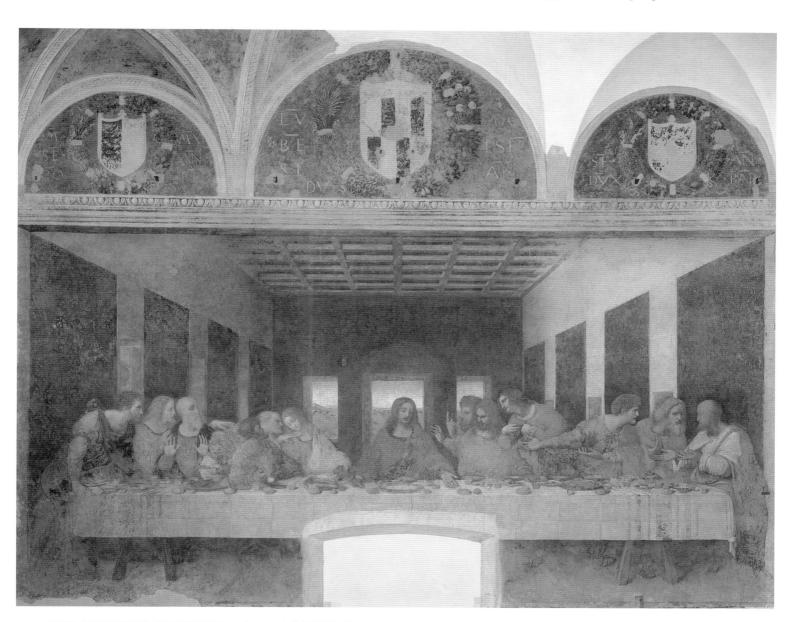

16.23. LEONARDO DA VINCI. Last Supper. 1495–97/98. Fresco, 13'9" x 29'10" (4.2 x 9.1 m). The lunettes above the painting have coats of arms surrounded by wreaths of fruit and leaves that are so subtly rendered that they were probably painted by Leonardo himself.

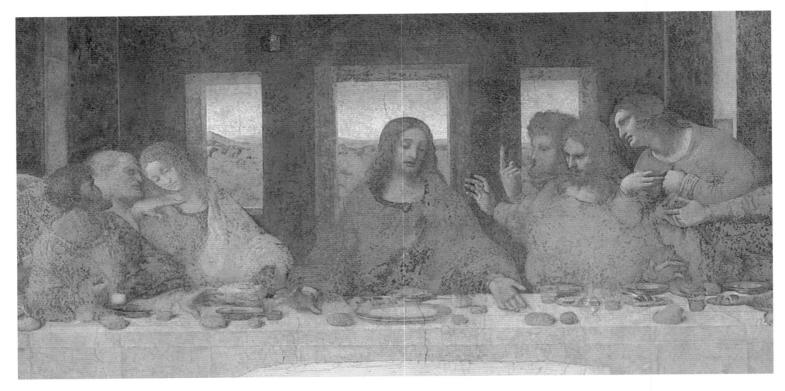

16.24. Detail of fig. 16.23

second window of a group of three, whether the group is read from the left or from the right. Windows are symbols of revelation, and Christ is the Second Person of the Trinity. How much of this was conscious or unconscious in the creation of Leonardo's painting is uncertain, but there is no question that he creates mathematical order out of dramatic confusion and that he emphasizes the impact of the revelation of betrayal on the inner lives of the apostles by identifying their reactions with the underlying numerical system.

In preliminary sketches made before he resolved his composition, Leonardo labeled each apostle, and in one of his manuscripts he described their respective attitudes and emotions. He later studied each from live models, some of whose names are known. Many drawings are preserved, including one in red chalk for St. Matthew (see fig. 16.8), who recoils as from a blow, his eyes staring, his mouth open. In the painting, he sinks back between St. Thomas, with his pointing, probing finger, and St. Philip, whose love for Christ seems evident in his expression, as the hands pressed to his chest protest that he is not the betrayer (fig. 16.25).

Judas is the only apostle who need not protest; he knows. He is also the only apostle who reaches for food, bearing the implication of having received the sacrament unworthily. Judas is the only apostle who recoils from Christ and the only one whose face is not in the light. His dark bulk is contrasted in the same group with the lighted profile of St. Peter and the face of St. John, whom, in defiance of tradition,

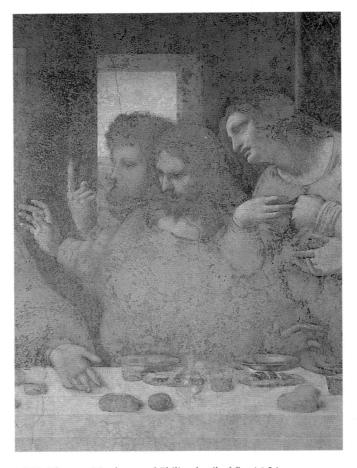

16.25. Thomas, Matthew, and Philip, detail of fig. 16.24

Leonardo has placed at Christ's right. Christ turns from Judas, and the resigned expression on his face suggests his words in the Gospels, "And the Son of man indeed goeth... but woe to that man by whom the Son of man shall be betrayed" (Luke 22:21, 22).

Here and there, especially in the pewter plates, the freshly unfolded tablecloth, the simple wineglasses, and the rolls set upon the table, we can catch an echo of the surface quality of the original painting. Every silken curl, every passage of flesh must once have been virtually perfect. Leonardo's forms have lost their definition but not their impact, his space its precision but not its depth. The psychological effect of the ruined masterpiece is still impressive.

In the Last Supper Leonardo has taken a step as definitive as that taken by Donatello eighty years before in the St. George and the Dragon relief (see fig. 7.17), but in a totally different direction. He has broken with the Quattrocento tradition that culminated in the illusionistic systems of Mantegna and Melozzo, which decreed that represented space must be an extension of the room in which the spectator stands. Although Leonardo's perspective is consistent, there is no place in the refectory where spectators can stand so that their eyes are on the same level as the vanishing point. The walls of the upper chamber in Jerusalem cannot be read as continuations of the real walls of the refectory, and the Albertian role of the picture as a vertical intersection through the visual pyramid has been abandoned. This is a perfect perspective, which could not be seen by any pair of human eyes standing in the refectory. Within this perspective, larger-than-life human beings exist and act on a grander plane, above our experience. Ideal masses inhabit ideal space to expound an idea, replacing the delight of the Quattrocento in visual reality and vivid anecdote. We are now truly in the High Renaissance, whose basic idea is Leonardo's single-handed creation and which will be adopted later by Michelangelo, Fra Bartolommeo, Raphael, and Andrea del Sarto.

It is noteworthy that this new and grander vision of ideal reality is expressed at just the moment when the reality of the Italian political situation was recognized as hopeless. After the French invasion of Italy and the Battle of the Taro in 1495, it was clear that no matter who claimed victory in that disastrous encounter, Italy was divided and would remain impotent in the face of the unified monarchies of Western Europe. Despite the appeals of Machiavelli and others, it was only a matter of time before the Italian states—with the exception of the Genoese and Venetian republics—would be overwhelmed by the forces of foreign tyranny. Florence and the papacy, however, would be allowed to maintain a shadowy independence. High Renaissance art in Florence and Rome can be understood as an extension into an ideal plane of those images of human grandeur and power that the Ital-

ians knew were doomed in real life. It is a valiant effort, and there is often something dreamlike about its noble productions as compared with the pedestrian solidity of early Quattrocento images.

Save for a five-year stay in Milan from 1508 to 1513, Leonardo was never again to spend more than two or three years, sometimes only a few months, in the same city. We have records that he returned to Florence and Rome repeatedly, stayed in Venice and Parma, and traveled about with the army of Cesare Borgia. Many of the artist's daring engineering and cartographic experiments date from this period.

In 1501 Fra Pietro da Novellara, acting as an agent for Isabella d'Este, wrote to the marchioness from Florence about a cartoon that Leonardo had made

depicting a Christ Child about one year old who, almost slipping from his mother's arms, grasps a lamb and seems to hug it. The mother, half rising from the lap of St. Anne, takes the Child as though to separate him from the lamb, which signifies the Passion. St. Anne, also appearing to rise from a sitting position, seems to wish to keep her daughter from separating the Child and the lamb, and perhaps is intended to represent the Church, which does not wish the Passion of Christ to be impeded. And these figures are life-sized, but they are in a small cartoon, because they are all either seated, or bending over, and one is placed in front of another, moving toward the left, and this study is not yet finished.

Whether Leonardo intended the symbolism that Fra Pietro finds in his work is less important than our realization that his approach to religious paintings must be recognized as valid. No matter how foreign it is to the manner in which many of us would approach Leonardo's painting today, Fra Pietro's emphasis on complex symbolism provides important documentation of how a painting could be received by a contemporary.

Leonardo's cartoon, exhibited at the monastery of the Santissima Annunziata, was intended for a picture for the high altar of the church. The cartoon is lost, but its composition is known from a surviving sketch. It excited admiration and influenced Florentine artists, especially Fra Bartolommeo, the young Michelangelo, and the still younger Raphael. They must have been impressed by those very qualities that Fra Pietro set forth—the compression and overlapping of figures that enabled the artist to fit three life-sized figures into a small cartoon. But the general public also thronged to see it, probably because in April 1501 they were praying for the intervention of St. Anne, traditionally a protector of the Florentine Republic, as a result of the threat from Cesare Borgia's armies. At least thirty-three works influenced by Leonardo's composition survive, and almost all are devotional images for private patrons.

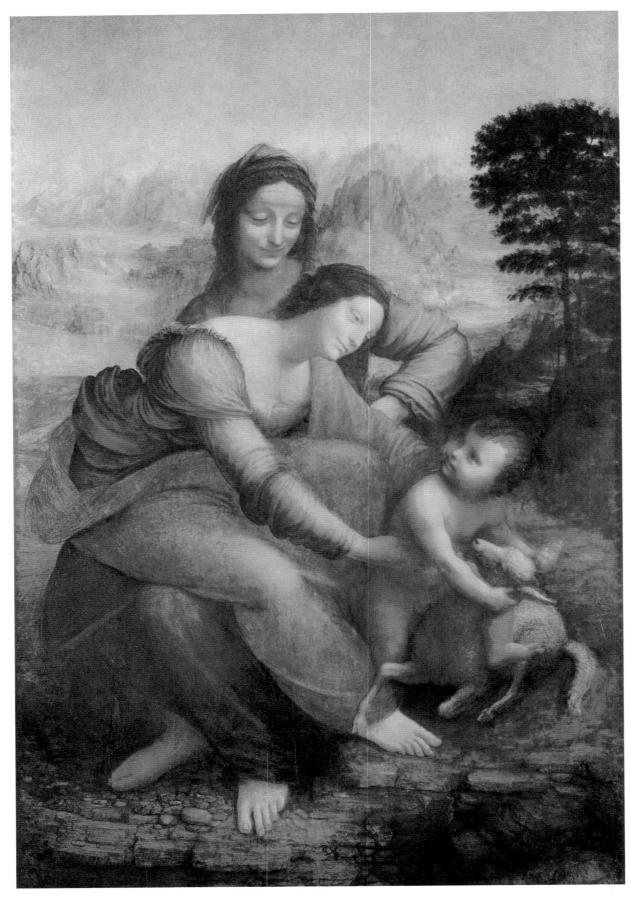

16.26. LEONARDO DA VINCI. Madonna and Child with St. Anne. c. 1508–13(?). Panel, $66^{1/4}$ x $51^{1/4}$ " (1.7 x 1.3 m). The Louvre, Paris

The Madonna and Child with St. Anne (fig. 16.26), deriving from the lost cartoon and painted for a still-unknown purpose, was imitated by Raphael in 1507. It was one of three paintings-the others were the Mona Lisa (fig. 16.27) and a bustlength figure of St. John the Baptist (not illustrated here)—that Leonardo took to France and kept with him until his death. If the Last Supper is the first High Renaissance wall painting, then the Madonna and Child with St. Anne is the first example of the new principles of unity, scale, and compression in panel painting. In the Last Supper the composition is the product of the emotions and actions of the moment; in the Madonna and Child with St. Anne the figures that make up a single group are now intertwined, and the tendency toward a living, moving pyramid that began with Pollaiuolo's St. Sebastian (see fig. 13.6) has reached its climax. It is no accident that the pyramidal composition produced by the interaction of the figures is an essential of classical art; although Leonardo could not have known this, the same principle is exemplified in the pedimental sculptures of the Parthenon. For Leonardo the activating principle of his classical composition and the origin of form itself is motion, which in his writings appears to be at the heart of his universe.

The relatively unmodeled appearance of the Virgin's face is due to overcleaning; the highlights and soft shadows have been rubbed off, and here and there the underdrawing shows through the surface of the cheeks and neck. The Virgin's blue mantle has apparently lost much of its color, but Leonardo's surface is nearly intact, and in the other drapery and the face of St. Anne, as well as in the foreground, with its rocky layers and rounded pebbles, we see Leonardo's use of *sfumato* to unite the painting. The term *sfumato* means "smoke-like," and it provides a simple way to describe the subtle transitions of Leonardo's modeling as he blurs the edges of forms and modulates from highlight into deep shadow. Throughout the painting, the enameled brilliance of late Quattrocento coloring has been replaced by a new, subdued tonality.

The figural pyramid divides the mountain landscape. This is not a poetic portrait of a natural landscape like those of Bellini, which evoke the mood of a time and place—any more than Leonardo's perspective can be related to a specific moment of vision—but a composite of observations and memories collected in his Alpine wanderings. The fantastic spires recall the Dolomites above Belluno so accurately that they make the rocky pinnacles of Leonardo's earlier backgrounds seem mere inventions. Escarpments, crags, lakes, rivers, and cascades recede and blend into the distance.

There is still debate about the identity of the sitter in the painting that is universally known as the *Mona Lisa* (fig. 16.27). According to Vasari, she was Lisa di Antonio Maria Gherardini, the wife of the prominent Florentine Francesco del Giocondo (Mona is a term of respect, a shortened version of the Italian phrase equivalent to "my lady"), but an even earlier source did not mention this identification, reporting

only that the painting had been made for Giuliano de' Medici. Vasari also wrote that Leonardo worked on the painting for three full years. It was probably executed between the cartoon and the final painting of the Madonna and Child with St. Anne and, like it, was kept by the artist and taken by him to France. These factors, plus the presence of an imaginary mountain landscape, suggest that we might consider the paintings together. In the Mona Lisa, in fact, Leonardo treated the single figure much as he had the intertwined group in the Madonna and Child with St. Anne. Earlier full-face or three-quarter portraits such as Botticelli's Portrait of a Man with a Medal of Cosimo de' Medici (see fig. 13.28) and Perugino's Francesco delle Opere (see fig. 14.17) concentrate on the head and shoulders, cutting the body at mid chest and raising the hands so they are visible within the frame; even Leonardo's own Ginevra de' Benci (see fig. 16.13) had conformed to this principle before it was truncated. Now Leonardo continues the figure well below the waist, and both arms appear complete. The hands, utterly relaxed, complete in their unity the spiral turn of the torso and head.

By implying a full-length portrait, Leonardo suggests that it is the whole person who is represented here. This new format was followed almost without exception in Italian portraiture—and indeed Northern European as well—through the nineteenth century. In Leonardo's invention the subject looks larger and grander than in Quattrocento portraits, in keeping with the new dignity and monumentality of the High Renaissance. The effect of grand stability would have been greater before the panel was cut down on both sides, eliminating colonnettes that framed the figure (the base of the colonnettes is still visible on the balustrade to either side).

The calm hint of a smile, about which so much has been written, and the composure of the hands were characteristic for a generation whose standards are summed up in the untranslatable word sprezzatura, from disprezzo (disdain). Sprezzatura is one of the norms of aristocratic behavior set out by Baldassare Castiglione (see fig. 17.56) in his book of dialogues, Il libro del cortegiano (The Book of the Courtier). Castiglione did not mean disdain for others, but a serene unconcern about economic realities or financial display that denotes the inheritors of wealth and power. The sense of satisfied self-confidence is new, and it is especially remarkable that it is expressed by a woman. Renaissance books of etiquette stressed that a woman should never look directly into a man's eyes, and one aspect of the painting's fame is surely the manner in which this woman challenges traditional cultural assumptions about appropriate female behavior.

This work has evoked a flood of literature, and whether or not Freud was correct in his interpretation of Leonardo's character, there is abundant evidence to suggest that the painter's feelings toward women were ambivalent. It seems unlikely that the sitter exercised a romantic attraction over

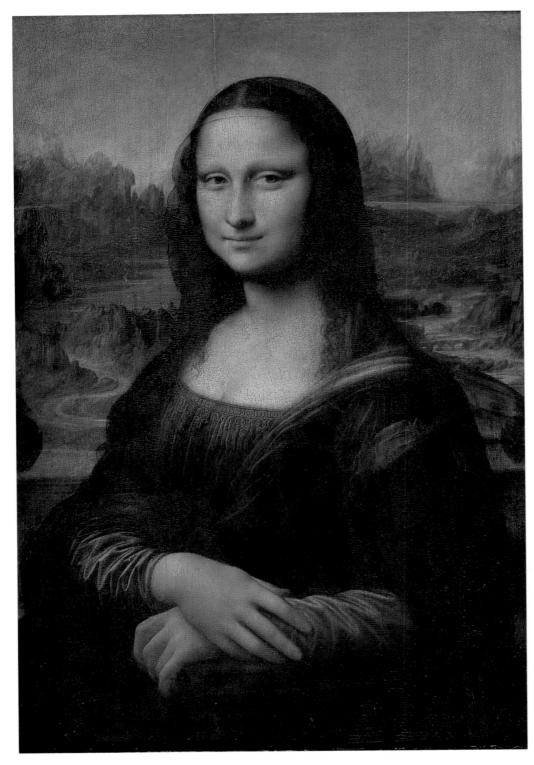

16.27. LEONARDO DA VINCI. Mona Lisa. 1503. Panel, 30¹/₄ x 21" (77 x 53 cm). The Louvre, Paris. The painting is now darkened and the colors are muted by layers of yellow varnish. Vasari had almost certainly never seen this painting, but his description suggests qualities no longer evident in the original: "The nose, with its beautiful nostrils, rosy and tender, seemed to be alive. The opening of the mouth, united by the red of the lips to the flesh tones of the face, seemed not to be colored but to be living flesh."

the artist. Moreover, we cannot dissociate her personality from the surrounding landscape; motif after motif is continuous in figure and landscape. The locks of hair falling over her right shoulder blend with rocky outcroppings through which a road winds; the folds of the scarf over the left shoulder are continued in the line of a distant bridge. As one watches, this wife of a Florentine burgher assumes chameleonlike roles that become more poetic and, perhaps, even threatening.

The nature that she dominates is the same world of roads, rocks, mists, and seas that Leonardo began using for backgrounds beginning with the *Baptism of Christ* (see figs. 13.11, 16.11); devoid of humans or animals, habitations, farms, fields, or even trees, it is dominated by Dolomitic crags like those in the *Madonna and Child with St. Anne*. The only human constructions, the roads and the bridge, lead to indistinguishable waters and unscalable rocks. Most subtle of all is the placing of the highest level of mist so that

it accentuates the expression of the eyes. The whole is covered with layers of darkened, yellowish varnish.

In 1503 Leonardo was commissioned by the Florentine Republic under Piero Soderini to paint the Battle of Anghiari for the Palazzo dei Priori. The now-lost picture was never finished, and only the central section can be reconstructed with any degree of certainty. During the brief period when it was in existence and sections of the cartoon for the painting survived, Leonardo's composition fundamentally changed the whole idea of battle painting. Leonardo's picture was intended to commemorate the 1440 victory of the Florentines over the forces of the Milanese duke Filippo Maria Visconti, who had been abetted by the treachery of Rinaldo degli Albizzi and other Florentine exiles. In the days when the Republic still had to contend with the invading forces of Cesare Borgia, it is understandable that the government would wish to make reference to this triumph over an ancient enemy on the walls of the Sala del Cinquecento (Hall of the Five Hundred); this room had been added to the Palazzo dei Priori to accommodate the Council of Five Hundred which ruled the new Republic. Apparently, Leonardo painted only the central section; for the remainder, perhaps separated by windows from the center, we have only vivid sketches. The work was executed in another of Leonardo's experimental techniques. Leonardo abandoned the painting in 1506, and what remained of it was apparently cleared away in 1557 by Vasari to make way for his murals glorifying the Medici principate under Grand Duke Cosimo I.

The original Republican decorations were also to include, on the other half of the same wall or on the opposite side of the room, the *Battle of Cascina* by Michelangelo (see fig. 16.41). Our most detailed notion of the effect of Leonardo's

lost painting is a drawing by the seventeenth-century Flemish painter Peter Paul Rubens (fig. 16.28). Although Rubens had seen only copies of a painting that disappeared before he was born, he seems to have been able to re-create something of the furious dynamism of the original through the power of his own imagination.

The central scene depicted the contest of four horsemen for the possession of the standard of the Republic. Leonardo wrote in his notebooks that the superiority of painting over poetry was evident in the immediacy with which the painter could represent the smoke rising from the battlefield, the dust of the ground mingled with blood and turning into a red mud under the hooves of the horses, the faces of the victors distorted by rage and exultation and those of the vanquished by pain and despair. To achieve this level of cosmic struggle, Leonardo converted the horses and riders, whose ancestors we have seen in his Adoration of the Magi and Sforza monument (see figs. 16.15, 16.20), into a tornado of intertwined figures. Leonardo's unified High Renaissance figural composition here reaches an intensity so great that we are torn between the fascination of watching the beautiful interplay of rhythmic elements-the streaming manes and tails, for example—and the urge to turn in fear from the snarling ferocity of the horses, who almost outdo the riders in violence. Their hooves interlock and they fight with their teeth while the riders' swords clash in midair and the horses crush fallen warriors below. More encounters must have filled the remaining spaces, as they cover many sheets of Leonardo's sketchbooks (fig. 16.29).

To the consternation of his contemporaries, Leonardo painted little or not at all during the last ten years of his life. He returned to Milan in 1506, where he was occupied for a

16.28. Copy after LEONARDO
DA VINCI. *Battle of Anghiari*. 1503–6 (destroyed). Copy of central section by
PETER PAUL RUBENS (c. 1615).
Pen and ink and chalk,
17³/₄ x 25¹/₄" (45 x 64 cm).
The Louvre, Paris. Leonardo's original was commissioned by the Florentine
Republic for the Sala del Cinquecento in the Palazzo dei Priori

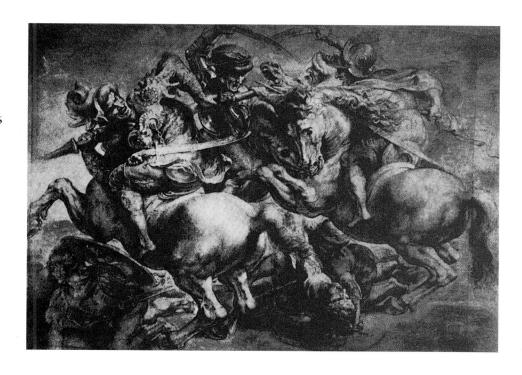

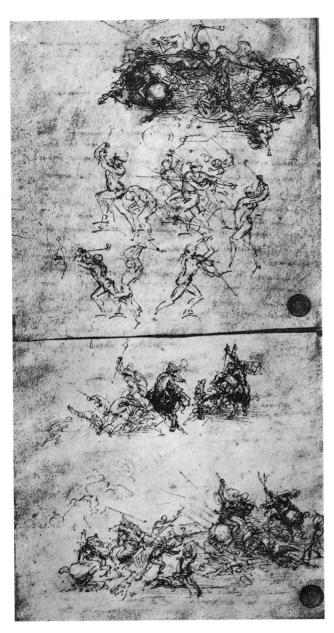

16.29. LEONARDO DA VINCI. *Two Sheets of Battle Studies*. c. 1503. Pen and ink, each approx. 6 x 6" (15.2 x 15.2 cm). Accademia, Venice

16.30. LEONARDO DA VINCI. Deluge. c. 1514–19. Black chalk, $6^{1/4}$ x $8^{1/4}$ " (16 x 21 cm). Royal Library, Windsor

while in the design of an equestrian monument for Giangiacomo Trivulzio, marshal of the Italian armies of King Louis XII of France. He was appointed Peintre et ingénieur ordinaire (painter and engineer) to the king, a position that apparently involved little work and gave the artist a handsome stipend. Except for a brief sojourn in Florence in 1508, he remained in Milan, largely occupied with his anatomical studies, until 1513, when he went to Rome at the invitation of Pope Leo X. The Roman phase of the High Renaissance had largely passed, with the completion of the Sistine Ceiling by Michelangelo and the first two Vatican Stanze by Raphael. Leonardo had a suite of rooms in the Vatican Belvedere. One of his noted accomplishments of this period was a pair of lizard-skin wings mounted on golden wires and attached to a tiny corset around the waist of a live lizard, which could thus march about like a little dragon, displaying its wings in the sunlight. The grandiosity of Michelangelo, then working in seclusion on the statues for the second version of the tomb of Julius II, can have held little appeal for Leonardo, and there is no record that Leo X entrusted him with any specific commission.

In 1517 Leonardo accepted the invitation of King Francis I of France to spend his remaining years at the little château of Cloux, near Amboise, where his only duty was to talk to the king. According to accounts by contemporary witnesses, his conversation radiated his immense learning and imagination, but of his artistic activity little is known. Among the works attributed to these years are drawings of water (fig. 16.30), whose powers Leonardo had spent much of his life studying; now the waters are unchained, descending destructively upon the earth. Leonardo claimed that water was more dreadful than fire, which dies when it has consumed that which feeds it, while a river in flood continues its destructive course until it rests at last in the sea: "But in what terms am

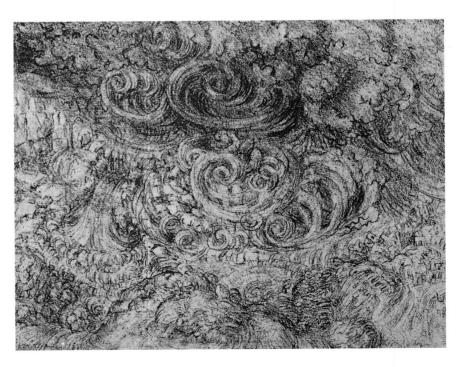

I to describe the abominable and awful evils against which no human resource avails? Which lay waste the high mountains with their swelling and exalted waves, cast down the strongest banks, tear up the deep-rooted trees, and with ravening waves laden with mud from crossing the ploughed fields carry with them the unendurable labors of the wretched tillers of the soil." The force of water in these drawings engulfs barely visible human constructions and assumes spiral shapes expressive of Leonardo's reverence for nature's power.

Michelangelo to 1505

In the Florence that Leonardo abandoned for Milan in the early 1480s, Michelangelo Buonarroti (1475–1564) was, as he put it himself, drinking in a love of stonecutters' tools with his wet-nurse's milk. By the time Leonardo returned in 1500, the young sculptor was a formidable competitor to him in the art of painting as well. Michelangelo's loyalty to the Florentine Republic meant that he became involved in producing heroic Republican imagery. Michelangelo became the dominant personality of the Florentine and later the Roman versions of the High Renaissance. In fact, he dominated the sixteenth century to such a degree that it was virtually impossible for artists to escape his influence. One could accept him or rebel against him, but one could not ignore him.

Michelangelo's character and stylistic approach place him in opposition to Leonardo. Where Leonardo was skeptical, Michelangelo believed; where Leonardo was apolitical, Michelangelo was, above all, a Florentine; where Leonardo looked on the world and humanity with detachment, Michelangelo was obsessed by guilt. Where Leonardo was intellectually and physically charming but seems to have cared little for those he attracted, Michelangelo was spare, taciturn, and irascible, yet consumed with a deep love for others that only in his old age was requited by the adoring reverence of his pupils. Where Leonardo was absorbed in the mysteries of nature, of which the human being was only a single facet, Michelangelo scorned landscape, which appears in his art only occasionally as a fragment of bleak rock or tree blasted by lightning. Where Leonardo considered the eye the window through which the soul assessed the physical world, Michelangelo in his writings extolled the eye's spheroid beauty or shrank from the emotional effect of the spiritual radiance from the eyes of those he loved. Throughout the seventy-five years of Michelangelo's known artistic production his main interest was in the life of the human soul as expressed in the structure and movements of the human body.

Michelangelo was born in a barren region of the Apennines, in the village of Caprese. His father, an impoverished but pretentious gentleman named Lodovico di Simone Buonarroti, was governor (podestà) of this Florentine out-

post. Before Michelangelo was a month old, Lodovico's oneyear term came to an end, and the family returned to Florence, but even in his old age the artist attached special importance to having been born in the rarefied air of this world of stone. He was given to a wet nurse who lived on a small family property at Settignano, a village of stonecutters that had been the home of Desiderio and the Rossellino family. It is difficult to resist the temptation of drawing a connection between his early love of stonecutters' tools and his fondness for representing the theme of the Virgin nursing the Christ Child.

In 1549, when the artist was already old, he was subjected to a questionnaire on the relative merits of painting and sculpture that was circulated by the humanist Benedetto Varchi. We already know that Leonardo, who was long dead, would have argued the superiority of painting. Michelangelo's reply stated that "the nearer painting approaches sculpture the better it is, and that sculpture is worse the nearer it approaches painting. Therefore it has always seemed to me that sculpture was a lantern to painting and that the difference between them is that between the sun and the moon." By sculpture Michelangelo explained that he meant works that are produced "by force of taking away [i.e., by carving]; sculpture that is done by adding on [i.e., by putting on pieces of clay one after another] resembles painting." He thus placed himself in opposition to such sculptors as Ghiberti and Donatello, who seem to have evolved their works, whether in bronze or marble, using preliminary studies in clay or wax, and who exploited optical and pictorial effects.

Michelangelo's theoretical opposition did not mean, however, that he never made sketches out of clay, wax, and other soft materials. Vasari, who worked for a while as a sculptural assistant to Michelangelo, utilized what is probably the sculptor's metaphor when he compared the process of carving a statue from a block of marble to that of lowering the water from a figure in a bath. The sculptor would draw the contours on the faces of the block, especially the front, and then pursue the profiles inward until the process of removal of the stone liberated the figure. In one of his poems, Michelangelo compared this procedure to that of God the Creator liberating man from matter.

Michelangelo's youthful desire to become an artist was opposed by his family, especially his father and uncle. These brothers fancied themselves as descendants of the counts of Canossa and therefore above mechanical labor. Eventually, they yielded and placed the boy in Ghirlandaio's studio in 1488, at the age of thirteen. He must have been skillful already, for he drew a salary instead of having his father pay for his indenture, as was the custom with apprentices. He could have found no better teacher from whom to absorb the traditions and techniques of the Quattrocento. In many a passage of the Sistine Ceiling one still feels the solidity of Ghirlandaio's form and spatial structure, and even fifty years

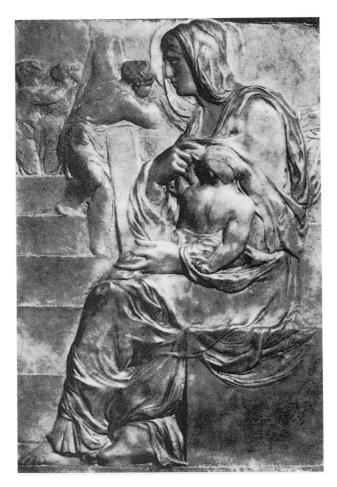

16.31. MICHELANGELO. *Madonna of the Stairs*. 1489–92. Marble, $21\frac{3}{4} \times 15\frac{3}{4}$ " (55.3 x 40 cm). Casa Buonarroti, Florence

after his apprenticeship, when he was occupied with the *Last Judgment* (see fig. 20.1), Michelangelo was still contemptuous of the newfangled method of painting in oil, preferring the traditional Tuscan fresco technique that he had learned in Ghirlandaio's shop. In none of his paintings does he employ the soft shadows used by Leonardo, insisting always on the clarity of the Florentine tradition.

He may well have taken part in the execution of Ghirlandaio's fresco cycle in the chancel of Santa Maria Novella (see fig. 13.42), although Ghirlandaio's style in this cycle is so consistent that it is impossible to identify any figures or passages by his thirteen-year-old assistant. After barely a year with Ghirlandaio, Michelangelo was invited into the house of Lorenzo the Magnificent, where he stayed and worked in a kind of art school about which we know little. It was held in the now-vanished Medici gardens, opposite the Church of San Marco. At the palace he would have been able to study works of ancient art—including marble sculpture, cameos, and coins—and Renaissance paintings and sculpture. He was under the tutelage of Bertoldo di Gio-

vanni, a sculptor who had been Donatello's assistant. In expeditions to Santa Croce and the Carmine, he made drawings after the frescoes of Giotto and Masaccio. It was in the Brancacci Chapel, in fact, that Michelangelo's criticism of a drawing by the sculptor Pietro Torrigiani earned him the blow that broke his nose and disfigured him for life.

At Lorenzo's table whoever arrived first sat closest to il Magnifico, and Michelangelo must sometimes have found himself sitting next to him or near Lorenzo's sons: Piero the Unlucky was Lorenzo's successor, Giuliano later became the ruler of Florence, and Giovanni later became Pope Leo X. In addition there would have been other family members and guests, including the Neoplatonic philosophers who were part of Lorenzo's circle. There must have been a heady atmosphere of political power and intellectual performance, especially for Michelangelo, who seems to have learned only a few phrases of Latin.

Probably from these years—and therefore before Michelangelo was eighteen—dates the artist's earliest extant work, the small marble relief known as the Madonna of the Stairs (fig. 16.31). It was deeply influenced by the rilievo schiacciato of Donatello (see fig. 7.17), as well as, possibly, by some ancient relief, cameo, or coin then in the Medici collections. For the only time in the work of Michelangelo, we are not exactly sure what forms exist under the shimmering drapery that covers the Virgin's limbs (it was later said of him that his figures were nude even when clothed), and there is other evidence of his youth and immaturity. But the back and right arm of the Christ Child are extraordinary, already surpassing sculptures of the Early Renaissance in their muscular power. Michelangelo would reuse this same back many years later in the figure of Day in the Medici Chapel (see fig. 18.4). Note that in this first known work, Michelangelo has chosen to represent the nursing Madonna, a theme that will reappear in the Medici Madonna (see fig. 18.6). The Madonna's sadness is a reference to Christ's Passion even at the time of his infancy, while the stairs probably indicate Mary's symbolic role as a stairway to heaven. The angels in the background wingless as almost always in Michelangelo's work-are spreading what seems less like a cloth of honor than a shroud. These background figures are unfinished, having yet to receive the final polish, while their heads are scarcely more than blocks. Already in the sculptor's adolescence, we sense a hint of a kind of artistic paralysis that would prevent him from finishing all but a handful of his sculptural works and even some of his paintings.

Another relief from the Medici period is the *Battle of Lapiths and Centaurs* (fig. 16.32), whose powerful movement contrasts sharply with the quiet introspection of the *Madonna of the Stairs*. Both strains coexisted in Michelangelo's nature, and the dichotomy between them may be witnessed again and again, often within the same work. The battle between the Lapiths and centaurs was a subject

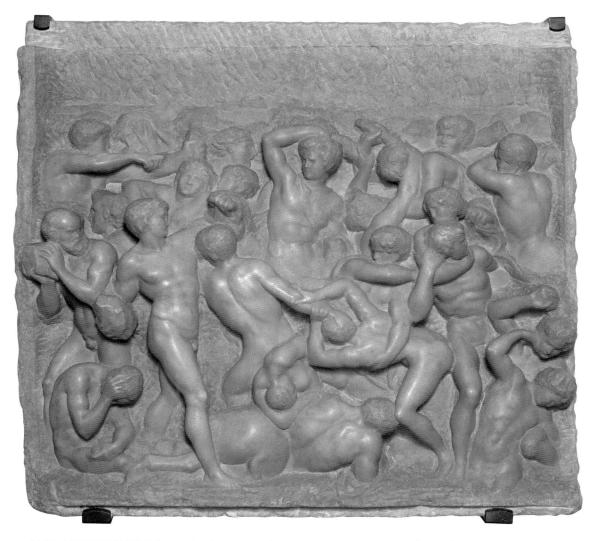

16.32. MICHELANGELO. *Battle of Lapiths and Centaurs*. c. 1492. Marble, 33¹/₄ x 35¹/₈" (84.5 x 89.2 cm). Casa Buonarroti, Florence

described by ancient writers, and there have been attempts to identify the figures and even to question whether this is indeed the subject. What is more to the point is that Ovid's account of the mayhem between the centaurs (who became drunk and attempted to carry off the Lapith women at a wedding feast) and the defenders has been reduced to symbolic and aesthetic terms. No blow connects with its intended victim, no stone strikes a human head, no club disfigures a human body. Occasionally, in this vibrant interlace of struggling figures, two actually wrestle, but this is as far as the artist will let himself go in depicting brutality.

If the *Madonna of the Stairs* is the ancestor of the sibyls of the Sistine Chapel (see fig. 17.32) and the *Medici Madonna* (see fig. 18.6), the figures in the *Battle of Lapiths and Centaurs* are progenitors of the herculean nudes of the *Battle of Cascina* (see fig. 16.41) and the *Last Judgment* (see fig. 20.1). The nudes are unfinished for the most part and some heads are so rough that they can hardly be distin-

guished from the rocks wielded by the centaurs. With his characteristic abhorrence of the monstrous—indeed of any violence done to the human body—Michelangelo has so subordinated the lower bodies of the centaurs that they are difficult to make out. The *Battle of Lapiths and Centaurs* is among the most advanced figural compositions of its time, but it is worth noting that in Michelangelo's composition the figural interlace does not, as in Pollaiuolo and Leonardo, construct a unifying geometric shape.

With the death of Lorenzo in 1492, however, this episode in Michelangelo's life was over, and the boy found himself back in the modest house of his father in the street that follows the curves of the old Roman arena near Santa Croce. If the sources are to be believed, Lorenzo's successor Piero the Unlucky did call the boy back to the Palazzo Medici for a few months but the only work he had for him was a figure sculpted from snow for the Medici courtyard; no evidence for this obviously temporary figure survives. The wooden

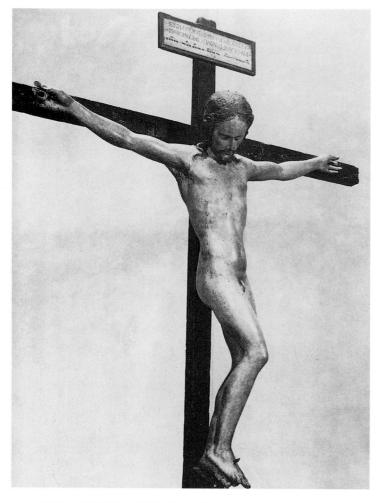

16.33. MICHELANGELO (attributed to). *Crucifix*. 1492. Painted wood, height 53" (1.35 m). Santo Spirito, Florence. This work is identified as the documented Crucifix that Michelangelo made as a gift for the prior of Sto. Spirito, Florence.

Crucifix (fig. 16.33) that many scholars identify as the one Michelangelo made for Santo Spirito would have been made at this time.

In contrast to the vigor of the figures in the battle relief (see fig. 16.32), the figure of the crucified Christ has an unexpected elegance of proportions and a graceful pose. The figure is absolutely nude, in keeping with the artist's reverence for the human body. This is consistent with Michelangelo's ideology, for he repeatedly depicted Christ as gloriously nude as any mythological Greek hero (when the figure was used for public devotion, however, it would certainly have had a loincloth made of fabric). The sculpture, the only work in wood that we know by Michelangelo, seems to foreshadow his later statues, especially the Captive now known as the Dying Slave (see fig. 17.44), on a grander scale, and the face recalls some in the battle relief. Michelangelo is reported to have carved the Crucifix in gratitude for the prior's permission to dissect corpses in the Hospital of Santo Spirito. Unlike Leonardo's anatomical study, which emphasized

physiology, Michelangelo's investigations were geared toward understanding gestures and movements and how they could express spiritual life. Like Leonardo, he dissected corpses well into his advanced years and hoped to author a treatise on anatomy for artists.

A brief visit to Venice in 1494 seems to have had little effect on either the guest or the host city, but during Michelangelo's stay in Bologna during the winter of 1494–95 he executed three statuettes to complete the tomb of St. Dominic. He also came into contact with the works of Jacopo della Quercia (see figs. 7.28–7.30), with their emphasis on the power and dignity of the human body, whether heroically nude or enveloped by surging waves of drapery. Jacopo's

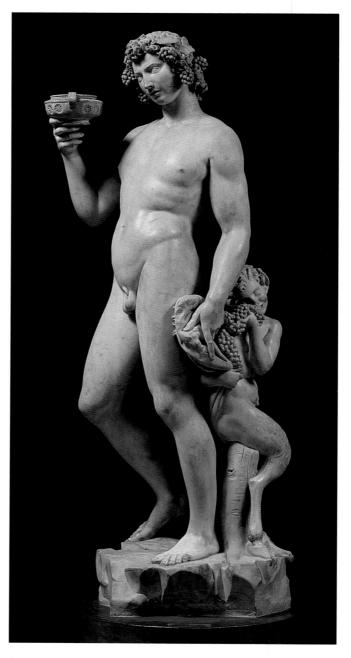

16.34. MICHELANGELO. *Bacchus*. 1496–97. Marble, height $79^{1}/2$ " (2 m). Bargello, Florence

influence on Michelangelo's style was immediate and profound, and it played an important role in the formation of some of the images on the Sistine Ceiling. Also, although its connection with specific works has never been successfully demonstrated, Savonarola's preaching may well have had an effect upon the young artist. In his old age Michelangelo still read Savonarola's works and in his mind remembered the sound of his voice.

Although the Rome of 1496, dominated by the Borgia pope Alexander VI, can have afforded little spiritual inspiration for the twenty-one-year-old artist, it did provide contact with ancient Roman architecture, sculpture, and painting, whose influence upon his art is incalculable. In the *Bacchus* (fig. 16.34), made for a rich Roman, Michelangelo explored human flesh in a manner unprecedented since antiquity. The figure's sensuality reveals the extent to which such beauty fascinated the young Florentine. The god of wine, completely nude and wreathed with vine leaves and bunches of grapes, is shown as deeply affected by alcohol: his eyes seem glazed

and he lurches unsteadily. The grapes that fall from his panther skin are coveted by a boy satyr. The flat surface of the marble block, still evident in the relieflike character of the satyr and the grapes, contrasts with the fullness and richness of the main figure.

In 1498 Michelangelo, then twenty-three, accepted a commission for what became one of his most famous works, the *Pietà* (fig. 16.35). This Northern subject—common in France and Germany but virtually unknown in Italy—was ordered by a French cardinal who did not survive to see the work completed. To obtain marble of the highest quality, the sculptor made the first of his many special trips to the quarries at Carrara. The contract for the group followed the typical rhetoric of artistic contracts in stating that it should be "the most beautiful work in marble which exists today in Rome." Unfortunately for the modern spectator, the work is now viewed against a background of opulent marble and it is raised too high and has to be tilted forward by a prop of cement inserted at the back. Originally Michelangelo

16.35. MICHELANGELO. *Pietà*. 1498/99–1500. Marble, height 68½" (1.74 m). St. Peter's, Vatican, Rome. Commissioned by the French Cardinal Jean de Bilhères Lagraulas for the chapel where he planned to be buried at Old St. Peter's

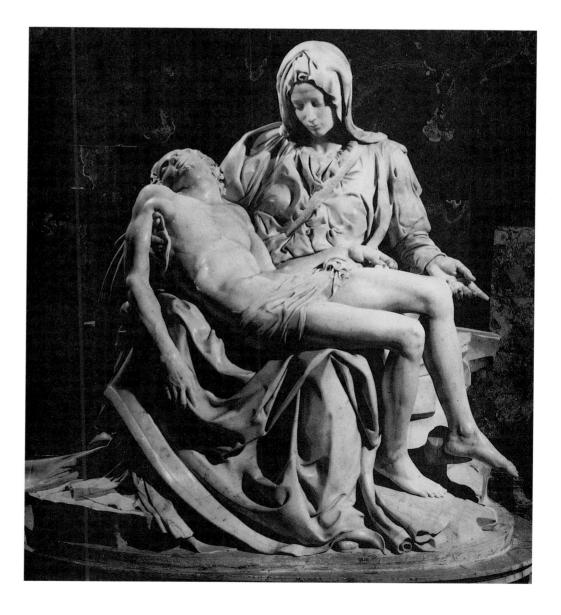

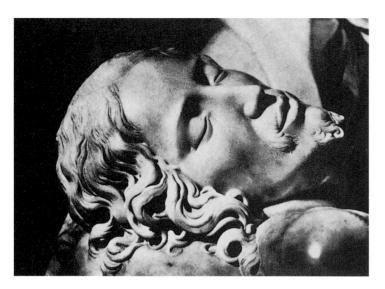

16.36. Head of Christ, detail of fig. 16.35

intended that the group be placed on or near the floor, so that the viewer had a clear view of the face of Christ.

After the muscular violence of the Battle and the sensuous richness of the Bacchus, it may seem strange that Michelangelo should return here to the Botticellian slenderness of the Crucifix, but these three apparently contrasting veins—and others besides—coexisted within the imaginative life of an artist too spontaneous and original ever to be reduced to a single stylistic formula or to submit to a single category of taste. Never did he carry refinement and delicacy to a higher level than in the complex rhythms of the drapery or the exquisitely finished torso and limbs of Christ. At certain points line seems to cut into the marble surface, setting up a conflict between form and contour that was to persist for several years in Michelangelo's style. This is especially evident in the features of Christ and Mary; the delicate curls of Christ's moustache and beard (fig. 16.36), for example, are incised into the marble.

The serenity of Michelangelo's interpretation of this tragic scene is expressed in part by the unified High Renaissance composition he has developed, which is based in part on a reversal of the normal figural proportions. So that Christ will not overwhelm Mary, she is larger in scale than he is. No trace of pain remains in his face, and his wounds are barely noticeable. With a single, calm gesture, the Virgin invites us to meditate on the meaning of Christ's death.

In Michelangelo's lifetime there was speculation about the discrepancy between Mary's apparent age here and her actual years—she should be about eighteen years older than her son, who was thirty-three at the time of his death—but if anything the artist has made her look as young as her son. Michelangelo's answer, perhaps deliberately mystifying, was that a virgin will retain the appearance of youth much longer than a married woman.

Vasari recorded that when the group was first placed in St. Peter's, an astonished crowd of Lombards thought it was by a fellow countryman, whereupon Michelangelo stole into St. Peter's at night and added his signature. It is the only genuine signature that appears on any of his sculptures.

The only preserved panel picture Michelangelo painted entirely himself-and even this seems incomplete here and there in the background—is the Doni Madonna (fig. 16.37). It was probably painted in 1503 to celebrate the wedding of Angelo Doni, a prosperous weaver, to Maddalena Strozzi, of the famous banking family. This couple was immortalized a few years later in Raphael's portraits (see figs. 16.47, 16.48). The painting is a tondo, a form often associated with marriage in Renaissance art, but the composition has been adapted from the intertwined figures of Leonardo's lost cartoon for the Madonna and Child with St. Anne (see p. 495); Michelangelo must have seen the cartoon in 1501, when he had returned to Florence from Rome and was at work on the David. The yellow-orange silk of Joseph's mantle clashes with Mary's rose tunic in a manner that anticipates the astonishing colors that emerged when the Sistine Ceiling frescoes were cleaned. The compressed grouping has the power of a spring coiled tightly within the frame, and this tension is increased by the sharp modeling of the folds of the drapery masses and the brilliant color.

The composition is stabilized by the horizontal band of stone separating foreground and background. In the smooth surfaces and precise contours of the foreground figures, Michelangelo created the masses as if he were working with marble instead of pigment. The modeling of the nude youths in the background, however, is softer; possibly Michelangelo began all the figures in this fluid style and only gradually brought them to the almost obsessive finish seen in the figure of Mary and the Christ Child. The nudes, direct ancestors of the nudes of the Sistine Ceiling, show an attitude toward human flesh as a continuous, pulsating substance that is different from the smoothly functioning human figures, almost like machines, that were designed by Leonardo (see fig. 16.5).

The difficult meaning of the picture has provoked some far-fetched explanations. Like many of Michelangelo's abstruse visual symbols, the *Doni Madonna* continues to defy exact interpretation, but certain elements are clear. Mary and Joseph appear to be presenting or giving the Christ Child, and *doni* is the Italian for "gifts," *dona* the Latin. The curious depression in the earth on whose edge the nude youths sit or lean is a half moon, a motif from the Strozzi arms, which appear in the frame of the painting. It was customary for family names to appear pictographically: pebbles (*sassetti*) are evident in some of Ghirlandaio's Sassetti Chapel frescoes. We have seen the importance of such symbols in works designed for the Medici.

The inclusion of the Baptist, patron saint of the city, is traditional in Florentine images of the Madonna and Child. The

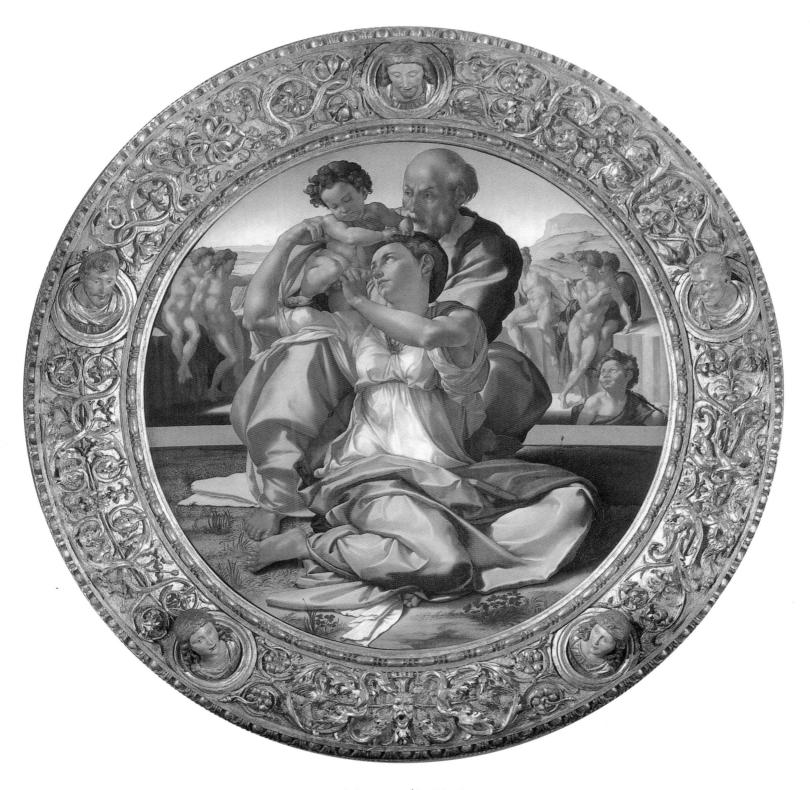

16.37. MICHELANGELO. Doni Madonna. c. 1503. Panel, diameter 47 $^{1}\!/_{4}$ " (1.2 m).

Uffizi Gallery, Florence. Probably commissioned by Angelo Doni.

The frame was designed by the artist. Michelangelo's medium here includes both tempera and oil, but Michelangelo applies oil glazes in a manner related to the tempera techniques he learned as an apprentice. Whereas the Flemings shaded their colors from the highlights down to the darkest tone or black, Michelangelo shades from the most intense area up toward the lightest value of the color. In painting fabric that changes color in shadow (*cangiante*), such as Joseph's yellow-orange silk, he shades from intense orange up to yellow highlights. The smoothness with which Michelangelo makes these transitions is possible only because of the slow-drying potential in the oil medium.

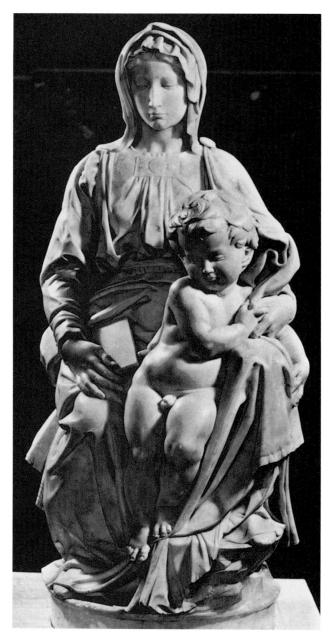

16.38. MICHELANGELO. *Bruges Madonna*. 1503–4. Marble, height 48" (1.2 m). Church of Onze Lieve Vrouwe, Bruges

name was common in Florence, and the first four sons of Angelo and Maddalena Doni, all of whom died shortly after birth, were named Giovanni Battista. The flower that rises near the edge of the font recalls Isaiah's prophecy of the Virgin Birth, "for he shall grow up before him as a tender plant, and as a root out of a dry ground." The picture was probably intended to place Angelo and Maddalena's conjugal life under the protection of the Holy Family, although we should not exclude the possibility that the painting might allude to the death of their first child. If this is the case, the date of the painting would be later.

The *Doni Madonna* is closely related to the *Bruges Madonna* (fig. 16.38), which was probably carved at about the same time and sold in 1506 to a Flemish wool merchant who took it north to Bruges. The Christ Child must have been done from the same model used for the Doni Christ Child. The Virgin is seated upon rocks, with one knee elevated, like that of Joseph in the *Doni Madonna*. Christ, still holding her hand, ventures forth with one hesitant foot. The head of the pensive Virgin, derived from that of Mary in the *Pietà*, is broader in proportion, with a new emphasis on the breadth of the forehead and the fullness of the eyebrows. The Virgin's arms, which emerge from slits in her mantle, were chipped when the statue was temporarily taken to Paris by Napoleon's troops.

As compared with the *Pietà*, the group is somewhat more compact, and both drapery and anatomical forms are simpler in definition. The statue is lovingly finished, although some passages at the back never received their final polish. The beauty of the Virgin and the sense of sad repose found in this tranquil group exemplify the life of the spirit with which Michelangelo was able to endow many of his works.

During the opening years of the Cinquecento, when Michelangelo was creating works for public and private patrons, he was also carrying out a far greater responsibility, the colossal David in marble (fig. 16.39; see also fig. 9). The figure was intended for one of the buttresses of the Cathedral of Florence, and the huge marble block assigned to Michelangelo had been languishing since the 1460s, when a figure of David had been partially blocked out by the sculptor Agostino di Duccio. Agostino was most likely executing a model designed by the aged Donatello, and the latter's death probably caused the officials of the Opera del Duomo to abandon the project. The planned marble statue of David was intended to join Donatello's colossal *Joshua*, in terra cotta painted to resemble stone, which had long been in position on one of the buttresses. The Joshua survived into the seventeenth century. Donatello and Brunelleschi had also made a model for a huge Hercules for the same program.

Such was the magnificence of the *David* when Michelangelo completed it in 1504 that the Florentines were reluctant to have it placed so high. A commission was formed to decide where the statue should go, and testimony recording the opinions of Filippino Lippi, Botticelli, Leonardo, Giuliano and Antonio da Sangallo, Piero di Cosimo, and other artists, as well as artisans and other citizens, is recorded, very nearly verbatim. Leonardo wanted the colossus to be in the Loggia dei Priori, the great three-arched portico for public ceremonies to the west of the Palazzo della Signoria that was later renamed the Loggia dei Lanzi (see fig. 1.2). The Sangallo brothers insisted that it be kept out of the rain because the marble was soft and had already suffered from exposure. Piero di Cosimo suggested that the commission ask Michelangelo. There is no record that it ever did, and no one

knows what his opinion would have been. But it is unlikely that he would have favored a position in the Loggia dei Priori, which would have dwarfed the colossus by contrast with the huge, open arches of the Loggia. In any case, the statue was placed where the herald, an official of the Republic, wanted it-in front of the Palazzo dei Priori as a symbol of the valiant Republic, which had elected Piero Soderini gonfaloniere (standard-bearer) for life and was staking everything on the Republic's continued freedom from the Medici. It took four days to haul the statue on rollers to its final position. One night after it was installed it was attacked with stones by a band of youths, probably Medici supporters.

The political symbolism of the work, recognized by the officials of the Republic in 1504, had been present from the start in the program of colossal figures planned for the Duomo, a building of the highest civic and religious importance. The total and triumphant nudity of the David is in keeping with Michelangelo's views on the divinity of the human body, while its emphatic muscularity is typical of Michelangelo's style. The prudery of Soderini's Republic kept the statue hidden from public gaze for two months until a brass girdle with twenty-eight hammered copper leaves could be devised and hung about the young hero's waist.

Michelangelo's hero is a boy of perhaps sixteen, not fully grown, but with the powerful muscles of a youth who has worked hard in the field. Michelangelo chose an unusual moment to represent, for he shows David before the battle. The sling is over his shoulder and the stone rests in his right hand. but his muscles are taut and his brow is wrinkled in a defiant scowl. The figure pulls powerfully to the left, away from the implied enemy, and David's apprehension is further indicated by the swelling veins in the hand and the sucking in of breath evident in the tense, contracted muscles of the abdomen. Michelangelo's David, his first adventure into the realm of the colossal, can be interpreted not only as a symbol of the Florentine Republic, but also of humanity raised to a new power—a plane of superhuman grandeur and beauty.

At the time of the third expulsion of the Medici from Florence, in 1527, a bench thrown from a window of the Palazzo dei Priori shattered the David's left arm and hand. The pieces were rescued by Vasari and Francesco Salviati, who were in their teens at the time, and kept until they could be reattached many years later. Just as the Sangallo brothers feared, the marble of the statue eventually suffered from exposure, and the fine finish on the top of the head and the upper surfaces of the shoulders is gone. In the nineteenth century the statue was removed to a skylighted rotunda built especially for it at the Accademia.

The pose, which was partly conditioned by the shallow shape of the block and Agostino di Duccio's efforts to carve a figure, must also be understood in terms of the intended position of the statue on the Duomo. Placed on one of the buttress pedestals (see fig. 6.2), the young hero would have

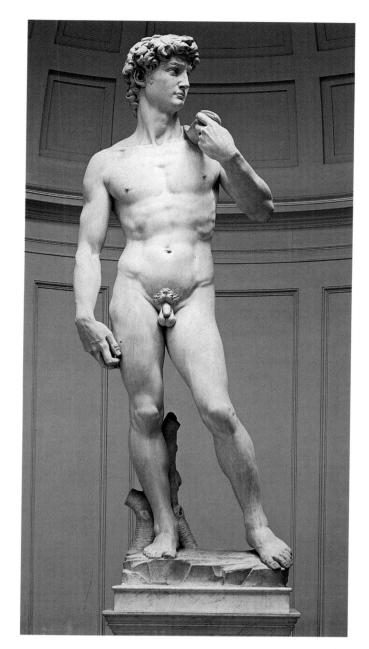

16.39. MICHELANGELO. David. 1501-4. Marble, height of figure without pedestal 17' (5.18 m); height of figure with pedestal 23' (7 m). Accademia, Florence (see fig. 9). Commissioned by the Opera del Duomo, Florence, to be placed on a buttress below the dome, but originally placed in front of the Palazzo dei Priori (see fig. 1.2)

looked defiantly out over the city. The knotty muscles and taut rib cage (fig. 16.40), the heavy projections of the hair, the sharp undercutting of the eyes, and the frowning brow were all intended to register from a distance. In the forms of the face, the conflict between mass and line, noted earlier in the Pietà, reaches a climax of intensity.

Shortly after the David was set in place, the sculptor received his first commission for a huge painting, a fresco of the Battle of Cascina for the Sala del Cinquecento in the

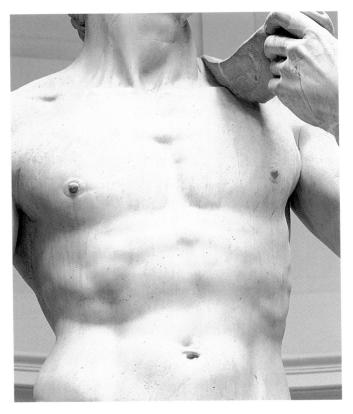

16.40. Torso of David, detail of fig. 16.39

Palazzo dei Priori, the same room where Leonardo had already been working for a year on the cartoon for the Battle of Anghiari (see p. 499). There is no evidence that Michelangelo objected or that he declared that he was a sculptor, not a painter. The moment chosen for his subject may seem trivial-the Florentine soldiers, cooling off in the Arno, are called out by a sudden alarm and caught in the act of struggling into their clothes and armor. Yet, like its predecessor, the Battle of Lapiths and Centaurs (see fig. 16.32), the Battle of Cascina gave Michelangelo the opportunity to demonstrate his mastery of the nude body. Working in secret in the Hospital of Sant'Onofrio, he produced a composition of interlocking figures, turning, twisting, crouching, climbing, tugging boots over wet legs, blowing trumpets, reaching to help comrades. Michelangelo probably derived much of his knowledge of figures climbing out of the water and pulling on clothes from visits to a Florentine public bath, which Leonardo frequented every Saturday for the same purpose. According to Vasari, in Michelangelo's cartoon some of the figures were drawn with crosshatching, others with shading and highlighted with white.

Although Michelangelo probably commenced painting the fresco after his return to Florence from Bologna in 1506, neither the unfinished painting nor a single scrap of the cartoon

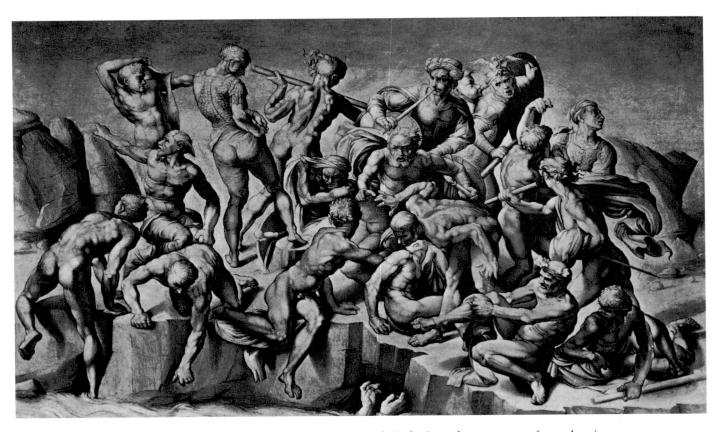

16.41. Copy after MICHELANGELO. *Battle of Cascina*. 1504–6 (destroyed). Early-sixteenth-century copy of central section, by ARISTOTILE DA SANGALLO. Grisaille on panel, 30 x 52" (76 x 132 cm). Collection the Earl of Leicester, Holkham Hall (Courtesy Courtauld Institute of Art, London). Michelangelo's original was commissioned by the Florentine Republic for the Sala del Cinquecento at the Palazzo dei Priori, Florence

remains. During its brief existence the cartoon became something of an art school in its own right and was widely imitated by Florentine masters of the High Renaissance and the Mannerist period as an example of how nude figures in action ought to be composed. The best evidence we have for the original appearance of the cartoon is Michelangelo's drawings for the figures in the foreground and the battles of mounted warriors in the background at either side. A copy (fig. 16.41) shows only the central part of the composition, which seems to have demonstrated Michelangelo's new vision of the power and energy of the human body.

Raphael in Perugia and Florence

After Leonardo and Michelangelo, the third and youngest member of the trio of High Renaissance masters is Raffaello Santi (or Sanzio; 1483-1520), known to us as Raphael. He was not an innovator in the same sense as were Leonardo and Michelangelo. He seldom attempted to push his paintings to the same point of completeness as did his older contemporaries, and he sometimes glossed over imperfect observation or handed grand ideas to more or less gifted pupils for execution. Yet for five centuries Raphael has been praised as the perfect High Renaissance painter. This is not difficult to understand, for in his art noble and ideal individuals move with dignity and grace through a calm, intelligible, and ordered world. His pictures mirror Renaissance aspirations for human conduct and Renaissance goals for the human mind. He unified the movements of his figures and the spaces of his compositions into ideal structures that are integrated and harmonized. But Raphael's order is not merely intellectual or contrived. The figures in his mature works seem to be impelled by an energy that causes them to twist and turn gracefully and to group into oval and spherical compositions. So easy is this motion, so harmonious the relations of the figures, that even at moments of high drama his pictures radiate a superhuman calm.

Born in Urbino, Raphael was brought up in its extraordinary atmosphere of literary, philosophical, and artistic culture and cosmopolitan elegance. His father was Giovanni Santi, a mediocre painter and versifier on whose rhymed chronicle we depend for much of our information about the reputation of Quattrocento painters. Both father and son seem to have had access to the Montefeltro court and to the Palazzo Ducale (see fig. 14.27), where the young Raphael could have seen works by Piero della Francesca, Botticelli, the Laurana brothers, Uccello, Melozzo da Forlì, the Spaniard Alonso Berruguete, and the Netherlander Justus of Ghent. From the palace's windows, Raphael looked out over a landscape filled with color and light.

When Raphael was eleven, his father died. We are not certain at what age the boy went to Perugia to be apprenticed to Perugino, but according to Vasari he was brought to Peru-

gino's studio by his father, who had written that Perugino was "equal in age and endeavor" to Leonardo. Raphael seems to have absorbed with ease both the virtues and the clichés of Perugino's style and he rapidly became the outstanding member of a busy workshop; by the age of sixteen he was already influencing other artists. At the same time he was learning how to manage a workshop, which during his maturity in Rome would help him maintain an impressive production schedule. It is often nearly impossible to separate the style of Raphael from that of his master. The young artist's hand must have been at work in many of Perugino's major commissions. Raphael's debt to Perugino is evident when we compare his Marriage of the Virgin (fig. 16.42), which Raphael proudly signed and dated in 1504 when he was only twenty-one years old, to Perugino's Christ Giving the Keys to St. Peter (see fig. 14.14). There is the same array of foreground figures, the same polygonal background temple, the same intervening piazza. Even the clear, simple colors of the painting—the cloudless blue sky; the strong, deep blues, roses, and yellows of the drapery; the sun-warmed tan of the stone; and the blue-green hills—are derived from Perugino.

A second glance will disclose how the twenty-one-year-old painter improved on his master. The serenity of this altarpiece, which is Raphael's most important early work, results from a High Renaissance integration of form and space. It was presumably commissioned for an altar dedicated to the Virgin's wedding ring in a church in Città di Castello, where Raphael painted several other pictures. According to the Golden Legend, the suitors for Mary, a virgin in the Temple, were to present rods to the high priest and Mary's hand would be granted to the one whose rod bloomed. Joseph is shown with his flowering rod in one hand, while the other, bearing a ring, is joined to Mary's by the high priest. On the left stand the other Temple virgins, on the right the rejected suitors, one of whom breaks his barren rod over his knees. The graceful figures are woven into a unity unknown in Perugino's art. The perspective orthogonals lead past the steps into the Temple, and we look directly through it to the horizon, while hills frame the structure.

The architecture of the Temple reflects the ideas of Raphael's fellow townsman, the much older Bramante, who two years earlier had been authorized to create the Tempietto (see fig. 17.9). One wonders, however, what Bramante or any other practicing architect would have thought of the scrolls treated like metal springs in which Raphael's characteristic spirals discharge against the sky. Despite its radial character, reflecting the ideas of Leonardo (see fig. 16.7) even more than those of Bramante, Raphael's design—a multifaceted building, each of whose sides is treated as a separate plane—still belongs stylistically to the Quattrocento. Its lofty shape also contains more than a hint of the Dome of the Rock in Jerusalem; this Islamic structure had been built on the site of Solomon's Temple and was often identified with it by travelers,

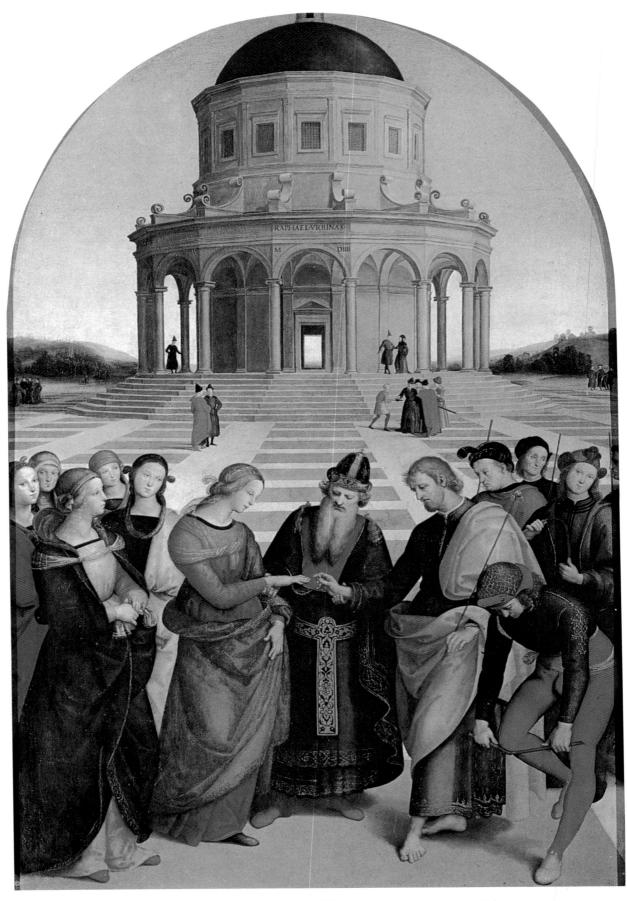

16.42. RAPHAEL. Marriage of the Virgin. 1504. Panel, $67 \times 46^{1}/2$ " (1.7 x 1.2 m). Brera Gallery, Milan. Probably commissioned by the Albizzini family of Città di Castello

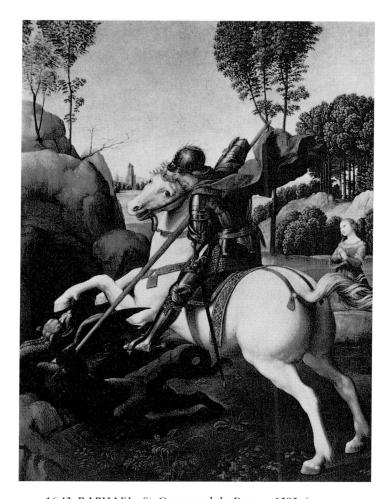

16.43. RAPHAEL. St. George and the Dragon. 1505–6. Panel, $11^{1}/8 \times 8^{1}/2$ " (28.3 x 21.6 cm). National Gallery of Art, Washington, D.C. (Mellon Collection). The painting is signed RAPHELO V (Raphael of Urbino) on the horse's bridle.

making it an appropriate model for the background of the subject of the Virgin's marriage. Perhaps some knowledge of this structure had reached Raphael.

Raphael's St. George and the Dragon (fig. 16.43) betrays the influence of Florentine art, especially Donatello's St. George relief (see fig. 7.17) and Leonardo's Battle of Anghiari (see fig. 16.28), to such a degree that we suspect the painter must already have visited the Tuscan metropolis. He also must have visited Rome, as the Torre della Milizia, a medieval structure still standing in the ancient Imperial Forums, is portrayed just above the muzzle of the horse. Here the curving rhythms of Raphael's forms are integrated in a new way. The warrior saint on his rearing charger is crossed with the masses of the landscape in an X-shape, so that the downward thrust of the lance discharges into the monster's breast all the energies of the picture. From the painter's proud signature on the bridle to the spiraling curves of the horse's tail and the clarity of the foliage, the forms have taken on a metallic precision. The gleaming armor and the reflection of

the princess in the water are rendered with almost Netherlandish delicacy.

Probably sometime in 1505 Raphael decided to settle in Florence, where his master Perugino had painted so many frescoes and altarpieces. He fell into an avid market; in three years, he painted no fewer than seventeen surviving Madonnas and Holy Families plus other major works for Florentine patrons. Pen drawings (fig. 16.44) show how he worked: even before he had decided just where the features were to go, Raphael let his hand revolve in a series of spontaneous curving motions. The resulting ovoid and spiral forms convey their energy to the figures and also help to explain the smoothly finished shapes of the completed paintings.

Once the relationship of masses was decided, Raphael condensed them into a Leonardesque pyramid. Probably the first of the series, dated 1505 by the inscription on the border of the Virgin's garment, is the *Madonna of the Meadows* (fig. 16.45), which still contains echoes of Leonardo's *Madonna and Child with St. Anne* (see fig. 16.26), especially in the placing of the Virgin's leg and foot. Most of the series belong to this new type, which we might even call the Madonna of the Land because an open expanse of Florentine countryside seems to be placed under the protection of the Virgin and Child and the infant Baptist, patron of the city. Here Raphael has, as throughout the series, let the Virgin's neckline dip to

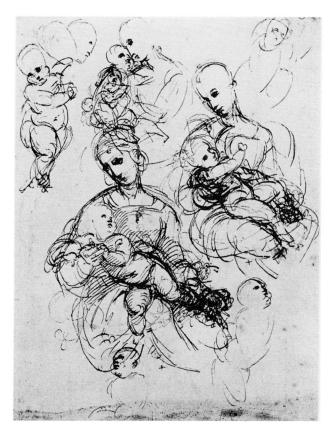

16.44. RAPHAEL. Studies of the Madonna and Child. c. 1507–8. Pen and ink, $10 \times 7^{1/4}$ " (25.4 x 18.4 cm). British Museum, London

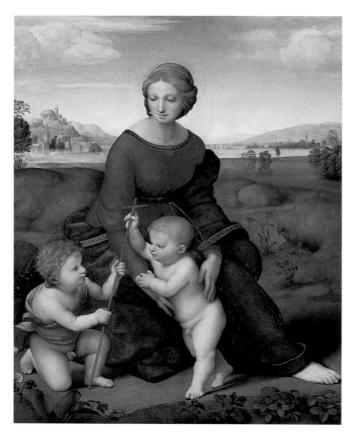

16.45. RAPHAEL. Madonna of the Meadows.
1505 or 1506. Panel, 44½ x 34¼ " (113 x 87 cm).
Kunsthistorisches Museum, Vienna. The date on Mary's neckline can be read as either 1505 or 1506.
Perhaps commissioned by Taddeo Taddei

follow the curves of the horizon and then put her on the same level as the hills. The clear, simple coloring and the easy upward movement of reciprocally balancing forms are Raphael's own, as is the return of energy from the downcast eyes of the Virgin to the group below. The halo, now reduced to a simple circle of gold seen in depth, enhances the grace of the linear movement and completes the balance between the ovoid forms and the distant landscape spaces.

One could argue that to Leonardo or Michelangelo, Raphael's Florentine Madonnas might have looked less complete than their own works, because Raphael was not interested in the problems of anatomy and expression that were important to them. To Raphael a picture was complete once its main masses were posed in a satisfying relationship, and line, color, and surface had a fluid interrelationship; at this point in his career he was not interested in defining shapes further. Nonetheless, in these Florentine Madonnas Raphael presents a noble and serene existence in which the pictorial harmonies seem to be a natural emanation from the divine figures. These gentle Virgins and sweet children are gracefully poised against the answering background of hills and deep blue sky.

In the *Small Cowper Madonna* (fig. 16.46), one of the most intimate of the series, the Virgin is seated upon a low bench before a landscape of open, road-traversed meadows and clumps of trees that are reflected in a still lake on one side while on the other they adorn the rounded slopes of a hill. On its summit stands a church that closely resembles the sanctuary of San Bernardino outside Urbino. The asymmetry of the hills is related to the pose of Christ's figure, and the smooth, gliding forms of the Virgin's hair are continued in the veils that descend from her head and course lightly about her shoulders and bust. Christ's head moves slightly away as his arms complete the circling motion of the veils. And the two divergent yet harmonious shapes are echoed in the haloes, delicate lines of gold against the blue.

It is a curious fact that some of the most convincing and accurate portraitists—Raphael, Holbein, Poussin, Ingres—sharply separated this vein of their production from the idealism of their more formal work. Raphael, cool and detached by nature, did not interpose his own feelings between the sitter and the observer, with the result that the subject's character is strongly suggested. Even here, it should be noted, he did not dwell on the individual idiosyncrasies in the manner of the Netherlandish realists. He set his Florentine patrons, like

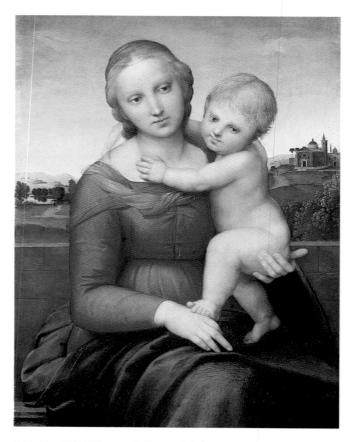

16.46. RAPHAEL. Small Cowper Madonna. c. 1505. Panel, $23\frac{3}{8}$ x $17\frac{3}{8}$ " (59.5 x 44 cm). National Gallery of Art, Washington, D.C.

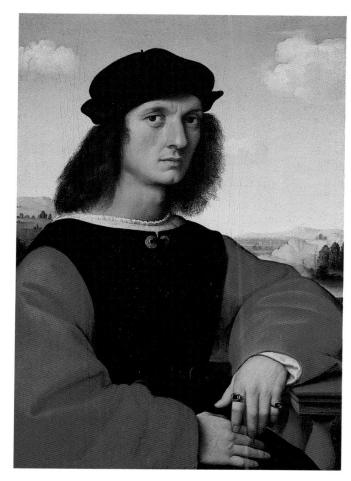

16.47. RAPHAEL. *Angelo Doni*. c. 1506. Panel, $24\frac{1}{2} \times 17\frac{1}{4}$ " (63 x 45 cm). Pitti Gallery, Florence. Probably commissioned by Angelo Doni

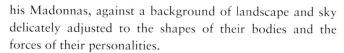

Angelo Doni, for example (fig. 16.47), relaxes outdoors with one arm on a balustrade, the shaggy masses of his hair reflected in the trees at the lower right, the bulky shapes of his arms and hands in the low hills of the background. The forms of his wife, Maddalena Strozzi Doni (fig. 16.48), are also integrated with the landscape, to the point that the artist repeated the pattern of the beaded border of her transparent shoulder veil in the foliage of the slender tree. As in Perugino's Francesco delle Opere (see fig. 14.17), an effect of energy is obtained by individual wisps of hair silhouetted against the sky. The wealthy wool merchant is impressive at thirty—cool, self-contained, firm. The portrait of his fifteenyear-old bride, however, has to compete with her obvious prototype, the Mona Lisa (see fig. 16.27). There are no mysteries concealed here—but neither, at this juncture, are there many in Raphael's art, except for his uncanny sense of proportion and balance. To the successful young painter, in command of the resources of the new style, the unknowable of

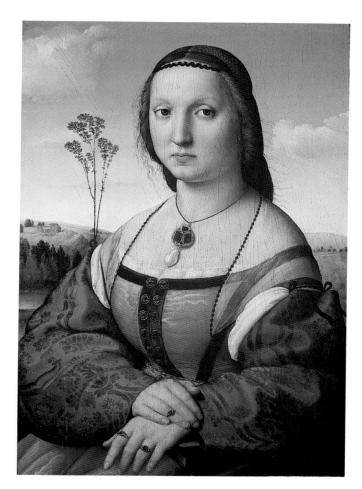

16.48. RAPHAEL. *Maddalena Strozzi Doni*. c. 1506. Panel, $24^{1}/2 \times 17^{1}/4$ " (63 x 45 cm). Pitti Gallery, Florence. Probably commissioned by Angelo Doni

Leonardo may not have seemed worth knowing. He seems to have been satisfied with his compositional perfection and, in these portraits as never in his Madonnas, he devoted some overtime to the careful modeling of the features and hands of the husband and wife, even to their rings, to the damask and moiré of Maddalena's dress, as well as to the careful approximation of her shoulders and chest to the shape and texture of the pearl that hangs from her pendant. Like Michelangelo, Raphael was destined to enter a new dimension once he left Florence for papal Rome, a crowning phase of his activities that belongs to the following chapter.

Fra Bartolommeo

From his Florentine drawings, we know that Raphael was familiar with the works of Leonardo and Michelangelo. He also learned from and influenced a Florentine named Baccio della Porta (1472–1517), who is known to us as Fra Bartolommeo after his assumption of the monastic habit and his temporary retirement to San Marco in 1500. By the time Raphael arrived in Florence, Fra Bartolommeo was at work

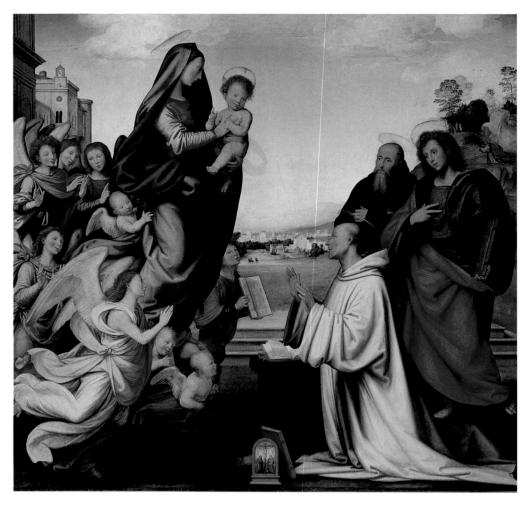

16.49. FRA BARTOLOMMEO. Vision of St. Bernard. 1504–7. Panel, 84 x 86 ¹/₄" (2.1 x 2.2 m). Accademia, Florence. Commissioned for the Badia, Florence

on his *Vision of St. Bernard* (fig. 16.49), an obvious attempt to update Filippino Lippi's painting of the same subject (see fig. 13.33) in terms of the new High Renaissance style. Everything immediate, personal, and introspective and all references to daily existence have been discarded in the search for a new idealism. The saint kneels before a classical pedestal on which books are open, but we are not asked to imagine that this is his outdoor study, as in Filippino. The setting is an aesthetic device designed for compositional purposes, and two other saints (apparently Anthony Abbot and John the Evangelist) from other eras are included who were most likely requested by the patron.

In contrast to Filippino's version, Mary is a completely heavenly vision, touching nothing earthly with her feet or hands; carrying her smiling child, she is borne into the scene by angels. One of the angels holds before the saint an open book, but he is so lost in the ecstatic realization of a transcendent vision that he does not even glance at it. The picture is in poor condition—much of the upper surface is lost—but the atmospheric landscape is intact, and the fig-

ures and drapery move with a grace that must have impressed the young Raphael. The broad curvilinear movement that is the basis for the composition was not invented by Fra Bartolommeo. Although his forms possess the gravity and amplitude of the High Renaissance, he had certainly been admiring the linear sweep of his great monastic predecessors such as Lorenzo Monaco (see fig. 5.12). The unusual device of a little picture-within-a-picture of the Crucifixion is probably borrowed from Fra Angelico's altarpiece for Fra Bartolommeo's home monastery of San Marco (see fig. 9.5), but Fra Bartolommeo has extended the illusion by leaning a book against it. For him, as for Fra Angelico, the device serves as a foreground counterpart for the vanishing point of perspective, in an attempt to achieve spatial harmony. Fra Bartolommeo's floating Madonna is probably the first of a series of High Renaissance visionary Madonnas, and it is the ancestor of Michelangelo's floating Virgin for the 1513 version of the tomb of Julius II (see p. 591) and of Raphael's Sistine Madonna (see fig. 17.54).

Luca Signorelli

Two artists, Luca Signorelli and Piero di Cosimo, are discussed here because their major works, although still Quattrocentesque in style, are incomprehensible without an understanding of the early achievements of Leonardo and Michelangelo.

Signorelli (after 1444–1523) was born in Cortona, a Florentine subject town in southern Tuscany. According to Vasari he was trained initially by Piero della Francesca, and later went to Florence, where he worked for many years and was influenced by the works of Antonio del Pollaiuolo in particular. He was called to Rome to complete the cycle of frescoes on the walls of the Sistine Chapel (see pp. 371–74), which had apparently been left incomplete by the group of painters assembled by Pope Sixtus IV. He painted for the Medici during the late 1480s and early 1490s; his *Court of Pan* (fig. 16.50) was influenced by the classicism of the circle surrounding Lorenzo the Magnificent, who greatly revered this sylvan deity. The *Court of Pan* has never been convinc-

ingly interpreted. Apparently, it represents the mythological god Pan instructing a group of largely nude divinities and aged shepherds in the art of music, using flutes cut from reeds. In this re-creation of classical antiquity, the crescent moon hangs over Pan's head, and the light of late afternoon models the figures like so many statues in the Medici gardens. The hips, legs, and feet of the nude at the left were probably taken from Botticelli's *Birth of Venus* (see fig. 13.26), and Signorelli seems to have had access to Michelangelo's *Bacchus* (see fig. 16.34) or to the sculptor's preliminary drawings, for the nude figure at the right reproduces the Bacchus from the back in almost every respect.

Like Leonardo and Michelangelo, Signorelli was fascinated by the human body in movement, and he was able to demonstrate this interest on a grand scale in the frescoes in the San Brizio Chapel in the Cathedral of Orvieto, painted from 1499 to 1504 (figs. 16.51, 16.52). Fra Angelico had commenced a fresco cycle illustrating the Last Judgment in the chapel in 1447, but he had finished only two of the compartments of the vaults before being called to Rome by Pope Nicholas V. Signorelli was originally employed to finish the vaults, but in 1500 he won the assignment to paint the walls as well.

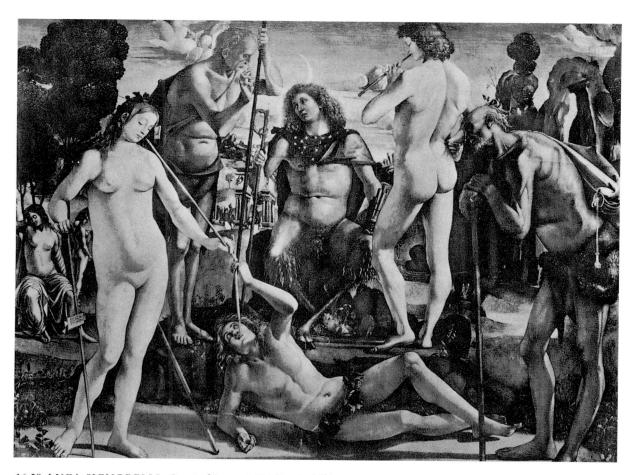

16.50. LUCA SIGNORELLI. Court of Pan. c. 1496. Panel, $6'4^{1}/_{2}$ " x 8'5" (1.95 x 2.56 m). Formerly Berlin, destroyed 1945. Probably painted for Lorenzo de' Medici

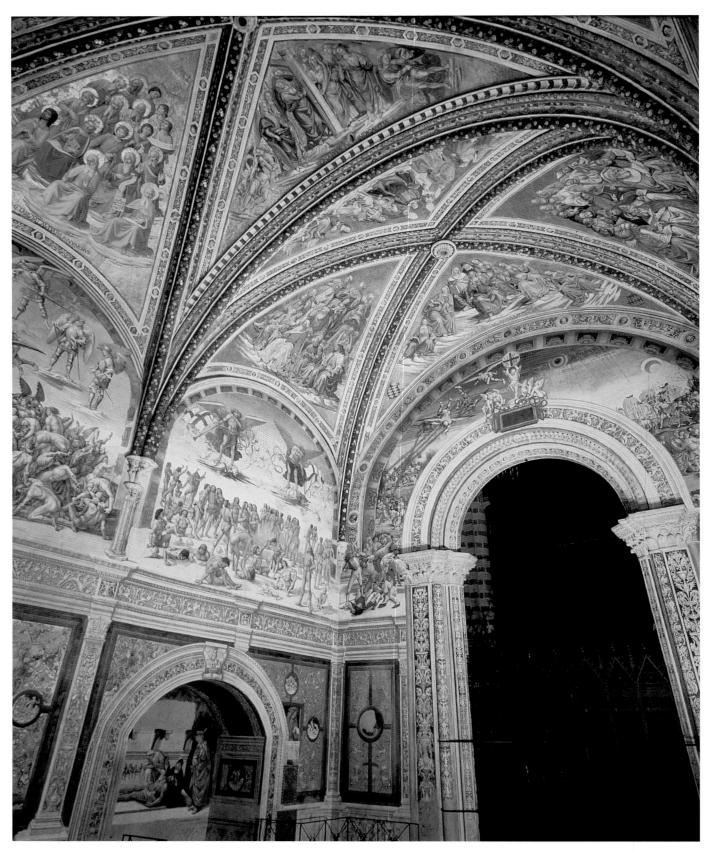

16.51. LUCA SIGNORELLI. View of the frescoes in the S. Brizio Chapel, Cathedral, Orvieto. 1499–1504.

Commissioned by the Opera of Orvieto Cathedral. The figures seen in the vaults show the blessed in heaven as part of a panoramic Last Judgment begun in the chapel by Fra Angelico in 1447. Of the figures shown here, only those in the leftmost section of the ceiling are by Fra Angelico; the others are all by Signorelli.

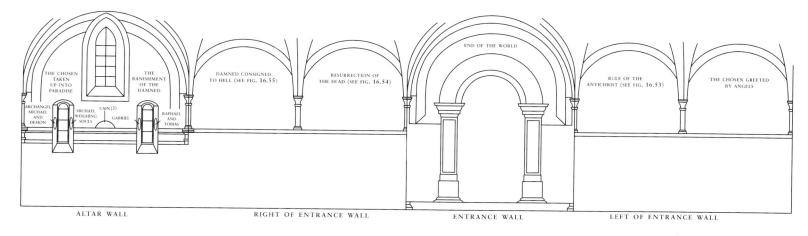

16.52. Diagram of the iconography of the San Brizio Chapel by Signorelli. Computerized reconstruction by Sarah Loyd, after Roettgen

One step into the interior, and we are caught up in a world of terrible action. Three of the six episodes of the end of the world are reproduced here. In the first we see the *Rule of the Antichrist* (fig. 16.53) as described in Matthew 24:5–31. Christlike in his garments, hair, and beard but terrible in his expression, the Antichrist repeats the words whispered into

his ear by a demon. Around him stand people of all ages, many of whom represent portraits (Dante is recognizable in the second row, to our right). In the background rises Signorelli's version of the Temple of Solomon, a Renaissance structure more ambitious than carefully articulated, its porches filled with soldiers who have stripped it of its ritual

16.53. LUCA
SIGNORELLI.
Rule of the Antichrist.
1499–1504. Fresco,
width approx. 23'
(7 m). S. Brizio Chapel,
Cathedral, Orvieto.
Commissioned
by the Opera of
Orvieto Cathedral

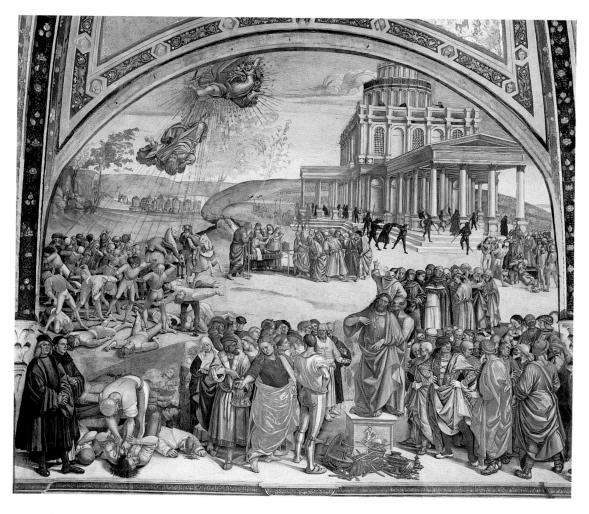

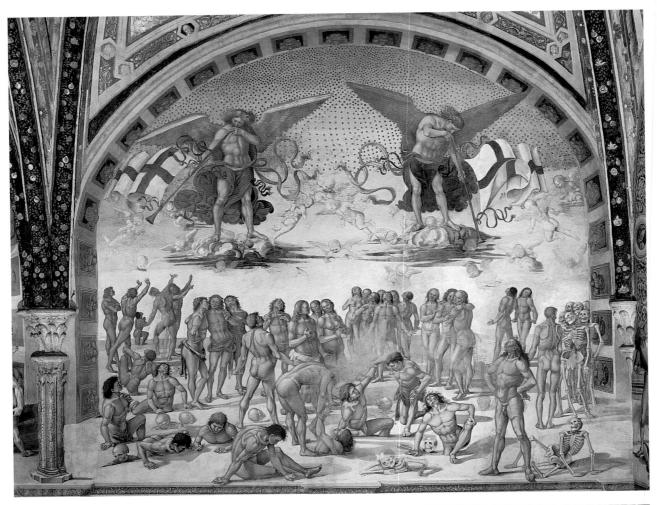

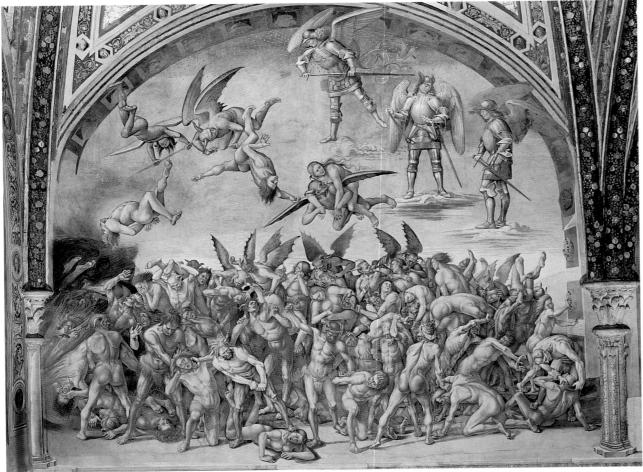

Opposite, above: 16.54. LUCA SIGNORELLI. Resurrection of the Dead. 1499–1504. Fresco, width approx. 23' (7 m). S. Brizio Chapel, Cathedral, Oriveto

Opposite, below: 16.55. LUCA SIGNORELLI. Damned Consigned to Hell. 1499–1504. Fresco, width approx. 23' (7 m). S. Brizio Chapel, Cathedral, Orvieto

vessels, now piled as gifts before the Antichrist, and who are beheading innocent people at the right. In the middle, the Antichrist is represented raising a dead person, but eventually he is cast down at the left, in a shower of golden rays by an angel. Signorelli has depicted himself full-length in contemporary costume and included Fra Angelico at his side.

The Resurrection of the Dead (fig. 16.54) was the most ambitious nude composition of its day, but in almost no time it was to be superseded by the Battle of Cascina (see fig. 16.41). Responding to the trumpets' call, the nudes, who seem to be made of stone or wood, crawl out of the stony plain before us and strut or dance about, sometimes embracing amiably, sometimes in conversation with skeletons who have yet to get their flesh back. Raised nodes in the gilded plaster at the top catch the light and produce a glittering effect that will later be used by Raphael in the Disputà (see fig. 17.48).

The wildest scene is the Damned Consigned to Hell (fig. 16.55). Heaven is guarded by the armored archangels Michael, Raphael, and Uriel, while demons with batlike wings carry off protesting mortals through the air. The foreground is filled with a howling tangle of devils and mortals on whom specific torments are being inflicted. One woman lies on her stomach, while a demon lifts her foot and tears her toes apart. Other demons rip off the ears or sink their teeth into their victims. Signorelli's wild imagination and rude vigor are enhanced by the brilliance of the coloring. The tan and white flesh tones themselves are vivid enough, but the skin of the demons often varies from orange to lavender and green on the same figure. After a while things begin to look a bit mechanized, partly because Signorelli employed several assistants, and as a result the details can sometimes be clumsy. But the effect of the cycle is beyond anything that had been seen in Italy before, and it is still overwhelming.

Piero di Cosimo

We know a great deal about Piero di Cosimo (1462–1521). He hated thunderstorms and fire, the latter to such an extent that he was afraid to cook, and he lived on hard-boiled eggs which he prepared fifty at a time. He never allowed anyone to prune his fruit trees or weed his flowers. He represents an exception within Italian art that reminds us that not all artists conformed in style to the period in which they lived.

A painting by Piero that is often identified as a *Portrait of Simonetta Vespucci* (fig. 16.56) may not represent this Florentine woman—the inscription was added later—and it may not even be a portrait. The female figure is shown as Cleopatra, with the asp coiled about her bosom. The picture may be somehow related to Lorenzo di Pierfrancesco de' Medici, one of whose personal emblems was the serpent biting its tail. Whatever the subject, Piero seems to have enjoyed setting up the shapes of the pure profile against the white and black thunderclouds and those of the breasts against the shapes of the hills. The whole picture is as unweeded and unpruned as Piero's garden.

His long panel representing a *Mythological Scene* (fig. 16.57) has been identified as a representation of the death of

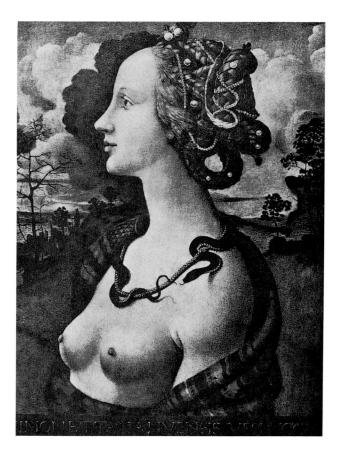

16.56. PIERO DI COSIMO. Portrait of Simonetta Vespucci(?). c. 1501. Panel, $22^{1/2}$ x $16^{1/2}$ " (57 x 42 cm). Musée Condé, Chantilly

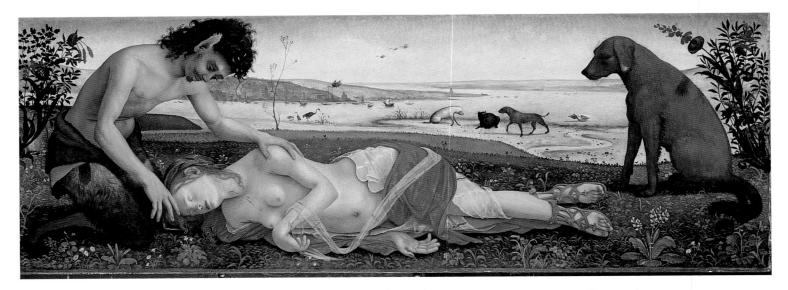

16.57. PIERO DI COSIMO. Mythological Scene. c. 1510. Panel, 253/4 x 721/4" (65.4 x 184.2 cm). National Gallery, London

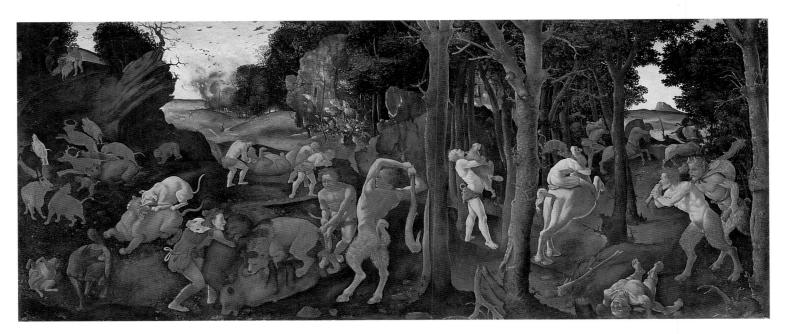

16.58. PIERO DI COSIMO. *Hunting Scene*. 1490s. Panel, 27³/₄ x 66³/₄" (70 x 170 cm). The Metropolitan Museum of Art, New York (Gift of Robert Gordon, 1875). Perhaps commissioned by Francesco del Pugliese

Procris, daughter of Erectheus, king of Athens. According to Ovid, Procris was pierced in the chest by a javelin thrown by her husband, Cephalus, who mistook her for an animal concealed in the forest. Here an almost-nude Procris, wounded in the throat, is mourned by a satyr, whose grief is as touchingly represented as is the wordless sympathy of the dog. Piero must have felt a deep kinship with animals. His simple, descriptive style is a far cry from the elaborate technique and observation of Leonardo, but it

seems absolutely appropriate for the uniquely personal interpretation of his subjects.

It may have been Francesco del Pugliese, the wealthy cloth merchant who had commissioned Filippino Lippi's *Vision of St. Bernard* (see fig. 13.33), who asked Piero to paint a series of panels representing the early history of humanity. Known as *spalliere*, such panels would originally have been installed above wooden wainscoting to decorate a room. The series illustrates an account from *De rerum*

natura (Concerning the Nature of Things) by the ancient Roman author Lucretius. One panel (fig. 16.58) depicts a battle between humans, a great variety of animals, and half-human creatures such as centaurs and satyrs. The forest setting is typically unpruned and at the mercy of Piero's hated fire, which breaks out here and there in wild gusts that seem to be brushed on quickly with bold brush-strokes. Piero pulls us into prehistory through a combination of distant landscape and foreshortened figures: a dead dog at the far left, a horse to the right of center, and a rotting corpse in the right foreground. How this evolutionis-

tic view of mankind was reconciled with the account in Genesis we can only guess. Certainly, Piero's panels are related to, and probably in their muscular vigor even influenced by, Michelangelo's *Battle of Lapiths and Centaurs* (see fig. 16.32). But, like Signorelli in his Orvieto frescoes, Piero depicts what was most repugnant to Michelangelo—humanity in a subhuman stage and subject to the depredations of antihuman creatures and forces. In the following chapter we will see how, with impassioned energy, Michelangelo and other artists attempted to raise humanity again to a divine level.

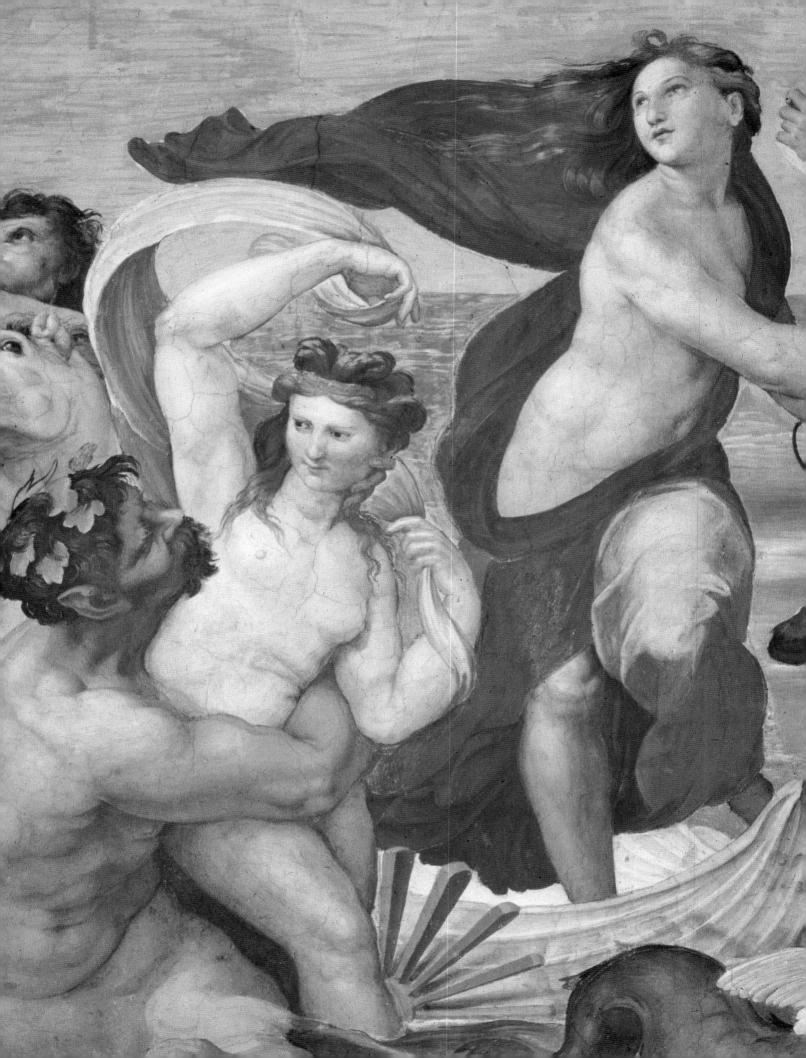

THE HIGH RENAISSANCE IN ROME

he next phase of Italian art and history is dominated, at the outset at least, by a single figure, Pope Julius II (fig. 17.1). As Cardinal Giuliano della Rovere, this forceful prelate had exercised great power earlier, during the pontificates of his uncle, Sixtus IV (1471-84), and of Sixtus's successor, Innocent VIII (1484-92). When Rodrigo Borgia ascended the papal throne as Alexander VI in 1492, Giuliano left Rome. His election as pope in 1503, following the less-than-monthlong pontificate of Pius III (September 22-October 18), was the beginning of what might be called an artistic revolution that started in the Vatican and expanded to Rome, to central Italy, to the entire peninsula, and eventually to all of Europe. Julius II loathed the Borgias and refused to use the rooms decorated by Pintoricchio in which Alexander VI had once lived. He immediately set about a program of reform in the Roman Church, while in the secular sphere he reestablished law and order in the crime-ridden streets of Rome and subjugated the rebellious Roman nobles. Next he set out to reconquer the lost provinces of the papacy. Then he began campaigns to drive foreign invaders out of Italy, beginning with the French in the north. His success there would doubtless have been followed by an expulsion of the Spaniards in the south and the unification of the peninsula under papal leadership if death had not stopped his meteoric career after ten years.

The last decade of the pope's life—his sixties—treated Europe to the spectacle of the pontiff standing in armor beside blazing cannons, attacking his enemies in language both coarse and violent, beating his cardinals with his cane when they hesitated to follow him through snow that was breasthigh on the horses, growing a beard in defiance of all custom and tradition, and acting in general like an unchained giant loose on the map of Italy. The modest attempts of Quattrocento popes to transform medieval Rome into a classical city were superseded by Julius's determination to rebuild whole sections, to drive broad avenues, bordered with palaces,

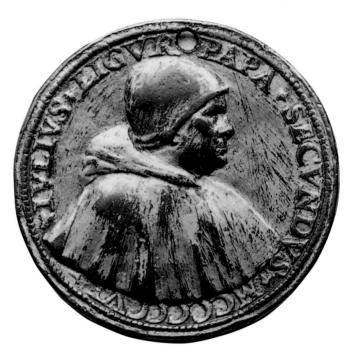

17.1. CARADOSSO. *Medal of Julius II*. Bronze, diameter 2¹/₄" (5.7 cm). Bibliothèque Nationale de France, Paris. Caradosso (c. 1452–c. 1527) was Bramante's collaborator for architectural ornament for his Milanese projects. Twelve copies of this medal were made, two in gold and ten in bronze. The reverse of this medal shows Bramante's plan for St. Peter's (see fig. 17.12). The medal was cast for the founding of St. Peter's.

through hovels and ruins alike, and to replace the Basilica of St. Peter's, now more than a thousand years old, with a new structure that would embody the imperial splendor and spiritual drive of his regime. Intellectually and artistically, the Rome of Julius II must have been an exciting place. It was also dusty and noisy from demolitions and reconstructions, and it was repeatedly threatened by the collapse of the pope's political schemes and invasion by his enemies.

The development of the Julian High Renaissance was supported by the pope's interest in the grandeur of ancient

Rome, his collecting and display of ancient works, and by the sensational discovery of the sculptural group of *Laocoön and His Sons* (fig. 17.2) in the ruins of Nero's Golden House in January 1506. The group itself was undeniably impressive, but it gained added stature and importance when Giuliano da Sangallo (see pp. 346–49) identified it as the *Laocoön* group that had been described by the ancient author Pliny in his *Natural History* (36.37–38). Pliny furthermore named

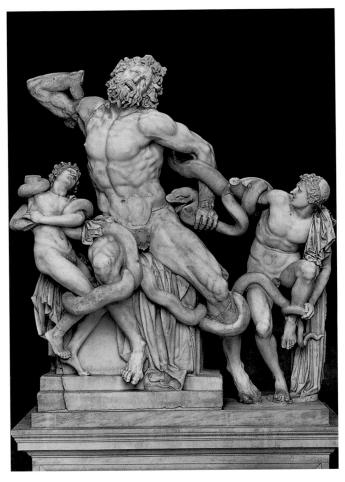

17.2. HAGESANDROS, ATHENODOROS, and POLYDOROS. *Laocoön and His Sons*.

Early first century B.C.E.(?). Marble, height 8' (2.4 m). Vatican Museums, Rome.

The three sculptors who carved this work were Greek, but they were probably working for a Roman patron who had commissioned a work reminiscent of earlier Hellenistic art. Within a few years of its discovery, at the invitation of the architect Bramante, one of Julius's confidants, four sculptors had made large wax models of the sculpture; one of these was then chosen to be executed in bronze. In 1523 Pope Leo X commissioned the sculptor Baccio Bandinelli to make a full-size marble copy to be presented to King Francis I of France.

the artists who had made the group. The Renaissance thus fortuitously acquired an ancient sculpture of high quality, made by named artists and mentioned in an authoritative ancient text. That Pliny had described it as "of all paintings and sculptures, the most worthy of admiration" only increased the adulation and attention the sculpture received. It was almost immediately bought by Pope Julius II, and less than six months after its discovery it was installed in a niche in the courtyard of his new palace, which was called the Belvedere (see figs. 17.18, 17.19). The impact of the sculpture was almost immediate; the impassioned struggle and dramatic muscular exertion of its figures played a role, for example, in Michelangelo's figures for the Sistine Chapel Ceiling, begun only two years after the discovery of the group.

Another ancient work that played a role in inspiring a change in the scale and muscularity of Renaissance figures was the so-called Belvedere Torso, a fragment of an ancient figure which bears the signature "Apollonios of Athens, the son of Nestor" (fig. 17.3). As prized as the signature was, no other works by this artist were (or are) known and his name appears in no documents or texts. The Belvedere Torso is first recorded in the 1430s, in a Roman collection, but its fame dates from the first decade of the sixteenth century, when it became part of the Vatican collections and was displayed in the Belvedere Palace, hence its name. Although the Renaissance normally restored ancient fragments to give an impression of completeness, this fragmentary torso was not touched; tradition has it that Michelangelo refused the opportunity to restore it because he feared he would be unequal to the task. As a result, the incomplete torso challenged the imaginations of Renaissance and later artists, who attempted in drawings, paintings, and small sculptures to creatively reconstruct the original arrangement of the head, arms, and lower legs. A number of Cinquecento paintings feature figures inspired by the fragment. Perhaps the most famous of these are found among the young men that decorate the Sistine Chapel Ceiling (see figs. 17.26, 17.28, 17.35, 17.37). The combined impact of the Belvedere Torso and the Laocoön on the development of High Renaissance sculpture and painting is incalculable.

It has been said Julius chose the High Renaissance as the artistic style that could best embody his new ideals, and one can hardly imagine him calling upon Botticelli or Perugino to create new visual symbols for his militancy. High Renaissance style, forged in the crisis of republican Florence, was a perfect instrument for him, and Michelangelo an ideal artist. Later these two were joined by Raphael and by Bramante, who was to become the most important High Renaissance architect and a close friend and confidant of the pope. The painters summoned by Sixtus IV for the first program in the Sistine Chapel returned to their cities without creating a common style (see pp. 371–75, 409–10). But, whether or not they knew it was happening, the three artists who carried out

17.3. MAARTEN VAN HEEMSKERCK. *Drawing of the Belvedere Torso*. 1532–36/37. Pen and ink on paper. Kupferstichkabinett, Berlin. The sculptural group known as the *Belvedere Torso*, which is signed by the otherwise unknown APOLLONIOS OF ATHENS, THE SON OF NESTOR, is probably a work of the first century B.C.E. emulating the style of the third century B.C.E. The animal skin on which he sits is sometimes thought to be that of a lion, which would identify the figure as Hercules. Heemskerck was a Dutch painter who visited Rome, where he met Vasari, in 1532–36/37. His drawings of Roman ruins and Renaissance works provide us with important information about the appearance of Rome in the 1530s (see fig. 20.21). When he saw the *Belvedere Torso* it was still lying on its back, and he shows it thus in one of his drawings. Of this fragment from antiquity, Michelangelo is reported to have said: "This is the work of a man who knew more than nature."

Julius's projects did, to an extent, submerge their personalities as they were inspired by the example of their patron.

The Roman period of the High Renaissance is distinct from its Florentine predecessor—grander in scope, freer in its dynamism—and it developed with rapidity from phase to more majestic phase. Pope Julius II, as patron, exercised a formative influence on High Renaissance style and should be considered one of its creators. Julius determined what was to be built, carved, or painted, and by whom; what were to be the subjects; how they were to be treated; and which among several alternate projects was to be executed. Such was the grandeur of Julius's undertakings that Italian art could never again return to its former, more modest, self.

Bramante

Donato di Pascuccio (1444–1514), known as Bramante, was from Urbino. He started as a painter of considerable creativity and first appears as an architect in Milan in 1485, when he undertook the rebuilding of Santa Maria presso San Satiro (fig. 17.4). Basically Albertian in its single-story, barrel-vaulted nave, with round arches supported by piers decorated with Corinthian pilasters, the church culminates in a crossing crowned by a Pantheonlike dome that gives us a hint of how Alberti's domes for the Malatesta Temple (see fig. 10:3) and Sant'Andrea at Mantua might have appeared. The most startling element of the interior, however, is the choir, which appears to stretch for three bays beyond the crossing, under a barrel vault matching that of the nave. But while our eyes can see this distance, we cannot enter it, for the choir does not exist. It is a triumph of the Renaissance art of deceit

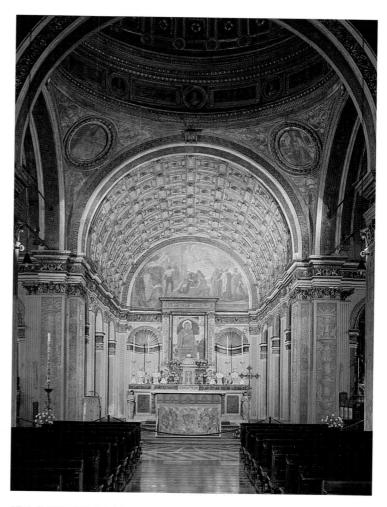

17.4. DONATO BRAMANTE. Interior view toward choir, Sta. Maria presso S. Satiro, Milan. 1485. Height of arch 34'9" (10.6 m)

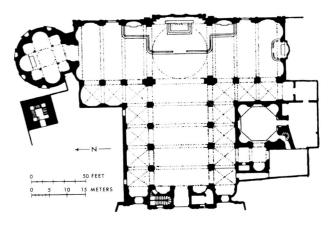

17.5. DONATO BRAMANTE. Plan of Sta. Maria presso S. Satiro, Milan

(fig. 17.5). Where we think there is a choir, a street outside limited the size of Bramante's small church; the illusion is created by stucco relief on a flat wall, and the actual depth is only a matter of a few feet. The false choir of Santa Maria

presso San Satiro indicates Bramante's preoccupation with space, and is a premonition, in miniature, of how the interior of Julius II's St. Peter's (see figs. 17.12–17.15) would have looked had it been completed and decorated according to his plans.

Santa Maria delle Grazie in Milan had been started in Gothic style in 1463, but in 1492 Duke Ludovico Sforza ordered the choir torn down and replaced by a Renaissance structure to house the tombs of the Sforza dynasty; Leonardo's drawings for a centrally planned church (see fig. 16.7) may be related to this project. Although no document connects Bramante's name with the present apse, transept, crossing, and dome, they are attributed to him under the influence of Leonardo da Vinci, whose ideas on radial architecture they reflect. Whether or not all the surface decorations were designed by Bramante himself, the structure is composed, like the examples in Leonardo's drawings, of permutations and combinations of geometric forms such as cubes, hemispheres, half-cylinders, and the like (figs. 17.6, 17.7). Bramante transformed the oculi (round windows) of the Gothic church into circles that are treated as ornament in

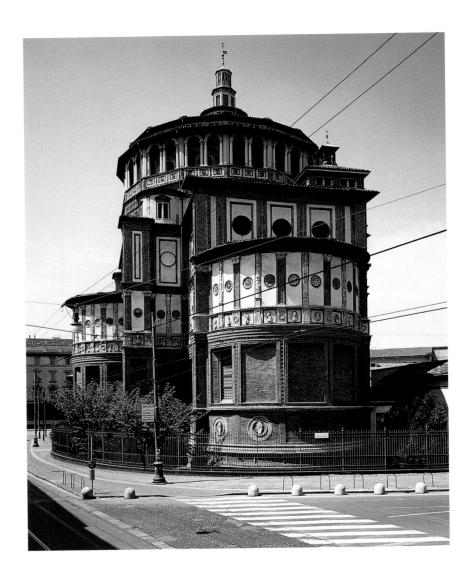

17.6. DONATO BRAMANTE. Sta. Maria delle Grazie, Milan. Begun 1492. Commissioned by Ludovico Sforza

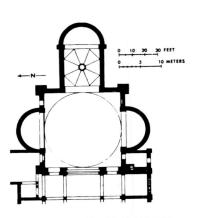

17.7. DONATO BRAMANTE. Plan of Sta. Maria delle Grazie

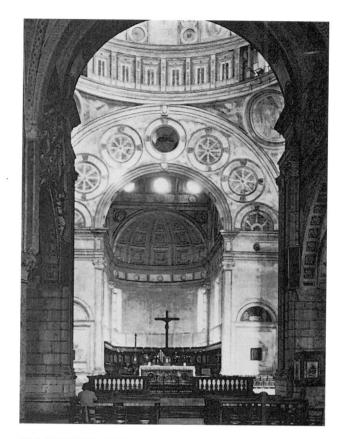

17.8. DONATO BRAMANTE. Interior view toward choir, Sta. Maria delle Grazie, Milan

the exterior decoration. In the interior (fig. 17.8), where apses curve outward around the dome, the circles are used to decorate the arches below the dome.

The fall of the Sforza dynasty in 1499 left Bramante without work at what was, for the Renaissance, the advanced age of fifty-four. He moved to Rome and immediately found work as an architect during the last years of the pontificate of Alexander VI. Under Julius II, Bramante developed with unexpected originality to become the leading architect of the High Renaissance.

The Tempietto (little temple; fig. 17.9) was commissioned in 1502 by Ferdinand and Isabella of Spain to mark the spot where St. Peter had been crucified, but it was probably not built immediately. The building is not mentioned in Francesco Albertini's 1510 guide to Rome, which describes the nearby but less important church, and the style of the Tempietto is incompatible with that of Bramante's first works in Rome. Thus the dates of design and construction remain uncertain. Instead of the Corinthian and Ionic orders preferred by Quattrocento architects, Bramante here chooses the more severe Roman Doric. The circular shape, however, which he could study in ancient round temples in Rome and Tivoli, allowed him to abandon the planimetric quality of Quattrocento architecture, which had already been chal-

lenged by Leonardo's radial schemes. The Tempietto has no single elevation; it exists in space like a work of sculpture, and, as we move about it, its peristyle and steps revolve around the central cylinder.

The spatial effect Bramante intended can be realized today only if we re-create in our minds the surrounding circular courtyard (figs. 17.10, 17.11). Each column of the outer peristyle would have related radially to a column of the Tempietto, tying the inner structure to its frame by a web of relationships across the surrounding space. The interrelationship of forms and spaces would have created a unity that is the product rather than the sum of its parts, an analysis that makes the Tempietto the architectural equivalent of Leonardo's lost cartoon for the *Madonna and Child with St. Anne* (see p. 495). Leonardo's ideas, therefore, provided the foundation for both the Florentine and the Roman phases of the High Renaissance. The intellectual order and inherent majesty of this building, whose solids and spaces are beautifully harmonized, justify the choice of Bramante as papal architect by Julius II.

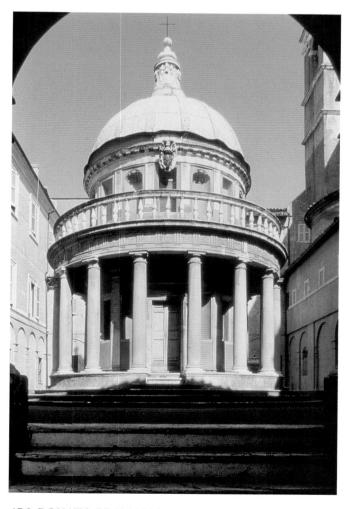

17.9. DONATO BRAMANTE. Tempietto,
S. Pietro in Montorio, Rome. Authorized 1502; completed after
1511. Height 47' (14 m). Commissioned by King Ferdinand and Queen Isabella of Spain

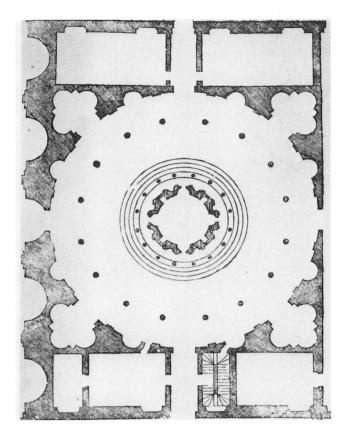

17.10. DONATO BRAMANTE. Plan of Tempietto, S. Pietro in Montorio, Rome (from Sebastiano Serlio, *Il terzo libro d'architettura*, Venice, 1551)

In 1506, with the excuse that it was in danger of imminent collapse, the pope commissioned Bramante to rebuild the Basilica of St. Peter's, archetype of Early Christian church architecture in the West, sanctified by more than eleven hundred years of ritual, and filled with monuments of sculpture and painting. In the mid-Quattrocento Pope Nicholas V had transferred the seat of the papacy from the Lateran Palace to the Vatican, and a new apse had been begun that was intended to replace the Early Christian one; Bernardo Rossellino was the builder, but it may have been designed by Alberti. Julius II decided to sweep aside both the revered basilica and its new apse. To Michelangelo's anger, he even destroyed the monolithic ancient columns that lined the nave, which were pulled down to be shattered on the pavement. This gesture of negation and affirmation launched the greatest architectural vision of the Renaissance on its perilous course. Twelve architects and twenty-two popes later, the building Bramante began was completed but, with its Michelangelesque shell and Baroque extensions, Bramante's design is barely recognizable.

The very grandiosity of the Julius-Bramante project is perhaps a symptom of the weaknesses of the High Renaissance as well as an expression of its ideals and aspirations. The immense structure could not possibly have been completed dur-

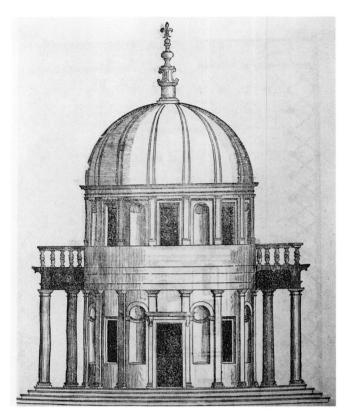

17.11. DONATO BRAMANTE. Elevation of Tempietto, S. Pietro in Montorio, Rome (from Sebastiano Serlio, *Il terzo libro d'architettura*, Venice, 1551)

ing the reign of the aging pope, but it was commenced with surprising speed considering the difficult situations on more than one front that Julius and his papacy were facing. Although there is more of Bramante's design in the interior than is often realized, we can reconstruct his exterior only through drawings by others and through a medal (fig. 17.12) by Caradosso made to celebrate the beginning of construction. The plan and axonometric reconstruction illustrated here (fig. 17.13) shows the Greek-cross plan, with its four equal arms ending in apses. At the corners are four smaller Greek crosses; in the outer angles are four towers. On each side the towers and central entrance are connected by three-bay loggie. An observer entering at a principal portal, while aware of the great dome, would have looked straight through the building; the view from one of the loggia entrances, on the other hand, would have offered a complex succession of spaces, culminating in the central area, and then repeated in reverse.

The church Bramante began to build was intended to have an apse of three bays (fig. 17.14). The tomb of St. Peter was to remain at the crossing, where it is today. The single-story, barrel-vaulted structure, recalling the interior of Santa Maria presso San Satiro, would have been crowned by a colossal dome on pendentives—not the vertical-ribbed dome of the Tempietto, but the dome of the Pantheon, set on a peristyle of

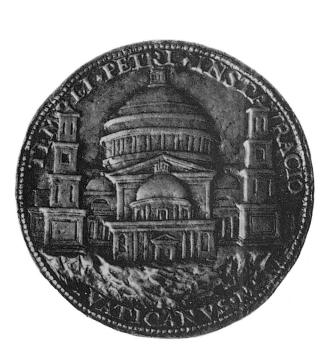

17.12. DONATO BRAMANTE. Design of exterior, St. Peter's, Vatican, Rome, on bronze medal, diameter 2¹/₄" (5.7 cm) by CARADOSSO. 1506. British Museum, London. Commissioned by Pope Julius II. For the front side of this medal, with its portrait of Julius II, see fig. 17.1

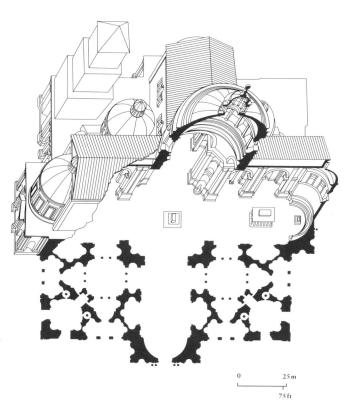

17.13. DONATO BRAMANTE. Plan and axonometric reconstruction of his design for St. Peter's of 1506

17.14. DONATO
BRAMANTE. Drawing
by BALDASSARE PERUZZI
of a Perspective Study, with
Section and Plan, of St. Peter's
(partially embodying
Bramante's second plan).
Pen and ink and pencil.
Gabinetto dei Disegni e Stampe,
Uffizi Gallery, Florence

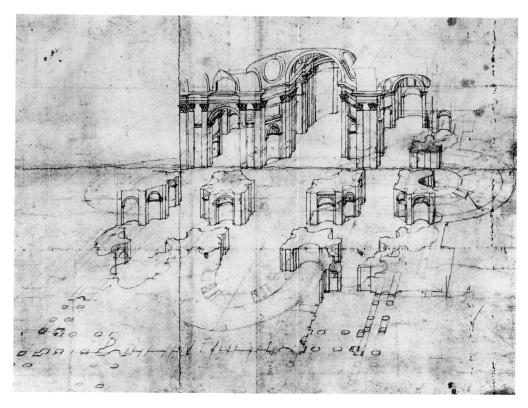

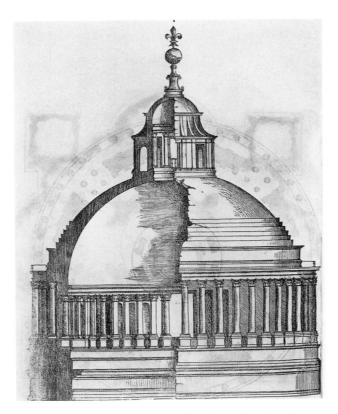

17.15. DONATO BRAMANTE. Elevation and section of dome, St. Peter's, Vatican, Rome (from Sebastiano Serlio, *Il terzo libro d'architettura*, Venice, 1551)

columns on the exterior and a smaller columned gallery on the inside (fig. 17.15). The hemispherical dome, with its horizontal elements, would have created an impression of masses at rest that deliberately contrasted with the soaring corner towers.

The area around the dome was built substantially as Bramante planned it (fig. 17.16). By 1514 the seventy-year-old architect was able to see in place the four arches of the crossing, the Corinthian order (including marble shafts, capitals, and entablatures), and the four pendentives, as well as the foundations of three of the arms of the cross and of some of the chapels. The four arches and piers are built on such a scale that they could not be changed and are visible today, in spite of the later marble and gold ornament that covers them. Despite this impressive beginning, however, much of the nave of Old St. Peter's still stood, and a temporary construction sheltered the saint's tomb. Bramante's dome was not even begun, and from the outside the building belongs to Michelangelo and to the later Baroque period.

Insight into the unity and harmony that Bramante devised for St. Peter's is offered by the pilgrimage church of Santa Maria della Consolazione at Todi, in Umbria. Begun in 1508, the church was long thought to have been based on a model by Bramante himself, although the only architect's

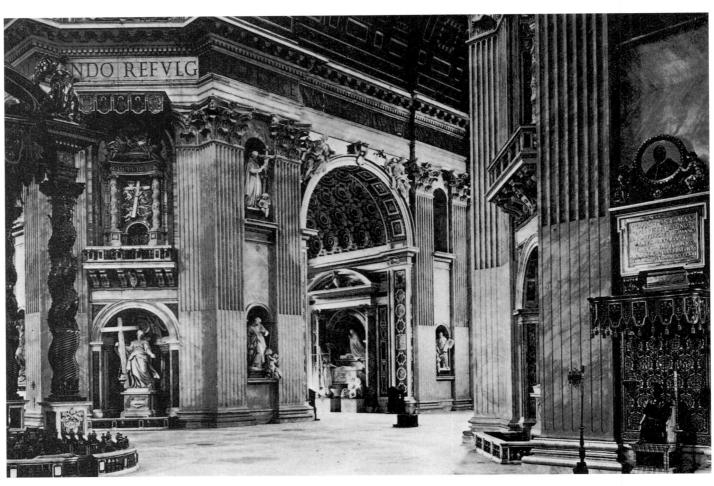

17.16. DONATO BRAMANTE, MICHELANGELO, and others. Interior view at crossing, St. Peter's, Vatican, Rome

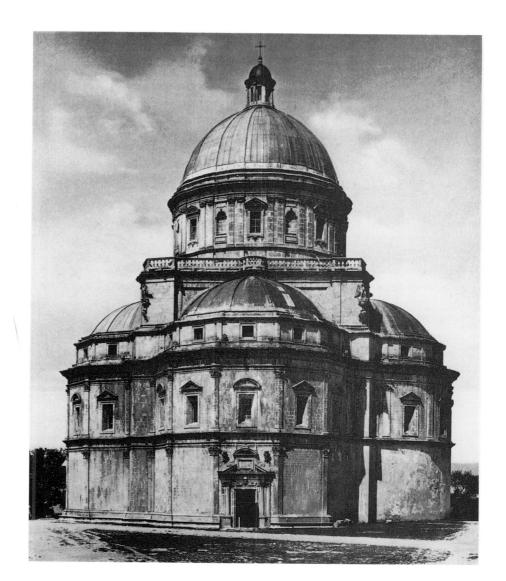

17.17. COLA DA CAPRAROLA and others. Sta. Maria della Consolazione. Begun 1508. Todi

name recorded is that of the otherwise obscure Cola da Caprarola (fig. 17.17). Four apses roofed by semidomes radiate from a central square, although there was apparently some question at first as to whether tradition might not necessitate a nave, as at Santa Maria del Calcinaio at Cortona (see fig. 14.11). The delicacy of the window frames, entablatures, and corner pilasters contrasts with the broad wall surfaces to create an effect of fragility and lightness unique among the centrally planned churches of the Renaissance. The Consolazione was not completed until the following century, and the entrance, balustrade, and dome show Roman taste of a later era.

Another vast project designed in 1505 by Bramante for Julius II, which like St. Peter's was left truncated at the architect's death, was the rebuilding of the papal palace. It was to be united to the earlier country house of the Belvedere, nearly a thousand feet away at the top of a hill, and the whole is now known as the Belvedere Palace. Bramante's plan proposed to join the palace and the country house by long corridors enclosing garden terraces, staircases, and fountains (fig. 17.18).

The enormous enclosed area would have become a huge garden. To articulate the surfaces on the lower level, Bramante used deep niches between pairs of Corinthian pilasters on high bases; each group of pilaster-niche-pilaster was joined to the next by arches set into the masonry of the wall (fig. 17.19). These arches were visually supported on simple pilasters that were joined to the entablature above the niches. making an interlocked scheme of two superimposed levels. On the upper levels the pilasters and their entablature gave articulation to the long side walls of the palace. While the huge barrel vaults of St. Peter's echo Alberti's Sant'Andrea (see fig. 10.8), the screen architecture of the Belvedere reflects Alberti's Palazzo Rucellai (see fig. 10.4) and the Albertian panels by Laurana (see fig. 14.28), as well as the Cancelleria (see fig. 10.10) and other Roman palaces. But the scale of the scheme transcends anything attempted in the Quattrocento. Together the pope and his architect, who read Dante to him in the evenings, created a plan more extensive than any other palace built between the days of Emperor Hadrian and those of Louis XIV. Time itself was against them, and their

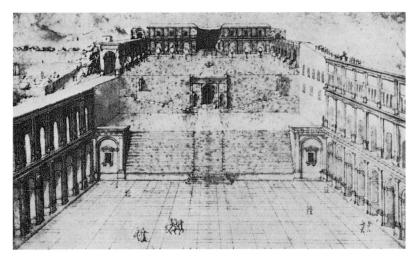

17.18. DONATO BRAMANTE. Belvedere, Vatican, Rome, as seen in an anonymous sixteenth-century drawing. Begun 1505. Collection Edmonde Patio, Geneva. Commissioned by Pope Julius II

Right: 17.19. DONATO BRAMANTE and others. Portion of north façade, Belvedere Court, Vatican, Rome. Begun 1505. Commissioned by Pope Julius II

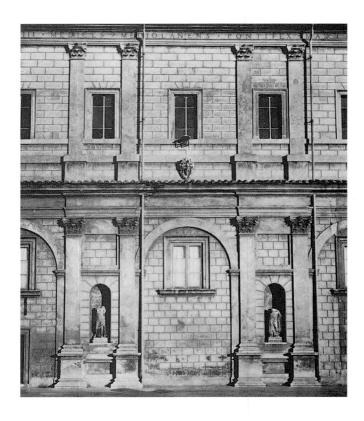

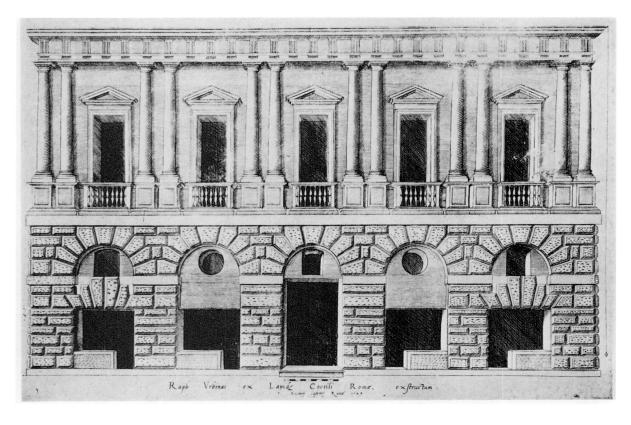

17.20. DONATO BRAMANTE. Façade, Palazzo Caprini, Rome. c. 1510. Engraving by Lafreri, 1519. Commissioned by Adriano Caprini

vision was doomed to incompletion. Later, Bramante's palace suffered insensitive additions and the amputation of the vista by an arm connecting the two sides that seems to have been explicitly designed to ruin the pleasure garden envisioned by Julius and Bramante.

Little remains of the other official buildings designed and in some cases built for the new Rome of Julius II. Although long since destroyed, Bramante's Palazzo Caprini (fig. 17.20)—also known as the House of Raphael because the artist bought it in 1517—cannot be ignored because it

provided a model for patrician town houses that replaced the popular three-story structure with superimposed orders established by Alberti's Palazzo Rucellai (see fig. 10.4). In the Palazzo Caprini, Bramante followed the Roman custom of devoting the ground floor to shops and setting above it a piano nobile destined for the owner. The heavily rusticated ground floor provided a base for engaged pairs of half-round columns, again on tall bases. This design was so successful that it was repeated a number of times in Roman palaces and elsewhere.

Michelangelo 1505 to 1516

In 1505, one year before Pope Julius II commissioned Bramante to rebuild St. Peter's, the pope called Michelangelo from Florence to design for him an enormous tomb decorated with sculptures to be placed in Old St. Peter's. We are not sure of its intended location in the old basilica, but it is possible that Julius intended his tomb to confront that of Peter, the first pope and the man on whose rock the Church was founded. To carry out his commission, Michelangelo abandoned several undertakings in Florence, including the fresco of the Battle of Cascina (see fig. 16.41). Today we have nothing but verbal accounts, written much later, a few drawings, and the carved decorations of the lower story with which to reconstruct the three-story mausoleum originally planned by Julius and Michelangelo. Scholars generally agree on the following: Michelangelo made a number of preliminary designs, and the one selected by the pope called for a freestanding structure with an oval burial chamber for the sarcophagus. The lower story of the exterior was to be decorated by niches containing statues of Victories flanked by herms, to which would be attached bound and struggling male Captives. There were to be at least eight Victories and sixteen Captives; one reconstruction calls for ten Victories and twenty Captives. On the second story statues of Moses, St. Paul, the Active Life, and the Contemplative Life were planned.

The principal dispute arises over the appearance of the top story. Vasari wrote: "The work rose above the cornice in diminishing steps, with a frieze of scenes in bronze, and with other figures and putti and ornaments in turn; and above there were finally two figures, of which one was the Heavens, who smiling held on his shoulder a bier together with Cybele, goddess of the earth, who seemed that she was grieving that she must remain in a world deprived of every virtue by the death of this man; and the Heavens appeared to be smiling that his soul had passed to celestial glory." Despite the fact that no text mentions any statue of the pope, some theories hold that the bier supported his effigy. One claims that the pope was recumbent (which would have made him almost invisible from the floor), another points out that the explicit word used for bier really meant the sella gestatoria, or portable papal throne, and that Julius II would have been

shown carried live into the next world, blessing as he went. Documents tell us that the marble block for a papal effigy was actually delivered. In all probability this was to have been a recumbent figure but destined for the sarcophagus in the burial chamber. A suggested reconstruction of the 1505 design, culminating in a bier that follows Vasari, is offered here (fig. 17.21).

After Michelangelo had spent a year bringing marble blocks from Carrara and had started the carving, the pope interrupted the commission. Although the circumstances were narrated several times by Michelangelo himself, with always richer and more picturesque detail, it is still not clear why the work was stopped. Presumably funds had to be diverted to the rebuilding of St. Peter's by Bramante. In any case the tomb was destined to become a nightmare for Michelangelo during the next forty years. Although never completed according to plan, the tomb was the first instance in which he combined figures and architecture and it served, therefore, as the germ of his major pictorial work, the Sistine Ceiling. Element after element designed for the 1505 version of the tomb came to fruition on the ceiling, and the ceiling in turn was to act as a crucible for new sculptural ideas utilized in later versions of the tomb.

Of the architecture and the more than forty over-life-size statues for the tomb, Michelangelo had completed only the niches with their rich decorations before he left in anger for

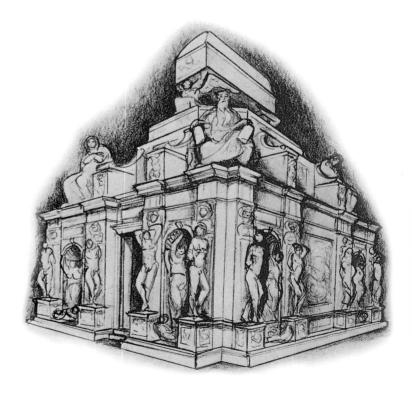

17.21. MICHELANGELO. Tomb of Pope Julius II.
Proposed reconstruction drawing of project of 1505.
Commissioned by Pope Julius II for Old St. Peter's, Rome

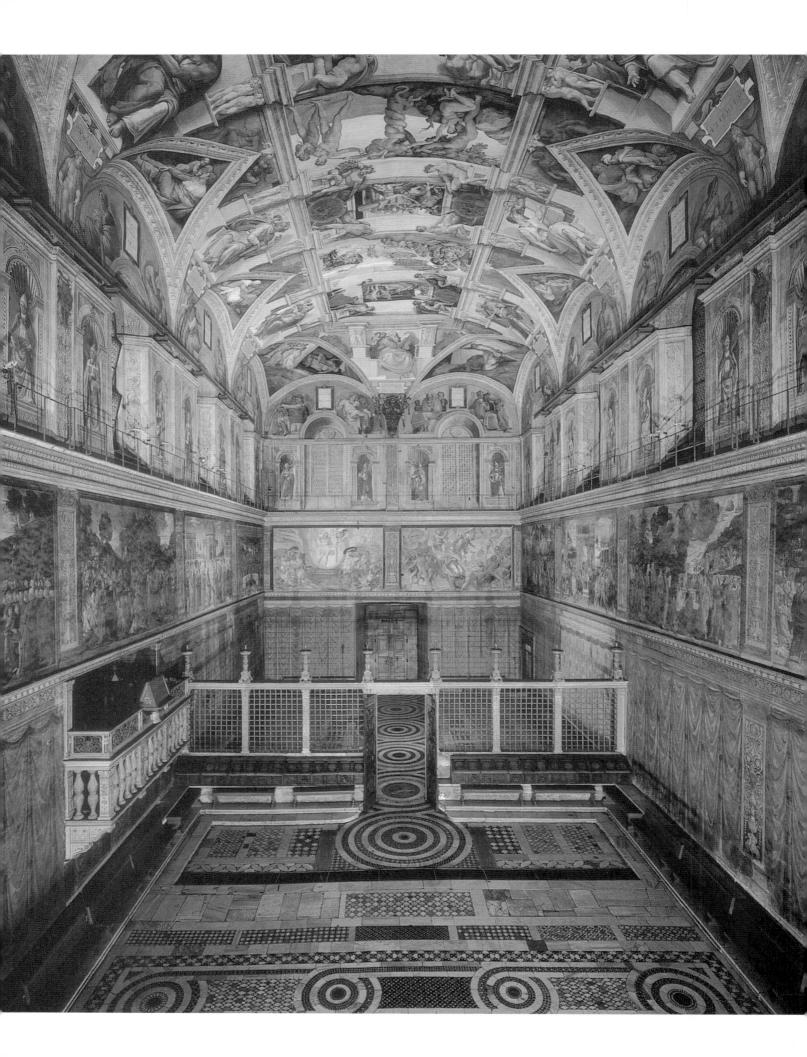

Florence in 1506. There is evidence to show, however, that the poses of the two *Captives* now in the Louvre (see figs. 17.44, 17.45) and the *Moses* (see fig. 17.43) were determined and blocked out at this time.

Although the pope had already envisioned inviting Michelangelo to paint the ceiling of the Sistine Chapel, Julius instead marched to Bologna in 1506, recaptured the city, and from there requested that the outflanked Florentines send Michelangelo to him. The sculptor spent the next eighteen months modeling and casting in bronze a colossal portrait of the pope. The finished work enjoyed an existence of little more than three years before antipapal forces, again in control of Bologna, pushed it from its pedestal on the façade of San Petronio, melted it down, and cast the bronze into a cannon, mockingly called La Giulia (a feminine version of Julius's name), to fire, it was said, at the backside of the fleeing pope. The life of this colossus was so short and its content so despised by the Bolognese that no reliable evidence, not even a sketch or description, has come down to us. We have nothing but our imaginations with which to reconstruct what must have been a vividly dramatic statue. Perhaps some of its grandeur is embodied in the prophets of the Sistine Ceiling.

Scarcely back in Florence in the spring of 1508, Michelangelo was called again to Rome when the idea of painting the Sistine Chapel became a definite commission. The program of Sixtus IV (fig. 17.22; see figs. 13.20, 14.14) stopped with images of popes at the window level, and the vault had been painted blue with gold stars. Here, according to Michelangelo's own later account, the pope wanted him to paint the twelve apostles, one in each of the spandrels between the arches. The central part of the ceiling was to be filled by "ornaments according to custom," apparently a network of geometric and decorative patterns (fig. 17.23). Michelangelo objected that the design would be "a poor thing." "Why?" asked the pope. "Because [the apostles] were poor too," replied Michelangelo. And then, still according to the artist's own version (written much later, at a time when he was threatened with lawsuits over the tomb), the pope told him he could paint anything he liked. There is no reason to doubt that the expansion of the program was due to Michelangelo's dissatisfaction. But despite the aura of romantic independence with which Michelangelo has been enveloped since the nineteenth century, it is hard to accept the idea that so determined a pope would have entrusted a complex theological program at the center of Western Christendom to an artist who, in all probability, could not read Latin. The huge cycle that eventually filled the ceiling is, visually and theologically, the most complex of all Renaissance fresco cycles (figs. 17.24, 17.25).

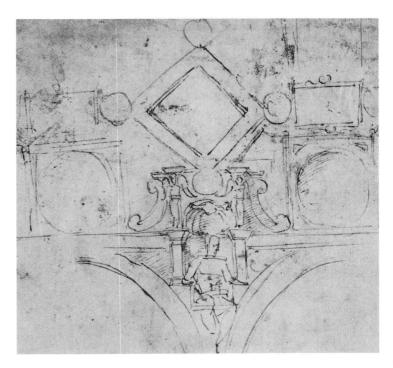

17.23. MICHELANGELO. Study for Sistine Ceiling (portion of sheet). c. 1508. Ink and black chalk, size of detail shown approx. 12×12 " (27.5 x 27.5 cm). British Museum, London

It is believed by many that Michelangelo had a theological adviser, and this person has been identified as Marco Vigerio della Rovere, Julius's fellow Franciscan and first cousin once removed. He was on the pope's first list of cardinals, elevated in 1503. His *Christian Decachord*, published in Rome in 1507 and dedicated to the pope, contains indications that it was Vigerio who advised Julius and Michelangelo in the preparation of the subjects for the program for the Sistine Ceiling.

At this point, the twelve apostles gave way to Old Testament prophets and sibyls from antiquity, seated on gigantic thrones. The thrones are niches framed by pairs of putti painted to resemble marble sculpture. The frames become part of a simulated architectural framework that spans the ceiling, merging with those of the thrones on the opposite side. At left and right above each throne two nude youths hold lengths of cloth that pass through slits in the rims of medallions painted to resemble bronze.

Nine scenes from Genesis, alternating between large and small, fill the center of the ceiling. This central spine of narratives is framed by the continuous cornices above the thrones of the prophets and sibyls. At certain points, the cornice seems to be supported by rams' skulls, an ancient Roman decorative motif; these are flanked by bronze-colored nude figures. In the four corners, triangular

Opposite: 17.22. MICHELANGELO and others. Sistine Chapel, Vatican, Rome. General view showing frescoes on the ceiling and side walls (see also fig. 17.25). The ceiling measures 45 x 128' (13.75 x 39 m)

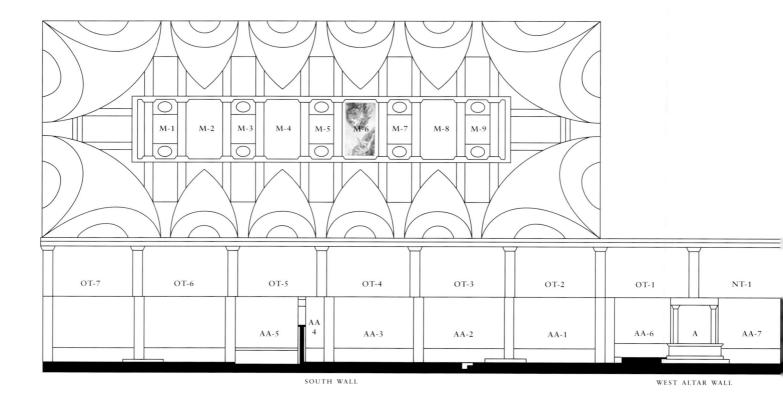

17.24. Iconographic diagram of the Sistine Chapel. Diagram by Sarah Loyd.

NOTE: All frescoes on altar wall destroyed by Michelangelo when he painted his Last Judgment, 1534-41 (see figs. 20.1-20.4)

FRESCOED ALTARPIECE

A. Assumption of the Virgin, by PIETRO PERUGINO, 1481–82 (destroyed)

FRESCOES OF THE UPPER WALLS,

OLD TESTAMENT LIFE OF MOSES, 1481-82:

OT-1. Finding of Moses, by PERUGINO (destroyed)

OT-2. Moses' Journey into Egypt, by SANDRO BOTTICELLI

OT-3. Moses in Egypt, by BOTTICELLI

OT-4. Crossing of the Red Sea, by COSIMO ROSSELLI

OT-5. Adoration of the Golden Calf, by ROSSELLI

OT-6. Punishment of Korah, Dathan, and Abiram, by BOTTICELLI (see fig. 13.20)

OT-7. Last Days of Moses, by LUCA SIGNORELLI

OT-8. Contest over the Body of Moses, by SIGNORELLI (on east wall, not on diagram, destroyed)

FRESCOES OF THE UPPER WALLS,

NEW TESTAMENT LIFE OF CHRIST, 1481-82:

NT-1. Nativity of Christ, by PERUGINO (destroyed)

NT-2. Baptism of Christ, by PERUGINO

NT-3. Christ Heals the Leper, by BOTTICELLI

NT-4. Calling of the Apostles, by DOMENICO GHIRLANDAIO

NT-5. Sermon on the Mount, by ROSSELLI

NT-6. Christ Giving the Keys to St. Peter, by PERUGINO (see figs. 14.14, 14.15)

NT-7. Last Supper, by ROSSELLI

NT-8. Resurrection of Christ, by GHIRLANDAIO (on east wall, not on diagram, destroyed)

spandrels contain more Old Testament scenes (also visible in fig. 17.25). Above the windows are lunettes and triangular areas that contain figures representing the generations of the ancestry of Christ. Michelangelo had to destroy two of these lunettes, as well as Perugino's frescoed altarpiece and two scenes from the earlier cycle on the walls, when he painted his *Last Judgment* on the altar wall (see fig. 20.1).

To read the various elements correctly the viewer must turn to face each of the four walls, and in order to read the narrative scenes right side up, one must start at the entrance and move toward the altar. This means that the narrative sequence must be read backward in time, starting with the story of Noah, which is immediately overhead when one enters the chapel, and culminating over the altar

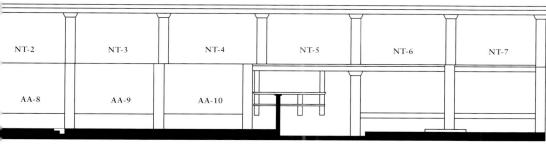

NORTH WALL

MAIN SCENES ON THE CEILING,

BY MICHELANGELO, 1508-12

M-1. Drunkenness of Noah, 1509

M-2. Deluge, 1509 (see figs. 17.28, 17.29)

M-3. Sacrifice of Noah, 1509

M-4. Fall of Adam and Eve and Expulsion, 1510 (see fig. 17.26)

M-5. Creation of Eve, 1510. (see fig. 17.34)

M-6. Creation of Adam, 1511-12 (see figs. 17.35, 17.36)

M-7. God Moving on the Face of the Waters, 1511-12

M-8. Creation of Sun, Moon, and Plants, 1511-12 (see fig. 17.37)

M-9. Separation of Light from Darkness, 1511-12 (see fig. 17.38)

TAPESTRIES DESIGNED BY RAPHAEL

(CONJECTURAL PLACEMENT), 1515-16

AA-1. Conversion of St. Paul

AA-2. Blinding of Elymas

AA-3. Sacrifice at Lystra

AA-4. St. Paul in Prison

AA-5. St. Paul Preaching at Athens (for cartoon, see fig. 17.60)

AA-6. Stoning of St. Stephen

AA-7. Miraculous Draught of Fishes

AA-8. Christ's Charge to Peter

AA-9. Healing of the Lame Man

(for cartoon, see figs. 17.58, 17.59)

AA-10. Death of Ananias

with what is the beginning of the creation story, God dividing light from darkness. This unusual approach, which inverts the narrative in time, is an important clue to understanding the chapel's iconography.

The meaning of the ceiling as a whole has been the subject of much controversy. Before we turn to this issue, it is important to point out that Julius II and Michelangelo were confronted with a chapel that was, in a sense, fully decorated. On the side walls there were parallel lives of Moses and Christ, above which were representations of historic popes in Renaissance-style niches. These three cycles encompassed the Old and New Testaments and papal history; even the apostles, the first suggestion for the ceiling's iconography, were emphasized in the scenes from the life of Christ.

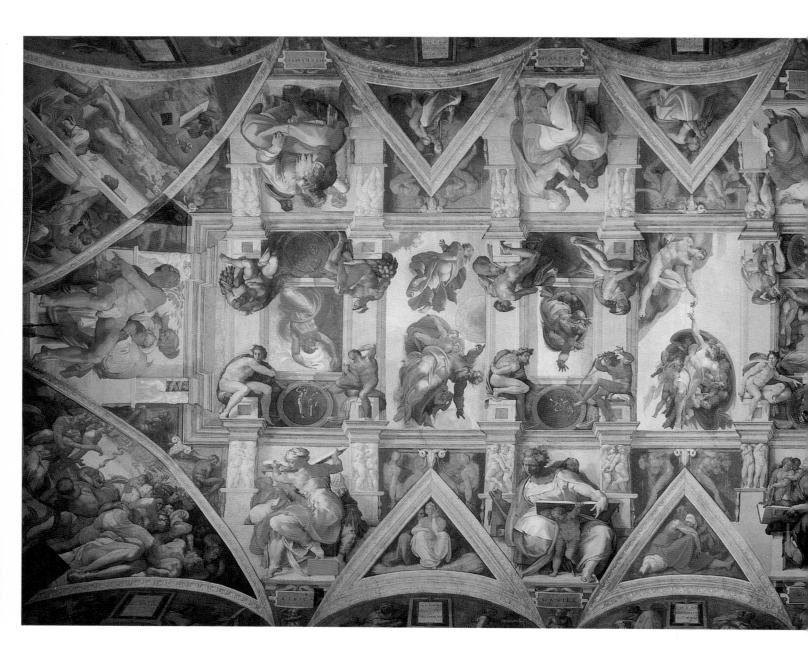

The ceiling was the obvious place for further figural or narrative decoration. The notion of placing enthroned figures on the ceiling is related to earlier chapel decoration; note, for example, the four sibyls in the Gothic cross vault of Ghirlandaio's Sassetti Chapel (see fig. 13.38). The substitution of prophets and sibyls for the apostles probably related to the decision to devote the central area to scenes taken from the Creation and Flood episodes described in the first book of the Bible.

Michelangelo's unwillingness to paint the twelve apostles, the subject proposed by the pope, suggests that he may have been allowed to play an important role in the evolution of the chapel's iconography. From what we can determine from Michelangelo's art, poetry, and life, he was a deeply thoughtful man of serious convictions. In addition, we have the

agenda of Pope Julius II and the involvement of his theological advisors, including Marco Vigerio della Rovere, and others in the papal retinue. How the decision was made to dedicate the spine of the chapel to scenes of the Creation and Flood will remain a mystery unless further documentation is discovered, and even that would not recover the discussions and debate that led to the result that we see today. Whatever the process, it should be clear that the Creation and Flood scenes were not chosen simply because they were important scenes not previously included in the chapel. Underlining this is the observation that the cycle starts with the sin of Noah and develops backward in time.

The interpretation of Michelangelo's poetry is as debated as the meaning of the ceiling, but it is clear that the themes

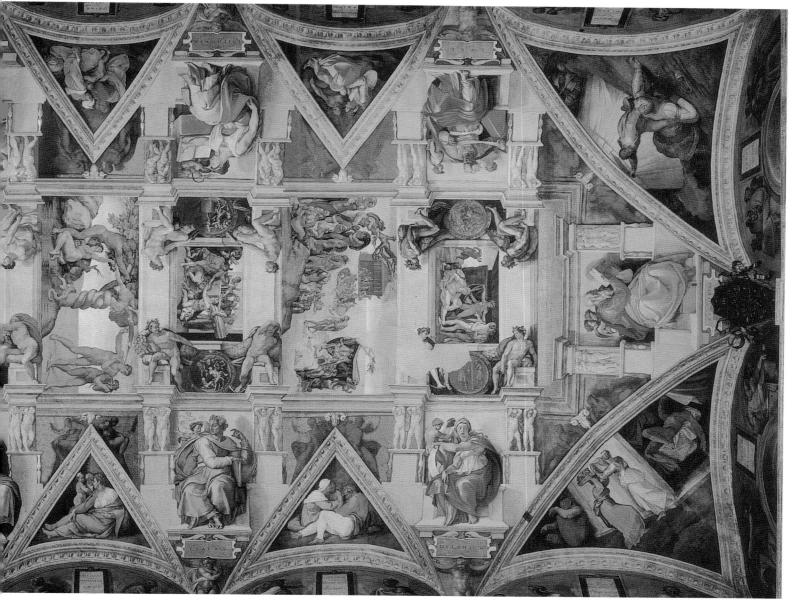

17.25. MICHELANGELO. View of the Sistine Ceiling frescoes, Vatican, Rome. 1508–12. 45 x 128' (13.75 x 39 m). Commissioned by Pope Julius II

that he explored there included God's creation of humanity, notions of beauty, and how human sin interferes with the individual's personal relationship to God. In this light, perhaps it is enough to say that the ceiling comments on all three of these issues. God's creation is the main subject of the ceiling, and the beauty of his creation is evident in the idealized nude figures that populate the scenes and decorate the enframement. In terms of human sinfulness, the cycle starts with the drunkenness of Noah, the sin of the one man God felt was worth saving from his wrathful flood. As we read backward through time and approach the sin of altar where the Mass is performed, we pass through the sin of Adam and Eve (fig. 17.26) and end with the titanic power of God as he energetically and enthusiastically creates humanity and the earth as

a setting for human life. The cycle culminates with a scene that marks the beginning of the biblical Creation, God making light in darkness. The metaphor of enlightenment is basic to this scene, which is located over the altar where, in Christian tradition, the ritual of the Mass reunites repentant humanity with God.

The prophets and sibyls are not here because they prophesied the events shown on the spine of the ceiling, for these took place before they lived. According to a basic principle of Christian theology, prophets and sibyls were able to foresee in these Old Testament events the revelation of the New Testament, the coming of Christ. For this reason the ancestors of Christ on the upper parts of the wall and the lower areas of the ceiling represent the physical origins of what

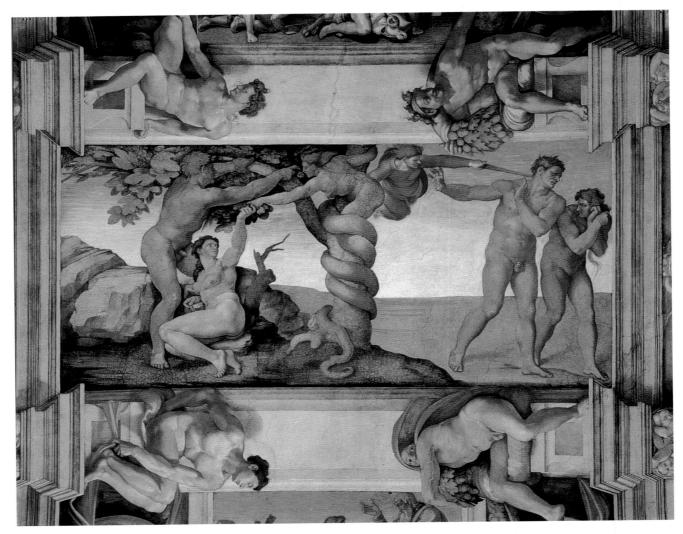

17.26. MICHELANGELO. Fall of Adam and Eve and Expulsion. 1510. Fresco, 9'2" x 18'8" (2.8 x 5.7 m). Sistine Ceiling

the prophets and sibyls understand will be humanity's spiritual destiny.

Another level of symbolism is provided by the garlands of oak leaves and acorns held by a number of the nudes. Rovere, the family name of Sixtus IV and Julius II, means oak; the oak tree of the family arms is found elsewhere in the Ouattrocento decorations.

The symbolic structure of the ceiling can in part be interpreted in terms of the prophetic allusions that the pope perceived in the tree that decorated his own coat of arms, for he considered himself divinely chosen to renew the Church. We have no way of knowing how readily Michelangelo accepted such a complex structure of interlocking allusions, but he expressed it visually in the interlocked design of the ceiling. In each scene and figure he expressed a formal grandeur so compelling that the nine scenes of the Genesis narrative have become the quintessential representations of this theme.

In 1508 Michelangelo set to work quickly, producing the hundreds of preliminary drawings that had to be made be-

fore large cartoons could be started. A few of the drawings survive, suggesting the labor that went into every detail, but the cartoons have perished. They were laid up against the moist intonaco, and their outlines incised into the surface with a stylus. The stylus marks in the plaster, which can even be seen in some photographs (see fig. 17.36), document Michelangelo's working method. Michelangelo designed a new kind of scaffolding that could bring him to the proper level without support from either the ceiling or the floor. It was based on beams that projected from holes in the walls; when the ceiling was restored in the late twentieth century, these holes were unblocked to become a base for rails for a mobile steel scaffolding. Michelangelo's scaffolding was arched like the vault and, except for infrequent removal so that the work could be seen from the floor, it was in place for the entire four and a half years of his undertaking. It permitted the artist to walk about as he wished and to paint from a standing position—not lying down, as is still popularly believed. In a drawing he shows himself painting the ceiling 17.27. MICHELANGELO. Sonnet with a caricature of the artist standing, painting a figure on the ceiling over his head. c. 1510. 11 x 17" (28 x 43 cm).

Casa Buonarroti, Florence

The text on the drawing reads:

I've got myself a goiter from this strain....

My beard toward Heaven, I feel the back of my brain
Upon my neck, I grow the breast of a Harpy;

My brush, above my face continually,

Makes it a splendid floor by dripping down....

Pointless the unseeing steps I go.

In front of me, my skin is being stretched

While it folds up behind and forms a knot,

And I am bending like a Syrian bow.

Jo gra Jacto rigozo renesso stato
chome Ja lacuna agacti Thombardia
oner da levo paese sh essi insisia
cha Jorza Inetre apicha socto mesto
Laborba alcielo ellamemoria semo
Tsullo serionio especto Jo darpra
espemel sopraluiso tuctama
mel Ja gocciando u richo panimeto
E lobi emerati miso mella peccia
e Jo del cul perocrapeso groppa
e passi seza glio ini muono riano
b i nazi misalinga lachorececia
e po pregarsi adietro suragroppa
e tedomi comarciso soviano
po Jallacci e strano
surgie ilinducio In lametre porta
ch mal si pra perocrama torta
lamia pertura merta
di Jedi orma gionami esmio onore
rio sedo Tloso bo meio pretore

standing up, and in the accompanying sonnet he described the physical discomfort he experienced while painting continuously from a standing position (fig. 17.27). By September 1508 Michelangelo was already painting, and by January 1509 he was already in difficulties. Apparently he did not know enough about the recipe for *intonaco*, despite advice from his friend Giuliano da Sangallo, then also at the papal court, and the *Deluge* became moldy and had to be scraped off and redone.

The course of his work paralleled dramatic events in the pontificate of Julius II. When Michelangelo ran out of money, which happened twice, he had to go to Bologna and beg from the pope, who was in a crucial phase of his war with France. At the time of Michelangelo's second trip, in December 1510, the pope had already grown the beard that gives him such a prophetic appearance in his late portraits. Perhaps Michelangelo was moved by the spectacle of the old man's heroism and his vision of a unified Italy. Whatever the source of inspiration, he seems to have become more deeply involved as the work proceeded. The first section of the ceiling to be undertaken—the Noah scenes and flanking prophets, sibyls, and spandrels—is populated by small-scale, neatly drawn figures and is relatively timid in handling. The

Deluge (fig. 17.28), first of the larger scenes, probably gives some suggestion of the *Battle of Cascina* (see fig. 16.41) in its carefully drawn figures composed into what seem to be sculptural groups.

Only two rocks remain above the rising waters, and groups of men, women, and children struggle to save themselves while the ark is shown receding into the distance. One of the most moving details is the father who holds in his arms the body of his drowned son (fig. 17.29). Michelangelo's precision extends even to the representation of benches and pots in the midst of this cosmic disaster.

One of the earlier prophets is *Isaiah* (figs. 17.30, 17.31), who is relatively youthful though he is prematurely grayhaired and his face is ravaged by disturbing thoughts. Deep in meditation, he closes his book and turns in a majestic movement. He is about to drop his left hand—on which his head had apparently been propped—as he listens to one of his accompanying putti (each of the prophets and sibyls has two attendant putti who exhort or inspire them). That he turns away from the *Deluge*, which is above and to his left, can be related to God's promise to him: "For as I have sworn that the waters of Noah should no more go over the earth; so have I sworn that I would not be angry with thee."

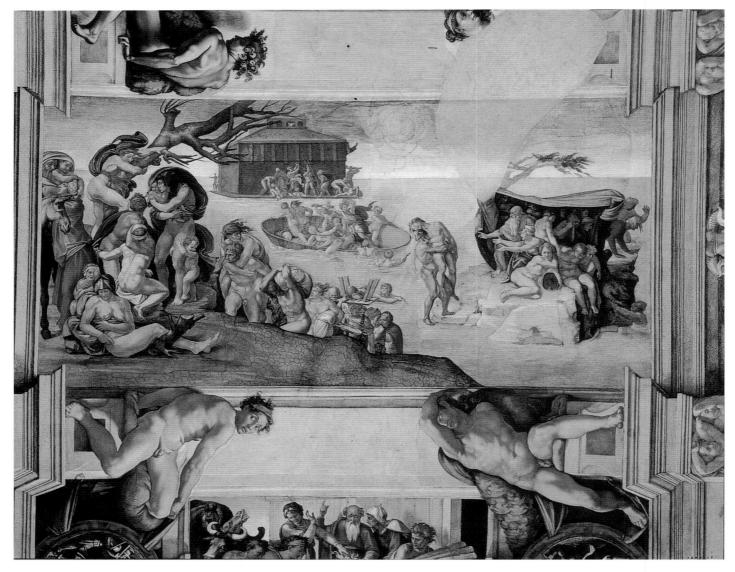

17.28. MICHELANGELO. Deluge. 1509. Fresco, 9'2" x 18'8" (2.8 x 5.7 m). Sistine Ceiling

Below: 17.29. Detail of fig. 17.28

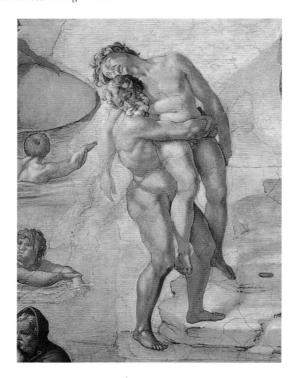

After the first section of the ceiling was completed in September 1510, the planks of the scaffolding were removed, and Michelangelo had his first chance to see how his figures looked from the floor. Even within the first section (the right third of fig. 17.25), we can see that his style was changing as he worked and that the figures were growing in size and breadth. His response to the 1510 viewing was immediate, and the figures in the second section are dramatically increased in scale.

The Temptation and Expulsion had always been depicted separately (see figs. 8.14, 8.15), but Michelangelo unites them (see fig. 17.26) with a huge tree that echoes the shape of the Della Rovere tree on the marble barrier below. In Michelangelo's overarching composition, the crime leads to its punishment, and the tempting Satan and avenging angel almost function as branches. Vigerio described the Temptation as an antitype or opposite of the Last Supper, and the

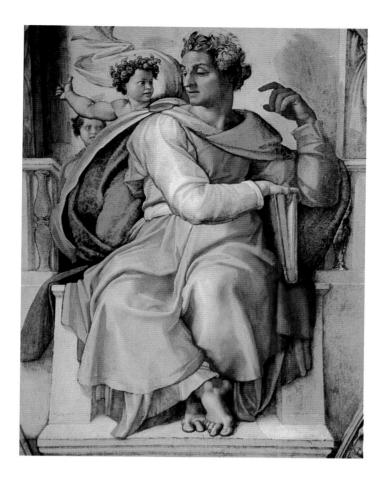

17.30. MICHELANGELO. *Prophet Isaiah*. 1509–10. Fresco. Sistine Ceiling

Below: 17.31. Head of Prophet Isaiah, detail of 17.30

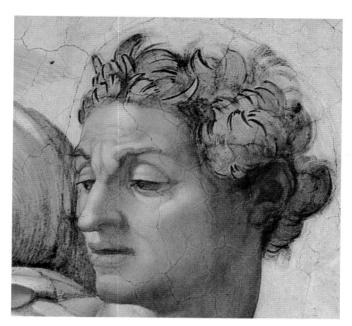

fruit of the Tree of Knowledge as an opposite to the Eucharist, fruit of the Tree of Life. He explained how Adam "turned his eyes from the morning light which is God, and gave himself over to the fickle and dark desires of woman," which is what seems to be happening in the fresco.

For the first time in the ceiling frescoes, Michelangelo's figures fill the foreground space and are scaled to harmonize with the surrounding nudes. The expressive depth has also increased; in no earlier figure do we find a face that approaches the anguished intensity of the expelled Adam. The right half of the scene is a commentary on the *Expulsions* of Masaccio and Jacopo della Quercia (see figs. 8.15, 7.30), whose scenes are here endowed with High Renaissance grandeur.

The Cumaean Sibyl (figs. 17.32, 17.33), immensely old and yet also incredibly muscular, turns her wrinkled face toward the altar. She reads a book while her attendants hold another. In her youth when she was beautiful, she was loved by Apollo, who promised to grant her as many years as the grains of sand she held in her hand; when she refused him, he doomed her to look her age. She has a special meaning for Rome because her Sibylline Books were believed to be preserved on the Capitoline Hill; she was therefore interpreted to symbolize the age and strength of the Roman Church. Her attendants look gently down on the aged face and the herculean left arm, which foretells in its superhuman might the arm of the Moses (see fig. 17.43).

Michelangelo placed the *Cumaean Sibyl* next to the scene of the creation of Eve from Adam's side (fig. 17.34), which Vigerio, following long tradition, compared to the creation of the Church from the side of Christ. God, who appears here for the first time in the Sistine Ceiling, stands on the ground, his mantle wrapped about him. The massive volumes of Michelangelo's figures here recall Masaccio in their bulk and even in their freely painted surfaces. It appears that the two scenes with Adam and Eve and their attendant prophet and sibyl date between the autumn of 1510 and the return of the pope to Rome the following summer, his armies routed, and the city awaiting the French attack that never materialized. On August 14, 1511, the eve of the Assumption of the Virgin, the pope attended the first Mass in the chapel after the planking had been removed for the second time.

In the final section of the ceiling, concomitant with the revival of papal hopes and the triumph of Julius's armies, both form and spirit are transformed. The first thing we notice is another increase in the scale of the figures. The prophets and sibyls, who have empty space around them in the first section of the ceiling and fill their thrones in the second, now overflow them. The footstools sink and the surrounding ornament gives way before these figures, who are nearly half again larger than their predecessors. In the narrative scenes, fewer, more colossal figures move within frames now too small to hold them. God himself, who was absent from the first four scenes and

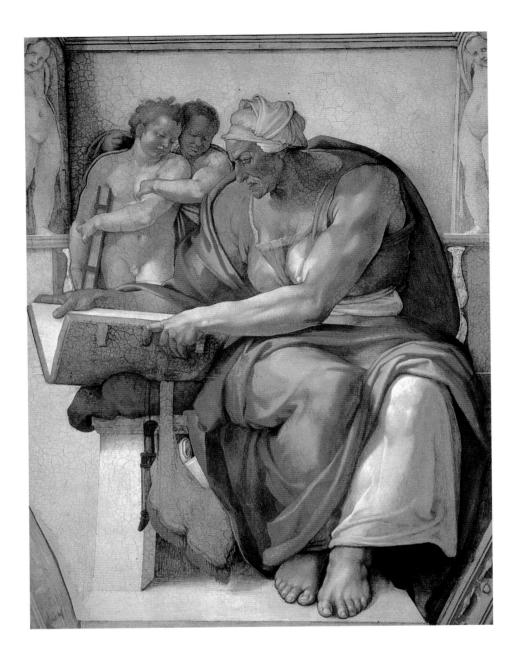

17.32. MICHELANGELO. Cumaean Sibyl. 1510. Fresco. Sistine Ceiling

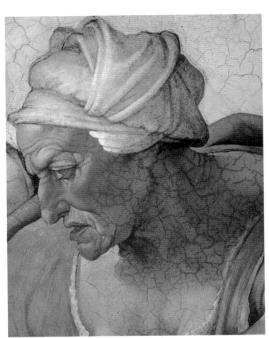

17.33. Detail of fig. 17.32

Opposite: 17.34. MICHELANGELO.

Creation of Eve. 1510. Fresco, 5'7" x 8'6¹/₂"

(1.7 x 2.6 m). Sistine Ceiling

who stood on the earth in the Creation of Eve, moves dramatically through the heavens in the last four scenes.

Of all the images that crowd the ceiling, the *Creation of Adam* (fig. 17.35) has most deeply impressed posterity. Here we are given a vision of the majesty of God and the nobility of humanity. Borne aloft, his mantle bursting with wingless angels, God moves before us, his calm gaze accompanying and reinforcing the movement of his arm (fig. 17.36). He extends his forefinger, about to touch that of Adam, whose name means earth and who reclines on the barren ground, his arm supported on his knee. The divine form is convex and explosive; the human is concave, receptive, and conspicuously impotent. All the pomp seen in traditional representation of the Almighty has vanished, and he is garbed in a short tunic that reveals the strength of his body. Even Michelangelo's precise depiction of veins, wrinkles, and gray hair cannot reduce the power radiated by this celestial apparition.

Love and longing seem to stream from the face of Adam toward the Omnipotent, who is about to give him life, strength, and responsibility. The beauty of God's creation is evident in the nobility of his proportions and in the pulsation of the forms and the flow of their contours. A century of Early Renaissance research into the nature of human anatomy seems in retrospect to lead to this single moment, in which all the pride of pagan antiquity in the glory of the body and all the yearning of Christianity for the spirit have reached a mysterious and perfect harmony.

The contact about to take place between the two index fingers has been described as a current, an electrical metaphor foreign to the sixteenth century but natural enough considering the river of celestial life surrounding God that seems ready to flow into the waiting body of Adam. At the same time, Michelangelo's new image symbolizes the instillation of divine power in humanity, which took place at the Incarnation.

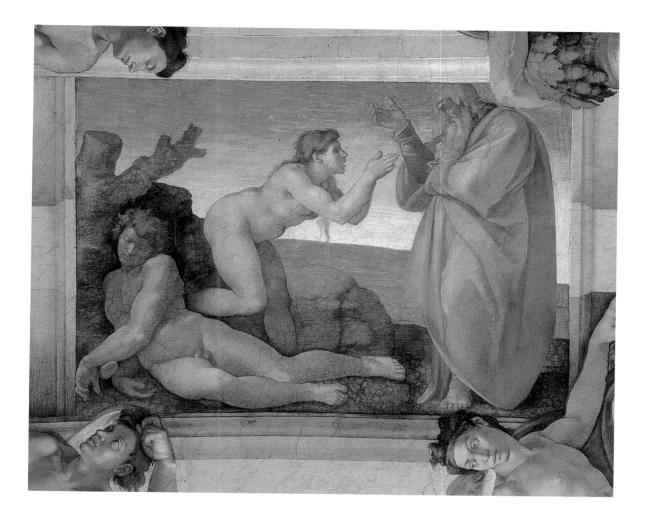

The mighty right arm of the Lord is revealed, naked as in no earlier representation. And directly below Adam, the arm of the veiled youth above the Persian Sibyl projects into the scene. This hand holds a cornucopia bursting with Della Rovere leaves and acorns. But the final explanation of the content of the *Creation of Adam* may lie in the third and fourth stanzas of the hymn *Veni Creator Spiritus* (Come, Holy Spirit); this is the hymn that was sung before each afternoon vote when the Sistine Chapel became the setting for a conclave to elect a new pope. A literal translation discloses the relation of text to image:

Thou, sevenfold in thy gifts,
Finger of the paternal right hand,
Thou, duly promised of the Father
Enriching our throats with the word,
Let thy light inflame our senses,
Pour thy love into our hearts,
Strengthen us infirm of body
Forever with thy manly vigor.

Divine guidance, then, explains not only the outpouring of love into the heart of Adam but the impotence of his body until the Lord fills it with "manly vigor." It could even be ar-

gued that the Della Rovere acorns (*glandes*) are related visually to the genitals of the nudes. In High Renaissance Rome such explicit symbolism was considered neither indecent nor irreverent, in contrast to the Florence of Soderini, which required a girdle to cover the genitals of the *David*.

The life studies that survive for this scene show that the power and idealism of Michelangelo's figures were derived from his own imagination. Muscles that in the live model were awkward are transfigured in the fresco by the force that flows through them, as well as by the rhythm of the lines, which relates profiles on opposite sides of a single limb to each other like intertwined themes in a polyphonic composition.

The final large scene depicts the *Creation of Sun, Moon, and Plants* (fig. 17.37). In a simple gesture, the Lord, sweeping through the heavens attended by angels, forces the sun out from one hand and, apparently simultaneously, the moon from the other. According to the account in Genesis, this event occurred on the fourth day. At the left Michelangelo shows the Lord from the back, stretching forth his hand on the third day to draw plant life from the earth. In one interpretation of the ceiling, a scholar has called attention to St. Augustine's quotation of the words of the Lord to Moses: "While my glory passeth by, . . . thou shalt see my back parts: but my face shall not be seen" (Exodus 33:22–23).

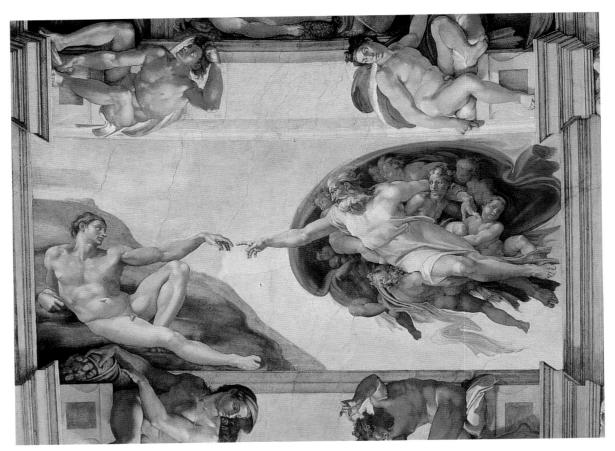

17.35. MICHELANGELO. Creation of Adam. 1511-12. Fresco, 9'2" x 18'8" (2.8 x 5.7 m). Sistine Ceiling

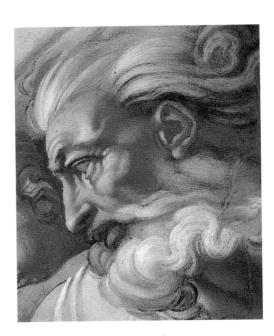

17.36. Head of God, detail of fig. 17.35

After the relative restraint of the preceding scenes, the violent movement of the Creation of Sun, Moon, and Plants comes as a shock. On the right the Lord hurtles toward us, then turns as swiftly to move away again. His fierce expression and the powerful masses in movement combine to raise the image to a new plane of grandeur. The sun and moon are whirling out of the space of the picture. All the forms are foreshortened in depth; Vasari expressed his wonder at how the Lord's right arm could be inscribed within a square and still seem completely projected in depth. And the figures are so huge that, if brought to the foreground plane, they could not be contained within the frame. A new pictorial freedom accompanies this new expressive depth. Broad sweeps of the brush indicate torrents of beard and hair, from which a few wisps escape and seem to dissolve into air. Line is still operative, as always in Michelangelo, but it is less important as a means for creating volume.

The last scene, but the first in Genesis, is the Separation of Light from Darkness (fig. 17.38) directly over the altar. Now even the point of view changes. For the only instance in the ceiling, one of the events is presented as if viewed from below. With his arms raised like those of the priest at the moment of the consecration of the Host, the Lord shows that his plan for human salvation was preexistent from the moment when he first separated light from darkness. This idea is illuminated in Vigerio's Christian Decachord by a

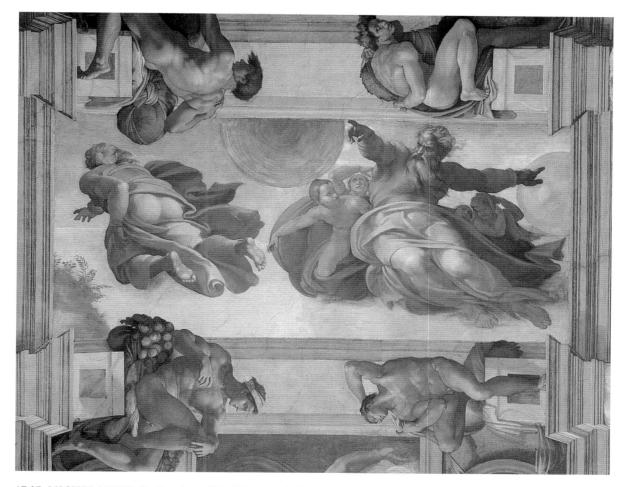

17.37. MICHELANGELO. Creation of Sun, Moon, and Plants. 1511–12. Fresco, $9'2" \times 18'8"$ (2.8 x 5.7 m). Sistine Ceiling

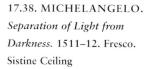

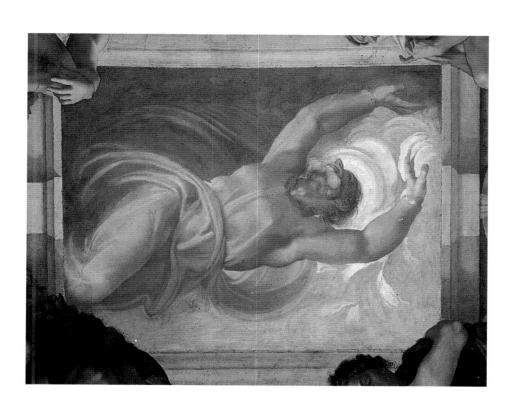

dialogue across the ages between Moses and St. John the Evangelist:

MOSES: In the beginning God created the heavens and the earth.

JOHN: In the beginning was the Word.

MOSES: The earth was without form and void.

JOHN: The Word was with God and the Word was God.

MOSES: Darkness was on the face of the abyss.

JOHN: In Him was life and the life was the light of men,

and the light shineth in darkness.

MOSES: The Spirit of God floated over the waters.

JOHN: And the Word was made flesh.

The words of Vigerio's dialogue unite the opposing scenes of Moses and Christ on the walls by juxtaposing the Old Testament words here put into the mouth of Moses with New Testament text drawn from John's Gospel. The message of the pictorial cycle of the chapel, ceiling, and walls culminates above the altar, where the sacrifice of the Eucharist, fruit of the Tree of Life, takes place.

The *Libyan Sibyl* (fig. 17.39) turns to close her book and replace it on its desk while she looks downward at the altar, as if about to step from her throne. One of her attendant putti points to her as both putti depart. The red chalk drawing for this figure (fig. 17.40) shows that, like the other female figures on the ceiling, the *Libyan Sibyl* was done from a male model. In the painting, Michelangelo has softened the male bone and muscle with a smooth veil of overlying tissue. At the lower left-hand corner of the study, he repeated the face, apparently in an effort to transform the features of his male model into the Hellenic beauty of a sibyl. In addition he has repeatedly analyzed the structure of the foot and hand, which in the fresco bear enormous weight.

The twenty nude youths seem to glory in their beauty and power. At first sight they may appear out of place in a Christian chapel, especially since most of their poses are drawn from antique prototypes. There is, however, a long tradition of nudity in Christian art: all souls are naked before God and are so depicted in the Last Judgment (see figs. 16.54, 16.55). The youths are descendants of those who appeared a few years earlier in the background of Michelangelo's *Doni Madonna* (see fig. 16.37). They uphold not only the medallions, most of which depict biblical scenes from the Book of Kings, but also garlands of Della Rovere leaves. Whether or not the nudes can ever be fully "explained," surely on one level they represented in Michelangelo's mind a vision of a new and transfigured humanity.

The twenty nudes offer a variety of types, movements, and poses, as well as expressions that suggest that they are responding to the scenes they flank. While the earliest pairs are virtually symmetrical in pose, the later pairs demonstrate dramatic contrasts in their positions. The beauty of their pro-

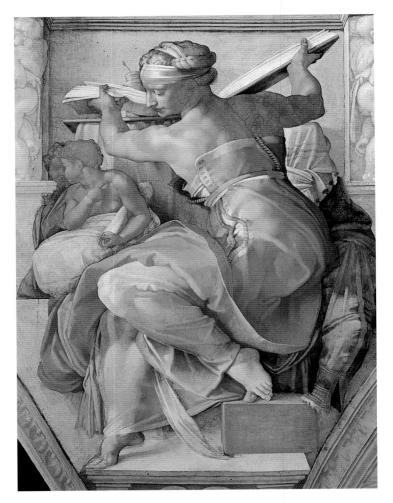

17.39. MICHELANGELO. *Libyan Sibyl*. 1511–12. Fresco. Sistine Ceiling

portions, the flowing lines of their contours, and the light shining on their youthful skin reflect in smaller scale the qualities of Adam in the *Creation of Adam*. One of the most beautiful is the youth above Jeremiah (visible at the lower left in fig. 17.37). While his pose is balanced in elegant equilibrium, his eyes gaze calmly into the abyss where God divides light from darkness.

The four spandrels at the corners of the chapel were painted with the adjacent sections of the ceiling and there is, therefore, a strong discrepancy in style between the first two, which are fairly timid in composition, and the powerful masses and drastic foreshortenings of the second two, which date from the final campaign. All four represent scenes from the Old Testament that prefigure the coming of Christ. Through Christ's words, the scene of the *Brazen Serpent* from the campaign of 1511–12 (fig. 17.41) was thought to foreshadow the Crucifixion: "Even as Moses lifted up the brazen serpent in the wilderness, so shall the Son of man be lifted up." At the left a young Moses lifts a woman's hand to the miracle-working image. On the right those who have yet to behold the serpent that will heal them writhe in a tangle of arms, legs, and pain-

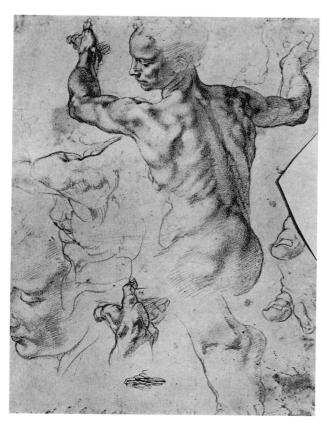

17.40. MICHELANGELO. Study for Libyan Sibyl. 1511. Red chalk, $11^3/8 \times 8^7/16$ " (28.9 x 21.4 cm). The Metropolitan Museum of Art, New York

racked bodies seen in dramatic foreshortening. Never had figures been so treated, not even at the most extreme moment of the ancient Hellenistic style. The Mannerist painters and the Venetian Tintoretto (see figs. 19.42, 20.36, 20.42) were greatly influenced by this composition.

Restoration has freed Michelangelo's surfaces from layers of lamp, candle, and incense smoke, a coating of animal glue, and even an application of Greek wine in the eighteenth century to brighten the colors; after this layer had darkened with time, another campaign resorted to extensive repainting. The results of the cleaning have banished forever the old conception of a grayed-down, marbly Michelangelo. The colors are as brilliant as those of the Doni Madonna (see fig. 16.37). The flesh is more delicately modeled than had been imagined previously, and the drapery vibrates with electric contrasts of hue and with effects of iridescence of startling vivacity. Isaiah, for example (see fig. 17.30), wears a tunic of a clear rose color, a blue cloak with a green lining, and an underskirt and sleeves of changing tones of gray, yellow, and lavender. These revelations help explain the coloring of the painters of the following decade.

After the death of Julius in February 1513, Michelangelo returned to the project of the tomb. Many of the stones quarried for this project, languishing in Piazza San Pietro, had "gone bad," as Michelangelo described it, and some had

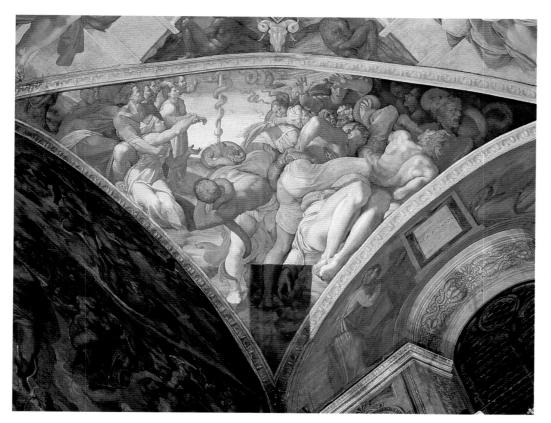

17.41. MICHELANGELO. Brazen Serpent. 1511–12. Fresco. Spandrel of Sistine Ceiling. This photograph shows the spandrel during the course of cleaning; the black square near the bottom had yet to be restored when this photograph was taken.

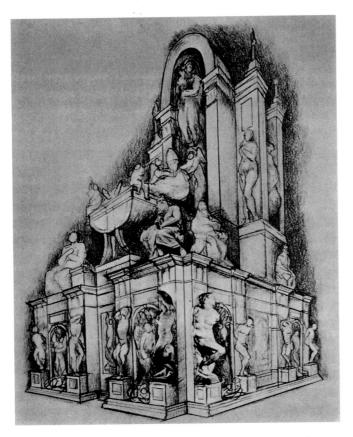

17.42. MICHELANGELO. Tomb of Pope Julius II. Proposed reconstruction drawing of project of 1513 (figs. 17.43–17.45 are shown in place). Commissioned by the heirs of Pope Julius II

even been stolen. Julius's heirs no longer required a freestanding tomb, probably because they were not sure if it would be possible, under a new pope, to place it in St. Peter's. One of the original rejected designs was revived, and about this we know a good deal from drawings and from the contract. The tomb was to be attached to the wall, with the pope interred in a sarcophagus on the second story and shown lifted from it or lowered into it by angels (fig. 17.42). Doubtless this was to utilize the same block ordered earlier and possibly even the pose designed earlier for the recumbent statue in the burial chamber. Above, in a lofty niche, was the Virgin and Child, floating as if in a vision. There were to be standing saints in other niches, but the rest was to have followed the 1505 project, save that the Victories would be reduced to six, the Captives to twelve, and the space intended for the door to the burial chamber filled with a relief.

Although Michelangelo worked for three years on the tomb, only three of the statues were brought even close to completion. The *Moses* (fig. 17.43) is now in place on the reduced version of the project dedicated in 1545 (see fig. 20.5), but two *Captives* (see figs. 17.44, 17.45), for which there was

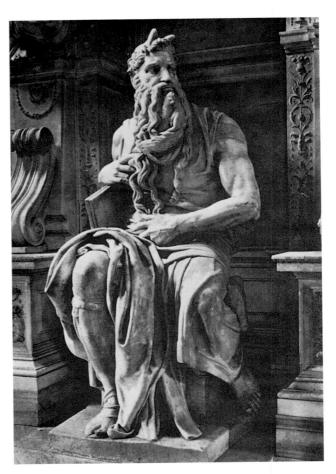

no room in the final version, were eventually given away by Michelangelo. *Moses* was originally intended to occupy a corner position on the second story where he would have been seen sharply from below and as a transitional figure between two faces of the monument. Today the sculpture is centralized and at ground level, and the torso seems unusually long, an effect that can be corrected if the viewer crouches and looks up at the figure from the far right.

This *Moses* has not just come down from Mount Sinai, nor is he angry at the Israelites for worshiping the Golden Calf. He holds the Tablets of the Law and looks outward with prophetic inspiration, as the man who saw God and talked with him on Mount Sinai. The horns on *Moses*' head are the horns generally shown there in Christian art, through a possibly deliberate mistranslation of the original Hebrew word for "shining," used in Exodus to describe Moses' face the second time he came down from Sinai (see p. 374).

The figure is related to some of the prophets and sibyls on the Sistine Ceiling. The left arm repeats almost exactly the left arm of the *Cumaean Sibyl* (see fig. 17.32). The face, whose expression is disturbed by Moses' encounter with God

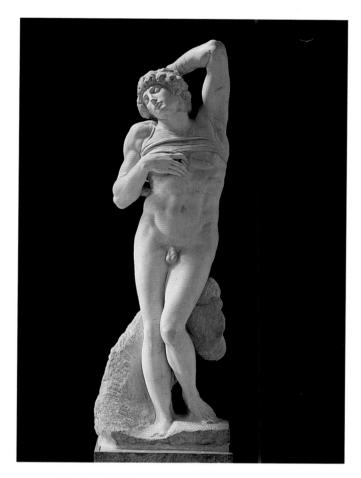

17.44. MICHELANGELO. *Captive* now known (incorrectly) as the *Dying Slave*. 1505–6, 1513–16. Marble, height 7'6" (2.3 m). The Louvre, Paris. Commissioned by Pope Julius II for his tomb

Michelangelo made detailed scale models for his earlier statues, and one of these for the *Moses* was surely seen by Raphael as early as 1511 (see p. 557), but the bulk of the carving is thought to have been done in 1513–16. In a letter of 1542, Michelangelo mentions that the *Moses* is almost finished, although he may have done more work on the face just before the statue was placed on the final tomb. Certainly, the subtle shifting of planes and the new softness of surfaces are unlike the hard precision of Michelangelo's earlier sculptural style; perhaps this was in part due to his intervening experience as a painter.

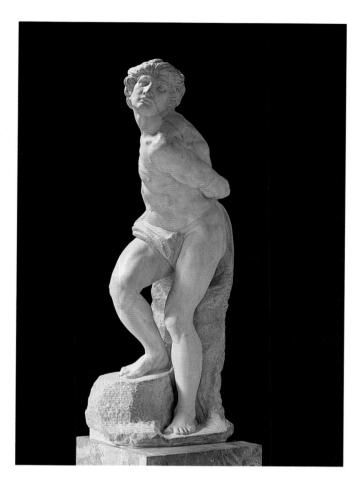

17.45. MICHELANGELO. *Captive* now known as the *Rebellious Slave*. 1513–16. Marble, height 7¹⁵/8" (2.15 m). The Louvre, Paris. Commissioned by Pope Julius II for his tomb

The two *Captives* in the Louvre may have been intended to flank the corner below *Moses* (see fig. 17.42). The *Captive* now known (incorrectly) as the *Dying Slave* (fig. 17.44) is not dying but is overpowered by bonds against which he plucks idly, as if he were drowsy, overcome by the effects of a potion. His tall figure seems about to sink slowly downward. During the period when this statue was being worked on, Michelangelo often drew figures almost or even entirely without contours, resorting to shading alone to indicate the pulsating, muscular surface of the figure. The contrast between the silken finish of the skin of the legs and the rough stone next to them suggests that Michelangelo intended to carve jagged rocks, as in the *Bruges Madonna* and the *David* (see figs. 16.38, 16.39; see also fig. 9).

Seemingly seething with rage, the *Captive* now known as the *Rebellious Slave* (fig. 17.45) struggles against the bands that tie back the powerful torso and arm. Although prefigured by some of the nudes in the Sistine Ceiling, this figure seems to come from another race. He seems crushed and anguished, and his forms have lost the resiliency of youth. The face, unfinished, held less interest for the artist than the body.

With its backward twist and rolling eyes, it suggests the agonized ancient sculpture of the *Laocoön* (see fig. 17.2), but the mouth is closed. Drill marks are visible at the roots of the hair and among the locks. The crisscrossing sweeps of the three-toothed chisel, employed almost like a brush, capture the energy of Michelangelo's creative process. The muscles are no longer individually defined and separated, but flow together in a tide that even obliterates the boundaries between leg and torso, torso and arm.

During his thirty-two years as cardinal of San Pietro in Vincoli (St. Peter in Bonds, or Chains), Julius had been known by the name of this church, as contemporary panegyrics and lampoons constantly remind us. His tomb was eventually erected there, and, as we will see, Raphael made St. Peter in his *Liberation of St. Peter from Prison* (see fig. 17.52) a recognizable portrait of Julius. The Introit of the Mass of St. Peter in Bonds contains a verse from Psalm 138: "Lord, thou hast proved me, and known me: Thou hast known my sitting down and my rising up." The Latin sentence concludes with "my resurrection," and that is what we were intended to see—dimly through the tomb's chamber door in 1505, triumphant on the second story in 1513: the resurrection of the pope, like St. Peter, from the earthly prison of the body to the eternity of the soul in heaven.

In 1550 Vasari wrote that the *Captives* were to be identified with the provinces captured by the pope, while Michelangelo's pupil Condivi said they were the Liberal Arts captive at the pope's death. An alternative explanation is that these figures, who twist and writhe in their bonds, are held prisoner by sin and that by the example of St. Peter they can appeal for deliverance, represented by the Victories in the niches. The herms (*termini* is the word usually used) are symbols of death, and to these *termini* the *Captives* were bound by narrow bands of cloth. The Latin word *vincula*, the source for *vinculi* in the name of the church, has been translated as "bands."

In both the 1505 and the 1513 versions, the tomb would have been an unprecedented combination of architecture and sculpture, rich in its complexity, powerful in its struggling figures, compelling in its suggestion of the torment of earthly existence and the heavenly release, and, in the end, transparently simple in its message.

Raphael in Rome

While Michelangelo was at work on the first campaign of the Sistine Ceiling, the young Raphael arrived in Rome, exactly when or why we are not sure. His style appealed to the pope, who stopped the work of the more conservative painter Sodoma and turned over the decorating of his Vatican apartments (the *Stanze*, or rooms) to Raphael (fig. 17.46). The first room to be painted, from 1509 to 1511, was the Stanza della Segnatura (Signature) (figs. 17.47, 17.48), named after the highest papal tribunal, which is held under the presidency

of the pope and the judgment of which requires his signature. Leaving the ceiling ornamentation Sodoma had started largely intact, Raphael had walls of brick built in front of the preexisting and perhaps unfinished frescoes of the walls, thereby slicing off some of the decorations of the embracing arches. On the new walls he painted his own frescoes, which set forth in their subjects the new ideals of Julius's reign. The first of the wall frescoes to be carried out was the scene popularly known as the Disputà (see fig. 17.48), or Disputation over the Sacrament, in which Raphael uses clouds and figures to suggest the apse of a church. The subject, which might better be called simply "Theology," is an exposition of the doctrine of the Eucharist, with Raphael's invention emphasizing that the church is an institution composed of people rather than architecture. The sacrament is traced from its origin in heaven, where God the Father, Christ, the Virgin, and St. John the Baptist are enthroned among saints, patriarchs, and prophets in a semicircle of clouds, while angels fill the golden sky above. The dove of the Holy Spirit appears between child-angels carrying the Gospels, while the wafer that represents the consecrated bread of the Eucharist (the Host) appears on the altar below, in a shining monstrance. This consecrated bread, representing the body of Christ, marks the center of the perspective scheme.

The tranquility of the heavenly figures is contrasted with the active theologians on earth, who seem to be debating the nature of the sacrament. At the left Jerome, his head bowed, contemplates his translation of the Bible, while Gregory, a portrait of Julius II before he grew the famous beard, gazes at the revelation upon the altar. Among the figures at the right can be made out the standing Sixtus IV and, with a laurel crown, Dante. Raphael has endowed the earthly figures with a physical presence and a gravity of bearing that is new to his style, and he has set them in an ideal perspective which, as in Leonardo's *Last Supper* (see fig. 16.23), is not the point of view of a person standing in front of the fresco but that of a colossus. As a student once noted, such High Renaissance paintings depict not another room but another realm.

While Raphael was painting the *Disputà*, Michelangelo continued work on the Sistine Ceiling, behind locked doors. Raphael's new monumental figures seem to have been his own independent response to the expectations of Julius, his High Renaissance patron. At the apex of the celestial dome (fig. 17.49), still covered with gold leaf and enlivened with raised plaster nodes as in Signorelli's Orvieto frescoes (see fig. 16.54), vague angelic shapes begin to take on substance along glittering, incised rays. Before them soar archangels, their hands linked and their drapery billowing in the golden light. Their spiral poses, which are also found in the figures below, are characteristic of Raphael's style throughout his career, as are the flowing lines of their drapery.

The medallions inserted by Raphael into Sodoma's ceiling decorations are related to the frescoes of the four walls

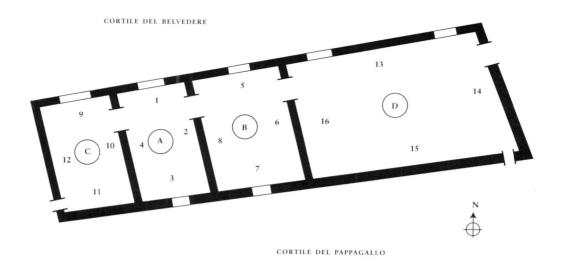

17.46. Iconographic diagram of the Raphael Stanze cycles

- A. STANZA DELLA SEGNATURA (1509-11)
- 1. Poetry, 1510-11 (see fig. 17.47)
- 2. Philosophy, 1510-11 (see fig. 17.47)
- 3. Fortitude, Prudence, and Temperance; Tribonian Handing the Law Code to Justinian; Gregory IX Approving the Decretals, 1510–11 (see fig. 17.48)
- 4. Disputà, 1510-11 (see figs. 17.48, 17.49)
- B. STANZA D'ELIODORO, 1512-14
- 5. Liberation of St. Peter from Prison, 1513 (see fig. 17.52)
- 6. Expulsion of Heliodorus, 1512-14 (see fig. 17.53)
- 7. Mass of Bolsena, 1512 (see fig. 17.53)
- 8. Expulsion of Attila, 1513-14 (see fig. 17.52)

- C. STANZA DELL'INCENDIO (RAPHAEL AND PUPILS, 1514–17)
- 9. Victory of Leo III
- 10. Battle of Ostia
- 11. Fire in the Borgo
- 12. Coronation of Charlemagne
- D. STANZA DEL COSTANTINO (WORKSHOP OF RAPHAEL, 1519-25)
- 13. Donation of Constantine
- 14. Apparition of the Cross to Constantine
- 15. Victory of Constantine over Maxentius
- 16. Baptism of Constantine

below. An allegorical figure of Theology, for example, is enthroned above the *Disputà*. Facing the *Disputà* is the *School of Athens*, or *Philosophy* (see fig. 17.47), which is recognized as a culmination of the High Renaissance ideal of formal and spatial harmony. It confronts the *Disputà*'s theologians with an imposing group of philosophers of classical antiquity, likewise engaged in solemn discussion.

The noble structure uses the Roman Doric order preferred by Bramante. Its barrel-vaulted spaces suggest Bramante's designs for St. Peter's (see fig. 17.14). At left and right are niches in which statues of Apollo and Minerva—ancient gods of the arts and wisdom—preside over the assemblage. Raphael's setting is not meant to suggest a real building; it is a pictorial invention designed to establish a grand classicized setting for his debaters.

In the center stand Plato and Aristotle, who still today, as in the Renaissance, are recognized as the two greatest philosophers of antiquity. The book Plato holds is his *Timaeus*, refer-

ring to his description of the origin and nature of the universe. Plato points upwards to heaven, the realm from which his ideas radiate. Aristotle holds his Nichomachean Ethics, a text that stresses the rational nature of humanity and the need for moral behavior. Aristotle points downward to earth as the source for his observations on the nature of reality. At the left Socrates can be seen engaged in argument, enumerating points on his fingers. The old man sprawling on the steps is Diogenes. At the lower left Pythagoras demonstrates his proportion system on a slate, while at the extreme right Ptolemy contemplates a celestial globe held before him and, just to the left, Euclid bends down to draw a circle on another slate. Euclid is a portrait of Bramante—an appropriate choice considering the latter's concern with geometry and centrally planned, domed architecture. To the far right, on the lowest level, Raphael has painted his self-portrait looking out. He is standing next to a portrait of Sodoma; one wonders how much Sodoma, whose frescoes were being covered up, appreciated the compliment.

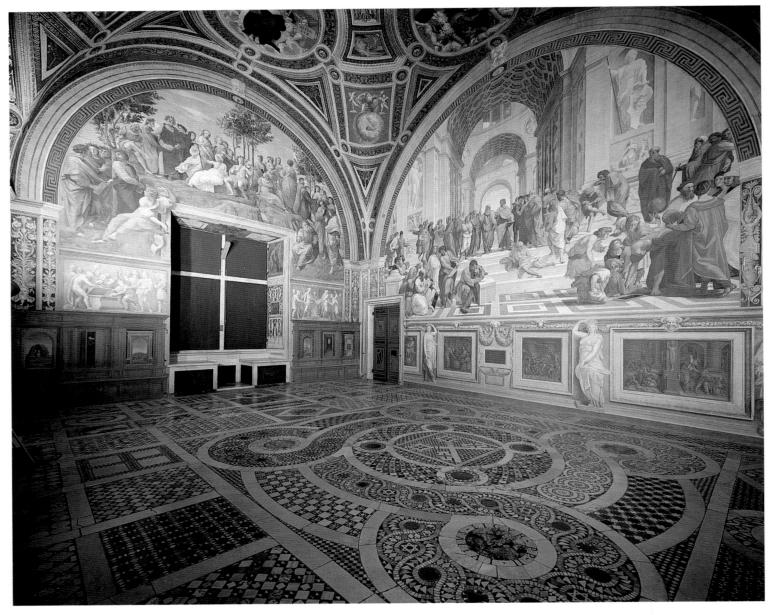

17.47. RAPHAEL. Stanza della Segnatura, Vatican, Rome. Fresco in the left lunette: *Poetry*. In the right lunette: *Philosophy*, also known as the *School of Athens*. 1510–11. Fresco, 19 x 27' (5.8 x 8.2 m). Stanza della Segnatura, Vatican, Rome. Commissioned by Pope Julius II. The popular but somewhat misleading name the *School of Athens* dates back only to the eighteenth century.

The large cartoon for the lower band of figures reveals the care and subtlety with which Raphael developed the relationships between the figures and the interchanges of glance and gestures that create both a sense of lively intellectual debate and aesthetic harmony. The cartoon's preservation (it is now in the Ambrosiana in Milan) is a testimony to the respect Raphael commanded at the time.

The suave, carefully studied poses of Raphael's figures reveal his study of surviving examples of ancient sculpture, and at this point it is appropriate to introduce another of the ancient sculptures that were so influential for Renaissance artists, the so-called *Apollo Belvedere* (fig. 17.50). When and where this sculpture was discovered is unknown, but it was

in the Vatican collections by 1509 and in the Belvedere by 1511. In 1523 it was described as "famous throughout the world." The elegant pose, the easy grace of movement, the smooth treatment of the muscles set off by the cape, and the calm, handsome face of the god had a powerful impact on Raphael and his contemporaries as they searched for models for their idealized figures.

In the foreground of the *School of Athens* (see fig. 17.47) sits a lonely man, his elbow on a marble block, his head propped on his hand. Wrapped in his own thoughts, he holds a pen over a piece of paper. Instead of the flowing mantles of the other philosophers, this bearded, burly man wears the short, hooded smock and soft boots of a sixteenth-century

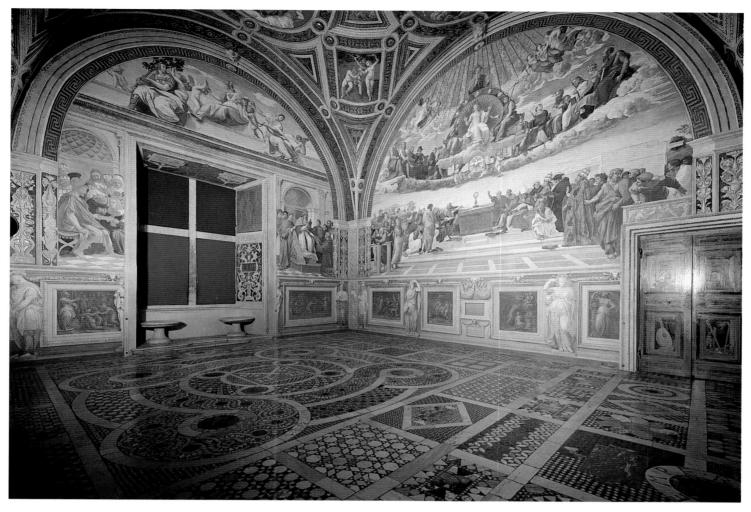

17.48. RAPHAEL. Stanza della Segnatura, Vatican, Rome.

Frescoes in the left lunette: Allegorical figures of Fortitude, Prudence, and Temperance, with Faith, Hope, and Charity; above: Allegory of Justice; left of window: Tribonian Handing the Law Code to Justinian (recently attributed to LORENZO LOTTO); right of window: Gregory IX Approving the Decretals, with portraits of Julius II as Gregory IX, and of Cardinals Giovanni de' Medici and Alessandro Farnese; right wall: Disputà (Disputation over the Sacrament) or Theology; above: Allegory of Theology. 1510–11. Size of Disputà, 19 x 27' (5.8 x 8.2 m)

Right: 17.49. Angels, detail of fig. 17.48

stonecutter. This figure of the stonecutter, which bears the features of Michelangelo, does not appear in Raphael's cartoon, revealing that he was added at the last minute, during the process of painting. Apparently, Raphael went into the Sistine Chapel with the rest of Rome in August 1511, experienced the new style, and returned to his own work to pay this tribute to the older artist. Perhaps he had actually seen the sculptor sitting dejectedly in the Piazza San Pietro, alongside one of the blocks for the tomb of Julius II. At any rate, Raphael's own style would never be quite the same. This stonecutter has a massive power not seen elsewhere in the *School of Athens*, nor indeed in Raphael's entire earlier production. In addition, the study of fighting men for the relief

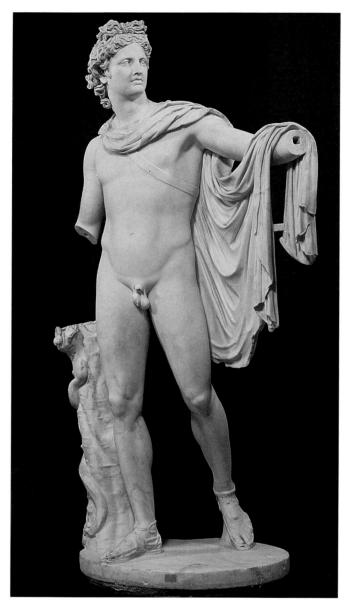

17.50. Apollo Belvedere, ancient Roman copy of a bronze sculpture, perhaps by the ancient Greek sculptor LEOCHARES. Second century C.E. Marble, 7'4" (2.2 m). Vatican, Rome. The sculpture owes its name to its placement, by 1511, in the Belvedere Palace at the Vatican. The figure probably originally held arrows in his left hand.

below Apollo (fig. 17.51) shows an interest in muscular anatomy and movement also learned from Michelangelo.

Raphael put his discovery of Michelangelo to work in the lunette representing three of the four Cardinal Virtues: Fortitude, Prudence, and Temperance (see fig. 17.48). The fourth, Justice, is in the ceiling roundel above, while the three Theological Virtues—Faith, Hope, and Charity—are represented by the putti accompanying the allegorical figures in the lunette. All the monumentality of the last phase of the Sistine Ceiling is here, but Raphael avoids the tension of

Michelangelo's figures by infusing his own grace into the grand manner. The composition is unified by the flow of line that sweeps from figure to figure, and all the surfaces glow with the fresh, blond tones and silvery light seen throughout the room. Fortitude holds a Della Rovere oak tree, and her legs and drapery are derived from Michelangelo's Moses. Prudence, as in Piero's Urbino portrait (see fig. 11.35), has two faces, one young, looking into a mirror, one old and bearded, looking backward. The long loops of Temperance's bridle continue the curves of the composition.

The fourth wall in this stanza represents *Poetry* (see fig. 17.47), with the central figure of Apollo leading a band of writers that includes Dante, Homer, and Sappho. Here the window becomes a positive force in the composition, serving as a base for the mountain of Parnassus where the writers are gathered.

The suave classicism of Raphael's Roman style is already showing signs of giving way to a new, more vigorous manner in the lunette of the Virtues in the Stanza della Segnatura. This dramatic, energetic phase comes to its climax in the second of the chambers, the Stanza d'Eliodoro (figs. 17.52, 17.53), apparently commissioned by Julius II in August 1511, when he still wore the beard he had grown the

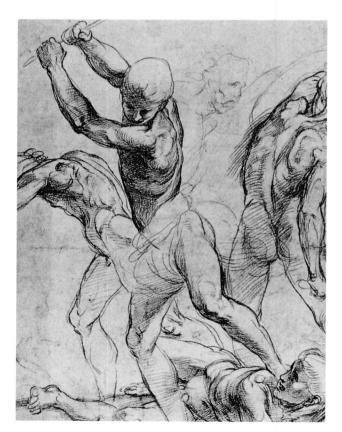

17.51. RAPHAEL. *Fighting Men* (study for relief sculpture in *School of Athens*). 1510–11. Red chalk over leadpoint, 15 x 11" (37.9 x 28.1 cm). Ashmolean Museum, Oxford

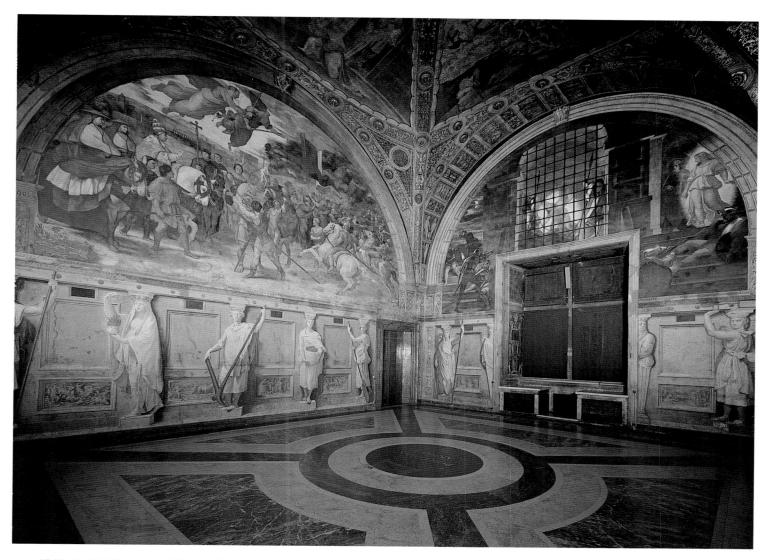

17.52. RAPHAEL. Stanza d'Eliodoro, Vatican, Rome. Frescoes on the left wall: Expulsion of Attila.

On the right wall: Liberation of St. Peter from Prison. 1513. Fresco, base line 21'8" (6.6 m). Commissioned by Pope Julius II

preceding winter. As early as February 1512, the pope removed his beard because things were "at a good point." An early study by Raphael for one of the wall compositions, in fact, shows him without it. When the news of the Battle of Ravenna, which seemed at first to be a defeat, reached Rome on April 14, 1512, the pope apparently began to grow his beard again; he is shown wearing it in three wall frescoes of the Stanza d'Eliodoro, and he is still wearing it on Michelangelo's final version of the tomb (see fig. 20.5).

Around one of the windows Raphael painted the *Mass of Bolsena* (see fig. 17.53), recounting a miracle that took place in 1263 (see p. 150). A Bohemian priest who did not believe in the presence of Christ in the Eucharist was celebrating Mass when, to his astonishment, the conse-

crated bread shed drops of blood in the form of a cross on the corporal, a cloth used in the Mass. The bloodstained cloth, still preserved today as a relic in the Cathedral of Orvieto, was adored by Julius II for a full day during his victorious march northward in 1506. Apparently, he attributed his success then, and his triumph over the French after Ravenna—the news of which reached him on June 29, 1512—to the intervention of this relic, and in Raphael's representation he is shown as if present at the original event.

The compositional movement, skillfully arranged around the off-center window, rises gracefully from the group of mothers at the lower left to the torch-bearing acolytes, the amazed priest, and the calm pope, seen in profile with a full beard. Below, at the right, kneel the officers of the Swiss

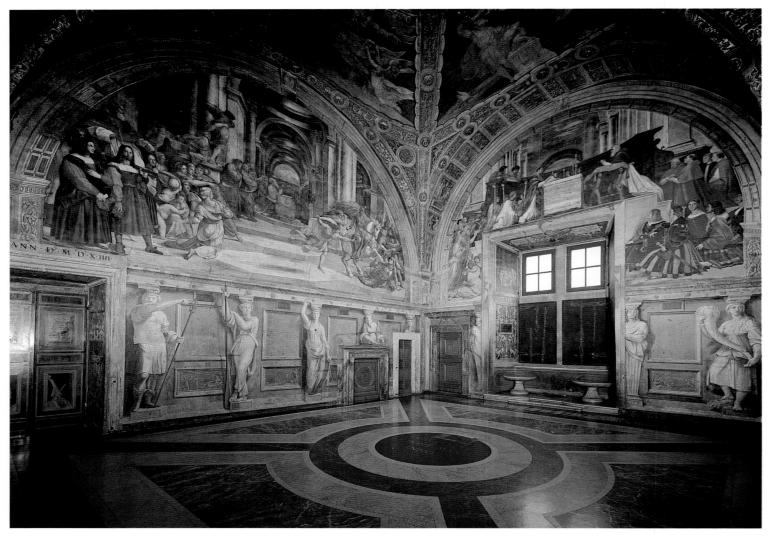

17.53. RAPHAEL. Stanza d'Eliodoro, Vatican, Rome. Frescoes on the right wall: *Mass of Bolsena*. 1512. On the left wall: *Expulsion of Heliodorus*. 1512–14. Fresco, base line 21'8" (6.6 m). Commissioned by Pope Julius II, who is seen at the left, carried in on his portable throne. Raphael stands behind, his head below Julius's extended left hand.

troops who spearheaded Julius's triumph in 1512. There is a greater breadth of handling here than in the Stanza della Segnatura, as well as heavier, Ionic architecture and a richness of color new in Raphael's art.

The second stanza is named after the fresco that depicts the *Expulsion of Heliodorus* (see fig. 17.53), an incident from the biblical book of Maccabees. One of the successors of Alexander the Great sent the general Heliodorus to steal the treasure of the Temple of Solomon in Jerusalem. In the midst of the raid a heavenly rider wearing gold armor appeared upon a white horse; he was accompanied by two youths "notable in their strength and beautiful in their glory." When they beat the general, he dropped the treasure and fell blinded before them. As in the *Mass of Bolsena*, the pope saw a parallel between this event and his own battle to expel a group of rebellious cardinals who had followed the command of the king of France to attack the papacy. The

bearded pontiff enters the scene carried on his portable papal throne, the *sella gestatoria*; the bearer in the foreground with the square beard has been identified as a portrait of either Marcantonio Raimondi (1487–1534), whose engravings of Raphael's compositions gave them wide currency and popularity, or of Raphael's pupil, Giulio Romano. Raphael himself, displaying an incipient beard, is seen partially hidden behind the chair.

Raphael's spiraling figures (see fig. 17.51) in the whirlwind group at the right have been invested with the weight and muscular power of Michelangelo. The disgrace of the general and the rage of his attendants are contrasted with the inspired anger of the celestial messengers, who float above the pavement. Like virtually all riders on rearing horses for the next three centuries, the celestial warrior exhibits the influence of Leonardo's *Battle of Anghiari* (see fig. 16.28). The architecture has changed sharply since the *School of Athens*

(see fig. 17.47); the masses are now heavier and more compact. The colors offer greater resonance—the vaults of the Temple shine with a deep golden light; in harmony with the *Mass of Bolsena*, the color chord is dominated by the reds and blacks of the pope and his entourage, against which the paler tones of the kneeling women form deliberate contrasts.

Facing the Mass of Bolsena, Raphael painted the Liberation of St. Peter from Prison (see fig. 17.52), which illustrates a passage from the Acts of the Apostles: "The same night Peter was sleeping between soldiers, bound with chains: and keepers outside the door guarded the prison. And the angel of the Lord appeared and a light shone in the prison. Hitting Peter on the side, he awoke him, saying, 'Rise up quickly.' And the chains fell off Peter's hands. . . . And he went out, and followed the angel. Peter knew not what the angel had done, and believed that he had seen a vision" (12:6-9). Raphael's St. Peter is a recognizable portrait of Julius II, for whom Peter's salvation was a reference to the deliverance of the papacy from the French invader. When the pope received the news of his unexpected victory in 1512, he had been praying at the Church of San Pietro in Vincoli (St. Peter in Chains); that night, in a reenactment of the liberation of Peter by the angel of light, Julius led a procession to the Castel Sant'Angelo that carried more torches than Rome had ever seen. But not long after, in 1513, probably while Raphael was painting this fresco, the pope died, and the subject may have taken on an additional meaning-the liberation of the old warrior from the earthly prison into eternal light.

Raphael's prison is a massive arch built of rusticated blocks like those Bramante was using at the time for the new palaces (still unfinished today) for the papal administration. The grate through which we look into the dungeon was derived from earlier representations of John the Baptist in prison, but the spectacular effect results from Raphael's new interest in and investigation of light. Light effects are everywhere: clouds drift in front of a waning moon and torches gleam on the armor of the guards, but the light from the angel transcends them all, filling the prison and shining in the dark streets through which he leads the spellbound Peter.

The room is completed by a final, dramatic fresco, the *Expulsion of Attila* (see fig. 17.52). This event took place in the fifth century, when the unarmed Pope Leo I routed the king of the Huns outside Ravenna through the miraculous intervention of Sts. Peter and Paul. Raphael has set the event before the gates of Rome as an allusion to Julius's expulsion of the French invaders, and perhaps even to the deliverance of the papal city from King Louis XII, who, in the summer of 1511, could have easily taken it and did not. The half of the Colosseum that was still standing and a Roman aqueduct can be seen in the distance at the left while at the right the advance of the barbarians is marked by flames in the forest. The seemingly wild confusion of the foreground resolves itself rapidly into a collision between the calm might of heaven at

the upper left and the impotent fury of the barbarians at the right. Riding a mule, the pope extends one hand, and when the two saints who float above draw their swords, Attila turns away terrified.

The movement of the figures and the treatment of forms and colors in this work have been described as "Baroque" or "proto-Baroque," referring to the exuberant style that came to dominate Catholic Europe in the seventeenth century. At times we almost seem to be looking at a work by the seventeenth-century Flemish painter Rubens, whose battle scenes are based on those of Leonardo (see fig. 16.28) and Raphael. The *Expulsion of Attila* was completed after the death of Julius II, who should have been seated on the mule; instead, Giovanni de' Medici appears twice, as a cardinal at the extreme left and as Pope Leo X, claiming for himself the miracle of Leo I.

The old pope was gone, yet Raphael had one more chance to immortalize him. The Sistine Madonna (fig. 17.54), which hung for centuries in San Sisto at Piacenza, in northern Italy, may have earlier fulfilled another purpose. It has been suggested that this painting, the first Madonna by Raphael to be painted on canvas, was created to hang above the bier of Julius II and that it was later sent to Piacenza because the principal church dedicated to St. Sixtus, patron saint of the Della Rovere family, was situated there. It has been pointed out, however, that the pope had promised the painting to Piacenza in appreciation for the assistance the city gave him in his war against the French. Nonetheless, the picture assumed a commemorative role. As can be verified by comparison with medals and other portraits, Sixtus is a portrait of Julius II, his beard and moustache shaggy as in his last, illnessridden days, just as we see him in the Liberation of St. Peter. The ornament of his cope is made up largely of oak leaves, and an acorn crowns his tiara. At the bottom, two putti lean on a wooden ledge and gaze upward at the vision.

This wooden ledge has been identified as the lid of Julius's coffin, with the papal tiara placed above his head, as the crown still is today in royal funerals. At the right kneels St. Barbara, gazing downward; as the patron saint of men-atarms, she is an appropriate pendant for Julius II. Because she was liberated from a tower (its battlements can be glimpsed in the back), she is the patron saint of the hour of death and of liberation from the earthly prison. The curtains are parted to reveal a vision, as the Madonna walks toward us, holding the Christ Child. Mother and child look upon us with eyes of unusual size, depth, and luminosity. Mary's pose is identical with that conceived by Michelangelo, probably as one of the alternates for the design of the tomb of Julius II accepted in 1505 and certainly for the definitive version in 1513 (see fig. 17.42). Either the idea of the floating Virgin arose in the pope's mind and was communicated to both artists, or it was developed by Michelangelo in 1505, not long after the completion of Fra Bartolommeo's Vision of St. Bernard (see fig.

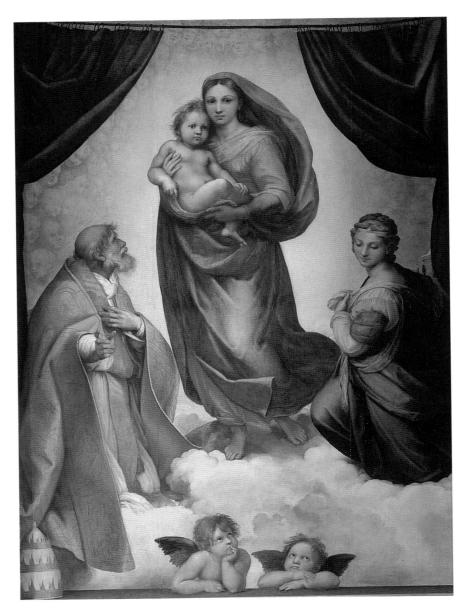

17.54. RAPHAEL. Sistine Madonna. 1513. Canvas, 8'8½" x 6'5" (2.7 x 1.9 m). Gemäldegalerie, Dresden. Commissioned by Pope Julius II for S. Sisto, Piacenza

16.49) and, like many of Michelangelo's ideas, influenced Raphael later.

In the nineteenth century the Virgin Mary in this allegory of the pope's entry into paradise became a popular representation of ideal motherhood, while in the late twentieth century the two somewhat nonchalant putti were widely reproduced as examples of typical childish behavior. The *Sistine Madonna*, in its rising and descending curves, its subtle balancing of masses, its rich tonalities of gold and green, gray and blue, its air of peace and fulfillment, is one of Raphael's most memorable creations. No one could have predicted at the time of his arrival in Rome, fresh from absorbing the ideas of Leonardo and Michelangelo in Florence, that in a few years Raphael of Urbino would earn the rank of a great artist, speaking with the full authority of the High Renaissance style.

Whoever she may have been, the sitter for the so-called Donna Velata (Veiled Woman; fig. 17.55) is probably the

same woman Raphael used as a model for the Sistine Madonna. In color this is the richest of Raphael's portraits, so fresh and glowing as to suggest that the artist has also absorbed the colorism of Venice. No trip there is recorded for Raphael, but in 1511 Sebastiano del Piombo brought to Rome a personal variation of the Venetian style. Only by assuming Venetian influence is it possible to understand the rich color chords of the frescoes in Julius's second stanza and the dazzling white-and-gold drapery of this portrait, the depth of the dark eyes and chestnut hair, the soft glow of the stones in the necklace, and the luminous pearl hanging from the woman's veil. In its asymmetrical placing, this jewel brings all the other ellipses of the composition into relation with each other.

The portrait of *Baldassare Castiglione* (fig. 17.56) is also typical of the moment of balance that Raphael achieved in Rome. As we have seen, Castiglione's *Book of the Courtier* established the qualities expected of an ideal gentleman in

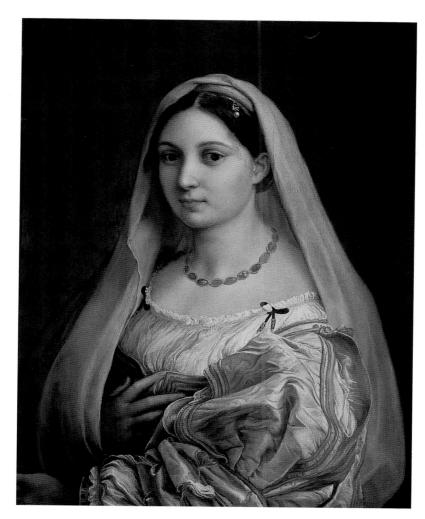

17.55. RAPHAEL. Donna Velata (Veiled Woman). c. 1513. Canvas, $33^{1/2}$ x $23^{1/2}$ " (85 x 60 cm). Pitti Gallery, Florence

Below: 17.56. RAPHAEL. Baldassare Castiglione. c. 1515. Canvas, $32^{1/4}$ x $26^{1/2}$ " (82 x 67 cm). The Louvre, Paris.

Rembrandt once tried to acquire this painting at auction; forced to retire when the bidding went out of his reach, he never forgot the composition, and twice did his own self-portrait in the pose and style of Raphael's *Castiglione*.

the High Renaissance (see p. 497). In addition, the book offered a new interpretation of the role of women in society: Castiglione's *nobil donna* was a woman of the court, educated in the ancient languages and, like men, with many "virtues of the mind." Castiglione was a friend of Raphael, who represents him with the *riposo*, or inner calm, that the author himself deems essential for gentlemanly character. The picture has been cut at the bottom, but old copies show it with the folded hands in their entirety. If it were complete, the appearance of harmony and restraint would be even more impressive.

The black, white, and gray of the garments embody the sobriety and restraint preached by Castiglione to a society that was reacting to the flamboyant colors of late Quattrocento dress. Raphael develops this monochromatic scheme with resonance against the golden gray of the background, which is reflected in warm highlights on the richly painted sleeves.

The death of Julius II brought a boyhood acquaintance of Michelangelo's, Cardinal Giovanni de' Medici, second son of Lorenzo the Magnificent, to the papal throne as Leo X. Perhaps based on memories of the young sculptor's behavior in the Palazzo Medici, the new pope—an easygoing, luxury-loving, corpulent man only thirty-eight years old at the time

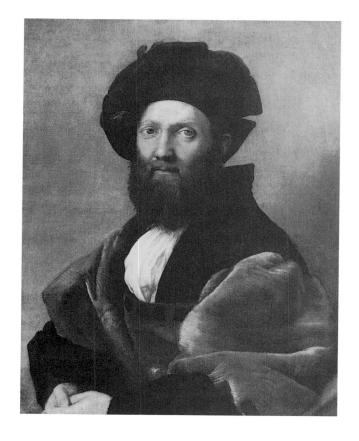

of his election-had little interest in Michelangelo: "É troppo terribile," said the pope, "non si puol pratichare chon lui" ("He is too violent; one can't deal with him"). The commissions in the Vatican, therefore, went chiefly to Raphael and his increasing entourage. Leo provided a relaxed atmosphere, and the Vatican was filled not only with artists, poets, philosophers, and musicians, but also with dancers, animaltamers, and clowns. Pious pilgrims from northern Europe were shocked by the appearance of the pope and his cardinals in hunting dress and would have been outraged had they attended Vatican ceremonies, including funerals and beatifications, at which the Olympian deities were extolled. The pontiff, who immediately dropped the aggressive political policy of his predecessor, seems to have had little interest in his spiritual mission, and no inkling of what effects the challenges led by Martin Luther were bound to wreak.

A few years after his accession, the pope sat for a group portrait in which Raphael established a new level for searching analysis of character (fig. 17.57). The pope is not occupied with affairs of state but with antiquarian erudition and the delight of possession. He sits before a table where he has been perusing a splendid Trecento illuminated manuscript that is so accurately represented that the original, still preserved, has been identified. Beside the manuscript rests a silver bell, with gold top and gold borders, covered with classical vine scrolls. Both manuscript and bell are rendered with such precision that we wonder if Raphael used a magnifying glass like the one held by the pope. At the pope's right stands his cousin, Cardinal Giulio de' Medici, son of the murdered Giuliano and subsequently Pope Clement VII; on Leo's left stands his nephew Cardinal Luigi de' Rossi. The three gazes cross but do not connect, creating a sense of tension that is increased by the dissonance of the warm orange reds of the cardinals' attire and tablecloth and the cool, purplish crimson of the pope's cape and hat. The pope's puffy countenance is rendered, like his shapely hands, with striking fidelity. The polished brass sphere on the chair contains a distorted reflection of the room similar to those found in earlier Flemish paintings, and although one can make out a window that is the source of illumination, Raphael's own figure is reduced to a few vague vibrations.

Under Leo X, Raphael rose to a level of power and wealth not previously enjoyed by any Italian artist. At Bramante's death in 1514, Raphael became papal architect and was charged with continuing the construction of St. Peter's. At the same time, he was showered with commissions for Madonnas, portraits, frescoes, and mosaics. He was asked to paint a third stanza (the Stanza dell'Incendio) and to design the decorations of other rooms in the Vatican, including a loggia built by Bramante and a loggetta and bathroom for Cardinal Bibbiena, one of Leo X's friends. Raphael directed the construction of new buildings, including at least one church and one palace, and a villa for Cardinal Giulio de' Medici (see fig. 17.61).

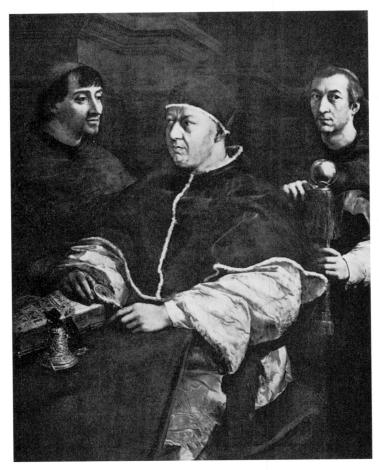

17.57. RAPHAEL. *Pope Leo X with Cardinals Giulio de' Medici and Luigi de' Rossi.* c. 1517. Panel, $60^{1/2}$ x 47" (1.54 x 1.2 m). Uffizi Gallery, Florence. Originally owned by Pope Leo X. Evidence suggests that during the Renaissance the presence of a portrait could substitute for a missing individual. At the wedding of Lorenzo di Piero de' Medici, Duke of Urbino, and Madeleine de la Tour d'Auvergne, a niece of Francis I, on September 8, 1518, this portrait was placed behind the table where the bride was seated; it made up for the absent pope and two cardinals.

Raphael was also appointed Superintendent of Antiquities—the first that we know anything about—and given power over excavations in the papal dominions. One of his major projects was a map of ancient Rome with its monuments traced and identified.

To keep up with this massive and manifold commitment, Raphael employed a number of assistants, including two masters named Giulio Romano and Perino del Vaga. On occasion, additional independent painters were called in to help with special assignments. As a result, the execution of Raphael's designs is at times uneven and the work of less skilled pupils painfully evident. Even some of Raphael's contemporaries, in an era indulgent to the workshop system, deplored these lapses. There is evidence that Raphael sometimes asked his pupils to make scale models of pictures

17.58. RAPHAEL. Healing of the Lame Man. 1515-16. Tapestry cartoon, watercolor on paper, 11'3" x 17'7" (3.4 x 5.4 m). Victoria and Albert Museum, London. Commissioned by Pope Leo X Medici for the tapestries for the Sistine Chapel. Raphael's ten cartoons are the earliest surviving examples of tapestry cartoons on paper.

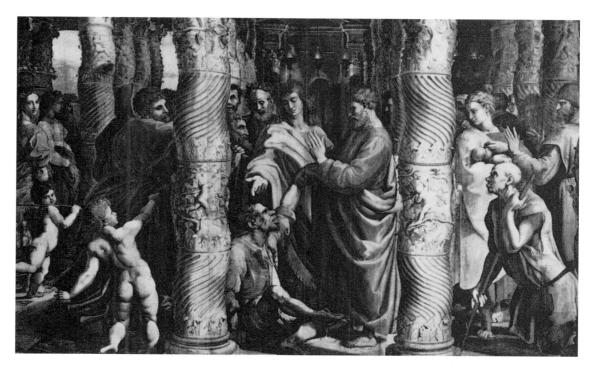

on the basis of his small sketches or verbal directions. When preserved, these models are invariably by the pupils, with an occasional possible correction from Raphael. However, they seldom correspond exactly to the finished compositions, which would indicate that the master then stepped in and somewhat reset the stage. Under the pressures exerted upon Raphael in these seven years, it is surprising that any substantial proportion of the finished paintings could have come from his brush, and yet, all in all, more than half the surface is by him in the most important commissions. Most of the detailed life studies, however, are by the pupils, who then presumably enlarged the approved model into a full-scale cartoon and carried out the preliminary painting. Only by this system of preplanning the design and execution of the paintings was it possible for Raphael to carry out so much himself, on such a grand scale, and with the freshness of original creation.

The grandest of the pictorial projects assigned to Raphael in this period was a series of ten tapestries, for which he produced ten full-scale cartoons in color (figs. 17.58–17.60) as guides for tapestry weavers in Flanders. The finished tapestries, representing scenes from the Acts of the Apostles, were a most prestigious commission, for they would be hung on the lower walls of the Sistine Chapel; covering approximately twelve hundred square feet, they completed the iconographic cycle that depicted the life of Christ and the life of Moses, the ancestry of Christ, the prophets and sibyls who foretold the coming of Christ, and scenes from Genesis (see fig. 17.24 for a diagram that demonstrates where the tapestries were hung in the chapel). Raphael must have been aware not only that his compositions would be on display at the center of papal power, but also that he was invading the sanctuary of

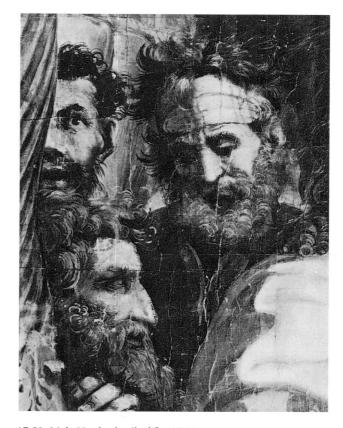

17.59. Male Heads, detail of fig. 17.58

Renaissance painting consecrated to Botticelli, Perugino, Signorelli, Ghirlandaio, and Michelangelo himself. While so exalted a destination probably did not cause him to alter his style, it did inspire him to devote his energies—and probably those of his whole shop as well—to these figural composi-

tions. As pointed out earlier (see p. 176), tapestries were much more expensive than frescoes or oil paintings, and Raphael was surely cognizant that his series would have this elite status within the chapel's historic decoration. Unfortunately, the tapestries based on Raphael's designs are seldom displayed in the Sistine Chapel today.

The resulting combination of large figures with the new architecture of the High Renaissance and with landscape backgrounds produced compositions that were exciting in their dense packing of elements and in their dramatic power. Moreover, since the series was reproduced in additional tapestries throughout the sixteenth, seventeenth, and eighteenth centuries, and in numerous engraved copies as well, they became the most influential of Raphael's compositions. They provided inspiration for such later artists as Poussin, Domenichino, David, and Ingres. The original cartoons had to be cut in strips for the convenience of the weavers, and eventually three cartoons were lost. The other seven were acquired by King Charles I of England in 1630, but they were not remounted and exhibited as works of art until 1699. In spite of retouching to hide the joints, the majestic forms and brilliant color upset the traditional notions of the serene gentleness of Raphael's art, which is largely based on his early Florentine Madonnas.

The cartoons were painted in a glue-based watercolor over charcoal preparation—often still visible—that was probably drawn by pupils, especially Giulio Romano, under Raphael's supervision. But by far the greater part of the color seems to have been laid on by Raphael himself, and there are passages in which the beauty and emotional fire of his mature style come through to us unaltered. Heads, drapery, landscape, and even, at times, architecture are painted with a new sketchy freedom that may be related to ancient Roman painting techniques. Perhaps Raphael's own immersion in antiquity—deeper, more prolonged, and more lasting in its effects than that of any other Renaissance artist until this time—had brought him into contact with Roman first-century painting.

But there are other sources as well. It has been noted how closely Raphael had studied Masaccio's frescoes (see fig. 5, 8.9) and how he revived Masaccio's method of enhancing the physical bulk and psychological presence of his figures by enveloping them in voluminous mantles. Raphael may have revisited Florence briefly in 1515, just before his embarkation on this cycle. To an artist with Raphael's sense of history, it may have seemed appropriate to return to Masaccio's images, in which the barefoot apostles had been invested with such dignity and power. To keep the figures large in comparison with their setting, they are set in front of massive architecture that is cut off at the top by the frame yet with breaks here and there that allow us to see, in the middle distance, the full extent and proportions of a classical order.

Raphael was able to contrast the largely decorative effect of the late Quattrocento wall frescoes, in which one must often search for the subjects, with the power of Michelangelo's scenes on the ceiling, especially those simplified subjects with which his tapestries would be placed in instant comparison. He therefore set the average height of a standing foreground figure at approximately eight feet, more than two-thirds the total height of the scene within the border. The effect of these heroic proportions against the restricted space, combined with the naturalism of Raphael's physical types, creates yet another Renaissance vision of ennobled humanity. This is no longer, as in the ceiling, a nude and predominantly male ideal race: through study of Masaccio, the man and woman in the street are raised to heroic stature and are framed—rough garments, bare feet, and all—by the richness of classical architecture.

In the Healing of the Lame Man (figs. 17.58, 17.59), for example, the group is centralized at the Gate of the Temple, the Porch of Solomon (Acts 3:1-11). In the cartoon St. Peter lifts the lame man by the left hand, instead of the right, as in the text, because Raphael knew that in the tapestry the composition would be reversed; for the same reason St. Peter blesses with his left. The setting is surprising and has even been called proto-Baroque in its vibrancy of form, light, and color. Apostles, mothers, children, and cripples move between spiral columns that reveal Raphael's interest in historical correctness. The screen before the chancel of Old St. Peter's had been formed by a group of Late Antique spiral columns that were believed to have come from the Temple of Solomon (in actuality they were probably brought to Rome in the fourth century C.E. from Syria). It was thought that Christ had often leaned against one of them to rest while teaching, and in the Cinquecento those obsessed by demons used to tie themselves to it to effect a cure. These columns were temporarily removed during the construction of Bramante's St. Peter's and were eventually relocated in various parts of the new building.

The columns' alternation of spiral fluting with vine scrolls and putti has been retained by Raphael, who apparently found sculptural and pictorial excitement in the contrasting motifs. The columns, multiplied in depth, provide richly colored shadows against which the figures are fitfully illuminated. Their pulsating contours contrast with the other forms, and especially the broad outlines of St. Peter's cloak.

Perhaps because of its balance of figural and architectural masses, *St. Paul Preaching at Athens* (fig. 17.60) became the most widely imitated of the cartoons. It was to be placed alone, just outside the marble barrier that divides the Sistine Chapel, as a symbol of the preaching mission of the apostles. St. Paul, raising his hands, reminds his hearers of their altar to the unknown God: "Whom therefore ye ignorantly worship, him declare I unto you" (Acts 17:23). The statue of Mars is seen from the back, while the Athenians listen, some with quiet conviction, others greatly disturbed. In the heavy-set soldier directly behind the preaching apostle the features

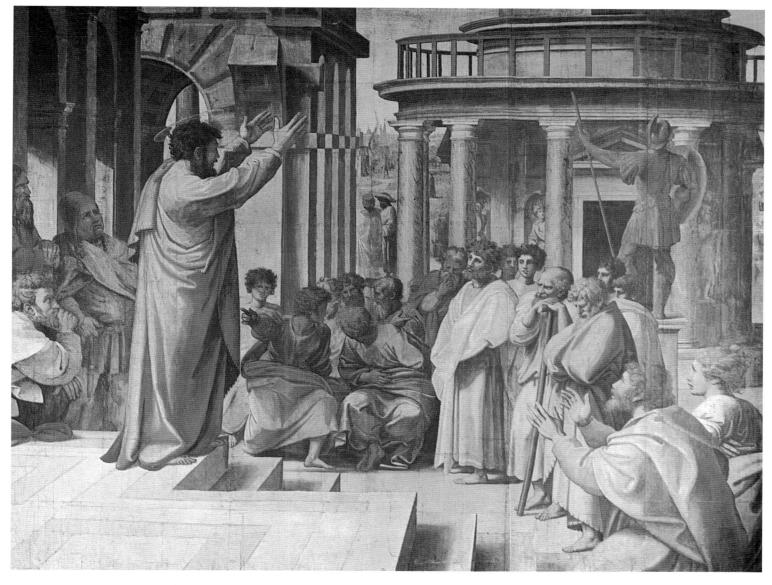

17.60. RAPHAEL. St. Paul Preaching at Athens. 1515–16. Tapestry cartoon, watercolor on paper, 11'3" x 14'6" (3.4 x 4.4 m). Victoria and Albert Museum, London. Commissioned by Pope Leo X Medici for the tapestries for the Sistine Chapel

of Leo X can be recognized. The commanding figure of St. Paul is derived from Masaccio's St. Peter in the *Tribute Money, St. Peter Baptizing the Neophytes*, and the *Raising of the Son of Theophilus* (see figs. 5, 8.10, 8.12, 8.21). The dramatic central group, their bodies twisted, the folds of their draperies agitated as by a storm, is one of the finest passages from Raphael's later period. The man and woman at the lower right, however, like the two putti at the left of the *Healing of the Lame Man*, show the style of Giulio Romano.

The architecture is noteworthy. The round temple is a tribute to Bramante (see fig. 17.9), and the unfinished rusticated buildings recall his structures for the papal tribunal. The patterns of the receding arcade produce a kind of checkerboard of light and dark, an unexpected instance of Raphael's inter-

est in geometry. The grandeur of the severe classical architecture is contrasted with the remote, dimly seen background of shaggy, ivy-covered towers that tell us more about Cinquecento Rome than ancient Athens.

Raphael's most ambitious architectural undertaking—save for St. Peter's itself, on which little was accomplished—was a villa designed for Cardinal Giulio de' Medici and known today as the Villa Madama (fig. 17.61). Originally, it was intended to have a two-towered façade facing St. Peter's, a circular courtyard, domed and porticoed rooms, gardens exploiting the slope of the hillside in descending levels, and many delightful fantasies and inventions. The project continued after Raphael died in 1520, but the death of Pope Leo X in 1521 diverted Cardinal Giulio's attention to the problem

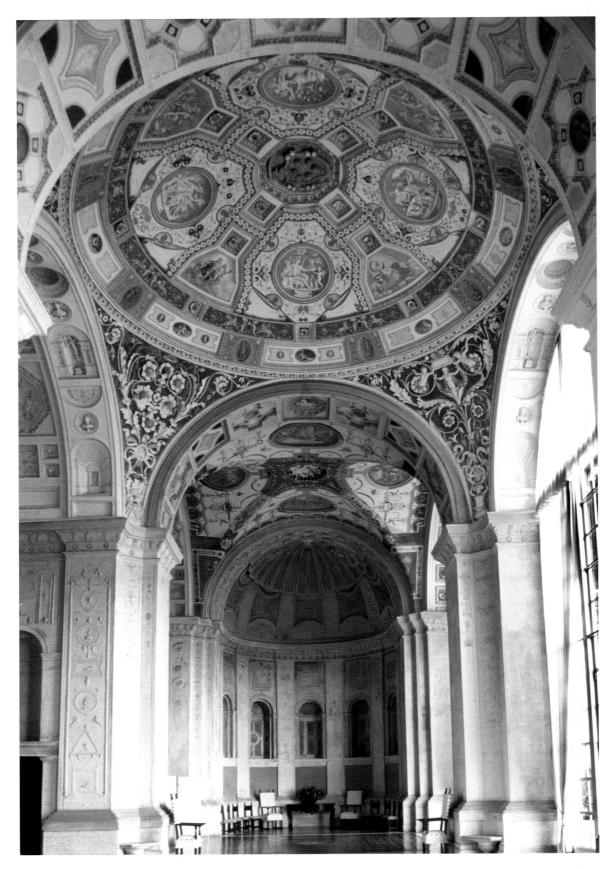

17.61. RAPHAEL. Interior of Medici Villa, now known as Villa Madama, Rome. c. 1515-21 (decorations by GIULIO ROMANO, GIOVANNI DA UDINE, and BALDASSARE PERUZZI). Commissioned by Cardinal Giulio de' Medici.

The function of the villa was to serve as a residence for high-ranking visitors to the papal court.

of hanging on to Medicean control of Florence. Even after his accession to the papacy as Clement VII in 1523, little more was done. The existing fragment, however, is enchanting.

The great hall, with its single-story arches, groin vaults, and central dome, all opening out through arches to the garden, was a new invention that gracefully harmonized the architectural space with nature outside. The delicate stucco grotteschi and paintings were carried out after Raphael's death by his pupils Giulio Romano and Giovanni da Udine and his associate, the Sienese painter-architect Baldassare Peruzzi. The cardinal instructed the painters that he did not care what the subjects were, so long as they were recognizable and one would not have to add explanatory inscriptions, like the painter who wrote, "This is a horse." Ovid would do as well as anything else, the cardinal said, but the Old Testament was only good enough for the loggia of the pope. The present illustration was taken after Fascist renovations, which include a marble floor more appropriate to a luxury hotel.

In late 1516 or early 1517 Cardinal Giulio commissioned Raphael to paint a large panel representing the Transfiguration (fig. 17.62) for his cathedral at Narbonne, in France. The completed picture was so impressive that the patron kept it at San Pietro in Montorio in Rome rather than sending it to France. The story tells how Christ went with Peter, James, and John to the top of a high mountain, and there suddenly Moses and Elijah appeared, and Jesus' countenance shone with light, and his raiment was "white and glistening." Then a bright cloud came upon them, and the voice of the Father could be heard saying, "This is my beloved Son in whom I am well pleased." This scene had been represented by Fra Angelico (see fig. 9.12) and Giovanni Bellini (see fig. 15.41), but the sequel is rarely shown—the demoniac boy whom the apostles could not cure in Christ's absence, but whom he healed immediately on his return. This is a difficult subject, and there is the possibility that it was added to the main theme of the Transfiguration to give Raphael an opportunity to demonstrate his artistic powers.

In the upper section the radiance of divinity and the wind of the spirit pull Christ upward, illumine and sustain the prophets in widening circles of rapturous contemplation, and momentarily blind the apostles in an unbearable intensity of revelation. Raphael's characteristic spiral movement sweeps through these figures: St. James struck to the ground as if by lightning, St. Peter writhing in torment, and St. John convulsed by divine energy, one hand groping in the air, the other hiding his eyes from the light.

The picture is designed in a giant figure eight and the theme and its interpretation suggest the powerlessness of humanity when separated from the source of energy in God. The lower portion was partly executed by pupils, especially Giulio Romano, who did many of the preliminary figure drawings. The possessed boy and his family are typical of

Giulio's style, but the St. Andrew at the lower left, turning from his book in amazement as the others argue or point, is not Giulio's. This group is surely by Raphael, and St. Andrew, with his outstretched hand and his foot projecting through the picture plane, not to mention the intense contrasts of light and dark around him, would provide a vital model for the young Caravaggio in Rome seventy years later.

Cleaning has revealed astonishing coloristic brilliance. The lower half of the picture displays intense reds, blues, yellows, greens, and pinks against the encompassing dark. In contrast, the color of the upper portion may testify to Raphael's interest in Venetian art, but since every new influence he absorbed became rapidly his own, the blue and gold of Christ's shining raiment are integral to the transfiguring radiance of the theme.

How was it that so serene and successful an individual as Raphael could imagine so mystical a subject and convey it with such power? One scholar has suggested that in his later years Raphael frequented the meetings of a group of priests and laymen called the Oratory of Divine Love, an organization about which little is known. The goal of the movement was the reform of the Church from within, not by means of a monastic order, but through the parishes. The program was simple: common prayer and preaching, frequent Communion (Communion was a rarity then), and works of neighborly love. One of the founders, Giovanni Carafa, eventually became Pope Paul IV. Together with another cofounder, Gaetano da Thiene, later canonized as St. Cajetan, Carafa spread the doctrines of the group into northern Italy. By March 1517 or perhaps even earlier, the society had Leo's approval; thus, at least seven months before Martin Luther nailed his ninety-five theses to the door of Wittenberg Cathedral, the reform of the Roman Church in Italy was quietly under way.

Although the Oratory was dissolved in 1524, its members expanded its original work in that of the newly founded Theatine Order. It may well be that we should look in the activities of this self-effacing, quiet group for the sources of Raphael's mysticism. It is worth remembering that Gaetano was often prostrate in ecstasy for hours before the Eucharist, like Raphael's three apostles, and that he preferred to celebrate Mass only at an altar in a chapel where the already consecrated sacrament was reserved for the veneration of the faithful. In this way, he could obtain, as he put it, "greater light and heat."

On Good Friday, April 6, 1520, after a brief illness, Raphael died at the age of thirty-seven. At his own request, his funeral was held in the Pantheon in Rome, with the unfinished *Transfiguration* hung above his bier, and he was buried there. Raphael's death was widely mourned, and with him passed that moment in Renaissance art when the ideals of classical antiquity and the aspirations of Christianity coexisted in harmony.

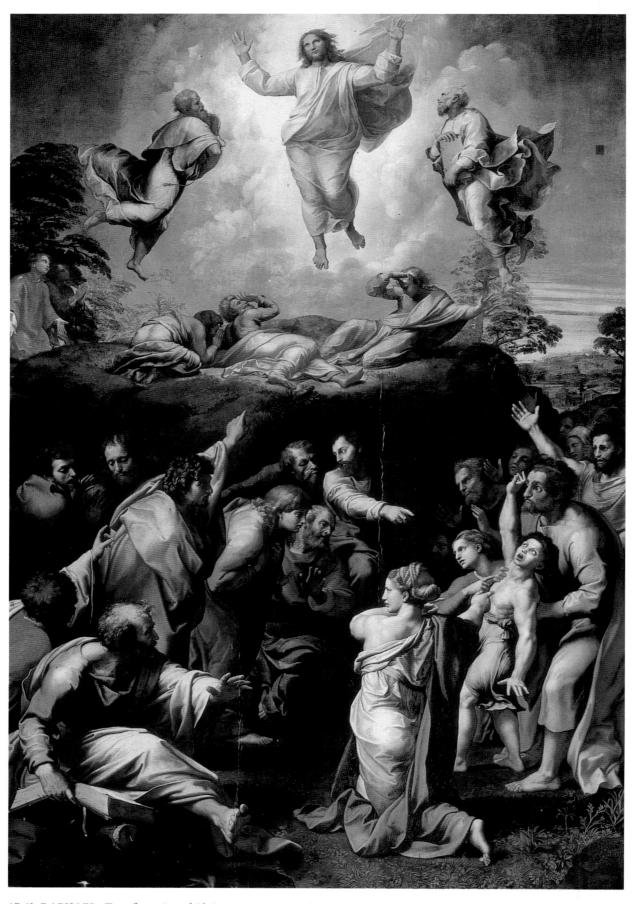

17.62. RAPHAEL. *Transfiguration of Christ.* c. 1516–20. Panel, 13'4" x 9'2" (4 x 2.8 m). Pinacoteca, Vatican, Rome. Commissioned by Cardinal Giulio de' Medici for the Cathedral of Narbonne

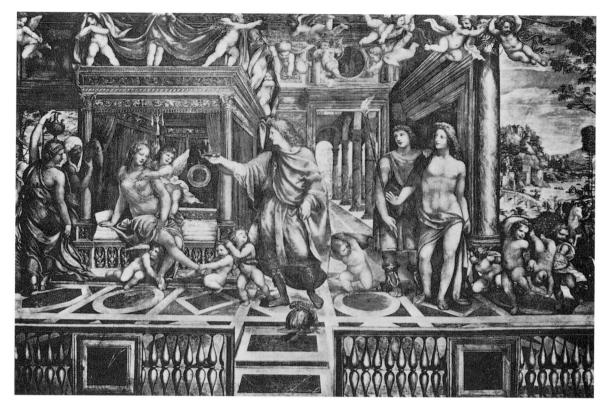

17.70. SODOMA. *Marriage of Alexander and Roxana*. c. 1517. Fresco, 12'1" x 21'9" (3.7 x 6.6 m). Bedroom, Villa Farnesina, Rome. Commissioned by Agostino Chigi

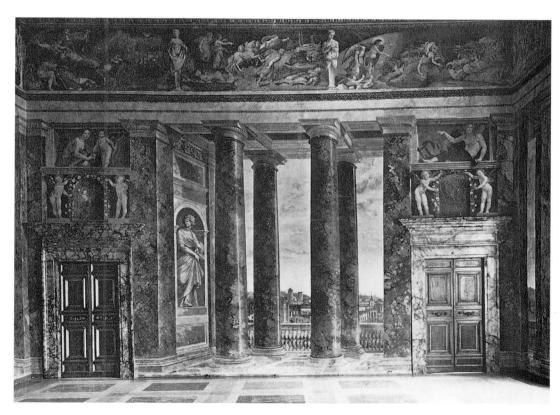

17.71. BALDASSARE PERUZZI. Perspective view. 1515–17. Fresco. Sala delle Prospettive, Villa Farnesina, Rome. Commissioned by Agostino Chigi

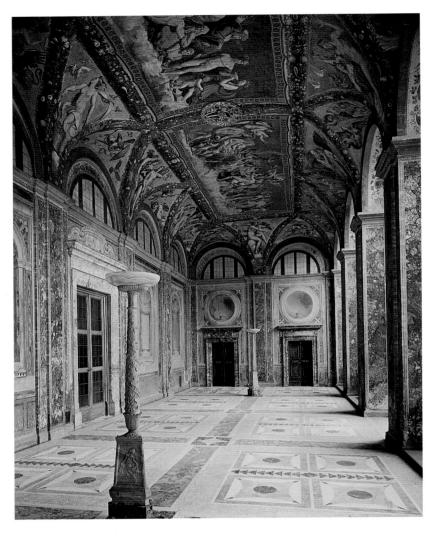

17.72. RAPHAEL and assistants. Frescoes, Loggia of Psyche, Villa Farnesina, Rome. 1518–19.
Commissioned by Agostino Chigi

Below: 17.73. RAPHAEL and assistants. Psyche Received on Olympus, eastern half of ceiling, Loggia of Psyche

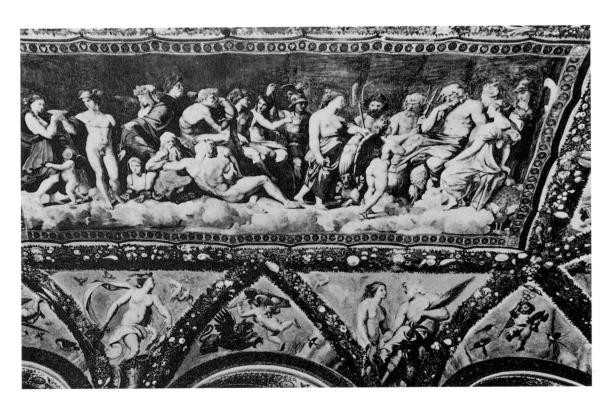

his direction, and occasionally with his direct intervention, in the garden loggia, the Loggia of Psyche (figs. 17.72, 17.73). Raphael's garlands of leaves, fruits, and flowers along the groins of the vaults and around the center of the ceiling transform the solid architecture into an open bower. The episodes of the story of Cupid and Psyche are seen against the blue sky, as if they are occurring in the openings of the bower, and the two central scenes fill two simulated tapestries overhead. The appearance of the interior, therefore, is all air and tension—the tension of the bower's garlands and the light tug of the awnings. Within this graceful illusion only those incidents of the legend of Cupid and Psyche that took place in heaven are represented. Perhaps the others were to go on the walls, now filled by simulated architecture, or perhaps the cycle was restricted to the airy episodes.

Although the noble female figures of Raphael's mature imagination are sometimes weakened by his pupils' pedestrian execution, those carried out by Giulio Romano, as in the *Cupid Pointing Out Psyche to the Three Graces* (fig. 17.74), can be quite grand. The figures are less supple than the *Galatea*, certainly, but full of a new statuesque, sculpturesque volume that is characteristic of Giulio as we have

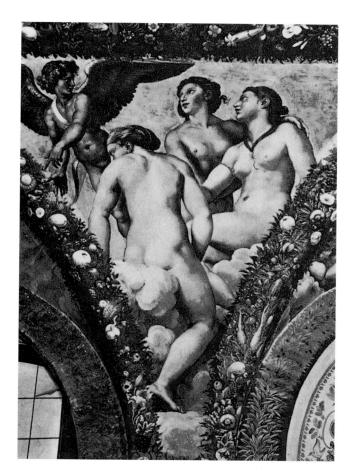

17.74. RAPHAEL and GIULIO ROMANO. Cupid Pointing Out Psyche to the Three Graces, compartment of ceiling, Loggia of Psyche

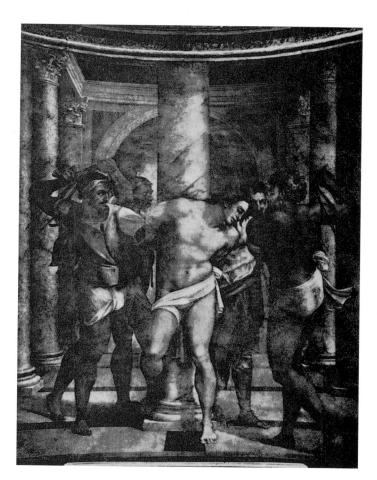

17.75. SEBASTIANO DEL PIOMBO. *Flagellation*. 1516–21. Fresco. Borgherini Chapel, S. Pietro in Montorio, Rome. Commissioned by Pierfrancesco Borgherini

seen his style in the *Transfiguration* (see fig. 17.62). The unusual coloristic passages in the back of one of the Graces must have come from Raphael's brush, which doubtless intervened at crucial moments again and again in works being painted by his pupils.

Within eight years after the completion of the last paintings in the Farnesina, Raphael, Chigi, and Leo X were in their tombs and, as we shall see, the world in which they moved had been swept out of existence. Sebastiano del Piombo's *Flagellation* in San Pietro in Montorio (fig. 17.75), begun in 1516, admits us to a darker world of experience to which we will soon become accustomed, as it was to be the scene of daily existence for much of central Italy for decades. Christ, based on a drawing by Michelangelo requested by Sebastiano, is tied to a column that stretches outside the limits of the picture and that appears to grow from the altar below. The mural exploits the curve of the chapel wall, making the wall itself disappear and leaving the marmoreal figure, painted with a mastery of anatomy, to be assailed by figures who appear to have sprung from the columns. This

powerful conceit, which converts a painting into a work of sculpture and projects Christ's suffering in three dimensions, returns us to the personality of Michelangelo, then absent in Florence. After Raphael's death, about which his contemporaries wrote as if it were the death of a saint, no one in Rome could continue in his vein. Other tendencies and ideals replaced the harmonies of Raphael, while impressive developments were taking place in the Florence of Michelangelo or the Venice of Giorgione and Titian.

Properzia de' Rossi

The only woman to receive her own biography in Vasari's Lives is an exceptional artist from Bologna named Properzia de' Rossi (c. 1490-1529 or 1530); in addition her likeness was memorialized in a woodcut portrait surrounded by a decorative mannerist frame designed by Vasari. Properzia's frame features flaming lamps at the top as symbols of inspiration, and the allegorical figure of La Scultura, with mallet and chisel, vigorously carving a bearded head. This is appropriate, for Properzia's fame was as a sculptor. Unfortunately she died young, and the only sure work in marble by her hand is a relief for the Cathedral of Bologna representing the Old Testament story of the Chastity of Joseph (fig. 17.76). Vasari also explained that Properzia was especially famous for her miniaturized carvings on fruit stones such as peach pits, and eleven of these, carved front and back, are thought to survive mounted in an elaborate silver filigree decoration in the Museo Civico in Bologna. We should be careful not to denigrate the carving of peach pits as unimportant or superficial, for in the sixteenth century this was a respected skill, as is clear from Vasari's discussion; such works are a reminder of the many activities of Renaissance artists that went beyond the painting, sculpture, and architecture so singlemindedly emphasized in modern scholarship. Vasari also reported that Properzia was active in copperplate engraving (we know that she trained with one of the most important engravers of the day, Marcantonio Raimondi) and that Vasari personally owned some of her drawings and her portrait, given to him by some of her friends. It was presumably on this that Vasari based the woodcut portrait in the *Lives*. Vasari stated that Properzia's reputation in Bologna was high, writing that "her fellow-citizens... regarded her as one of the greatest miracles produced by nature in our days."

Vasari wrote that Properzia's interpretation of the *Chastity* of *Joseph* was inspired by her unrequited love for a handsome young man; whether this is the case or whether it is merely a local tale or one of Vasari's inventions is unknown. Properzia's relief emphasizes the contrast between the voluptuous, eager wife of Potiphar and Joseph's determination to escape, which is conveyed not only by the forcefulness of his movement but also by the sweep of his drapery. In an amazing passage, Vasari hinted at the therapeutic value of making art, stating that by creating the relief Properzia "had partly quenched the raging fire of her passion." Vasari continues to report that through the machinations of a rival male sculptor, Properzia was paid poorly for her work and prevented from gaining more commissions for the Cathedral.

Vasari began his life of Properzia with the statement that "It is an extraordinary thing that in all those arts and all those exercises wherein at any time women have thought fit to play a part in real earnest, they have always become most excellent and famous in no common way, as one might easily demonstrate by an endless number of examples." This is a remarkable statement for the Renaissance period, when the organization of society was such that few women were able to achieve the training necessary to function as artists in a discriminating and competitive arena. Vasari then proceeded to list famous ancient and Renaissance women who were accomplished in war, poetry, philosophy, oratory, grammar, the sciences, and letters. Like so many Renaissance women, Properzia had been trained in music as well as in art.

In the 1550 edition Properzia is the only woman artist mentioned in the *Lives*, but in the 1568 edition Vasari incorporated into Properzia's short life remarks on other women artists: Sister Plautilla; Madonna Lucrezia, the wife of Count Clemente Pietra; and Sofonisba Anguissola of Cremona (see figs. 19.39, 19.40). He concluded with a quote from Ariosto's contemporary epic *Orlando Furioso*: "Women have been excellent in every art they have tried."

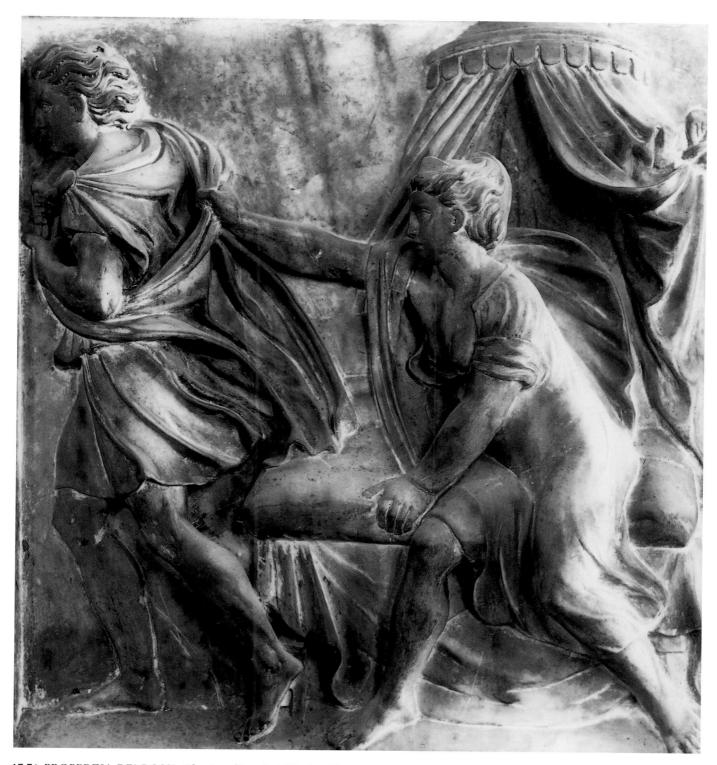

17.76. PROPERZIA DE' ROSSI. Chastity of Joseph. 1520s. Marble. Museo di San Petronio, Bologna. Originally carved for the portal of San Petronio (for earlier examples of this decorative project see figs. 7.27–7.30)

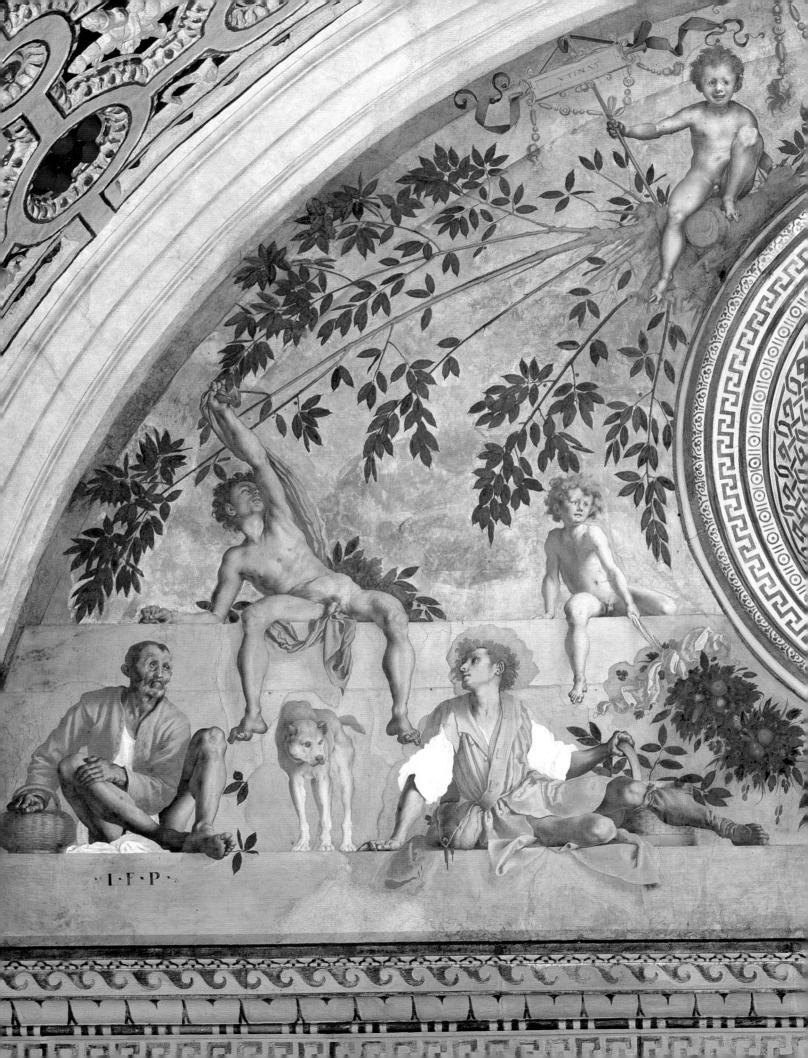

HIGH RENAISSANCE AND MANNERISM

n the history of writings on Italian art, no development has caused so much confusion as the fluctuating reputations—what in Italian is called "la fortuna critica," the critical fortune—of the artists at work in central Italy following the High Renaissance. No other phase of Italian art is so difficult to fit into the historical evolution we have grown to expect from the earlier developments from Late Gothic to Early Renaissance to High Renaissance. It is likely that the changes in art after the High Renaissance are in part a reflection of the difficulties of Italian Cinquecento history. In keeping with the tenets followed throughout this book, an attempt will be made to interpret intellectual concepts and artistic events in terms of history, but first it will be necessary to examine the nature and origin of the much-discussed terms "Mannerism" and "maniera."

A glance at the illustrations in this chapter as compared with those in the two preceding ones should persuade the reader that something strange has happened. These pictures, statues, and buildings no longer fit the ideals of the High Renaissance. When artists and writers of the seventeenth and eighteenth centuries examined the tensions and distortions, the visual and emotional transformations of the years around 1520, they characterized these developments as a decline and referred contemptuously to what they called the maniera (manner). This is derived from the Italian word mano (hand), and the word maniera was chosen because it signifies the ascendancy of manual practice—and especially the art of drawing-over the visual observation and intellectual clarity of the High Renaissance. The assertion that there had been a post-High Renaissance decline in central Italian art persisted throughout the nineteenth century; the decline was generally attributed to the excessive imitation of Michelangelo, the pernicious influence of Giulio Romano, or both.

Shortly before World War I, in an artistic atmosphere charged with revolutionary developments that overturned traditional Western aesthetic precepts, the works of artists active c. 1520 that had been condemned or ignored for more

than three hundred years began to excite interest. The phenomenon was not unlike the revival of such once-forgotten artists as Botticelli in the 1880s or Piero della Francesca about 1900, but this revival was complicated by the difficult and even contradictory nature of the material.

The first twentieth-century scholars who discussed the period paralleled the anti-academic manifestos of the early twentieth century to the positions taken by Pontormo, Rosso Fiorentino, and others against the principles of Michelangelo and Raphael. They named this phenomenon "Mannerism," and the post–High Renaissance generation of artists was thus dubbed Mannerists. The expression was fraught with danger, since "mannerist" and "mannerism" describe something quite different from the startlingly original works of art under discussion. Some writers argued that Mannerism was a new period between the High Renaissance and the Baroque, forming a Hegelian succession of thesis, antithesis, and synthesis.

Like all intellectual abstractions imposed upon the events of history, the concept of Mannerism had an effect beyond the history of art. As a result of the attempt to define the principles of Mannerist style and apply them to the analysis of literature and music, and even of life and behavior, Shakespeare became a Mannerist, and Hamlet and Queen Elizabeth I became Mannerist characters. Recent critics have reacted against such ideological excesses and have instead drawn attention to the coexistence of High Renaissance and Mannerist artists in the same artistic center at the same moment. They have emphasized the difficulty of forcing the painting of the Venetians or the architecture of Palladio into the Mannerist mold, and have pointed out the discrepancy between the artistic generation of about 1520 and the artists of the second half of the Cinquecento in Florence and Rome. Some writers have recommended complete abandonment of the word "Mannerism," a losing battle considering all the ink that has been spilled in the past eighty years.

One sensible course might be to recall that diametrically opposed styles, sometimes as many as three at once, coexisted

at other periods in Italian art, as was the case, for example, during the period covered in Chapters 13 and 14, or even, for that matter, during the Early Renaissance itself. The term "Mannerist" will be used in the following pages, not because it is any more accurate than "Gothic," let us say, as an art historical term, but because it has become so deeply embedded in our experience that we cannot just forget about it. Misnomer though it may be, the term "Mannerism" is doubtless here to stay. Although they are included here under the broadly defined category of Mannerism, those court artists of the second half of the Cinquecento whose style is indeed mannered (see Chapter 20) are referred to in this book as representatives of a particular subcategory of Mannerism called the *maniera*.

As we look back on the history of Italian art, we note that its chief sources of power were found in the republics and the Church, not solely because these were the patrons who could commission the most ambitious works of art, but also because they constituted the social forces that sustained and, to a degree, inspired the artists. Throughout the Renaissance both Church and republics came under intermittent but sometimes fierce attack. Nonetheless, they resisted and survived, and some of the crucial manifestations of Italian art (the Early Renaissance in Florence, the High Renaissance in Florence and Rome) owe much to the role and patronage of these institutions.

In Chapter 17 we have already had some insight into the dangers posed to the papacy during Leo X's tenure as pope. The state of affairs in Florence, meanwhile, was equally unfortunate and was bound in time to grow worse. Since their expulsion in 1494, the Medici had been scheming to return, and their reinstatement in 1512 followed the sack of nearby Prato by Spanish troops under Julius II and the expulsion of Piero Soderini, who fled into exile. While Julius II lived, the Medici ruled Florence again in the mild government of Giuliano, youngest brother of Cardinal Giovanni. Giuliano believed in control from behind the scenes, in the traditional manner of the Medici, leaving the framework of the Republic externally intact, but Giovanni's elevation to the papacy as Leo X in 1513 brought about a sharp change. He replaced Giuliano with their nephew Lorenzo, who entertained sterner ideas. In 1516 the pope, having driven out the rightful duke of Urbino, invested Lorenzo with the duchy. To the great distaste of the Florentines, Lorenzo maintained a ducal splendor in their midst and behaved as if he were duke of Florence. Leo X used Lorenzo as a pawn in his dynastic ambitions and married him off to a French royal princess, but the princess died in childbirth in April 1519, and six days later Lorenzo followed her to an early grave. The direct male line of Cosimo de' Medici was thus extinct.

For four years, power in the Florentine state was exercised by Leo's cousin, Cardinal Giulio de' Medici, still without disturbing the now-sham Republic. Leo X's death in 1521 brought a non-Italian pope to the chair of St. Peter, a pious and learned Dutchman who, as Adrian VI, made a sincere effort at internal reform. He ejected the entourage of Leo X, including the artists, and all artistic projects in the Vatican came to a halt. After less than two years, Adrian died suddenly, under general suspicion of poison. Giulio de' Medici was elected Pope Clement VII and continued to control the Florentine Republic. It was not long before the Florentines realized that, under the Medici popes, they had lost not only their internal liberties but also their external independence. From a position as one of the proudest of the medieval republics and the founder of the idea of liberty in modern times, Florence had sunk to the status of a captive province of the papacy. Commercial activity stagnated, and so did morale. Money and power were now centered in Rome.

Michelangelo 1516 to 1533

In the midst of this discouraging picture, Michelangelo reappeared in Florence at the end of 1516 to carry out an important commission, Pope Leo X's project for a facade for San Lorenzo. This Medicean church had become more important than ever as a symbol of dynastic power now that the head of the family was a duke, and it became even more so once he was allied with the royal family of France. In the year of his death, Giuliano da Sangallo, now well over seventy, submitted several drawings of alternative projects for the façade. One remarkable design (fig. 18.1) masked Brunelleschi's clerestory and the lateral chapels along the side aisles with a two-story temple, flanked by freestanding bell towers topped by tiny cruciform temples ending in pyramids, crosses, and orbs. The central pediment would have bristled with sculpture, notably a statue of the seated Leo X flanked by saints, as if in an altarpiece. In both the central façade and the corner towers, the superimposed engaged colonnades would have culminated in square piers at the corners. Although the campanili recall those designed for St. Peter's by Bramante (see fig. 17.12), Giuliano's do not taper upward. Moreover, his Doric order is imitated almost exactly from one he had drawn from the ancient Roman Basilica Emilia. In all these respects, his drawing was followed by his younger brother Antonio in the campanili and interior of the Madonna di San Biagio at Montepulciano (see figs. 11, 18.58, 18.60) only a few years later. But Giuliano's grand design misses the point of High Renaissance composition not only because the mullioned windows are an anachronism recalling the Palazzo Medici and its successors, but also because the effect is a cumulative one, derived from multiple, superimposed elements, rather than from the principle of unified dynamic growth that infused the architecture of Leonardo and Bramante.

The commission instead went to Michelangelo, who for three years worked on plans for the façade, which he

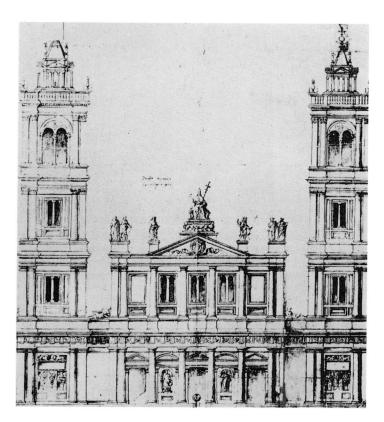

18.1. GIULIANO DA SANGALLO.

Design for the façade of S. Lorenzo, Florence. 1516. Drawing. Gabinetto dei Disegni e Stampe, Uffizi Gallery, Florence. Commissioned by Cardinal Giulio de' Medici on behalf of Pope Leo X de' Medici

intended, in his own words, to be a "mirror of architecture and sculpture of all Italy." His planned two-story structure, almost freestanding, was to include twelve standing statues in marble, six seated ones in bronze, and fifteen reliefs. Michelangelo spent many months quarrying the marble, first at Carrara, then at Seravezza, within the boundaries of the Florentine Republic. To reach the new quarries of the latter, he had to build a road through the mountains. Although we know too little about the final projected appearance of the façade, the wooden model built to Michelangelo's specifications still exists (fig. 18.2). Within its dense and compact structure of interlocking elements, the statues and reliefs must have been intended to jut forth from the niches and frames, imparting a passionate interplay of masses and of lights and darks. Michelangelo's sculptural ideas, expressed in drawings and in lost models for the statues, must have had an overwhelming effect on his Florentine contemporaries.

Suddenly, in March 1520, the contract for the façade of San Lorenzo was annulled and the marbles abandoned, to Michelangelo's violent indignation. The reason, however, is not hard to find. The death of Lorenzo in May of 1519 had deprived the façade of its principal *raison d'être* and the money was needed for another project, the tomb chapel for the two dukes, Lorenzo and Giuliano (who had died in 1516), as well as for the two brothers who may conveniently be called the Magnifici, Lorenzo the Magnificent (died 1492) and Giuliano (murdered in 1478). According to a document,

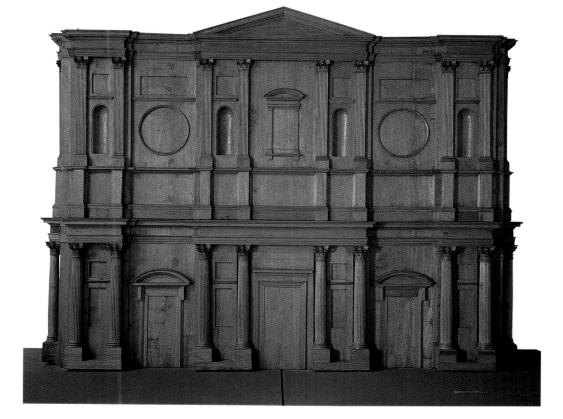

18.2. MICHELANGELO.
Model for the façade
of S. Lorenzo, Florence. 1517.
Wood, 7' x 9'4"
(2.1 x 2.8 m).
Casa Buonarroti, Florence.
Commissioned by Cardinal
Giulio de' Medici on behalf

of Pope Leo X de' Medici

plans for the funerary chapel (fig. 18.3) were divulged in secrecy by Cardinal Giulio to a canon of San Lorenzo in June 1519, less than a month after Lorenzo's death. Construction began in November 1519, and Michelangelo was the architect from the start. He was apparently asked to build on a plan that would be a twin to Brunelleschi's sacristy on the left side of the transept (see figs. 3, 6.7, 6.8). The windows on the exterior of the Medici Chapel, however, which harmonize with those of the sacristy, do not always correspond to those on the interior, for Michelangelo arranged the lighting to produce a subdued, all-over illumination essential for the prevailing mood of his architectural and sculptural compositions.

The work progressed irregularly and was never completed. Some of the sculptures were never finished, others never started. Nevertheless, the Medici Chapel is the only one of Michelangelo's architectural-sculptural fantasies to be realized in anything approaching entirety. The tombs and their sculptures must have been designed rapidly, because by April 1521

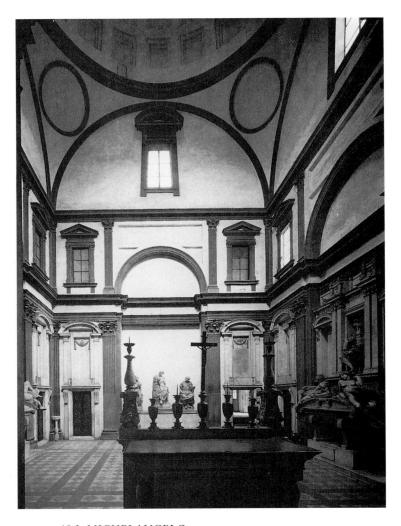

18.3. MICHELANGELO.Medici Chapel, S. Lorenzo, Florence. 1519–34. Commissioned by Cardinal Giulio de' Medici, who later became Pope Clement VII

Michelangelo was in Carrara with measured drawings, ready to order the marble blocks. Letters and sketches indicate that at first a large, freestanding monument was planned, with one tomb on each of its four sides, but the final arrangement placed the two dukes in wall tombs and relegated the Magnifici to a third wall (fig. 18.3), under the statues of the Madonna and Sts. Cosmas and Damian. This wall was never completed: the *Medici Madonna* (see fig. 18.6) was left unfinished, and the statues of the patron saints were eventually made by pupils.

During the pontificate of Adrian VI no marble was shipped, but early in 1524, a few months after the accession of Clement VII, the blocks began to arrive in Florence. By March 1526 four statues were almost finished, and in June two more were begun and one was ready to start; the only other important figures that were planned were four river gods to go in front of the tombs; these were never started but are known from drawings and a model. By June 1526 Clement's political machinations had involved the papacy beyond rescue, and hostilities broke out between the pope and Emperor Charles V. In September the Vatican and St. Peter's were attacked and plundered by the Colonna party, and in January 1527 the pope ordered the fortification of Rome against the imperial forces. Early in the morning of May 7, 1527, began the terrible sack that seems to have put an end to the High Renaissance, or what was left of it, in Rome. After months of unspeakable horror—looting, burning, rapine, torture, murder, desecration the pope, a prisoner in Castel Sant'Angelo since June, escaped and fled to Orvieto. Many statesmen, scholars, and members of the general populace felt that this humiliation was the judgment of God for the paganism of Medicean Rome.

In the contemporary sources, four intertwined themes can be distinguished: a deep sense of collective guilt, a desire for punishment, a need for healing the wounds inflicted by punishment, and a longing for a restoration of order in which individuals would no longer be free to seek their own destruction. But some of these themes date from before the Sack of Rome. Itinerant preachers had long predicted the ruin of the Church, and years earlier Machiavelli had declared in Florence that "the nearer people are to the Church of Rome . . . the less religious are they. And whoever examines the principles upon which that religion is founded and sees how widely different . . . its present practices and application are, will judge that her ruin or chastisement is at hand. . . . The evil example of the court of Rome has destroyed all religion and piety in Italy."

Not until October 1528 was the pope able to return, poverty-stricken, to his burned-out and half-depopulated capital. Florence, meanwhile, had thrown off the Medici yoke for the third time and reestablished the Republic. But in 1530 Florence was captured by a combination of papal and imperial forces, in an alliance that would force despotism on

most of Italy. The new Medici governor of the city gave orders for Michelangelo's assassination because the artist had aided the Republic in fortifying itself against invasion. The canon of San Lorenzo hid the artist until the pope issued an order sparing Michelangelo so that he might continue work on the Medici Chapel. This proceeded in a desultory fashion, interrupted by the artist's trips to Rome. Aided by Emperor Charles V, Clement installed Alessandro, probably the illegitimate son of Lorenzo, but widely believed to be the son of the pope himself, and known for his vices and his cruelty, as the first hereditary duke of Florence. When the pope died in 1534, Michelangelo was in Rome and was unwilling to risk his life to the limited mercies of Alessandro. Not even after the duke's assassination in 1537 would he return to Florence, and not until 1545 were the statues placed on the tombs by Michelangelo's pupils. Only those of the dukes were completed to the penultimate details, and the four statues of the Times of Day still show passages of rough marble.

In his architectural formulation Michelangelo added an extra story to the Brunelleschian scheme, perhaps in part to

raise the windows, the principal sources of illumination, above the neighboring housetops. In his pietra serena pilasters, however, he maintained a close correspondence to Brunelleschi's norms. The coffering of the Pantheonlike dome, bare and white today, was originally ornamented in color by Giovanni da Udine, Raphael's specialist in decoration, but Clement had the decorations whitewashed. The traditional two-tone architecture of pietra serena and white is set in opposition to a second marble architecture, richly carved and polished; this is ostensibly enclosed by the first yet it refuses to remain within its enclosures. Incommensurate in style, character, substance, proportion, and scale with the first architecture, the second consists not only of the tombs with their statues but also of the flanking tabernacles, which are of unprecedented shape and still-enigmatic purpose. These protrude so far beyond the pilasters that they nearly meet at the corners, in front of the imprisoned Corinthian capitals of the primary scheme.

The sarcophagi of the dukes (figs. 18.4, 18.5) have arched tops supporting reclining male and female figures representing

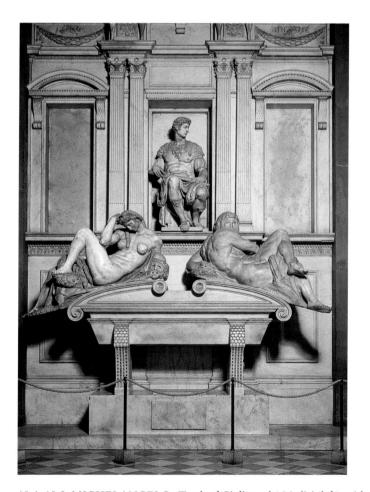

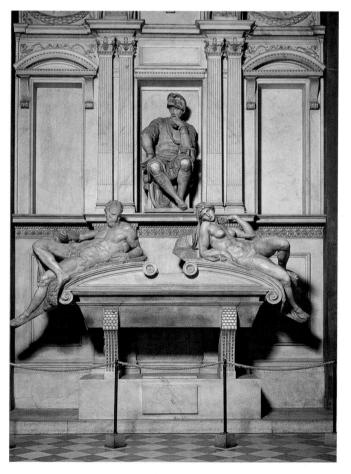

18.4, 18.5. MICHELANGELO. Tomb of Giuliano de' Medici (left), with allegorical figures of *Night* and *Days*. Tomb of Lorenzo de' Medici (right), with allegorical figures of *Dusk* and *Dawn*. 1519–34.

Marble, height of seated figures approx. 5'10" and 5'8" (1.8 and 1.7 m). Medici Chapel, S. Lorenzo, Florence

Night and Day, Dawn and Dusk. The dukes, shown as young men in Roman armor, sit in niches in the second story. The often-heard criticism that the Times of Day appear to be slipping off the sarcophagi would be less justified if the river gods, intended to lie on a platform just off the floor, had been executed, for they would have completed a roughly circular composition of figures. Michelangelo's figures tend to outgrow their enclosures (think of the steady expansion in size of the figures of the Sistine Ceiling), and one can watch the continuous increase in size of the Times of Day throughout the sketches for the ducal tombs.

On a sheet of studies for architectural details in the chapel, Michelangelo wrote the following: "The heavens and the earth, Night and Day, are speaking and saying, We have with our swift course brought to death the Duke Giuliano; it is just that he take vengeance upon us as he does, and the vengeance is this: that we having slain him, he thus dead has taken the light from us and with closed eyes has fastened ours so that they may shine forth no more upon the earth. What would he have done with us then while he lived?"

Michelangelo did not follow his own notes literally, because the eyes of all the figures save those of Night are wide open. Under a sketch for the third wall, then planned to contain the tombs of the Magnifici and the Medici Madonna, he wrote: "Fame holds the epitaphs in position; it goes neither forward nor backward for they are dead and their working is finished." That the ducal statues were not intended to be recognizable portraits of the bearded Medici dukes is again shown by Michelangelo's words, recorded by a contemporary: "He did not take from the Duke Lorenzo nor from the Lord Giuliano the model just as nature had drawn and composed them, but he gave them a greatness, a proportion, a dignity . . . which seemed to him would have brought them more praise, saying that a thousand years hence no one would be able to know that they were otherwise." Roman armor was appropriate to captains of the Roman Church, which the dukes were, and even more so to Roman patricians, a rank conferred on Lorenzo and Giuliano in a ceremony on the Capitoline Hill in 1513 that was complete with Roman trophies, Medici symbols, personifications of the rivers Tiber and Arno, and an altar at which Mass was celebrated.

In the chapel the statues of the dukes, as well as the priest behind the altar, gaze toward the *Medici Madonna* (fig. 18.6). She is represented as the *Virgo lactans*, or nursing Virgin—the oldest and one of the most persistent motifs in Michelangelo's art (see fig. 16.31). *Day* and *Dusk*, both male, face the Virgin and Child; *Dawn* and *Night*, both female, turn from them (see figs. 18.4, 18.5). *Dawn* is characterized as a virgin, with firm, high breasts; *Night*, whose abdomen and breasts are distorted by childbirth and lactation, as a mother. In the Virgin Mary these two states are united.

The celebration of the Mass of the Dead (which in the late seventeenth century was still being celebrated in the chapel four times daily) is the central energizing principle of the chapel. The celebrant was probably to have looked up from the *Virgo lactans* to a fresco of the Resurrection in the nowblank lunette. Such an image would have been required by the dedication of the chapel to the Resurrection, and the theme of the Epistle for the Mass of the Dead is the Resurrection. One drawing on the subject by Michelangelo (fig. 18.7) corresponds to the shape of the lunette and can be connected with no other commission. After the darkness of his Passion and death, Christ leaps from the tomb. He is totally nude, as always in Michelangelo's Resurrection drawings.

Suggestions locate frescoes of the Attack of the Fiery Serpents and the Delivery by the Brazen Serpent, for which an otherwise unexplained Michelangelo drawing survives, over the ducal tombs. But in neither sketch does the Brazen Serpent itself appear, probably because it foretold the cross, and the crucifix on the altar would have fulfilled that function. The papal bull Exsurge, Deus, launched against the Lutherans by Leo X on June 15, 1520, while Michelangelo was at work on plans for the Medici Chapel, may shed light

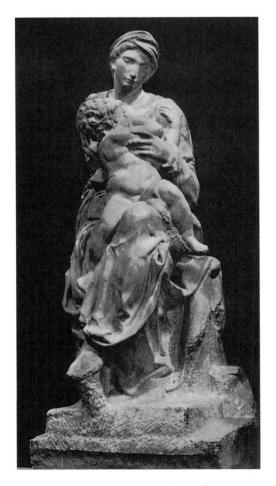

18.6. MICHELANGELO. *Medici Madonna*. Designed 1521; carved 1524–34. Marble, height 99¹/₂" (2.5 m). Medici Chapel, S. Lorenzo, Florence

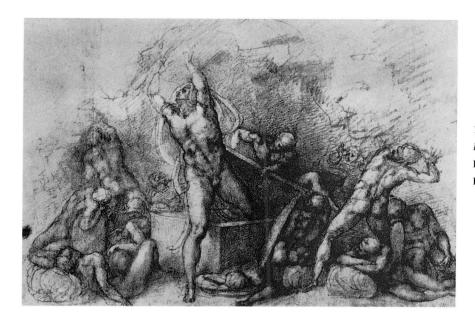

18.7. MICHELANGELO.

Resurrection. 1520–25(?).

Black chalk, 9½ x 135/8" (24 x 35 cm).

Royal Library, Windsor

on the iconography of the chapel: "Arise, O God, and judge Thine own cause . . . rise up, O Peter . . . defend the cause of the Holy Roman Church, mother of all Churches . . . there rise up lying teachers, introducing sects of perdition . . . whose tongue is fire, restless evil, full of deadly venom . . . they begin with the tongue to spread the poison of serpents." Leo's appeal to the Resurrection was personal, for he was crowned on Easter Sunday.

The never-completed river gods may represent the rivers of paradise or their significance may have been geographic, since Vasari, who was one of Michelangelo's assistants in the chapel, remembered that Michelangelo "wished all the parts of the world were there."

The compositions of the two ducal tombs are opposites in subtle and significant ways. While *Giuliano* (see fig. 18.4) is characterized as open and cheerful, *Lorenzo* (see fig. 18.5) is closed, moody, self-contained, and deserving of his nickname, *Il Pensieroso* (The Thinker). *Giuliano* idly holds several coins, as if in intended largesse; *Lorenzo* plants his elbow on a closed money box, decorated with a fierce mask. Light plays freely on the face of *Giuliano*, but *Lorenzo*'s is enshadowed by his helmet and half-hidden by his hand.

Giuliano and Lorenzo, while related to some of the types and poses of the Sistine Ceiling, are less massive and energetic. A strange lassitude overcomes both, and it is perhaps worth remembering that while at work on the statues, Michelangelo, then only in his late forties, wrote that he was already old, and that if he worked one day he had to rest four. Their shoulders slope, muscles sag, hands hang heavily. The drowsy face of Giuliano (fig. 18.8) is drained of the fire and conviction of the David, let us say, or the prophets of the Sistine Ceiling. Although the Times of Day are extremely muscular—the pulsating masses of Day's gigantic back surpass anything that Michelangelo had achieved earlier in the

projection of male musculature—they either writhe in helpless involvement with their own limbs or droop in painful weariness. The male faces are unfinished. *Day*'s is merely blocked out, but in the rough surfaces of *Dusk*'s sad head some have discerned Michelangelo's own disfigured face.

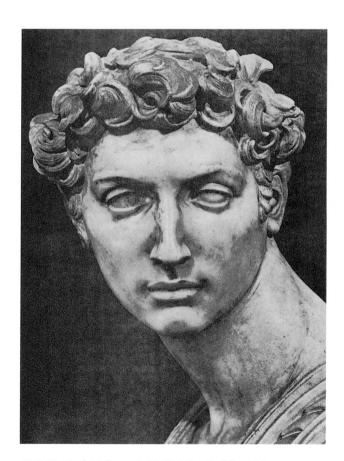

18.8. Head of Giuliano de Medici, detail of fig. 18.4

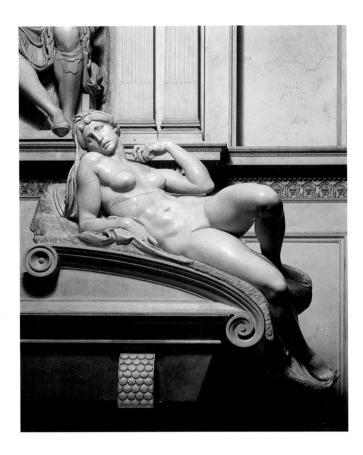

18.9. MICHELANGELO. *Dawn*, on the Tomb of Lorenzo de' Medici (see fig. 18.5), Medici Chapel. Designed 1521; carved 1524–34. Marble, length 81" (2.1 m)

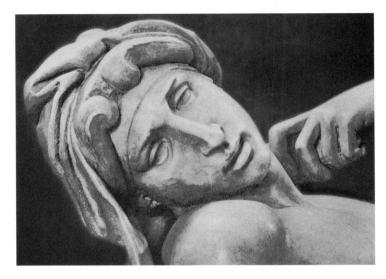

18.10. Detail of fig. 18.9

The finished—or almost finished—female faces are strangely ornamental and, although superficially unreal, nonetheless deeply poetic. *Night*, with her strongly Hellenic nose and not quite closed eyes, a star caught in the crescent of her diadem, dreams fitfully of her lost children. The tragic *Dawn* (figs. 18.9, 18.10), her brows knitted in a shape recalling the facial structure of the Italo-Byzantine Madonnas of the Duecento, seems to be grieving over her childlessness.

Michelangelo's mighty female forms were done from male models, and many male studies for the figure of *Night* are preserved; the female breasts seen in the finished sculpture do not appear in the studies. The ornamental shapes of thighs, shins, and ankles carry the taut arcs of the sarcophagi into the figural masses. The *Medici Madonna* (see fig. 18.6) was reshaped many times and cut down in the process; the lower portions reveal the original scale of the group. Although the deeply meditative face of the Virgin and the muscular body of the Child never received their final polish, Michelangelo's use of the three-toothed chisel gives these passages an atmospheric quality, as if seen through a veil of haze.

The total effect of the sculpture is disturbing, and so are the details of the ornament. The leering mask, symbol of false dreams—for which Michelangelo cut away the original left arm of *Night* and started a new one twisted behind her shoulder—brings into larger focus the tiny, snarling masks of the frieze that runs behind the Times of Day, suggesting that death is a nightmare from which we will awaken. The architecture of the chapel, the mood of its statues, and its personalized decorative motifs had an immediate and profound effect on contemporary artists at work in Florence. In what has come to be known as the crisis of Mannerism, the Medici Chapel is a central monument.

While engaged in the carving of the statues for the Medici Chapel, Michelangelo was taking a radical step in the development of new architectural forms. A new library for San Lorenzo, to house the Medicean collection of books and manuscripts, had been on Cardinal Giulio de' Medici's mind as early as June 1519, but the commission for the structure was only given to Michelangelo after Giulio became Pope Clement VII in November of 1523. The Laurentian Library had to be constructed as a third story on top of the monastic buildings connected with San Lorenzo. Construction began in 1524, was halted in 1526, recommenced along with the Medici Chapel after 1530, and was abandoned in 1534, when Michelangelo took up residence in Rome. In 1557 he sent a model for the staircase, but he never saw the building in its present form.

The entrance hall is startling (fig. 18.11). Its two tall stories are composed of superimposed orders of coupled Tuscan columns that ostensibly support the abbreviated entablatures

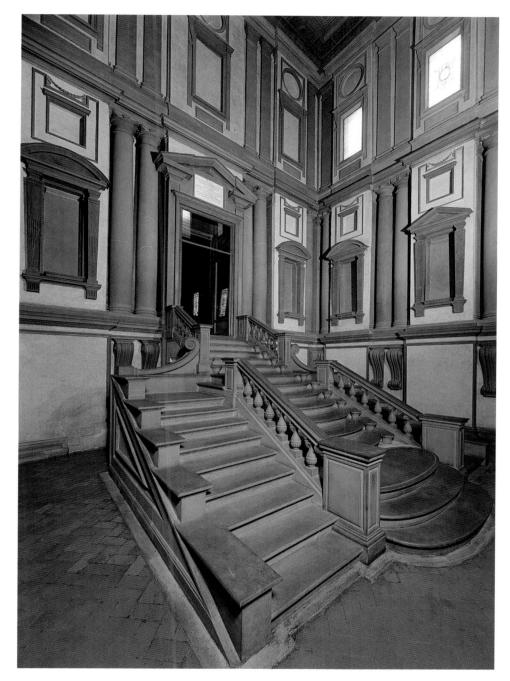

18.11. MICHELANGELO. Entrance Hall, Laurentian Library, S. Lorenzo, Florence. 1524–34; staircase completed 1559. Commissioned by Pope Clement VII

but in reality are recessed into niches in the wall, where they are flanked by pilasters. This extraordinary idea, which seems to have been developed from the walled-in pilasters in the corners of the Medici Chapel, suggests a reversal of the functions of wall and column. What is revived, on a grand scale and in architectural terms, is nothing less than the conflict between line and mass that we saw in Michelangelo's early sculpture. Mass protrudes into the space of the room, line cuts against it. Not since Minoan times had supports ta-

pered downward as these pilasters do, and never before had pilasters been cut into three unequal segments by variation in surface fluting. The staircase, whose design, we are told, came to Michelangelo in a dream, opposes ascending lateral flights with a descending central stair with bow-shaped steps that seem to push downward. Still today tourists generally pause before ascending, and most choose the outer stairs rather than moving against the downward cascade of the central steps.

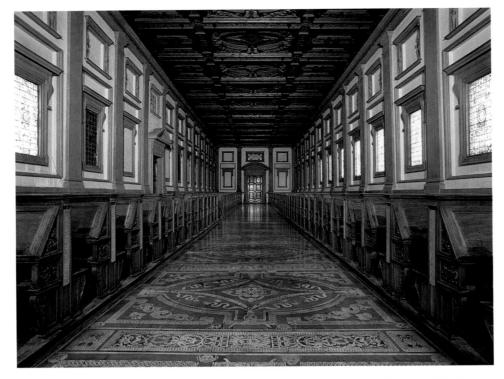

18.12. MICHELANGELO. Reading Room, Laurentian Library, S. Lorenzo, Florence. 1524-33

At first sight the long reading room looks more conventional (fig. 18.12). The pilasters support, the walls do not move inward, and there are no floating consoles. And then, as we analyze the structure and space, we come to realize that the battle is still on, and we are caught in it. Pilasters, ceiling beams, and floor patterns unite to produce a continuous cage of space in which the reading desks (also designed by Michelangelo) are trapped, two to a bay, and the observer with them. Similar linear refinements are elaborated in the windows and tabernacles, but the precision of ornament serves only to underscore the most disturbing aspect of the room—it has no reasonable focus or terminus. Since all the bays are identical, like cars in a train, the succession could contain two more or three less with no effect on the purely additive composition.

Today we see the Laurentian Library without its crowning feature, which would have completed the sequence of contrasting spatial configurations with a climax that might even be compared to the effect of Poe's "The Pit and the Pendulum." The parade of identical bays was to have led to one of the strangest spatial ideas of the Renaissance (fig. 18.13), a triangular rare-book room enclosing a maze of reading desks lit from concealed sources. In point of fact, the space available to Michelangelo between preexistent buildings outside was triangular, but another artist would probably have tried to cut the corners and fit a rectangle, or at most a circle, into the triangular shape. Michelangelo made a virtue of necessity. Alas, his rare-book room was never built.

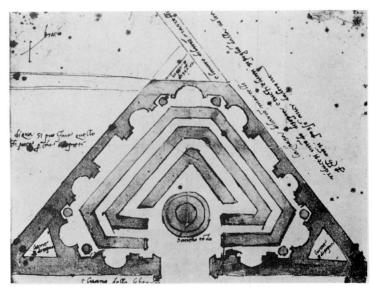

18.13. MICHELANGELO. Plan for Triangular Rare-Book Room of the Laurentian Library. 1525–26. Pen and ink, $8^{3/4} \times 11^{\circ}$ (22 x 28 cm). Casa Buonarroti, Florence

Four more *Captives* (two of which are reproduced here) and one *Victory* (see figs. 18.15–18.18) for the tomb of Julius II are preserved in Florence, and the most reasonable assumption is that Michelangelo set to work on them in Florence after all Medicean operations were suspended late in

1526. The most troublesome of the heirs of Julius II, Francesco Maria della Rovere, duke of Urbino, had recaptured his duchy after the death of Leo X in 1521 and was an implacable enemy of the Medici. As ally of the Florentine Republic, he passed through Florence twice during this period, and it can be assumed that he used his presence there to bring pressure on Michelangelo to complete the tomb. The Florence *Captives* are larger than those in the Louvre (see figs. 17.44, 17.45), but would certainly have been carved down, as was Michelangelo's practice with all statues.

The fourth project for Julius's tomb was formalized in a written contract in 1532. It called for a wall tomb (fig. 18.14) with the Moses still on the upper story and the pope reclining on a sarcophagus. The meaning of the tomb has changed since the earlier projects, for the idea of resurrection has been discarded; the *Captives*, like Atlas figures, support the cornice, straining under its enormous weight. The *Victory*, too, has changed its meaning. The youthful figure is engaged in subduing rather than liberating a captive. A revival of the old Psychomachia theme takes place not only in the *Victory* but also in the newly liberated Florence. Niccolò Capponi, *gon*-

faloniere of the Republic, asked the Florentines in 1527: "Do you hold dear the conquering of your enemies?... Then conquer yourselves, put down wrath, let hatred go, put aside bitterness." Speaking of the miserable state of the Medici pope, prisoner in Castel Sant'Angelo, he warned: "Not the words that are said, ignominiously or injuriously, against enemies, but the deeds that are done, prudently or valorously, give, won or lost, the victory." These words were delivered in the great hall of the Palazzo dei Priori, which still may have held the beginnings of the Battle of Cascina (see fig. 16.41) and certainly showed the unfinished Battle of Anghiari (see fig. 16.28). The following year, in the same place, Capponi pointed out that the Florentines triumphed without bloodshed, through the intervention of God: "To his divine Majesty, therefore, we have to lift the eyes of our mind, recognizing God alone as our King and Lord, hoping firmly in him, who has undertaken the protection of this city and state."

The twisted *Victory* group (fig. 18.15), one of Michelangelo's most original conceptions, is now tilted somewhat forward. Originally, the young hero stopped his struggle to look upward toward heaven, drawing with one hand the mantle,

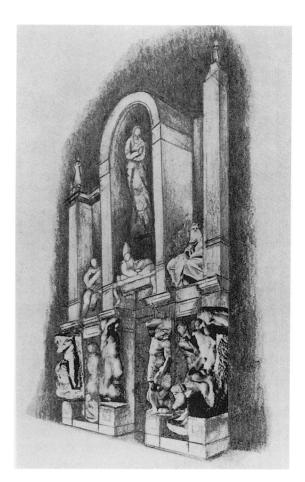

18.14. MICHELANGELO. Tomb of Pope Julius II.Proposed reconstruction drawing of project of 1532.Compare with the earlier versions of the tomb, figs. 17.21 and 17.42

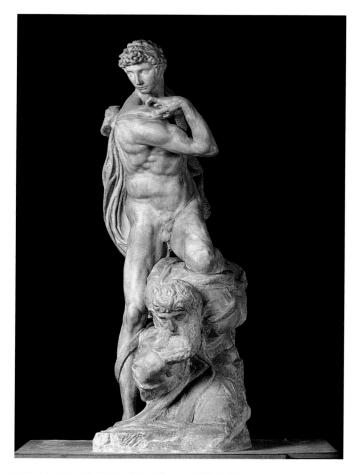

18.15. MICHELANGELO. *Victory.* 1527–28. Marble, height 8'6³/₄" (2.6 m). Palazzo Vecchio, Florence. Commissioned for the Tomb of Pope Julius II

symbol of heavenly protection, around him. Seen upright, the group loses its strained appearance and harmonizes with the architecture of the tomb for which it was designed (see fig. 18.14). Quite as important, it regains its lofty dignity—a kind of soaring quality, intended not only for its aesthetic result but also for its moral significance. The lanky victor is intent on communication with divinity, like an Abraham or a David. While the beard of the vanquished is largely uncut marble, elsewhere almost all the work with the toothed chisel has been completed. Here and there the muscled torso has received its finish. As in the related face of the *Medici Madonna* (see fig. 18.6), one sees the countenance of the *Victory* (fig. 18.16) as through a haze of chisel strokes. This figure, beautiful as a Hellenic warrior and sensitive as Donatello's *St. George*, remains one of Michelangelo's least understood creations.

It is unrealistic to guess at the order planned for the four *Captives* (figs. 18.17, 18.18) on the lower story of the tomb formalized in the 1532 contract. Some of the motifs may go back as far as the 1505 project (see fig. 17.21), notably the classical pose with legs crossed (fig. 18.17). When Michelangelo came to carve the statue, however, he made it writhe and twist in a new manner, transmitting the weight from the upraised left elbow through the body to the unaided left foot. To support this weight, the torso arches, the chest lifts as though in pain, and the bearded head is tilted back.

In all four *Captives* Michelangelo's chief interest lay in the torsos, which are, from the front at least, fully developed with the toothed chisel and lack only surface finish. Sometimes an arm or a leg is brought to a similar condition, but never a head. The heads remain either roughed in or, as in one strik-

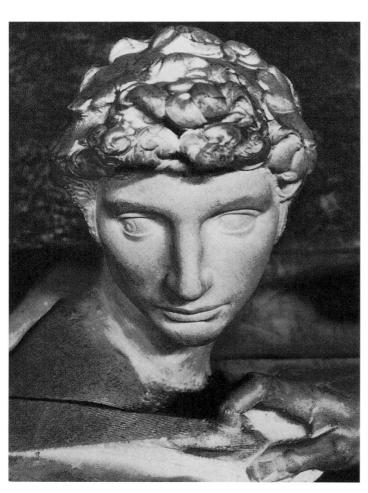

18.16. Head of Victory, detail of fig. 18.15

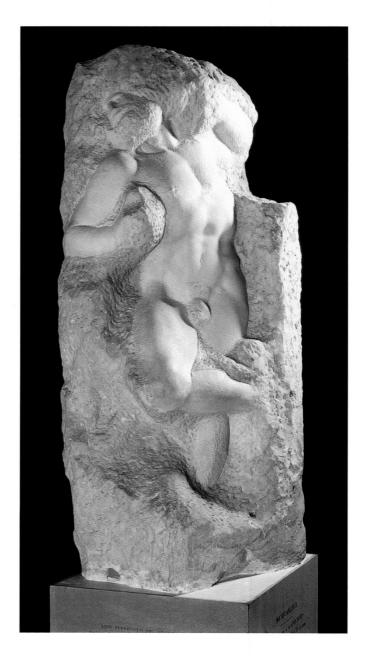

ing instance (fig. 18.18), still encased in the block, save for features faintly visible on one side as through a dense cloud of marble. Sometimes the statues have been started from two sides at once, sometimes from three, but in each case the back is still concealed within the block. One can usually follow the contours around the torso up to the point where the shape suddenly disappears. The vast areas of muscle and skin heave, swell, subside, or shine silkily against the drilled blocks of stone. Whatever might have been Michelangelo's conscious intent—he must have thought he would finish the statues—their present condition reveals essential aspects of his nature as well as the turmoil of the years during which he worked on them. To watch these giants struggle to free themselves from the surrounding marble has for four centuries been a strongly empathetic experience for viewers.

The unfinished portions of these *Captives* show the stages of Michelangelo's working practice. The marks of the drill used to define major elements can still be seen. Certain areas are roughed out with the pointed cylindrical chisel, while some surfaces have reached a somewhat higher state of completion under the strokes of the coarse, two-toothed chisel. A three-toothed chisel was used to add more detail, and it was with this tool that Michelangelo achieved the breathing, pulsating surface much praised by Vasari. The final surface finish would have been created with a file and the polishing with pumice and straw pads. That the *Captives* are so effective as works of art despite their unfinished condition suggests that Michelangelo worked in a manner that kept his need for expression always in the forefront.

18.18. MICHELANGELO. "Blockbead" Captive. 1527–28. Marble, height 8'7¹/2" (2.63 m). Accademia, Florence. Commissioned for the Tomb of Pope Julius II

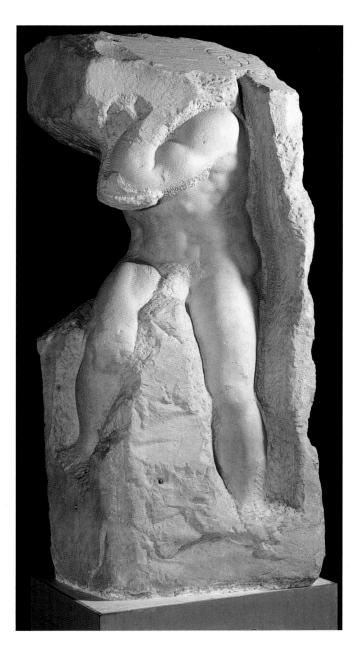

Andrea del Sarto

The absence of Leonardo, Michelangelo, and Raphael from Florence after 1508-9 left a clear field for other artists. One of these, Andrea del Sarto (1486-1530), sailed through Mannerism untouched by the disorders of the era. One senses in Andrea's early work echoes of Leonardo, Raphael, and Fra Bartolommeo, but it is the naturalism of Andrea's teacher Piero di Cosimo-in whose shop he remained from about 1498 to 1508—that is most evident in his frescoes of the life of St. Philip Benizzi. These are located in the atrium of the Santissima Annunziata, which had long been resplendent with Baldovinetti's light-filled Nativity (see fig. 12.33). Throughout the series, Andrea retained the sense of outdoor light and atmosphere seen in Baldovinetti's fresco; this was, in fact, suggested by the site itself, which was filled with sunlight. The fantastic landscape masses, jutting rocks, and trees in the Punishment of the Gamblers (fig. 18.19) obviously derive from Piero di Cosimo. A bolt of lightning severs the tree and kills the gamblers. The easy spaciousness of Andrea's landscape setting, with its continuous paths, distant mountains, and carefully observed clouds, submerges the welldrawn but somehow less-than-significant figures. His fresco surface, lightly and freely brushed, glows with flower tones against the blue-greens in the ascending landscape.

In the solemn *Annunciation* of 1512 (fig. 18.20), he adopts something of the measured dignity of the High Renaissance style, already practiced for several years by Fra Bartolommeo. The large-scale figures that almost fill the foreground are united with the remote distance by a well-constructed perspective. Mary stands before the Temple, and Gabriel unexpectedly approaches from the right. The broad, graceful figures and grand heads turn beautifully in relation to the distant perspective, whose apex is placed behind the head of a seated, almost nude figure. The deep blue sky, of almost Peruginesque clarity, harbors only an occasional cloud; from one of these descends the dove of the Holy Spirit. The reds, blues, and oranges of the color scheme offer a new richness in Andrea's style.

In 1514 he returned to the Annunziata to paint the *Birth of the Virgin* (fig. 18.21), which might be interpreted as a High Renaissance commentary on the diffuse miscellany of Domenico del Ghirlandaio's fresco on the same subject (see fig. 13.42). The patrician interior reflects the architectural ideals of Giuliano da Sangallo (see pp. 346–49), and the massive figures, echoing Raphael's Stanza d'Eliodoro and Michelangelo's Sistine Chapel, are united by the same kind of curving rhythm that in the St. Philip Benizzi series flowed through the landscape. The deep shadows of the mature Raphael have also made their way to Florence, which had generally remained impervious to Leonardo's mysterious *chiaroscuro*. The angels on their clouds above the bed canopy, joining the dancelike movement of the foreground figures, were derived from an engraving by the German artist Albrecht Dürer, while Joseph, in the center toward

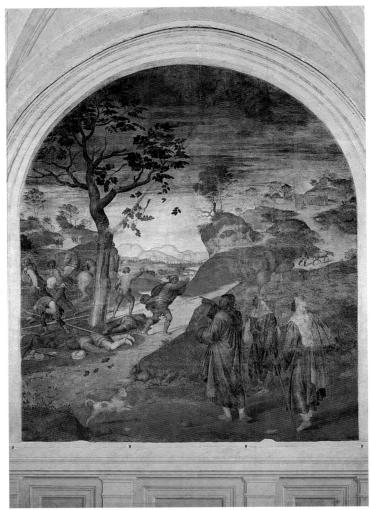

18.19. ANDREA DEL SARTO.

Punishment of the Gamblers, from the life of St. Philip Benizzi.
1510. Fresco, 11'9" x 10' (3.6 x 3 m).

Atrium, SS. Annunziata, Florence.

Commissioned by Fra Mariano, the church's sacristan

the back, is lifted in reverse from Raphael's portrait of Michelangelo in the *School of Athens* (see fig. 17.47). The incorporation of these motifs would have been understood at the time as an indication of Andrea's skill and creativity.

In the *Madonna of the Harpies* (fig. 18.22), Andrea has arrived at a noble statement of the Florentine version of Roman grandeur. Vasari explained that Andrea painted the St. John the Evangelist on the Virgin's left from a clay model by Jacopo Sansovino that the sculptor had submitted, in competition with Baccio da Montelupo, for the statue of the saint at Orsanmichele. But the real inventor of the figure was Raphael; Sansovino had merely reversed the philosopher holding a book, between Pythagoras and the portrait of Michelangelo, in the *School of Athens*. Since Raphael himself reused the figure in the *Galatea* (see fig. 17.69), these borrowings demonstrate the lack of any sense of personal ownership of a figural motif among High Renaissance artists, and their interest in extracting

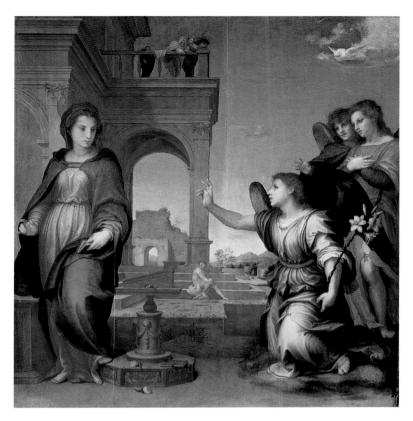

18.20. ANDREA DEL SARTO.

Annunciation. 1512.

Panel, 71½ x 71½ (1.8 x 1.8 m).

Pitti Gallery, Florence.

Commissioned for the Monastery of S. Gallo, Florence

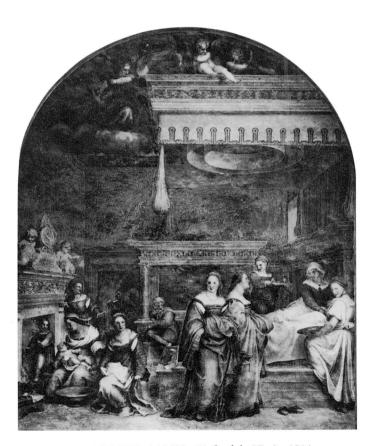

18.21. ANDREA DEL SARTO. Birth of the Virgin. 1514. Fresco, $13'5^{1/2}$ " x 11'4" (4 x 3.5 m). Atrium, SS. Annunziata, Florence

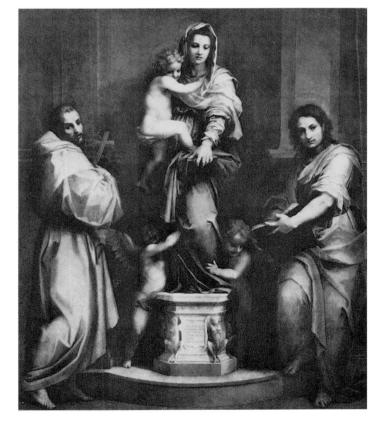

18.22. ANDREA DEL SARTO. Madonna of the Harpies. 1517. Panel, $81^{1}/2 \times 70^{\circ}$ (2 x 1.8 m). Uffizi Gallery, Florence. Commissioned for the high altar of S. Francesco in Via Pentolini, Florence, by the abbess

the maximum effect from a handsome invention. The influence of Michelangelo is evident in the increased dignity, even majesty, of Andrea's forms, in the severity of his architectural background, and in the sculptural roundness of his figures.

These various elements are assimilated by Andrea, whose altarpiece is, in the last analysis, wholly original. It is unified by his own sense of formal harmony and deep-toned color, as well as by his characteristic melancholy sweetness seen in the expressions of St. Francis and the Virgin. The harpies who guard her throne are doubtless there as leaders of souls to another world. The strong, simplified composition, the poise and counterpoise of masses, and the eloquence of figural style achieved by Andrea in this and other contemporary pictures gave him the leadership of Florentine painting toward the end of the second decade of the Cinquecento.

In 1523, with his wife, her daughter, and her sister, Andrea fled the plague, which had returned to Florence, for the healthful air of the Mugello. There, in 1524, in the village of Luco, he painted a *Lamentation* (fig. 18.23) that transforms grief into lyric exaltation. In deliberate reminiscence of a well-known composition by Perugino, the dead Christ is upheld in a seated position by John the Evangelist, while the Virgin holds his left hand and looks downward. Mary Magdalen, kneeling in prayer before the feet she once washed with her tears and dried with her hair, withdraws into meditation. This is not a historical scene, for Sts. Peter and Paul appear at the sides, and St. Catherine looks quietly from her kneeling position, her hands crossed on her chest.

The dedication of the church in Luco to St. Peter and the fact that its abbess was called Catherine account for the presence of these two saints. Christ's body is presented mystically in the form of the sacrament, and the chalice stands in the center foreground, covered by the paten or plate on which the Host appears, mysteriously erect. It is the Eucharist that draws the gaze of all the saints save John, who looks, as he was bidden, toward Christ's mother. Andrea's wife, stepdaughter, and sister-in-law posed for the Virgin, the Magdalen, and Catherine; the town of Luco appears in the background in the evening light. It is hard to explain the intimacy of this family-style Lamentation by any other supposition than the arrival in Florentine territory of the quietist doctrines of the Oratory of Divine Love. The sacrament, "source of light and heat," draws all to itself, and we are to forget the pathos of the darkened face of Christ as we contemplate his perpetuation in the shining wafer.

Andrea's huge Assumption of the Virgin (fig. 18.24) was painted for the Church of Sant'Antonio dei Servi in Cortona. Although, like so many of Andrea's Madonnas, this one is a portrait of his wife, there is an air of unreality about the picture. Mary, seated on clouds, her hands folded in prayer, is surrounded by sturdy putti. The light shines on the circle of saints, but then darkness closes in, the golden light fails, and we glimpse part of a rocky cliff in the background. The altarpiece combines clarity and dimness, substance and dissolution, reality and vision, in a manner that suggests the developments of the seventeenth century.

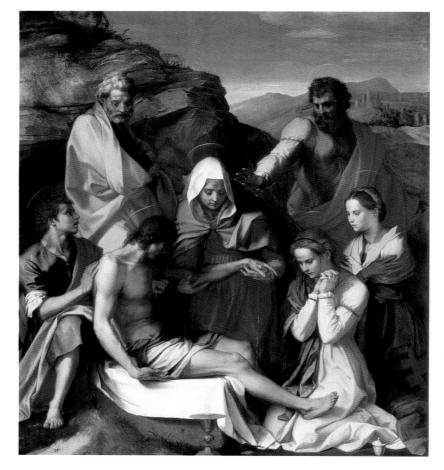

18.23. ANDREA DEL SARTO. *Lamentation*. 1524. Panel, 94 x 80" (2.4 x 2 m). Pitti Gallery, Florence. Commissioned by Abbess Caterina di Tedaldo for the high altar of S. Pietro in Luco, near Florence

Opposite: 18.24. ANDREA DEL SARTO.

Assumption of the Virgin. 1526–29.

Panel, 93 x 81" (2.36 x 2.05 m). Pitti Gallery, Florence.

Commissioned by Margherita Passerini for

Sant'Antonio dei Servi, Cortona

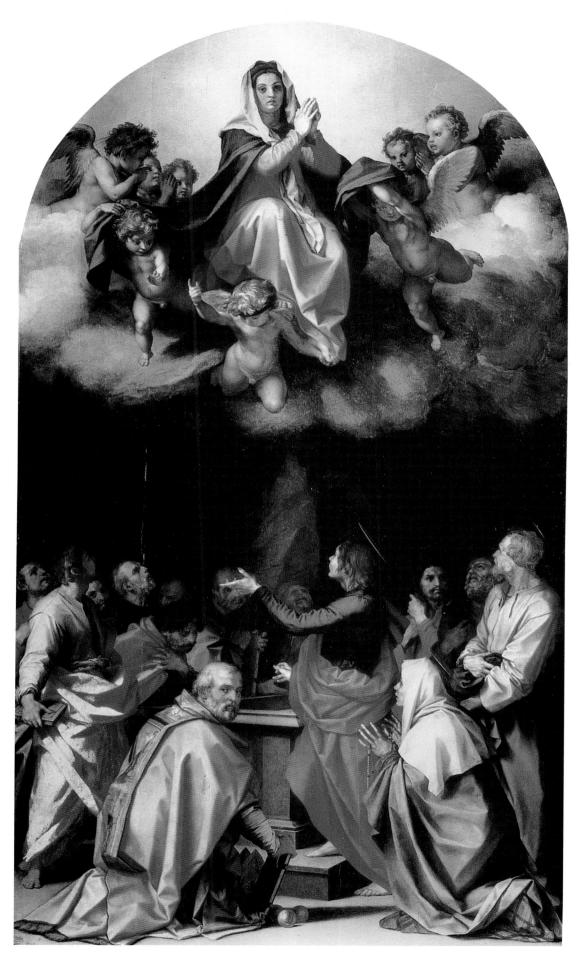

HIGH RENAISSANCE AND MANNERISM • 597

Pontormo

Andrea del Sarto remained a High Renaissance painter even in his most mystical phase, but his pupil Jacopo Carucci da Pontormo (1494–1557) is often identified as a Mannerist. Pontormo creates a world of fantasy and poetry that is unprecedented in the history of Italian Renaissance art.

As a youth of eighteen, according to Vasari, Pontormo studied with Leonardo da Vinci, Piero di Cosimo, and Andrea del Sarto in succession. Temperamentally, he was certainly closest to Piero, and indeed in his later years Pontormo was also to become a recluse, shutting himself away from the world in a studio accessible only by means of a ladder, which he could draw up after him. But even in his early works the strangeness of his style is evident. In his Visitation (fig. 18.25) in the atrium of the Santissima Annunziata, for example, Pontormo already transforms High Renaissance structure. At first sight his composition looks like an exaggeration of High Renaissance symmetry, for the main incident is centralized and the figures are neatly arranged within the architectural setting. But then, instead of balancing the woman seated on the stairs at the left with a similar motif at the right, Pontormo breaks the symmetry by introducing a naked boy who looks down at his left leg and seems to scratch it gently. This figure initiates a strong and unexpected lateral surge inward and upward along lines continued by the kneeling St. Elizabeth. The bright and sometimes jarring color combinations, based on those established in Michelangelo's Sistine frescoes-Elizabeth wears a golden yellow tunic with a sea green outer sleeve and a violet inner sleeve—heighten the unconventional figural composition.

One wonders why the *Visitation*, which took place in front of Elizabeth's house, should be staged in a monumental exedra at the apex of a pyramid of steps; there appears to be a ritual intention, for the setting draws attention to the apex of the arch where, instead of the expected semidome, we see the Sacrifice of Isaac between chanting putti holding urns of flowers. The Sacrifice of Isaac was traditionally held to foretell that of Christ, and its juxtaposition with the Visitation converts the prenatal meeting of Christ and St. John the Baptist into a prophecy of their martyrdoms.

A fuller expression of Mannerism is seen in Pontormo's contributions to the nuptial chamber of Pierfrancesco Borgherini in the Palazzo Borgherini (now Palazzo Rosselli del Turco), an example of Florentine High Renaissance architecture that still stands in Borgo Santi Apostoli. Pierfrancesco, a close friend of Michelangelo, ordered a series of paintings of the Story of Joseph from Andrea del Sarto, Pontormo, and two other painters that was to be incorporated into the wainscoting of the room. Pontormo's *Joseph in Egypt* (fig. 18.26) breaks with the High Renaissance in its crowds of nervous figures, statues pulsating on the tops of slender columns, uncertain and unprotected staircases spiraling to nowhere, broken and spasmodic rhythms, irrational light and space, and avoidance of

centrality, symmetry, or any other form of unifying compositional device. The picture splits up into little vignettes, some very close to us, some far away, yet without apparent connection, exploiting irrational jumps in scale, from Pharaoh's dream at the upper right, to the discovery of the cup in the center, to the reconciliation of Joseph and his brethren at the left.

Through the whole picture there runs a sense of terror. A center-background group of figures, clinging about a gigantic boulder, seems transfixed, as one is in dreams, by a power beyond comprehension or control; they have been interpreted in terms of the brethren's lament: "Why shall we die before thine eyes, both we and our land?" (Genesis 47:19). The relevance of the verse for contemporary Florentines, well aware that they had lost both freedom and independence, may not be accidental. The Germanic buildings in the background are derived from the engravings of Albrecht Dürer. Vasari, indeed, blamed Pontormo for having sacrificed Italian grace to Northern strangeness in his figures as well. The anxious boy in contemporary costume shown seated on the step in the foreground was identified by Vasari as Pontormo's pupil and adopted son, Agnolo Tori, called Bronzino (see Chapter 20).

A different mood is celebrated in the bucolic fresco Pontormo painted, probably in 1520–21, for the Villa Medici at Poggio a Caiano (fig. 18.27), built some forty years earlier for

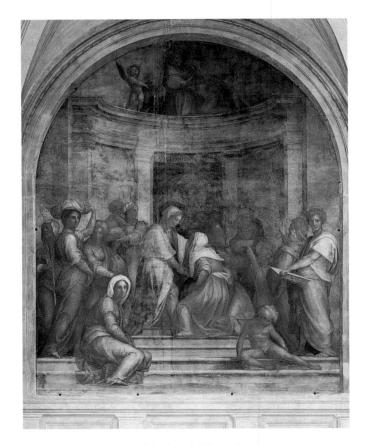

18.25. PONTORMO. *Visitation*. 1514–16. Fresco, 12'10" x 11' (3.9 x 3.35 m). Atrium, SS. Annunziata, Florence. Commissioned by the Servites of SS. Annunziata

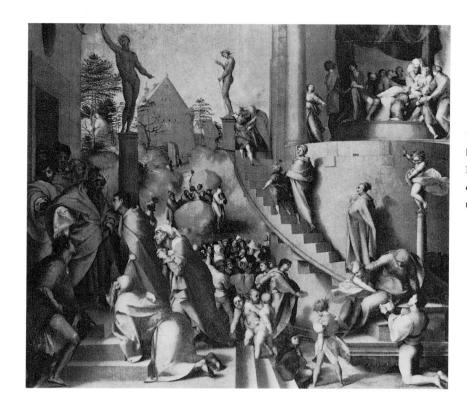

18.26. PONTORMO. *Joseph in Egypt.* c. 1518. Panel, 38 x 43¹/8" (96.5 x 109.5 cm). National Gallery, London. Painted for the nuptial chamber of Pierfrancesco Borgherini in the Palazzo Borgherini, Florence

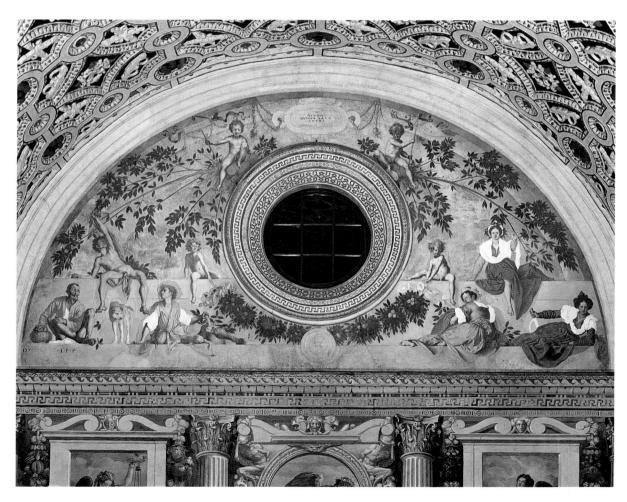

18.27. PONTORMO. *Vertumnus and Pomona*. Probably 1520–21. Fresco, 15 x 33' (4.6 x 10 m).
[®] Villa Medici, Poggio a Caiano. Commissioned by Cardinal Giulio de' Medici. For a view of the villa, see figs. 12.25, 12.26.

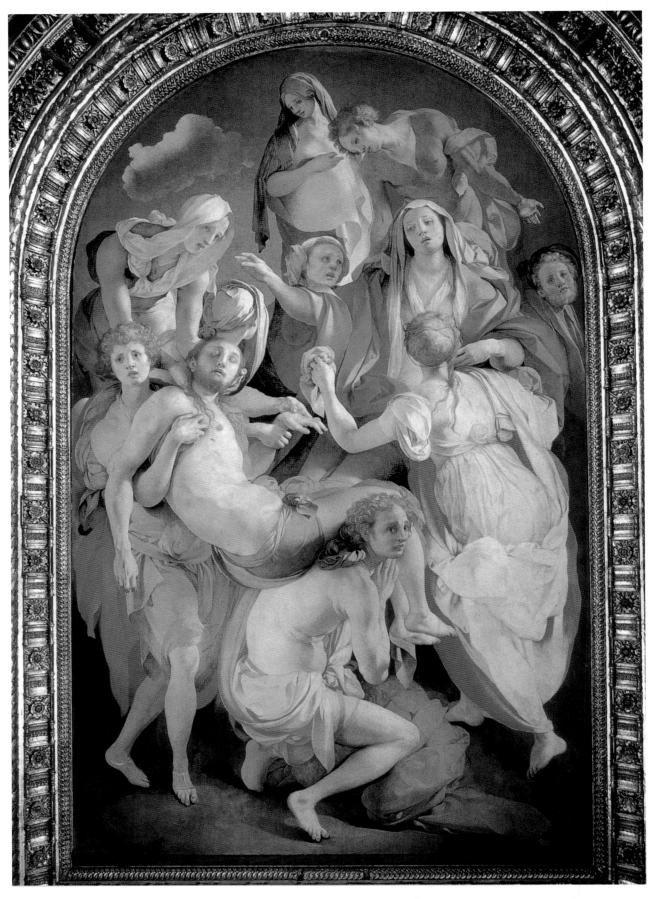

Lorenzo the Magnificent (see fig. 12.25). Leo X wanted the great hall decorated with classical subjects, and placed Cardinal Giulio in charge of the project at the same time that the cardinal was watching over the progress of Michelangelo's designs for the Medici Chapel. Andrea del Sarto and others were commissioned to paint the side walls and Pontormo the end walls, but at the death of Leo in 1521 the work was interrupted, not to be resumed until much later in the century. Of Pontormo's share, only one lunette was ever completed. Vasari wrote that the subject—Vertumnus, Roman god of harvests, and Pomona, goddess of fruit trees—was provided by the humanist Paolo Giovio.

The motto "GLOVIS" below the oculus was that of Lorenzo de' Medici, duke of Urbino, who died in 1519. Read backward, it comes out "si volge," or "it turns," a reference to the reversals of fate that characterized the history of the Medici. Another inscription, above the oculus, comes from Virgil's Georgics (I, 21), in which the gods are depicted in bucolic activities. Vertumnus and Pomona are united by the garland of fruits and vegetables under the window and by the laurel branches, symbols of Lorenzo, which seem to grow from its frame. While old Faunus, god of the woods, crouches in the left corner, Vertumnus turns to gaze at the beautiful Apollo seated on the low wall in a strikingly natural pose, reaching up to the laurel branches. Opposite him a clothed and chaste Diana holds a laurel branch. The content of Pontormo's lunette is close to that of an elegy that the poet Ariosto composed for Lorenzo.

The sunlit scene of this enchanted terrace is deceptive, for Pontormo's composition here challenges the unity and logic of the High Renaissance. The window frame becomes a base for the two uppermost putti, the ground is nonexistent, space is nowhere defined, the figures are poised on the horizontals as if balanced on wires, and the composition, on its three levels, is laced together by the laurel branches. Every seemingly relaxed pose is in reality tense when compared with the poses in Michelangelo's Sistine Ceiling or Raphael's Stanze. Where in Renaissance art have we seen a front view of a stretching nude youth (a god, no less!) with his legs spread wide, above a dog with its back arched, also stretching itself? The animal naturalism of such poses negates the idealism of the High Renaissance and, it should be noted, also precludes the possibility of easy motion developed in the fifteenth century. Figures and vegetation are fixed within a web of delicate color and convoluted linear patterns.

Pontormo's *Entombment* (fig. 18.28), the nucleus of the cycle of paintings for the Capponi family in their tiny chapel in Santa Felicita, is a work of poignancy and beauty, but is this an Entombment or a Deposition? There is no tomb, there are no crosses. Stranger yet, no clear demarcation separates earth from sky, and the only identifiable object in the background is a floating cloud. Like Andrea del Sarto's

Lamentation (see fig. 18.23), this is a meditative picture and its real subject is the Eucharist. Two unidentifiable youths carry the lifeless body of Christ while two women tend to Mary, who stretches out one hand above the shining body. The wounds, already washed, are barely visible. The figures ascend in the mysterious space like a fountain in a Renaissance garden, the spray wafted by the wind. Every motion is slow, dreamlike, unreal. At the top, St. John, the Beloved Disciple, bends over not through his own volition but as if carried by the now descending waters of the fountain and the arch of the frame, stretching out his hands toward the body. No one weeps. The faces betray either an intense yearning or a look of surprise.

The colors are derived in part from the Sistine Ceiling again, but here the pinks, sharp greens, pale but intense blues appear in improbable places, including what looks like the skin of the two youths but on inspection turns out to be tight-fitting leather jerkins. The effect is like colored lights playing over a fountain of figures. At the upper right, the young man with blond curls and beard, full lips, and wide-staring eyes (fig. 18.29) is Pontormo himself. In looking at that face one can understand why, as Vasari related, Pontormo walled up the chapel for three years and let no one enter while he painted so private a testament.

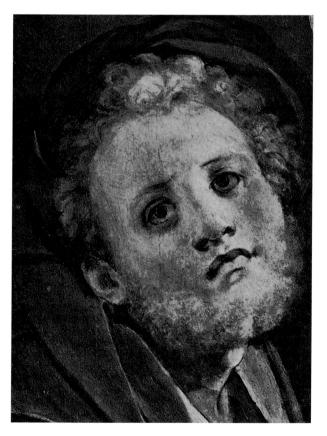

18.29. Self-portrait, detail of fig. 18.28.

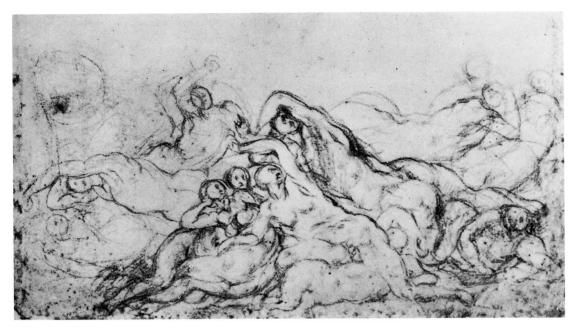

18.30. PONTORMO.

Study for Deluge Fresco for

San Lorenzo (portion of sheet).
c. 1546. Red chalk, whole sheet

16¹/₂ x 8¹/₂" (41.9 x 21.6 cm).

Gabinetto dei Disegni e Stampe,

Uffizi Gallery, Florence.

Commissioned

by Cosimo de' Medici

After the Capponi chapel Pontormo seems to have become morose and introverted. His *Last Judgment* frescoes (1546–51) for the chancel of San Lorenzo were destroyed in a later remodeling of the building. What we see in the drawings (fig. 18.30) is how the autonomy of the individual human figures is overwhelmed by the movement of the linear composition.

Rosso Fiorentino

Pontormo's contemporary Giovanni Battista di Jacopo is known to us by his nickname of Rosso Fiorentino (the redheaded Florentine; 1495-1540). Rosso's Assumption of the Virgin (fig. 18.31) is found, along with works by Baldovinetti and Andrea del Sarto, in the atrium of Santissima Annunziata. The foreground is crowded with the twelve apostles, wall-to-wall with no landscape background. Their massive cloaks collide and one falls over the edge of the frame to drop into the spectator's space. In the upper portion the Virgin is shown ascending so quickly that she will soon be out of view. She is enclosed within a ring of smiling putti, whose arms and clasped hands make a continuous circle in depth, their feet flying out as the ring revolves. All this takes place to the music of a lute and a flute played by angels below the Virgin's feet. To cap the climax, the putti who hold the girdle that Mary customarily drops to St. Thomas tie it in knots and tease him by dangling it in front of his nose! Note the strange and even disturbing expressions of the apostles.

Vasari related the pranks played by Rosso, especially the torments inflicted by his mischievous pet monkey on the monks of Santa Croce. Rosso did not abandon his practical jokes even when treating a subject as serious as the *Descent from the Cross* (fig. 18.32), but he also showed that he could raise these devices to the level of high tragedy. The figures stand out

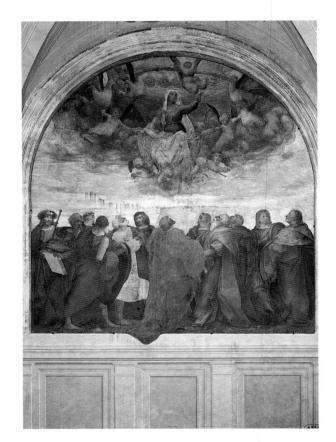

against the geometrical patterns of the cross and ladders, and all the forms are powerfully projected in a low side light. There is no center; as in the contemporary *Vertumnus and Pomona* lunette by Pontormo (see fig. 18.27), the composition weaves

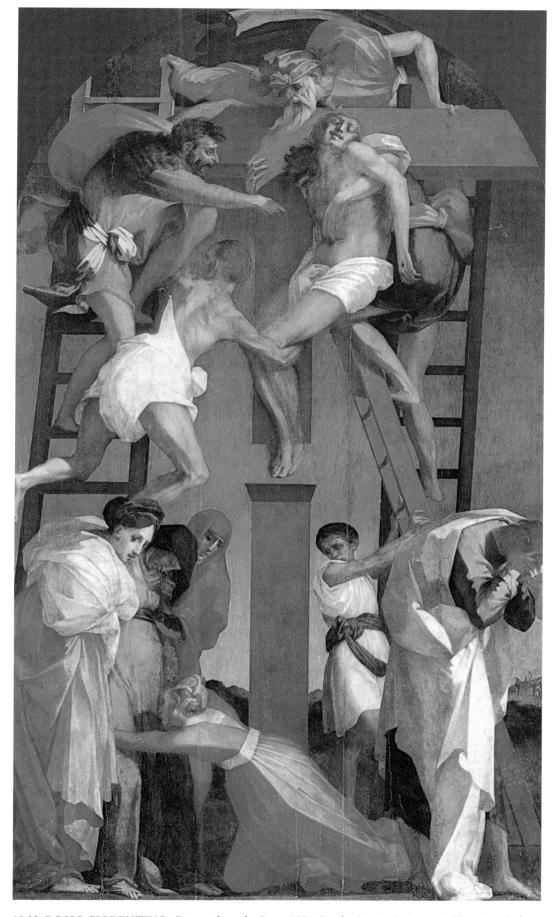

18.32. ROSSO FIORENTINO. *Descent from the Cross.* 1521. Panel, 13' x 6'6" (4 x 2 m). Pinacoteca, Volterra. Commissioned for the Chapel of the Compagnia della Croce di Giorno in the church of San Francesco in Volterra

a fabric of shapes that seeks the frame rather than the central axis. Again, as in Pontormo, the figures assume poses of the utmost extension or are cramped in postures from which they cannot move freely. But there the resemblance stops. Rosso's muscle-bound figures are hard, as if carved from wood, and their bodies and faces are formed of cubic shapes that relate to the planes of the cross and ladders. In the kneeling, stretching Magdalen under the cross, a knife-edge crease splits the figure into light and dark halves; to show that this is no accident, her belt is bent as it goes around the crease.

Other figures, however, are treated on a different principle. The beard of Joseph of Arimathea, who leans over the top of the cross, seems to be composed of twisted rags (fig. 18.33). John the Evangelist, turning away from the cross and covering his face with his hands, collapses into a bundle of cloth caught in the raking light. When we turn to the face of Christ, we find an unexpected smile.

Rosso went to Rome and was there to suffer severely during the Sack of 1527. His *Moses Defending the Daughters* of *Jethro* (fig. 18.34), whose pink and blue color scheme contrasts with its brutal subject, makes sense only as a comment on Michelangelo's *Brazen Serpent* spandrel (see fig. 17.41). Moses, flailing away with his fists, creates the apex of an apparently conventional High Renaissance pyramid

based on the prostrate Midianites. But the pyramid is dissolved and tied to the frame by a ferocious Midianite at the upper left and a provocative daughter of Jethro at the upper right, whose body is partially covered by drapery that reveals more than it hides. The foreshortened figures become almost abstract planes of tone, subdivided by the patches. Rosso fled from the horrors of the Sack of Rome and moved to France, where he and other Italian émigrés created a French version of the Mannerist style.

Perino del Vaga

The style of a third Florentine Mannerist, Piero Bonaccorsi, known as Perino del Vaga (1500/1–47), differs sharply from that of Pontormo and Rosso, possibly because of his association with Raphael in Rome. Perino bridges, in fact, the historical gap between the Roman High Renaissance and the *maniera*, the dominant style of the middle and late Cinquecento, of which he was one of the founders. After the Sack, he took refuge in Genoa. His *Adoration of the Child* (fig. 18.35) is a variant on the Nativity, although neither shed, manger, ox, ass, nor shepherds are present. Perino's signature and the date 1534 appear on the foreshortened tablet in the foreground—a device borrowed from Albrecht Dürer. The Christ

18.33. Head of Joseph of Arimathea, detail of fig. 18.32

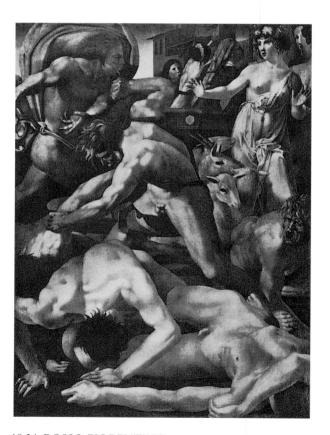

18.34. ROSSO FIORENTINO. Moses Defending the Daughters of Jethro. c. 1523. Canvas, 63 x $46^{1/2}$ " (1.6 x 1.2 m). Uffizi Gallery, Florence

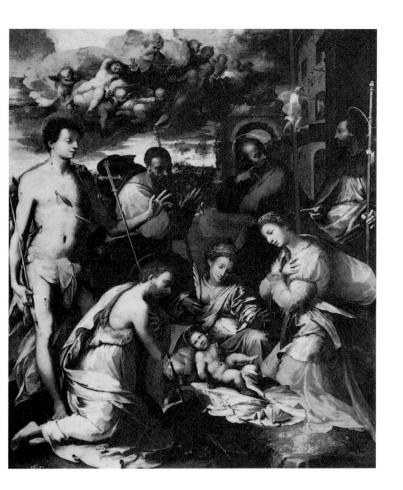

Child, whose pose is derived from one of Michelangelo's nudes in the Sistine Ceiling, looks and points toward John the Baptist. The cloud-borne God the Father at the top of the picture is accompanied by child-angels, and around the Child and Mary stand or kneel six saints, only one of whom, Joseph, was present at his birth. Sebastian on the left and Roch on the right were protectors against the plague; John the Baptist (adult here, but traditionally only three months older than Christ), Catherine of Alexandria, and James the Greater were possibly required by the patrons. The languid grace and sensuous flesh of Sebastian, who toys with an arrow, and the smooth shoulder of John the Baptist contrast with the dense draperies that conceal the female bodies. Acute preciosity and metallic brilliance of color are combined with chiaroscuro derived from Raphael's latest works. A shaft of light at the upper right strikes a male figure from whose right hand dangles a slaughtered lamb, a symbol of Christ's sacrifice.

Perino's cycle of frescoes for the Palazzo del Principe in Genoa was painted somewhat earlier. The most surprising is the *Fall of the Giants* (fig. 18.36), an enormous ceiling

18.35. PERINO DEL VAGA. Adoration of the Child. 1534. Panel, transferred to canvas, 9'1/4" x 7'31/8" (2.74 x 2.21 m). National Gallery of Art, Washington, D.C. (Kress Collection). Commissioned by the Basadonne family for Sta. Maria della Consolazione, Genoa

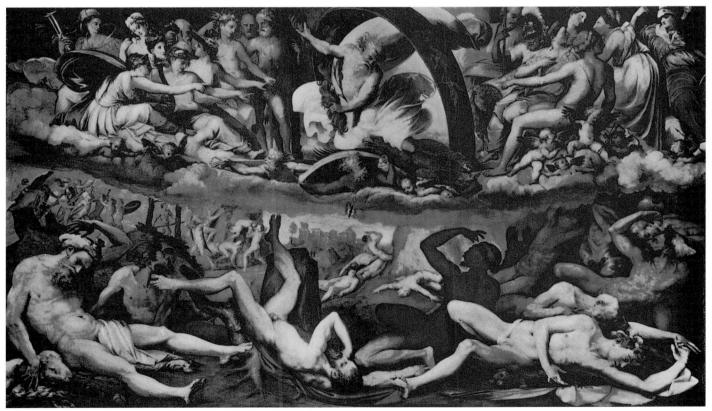

18.36. PERINO DEL VAGA. Fall of the Giants. Begun c. 1529. Fresco, approx. 21 x 30' (6.4 x 9.2 m). 🗎 Palazzo del Principe, Genoa. Commissioned by the Doria family

painting. The subject, a typical Mannerist invocation of political authority, invites comparison with Giulio Romano's illusionistic treatment of the same theme (see fig. 18.70). Both may have been suggested by the arrival of Charles V in Italy in 1530. He landed in Genoa, where he was greeted with cries of "Long live the emperor of the world!" Jupiter, whose face is almost identical with that of God the Father in the Basadonne altarpiece (see fig. 18.35), brandishes his thunderbolt from the foreshortened circle of the zodiac, surrounded by Perino's typically sensuous deities. Meanwhile, the rather weak giants pile up on the ground in dreamlike attitudes, nerveless before the thundering king of the gods.

Domenico Beccafumi

The Sienese Domenico Beccafumi (1485–1551) can be compared to Pontormo in the sensitivity, poetry, and careful

craftsmanship of their pictures. The traditional Sienese grace of line and surface and delicacy of color continue—but at high intensity—in Beccafumi's paintings. His Stigmatization of St. Catherine (fig. 18.37) might at first glance be taken for a High Renaissance work, but it shows many traits that we call Mannerist. Its symmetrical format goes back to Perugino, the grand simplicity of the architecture is in keeping with Bramante's noble style, and the softening effects of the chiaroscuro recall Leonardo's sfumato. And then differences appear. The floor patterns are so pervaded by shifting lights as to offer no rational successions. The two foreground piers are so closely associated with the flanking St. Benedict and St. Jerome that piers and figures seem to merge; the bases of the piers are replaced by the feet of the saints, while the folds of the saints' habits suggest less the shapes of their bodies than the rigid verticals of the piers. The arches, pendentives, and vaults (in Italian vele, or veils)

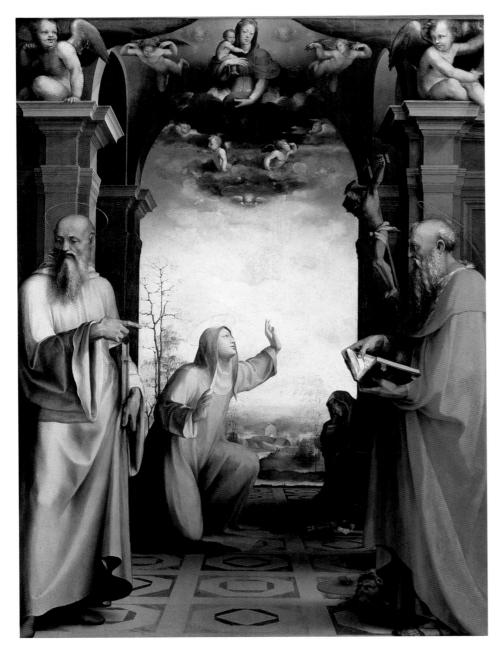

18.37. DOMENICO BECCAFUMI.

Stigmatization of St. Catherine. c. 1518.

Panel, 80³/₄ x 61¹/₂" (2 x 1.56 m).

Pinacoteca, Siena.

Commissioned for the Benedictine

Convent of Monte Oliveto, near Siena

become veils or curtains upheld by putti that dissolve to admit the apparition of the Virgin and Child. The clouds fade into the haze that conceals the sky, and this, in turn, blends into the ground mists floating upward from the hillocks and valleys of the landscape.

A High Renaissance artist would probably have placed the main figure in the center, but Beccafumi shows St. Catherine kneeling on the left. Awaiting the stigmata, she raises her hands in a manner that continues the orthogonals of the cornices and the arms of the cross, and thus lines that should recede into space are transformed into a diagonal in a single plane. At the same time the orthogonals of the floor, instead of carrying our eye, as Raphael's do, to a clearly seen horizon, lead us into impenetrable mist, and that mist, rather than any person or object, occupies the center of the composition.

Features are brilliantly modeled, but their shadows are murky. Drapery masses shine like flames, but while the edges are clear enough, the exact shape of any fold is not. Things and beings lurk in the shadows—St. Catherine's lily and book, St. Jerome's lion. In this language of diaphanous color and tremulous line, Beccafumi seems to be telling us that all substance is an illusion, that earthly reality will vanish into the shadows and luminous mist. Not only does he transform substance, he also annihilates space. The predella (fig. 18.38) shows St. Catherine as unwilling to approach the altar because of her sense of unworthiness. Yet she is miraculously given Communion by an angel, and once again the space is pervaded by an otherworldly light.

Beccafumi's huge *Fall of the Rebel Angels* (fig. 18.39), still unfinished, was apparently rejected by its patrons at the Church of San Niccolò del Carmine, who then required Beccafumi to paint a second version which is still in the church (fig. 18.40). An examination of the two versions suggests that one problem must have been the representation of

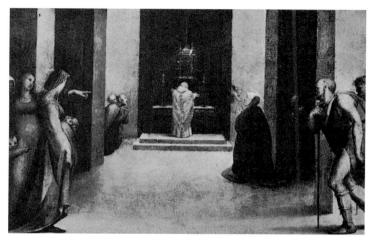

18.38. DOMENICO BECCAFUMI.

Communion of St. Catherine, on the predella
of the St. Catherine altarpiece (see fig. 18.37). c. 1518.

Panel, 12 x 17¹/₄" (30.5 x 43.8 cm). Pinacoteca, Siena

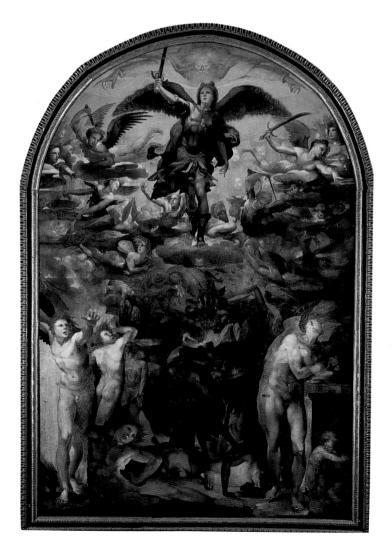

18.39. DOMENICO BECCAFUMI.

Fall of the Rebel Angels (first version). c. 1524.

Oil on panel, 11'4¹/₂" x 7'4" (3.5 x 2.2 m). Pinacoteca, Siena.

Commissioned for the Church of San Niccolò del Carmine, Siena

God the Father. In the first version, he seems an afterthought. Half lost in the mist above St. Michael, his head is foreshortened and his arms are squeezed in along the inner curve of the arch; the picture would have been quite complete without him, and the difference in finish between Michael and God also suggests that the latter was a last-minute addition. Perhaps Beccafumi somehow misunderstood the requirements of the commission and neglected to figure God into his original composition. Another possibility is that the increasing threat of the Reformation and its criticism of the Catholic emphasis on saints led the monks to request that God, who was not traditionally represented in this scene, be added. Whatever the scenario, the first version, with its rather spectral representation of God, was unacceptable; in the second, majestically enthroned, robed in a brilliant red, and adored by ranks of angels, he dominates the event with appropriate authority.

Beccafumi provides us with two different versions of hell. In the original version, all is chaos. St. Michael, his spread wings flickering with peacock eyes, brandishes his sword while in the clouds about him other angels flail away at the rebels. At the bottom of the picture, near the observer, hell opens. Pale, nude fallen angels, mostly wingless now, twist

and turn in agony, gesticulate and cry out, and fall to the ground writhing as the heat torments them. In a manner unprecedented in Italy, Beccafumi allows us to look into the phosphorescent lights of hell.

In Beccafumi's second version, the light effects, being brought to completion, are even more impressive. The terror of the fire is somewhat in the distance, seen through arches to left and right, but in the foreground center a sudden burst of fire illuminates a terrifying mouth, complete with curling tongue and broken teeth, and the foreshortened, grasping claw of a terrible monster.

When the second version was updated with a new marble frame in 1688, the five predella panels praised by Vasari became unnecessary. Three are lost, but two scenes from the legend of St. Michael survive (figs. 18.41, 18.42). In what is probably the leftmost predella, the sixth-century Pope Gregory I is shown leading a procession during an outbreak of the plague; as he crossed the Tiber he looked up to see Michael standing atop the Mausoleum of Hadrian. The archangel then sheathed his sword to indicate that the epidemic, God's punishment on a sinful humanity, would be stopped; henceforth the mausoleum became known as the

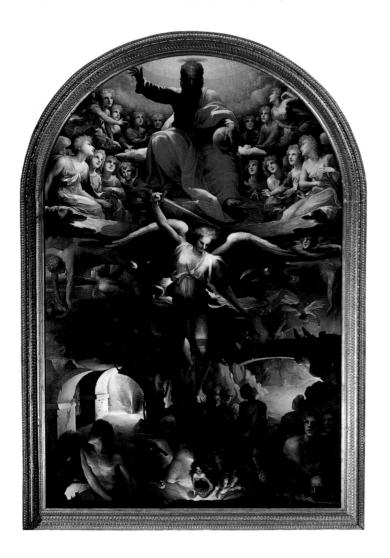

Fall of the Rebel Angels (second version). c. 1528. Oil on panel, 11'4¹/2" x 7'4" (3.5 x 2.2 m). ☐ Church of San Niccolò del Carmine, Siena. Of this picture Vasari wrote: "The Sienese painter Baldassare Peruzzi never tired of praising this picture, and one day when I was passing through Siena, as I was looking

18.40. DOMENICO BECCAFUMI.

and one day when I was passing through Siena, as I was look at it with him, I myself was amazed at both the altarpiece and the five small stories in the predella, which are executed in tempera in a most judicious and beautiful manner."

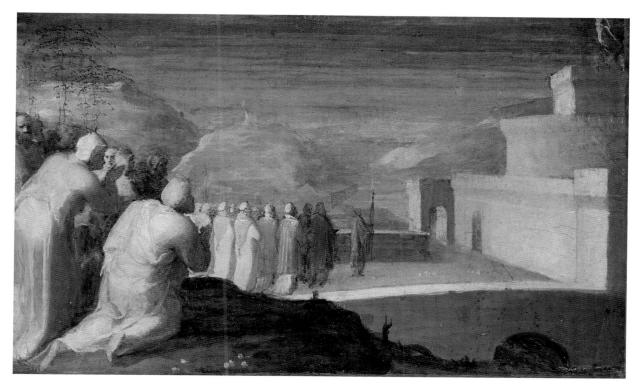

18.41. DOMENICO BECCAFUMI. The Appearance of St. Michael on the Castel Sant'Angelo. c. 1528. Tempera on panel, 9 x $14^{1}/4$ " (22.9 x 36.2 cm). Carnegie Museum of Art, Pittsburgh. Commissioned for the Church of San Niccolò del Carmine, Siena

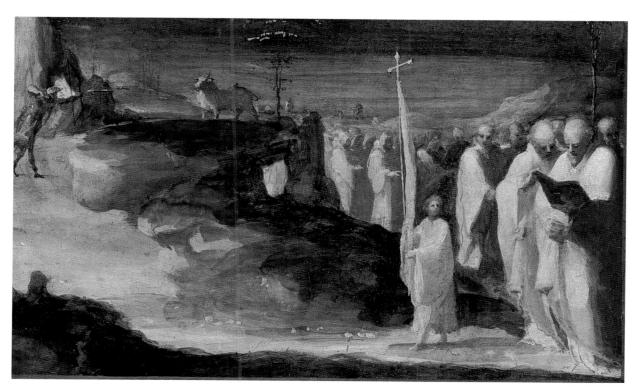

18.42. DOMENICO BECCAFUMI. *The Miracle of St. Michael on Mt. Gargano.* c. 1528. Tempera on panel, $8^{7/8} \times 14^{3/8}$ " (22.5 x 36.5 cm). Carnegie Museum of Art, Pittsburgh. Commissioned for the Church of San Niccolò del Carmine, Siena

Castel Sant'Angelo and a statue of Michael was placed on the top. The scene in the second surviving predella panel explains how a famous pilgrimage site, a cave on Mt. Gargano in southern Italy, became sanctified to St. Michael; a hunter's arrow shot at a bull reversed direction to hit the hunter, after which the archangel Michael appeared and asked that this spot be consecrated to him. The procession winding up the path indicates that the consecration is about to take place. Vasari mentioned these predella panels when they were still a part of the altarpiece complex, saying that they were "executed in tempera in a most judicious and beautiful manner."

The medium of these predella panels is most unusual, for here Beccafumi has abandoned the oil he used for the two versions of the altarpiece for the old-fashioned, less flexible medium of tempera. The tempera is not used in a traditional manner, in careful layers to build up deep effects of color. Rather here it is applied loosely, almost like thin washes, and Beccafumi has also returned to the use of the white highlights that were common in tempera painting before the dark shadows of Leonardo's *sfumato*. But why use tempera in such a new and novel manner? Beccafumi had recently visited Rome; while there he may have seen the newly discovered ancient Roman frescoes in the Baths of Titus; his predella panels look less like earlier tempera works than like ancient frescoes. Even the yellow-pink-green color scheme is reminiscent of these models.

Correggio

The contrast between High Renaissance and Mannerist tendencies that characterizes Florence and Siena in the early Cinquecento separates in a similar way Correggio and Parmigianino, two artists from the city of Parma. The youthful works of Antonio Allegri, known as Correggio (c. 1489-1534) from the northern Italian town of his birth, were deeply influenced by Leonardo, whose ideas he absorbed secondhand. In 1518 Correggio arrived in Parma, where he appears to have fallen under the spell of the Roman High Renaissance, again not from originals but from drawings and engravings. He may also have seen paintings by Raphael in Bologna and in Piacenza (the Sistine Madonna was then in Piacenza; see fig. 17.54). Sixteenth-century writers assert that Correggio never went to Rome, but the evidence suggests that this is not the case. Regardless of how Correggio knew what was going on in Rome, he transformed the Roman heritage into his own personal style, becoming in a few years a leading painter of northern Italy. Vasari praised him, saying that he was "the first in Lombardy to begin things in the modern manner, for which reason it is judged that if Antonio had left Lombardy and been to Rome, he would have achieved wonders, and rivalled many who were held to be great in his time."

One of Correggio's earliest works in Parma was the decoration of a room in the private apartments of the abbess in the Convent of San Paolo (fig. 18.43; see also fig. 10). The patron

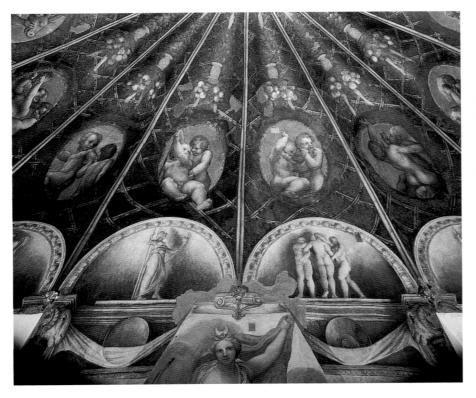

18.43. CORREGGIO.
Frescoes of the Camera di San Paolo.
c. 1518–20. Fresco.
Convent of San Paolo, Parma.
Commissioned by Giovanna da Piacenza,
Abbess of the Convent of San Paolo.
(For the full view, see fig. 10.)

was Giovanna da Piacenza, a strong-willed and well-educated abbess from an important family of art patrons. The largest figure in the cycle is a representation over the fire-place of Diana, the virgin huntress of ancient mythology who headed a tribe of virgins living isolated in the wilderness. This prominent figure must be a reference to the patron in mythological guise. Giovanna's family coat of arms, featuring crescent moons, one of the symbols of Diana, is found in the center of the ceiling.

The Convent of San Paolo was unusual in that the abbess reported directly to the pope and was not under the control of the local bishop; in addition, it had become the place where the unmarried daughters of the local aristocracy became nuns. This combination meant that the convent under Giovanna had an unusually liberal, intellectual, and sophisticated atmosphere.

Correggio's decorative scheme is enchanting, with the effect of a garlanded and beribboned pergola, decorated with bunches of fruit, that stretches overhead. The idea is probably derived from examples by Mantegna (see fig. 15.25) and Raphael (see figs. 17.72, 17.73). Oval openings give the spectator a view of cavorting putti in movement against the blue sky. Arches at the base of the pergola are painted to represent illusionistic niches filled with sculptures based on antique themes and models. Unifying the decoration on the lowest level are pairs of rams' heads adorned with beaded necklaces; some of these have witty and even rather bemused expressions. These heads in turn support draped cloths holding golden plates and jugs. The lower walls, now bare, were probably decorated with tapestries; elegant furniture would have completed the effect.

The iconographic content is obscure and has been difficult to sort out, but there are enough clues to tell us that those who designed it were erudite humanists. The figures that have been identified include Fortune, the Three Graces, Tellus (the earth goddess), Juno (as a representation of Air), the Three Fates, Pan, and others. A drawing demonstrates that Correggio adapted motifs from ancient coins, the

18.44. CORREGGIO.

Madonna and Child with Sts. Jerome and Mary Magdalen.

After 1523. Panel, 7'8¹/₂" x 4'7¹/₂" (2.35 x 1.41 m).

Pinacoteca, Parma. Commissioned by Briseide Colla, widow of Orazio Bergonzi, for Sant'Antonio, Parma.

Vasari praised this painting: "In Sant'Antonio in Parma he painted a panel picture showing the Madonna and Saint Mary Magdalene, with a boy nearby in the guise of a little angel, who is holding a book and smiling so naturally. . . . This work, which also contains a Saint Jerome, is especially admired by other painters for its astonishing and beautiful coloring, and it is difficult to imagine anything better."

collecting and study of which was a preoccupation of humanists in Parma.

Some of the iconography has been connected to a quarrel the abbess Giovanna was having with the local bishop. He wanted to assert local authority over the convent and clamp down on what he felt were abuses. While some of the iconographic details may have been intended to serve Giovanna's cause, the effect of the room as a decorative Renaissance totality is its most lasting impression.

From the start of Correggio's mature period, he seems to have been intent on substituting emotional for formal principles in the unification of his compositions, religious and secular alike. No longer are the saints sedately balanced around a central Madonna figure, as in works by Giovanni Bellini and Raphael. Rather they are drawn together in unconventional compositions by the implication of emotional relationships. In the *Madonna and Child with Sts. Jerome and Mary Magdalen* (fig. 18.44), Mary holds the Christ Child in the crook of her left arm. The Magdalen presses her cheek against his thigh, bringing one foot toward her lips. He caresses her mass of silken hair but seems to

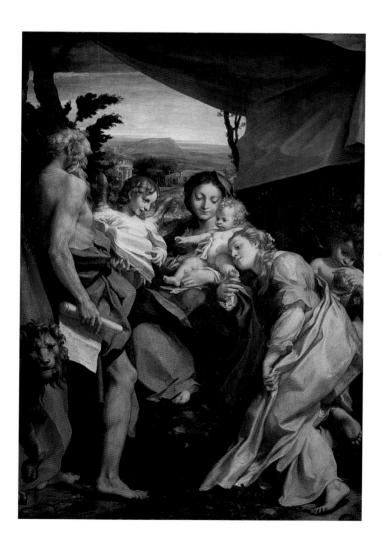

concentrate his attention on the book lifted up by the aged St. Jerome as a youthful angel turns the pages. Behind this apparently spontaneous burst of mutual affection is a deeper message. The Magdalen's angel displays her ointment jar, and the Magdalen herself was destined to wash the feet of the adult Christ with her tears and dry them with her hair. Christ, meanwhile, for all his babyish expression, is conferring his blessing on Jerome's translation of the Bible from its ancient sources, represented by the scroll in the saint's right hand.

Human emotion and sacred purpose are thus inextricably blended in Correggio's art. His tumultuous shapes—whether of cloth that flows like melting marble, or of tanned male and white female and infantile flesh, or of torrential, honeyed hair—are swept together by these two organizing principles into a sweet climax that seems to be half erotic, half religious. One might say that it is love that makes Correggio's world go round. Sometimes his imagery remains on

a level of delightful sweetness, unquestioning and childlike. He never seems to have been perplexed by the conflict between the two realms he so happily united. But his forms are so soft, his light and shade so melting, his surfaces so delicious, his people so irresistible, that it is unnecessary to fault his joining of the two spheres. As far as we know, his religious paintings never fell victim to the strictures of the Council of Trent, which sternly forbade nudity in religious works. Correggio's works became an essential ingredient of religious art in the Baroque period, inspiring such artists as Rubens and Bernini.

In Correggio's famous Adoration of the Shepherds or, as it is more generally called, Holy Night (fig. 18.45), the "light and heat" that St. Cajetan had sought in the Eucharist are fused with St. Bridget's vision of the glowing Christ Child and identified with Correggio's own energizing principle of love. A believable if incandescent baby, expertly foreshortened and lying on a bundle of wheat in reference to the

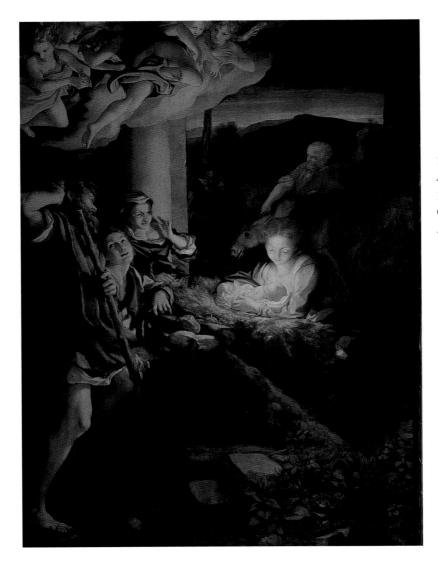

18.45. CORREGGIO.

Adoration of the Shepherds (Holy Night).
1522. Panel, 8'5" x 6'2" (2.6 x 1.9 m).

Gemäldegalerie, Dresden. Commissioned by

Alberto Pratoneri for S. Prospero, Reggio Emilia

Eucharist, is the source of light for the entire painting, as in Gentile da Fabriano's predella a century earlier (see fig. 8.4). Christ illuminates Mary's sweetly smiling face, while the midwife draws back and raises her hand, as if to protect herself from the intensity of the radiance. In addition, the light falls on two shepherds, the young one looking up rapturously at his companion, and on the angels who sweep in on a cloud in brilliantly foreshortened poses. The same light touches the faces of Joseph and the ox and ass, leaving in darkness the hills, over which can be seen the first glimmer of dawn.

In 1640 the Este family, then dukes of Modena, took possession of the painting and carried it off to their palace, to the infinite sorrow of the inhabitants of Reggio Emilia; the parish priest inscribed its loss in San Prospero's register of the dead.

Correggio's dome compositions opened up a whole new field for religious painting for painters of his own and later

centuries. The earliest of these represents the Vision of St. John the Evangelist (figs. 18.46, 18.47). Correggio took as his point of departure Mantegna's Camera picta (see fig. 15.24), and the drum of the dome serves as a frame through which we look into the open sky. On clouds banked round the cornice, the apostles are seated in pairs, their poses recalling Michelangelo's nudes on the Sistine Ceiling, while in the center Christ ascends into heaven. There are other suggestions of the Sistine Ceiling in the muscular power of the figures, who are supported by putti like those who surround Michelangelo's figures of God on his flights through space. The foreshortenings betray a knowledge of the Brazen Serpent (see fig. 17.41), and the idea of representing a divine figure floating past an opening must have been suggested by the Separation of Light from Darkness (see fig. 17.38). But the handling of the forms shows Correggio's softer style, without any of Michelangelo's linear definition or tension. Correggio has given us a surprising view of the ascending Christ from

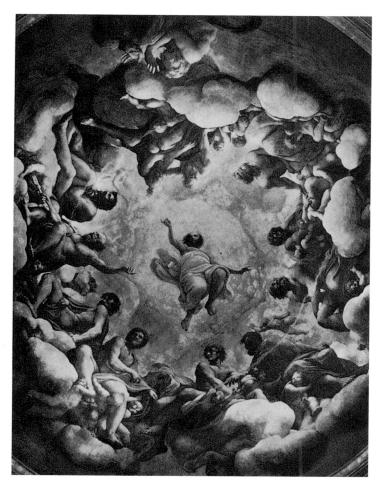

18.46. CORREGGIO. Vision of St. John the Evangelist. 1520–22. Fresco in dome, greatest width 31'8" (9.65 m). S. Giovanni Evangelista, Parma

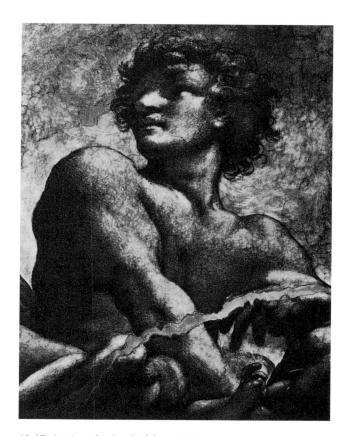

18.47. An Apostle, detail of fig. 18.46

below, sharply foreshortened from an unconventional angle. To view the scene correctly, you must hold the illustration overhead and look up.

Such views are abundantly visible in the dome of the Cathedral of Parma, which Correggio painted in 1526–30 (figs. 18.48–18.50) as part of an extensive series of frescoes. The damaged composition, prototype of innumerable Baroque domes, shows the *Assumption of the Virgin* in the center, surrounded by a ring of ascending figures who are for the most part nude. As we watch, this ring seems to ascend, leaving the apostles behind.

In Correggio's dome compositions we are dealing with rapture in the strict etymological sense of the word. The central figure is rapt—torn loose from earthly moorings—and carried upward as the spectator is intended to be, vicariously at least. No wonder, therefore, that some of the

artist's most alluring compositions deal with classical abduction scenes, especially the series made for Federigo Gonzaga, first duke of Mantua, but never delivered. The duke intended to line a room in the palace with the Loves of Jupiter—a far cry from Mantegna's chaste frescoes nearby (see fig. 15.23). Jupiter was a mythical ancestor of the Gonzaga family and, in his amorous exploits, not unlike Federigo. In Correggio's Jupiter and Ganymede (fig. 18.51), a favorite High Renaissance and Mannerist subject, Ganymede swings in the grip of Jupiter's fierce eagle, whose wings darken the air. Dazzlingly foreshortened, the boy looks back toward the spectator with an expression that seems to combine fear and pleasure. Below the floating figure, mountains, slopes, and valleys lead the eye to the horizon. The boy's leave-taking is dramatized by the leap of his beautiful white dog, desperate at his master's departure.

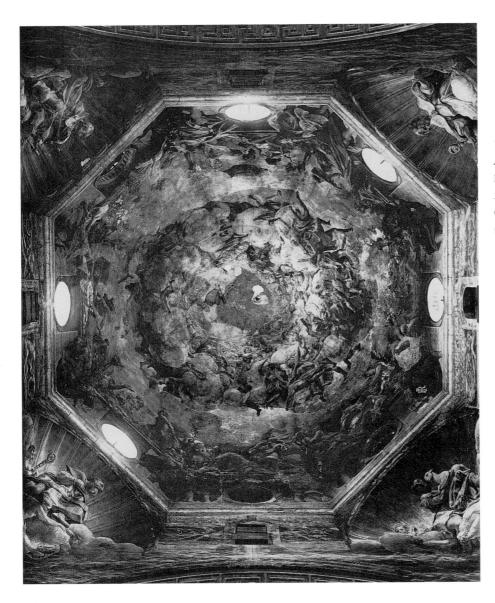

18.48. CORREGGIO.

Assumption of the Virgin. 1526–30.

Fresco in dome, diameter of base of dome 35'10" x 37'11" (10.9 x 11.6 m).

Cathedral, Parma. Commissioned by the authorities of Parma Cathedral

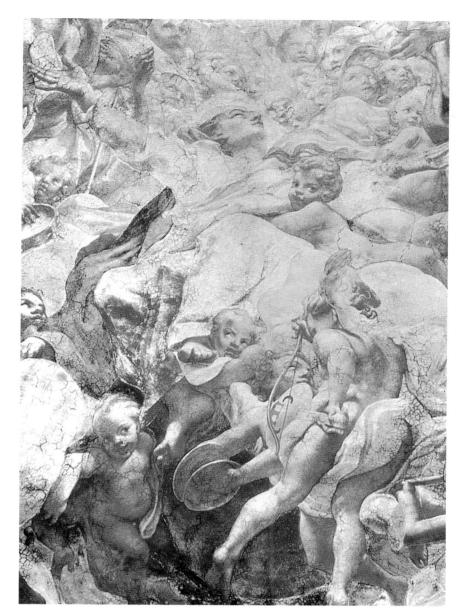

18.49. The Virgin Mary, detail of fig. 18.48

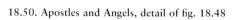

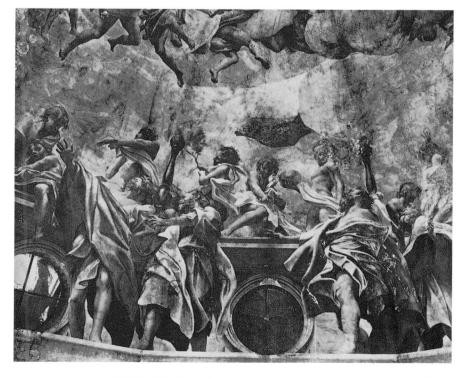

HIGH RENAISSANCE AND MANNERISM • 615

18.51. CORREGGIO. *Jupiter and Ganymede*. Early 1530s. Canvas, $64^{1/2}$ x 28" (164 x 71 cm). Kunsthistorisches Museum, Vienna. Commissioned by Federigo Gonzaga

No such picture had ever been painted in earlier Italian art, nor had anything like the daring *Jupiter and Io* (fig. 18.52) been seen before. The jealousy of Juno forced her promiscuous husband to seduce Io, a mortal maiden, in the guise of a cloud. Io sits in a pose familiar to us from Raphael's frescoes in the Farnesina (see figs. 17.67, 17.74). Her head thrown back, she accepts the embrace of one huge, cloudy paw, as the face of Jupiter surfaces from the cloud to plant a kiss on her lips. The contrast between the trembling warmth of Io's flesh and the mystery of the attack by the cold yet divine cloud increases the intensity of what is clearly a representation of sexual desire and climax. The ecstasy represented here parallels that experienced by the saints in Correggio's altarpieces, and

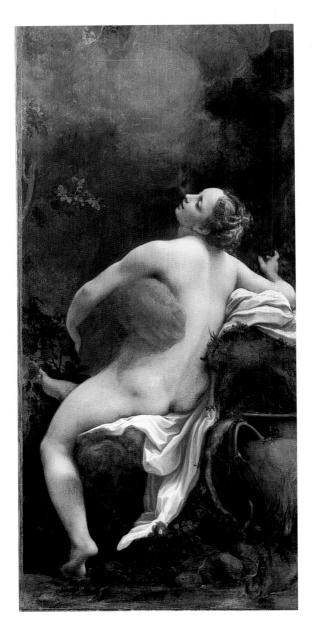

18.52. CORREGGIO. *Jupiter and Io*.

Early 1530s. Canvas, 64¹/₂ x 28"(164 x 71 cm).

Kunsthistorisches Museum, Vienna.

Commissioned by Federigo Gonzaga

at his death he stood alone, save for his contemporary Titian, in his ability to accept human sexuality as a subject for art, on a level with and interchangeable with religion.

Parmigianino

Correggio's slightly younger contemporary in Parma, Francesco Mazzola, called Parmigianino (1503–40), stands in strong contrast to Correggio's High Renaissance, even proto-Baroque style. Parmigianino, unmistakably a Mannerist, introduces himself to us in his startling *Self-Portrait in a Convex Mirror* (fig. 18.53). Vasari, who knew the picture when it belonged to the letter writer and lampooner Pietro Aretino,

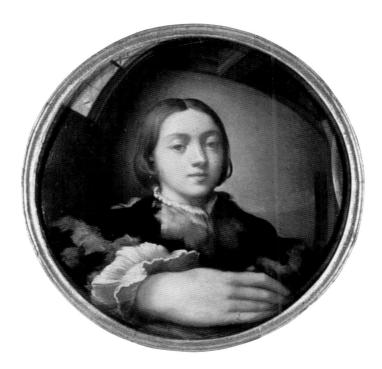

18.53. PARMIGIANINO. *Self-Portrait in a Convex Mirror.* 1524. Panel, diameter 9¹/₂" (24 cm). Kunsthistorisches Museum, Vienna

wrote that Parmigianino painted it just before his departure for Rome in 1524, when he was twenty-one, to show his skill in "the subtleties of art." Fascinated by his own reflection in a barber's convex mirror, he decided to reproduce it exactly. He had a carpenter turn a wooden sphere on a lathe and then saw off a section similar in size to a convex mirror. On this surface he painted himself looking outward with an air of utter detachment, "so beautiful," Vasari said, "that he seemed an angel rather than a man." His face is far enough back from the surface not to suffer distortion, but his hand and sleeve are enormously enlarged, and the skylight of his studio and the opposite wall are sharply curved.

In the High Renaissance, self-portraits are rare, and they generally appear in lieu of signatures, looking out from a lower corner. In Mannerist art they become more numerous, and they are generally revealing and disturbing. Leonardo had called the mirror the "master of painters," and he asserted that painters' minds should resemble it insofar as it "transforms itself into the color of that which it has as object, and is filled with as many likenesses as there are things before it." But he was not referring to a curved mirror, which he compared to the distortion made by moving water on objects seen through it. Parmigianino, however, has delighted in these distortions. The curved surface, which to Jan van Eyck (in the *Double Portrait (Arnolfini Betrothal?)*; not illustrated) and Raphael (see fig. 17.57) was a fascinating distortion fit only for a small position in the background, now becomes the whole image.

The commission for Parmigianino's bravura *Vision of St. Jerome* (fig. 18.54) required the presence of the two saints

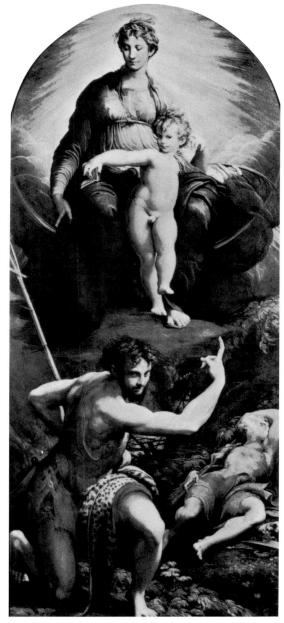

18.54. PARMIGIANINO. *Vision of St. Jerome.* 1526–27. Panel, 11'6" x 5' (3.429 x 1.52 m). National Gallery, London. Commissioned by Maria Bufalini for her husband's family chapel at S. Salvatore in Lauro, Rome. St. John the Baptist was the patron saint of Maria's father-in-law, while Jerome was chosen because of his connection with the legal profession practiced by both her husband and his father. After the Sack of Rome, the painting was taken by the Bufalini to their palace in Città di Castello. The unusually narrow format is probably related to the fact that the commission originally called for flanking panels of Joachim with Anna and the Conception of the Virgin.

below, but perhaps it was Parmigianino's idea to contrast them so dramatically. In pose and scale the Baptist dominates the lower portion, while St. Jerome is apparently shown sleeping to suggest that the painting represents his vision. John looks out at us and, with a bold and exaggerated gesture, directs us to the Virgin and Child, who are floating in midair, a position that becomes popular in the sixteenth century. The complex and strained pose of the Baptist, the emphasis on foreshortened forms, and the long, unusually proportioned figures are all typical attributes of Mannerist art. In the darkness that veils any possibility of establishing spatial relationships, rays of light flash from the Madonna's head and shoulders like shards of ice.

Parmigianino's *Madonna of the Long Neck* was commissioned in 1534 but left unfinished when the artist died in 1540 (fig. 18.55). Here the elongated proportions, sloping shoulders, and preciosity of surface of the *Vision of St. Jerome* are refined to produce shapes of startling ornamental beauty. The Christ Child is asleep in a pose suggestive of death, his left arm hanging as in Michelangelo's Rome *Pietà* (see fig. 16.35). At the left are five graceful figures; one holds a huge urn and looks up at the Virgin, another, possibly a self-portrait, gazes past us. The Virgin's body and neck are dramatically attenuated, and her forehead and glossy curls are adorned with ropes of pearls and an enormous ruby. Even more astonishing than her long neck, perhaps, is the length of her fingers.

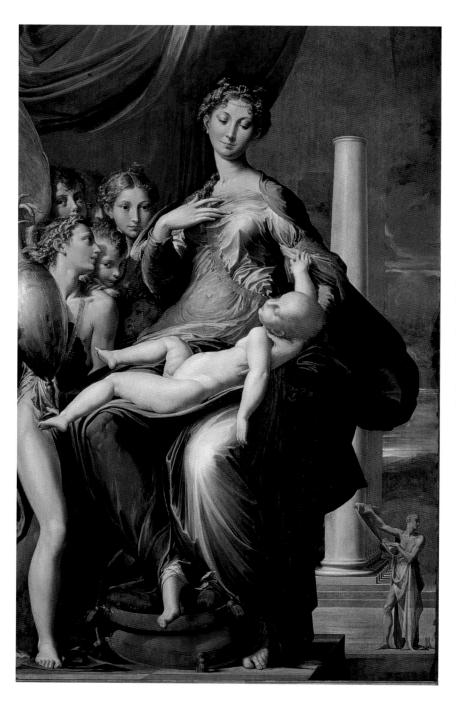

18.55. PARMIGIANINO.

Madonna and Child with Angels and St. Jerome, now popularly known as the Madonna of the Long Neck. 1534–40. Panel, 85 x 52" (2.19 x 1.35 m). Uffizi Gallery, Florence. Commissioned by Elena Baiardi for her husband's funerary chapel in the Church of the Servites, Parma. Despite its unfinished state, it was placed on its altar in 1542. The origin of the painting's nickname is evident, but it has only recently been pointed out by Mary Vaccaro that the patron's father wrote Petrarchan poetry in which he praised a woman's neck as the most important indication of female beauty.

Whether or not the Christ Child's head was to remain bald is uncertain. It might be recalled that Joseph was shaved while in prison and a tradition insists that Christ was also. But even more disturbing than any of the figural representations is the incomplete column, smooth and polished but without a capital, that stands in the background. Its base reveals that the artist intended to represent a temple portico, and preserved drawings show that it was to be Corinthian. At the base of the column is a figure with a scroll representing St. Jerome; he would have been in conversation with St. Francis; the two saints were required by the commission. Francis was a reference to the patron's husband, while Jerome was a saint who was important for female patrons because of his connection with the worship of the Virgin Mary.

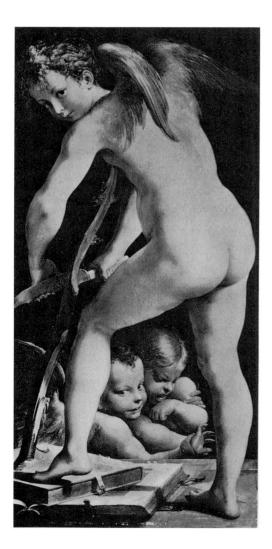

18.56. PARMIGIANINO. *Cupid Carving His Bow.* 1535. Panel, 53 x 25³/₄" (1.35 x 65.3 cm). Kunsthistorisches Museum, Vienna. Commissioned by Cavalier Baiardo

About contemporary with the *Madonna of the Long Neck* is *Cupid Carving His Bow* (fig. 18.56), which was ordered by a private patron. The epicene youth turns his naked back to us yet twists his head about for one arch glance at our discomfiture. With one foot braced on books, apparently symbolic of love's triumph over reason, he carves his bow from a freshly cut sapling. One putto in the background screams in pain while his companion mischievously twists his chubby arm, trying to force his already burned hand back against Cupid's hot leg. The figure, drawn with fantastic linear precision in the contours, shimmering with reflected lights, is painted with a mother-of-pearl surface that dazzled the young Peter Paul Rubens, who made a copy of this picture.

Pordenone

A shocking contrast to the refined sensuality of the two painters of Parma is furnished by Giovanni Antonio de Sacchis (1483/84-1539), called Pordenone from the town of his birth in Friuli, a sub-Alpine region northeast of Venice. Among the early Cinquecento painters of northern Italy, Pordenone is surely the most startling. In his life, as well as in his art, he seems to have been a person of unbridled energy and ambition—and few scruples. According to charges made in court, he hired a band of cutthroats to murder his brother Baldassare so that he could lay hands on the entire paternal inheritance. He shuttled back and forth throughout northern Italy and even to far-off Genoa, turning out altarpieces, organ panels, and especially frescoes, at amazing velocity. In 1516 he journeyed to Umbria for some fresco commissions and he must also have visited Rome, although no visit is documented.

Brought up under diluted Venetian influence in the provinces, he lost no time in absorbing the latest in Rome but without benefit of the study of the figure and disegno that were the foundation for the Roman High Renaissance. He brought back to the north vivid and simplified memories, and perhaps sketches, of the achievements of Michelangelo and Raphael. Pordenone never fully detached himself from Friuli, though from 1528 on he was active in Venice and its environs, where he was esteemed for his frescoes on the outer walls of palaces and cloisters-exposed to the weather and thus foredoomed to ruin—and for his works in the Doge's Palace, destroyed in fires in 1574 and 1577. It is difficult to assess the effect of these lost works on Titian (see Chapter 19) and, more probably, on Tintoretto, of whose dramatic style Pordenone was a precursor. We must judge him now mostly by his surviving fresco cycles, which are painted with speed, vigor, and an unusual coarseness of expression and execution; these are works intended to shock.

His most powerful cycle is the Passion series in the Cathedral of Cremona. A cycle of the life of Christ had been begun

by local Cremonese painters and continued by Romanino of Brescia, whom Pordenone apparently contrived to have dismissed so that he could complete the series himself. Like Pordenone's other episodes in the nave arcade, his scene of the Nailing of Christ to the Cross (fig. 18.57) is seen from below in Mantegnesque illusionism; it exploits as never before the space in which the observer stands. Demonic faces glower from the dimness at the left, above a soldier who has felled one of his own comrades and holds him by the hair so that he may terminate their private quarrel with a thrust from his short sword. Scrabbling helplessly for a handhold in the painted architecture outside the scene, the victim seems about to fall over the edge onto our heads. The pose and the muscular back reveal the influence of the works of Michelangelo, as does the dense concentration of foreshortened contrapposto figures throughout the scene.

Center stage is occupied by a bald figure whose bestiality is underscored by his huge belly, loosely tied breeches, and pendulous codpiece. On the extreme right, the foreshortened cross is being shoved into the scene from outside the painted frame by one of the prophets. Christ is crowned with thorns, his eyes closed, and his legs so sharply bent that the thighs disappear from view. He writhes as a gigantic hammer drives the spike into his right hand, which gushes blood, while a foreshortened and twisted executioner holds

ready another hammer. The tumult of figures surging into the scene and spilling out of it is delineated by broad, rough strokes and a violence seldom found in Italian art. In spite of his brilliance and daring, violence to Pordenone is its own message; he seems to have little to say of a spiritual nature, in contrast to his successor Tintoretto (see pp. 663–72).

Defining Mannerism

Up to this point it has been possible to avoid a "definition" of Mannerism. Now that we have seen the style in operation, we are at least in a position to make a few generalizations. Whereas the content of High Renaissance art is often ideal, Mannerist art often chooses subjects that are abnormal or anormal, and the strange and unexpected aspect of a subject may be emphasized. Mannerist interpretations sometimes stress uncontrolled emotion or withdrawal. In High Renaissance art the narrative will usually be direct, compact, and comprehensible; in Mannerist art it is often elaborate, involved, and obtuse. While space in a High Renaissance work will be measured, harmonious, and ideal, Mannerist space can be disjointed, spasmodic, and/or limited to the foreground plane. High Renaissance compositions are harmonious and integrated, they are often central-

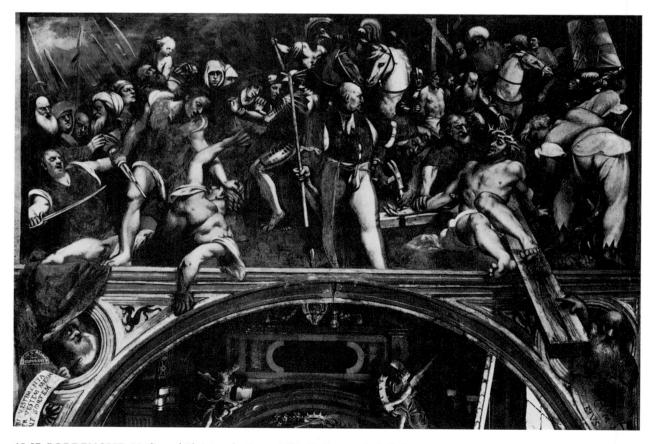

18.57. PORDENONE. Nailing of Christ to the Cross. 1521-22. Fresco. Cathedral, Cremona

ized, and they may assume a pyramidal or conical form; Mannerist compositions may be conflicting, and forms often seek the frame or violate it. While High Renaissance proportions are normative and idealized, Mannerist proportions can be uncanonical, usually attenuated. The figures in a High Renaissance work are gracefully and naturally posed and often suggest the possibility of movement, while Mannerist figures are tensely posed, overextended, or confined or appear in an exaggerated or excessive contrapposto. While High Renaissance color is balanced, controlled, and harmonious, Mannerist color is contrasting and surprising.

Leonardo, Fra Bartolommeo, Raphael, and to a great extent the mature Michelangelo belong in the High Renaissance category, as do Andrea del Sarto and Correggio. To Mannerism we can assign Pontormo, Rosso, Perino del Vaga, Beccafumi, Parmigianino, Pordenone, and, to a great extent, the Michelangelo of the Medici Chapel. The two categories, or schools, overlap chronologically, so they cannot be considered separate periods. Mannerism seems to appear by 1517, and we must think of the period from about 1517 to the early 1530s as one divided between opposing tendencies. During the 1530s a related style that will be called the *maniera* takes over almost entirely in central Italy (discussed in Chapter 20).

Antonio da Sangallo the Elder

Many of the formal qualities discussed above are applicable to architecture, and some are abundantly visible in Michelangelo's buildings. He had, nonetheless, architectural rivals in Florence who maintained independence from his ideas and theories. One of these was Antonio da Sangallo the Elder (1455–1534), younger brother of Giuliano. During his youth, Antonio was active chiefly as a military architect, and he also designed religious and civic structures for minor centers. He was engaged to complete the Church of Santa Maria del Calcinaio at Cortona, left unfinished at the death of Francesco di Giorgio (see fig. 14.11-14.13). When Giuliano died in 1516, Antonio was left in a position of prominence and, two years later, accepted one of the major commissions of the period, the pilgrimage church of the Madonna di San Biagio at Montepulciano (figs. 18.58, 18.59; see also fig. 11). The church was built to commemorate a miracle that took place on one of the slopes surrounding the city, and thus Antonio had an enviable site in the midst of a magnificent landscape unencumbered by preexisting constructions.

The structure, on which he worked from 1518 until his death in 1534, was the most ambitious church building of the period with the exception of St. Peter's in Rome, whose construction was dormant after the death of Bramante in spite

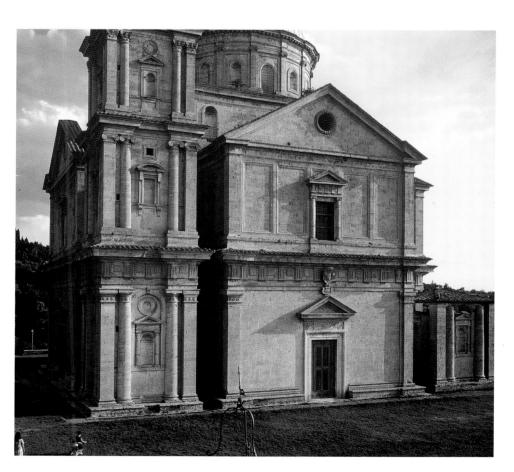

18.58. ANTONIO DA SANGALLO THE ELDER. Madonna di S. Biagio, Montepulciano. 1518–34. (For the full view, see fig. 11.)

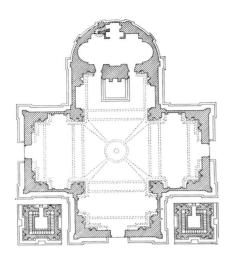

18.59. ANTONIO DA SANGALLO THE ELDER. Plan of Madonna di S. Biagio

of designs submitted by Raphael, Peruzzi, and others. Antonio chose a Greek-cross plan crowned with a dome, similar to that of his brother Giuliano's Santa Maria delle Carceri at Prato, an unfinished commission he also inherited (see figs. 12.27–12.29). Antonio eschewed the typical Florentine marble incrustation, however, and constructed his church inside and out, except for the barrel vaults, of blocks of travertine that confer upon the building a clifflike massiveness that is unexpected after the surface elegance of the Florentine tradition. The main façade was to be flanked by two lofty, freestanding towers, but only one was built. While these towers may have been suggested by those Bramante designed for St. Peter's, it should be recalled that such towers reappear constantly in Leonardo's architectural drawings (see fig. 16.7).

Antonio set up the three cubic stories of the towers in a canonical succession of Doric, Ionic, and Corinthian orders. The octagonal fourth story was not built until 1564, and it may or may not follow the original plans. Because only one tower was completed, much of the effect Antonio intended is

dissipated, but if we complete the second tower mentally, it is not hard to imagine the tension that would have existed between these massive verticals and the planar, less energetic façades. The façades, in fact, continue the Doric order of the first story only in pilaster form. The second story is divided into recessed panels, the center one penetrated by a window enclosed in a pedimented tabernacle.

In contrast, the towers are richly articulated, with square corner piers composed of engaged columns, so that the intervening wall spaces are sharply recessed and the entablatures broken. Giuliano had drawn a Roman Doric order almost exactly similar to this one, including the square corner piers and the ornamented necking band, from the ruins of the Basilica Emilia in Rome, and utilized these motifs in his design for the façade of San Lorenzo in Florence (see fig. 18.1).

Wherein, then, lies the originality of the younger brother, who merely adapted two years later what was, after all, company property? Perhaps it is the new sense of drama, never present in Giuliano's work and never absent from that of Antonio. A struggle seems to be going on between the clustered column-and-pier at the corners of the campanile and the massive wall. The latter is enlivened not by the gracious windows favored by Giuliano, but by tabernacles capped on the second story with segmental pediments whose lower cornices are broken, a motif later used by Michelangelo. The jagged effect of the entablatures is heightened on the fourth story by corner obelisks. And even the raking cornices of the pediments of the three façades are broken against the sky. The dome, so impressive a feature of the building when seen from behind the apse, carries only a slight effect from the main façade, where it would have been outflanked by the towers.

The effect of the interior is overwhelming (fig. 18.60)—not in terms of space, which one would expect in the Brunelleschi-Alberti-Bramante tradition, but of brute mass. The accent is not on the walls but on the articulation of the corners—both

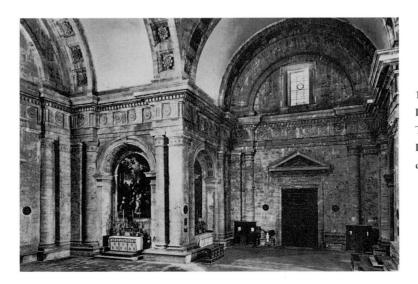

18.60. ANTONIO DA SANGALLO THE ELDER. Interior, Madonna di S. Biagio

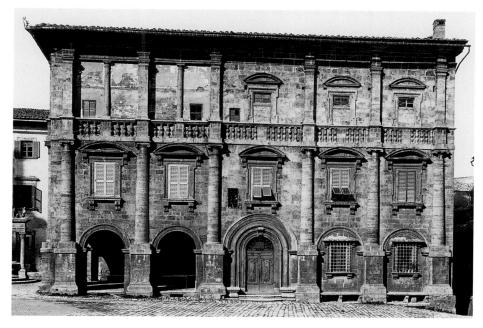

18.61. ANTONIO DA SANGALLO THE ELDER. Palazzo Tarugi, Montepulciano. c. 1515

recessed and jutting—which are treated almost as if they were the inner walls of the ground stories of the towers. The Roman Doric order is identical, inside and out, but these strong projections appear rather pugnacious when moved indoors; the piers carry arches that are just as heavy. The inside walls are travertine throughout, so the supports do not detach themselves from the walls in the traditional Florentine fashion. The barrel vaults, however, are white *intonaco*, with the result that the ground floor seems to sustain soaring arches against a white expanse of sky.

Montepulciano, a Cinquecento cultural center in spite of its small size, is lined with palaces by major architects, including several by or attributed to Antonio da Sangallo the Elder. The most original of these is the Palazzo Tarugi (fig. 18.61), which has two façades fronting on the principal piazza opposite the cathedral. Antonio made each façade roughly symmetrical, but he varied the articulation so as to introduce an open corner arcade on the ground floor and an open loggia, now walled in, on the top floor. Convenient and delightful as these corner porches must have been for the inhabitants, who probably required their presence in the design, they violate the symmetry of the façades in spite of the ponderous, central arch, which seeks to maintain its dominance. And in a reversal of the traditional pattern, the first story is Ionic, the second Doric. Finally, the Ionic columns of the ground story, perched on lofty podia, rise to embrace the piano nobile as well, an early example of the giant order later used by Michelangelo. No stringcourse separates the two first floors; thus the windows of the piano nobile seem to be floating upward, beating against the balustrade that runs across the second floor.

Antonio da Sangallo the Younger

The last member of the Sangallo family to concern us is Antonio da Sangallo the Younger (1485-1546), nephew of Giuliano and Antonio the Elder. He was an imaginative architect whose two major undertakings came to grief at the hands of Michelangelo. Originally a carpenter who was responsible for the colossal centering for Bramante's four great arches to uphold the dome of St. Peter's, Antonio soon became an architect in his own right. His star ascended in 1517 when the powerful Cardinal Alessandro Farnese acquired a palace in the center of Rome and decided to rebuild it from Antonio's designs. That it is the most majestic and influential of all Roman Renaissance palaces is due to the combined efforts of Antonio and Michelangelo. Antonio's design was ambitious from the start—an immense rectangle (figs. 18.62, 18.63) whose façade is a towering block of masonry recalling the Palazzo Strozzi (see fig. 12.21), but with rustication restricted to the corners and the central, arched entrance.

Both the rows of applied pilasters—what might be called the Alberti-Laurana tradition—and Bramante's use of engaged columns are here abandoned in favor of regularly spaced windows enframed with columns and pediment, the so-called aedicula window. On the ground floor, Antonio adopted the "kneeling window" type (used by Michelangelo in 1517 at the Palazzo Medici in Florence; see fig. 6.17); here they are connected by a stringcourse that continues their sills. For the second-floor aediculae, Antonio used a Corinthian order, supported on high bases resting on a stringcourse and unified by a smaller stringcourse at sill

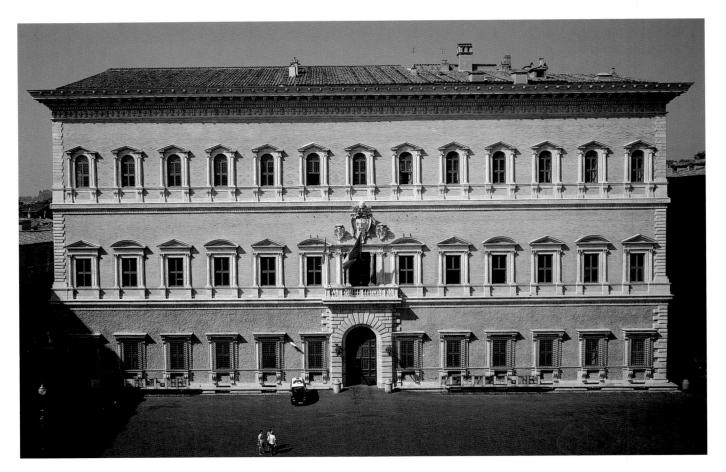

18.62. ANTONIO DA SANGALLO THE YOUNGER and MICHELANGELO. Palazzo Farnese, Rome. 1517–50. Commissioned by Cardinal Alessandro Farnese. For the palace's courtyard, see fig. 20.9.

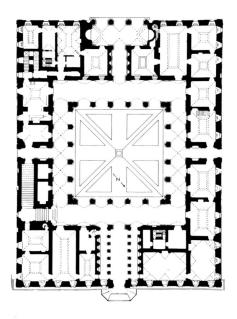

18.63. ANTONIO DA SANGALLO
THE YOUNGER and MICHELANGELO.
Plan of Palazzo Farnese

level, as on the ground story. The windows have alternating triangular and arched pediments, save for the central window, which was originally a large arch, repeating the motif of the entrance portal below. The third story is a combination of both lower ones, for now columned aediculae rest on consoles like those of the first floor. But here the windows are arched so that they break upward into the triangular pediments. All the architectural trim, including the massive quoins at the corners, is in stone set off against the flat surface of tan brick walls. This important distinction in color and materials can be more easily appreciated as a result of the recent cleaning of the palace.

The grand effect of this façade depends largely on a single change made by Michelangelo. Antonio's cornice would probably have been narrow, more or less on the scale of the stringcourses between the stories, and the whole would have created a rather diffuse impression. Only the front wing of the palace had been carried out before the Sack of Rome in 1527, and only, irregularly, through the level of the *piano nobile*. Not until 1539–40 did Alessandro, now Pope Paul III, resume the original design, with some internal changes, under the original architect. But in 1546 the pope, dissatisfied with Antonio's design for the cornice, called in Sebastiano del Piombo, Perino del Vaga, Giorgio Vasari, and Michelangelo to provide competing designs.

He accepted the colossal cornice by Michelangelo, which is even heavier than that of the Palazzo Strozzi; it combines elements from various orders and was so heavy that in some places Antonio's walls had to be rebuilt to provide an adequate foundation.

It is Michelangelo's cornice that imparts unity to the structure. According to Vasari's probably exaggerated account, such was Antonio's displeasure that he died of shock and grief. A second alteration by Michelangelo drew the elements of the building to a central focus: he eliminated the arch of the centralized opening on the second story and framed it with the second floor's Corinthian order in a column-pilaster-column grouping. This gave a new unity to the second story and allowed space for Michelangelo to insert the Farnese arms on enormous cartouches.

Antonio's three-aisled entrance loggia (fig. 18.64) is a little basilica in itself, for the central aisle is barrel-vaulted, the side aisles flat-roofed, and both are supported by a Roman Doric order. The low, almost cavernous effect is in-

creased by the narrow entablature, which makes the ribs of the coffered vault seem to rise directly from the columns. It must have been designed before Giulio Romano left for Mantua in 1524, because Giulio adapted the idea at the Palazzo del Te. Antonio's courtyard would have been conventional—a grand reproduction of the superimposed orders of the Colosseum, along the lines of such Quattrocento archaeological courtyards as that of the Palazzo Venezia (see fig. 10.9)—but, as we shall see, Michelangelo added a third story that transformed this design as well (see fig. 20.9). For Antonio's projects for St. Peter's, we must again turn to the later work of Michelangelo (see p. 697).

Baldassare Peruzzi

Meanwhile in Rome, Baldassare Peruzzi (1481–1536), one of the leaders of the High Renaissance (see pp. 571–73), seems to have succumbed to Mannerism in an extraordinary

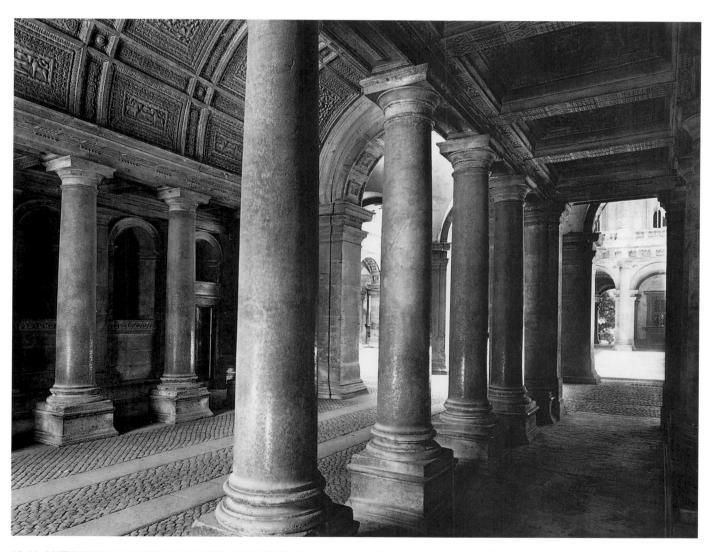

18.64. ANTONIO DA SANGALLO THE YOUNGER. Entrance loggia, Palazzo Farnese, Rome. Begun before 1524

building now named, on account of its ground-floor columns, the Palazzo Massimo alle Colonne (fig. 18.65). The present fantastic view was not possible until the late nineteenth century, when the street was widened; at the time the Massimo family commissioned the building, the irregular curve of the façade would have seemed less illogical because it followed the curve of the street. From no single point of view would the entire façade have been visible, and Peruzzi's design, like that of Vasari a generation later for the Uffizi in Florence (see fig. 20.40), must have been an experience in time as well as in space. His supports—pilasters, single columns, paired columns—create a sequence, while the central opening was placed where the bend in the road became most acute.

Peruzzi chose a Tuscan order deprived even of triglyphs so that the eye is led around the bend without interruption. From street level, the windows of the *piano nobile*, each on its broad podium, must have seemed to move around the bend in a solemn, regular rhythm, while the third and fourth stories float in the rusticated wall, their window frames decorated with moldings and scrolls.

Giulio Romano

It is fitting to close with a fantastic structure, the Palazzo del Te in Mantua, which Giulio Romano (c. 1499–1546), Raphael's pupil and heir, constructed and decorated from

1527 to 1534 for Federigo Gonzaga, a marquis who was made first duke of Mantua while the building was under way. The palace (figs. 18.66, 18.67) is known for the region in which it is situated; the Te is the name, of unknown origin, applied to a peaceful island that connected the fortified city of Mantua, then surrounded entirely by lakes, with the mainland. The meadows of the Te had been the scene of Federigo's horse-breeding ventures, and the first plan here, possibly executed in 1526, involved the addition of a frescoed banqueting hall to the stables. This soon expanded into a small country palace to be used for entertaining.

Giulio articulated the three outer façades with a rhythmic sequence of distinct groups of forms, unified by his use of a Roman Doric order probably derived from the Basilica Emilia. This order embraces the ground story and a mezzanine for servants and storerooms. A feeling of tension and compression is created by the unusual rustication. While the second story is rusticated in flat, Albertian blocks like those of Peruzzi's Palazzo Massimo alle Colonne, the windows and arches of the first story are so heavily rusticated that their quoins and archivolts seem to expand as if they are about to devour the elegant architecture surrounding them. This conflict has been described as a struggle of formlessness against form.

The courtyard goes to even greater extremes (fig. 18.68). The pilasters have become engaged columns of great nobility.

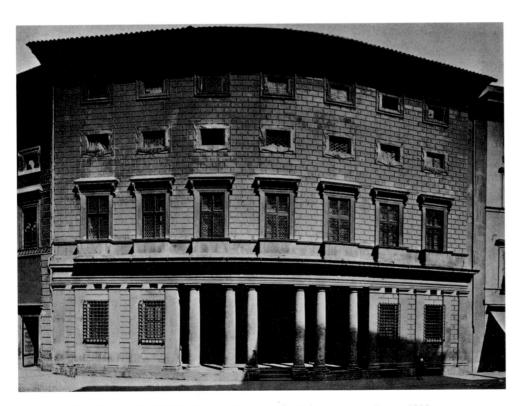

18.65. BALDASSARE PERUZZI. Palazzo Massimo alle Colonne, Rome. Begun 1532. Commissioned by Pietro, Luca, and Angelo Massimo

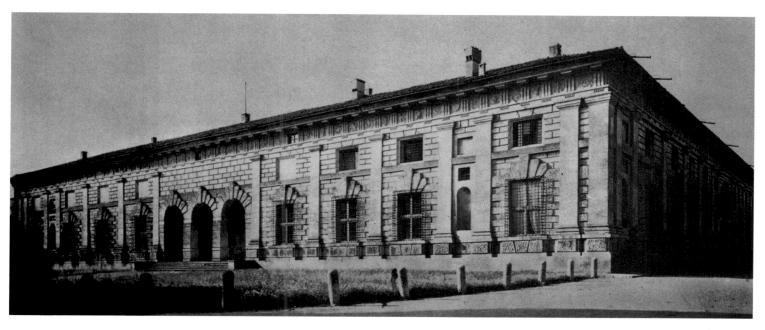

18.66. GIULIO ROMANO. North façade, Palazzo del Te, Mantua. 1527-34. Commissioned by Federigo Gonzaga

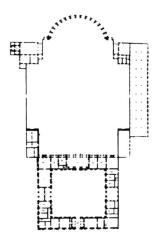

18.67. GIULIO ROMANO. Plan of Palazzo del Te

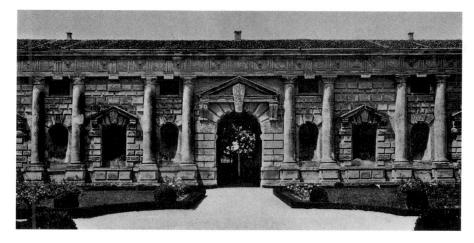

18.68. GIULIO ROMANO. Courtyard, Palazzo del Te

The stringcourse separating ground floor and mezzanine has vanished, the Albertian blocks have increased in size and projection, and some are roughened, as if the conflict between form and formlessness in the outer façades had ended in the fusion of extremes. But the war has entered a new phase. The windows are capped by pediments whose raking angles do not quite meet at the apex; the suggestion is that they have been forced apart by the rusticated keystones below them, which themselves are raised slightly compared to the neighboring stones. Giulio's design proposes that the elements of architecture are battling with each other, and that the earlier Renaissance harmony of forms has given in to

internal forces in the design. There is one more unexpected element here, and then the climax: between every two columns, whether widely spaced or paired, the central triglyph drops down, leaving a blank hole above it.

Nothing like this had ever been seen in Renaissance architecture, but Giulio may have noticed this alarming phenomenon in the tottering ruins that surrounded his house in Rome (he was brought up next door to the Forum of Trajan). He did not use this motif, however, in an attempt to create an imitation ruin. It is too systematic for that, for it reoccurs at regular intervals, and on only two of the inner façades of the courtyard. The effect on the contemporary observer must

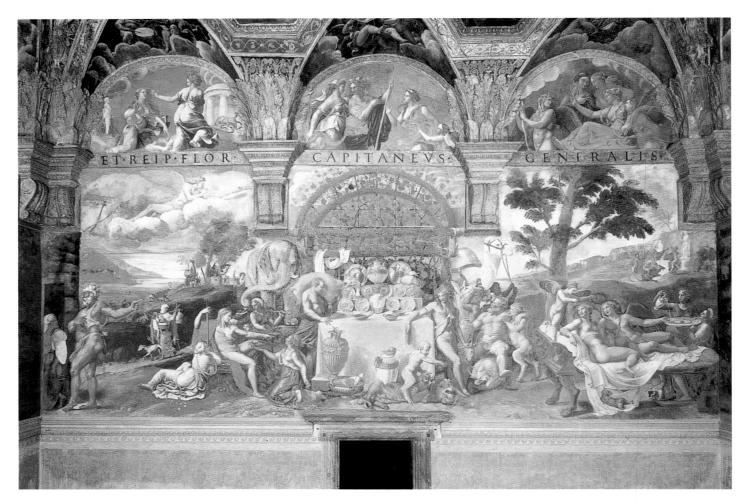

18.69. GIULIO ROMANO. Wedding Feast of Cupid and Psyche.
1527–30. Fresco, Sala di Psiche, Palazzo del Te, Mantua. Commissioned by Federigo Gonzaga.
Secular decorations in the palaces and villas of rulers were clearly made to impress important and not-so-important visitors; Charles V dined in this room when he visited Mantua in 1530, soon after the frescoes were completed.

have been dramatic, for here the Renaissance acceptance of the principles of the ancient vocabulary of architecture and the High Renaissance sense of order are challenged by what seem to be internal forces.

The interior, in which Emperor Charles V was entertained, had rooms unmatched in their time for luxury and splendor; now they are stripped of the furnishings mentioned in inventories. But the pictorial decoration, which Giulio and his pupils executed at breakneck speed, still survives. The Sala di Psiche (fig. 18.69) tells in detail the story of Cupid and Psyche, which in the Farnesina had been limited to its airy episodes (see figs. 17.72–17.74). The wedding feast covers two walls in a panorama of gods, nymphs, satyrs, and animals in an endless fabric of largely nude figures against peacock-green foliage that is heightened by the silver and gold table service.

In sharpest contrast to this voluptuous scene is the Sala dei Giganti (fig. 18.70), a room of the same size and shape

as the Sala di Psiche at the opposite corner of the palace. The entire room, doors and all, has been painted in a continuous representation of the destruction, by thunderbolts from the hand of Jupiter, of the rebellious giants who had attempted to assault Mount Olympus. The palaces and caves of the colossal giants seem to collapse upon them—and upon us as we watch. The spiraling pattern of the floor adds to the effect and there was once a rough fireplace which, when lit, suggested the consumption of the giants by flames. These frescoes, painted in a hurry after the emperor's first visit in 1530 so that he could see them completed when he came again two years later, have been interpreted as an expression of feelings widespread among Italians; after the annihilation of so many values that had seemed permanent until the Reformation, the Sack of Rome, and other events, many welcomed the new order of absolutism. The Sala dei Giganti makes explicit the conflict we have found in the arts during the period of Mannerism.

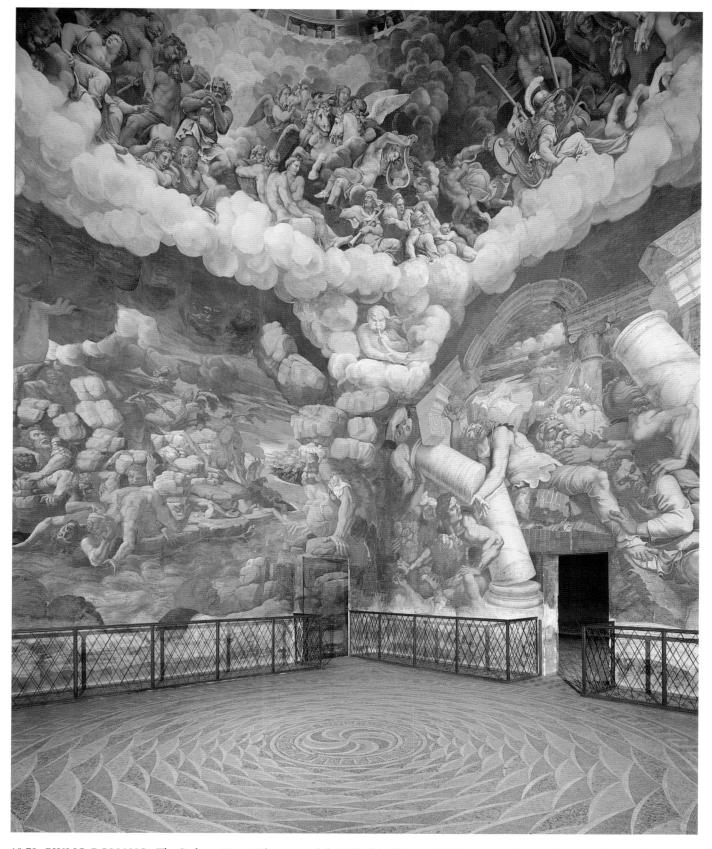

18.70. GIULIO ROMANO. The Gods on Mount Olympus and the Fall of the Giants. 1530–32. Fresco. Sala dei Giganti, Palazzo del Te, Mantua. Commissioned by Federigo Gonzaga

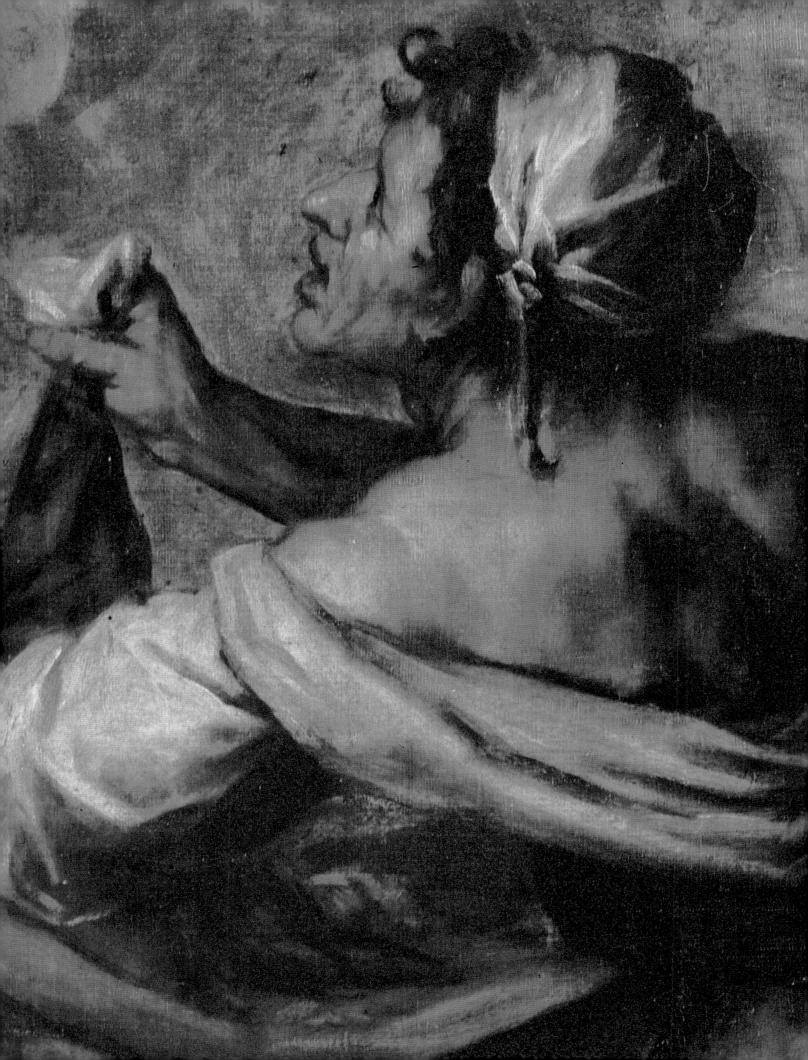

HIGH AND LATE RENAISSANCE IN VENICE AND ON THE MAINLAND

he passing of the High Renaissance and Mannerist artists of central Italy, almost all of whom were dead or in decline before 1540, eventually left the Venetian painters in a position of supremacy in Europe, challenged only by Michelangelo. As in Quattrocento Florence, the general level of quality in Cinquecento Venice was high, and derivative works by minor artists seem at first to be more original than they are because they partake of the qualities demonstrated by the innovators.

Several Venetian painters survived from the Quattrocento: one member of the Vivarini family lingered on, Carpaccio was still painting, and Giovanni Bellini continued creating paintings of depth and beauty until his death in 1516. Two innovative painters now emerged on this crowded stage: Giorgione, briefly, and Titian, with an activity that spanned six decades. Titian remained in control of Venetian painting until the last quarter of the century. About the middle of the century, the painters Tintoretto and Veronese made their appearance. Lotto carried the Venetian style from Lombardy to the Marches, the School of Ferrara fell under the spell of Venice, and after an important work by Titian arrived in Brescia, a new school arose in that Lombard city under Venetian influence.

It is important to understand that the Republic of St. Mark, whose artistic production in the early Cinquecento suggests a position of security and splendor, was actually in a precarious situation. Perhaps only its location saved Venice from the peril of dynastic rule, which extinguished the liberties of its sister republic, Florence. Venice was, in fact, involved in the warfare between France and the Holy Roman Empire that devastated so much of Italy. Moreover, it had profited from the fall of the Borgia family in 1503 by annexing many papal dominions in the Romagna. Julius II, not satisfied with recapturing these in 1506, in 1508 organized the League of Cambrai, which in the ensuing months temporarily stripped from Venice almost all its possessions on the Italian mainland. Most were eventually

regained, but throughout the sixteenth century Venice was compelled to adopt a defensive position with regard to the European monarchies, and especially the Holy Roman Empire, which under Charles V had assumed mastery over much of Europe. It is ironic that the greatest Venetian painter, Titian, would find important patrons in the Hapsburg rulers Charles V and his son Philip II.

It is curious that, at the moment when Bellini and Giorgione were putting a new emphasis on landscape and the beauties of nature, Venice possessed little nature to enjoy. It may well be that one ingredient of the interest in landscape on the part of artists and patrons is the absence of landscape from daily experience. The Romantic movement in England—nature poetry and nature painting—went hand in hand with the Industrial Revolution, which was rapidly devouring the landscape around major urban centers, and the explosion of landscape painting in France in the middle of the nineteenth century accompanied the triumph of industrialism and the resulting expansion of Paris and the industrialization of its suburbs.

Giorgione

Be that as it may, the landscapes of the late Bellini and the art of Giorgione explore nature in a new way. While Bellini may be credited with the invention of the Venetian landscape, Giorgione, his pupil, is more of a mystery. Giorgio (in Venetian dialect, Zorzi) was born in Castelfranco, on the Venetian mainland, probably about 1475–77, and came to Venice at an early age. A few documents record his activities in 1507–8, and in 1510 he died, still young, of the plague. According to a tradition retold by Vasari, Giorgione ("-one" is the Italian suffix for "big") was given to worldly delights and was a good conversationalist and a great lover. He sang beautifully, accompanying himself on the lute.

About the works of no other Italian painter save Giotto is there so little agreement. Some scholars give Giorgione credit for dozens of paintings in a variety of styles, others reduce

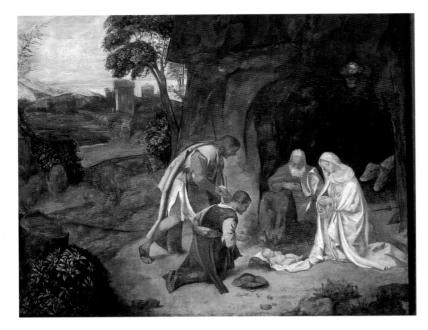

19.1. GIORGIONE. *Nativity and Adoration* of the Shepherds (Allendale Nativity). c. 1505(?). Panel, 35³/₄ x 43¹/₂" (90.8 x 110.5 cm). National Gallery of Art, Washington, D.C. (Kress Collection)

Below: 19.2. GIORGIONE. Enthroned Madonna with Sts. Liberalis and Francis. c. 1500–5.

Panel, 78³/₄ x 60" (2 x 1.5 m).

Cathedral, Castelfranco. Commissioned by Tuzio Costanzo, perhaps to commemorate the death of his son Matteo in 1504

the list to a bare half-dozen. The *Nativity and Adoration of the Shepherds* (fig. 19.1) is usually accepted. Giorgione's style is already evident in the luminous combination of red, blue, and yellow draperies with the landscape's greens and tans. The natural elements dominate the figures and we seem almost to be looking at a landscape with a Nativity rather than the reverse. And it is a convincing landscape—wild, rocky, and unsentimental as compared with the transfigured nature of Bellini. It is the artist's love of wildness for wildness' sake that gives Giorgione's landscapes their special quality. The rocks are gloomy and frightening, the cave dark. No road winds through the landscape, and the few buildings seem in danger of being reabsorbed into the world Giorgione has imagined.

The painter's only surviving altarpiece, the *Enthroned Madonna with Sts. Liberalis and Francis* (fig. 19.2), is in situ in the Cathedral of Castelfranco. Even this symmetrical composition is not without its surprises. Ordinarily, a Renaissance artist provides some means of access to the Virgin, but Giorgione's Mary is seated on a throne that rises beyond the limits of the frame and is completely without visible steps. His heavenly queen is, for all her gentle beauty, as remote as Cimabue's.

St. Liberalis, on the left, carries a lance with a cross banner; St. Francis points to his wounded side. Behind Mary's throne, our gaze moves out freely over land and sea. There is a port above St. Francis, while a village above St. Liberalis is protected by a tower. Both landscapes show signs of warfare. Two soldiers have stopped by a bend in the road at the right, and at the left the guard tower is shattered as if by artillery.

These allusions, coupled with the melancholic mood of the picture, permit us to interpret the lofty placing of the Virgin as an appeal for her intercession during a period of military occupation. The pyramidal composition suggests a familiarity with the Florentine High Renaissance, which Giorgione could have

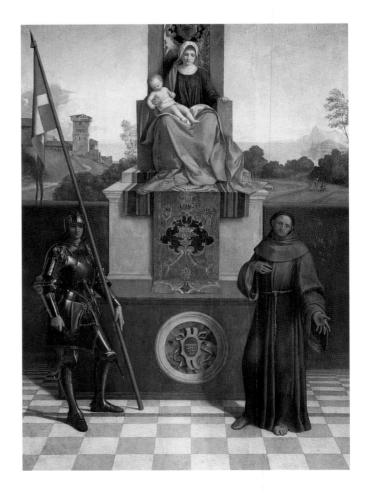

acquired through the visit of Fra Bartolommeo to Venice in 1508. But within the pyramid, Giorgione plays with characteristically Venetian diagonals: the slanting spear and the parallel motion of the drapery over the Virgin's right knee are answered by counterdiagonals in the smaller folds of her mantle.

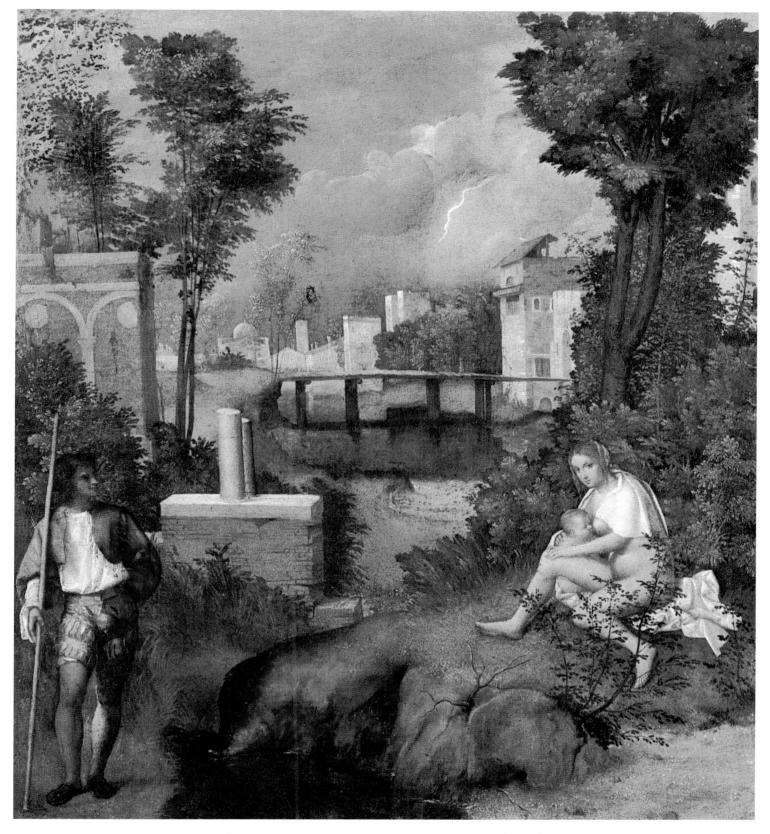

19.3. GIORGIONE. Tempestuous Landscape with the Soldier and the Gypsy. 1505-10. Canvas, 321/4 x 283/4" (82 x 73 cm). Accademia, Venice

Giorgione's *Tempestuous Landscape with the Soldier and the Gypsy* (fig. 19.3) has been the subject of scholarly controversy. Who is the nude woman? Why is she nursing her child

outdoors? Who is the soldier standing nearby? Many efforts have been made to find a subject for the painting in literature or the Bible; it has even been suggested that the picture has no

literary subject. In 1530, twenty years after Giorgione's death, the Venetian Marcantonio Michiel saw it in the house of Gabriel Vendramin and referred to it in his journal: "The little landscape on canvas with the tempest, with the gypsy and the soldier, was from the hand of Zorzi da Castelfranco." An X ray shows that where the soldier now stands Giorgione originally painted a nude woman bathing; a change from nude woman to clothed soldier seems completely illogical in the context of any narrative, and suggests that the painting could be a caprice—a painting of a mood—on Giorgione's part.

Again, he shows us an unfriendly nature. In this unkempt, weedy world, the trees are unpruned, the bushes shaggy, the columns ruined, the bridge precarious. And the scene is threatened by a low storm cloud that casts the shadow of the bridge on the river and by a bolt of lightning that illuminates the scene with a sudden glare. A high level of humidity is suggested, and there is a crackling tension in the air.

One of his last paintings, or so we are led to believe because it was finished by Titian, is the *Sleeping Venus* (fig. 19.4), the first of a series of recumbent Venuses by later painters. Far removed from Botticelli's Christianized goddess (see fig. 13.26), who stands nude at her birth, Giorgione's Venus sleeps nude, and her body echoes the curves of the earth. The landscape was completed by Titian, who soon acquired a dominance over his Venetian contemporaries almost

equal in authority to that exerted by Michelangelo in central Italy.

Another unconventional picture, the so-called *Fête Champêtre* (fig. 19.5), has been attributed to both the last phase of Giorgione's art and the earlier stages of Titian's. The subject is probably an allegory of poetry. Two gentlemen, one fashionably dressed and playing a lute, are seated on the ground in conversation, paying no attention to two nude women. One of these women seems about to give voice to a recorder, while the other pours water back into a well from a pitcher. The landscape lacks clear-cut shapes or edges, form is lost in shadow, and there is almost more shadow than light. The face of the young man on the left, for instance, seems full of expression, but it is so deeply shaded that we can see little more than the profile and the position of one eyebrow.

The poetic mood evoked by the subject is used by some critics to support the attribution to Giorgione, while others argue that the complex figural composition and the manner in which the figures dominate the landscape are atypical of Giorgione's usual approach. If the painting is by Giorgione, he has started to move his brush with greater freedom, animating the shadow world with the motion of his hand as well as with the saturation of color. There will perhaps never be a definitive answer to authorship in this case, which documents the intersection between the two artists who together revolutionized Venetian painting at the beginning of the Cinquecento.

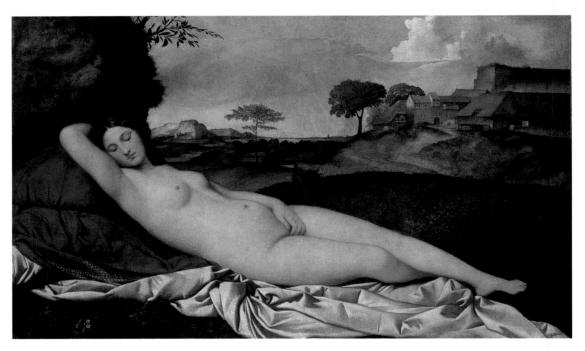

19.4. GIORGIONE (finished by Titian). Sleeping Venus. c. 1510. Canvas, $42\frac{3}{4}$ x 69" (1.1 x 1.75 m). Gemäldegalerie, Dresden.

X rays reveal a kneeling Cupid at Venus's feet who was overpainted when this area of the work was damaged. In 1525 this painting was described as "The canvas of the nude Venus, sleeping in the countryside with Cupid, was by Zorzi [Giorgione] of Castelfranco, but the landscape and Cupid were completed by Titian." The face in its present state is doubted to be by the hand of either artist and was probably repainted in Dresden in the early nineteenth century.

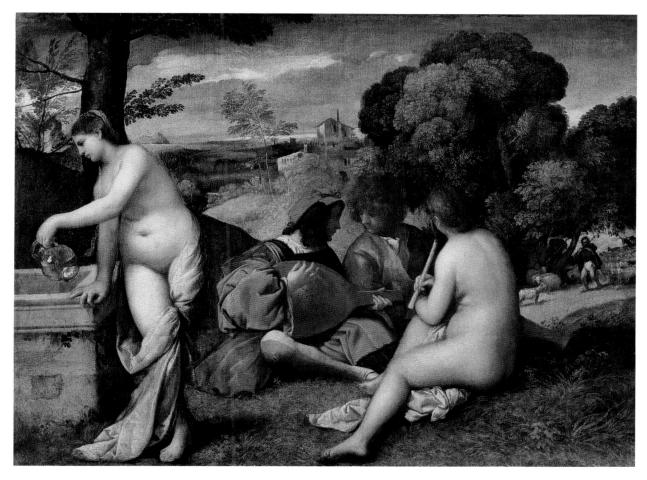

19.5. GIORGIONE or TITIAN. *Pastoral Scene*, now known as the *Fête Champêtre*. c. 1510. Canvas, $43\frac{1}{4} \times 54\frac{1}{4}$ " (1.1 x 1.37 m). The Louvre, Paris.

The impact of the picture is evidenced by the fact that it (along with an engraving after Raphael's *Judgment of Paris*) became a potent influence on the nineteenth-century painter Édouard Manet when he created his notorious *Déjeuner sur l'herbe*.

Titian

Tiziano Vecellio, known in English as Titian, was born in Cadore, high in the mountains at the beginning of the spectacular ranges of the Dolomites. He lived until 1576 and attempted to give the impression of immense age. The tradition that he lived to ninety-nine, and was therefore born about 1477, is no longer accepted. When Vasari visited Titian in 1566, he recorded Titian's age as seventy-six, which would place the date of his birth in 1489 or 1490. No independent artistic activity on Titian's part is recorded before 1508 when, barely twenty years old according to his friend Ludovico Dolce, he assisted Giorgione in painting frescoes on the exterior of the German commercial headquarters in Venice. No securely dated works by him before 1511 survive, and contemporary sources describe him as still young when, in 1516-18, he painted the Assumption of the Virgin (see fig. 19.8). The most probable date for his birth would therefore be about 1488.

His documented career, then, would span sixty-eight years. During this career Titian made one of the crucial discoveries in the history of Western painting. He was the first painter in modern times to free the brush from the task of exactly describing tactile surfaces, volumes, and details, and to convert it into a vehicle for the direct perception of light through color and—equally important—for the expression of feeling. Others had taken steps on this road, but it was Titian who found and crossed the bridge. As early as the *Assumption of the Virgin*, Titian demonstrated his knowledge and mastery of this new type of brushwork, but he restricted its use to areas relatively remote from the observer. Long before the end of his life he was painting entire pictures by this method, as were many other painters in Venice. The technique of raised brushstrokes of thick paint that he uses is called *impasto*.

Brushwork was, however, only the beginning of Titian's style. Contemporaries tell how he built up his pictures in oil over a reddish ground to establish a warm base for all the colors, and how in his later years he would turn his paintings face to the wall for months and then study them anew as if they were his worst enemies. New layers of paint might then be applied, especially glazes (the Italian word *velatura*, or veiling,

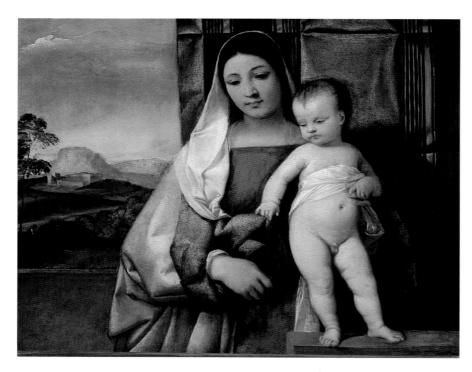

19.6. TITIAN. *Madonna and Child*, known popularly as the *Gypsy Madonna*. c. 1511–12. Panel, 26 x 32¹/₂" (66 x 82.6 cm). Kunsthistorisches Museum, Vienna

Opposite: 19.7. TITIAN.

Portrait of a Bearded Man (Self-Portrait?).

c. 1512. Canvas, 32 x 26"
(81.2 x 66 cm). National Gallery, London.

The initials T. V. on the parapet are thought to be the signature of Titian, whose name in Italian is Tiziano Vecellio. Some have identified this with Titian's portrait of a member of the Barbarigo family, which was described by Vasari as "very beautiful since the flesh seemed true and natural, the hairs so precisely drawn you could count them, as you could the stitches on the silvery satin jacket worn by the figure."

expresses well the role these glazes play) that tone down colors that might stand out too much and that create a unity among colors, shadows, and highlights. "Trenta, quaranta velature!" ("Thirty, forty glazes!") he is said to have cried, and possibly there are that many, except where zealous restorers have cleaned them off, stripping Titian's paintings down to the strong colors he intended to tone down and unite. One of his assistants wrote that at the end of his life Titian "painted more with his fingers than with his brushes."

Ludovico Dolce, who knew Titian well, wrote that he arrived in Venice at the age of eight with his older brother and was set to work with a mosaicist named Zuccato. Dissatisfied, he was taken on by Gentile and then Giovanni Bellini. Even in this authoritative shop he did not stay long, but moved on to study with Giorgione. By 1510 he seems to have become independent. The young man was also a shrewd businessman who invested his earnings; by 1531 he was able to buy a palatial residence in Venice, looking out across the lagoons and, on clear days, to the peaks below where he had been born. In 1533, already wealthy and famous, Titian was summoned to Bologna to meet Emperor Charles V, who made him a count and his children hereditary nobles. In 1545 and 1546 he was in Rome, where he was awarded Roman citizenship on the Capitoline Hill. Twice the emperor called him to Augsburg as court painter. There is even a famous tale that one day, when Charles V was visiting his studio, Titian chanced to drop his brush and the emperor stooped to pick it up.

From the start of his career, Titian showed his impatience with the cliché. Every motif, every convention had to be seen afresh. In his early *Madonna and Child* (fig. 19.6), nicknamed the *Gypsy Madonna* because of the unusual dark hair and eyes

of Mary, he takes the theme of the parapet, standing child, and cloth of honor, familiar from the works of the Bellini, and pushes them off center. The Virgin stands slightly to the right of center, but she overlaps only one edge of the cloth of honor, which has been moved to leave a single landscape view instead of the customary two. The parapet runs less than halfway across the lower edge, and the disjunction between parapet and cloth of honor leads our eye upward in a slight diagonal over a second parapet to the hills and mountains of the background. Throughout Titian's career, diagonal placings and views will be used in increasing intensity to break the traditional symmetry of Renaissance pictures. But another of Titian's lifelong compositional principles is already visible in the Gypsy Madonna—the Virgin forms an equilateral triangle. The triangle and the diagonal are for Titian's art what the spiral is for Raphael and the block for Michelangelo.

In the *Gypsy Madonna*, the sweetness of Bellini's Madonnas is replaced by a sturdy naturalism. The sun shines full on her face, with its large, wide-set eyes, and a half-shadow lingers on her neck. Her cheeks and lips glow in the light. Her quiet grace is impressive, and her child is a sturdy boy.

A bold early work by Titian is the *Portrait of a Bearded Man* (fig. 19.7), which some have argued is a self-portrait. With his usual ease, Titian rests the man's elbow on the parapet so that the sleeve overlaps the edge and seems to jut into our space. The life-size sitter, the unified composition, and the simplified brushwork—which on close inspection emphasizes breadth rather than detail—create a figure that is convincing from a distance. If this is a self-portrait, perhaps it was made as a *trompe l'oeil* demonstration, to be placed in a window to momentarily deceive a passerby. Although the

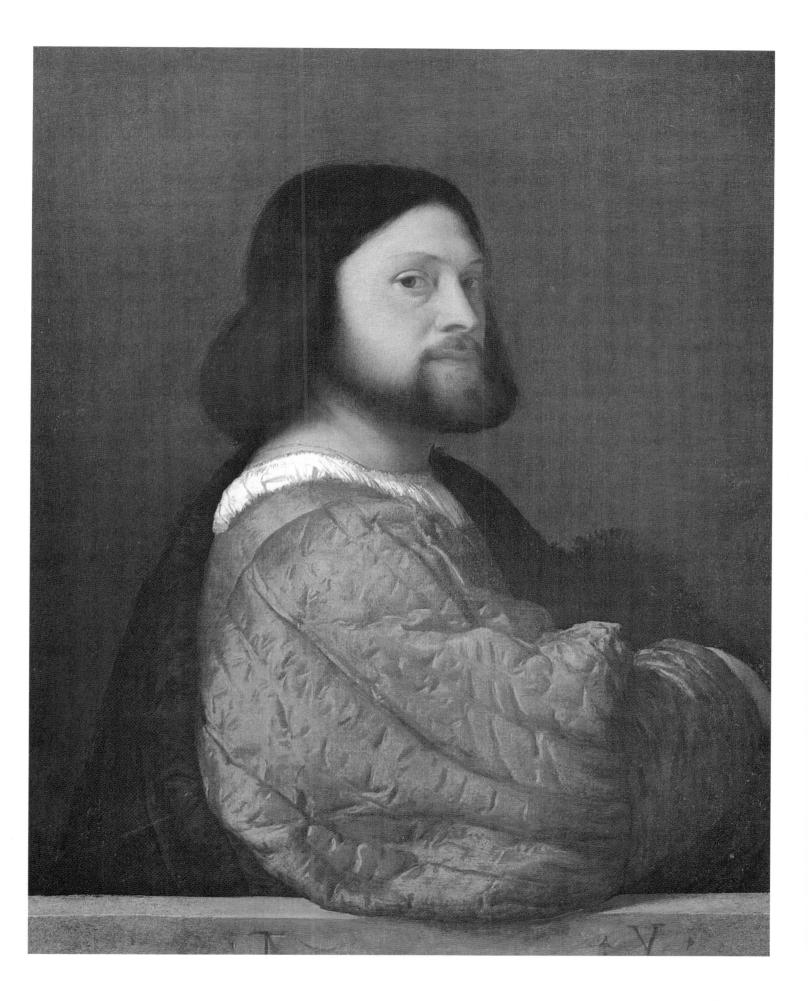

HIGH AND LATE RENAISSANCE IN VENICE AND ON THE MAINLAND • 637

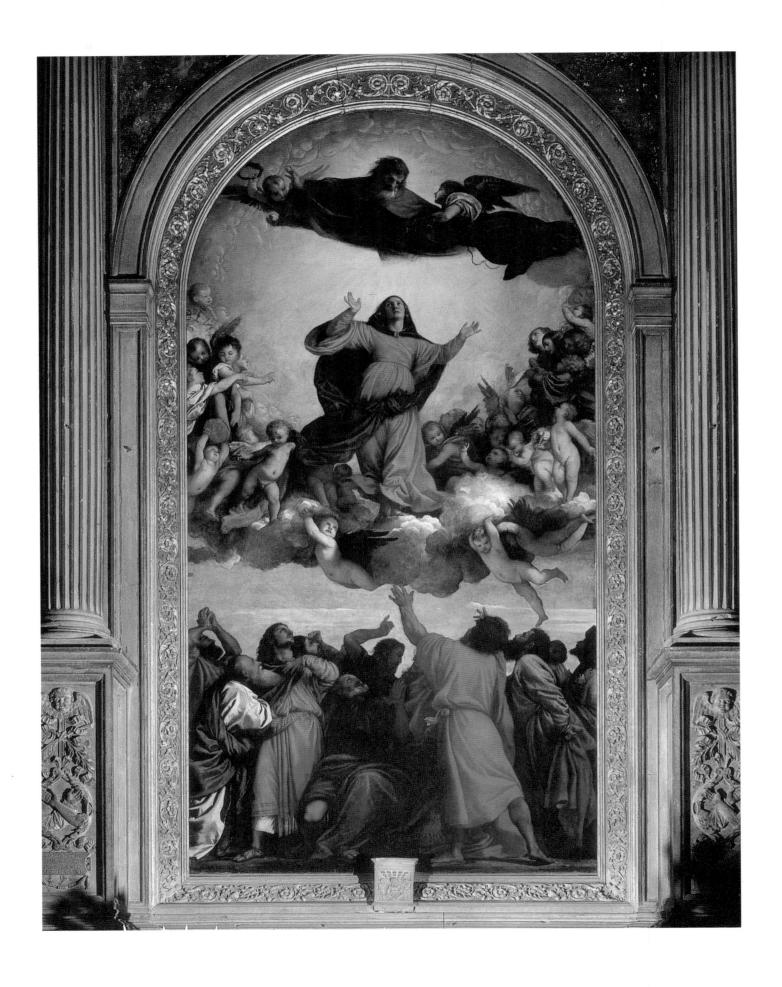

Opposite: 19.8. TITIAN. Assumption of the Virgin. 1516–18. Panel, 22'6" x 11'10" (6.9 x 3.6 m).

Sta. Maria Gloriosa dei Frari, Venice. Commissioned by Germano da Caiole, the Abbot of the Monastery of the Frari. (For a view of the painting in situ in the church, see figs. 1, 5.17.)

The marble frame on the painting is original, and was also commissioned by Caiole. The work is signed on the Virgin's sarcophagus, with letters that seem to be carved into the stone.

19.9. Angels, detail of fig. 19.8

body is almost at right angles to the picture plane, the head turns and the eyes calmly engage us. The broad, spiral motion of arm and head suggests that Titian already knew something about what was going on in Florence, but he has handled the pose in his own way. The manner in which the hand suddenly turns out of sight, into shadow, is surprising and un-Florentine. The light illuminates the near side of the face, emphasizing the cheek, forehead, and strong, straight nose. The face holds its own against the beauty of the blue-violet sleeve, which catches and holds our eye against the warm stone and gray background.

Titian's Assumption of the Virgin (figs. 19.8, 19.9) is over twenty feet high, but it seems even larger because of his handling of the figures, who are heroic in both proportion and deportment. This grand picture competes successfully with the vast Gothic interior of the Church of Santa Maria Gloriosa dei Frari (see figs. 1, 5.17, 5.18), on whose high altar it still stands. There may or may not be some relation to the Sistine Madonna of Raphael (see fig. 17.54). Titian was not to visit Florence and Rome until 1545, but some notion of the grandeur and scale of the central Italian High Renaissance could have been brought to Venice by Fra Bartolommeo and others, and possibly he came to know certain aspects of the style through drawings and prints.

Titian has imagined the moment of the Assumption—the physical ascent into heaven of the Virgin's body miracu-

lously reunited with her soul after burial—as a scene of cosmic jubilation. The foreground is filled with healthy, sturdy apostles who gesticulate wildly. Their movements converge to form a triangle from whose apex the Virgin ascends on a curving cloud populated by putti (fig. 19.9). These are not the cute, impish babies of Quattrocento tradition, but robust children who sail upward with Mary into the golden light, which warms their bodies and flashes from their curly hair. In the midst of this throng, Mary sways in the winds of heaven and her mantle billows about her, creating more diagonals and triangles. Even God the Father floats diagonally toward us in space. Activated by an irresistible upward drive, humanity conquers heaven in the person of Titian's Mary, her entire being yearning for this final realization.

And finally there is the color, which is unforgettable to anyone who has seen the painting in situ. Perhaps the necessity for broad effects that would be visible from a distance persuaded Titian to restrict himself to a few dominant hues—reds, blues, and greens in the garments of the apostles and the traditional blue and red for Mary's mantle and tunic, set off against a clear blue sky below and the gold of heaven above. The result is a composition of grand simplicity, a symphonic structure in massive chords that reaches the observer immediately and directly.

Before we leave the *Assumption*, it is worthwhile to read what Titian's contemporary Ludovico Dolce wrote about the picture and its original reception in Venice:

Here Titian, a young man even now, painted in oils the Virgin ascending to heaven amongst many escorting angels; and above her he did a figure of God the Father, flanked by a pair of angels. . . . And certainly the grandness and awesomeness of Michelangelo, the charm and loveliness of Raphel, and the coloring proper to nature are incorporated into this painting. It was, nevertheless, the first public commission that Titian carried out in oils; and he did it in the shortest space of time, and in his youth. All of which meant that the clumsy artists and dimwit masses, who had seen up till then nothing but the dead and cold creations of Giovanni Bellini, Gentile, and Vivarino (the fact being that Giorgione had not yet received a public commission for a work in oils, and that his creations were mostly limited to half-figures and portraits)—works that had no movement and no projection—grossly maligned this same picture. Later the envy cooled off, and the truth, little by little, opened people's eyes, so that they began to marvel at the new style opened up by Titian in Venice. . . . And certainly one can speak of a miracle at work in the fact that, without as yet having seen the antiquities of Rome, which were a source of enlightenment to all excellent painters, and purely by dint of that little tiny spark which he had uncovered in the works of Giorgione, Titian discerned and apprehended the essence of perfect painting.

Probably a year or so earlier than the *Assumption*, Titian painted the so-called *Sacred and Profane Love* (fig. 19.10), about whose interpretation much has been written. The following summary combines elements drawn from several interpretations. Two women, so similar in form and coloring that they look like sisters, sit on a fountain in the late afternoon. One is clothed in white, girdled with a locked belt, gloved, and holds a closed jar; she is seen against a fortified hill town to which a huntsman returns, while in the countryside two rabbits, symbols of love, establish a mood of quiet peace; as she looks past us, seeming to be listening, she toys with a cut rose.

The other figure is nude, save for a white scarf and a rose-colored cloak, and she holds aloft an urn from which a flame rises. Behind her stretches an open and luminous landscape in which, before a lake, huntsmen catch up with a rabbit, shepherds tend their flocks, and a church steeple rises above the horizon. The fountain has the shape of a sarcophagus, and its lid is thrust aside so that Cupid may stir its waters. A golden bowl half filled with clear water rests upon the edge. On the sarcophagus are carved the arms of Niccolò Aurelio, vice-chancellor of the Venetian Republic; to the left, a horse is led by its mane by one groom while others flee. To the right, a man is beaten and a woman is led by her hair.

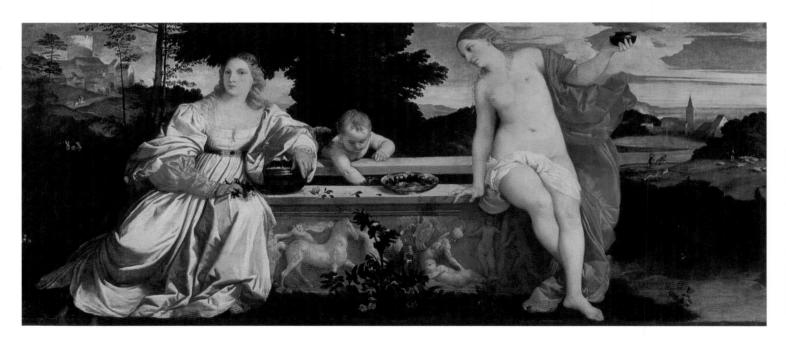

19.10. TITIAN. Sacred and Profane Love. 1514. Canvas, $3'11" \times 9'2" (1.2 \times 2.8 \text{ m})$. Borghese Gallery, Rome. Probably commissioned by Niccolò Aurelio in celebration of his wedding to Laura Bagarotto in 1514

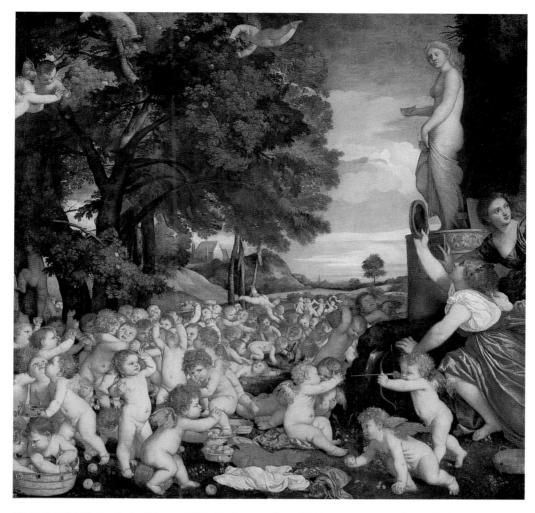

19.11. TITIAN. Festival of Venus. 1518–19. Canvas, 68 x 68" (1.7 x 1.7 m). Prado, Madrid. Commissioned by Alfonso d'Este for his studiolo, called the Camerino d'Alabastro in the Castle at Ferrara. The lower surfaces of the walls were decorated with white marble reliefs of classical subjects. This was not the first work Alfonso commissioned from Titian, for in 1516 Titian had made a painting of the Tribute Money for the door of a cabinet for Alfonso; this painting, now lost, serves as an important reminder that Renaissance artists were often engaged by patrons to produce small, functional works. We know from documents that the Festival of Venus was completed and delivered, with Titian in attendance, in less than a year. The signature of Titian is found on the lower right edge of the white cloth in the central foreground.

While the meaning of some details remains obscure or debatable, it seems evident that this is a picture about love and marriage; the style allows a dating in the teens, and Aurelio's marriage in 1514 suggests that the painting may be connected to that event. The woman dressed in white could be a portrait of the bride, Laura Bagarotto, or a representation of an idealized bride, while the nude figure, who is in the company of winged Cupid, is surely Venus. Thus the traditional title should probably be discarded, but the iconography is so unique that it is difficult to know what to put in its place. Titian has composed this vision in terms of his characteristic triangles in a simple harmony

based on whites and silver-grays, blues, roses, and deep greens that already show the warmth and depth of his glazing technique.

The Renaissance interest in ancient mythological themes can be seen in three pictures that Titian painted for Alfonso d'Este, duke of Ferrara. Alfonso apparently requested that two of Titian's works follow literary descriptions by the third-century Roman author Philostratus of pictures he had seen in a villa near Naples. First is the *Festival of Venus* (fig. 19.11), representing cupids before a statue of Venus; they romp through a meadow devouring baskets of her golden apples and even fly into the trees to pick more fruit; Titian's

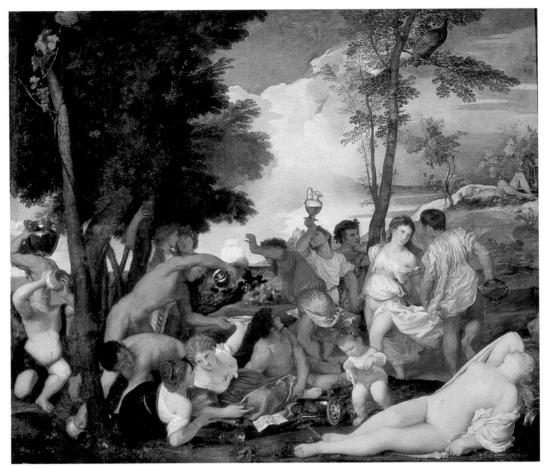

19.12. TITIAN. Bacchanal of the Andrians. c. 1522-23 or later. Canvas, 69 x 76" (1.75 x 1.93 m). Prado, Madrid. Commissioned by Alfonso d'Este for his studiolo in the Castle at Ferrara. The musical composition seen in the foreground is identifiable as a song for four voices attributed to Adrian Willaert; the text in translation reads "He who drinks and does not drink again, does not know what drinking is." Willaert was a favorite composer of the patron.

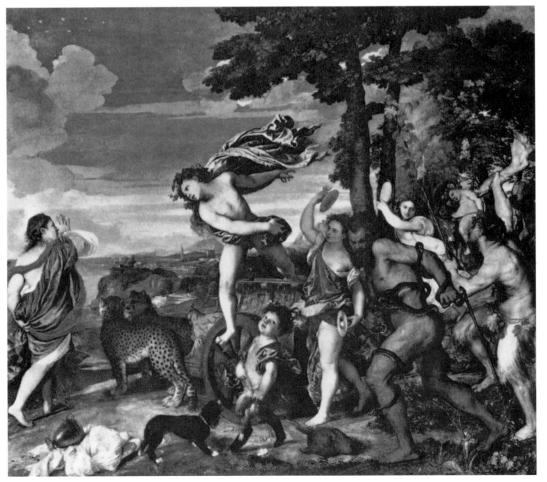

19.13. TITIAN. Bacchus and Ariadne. 1522-23. Canvas, 69 x 75" (1.75 x 1.91 m). National Gallery, London. Commissioned by Alfonso d'Este for his studiolo in the Castle at Ferrara. Titian faithfully follows descriptions written by the ancient authors Catullus and Ovid. Titian came to Ferrara to install the painting in February of 1523. The painting is signed on the amphora that lies in the lower left foreground.

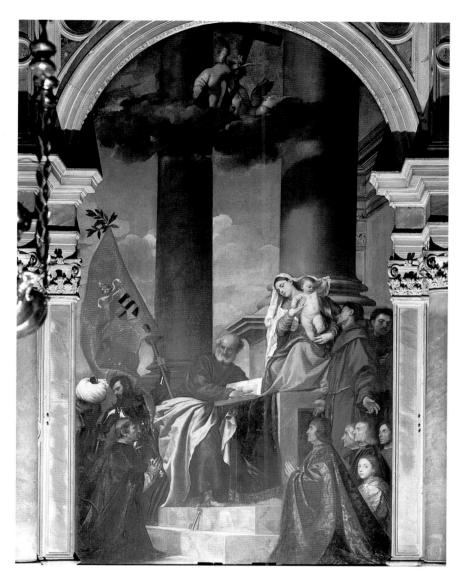

19.14. TITIAN.

dependence on the ancient text is evident, while another quotation from antiquity is seen in the nymph with the tambourine at the right, who is derived from a figure on an ancient Roman sarcophagus.

The second features the *Bacchanal of the Andrians* (fig. 19.12), the inhabitants of the island of Andros, where a river of wine gushes from the ground. Inflamed with wine and love, the Andrians dance, gather in couples, or sleep, like the nude Ariadne, below right. One little boy unashamedly urinates, while at the top of the hill the god of the river of wine, caught in a shaft of sun, lies in a torpor.

The final painting of the series, *Bacchus and Ariadne*, whose subject is drawn from a variety of classical sources in a synthesis perhaps suggested by the poet Ariosto, shows Bacchus leaping from his chariot to rescue Ariadne, who had been abandoned on the island of Naxos by Theseus (fig. 19.13). The god is attended by drunken maenads clashing cymbals and satyrs brandishing sticks and the hindquarter of a goat

torn apart for their feast. The male figure struggling with snakes was inspired by the *Laocoön* group, discovered in Rome less than two decades earlier (see fig. 17.2).

In these three paintings Titian reaches a new freedom of figural composition and brilliance of coloristic expression. The rich flesh tones and the sparkle of the blues and roses were clearly designed to stand out against the alabaster architecture of Alfonso's room. But the eloquence of color in the shadows is almost more surprising than its vibrancy in the light. Note the sheen of the crystal pitcher against the cloud or the glow of the coats of the leopards where they are cast into shadow by the leaping Bacchus.

Meanwhile, in his religious works, Titian was exploiting the implications of what might be called his diagonal-triangular principle for monumental composition. An example is the *Madonna of the Pesaro Family* (figs. 19.14, 19.15; see also fig. 12), commissioned for a side aisle altar in Santa Maria Gloriosa dei Frari. The scene is laid outdoors in full sunlight,

but Titian chooses the portico of the Virgin's heavenly palace as his setting. An armored warrior holding an olive-crowned flag with the arms of the Pesaro family presents Saint Peter, in the middle, with a captured Turk. This is a reference to the Battle of Santa Maura, which was won in 1502 by Jacopo Pesaro, bishop of Paphos and commander of the papal galleys. Jacopo himself kneels at the left, accompanied by a turbaned Turkish prisoner, and at the right kneel five male members of his family.

An artist in the conservative Venetian tradition would have given us a symmetrical composition, but Titian has deployed his diagonals and triangles in depth and height. First, he has turned the palace at a sharp angle to the picture plane, then set the Virgin so far to one side that her head forms one corner of an equilateral triangle whose other two points are provided by the kneeling chiefs of the Pesaro clan. Similar triangles in smaller scale reappear throughout in figures and drapery patterns. The final composition, which is the result of experimentation with the illusionistic architecture in the course of painting, is derived from Titian's concern with relating the painting to its original setting, in the left side aisle of the church (see fig. 5.18).

The columns, which seem to be inspired by the piers of the Gothic church of the Frari (see figs. 1, 5.17), soar beyond the arched frame, and at the top a cloud floats in, bearing putti holding a cross. The result is noble and dramatic. Titian's pictures of the 1520s have all the harmony of the High Renaissance, but with a new power of shapes rather than muscular action. Now Titian's color has quieted down; the *Pesaro Madonna* is darker and richer than the work of the preceding decade, softened by his application of multiple glazes.

When, at some time in the mid-1520s, Titian took up the subject of the *Entombment* (fig. 19.16), he did so in a measured and controlled fashion. The pose of Christ is borrowed from that of the dead Meleager carried from the boar hunt in Roman sarcophagus reliefs. Titian has fitted his central

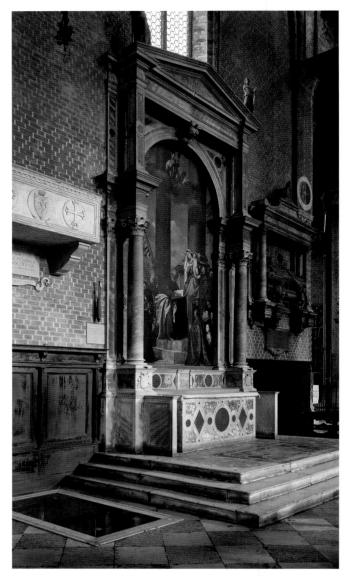

19.15. TITIAN. Figure 19.14 seen in situ in Sta. Maria Gloriosa dei Frari, Venice. (see fig. 12)

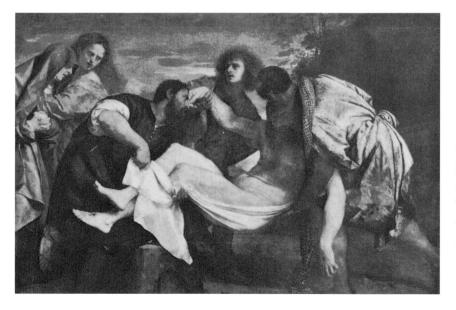

19.16. TITIAN. *Entombment*. Mid-1520s(?). Canvas, 58 x 81" (1.47 x 2.05 m). The Louvre, Paris. Probably commissioned by a member of the Gonzaga family. The painting has been enlarged with strips of canvas across the top and the bottom which add approximately eight inches to the height.

19.17. TITIAN. *Man with the Glove*. c. 1520–21(?). Canvas, 39³/8 x 35" (100 x 88.9 cm). The Louvre, Paris. Titian's signature is represented as if carved into the stone block on the right.

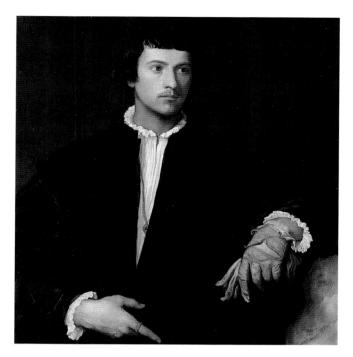

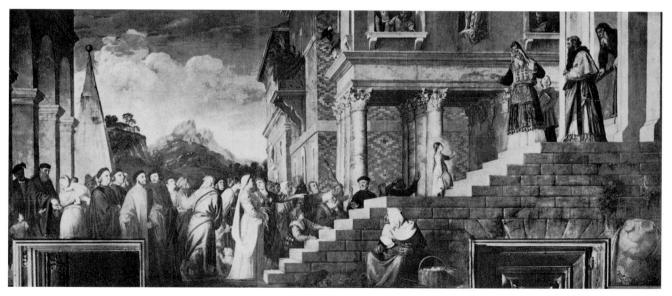

group—Christ, Nicodemus, Joseph of Arimathea, and John—into an isosceles triangle, but the diagonals of Christ's thighs form one side of another isosceles triangle that has its apex at the head of the Virgin; the other two sides correspond to those of the lower left corner of the frame. These intersecting triangles are enriched by numerous curving shapes. Within the composition the heads, simplified to geometric essentials as in the *Pesaro Madonna*, exchange glances of tragic intensity.

Titian's portraiture in the 1520s enters a similar phase of dignity and reserve. No expression crosses the face of the *Man* with the Glove (fig. 19.17), and the triangular relationship of

hands and face functions within a color scheme restricted to black, white, and flesh tones. Yet one cannot escape the solemnity of the gaze, the luminosity of the eyes, the naturalism of the face, and the informality of the pose, all of which give the portrait a strong sense of individual character. Titian clearly sees the limited color palette as a challenge, and the effect of living, warm flesh against the black and white of the costume and the beige of the torn glove, which gives the painting its modern name, is impressive.

In the 1530s a more conservative phase of Titian's work begins, epitomized by the *Presentation of the Virgin* (figs. 19.18,

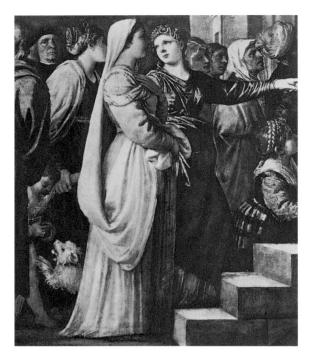

19.19. Women, detail of fig. 19.18

19.19) for the Scuola della Carità in Venice. The painting depends for its effect more on areas of bright costumes and rich marbles than on form or movement. The details are rich in color, but the figures are withdrawn in expression and austere in form. The three-year-old Virgin, center of a soft radiance of light, is a touching figure as she pauses, and the grand high priest is dressed with attention to the biblical description of his vestments, including the jeweled breastplate. The grouping of portraits on the left are certainly members of the *scuola* that was Titian's patron.

Titian's so-called *Venus of Urbino* (fig. 19.20) was finished in 1538 for Guidobaldo II della Rovere. In this, the earliest of his series of recumbent Venuses, Titian returned with such fidelity to the pose of Giorgione's *Venus* (see fig. 19.4) that one suspects that the patron requested it. But now the sleeper has awakened and looks at us with a calculating stare. She lies upon a couch, her dog asleep at her feet; one hand idly holds a nosegay of flowers; and her rich, silky, golden brown hair floods over her shoulder in a contrast of textures and colors that Titian used and reused from his youth to old age. Titian has divided his background between the cubicle in which the nude reclines and an

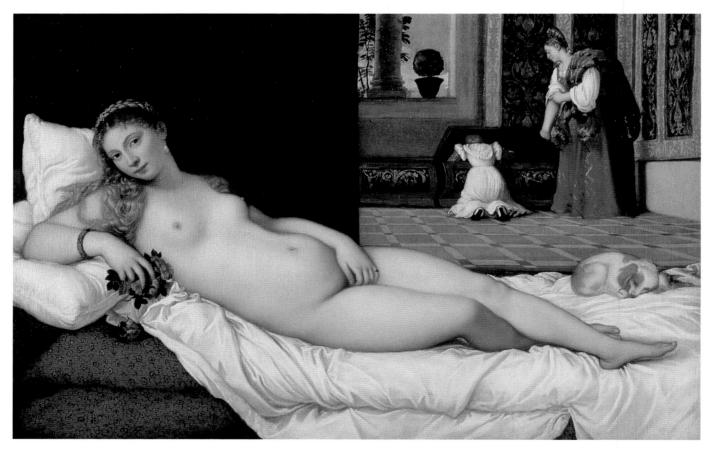

19.20. TITIAN. *Venus of Urbino*. Finished in 1538. Canvas, 47 x 65" (1.19 x 1.65 m). Uffizi Gallery, Florence. Commissioned by Guidobaldo II della Rovere, Duke of Camerino (and later Duke of Urbino). The recent conservation of the picture demonstrated that the painting was damaged when it was adhered to a new lining by ironing; as a result, Titian's rich, raised *impasto* brushwork was flattened.

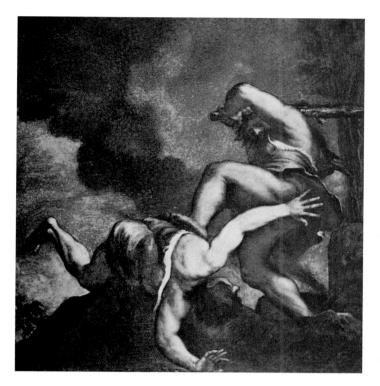

19.21. TITIAN. *Cain Killing Abel.* 1542. Canvas, 9'2" (2.8 m) square. Sacristy, Sta. Maria della Salute, Venice. Commissioned for Sto. Spirito in Isola, Venice

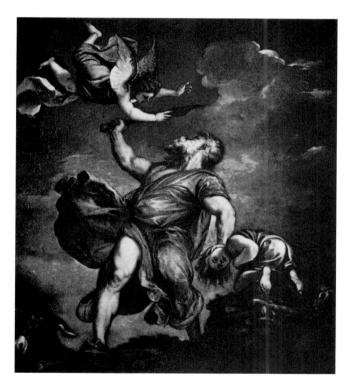

19.22. TITIAN. *Sacrifice of Isaac*. 1542. Canvas, 10'6" x 9'2" (3.2 x 2.8 m). Sacristy, Sta. Maria della Salute, Venice. Commissioned for Sto. Spirito in Isola, Venice

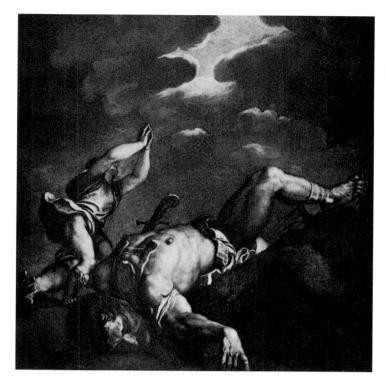

19.23. TITIAN. *David and Goliath.* 1542. Canvas, 9'2" (2.8 m) square. Sacristy of Sta. Maria della Salute, Venice. Commissioned for Sto. Spirito in Isola, Venice

adjoining chamber, paved with marble, hung with brocades, and lit by an opening onto treetops. In this palatial environment, a splendidly dressed woman looks on while a girl in white searches for something in one of a pair of carved and gilded *cassoni*, the chests in which clothes were kept in the Renaissance.

Is this Venus at all? Guidobaldo's correspondence, which betrays his impatience to receive this picture, refers to the subject simply as "the nude woman." Only her connection with Giorgione's earlier and Titian's later Venuses suggests otherwise. If this is Venus, then Titian has gone to considerable pains to demythologize her, to represent her as a prince's lover who basks in the warmth of her own flesh, while her lady-inwaiting and maidservant find a garment splendid enough to clothe her. Recent analyses of the painting have raised important questions about how it was interpreted by the Renaissance men who were surely its primary audience, and how it reveals the role of women in Cinquecento Italy.

Titian painted an uninterrupted sequence of dramatic, passionate works from the early 1540s until he was stopped by death. In 1542 he accepted a commission, offered originally to Vasari when he visited Venice, for three scenes of violent action for the ceiling of the Church of Santo Spirito in Isola (figs. 19.21–19.23). The subjects, *Cain Killing Abel, Sacrifice of Isaac*, and *David and Goliath*, prefigure Christ's sacrifice. Here Titian, who still had not visited Rome, showed for the first time a sustained interest in the heroic poses and powerful musculature of the Roman High Renaissance. In the heavily muscled figures,

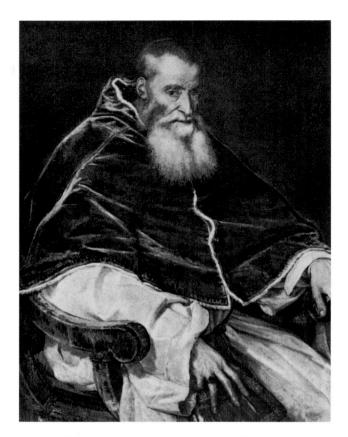

19.24. TITIAN. *Pope Paul III Farnese*. 1543. Canvas, 45 x 35" (114 x 89 cm). Museo di Capodimonte, Naples. Commissioned by Pope Paul III.

It is always difficult to determine the length of time it took to produce a work of art, in part because the artist was probably executing several other works at the same time. However, in 1531 documents indicated that Titian started and completed a half-length figure of a saint in a month. This portrait may have taken a similar length of time.

who seem almost to fall out of the confines of the paintings, there is an echo of Giulio Romano's giants (see fig. 18.70), while the influence of ancient sculptures probably also plays a role. But Titian's figures are interpenetrated by light and color.

Among the earliest in a series of portraits in the new, emotionally charged style is *Pope Paul III Farnese* (fig. 19.24), which Titian painted when the pope visited Bologna in 1543. This unwilling supporter of the Counter-Reformation was at heart a Renaissance prince, and he is shown in a restless pose, twisted in his chair, one hand on his purse, his head jutting forward, his gaze glinting in our direction. The characterization of the shrewd face and the powerful drawing of the features, hands, hair, and beard, painted with the relatively fine brushes traditionally in use in Venice, are combined with an electrifying display of reds

and flashes of light on the velvet papal garment known as the *mozzetta*. Titian beat these strokes onto the canvas with a broad, heavy brush. His highlights crackle from the picture with a new freedom, living a life of their own to such an extent that they almost dominate the composition.

As Titian's lifework culminates in a final quarter century of activity, the new freedom of light and brushwork increases, often at the expense of solid form. Tactile reality is softened, dissolved, even shattered by bursts of brushwork that record luminary visions. Generally, these are connected with erotic imagery or with scenes of religious experience. Three times Titian repeated, for various patrons, his composition showing how the mortal Danaë was seduced by Jupiter, who descended upon her as a shower of golden coins (fig. 19.25). In the pose of Danaë, Titian utilized a pose from Michelangelo, who derived the motif from an ancient Roman relief and used it for a picture of Leda—a woman seduced by Jupiter in the form of a swan—and for the *Night* (see fig. 18.4) of the Medici Chapel.

In the version Titian painted for King Philip II of Spain (fig. 19.25), he included a greedy maidservant stretching out her apron to try to catch some of the coins. Her gnarled ugliness and avarice contrast with the beauty and rapture of Danaë; one woman looks for material gain, the other waits for a love that, for all the fullness of its physical expression, is divine in origin and expressed in light. The loose brushwork

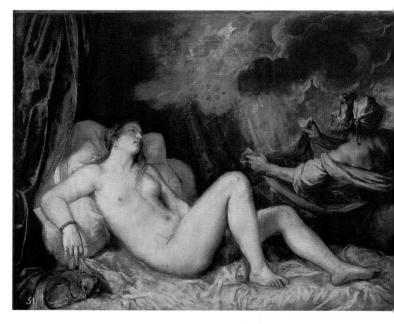

19.25. TITIAN. *Danaë*. 1552–53(?). Canvas, 50¹/₄ x 70" (1.28 x 1.78 m). Prado, Madrid. Commissioned by Philip II of Spain. This painting is a variation of a composition originally created for Cardinal Alessandro Farnese, grandson of Pope Paul III (1545–46; now in the Gallerie Nazionali di Capodimonte, Naples).

19.26. TITIAN. *Martyrdom of St. Lawrence*. c. 1548–57. Canvas, 16'5" x 9'2" (5 x 2.8 m). Chiesa dei Gesuiti, Venice.

Commissioned by Lorenzo Massolo for his tomb chapel in Sta. Maria dei Crociferi, Venice. Renaissance artists did not hesitate to replicate their works if commissioned to do so, and in 1564–67 Titian produced a variation of this altarpiece for King Philip II of Spain (now in the Escorial). When Vasari visited Titian's studio he saw the version being painted for Philip and praised it as "executed with admirable skill, ingenuity, and good judgment." Many of Titian's works, including this one, were known throughout Europe as the result of prints made by the Netherlandish artist Cornelis Cort, who in 1565 reached an agreement with Titian to reproduce his works.

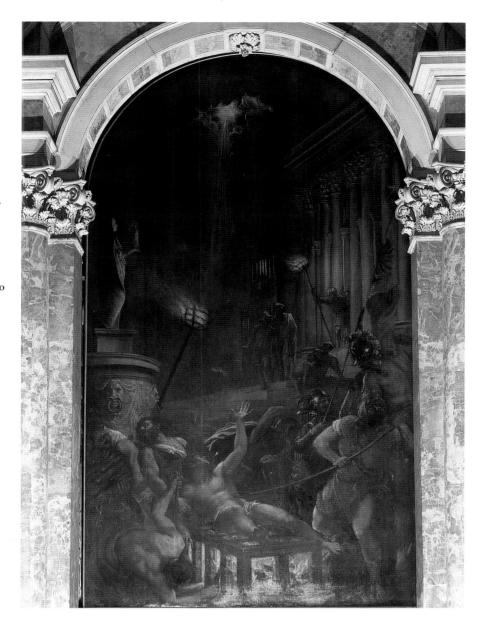

of Titian's late style releases Danaë's warm, glowing body from any trace of Michelangelesque muscular tension, shatters the drapery folds into luminary reflections, and culminates in the glorious burst of golden, copper, silver, and turquoise rays flooding from the cloud. Titian termed his paintings of mythological subjects *poesie* (poetries), but whether this is a term invented by him is uncertain.

When Vasari and Michelangelo visited Titian's studio in the Belvedere Palace in Rome, they saw the Venetian painter's first version of this subject, painted for Cardinal Alessandro Farnese. Vasari wrote that he and Michelangelo

praised it, as one does in the presence of the painter. After [we] had left, in discussing Titian's method, Michelangelo praised it, saying that his color [colorito] and his style much pleased him, but that it was a pity that Venetian painters did not learn to draw well from the beginning, and that they did not pursue a

better method in their studies. 'For,' he said, 'If Titian had been in any way assisted by art and design [disegno], as he is by nature, and above all in counterfeiting life, no one could do better work, for he has a fine spirit and a beautiful and lively manner.'

Whether Michelangelo actually said this is uncertain, but the nature of his comments supports Vasari's assertion in his *Lives* that Florentine drawing (*disegno*) was superior over Venetian color (*colore*).

Titian's huge altarpiece of the *Martyrdom of St. Lawrence* (fig. 19.26) represents the Early Christian saint being burned on a grill after he refused to make a sacrifice to the ancient Roman gods. Titian sets the scene at night, in part so he can contrast the warm embers of the flames below with the white light of heaven that breaks through the clouds above, and to which Lawrence reaches. The saint's tormentors, some of

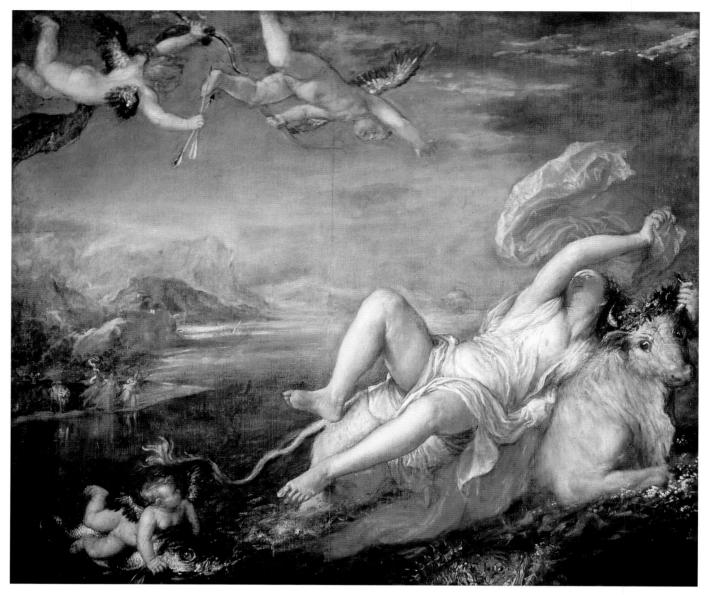

19.27. TITIAN. *Rape of Europa*. 1559–62. Canvas, 73 x 81" (1.85 x 2.05 m). Isabella Stewart Gardner Museum, Boston. Commissioned by Philip II of Spain.

Twelve years after the painting arrived in Spain, Titian was still waiting to be paid by the king.

whom wear armor that catches the glints of the flames and torches, blow on the flames or force Lawrence back down on the grill with a giant pitchfork. Titian represents the saint dramatically foreshortened in the illusionistic space, at a rising angle that contrasts with the downward slope of the buildings to the right. The composition is closed on the left by an impassive ancient idol seen from below. These forceful angles of vision, the strong movement of the saint and his tormentors, and the crackling flames and diagonal torches draw the spectator into a confrontation between torture and redemption that cannot be ignored. This image, in which perhaps 50 percent of the surface is pure black, is the most evocative night scene since Raphael's *Liberation of St. Peter from Prison* (see fig. 17.52); like that work, it

must have played a role in inspiring the nocturnal visions of later Baroque painters.

A completely different mood is captured in the *Rape of Europa* (fig. 19.27). The nymph Europa had been walking along the seashore with companions when Jupiter appeared as a white bull. Europa innocently wove garlands of flowers for the bull, but he suddenly swept off with her across the waters, leaving her alarmed companions on the shore. Europa clings to one of the bull's horns and tries to maintain her balance. The bull's speed lifts her garment to expose her legs and carries her rose-colored mantle upward. The picture's direction from left to right is accelerated by cupids, who ride on a fish or swoop in the air. Titian expresses the departure from earth in terms of the spatial

separation between the foreground figures and a distant landscape, exaggerating the distance between foreground and background by diminishing the figures and mountains to tiny proportions. In the landscape the flashing brushwork suggests mountains, sea, clouds, and sky through indistinguishable fluctuations of blue, silver, and apricot. Chords of deeper blue and silver play through the water, and the foam around the bull's forelegs parts to reveal a large, spiny fish. Blue and silver lights fluctuate through the bull's shaggy coat and Europa's filmy garments.

When Vasari visited Titian's studio in 1566, he recognized how the artist's style had changed:

his method of painting in these late works is very different from the technique he had used as a young man. For the early works are executed with a certain finesse and an incredible diligence, so that they can be seen from close to as well as from a distance; while these last pictures are executed with broad and bold strokes and smudges, so that from nearby nothing can be seen whereas from a distance they are perfect. . . . This method of painting has caused many artists, who have wished to imitate him and thus display

their skill, to produce clumsy pictures. For although many people have thought that they are painted without effort, this is not the case. . . . [This style of painting] makes the pictures appear alive and painted with great art, concealing the labor.

In the last decades of Titian's life, he developed a new type of action portrait, as seen in the portrait of the scholar, artist, collector, and art dealer Jacopo Strada (fig. 19.28). To indicate his profession, Strada holds a marble statuette of Venus, while ancient coins, a fragmentary torso, and a bronze figurine lie on the table. Strada's success is shown by his rich costume, fur cape, and massive gold chain with medallion, his gentlemanly status by the sword and dagger, and his scholarship by the books (Strada had a library of over three thousand volumes). The diagonals of arms, marble statuette, and sidelong glance give to the customary sixteenth-century portrait-with-attributes the excitement of a dramatic moment. This apotheosis of antiquarian commerce could almost be mistaken for a detail from a larger, narrative picture. Finished as far as the aged Titian ever finished anything, Jacopo Strada shows a controlled version of his rich brushwork and luminous glazes.

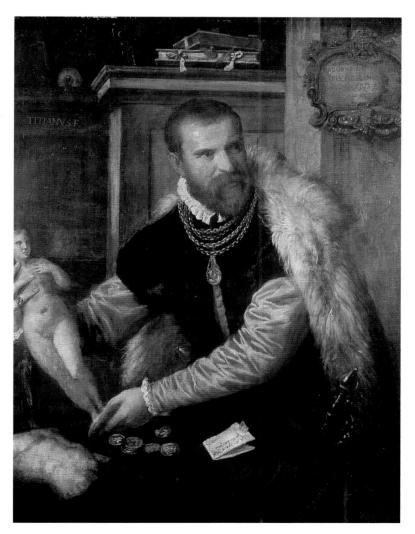

19.28. TITIAN. *Jacopo Strada*. 1567–68. Canvas, 49 x 37 ¹/₂" (124 x 95 cm). Kunsthistorisches Museum, Vienna. Probably commissioned by Jacopo Strada. The portrait was painted in Venice, when Strada was there purchasing works for Albrecht V of Bavaria. The letter on the table is addressed to Titian in Venice and perhaps functioned as a kind of signature.

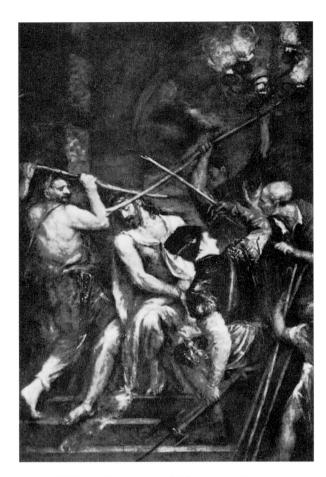

19.29. TITIAN. Crowning with Thorns. c. 1570. Canvas, 9'2" x 5'11 1 /2" (2.8 x 1.8 m). Alte Pinakothek, Munich. Vasari wrote that Titian's method of retouching and repainting his works "is judicious, beautiful, and magnificent, because the pictures seem to come alive. . . . "

At the close of Titian's life, his thoughts, like those of Michelangelo at a similar age, turned with intensity toward religious subjects, especially the Passion of Christ. Contemplating the approach of his own death, he seems to be meditating on Christ's suffering in pictures for which no patron is known. In the 1540s Titian had painted the Crowning with Thorns (not illustrated here) in a vigorous, physical style similar to that of the Salute ceiling (see figs. 19.21-19.23); he took up this subject again about 1570 (fig. 19.29) in a picture, perhaps unfinished, found in his studio after his death. In this later picture, which was acquired by Domenico Tintoretto, son of the painter, the violence is communicated by color and brushwork, not muscular activity. The blows strike the wounded head from staves wielded by figures that seem to be virtually weightless. The drama of shadows and lights acquires its ferocity through the vibrancy of the brushwork and what might be called the slow burn of the coloring. *Impasti* rain upon the canvas. The compositional triangles clash and interlock, increasing the storm of pain that surrounds the suffering Christ.

The frequent motives of torment and chaos that recur in Titian's last years are resolved in the Pietà (fig. 19.30). We are drawn into the painting by the Magdalen, who rushes toward us, hair streaming, arm outstretched, and her mouth open in a cry of grief. In a heavily rusticated niche, Mary holds the dead Christ. Statues of Moses and the Hellespontine Sibyl stand on bases formed by snarling lions' heads. Moses carries the tablets with the Ten Commandments and the rod with which he struck water from the rock. St. Jerome kneels before Christ, holding his hand and looking up into his face. The motif of the rushing Magdalen is repeated, diagonally, by a soaring putto who carries an immense torch. Below the statue of Moses, another putto holds the Magdalen's jar of ointment; below the sibyl a votive picture leaning against the pedestal shows Titian and his son Orazio in prayer before the Pietà, asking for deliverance from the plague.

Within the niche above Christ, a golden apse mosaic appears as a reminder, in Titian's own memorial, of his place in a Venetian tradition that encompasses both the mosaic domes and apses of San Marco and the illusionistic ones that appear in the paintings of his teacher, Giovanni Bellini, and others (see figs. 15.39, 15.40). Shimmering in the luminous glow, we can make out a pelican striking her breast, a traditional symbol of Christ's blood shed for humanity.

The Pietà was painted by Titian for his tomb in Santa Maria Gloriosa dei Frari, the church that contained two of his masterpieces. He was not able to complete it, for both he and Orazio died in the plague of 1576. He had already represented himself as the kneeling St. Jerome, with whose torments in the desert he seems to have felt some form of mystical identification. After Titian's death, the picture was finished, in a manner of speaking, by his assistant Palma Giovane, but it is not easy to discover just what he did. Certainly, he spared it the tight detail added to other unfinished works. In general, the broken brushwork seems to be Titian's, and the painting contains glorious passages, especially in the green tunic of the Magdalen and the masses of her light-brown hair. Echoes of form seem to vibrate about the faces of Christ and the Virgin and light to break from the thorn-crowned head. The closed eyes are barely indicated. But the tremulous disorder of the surface is locked into the massive triangles of the composition, crossing in depth as they emanate from or converge upon Christ and Mary. The hypotenuse of Titian's last triangle, by his own careful design, is formed by his own body and by the direction of his gaze as, in the semblance of St. Jerome, he concentrates all his being on that of Christ.

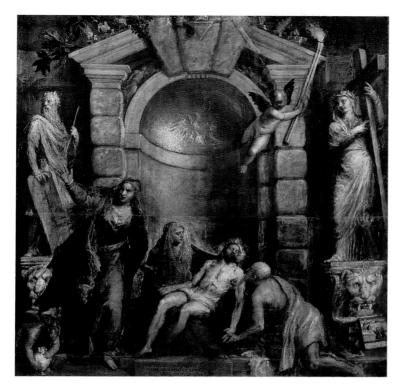

19.30. TITIAN (finished by PALMA GIOVANE). *Pietà*. c. 1576. Canvas, 11'6" x 12'9" (3.5 x 3.9 cm). Accademia, Venice.

Begun by Titian for his own tomb in Sta. Maria Gloriosa dei Frari, Venice. Palma inscribed the work: "What Titian had left unfinished, Palma respectfully completed, and dedicated the work to God."

The surface on which Titian painted this large painting was made of seven canvases different in type and weave; X-ray examination has revealed that one canvas had a head, perhaps a self-portrait, already painted on it. He was clearly recycling fragments of canvas that he had available.

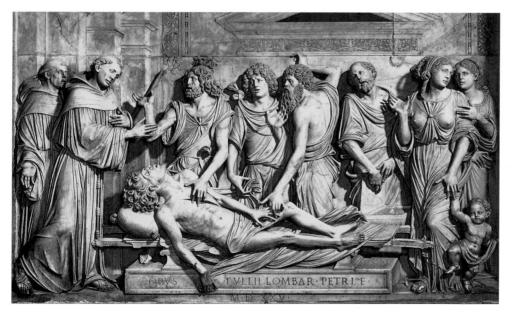

19.31. TULLIO LOMBARDO.

St. Anthony of Padua and the Miracle of the Miser's Heart (portion). 1520–25. Marble, width of relief 8'2½" (2.5 m); height of figures 4'3" (1.3 m). ① Chapel of St. Anthony, the Santo, Padua. Commissioned by the Governors of the Santo.

Tullio had already made one relief for Anthony's tomb chapel in the first years of the sixteenth century, and he was later commissioned to create a third but he died without having started it.

Tullio Lombardo

The continuing significance of antique models for Italian sculptors is demonstrated in a marble relief by Tullio Lombardo (c. 1455–1532) representing *St. Anthony of Padua and the Miracle of the Miser's Heart*. It was made for the tomb chapel of the saint in his church of the Santo in Padua (fig. 19.31). When it was first put into place, it must have seemed like a monumental demonstration of how an an-

cient Roman sculptor might have sculpted this Christian theme. The story is a dramatic one, for the saint had predicted that the heart of a famous miser would after his death be found not in his body, but in his money chest. The episode is clearly stated, with the Franciscan saint gesticulating over the emaciated corpse and the male onlookers expressing their astonishment and dismay, perhaps because they fear they may be guilty of the same sin. The women, however, express no surprise, and perhaps the forward one, whose breasts are

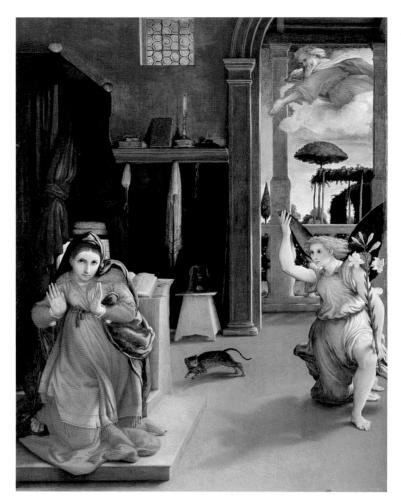

clearly seen through her classicized drapery and who also has a child at her feet, is meant to be a representation of the virtue Charity, who is often shown suckling a child. Despite the Christian theme, the artist seems focused on reviving an antique mode, with impressive figures, some in antique dress, seen against a background of ancient architecture, complete with a pediment, an arcade of receding arches, and low relief decorative patterns drawn from Roman models. The dramatic response of the witnesses to the miracle cannot overwhelm the stable composition.

That an emphasis on ancient Roman style would be found in the works of a Venetian sculptor at this time is not surprising, for Venetian intellectuals and politicians of the period were arguing that Venice was the true heir of ancient Imperial Rome. Venetians in the city and in Venetian holdings on the mainland, which included Padua, were actively collecting and displaying antiquities and patronizing architecture built in a classicized mode.

Lorenzo Lotto and Paris Bordone

A strikingly original and almost equally long-lived contemporary of Titian was the somewhat older Lorenzo Lotto

(1480–1556), who spent most of his active years far from the city of the lagoons. Most of Lotto's works were produced for centers on the Venetian mainland and in what is now Lombardy and the Marches. Only relatively late in his life did he settle in Venice, and even then he did not break his ties with the mainland. Throughout his career Lotto retained his own individuality, and his personal inventions run from examples of extreme naturalism through an interest in the bizarre that may reflect the influence of central Italian Mannerism. What is most consistent throughout his work is a preoccupation with the effect of unusual combinations of color, which Lotto used to entrance his viewer and, on occasion, to enhance the mood of his subject.

In Lotto's Annunciation (fig. 19.32), we are in Mary's chamber, represented with fidelity to detail yet lighted in surprising ways, even from below. Mary has been reading at a prie-dieu when God the Father bursts in from the loggia, stretching forth his hands as if sending down the dove of the Holy Spirit, although no dove is seen. Gabriel runs in through the door bearing a huge lily. He drops suddenly to one knee, leaving the other bare, and raises his arm in a theatrical gesture, staring with wide-open eyes under flying yellow locks of hair. Mary turns toward us and opens her

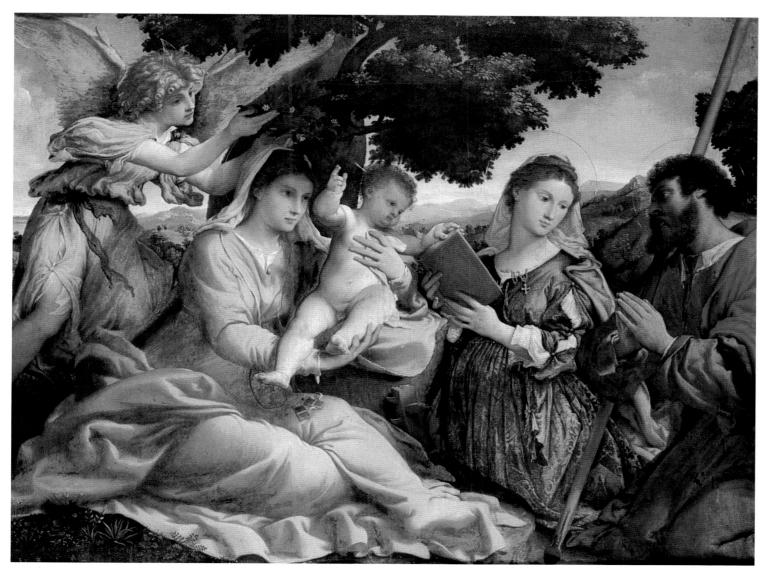

19.33. LORENZO LOTTO. Sacra Conversazione. c. 1520s. Canvas, 443/4 x 60" (1.13 x 1.52 m). Kunsthistorisches Museum, Vienna

hands in wonder, yet at the same time she seems to shrink into herself, her eyes staring in an expression that is half awe, half trance. A cat scurries away in terror, casting a shadow on the floor, as does the rushing angel.

The very oddness of the scene and its peculiar lighting suggest a familiarity with Parmigianino and Beccafumi. The objects in the Virgin's room include a curtained bed decorated with gold balls, a shelf with books, a candle, and an inkstand, a towel hanging from a nail, and, strangest of all, an hourglass with the sands half run out, partly covered with a cloth. Exactly what motivated this painting will probably never be known; perhaps Lotto set out to create an Annunciation distinctly different from any that had previously been painted.

In Lotto's *Sacra Conversazione* (fig. 19.33), the blue of Mary's tunic and mantle fills the picture as if with the distilled quintessence of sky and distant hills. The picture is a

hymn to youth, health, and beauty. The partly shadowed features of the Virgin Mary and Catherine seem almost ancient Greek in their breadth, harmony, and the sense of calm detachment with which they welcome James the Greater into their company. Lotto's brushwork, rich yet restrained, recalls that of Correggio rather than the bold, free strokes of Titian, which Lotto never emulated.

A somewhat more prosaic painter than Lotto, but an artist who developed his own interpretation of Venetian material splendor, was Paris Bordone (1500–1571), from Treviso on the mainland. At an early age he studied with Titian who, by Bordone's account, treated him badly. On his own, he developed a special sort of vision, as if his world of rich foliage, grand architecture, glowing flesh, and sparkling silks were seen in a glass darkly. Bordone absorbed Titian's glazing technique, which he adapted to his own purposes.

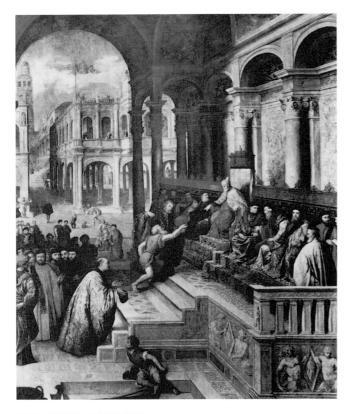

19.34. PARIS BORDONE.

A Fisherman Delivering the Ring. c. 1534–35. Canvas, 12'15/8" x 9'10 1/8" (3.7 x 3 m). Accademia, Venice.

Commissioned for the Sala dell'Albergo of the Scuola Grande di S. Marco, Venice

Bordone can be credited with the invention of a new type of architectural painting, evident in *A Fisherman Delivering the Ring* (fig. 19.34), which shows a citizen bringing back to the Doge the ring with which Venice annually wed the sea in a splendid ceremony. The portrait figures are gracefully grouped in and before High Renaissance loggie and galleries of white and colored marble, sometimes embellished with mosaics. The architecture seems to reflect the influence of Jacopo Sansovino, who arrived in Venice in 1527. It may even have enjoyed the benefit of his expertise in the projection of the perspective.

The Mainland

During the first two decades of the Cinquecento, the plain of the Po, with its wealthy cities, was the victim of dynastic strife between the Venetian Republic, the Sforza dukes, the French kings, the Hapsburg emperors (who were also kings of Spain), and the papacy. Louis XII of France, who had dethroned and imprisoned Ludovico Sforza in 1500, was himself ejected by Swiss troops in the service of Julius II in 1512. Nonetheless King Francis I of France returned to the

duchy of Milan in 1515, only to lose it for good to Charles V in 1521; Milan, once a brilliant creative center, became a Spanish province, ill-governed and economically depressed. Parma, under the papacy, and Mantua and Ferrara, independent duchies, fared better. So did the cities of Bergamo, Brescia, Verona, and Vicenza, all enjoying the enlightened government of Venice, which quickly recovered its political and economic fortunes. Artistically, the heritage of Mantegna remained a force to be reckoned with in Milan, although less powerful than the physical presence, activity, and teaching of Leonardo da Vinci. Parma, as we have seen, had strong ties to Rome. Ferrara had its own artistic tradition, but Brescia and Cremona did not. All three were inevitably submerged in the tide of colorism flowing from Venice.

Bramantino, Dosso Dossi, Savoldo, and Moretto

At the turn of the century, the Milanese scene was dominated by clones of Leonardo, whose works at times were so close to his that attribution problems still plague specialists. These imitators are seldom original. One of the few holdouts was Bartolomeo Suardi (c. 1465-1530), known as Bramantino because he studied painting with Bramante. Bramantino was the most original painter of the Milanese School, and his Adoration of the Magi (fig. 19.35) shows the characteristic style from which he never wavered, despite a sojourn in Rome just before the arrival of Raphael. If one looks for influences, one might find them in the spatial construction of Mantegna and the coloring of Giovanni Bellini, but both have been assimilated into Bramantino's personal vision. The painting, whose small size and symmetrical disposition suggest it was made for private devotion, offers the clarity and serenity typical of this artist.

Seated on a block of stone in a ruined classical building, the Virgin is flanked by Isaiah and Daniel. The latter is shown as a wayfarer, disheveled in appearance and looking out to the spectator. On either side stand two bareheaded Magi, the older carrying what looks like an ancient gold vase, the younger a rose quartz bowl. The third Magus is barely visible behind the youngest, and Joseph is relegated to the extreme left. Bramantino was fascinated with the asymmetrical balances between the circular turban, the circular basin, the rectangular basins, and the architecture, which was perfect until it was suddenly shattered. The broad handling of anatomical forms and drapery is as typical of Bramantino as is the harmony of the colors, which is dominated by the sonorous blue in the Virgin's mantle, the rose of her tunic, the red lining of the left-hand Magus's cloak, and the

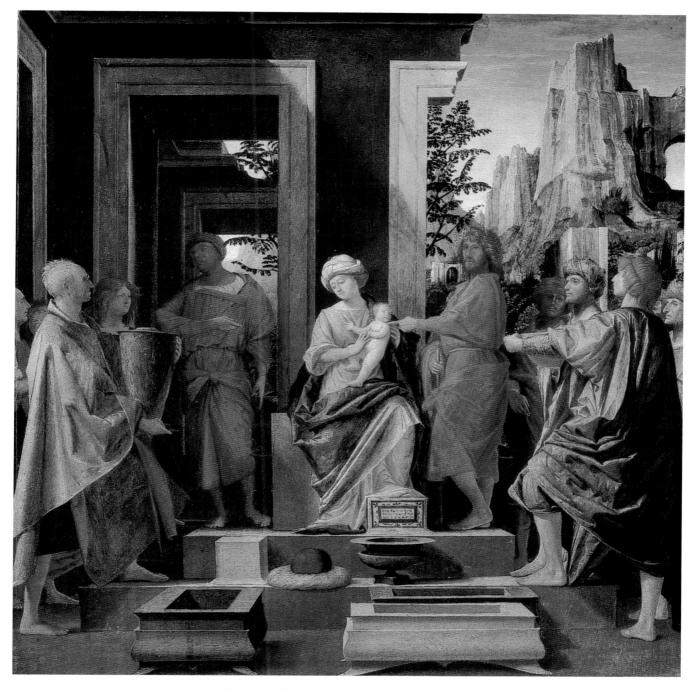

19.35. BRAMANTINO. Adoration of the Magi. c. 1500. Panel, 223/8 x 215/8" (56.8 x 55 cm). National Gallery, London

unexpected and magnificent olive-green of the cloak of the youngest Magus. In spite of the Leonardo followers, Bramantino was able to achieve his personal version of the High Renaissance style.

The occasional elements from Giorgione in Lorenzo Lotto's style became so prevalent in certain northern Italian centers as to constitute a real "Giorgionism," depending for its effect on a combination of figures at ease in a romantic landscape. There were scores of practitioners of the Giorgionesque manner on the mainland, and many achieved a high level of poetic charm. The Ferrarese School fell under the Giorgionesque spell led by the Dossi brothers, especially Dosso Dossi (Giovanni de Lutero; c. 1490–1542).

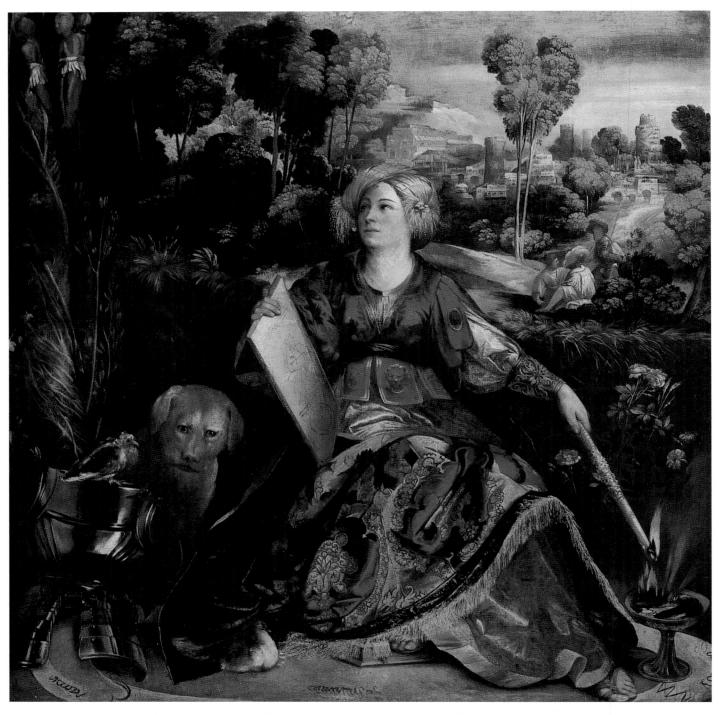

19.36, DOSSO DOSSI. Melissa. 1520s. Canvas, 691/4 x 681/2" (1.76 x 1.74 m), Borghese Gallery, Rome

His *Melissa* (fig. 19.36) represents a benign character in Ariosto's *Orlando Furioso* who frees humans turned into animals or plants by the sorceress Alcina. When Melissa burns Alcina's seals and erases her spells, two men begin to emerge from the trunks of trees. Men-at-arms, presumably just liberated, relax in the background, while a convincing dog (in whom surely lurks a person) gazes longingly at the suit of armor he will soon be allowed to resume. Dosso

tames Giorgione's hostile nature; his trees are an array of standardized landscape elements that provide a perfect setting for this magical scene. The glow of the crimson-and-gold brocade of Melissa's fringed robe is alluring against the gold-and-green sparkle of trees and meadows.

In Venetian territory since 1426, the Lombard city of Brescia had been subject to influences from Leonardesque Milan and Bellinesque Venice. Nonetheless its painters

generally maintained a tradition of sober naturalism that is often considered characteristic of Lombardy as a whole. The Brescian Girolamo Savoldo (c. 1480-after 1548) was working in Florence in 1508, where he absorbed something from the Florentine anatomical and draftsmanly tradition, but in 1520 he settled in Venice, and he is often included among the Venetian School. Of the same generation as Giorgione and Lotto, Savoldo generally uses figure and landscape arrangements from the Giorgionesque tradition. His deep coloristic resonance emanates from glazes similar to those of the younger Paris Bordone, but his poetry is deeper and more intense, possibly because it is firmly based in fact. The two figures in *Tobias and the Angel* (fig. 19.37) were painted from models posed in a strong crosslight. It is not hard to imagine Savoldo picking up wings for the archangel at the poultry market, and the fish-the oil from whose liver will restore the sight of Tobias's father—looks

fresh. Here miracles are achieved by figures who seem as if they are a natural part of everyday life.

Alessandro Bonvicino, called Moretto (1498–1554), is a sturdy realist who grew to maturity in Brescia during Savoldo's absence and came to dominate the local scene. Like Savoldo, he began under the spell of Giorgione, but Moretto's devotion to fact soon took over, even in the realization of religious visions. His realism is evident in the *Ecce Homo with Angel* (fig. 19.38), which is not the customary representation of the tormented Jesus in his mock royal robe, crowned with thorns, sceptered with a reed, and displayed by Pilate to the people of Jerusalem. Here Christ is presented by a grieving angel who holds the seamless garment woven by Mary. Modeled with a combination of Michelangelesque grandeur and earthy literalism, Christ sits across a step in a narrow staircase. The painting emphasizes Christ's physical torture and mental humiliation,

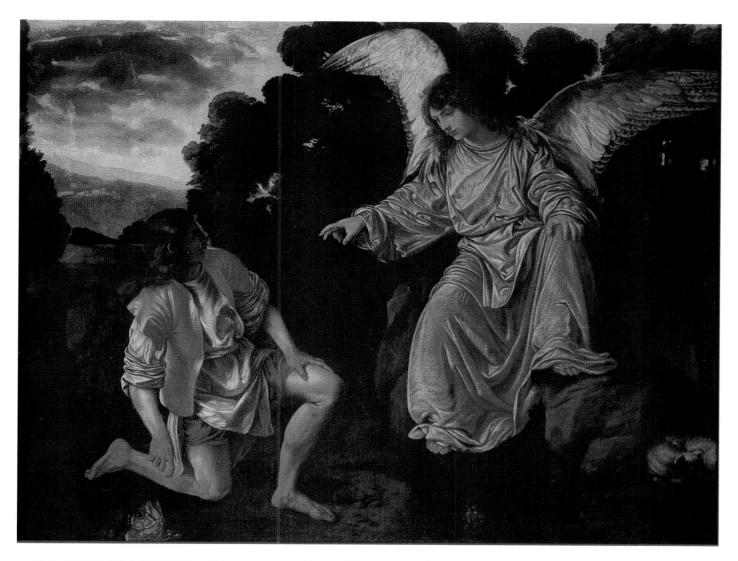

19.37. GIROLAMO SAVOLDO. Tobias and the Angel. Early 1530s. Canvas, 373/4 x 491/2" (95.9 x 125.7 cm). Borghese Gallery, Rome

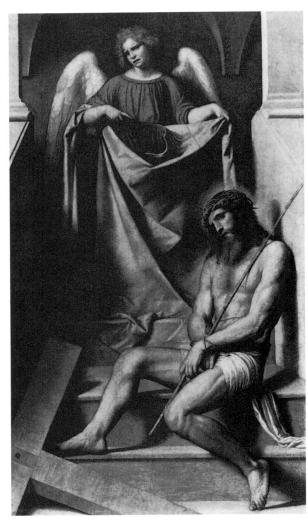

19.38. MORETTO. *Ecce Homo with Angel.* c. 1550–54. Canvas, 84¹/₄ x 49¹/₄" (2.14 x 1.25 m). Pinacoteca Tosio Martinengo, Brescia

and through his position on the steps, the stairway to Pilate's palace becomes the stairway to heaven ("No man cometh unto the Father, but by me." John 14:6). Thus the literalism of Moretto's art is raised to the level of spirituality.

Sofonisba Anguissola

During the Middle Ages women played a considerable role in the art of manuscript illumination, much of which was done in convents. Although lists of women illuminators are preserved, no surviving Italian manuscript can be specifically connected with a female artist. But when panel and fresco painting began to flourish on the Italian peninsula, the secular *bottega* within which these works were created became part of the strictly controlled world of male activity. The exclusionary nature of the guilds meant that women were generally prevented from practicing in the crafts and professions. The growing necessity of study from the nude as Renaissance

art developed reinforced the exclusion of women. But with changes in the social and intellectual status of women in society and the transformation of painting from a Mechanical to a Liberal Art in the course of the Cinquecento, women artists began to emerge. A precedent for this in antique sources supported women's acceptance as professional artists, for in his *Natural History* Pliny the Elder had written, "Women too have been painters." At first women artists were considered to be something between an oddity and a miracle, but soon success won them respect in their own right. Most were their father's assistants; the only successful woman painter of this era not trained at home was Sofonisba Anguissola (c. 1532–1625).

She was the eldest of six daughters of Amilcare Anguissola, a learned and noble gentleman in Cremona. Sofonisba was named after a queen of ancient Tyre, and three of her five sisters were named Minerva, Europa, and Elena (after Helen of Troy). Amilcare brought two of his daughters to study the art of painting with Bernardino Campi, youngest of a dynasty of painters who controlled artistic life in Cremona. Since Amilcare never traveled, it is unlikely that the young women had other artistic contacts, and under such circumstances the inventiveness and originality of Sofonisba are even more impressive. The sisters were also taught musical performance, languages, and literature, but Amilcare's concern with painting may not have been limited to its prestige as a cultural pursuit. He complained to Michelangelo of the difficulty of supporting six daughters in their appropriate station in life.

Sofonisba's career is still being reconstructed, but at the present moment we know of only a few religious subjects by her hand. It is interesting to note that among her many self-portraits there are examples that show her at the easel painting a Madonna and Child. Such a scene is perhaps based on images of St. Luke, the patron saint of artists who, tradition held, had painted a portrait of Mary and the infant Christ from life. Many of Sofonisba's portraits appear to have been commissioned, and they must have provided a welcome addition to the family income. They deserve a high rank in the history of Italian portraiture for their directness, penetration of character, and pictorial skill.

The Campi family of painters and their pupils are today studied only by specialists, but Sofonisba Anguissola has become a hero for those who are reexamining the role of women in art. Amilcare wrote to Michelangelo in 1557, offering to have her "color in oil" a drawing by Michelangelo, if he would so favor her. Amilcare apparently knew that in his last years Michelangelo made a practice of giving drawings to others to paint from, and judging from Amilcare's next letter, Michelangelo complied. Neither the drawing, the painting, nor Michelangelo's response to Sofonisba's work is preserved, but the reply must have been complimentary, as Amilcare thanked him profusely.

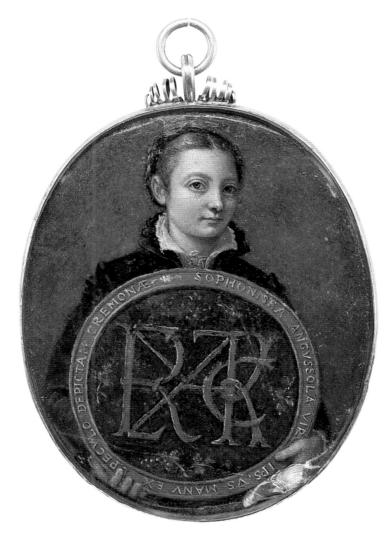

19.39. SOFONISBA ANGUISSOLA. *Self-Portrait.* c. 1552. Oil on parchment on cardboard, $3^{1}/4 \times 2^{1}/2$ " (8.3 x 6.4 cm). Museum of Fine Arts, Boston. It has been suggested that this miniature was intended to be a gift to the miniaturist Giulio Clovio.

Anguissola painted more than a dozen self-portraits; in some she represents herself as a painter, but in many she shows herself playing an instrument or reading. In addition, there is a self-portrait showing her with her husband and another portrait in which she shows Bernardino Campi, one of her teachers, in the act of painting her portrait. Since the latter was conceived and painted by Sofonisba, it too must be considered a self-portrait. Why Anguissola painted so many self-portraits is revealed in a remark made by Annibale Caro, who wrote "there is nothing I desire more than an image of the artist herself, so that in a single work I can exhibit two marvels, one the work, the other the artist." Anguissola's self-portraits were prized because they documented her novelty in Renaissance Italy.

Of the self-portraits by Anguissola, the one discussed here is a miniature (fig. 19.39), an important category of art during the sixteenth century: husbands carried miniatures of

their wives, lovers miniatures of their mistresses. Miniatures were given as gifts and collected by connoisseurs. As Vasari wrote, "such works are not for public viewing, and cannot be seen by everyone, such as paintings, sculpture, and architecture by our other artists and artisans." This accolade appeared in his "Life of Giulio Clovio," an important miniaturist whose portrait Anguissola painted and with whom she may have studied the art of miniature painting.

The unusual large medallion that Anguissola holds has proved difficult to interpret. The inscription around the edge identifies the artist/sitter as Sofonisba Anguissola from Cremona. The overlapped, decorative letters in the middle have been interpreted as referring to her family name and the first letters of her sisters' names. Another theory is that the letters refer to a Latin phrase that not only identifies Sofonisba as a member of a noble Cremonese family, but which also proclaims her as a virtuous artist.

Sofonisba Anguissola is acknowledged to have invented a new type of group portraiture in which the sitters are not merely aligned and accompanied by conventional props, as was customary, but shown in lively activity. An impressive example is the Portrait of the Artist's Three Sisters with Their Governess (fig. 19.40). Sensitive to the interplay of intimacy and rivalry in a large household, Sofonisba has concentrated on a single moment during a game of chess. An older sister has made her move and turns for admiration to the artist and to us. The next oldest, planning a coup, searches her sister's unsuspecting face and raises her right hand for the devastating move. The youngest sister sees what is coming and laughs, while a governess looks on. Anguissola's painting is ambitious in composition and revolutionary in the mood of shared family experience that it conveys.

Apparently Bernardino Campi was able to substitute for life drawing from the nude some other form of anatomical study, probably from mid-sixteenth-century anatomical drawings and engravings, for in Anguissola's painting the masses of the figures are convincing and correct, and everything that propriety allows to emerge from the stiffness of sixteenth-century costume is carefully constructed. Anguissola's brushwork delineates every nuance of the faces and detail of the fabrics.

Anguissola's fame was international, and works by her entered the collections of Pope Julius III and the Borghese, Este, Farnese, and Medici families during her lifetime. In 1558 Anguissola went on a voyage to Sicily, and the next year she was appointed lady-in-waiting to the queen of Spain, to whose territories both Cremona and Sicily belonged. While serving in Spain, she painted the king and queen and many members of the court in the restrained manner required by court etiquette there. She eventually returned to Sicily, where she died in 1625 at the age of ninety-two, the first internationally recognized woman artist of whom we have any certain knowledge and a large body of works.

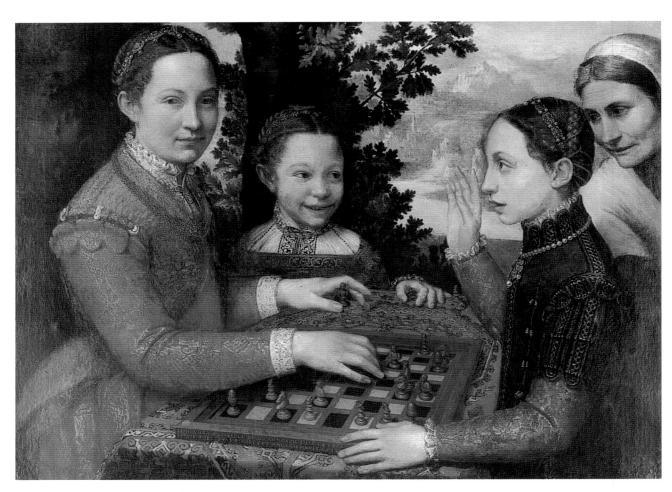

19.40. SOFONISBA ANGUISSOLA. *Portrait of the Artist's Three Sisters with Their Governess.* 1555. Oil on canvas, 27% (6 x 37" (70 x 94 cm). Narodowe Museum, Poznań.

Of this painting Vasari wrote: "I must relate that I saw this year in the house of her father at Cremona, in a picture executed with great diligence by her hand, portraits of her three sisters in the act of playing chess, and with them an old woman of the household, all done with such care and such spirit, that they have the appearance of being alive."

Tintoretto

In the middle and late Cinquecento, Tintoretto and Veronese disputed the leadership of the Venetian School with Titian. The older and more dramatic of these younger artists is Iacopo Robusti (1518-94), called Tintoretto after his father's trade as a dyer. Fruitless attempts have been made to identify Tintoretto's teacher, a matter perhaps of slight importance considering the originality of his style from the beginning of his career to its end. But Carlo Ridolfi, who wrote about Tintoretto in the seventeenth century and had access to local traditions, records that he worked in the studio of Titian until the great man saw one of the boy's drawings, inquired who did it, and ejected him from his house. To the end of his days, however, Tintoretto had an unrequited admiration for Titian, whom he considered his true teacher. Titian's contrary opinion of Tintoretto may have arisen partly from fear, for, as we shall see, this daring young man offered formidable competition to all artists desiring public commissions. But more likely his distaste is attributable to fundamental incompatibilities of personality, stylistic aims, and methods. The careful craftsman, with his endless succession of glazes and his distrust of his own unfinished paintings, may well have been offended by Tintoretto's impetuosity.

We are told that in 1564, when the artists competing for the commission of a ceiling painting in the Scuola di San Rocco in Venice arrived with their scale models, according to instructions, they were outraged to find that during the night Tintoretto had installed his full-sized, completed painting on the ceiling. This and other infractions of union rules aroused hostility from the artists and also from conservative elements of the Venetian citizenry. Nevertheless, Tintoretto's strategy worked, and he obtained many commissions that he executed at hitherto unimagined speed. This speed also made enemies for him, but it is an essential aspect of his style. Tintoretto's art offers rapid action and passionate emotion, both of which are supported by the velocity of his execution.

This was attainable first by shorthand drawing methods. A story is told about two Flemish artists, the scrupulous realism of whose detailed and polished drawings astonished the Venetian public. Tintoretto's response was to pick up a piece of unsharpened charcoal and in a matter of minutes, with a few rough, hooklike strokes, knock an action figure into abundant and astonishing life, whereupon he commented, "We poor Venetians can only draw like this." Tintoretto's preserved drawings (fig. 19.41) are almost exclusively in this hasty style, yet he considered them accurate enough to serve for his pictorial compositions. Although, according to Ridolfi, an inscription on the wall of Tintoretto's studio proudly proclaimed "the Color of Titian and the Drawing of Michelangelo," suggesting that his art was a combination of these two forces, we never encounter detailed Tintoretto life studies in Michelangelo's manner.

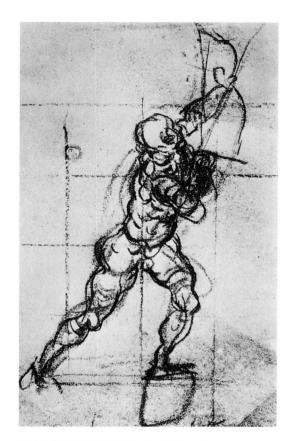

19.41. TINTORETTO. *Study for a Bowman in the Capture of Zara*. Before 1585. Black chalk, 14³/₈ x 8⁵/₈" (36 x 22 cm).

Gabinetto dei Disegni e Stampe, Uffizi Gallery, Florence

Tintoretto apparently had little patience with the drawnout methods of Titian. He must have felt an overpowering urge to cover vast areas of canvas with rapidity. Financial rewards, incidentally, seem to have had little to do with this desire, as he often underbid his competitors and is reported to have painted certain works for the cost of the materials alone. In order to speed up his production, Tintoretto primed his canvases with dark tones—gray-green, brown, or slate-gray—and sometimes even divided the priming into different color areas to correspond to the tonal divisions of the finished painting. Figures from the sketches were then outlined on the priming, which served as the basic tone for the shadows. Once the lights were painted in with bright colors, creating an effect rather like drawing on a blackboard with colored chalks, the picture was virtually complete and needed only a few tonal refinements in crucial areas. As a result, the underlying darks dominate Tintoretto's pictures, which sometimes look as if the action were taking place in the middle of a thunderstorm, illuminated by sudden flashes of lightning. Unfortunately, in many canvases the dark underpainting has begun to show through, dimming the overlying colors.

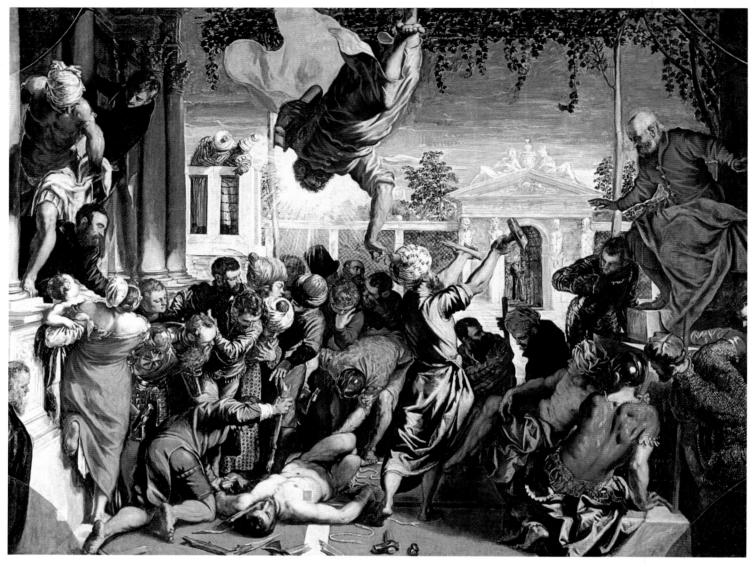

19.42. TINTORETTO. St. Mark Freeing a Christian Slave. 1548. Canvas, 13'7" x 17'10" (4.16 x 5.44 m). Accademia, Venice. Commissioned by the head of the Confraternity of S. Marco for the Scuola Grande di S. Marco

A further increase in the speed of execution was afforded by Tintoretto's use of the wide, square-ended brush introduced by Titian, but Tintoretto's strokes were so wide that the nine-teenth-century critic John Ruskin accused him of painting with a broom. Today the vigor of Tintoretto's brushwork is a source of enjoyment, but there is evidence that in the late 1540s, when he introduced his new style at full intensity, his technique was considered by some of his contemporaries to be an indication of deplorably hasty execution.

In order to draw and paint not only with rapidity but with conviction, Tintoretto prearranged his compositions by posing small wax figures in wooden box-stages, sometimes even hanging them from wires and turning them at angles to the foreground plane to study the foreshortenings that play so important a role in his dramatic technique. He even moved little lamps about to achieve vivid *chiaroscuro* contrasts. By means

of a grid of horizontal and vertical threads or wires across the stage—like the veil invented by Alberti that became standard in sixteenth-century "drawing machines"—Tintoretto could record his composition on squared paper in a relatively short time, and, using another grid, his pupils could enlarge it on the dark-primed canvas in a matter of hours, ready for their master to paint in the lighted areas. A high rank in the brigade of pupils was occupied by the painter's daughter. Although no certain pictures by her are known, it is probable that many square yards of her father's canvases, including important figures, were painted by Marietta Robusti.

If Tintoretto had died at an early age, like Masaccio, he would have remained a charming art historical curiosity. His first serious threat to the Titianesque establishment was his *St. Mark Freeing a Christian Slave*, painted for the Scuola Grande di San Marco (fig. 19.42). According to legend, the slave of a

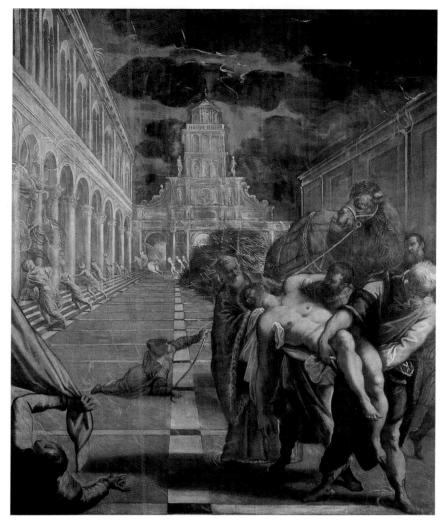

19.43. TINTORETTO. *Transport of the Body of St. Mark.* 1562–66. Canvas, 13'10" x 10' (4.2 x 3 m). Accademia, Venice. Commissioned by Tommaso Rangone for the Scuola Grande di S. Marco

knight of Provence left without permission to go to Alexandria to venerate the relics of St. Mark. On his return, his master decided to punish him by having his eyes gouged out and his legs broken with hammers, but St. Mark himself came down from heaven to liberate the slave. At the right, the knight is about to fall off his throne with surprise, while on the ground the foreshortened figure of the slave is surrounded by broken ropes and miraculously smashed hardware. A wave of astonished servants, executioners, and bystanders, at once moving away and looking backward and down, flank the saint. At the top, St. Mark zooms downward into the picture. In combination with the turbaned servant lifting a broken hammer, St. Mark forms a kind of pinwheel composition in depth; this twisted, turning vortex appears in many of Tintoretto's paintings as the basis for his cyclonic compositions.

In St. Mark Freeing a Christian Slave, the colors blaze against the dark shadows, and the brushwork of the drapery, glittering armor, sparkling curls, and faces throbbing with

emotion is bold and vigorous. Restoration has revealed that it was originally intended as a ceiling painting in a roughly octagonal shape, and that the artist placed figures diagonally so that they are parallel to, or at right angles to, the corners cut off by the frame.

When the picture was unveiled in 1548, the adverse criticism, emanating largely from the studio of Titian (in spite of the support given Tintoretto by Pietro Aretino), caused the artist to take his picture back. For several years he kept it in his studio, but eventually he returned it to the *scuola*, and in 1562 the guardian of the *scuola*, Tommaso Rangone of Ravenna, offered to pay for three more pictures to continue the narration of the Legend of St. Mark. One of the three represents the *Transport of the Body of St. Mark* (fig. 19.43). Captured by the enemy, the saint was dragged through the streets of Alexandria for two days until he died. As they were about to burn his body, a storm broke, the enemy fled, and the Christians were able to carry the body reverently to burial.

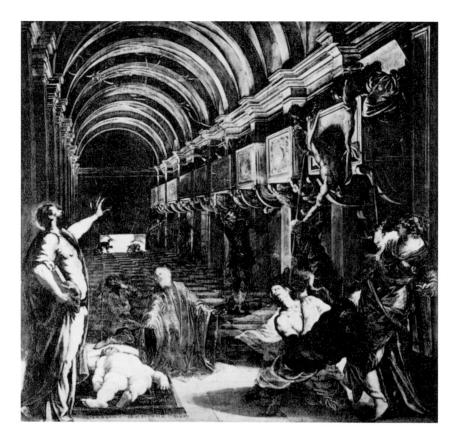

19.44. TINTORETTO. *Discovery of the Body of St. Mark.* 1562–66. Canvas, 13'1¹/₂" (4 m) square. Brera Gallery, Milan. Commissioned by Tommaso Rangone for the Scuola Grande di S. Marco

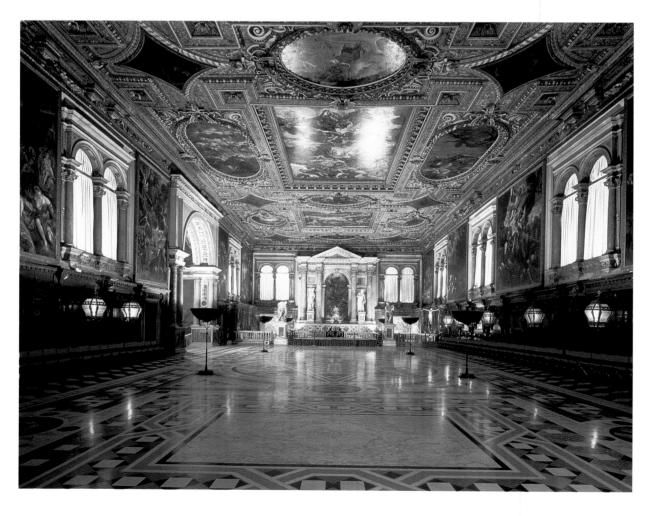

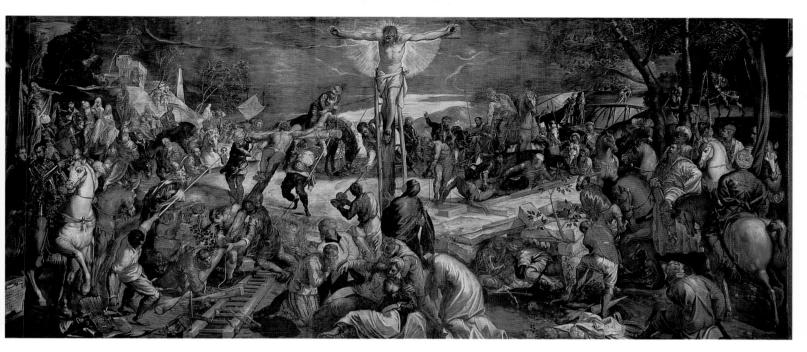

19.46. TINTORETTO. *Crucifixion*. 1565. Canvas, 17' 7" x 40' 2" (5.4 x 12.3 m).

⊞ End wall of Sala dell'Albergo, Scuola di S. Rocco, Venice. Commissioned by the Brotherhood of S. Rocco.

The Sala dell'Albergo was painted in 1564–67, the ceiling of the Sala Grande in 1575–77 and the walls in 1577–81, and the wall paintings in the ground-floor room in 1583–87.

Tintoretto has set the scene in a long paved square not unlike the Piazza San Marco in Venice. The orthogonals formed by the paving stones and the arcades recede rapidly into the distance, while the little band of devoted Christians, about to load the body onto a camel, emerge at the right. The tension in depth, appearing here for the first time in Tintoretto's art, became a standard compositional device in his mature and late works, as frequent as the pinwheel and sometimes combined with it. The perspective is accurate enough as far as the orthogonals go, but the arches, possibly painted by pupils, do not coordinate with the rest of the setting. This is the kind of detail that Tintoretto allowed to pass and that must have infuriated other artists. But his foreshortening of the figures, the rapidity of their action, and the rush of the figures for shelter under the arcade show all the power of Tintoretto's hand. Such effects could not have been attained by conventional methods, and if Tintoretto had tried to paint them slowly, they would have been less effective and spontaneous. And if the lightning is a trifle stagy (Giorgione did it better), the rush of water across the stones of the piazza is convincing. Rangone, in the gown of a Venetian patrician, is shown gently supporting the head of the saint on his chest, while Tintoretto has painted his own bearded features just to the right of the camel's hairy neck.

The third canvas from the series (fig. 19.44) is equally dramatic. Centuries have passed, and a group of Venetians has come to Alexandria to rescue the saint's body from the Sara-

cens. As they search the crypt of the cathedral, taking bodies down from sarcophagi and opening up a trapdoor in the floor (with a wonderful light effect), St. Mark emerges, shows them his true body, and puts a stop to the despoiling of the tombs. Again the power of the composition is achieved by the tension between the succession of arches moving rapidly inward in perspective (correct, this time), and the figures moving out at the right. An added element is the placing of the hand of the saint at the vanishing point of the perspective, bringing its motion to a sudden halt, as he arrests also the well-meaning sacrilege of the Venetians. As is generally the case with Tintoretto, the architecture is thinly painted, so that large areas of dark priming are not even covered, while careful modeling is reserved for the most important figures. Again Rangone appears just to the left of center, kneeling in reverence as he contemplates the body of Venice's patron saint.

Tintoretto's crowning achievement is a cycle of some fifty paintings for the Scuola di San Rocco and its neighboring church (fig. 19.45; see also fig. 13). The principal *scuola* rooms are filled with Tintoretto paintings carried out between 1564 and 1587. The *Crucifixion* in the Sala dell'Albergo (fig. 19.46) presents a panorama of Golgotha populated by a crowd of soldiers, executioners, horsemen, and apostles. The scene is divided by the cross; its top is cut off, and the shadowed head of Christ leans down almost as if from heaven. At the left the cross of the penitent thief is being partly lifted, partly tugged

19.47. Virgin, St. Joseph of Arimathea, and others, detail of fig. 19.46

into place by ropes; at the right the impenitent thief is about to be tied to his cross. A soldier on a ladder behind Christ reaches down to take the reed with the sponge soaked in vinegar from another soldier on the ground. The tumult of the crowd, the grief of the apostles, and the yearning of the penitent thief seem to come to a focus in the head of Christ.

Due to Tintoretto's light-on-dark technique, his figures sometimes have a tendency to look a bit ghostly, but the foreground figures in the *Crucifixion* (fig. 19.47), grouped in a massive pyramid at the base of the cross, are defined by vigorous contours and are modeled to create a strong sculptural effect. Here, as throughout his work, Tintoretto's interest in expression is evident in the head of the aged Joseph of Arimathea, who, holding his hands crossed on his breast, looks with sympathy at the Virgin swooning under the cross. The little group, huddled as if for protection against the hostility of the surrounding crowds, forms the base of the composition.

For the Sala Grande on the upper story, Tintoretto's theological advisers developed a scheme relating Old and New Testament subjects to each other and to the scuola's charitable purposes. Although each scene, like those of Michelangelo on the Sistine Ceiling, is part of a vast iconographic and formal totality, they also function as individual images. Because Moses Striking Water from the Rock (fig. 19.48) is a ceiling painting, the reproduction should be held overhead to appreciate Tintoretto's method. We look up along the diagonals of the square, past a series of foreshortened, rapidly moving figures, to the miracle on which the figures converge—water pouring in clear arcs of light at the touch of Moses' rod. The illusion suggests that the water would fall on our heads were it not for the intervening receptacles. At the upper right corner, God the Father floats into the picture, partly enclosed in a circle of light intended to symbolize the

19.48. TINTORETTO. Moses Striking Water from the Rock. 1575–77. Canvas, 18'2½" x 17'2¾" (5.6 x 5.3 m).

☐ Ceiling of Sala Grande, Scuola di S. Rocco, Venice. Commissioned by the Brotherhood of S. Rocco

circles of heaven. The composition is built on the opposition of the arcs, the heavenly circle, and the smaller circles of the bowls to the tumultuous movement of the active figures. In the scenes of the Sala Grande, Tintoretto's light-on-dark technique imparts a shadowy and diaphanous appearance to the figures, even when he devoted some modeling to an occasional important face or limb. The light areas surrounding silhouetted dark heads often seem more solid than the heads themselves. Generally, the principal figures are lifted to an upper level. In the Nativity (fig. 19.49), the adoring shepherds, a woman, and some animals are below, while the Holy Family and two more women huddle in the hayloft above, illuminated by the light coming through the rafters and the ruined roof. Here, as in other San Rocco compositions, figural diagonals complement and continue those established for the space by the perspective orthogonals.

In the *Temptation* (fig. 19.50), Christ has taken refuge in a ruined shed on a rocky eminence while a beautiful Satan holds out stones, tempting him to change them into bread. The *Last Supper* (fig. 19.51) is transformed from the announcement of the betrayal seen in Leonardo into the older Byzantine subject of the Institution of the Eucharist. We must look past servants and a dog in the foreground to where Christ gives the Eucharist to St. Peter. Only eleven apostles can be counted; Judas has already left. As in several of

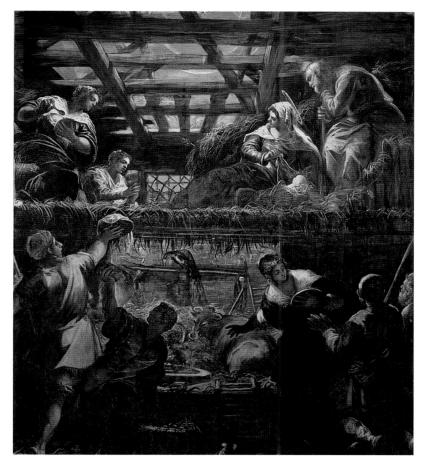

19.49, 19.50, 19.51. TINTORETTO. Nativity (left), Temptation of Christ (below left), Last Supper (below right). 1577-81. Canvas, height of each 17'9" (5.4 m). 🛍 Walls of Sala Grande, Scuola di S. Rocco, Venice. Commissioned by the Brotherhood of S. Rocco

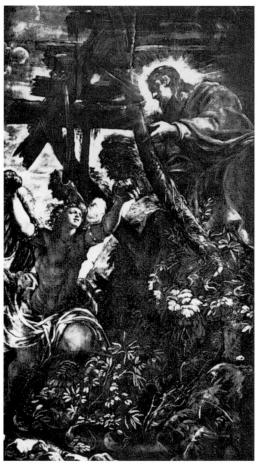

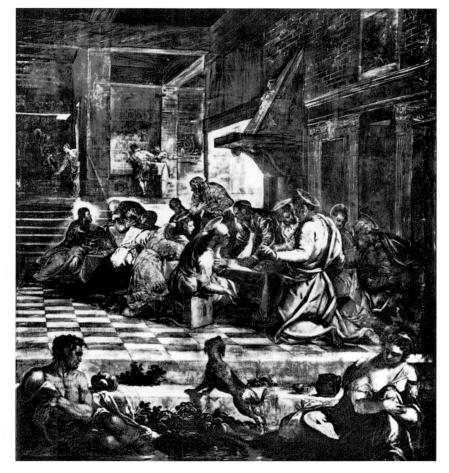

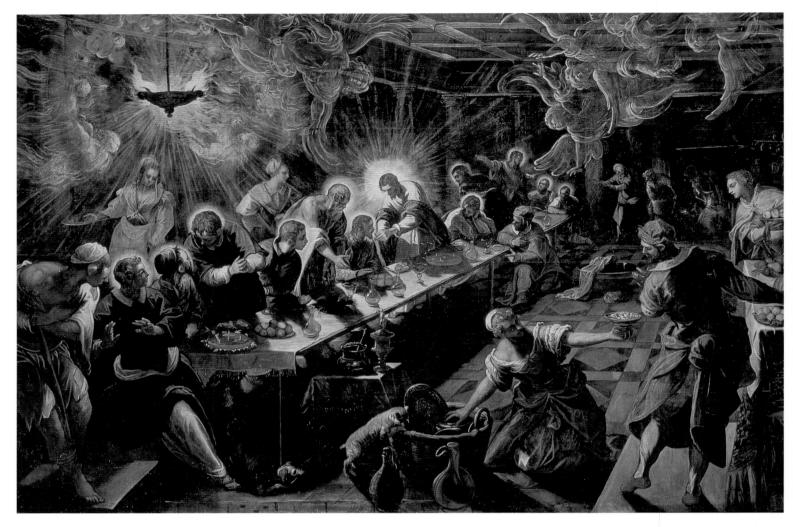

Tintoretto's paintings of the Last Supper, the chief figures are deep in the receding perspective construction. At the top of a flight of steps, we look into the kitchen, where food is being prepared and dishes arrayed—a deliberate contrast, as in Pietro Lorenzetti (see fig. 4.23), to the spiritual nourishment of the Eucharist.

Tintoretto was responsible for several hundred surviving works, as well as for a considerable number that, with paintings by Giovanni Bellini, Titian, and others, perished in a fire that gutted the Doge's Palace in Venice in 1577, and it is impossible to give more than a brief summary of his style and artistic activity. In his last years material substance and worldly concerns both seem to dissolve before our eyes, and in the darkness of his paintings a transcendent light shines. This is evident in the huge representation of *Paradise* that Tin-

toretto, his son Domenico, and his assistants created to replace an earlier fresco of this subject in the Hall of the Great Council at the Doge's Palace (see fig. 19.61).

One of Tintoretto's last works, finished in the year of his death, is the *Last Supper* in San Giorgio Maggiore (fig. 19.52), where its otherworldliness contrasts with the architectural setting by Palladio (see figs. 19.75–19.77; see also fig. 14). The painting is placed on the side wall to the right of the freestanding high altar, and to understand the dynamism of Tintoretto's composition, you need to hold the illustration on your right so that it is receding away from you. The long table, set on a diagonal in depth, divides the material from the spiritual. To the right of the diagonal, servants gather up the remains of the feast and stack the dishes in a basket, where they attract the interest

of a cat. A dog crunches a bone at the foot of the table. Another servant (distinguished as such by his clothing and his cap, although it has also been suggested that the figure might be Judas) sits on the floor with his elbow on the table, trying to understand what he sees. But behind the table the emphasis is on the light of the spirit. Starting from the heads of the eleven apostles, it bursts in rays from the head of Christ, who stands to give Communion to a waiting apostle, streams from the flames of the hanging lamp, and floats in wisps that assume the shapes of angels—heavenly ministers who contrast with the worldly servants. At the end of his life, Tintoretto's light-on-dark technique, invented to lend speed to his brush, becomes a vehicle for revelation.

We cannot leave Tintoretto without a word about his portraits, of which more than 150 are known. Even if we could imagine this impetuous artist buckling down to a minute transcription of his sitters' features in the Lombard manner, numbers alone would preclude such treatment. Features and costumes are broadly painted with no concern for details of attire, but Tintoretto's pictorial shorthand can suggest that his sitters are complex personalities, capable of deep emotion and decisive action. Perhaps it was this reservoir of latent feeling, often enhanced by the rich coloring of

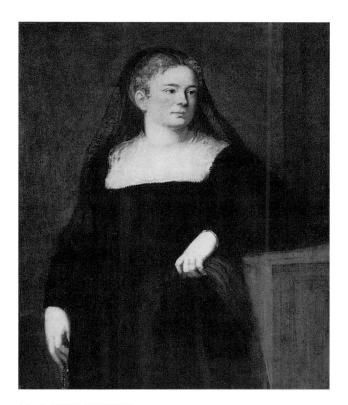

19.53. TINTORETTO.
Portrait of a Woman in Mourning.
c. 1550. Canvas, 41 x 34³/₄" (104.1 x 88.3 cm).
Gemäldegalerie, Dresden

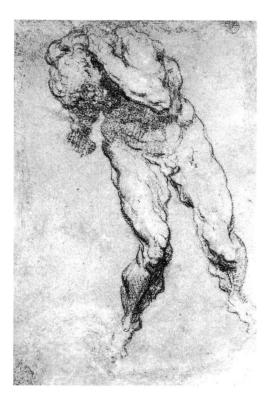

19.54. TINTORETTO. *Study of Nude after a Statuette by Michelangelo*. Black and white chalk on blue paper. Gabinetto dei Disegni e Stampe, Uffizi Gallery, Florence

the costumes as a foil for the faces, that made such portraiture attractive to the Venetian patriciate.

In *Portrait of a Woman in Mourning* (fig. 19.53), he had only deep black to rely on for the costume. Still Tintoretto played the pale face of the sitter and her blond hair and white scarf against the black of the dress and background and heightened the effect by the pose and strong side lighting. In consequence, this portrait takes on some of the emotional depth of his religious narratives. Tintoretto wants the viewer to share her grief and admire her noble demeanor.

Is Tintoretto, as some say, a Mannerist? If Pontormo, Rosso, Perino del Vaga, Beccafumi, Parmigianino, and Pordenone are Mannerists, then he is not. Tintoretto's style, no matter how feverish, is devoid of the conflicts of the central Italian Mannerists of the 1520s and 1530s. His studies of central Italian art—and he worked long to assimilate Michelangelo's style to his own needs from drawings and small models of Michelangelo's figures (fig. 19.54)—were intended to liberate him from the stereotypes of his youth. The elements he paints are firmly founded on observation. Insubstantial though his compositions may seem, they are based on rigorous, consistent logic. The violent activity is disciplined and ordered to produce a clear, often mathematically formulated expression of channeled velocity. His figures,

however violently they may throb with emotion, are not tormented but deeply expressive. While their bodies move at angles to the picture plane or in alarming trajectories through space, their limbs convey the forces of the composition as a whole. Although his works are often surprising, they are never bizarre. He speaks in parables, but not in riddles. He aims to express the harmony of physical and spiritual reality, and in this he is a creation of the Renaissance.

Paolo Veronese

The second of the aged Titian's competitors was Paolo Caliari (1528–88), called Paolo Veronese because of his birth and training in Verona. He came to Venice in 1553, and for the next thirty-five years delighted the Venetians with his style, which in some ways seems to be diametrically opposed to that of Tintoretto. Veronese, too, painted biblical suppers, but his

concern was with material splendor and sumptuous costumes. In his canvases, contemporary Venice passes before our eyes in a parade of marble palaces and healthy people, dressed in velvets, satins, and brocades, eating, drinking, and making love with a stolid conviction that this was all they were meant to do in this world. In his festivals and pageants, Veronese offers a banquet of delicious hues that are almost always high and clear, dominated by the pale tones of marble columns and by lemonyellows, light blues, silvery whites, and delicate salmon colors.

Looking a little more deeply into Veronese, however, one encounters two surprises. First, as Carlo Ridolfi, writing sixty years after the artist's death, explained, he was a model of rectitude and piety who brought up his sons according to severe religious and moral principles. Though he "wore expensive clothes and velvet shoes," he lived "far from luxury: was parsimonious in his expenses, whereby he had the money to acquire many farms and to accumulate riches and furnishings."

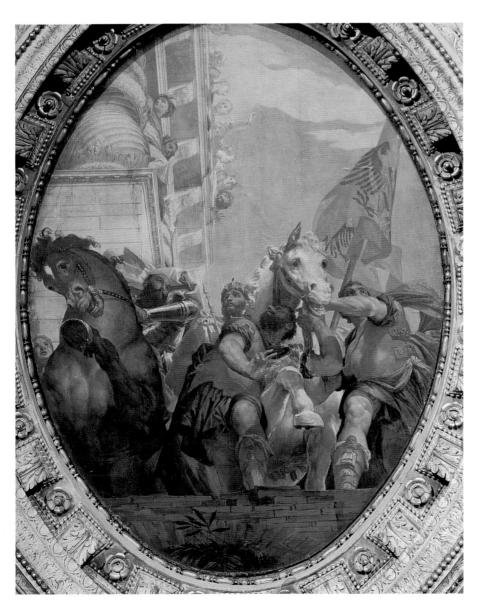

Second, Veronese was as impatient as Tintoretto with Titian's time-consuming methods and, like Tintoretto, invented a shorthand for his pictorial statements.

The principal purpose of Veronese's art was to achieve a kind of intoxication with intense color. Establishing the basic masses of his architectural settings, Veronese subdivided the remaining fields into areas. Each area would be covered with a layer of bright underpaint, giving Veronese his ground color and allowing him to see exactly its relationship to the adjoining hue. Once these layers dried, he could rapidly paint in a system of simplified and precalculated lights in a modified version of the same hue or in a contrasting hue to give a hint of iridescence while avoiding shadows. This method enabled Veronese to paint drapery and architecture rapidly, and yet with a seeming accuracy of detail, derived from his precise placing of the lights, which vanishes at close range. He maintains, as it were, a threshold of visual observation that keeps the observer standing a certain distance from his canvases and subject always, therefore, to the total decorative effect. By these means, Veronese was able to cover an acreage of canvas without any appearance of haste.

Two years after his arrival in Venice, Veronese began the series of frescoes, altarpiece, ceiling paintings, and organ shutters that transform the little Church of San Sebastiano into a dazzling display of Venetian painting by a single artist. In the central ceiling oval he painted the Triumph of Mordecai (fig. 19.55), envisioning the biblical scene (Esther 8:15) as if it were happening in a Renaissance city: "And Mordecai went out from the presence of the king in royal apparel of blue and white, and with a great crown of gold, and with a garment of fine linen and purple: and the city . . . rejoiced and was glad." Veronese's ceiling painting of mighty steeds below spiral columns and balconies with lords and ladies shown against the blue, was a daring demonstration of figures in di sotto in sù illusionism. Like Mantegna (see fig. 15.24), whose murals in Mantua he must have studied in detail, Veronese plays tricks on the spectator: we instinctively duck from the threatening hooves. According to the story, Mordecai will soon fall from power and be executed; by showing the crowned Mordecai and his attendants arriving full tilt at the crumbling brickwork on the edge of an abyss, Veronese seems to be making a reference to the transitory nature of his triumph.

Veronese went to Rome in 1560, but his trip had little effect on his style. He was a Veronese and an adopted Venetian before he went, and he returned not at all Romanized. But he must have made some drawings, and he did adopt an occasional motif that pleased him. It is not hard to imagine that he walked critically through the Farnesina (see figs. 17.65–17.74), which may well have impressed him as a bit old-fashioned. In his own utterly different frescoes in the

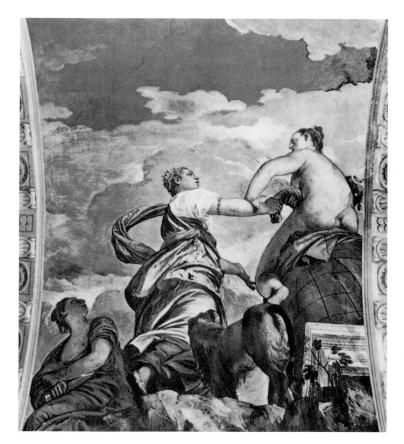

19.56. VERONESE.

Abundance, Fortitude, and Envy.
1560–62. Fresco. Ceiling, Villa Barbaro, Maser.
Commissioned by Marcantonio and
Daniele Barbaro for their villa designed by
Palladio (see figs. 19.73, 19.74)

main rooms of the Villa Barbaro at Maser, Veronese not only accommodated his illusionistic designs to Palladio's architecture (see figs. 19.73, 19.74), but seems to pay tribute to Raphael's Cupid Pointing Out Psyche to the Three Graces (see fig. 17.74) in his ceiling fresco of Abundance, Fortitude, and Envy (fig. 19.56) by adopting the figure seen from the rear and adapting it to a di sotto in sù view. Fortitude, with her lion, steadies the cornucopia in the hand of Abundance, and nobody pays any attention to Envy with her ugly knife. The high, silvery clouds recall those of the early Titian. The figures represent only a small portion of Veronese's splendid decoration at Maser, the iconographic program of which may have been designed by Daniele Barbaro himself and which is replete with symbolism and learned references. There are many brilliant trompe l'oeil effects, with painted figures that seem to be looking down from balconies or peeking through partially open doors. There are also Barbaro family portraits and landscapes both idyllic and naturalistic; some of the latter portray laborers working in the fields.

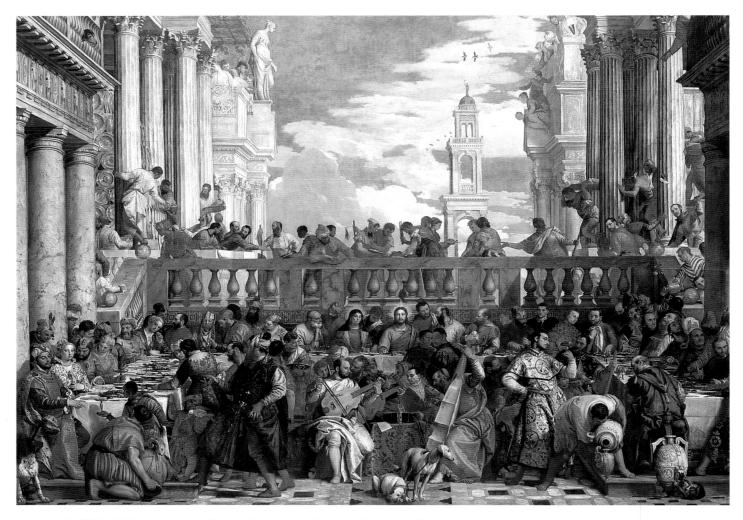

19.57. VERONESE. Marriage at Cana. 1563. Canvas, 21'10" x 32'6" (6.7 x 10 m).

The Louvre, Paris. Commissioned for the refectory of the Benedictine Monastery of S. Giorgio Maggiore, Venice (see figs. 19.75–19.77)

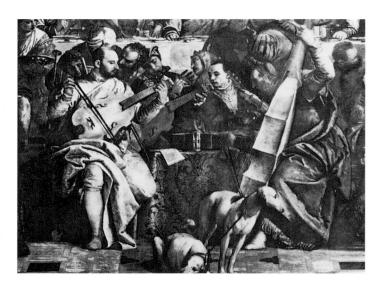

19.58. Musicians, detail of fig. 19.57

The largest of all Veronese's scenes of feasting is the *Marriage at Cana* (fig. 19.57), painted for the refectory of San Giorgio Maggiore. Perhaps Tintoretto's spiritualized *Last Supper* (see fig. 19.52), painted for the chancel of the same church a generation later, contains an element of reaction to the material splendor of Veronese. The table is laid on an open terrace, with flanking Roman Doric colonnades and a higher terrace at the back, set off by a balustrade beyond which one looks out to a campanile and cumulus clouds.

One hardly notices Christ and Mary in the midst of so much architecture, so many brocaded costumes, and all the good things to eat and drink on the table. The master of the feast directs operations at the left; a black youth hands a glass of wine to a guest and a cat at the right rolls over to scratch a mask on the amphora. The group of musicians in the center (fig. 19.58) includes portraits of the painter Jacopo Bassano with a viol, Veronese with a viola da braccio, and Titian with a bass viol. If anybody is concerned about the miracle that has just taken place, the spectator would never know it.

Ten years later, another refectory painting landed Veronese in trouble (fig. 19.59). He was brought before the Inquisition and asked to account for the presence in the painting of "buffoons, drunkards, dwarfs, Germans, and similar vulgarities," in a trial whose record is still preserved. Veronese replied that there is a kind of license observed by poets, painters, and madmen, and to this he appealed. He had apparently been commissioned to paint a Last Supper, and the Holy Office presumed this was what they were looking at. Veronese agreed to call the painting the *Feast in the House of Levi*, a subject that would give him the freedom to leave in the offending figures, including a drunk soldier on the stairs at the right.

To clarify this new meaning, Paolo inscribed "lucae cap. v" on the balustrade, which includes this passage: "And Levi made him a great feast in his own house: and there was a great company of publicans and of others that sat down with them. But their scribes and Pharisees murmured against his disciples, saying, Why do ye eat and drink with publicans and sinners? And Jesus answering said unto

them, 'They that are whole need not a physician; but they that are sick'" (Luke 5:29–31). Christ sits in the center, chatting with the publicans and their attendants, who combine to weave a changing fabric of rose, yellow, blue, green, and silver against the pale stone and the blue of the sky, with its sultry clouds. Veronese's architectural setting is reminiscent of the opulent version of classical architecture developed by Jacopo Sansovino (see fig. 19.67), with veined marble for the columns of the smaller order and gilded Victories in the spandrels.

Veronese's Mystical Marriage of St. Catherine (fig. 19.60) is a festive picture, but there is little mysticism about it. The Virgin is seated at the top of three steps, between massive columns seen diagonally, somewhat in the manner of those Titian introduced into his Madonna of the Pesaro Family (see fig. 19.14). The sun warms the columns and the splendid fabrics, as well as the angel heads and the two swooping putti (recalling those in Titian's Rape of Europa; see fig. 19.27), who hold the Virgin's crown and the saint's palm. St. Catherine was a princess, and Veronese has represented

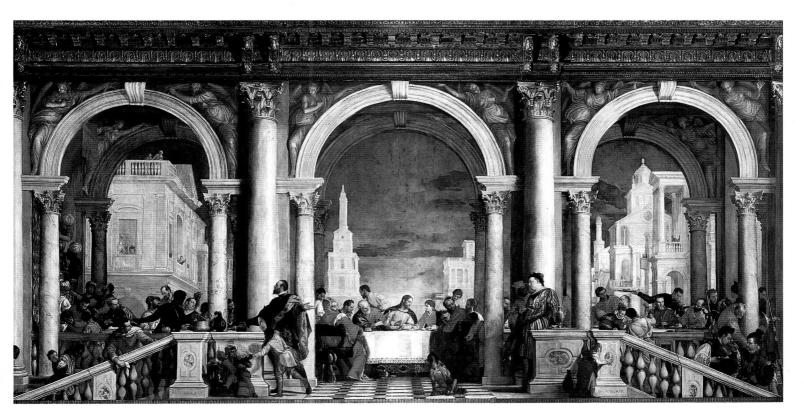

19.59. VERONESE. Feast in the House of Levi. 1573. Canvas, 18'3" x 42' (5.6 x 12.8 m). Accademia, Venice. Commissioned for the refectory of the Dominican Monastery of SS. Giovanni e Paolo; the patron was probably Andrea Buono, a friar at the monastery

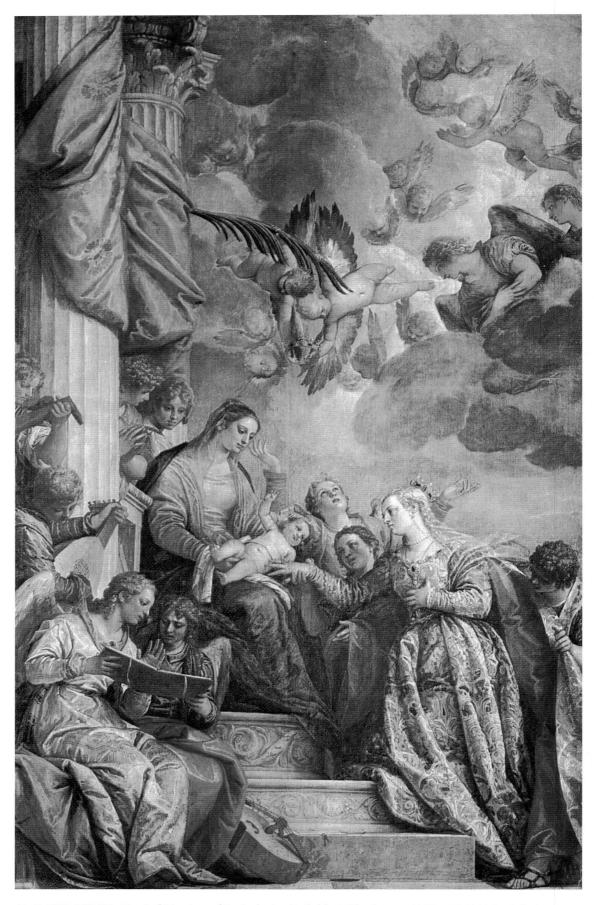

19.60. VERONESE. Mystical Marriage of St. Catherine. Probably 1570s. Canvas, 12'5" x 7'11" (3.8 x 2.4 m). Accademia, Venice. Commissioned for the high altar of S. Caterina, Venice

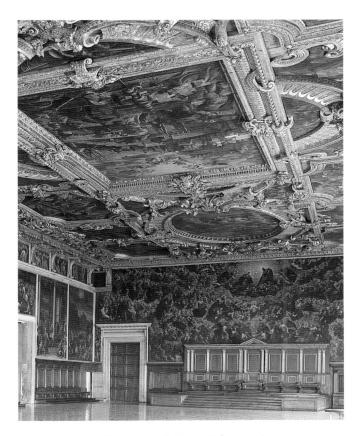

19.61. Hall of the Great Council, Doge's Palace, Venice. The oval ceiling painting visible here is the â Triumph of Venice, by Veronese and pupils (see fig. 19.62); end wall painting, â Paradise, by Tintoretto and pupils. 1585–90. Commissioned by the city government of Venice

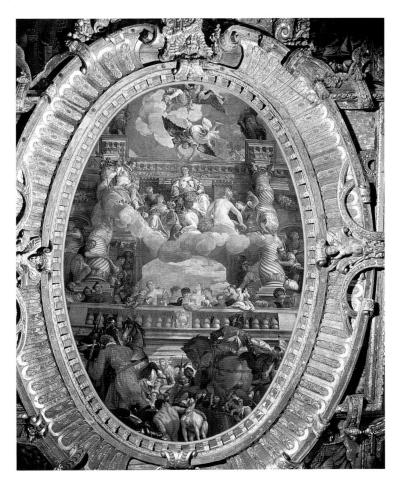

her dressed in damask. Veronese's juxtaposed hues are at their best in the pair of angels seated at the lower left-hand corner. Instead of paying attention to the divine favor bestowed on St. Catherine, they seem to be arguing over a piece of music and are not quite ready for the festival. Few passages in Venetian painting are more seductive than the white-and-gold brocade, green silk, and heavy orange taffeta of their garments.

Probably in 1585 Veronese and his workshop painted the *Triumph of Venice* (figs. 19.61, 19.62) on the ceiling of the Hall of the Great Council in the Doge's Palace. The architecture recedes grandly upward, and clouds carry with it the sceptered Venice, flanked by allegorical figures and enthroned between the towers of the Arsenal, from which Venetian galleys sailed forth to dominate the seas. Tintoretto's late *Last Supper* (see fig. 19.52) takes us into a world of personal mysticism; Veronese's

composition leads to the Baroque and the ceiling painters of the seventeenth century, who studied its principles and experimented with the possibilities of its daring flight.

Jacopo Bassano

Jacopo dal Ponte, called Bassano (c. 1517/18–92), belonged to the second generation of a dynasty of painters that would later include his four sons. Jacopo's best work was achieved by close observation and careful study. After escaping from the limited possibilities of his hometown, picturesque Bassano, he seems to have fallen under the influence of the Florentine Francesco Salviati, who visited Venice in 1536 and who must have acquainted Jacopo with some of the inventions of the central Italian *maniera*.

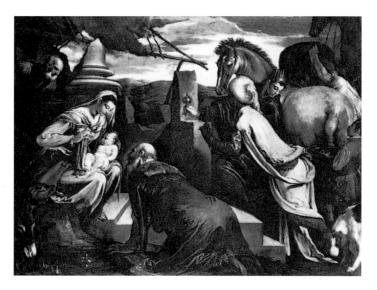

19.63. JACOPO BASSANO. *Adoration of the Magi.* c. 1563–64. Canvas, 37 x 46" (94 x 116.6 cm). Kunsthistorisches Museum, Vienna

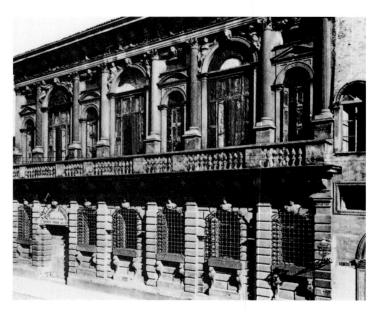

19.64. MICHELE SANMICHELI. Palazzo Bevilacqua, Verona. c. 1532–33

Although of unequal quality, Bassano's work can be dazzling in its combination of rustic naturalism with a daring freshness of invention and color. The dogs, horses, and donkey of the *Adoration of the Magi* (fig. 19.63) are astonishingly alive, while the elegantly attenuated Virgin and Magi radiate the princely splendor of the Venetian society for whom Bassano painted, as well as something of the artificiality of the *maniera*.

Michele Sanmicheli

Bramante's rich classical tradition had been continued throughout the cities of northern Italy by a host of talented architects, but the Roman version of the High Renaissance style was imported to the north only by artists who had experienced the new grand manner in full operation in the Rome of Julius II and Leo X. One of these was Michele Sanmicheli (1484-1559), an architect from Verona who worked from 1509 to 1521 at the Cathedral of Orvieto and who, in 1526, collaborated with Antonio da Sangallo the Younger in a survey of papal fortifications. On his return to Verona, after the Sack of Rome in 1527, Sanmicheli began constructing fortifications, ornamented with splendid Renaissance gates, and Renaissance palaces and churches that transformed this Gothic city into one of the richest centers of Renaissance architecture in northern Italy, to be ranked only after Venice itself (where Sanmicheli later built two palazzi on the Grand Canal) and the Vicenza of Palladio. While based on the general principles of Bramante's Palazzo Caprini (see fig. 17.20), with a rusticated lower story and a columned *piano nobile*, such Sanmicheli palaces as the Palazzo Bevilacqua (fig. 19.64) are strikingly original and often reflect aspects of the Roman monuments still standing in Verona.

As in the Roman palaces by Giulio Romano and other followers of Raphael that Sanmicheli studied, the groundfloor pilasters of the Palazzo Bevilacqua are rusticated, but now they are so encased in heavy blocks that only the capitals can escape. The three huge, arched windows of the piano nobile alternate with a complex arrangement of smaller arched windows that are surmounted by pediments and rectangular attic windows. This combination of interlocked architectural motifs contrasts with sculpted figures, heads, and garlands across the top of the structure. While four of the eight columns are fluted normally, the other four have spiral fluting—a device derived from Late Roman architecture that is unusual in the Renaissance. Two run clockwise, two counterclockwise, and they are arranged so that a clockwise example is paired with a counterclockwise one. Coupled with the rich ornamentation of the frieze, the effect is one of disturbing complexity.

One of Sanmicheli's most impressive and inventive works is the highly ornamented Pellegrini Chapel (fig. 19.65) attached to the church of San Bernardino in Verona. Built from

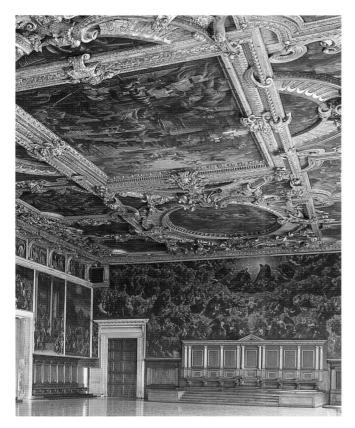

19.61. Hall of the Great Council, Doge's Palace, Venice. The oval ceiling painting visible here is the [®] *Triumph of Venice*, by Veronese and pupils (see fig. 19.62); end wall painting, [®] *Paradise*, by Tintoretto and pupils. 1585–90. Commissioned by the city government of Venice

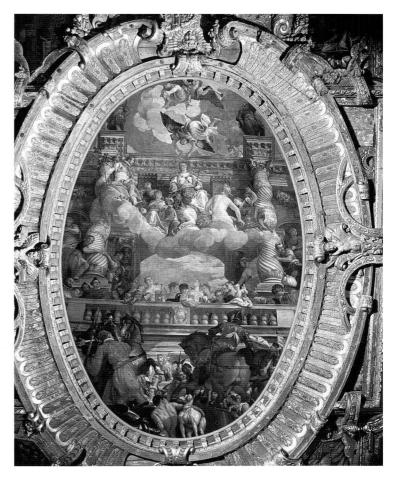

19.62. VERONESE and pupils. *Triumph of Venice* (see also 19.61). Probably 1585. Canvas, 29'8" x 19' (9 x 5.8 m).

☐ Ceiling of Hall of the Great Council, Doge's Palace, Venice.

Commissioned by the city government of Venice

her dressed in damask. Veronese's juxtaposed hues are at their best in the pair of angels seated at the lower left-hand corner. Instead of paying attention to the divine favor bestowed on St. Catherine, they seem to be arguing over a piece of music and are not quite ready for the festival. Few passages in Venetian painting are more seductive than the white-and-gold brocade, green silk, and heavy orange taffeta of their garments.

Probably in 1585 Veronese and his workshop painted the *Triumph of Venice* (figs. 19.61, 19.62) on the ceiling of the Hall of the Great Council in the Doge's Palace. The architecture recedes grandly upward, and clouds carry with it the sceptered Venice, flanked by allegorical figures and enthroned between the towers of the Arsenal, from which Venetian galleys sailed forth to dominate the seas. Tintoretto's late *Last Supper* (see fig. 19.52) takes us into a world of personal mysticism; Veronese's

composition leads to the Baroque and the ceiling painters of the seventeenth century, who studied its principles and experimented with the possibilities of its daring flight.

Jacopo Bassano

Jacopo dal Ponte, called Bassano (c. 1517/18–92), belonged to the second generation of a dynasty of painters that would later include his four sons. Jacopo's best work was achieved by close observation and careful study. After escaping from the limited possibilities of his hometown, picturesque Bassano, he seems to have fallen under the influence of the Florentine Francesco Salviati, who visited Venice in 1536 and who must have acquainted Jacopo with some of the inventions of the central Italian *maniera*.

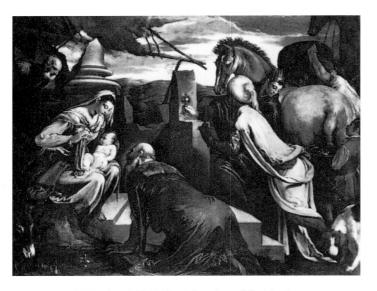

19.63. JACOPO BASSANO. *Adoration of the Magi.* c. 1563–64. Canvas, 37 x 46" (94 x 116.6 cm). Kunsthistorisches Museum, Vienna

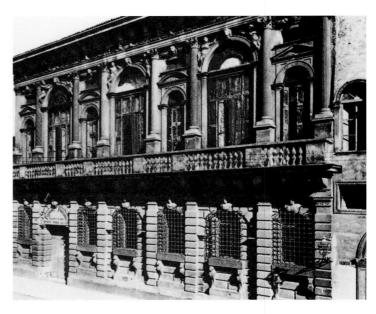

19.64. MICHELE SANMICHELI. Palazzo Bevilacqua, Verona. c. 1532–33

Although of unequal quality, Bassano's work can be dazzling in its combination of rustic naturalism with a daring freshness of invention and color. The dogs, horses, and donkey of the *Adoration of the Magi* (fig. 19.63) are astonishingly alive, while the elegantly attenuated Virgin and Magi radiate the princely splendor of the Venetian society for whom Bassano painted, as well as something of the artificiality of the *maniera*.

Michele Sanmicheli

Bramante's rich classical tradition had been continued throughout the cities of northern Italy by a host of talented architects, but the Roman version of the High Renaissance style was imported to the north only by artists who had experienced the new grand manner in full operation in the Rome of Julius II and Leo X. One of these was Michele Sanmicheli (1484-1559), an architect from Verona who worked from 1509 to 1521 at the Cathedral of Orvieto and who, in 1526, collaborated with Antonio da Sangallo the Younger in a survey of papal fortifications. On his return to Verona, after the Sack of Rome in 1527, Sanmicheli began constructing fortifications, ornamented with splendid Renaissance gates, and Renaissance palaces and churches that transformed this Gothic city into one of the richest centers of Renaissance architecture in northern Italy, to be ranked only after Venice itself (where Sanmicheli later built two palazzi on the Grand Canal) and the Vicenza of Palladio. While based on the general principles of Bramante's Palazzo Caprini (see fig. 17.20), with a rusticated lower story and a columned piano nobile, such Sanmicheli palaces as the Palazzo Bevilacqua (fig. 19.64) are strikingly original and often reflect aspects of the Roman monuments still standing in Verona.

As in the Roman palaces by Giulio Romano and other followers of Raphael that Sanmicheli studied, the groundfloor pilasters of the Palazzo Bevilacqua are rusticated, but now they are so encased in heavy blocks that only the capitals can escape. The three huge, arched windows of the piano nobile alternate with a complex arrangement of smaller arched windows that are surmounted by pediments and rectangular attic windows. This combination of interlocked architectural motifs contrasts with sculpted figures, heads, and garlands across the top of the structure. While four of the eight columns are fluted normally, the other four have spiral fluting—a device derived from Late Roman architecture that is unusual in the Renaissance. Two run clockwise, two counterclockwise, and they are arranged so that a clockwise example is paired with a counterclockwise one. Coupled with the rich ornamentation of the frieze, the effect is one of disturbing complexity.

One of Sanmicheli's most impressive and inventive works is the highly ornamented Pellegrini Chapel (fig. 19.65) attached to the church of San Bernardino in Verona. Built from

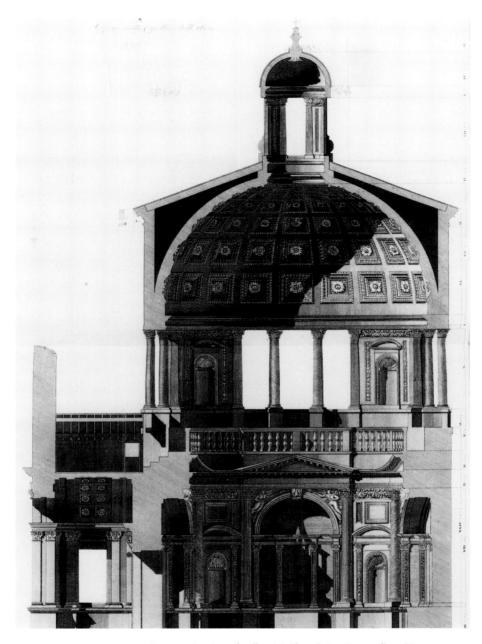

19.65. MICHELE SANMICHELI. Section of Pellegrini Chapel, San Bernardino, Verona. 1529–57. Engraving by B. GIULIARI, from *La cappella della famiglia Pellegrini*, Verona, 1816. Commisioned by Margarita Pellegrini, who dedicated it to St. Anne, patron saint of childbirth and mothers. Margarita Pellegrini's will of 1534 speaks of the chapel's "most perfect and most dignified beauty," while a later will endows it "so that a work of such superlative beauty may be maintained in its laudable state and be decorously conserved."

1529 to 1557, it was commissioned by Margarita Pellegrini as a funerary chapel for herself and her son, who had died at the age of eighteen in 1528; her daughter was also buried in the chapel. Noticeably absent is Margarita's husband, Benedetto Raimundi de' Guareschi, who, although wealthy, was of inferior social status; his coat of arms, which was also that of their son, is less important in the chapel's decoration

than are the arms of Pellegrini. The scale and elaborate decoration of the Pellegrini Chapel were clearly intended to establish the continuing importance of Margarita's family in Verona. Documents reveal that rather than leaving the architect on his own, Margarita played an important role in advising him over the three decades needed to design and build the chapel. The centralized plan features a vestibule that

leads into a tall cylinder supporting a coffered dome with a tall lantern; three altars are found in niches. The abundant decorative motifs, with spirally fluted columns, rich garlands, balustrades, and bold rosettes in the coffers of the dome, were based not only on ancient Roman monuments Sanmicheli had studied in Rome, but on the many ancient monuments that survived in Verona itself.

Jacopo Sansovino

The Grand Canal in Venice is, by virtue of its succession of palaces, one of the most beautiful thoroughfares in the world, but not one of its Renaissance palaces was built by an architect born in Venice. The tradition began with Early Renaissance palaces, which are largely by such Lombard ar-

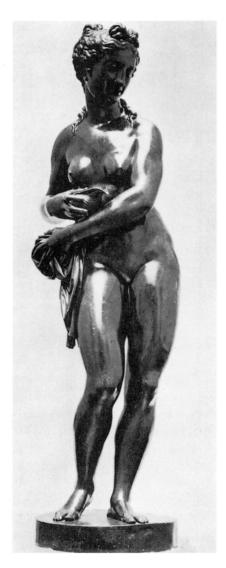

19.66. JACOPO SANSOVINO. *Venus Anadyomene*. Before 1527(?). Bronze, height 66" (168 cm). National Gallery of Art, Washington, D.C. (Mellon Collection). Probably commissioned by Federigo Gonzaga for the Sala di Psiche, Palazzo del Te, Mantua

chitects as the Lombardo family and Mauro Codussi. The High Renaissance Venetian palace was the invention of a Florentine, Jacopo Tatti (1486-1570), who was called Sansovino after his teacher, Andrea Sansovino. He was known chiefly as a sculptor before he came to Venice, and had he remained one, it is doubtful that Jacopo would have commanded our attention, in spite of the charm of such works as the bronze Venus Anadyomene (fig. 19.66), which is probably the Venus ordered by Duke Federigo Gonzaga for the Sala di Psiche in the Palazzo del Te at Mantua. Pietro Aretino wrote to Federigo in 1527 that this statue was "so true and so live that it fills with desire everyone who beholds it." The magnificence and authority of Jacopo's classical style establish him as the most original architectural thinker in Venice. His works laid down the principles on which Venetian architecture was to proceed for the next two centuries.

Sansovino's arrival in Venice in 1527, after the Sack of Rome, must have been liberating, trained as he was in the High Renaissance environment of Bramante, Raphael, and Peruzzi. Florence, with its narrow streets and its tradition of fortress-palaces, could offer only limited opportunities to an architect brought up on Roman columns, arches, and balconies; Venice, on the other hand, suffered from no such physical restrictions. The lagoons protected the city, and its public and private buildings could exploit the advantages of light and air; Venetian palaces, from the Romanesque-Byzantine through the Gothic and Early Renaissance, present to the Grand Canal a series of wide windows and superimposed open arcades built of white limestone, the luminosity of which imparts a special brilliance to the Venetian scene. Sansovino's Roman architectural heritage could therefore be allowed an almost ideal freedom of expression.

His Library of San Marco (fig. 19.67) was commenced in 1537 to shelter the manuscripts left to the Republic by Cardinal Bessarion, the Greek humanist and patriarch of Constantinople who became a Latin prelate. An ancient prototype has been adduced—the Roman Emperor Hadrian's marble library described by Pausanias—and it has been suggested that the writings of Vitruvius, whose architectural treatise was known in a Venetian edition of 1511, influenced the decision to situate the reading room to face the morning light. It was placed in a commanding position, safe from high tides, on the upper story. Sansovino's groundstory arcade is in the Roman Doric order, based on that of the Colosseum, with keystones carved into alternating masks and lions' heads and with recumbent figures in the spandrels. In the taller, Ionic second story, Sansovino shows his originality. The engaged columns on high bases, like the second-story columns of Bramante's Palazzo Caprini (see fig. 17.20), support an entablature whose frieze of putti and garlands encloses a half-story of mezzanine windows hidden in the ornamentation. Each arch is flanked by pairs of fluted columns that are two-thirds the height of the

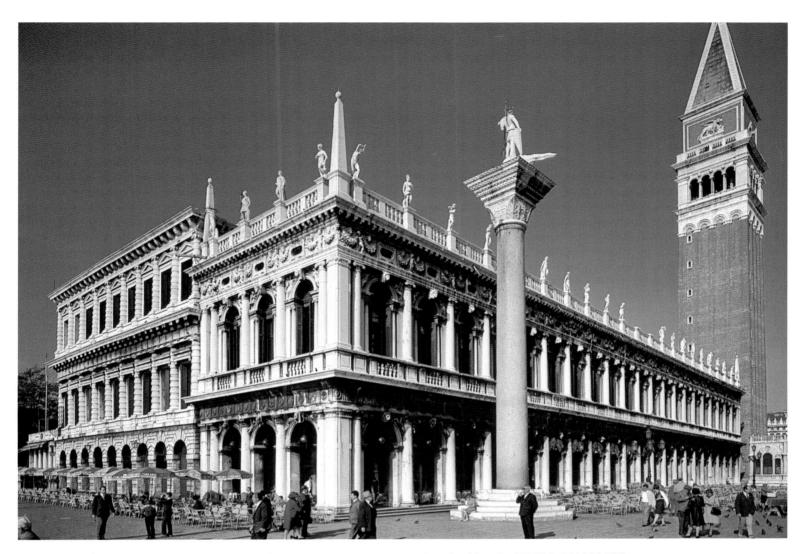

19.67. JACOPO SANSOVINO. Library of S. Marco, Venice. Begun 1537. Completed by VINCENZO SCAMOZZI. Commissioned by the Procurators of St. Mark's; to the left is Sansovino's Zecca (Mint); see fig. 19.68.

In 1554 construction on the library was interrupted, only to be resumed after the master's death in 1570 by his pupil Vincenzo Scamozzi. Nonetheless, the work was continued with fidelity to Jacopo's designs, and the library stands as a unified monument.

smooth, larger columns. The pairing of these smaller columns in depth creates an effect of plastic richness that is increased by the figures of the spandrels and friezes.

The verticals are accented at the corners by piers articulated by pilasters, and the crowning balustrade is divided by high bases that support statues and obelisks. All traditional boundaries—walls, corners, top—are thus dissolved. No walls are apparent on either story, only clusters of columns and the piers to which they are engaged or around which they are deployed. The upper contour of the structure, until this moment in Renaissance architectural history invariably marked by an unbroken cornice, is here dissolved against the Venetian sky. Verticals are prolonged from the ground to the heads of the statues, with an effect comparable to that of the pinnacles marking the divisions of Gothic buildings. The mass of the

building encloses the shadows of the ground-story portico and upper-story windows; the balustrade and statues incorporate the sky. Palladio called the building "probably the richest ever built from the days of the ancients up to now," and Pietro Aretino pronounced it "superior to envy."

For the Zecca (mint; fig. 19.68, and see fig. 19.67), Sansovino created an effect of impregnability by interrupting the columns with rusticated bands, an idea derived from the Porta Maggiore, one of the ancient city gates of Rome. The mint was originally erected with two stories, but Sansovino later had to add a protective third story required by the heat of the foundries. The total effect is imposing, and although some of the horizontals continue those of the neighboring Library of San Marco, the proportions of the Zecca are deliberately kept separate from the library's luxurious beauty.

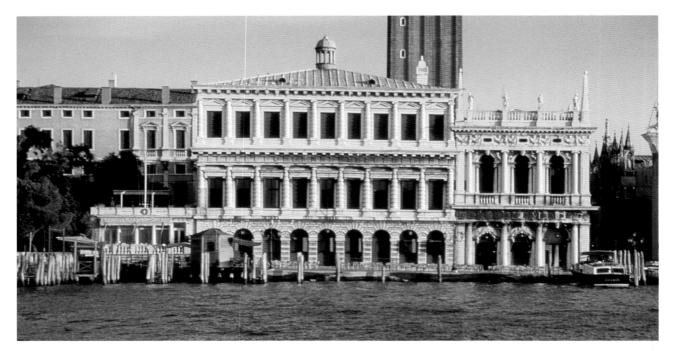

19.68. JACOPO SANSOVINO. Zecca (Mint), Venice. 1536-45. Third story added in 1558-66. Commissioned by the Council of Ten

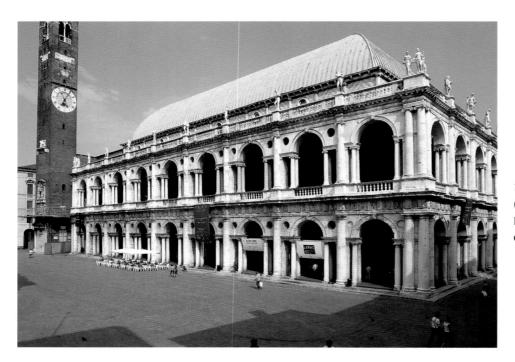

19.69. PALLADIO. Basilica (Palazzo della Ragione), Vicenza. Begun 1549; completed 1614. Commissioned by the city council

Andrea Palladio

Andrea di Pietro (1508–80) is known by the name Palladio—derived from Pallas Athena, goddess of wisdom—bestowed by his patron, the humanist Giangiorgio Trissino. Palladio was brought up in Vicenza, which he turned into one of the most beautiful cities in Italy through buildings designed in a new, more archaeological version of the Renaissance style. Trissino took Palladio to Rome with him, where the young architect studied the works of the High Renaissance architects and the ruins of antiquity. Palladio also mastered the

writings of Vitruvius and Alberti, and made influential literary contributions of his own, including *The Antiquities of Rome* (*L'antichità di Roma*), printed in 1554, and *The Four Books on Architecture* (*I quattro libri dell'architettura*), which appeared in 1570. In the latter, the *virtus* of Roman art, so important a principle to Alberti (see p. 265), is applied to the architectural problems—domestic, public, and religious—of Palladio's own day.

In 1549 Palladio commenced a two-story addition of open loggie wrapped around the fourteenth-century Palazzo della Ragione (fig. 19.69), a typical example of the public halls

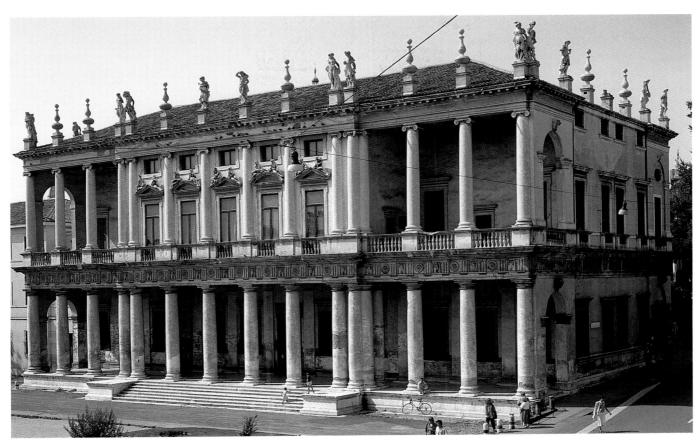

19.70. PALLADIO. Palazzo Chiericati, Vicenza. Begun 1551, completed in the seventeenth century after Palladio's design. Commissioned by Girolamo Chiericati.

Palladio wrote: "Now that we have talked of walls by themselves, it is appropriate to move on to their ornaments, of which columns, when located properly and in proportion to the whole building, are by far the most important that can be applied to a building."

built in northern Italian cities at the close of the Middle Ages. Palladio himself called it his Basilica, justifying the term by the structure's use as a law court, the original function of Roman basilicas; he wrote that he did "not doubt that this building may be compared with the ancient edifices, and ranked among the most noble and most beautiful fabrics that have been made since the ancient times, not only for its grandeur and its ornaments, but also for the materials."

Derived from Sansovino's Library of San Marco (see fig. 19.67), Palladio's Basilica is less highly decorated and less reliant on sculpture. What we know today as the "Palladian motif or window"—an arched opening supported by columns and flanked by narrow compartments—is anticipated in Sansovino's second story and had probably originated in the circle of Bramante in Rome. In the Renaissance, it is virtually always enframed by a giant order supporting an entablature. Palladio uses it for both stories of the Basilica, demonstrating how the motif made it possible to vary the proportions of bays. Here the corner bays are narrower than the others because the intervals between the small and the embracing orders are less, while the arches maintain the same radius throughout the building. This new flexibility in

organization is typical of Palladio's approach to the resolution of architectural problems.

There are some curious aberrations. The columns of the large order are doubled on the corners, creating a bundle of three columns when seen from both sides. Sansovino's device of coupling columns in depth is used by Palladio, but the shafts do not rest on conventional bases. Palladio has substituted unmolded cylinders, apparently so the columns will not detract from the bases of the giant order. The medieval roof is still visible, but Palladio has deployed his arcades so that the old walls are invisible, and the roof seems moored to his building almost like a tent.

The most original of Palladio's private residences in Vicenza is probably the Palazzo Chiericati (fig. 19.70). For his other urban dwellings, where he was restricted by narrow streets, Palladio designed classical façades in variations of the Bramante tradition. But here his loggie look out on a large open piazza, and he was able to give free rein to his architectural imagination. The ground story is a Bramantesque loggia (see fig. 17.9), but the paired columns and jutting entablature in the center divide this into three. The logic for this becomes apparent in the second story, a loftier Ionic

loggia, but here the central area is unexpectedly filled in by a wall so that a solid block of masonry appears suspended among the columns. On the top of the building, the internal divisions are suggested by the alternation of clustered statues with large, fantastic urns.

Palladio's most influential building for the history of domestic architecture is the Villa Rotonda (fig. 19.71), a rural retreat sited on an eminence near Vicenza. "The site [for the Villa Rotunda] is one of the most pleasing and delightful that one could find . . . because it enjoys the most beautiful vistas on each side," Palladio wrote, "some of which are restricted, others more extensive, and yet others which end at the horizon, [and] loggias have been built on all four sides." Like most of the villas designed by Palladio, the building is organized around a classical temple portico, but the Villa Rotonda is unique in having four such porticoes, one for each cardinal point of the compass (fig. 19.72). Each commands a different view and enjoys different atmospheric qualities. Each is protected on the sides by diaphragm walls

that ward off the sun but which are pierced by an arch to admit ventilation; the inhabitants could thus profit from an almost endless variety of sun and shade, breeze, and shelter. It is no wonder that Palladio's ideas were adopted with special enthusiasm in the architecture of plantation mansions in the American South, where protection against the sun was essential.

Each portico is reached by steps flanked by projecting walls. On the corners of these walls and on each pediment, statues extend the axes of the villa. Yet despite these details, the villa is austere in its flat walls, severe Ionic columns, and undecorated frieze. It has been demonstrated that Palladio used the numerical ratios of the harmonic relationships of the Greek musical scales, known in theory during the Renaissance, to calculate the proportional relationships in and between the rooms in his villas. Palladio's ratios are more elaborate than those of Brunelleschi or Alberti, and although not consciously discerned by the observer, they are responsible for the effect of harmony and balance so evident in Palladio's buildings.

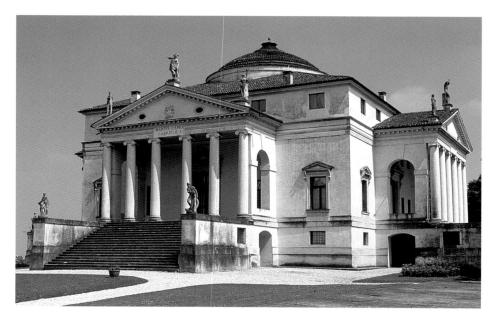

19.71. PALLADIO. Villa Almerico, now known as Villa Rotonda or Villa Capra, Vicenza. Begun 1550. Completed by VINCENZO SCAMOZZI. Commissioned by Paolo Almerico. On the siting of a country villa Palladio wrote:

it seems to me particularly relevant to discuss the site and location to be chosen for those buildings and their planning; since we are not (as is usually the case in towns) enclosed by fixed and predetermined boundaries such as public walls and those of neighbors, it is the business of the sensible architect to investigate and assess a convenient and healthy location with the greatest care and diligence, because we stay in the country mainly in the summer when our bodies grow weak and sick because of the heat even in the healthiest spots.

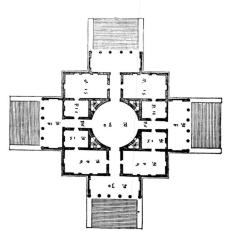

19.72. PALLADIO. Plan of Villa Almerico/Rotonda, Vicenza

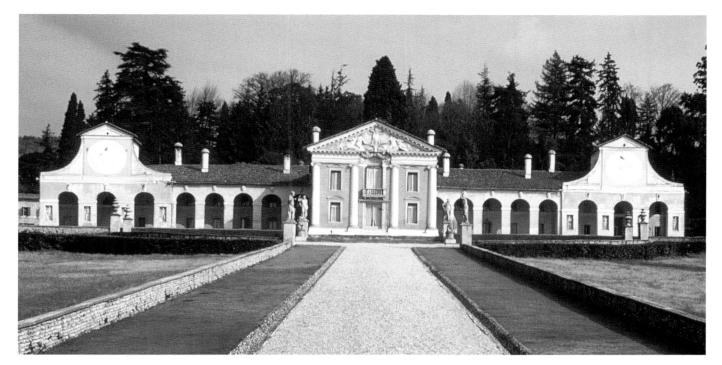

19.73. PALLADIO. Façade, Villa Barbaro, Maser. 1550s.

Commissioned by Daniele and Marcantonio Barbaro as a rebuilding of a family estate, some of the foundations of which were incorporated in Palladio's design.

Palladio seems to have become a member of the Barbaro household staff, and when Daniele Barbaro died, his will mentioned "Palladio, our architect."

19.74, PALLADIO, Plan, Villa Barbaro, Maser, 1550s

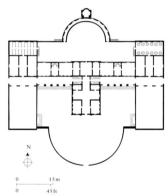

Palladio's Villa Barbaro at Maser (figs. 19.73, 19.74) was the modest main building for a small working farm, and the manner in which the flanking wings extend into the landscape has a practical rather than a theoretical or ideological basis. As at the Villa Rotonda, the main façade is based on an ancient temple façade, but here the entablature is unexpectedly broken by garlands that decorate the top of a large balconied window that allows the patrons a view over their pastures and farmlands. The arcaded wings to either side culminate in large sundials and structures that suggest dovecotes. A semicircular nymphaeum behind the villa has a spring-fed cascade, a fish pond, a grotto, fountains, and extensive sculptural decoration. The water from this pond flowed into the kitchen, and then out to a series of fountains in front of the villa. The water ended as irrigation for the farm's orchards. Unfortunately, the extensive practical gardens and orchards of the Villa Barbaro do not survive.

The elaborate sculptural decoration in stucco that adds elegance and focus to the façade was in part designed and executed by Marcantonio Barbaro, who, with Daniele Barbaro, was one of the patrons for the villa; a main feature of the pedimental decoration is the Barbaro coat of arms. The brothers were powerful Venetian aristocrats—Daniele was a papal prelate and Marcantonio a prominent statesman—with strong interest in the arts. Daniele authored an annotated edition of the writings of Vitruvius which was published in 1556 with illustrations by Palladio, while Marcantonio played a continuing role in Venetian building and sculptural projects until his death in 1595. The involvement of both brothers with architecture supports the assertion that they collaborated with Palladio on certain details of the villa's design. In 1560–62 the painter Veronese decorated the interior of the brothers' villa with a splendid set of trompe l'oeil murals (see fig. 19.56).

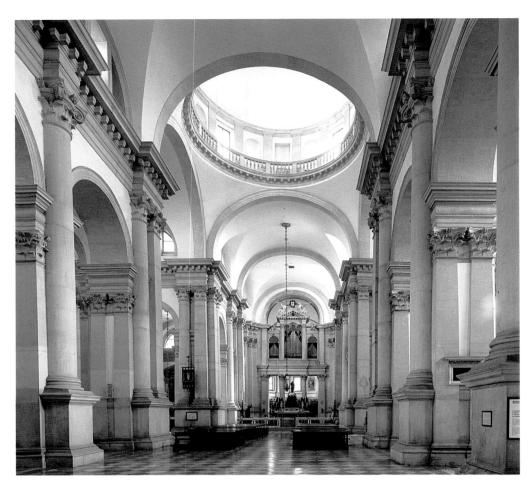

19.75. PALLADIO. Interior, S. Giorgio Maggiore, Venice (for the façade, see figs. 14, 19.77). Begun 1566.

Commissioned by the monastery's abbot, Andrea Pampuro da Asolo

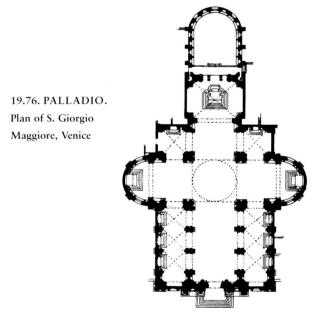

Palladio's few churches are milestones in architectural history. His grandest interior is that of San Giorgio Maggiore (figs. 19.75, 19.76). The design is Albertian in the sense that it is conceived in terms of a single giant order flanking arches supported by a smaller order, but unlike Alberti's Sant'Andrea in Mantua (see figs. 10.6, 10.8), San Giorgio Maggiore retains the traditional side aisles of a basilica. The sculptural quality of the interior is based on a sustained opposition between engaged columns and pilasters. The inner order consists of smaller pilasters, coupled in depth like the paired columns of Sansovino's Library of San Marco (see fig. 19.67); the giant order consists of single engaged columns, and at the corners of the crossing the columns are paired with giant pilasters. The effect of the interior is predicated on combinations of flat and rounded forms, and decoration is almost totally eliminated. The convex frieze is devoid of ornament, the columns and pilasters unfluted, and even the leaves of the capitals simplified.

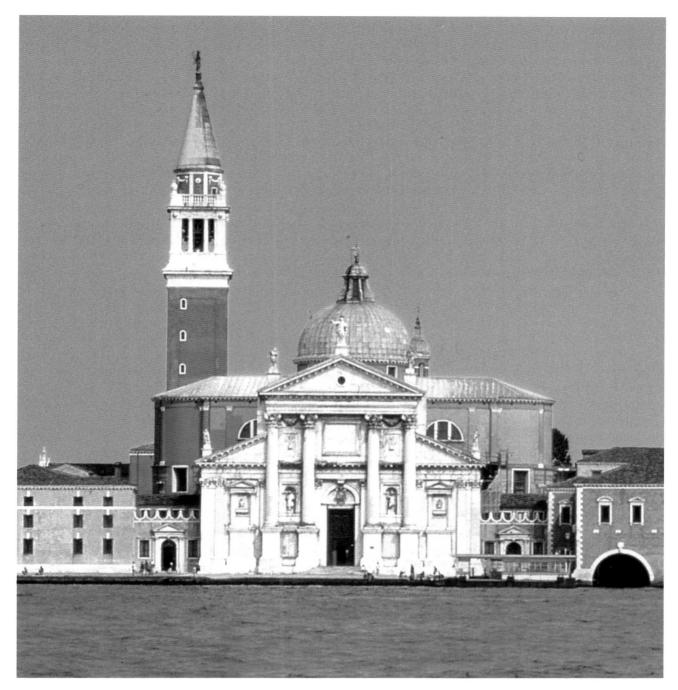

19.77. PALLADIO. Façade of S. Giorgio Maggiore, Venice. Completed by VINCENZO SCAMOZZI, 1610. (see fig. 14)

San Giorgio Maggiore was commenced in 1566, but Palladio did not live to see the façade, which was erected from his designs by Scamozzi (fig. 19.77; see also fig. 14). Here Palladio presented a solution to the dilemma of the architect confronted with devising a classical façade for the difficult shape of the Christian basilica. At Santa Maria Novella (see fig. 10.5), Alberti had bridged the gap between the side-aisle roofs and the central temple shape by means of giant consoles, but this was a mere screen. At Sant'Andrea in Mantua

(see fig. 10.6)—not actually a basilica—he applied a small façade to a large church. Palladio amplified Alberti's notion of two interpenetrating orders seen on the Sant'Andrea façade into two intersecting temples—one low and broad and articulated by pilasters to accommodate the side-aisle roofs, the other tall and slender with engaged columns to embrace the lofty nave. This solution—ingenious, harmonious, and definitive—was never used again, perhaps because any further use could only appear to be an imitation.

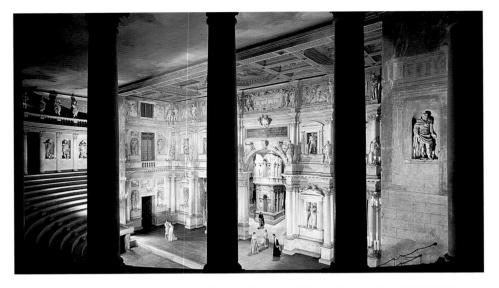

19.78. PALLADIO. Interior, Olympian Theater, Vicenza. 1580–84. Executed by VINCENZO SCAMOZZI, who designed the stage setting. Commissioned by the Accademia Olimpica, of which Palladio was a member.

Palladio's theater was in part inspired by the ruins of the ancient Roman theater in Vicenza and other Roman theaters he had visited, as well as by his study of Vitruvius's comments on ancient theaters. The inaugural performance of the theater, in 1585, featured a performance of Oedipus Rex by Sophocles, translated into Italian and complete with music composed for the chorus by the Organist of San Marco in Venice. A letter written by Filippo Pigafetta after attending the opening production described the theater in detail, concluding that every part "seems worked by the hand of Mercury and decorated by the Graces themselves."

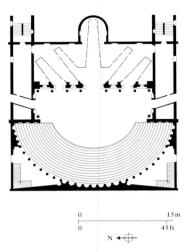

19.80. PALLADIO. Plan of Olympian Theater, Vicenza. 1580–84

19.79. PALLADIO. View of stage, Olympian Theater, Vicenza. 1580–84. Executed by VINCENZO SCAMOZZI

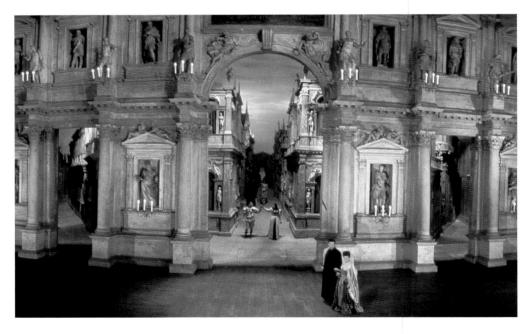

Palladio never saw many of his designs completed. After his death Scamozzi executed the Olympian Theater at Vicenza (figs. 19.78, 19.79), one of several Cinquecento attempts to re-create, usually in temporary materials such as wood and stucco, the shape and appearance of an ancient Roman theater. The building, intended for the production

of contemporary and classical drama, is typical of the classicizing ideals of the society for which Palladio built. The stage as designed by Scamozzi is provided with fixed scenery based on the ancient Roman *scenae frons*. But Scamozzi's arrangement of columns, statues, tabernacles, and reliefs follows no exact model. The three central openings lead into radiating

19.81. ALESSANDRO VITTORIA.

St. Jerome. 1576(?). Marble, height 66 ½ (1.7 m).

SS. Giovanni e Paolo, Venice. Commissioned for the Scuola di S. Fantin, Venice

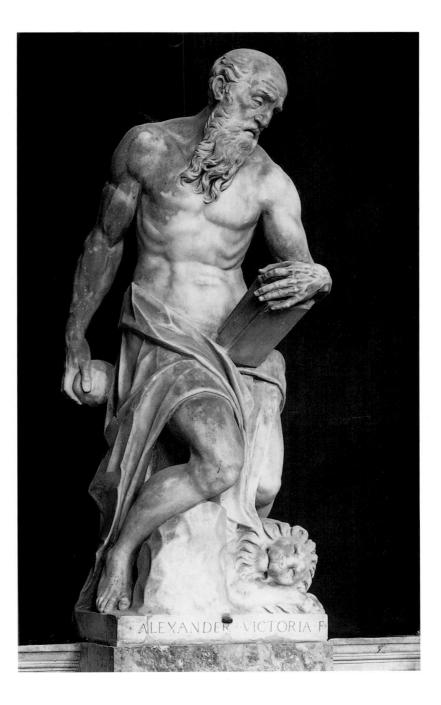

streets that seemingly terminate at a vast distance from the stage; this illusion is created by a rising pavement and the rapidly diminishing height of the buildings that line these avenues. But these Renaissance palaces are only a few feet deep, and the streets rise up as the rooftops descend (fig. 19.80).

Alessandro Vittoria

With its predominantly pictorial interests, Venice does not seem to have encouraged sculptors. Every important Italian Renaissance sculptor working in Venice came from Tuscany, and all but two of them were Florentines. Nonetheless, sculpture was needed in Venice, as elsewhere, for tombs, altars, and exterior decoration.

Alessandro Vittoria (1525–1608), who came from Trento, in the Adige Valley north of the plain of the Po, is clearly related to the innovators in painting. His *St. Jerome* (fig. 19.81) demonstrates that he has studied the lessons of central Italian anatomy, but the figure is now caught up in the current of Counter-Reformation religiosity also seen in the late works of Titian and Tintoretto. The penitent saint, withdrawn from the world in a state of self-lacerating catatonia, seems almost to be floating over his rock rather than kneeling on it. His lion is reduced to a symbol and the sculptor concentrates on the swollen veins in arms and hands and, above all, on the look of terror at the emptiness within. The complex pose of the almost nude figure reveals the impact of Mannerist concerns, but the gripping expressiveness is Vittoria's own.

MICHELANGELO AND THE MANIERA

final paradox in the history of Italian Renaissance art is the coexistence during the middle and late Cinquecento of the late style of Michelangelo and the later phase of Mannerism that here will be called the *maniera*. While the artists of the *maniera* placed Michelangelo at the summit of greatness in their writings and borrowed figures, groups, and compositional ideas from his works, the art of the *maniera* lacks the energy and tension of his work, and is characterized by artificiality and elaboration. These ideals were institutionalized with the founding of the Florentine Academy in 1563 under the sponsorship of Duke Cosimo I de' Medici; this new institution soon came to play an important role in controlling production and dictating artistic style.

The prime movers of the maniera were about thirty-five years younger than Michelangelo and, although Michelangelo had been one of the founders of High Renaissance style, this had not prevented him from devising inventions of a strikingly different sort in Florence between 1516 and 1534. It should be kept in mind that Michelangelo never relaxed his republican principles, although briefly toward the end of his life he entertained the possibility of returning to Florence to work for the duke. He kept aloof from dynastic patrons save when they promised the liberation of Florence, and he worked for the Church—at times without pay—and for himself. The leaders of the maniera, on the other hand, were court artists whose works were mainly intended to glorify dynastic rule, court society, and a formalized version of religion. The linear and formal complexities of their art matched the allegorical conceits found so frequently in their subject matter.

Michelangelo after 1534

The central monument of mid-Cinquecento painting in Rome is Michelangelo's *Last Judgment* (fig. 20.1), painted in 1536–41. Early in 1534 Pope Clement VII Medici discussed with Michelangelo a new fresco for the altar wall of the Sistine

Chapel; the subject has been tentatively identified as the Resurrection. But Clement died that year, and the new pope, Paul III, commissioned Michelangelo to paint the *Last Judgment*. This penitential subject must have seemed more appropriate at a time when the papacy was still reeling from the Sack of Rome and when it was under attack from both the Protestants in the north and those in Italy who were demanding greater fiscal responsibility and moral behavior. Images of justice and punishment, sacred and secular, had already appeared on a grand scale in Italy (see figs. 18.36, 18.39, 18.40, 18.70), but the dedication of the altar wall in the pope's private chapel to this theme indicates a new sobriety and intensity.

The subject captured the imagination of the aging artist, who devoted a series of studies to the huge composition and the poses of individual figures. Perugino's frescoed altarpiece of the Assumption of the Virgin and his Nativity and Finding of Moses, both part of the fifteenth-century narrative program lining the side walls of the chapel, had to be destroyed, as did figures of four popes and Michelangelo's own lunettes over the windows, which represented the first seven generations of the ancestry of Christ. The two windows in this wall had to be blocked over to provide the vast unified field that Michelangelo needed for his panoramic composition, which seems to dissolve the entire altar wall. Medieval Last Judgments were usually hierarchical, compartmentalized structures in which all figures, including sometimes even the resurrected dead, are dressed according to their social position, and Christ, the Virgin, and the apostles are enthroned in heaven. Instead, Michelangelo has represented a unified scene without any break, without thrones, without insignia of rank, generally even without clothes. In a huge clockwise motion, figures rise from their graves, gather round the central Christ, and sink downward toward hell.

What gives the fresco its special character is the vision of the Second Coming in Matthew 24:30–31: "And then shall appear the sign of the Son of man in heaven: and then shall all the tribes of the earth mourn, and they shall see the Son

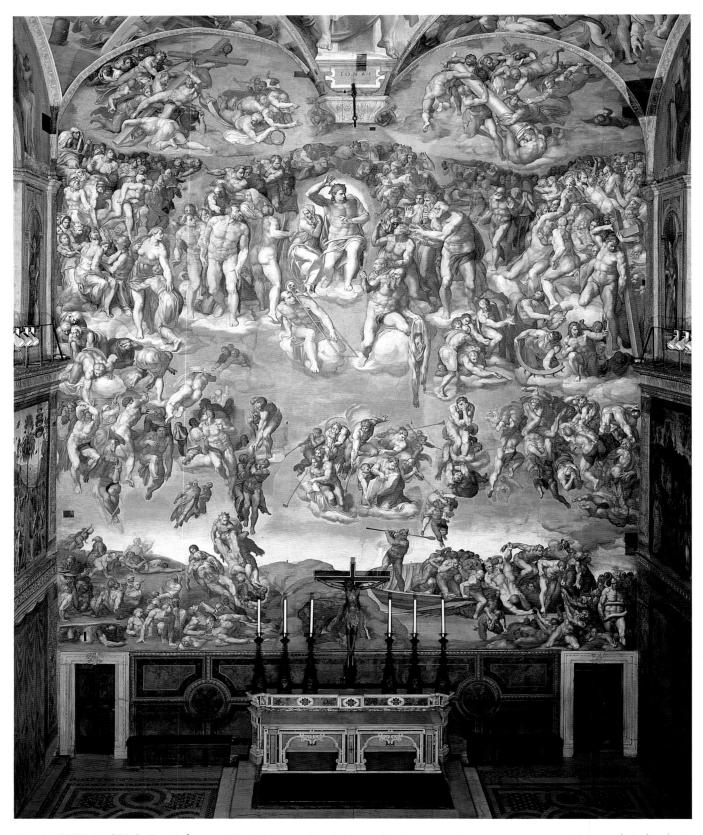

20.1. MICHELANGELO. *Last Judgment*. 1536–41. Fresco, 48 x 44' (encompassing approx. 190 square meters or 2100 square feet of surface). Sistine Chapel, Vatican, Rome. Commissioned by Pope Paul III Farnese. Some of the draperies that were painted over Michelangelo's nude figures after his death were removed in the recent restoration, but some were retained, especially in cases where Michelangelo's original plaster layer had been removed. The rectangular black patches (such as the one in the upper-right corner) are areas of the wall yet to be cleaned when this photograph was taken; they indicate how dark the fresco was before restoration.

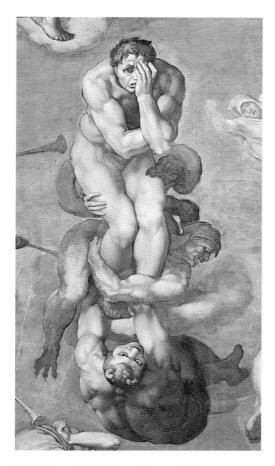

20.2. Damned Soul Descending to Hell, detail of fig. 20.1

of man coming in the clouds of heaven with power and great glory. And he shall send his angels with a great sound of a trumpet, and they shall gather together his elect from the four winds, from one end of heaven to the other." The open background of the fresco should be interpreted as the fulfillment of Christ's words a few verses later: "Heaven and earth shall pass away." Only enough of the earth is shown to provide graves from which the dead can crawl. Some corpses are well preserved, some skeletons, in conformity with the tradition already seen in Signorelli's Orvieto frescoes (see fig. 16.54). The dead show no joy in resurrection or in the recognition of those they knew in life, only dread of the judgment taking place around and above them. Some are still dazed, others hopeless; some look upward in awe and wonder. Some soar upward; others are fought over by angels who want to lift them and demons intent on dragging them down (fig. 20.2).

The nudity of most of the figures—so shocking to the prudery of the Counter-Reformation that Michelangelo's pupil Daniele da Volterra was commissioned in 1565 to paint drapery over some of the offending portions—is in harmony with Michelangelo's lifelong concern with the human figure. Thus both the dead rising from their graves and the elect in heaven are shown naked before Christ. To help unify the composition, Michelangelo increased the scale of the figures in the

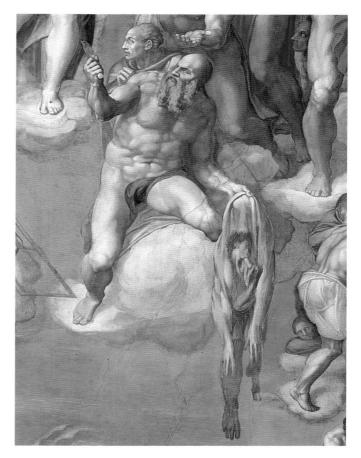

20.3. St. Bartholomew holding his flayed skin, which bears the features of Michelangelo, detail of fig. 20.1

upper part of the fresco. Here the figures are broader and fuller than those of the Sistine Ceiling—the proportions heavier, the heads smaller, and the modeling even more vigorous. Michelangelo generally omits wings and haloes, perhaps because they seemed hindrances to the expression of bodily perfection as he understood it. Only their greater power and often startling beauty distinguish the angels from ordinary mortals. The dominant color is that of human flesh against a vivid blue sky with a few touches of brilliant drapery that echo the rich hues of the ceiling. The dead rising from their graves still preserve the colors of the earth—dun, ocher, drab.

Christ is placed in the zone best lighted by the windows on either side and given a scale greater than that of the gigantic apostles who surround him. Although his attention is largely occupied with the gesture of damnation—his right hand held high as he turns in this direction—his left is extended gently, as if summoning the blessed up toward him. Instead of the traditional mandorla, a subtle radiance extends from the figure. Michelangelo's beardless and almost nude Christ is a summation of his new, more massive canon of proportion. The apostle Bartholomew, who was flayed alive, holds his empty skin; the face is an anguished self-portrait of Michelangelo (fig. 20.3), revealing, as do the artist's letters and poems, intense feelings of guilt and inadequacy:

I live for sin, dying to myself I live; It is no longer my life, but that of sin: My good by Heaven, my evil by myself was given me, By my free will, of which I am deprived.

As the damned descend to their fate, a few struggle against the angels who drive them from heaven; most, however, seem resigned to the force of divine will. As a child, Michelangelo must have contemplated the torments of hell as depicted in a number of colossal works in Florence, including the Last Judgment in the Baptistery (see fig. 2.15) and the Hell by Nardo di Cione in Santa Maria Novella (see fig. 5.5). He read Dante's Inferno (which Nardo illustrated), and most likely knew Giotto's Last Judgment in Padua (see fig. 3.4). But in the final analysis, it is surprising how little these works seem to have affected him. His interests here moved in a realm beyond that of physical torment, indeed physical experience of any sort. Charon drives the damned from his boat into hell with an oar, as Dante says he should, but the oar never touches a body. The only torments shown are spiritual, and only a glimmer of fire appears on the horizon. But grimacing devils stare from the darkness of a hell mouth that opens directly above the altar (fig. 20.4), reminding the celebrant at Mass, often the pope himself, that he is in the same mortal danger as all humanity.

The cleaning and restoration of the fresco have revealed the unifying quality of the brilliant blue of the sky; the pigment used here is ground lapis lazuli, which in the Renaissance was called ultramarine. The *giornata* patches reveal that Michelangelo spent 449 days painting the fresco. At one point Michelangelo fell from the scaffolding, injuring his leg. The differences between the outlines for some of the figures, scratched into the plaster surface freehand or from cartoons, and the subsequent painted forms reveal that Michelangelo frequently changed his mind about details of the figural composition.

The figure in the lower right-hand corner with a serpent wound around his body is supposedly a portrait of Biagio da Cesena, a papal official who criticized the nudity of Michelangelo's figures after he had seen earlier portions of the composition, stating that "such pictures were better suited to a bathroom, or a roadside wine shop, than to a chapel of a pope." When Biagio complained to Pope Paul III that Michelangelo had painted him in hell, the pontiff replied that his authority, while encompassing heaven and earth, did not extend into hell.

In 1542, still hounded by the heirs of Julius II to finish the tomb (the final, reduced version was not dedicated until 1545; fig. 20.5), the sixty-seven-year-old artist took up his brushes and climbed still another scaffold to paint a chapel constructed for Pope Paul III just outside the entrance to the Sistine Chapel. Interrupted by illness and other commissions, he worked spasmodically on frescoes of the *Crucifixion of St. Peter* and the *Conversion of St. Paul* (figs. 20.6, 20.7). The Pauline Chapel was not completed until the spring of 1550, several months after the pope's death.

Against barren landscapes, the two scenes are staged with cataclysmic violence. Saul, on the road to Damascus to persecute Christians, is struck down by a heavenly apparition and falls from his horse: "And suddenly there shined round

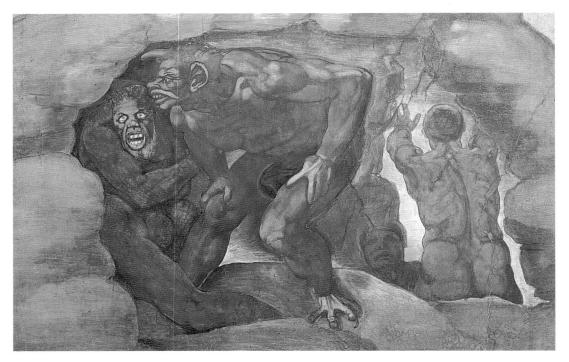

20.4. Demons in Hell, detail of fig. 20.1.
The recent restoration revealed that while the basic medium is fresco, oil was used in areas of the lower part of the painting where Michelangelo wanted metallic green and blue tones that could not be accomplished in fresco.

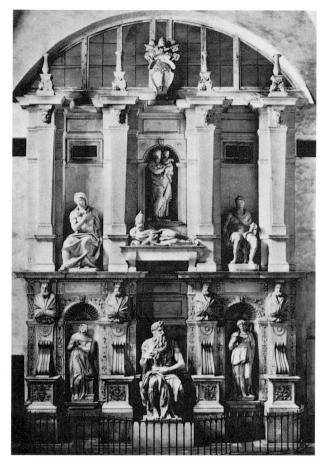

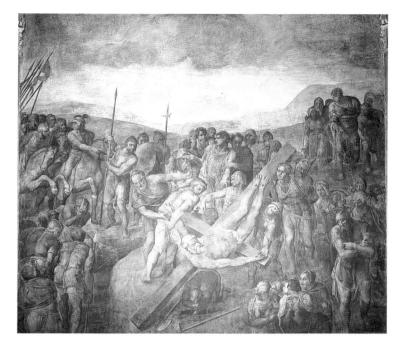

20.6. MICHELANGELO. Crucifixion of St. Peter. 1545–50. Fresco, 20'4" x 22' (6.2 x 6.7 m). Pauline Chapel, Vatican, Rome. Commissioned by Pope Paul III Farnese

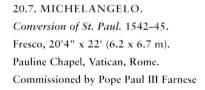

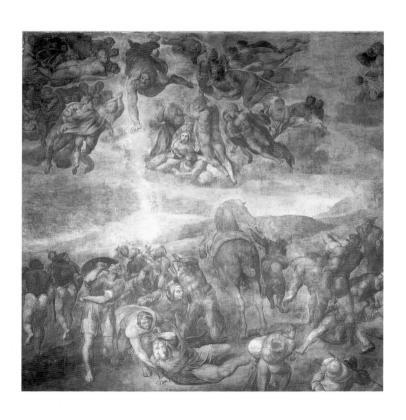

about him a light from heaven: And he fell to the earth, and heard a voice saving unto him, Saul, Saul, why persecutest thou me?" (Acts 9:3–4). The vision is here fully corporeal. A foreshortened Christ appears in the sky among angelic platoons whose figures have been compressed into blocks, their curves flattened into planes. As Christ moves downward and outward, the foreshortened horse leaps upward and inward, splitting Saul's attendants into blocks of figures. The dramatic figure of the blinded Saul (fig. 20.8)—shortly to become the apostle Paul—was clearly inspired by Raphael's blinded Heliodorus (see fig. 17.52). He falls forward as if struck by a force emanating from the floating Christ, and his face reflects both the blindness of Homer in ancient busts of the poet and the agony of the ancient Laocoön group (see fig. 17.2). Unexpectedly old (St. Paul was a young man at the time of his conversion), the face with its snowy, two-tailed beard was probably intended to suggest that of the patron (see Titian's portrait, fig. 19.24).

The *Crucifixion of St. Peter* shows the elevation of Peter's cross. The composition is traversed by the powerful diagonal of the cross. For all the massiveness of the figures, they are strangely weightless. Some of the foreground figures are cut off at the waist or knee by the frame. Renaissance perspective is abandoned and, with an archaistic disregard of illusionistic space, what is behind is here represented as above.

The strange composition, with its figures floating upward, culminates in an awestruck group silhouetted against distant promontories. They look down or at each other with expressions of trancelike wonder that are shared by the soldiers and executioners. Few figures are shown in action, and *contrapposto* has disappeared almost entirely, as have hatred, anger, and all emotions save awe and fear. As in a Passion play in which the actors are all townsfolk, there is little distinction between executioner and martyr, pagan and Christian.

When he finished the frescoes in 1550, Michelangelo was seventy-five. His failing eyesight and general ill health prevented him from undertaking monumental pictorial commissions, but he could still carve stone and design buildings. At this time, his architectural forms became grander and more richly articulated, as if his sense of mass, which in his earlier art had arisen from the human figure, could function on its own in the abstract shapes of architecture. Aside from his continued long-distance supervision of the details of the Laurentian Library (see figs. 18.11, 18.12), two of Michelangelo's three most important late architectural projects had been commenced by Antonio da Sangallo the Younger (see pp. 623–25).

We have seen the effect Michelangelo's central window and colossal cornice had on Antonio's façade of the Palazzo Farnese (see fig. 18.62). In Antonio's courtyard Michelangelo intervened with revolutionary results (fig. 20.9). He carried out

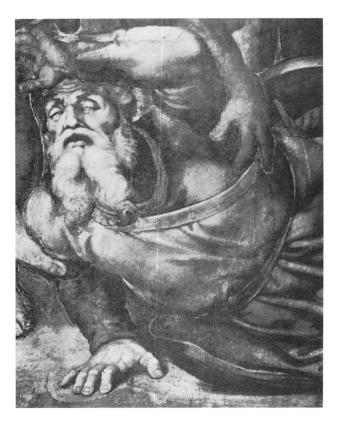

20.8. Detail of fig. 20.7

and MICHELANGELO.

Courtyard, Palazzo Farnese, Rome. 1517–46 and 1547–50.

Commissioned by Alessandro Farnese, who later became

Pope Paul III Farnese (see also figs. 18.62-18.64)

696 • THE CINQUECENTO

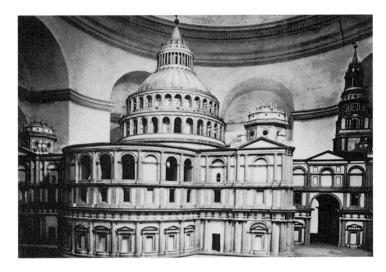

20.10. ANTONIO DA SANGALLO THE YOUNGER. Model for St. Peter's, Vatican, Rome. 1539–46. Wood. Museo Petriano, Vatican, Rome. Commissioned by Pope Paul III Farnese

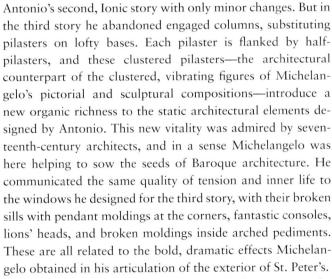

Here Michelangelo took over completely. Antonio the Younger had continued the construction of Bramante's basic project, whose piers and arches to uphold the dome had been built and could not be changed in any essential respect (see fig. 17.14). Vasari's fresco (see fig. 20.39) shows the state of affairs at that time: Bramante's coupled pilasters are already built, the barrel vaults of the transept still have their wooden centering, Bramante's temporary Doric construction around the apse appears at the left, and at the right a portion of the nave of the old Constantinian Basilica of St. Peter's still stands. But in the center, masons are laying the stones of a feature Michelangelo particularly disliked, a huge ambulatory added by Antonio. It can also be seen on the plan being

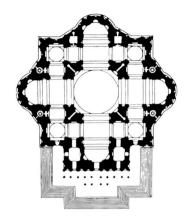

20.11. MICHELANGELO.

Plan of St. Peter's, Vatican, Rome. 1546–64. Michelangelo's work on St. Peter's was commissioned by Pope Paul III Farnese.

For Bramante's original plan for St. Peter's, see figs. 17.12–17.15. For a view of interior crossing as completed, see fig. 17.16.

presented to the pope. This system of galleries and loggie would have inflated the church to almost double its already gigantic size; the model (fig. 20.10) shows that the ambulatory would have supported a mezzanine and Ionic second story whose largely open arches had no obvious purpose. An open gallery would have connected the main building to an almost independent façade culminating in two campanili as lofty as the dome.

Admittedly, Antonio's design is fantastic. At no point can the eye select a single dominant feature; always it has to choose between two of apparently equal importance. Even the dome has superimposed peristyles, and the ribbed shell (instead of Bramante's hemisphere; see fig. 17.15) is crushed between the peristyles and the outsize lantern. Bramante's corner towers are converted into strange octagonal structures lighted by oculi and bristling with obelisks.

Michelangelo wrote a devastating letter criticizing the design as Germanic. He pointed out that it would take an army of guards to clear the loggie at nightfall, that they would provide shelter for all kinds of crime, and that in order to construct the ambulatories, whole sections of the Vatican, including the Sistine and Pauline chapels, would have to be demolished. Whoever departed from Bramante, Michelangelo said, "departed from the truth." He then accepted the commission to complete St. Peter's without pay, for the salvation of his soul, and developed a new, unified plan. He eliminated the ambulatories and the façade with its towers. The Greek-cross plan of Bramante was reinstated (fig. 20.11; see also fig. 17.13), along with the unifying

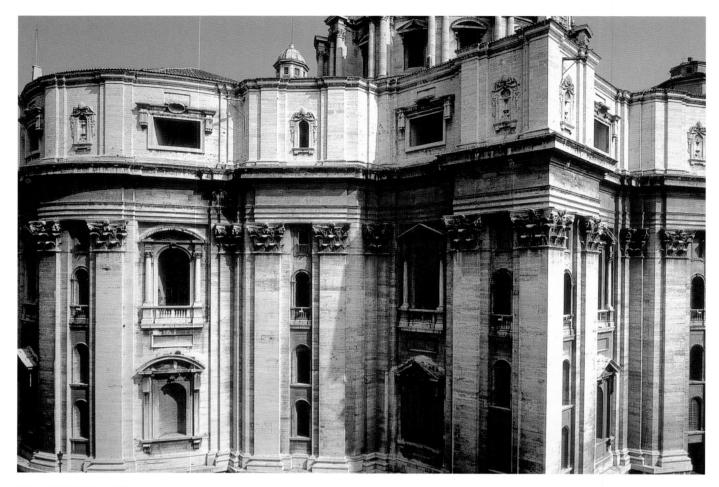

20.12. MICHELANGELO. St. Peter's, Vatican, Rome. View of back. 1546–64 (For a fuller view, see fig. 15)

colossal order on the exterior. In the interests of the stability of the dome, however, Michelangelo also suppressed Bramante's smaller Greek crosses, substituting simpler domed spaces (two exterior domes, built later, probably reflect Michelangelo's designs) and increasing the bulk of the piers. Michelangelo's façade was to have been a temple shape of freestanding columns, subordinate to the crowning effect of the dome.

In order to unify the exterior (fig. 20.12; see also fig. 15), Michelangelo adopted the Corinthian order as an embracing theme, using paired Corinthian pilasters in the lower mass of the church and paired Corinthian columns in the peristyle and lantern of the dome (fig. 20.13). He designed a Florentine ribbed dome instead of Bramante's hemisphere, dividing it by sixteen ribs rather than the eight seen in the Florentine dome, and even these and the ribs of the culminating

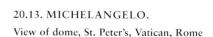

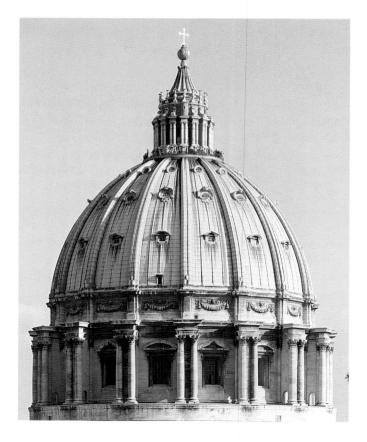

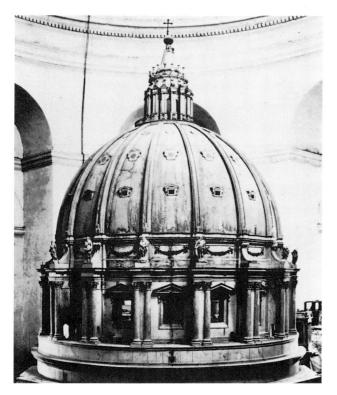

20.14. MICHELANGELO.Model for dome of St. Peter's, Vatican, Rome. 1558–61.Wood. Museo Petriano, Vatican, Rome.Commissioned by Pope Paul III Farnese

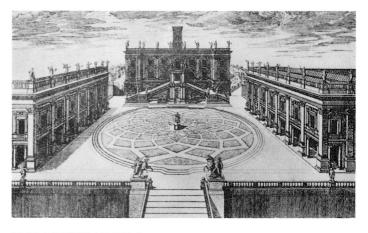

20.15. MICHELANGELO.
Campidoglio, Rome. 1538–64.
Engraving by ÉTIENNE DUPÉRAC, 1569.
The equestrian monument in the center of the piazza is the ancient Roman bronze *Equestrian Monument to Marcus Aurelius* (see fig. 1.1).

lantern are paired (fig. 20.14). Thus the entire church, from the ground to the sphere on the lantern, gives the impression of a colossal monolith. To increase its unity and density, Michelangelo cut across the reentrant angles of the transept with diagonal masses. At his death the drum and peristyle of the dome were still under construction. The dome as finally built was heightened somewhat from Michelangelo's original design, which was closer to a hemisphere, but by and large the effect of the building, seen from the sides or back, follows his intentions. Unfortunately, the unifying dome, so important as the centralizing element in Bramante's and Michelangelo's conception, can now hardly be seen from the façade because the nave was lengthened in the seventeenth century.

The grand unity of the structure overwhelms the details, and the warfare between wall and column that had reached a deadlock in Michelangelo's Medici Chapel and Laurentian Library is here resolved; the column has at last won. While the basic forms and spaces of the interior were decided by Bramante, the plastic, sculptural effect of the interior details, which he would surely have left quite severe, is diminished by

the seventeenth-century addition of inlaid designs in colored marble and gold mosaic (see fig. 17.16).

Michelangelo's single but influential contribution to civic design was his scheme to unify and decorate the Capitoline Hill—the center of ancient Rome (fig. 20.15). Against his will, in 1538 he moved the Roman bronze equestrian statue of Marcus Aurelius (see fig. 1.1), then considered a portrait of Constantine, to the central position in this piazza. He provided the statue with an ovoid base and designed a double flight of steps for the main entrance of the Palazzo Senatorio at the back of the piazza. Michelangelo probably made no further designs before 1561, when work on a broader Capitoline project began. Certainly he was responsible for the general idea of the project, whose two facing palaces, the Palazzo dei Conservatori and Palazzo Nuovo, are at an awkward angle to each other because of the configuration of the terrain and preexisting structures that had to be incorporated. Michelangelo's design for the pavement of the piazza uses a radiating pattern to disguise the relationship, and as a result most visitors presume that the buildings are parallel to each other.

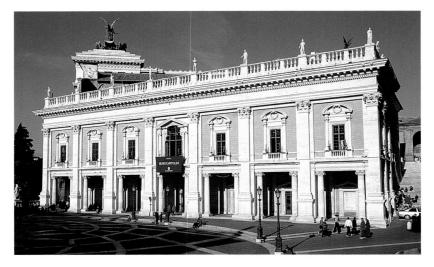

20.16. MICHELANGELO. Palazzo Nuovo, Campidoglio, Rome.

The matching Palazzo Nuovo and Palazzo dei Conservatori were built following designs by Michelangelo. The earlier of the two, Palazzo dei Conservatori, was begun in 1563; Palazzo Nuovo, seen here, was not completed until the seventeenth century.

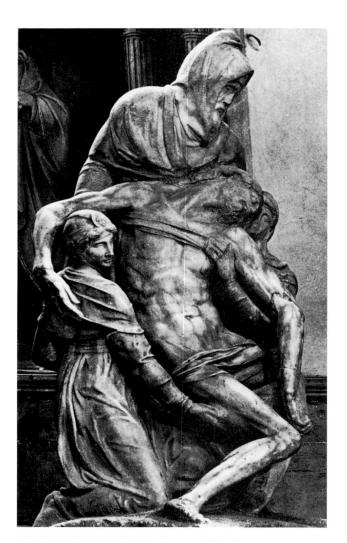

20.18. MICHELANGELO. *Pietà*. c. 1547–55. Marble, height 92" (2.33 m). Museo dell'Opera del Duomo, Florence. Begun by Michelangelo for his own tomb

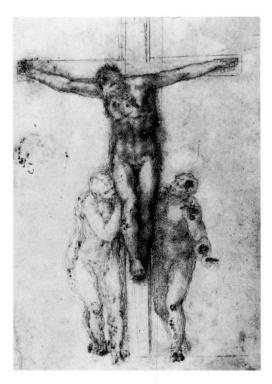

20.17. MICHELANGELO. Crucifixion. 1550–60(?). Black chalk, 16³/8 x 11" (42 x 28 cm). British Museum, London

Michelangelo's flanking Palazzi for the Campidoglio (fig. 20.16) are, like St. Peter's, embraced by a colossal Corinthian order, within which a small Ionic order seems imprisoned. The use of a straight entablature for the portico, rather than the arched arcade that was traditional (see fig. 6.6), is a typical Michelangelism.

In the aged artist's last letters and poems, death is always near. But he no longer dreams of the mighty Creator, nor even of the awesome Judge, but rather of the merciful Redeemer. His drawings of the crucified Christ are dedicated to

That Love divine
Which opened to embrace us
His arms upon the Cross.

Sometimes the figures of Mary and John the Evangelist seem unable to bridge the gap that separates them from God, and they cry soundlessly in the void below the cross; sometimes (fig. 20.17) the same last shudder that pierces the crucified unites them with him, as they embrace him, pressing themselves against him, trying to merge their being in his. Michelangelo's eyesight is no longer clear, his hand shakes, and the contours tremble, but vague though the shapes are, their masses are almost architectural, and the misty figures are grouped into compositions of a grand simplicity.

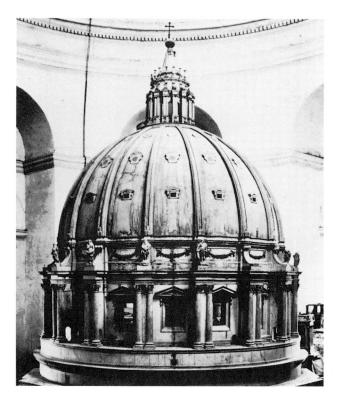

20.14. MICHELANGELO.Model for dome of St. Peter's, Vatican, Rome. 1558–61.Wood. Museo Petriano, Vatican, Rome.Commissioned by Pope Paul III Farnese

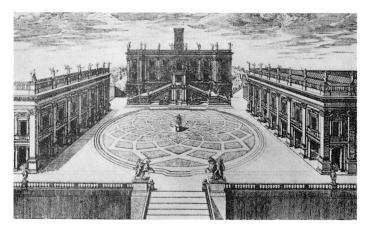

20.15. MICHELANGELO.
Campidoglio, Rome. 1538–64.
Engraving by ÉTIENNE DUPÉRAC, 1569.
The equestrian monument in the center of the piazza is the ancient Roman bronze *Equestrian Monument to Marcus Aurelius* (see fig. 1.1).

lantern are paired (fig. 20.14). Thus the entire church, from the ground to the sphere on the lantern, gives the impression of a colossal monolith. To increase its unity and density, Michelangelo cut across the reentrant angles of the transept with diagonal masses. At his death the drum and peristyle of the dome were still under construction. The dome as finally built was heightened somewhat from Michelangelo's original design, which was closer to a hemisphere, but by and large the effect of the building, seen from the sides or back, follows his intentions. Unfortunately, the unifying dome, so important as the centralizing element in Bramante's and Michelangelo's conception, can now hardly be seen from the façade because the nave was lengthened in the seventeenth century.

The grand unity of the structure overwhelms the details, and the warfare between wall and column that had reached a deadlock in Michelangelo's Medici Chapel and Laurentian Library is here resolved; the column has at last won. While the basic forms and spaces of the interior were decided by Bramante, the plastic, sculptural effect of the interior details, which he would surely have left quite severe, is diminished by

the seventeenth-century addition of inlaid designs in colored marble and gold mosaic (see fig. 17.16).

Michelangelo's single but influential contribution to civic design was his scheme to unify and decorate the Capitoline Hill—the center of ancient Rome (fig. 20.15). Against his will, in 1538 he moved the Roman bronze equestrian statue of Marcus Aurelius (see fig. 1.1), then considered a portrait of Constantine, to the central position in this piazza. He provided the statue with an ovoid base and designed a double flight of steps for the main entrance of the Palazzo Senatorio at the back of the piazza. Michelangelo probably made no further designs before 1561, when work on a broader Capitoline project began. Certainly he was responsible for the general idea of the project, whose two facing palaces, the Palazzo dei Conservatori and Palazzo Nuovo, are at an awkward angle to each other because of the configuration of the terrain and preexisting structures that had to be incorporated. Michelangelo's design for the pavement of the piazza uses a radiating pattern to disguise the relationship, and as a result most visitors presume that the buildings are parallel to each other.

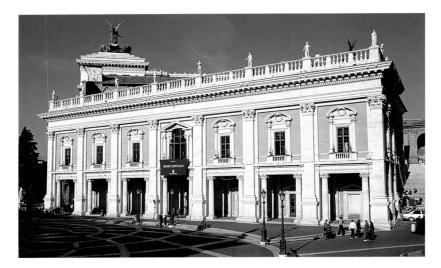

20.16. MICHELANGELO. Palazzo Nuovo, Campidoglio, Rome. The matching Palazzo Nuovo and Palazzo dei Conservatori were built following designs by Michelangelo. The earlier of the two, Palazzo dei Conservatori, was begun in 1563; Palazzo Nuovo, seen here, was not completed until the seventeenth century.

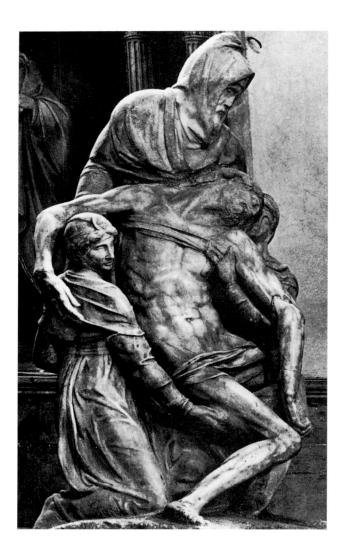

20.18. MICHELANGELO. *Pietà*. c. 1547–55. Marble, height 92" (2.33 m). Museo dell'Opera del Duomo, Florence. Begun by Michelangelo for his own tomb

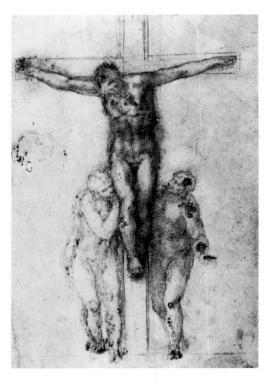

20.17. MICHELANGELO. *Crucifixion*. 1550–60(?). Black chalk, 16³/8 x 11" (42 x 28 cm). British Museum, London

Michelangelo's flanking Palazzi for the Campidoglio (fig. 20.16) are, like St. Peter's, embraced by a colossal Corinthian order, within which a small Ionic order seems imprisoned. The use of a straight entablature for the portico, rather than the arched arcade that was traditional (see fig. 6.6), is a typical Michelangelism.

In the aged artist's last letters and poems, death is always near. But he no longer dreams of the mighty Creator, nor even of the awesome Judge, but rather of the merciful Redeemer. His drawings of the crucified Christ are dedicated to

That Love divine
Which opened to embrace us
His arms upon the Cross.

Sometimes the figures of Mary and John the Evangelist seem unable to bridge the gap that separates them from God, and they cry soundlessly in the void below the cross; sometimes (fig. 20.17) the same last shudder that pierces the crucified unites them with him, as they embrace him, pressing themselves against him, trying to merge their being in his. Michelangelo's eyesight is no longer clear, his hand shakes, and the contours tremble, but vague though the shapes are, their masses are almost architectural, and the misty figures are grouped into compositions of a grand simplicity.

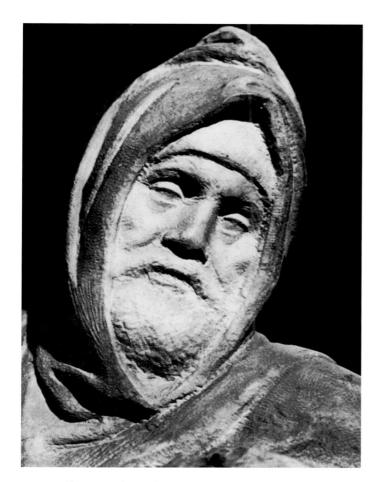

20.19. Self-portrait of Michelangelo as Nicodemus or Joseph of Arimathea, detail of fig. 20.18

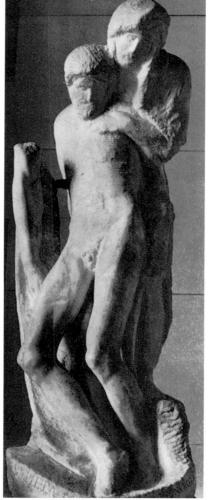

20.20. MICHELANGELO. *Pietà*. 1554–64. Marble, height 63³/s" (1.6 m). Castello Sforzesco, Milan. Intended by Michelangelo for his own tomb

Two unfinished and broken Pietàs remain as sculptural witnesses of Michelangelo's inner life in his last years. One, carved before 1555 (fig. 20.18), was meant for his own tomb. He had already carefully removed the left leg, apparently to replace it, when, in a fit of desperation—he claimed the stone was too hard and would not obey him, but doubtless there were psychological reasons as well—he started to destroy the work. He smashed the group in several places before his pupils stopped him. They pieced together the breaks, but the leg has completely disappeared. In spite of this mutilation, and an attempt by one of the pupils to finish the Magdalen so that she is now out of proportion with the other figures, the effect of the group is immensely moving. The theme is the relentless power of death, which seems to be drawing Christ downward into the tomb with a force that the human figures are powerless to prevent; sinking with him are the Magdalen, the Virgin, and a figure at the top who represents either Nicodemus, who was present at the Crucifixion, or Joseph of Arimathea, the rich man who allowed Christ to be buried in his tomb. The features of the figure at the top are Michelangelo's own (fig. 20.19). The difference between this gentle, controlled self-image and the agonized one on the empty skin in the *Last Judgment* (see fig. 20.3) gives us new insight into the final period of Michelangelo's life and art. Rough though the unfinished surfaces of this *Pietà* may be, the emotional and spiritual relationships and the power of the forms and composition need no analysis.

Only a few days before his death in February 1564, Michelangelo began to work again on a *Pietà* that he had started ten years or so earlier (fig. 20.20). It went through at least two main stages. The original version consisted of the Virgin holding the slender, dead Christ in her arms. But in a last feverish burst of activity, he cut away the head and shoulders of the Christ, leaving the right arm still hanging, and began to fashion a new head for Christ out of the Virgin's shoulder and chest. Then he cut into the new heads, drawing

them even closer together in the process of merging we have seen in his late work. One gets the feeling not that they are sinking into the grave, but that the Virgin is standing at its brink and that Christ floats almost weightlessly in her arms.

Six days before his death, at nearly eighty-nine, he was still working on the group. He fell ill after exposure to the rain, and at first refused his pupils' counsel to go to bed; he eventually succumbed, probably to pneumonia. In his will he consigned his soul to God, his body to the earth, his belongings to his nearest relatives, and asked the friends around him, including Tommaso Cavalieri, to remember in his death the death of Christ.

The Maniera

After such disclosures, one turns with some difficulty to the artists of the *maniera*, who believed that they stood, with Michelangelo, at the summit achieved by art since antiquity. Vasari wrote that he and his contemporaries had discovered the perfect formula for grace of body and feature and for beauty of composition. Their contemporaries in Venice, where the Renaissance still flourished, were by no means convinced. The Venetian Ludovico Dolce used the word *maniera* derogatorily, to refer to artists in whose paintings the faces and figures looked too much alike; to Vasari, this was an advantage because it sped up production time. In the last analysis one's estimate of the *maniera* is a matter of personal taste and judgment, but it is hardly open to question that by the middle of the Cinquecento in central Italy the Renaissance, in its etymological sense of "rebirth," was over.

Michelangelesque, Raphaelesque, and even Leonardesque forms linger on and whole motifs are sometimes borrowed, but the world has changed. It seems that the artist no longer experienced the excitement of discovery, and nature—the ultimate reference point for Masaccio, Leonardo, and other earlier artists—takes second place to the refined inventions of the *maniera* artist. What follows, therefore, is in a sense an epilogue.

The Michelangelesque Relief

Michelangelo is known to have planned a number of sculptural reliefs for inclusion in the tomb of Julius II and other undertakings, but scholars are uncertain about what their style might have been because so few finished relief sculptures by Michelangelo are known. Would the marble panels for Julius's tomb have been in low or high relief? And what would have been the appearance of those in bronze? Also to be considered here is the role of the low and high reliefs from antiquity on display in private collections.

The extent of the ancient sculptural remains available to central Italian artists is revealed in a view of the courtyard of the palace of Cardinal Andrea della Valle in the 1530s (fig. 20.21). Almost every available space is filled with figures and reliefs, many of them fragmentary. We can only imagine how artists of the period, including Michelangelo, must have pored over these works and those displayed in the Belvedere Palace (see figs. 17.2, 17.3, 17.50). The lively conversations that they must have engaged in while in front of these works are lost to us, but the evidence of the impact of such collections

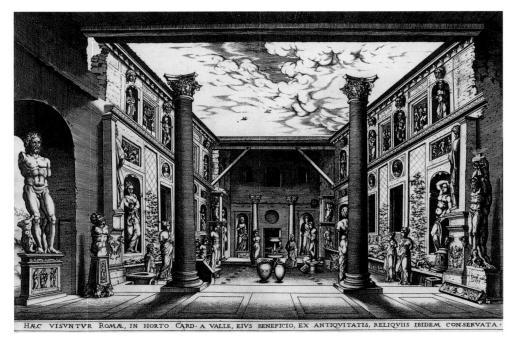

20.21. Ancient sculpture displayed in the 1530s in the courtyard of the Palazzo of Cardinal Andrea della Valle (later known as Palazzo Valle-Capranica), Rome, as seen in an engraving made by HIERONYMUS COCK in 1553 after a lost drawing by M. VAN HEEMSKERCK. Van Heemskerck was in Rome between 1532 and 1536/37, but the cardinal died in 1534.

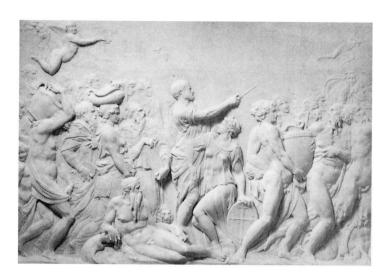

20.22. PIERINO DA VINCI. Cosimo I as Patron of Pisa. 1549. Marble, 287/8 x 63" (73 x 160 cm). Museo Vaticano, Rome. Probably commissioned by Duke Cosimo de' Medici

of antiquities is preserved in the works that Renaissance artists created under their inspiration.

A large, exquisitely carved, marble, low-relief panel representing Cosimo I as Patron of Pisa (fig. 20.22) by Pierino da Vinci (probably 1521-54) demonstrates the influence of both ancient reliefs and the style of Michelangelo. Pierino was deeply influenced by Michelangelo, whom he had met in Rome. The relief shows the duke lifting a figure representing Pisa. With a general's baton, Cosimo drives away Pisa's enemies, who are laden with plunder. Behind him reclines the bearded River Arno, doubtless derived from one of Michelangelo's river gods planned for the Medici Chapel. This figure is a reference to Cosimo's plans to deepen the Arno, rebuild the port of Pisa, and connect it with a canal to the new port at Livorno. Among the other allegorical figures, the University of Pisa, which Cosimo reorganized and reestablished, is shown holding a great book. The polished Michelangelesque figures in low and still lower relief are defined with linear perfection. In the left background a galley can be seen, and the sculpture would, if finished, doubtless have shown other vessels. The fact that Pierino's groups in the round are highly dependent on the Victory for Julius's tomb (see fig. 18.15) supports the suggestion that Michelangelo's marble reliefs might have looked like this.

A possibility for those in bronze is suggested by the work of another Michelangelo imitator, Vincenzo Danti (1530-76), who also produced groups based on the Victory. His Moses and the Brazen Serpent (fig. 20.23) suggests the hazy, sketchy style of Michelangelo's composition drawings translated into bronze. The relief offers a wide variety of projections and a free handling of detail that produce, as light moves over the bronze, an equivalent of the *chiaroscuro* effects and floating contours of rapid drawing in charcoal or chalk (see fig. 18.7). The composition is based on Michelangelo's spandrel for the Sistine Ceiling (see fig. 17.41), but there Moses is relegated to the background. Danti, instead, has placed the tall, bony figure of the lawgiver so that his right hand, and the staff around which the Brazen Serpent is entwined, are centered. Around and behind him are heaped the writhing figures of the children of Israel, the men mostly nude, their poses borrowed from the Last Judgment to display Danti's intimate knowledge of the works of Michelangelo. The effect of distance is achieved by Danti's spontaneity in modeling the wax from which a mold was made for the cast in bronze. The suggestiveness and accidental effects of the model are preserved even in the figures and drapery. As a result, Danti suggests less a historical event than a vision of sudden healing and salvation.

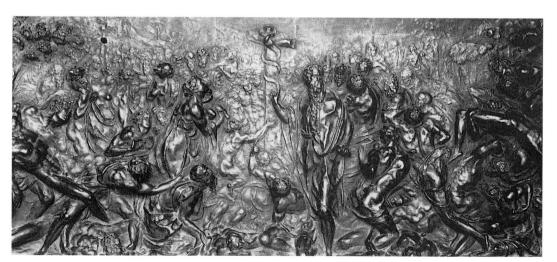

20.23. VINCENZO DANTI. Moses and the Brazen Serpent. 1559. Bronze, 323/8 x 673/4" (82 x 172 cm). Museo Nazionale del Bargello, Florence. Commissioned by Duke Cosimo de' Medici

Benvenuto Cellini

Among the sculptors who found work in Florence under the Medici rulers of the middle and later Cinquecento, the most familiar figure is Benvenuto Cellini (1500–71), partly because his vivid (but unfinished) autobiography is still widely read. Cellini called his autobiography his *Vita*, following Vasari's model; he began it in 1558, when Vasari was revising and expanding his own *Vite*. It is important that the first autobiography of modern times was written by an artist; the self-interest we have seen in works by earlier artists reaches a kind of Renaissance culmination in this work, which seems intended to promote Cellini's reputation with his contemporaries and guarantee his importance for posterity. After many years of activity as a

goldsmith in Rome, including hair-raising adventures during the Sack of 1527, Cellini had a prolonged stay in France in the service of King Francis I. Francis I paid Cellini an annual salary of seven hundred *scudi* (the same that he had paid Leonardo da Vinci), plus additional payments for each work that he produced for the king. When Cellini settled in Florence later, he attracted the attention of Duke Cosimo I.

Cellini's gold and enamel container for salt and pepper is the most famous example of Renaissance goldsmithery (fig. 20.24); according to Cellini the price was one thousand *scudi*. Cellini tells us that he had five workmen (two Italian, two French, and one German) to help him with this and other artistic activities for the king, and he describes in detail the work's subject matter:

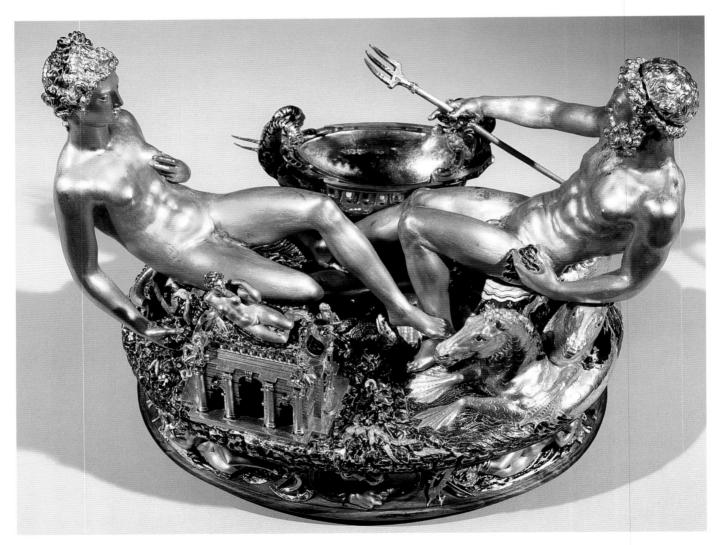

20.24. BENVENUTO CELLINI. Saltcellar of King Francis I of France (container for salt and pepper). 1540–43. Gold and enamel, 10½ x 13½8" (26.67 x 33.34 cm). Kunsthistorisches Museum, Vienna. Based on a model originally prepared for Cardinal Ippolito d'Este; commissioned by King Francis I. In 1562 the saltcellar was almost melted down, but it escaped the fate that befell many examples of Renaissance goldsmith work, including works by Cellini that are only known through the descriptions in his autobiography. The saltcellar is the only major example of Cellini's goldsmith work to survive.

I represented the Sea and the Land, both seated, with their legs intertwined just as some branches of the sea run into the land and the land juts into the sea. . . . I had placed a trident in the right hand of the Sea. . . . The water is represented with its waves, and then it was beautifully enamelled in its own color. . . . The Land I had represented by a very handsome woman . . . entirely naked like her male partner. On a black ebony base . . . I had set four gold figures . . . representing Night, Day, Twilight, and Dawn. Besides these there were . . . the four chief winds, partly enameled and finished off as exquisitely as can be imagined.

The figures of the Times of Day were inspired by Michelangelo's figures at the Medici Chapel at San Lorenzo (see figs. 18.4, 18.5, 18.9). The salt was offered in a boat placed by the side of Sea, while pepper was served in a covered triumphal arch placed beside Land. Several motifs refer to the French king, including the lilies on the cloth below Land, an elephant, and a salamander, Francis I's personal emblem. The intertwining of the figures and forms is typical of the *maniera*, as are the slender proportions of the female figure, the rich materials, and the virtuosity of detail and execution.

In his autobiography, Cellini always places himself at the center of activities, as is witnessed in the following passage: "When I set [the saltcellar] before the King he gasped in amazement and could not take his eyes off it. Then he instructed me to take it back to my house, and said that in due course he would let me know what I was to do with it. I took it home, and at once invited some of my close friends; and with them I dined very cheerfully, placing the saltcellar in the middle of the table. We were the first to make use of it."

In 1545 Duke Cosimo commissioned Cellini to make a large sculpture of *Perseus and Medusa* (fig. 20.25). In this mythological theme Perseus decapitates the Gorgon Medusa, whose hair was composed of writhing snakes and whose glance could turn a person to stone. Owing to the difficulty of casting a figure of this size in bronze, this project occupied him until 1554.

The destination of the work for the Loggia dei Lanzi (see fig. 1.2), where it would be paired with Donatello's *Judith and Holofernes* (see fig. 12.5), probably led Cellini to devise a kind of parallelism between the triumphant figures, the defeated enemies, and even the cushions of the bases—iconographically justifiable for *Judith* but hard to understand for *Perseus*. The modeling of the nude figure shows Cellini's study of anatomy, while the play of light on the surfaces and the number of viewpoints needed to understand the composition (especially the twisted, flattened body of Medusa under Perseus's feet) are in the tradition of Michelangelo's marble nudes. But, unlike Donatello, there is no attempt to evoke horror at the decapitation; the perfection of workmanship, born of Cellini's training as a goldsmith, seems to

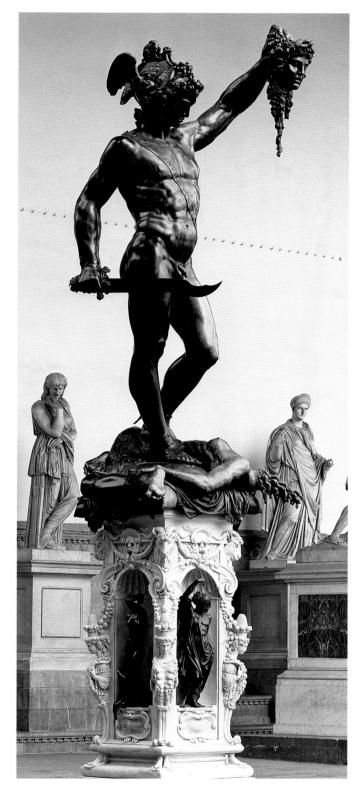

20.25. BENVENUTO CELLINI. *Perseus and Medusa* (see fig. 1.2). 1545–54. Bronze with marble pedestal, height 18' (5.5 m) with base. ⚠ Loggia dei Lanzi, Florence. Commissioned by Duke Cosimo de' Medici. Recently restored, the bronze statue has been returned to the Loggia dei Lanzi, but the marble base and its small bronze figures are now replaced with copies and the originals are in the Museo Nazionale del Bargello, Florence.

preempt any possibility of drama. The rich locks of Perseus's hair, the writhing serpents, and even the torrents of blood gushing from the truncated neck of Medusa are transformed into ornamental shapes similar to those that animate the extravagant decoration of the pedestal. Like Michelangelo in the *Pietà* in St. Peter's (see fig. 16.35), Cellini placed his signature on a strap crossing Perseus's breast.

In his autobiography Cellini describes the casting of the *Persus and Medusa* in detail, describing a number of dramatic events, including when the fire for the casting set the workshop ablaze and when the furnace exploded and cracked the cover. At one point Cellini fell ill and went to bed, but when the metal refused to melt properly he had to be awakened; he solved the problem by throwing all the household's pewter

plates and bowls into the reluctant metal. This is important because in an earlier passage in the autobiography Cellini reports that Cosimo I doubted that he had the technical ability to complete this project. When the project was finished, Cellini told Cosimo: "I think I am justified in saying that no man on earth could have produced my Perseus."

In the same year that Cellini began the *Perseus*, he also began a bust of the man who was its patron, Cosimo I (fig. 20.26). In its pedestal base and curved lower outline, it follows the format of ancient busts rather than the truncated bust form used in the Quattrocento (see fig. 10.38); Cosimo's armor, with a fierce lion's head decorating each shoulder, is based on antique models as well. Other changes evident here are the use of the more prestigious medium of bronze and the

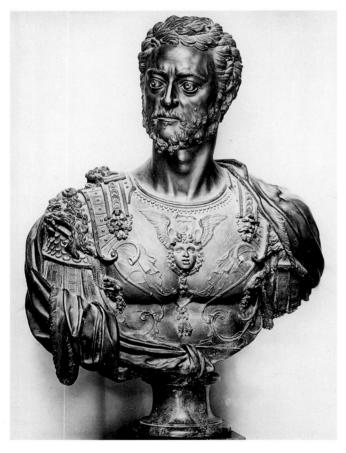

20.26. BENVENUTO CELLINI.

Portrait of Grandduke Cosimo de' Medici. 1545–47.

Bronze, originally partially gilded with enamel eyes;
height 3'7" (1.1 m). Museo Nazionale del Bargello, Florence.

Cellini wrote that he made this bust for his own personal satisfaction, but the nature of his character as revealed in his autobiography suggests that it was surely made to draw Cosimo I's attention to Cellini and his works.

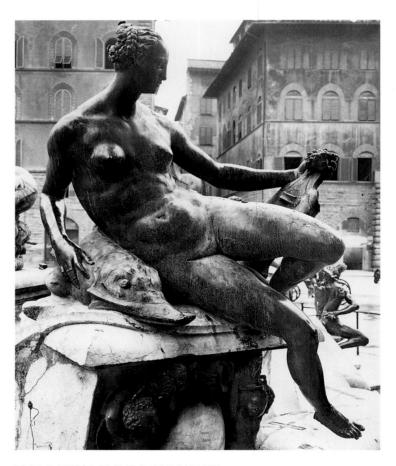

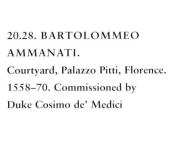

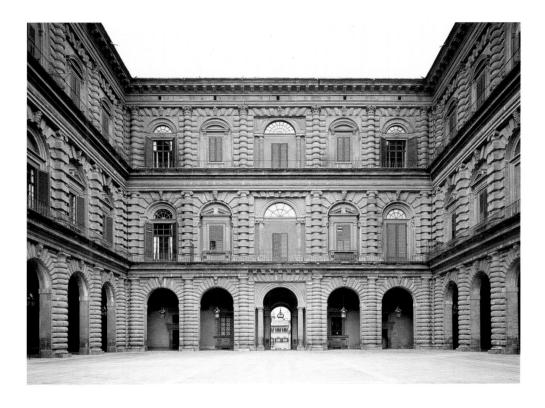

larger than life-sized scale. The matte surface finish of the armor contrasts with the smoother surfaces of cloth and flesh. Cosimo's stiffly held head, rigid neck, and imperious gaze endow the duke with an autocratic and even imperial effect. In addition, we are awed by the technical subtlety of Cellini's casting and chasing of the bronze, as we are with the *Saltcellar*, the *Perseus*, and with Cellini's autobiography and the vivid personality he constructed there.

Bartolommeo Ammanati

Closer to Michelangelo was Bartolommeo Ammanati (1511–92), whose marble and bronze Fountain of Neptune occupied the sculptor and his shop from 1560 to 1575. A Sea Nymph (fig. 20.27) on the fountain, probably executed by an assistant using Ammanati's model, is instructive with regard to the relation of maniera artists to Michelangelo. While obviously derived from the Medici Chapel Dawn (see fig. 18.9), it is also very different. Where Michelangelo is tense, Ammanati is relaxed; where Michelangelo is tragic, Ammanati is serene. Michelangelo's devices, including even the famous pose "slipping off" the support, have been ornamentalized. The motive is Michelangelesque, but the drama is gone. This is true of much of Ammanati's sculpture and, as will be seen, of many paintings by Vasari and Alessandro Allori as well.

Characteristic of the grandiosity of late Cinquecento architecture is the courtyard of the Palazzo Pitti (fig. 20.28),

added by Ammanati to the original Quattrocento structure (see fig. 10.34), after it was purchased in 1549 by Cosimo for his duchess, Eleonora da Toledo. It was when the Medici moved to Palazzo Pitti, leaving behind their former living quarters in the Florentine republican city hall, that the Palazzo dei Priori became known as the "old palace"-Palazzo Vecchio—a name that has unfortunately stuck to the present day. Ammanati had worked in Venice under Jacopo Sansovino, and doubtless had the Zecca (see fig. 19.68) in mind when designing the Pitti courtyard, but he carried the rustication further, embracing columns, walls, arches, and lintels. Only capitals, bases, entablatures, and ornamental window frames escape. Although the rusticated blocks are rough in contrast to Sansovino's smooth ones, they have none of the rude, formless quality so disturbing in the architecture of Giulio Romano (see fig. 18.68). On the ground story (Tuscan) the blocks are rounded and contiguous, on the second (Ionic) square and separated, on the third (Corinthian) rounded and separated. For all its colossal scale, the courtyard is ultimately ornamental. The window tabernacles of the second story bear the same relationship to Michelangelo's originals in the vestibule of the Laurentian Library (see fig. 18.11) as does Ammanati's Sea Nymph to Michelangelo's Dawn.

Ammanati took his original designs for the Ponte Santa Trinita (fig. 20.29) to Michelangelo shortly before the latter's death, and the older artist criticized and corrected them. The

20.29. BARTOLOMMEO AMMANATI. Ponte Santa Trinita, Florence. Begun 1566 (rebuilt after 1945). Commissioned by Duke Cosimo de' Medici

soaring flight of the roadway over the river, the tension of the flattened arches, and the potent simplicity of the wedge-shaped pylons should be credited to Michelangelo, even if the details were perhaps softened by Ammanati. Ponte Santa Trinita was blown up by the retreating Germans in 1944 and rebuilt after the war, using the original plans, discovered in the Florentine archives, and the same quarry, located in the Boboli Gardens behind Palazzo Pitti.

Giovanni Bologna

The swan song of Late Renaissance sculpture in Florence was performed by a non-Italian who for more than half a century was active in Italy. Jean Boulogne (1529–1608) was born in Douai in Flanders but is generally known by the Italianized versions of his name, Giovanni Bologna or Giambologna. He

rapidly absorbed a variety of Italian sources, including Donatello, Ghiberti, Verrocchio, Michelangelo, and the sculptors of the *maniera*, but in freedom of invention and skill of execution he surpassed his contemporaries.

Giovanni Bologna added his own contributions to the statuary of the Piazza della Signoria, including the *Rape of the Sabine Woman* (figs. 20.30, 20.31), placed in 1583 by Grand Duke Francesco I under the Loggia dei Lanzi (see fig. 1.2) in the spot once occupied by Donatello's *Judith and Holofernes*. The identification of the subject mattered so little to Giambologna that he called earlier versions of the same group Paris and Helen, Pluto and Proserpina, and Phineus and Andromeda. His chief interest lay in the energy of the spiral movement and the vitality of the male and female figures, and he succeeded so well in their rendition that Baroque sculptors, particularly Bernini, never forgot this group.

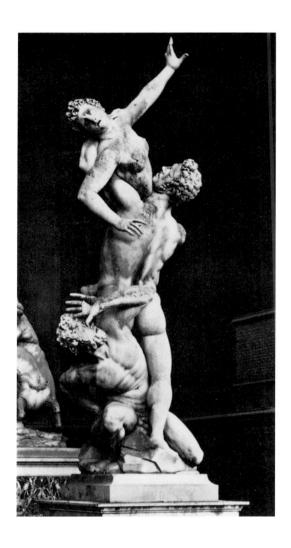

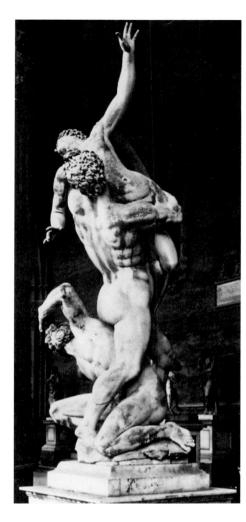

20.30, 20.31. GIOVANNI BOLOGNA. Rape of the Sabine Woman. 1581-82. Marble, height 13'6" (4.1 m). 🗓 Loggia dei Lanzi, Florence (see fig. 1.2)

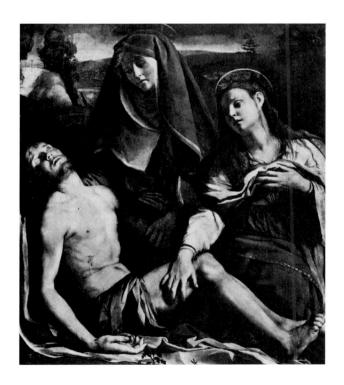

Bronzino and Francesco Salviati

After Pontormo, the leading painter in Tuscany was his pupil Agnolo Tori, called Bronzino (1503-72), who is the boy in a cloak seated on the steps in Pontormo's Joseph in Egypt (see fig. 18.26). Although Bronzino absorbed much from Pontormo, he does not seem to have responded to his teacher's somewhat bizarre imagination. "Cold" and "hard" are the adjectives that come to mind as we attempt to characterize Bronzino's style; metal, marble, and porcelain are the substances his pictures suggest.

Bronzino's early style is represented by the Pietà (fig. 20.32), once attributed to Pontormo but now given to Bronzino. Instead of the soaring fountain of figures in Pontormo's Capponi Entombment (see fig. 18.28), Bronzino

20.32. BRONZINO. Pietà. c. 1530. Panel, $41\frac{1}{4} \times 39\frac{1}{2}$ " (1.05 x 1 m). Uffizi Gallery, Florence. Perhaps commissioned for Sta. Trinita, Florence

reverts to a closed composition of sculptural masses recalling the Luco Lamentation (see fig. 18.23) by Andrea del Sarto. Linear contours, sometimes precisely drawn in Quattrocento style, isolate features, anatomical details, and drapery folds. Even the distant landscape—a rare feature in Bronzino's art-looks Quattrocentesque in the stylization of trees and hills. Calvary at the left and a small woods at the right anchor the arc of the horizon, locking it to the upper corners of the frame; in the lower corners Christ, his limbs stiffened in rigor mortis, fits into the left, and the Magdalen into the right. Yet for all Bronzino's chill, it would be a mistake to suppose that he is an unemotional artist. Even within the rigidity of compositional arrangements and metallic surfaces intense feeling is evident in the distraught eyes and open mouth of the Magdalen and the dead features of Christ, illuminated from below.

Bronzino was the perfect artist for Cosimo I, who was installed as second duke of Florence in 1537 and who in 1569 became grand duke of Tuscany. Again and again, Bronzino and his pupils portrayed the new monarch, his family, and his court in elegant images that capture the qualities of Cosimo's absolutism. The melancholy stare of Bronzino's portrait of Bartolommeo Panciatichi (fig. 20.33) issues from a frozen mask, and every surface and detail are drawn with

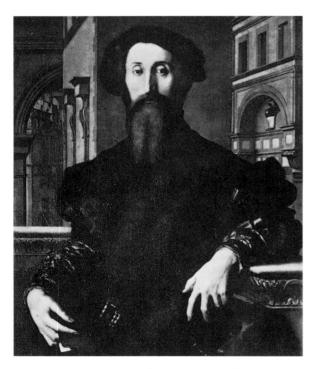

20.33. BRONZINO. *Bartolommeo Panciatichi*. c. 1540. Panel, $41\frac{3}{8} \times 33\frac{1}{2}$ " (104 x 84 cm). Uffizi Gallery, Florence. Probably commissioned by the sitter

pitiless accuracy. The young man stands, his elbow propped on a pedestal, against a background of utter unreality. Fragments of buildings, incommensurable in character, style, and scale, deprived of bases, entrances, or connecting streets, and arranged at baffling angles in depth, are drawn with inhuman hardness—a world of carved stone without a living being or plant and almost without sky.

Bronzino's Allegory with Venus and Cupid (fig. 20.34), ordered by Cosimo I de' Medici as a present for King Francis I of France, can be seen as a summary of the stylistic tendencies and moral dilemmas of the age. Its intricate symbolism continues to provoke scholarly interest and controversy; two divergent theories have identified the main theme as the Exposure of Luxury and Venus Disarming Cupid. The bald, winged figure with the hourglass at the upper right is almost certainly Time; he draws back a curtain to unveil a scene that seems to represent incipient incest. Cupid rubs against his mother, Venus, kissing her and squeezing her nipple while a putto (Jest or Folly?) pelts the shameless pair with roses. At the lower left, Venus's doves bill and coo. The screaming figure at the left edge has been identified as the female allegory of Jealousy, but another interpretation suggests that this is an allegorical figure of Syphilis. To the right, with the face of a beautiful girl, is a monster with a serpent's tail and the hind legs and claws of a lion. She wears a green dress and carries a honeycomb in one hand and a scorpionlike stinger in the other; she probably represents Fraud. While the choice of the main subject was surely based on Cosimo's knowledge of the interest of the king of France in erotic themes, the exposure by Time and the stinger of the deceptively beautiful girl add an element of moral condemnation. The difficulty in decoding the many symbols should be understood as an indication of the maniera interest in scholarly complexity and obscure detail; at the same time it demonstrates a kind of intellectual arrogance in the invention of motifs that are intentionally hard to unravel.

The cold and fanatical perfection of the artist's draftsmanship models the figure of Venus in crystalline light. The varieties of anatomies (male, female, young, old), the pearls, the shining locks of hair, and the glittering masks—symbols of Deceit in the lower right corner—are all set against silks of piercing green, blue, and violet. The picture was surely meant to impress a foreign ruler with the tremendous skill of the Florentine artistic tradition. The deliberate lasciviousness of the nudes should be compared with the purity of Michelangelo's figures, who come to us unclothed as if from the mind of God. It is characteristic of the period that the same society that could accept a private picture such as this also added bits of drapery to many of the nudes in Michelangelo's more public Last Judgment; Michelangelo was even condemned as salacious by Pietro Aretino, who himself was one of the most scandalous figures of the age.

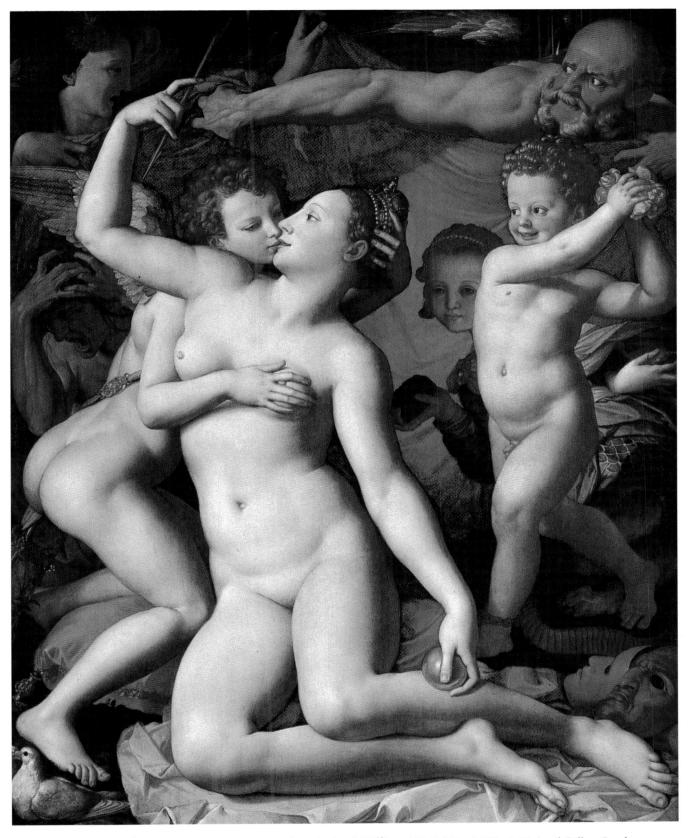

20.34. BRONZINO. *Allegory with Venus and Cupid.* Mid-1540s. Panel, 57¹⁰/16 x 46 " (1.465 x 1.168 m). National Gallery, London. Commissioned by Cosimo I de' Medici as a gift for King Francis I of France

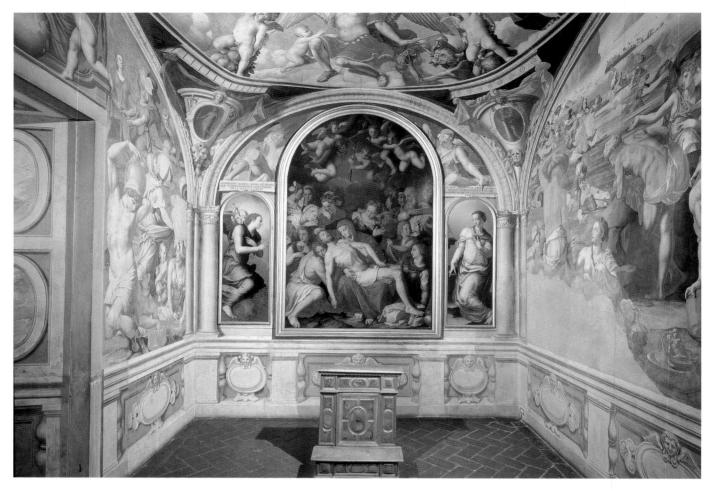

20.35. BRONZINO. Altarpiece and frescoes in the Chapel of Eleonora da Toledo, Palazzo Vecchio, Florence. c. 1540. Fresco and tempera, size of chapel 16'1" (4.9 m) deep x 12'7" (3.8 m) wide. (see fig. 16)

Bronzino decorated the walls and ceiling of a chapel (fig. 20.35; see also fig. 16) for Cosimo's duchess Eleonora da Toledo in the Palazzo dei Priori, using a technique far more time-consuming than the traditional one. Damaged portions indicate that the underpainting was in true fresco and the detailed finished layer added in tempera. The Crossing of the Red Sea (fig. 20.36) was intended to recall Michelangelo's Deluge (see fig. 17.28). This kind of quotation lent authority to the learned maniera style, but none of Michelangelo's poses are exactly, or even approximately, repeated, and Bronzino shows that he can vary the vocabulary and improvise on a Michelangelesque theme. He tosses figures about with abandon in the rising sea, along with the floating baggage of Pharaoh's army. The well-preserved portions show muscular anatomies that, although devoid of Michelangelo's energy, are rendered with all the precision of Bronzino's panel paintings and glow with the same cold, pearly light.

Nearly contemporary with Bronzino's frescoes in the chapel of Eleonora da Toledo are those by Francesco Salviati (1510–63) in the Sala dell'Udienza in the Palazzo dei Priori. Salviati, a boyhood companion and lifelong friend of Giorgio

Vasari, retained his own striking individuality in decorative frescoes in Rome and Florence. The *Triumph* of *Camillus* (fig. 20.37) displays his erudition and virtuosity. The general on his triumphal cart, the barbarian captives, the trophies and standards, and even the altar to Juno with its smoking lamps are based on Salviati's study of ancient Roman historical reliefs rather than on direct observation of nature. The ornamentalized horses, for example, are imitated from Imperial Roman reliefs. The procession is compressed into the foreground plane in the manner of Salviati's ancient prototypes, yet he allowed himself imaginative freedom in the mountain landscape and the low, luminous clouds. Out of the profusion of archaeological elements, an occasional contemporary portrait stands out with clarity.

The point of no return in *maniera* complexity is exemplified by Salviati's frescoes in the Palazzo Sacchetti in Rome (fig. 20.38). Probably representing the havoc wrought by the Ark of the Lord when carried off by the Philistines (I Samuel: 5–6), the frescoes simulate wall paintings of different proportions and deliberately do not harmonize with the shapes of the upper windows. These "paintings" are scattered about

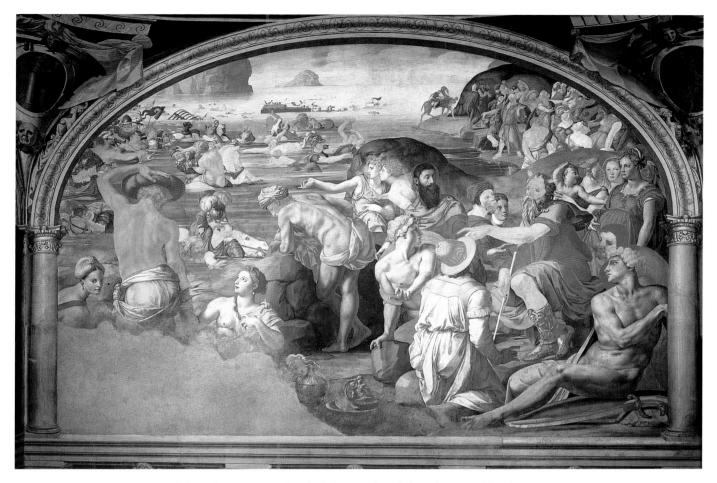

20.36. BRONZINO. Crossing of the Red Sea. Fresco. Chapel of Eleonora da Toledo, Palazzo Vecchio, Florence

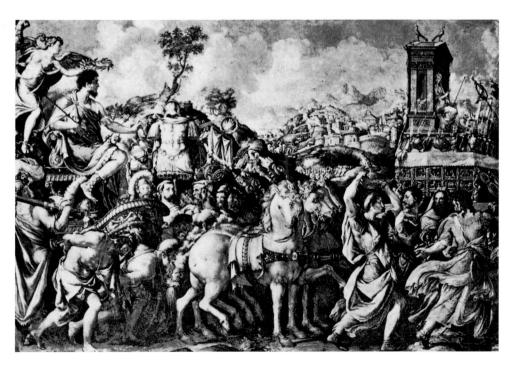

20.37. FRANCESCO SALVIATI.

Triumph of Camillus.

Mid-1540s. Fresco, 13'10" x 19'4"

(4.2 x 5.9 m). Sala dell'Udienza,

Palazzo Vecchio, Florence.

Commissioned by Duke

Cosimo de' Medici

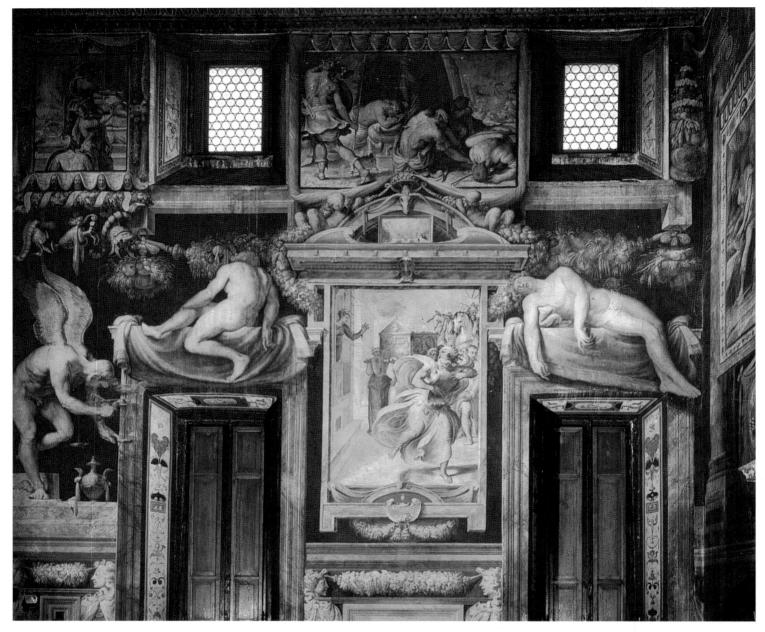

20.38. FRANCESCO SALVIATI. Fresco decoration. c. 1553. Salone, Palazzo Sacchetti, Rome. Probably commissioned by Cardinal Ricci da Montepulciano

the wall like the paintings-within-paintings in ancient Pompeiian murals, which Salviati could not have seen, although he may have known similar examples in Rome or elsewhere that are now lost. All are enclosed in fantastic painted frames, all different, intertwined with a jumble of garlands and sculptured figures. Out of the darkness under the helmet, jar, and vegetables that dangle from one of the frames emerges Father Time, and his hands overlap the simulated marble frame of the lower windows as he steps from his pedestal as if into the space of the room. Above the lower window frames, nudes—like Michelangelo nudes in a drugged torpor—languish in poses of abandoned sensuality, one seen from the back, the other from the front, on draped cloths that almost cover the

tops of the window frames. Nothing more contrary to the principles of Renaissance harmony could be imagined, yet all is done with exquisitely refined colors and draftsmanly skill.

Giorgio Vasari

The prince of the Florentine *maniera* was Giorgio Vasari (1511–74), into whose *Lives of the Most Eminent Painters*, *Sculptors*, *and Architects*, an immense reservoir of knowledge, tradition, opinion, theory, and legend, we have dipped from time to time. So successful was Vasari's formula for inventing figures and compositions, so slight his necessity for further study from nature, so well disciplined his army of

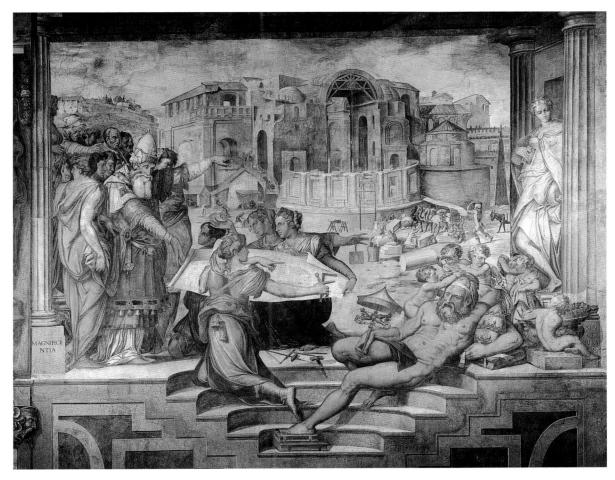

20.39. GIORGIO VASARI. *Paul III Farnese Directing the Continuance of St. Peter's*, from a cycle of the life of Pope Paul III Farnese. 1544. Fresco. Great Hall, Palazzo della Cancelleria, Rome. Commissioned by Cardinal Alessandro Farnese

assistants, that with their aid Vasari was able to cover many Florentine and Roman walls and ceilings with frescoes and oil paintings. While these are often unreal and pompous, they seldom lack decorative effect or historical interest. Enormous altarpieces from his studio line the side aisles of Santa Croce, Santa Maria Novella, and other Florentine churches; vast battle scenes and smaller decorative works fill the halls and smaller chambers of the Palazzo dei Priori. His Paul III Farnese Directing the Continuance of St. Peter's (fig. 20.39), painted before Michelangelo was appointed architect by Pope Paul III, forms a part of the decorations of the Cancelleria in Rome (see fig. 10.10), a building begun as a cardinal's palace and converted in the Cinquecento into offices for the pontifical government. Vasari and his pupils painted the frescoes lining the great hall in one hundred working days; he boasted of this to Michelangelo, who replied, "Si vede bene" ("So one sees").

Doric porticos frame concave, semicircular steps based on Bramante's design for the fountain of the Vatican Belvedere. On one side is a statue labeled Magnificentia, on the other Sinceritas opens a door in her body to display her heart. The pope is followed by Renaissance architects, including Bramante, but the pontiff's attendants are allegorical figures in classical costume. Paul III lifts one Michelangelesque hand to point to the unfinished St. Peter's (see p. 697), while with the other he approves the plan of Antonio da Sangallo the Younger, held up by figures identified as the Arts of Design and Construction by the tools they hold or that lie on the steps below. At the right Father Tiber, his elbow and foot propped on books, reclines on the steps, embracing the papal tiara and holding an umbrella sheltering the crossed keys. The style is standard *maniera*—linear, elaborate, and learned—and Vasari's sources include many figures borrowed from Michelangelo and Raphael. What seems odd is that Vasari's taste is not that of the Renaissance, about which he knew more than any of his contemporaries.

The supreme example of Vasari's architecture is the Uffizi (Offices), commissioned by Cosimo to house the functions and records of his government (fig. 20.40). By unifying the region's administration, the building expresses the political unity achieved by Cosimo. Its four stories line three sides of a space that is more like a street than a piazza. The Uffizi derives its effect from the repetition of elements: two Tuscan columns and a pier on the ground story, while on the second story a triplet of mezzanine windows alternates with

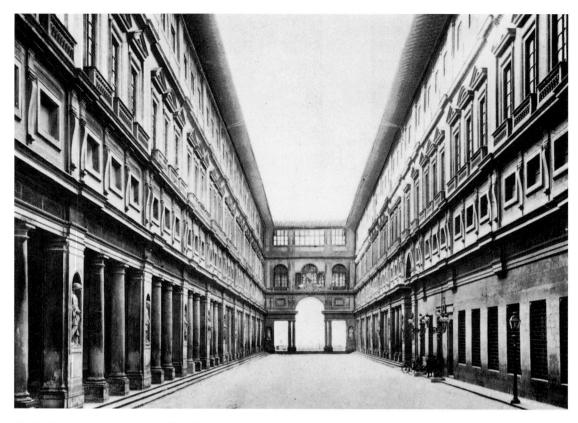

20.40. GIORGIO VASARI. Uffizi, Florence. 1559–80s. Completed by BERNARDO BUONTALENTI and ALFONSO PARIGI. Commissioned by Cosimo I de' Medici. It has been suggested that the basic outlines of the plan were suggested to Vasari by Cosimo I. The building initially housed the offices of the thirteen administrative authorities of the Medicean state, a function revealed in the piers that divide the loggias into distinct units with an entrance door for each of the offices. The upper floor of the building now houses an important art museum that includes treasures from the Medici collections and many additional works.

Michelangelesque consoles. The third story features another triad of windows, and the open loggia of the fourth (now unfortunately glazed) reflects the Tuscan columns of the ground story. The only break in the uniformity comes at the end, where a central arch with a Palladian motif above it opens the vista in the direction of the Arno River.

Vasari's structure incorporated existing buildings, including private houses and almost the entire Church of San Piero Scheraggio, where Dante had spoken and so many important events of Republican Florence had taken place. The Uffizi's façades mask the disparity of old and new buildings visible when one looks at the structure from the back. The huge complex, so rapidly remodeled, strung together, and refaced, contained such extensive openings and reached such a height that Vasari was constrained to use steel girders to reinforce it, one of the earliest known instances of metal architecture.

The Studiolo

Our consideration of Florentine art draws toward a close with a characteristic invention of the *maniera*, the *studiolo* of Francesco I de' Medici, son and successor of Cosimo I.

This tiny chamber within the Palazzo dei Priori (see fig. 2.45) was dedicated to the geological, mineralogical, and alchemical interests of this self-centered and ineffectual ruler. Its walls are lined with two tiers of oil paintings on slate or panel that act as doors for cupboards containing Francesco's scientific books, specimens, and instruments. Two doors, not distinguished in any way from the cupboard doors, cover the only windows: Francesco preferred to work by candlelight. The intimate scale of the project allowed Vasari and his pupils to develop their imaginative abilities, technical skill, and jewel-like delicacy of color. Eight sculptors made the bronze statuettes, and the paintings were by no fewer than twenty-four artists. This precious chamber is the only sixteenth-century room in Europe to survive with its oil paintings intact; all that is missing today is the furniture upon which Francesco examined his many treasures.

Vasari's contributions include the *Perseus and Andromeda* (fig. 20.41); legend states that when Perseus held up the head of Medusa and plunged his sword into the dragon that was about to attack Andromeda, the dragon turned to stone and its blood, streaming through the water, turned to coral. In the foreground Andromeda is chained to the rock while mermaids

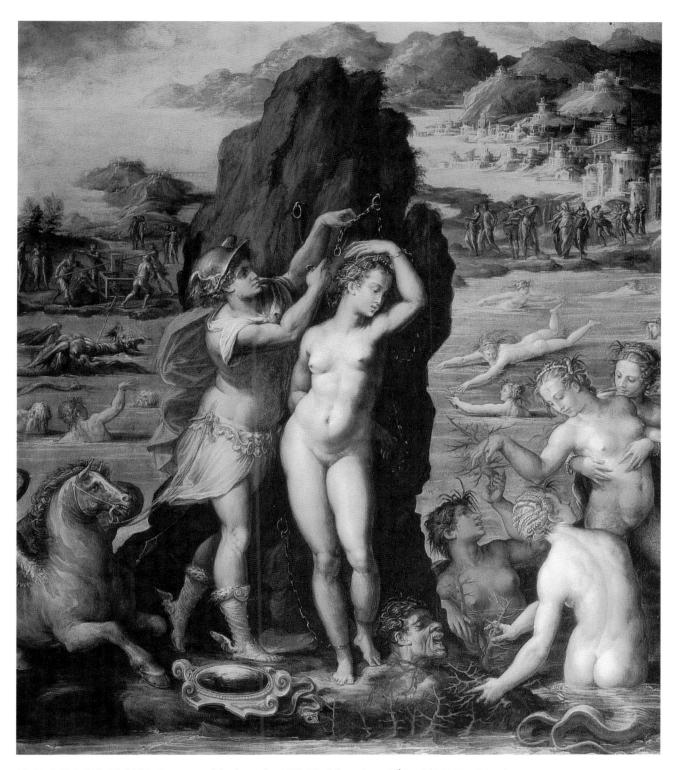

20.41. GIORGIO VASARI. Perseus and Andromeda. 1570–72. Oil on slate, $61\frac{1}{2}$ x 34" (156 x 86 cm). $\stackrel{\triangle}{\mathbb{D}}$ Studiolo, Palazzo Vecchio, Florence. Commissioned by Francesco I de' Medici

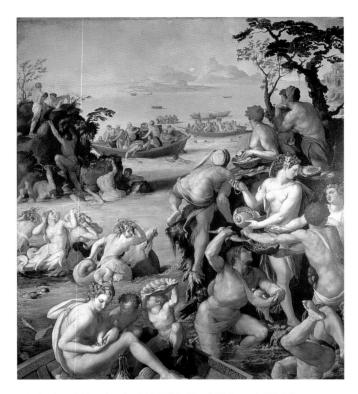

retrieve branches of coral. In the background, stylized promontories sparkle with classical buildings, and on the beach workmen draw the dragon onto land with a huge winch.

Just as toylike and unreal is the *Pearl Fishers* (fig. 20.42) by Bronzino's follower Alessandro Allori (1535–1607), whose style is imitated from the cool, smooth manner of his teacher. Exquisite male and female nudes, human and mythological, play about on rocks, dive off boats, and bring up shells overflowing with sea water and pearls. Over and over the figures quote Michelangelo (the central nude seen from the back comes straight out of the *Battle of Cascina*; see fig. 16.41), but in the most playful way. The echoes of the *Deluge* on the Sistine Ceiling (see fig. 17.28) are transformed by Allori's predominantly pink and blue coloring.

The artists who contributed to the *studiolo* created surprising variations on the *maniera* formula. Three among them, nonetheless, seem to have harbored the ideal of a reform—Santi di Tito and two painters hardly known outside the *studiolo*, Mirabello Cavalori (before 1520–72) and Girolamo Macchietti (1535/41–92). Their styles are similar, but due to the age gap between them Cavalori should probably be credited as the innovator. But any argument about him is difficult to sustain because his production is an enigma: only four pictures by him are known, and all were painted in the last four years of his life. After the artificiality

of the *maniera* paintings in the *studiolo*, his pictures and those of Macchietti are like windows into the earlier Cinquecento. Neither artist was able to transfer his naturalism to hieratic themes (as Caravaggio was to do only twenty years later), but here they were assigned or they selected subjects from daily life, to which their only possible addition appears to be the architectural setting, a severe Tuscan order similar in both.

The devotion to naturalism in Cavalori's Wool Factory (fig. 20.43) cannot be paralleled, even in Lombardy. It is hard to imagine that the figures were unposed, but the artist has done his utmost to make them look as if they were. Probably he made sketches in a wool factory, of which there were many in Florence, and models—perhaps even the workmen—could have posed later in Cavalori's studio. Here people do what they are doing because they have to, not because they are forced into the artistic poses of the *maniera*, and the men are not nude to display the beauty of their anatomy; they have stripped because they are hot, displaying far-from-ideal bodies wearing typical Cinquecento undershorts. In fact, the only "nudes" are those who are carrying firewood, stuffing it into the flames, or churning the masses of wool in the boiling caldron. Behind them a wringer is being twisted, and at the top of the steps the wool, wound on a huge spindle, is being carded. Cavalori seems to have taken special pleasure in representing the felt hats and peaked caps of the workmen.

No abstract scheme, either imposed upon the figures or derived from them, unites their activities, but a strong side light gives deep shadows, uniformly smooth brushwork suggests textures, and a hectic sense of hard labor under pressure is expressed. We can see, feel, hear, and even, it seems, smell the factory. Yet there is a grand architectural setting and, in spite of everything, an indefinable Renaissance nobility. Grand Duke Francesco may have liked such proletarian pictures as oddities, especially since the wealth of his dominion still depended largely on wool, but the *Wool Factory* was not the kind of picture calculated to gain Cavalori lucrative public commissions.

Girolamo Macchietti's *Baths at Pozzuoli* (fig. 20.44) is similar to the *Wool Factory* in its naturalistic concept and smooth pictorial style. One can hardly expect that these hot-spring baths, not far from Naples, were set in architecture of such grandeur, and most likely Macchietti had never seen them. He could, however, have studied and sketched in the Florentine public baths, as did Leonardo and Michelangelo, and the resemblances between the youth reclining on the steps and the seated figure having his leg toweled and their counterparts in Michelangelo's *Battle of Cascina* (see fig. 16.41) are due not to imitation but to the fact that such poses could be seen daily in any public bath. A statue of Aesculapius, god of health, presides over the scene from the left, but so unobtrusively that he almost seems one of the bathers. Here, too, one feels the temperature; the figures in the foreground stand happily in

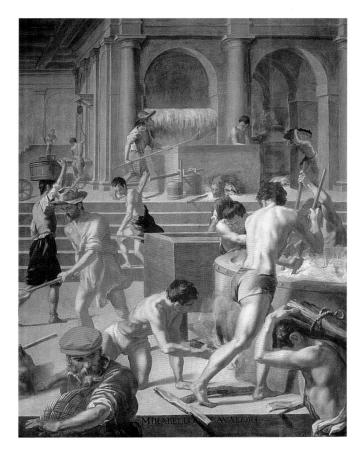

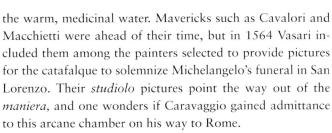

We have come full circle. From the moment of its construction the Palazzo dei Priori had been the home of the Florentine Republic, and its simplicity and power had symbolized the qualities of individual character so important for the Republic. Through two and a half centuries these qualities, in crisis and in triumph, had inspired one of the great periods in the history of human artistic imagination. By the late sixteenth century the Republic was over, and it is ironic that the massive building, deprived of its original meaning, should have provided the setting for an absolutist ruler who divined secret mysteries by artificial light. The fortress from which the Florentines of the Renaissance had issued to conquer reality has become both the refuge for a Mannerist flight from reality and a womb for the germination of a new vision of reality.

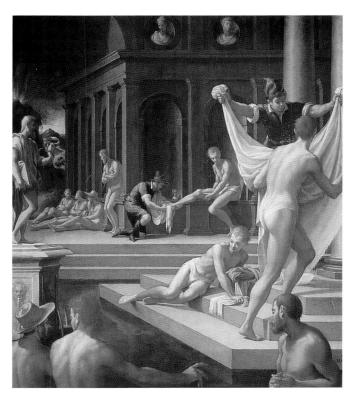

Lavinia Fontana of Bologna

Lavinia Fontana was the daughter of the painter Prospero Fontana, who had trained with a pupil of Raphael and who worked as an assistant to Vasari in Rome and Florence. Lavinia, raised and trained in the city of Bologna, studied with her father. She became a successful artist who worked for several popes. She specialized in portraits, although she also painted small paintings of religious subjects intended for private devotion and the occasional mythological theme. She was the first woman accepted into the prestigious Accademia di San Luca, the organization of painters, in Rome. Of her selfportraits, one of the most interesting seems to be a marriage portrait (fig. 20.45). While the empty easel in the background hints at her career as a painter, she chooses to show herself as a musician, playing a spinet in the foreground while a servant holds the music. As important as her accomplishments in art and music are the suggestions of status, wealth, and personal dignity—seen in her pose, costume, and jewelry—that confirm her success as a painter. In another self-portrait now in the Medici self-portrait collection in the Uffizi (not illustrated), Fontana painted herself preparing to draw from some of the

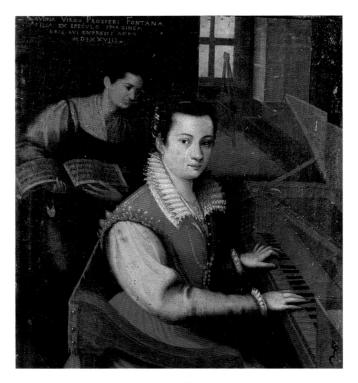

20.45. LAVINIA FONTANA. *Self-Portrait at the Spinet*. 1577. Oil on canvas, $10^{5/8} \times 9^{1/2}$ " (27 x 24 cm). Accademia di San Luca, Rome. Sitting on the spinet is a piece of coral carved into the shape of a love-knot, a symbol of betrothal. The inscription on the painting, "Lavinia, the unmarried daughter of Prospero Fontana, took this, her image, from the mirror, 1577," indicates that the painting was made before Fontanta's marriage that same year to Giovan Paolo Zappi, a fellow-pupil in her father's studio. They had eleven children, and it is said that Zappi assisted her by painting the backgrounds and costumes in some of her works.

antiquities and copies of antique works in her personal collection. The emphasis on details of costume and rank in Fontana's works accords well with the courtly nature of the *maniera* in the later sixteenth century.

Postlude

For the absolutist elegance of grand-ducal Florence, the *maniera* was a perfect vehicle. But even Counter-Reformation Rome was populated by *maniera* artists of intense productivity, great authority, high position, and, it might be argued, limited talent and taste. In this context, the last works of Michelangelo are exceptional. In retrospect, the dramatic architectural style created by Michelangelo in his last Roman works seems to point the way toward the architectural triumphs of the Roman Baroque, and in a sense it did, because some of his pupils were instrumental in laying the groundwork of Early Baroque architecture.

Strong countercurrents to the *maniera* in central Italy were led by two outsiders to Rome, the architect Vignola and the

painter Barocci, neither of whom owes much to Michelangelo. Whether either belongs in a book on Renaissance art is as debatable as whether they should be used to introduce a book on Baroque art. Even if they elude easy classification, these artists are too important to omit from a period in which, chronologically at least, they lived and worked.

Giacomo da Vignola

Jacopo Barozzi (1507–73), born in Vignola, near Bologna, is known as Giacomo da Vignola. He started as a painter under the tutelage of Sebastiano Serlio, the architect and perspective painter who is best known for his treatise *General Rules for Architecture* (*Regole generali di architettura*) and for his role in transporting the Renaissance to France. Serlio had studied under Peruzzi in Rome, and thus Vignola was brought into contact with High Renaissance tradition even before he arrived in Rome in 1530. He worked with Peruzzi and Antonio da Sangallo the Younger in the Vatican and was employed in finishing the Palazzo Farnese and, after 1564, St. Peter's itself.

Vignola's work reveals his desire to revive and codify the Bramantesque tradition, an ambition not unusual for this era of treatises and standardization. Instead of inventing their own capitals, as had so many Quattrocento architects and indeed Michelangelo himself, maniera architects generally were content with copies of Bramante's capitals for St. Peter's. But Vignola settled the course of classical architecture for the next three and a half centuries with his Rules for the Five Architectural Orders (Regola delli cinque ordini di architettura), first published in 1562 and reprinted in innumerable editions that came to an end only when the tradition of classical architectural training died out in the twentieth century. In this work, thirty-two illustrations laid down principles for the design, proportions, and employment of the orders then recognized— Tuscan, Doric, Ionic, Corinthian, and Composite—including shafts, capitals, bases, and entablatures. All were based on ancient Roman models, thus imposing Bramantesque taste on posterity while ignoring the fantasies of Roman architecture that delight modern students.

Neither experience in completing Michelangelo's buildings nor collaboration with the *maniera* architects Vasari and Ammanati seems to have had any effect on Vignola other than to reinforce his classicism. He is best known today for the interior of the Gesù, the mother church of the Jesuit Order, in Rome. Often considered the earliest Baroque church, the plan of the Gesù was derived from Alberti's Sant'Andrea in Mantua (see figs. 10.7, 10.8).

Vignola's Villa Farnese at Caprarola is perhaps the most overwhelming secular building of the Renaissance in its dimensions, its hilltop site, and its grand proportions (fig. 20.46). Vignola was faced with an unusual problem, for the commission required the villa be built atop a preexisting pentagonal fortress. In 1581 Michel de Montaigne stated that the

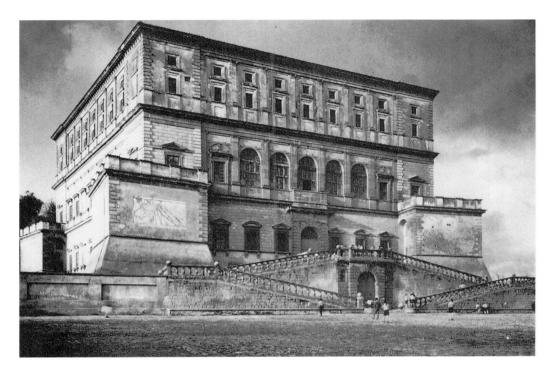

20.46. GIACOMO
DA VIGNOLA.
Façade, Villa Farnese,
Caprarola. Begun 1559.
Commissioned by Cardinal
Alessandro Farnese

villa was "pentagonal in form, but looks like a pure rectangle. Inside it is perfectly round." The tension between the five sides of the fortress pedestal and our expectation of four for the villa is the source of much of our pleasure in the design. Vignola reinforced the angles of the fortress with quoins, crowned it with a cornice and parapet, and provided it with two superimposed, rusticated, and arched entrances connected by balustraded ramps and flanked by pedimented windows. The motif of the corner bastions is continued, still with quoins, in the upper stories. Between these towering corners a seven-bay order stretches across each façade, with Ionic on the second story and Corinthian on the third. The pilaster sequence of the second story embraces a loggia (now glazed) of arches that affords a view over the surrounding hills and valleys. Windows fill these bays on the other sides. The final story is subdivided into a row of oblong windows below a mezzanine of square ones, embraced by the same giant order.

The circular courtyard had been mentioned by Alberti, who equated it with the round plans of some ancient temples. The example at the Villa Farnese (fig. 20.47) is the first to be completed. Rusticated arches uphold a *piano nobile* of paired Ionic engaged columns flanking arches that culminate in a balustrade with urns that conceals the setback third story. The courtyard thus appears as a revival, in circular form, of the two-story scheme of Bramante's Palazzo Caprini (see fig. 17.20). The villa's spiral staircase (fig. 20.48), composed of paired Tuscan columns, recalls Bramante's spiral ramp for the Vatican Belvedere.

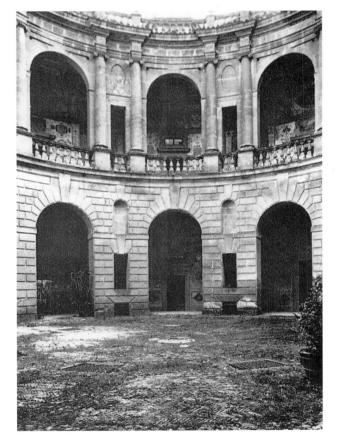

20.47. GIACOMO DA VIGNOLA.

Courtyard, Villa Farnese, Caprarola. Designed c. 1556–58, completed by 1579. Diameter approx. 67'3" (20 m). The barrel-vaulted portico that surrounds the courtyard was decorated with forty-six frescoed coats of arms of the Farnese and related families and with busts of the first twelve Roman emperors, whom the Farnese seem to have been claiming as ancestors.

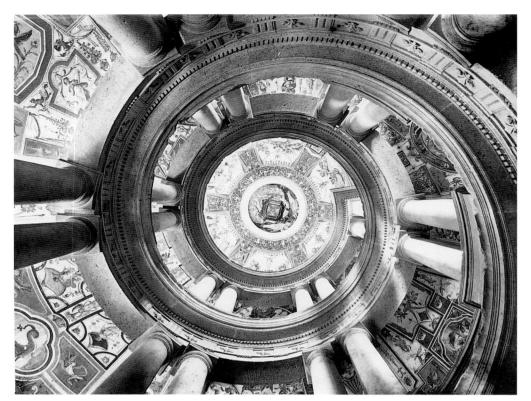

20.48. GIACOMO DA VIGNOLA. Spiral staircase, Villa Farnese, Caprarola

Federico Barocci

Ironically, the Emilian architect Vignola based his style on that of Bramante of Urbino, while the painter Federico Barocci (1526–1612) from Urbino dedicated much of his life to a revival of the inventions of the Emilian artist Correggio. And as Vignola was, with the exception of Michelangelo, the most powerful architect in central Italy during the 1550s and 1560s, so Barocci was the most significant painter in that region between the death of Michelangelo and the arrival in Rome of the Carracci and Caravaggio in the 1590s. Barocci's long career overlapped the beginnings of the Baroque style, and he appears to have had considerable effect on later painters, especially Rubens.

Although Barocci was profoundly influenced by the work of Correggio and by Venetian painters, we are still uncertain where and under what circumstances he saw their works. During two trips to Rome he studied the work of Raphael in particular and was protected by Federico Zuccari, the accomplished but monotonous leader of the Roman *maniera*. Barocci left Rome in 1563, in poor health and with the suspicion that he had been poisoned, presumably by a jealous rival. Thereafter, he seldom left his mountain home at Urbino, where the classicism of his illustrious forebears, Piero della Francesca, Bramante, and Raphael, seems to have held little meaning for him.

It is Correggio who is uppermost in Barocci's mature work, especially his celebrated *Madonna del Popolo* (fig. 20.49). In Piero's altarpiece for a similar confraternity in Sansepolcro

more than a century before (see fig. 11.21), the decisive principle had been the Virgin's enduring protection of a group of mortals. For Barocci the essential was the dramatic instant of the Virgin's intercession for her people before a loving Christ. The scene is caught up in a bewitching fusion of everyday experience with otherworldly rapture. In the surging crowd below, an elegantly dressed mother tries to interest her children in the heavenly apparition, but they are attracted by the beggar in the foreground and the player of the *vielle*—a four-stringed popular instrument operated by a crank—who in turn resists the beggar's request for charity. At the extreme lower right a brown-and-white puppy appeals to the spectator.

With almost no gap between earthly byplay and heavenly apparition, one ascends over the heads of mothers with baskets to child-angels, who support a beautiful Virgin, her hands spread gracefully in appeal. Christ appears to bless the crowd, while the dove of the Holy Spirit soars over their heads. Light plays over figures, faces, and bright garments as if through colored mists, as lightly as the Correggiesque smiles that move across the faces. Barocci's studies for this and other paintings include color drawings made with pastels (sticks of dry color) or with colored chalks that glow in opalescent tones on paper generally tinted a rich robin's-egg blue. In the dissolving colors and smiling charm of the subjects, we seem to have left the solemnity and tensions of the late Cinquecento far behind. Barocci's excitement in his discoveries and his enthusiastic study of color, movement, and light are a reminder of the accomplishments of earlier Renaissance artists.

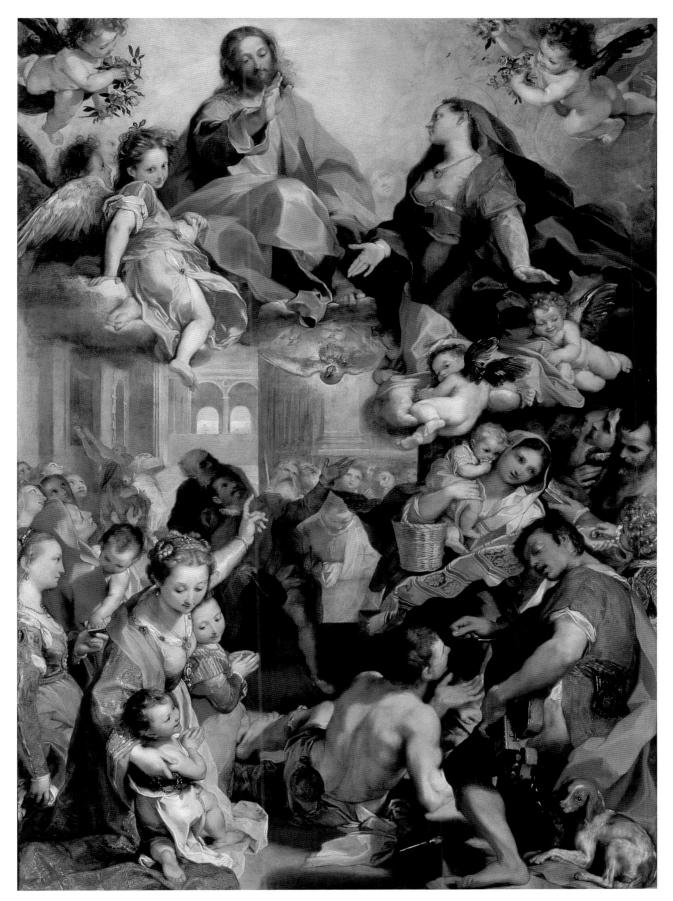

20.49. FEDERICO BAROCCI. Madonna del Popolo. 1575–79. Panel, $11'9^3/8" \times 8'3^1/4" (3.6 \times 2.5 \text{ m})$. Uffizi Gallery, Florence. Commissioned by the Confraternity of the Misericordia, Arezzo

GLOSSARY

This glossary is limited to the most frequently used terms. Cross-references are indicated by the use of SMALL CAPITALS.

AEDICULE (or **AEDICULA**) (pl. AEDICULAE). In architecture, a frame around a window, door, or niche decorated in a classicizing manner, with COLUMNS, ENTABLATURE, and pediment, as seen in the windows of the Palazzo Farnese (fig. 18.62).

ALTARPIECE. A painted or sculpted religious image that stands upon and at the back of an altar; for a typical example, see Orcagna's altarpiece (fig. 5.1). It may depict the CRUCIFIXION, the Virgin and Child, and/or various saints, including the saint to whom the particular church or altar is dedicated. In certain periods it includes decorated gables and PINNACLES, as well as a PREDELLA. See also *MAESTÀ*.

ANNUNCIATION. The announcement by the angel Gabriel to the Virgin Mary of the Incarnation of Jesus Christ (Luke 1:26–38). In many representations of this scene a dove appears, to indicate that the Virgin has conceived by the Holy Spirit and will bear the Son of God; see the examples by Ghiberti, Fra Angelico, and Lorenzo Lotto (figs. 7.5, 9.3, and 19.32). The Annunciation to the Shepherds is the scene in which angels announce to shepherds the birth of Christ (Luke 2:8–14); see the example by Taddeo Gaddi (fig. 3.30).

ANTIPOPE. A rival pope, elected in opposition to another, who is later judged not to be a part of the accepted succession of popes. In general, it refers to the popes elected at Avignon in opposition to those at Rome during the Great Schism (1378–1417), and to a series of popes elected at Pisa and Basel.

APOCALYPSE. The Book of Revelation, the last book of the New Testament, in which St. John narrates the visions he experienced on the island of Patmos. A major source of iconography for Last Judgment scenes, as in figs. 2.15, 3.16, 4.34, 20.1.

APOCRYPHA. A group of writings once included in versions of the Bible, but now generally excluded. The scene of the two midwives bathing Christ in Nicola Pisano's *Annunciation*, *Nativity*, and *Annunciation to the Shepherds* (fig. 2.27) is drawn from apocryphal sources, as is Filippino Lippi's scene of *St. Philip Exorcising the Demon in the Temple of Mars* in the Strozzi Chapel in Santa Maria Novella in Florence (fig. 13.36).

APSE. A large semicircular or polygonal niche, as seen in Leonardo's drawing of churches (fig. 16.7), at Sta. Maria della Consolazione in Todi (fig. 17.17), and behind the Virgin in Domenico Veneziano's St. Lucy altarpiece (fig. 11.8).

ARCADE. A series of ARCHES with their supporting COLUMNS or PIERS, as in the courtyard of the Palazzo Ducale at Urbino (fig. 14.27).

ARCH. A means of construction in which an opening, usually semicircular, is spanned by a series of wedge-shaped elements. It is supported from below by walls, PIERS, or COLUMNS, and by BUTTRESSING at the sides. See the courtyard of the Palazzo Ducale at Urbino (fig. 14.27).

ARCHITRAVE. The LINTEL and the lowest part of an ENTABLATURE; see Bramante's Tempietto (fig. 17.9).

ARRICCIO. The layer of relatively coarse plaster that is the first layer applied to a wall in the making of a FRESCO; see fig. 1.16.

ARTE (pl. ARTI). See GUILDS.

ARTS, LIBERAL. The seven liberal arts, which are derived from the curriculum for secular learning during the Middle Ages, are grammar, rhetoric, logic, arithmetic, music, geometry, and astronomy. They were frequently represented allegorically during the Middle Ages and the Renaissance; see Pollaiuolo's tomb of Pope Sixtus IV (fig. 13.9).

ARTS, MECHANICAL. Practical occupations that involved working with the hands. During the Middle Ages, the mechanical arts included painting, sculpture, and architecture. Contrasted to the LIBERAL ARTS.

A SECCO. See FRESCO.

ASCENSION. The ascent of Christ into heaven, as witnessed by his disciples forty days after the RESURRECTION (Luke 24:51 and Acts of the Apostles 1:9–12). Part of the narrative cycles at Giotto's Arena Chapel (fig. 3.3), Andrea da Firenze's chapter house frescoes at Santa Maria Novella (fig. 5.7), and Ghiberti's first set of baptistery doors (fig. 7.4).

ASSUMPTION. The ascent of the Virgin Mary to heaven after her death and burial when, according to Roman Catholic belief, her soul was reunited with her body; see the examples by Correggio (fig. 18.49) and Titian (fig. 19.8).

ATTIC STORY. An extra story that appears above the ENTABLATURE; see the exterior view of Michelangelo's design for St. Peter's in Rome (figs. 15, 20.12).

AVELLO (pl. AVELLI). Italian word for tomb, generally used by art historians to refer to a tomb surmounted by a Gothic arch and often built into an opening between two chapels or as a series in a wall, as across the façade of Sta. Maria Novella (fig. 10.5).

BALDACCHINO. A canopy, usually placed over an altar or over the reserved sacrament.

BARREL VAULT. A semicylindrical VAULT; see the barrel vaults surmounting the nave and side chapels of Sant'Andrea in Mantua (fig. 10.8).

BASE. The lowest element of a COLUMN, wall, or DOME, occasionally of a statue; see the base of the column in Piero della Francesca's *Annunciation* (fig. 11.30) or the elaborately worked base of Cellini's statue of Perseus (fig. 20.25).

BASILICA. A general term applied to any church that, like Early Christian basilicas, has a longitudinal NAVE that terminates in an APSE and is flanked by SIDE AISLES; see figs. 6.7, 6.10–6.12.

BAY. An individual unit of space defined by PIERS and VAULTS in a vaulted structural system; the term also refers to the vertical definitions of these same units on the exterior or interior surfaces of a building, as indicated by such elements as BUTTRESSES and COLUMNS. The individual bays are evident in the plan of Brunelleschi's Sto. Spirito (fig. 6.12).

BEATO (fem. BEATA). Italian word for blessed. Specifically, beatification is a papal decree that declares a deceased person to be in the enjoyment of heavenly bliss (beatus) and grants a form of veneration to him or her. It is usually a step toward canonization. The painter who in English is called Fra Angelico is in Italian called Beato Angelico, even though he was not beatified until the twentieth century.

BENEDICTINE ORDER. Founded by St. Benedict of Nursia (c. 480–c. 543) at Subiaco near Rome, the Benedictine rule spread to England and much of Western Europe in the next two centuries. Less austere than other early ORDERS, the Benedictines divided their hours among religious worship, reading, and work, generally either educational or agricultural.

BIRETTA. The square cap worn by ecclesiastics, that of priests being black, of bishops purple, and of cardinals red; see Raphael's Pope Leo X with Cardinals Giulio de' Medici and Luigi de' Rossi (fig. 17.57).

BLIND ARCADE. A closed ARCADE, as above the entrance door of Codussi's S. Zaccaria (fig. 15.50).

BOLE. The red pigment used as a glue to adhere gold leaf to the plaster surface in panel painting. If the gold on a painting was thin or has been rubbed, the bole may be visible, as it is near the top of Duccio's *Entry into Jerusalem* (fig. 4.10).

BOTTEGA. Italian word for shop, used to describe both the group of assistants who worked with an artist and the place where they worked.

BRACCIO (pl. BRACCIA). Italian word for arm. A unit of linear measurement used in many Italian centers, but varying from place to place; in Florence a braccio is approximately 1.913 modern feet (58.3 cm).

BUTTRESS. A masonry support that counteracts the outward thrust of an ARCH or VAULT; diagonal buttresses are visible in the exterior view of the Cathedral of Florence (fig. 6.2).

CALVARY. See GOLGOTHA.

CAMALDOLITE ORDER. An independent branch of the BENE-DICTINE ORDER founded by St. Romuald to establish the Eastern eremitic (solitary) form of monasticism in the West. St. Romuald was born in Ravenna about 950 and died in 1027. The painter known as Lorenzo Monaco (see pp. 164–68) was a member of this order, and Brunelleschi's church of Santa Maria degli Angeli (fig. 6.13) was intended for this order.

CAMPANILE. From the Italian word *campana* (bell). A bell tower either attached to a church or freestanding nearby; see figs. 6.2, 18.1.

CAMPO. Italian word for field; used in Siena, Venice, and other cities to denote certain public squares; for the irregularly shaped Campo in Siena, see fig. 1.6. See also PIAZZA.

CANTORIA. The Italian word for a balcony used by musicians, as in the examples by Luca della Robbia and Donatello once in Florence Cathedral (figs. 10.21–10.25).

CAPITAL. The decorated, crowning member of a COLUMN or PI-LASTER, on which rests the LINTEL or the arches of an ARCADE; see the courtyard of the Palazzo Ducale in Urbino (fig. 14.27). See also ORDER.

CAPOMAESTRO. Italian word for headmaster, used for the person in charge of design and construction for a cathedral or major governmental structure. The artist Giotto served as *capomaestro* of Florence Cathedral from 1334 until his death in 1337.

CARMELITE ORDER. Begun in the mid-twelfth century by a crusader named Berthold and his followers, who settled in caves on Mt. Carmel and led lives of silence, seclusion, and abstinence. About 1240 they migrated to Western Europe, where the rule was altered, the austerities mitigated, and the ORDER changed to a mendicant (begging) one, analogous to the DOMINICAN and FRANCISCAN ORDERS. Santa Maria del Carmine in Florence (see figs. 5, 8.9–8.10, 8.14, 8.15, 8.21) is a church of the Carmelite Order.

CARTELLINO. See TITULUS.

CARTHUSIAN ORDER. Founded by St. Bruno (c. 1030–1101) at Chartreuse near Grenoble in 1084. Carthusians follow a life of prayer, silence, and extreme austerity. The Certosa at Pavia (figs. 15.54–15.56) is an example of a Carthusian monastery.

CARTOON. Full-scale preparatory drawing on one or more sheets of heavy paper; see Raphael's tapestry cartoons for the Sistine Chapel (figs. 17.58–17.60).

CARYATID. A female figure that structurally or decoratively takes on the function of a COLUMN or PILASTER.

CASINO. A garden house.

CASSONE (pl. CASSONI). Italian term for large painted or carved chests for clothing, as seen in the background of Titian's Venus of Urbino (fig. 19.20). Pairs of cassoni were given to newlyweds. Pesellino's painting of the Triumphs of Love, Chastity, and Death (fig. 12.37) was originally part of a cassone.

CATHEDRAL. The church in which the bishop of a diocese has his permanent *cathedra*, or episcopal throne; not all large churches are cathedrals, and a town or city, no matter its size, can have only one cathedral. See the cathedrals of Florence (figs. 5.14, 6.2–6.5) and Siena (fig. 2.33).

CENACOLO. Italian word for supper room or REFECTORY, as in the Cenacolo of Sant'Apollonia, location for Castagno's Last Supper (fig. 11.11). The term is also used to refer to a representation of the Last Supper.

CERTOSA. Italian title for a Carthusian monastery (see figs. 15.54–15.56). Derived from Chartreuse, where St. Bruno founded a monastery in 1084.

CHALICE. Generally, a drinking cup, but specifically the cup used to hold the wine consecrated during the EUCHARIST; see the chalice in the foreground of Andrea del Sarto's *Lamentation* (fig. 18.23).

CHANCEL. The space in a church that is reserved for the clergy and

choir; it is set off from the NAVE by steps and occasionally by a screen; see Palladio's S. Giorgio Maggiore (figs. 19.75, 19.76).

CHAPTER HOUSE. The meeting hall within a monastery where the residents gather to discuss matters of governance. The so-called "Spanish Chapel" at Santa Maria Novella in Florence (fig. 5.8) and the Pazzi Chapel at Santa Croce in Florence (figs. 6.14–6.16) are both examples. In Italian churches chapter houses are usually located off the east or back side of the CLOISTER

CHASING. The ornamenting of metal by engraving; see Ghiberti's bronze *Gates of Paradise* (figs. 6, 10.15).

CHERUB (pl. CHERUBIM). One of an order of angelic beings ranking second to the SERAPHIM in the celestial hierarchy, usually represented as a baby angel; see Donatello's *Cantoria* (figs. 10.24, 10.25).

CHIAROSCURO. In painting, the contrast of light and shade—from the Italian *chiaro* (light) and *oscuro* (dark)—to enhance modeling, as in Masaccio's *Expulsion* (figs. 8.15–8.17).

CHRISTUS MORTUUS. Latin phrase for dead Christ, as in Giotto's Crucifix (fig. 3.1).

CHRISTUS PATIENS. Latin phrase for suffering Christ. A cross with a representation of the dead Christ, as seen in Coppo's and Cimabue's *Crucifixes* (figs. 2.11, 2.12, 2.18, 2.19). This type in general superseded representations of the CHRISTUS TRIUMPHANS.

CHRISTUS TRIUMPHANS. Latin phrase for triumphant Christ. A cross with a representation of a living Christ, eyes open and triumphant over death, as seen in the crosses in figs. 2.2 and 2.9. Scenes of the PASSION are usually depicted at the sides.

CIBORIUM. Another word for BALDACCHINO, the canopy usually placed over an altar or over the reserved sacrament.

CINQUECENTO. Italian word for five hundred, used to refer to the 1500s—the sixteenth century.

CISTERCIAN ORDER. A reform movement in the BENEDICTINE ORDER, it was started in France in 1098 by St. Robert of Molesme for the purpose of reasserting the original BENEDICTINE ideals of field work and a life of severe simplicity.

CLAUSURA. Latin word for closure, used to signify the restriction of certain orders of monks and nuns to sections of their convents and to their prohibition against speaking to lay persons. Andrea del Castagno's Last Supper (fig. 11.11) was painted for a nunnery in which CLAUSURA was practiced.

CLERESTORY. An area that is elevated above adjacent rooftops, usually along a central axis; it has windows on the sides, and its purpose is to allow light into the interior. In many churches the clerestory is in the NAVE, which is higher than the SIDE AISLES; for example, see Sta. Maria Novella (fig. 2.41).

CLOSED DOOR. See PORTA CLAUSA.

CLOSED GARDEN. See HORTUS CONCLUSUS.

COFFER. In architecture, a recessed panel in a ceiling or vault, as seen in Sant'Andrea in Mantua (fig. 10.8), Piero della Francesca's *Madonna and Child with Saints* (fig. 11.33), and Melozzo da Forli's *Sixtus IV, His Nephews, and Platina, His Librarian* (fig. 14.22).

COLONNADE. A continuous row of COLUMNS supporting an ENTABLATURE, as in Domenico Veneziano's *Annunciation* (fig. 11.9) and Bramante's Tempietto (fig. 17.9).

COLONNETTE. A slender, columnar decorative motif, as seen in Donatello's *Cantoria* (fig. 10.24).

COLOSSAL (or GIANT) ORDER. See GIANT ORDER.

COLUMN. A freestanding cylindrical support, usually consisting of a BASE, a rounded SHAFT, sometimes fluted, and a CAPITAL; for examples see figs. 6.10, 19.70, 19.71. See also ORDER.

COMPAGNIA. See COMPANY.

COMPANY (Italian: compagnia). In Renaissance terms, a fraternal organization under ecclesiastical auspices and dedicated to good works. In Venice it was usually called a SCUOLA (school), though it had no educational function, and in Tuscany it was sometimes called a CONFRATERNITY.

COMPOSITE ORDER. See ORDER.

COMPOUND PIER. A supporting PIER which has COLONNETTES, half-columns, or PILASTERS attached to it, as in Santa Maria Novella in Florence (fig. 2.41). Often used in Gothic churches, the compound pier is also known as a cluster pier.

CONDOTTIERE. Italian term meaning mercenary military leader; see the monuments to Gattamelata (fig. 10.31), Hawkwood (fig. 11.2), Tolentino (fig. 11.20), and Colleoni (fig. 13.16).

CONFRATERNITY. See COMPANY.

CONSOLE. A bracket, usually formed of VOLUTES that project from a wall to support a LINTEL, CORNICE, or other member, as on the Palazzo Medici cornice (fig. 6.18), or in Michelangelo's Laurentian Library entrance hall (fig. 18.11).

CONTADO. Countryside or rural area around a city.

CONTRAPPOSTO. Italian word for set against. A term describing the position assumed by the human body when the weight is borne on one leg while the other is relaxed. Contrapposto can suggest that a figure has the potential for movement; see Donatello's St. Mark (fig. 7.13).

COPE. A semicircular cloak or cape worn by ecclesiastics in processions and on other solemn ceremonial occasions. The angel in the foreground of Hugo van der Goes's Portinari altarpiece (fig. 13.34) wears a cope.

CORREL. An arrangement of stones that projects from the surface of a wall to provide support; see the corbels on the Palazzo dei Priori (fig. 2.45).

CORBEL TABLE. A row of CORBELS, as on the Palazzo dei Priori (fig. 2.45).

CORINTHIAN ORDER. See ORDER.

CORNICE. The crowning, projecting architectural feature, especially the uppermost part of an ENTABLATURE. See the Palazzo Medici cornice (fig. 6.18).

CORPUS CHRISTI. Latin phrase for body of Christ. At the Feast of Corpus Christi, the presence of Christ in the EUCHARIST is honored, and there is a procession of the HOST.

CORPUS DOMINI. Latin phrase for body of God. See also CORPUS CHRISTI.

CROCKETING. A decorative device, usually leaf like in shape, that surmounts the gables and PINNACLES of Gothic architecture and the frames of panel paintings; note the crockets along the top of the throne of Giotto's *Enthroned Madonna with Saints* (fig. 3.20). For an especially florid example see fig. 8.2.

CROSS VAULT. See GROIN VAULT.

CRUCIFIX. From the Latin word *crucifixus* (an object made in the shape of a cross). A painted or sculpted representation of a cross with the figure of Christ crucified on it; see figs. 2.11, 2.18, 2.19, 3.1.

CRUCIFIXION. The death of Christ on the cross, described in all four of the GOSPELS (e.g., Matthew 27:33–56). In Christian theology, the Crucifixion represents Christ's sacrifice for the sins of the world, an act that made it possible for humanity to gain access to paradise. Because it is the central mystery in Christianity, it is frequently represented; see examples by Masaccio, Mantegna, and Tintoretto (figs. 8.23, 15.19, and 19.46).

CRUCIFORM. A word used to describe the Latin cross-shape of many Christian churches; see figs. 2.42, 5.15, 5.18, 6.7, 6.12, 19.76.

CUPOLA. Another word for DOME: a rounded, convex roof or vaulted ceiling, usually hemispherical on a circular BASE and requiring BUTTRESS-ING; see Brunelleschi's cupola for Florence Cathedral (fig. 6.2) and Michelangelo's for St. Peter's (fig. 20.14).

CUSPING. In Gothic architecture, a motif composed of a series of scallops that decorate an arched opening; also used to decorate Gothic niches for sculpture and the frames of panel paintings. See the niche for Nanni di Banco's *Four Crowned Martyrs* (fig. 7.18) and the frame of Lorenzo Monaco's *Coronation of the Virgin* (fig. 5.12).

DALMATIC. An ecclesiastical vestment with wide sleeves and a shirt slit at the sides, worn in the Western church by deacons at High MASS. The full-length angels at the top of the tomb of the Cardinal Prince of Portugal

are shown wearing dalmatics (fig. 12.15). A similar garment was also worn by kings at coronation.

DENTILS. A decorative molding derived from antiquity that consists of a row of small, projecting blocks; used as a motif on IONIC and CORINTHIAN CORNICES, as on the Palazzo Medici (fig. 6.18).

DEPOSITION. The removal of Christ's body from the cross after the CRUCIFIXION; also known as the Descent from the Cross. See the examples by Pietro Lorenzetti and Rosso Fiorentino (figs. 4.21, 18.32).

DESCENT FROM THE CROSS. See DEPOSITION.

DIAPHRAGM ARCH. An ARCH set within a wall that divides one spatial area from another. Such walls are found on the sides of the four porches of Palladio's Villa Almerico (fig. 19.71).

DIPTYCH. ALTARPIECE or devotional picture consisting of two wooden panels joined together.

DISEGNO. The Italian word for design or drawing, used in the Renaissance to refer to the emphasis on precise figure drawing in Florentine and Roman art, especially of the High Renaissance.

DI SOTTO IN SÙ. Italian phrase that refers to the idea of looking up from below. A type of ILLUSIONISM in painting, achieved by means of sharp FORESHORTENING, in which the figures and architecture seem to be high above and receding from the spectator; see Mantegna's frescoes in the Camera picta (fig. 15.24) and Correggio's Vision of St. John the Evangelist (fig. 18.46).

DOGE. Italian word for the elected head of state in Venice and Genoa. A figure of a doge is shown in Paris Bordone's A Fisherman Delivering the Ring (fig. 19.34).

DOME. A large CUPOLA supported by a circular wall or DRUM, or, over a noncircular space, by corner structures; see figs. 6.2, 20.13. See also PENDENTIVE.

DOMINICAN ORDER. Founded as a preaching ORDER at Toulouse in 1216 by St. Dominic. The Dominicans lived austerely and believed in having no possessions, surviving by charity and begging. After the FRANCISCANS, they became the second great mendicant (begging) order. The churches of Santa Maria Novella (figs. 2.41, 2.42) and San Marco in Florence are of the Dominican Order. The painter Fra Angelico (see pp. 246–54) was a Dominican monk.

DONOR. The person or group who commissions and pays for a work of art or architecture for public display, usually as a religious donation to a church or monastery. The donor is occasionally represented in the work, as in Giotto's Arena Chapel (fig. 3.16), Masaccio's *Trinity* (fig. 8.26), and Mantegna's *Madonna of the Victory* (fig. 15.25). See also PATRON.

DORIC ORDER. See ORDER.

DRUM. One of several sections composing the SHAFT of a COLUMN. Also, a cylindrical wall supporting a DOME; see Bramante's Tempietto (fig. 17.11) and St. Peter's (fig. 17.15).

DUECENTO. Italian word for two hundred, used to refer to the 1200s—the thirteenth century; also called *Dugento*.

DUOMO. Italian word for CATHEDRAL.

EGG-AND-DART. A decorative molding derived from antiquity that consists of alternating oval and pointed, arrowlike forms, as in the FRIEZE of Donatello's *Annunciation* (fig. 10.27).

ENTABLATURE. The upper part of an architectural ORDER; see the portico of the Villa Medici at Poggio a Caiano (fig. 12.26).

EUCHARIST. From the Greek word for thanksgiving. The sacrament of the Lord's Supper, celebrated in the MASS. Eucharist can refer to the consecrated bread and wine used in the rite of Communion, or to the rite itself.

EXEDRA. A semicylindrical architectural space or shape surmounted by a half-dome; see the exedrae on Brunelleschi's dome for Florence Cathedral (fig. 6.3).

EX-VOTO. Latin phrase meaning from a vow. An ex-voto is an offering made to fulfill a vow. It is frequently a painting presented to a church in hope of or gratitude for divine help.

FATHERS OF THE CHURCH. The four Latin Fathers of the Church are Sts. Jerome, Ambrose, Augustine, and Gregory. They were early teachers and defenders of Christianity; they are represented, with the four evangelists, in the bottom panels of Ghiberti's North Doors (fig. 7.4).

FORESHORTENING. The technique used in painting or RELIEF sculpture to suggest that figures, parts of the body, or other forms are shown in sharp recession, as in Mantegna's *Foreshortened Christ* (fig. 15.21).

FRANCISCAN ORDER. Founded by St. Francis of Assisi (Giovanni di Bernardone, 1181/82–1226) for the purpose of ministering to the spiritual needs of the poor and imitating as closely as possible the life of Christ, especially in its poverty. The first great mendicant (begging) ORDER. Examples of Franciscan churches include Santa Croce in Florence (figs. 2.43, 2.44) and Santa Maria Gloriosa dei Frari (figs. 1, 5.17, 5.18) in Venice.

FRESCO. Italian word for fresh. A painting made on wet plaster with pigments suspended in water so that the plaster absorbs the colors and the painting becomes part of the wall; see fig. 1.16. FRESCO A SECCO, or painting on dry plaster (secco is Italian for dry), was also used, but it is a much less durable technique, and the paint tends to flake off with time.

FRIEZE. The middle part of the ENTABLATURE; also, any horizontal band decorated with moldings, RELIEF sculpture, or painting. The frieze of Donatello's *Annunciation* (fig. 10.27) is decorated with several motifs drawn from classical antiquity.

GENIUS (pl. GENII). In Roman and Renaissance art, usually the guardian spirit of a person, place, or thing, though it may be purely decorative. Genii are represented in human form frequently seminude and winged; see the genii on the base of the tomb of the Cardinal Prince of Portugal (fig. 12.15).

GESSO. A mixture of finely ground plaster and glue used to prepare the surface of a wooden panel for TEMPERA painting (see fig. 1.12), or to prepare a wooden sculpture for POLYCHROMY, as in Donatello's *Penitent Magdalen* (fig. 12.3).

GIANT (or **COLOSSAL**) **ORDER**. PILASTERS or COLUMNS that span more than one story of a structure; see the pilasters on the exterior and interior of St. Peter's in Rome (figs. 15, 17.16, 20.12).

GILDING. Coating with gold, gold leaf, or some gold-colored substance; see Orcagna's altarpiece (fig. 5.1); for a diagram, see fig. 1.12. Techniques were devised in Italy for gilding on painting, sculpture, and architectural ornament.

GLAZES. In oil painting, thin layers of superimposed translucent varnish, often with a small amount of pigment added, to modify color and build up a rich, sonorous effect. Titian used glazes extensively in such later pictures as the *Rape of Europa* (fig. 19.27).

GOLDEN LEGEND. A collection of saints' lives written in the thirteenth century by Jacopo da Voragine, archbishop of Genoa. The scene of the Virgin Mary appearing to St. Bernard, as painted by Filippino Lippi, is drawn from the Golden Legend (fig. 13.33).

GOLGOTHA. Aramaic word for skull; thus, the Place of the Skull. Golgotha is the site outside Jerusalem where Christ was crucified (Matthew 27:33). CALVARY, another name for the same place, is from the Latin word for skull, *calvaria*. Note the skulls visible below the crosses of Christ in Giotto's *Crucifix* (fig. 3.1) and *Crucifixion* (fig. 3.14).

GONFALONIERE. Italian for standard-bearer; the title given an important Florentine political official; the male DONOR in Masaccio's *Trinity* is dressed in the robes of a *gonfaloniere* (fig. 8.26).

GOSPEL. In Christian usage, the name given to the first four books of the New Testament, which relate the story of Christ's life and teachings. These books are traditionally ascribed to the evangelists Matthew, Mark, Luke, and John.

GRISAILLE. Monochromatic painting in shades of gray; see Giotto's *Virtues* and *Vices* in the Arena Chapel (figs. 3.17–3.19).

GROIN VAULT. A VAULT formed by the intersection at right angles of two BARREL VAULTS of equal height and diameter; where they meet the

groins form a diagonal cross. See Sta. Maria Novella (fig. 2.41). Also known as a CROSS VAULT.

GROTTESCHI. A Renaissance decorative scheme in paint or stucco that uses motifs discovered during the Renaissance in an ancient Roman setting that was presumed to be a grotto, hence the name. These motifs were interwoven into a variety of patterns to cover walls or PILASTERS; see Pintoricchio's Piccolomini Library frescoes (figs. 7, 14.20) and Raphael's Villa Madama (fig. 17.61).

GUILDS. Arti (sing. Arte) in Italian. Independent associations of bankers and of artisan-manufacturers. The seven major guilds in Florence were: Arte di Calimala—refiners of imported wool; Arte del Cambio—bankers and money changers; Arte dei Giudici e Notai—judges and notaries; Arte della Lana—wool merchants who manufactured their own cloth; Arte dei Medici e Speziali—doctors, pharmacists, and painters; Arte della Seta—silk weavers and sculptors in metal; Arte dei Vaiai e Pellicciai—furriers. Other guilds include the Arte dei Corazzai e Spadai—armorers and swordmakers; the Arte dei Linaioli e Rigattieri—linen drapers and peddlers; and the Arte di Pietra e Legname—workers in stone and wood, including stone sculptors. See also MERCANZIA.

GUILLOCHE. An ancient decorative motif composed of a curvilinear motif of interlaced lines; it is used for the FRIEZE in Castagno's *Last Supper* (fig. 11.12).

HARPY (pl. HARPIES). From the Greek word meaning snatcher. A female monster who carries souls to hell; a combination of a woman's head and body with a bird's wings, legs, claws, and tail; see the harpies on the base of the Madonna's pedestal in Andrea del Sarto's *Madonna of the Harpies* (fig. 18.22). Harpies occasionally appear as more benign spirits who carry souls to another world.

HELLENISTIC. The historic period from the time of Alexander the Great in the fourth century B.C.E. until the first century B.C.E. The *Belvedere Torso* (fig. 17.3) is an example of art from this period.

HERM. The torso of a male figure emerging from a pedestal; sometimes used as a PILASTER; see the final version of Michelangelo's tomb of Julius II (fig. 20.5).

HORTUS CONCLUSUS. Latin phrase for CLOSED GARDEN; refers to the phrase "A garden enclosed is my sister, my spouse; a spring shut up, a fountain sealed" (Song of Solomon 4:12). Often used as a symbol of Mary's virginity in scenes of the ANNUNCIATION; see the example by Fra Angelico (fig. 9.3).

HOST. From Latin *hostia* (sacrificial victim). In some Christian denominations the term Host is used to designate the bread or wafer consecrated in the EUCHARIST or MASS and regarded as the body of Christ. The priest is holding up the Host in Raphael's *Mass of Bolsena* (fig. 17.53).

HUMANIST, HUMANISM. The title of humanist in the Renaissance was originally applied to a teacher of humanistic studies, a curriculum that included rhetoric, grammar, poetry, history, and moral philosophy; at the base of many of these disciplines was the study of ancient texts on these topics in Latin and, eventually, in Greek as well. Already in the fourteenth century, scholars and writers had been inspired by the ideas they found in ancient texts, which confirmed their new intellectual and scientific interest in understanding the world. The praise for the deeds of great figures from antiquity that the humanists found in Greek and Roman texts supported the notions of pride and fame that were becoming important in a society whose major figures were successful business entrepreneurs and bankers.

During this period humanism was, with some effort, integrated with Christianity; it sought to supplement faith by insisting on the dignity of the individual and the human potential for achievement.

ICON. From the Greek term for image or likeness, but commonly used in the Orthodox denominations to designate a panel painting representing Christ, the Virgin Mary, a saint, or a religious narrative.

ICONOGRAPHY. The identification and study of the subject matter of a work of art, including the identification of symbols.

ILLUSIONISM. Technique of representing the objects in a work of art, usually a painting, so they seem to be weighty and tangible and existing within actual space; see Perugino's *Christ Giving the Keys to St. Peter* (fig. 14.14).

IMPASTO. Raised brushstrokes of thick paint, as in Titian's Rape of Europa (fig. 19.27).

IMPOST BLOCK. A square block placed above the CAPITAL in an architectural ORDER; for examples, see Brunelleschi's church of S. Lorenzo, in which the impost blocks are decorated (fig. 6.10), and his church of Santo Spirito, in which they are left plain (fig. 6.11).

IN SITU. In its original location.

INTARSIA. Inlaid cabinetwork composed of various woods; see the Duke of Urbino's STUDIOLO (figs. 14.29, 14.30) and the SACRISTY of the Cathedral of Florence (fig. 12.20).

INTONACO. The layer of smooth plaster on which a FRESCO is painted; see fig. 1.16.

IONIC ORDER. See ORDER.

ISTORIA. Italian term for history or historical narrative. See also STORIA.

LAMENTATION. The mourning of Christ's mother and his followers over the body of Christ after the DEPOSITION. Not mentioned in biblical accounts of the CRUCIFIXION; see the example by Botticelli (fig. 13.31).

LANTERN. The official architectural term for a windowed turret at the top of a DOME; see the lanterns at the top of the domes in figs. 11, 6.4, 17, 17

LAST JUDGMENT. The second coming of Christ, when he will judge souls to determine whether individuals will be sent to heaven or to hell. Representations of this subject are usually accompanied by a multitude of saints and angels, and there are scenes from heaven and hell. See the examples by Giotto and Michelangelo (figs. 3.4, 20.1).

LINTEL. The horizontal beam spanning an opening, as on the façade of Peruzzi's Palazzo Massimo alle Colonne (fig. 18.65).

LITANY. A form of group prayer consisting of a series of supplications by the clergy with responses from the congregation.

LITURGY. The ceremonies of public worship, including the required prayers and other readings.

LOGGIA (pl. LOGGIE). A gallery or ARCADE open to the air on at least one side; see Brunelleschi's Ospedale degli Innocenti (fig. 6.6).

MACHICOLATIONS. Openings in a projecting wall or parapet through which pitch or molten lead might be cast upon the enemy beneath; see the machicolations across the top of the Palazzo dei Priori in Florence (fig. 2.45).

MADONNA OF MERCY. A representation of the standing Virgin Mary protecting worshipers, usually kneeling, under her mantle. In Italian, *Madonna della Misericordia*. See the example by Piero della Francesca and others (fig. 11.21).

MAESTÀ. Italian term meaning Virgin in Majesty. A large ALTARPIECE of the Virgin enthroned, adored by saints and angels; see Duccio's *Maestà* for Siena Cathedral (fig. 4.2).

MANDORLA. From the Italian word for almond. An oval or almond-shaped halo that surrounds the body of a figure to indicate divinity or holiness; see the Florentine Baptistery mosaic (fig. 2.15), Giotto's *Last Judgment* (fig. 3.4), Orcagna's Strozzi altarpiece (fig. 5.1), and Nanni di Banco's *Assumption of the Virgin* (fig. 7.19). In Torriti's *Coronation of the Virgin*, the Virgin and Christ share a mandorla (fig. 2.21), but in the *Last Judgment* (fig. 4.31) they have individual mandorlas.

MANIERA. The name used here for a style that flourished in the Italian courts during much of the second half of the sixteenth century. Many of the works were designed to glorify dynastic rule, court society, and a formalized version of religion. Characterized by formal complexity, elongated figures, and allegorical conceits. See also MANNERISM.

MANNERISM. A complex artistic style that arose in the sixteenth century; for an explanation see pp. 620–21. See also MANIERA.

MASS. The celebration of the EUCHARIST to perpetuate the sacrifice of Christ upon the cross, including readings from one of the GOSPELS and an epistle; also the form of LITURGY used in this celebration.

MAZZOCCHIO. A wire or wicker frame around which a hood or *cappuccio* was wrapped to form a headdress commonly worn by fifteenth-century Florentine men; see Uccello's *Deluge* (fig. 11.3).

MERCANZIA, MERCATANZIA. The merchants' GUILD.

MINORITES. A name once used for the Franciscan Friars Minor, the largest of the three branches of the FRANCISCAN ORDER.

MITRE. A hat terminating in tall peaks at the front and back—the distinctive headdress of the pope, bishops, and abbots. Mitres are worn by St. Zenobius in Domenico Veneziano's St. Lucy altarpiece (fig. 11.8), the deceased in the tomb of the Cardinal Prince of Portugal (fig. 12.17), and St. Louis of Toulouse in Giovanni Bellini's San Giobbe altarpiece (fig. 15.40).

MONSTRANCE. An open or transparent receptacle of gold or silver in which the consecrated HOST is exposed for adoration; one is shown on the altar in Raphael's *Disputà* (fig. 17.48).

MOZZETTA. A cape with a hood worn by the pope and other dignitaries of the Church; see Titian's *Pope Paul III* (fig. 19.24).

MULLION. A vertical COLONNETTE or support dividing a window into two or more openings; see the Palazzo Medici (fig. 6.17).

NAVE. The large central hall, usually axial and often with a CLERESTORY, that characterizes the BASILICA plan; see Brunelleschi's Sto. Spirito (fig. 6.11).

NEOPLATONISM. A school of Greek philosophy established in Alexandria in the third century c.e. that was revived by Italian humanists in the fifteenth century. These scholars translated the works of Plato and Plotinus and tried to evolve a system that would reconcile Christian beliefs with Neoplatonic mystical thought. How much impact this movement had on art is still debated. See also PLATONIC ACADEMY.

NYMPHAEUM. Literally "a place for nymphs." A term used to describe a garden that uses pools, fountains, and statuary to create a secluded woodland effect. A semicircular nymphaeum is found behind Palladio's Villa Barbaro at Maser (figs. 19.73, 19.74).

OCULUS (pl. OCULI). A circular opening in a wall, as in the CLERESTORY and DRUM of the Cathedral of Florence (fig. 6.2) or at the apex of a DOME, as at Sta. Maria delle Carceri in Prato (fig. 12.29).

OIL PAINT. Pigments mixed with the slow-drying and flexible medium of oil and applied to a panel covered with GESSO, as in TEMPERA painting, or to a stretched canvas strengthened with a mixture of glue and white pigment.

OPERA DEL DUOMO. Board of Works of a CATHEDRAL, the organization that often functions as the PATRON for works of art created for the Cathedral. A cathedral museum is sometimes known as the Museo dell'Opera del Duomo.

ORATORY OF DIVINE LOVE. A CONFRATERNITY, founded in Rome, which received the grudging approval of Pope Leo X by 1517. Its goal was the reform of the Church from within, and it was pledged to the cultivation of the spiritual life of its members by prayer and frequent Communion and to the performance of charitable works. Dissolved in 1524. Its members expanded their original work into the newly founded THEATINE ORDER

ORDER (architectural). A series of Greek and Roman architectural systems that give aesthetic definition and decoration to the post-and-lintel system; an order is characterized by a COLUMN (usually including BASE, SHAFT, and CAPITAL) and its ENTABLATURE (including ARCHITRAVE, FRIEZE, and CORNICE). The five classical orders are the DORIC (fig. 17.9), IONIC (figs. 19.71, 20.47), CORINTHIAN (figs. 11, 17.16, 19.77), TUSCAN (fig. 18.65), and COMPOSITE (fig. 9.9). PILASTERS, or half-columns that span two stories of a structure, are referred to as examples of the GIANT or COLOSSAL ORDER.

ORDER (monastic). A religious society or fraternity living under a particular rule. See BENEDICTINE, CAMALDOLITE, CARMELITE, CARTHUSIAN, CISTERCIAN, DOMINICAN, FRANCISCAN, and THEATINE.

ORTHOGONALS. Lines running at right angles to the plane of the picture surface but, in a representation using one-point perspective, converging toward a common vanishing point in the distance; the orthogonals are clearly visible in the piazza of Perugino's *Christ Giving the Keys to St. Peter* (fig. 14.14). For a diagram see fig. 10.14.

PALAZZO (pl. *PALAZZI*). Italian word for palace, but during the Renaissance and later the word was also used for large civic or even religious buildings, as well as for relatively modest town houses.

PALLADIAN MOTIF. An arched opening supported by COLUMNS and flanked by narrow, flat-topped openings. This motif was popularized by Palladio (see his Basilica, fig. 19.69).

PALMETTES, PALMETTO DECORATION. An ancient decorative motif composed of long, thick palm fronds fanned out to form circular patterns, as in Donatello's *Cantoria* (fig. 10.24).

PASSION OF CHRIST. The sufferings of Christ during the last week of his earthly life or the representation of his sufferings in narrative or pictorial form as at Giotto's Arena Chapel (fig. 3.2), or in the cycle in the Collegiata at San Gimignano (figs. 4.18, 4.19).

PASTIGLIA. Raised plaster decoration, as seen in the letters that seem to be coming from Gabriel's mouth in Simone Martini and Lippomemmi's Annunciation with Two Saints (fig. 4.15) or on the frame of fig. 15.39.

PATEN. The shallow dish, usually circular, on which the HOST is laid during the EUCHARIST or MASS; see the paten resting atop the CHALICE in Andrea del Sarto's *Lamentation* (fig. 18.23).

PATRON. The person or group who commissions and pays for a work of art or architecture. The patron is sometimes represented in the work, as in Giotto's Arena Chapel (fig. 3.16), Masaccio's *Trinity* (fig. 8.26), and Mantegna's *Madonna of the Victory* (fig. 15.25). See also DONOR.

PENDENTIVE. In a domed structure, the four curved triangular segments that provide a transition from the four supporting piers to the DRUM or to the circular base of the DOME; see Brunelleschi's Pazzi Chapel (fig. 6.15) and Bramante's Santa Maria presso S. Satiro (fig. 17.4).

PERISTYLE. A COLONNADE or ARCADE around a building or open court; see the courtyard of the Palazzo Ducale at Urbino (fig. 14.27).

PIANO NOBILE. Italian phrase meaning noble floor or floor for the nobles. It refers to the second story of a building (American style; in European style this is called the first story), intended for the owner and family; see Bramante's Palazzo Caprini (fig. 17.20).

PIAZZA (pl. PIAZZE). Italian word for public square; see the huge piazza in Perugino's Christ Giving the Keys to St. Peter (fig. 14.14). See also CAMPO

PIER. A vertical architectural support used in an arched or vaulted structural system. Piers are usually rectangular in section, but if used with an ORDER, they may be decorated with half-columns or PILASTERS with BASES and CAPITALS of the same design. For an example see the interior of Florence Cathedral (fig. 5.14).

PIETÀ. Italian word meaning both pity and piety. It designates a representation of the dead Christ generally, but not always, mourned by the Virgin, and with or without saints and/or angels; see Michelangelo's Florence *Pietà* (fig. 20.18). When the representation shows a larger group of figures, it is usually termed a LAMENTATION; see the example by Andrea del Sarto (fig. 18.23).

PIETRA FORTE. The tan stone traditionally employed by Florentine builders. The Palazzo dei Priori in Florence is built of pietra forte; see fig. 2.45.

PIETRA SERENA. The gray Tuscan limestone used in Florence. Brunelleschi used *pietra serena* in the Ospedale degli Innocenti, the Pazzi Chapel, and many other structures (see figs. 6.6–6.12, 6.15).

PILASTER. A shallow, virtually flat vertical element having a CAPITAL and BASE. A pilaster is engaged in a wall, from which it projects, and is decorative rather than structural. See the exterior and interior of

Sant'Andrea in Mantua (figs. 10.6, 10.8) and of St. Peter's in Rome (figs. 15, 17.16, 20.12).

PINACOTECA. Italian word for picture gallery.

PINNACLE. A pointed ornamental motif used along the crest of paintings, sculptural niches, and buildings. It is mainly decorative and is especially common in the Gothic period; see the Siena Cathedral façade (fig. 2.33), Giotto's design for the Campanile in Florence (fig. 3.25), and the niche for Nanni di Banco's Four Crowned Martyrs (fig. 7.18).

PINXIT. Latin word for he/she painted; often used in artists' signatures. PLATONIC ACADEMY. An informal group of Florentine humanists and scholars, founded by Marsilio Ficino, who translated Plato and Plotinus into Latin. The academy's history is uncertain, but it was apparently encouraged by Cosimo de' Medici. See also NEOPLATONISM.

POLYCHROMY. The addition of many colors, especially to sculptures, to achieve a naturalistic or colorful effect; see Donatello's *Penitent Magdalen* (fig. 12.3).

POLYPTYCH. An ALTARPIECE or devotional object consisting of more than three sections joined together; see Pietro Lorenzetti's Pieve altarpiece (fig. 4.20) and Orcagna's Strozzi Chapel altarpiece (fig. 5.1).

PORPHYRY. A rare, hard, purplish red stone; the wall behind the tomb of the Cardinal of Portugal is porphyry (fig. 12.15). Sometimes Renaissance sculptors and architects used red marble or even red sandstone as a substitute.

PORTA CLAUSA. Latin phrase for closed door; refers to Ezekiel's vision of the door of the sanctuary in the Temple of Solomon in Jerusalem that was closed because only the Lord could enter it (Ezekiel 44:1–4). Interpreted as a prophecy and used as a symbol of Mary's virginity, often in scenes of the ANNUNCIATION; see the example by Piero della Francesca (fig. 11.30).

POUNCING. A method of transferring a CARTOON to a surface preparatory to painting. Small holes pricked along the outlines of the drawing are dusted with powdered charcoal so that the lines of the composition are transferred to the surface beneath. The cartoon used in this method is called a *SPOLVERO*. Piero della Francesca often used pounced cartoons and the *spolvero* technique to transfer his carefully designed heads to the FRESCO surface in his cycle at San Francesco in Arezzo; see figs. 11.26, 11.28.

PREDELLA. Pedestal of an ALTARPIECE, usually decorated with small narrative scenes; see Orcagna's Strozzi Chapel altarpiece (fig. 5.1), Lorenzo Monaco's Coronation of the Virgin (fig. 5.12), and Gentile da Fabriano's Adoration of the Magi (fig. 8.2).

PRIE-DIEU. French phrase literally meaning "pray God." A small prayer desk with a footpiece on which to kneel and a support to hold a book; a *prie-dieu* is visible behind the Virgin Mary in Lotto's *Annunciation* (fig. 19.32).

PRIORI. Italian word for priors, the council or principal governing body of a town.

PUNCH WORK. The addition of patterned effects by using stamps that indent the surface of a panel painting; see figs. 4.13, 4.15.

PUTTO (pl. **PUTTI**). A figure of a male baby, often winged, that is used in Renaissance painting, sculpture, and architectural decoration. Sometimes these figures personify love and are called cupids or *amoretti*; sometimes they are intended to represent angels and are called *angeletti*. Often they are purely decorative. The term putto is of modern application; documents sometimes refer to these figures as *spiritelli*. They are especially common in the art of Donatello; see his *Annunciation* (fig. 10.27) and also the putti on Desiderio's Marsuppini tomb (figs. 12.9, 12.10).

QUATREFOIL. The elegant French Gothic shape used, for example, for the first two sets of bronze doors created for the Florentine Baptistery, by Andrea Pisano and Lorenzo Ghiberti; see figs. 3.34, 7.4, 7.6.

QUATTROCENTO. Italian word for four hundred, used to refer to the 1400s—the fifteenth century.

QUOIN. Larger, heavier blocks of stone used along the corners to define and frame an architectural structure; see figs. 16.11, 18.62, 20.46.

REFECTORY. The dining hall of a monastery, often decorated with a painting of the Last Supper (see Leonardo's *Last Supper*; fig. 16.22). See also *CENACOLO*.

RELIEF. Sculpture in which the figures or forms are united with a background and project from it. It is called high relief (fig. 2.38) or low relief (figs. 10.33, 10.34) depending on the amount of projection. Ghiberti and Donatello evolved a kind of relief that combined high and low relief called pictorial relief (see figs. 7.23, 10.18). See also *RILIEVO SCHIACCIATO*.

RESURRECTION. The rising again of Christ on the third day after his death and burial, a scene mentioned in the GOSPELS but not directly described; see the examples by Piero della Francesca and Michelangelo (figs. 11.23, 18.7).

RIBBED VAULT. A GROIN VAULT whose groins are accentuated by projecting stone ribs; see Sta. Maria Novella (fig. 2.41).

RILIEVO SCHIACCIATO. Italian term for flattened RELIEF; refers to a kind of sculpture initiated by Donatello in which distance and perspective are achieved by optical suggestion rather than sculptural projection; see Donatello's St. George and the Dragon (fig. 7.17) and Michelangelo's Madonna of the Stairs (fig. 16.31).

RINCEAU (pl. RINCEAUX). An ancient decorative motif composed of the leafy tendrils of a vine, usually arranged to form a pattern of repeated spirals; see the altar in Ghiberti's competition panel (figs. 7.2, 7.3).

ROSARY. A string of beads ending in a crucifix. The form in present use was developed by the DOMINICAN ORDER as an aid to memory in the recitation of prayers. In the fifteenth and sixteenth centuries there were many forms of rosaries; see fig. 15.59.

RUSTICATION. Protruding masonry, frequently with a roughened surface; see the Palazzo dei Priori (fig. 2.45), the Palazzo Pitti (fig. 10.13), Giulio Romano's Palazzo del Te (fig. 18.68), and Ammanati's courtyard of the Palazzo Pitti (fig. 20.28).

SACRA CONVERSAZIONE. Italian term for sacred conversation. A Madonna and Child accompanied by four or more saints either conversing or silently communing in a unified, continuous space; see Mantegna's S. Zeno altarpiece (fig. 15.16) and Bellini's S. Zaccaria altarpiece (fig. 15.43).

SACRISTY. The room near the high altar where the clothing and objects needed for the MASS are stored and where the persons involved in the ceremony dress; see the Sacristy of Florence Cathedral, with its elaborate *INTARSIA* decoration (fig. 12.20).

SALA. Italian word for room or hall.

SCUOLA (pl. SCUOLE). See COMPANY.

SERAPH (pl. SERAPHIM). A celestial being or angel of the highest order, usually represented with three sets of wings and sometimes shown as a head with wings; see the seraphim that compose the MANDORLA of Christ in Orcagna's Strozzi altarpiece (fig. 5.1) and of Sassetta's *St. Francis in Ecstasy* (fig. 14.1). See also CHERUB.

SFUMATO. Italian term for smoky, used for the method developed by Leonardo da Vinci of modeling figures by virtually imperceptible gradations from light to dark; see the *Madonna of the Rocks* (fig. 16.17).

SGRAFFITO (pl. SGRAFFITI). A technique of scratched and tinted designs in plaster used for Florentine house façades; seen in the FRIEZE of the Palazzo Medici courtyard (fig. 6.19). Also any drawings or writings scratched on a wall.

SHAFT. A cylindrical form; in architecture, the part of a COLUMN or PIER between BASE and CAPITAL; see the courtyard of the Palazzo Ducale at Urbino (fig. 14.27).

SIBYLS. Greek and Roman prophetesses who were thought to have foretold the coming of Christ; see Michelangelo's Sistine Ceiling (figs. 17.32, 17.39). Rather than being known by individual names, the sibyls are known by their location; thus the Delphic Sibyl is from Delphi, the Cumaean Sibyl from Cumae, and the Tibertine Sibyl, from Rome, is named for the Tiber River.

SIDE AISLE. One of the corridors parallel to the NAVE of a church, separated from it by an ARCADE or COLONNADE; see the side aisles flanking the nave in Brunelleschi's Sto. Spirito (fig. 6.11).

SIGNORIA. Italian word for lordship, used to refer to the governing bodies of Florence.

SILVERPOINT. A drawing made with a slender silver rod or wire on paper coated with a colored, slightly grainy preparation; see Leonardo's Study of Drapery (fig. 16.12) and the Study of the Head of the Angel (fig. 16.19)

SINOPIA. Preliminary brush drawing, in red earth mixed with water, for a painting in FRESCO; usually done on the *ARRICCIO* of the wall; see figs. 1.16, 1.17. This Italian term derives from the city of Sinope in Asia Minor which was famous for its red earth.

SOFFIT. The underside of an ARCH, as seen in the background in fig. 14.22.

SPALLIERA (pl. *SPALLIERE*). Italian term for one of the large horizontal paintings placed in a Florentine Renaissance home high on the wall, above the paneled wainscoting. Botticelli's *Venus and Mars* (fig. 13.24) may originally have functioned in this manner.

SPANDREL. The roughly triangular area between two adjoining ARCHES; see the sequence of spandrels in the courtyard of the Palazzo Ducale at Urbino (fig. 14.27) and the spandrels on either side of the arch in Foppa's *Crucifixion* (fig. 15.52).

SPOLVERO. Italian term for dust off, used for a preparatory drawing employed to transfer a CARTOON to a surface for painting in the method known as POUNCING. Small holes pricked along the outlines of the drawing are dusted with powdered charcoal so that the lines of the composition are transferred to the surface beneath. Piero della Francesca often used pounced cartoons and the *spolvero* technique to transfer his carefully designed heads to the FRESCO surface in his cycle at San Francesco in Arezzo; see figs. 11.26, 11.28.

STANZA (pl. *STANZE*). Italian word for room, as in the *stanze* that Raphael painted for Pope Julius II (see figs. 17.47, 17.49, 17.52, 17.53).

STIGMATA. Marks corresponding to the wounds of the crucified Christ that appear on the hands, feet, and side of religious persons after prolonged meditation. They are believed to be a token of divine favor. St. Francis, the example most frequently represented, is said to have received the stigmata in 1224; see Giotto's and Giovanni Bellini's representations of this scene (figs. 3.24, 15.42).

STORIA. Italian term for story or history, used by Alberti to refer to a representation of an historical narrative or episode. See also *ISTORIA*.

STRINGCOURSE. In architecture, a horizontal band decorating and uniting the surface of a building, as seen in fig. 18.62.

STUDIOLO. Italian for small study; used to describe the small, specially decorated chambers in Renaissance PALAZZI where books, works of art, and objects of historical and scientific interest were kept; see the Studiolo of Federico da Montefeltro in the Palazzo Ducale, Urbino (fig. 14.29).

STYLOBATE. The platform on which COLUMNS rest. The top step of Brunelleschi's Ospedale degli Innocenti (fig. 6.6) is the stylobate.

TABERNACLE. An elegant classicizing frame, usually at least somewhat three-dimensional. Also used to describe a shrine intended to contain the consecrated bread and wine. For tabernacle windows see figs. 18.3, 20.28; for tabernacle niches see fig. 18.11.

TEMPERA. Ground colors mixed with yolk of egg; see fig. 1.12 for a diagram of a typical tempera painting. Tempera was widely used for Italian panel painting before the sixteenth century.

TEMPLE. Non-Christian religious structure.

TERRA-COTTA. Italian word for baked earth. A hard glazed or unglazed earthenware used for sculpture and pottery or as a building material. The word can also mean something made of this material or the color of it, a dull brownish-red. Terra-cotta PUTTI decorate the top of Donatello's *Annunciation* (fig. 10.27).

TERRA VERDE. Italian for green earth, the color used for the underpaint of flesh tones in TEMPERA painting and sometimes as the main color for FRESCOES, as in Uccello's Chiostro Verde frescoes (figs. 11.3, 11.4).

THEATINE ORDER. Founded jointly in 1524 by St. Cajetan and Giovanni Carafa (later Pope Paul IV). Also called the Society of Clerks Regular. It presented a new model of deportment marked by extreme austerity, a devotion to pastoral work, and a strong emphasis on prayer and EUCHARISTIC devotion.

TIARA (papal). The pope's pointed crown, which is surmounted by the orb and cross; earlier it was quite simple, as is shown in Maso di Banco's fresco of St. Sylvester (fig. 3.28), but later examples have three crowned tiers, as in Raphael's *Sistine Madonna* (fig. 17.54). An emblem of the pope's sovereign power, it has little sacred character and is not worn during celebrations of the MASS, at which time the pope wears a MITRE.

TIE-ROD. An iron rod used structurally to keep the base of an ARCH or VAULT from spreading; tie-rods are visible at the Arena Chapel (fig. 3.2), Florence Cathedral (see fig. 5.14), and Santa Maria Gloriosa dei Frari (figs. 1, 5.17), and there is even one in Giovanni Bellini's S. Zaccaria altarpiece (fig. 15.43).

TITULUS. Latin term for inscription; also the name given to the label that Pilate ordered to be placed on the cross of Christ (John 19:19–20). In paintings and sculptures it often bears the initials INRI, the abbreviation for Jesus Nazarenus Rex Judaeorum—Jesus of Nazareth, King of the Jews. For examples see paintings by Coppo di Marcovaldo (fig. 2.11), Perugino (fig. 14.16), Mantegna (fig. 15.19), and Antonello da Messina (fig. 15.34). Also known as a *CARTELLINO*.

TONDO. Italian term for circular painting or RELIEF; see Domenico Veneziano's Adoration of the Magi (fig. 11.7) and Michelangelo's Doni Madonna (fig. 16.37).

TRANSEPT. In a cross-shaped Christian church, the crossarms placed perpendicular to the NAVE. The transepts usually separate the NAVE from the CHANCEL or APSE; see the plans in figs. 6.12, 10.7.

TRANSVERSALS. In a scientific perspective composition, the horizontal lines that run parallel to the picture plane and intersect the ORTHOGONALS; the transversals are clearly visible in the piazza in Perugino's Christ Giving the Keys to St. Peter (fig. 14.14). For a diagram see fig. 10.14.

TRAVERTINE. A light-colored porous limestone used in Italy, especially Rome, for building. The exteriors of St. Peter's and of the Palazzo dei Conservatori on the Capitoline are largely of travertine; see figs. 15, 20.12, 20.16.

TRECENTO. Italian word for three hundred, used to refer to the 1300s—the fourteenth century.

TRIGLYPH. In the DORIC ORDER, the element in the FRIEZE that seems to be composed of three vertical rectangles, as seen in the ENTABLATURE in fig. 18.66.

TRIPTYCH. An ALTARPIECE or devotional object consisting of three sections; see Nardo's *Madonna and Child with Saints* (figs. 1.15, 5.6) and also figs. 4.24, 8.6.

TROMPE L'OEIL. From the French for "fool/trick the eye." A kind of illusionistic painting or, much less frequently, sculpture, that emphasizes naturalistic effects and scale in an effort to convince the viewer that the object or scene represented is real and not painted or sculpted, as in Mantegna's Camera picta (fig. 15.24) or Veronese's frescoes in the Villa Barbaro at Maser (fig. 19.56).

TUSCAN ORDER. See ORDER.

ULTRAMARINE. An intense blue pigment made from pulverized lapis lazuli, a semiprecious stone found in the Near East. Documents of commission often specified that painters use ultramarine for such important areas as the Virgin Mary's mantle.

VAULT. A structural system based on the ARCH and including the BARREL VAULT, GROIN VAULT, RIBBED VAULT, and DOME.

VICES. Coming from the same tradition as the VIRTUES, and frequently paired with them, they are more variable but usually include Pride, Avarice, Wrath, Gluttony, and Lust. Others such as Folly, Inconstancy, and Injustice are selected to make a total of seven. Seven virtues and seven vices are paired in the bottom register of Giotto's Arena Chapel (figs. 3.4, 3.17–3.19).

VIRTUES. Divided into the three Theological Virtues of Faith, Hope, and Charity, and the four Cardinal Virtues of Prudence, Justice, Fortitude, and Temperance. As with the VICES, the allegorical representation of the Virtues as human figures in the Renaissance derives from a long medieval tradition in manuscripts and sculpture and from such literary sources as the *Psychomachia* of Prudentius and writings of St. Augustine, with their commentaries. Seven virtues and seven vices are paired in the bottom register of Giotto's Arena Chapel (figs. 3.4, 3.17–3.19).

VOLGARE. Italian word for vulgar or "of the people"; used to denote the developing Italian language as distinct from Latin.

VOLUTE. Ornament resembling a rolled scroll. Especially prominent on CAPITALS of the Ionic and Composite ORDERS; see figs. 3, 6.8, 9.9, 19.71, 20.47.

VULGATE. The Latin version of the Bible that St. Jerome prepared at the end of the fourth century c.e.

WASH. A broad thin layer of diluted pigment or ink used to create shadows in some drawings to enhance the effect of shadow. Also refers to a drawing made in this technique. Wash is used to create shadows in Leonardo da Vinci's preparatory drawing of the *Adoration of the Magi* (fig. 16.15).

BIBLIOGRAPHY

Because of the extensive recent publications in the field of Renaissance art, the bibliography has been updated for this edition. Preference has been given to the most important recent books and to books in English. Additional bibliographies in greater depth can be found in virtually all the volumes listed here. Sources for periodical articles, which often offer the most important updated ideas about the period and its artists, include the *Bibliography of the History of Art* and the *Art Index* (available on CD-ROM). *Dissertation Abstracts*, another useful tool in the search for new research, is also available online. This bibliography was compiled with the aid of Ray Anne Lockard, Head Librarian, Frick Fine Arts Library, University of Pittsburgh.

I. GENERAL SURVEYS

- ADAMS, LAURIE SCHNEIDER, *Italian Renaissance Art*, Westview, Boulder, Colo., and London, 2001.
- ——, Key Monuments of the Italian Renaissance, Westview, Boulder, Colo., 2000.
- ASTON, MARGARET, ed., *The Panorama of the Renaissance*, Thames & Hudson, London, 1996.
- GRAHAM-DIXON, ANDREW, Renaissance, BBC, London, 1999.
- PAOLETTI, JOHN T., and RADKE, GARY M., Art in Renaissance Italy, 2nd ed., Harry N. Abrams, New York, 2002.
- TURNER, JANE, ed., Encyclopedia of Italian Renaissance and Mannerist Art, Grove's Dictionaries, New York, 1999.

II. BIBLIOGRAPHIES

- DUNKELMAN, MARTHA LEVINE, Central Italian Painting, 1400–1465: An Annotated Bibliography, G. K. Hall, Boston, 1986.
- KARPINSKI, CAROLINE, Italian Printmaking, Fifteenth and Sixteenth Centuries: An Annotated Bibliography, G. K. Hall, Boston, 1987.
- ROSENBERG, CHARLES M., Fifteenth-Century North Italian Painting and Drawing: An Annotated Bibliography, G. K. Hall, Boston, 1986.
- STUBBLEBINE, JAMES H., Dugento Painting: An Annotated Bibliography, G. K. Hall, Boston, 1983.
- WILK, SARAH BLAKE, Fifteenth-Century Central Italian Sculpture: An Annotated Bibliography, G. K. Hall, Boston, 1986.

III. PRIMARY SOURCES: ANTHOLOGIES

- CHAMBERS, DAVID, *Patrons and Artists in the Italian Renaissance*, University of South Carolina Press, Columbia, 1971.
- GILBERT, CREIGHTON E., Italian Art, 1400–1500: Sources and Documents in the History of Art, Northwestern University Press, Evanston, Ill., 1992.
- GLASSER, HANNELORE, Artists' Contracts of the Early Renaissance, Garland, New York, 1977.
- HOLT, ELIZABETH, *Literary Sources of Art History*, Princeton University Press, Princeton, N.J., 1947 (paperback edition entitled *A Documentary History of Art*).
- KLEIN, ROBERT, and ZERNER, HENRI, *Italian Art*, 1500–1600: Sources and Documents in the History of Art, Prentice Hall, London, 1966.

IV. PRIMARY SOURCES: WRITINGS BY RENAISSANCE INDIVIDUALS

- ALBERTI, LEON BATTISTA, *On Painting*, edited by Martin Kemp, trans. by Cecil Grayson, Penguin Books, Harmondsworth, 1991.
- ——, On Painting and on Sculpture, the Latin Texts of De Pictura and De Statua, edited with translation, introduction and notes by Cecil Grayson, Phaidon, London, 1972.
- ——, Ten Books on Architecture, edited by J. Rykwert, trans. by J. Leoni, Tiranti, London, 1955.

- ANTONINE OF FLORENCE, SAINT, *Lettere*, Florence, 1736; reprinted Tipografica Barbèra, Bianchi e C, Florence, 1859.
- —, Opera a benvivere, Venice, 1578; reprinted Libreria editrice fiorentina, Florence, 1923.
- —, Opus chronicorum, Venice, [1480?]; Lyons, 1587.
- ——, Summa theologica, Venice, 1480; reprinted Verona, 1740; reprinted Akademische Druck und Verlagsanstalt, Graz, 1959.
- BAROCCHI, PAOLA, Trattati d'arte del Cinquecento fra Manierismo e Controriforma, 3 vols., Laterza, Bari, 1960-62.
- CASTIGLIONE, BALDASSARE, *The Book of the Courtier*, Penguin Books, Harmondsworth, 1992.
- CELLINI, BENVENUTO, *The Autobiography of Benvenuto Cellini*, trans. by George Bull, Penguin Books, Harmondsworth, 1998.
- CENNINI, CENNINO, The Craftsman's Handbook (Il libro dell'arte), trans. by D. V. Thompson, Jr., Dover, New York, 1954.
- CONDIVI, ASCANIO, *The Life of Michelangelo*, edited by Hellmut Wohl, Phaidon, Oxford, 1976.
- FILARETE (ANTONIO AVERLINO), Treatise on Architecture, trans. with an introduction and notes by J. R. Spencer, 2 vols., Yale University Press, New Haven, Conn., 1965.
- GHIBERTI, LORENZO, I Commentarii, edited by Lorenzo Bartoli, Giunti, Florence, 1998.
- LEONARDO DA VINCI, Leonardo da Vinci on Painting: A Lost Book (Libro A), edited by C. Pedretti, Peter Owen, London, 1965.
- ——, Leonardo on Painting: An Anthology of Writings by Leonardo da Vinci with a Selection of Documents Relating to His Career as an Artist, edited by Martin Kemp and Margaret Walker, Yale University Press, New Haven, Conn., 1989.
- ——, The Literary Works of Leonardo da Vinci, edited by J. P. Richter, Phaidon, London, 1970.
- ——, The Notebooks of Leonardo da Vinci, edited by E. MacCurdy, G. Braziller, New York, 1955.
- ——, *Treatise on Painting*, trans. and annotated by A. P. McMahon, 2 vols., Princeton University Press, Princeton, N.J., 1956.
- MANETTI, ANTONIO DI TUCCIO, *The Life of Brunelleschi by Antonio di Tuccio Manetti*, edited by Howard Saalman, Pennsylvania State University Press, University Park, and London, 1970.
- MARTINI, FRANCESCO DI GIORGIO, *Trattati di Architettura*, *Ingegneria e Arte Militare*, edited by Corrado Maltese, 2 vols., Milan, 1967.
- MICHELANGELO, Complete Poems and Selected Letters of Michelangelo, 2nd ed., edited by R. N. Linscott, trans. by C. Gilbert, Random House, New York, 1965.
- ——, The Letters of Michelangelo, edited and trans. by E. H. Ramsden, Peter Owen, London, 1963.
- ——, *The Poetry of Michelangelo*, edited by James Saslow, Yale University Press, New Haven, Conn., 1991.
- PALLADIO, ANDREA, I Quattro Libri dell'architettura, Venice, 1570; reprinted in facsimile by Hoepli, Milan, 1951; reprinted Harvard University Press, Cambridge, Mass., 1997.
- PICCOLOMINI, ENEA SILVIO, *I Commentari*, edited by Mino Marchetti, 2 vols., Cantagalli, Siena, 1997.
- RIDOLFI, CARLO, The Life of Titian, edited by Julia Conaway Bondanella, trans. by Julia Conaway Bondanella and Peter Bondanella, Pennsylvania State University Press, University Park, 1996.
- SERLIO, SEBASTIANO, Sebastiano Serlio on Architecture, trans. by Vaughan Hart and Peter Hicks, 2 vols., Yale University Press, New Haven, Conn., 1996–2001.

- VASARI, GIORGIO, *Lives of the Most Eminent Painters, Sculptors, and Architects*, trans. by G. du C. De Vere, 10 vols., Medici Society, London, 1912–15.
- ——, Vasari on Technique, edited by G. B. Brown, Dover, New York, 1960.
 VIGNOLA, GIACOMO BAROZZI DA, Regola delli Cinque Ordini di Architettura, Rome, 1562.

V. THEORY

- BLUNT, ANTHONY, Artistic Theory in Italy, 1450–1600, Clarendon Press, Oxford, 1966.
- EDGERTON, SAMUEL Y., The Heritage of Giotto's Geometry: Art and Science on the Eve of the Scientific Revolution, Cornell University Press, Ithaca, N.Y., 1991.
- ——, The Renaissance Rediscovery of Linear Perspective, Harper and Row, London, 1976.
- FREEDBERG, DAVID, *The Power of Images*, University of Chicago Press, Chicago, 1989.
- PANOFSKY, ERWIN, *Meaning in the Visual Arts*, Doubleday, Garden City, N.Y., 1957.
- —, Studies in Iconology: Humanistic Themes in the Art of the Renaissance, Oxford University Press, Oxford, 1939.
- ROSKILL, MARK W., Dolce's Aretino and Venetian Art Theory of the Cinquecento, University of Toronto Press, Toronto, 2000.
- SUMMERS, DAVID, *The Judgment of Sense*, Cambridge University Press, Cambridge, 1990.
- ——, Michelangelo and the Language of Art, Princeton University Press, Princeton, N.J., 1981.
- WILLIAMS, ROBERT, Art Theory and Culture in Sixteenth-Century Italy: From Techne to Metatechne, Cambridge University Press, Cambridge, 1997.
- WOHL, HELLMUT, Aesthetics in Italian Renaissance Art, Cambridge University Press, Cambridge, 1999.

VI. ITALIAN ART AND ITS SOCIAL, HISTORICAL AND CULTURAL BACKGROUND

- AMES-LEWIS, FRANCIS, The Intellectual Life of the Early Renaissance Artist, Yale University Press, New Haven, Conn., 2000.
- ——, and BEDNAREK, ANKA, eds., Decorum in Renaissance Narrative Art, Birbeck College, London, 1992.
- ——, and ROGERS, MARY, eds., Concepts of Beauty in Renaissance Art, Ashgate, Aldershot, 1998.
- ANDREWS, LEW, Story and Space in Renaissance Art: The Rebirth of Continuous Narrative, Cambridge University Press, Cambridge, 1995.
- ARNOLD, LAUREN, Princely Gifts and Papal Treasures: The Franciscan Mission to China and Its Influence on the Art of the West, 1250–1350, Desiderata Press, San Francisco, 1999.
- BARKAN, LEONARD, Unearthing the Past: Archeology and Aesthetics in the Making of Renaissance Culture, Yale University Press, New Haven, Conn., 1999.
- BARKER, EMMA, WEBB, NICK, and WOODS, KIM, The Changing Status of the Artist, Yale University Press, New Haven, Conn., 1999.
- BAROLSKY, PAUL, Faun in the Garden: Michelangelo and the Poetic Origins of Italian Renaissance Art, Pennsylvania State University Press, University Park, 1994.
- ——, Giotto's Father and the Family of Vasari's Lives, Pennsylvania State University Press, University Park, 1991.
- ——, Infinite Jest: Wit and Humor in Italian Renaissance Art, University of Missouri Press, Columbia, Mo., 1978.
- —, Michelangelo's Nose: A Myth and Its Make, Pennsylvania State University Press, 1990.
- , Why Mona Lisa Smiles and Other Tales by Vasari, Pennsylvania State University Press, University Park, 1991.
- BARON, HANS, *The Crisis of the Early Italian Renaissance*, rev. ed., 2 vols., Princeton University Press, Princeton, N.J., 1966.

- BAXANDALL, MICHAEL, Giotto and the Orators: Humanist Observers of Painting in Italy and the Discovery of Pictorial Composition 1300–1450, Clarendon Press, Oxford, 1971.
- ——, Painting and Experience in Fifteenth-Century Italy: A Primer in the Social History of Pictorial Style, 2nd ed., Oxford University Press, Oxford, 1988.
- BELL, RUDOLPH M., How To Do It: Guides to Good Living for Renaissance Italians, University of Chicago Press, Chicago, 1999.
- BOBER, PHYLLIS PRAY, and RUBINSTEIN, R. O., Renaissance Artists and Antique Sculpture: A Handbook of Sources, Harvey Miller, London, 1986.
- BURCKHARDT, JACOB, The Altarpiece in Renaissance Italy, Phaidon, Oxford, 1988.
- ——, The Civilization of the Renaissance in Italy, trans. by S. G. Middlemore, Phaidon, Oxford, 1965.
- BURKE, PETER, The European Renaissance: Centres and Peripheries, Blackwell Publishers, Oxford, 1998.
- ——, The Fortunes of the Courtier: The European Reception of Castiglione's Cortegiano, Polity Press, London, 1995.
- CAFRITZ, ROBERT, *Places of Delight: The Pastoral Landscape*, Phillips Collection in association with the National Gallery of Art, Washington, D.C., 1988.
- CAMPBELL, LORNE, *Renaissance Portraits*, Yale University Press, New Haven, Conn., 1990.
- CANNON, JOANNA, and WILLIAMSON, BETH, eds., Art, Politics, and Civic Religion in Central Italy, 1261–1352, Ashgate, Aldershot, 2000.
- CARLINO, ANDREA, Books of the Body: Anatomical Ritual and Renaissance Learning, University of Chicago Press, Chicago, 1999.
- CARMAN, CHARLES H., Images of Humanist Ideals in Italian Renaissance Art, Edwin Mellen Press, Lewiston, N.Y., 2000.
- CHASTEL, ANDRÉ, *The Age of Humanism: Europe 1480–1530*, trans. by K. M. Delavenay and E. M. Gwyer, McGraw-Hill, New York, 1964.
- The Crisis of the Renaissance, 1520-1600, Skira, Geneva, 1968.
- ——, Studios and Styles of the Italian Renaissance, trans. by J. Griffin, Thames & Hudson, London, 1966.
- COLE, ALISON, Virtue and Magnificence: Art of the Italian Renaissance Courts, Harry N. Abrams, New York, 1995.
- COLE, BRUCE, Italian Art, 1250–1550: The Relation of Renaissance Art to Life and Society, Harper and Row, London, 1987.
- —, The Renaissance Artist at Work, from Pisano to Titian, John Murray, London, 1983.
- COSGROVE, DENIS, The Palladian Landscape: Geographical Change and Its Cultural Representations in Sixteenth-Century Italy, Leicester University Press, Leicester, 1992.
- CRANSTON, JODI, *The Poetics of Portraiture in the Italian Renaissance*, Cambridge University Press, Cambridge, 2000.
- DEMPSEY, CHARLES, *Inventing the Renaissance Putto*, University of North Carolina Press, Chapel Hill, 2001.
- DERBES, ANNE, Picturing the Passion in Late Medieval Italy: Narrative Painting, Franciscan Ideologies, and the Levant, Cambridge University Press, Cambridge, 1996.
- EMISON, PATRICIA, Low and High Style in Italian Renaissance Art, Garland, New York, 1997.
- FLEMING, JOHN, From Bonaventura to Bellini: An Essay in Franciscan Exegesis, Princeton University Press, Princeton, N.J., 1982.
- GARDNER, JULIAN, Patrons, Painters, and Saints: Studies in Medieval Italian Painting, Variorum, Aldershot, 1993.
- GOLDTHWAITE, RICHARD A., Wealth and the Demand for Art in Italy 1300–1600, Johns Hopkins University Press, Baltimore, 1993.
- GOMBRICH, ERNST H., New Light on Old Masters, Phaidon, Oxford, 1986.
- —, Norm and Form: Studies in the Art of the Renaissance, Phaidon, London, 1966.
- HALE, J. R., Artists and Warfare in the Renaissance, Yale University Press, New Haven, Conn., 1990.
- HARRIES, KARSTEN, Infinity and Perspective, MIT Press, Cambridge, Mass., 2001.

- HAUSER, ARNOLD, *The Social History of Art*, trans. in collaboration with the author by S. Goodman, Routledge & Kegan Paul, London, 1951.
- HAYWARD, J. L., Virtuoso Goldsmiths and the Triumph of Mannerism, Sotheby Parke-Bernet, New York, 1976.
- HERLIHY, DAVID, and KLAPISCH-ZUBER, CHRISTIANE, *The Tuscans and Their Families*, Yale University Press, New Haven, Conn., 1985.
- HOLMES, GEORGE, Florence, Rome, and the Origins of the Renaissance, Clarendon Press, Oxford, 1986.
- HUGHES, GRAHAM, Renaissance Cassoni: Masterpieces of Early Italian Art: Painted Marriage Chests 1400–1550, Art Books International, London, 1997.
- Images of the Individual: Portraits in the Renaissance, British Museum, London, 1998.
- JARDINE, LISA, and BROTTO, JERRY, Global Interests: Renaissance Art Between East and West, Reaktion, London, 2000.
- JONES, ANN ROSALIND, and STALLYBRASS, PETER, Renaissance Clothing and the Materials of Memory, Cambridge University Press, Cambridge, 2000.
- KEMP, MARTIN, Behind the Picture: Art and Evidence in the Italian Renaissance, Yale University Press, New Haven, Conn., 1997.
- ——, Geometrical Perspective from Brunelleschi to Desargues: A Pictorial Means or an Intellectual End?, Oxford University Press, Oxford, 1985.
- ——, The Science of Art: Optical Themes in Western Art from Brunelleschi to Seurat, Yale University Press, New Haven, Conn., 1989.
- KRISTELLER, PAUL O., *Renaissance Thought and Its Sources*, Columbia University Press, New York, 1979.
- KUHN, RUDOLF, On Composition as Method and Topic: Studies in the Work of L. B. Alberti, Leonardo, Michelangelo, Raphael, Rubens, Picasso, Bernini, and Ignaz Günther, Peter Lang, New York, 2000.
- LADIS, ANDREW, and WOOD, CAROLYN, eds., The Craft of Art: Originality and Industry in the Italian Renaissance and Baroque Workshop, University of Georgia Press, Athens, 1995.
- LARNER, JOHN, Culture and Society in Italy, 1290–1420, Scribner's, New York, 1971.
- LESNICK, DANIEL R., Preaching in Medieval Florence: The Social World of Franciscan and Dominican Spirituality, University of Georgia Press, Athens, 1989.
- LEVENSON, JAY A., ed., Circa 1492: Art in the Age of Exploration., Yale University Press, New Haven, Conn., 1991.
- LEVEY, MICHAEL, *High Renaissance*, Penguin Books, Harmondsworth, 1975.
- MACK, ROSAMOND E., Bazaar to Piazza: Islamic Trade and Italian Art, University of California Press, Berkeley, 2002.
- MANCA, JOSEPH, Moral Essays on the High Renaissance: Art in Italy in the Age of Michelangelo, University Press of America, Lanham, Md., 2001.
- MARTINDALE, ANDREW, The Rise of the Artist in the Middle Ages and the Early Renaissance, McGraw-Hill, New York, 1972.
- MUSACCHIO, JACQUELINE MARIE, *The Art and Ritual of Childbirth in Renaissance Italy*, Yale University Press, New Haven, Conn., 1999.
- NELSON, ROBERT S., ed., Visuality Before and Beyond the Renaissance, Cambridge University Press, Cambridge, 2000.
- NORMAN, DIANA, ed., Siena, Florence, and Padua: Art, Society, and Religion 1280–1400, 2 vols., Yale University Press, New Haven, Conn., 1995.
- NORTH, MICHAEL, and ORMROD, DAVID, eds., *Art Markets in Europe*, 1400–1800, Ashgate, Aldershot, 1998.
- PANE, ROBERTO, *Il rinascimento nell'Italia meridinale*, 2 vols., Edizioni di Comunità, Milan, 1975–77.
- PANOFSKY, ERWIN, Renaissance and Renascences in Western Art, 2 vols., Almquist and Wiksell, Stockholm, 1960 (1 vol. ed., 1965).
- POPE-HENNESSY, JOHN, *The Portrait in the Renaissance*, Princeton University Press, Princeton, N.J., 1966.
- RICHARDSON, BRIAN, Printing, Writers, and Readers in Renaissance Italy, Cambridge University Press, Cambridge, 1999.
- RICKETTS, JILL M., Visualizing Boccaccio: Studies in Illustrations of the Decameron from Giotto to Pasolini, Cambridge University Press, Cambridge, 1997.

- ROGERS, MARY, ed., Fashioning Identities in Renaissance Art, Ashgate, Aldershot. 2000.
- ROSENBERG, CHARLES M., ed., Art and Politics in Late Medieval and Early Renaissance Italy, University of Notre Dame Press, Notre Dame, Ind., 1990.
- RUBIN, PATRICIA LEE, and WRIGHT, ALISON, with PENNY, NICHOLAS, Renaissance Florence: The Art of the 1470s, National Gallery, London, 1999.
- RUNDLE, DAVID, The Hutchinson Encyclopedia of the Renaissance, Helicon, Oxford, 1999.
- SASLOW, JAMES M., Ganymede in the Renaissance, Yale University Press, New York, Conn., 1986.
- SCHMIDT, VICTOR, ed., Italian Panel Painting of the Duecento and Trecento, National Gallery of Art, Washington, D.C., 2002.
- SCHULTZ, BERNARD, Art and Anatomy in Renaissance Italy, UMI Research Press, Ann Arbor, Mich., 1985.
- SEZNEC, JEAN, The Survival of the Pagan Gods: The Mythological Tradition and Its Place in Renaissance Humanism and Art, trans. by B. Sessions, Princeton University Press, Princeton, N.J., 1953.
- SHAW, CHRISTINE, *The Politics of Exile in Renaissance Italy*, Cambridge University Press, Cambridge, 2000.
- SHEARMAN, JOHN, Mannerism, Penguin Books, Harmondsworth, 1967.
 —, Only Connect Art and the Spectator in the Italian Renaissance,
 Princeton University Press, Princeton, N.J., 1992.
- SMYTH, CRAIG H., Mannerism and Maniera, Augustin, Locust Valley, N.Y., 1961.
- STARN, RUDOLPH, and PARTRIDGE, LOREN, *The Arts of Power:*Three Halls of State in Italy, 1300–1600, University of California Press,
 Berkeley, 1992.
- STEINBERG, LEO, *The Sexuality of Christ in Renaissance Art and Modern Oblivion*, 2nd ed., University of Chicago Press, Chicago, 1996.
- STEPHENS, JOHN, The Italian Renaissance: The Origins of Intellectual and Artistic Change Before the Reformation, Longman, London, 1990.
- TALVACCHIA, BETTE, Taking Positions: On the Erotic in Renaissance Culture, Princeton University Press, Princeton, N.J., 1999.
- THORNTON, DORA, The Scholar in His Study: Ownership and Experience, Yale University Press, New Haven, N.J., 1997.
- THORNTON, PETER, *The Italian Renaissance Interior* 1400–1600, Weidenfeld and Nicolson, London, 1991.
- TINAGLI, PAOLO, Women in Italian Renaissance Art: Gender, Representation, Identity, Manchester University Press, Manchester, 1997.
- TOMAN, ROLF, ed., *The Art of the Italian Renaissance*, Thunder Bay Press, San Diego, Calif., 1995.
- TRONZO, WILLIAM, ed., Italian Church Decoration of the Middle Ages and Early Renaissance: Functions, Forms, and Regional Traditions, Nuova Alfa Editoriale, Bologna, 1989.
- VENTURI, ADOLFO, Storia dell'arte italiana, 11 vols. in 25 parts, Hoepli, Milan, 1901–40.
- VERDON, TIMOTHY, and HENDERSON, JOHN, Christianity and the Renaissance: Image and Religious Imagination in the Quattrocento, Syracuse University Press, Syracuse, N.Y., 1990.
- WALEY, DANIEL, The Italian City-Republics, Weidenfeld and Nicolson, London, 1969.
- WARNKE, MARTIN, The Court Artist: On Ancestry of the Modern Artist, trans. by David McLintock, Cambridge University Press, Cambridge, 1993.
- WELCH, EVELYN S., Art and Society in Italy, 1350–1500, Oxford University Press, Oxford, 1997.
- WHITE, JOHN, Art and Architecture in Italy, 1250–1400, 3rd ed., Pelican History of Art, Yale University Press, New Haven, Conn., 1993.
- ------, Studies in Late Medieval Italian Art, Pindar Press, London, 1984.
- WIND, EDGAR, Pagan Mysteries in the Renaissance, Faber & Faber, London, 1958.
- WISCH, BARBARA, and AHL, DIANE COLE, eds., Confraternities and the Visual Arts in Renaissance Italy, Cambridge University Press, Cambridge, 2000.

- WOHL, HELLMUT, The Aesthetics of Italian Renaissance Art: A Reconsideration of Style, Cambridge University Press, Cambridge, 1999.
- WÖLFFLIN, HEINRICH, Classic Art, 2nd ed., Phaidon, London, 1953.
- WOODS-MARSDEN, JOANNA, Renaissance Self-Portraiture: The Visual Construction of Identity and the Social Status of the Artist, Yale University Press, New Haven, Conn., 1998.
- WYSS, EDITH, The Myth of Apollo and Marsyas in the Art of the Italian Renaissance: An Inquiry into the Meaning of Images, University of Delaware Press, Newark, 1996.

VII. ART AND CULTURE IN SPECIFIC CENTRES Assisi

ROMANINI, ANGIOLA MARIA, Assisi: The Frescoes in the Basilica of St. Francis, Rizzoli, New York, 1998.

Bologna

- MOSKOWITZ, ANITA FIDERER, Nicola Pisano's Arca di San Dominica and Its Legacy, Pennsylvania State University Press, University Park, 1994.
- TERPESTRA, NICHOLAS, Lay Confraternities and Civic Religion in Renaissance Bologna, Cambridge University Press, Cambridge, 1995.

Ferrara

- BARSTOW, KURT, The Gualenghi-d'Este Hours: Art and Devotion in Renaissance Ferrara, J. Paul Getty Museum, Los Angeles, 2000.
- NICOLSON, BENEDICT, The Painters of Ferrara: Cosmè Tura, Francesco del Cossa, Ercole de' Roberti, and Others, Elek, London, 1950.
- ROSENBERG, CHARLES M., The Este Monuments and Urban Developments in Renaissance Ferrara, Cambridge University Press, Cambridge, 1997.
- TUOHY, THOMAS, Herculean Ferrara: Ercole d'Este, 1471–1505, and the Invention of a Ducal Capital, Cambridge University Press, Cambridge, 1996.
- VISSER TRAVAGLI, ANNA MARIA, Ferrara, Palazzo Schifanoia e Palazzina Marfisa a Ferrara, Electa, Milan, 1991.

Florence

- AMES-LEWIS, FRANCIS, ed., Cosimo "il Veccho" de' Medici 1389–1464, Clarendon Press, Oxford, 1992.
- ——, *The Early Medici and Their Artists*, Birbeck College, London, 1995. ANDRES, GLENN, HUNISAK, JOHN, and TURNER, RICHARD, *The Art of Florence*, 2 vols., Abbeville Press, New York, 1994.
- ANTAL, FREDERICK, Florentine Painting and Its Social Background, Kegan Paul, London, 1948.
- BALDINI, UMBERTO, ed., Santa Maria Novella: Kirche, Kloster, und Kreuzgange, Urachaus, Stuttgart, 1982.
- —, and NARDINI, BRUNO, Santa Croce: La Basilica, Le Cappelle, I Chiostri, Il Museo, Centro Internazionale del Libro, Florence, 1983.
- BARRIAULT, ANNE B., Spalliere Paintings of Renaissance Tuscany, Pennsylvania State University Press, University Park, 1994.
- BARZMAN, KAREN-EDIS, The Florentine Academy and the Early Modern State, Cambridge University Press, Cambridge, 2000.
- BASKINS, CRISTELLE LOUISE, Cassone Painting, Humanism, and Gender in Early Modern Italy, Cambridge University Press, Cambridge, 1998.
- BEYER, ANDREAS, and BOUCHER, BRUCE, ed., Piero de' Medici "il Gottoso" (1416–1469), Akademie Verlag, Berlin, 1993.
- BOSKOVITS, MIKLOS, Pittura florentina alla vigilia del Rinascimento, Edam, Florence, 1975.
- BRUCKER, GENE A., Renaissance Florence, University of California Press, Berkeley, 1983.
- BRUNI, LIONARDO, *History of the Florentine People*, edited and trans. by James Hankins, Harvard University Press, Cambridge, Mass., 2001.
- BUTTERS, SUZANNE B., The Triumph of Vulcan: Sculptors' Tools, Por-
- phyry, and the Prince in Ducal Florence, 2 vols., Olschki, Florence, 1996. CHERUBINI, GIOVANNI, and FANELLI, GIOVANNI, eds., Il Palazzo Medici Riccardi di Firenze, Giunti, Florence, 1990.
- CIAPPELLI, GIOVANNI, and RUBIN, PATRICIA LEE, eds., Art, Memory, and Family in Renaissance Florence, Cambridge University Press, Cambridge, 2000.
- CLARKE, PAULA C., The Soderini and the Medici: Power and Patronage in Fifteenth-Century Florence, Clarendon Press, Oxford, 1991.

- COCHRANE, ERIC, Florence in the Forgotten Centuries 1527–1800, University of Chicago Press, Chicago, 1973.
- CONNELL, WILLIAM J., and ZORZI, ANDREA, eds., Florentine Tuscany: Structures and Practices of Power, Cambridge University Press, Cambridge, 2000.
- COX-REARICK, JANET, *Dynasty and Destiny in Medici Art*, Princeton University Press, Princeton, N.I., 1984.
- CRABB, ANN, The Strozzi of Florence: Widowhood and Family Solidarity in the Renaissance, University of Michigan Press, Ann Arbor, 2000.
- EDGERTON, SAMUEL Y., Pictures and Punishment: Art and Criminal Prosecution During the Florentine Renaissance, Cornell University Press, Ithaca, N.Y., 1985.
- FRANKLIN, DAVID, *Painting in Renaissance Florence*, 1500–1550, Yale University Press, New Haven, Conn., 2001.
- FREMANTLE, RICHARD, God and Money: Florence and the Medici in the Renaissance, Including Cosimo I's Uffizi and Its Collections, Olschki, Florence, 1992.
- GODMAN, PETER, From Poliziano to Machiavelli: Florentine Humanism in the High Renaissance, Princeton University Press, Princeton, N.I., 1997.
- GOLDTHWAITE, RICHARD A., Banks, Palaces, and Entrepreneurs in Renaissance Florence, Variorum, Aldershot, 1995.
- ——, The Building of Renaissance Florence: An Economic and Social History, Johns Hopkins University Press, Baltimore, 1980.
- GURRIERI, FRANCESCO, et al., *The Cathedral of Santa Maria del Fiore in Florence*, trans. by Anthony Brierley, 2 vols., Cassa di Risparmio di Firenze, Florence, 1994–95.
- HAAS, LOUIS, The Renaissance Man and His Children: Childbirth and Early Childbood in Florence, 1300–1600, Macmillan, Basingstoke, 1998.
- HAGER, SERAFINA, ed., Leonardo, Michelangelo, and Raphael in Renaissance Florence from 1500 to 1508, Georgetown University Press, Washington, D.C., 1992.
- HALL, MARCIA, Renovation and Counter-Reformation: Vasari and Duke Cosimo in Sta. Maria Novella and Sta. Croce 1565–1577, Clarendon Press, Oxford, 1979.
- HARTT, FREDERICK, "Art and Freedom in Quattrocento Florence", in Essays in Memory of Karl Lehmann, 114–31, Institute of Fine Arts, New York, 1964.
- Florentine Art Under Fire, Princeton University Press, Princeton, N.J., 1949.
- ———, GINO CORTI, and KENNEDY, CLARENCE, The Chapel of the Cardinal of Portugal, 1434–1459, at San Miniato in Florence, University of Pennsylvania Press, Philadelphia, 1964.
- JACKS, PHILIP, Vasari's Florence: Artists and Literati in the Medicean Court, Cambridge University Press, Cambridge, 1995.
- KANTER, LAURENCE B., Painting and Illumination in Early Renaissance Florence, 1300–1450, Metropolitan Museum of Art, New York, 1994.
- KENT, DALE, Cosimo de' Medici and the Florentine Renaissance: The Patron's Oeuvre, Yale University Press, New Haven, Conn., 2000.
- ——, The Rise of the Medici: Faction in Florence 1426–1434, Oxford University Press, Oxford, 1978.
- LORENZI, LORENZO, Devils in Art: Florence from the Middle Ages to the Renaissance, trans. by Mark Roberts, Centro Di, Florence, 1997.
- MAGINNIS, HAYDEN B. J., Painting in the Age of Giotto: A Historical Reevaluation, Pennsylvania State University Press, University Park, 1997.
- MALLETT, MICHAEL, and MANN, NICHOLAS, Lorenzo the Magnificent: Culture and Politics, Warburg Institute, London, 1996.
- MASSINELLI, ANNA MARIA, and TUENA, FILIPPO, Treasures of the Medici, Thames & Hudson, London, 1992.
- MUCCINI, UGO, The Salone del Cinquecento of Palazzo Vecchio, Le Lettere, Florence, 1990.
- ——, and CECCHI, ALESSANDRO, The Apartments of Cosimo in Palazzo Vecchio, Le Lettere, Florence, 1991.
- OFFNER, RICHARD A., A Critical and Historical Corpus of Florentine Painting, Section III, 8 vols., Section IV, 4 vols., New York University Press, New York, 1930–67.

- ——, Studies in Florentine Painting: The Fourteenth Century, Sherman, New York, 1927; reprinted Junius Press, New York, 1972.
- OLSON, ROBERTA J. M., *The Florentine Tondo*, Oxford University Press, Oxford, 2000.
- PAATZ, WALTER, Die Kirchen von Florenz, 5 vols., V. Klostermann, Frankfurt am Main, 1952–55.
- PILLIOD, ELIZABETH, Pontormo, Bronzino, and Allori: A Genealogy of Florentine Art, Yale University Press, New Haven, Conn., 2001.
- TRACHTENBERG, MARVIN, Dominion of the Eye: Urbanism, Art, and Power in Early Modern Florence, Cambridge University Press, Cambridge, 1997.
- TREXLER, RICHARD C., Public Life in Renaissance Florence, Academic Press, New York, 1980.
- TURNER, RICHARD A., Renaissance Florence: The Invention of a New Art, Harry N. Abrams, New York, 1997.
- VAVALÀ, EVELYN SANDBERG, Studies in the Florentine Churches, Olschki, Florence, 1959.
- Uffizi Studies: The Development of the Florentine School of Painting, Olschki, Florence, 1948.
- WACKERNAGEL, MARTIN, The World of the Florentine Renaissance Artist: Projects and Patrons, Workshop and Art Market, trans. by Alison Luchs, Princeton University Press, Princeton, N.J., 1981.

Genoa

CARACENI, FIORELLA, A Renaissance Street: Via Garibaldi in Genoa, Sagep, Genoa, 1993.

Gubbio

RAGGIO, OLGA, The Gubbio Studiolo and Its Conservation, 2 vols., Metropolitan Museum of Art, New York, 1999.

Mantua

- CHAMBERS, DAVID, and MARTINEAU, JANE, eds., Splendours of the Gonzaga, Victoria and Albert Museum, London, 1982.
- VERHEYEN, EGON, The Paintings in the Studiolo of Isabella d'Este at Mantua, New York University Press, New York, 1971.
- , The Palazzo del Te, Johns Hopkins University Press, Baltimore, 1977.

Milan KIRSCH, EDITH, Five Illuminated Manuscripts of Giangaleazzo Visconti,

Pennsylvania State University Press, University Park, 1991.

La Storia di Milano, Treccani, Milan, 1953-62.

WELCH, EVELYN S., Art and Authority in Renaissance Milan, Yale University Press, New Haven, Conn., 1995.

Naples

- BACCO, ENRICO, Naples, An Early Guide, Italica Press, New York, 1991.BENTLEY, JERRY H., Politics and Culture in Renaissance Naples, Princeton University Press, Princeton, N.J., 1987.
- BOLOGNA, FERDINANDO, *I pittori alla corte angioina di Napoli*, 1266–1414, Ugo Bozzi Editore, Rome, 1969.
- DE SERTA, CESARE, Napoli (La città nella storia d'Italia), 5th ed., Laterza, Rome-Bari, 1991.
- HERSEY, GEORGE L., Alfonso II and the Artistic Renewal of Naples, 1485–1495, Yale University Press, New Haven, Conn., 1969.
- ——, The Argonese Arch at Naples, 1443–1475, Yale University Press, New Haven, Conn., 1973.
- LEONE DE CASTRIS, PIERLUIGI, Arte di corte nella Napoli angioina, Cantini, Florence, 1986.
- MUSCA, GIOSUÈ, TATEO, FRANCESCO, ANNOSCIA, ENRICO, and LEONE DE CASTRIS, PIERLUIGI, *La Cultura angioina*, Silvana, Milan, 1985.

Napoli fra Rinascimento e Illuminismo, Electa, Naples, 1991.

RYDER, A. F. C., Alfonso the Magnanimous: King of Aragon, Naples, and Sicily, 1396–1458, Clarendon Press, Oxford, 1990.

Padua

- CHAPMAN, HUGO, Padua in the 1450s: Marco Zoppo and His Contemporaries, British Museum, London, 1998.
- KOHL, BENJAMIN G., *Padua Under the Carrara*, 1318–1405, Johns Hopkins University Press, Baltimore, 1998.

MOLFINO, ALESSANDRA MOTTOLA, and NATALE, MAURO, eds., *Le Muse e il principe, Arte di corte nel Rinascimento padano*, 2 vols., Museo Poldi-Pezzoli, Milan, 1991.

Rome

- ACKERMAN, JAMES S., The Cortile del Belvedere, Vatican City, 1954.
- BURROUGHS, CHARLES, From Signs to Design: Environmental Process and Reform in Early Renaissance Rome, MIT Press, Cambridge, Mass., 1990.
- CHASTEL, ANDRÉ, The Sack of Rome, 1527, Princeton University Press, Princeton, N.I., 1983.
- COFFIN, DAVID R., Gardens and Gardening in Papal Rome, Princeton University Press, Princeton, N.J., 1991.
- -------, The Villa in the Life of Renaissance Rome, Princeton University Press, Princeton, N.I., 1979.
- ETTLINGER, L. D., The Sistine Chapel Before Michelangelo, Clarendon Press, Oxford, 1965.
- FREIBERG, JACK, The Lateran in 1600: Christian Concord in Counter-Reformation Rome, Cambridge University Press, Cambridge, 1995.
- GARDNER, JULIAN, The Tomb and the Tiara: Curial Tomb Sculpture in Rome and Avignon in the Later Middle Ages, Clarendon Press, Oxford, 1991.
- GRAFTON, ANTHONY, ed., Rome Reborn: The Vatican Library and Renaissance Culture, Yale University Press, New Haven, Conn., 1993.
- HERSEY, GEORGE L., High Renaissance Art in St. Peter's and the Vatican: An Interpretive Guide, University of Chicago Press, Chicago, 1993.
- KESSLER, HERBERT L., and ZACHARIAS, JOHANNA, Rome 1300: On the Path of the Pilgrim, Yale University Press, New Haven, Conn., 2000.
- KRAUTHEIMER, RICHARD, *Rome, Profile of a City*, 312–1308, Princeton University Press, Princeton, N.J., 1980.
- LEE, EGMONT, Sixtus IV and Men of Letters, Edizioni di Storia e Letteratura, Rome, 1978.
- LEWINE, CAROL F., *The Sistine Chapel Walls and the Roman Liturgy*, Pennsylvania State University Press, University Park, 1993.
- MAGNUSON, TORGIL, Studies in Roman Quattrocento Architecture, Almquist and Wiksell, Stockholm, 1958.
- MANCINELLI, FABRIZIO, ed., The Sistine Chapel, Knopf, New York, 1991
- NICHOLS, FRANCIS MORGAN, ed., The Marvels of Rome: Mirabilia Urbis Romae, Italica Press, New York, 1986.
- OSTROW, STEVEN F., Art and Spirituality in Counter-Reformation Rome: The Sistine and Pauline Chapels in S. Maria Maggiore, Cambridge University Press, Cambridge, 1996.
- PARTRIDGE, LOREN W., The Art of Renaissance Rome, 1400–1600, Harry N. Abrams, New York, 1996.
- PIETRANGELI, CARLO, ed., The Sistine Chapel: The Art, the History, and the Restoration, Harmony Books, New York, 1986.
- RICE, LOUISE, Altars and Altarpieces of New St. Peter's: Outfitting the Basilica, Cambridge University Press, Cambridge, 1997.
- ROWLAND, INGRID D., The Culture of the High Renaissance: Ancients and Moderns in Sixteenth-Century Rome, Cambridge University Press, Cambridge, 1998.
- SMITH, GRAHAM, The Casino of Pius IV, Princeton University Press, Princeton, N.J., 1977.

Siena

- BORTOLOTTI, LANDO, Siena, Laterza, Rome, 1983.
- CHELAZZI DINI, GIULIETTA, ANGELINI, ALESSANDRO, and SANI, BERNARDINA, Five Centuries of Sienese Painting: From Duccio to the Birth of the Baroque, Thames & Hudson, London, 1998.
- CHRISTIANSEN, KEITH, Painting in Renaissance Siena, 1420–1500, Harry N. Abrams, New York, 1989.
- COLE, BRUCE, Sienese Painting, from Its Origin to the Fifteenth Century, Harper and Row, London, 1980.
- ———, Sienese Painting in the Age of the Renaissance, Indiana University Press, Bloomington, 1985.

- WOHL, HELLMUT, The Aesthetics of Italian Renaissance Art: A Reconsideration of Style, Cambridge University Press, Cambridge, 1999.
- WÖLFFLIN, HEINRICH, Classic Art, 2nd ed., Phaidon, London, 1953.
- WOODS-MARSDEN, JOANNA, Renaissance Self-Portraiture: The Visual Construction of Identity and the Social Status of the Artist, Yale University Press, New Haven, Conn., 1998.
- WYSS, EDITH, The Myth of Apollo and Marsyas in the Art of the Italian Renaissance: An Inquiry into the Meaning of Images, University of Delaware Press, Newark, 1996.

VII. ART AND CULTURE IN SPECIFIC CENTRES

ROMANINI, ANGIOLA MARIA, Assisi: The Frescoes in the Basilica of St. Francis, Rizzoli, New York, 1998.

Bologna

- MOSKOWITZ, ANITA FIDERER, Nicola Pisano's Arca di San Dominica and Its Legacy, Pennsylvania State University Press, University Park, 1994.
- TERPESTRA, NICHOLAS, Lay Confraternities and Civic Religion in Renaissance Bologna, Cambridge University Press, Cambridge, 1995.

Ferrara

- BARSTOW, KURT, The Gualenghi-d'Este Hours: Art and Devotion in Renaissance Ferrara, J. Paul Getty Museum, Los Angeles, 2000.
- NICOLSON, BENEDICT, The Painters of Ferrara: Cosmè Tura, Francesco del Cossa, Ercole de' Roberti, and Others, Elek, London, 1950.
- ROSENBERG, CHARLES M., The Este Monuments and Urban Developments in Renaissance Ferrara, Cambridge University Press, Cambridge, 1997.
- TUOHY, THOMAS, Herculean Ferrara: Ercole d'Este, 1471–1505, and the Invention of a Ducal Capital, Cambridge University Press, Cambridge, 1996.
- VISSER TRAVAGLI, ANNA MARIA, Ferrara, Palazzo Schifanoia e Palazzina Marfisa a Ferrara, Electa, Milan, 1991.

Florence

- AMES-LEWIS, FRANCIS, ed., Cosimo "il Veccho" de' Medici 1389–1464, Clarendon Press, Oxford, 1992.
- ——, The Early Medici and Their Artists, Birbeck College, London, 1995.

 ANDRES, GLENN, HUNISAK, JOHN, and TURNER, RICHARD, The
 Art of Florence, 2 vols., Abbeville Press, New York, 1994.
- ANTAL, FREDERICK, Florentine Painting and Its Social Background, Kegan Paul, London, 1948.
- BALDINI, UMBERTO, ed., Santa Maria Novella: Kirche, Kloster, und Kreuzgange, Urachaus, Stuttgart, 1982.
- —, and NARDINI, BRUNO, Santa Croce: La Basilica, Le Cappelle, I Chiostri, Il Museo, Centro Internazionale del Libro, Florence, 1983.
- BARRIAULT, ANNE B., Spalliere Paintings of Renaissance Tuscany, Pennsylvania State University Press, University Park, 1994.
- BARZMAN, KAREN-EDIS, *The Florentine Academy and the Early Modern State*, Cambridge University Press, Cambridge, 2000.
- BASKINS, CRISTELLE LOUISE, Cassone Painting, Humanism, and Gender in Early Modern Italy, Cambridge University Press, Cambridge, 1998.
- BEYER, ANDREAS, and BOUCHER, BRUCE, ed., Piero de' Medici "il Gottoso" (1416–1469), Akademie Verlag, Berlin, 1993.
- BOSKOVITS, MIKLOS, Pittura florentina alla vigilia del Rinascimento, Edam, Florence, 1975.
- BRUCKER, GENE A., *Renaissance Florence*, University of California Press, Berkeley, 1983.
- BRUNI, LIONARDO, *History of the Florentine People*, edited and trans. by James Hankins, Harvard University Press, Cambridge, Mass., 2001.
- BUTTERS, SUZANNE B., The Triumph of Vulcan: Sculptors' Tools, Porphyry, and the Prince in Ducal Florence, 2 vols., Olschki, Florence, 1996.
- CHERUBINI, GIOVANNI, and FANELLI, GIOVANNI, eds., *Il Palazzo Medici Riccardi di Firenze*, Giunti, Florence, 1990.
- CIAPPELLI, GIOVANNI, and RUBIN, PATRICIA LEE, eds., Art, Memory, and Family in Renaissance Florence, Cambridge University Press, Cambridge, 2000.
- CLARKE, PAULA C., The Soderini and the Medici: Power and Patronage in Fifteenth-Century Florence, Clarendon Press, Oxford, 1991.

- COCHRANE, ERIC, Florence in the Forgotten Centuries 1527–1800, University of Chicago Press, Chicago, 1973.
- CONNELL, WILLIAM J., and ZORZI, ANDREA, eds., Florentine Tuscany: Structures and Practices of Power, Cambridge University Press, Cambridge, 2000.
- COX-REARICK, JANET, Dynasty and Destiny in Medici Art, Princeton University Press, Princeton, N.J., 1984.
- CRABB, ANN, The Strozzi of Florence: Widowhood and Family Solidarity in the Renaissance, University of Michigan Press, Ann Arbor, 2000.
- EDGERTON, SAMUEL Y., Pictures and Punishment: Art and Criminal Prosecution During the Florentine Renaissance, Cornell University Press, Ithaca, N.Y., 1985.
- FRANKLIN, DAVID, *Painting in Renaissance Florence*, 1500–1550, Yale University Press, New Haven, Conn., 2001.
- FREMANTLE, RICHARD, God and Money: Florence and the Medici in the Renaissance, Including Cosimo I's Uffizi and Its Collections, Olschki, Florence, 1992.
- GODMAN, PETER, From Poliziano to Machiavelli: Florentine Humanism in the High Renaissance, Princeton University Press, Princeton, N.J., 1997.
- GOLDTHWAITE, RICHARD A., Banks, Palaces, and Entrepreneurs in Renaissance Florence, Variorum, Aldershot, 1995.
- ------, The Building of Renaissance Florence: An Economic and Social History, Johns Hopkins University Press, Baltimore, 1980.
- GURRIERI, FRANCESCO, et al., *The Cathedral of Santa Maria del Fiore in Florence*, trans. by Anthony Brierley, 2 vols., Cassa di Risparmio di Firenze, Florence, 1994–95.
- HAAS, LOUIS, The Renaissance Man and His Children: Childbirth and Early Childbood in Florence, 1300–1600, Macmillan, Basingstoke, 1998.
- HAGER, SERAFINA, ed., Leonardo, Michelangelo, and Raphael in Renaissance Florence from 1500 to 1508, Georgetown University Press, Washington, D.C., 1992.
- HALL, MARCIA, Renovation and Counter-Reformation: Vasari and Duke Cosimo in Sta. Maria Novella and Sta. Croce 1565–1577, Clarendon Press, Oxford, 1979.
- HARTT, FREDERICK, "Art and Freedom in Quattrocento Florence", in Essays in Memory of Karl Lehmann, 114–31, Institute of Fine Arts, New York, 1964.
- ——, Florentine Art Under Fire, Princeton University Press, Princeton, N.J., 1949.
- ———, GINO CORTI, and KENNEDY, CLARENCE, The Chapel of the Cardinal of Portugal, 1434–1459, at San Miniato in Florence, University of Pennsylvania Press, Philadelphia, 1964.
- JACKS, PHILIP, Vasari's Florence: Artists and Literati in the Medicean Court, Cambridge University Press, Cambridge, 1995.
- KANTER, LAURENCE B., *Painting and Illumination in Early Renaissance Florence*, 1300–1450, Metropolitan Museum of Art, New York, 1994.
- KENT, DALE, Cosimo de' Medici and the Florentine Renaissance: The Patron's Oeuvre, Yale University Press, New Haven, Conn., 2000.
- ——, The Rise of the Medici: Faction in Florence 1426–1434, Oxford University Press, Oxford, 1978.
- LORENZI, LORENZO, *Devils in Art: Florence from the Middle Ages to the Renaissance*, trans. by Mark Roberts, Centro Di, Florence, 1997.
- MAGINNIS, HAYDEN B. J., Painting in the Age of Giotto: A Historical Reevaluation, Pennsylvania State University Press, University Park, 1997.
- MALLETT, MICHAEL, and MANN, NICHOLAS, Lorenzo the Magnificent: Culture and Politics, Warburg Institute, London, 1996.
- MASSINELLI, ANNA MARIA, and TUENA, FILIPPO, Treasures of the Medici, Thames & Hudson, London, 1992.
- MUCCINI, UGO, The Salone del Cinquecento of Palazzo Vecchio, Le Lettere, Florence, 1990.
- ——, and CECCHI, ALESSANDRO, *The Apartments of Cosimo in Palazzo Vecchio*, Le Lettere, Florence, 1991.
- OFFNER, RICHARD A., A Critical and Historical Corpus of Florentine Painting, Section III, 8 vols., Section IV, 4 vols., New York University Press, New York, 1930–67.

- ——, Studies in Florentine Painting: The Fourteenth Century, Sherman, New York, 1927; reprinted Junius Press, New York, 1972.
- OLSON, ROBERTA J. M., The Florentine Tondo, Oxford University Press, Oxford, 2000.
- PAATZ, WALTER, *Die Kirchen von Florenz*, 5 vols., V. Klostermann, Frankfurt am Main, 1952–55.
- PILLIOD, ELIZABETH, Pontormo, Bronzino, and Allori: A Genealogy of Florentine Art, Yale University Press, New Haven, Conn., 2001.
- TRACHTENBERG, MARVIN, Dominion of the Eye: Urbanism, Art, and Power in Early Modern Florence, Cambridge University Press, Cambridge, 1997.
- TREXLER, RICHARD C., Public Life in Renaissance Florence, Academic Press, New York, 1980.
- TURNER, RICHARD A., Renaissance Florence: The Invention of a New Art, Harry N. Abrams, New York, 1997.
- VAVALÀ, EVELYN SANDBERG, Studies in the Florentine Churches, Olschki, Florence, 1959.
- Uffizi Studies: The Development of the Florentine School of Painting, Olschki, Florence, 1948.
- WACKERNAGEL, MARTIN, The World of the Florentine Renaissance Artist: Projects and Patrons, Workshop and Art Market, trans. by Alison Luchs, Princeton University Press, Princeton, N.J., 1981.

Genoa

CARACENI, FIORELLA, A Renaissance Street: Via Garibaldi in Genoa, Sagep, Genoa, 1993.

Gubbio

RAGGIO, OLGA, The Gubbio Studiolo and Its Conservation, 2 vols., Metropolitan Museum of Art, New York, 1999.

Mantua

- CHAMBERS, DAVID, and MARTINEAU, JANE, eds., Splendours of the Gonzaga, Victoria and Albert Museum, London, 1982.
- VERHEYEN, EGON, The Paintings in the Studiolo of Isabella d'Este at Mantua, New York University Press, New York, 1971.
- ——, *The Palazzo del Te*, Johns Hopkins University Press, Baltimore, 1977. *Milan*
- KIRSCH, EDITH, Five Illuminated Manuscripts of Giangaleazzo Visconti, Pennsylvania State University Press, University Park, 1991.
- La Storia di Milano, Treccani, Milan, 1953-62.
- WELCH, EVELYN S., Art and Authority in Renaissance Milan, Yale University Press, New Haven, Conn., 1995.

Naples

- BACCO, ENRICO, Naples, An Early Guide, Italica Press, New York, 1991.BENTLEY, JERRY H., Politics and Culture in Renaissance Naples, Princeton University Press, Princeton, N.J., 1987.
- BOLOGNA, FERDINANDO, I pittori alla corte angioina di Napoli, 1266–1414, Ugo Bozzi Editore, Rome, 1969.
- DE SERTA, CESARE, *Napoli (La città nella storia d'Italia)*, 5th ed., Laterza, Rome-Bari, 1991.
- HERSEY, GEORGE L., Alfonso II and the Artistic Renewal of Naples, 1485–1495, Yale University Press, New Haven, Conn., 1969.
- ——, The Argonese Arch at Naples, 1443–1475, Yale University Press, New Haven, Conn., 1973.
- LEONE DE CASTRIS, PIERLUIGI, Arte di corte nella Napoli angioina, Cantini, Florence, 1986.
- MUSCA, GIOSUÈ, TATEO, FRANCESCO, ANNOSCIA, ENRICO, and LEONE DE CASTRIS, PIERLUIGI, *La Cultura angioina*, Silvana, Milan, 1985.
- Napoli fra Rinascimento e Illuminismo, Electa, Naples, 1991.
- RYDER, A. F. C., Alfonso the Magnanimous: King of Aragon, Naples, and Sicily, 1396–1458, Clarendon Press, Oxford, 1990.

Padua

- CHAPMAN, HUGO, Padua in the 1450s: Marco Zoppo and His Contemporaries, British Museum, London, 1998.
- KOHL, BENJAMIN G., *Padua Under the Carrara*, 1318–1405, Johns Hopkins University Press, Baltimore, 1998.

MOLFINO, ALESSANDRA MOTTOLA, and NATALE, MAURO, eds., *Le Muse e il principe, Arte di corte nel Rinascimento padano*, 2 vols., Museo Poldi-Pezzoli, Milan, 1991.

Rome

- ACKERMAN, JAMES S., The Cortile del Belvedere, Vatican City, 1954.
- BURROUGHS, CHARLES, From Signs to Design: Environmental Process and Reform in Early Renaissance Rome, MIT Press, Cambridge, Mass., 1990.
- CHASTEL, ANDRÉ, *The Sack of Rome*, 1527, Princeton University Press, Princeton, N.J., 1983.
- COFFIN, DAVID R., Gardens and Gardening in Papal Rome, Princeton University Press, Princeton, N.J., 1991.
- ——, The Villa in the Life of Renaissance Rome, Princeton University Press, Princeton, N.J., 1979.
- ETTLINGER, L. D., *The Sistine Chapel Before Michelangelo*, Clarendon Press, Oxford, 1965.
- FREIBERG, JACK, The Lateran in 1600: Christian Concord in Counter-Reformation Rome, Cambridge University Press, Cambridge, 1995.
- GARDNER, JULIAN, The Tomb and the Tiara: Curial Tomb Sculpture in Rome and Avignon in the Later Middle Ages, Clarendon Press, Oxford, 1991.
- GRAFTON, ANTHONY, ed., Rome Reborn: The Vatican Library and Renaissance Culture, Yale University Press, New Haven, Conn., 1993.
- HERSEY, GEORGE L., High Renaissance Art in St. Peter's and the Vatican: An Interpretive Guide, University of Chicago Press, Chicago, 1993.
- KESSLER, HERBERT L., and ZACHARIAS, JOHANNA, Rome 1300: On the Path of the Pilgrim, Yale University Press, New Haven, Conn., 2000.
- KRAUTHEIMER, RICHARD, *Rome*, *Profile of a City*, 312–1308, Princeton University Press, Princeton, N.J., 1980.
- LEE, EGMONT, Sixtus IV and Men of Letters, Edizioni di Storia e Letteratura, Rome, 1978.
- LEWINE, CAROL F., *The Sistine Chapel Walls and the Roman Liturgy*, Pennsylvania State University Press, University Park, 1993.
- MAGNUSON, TORGIL, Studies in Roman Quattrocento Architecture, Almquist and Wiksell, Stockholm, 1958.
- MANCINELLI, FABRIZIO, ed., *The Sistine Chapel*, Knopf, New York, 1991.
- NICHOLS, FRANCIS MORGAN, ed., The Marvels of Rome: Mirabilia Urbis Romae, Italica Press, New York, 1986.
- OSTROW, STEVEN F., Art and Spirituality in Counter-Reformation Rome: The Sistine and Pauline Chapels in S. Maria Maggiore, Cambridge University Press, Cambridge, 1996.
- PARTRIDGE, LOREN W., The Art of Renaissance Rome, 1400–1600, Harry N. Abrams, New York, 1996.
- PIETRANGELI, CARLO, ed., The Sistine Chapel: The Art, the History, and the Restoration, Harmony Books, New York, 1986.
- RICE, LOUISE, Altars and Altarpieces of New St. Peter's: Outfitting the Basilica, Cambridge University Press, Cambridge, 1997.
- ROWLAND, INGRID D., The Culture of the High Renaissance: Ancients and Moderns in Sixteenth-Century Rome, Cambridge University Press, Cambridge, 1998.
- SMITH, GRAHAM, *The Casino of Pius IV*, Princeton University Press, Princeton, N.J., 1977.

Siena

- BORTOLOTTI, LANDO, Siena, Laterza, Rome, 1983.
- CHELAZZI DINI, GIULIETTA, ANGELINI, ALESSANDRO, and SANI, BERNARDINA, Five Centuries of Sienese Painting: From Duccio to the Birth of the Baroque, Thames & Hudson, London, 1998.
- CHRISTIANSEN, KEITH, *Painting in Renaissance Siena*, 1420–1500, Harry N. Abrams, New York, 1989.
- COLE, BRUCE, Sienese Painting, from Its Origin to the Fifteenth Century, Harper and Row, London, 1980.
- ——, Sienese Painting in the Age of the Renaissance, Indiana University Press, Bloomington, 1985.

- MAGINNIS, HAYDEN B. J., *The World of the Early Sienese Painter*, Pennsylvania State University Press, University Park, 2001.
- NORMAN, DIANA, Siena and the Virgin: Art and Politics in a Late Medieval City State, Yale University Press, New Haven, Conn., 1999.
- POPE-HENNESSY, JOHN, Sienese Quattrocento Painting, Phaidon, Oxford,
- RIEDL, PETER ANSELM, and SEIDEL, MAX, Die Kirchen von Siena, Bruckmann, Munich, 1985-.
- SOUTHARD, EDNA CARTER, The Frescoes in Siena's Palazzo Pubblico, 1289–1539: Studies in Imagery and Relations to Other Communal Palaces in Tuscany, Garland, New York, 1979.
- VAN OS, HENK, Sienese Altarpieces, 1215–1460, 2 vols., Egbert Forsten Publishing, Groningen, 1990.

Urbino

- CHELES, LUCIANO, The Studiolo of Urbino: An Iconographic Investigation, Pennsylvania State University Press, University Park, 1986.
- ROTONDI, PASQUALE, *The Ducal Palace of Urbino*, Tiranti, London, 1969. Venice
- AIKEMA, BERNARD, and BROWN, BEVERLY LOUISE, eds., Renaissance Venice and the North: Crosscurrents in the Time of Bellini, Dürer, and Titian, Thames & Hudson, London, 1999.
- BROWN, KATHERINE T., The Painter's Reflection: Self-Portraiture in Renaissance Venice, 1458–1625, Olschki, Florence, 2000.
- BROWN, PATRICIA FORTINI, Art and Life in Renaissance Venice, Prentice Hall, New York, 1997.
- ——, Venetian Narrative Painting in the Age of Carpaccio, Yale University Press, New Haven, Conn., 1988.
- ——, Venice and Antiquity: The Venetian Sense of the Past, Yale University Press, New Haven, Conn., 1996.
- CONCINA, ENNIO, A History of Venetian Architecture, Cambridge University Press, Cambridge, 1993.
- DAVIS, ROBERT C., The War of the Fists: Popular Culture and Public Violence in Late Renaissance Venice, Oxford University Press, Oxford, 1994
- DEMUS, OTTO, *The Mosaics of San Marco in Venice*, University of Chicago Press, Chicago, 1984.
- FRANZOI, UMBERTO, Palaces and Churches on the Grand Canal in Venice, Storti, Venice, 1991.
- HILLS, PAUL, Venetian Color: Marble, Mosaic, Painting, and Glass, Yale University Press, New Haven, Conn., 1999.
- HOWARD, DEBORAH, The Architectural History of Venice, Holmes & Meier, New York, 1981.
- ——, Venice and the East: The Impact of the Islamic World on Venetian Architecture, 1100–1500, Yale University Press, New Haven, Conn., 2000.
- HUSE, NORBERT, and WOLTERS, WOLFGANG, *The Art of Renaissance Venice: Architecture, Sculpture, and Painting*, University of Chicago Press, Chicago, 1990.
- LIEBERMAN, RALPH, Renaissance Architecture in Venice, 1450–1540, Frederick Muller, London, 1982.
- MARTINEAU, JEAN, and HOPE, CHARLES, eds., *The Genius of Venice* 1500–1600, Royal Academy of Arts, London, 1983.
- PINCUS, DEBRA, *Tombs of the Doges of Venice*, Cambridge University Press, Cambridge, 2000.
- ROSAND, DAVID, Myths of Venice: The Figuration of a State, University of North Carolina, Chapel Hill, 2001.
- ——, Painting in Sixteenth-Century Venice: Titian, Veronese, Tintoretto, Cambridge University Press, Cambridge, 1997.
- SINDING-LARSEN, STAALE, Christ in the Council Hall: Studies in the Religious Iconology of the Venetian Republic, L'Erma di Bretschneider, Rome, 1974.
- STEER, JOHN, Venetian Painting: A Concise History, Thames & Hudson, London, 1970.
- TAFURI, MANFREDO, Venice and the Renaissance, trans. by Jessica Levine, MIT Press, Cambridge, Mass., 1989.

WILDE, JOHANNES, Venetian Art from Bellini to Titian, Oxford University Press, Oxford, 1974.

VIII. WOMEN IN ITALIAN RENAISSANCE ART

- CHENEY, LIANA DE GIROLAMI, FAXON, ALICIA CRAIG, and RUSSO, KATHLEEN LUCEY, eds., Self-Portraits of Women Artists, Ashgate, Aldershot, 2000.
- DIXON, ANNETTE, Women Who Ruled: Queens, Goddesses, Amazons, in Renaissance and Baroque Art, Merrell, London, 2002.
- JACOBS, FREDERICKA HERMAN, Defining the Renaissance Virtuosa: Women Artists and the Language of Art History and Criticism, Cambridge University Press, Cambridge, 1997.
- JOHNSON, GERALDINE A., and GRIECO, SARA F. MATTHEWS, eds., Picturing Women in Renaissance and Baroque Italy, Cambridge University Press, Cambridge, 1997.
- KING, CATHERINE, Renaissance Women Patrons: Wives and Widows in Italy, c. 1300–1550, Manchester University Press, Manchester, 1998.
- KING, MARGARET L., Women of the Renaissance, University of Chicago Press, Chicago, 1991.
- KLAPISCH-ZUBER, CHRISTIANE, Women, Family, and Ritual in Renaissance Italy, University of Chicago Press, Chicago, 1985.
- LAWRENCE, CYNTHIA, ed., Women and Art in Early Modern Europe: Patrons, Collectors, and Connoisseurs, Pennsylvania State University Press, University Park, 1997.
- MIGIEL, MARILYN, and SCHIESARI, JULIANA, eds., Refiguring Woman: Perspectives on Gender and the Italian Renaissance, Cornell University Press, Ithaca, N.Y., 1991.
- PANIZZA, LETIZIA, ed., Women in Italian Renaissance Culture and Society, European Humanities Research Centre, Oxford, 2000.
- REISS, SHERYL E., and WILKINS, DAVID G., eds., Beyond Isabella: Secular Women Patrons of Art in Renaissance Italy, Truman State University Press, Kirksville, Mo., 2001.
- RUSSELL, H. DIANE, with BARNES, BERNADINE, Eva/Ave: Woman in Renaissance and Baroque Prints, National Gallery of Art, Washington, D.C., 1990.
- TINAGLI, PAOLO, Women in Italian Renaissance Art: Gender, Representation, Identity, Manchester University Press, Manchester, 1997.

IX. PATRONAGE

- CHAMBERS, DAVID, *Patrons and Artists in the Italian Renaissance*, University of South Carolina Press, Columbia, 1971.
- GOFFEN, RONA, Piety and Patronage in Renaissance Venice: Bellini, Titian, and the Franciscans, Yale University Press, New Haven, Conn., 1986.
- KEMPERS, BRAM, Painting, Power, and Patronage: The Rise of the Professional Artist in the Italian Renaissance, Penguin Books, Harmondsworth, 1992.
- KENT, DALE, Cosimo de' Medici and the Florentine Renaissance: The Patron's Oeuvre, Yale University Press, New Haven, Conn., 2000.
- KENT, F. W., and SIMMONS, PATRICIA, with EADE, J. C., Patronage, Art and Society in Renaissance Italy, Oxford University Press, Oxford, 1987.
- KING, CATHERINE, Renaissance Women Patrons: Wives and Widows in Italy, c. 1300–1550, Manchester University Press, Manchester, 1998.
- NOVA, ALESSANDRO, The Artistic Patronage of Pope Julius III (1550–1555): Profane Imagery and Buildings for the De Monte Family in Rome, Garland, New York, 1988.
- REISS, SHERYL E., and WILKINS, DAVID G., eds., Beyond Isabella: Secular Women Patrons of Art in Renaissance Italy, Truman State University Press, Kirksville, Mo., 2001.
- RICHARDS, JOHN, Altichiero: An Artist and His Patrons in the Italian Trecento, Cambridge University Press, Cambridge, 2000.
- ROBERTSON, CLAIRE, Il Gran Cardinale: Alessandro Farnese, Patron of the Arts, Yale University Press, New Haven, Conn., 1992.
- WILKINS, DAVID G., and WILKINS, REBECCA L., The Search for a Patron in the Middle Ages and the Renaissance, Edwin Mellen Press, Lewiston, N.Y., 1996.

ZERVAS, DIANE FINIELLO, The Parte Guelfa, Brunelleschi, and Donatello, Augustin, Locust Valley, N.Y., 1988.

X. ARCHITECTURE

- ACKERMAN, JAMES S., The Villa: Form and Ideology of Country Houses, Thames & Hudson, London, 1990.
- BURCKHARDT, JACOB, The Architecture of the Italian Renaissance, edited by Peter Murray, University of Chicago Press, Chicago, 1985.
- DEHIO, G., and VON BEZOLD, G., Die Kirchliche Baukunst des Abendlandes, Arnold Bergsträsser, Stuttgart, 1884–1901.
- FURNARI, MICHELE, Formal Design in Renaissance Architecture: From Brunelleschi to Palladio, Rizzoli, New York, 1995.
- GOLDTHWAITE, RICHARD A., The Building of Renaissance Florence: An Economic and Social History, Johns Hopkins University Press, Baltimore, 1980.
- HART, VAUGHN, and HICKS, PETER, eds., Paper Palaces: The Rise of the Renaissance Architectural Treatise, Yale University Press, New Haven, Conn., 1998.
- HEYDENREICH, LUDWIG H., Architecture in Italy, 1400–1500, Yale University Press, New Haven, Conn., 1996.
- LAZZARO, CLAUDIA, *The Italian Renaissance Garden*, Yale University Press, New Haven, Conn., 1990.
- LOTZ, WOLFGANG, Architecture in Italy, 1500–1600, Yale University Press, New Haven, Conn., 1995.
- MILLER, MAUREEN, Bishop's Palace: Architecture and Authority in Medieval Italy, Cornell University Press, Ithaca, N.Y., 2001.
- MILLON, HENRY A., and LAMPUGNANI, VITTORIO MAGNAGO, eds., The Renaissance from Brunelleschi to Michelangelo: The Representation of Architecture, Bompiani, Milan, 1994.
- MURRAY, PETER, Renaissance Architecture, Thames & Hudson, London, 1969; rev. ed. 1986, reprinted 1991 and 1992.
- , Renaissance Architecture, Faber & Faber, London, 1971.
- PAYNE, ALINA A., The Architectural Treatise in the Italian Renaissance, Cambridge University Press, Cambridge, 1999.
- SAALMAN, HOWARD, The Transformation of Buildings and the City in the Renaissance, 1300–1500, Astrion, Champlain, N.Y., 1996.
- SMITH, CHRISTINE, Architecture in the Culture of Early Humanism: Ethics, Aesthetics, and Eloquence, Oxford University Press, Oxford, 1992.
- VAN DER REE, PAUL, SMIENK, GERRIT, and STEENBERGER, CLEMENS, *Italian Villas and Gardens*, Prestel, Munich, 1992.
- WESTFALL, CARROLL WILLIAM, In This Most Perfect Paradise: Alberti, Nicholas V, and the Invention of Conscious Urban Planning in Rome, 1447–55, Pennsylvania State University Press, University Park, 1974.
- WITTKOWER, RUDOLF, Architectural Principles in the Age of Humanism, 3rd ed., rev. Tiranti, London, 1962.

XI. PAINTING

- BERENSON, BERNARD, *Italian Painters of the Renaissance*, Phaidon, London, 1968, and Collins (Fontana), London, 1960.
- ——, Italian Pictures of the Renaissance, 7 vols., Phaidon, London, 1957–68.
 BOLOGNA, FERDINANDO, Early Italian Painting: Romanesque and Early Medieval, Van Nostrand, London, 1964.
- BOMFORD, DAVID, ed., *Italian Painting Before 1400*, National Gallery Publications, London, 1989.
- , JILL DUNKERTON, GORDON, DILLIAN, and ROY, ASHOK, Art in the Making: Italian Painting Before 1400, National Gallery Publications, London, 1989.
- BORSOOK, EVE, *The Mural Painters of Tuscany from Cimabue to Andrea del Sarto*, 2nd ed., rev. and enlarged, Clarendon Press and Oxford University Press, Oxford, 1980.
- BURCKHARDT, JACOB, *The Altarpiece in Renaissance Italy*, edited by Peter Humfrey, Cambridge University Press, Cambridge, 1988.
- CAST, DAVID, The Calumny of Apelles: A Study in the Humanist Tradition, Yale University Press, New Haven, Conn., 1981.

- CASTELNUOVO, ENRICO, ed., La Pittura in Italia: Il Duecento e il Trecento, 2 vols., Electa, Milan, 1986.
- CRANSTON, JODI, The Poetics of Portraiture in the Italian Renaissance, Cambridge University Press, Cambridge, 2000.
- CROWE, JOSEPH A., and CAVALCASELLE, GIOVANNI B., A History of Painting in Italy, edited by L. Douglas, 2nd ed., 6 vols., John Murray, London, 1903–14.
- —, A History of Painting in North Italy, edited by T. Borenius, 3 vols., Scribner's, New York, 1912.
- DEWALD, ERNEST, T., Italian Painting, 1200–1600, Holt, Rinehart and Winston, New York, 1961.
- DUNKERTON, JILL, ed., Giotto to Dürer: Early Renaissance Painting in the National Gallery, Yale University Press, New Haven, Conn., in association with National Gallery Publications, London, 1991.
- FREEDBERG, S. J., Painting in Italy, 1500–1600, Penguin Books, Harmondsworth, 1990.
- ——, Painting of the High Renaissance in Rome and Florence, Harper and Row, London, 1972.
- FREMANTLE, RICHARD, Florentine Gothic Painters from Giotto to Masaccio, Martin Secker and Warburg, London, 1975.
- FRIEDLAENDER, WALTER F., Mannerism and Anti-Mannerism in Italian Painting, Columbia University Press, New York, 1957.
- GARRISON, EDWARD B., Italian Romanesque Panel Painting: An Illustrated Index, Olschki, Florence, 1949; reprinted Hacker Art Books, New York, 1976.
- HALL, MARCIA B., Colour and Meaning: Practice and Theory in Renaissance Painting, Cambridge University Press, Cambridge, 1992.
- ——, Color and Technique in Renaissance Painting, Augustin, Locust Valley, N.Y., 1987.
- HOENIGER, CATHLEEN SARA, Renovation of Painting in Tuscany, 1200–1500, Cambridge University Press, Cambridge, 1995.
- HUMFREY, PETER, and KEMP, MARTIN, eds., *The Altarpiece in the Renaissance*, Cambridge University Press, Cambridge, 1990.
- LAVIN, MARILYN ARONBERG, The Place of Narrative: Mural Decoration in Italian Churches, 431–1600, University of Chicago Press, Chicago, 1990.
- MARLE, RAIMOND VAN, The Development of the Italian Schools of Painting, 19 vols., Nijhoff, The Hague, 1923–38.
- MEISS, MILLARD, The Great Age of Fresco: Discoveries, Recoveries, and Revivals, Phaidon, London, 1970.
- —, Painting in Florence and Siena After the Black Death, Princeton University Press, Princeton, N.J., 1951.
- NEWBERRY, TIMOTHY J., BISACCA, GEORGE, and KANTER, LAU-RENCE B., *Italian Renaissance Frames*, Metropolitan Museum of Art, New York, 1990.
- ROETTGEN, STEFFI, *Italian Frescoes*, 2 vols., Abbeville Press, New York, 1996–97.
- SINISGALLI, ROCCO, A History of the Perspective Scene from the Renaissance to the Baroque: Borromini in Four Dimensions, trans. by Lasse Hodne, Cadmo, Florence, 2000.
- SMART, ALASTAIR, *The Dawn of Italian Painting*, c. 1250–1400, Phaidon, Oxford, 1978.
- THOMAS, ANABEL, *Painter's Practice in Renaissance Tuscany*, Cambridge University Press, Cambridge, 1995.
- WHITE, JOHN, *The Birth and Rebirth of Pictorial Space*, Faber & Faber, London, 1987.
- ZAMPETTI, PIETRO, Paintings from the Marches: Gentile to Raphael, Phaidon, London, 1971.

XII. SCULPTURE

- AMES-LEWIS, FRANCIS, *Tuscan Marble Carving 1250–1350*, Ashgate, Aldershot, 1997.
- McHAM, SARAH BLAKE, ed., Looking at Italian Renaissance Sculpture, Cambridge University Press, Cambridge, 1998.
- MORSCHECK, CHARLES R., Relief Sculpture for the Façade of the Certosa di Pavia, 1473–1499, Garland, New York, 1978.

- MOSKOWITZ, ANITA FIDERER, *Italian Gothic Sculpture*, c. 1250–1400, Cambridge University Press, Cambridge, 2001.
- OLSON, ROBERTA J. M., Italian Renaissance Sculpture, Thames & Hudson, London, 1992.
- POPE-HENNESSY, JOHN, *Italian Gothic Sculpture*, 4th ed., Phaidon, London, 1996.
- ———, Italian High Renaissance and Baroque Sculpture, 4th ed., Phaidon, London, 1996.
- , Italian Renaissance Sculpture, 4th ed., Phaidon, London, 1996.
- SEYMOUR, CHARLES, Sculpture in Italy, 1400–1500, Pelican History of Art, Yale University Press, New Haven, Conn., 1966.

XIII. DRAWING

- AMES-LEWIS, FRANCIS, Drawing in Early Renaissance Italy, Yale University Press, New Haven, Conn., 1981.
- ———, Drawing in the Italian Renaissance Workshop, Victoria and Albert Museum, London, 1983.
- BAMBACH, CARMEN C., Drawing and Painting in the Italian Renaissance Workshop: Theory and Practice, 1300–1600, Cambridge University Press, Cambridge, 1999.
- BERENSON, BERNARD, *The Drawings of the Florentine Painters*, 3 vols., University of Chicago Press, Chicago, 1938.
- BJURSTRÖM, PER, Italian Drawings from the Collection of Giorgio Vasari, Nationalmuseum, Stockholm, 2001.
- DEGENHART, BERNHARD, and SCHMITT, ANNEGRIT, Corpus der italienischen Zeichnungen, 1300–1450, Mann, Berlin, 1968.
- FAIRBAIRN, LYNDA, *Italian Renaissance Drawings*, 2 vols., Oxford University Press, Oxford, 1998.
- FEINBERG, LARRY J., From Studio to Studiolo: Florentine Draughtsmanship under the First Medici Grand Dukes, Allen Memorial Art Museum, Oberlin, Ohio, 1991.
- Italian Drawings in the Department of Prints and Drawings in the British Museum, 4 vols., British Museum, London, Vol. I: POPHAM, ARTHUR E., and POUNCEY, PHILIP, The 14th and 15th Centuries, 2 vols., 1950;
 Vol. II: WILDE, JOHANNES, Michelangelo and His Studio, 1953; Vol. III: POUNCEY, PHILIP, and GERE, JOHN A., Raphael and His Circle, 2 vols., 1962; Vol. IV: POPHAM, ARTHUR E., Artists Working in Parma in the 16th Century, 2 vols., 1967.
- POPHAM, ARTHUR E., The Italian Drawings of the XV and XVI Centuries in the Collection of His Majesty the King at Windsor Castle, Phaidon, London, 1949.
- TIETZE, HANS, and TIETZE-CONRAT, ERICA, The Drawings of the Vene-tian Painters in the Fifteenth and Sixteenth Centuries, Augustin, Locust Valley, N.Y., 1944.

XIV. OTHER ARTS

- Early Italian Engravings from the National Gallery of Art, National Gallery of Art, Washington, D.C., 1973.
- KRISTELLER, PAUL, Early Florentine Woodcuts, with an Annotated List of Florentine Illustrated Books, Holland, London, 1968.
- LADIS, ANDREW, Italian Renaissance Maiolica from Southern Collections, Georgia Museum of Art, University of Georgia, Athens, 1989.
- LANDAU, DAVID, and PARSHALL, PETER, *The Renaissance Print*, 1470–1550, Yale University Press, New Haven, Conn., 1994.
- LINCOLN, EVELYN, *The Invention of the Italian Renaissance Printmaker*, Yale University Press, New Haven, Conn., 2000.
- MARCHINI, GIUSEPPE, *Italian Stained Glass Windows*, Thames & Hudson, London, 1957.
- REED, SUE WALSH, Italian Etchers of the Renaissance and Baroque, Northeastern University Press, Boston, 1989.
- TOESCA, PIETRO, La pittura e la miniatura nella Lombardia, Einaudi, Turin, 1966.
- WILLIAMS, KIM, Italian Pavements: Patterns in Space, Anchorage Press, Houston, Tex., 1997.

XV. ARTISTS

Alberti

- BORSI, FRANCO, Leon Battista Alberti: The Complete Works, Faber & Faber, London, 1989.
- GADOL, JOAN, Leon Battista Alberti: Universal Man of the Renaissance, University of Chicago Press, Chicago and London, 1969.
- GRAFTON, ANTHONY, Leon Battista Alberti: Master Builder of the Italian Renaissance, Allen Lane, London, 2001.
- JARZOMBEK, MARK, On Leon Battista Alberti: His Literary and Aesthetic Theories, MIT Press, Cambridge, Mass., 1989.
- JOHNSON, EUGENE J., S. Andrea in Mantua: The Building History, Pennsylvania State University Press, University Park, 1975.
- TRAVENOR, ROBERT, On Alberti and the Art of Building, Yale University Press, New Haven, Conn., 1998.

Altichiero

RICHARDS, JOHN, Altichiero: An Artist and His Patrons in the Italian Trecento, Cambridge University Press, Cambridge, 2000.

Fra Angelico

- BONSANTI, GIORGIO, Beato Angelico: Catalogo completo, Octavo, Florence, 1998.
- DIDI-HUBERMAN, GEORGES, Fra Angelico: Dissemblance and Figuration, trans. by Jane Marie Todd, University of Chicago Press, Chicago, 1995.
- GILBERT, CREIGHTON, A Renaissance Image of the End of the World: Fra Angelico and Signorelli at Orvieto, Pennsylvania State University Press, University Park, 2001.
- HOOD, WILLIAM, Fra Angelico at San Marco, Yale University Press, New Haven, Conn., 1993.
- MORACHIELLO, PAOLO, Fra Angelico: The San Marco Frescoes, Thames & Hudson, London, 1996.
- POPE-HENNESSY, JOHN, Fra Angelico, Phaidon, London, 1952; 2nd ed., Cornell University Press, Ithaca, N.Y., 1974.
- -----, Fra Angelico, Constable, London, 1990.
- SPIKE, JOHN, Fra Angelico, Abbeville Press, New York, 1996.

Sofonisba Anguissola

- FERINO-PAGDEN, SYLVIA, and KUSCHE, MARIA, Sofonisba Anguissola: A Renaissance Woman, National Museum of Women in the Arts, Washington, D.C., 1995.
- GREGORI, MINA, ed., Sofonisba Anguissola e le sue sorelle, Leonardo arte, Milan 1994
- PERLINGIER, ILYA SANDRA, Sofonisba Anguissola: First Great Woman of the Renaissance, Rizzoli, New York, 1992.
- PINESSI, ORIETTA, Sofonisba Anguissola: un pittore alla corte di Filippo II. Selene, Milan, 1998.

Antonello da Messina

- BOTTARI, STEFANO, *Antonello da Messina*, trans. by G. Scaglia, George Rainbird, London, 1957.
- VIGNI, GIORGIO, All the Paintings of Antonello da Messina, trans. by A. F. O'Sullivan, Oldbourne, London, 1963.

Baldovinetti

KENNEDY, RUTH W., Alesso Baldovinetti: A Critical and Historical Study, Yale University Press, New Haven, Conn., 1938.

Barocci

- EMILIANI, ANDREA, Federico Barocci: Urbino, 1535–1612, Nuova Alfa, Bologna, 1985.
- TURNER, NICOLAS, Federico Barocci, Vilo, Paris, 2000.

Fra Bartolommeo

FISCHER, CHRIS, Fra Bartolommeo, Master Draughtsman of the Renaissance, Museum Boymans-van Beuningen, Rotterdam, 1990.

Jacopo Bassano

- AIKEMA, BERNARD, Jacopo Bassano and His Public: Moralizing Pictures in an Age of Reform, c. 1535–1600, trans. by Andrew P. McCormick, Princeton University Press, Princeton, N.J., 1996.
- BERDINI, PAOLO, *The Religious Art of Jacopo Bassano: Painting as Visual Exegesis*, Cambridge University Press, Cambridge, 1997.

Beccafumi

Domenico Beccafumi e il suo tempo, Electa, Milan, 1990.

TORRITI, PIERO, Beccafumi, Electa, Milan, 1998.

Giovanni Bellini

GOFFEN, RONA, Giovanni Bellini, Yale University Press, New Haven, Conn., 1989.

—, and SCIRÈ, GIOVANNA NEPI, Il colore ritrovato: Bellini a Venezia, Electa, Milan, 2000.

ROBERTSON, GILES, Giovanni Bellini, Clarendon Press, Oxford, 1968.

TEMPESTINI, ANCHISE, Giovanni Bellini, Fabbri Editori, Milan, 1997.

, Giovanni Bellini, Electa, Milan, 2000.

WIND, EDGAR, Bellini's Feast of the Gods: A Study in Venetian Humanism, Harvard University Press, Cambridge, Mass., 1948.

Jacopo Bellini

EISLER, COLIN T., The Genius of Jacopo Bellini: The Complete Paintings and Drawings, British Museum, London, 1989.

Benedetto da Maiano

LEIN, EDGAR, Benedetto da Maiano, Lang, New York, 1988.

Bertoldo di Giovanni

DRAPER, JAMES DAVID, Bertoldo di Giovanni, Sculptor of the Medici Household: Critical Reappraisal and Catalogue Raisonné, University of Missouri Press, Columbia, 1992.

Botticelli

BALDINI, UMBERTO, et al., Primavera: The Restoration of Botticelli's Masterpiece, Harry N. Abrams, New York, 1986.

CLARK, KENNETH, The Drawings of Sandro Botticelli for Dante's Divina Commedia, Thames & Hudson, London, 1976.

DEMPSEY, CHARLES, The Portrayal of Love: Botticelli's Primavera and Humanist Culture at the Time of Lorenzo the Magnificent, Princeton University Press, Princeton, N.J., 1992.

ETTLINGER, LEOPOLD DAVID, and HELEN S., *Botticelli*, Thames & Hudson, London, 1976.

KANTER, LAURENCE B., Botticelli's Witness: Changing Style in a Changing Florence, Isabella Stewart Gardner Museum, Boston, 1997.

LIGHTBOWN, RONALD, Botticelli, 2 vols., Elek, London, 1978.

——, Sandro Botticelli: Life and Work, Thames & Hudson, London, 1989.LUCINAT, CRISTINA ACIDINI, Botticelli: Allegorie mitologiche, Electa, Milan, 2001.

ZÖLLNER, FRANK, Botticelli: Images of Love and Spring, Prestel, Munich, 1998.

Bramante

BORSI, FRANCO, Bramante, Electa, Milan, 1989.

BRUSCHI, ARNALDO, Bramante, Thames & Hudson, London, 1977.

Bronzino

COX-REARICK, JANET, Bronzino's Chapel of Eleanora in the Palazzo Vecchio, University of California Press, Berkeley, 1993.

McCORQUODALE, CHARLES, Bronzino, Harper and Row, London, 1981.PARKER, DEBORAH, Bronzino: Renaissance Painter as Poet, Cambridge University Press, Cambridge, 2000.

SMYTH, CRAIG HUGH, Bronzino as a Draughtsman: An Introduction, Augustin, Locust Valley, N.Y., 1971.

Brunelleschi

BATTISTI, EUGENIO, Brunelleschi, The Complete Work, Thames & Hudson, London, 1981.

GÄRTNER, PETER J., Filippo Brunelleschi 1377–1446, Könemann, Cologne, 1998.

IPPOLITO, LAMBERTO, and PERONI, CHIARA, La Cupola di Santa Maria del Fiore, La Nuova Italia Scientifica, Rome, 1997.

KING, ROSS, Brunelleschi's Dome: How a Renaissance Genius Reinvented Architecture, Chatto and Windus, London, 2000.

KLOTZ, HEINRICH, Filippo Brunelleschi: The Early Works and the Medieval Tradition, Academy Editions, London, 1990.

MANETTI, ANTONIO DI TUCCIO, *The Life of Brunelleschi*, edited by Howard Saalman, Pennsylvania State University Press, University Park, 1970.

PRAGER, FRANK D., and SCAGLIA, GIUSTINA, Brunelleschi: Studies of His Technology and Inventions, MIT Press, Cambridge, Mass., 1970.

SAALMAN, HOWARD, Filippo Brunelleschi: The Buildings, Pennsylvania State University Press, University Park, 1993.

——, Filippo Brunelleschi: The Cupola of Santa Maria del Fiore, Zwemmer, London, 1980.

Carbaccio

BROWN, PATRICIA FORTINI, Venetian Narrative Painting in the Age of Carpaccio, Yale University Press, New Haven, Conn., 1988.

HUMFREY, PETER, Carpaccio: catalogo completo dei dipinti, Cantini, Florence, 1991.

LAUTS, JAN, Carpaccio: Paintings and Drawings, Phaidon, London, 1962.
MASON, STEFANIA, Carpaccio: The Major Pictorial Cycles, Skira, Milan, 2000.

SGARBI, VITTORIO, Carpaccio, Abbeville Press, New York, 1994.

Andrea del Castagno

HORSTER, MARITA, Andrea del Castagno: Complete Edition with a Critical Catalogue, Phaidon, Oxford, 1980.

SPENCER, JOHN R., Andrea del Castagno and His Patrons, Duke University Press, Durham, N.C., 1991.

Pietro Cavallini

HETHERINGTON, PAUL, Pietro Cavallini: A Study in the Art of Late Medieval Rome, Sagittarius Press, London, 1979.

TOMEI, ALESSANDRO, Pietro Cavallini, Silvana, Milan, 2000.

Cellini

POPE-HENNESSY, JOHN, Cellini, Macmillan, London, 1985.

SCALINI, MARIO, Benvenuto Cellini, Scala, Milan, 1995.

Cimabue

BATTISTI, EUGENIO, *Cimabue*, trans. by R. and C. Enggass, Pennsylvania State University Press, University Park, 1966.

BELLOSI, LUCIANO, Cimabue, Abbeville Press, New York, 1998.

CHIELLINI, MONICA, Cimabue, Harper and Row, London, 1988.

Correggio

The Age of Correggio and the Carracci: Emilian Painting in the Sixteenth and Seventeenth Centuries, Cambridge University Press in association with National Gallery of Art, Washington, D.C., 1987.

BAMBACH, CARMEN C., Correggio and Parmigianino: Master Draughtsmen of the Renaissance, British Museum, London, 2000.

BROWN, DAVID ALAN, The Young Correggio and His Leonardesque Sources, Garland, New York, 1981.

EKSERDJIAN, DAVID, *Correggio*, Yale University Press, New Haven, Conn., 1997.

FABIAŃSKI, MARCIN, Correggio: le mitologie d'amore, Silvana, Milan, 2000.

GHIDIGLIA QUINTAVALLE, AUGUSTA, Correggio: The Frescoes in San Giovanni Evangelista in Parma, trans. by Olga Ragusa, Harry N. Abrams, New York, 1964.

GOULD, CECIL, The Paintings of Correggio, Faber & Faber, London, 1977.

MENDOGNI, PIER PAOLO, *Il Correggio e il Monastero di San Paolo*, PPS, Parma, 1996.

POPHAM, ARTHUR E., Correggio's Drawings, Oxford University Press, London, 1957.

SMYTH, JANICE, Correggio's Frescoes in Parma Cathedral, Princeton University Press, Princeton, N.J., 1997.

Daddi

OFFNER, RICHARD, A Critical and Historical Corpus of Florentine Painting, Section III, Vols. III and IV, New York University Press, New York, 1930 and 1934.

Vincenzo Danti

FIDANZA, GIOVAN BATTISTA, Vincenzo Danti, 1530–1576, Olschki, Florence, 1996.

SUMMERS, DAVID, The Sculpture of Vincenzo Danti: A Study in the Influence of Michelangelo and the Ideals of the Maniera, Garland, New York, 1979.

Domenico Veneziano

WOHL, HELLMUT, The Paintings of Domenico Veneziano: A Study in Florentine Art of the Early Renaissance, Phaidon, Oxford, 1980.

Donatello

- AVERY, CHARLES, Donatello: An Introduction, John Murray, London, 1994.
- BENNETT, BONNIE A. and WILKINS, DAVID G., *Donatello*, Phaidon, Oxford, 1984.
- HARTT, FREDERICK, Donatello, Prophet of Modern Vision, photographs by David Finn, Thames & Hudson, London, 1974.
- HERZNER, VOLKER, "Regesti Donatelliani", Rivista dell'Istituto Nazionale d'Archeologia e Storia dell'Arte 3, vol. 2 (1979), 169–228.
- Italian Renaissance Sculpture in the Time of Donatello, Detroit Institute of Arts, Detroit, Mich., 1985.
- JANSON, H. W., The Sculpture of Donatello, 2 vols., Princeton University Press, Princeton, N.J., 1957.
- LIGHTBOWN, R. W., Donatello and Michelozzo: An Artistic Partnership and Its Patrons in the Early Renaissance, 2 vols., Harvey Miller, London, 1980.
- MUNMAN, ROBERT, Optical Corrections in the Sculpture of Donatello, American Philosophical Society, Philadelphia, 1985.
- POESCHKE, JOACHIM, Donatello and His World: Sculpture of the Italian Renaissance, trans. by Russell Stockman, Harry N. Abrams, New York, 1993.
- POPE-HENNESSY, JOHN, *Donatello Sculptor*, Abbeville Press, New York and London, 1993.

Dosso Dossi

- CIAMMITTI, LUISA, OSTROW, STEVEN F., and SETTIS, SALVATORE, Dosso's Fate: Painting and Court Culture in Renaissance Italy, Getty Research Institute, Los Angeles, 1998.
- GIBBONS, FELTON, Dosso and Battista Dossi, Court Painters at Ferrara, Princeton University Press, Princeton, N.J., 1968.
- HUMPHREY, PETER, and LUCCO, MAURO, Dosso Dossi: Court Painter in Renaissance Ferrara, Metropolitan Museum of Art, New York, 1998.

Duccio

- BELLOSI, LUCIANO, Duccio: The Maestà, Thames & Hudson, London, 1999.
- DEUCHLER, FLORENS, Duccio, Electa, Milan, 1984.
- SATKOWSKI, JANE, Duccio di Buoninsegna: The Documents, edited by Hayden B. J. Maginnis, Georgia Museum of Art, Athens, 2000.
- STUBBLEBINE, JAMES H., Duccio di Buoninsegna and His School, 2 vols., Princeton University Press, Princeton, N.J., 1979.
- WHITE, JOHN, Duccio: Tuscan Art and the Medieval Workshop, Thames & Hudson, London, 1979.

Ercole de' Roberti

MANCA, JOSEPH, The Art of Ercole de' Roberti, Cambridge University Press, Cambridge, 1992.

Lavinia Fontana

- CANTARO, MARIA TERESA, Lavinia Fontana bolognese: "pittora singolare" 1552–1614, Jandi Sapi, Milan, 1989.
- FORTUNATI, VERA, Lavinia Fontana, 1552-1614, Electa, Milan, 1994.
- , Lavinia Fontana of Bologna, 1552–1614, Electa, Milan, 1998.

Foppa

BALZARINI, MARIA GRAZIA, Vincenzo Foppa, Jaca, Milan, 1997.

Francesco di Giorgio

WELLER, ANDREW STUART, Francesco di Giorgio, 1439–1501, University of Chicago Press, Chicago, 1943.

Agnolo Gaddi

COLE, BRUCE, Agnolo Gaddi, Clarendon Press, Oxford, 1977.

Taddeo Gaddi

LADIS, ANDREW, Taddeo Gaddi: Critical Reappraisal and Catalogue Raisonné, University of Missouri Press, Columbia, 1982.

Gentile da Fabriano

CHRISTIANSEN, KEITH, Gentile da Fabriano, Cornell University Press, Ithaca, N.Y., 1982.

Ghiberti

KRAUTHEIMER, RICHARD, and KRAUTHEIMER-HESS, TRUDE, Lorenzo Ghiberti, 2nd ed., Princeton University Press, Princeton, N.J., 1970

Lorenzo Ghiberti nel suo tempo, Olschki, Florence, 1980.

Ghirlandaio

- BORSOOK, EVE, Francesco Sassetti and Ghirlandaio at Santa Trinità, Florence: History and Legend in a Renaissance Chapel, Davaco, Doornspijk, 1981.
- CADOGAN, JEANNE K., *Domenico Ghirlandaio: Artist and Artisan*, Yale University Press, New Haven, Conn., 2000.
- KECKS, RONALD G., Domenico Ghirlandaio und die Malerei der Florentiner Renaissance, Deutscher Kunstverlag, Munich, 2000.

Giambologna

- AVERY, CHARLES, Giambologna: The Complete Sculpture, Phaidon and Christie's, Oxford, 1987.
- Giambologna, 1529–1608, Sculptor to the Medici, Victoria and Albert Museum, London, 1978.
- GIBBONS, MARY WEITZEL, Giambologna: Narrator of the Catholic Reformation, University of California Press, Berkeley, 1995.

Giorgione

- ANDERSON, JAYNIE, Giorgione: The Painter of "Poetic Brevity", Flammarion, Paris and New York, 1997.
- BALDASS, LUDWIG VON, *Giorgione*, trans. by J. M. Brownjohn, Thames & Hudson, London, 1965.
- FRINGS, GABRIELE, Giorgiones L\u00e4ndliches Konzert: Darstellung der Musik als k\u00fcstlerisches Programm in der venezianischen Malerei der Renaissance, Mann, Berlin, 1999.
- GUIDONI, ENRICO, Giorgione: Opere e significati, Editalia, Rome, 1999. PIGNATTI, TERISIO, Giorgione: The Complete Edition, Rizzoli, New York, 1997.
- , and PEDROCCO, FILIPPO, Giorgione, Rizzoli, Milan, 1999.
- SETTIS, SALVATORE, Giorgione's Tempest: Interpreting the Hidden Subject, Polity Press, Cambridge, 1990.

Giotto

- BACCHESCHI, EDI, and MARTINDALE, ANDREW, *The Complete Paintings of Giotto*, Weidenfeld and Nicolson, London, 1969.
- BARASCH, MOSHE, Giotto and the Language of Gesture, Cambridge University Press, Cambridge, 1987.
- CIATTI, MARCO, and SEIDEL, MAX, Giotto: La Croce di Santa Maria Novella, Edifir, Florence, 2001.
- COLE, BRUCE, Giotto and Florentine Painting, 1280–1375, Harper and Row, London, 1976.
- -----, Giotto: The Scrovegni Chapel, G. Braziller, New York, 1993.
- FLORES D'ARCAIS, FRANCESCA, Giotto, trans. by R. Rosenthal, Abbeville, New York, 1995.
- GNUDI, CESARE, Giotto, Heinemann, London, 1959.
- GOFFEN, RONA, Spirituality in Conflict: Saint Francis and Giotto's Bardi Chapel, Pennsylvania State University Press, University Park, 1988.
- LADIS, ANDREW, ed., *Giotto and the World of Early Italian Art*, 4 vols., Garland, New York, 1998.
- MEISS, MILLARD, Giotto and Assisi, Norton, New York, 1960.
- SMART, ALISTAIR, *The Assisi Problem and the Art of Giotto*, Oxford University Press, London, 1971.
- STUBBLEBINE, JAMES H., Assisi and the Rise of Vernacular Art, Harper and Row, London, 1985.
- —, ed., Giotto: The Arena Chapel Frescoes, Thames & Hudson, London, 1969.
- TINTORI, LEONETTO, and BORSOOK, EVE, Giotto: The Peruzzi Chapel, Harry N. Abrams, New York, 1965.
- TRACHTENBERG, MARVIN L., The Campanile of Florence Cathedral: "Giotto's Tower", New York University Press, New York, 1971.

Giovanni di Paolo

POPE-HENNESSY, JOHN, *Giovanni di Paolo*, 1403–1483, Oxford University Press, New York, 1937.

——, Paradiso, The Illuminations to Dante's Divine Comedy by Giovanni di Paolo, Thames & Hudson, London, 1993.

Giovannino de' Grassi

The Visconti Hours, National Library, Florence, G. Braziller, New York, 1972.

Giulio Romano

HARTT, FREDERICK, Giulio Romano, 2 vols., Yale University Press, New Haven, Conn., 1958.

VINTI, FRANCESCA, Giulio Romano pittore e l'antico, Nuova Italia, Florence, 1995.

Benozzo Gozzoli

AHL, DIANE COLE, *Benozzo Gozzoli*, Yale University Press, New Haven, Conn., 1996.

LUCHINAT, CRISTINA ACIDINI, ed., The Chapel of the Magi: Benozzo Gozzoli's Frescoes in the Palazzo Medici-Riccardi, Florence, Thames & Hudson, London, 1994.

Guido da Siena

STUBBLEBINE, JAMES H., Guido da Siena, Princeton University Press, Princeton, N.J., 1964.

Leonardo da Vinci

AHL, DIANE COLE, ed., Leonardo da Vinci's Sforza Monument Horse: The Art and the Engineering, Lehigh University Press, Bethlehem, Pa., 1995.

BARCILON, PININ BRAMBEILLA, and MARANI, PIETRO C., Leonardo: The Last Supper, University of Chicago Press, Chicago, 2001.

BROWN, DAVID ALAN, *Leonardo da Vinci: Origins of a Genius*, Yale University Press, New Haven, Conn., 1998.

CLARK, KENNETH, *The Drawings of Leonardo da Vinci in the Collection of Her Majesty the Queen at Windsor Castle*, 2nd ed., 3 vols., rev. with the assistance of Carlo Pedretti, Phaidon, London, 1968.

—, Leonardo da Vinci, rev. ed., Penguin Books, Harmondsworth, 1988. FARAGO, CLAIRE, Leonardo da Vinci: Selected Scholarship, 5 vols., Garland, New York, 1999.

KEMP, MARTIN, Leonardo da Vinci: The Wonderful Works of Nature and Man, J. M. Dent, London, 1981.

——, and ROBERTS, JANE, with STEADMAN, PHILIP, *Leonardo da Vinci*, Yale University Press, New Haven, Conn., 1981.

MAIORINO, GIANCARLO, Leonardo da Vinci, The Daedalian Mythmaker, Pennsylvania State University Press, University Park, 1992.

MARANI, PIETRO C., Leonardo Da Vinci: The Complete Paintings, Harry N. Abrams, New York, 2000.

NULAND, SHERWIN B., *Leonardo da Vinci*, Weidenfeld and Nicolson, London, 2000.

PEDRETTI, CARLO, Leonardo Architect, Thames & Hudson, London, 1986.

POPHAM, ARTHUR E., *The Drawings of Leonardo da Vinci*, Reynal and Hitchcock, New York, 1945.

STEINBERG, LEO, Leonardo's Incessant Last Supper, MIT Press, Cambridge, Mass., 2001.

TUCKER, RICHARD A., *Inventing Leonardo*, University of California Press, Berkeley, 1994.

WASSERMAN, JACK, Leonardo da Vinci, Thames & Hudson, London, 1987.

ZWIJNENBERG, ROBERT, Writings and Drawings of Leonardo da Vinci: Order and Chaos in Early Modern Thought, Cambridge University Press, Cambridge, 1990.

Filippino Lippi

NEILSON, KATHERINE B., *Filippino Lippi*, Harvard University Press, Cambridge, Mass., 1938.

SALE, J. RUSSELL, Filippino Lippi's Strozzi Chapel in Santa Maria Novella, Garland, New York, 1979.

Fra Filippo Lippi

FOSSI, GLORIA, Filippo Lippi, Constable, London, 1990.

HOLMES, MEGAN, Fra Filippo Lippi: The Carmelite Painter, Yale University Press, New Haven, Conn., 1999.

RUDA, JEFFREY, Fra Filippo Lippi: Life and Work with a Complete Catalogue, Phaidon, London, 1993.

Ambrogio and Pietro Lorenzetti

CANNON, JOANNA, and VAUCHEZ, ANDRÉ, Margherita of Cortona and the Lorenzetti: Sienese Art and the Cult of a Holy Woman in Medieval Tuscany, Pennsylvania State University Press, University Park, 1999.

CARLI, ENZO, Pietro e Ambrogio Lorenzetti, Silvana, Milan, 1971.

DEWALD, ERNEST T., Pietro Lorenzetti, Harvard University Press, Cambridge, Mass., 1930.

ROWLEY, GEORGE, Ambrogio Lorenzetti, 2 vols., Princeton University Press, Princeton, N.J., 1958.

STARN, RANDOLPH, Ambrogio Lorenzetti. The Palazzo Pubblico, Siena, G. Braziller, New York, 1994.

VOLPE, CARLO, Pietro Lorenzetti, Electa, Milan, 1989.

Lotto

BERENSON, BERNARD, Lorenzo Lotto, Phaidon, London, 1956.

BIANCONI, PIERO, All the Paintings of Lorenzo Lotto, trans. by P. Colacicchi, 2 vols., Oldbourne, London, 1963.

BROWN, DAVID ALAN, HUMFREY, PETER, and LUCCO, MAURO, Lorenzo Lotto: Rediscovered Master of the Renaissance, National Gallery of Art, Washington, D.C., 1997.

HUMFREY, PETER, Lorenzo Lotto, Yale University Press, New Haven, Conn., 1997.

Mantegna

BOORSCH, SUZANNE, et al., *Andrea Mantegna*, Harry N. Abrams, New York, 1992.

CHRISTIANSEN, KEITH, Andrea Mantegna: Padua and Mantua, G. Braziller, New York, 1994.

FIOCCO, GIUSEPPE, The Frescoes of Mantegna in the Eremitani Church, Padua, 2nd ed., Phaidon, Oxford, 1978.

GREENSTEIN, JACK M., Mantegna and Painting as Historical Narrative, University of Chicago Press, Chicago, 1992.

LIGHTBOWN, R. W., Mantegna: With a Complete Catalogue of the Paintings, Drawings and Prints, Phaidon Christie's, Oxford, 1986.

MARTINEAU, JANE, ed., Andrea Mantegna, Painter, Draughtsman and Printmaker of the Italian Renaissance, Thames & Hudson, London, 1992.

Simone Martini

MARTINDALE, ANDREW, Simone Martini: Complete Edition, Phaidon, London, 1988.

Masaccio

AHL, DIANE COLE, ed., *The Cambridge Companion to Masaccio*, Cambridge University Press, Cambridge, 2002.

BALDINI, UMBERTO, and CASAZZA, ORNELLA, *The Brancacci Chapel*, Thames & Hudson, London, 1992.

BECK, JAMES, Masaccio: The Documents, Augustin, Locust Valley, N.Y., 1978.

BERTI, LUCIANO, Masaccio, Pennsylvania State University Press, University Park, 1967.

GOFFEN, RONA, ed., Masaccio's Trinity, Cambridge University Press, Cambridge, 1998.

JOANNIDES, PAUL, Masaccio and Masolino: A Complete Catalogue, Phaidon, London, 1993.

LADIS, ANDREW, Brancacci Chapel, Florence, G. Braziller, New York, 1993. SHULMAN, KEN, Anatomy of a Restoration: The Brancacci Chapel,

SPIKE, JOHN T., Masaccio, Abbeville Press, New York, 1995.

Maso di Banco

LUCHINAT, CRISTINA ACIDINI, and LUSANNA, ENRICA NERI, Maso di Banco: la Cappella di San Silvestro, Electa, Milan, 1998.

WILKINS, DAVID G., Maso di Banco: A Florentine Artist of the Early Trecento, Garland, New York, 1985.

Masolino (see also Masaccio)

Walker, New York, 1991.

JOANNIDES, PAUL, Masaccio and Masolino: A Complete Catalogue, Phaidon, London, 1993.

ROBERTS, PERRI LEE, Masolino da Panicale, Clarendon Press, Oxford, 1993.

Melozzo da Forlì

- CLARK, NICHOLAS, Melozzo da Forlì, Pictor Papalis, Sotheby's, London, 1990.
- FOSCHI, MARINA, and PRATI, LUCIANA, Melozzo da Forlì: la sua città e il suo tempo, Leonardo Arte, Milan, 1994.

Michelangelo

- ACKERMAN, JAMES S., *The Architecture of Michelangelo*, University of Chicago Press, Chicago, 1986.
- ARGAN, GIULIO CARLO, and CONTARDI, BRUNO, Michelangelo: Architect, Thames & Hudson, London, 1993.
- BALDINI, UMBERTO, *The Complete Sculpture of Michelangelo*, Thames & Hudson, London, 1982.
- BAROLSKY, PAUL, Michelangelo's Nose: A Myth and Its Maker, Pennsylvania State University Press, University Park, 1990.
- BECK, JAMES, PAOLUCCI, ANTONIO, and SANTI, BRUNO, Michelangelo: The Medici Chapel, Thames & Hudson, London, 1994.
- CLEMENTS, ROBERT J., Michelangelo's Theory of Art, New York University Press, New York, 1961.
- DE TOLNAY, CHARLES, ed., *The Art and Thought of Michelangelo*, trans. by N. Buranelli, Pantheon Books, New York, 1964.
- -----, The Complete Works of Michelangelo, Reynal, New York, 1965.
- —, *Michelangelo*, 5 vols. of 6, Princeton University Press, Princeton, N.J., 1943–60.
- DE VECCHI, PIERLUIGI, and COLALUCCI, GIANLUIGI, Michelangelo: The Vatican Frescoes, Abbeville Press, New York, 2000.
- GOLDSCHEIDER, LUDWIG, Michelangelo: Paintings, Sculpture, and Architecture, 6th ed., Phaidon, London, 1996.
- HARTT, FREDERICK, David By the Hand of Michelangelo: The Original Model Discovered, photographs by David Finn, Thames & Hudson, London, 1987.
- -----, Michelangelo, Thames & Hudson, London, 1964.
- , Michelangelo Drawings, Thames & Hudson, London, 1971.
- , Michelangelo: The Complete Sculpture, Thames & Hudson, London, 1969.
- The Sistine Chapel, 2 vols., Barrie and Jenkins, London, 1991.
- ——, and FINN, DAVID, Michelangelo's Three Pietàs, Harry N. Abrams, New York, 1976.
- HIBBARD, HOWARD, Michelangelo, 2nd ed., Penguin Books, Harmondsworth, 1988.
- HIRST, MICHAEL, Michelangelo and His Drawings, Yale University Press, New Haven, Conn., 1988.
- HUGHES, ANTHONY, Michelangelo, Phaidon, London, 1997.
- The Last Judgment: The Restoration, Rizzoli, New York, 1999.
- MANCINELLI, FABRIZIO, ed., Michelangelo: The Sistine Chapel: The Restoration of the Ceiling Frescoes, Canova, Trevico, 2001.
- MILLON, HENRY A., Michelangelo Architect: The Façade of San Lorenzo and the Drum and Dome of St. Peter's, Olivetti, Milan, 1988.
- MURRAY, LINDA, Michelangelo, Thames & Hudson, London, 1980.
- ——, Michelangelo, His Life, Work and Times, Thames & Hudson, London, 1984.
- NAGEL, ALEXANDER, Michelangelo and the Reform of Art, Cambridge University Press, Cambridge, 2000.
- PARTRIDGE, LOREN W., The Last Judgment: A Glorious Restoration, Harry N. Abrams, New York, 1997.
- -----, The Sistine Chapel Ceiling, G. Braziller, New York, 1996.
- PIETRANGELI, CARLO, et al., The Sistine Chapel, A New Light on Michelangelo: The Art, the History, and the Restoration, Harmony Books, New York, 1986.
- POESCHKE, JOACHIM, Michelangelo and His World: Sculpture of the Italian Renaissance, Harry N. Abrams, New York, 1996.
- RICHMOND, ROBIN, Michelangelo and the Creation of the Sistine Ceiling, Barrie and Jenkins, London, 1992.
- , Michelangelo and the Sistine Ceiling, Crescent, New York, 1995.
- SEARS, ELIZABETH, ed., The Religious Symbolism of Michelangelo: The Sistine Ceiling, Oxford University Press, Oxford, 2000.

- SEYMOUR, CHARLES, JR., ed., Michelangelo: The Sistine Chapel Ceiling, Norton, New York, 1981.
- ——, Michelangelo's David: A Search for Identity, University of Pittsburgh Press, Pittsburgh, Pa., 1967.
- STEINBERG, LEO, Michelangelo's Last Paintings: The Conversion of St. Paul and the Crucifixion of St. Peter, Oxford University Press, Oxford, 1975
- SYMONDS, JOHN ADDINGTON, The Life of Michelangelo Buonarroti: Based on Studies in the Archives of the Buonarroti Family at Florence, University of Pennsylvania Press, Philadelphia, 2001.
- WALLACE, WILLIAM E., Michelangelo at San Lorenzo: The Genius as Entrepreneur, Cambridge University Press, Cambridge, 1994.
- ——, Michelangelo: Selected Scholarship in English, 5 vols., Garland, Hamden, Conn., 1995.
- WEINBERGER, MARTIN, Michelangelo the Sculptor, 2 vols., Columbia University Press, New York, 1967.

Michelozzo di Bartolommeo

- CAPLOW, HARRIET McNEAL, Michelozzo, 2 vols., Garland, New York, 1977.
- LIGHTBOWN, R. W., Donatello and Michelozzo: An Artistic Partnership and Its Patrons in the Early Renaissance, H. Miller, London, 1980.
- MOROLLI, GABRIELE, ed., Michelozzo: scultore e architetto, Centro Di, Florence, 1998.

Lorenzo Monaco

EISENBERG, MARVIN, Lorenzo Monaco, Princeton University Press, Princeton, N.J., 1989.

Moron

HUMFREY, PETER, Giovanni Battista Moroni: Renaissance Portraitist, Kimbell Art Museum, Fort Worth, Tex., 2000.

Nanni di Banco

BERGSTEIN, MARY, *The Sculpture of Nanni di Banco*, Princeton University Press, Princeton, N.J., 2000.

Orcagna

- KREYTENBERG, GERT, Orcagna, Andrea di Cione: ein universeller Künstler der Gotik in Florenz, P. von Zabern, Mainz, 2000.
- ——, Orcagna's Tabernacle in Orsanmichele, Florence, Harry N. Abrams, New York, 1994.

Palladio

- ACKERMAN, JAMES S., *Palladio*, rev. ed., Penguin Books, Harmondsworth, 1978.
- -----, Palladio's Villas, Augustin, Locust Valley, N.Y., 1967.
- BOUCHER, BRUCE, Andrea Palladio: The Architect in His Time, Abbeville Press, New York and London, 1998.
- CONSTANT, CAROLINE, *The Palladio Guide*, Princeton Architectural Press, Princeton, N.J., 1985.
- COSGROVE, DENIS, The Palladian Landscape: Geographical Change and Its Cultural Representations in Sixteenth-Century Italy, Pennsylvania State University Press, University Park, 1993.
- HOLBERTON, PAUL, Palladio's Villas: Life in the Renaissance Countryside, Murray, London, 1990.
- TRAGER, PHILIP, The Villas of Palladio, Little Brown, Boston, 1986.
- WITTKOWER, RUDOLF, *Palladio and Palladianism*, G. Braziller, New York, 1974.

Palma Vecchio

RYLANDS, PHILIP, *Palma Vecchio*, Cambridge University Press, Cambridge, 1990.

Paolo Veneziano

MURARO, MICHELANGELO, *Paolo da Venezia*, Istituto Editoriale Italiano, Milan, 1969.

Parmigianino

- BAMBACH, CARMEN C., Correggio and Parmigianino: Master Draughtsmen of the Renaissance, British Museum, London, 2000.
- CHIUSA, MARIA CHRISTINA, Parmigianino, Electa, Milan, 2001.
- FREEDBERG, SYDNEY J., Parmigianino, His Works in Painting, Harvard University Press, Cambridge, Mass., 1950.

POPHAM, ARTHUR E., *The Drawings of Parmigianino*, Beechhurst Press, New York, 1953.

Pietro Perugino

BECHERER, JOSEPH ANTENUCCHI, ed., Pietro Perugino: Master of the Italian Renaissance, Rizzoli, New York, 1997.

Piero della Francesca

- BERTELLI, CARLO, *Piero della Francesca*, Yale University Press, New Haven, Conn., 1992.
- CALVESI, MAURIZIO, Piero della Francesca, Rizzoli, New York, 1998.
- CLARK, KENNETH, Piero della Francesca, rev. ed., Phaidon, London, 1969.
- COLE, BRUCE, Piero della Francesca: Tradition and Innovation in Renaissance Art, HarperCollins, New York, 1993.
- GILBERT, CREIGHTON, Change in Piero della Francesca, Augustin, Locust Valley, N.Y., 1968.
- GINZBERG, CARLO, *The Enigma of Piero: Piero della Francesca*, trans. by Martin Ryle and Kate Soper, Verso, New York, 2000.
- LAVIN, MARILYN ARONBERG, Piero della Francesca, Thames & Hudson, London, 1992.
- ———, Piero della Francesca's Baptism of Christ, Yale University Press, New Haven, Conn., 1981.
- ——, Piero della Francesca: The Flagellation, Penguin Books, Harmondsworth, 1972.
- —, Piero della Francesca: San Francesco, Arezzo, G. Braziller, New York, 1994.
- LIGHTBOWN, R. W., Piero della Francesca, Abbeville Press, New York, 1992. POPE-HENNESSY, JOHN, The Piero della Francesca Trail, Thames & Hudson, London, 1992.

Piero di Cosimo

FERMOR, SHARON, Piero di Cosimo: Fiction, Invention and Fantasia, Reaktion, London, 1993.

Pisanello

- GORDON, DILLIAN, and SYSON, LUKE, *Pisanello: Painter to the Renaissance Court*, Yale University Press, New Haven, Conn., 2001.
- PACCAGNINI, GIOVANNI, *Pisanello*, trans. by Jane Carroll, Phaidon, London, 1973.
- SINDONA, ENIO, Pisanello, trans. by J. Ross, Harry N. Abrams, New York, 1961.
- WEISS, ROBERTO, Pisanello's Medallion of the Emperor John III Palaeologus, British Museum, London, 1966.
- WOODS-MARSDEN, JOANNA, The Gonzaga of Mantua and Pisanello's Arthurian Frescoes, Princeton University Press, Princeton, N.J., 1988.

Andrea and Nino Pisano

MOSKOWITZ, ANITA FIDERER, *The Sculpture of Andrea and Nino Pisano*, Cambridge University Press, Cambridge, 1987.

Giovanni Pisano

AYRTON, MICHAEL, Giovanni Pisano, Thames & Hudson, London, 1969. Nicola Pisano

- ANGIOLA, ELOISE, Nicola Pisano: The Pisa Baptistery Pulpit, University Microfilms, Ann Arbor, Mich., 1975.
- CRICHTON, GEORGE H., and ELSIE R., Nicola Pisano and the Revival of Sculpture in Italy, Cambridge University Press, Cambridge, 1938.
- MOSKOWITZ, ANITA FIDERER, Nicola Pisano's Arcadi San Dominica and Its Legacy, Pennsylvania State University Press, University Park, 1994.

Antonio and Piero del Pollaiuolo

ETTLINGER, LEOPOLD D., Antonio and Piero Pollaiuolo: Complete Edition with Critical Catalogue, Phaidon, Oxford, 1978.

Pontormo

- CLAPP, FREDERICK M., Jacopo Carucci da Pontormo, His Life and Work, Yale University Press, New Haven, Conn., 1916.
- COX-REARICK, JANET, *The Drawings of Pontormo*, 2 vols., Hacker Art Books, New York, 1983.
- ——, Dynasty and Destiny in Medici Art: Pontormo, Leo X, and the Two Cosimos, Princeton University Press, Princeton, N.J., 1984.

- CROPPER, ELIZABETH, Pontormo: Portrait of a Halberdier, Getty Museum, Los Angeles, 1997.
- NIGRO, SALVATORE S., ed., *Pontormo Drawings*, Harry N. Abrams, New York, 1992.

Properzia de' Rossi

BLUESTONE, NATALIE HARRIS, "The Female Gaze: Women's Interpretations of the Life and Work of Properzia De' Rossi, Renaissance Sculptor", in *Double Vision: Perspective on Gender and the Visual Arts*, Associated University Presses, London, 1995.

Jacopo della Quercia

- BECK, JAMES H., *Jacopo della Quercia*, Columbia University Press, New York, 1991.
- HANSON, ANNE C., Jacopo della Quercia's Fonte Gaia, Clarendon Press, Oxford, 1965.
- SEYMOUR, CHARLES, *Jacopo della Quercia*, Yale University Press, New Haven, Conn., 1973.

Raphael

- AMES-LEWIS, FRANCIS, *The Draftsman Raphael*, Yale University Press, New Haven, Conn., 1986.
- BECK, JAMES, Raphael, Thames & Hudson, London, 1987.
- ——, *Raphael: The Stanza della Segnatura*, G. Braziller, New York, 1993. ETTLINGER, LEOPOLD D., *Raphael*, Phaidon, Oxford, 1987.
- HALL, MARCIA B., After Raphael: Painting in Central Italy in the Sixteenth Century, Cambridge University Press, Cambridge, 1999.
- JOHANNIDES, PAUL, *The Drawings of Raphael with a Complete Catalog*, University of California Press, Berkeley, 1983.
- JONES, ROGER, and PENNY, NICHOLAS, *Raphael*, Yale University Press, New Haven, Conn., 1983.
- JOOST-GAUGIER, CHRISTIANE L., Raphael's Stanza della Segnatura: Meaning and Invention, Cambridge University Press, Cambridge, 2002.
- MEYER ZUR CAPELLEN, JÜRG, Raphael: A Critical Catalogue of His Paintings, Vol. 1., Arcos, Landshut, 2001.
- OBERHUBER, KONRAD, Raphael: The Paintings, Prestel, New York, 1999.
- PARTRIDGE, LOREN, and STARN, RANDOLPH, A Renaissance Likeness: Art and Culture in Raphael's Julius II, University of California Press, Berkeley, 1980.
- PEDRETTI, CARLO, Raphael: His Life and Work in the Splendours of the Italian Renaissance, Giunti, Florence, 1989.
- SHEARMAN, JOHN, Raphael's Cartoons in the Collection of Her Majesty the Queen and the Tapestries for the Sistine London, 1972.
- ——, and HALL, MARCIA B., eds., *The Princeton Raphael Symposium:*Science in the Service of Art History, Princeton University Press, Princeton, N.J., 1990.

Luca della Robbia

POPE-HENNESSY, JOHN, Luca della Robbia, Phaidon, Oxford, 1980.

Antonio and Bernardo Rossellino

SCHULZ, ANNE MARKHAM, *The Sculpture of Bernardo Rossellino and His Workshop*, Princeton University Press, Princeton, N.J., 1977.

Rosso Fiorentino

- CARROLL, EUGENE A., Rosso Fiorentino: Drawings, Prints, and Decorative Arts, National Gallery of Art, Washington, D.C., 1987.
- FRANKLIN, DAVID, Rosso in Italy, Yale University Press, New Haven, Conn., 1994.

Sangallo

FROMMEL, CHRISTOPH L., and ADAMS, NICHOLAS, *The Architectural Drawings of Antonio da Sangallo the Younger and His Circle*, MIT Press, Cambridge, Mass., 1994.

Jacopo Sansovino

BOUCHER, BRUCE, *The Sculpture of Jacopo Sansovino*, Yale University Press, New Haven, Conn., 1991.

HOWARD, DEBORAH, Jacopo Sansovino: Architecture and Patronage in Renaissance Venice, Yale University Press, New Haven, Conn., 1987.

Andrea del Sarto

- FREEDBERG, SYDNEY J., Andrea del Sarto, 2 vols., Harvard University Press, Cambridge, Mass., 1963.
- NATALI, ANTONIO, Andrea del Sarto, Abbeville Press, New York, 1999.
- SHEARMAN, JOHN, Andrea del Sarto, 2 vols., Clarendon Press, Oxford, 1965.

Sassetta

- POPE-HENNESSY, JOHN, Sassetta, Chatto and Windus, London, 1939. Savoldo
- BOSCHETTO, ANTONIO, Gian Girolamo Savoldo, Bramante, Milan,
- GILBERT, CREIGHTON, The Works of Girolamo Savoldo: The 1955 Dissertation, with Review of Research, Garland, New York, 1986.

Sebastiano del Piombo

- HIRST, MICHAEL, Sebastiano del Piombo, Clarendon Press, Oxford, 1981. Serlio
- FROMMEL, SABINE, Sebastiano Serlio architetto, Electa, Milan, 1998. Signorelli
- GILBERT, CREIGHTON, A Renaissance Image of the End of the World: Fra Angelico and Signorelli at Orvieto, Pennsylvania State University Press, University Park, 2001.
- HENRY, TOM, and KANTER, LAURENCE B., Luca Signorelli The Complete Paintings, Thames & Hudson, London, 2002.
- KURY, GLORIA, The Early Work of Luca Signorelli, 1465–1490, Garland, New York, 1978.
- PAOLUCCI, ANTONIO, Luca Signorelli, Constable, London, 1991.
- RIESS, JONATHAN B., Luca Signorelli: The San Brizio Chapel, Orvieto, G. Braziller, New York, 1995.
- ——, The Renaissance Antichrist: Luca Signorelli's Orvieto Frescoes, Princeton University Press, Princeton, 1995.
- TESTA, GIUSI, ed., La Cappella nova o di San Brizio nel Duomo di Orvieto, Rizzoli, Milan, 1996.

Sodoma

HAYUM, ANDRÉE, Giovanni Antonio Bazzi - "Il Sodoma", Garland, New York, 1976.

Tintoretto

- NICHOLS, TOM, Tintoretto: Tradition and Identity, Reaktion, London, 1999.
- RIDOLFI, CARLO, The Life of Tintoretto and of His Children Domenico and Marietta, trans. by and introduction by Catherine and Robert Enggass, Pennsylvania State University Press, University Park, 1984.
- ROSAND, DAVID, *Painting in Sixteenth-Century Venice: Titian, Veronese, Tintoretto*, Cambridge University Press, Cambridge, 1997.
- TIETZE, HANS, Tintoretto: The Paintings and Drawings, Phaidon, New York, 1948.
- VALCANOVER, FRANCESCO, *Tintoretto*, Thames & Hudson, London, 1985.

Titian

- BIADENE, SUSANNA, ed., *Titian: Prince of Painters*, Prestel, Munich, 1990.
- COLE, BRUCE, Titian and Venetian Painting, 1450–1590, Westview, Oxford,
- FREEDMAN, LUBA, *Titian's Portraits Through Aretino's Lens*, Pennsylvania State University Press, University Park, 1995.
- GOFFEN, RONA, *Titian's Women*, Yale University Press, New Haven, Conn., 1997.
- ——, ed., *Titian's Venus of Urbino*, Cambridge University Press, Cambridge, 1997.
- MEILMAN, PATRICIA, *Titian and the Altarpiece in Renaissance Venice*, Cambridge University Press, Cambridge, 2000.
- NASH, JANE C., Veiled Images: Titian's Mythological Paintings for Philip II, Art Alliance Press and Associated University Presses, Philadelphia, 1985.

- PANOFSKY, ERWIN, *Problems in Titian*, *Mostly Iconographic*, New York University Press, New York, 1969.
- PEDROCCO, FILIPPO, Titian: The Complete Paintings, Thames & Hudson, London, 2001.
- ROSAND, DAVID, Painting in Cinquecento Venice: Titian, Veronese, Tintoretto, Yale University Press, New Haven, Conn., 1982.
- -----, Titian, Thames & Hudson, London, 1987.
- ——, Titian and the Venetian Woodcut, National Gallery of Art, Washington, D.C., 1976.
- WETHEY, HAROLD E., The Paintings of Titian, 3 vols., Phaidon, London, 1969-75.
- ——, Titian and His Drawings: With Reference to Giorgione and Some Close Contemporaries, Princeton University Press, Princeton, N.J., 1987.

Tura

- CAMPBELL, STEPHEN J., Cosmè Tura of Ferrara: Style, Politics, and the Renaissance City, 1450–1495, Yale University Press, New Haven, Conn., 1997.
- MANCA, JOSEPH, Cosmè Tura, Oxford University Press, Oxford, 2000.
- BORSI, FRANCO, and BORSI, STEFANO, *Paolo Uccello*, Thames & Hudson, London, 1994.
- POPE-HENNESSY, JOHN, *The Complete Work of Paolo Uccello*, 2nd ed., Phaidon, London, 1969.
- SCHEFER, JEAN LOUIS, The Deluge, The Plague: Paolo Uccello, University of Michigan Press, Ann Arbor, 1995.

Vasari

- BAROLSKY, PAUL, Giotto's Father and the Family of Vasari's Lives, Pennsylvania State University Press, University Park, 1991.
- ——, Why Mona Lisa Smiles and Other Tales by Vasari, Pennsylvania State University Press, University Park, 1991.
- BJURSTRÖM, PER, Italian Drawings from the Collection of Giorgio Vasari, Nationalmuseum, Stockholm, 2001.
- BOASE, T. S. R., Giorgio Vasari: The Man and the Book, Princeton University Press, Princeton, N.J., 1979.
- CABLE, CAROLE, Giorgio Vasari, Architect: A Selected Bibliography of Books and Articles, Vance Bibliographers, Monticello, Ill., 1985.
- RUBIN, PATRICIA LEE, Giorgio Vasari: Art and History, Yale University Press, New Haven, Conn., 1995.

Veronese

- COCKE, RICHARD, Paolo Veronese: Piety and Display in an Age of Religious Reform, Ashgate, Aldershot, 2001.
- ------, Veronese's Drawings, Sotheby Publications, London, 1984.
- DELOGU, GIUSEPPE, Veronese: The Supper in the House of Levi, Pizzi, Milan, 1948.
- REARICK, WILLIAM R., *The Art of Paolo Veronese*, Cambridge University Press, Cambridge, 1988.
- ROSAND, DAVID, Painting in Sixteenth-Century Venice: Titian, Veronese, Tintoretto, Cambridge University Press, Cambridge, 1997.

Verrocchio

- BULE, STEVEN, ed., Verrocchio and Late Quattrocento Sculpture, Le Lettere, Florence, 1992.
- BUTTERFIELD, ANDREW, *The Sculptures of Andrea del Verrochio*, Yale University Press, New Haven, Conn., 1997.
- PASSAVANT, GUNTER, Verrocchio: Sculptures, Paintings and Drawings, trans. by Katherine Watson, Phaidon, London, 1969.

Vignola

- ACKERMAN, JAMES S., and LOTZ, WOLFGANG, Vignoliana, Augustin, Locust Valley, N.Y., 1965.
- WALCHER CASOTTI, MARIA, *Il Vignola*, 2 vols., Università, Instituto di storia dell'arte antica e moderna, Trieste, 1960.

Vittoria

MARTIN, THOMAS, Alessandro Vittoria and the Portrait Bust in Renaissance Venice, Clarendon Press, Oxford, 1998.

INDEX

Page numbers are in roman type. Italic page references denote illustrations. Names of artists and architects whose works are illustrated are indicated with CAPITALS. Titles of works are in italics. Boldfaced page references signify major discussions of a given topic, artist, theme, or artwork.

A

Abundance, Fortitude, and Envy (Paolo Veronese), ceiling painting, 673, 673, 685 Accademia di San Luca, 719 Adoration of the Child (Piero della Francesca), 168, 322, 326, 327 (Perino del Vaga), 604-5, 605, 606 The Adoration of the Infant Jesus (Fra Filippo Lippi), 168, 262, 262, 349 Adoration of the Magi: (Jacopo Bassano), 678, 678 (Sandro Botticelli), 371, 372, 373, 374-76, 375, 486 (Bramantino), 656, 657 (Domenico Veneziano), 298, 298, 376 (Leonardo da Vinci), 375, 486-89, 487, 499 (Masaccio), from the Pisa polyptych, 239-40, 239, 298, 317 (Nicola Pisano), 81, 81 Adoration of the Magi (Strozzi altarpiece) (Gentile da Fabriano), 143, 168, 222, 223-27, 225, 226, 227, 232, 239-40, 247, 298, 317, 321, 349, 425, 613 Adoration of the Shepherds (Holy Night) (Correggio), 121, 612-13, 612 Adoration of the Shepherds (Portinari altarpiece) (Hugo van der Goes), 327, 387, 387, 395 Adrian VI, Pope, 582, 584 aedicule, 724 Agony in the Garden: (Giovanni Bellini), 424, 451, 451 (Andrea Mantegna), 437, 438, 451 Agostino di Duccio, 266, 508, 509 ALBERTI, LEONBATTISTA, 46, 181, 214, 217, 258, 265-76, 317, 319, 329, 345, 346, 359, 378, 383, 410, 415, 421, 466, 468, 495, 530, 626, 664, 682, 684, 686, 721 on architecture, 278, 345, 346, 421, 466, 482, 626, 682, 684, 686, 721 influence of, 274, 317, 319, 415 Malatesta Temple (San Francesco), Rimini, 266-267, 266, 267, 317, 464, 527 on painting, 250, 265, 275-76, 279 Palazzo Rucellai, Florence, with Bernardo Rossellino, 267-69, 268, 273, 289, 533, 535 Palazzo Venezia, Rome, 272, 272, 625 perspective construction, 275, 275 perspective system, 304, 432 Sant'Andrea, Mantua, 270-72, 270, 271, 271, 439, 533, 686, 687, 720 Santa Maria Novella, Florence, 89, 264, 269-70, 269, 687 San Sebastiano, Mantua, 348 writings, 265, 269, 274, 275-76, 354-55, 379 Albertini, Francesco, 529 Alexander VI, Pope, 383, 412, 505, 529, 571

The Allegory of Fortune (Pintoricchio), inlaid floor, 413. 415 Allegory of Good Government (Ambrogio Lorenzetti), 51, 124, 145-49, 145, 146, 147, 148, 161, 173, 224 Allegory with Venus and Cupid (Agnolo Bronzino), 710, 711 ALLEGRI See Correggio (Antonio Allegri) ALLORI, ALESSANDRO, 718 Pearl Fishers, 551, 718 altar frontals, definition of, 45 altarpiece, definition of, 45, 724 ALTICHIERO, 173 Martyrdom of St. George, fresco, oratory, San Giorgio, Padua, 173, 174 AMADEO, GIOVANNI ANTONIO, 466 Certosa, Pavia, façade, 466, 468 Amalfi, 60 Amiens, France, Notre Dame, 102, 104 AMMANATI, BARTOLOMMEO, 707-8 Fountain of Neptune, 706, 707 Palazzo Pitti, Florence, courtyard, 274, 707, 707 Ponte Santa Trinita, Florence, 394, 707-8, 708 Amsterdam, 466 anatomical study, 481, 504, 662 ancient architecture See also Roman architecture, ancient ancient art, 76, 307, 497, 505, 654 architecture, 268, 720 frescoes, 610, 714 military architecture, 91 painting, 566 sarcophagi, 362, 644 sculpture, 556, 702-3 theater, 688 See also Roman art, ancient ANDREA DA FIRENZE (Andrea Bonaiuti), Triumph of the Church and Navicella, fresco, Spanish Chapel, Santa Maria Novella, Florence, 51, 161, 162, 168 ANDREA DEL SARTO, 495, 594-97, 598, 601, 602, 621 Annunciation, 594, 595 Assumption of the Virgin, 596, 597 Birth of the Virgin, fresco, SS. Annunziata, Florence, 594, 595 Lamentation, 596, 596, 601, 710 Madonna of the Harpies, 594–96, 595 Punishment of the Gamblers, fresco, SS. Annunziata, Florence, 594, 594 ANGELICO, FRA (Giovanni da Fiesole; Guido di Pietro), 168, 245, 246-54, 265, 276, 298, Annunciation and Scenes from the Life of the Virgin, 247-48, 247, 248, 249, 252, 276, 301 Chapel of Nicholas V, Rome, frescoes, 321 Descent from the Cross, frame and pinnacles by Lorenzo Monaco, 168, 246-47, 246, 247, 277, 298, 313, 318

San Marco Monastery, Florence, frescoes

276, 301

Annunciation, 182, 196, 252-54, 252, 253,

310, 329, 339, 349, 402, 409, 416, 517, 521 Madonna and Saints (San Marco altarpiece), 182, 249, 249, 276, 379, 516 Beheading of Sts. Cosmas and Damian, 182, 251, 251 Miracle of the Deacon Justinian, 158, 182, 250-51, 250

Coronation of the Virgin, 182, 254, 254 Transfiguration, 182, 254, 254, 569 Angelo Doni (Raphael), 411, 506, 515, 515 Anghiari, Battle of, 320 ANGUISSOLA, SOFONISBA, 578, 660-62 Portrait of the Artist's Three Sisters with Their Governess, 662, 662 Self-Portrait, 661, 661 Annunciation, 80 Annunciation. (Andrea del Sarto), 594, 595 (Fra Angelico), 182, 196, 252-54, 252, 253, (Alesso Baldovinetti), fresco, 339, 354, 354, 355 (Alesso Baldovinetti) (Uffizi), 328, 350-51, 351 (Sandro Botticelli), 382, 382, 473 (Domenico Veneziano), 300-301, 300 (Donatello), 258, 284, 284, 351, 382 (Lorenzo Ghiberti), 164, 201-3, 203 (Giotto di Bondone), 101, 101, 168 (Leonardo da Vinci), 484-85, 484, 486, 498 (Fra Filippo Lippi), 178, 257-58, 257 (Lorenzo Lotto), 654, 654 (Piero della Francesca), 320-21, 320 Annunciation, Nativity, and Annunciation to the Shepherds (Nicola Pisano), 80, 80, 129, 238 Annunciation and Scenes from the Life of the Virgin (Fra Angelico), 247-48, 247, 248, 249, 252, 276, 301 Annunciation to the Shepherds (Taddeo Gaddi), fresco, 120, 121, 321 Annunciation with Two Saints (Simone Martini), with Lippo Memmi, 128, 134, 135 Ansuino da Forli, 415, 432 antipope, 724 antiquity, 346, 477 inspiration of, 181 role of, in Italian art, 35-37 study of, in the Renaissance, 55 ANTONELLO DA MESSINA, 447-50, 452-53 Crucifixion, 448, 448 Portrait of a Man, 448, 448 St. Jerome in His Study, 446, 447 St. Sebastian, 448-50, 449, 454 Virgin Annunciate, 447-48, 447 Antonine of Florence, Saint, 246, 247, 248, 251, 261-62, 263, 277, 321, 329, 489 Apelles, 383 Apocalypse, 724 Apocrypha, 724 Apollo and Daphne (Antonio del Pollaiuolo), 364-65, 364 Apollo Belvedere, ancient Roman sculpture, 443, 556, 558, 702 Apollonios of Athens, the Son of Nestor, 527 The Appearance of St. Michael on the Castel Sant'Angelo (Domenico Beccafumi), 474-75, 608-10, 609 Appiano, Semiramide d', 377, 379 apprentices, 44 April (Francesco della Cossa), 19, 471, 472 apse, 724 Aquarius (Baldassare Peruzzi), ceiling frescoes, 573, 573, 616 arcade, 724 arch, 724 Architectural Perspective and Background Figures for Adoration of the Magi (Leonardo da Vinci), 486, 487

architecture: Liberation of the Companions of St. James, base, 724 basilica, 190, 270-71, 687, 724 depiction of, 100 fresco, Chapel of St. Felix (formerly Basilica (Palazzo della Ragione), Vicenza Duecento, 88-91 St. James), Sant'Antonio, Padua, 173, Florentine, 168-69, 273-74 173, 425 (Andrea Palladio), 682-83, 682 Gothic, 88-91, 181, 195, 206 avello, 724 Basilica Emilia, Rome, 582, 622, 626 AVERLINO Basilica of San Marco, Venice, 445 High Renaissance, 421 practice of, 52-54 See Filarete, Antonio (Antonio Averlino) Basilica of St. Peter's, Vatican, Rome, 525, 530 Avignon, 75, 118, 135-37 Basilica of the Santa Casa, Loreto, Sacristy of Ouattrocento, 181-97 Renaissance, 319, 463-64 St. Mark, 418, 418, 419, 419 Venice, 463-65, 678-89 BASSANO, JACOPO (Jacopo dal Ponte), 677 Adoration of the Magi, 678, 678 See also Roman architecture, ancient В Baths at Pozzuoli (Girolamo Macchietti), 718, 719 architrave, 724 Battista Sforza (Francesco Laurana), 324, 419, 419 Arena Chapel, Padua, 51, 92, 95-108, 95, 97, Bacchanal of the Andrians (Titian), 443, 642, 643 Battista Sforza and Frederico da Montefeltro (Piero 98, 99, 100, 101, 102, 103, 105, 106, 107, 108, 116, 119, 122, 129, 167, Bacchus (Michelangelo Buonarroti), 504, 505, 517 della Francesca), 324, 324, 325, 360, 419 168, 694 Bacchus and Ariadne (Titian), 443, 642, 643 Battle of Anghiari (Leonardo da Vinci), 499 iconography, 95, 96 copy after, 313, 499, 499, 510, 513, 560, BACCIO Aretino, Pietro, 616, 665, 681, 710 See Bartolommeo, Fra (Baccio della Porta) 561, 591 Battle of Cascina (Michelangelo Buonarroti), 509 Arezzo, 318 Baccio d' Agnolo, 186 Baccio di Montelupo, 205 copied by Aristotile da Sangallo, 499, 503, 510, San Francesco, Chapel, 313-21, 315, 317, 318, 319, 320, 419, 490 Baglioni family, 408 511, 521, 535, 543, 591, 718 iconography, 316, 317 Baiardi, Elena, 618 Battle of Constantine and Maxentius (Piero della Francesca), 317, 318, 319 ARNOLFO DI CAMBIO, 82, 83, 89-90, 168, 184 baldacchino, 724 Cathedral, Florence, 36, 53, 90, 91, 164, 168, Baldassare Castiglione (Raphael), 497, Battle of Heraclius and Chosroes (Piero della 169, 184, 185, 185, 213-14, 213, 286, 294, 562-63, 563 Francesca), 317, 319-20, 319, 490 BALDOVINETTI, ALESSO, 299, 339, 350-55, Battle of Lapiths and Centaurs (Michelangelo 294, 304, 309-10, 309 Palazzo dei Priori (Palazzo Vecchio), Florence, 360, 364, 387, 491, 602 Buonarroti), 476, 502-3, 503, 504, 510, 523 90, 91, 196, 394, 707, **716**, 719 Battle of San Romano (Paolo Uccello), 173, 196, Annunciation, fresco, Chapel of the Cardinal of 296-97, 296, 297, 310, 319, 379, 403, 486 Santa Croce, Florence, 54, 89, 89, 112, 164, Portugal, San Miniato, Florence, 339, 354, 165, 172, 190, 258, 284, 284, 289-91, 290, 354, 355 Battle of the Nudes (Antonio del Pollaiuolo), 361-62, 361 Annunciation (Uffizi), 328, 350-51, 351 291, 316, 336-38, 337, 351, 382 bay, 724 arriccio, 49, 724 Madonna and Child, 351-53, 352, 354 Nativity, fresco, SS. Annunziata, Florence, 168, Arrival of Cardinal Francesco Gonzaga (Andrea See Sodoma (Giovanni Antonio Bazzi) 353, 353, 491, 594 Mantegna), 439-41, 440, 441, 613, 614 Arrival of the Ambassadors of Britain at the Portrait of a Young Woman, 354-55, 355 beato, 724 BECCAFUMI, DOMENICO, 606-10, 621, 655 Court of Brittany (Vittore Carpaccio), 458, The Appearance of St. Michael on the Castel See Maso di Banco; Nanni di Banco 459, 463 Sant'Angelo, 474-75, 608-10, 609 art, survival of, 94 Bandinelli, Baccio, 335, 526 Communion of St. Catherine, 607, 607 Baptism of Christ: arte, 724 Fall of the Rebel Angels (first version), 607-8, Arte dei Medici e Speziali, 42-43 (Piero della Francesca), 312, 313 (Andrea del Verrocchio), with Leonardo da 607, 691 Arte della Seta, 43 Vinci, 366-67, 367, 484, 498 Fall of the Rebel Angels (second version), 607-8, Arte di Pietra e Legname, 43, 53 608, 691 Baptism of Hermogenes (Andrea Mantegna), art history, practice of, 54-55 fresco, 432, 433 The Miracle of St. Michael on Mt. Gargano, artists, 42-45 baptisteries, role of, 79 608-10, 609 social position of, 43-44 Baptistery, Castiglione Olona, 243, 243, 405 Stigmatization of St. Catherine, 606-7, 606 Art Nouveau, 390 Baptistery, Florence, 54, 68, 69, 107, 122-23, 122, Beheading of Sts. Cosmas and Damian Art of Architecture (Andrea Pisano), 43, 44, (Fra Angelico), 182, 251, 251 187, 410, 694 54, 122 BELLINI, GENTILE, 429, 431, 444-45, 454, door competition, 199-201 Art of Painting (Andrea Pisano), 43, 43, 45, 48, 122 East Doors, 17, 220, 276-78, 276, 277-78, 277, 457, 497, 632, 636 Portrait of a Turkish Boy, attrib., 445, 445 Art of Sculpture (Andrea Pisano), 43, 43, 52, 278, 279, 288, 300, 407 North Doors, 164, 183, 201-3, 202, 203, 232, Portrait of Sultan Mahomet II, 322, 445, 445 81, 122, 284 276, 277, 301 Procession of the Relic of the True Cross, arts, liberal and mechanical, 43-44, 724 South Doors, 123, 123, 167, 199, 201, 276 444. 444 Ascension, 724 BELLINI, GIOVANNI (Giambellino), 35, Baptistery, Pisa, 79-80, 79, 80, 81, 81, 129, 238 a secco, 51, 724 Baptistery, Siena, Baptismal Font, 183, 215-16, 429, 431, 442, 450-57, 461, 611, 631, Assisi, 37, 409 216, 399, 493 636, 652, 656 San Francesco, Lower Church, 45, 116, 116, Agony in the Garden, 424, 451, 451 117, 139, 140, 141, 141, 142, 321, Barbarigo family, 636 Enthroned Madonna and Child with Saints 384, 670 Barbaro, Daniele, 673, 685 (San Giobbe altarpiece), computerized re-St. Martin Chapel, 133, 134, 158 Barbaro, Marcantonio, 685 construction, 453-54, 454, 457, 459, 652 San Francesco, Upper Church, 73-76, 73, 75, See Donatello (Donato di Niccolò Bardi) Enthroned Madonna and Child with Sts. Peter, 116 - 18Barna da Siena, 51 Nicholas, Benedict, and Mark (Frari altar-Assumption, 724 piece), Sacristy, Santa Maria Gloriosa dei Assumption of the Virgin: BAROCCI, FEDERICO, 722 Frari, Venice, 452-53, 453, 652 Madonna del Popolo, 722, 723 (Andrea del Sarto), 596, 597 (Correggio), fresco, 614, 614, 615 Baroque, 407, 416, 422, 561, 581, 612, 614, Entbroned Madonna with Saints (San Zaccaria 650, 677, 708, 722 altarpiece), 324, 450, 456, 457, 464 (Nanni di Banco), gable, 164, 213-14, Madonna and Child, 450-51, 450 architecture, 697, 720 213, 304 Pietà, 451-52, 452, 473 (Rosso Fiorentino), fresco, BAROZZI St. Francis in Ecstasy, 454-57, 455 602, 602 See Vignola, Giacomo da (Jacopo Barozzi) Transfiguration of Christ, 454, 455, 569 (Titian), 172, 635, 638, 639-40, 639 barrel vault, 724 BARTOLO BELLINI, JACOPO, 429-32, 437, 451, 468 Athens: Flagellation, drawing, 431-32, 431 See Domenico di Bartolo Erechtheum, 209 Parthenon, 497 BARTOLOMEO, FRA (Baccio Della Porta), 457, Madonna of Humility with Donor (Lionello 495, 515-16, 594, 621, 632, 639 d'Este?), 429, 430, 451, 465 atmospheric perspective, 226, 325 Madonna of the Cherubim, 429, 429 Vision of St. Bernard, 387, 516, 516, 561-62 attic story, 724 "Atys-Amorino" (Donatello), 283, 283 Bartolommeo Panciatichi (Agnolo Bronzino), Nativity, drawing, 168, 431, 431 Bellini family, 444 710, 710 Avanzi, Jacopo, 173

Belvedere, Vatican, Rome (Donato Bramante), BOTTICELLI, SANDRO (Alessandro di Mariano Dome, 168, 181, 184-87, 184, 186, 267, 410, 36, 526, 533-34, 534, 721 Filipepi), 261, 276, 330, 359, 371-85, 390, 482, 509 473, 477, 508, 511, 526, 574, 581 Ospedale degli Innocenti, Florence, 187-88, 187, Bembo, Bernardo, 485 Bembo, Pietro, 443 Adoration of the Magi, 371, 372, 374-76, 203, 237, 700 Benci, Ginevra de', 485 375, 486 Sacrifice of Isaac, 199, 200 Self-Portrait, 371, 373 Santa Croce, Florence, Pazzi Chapel, 193-95, Benci di Cione, 38 BENEDETTO DA MAIANO, 343-46 Annunciation, 382, 382, 473 193, 194, 348 Birth of Venus, 380-81, 380, 381, 384, 517, Bust of Pietro Mellini, 343, 343, 419 San Lorenzo, Florence, 89, 178, 182, 187, 188, 188, 190-92, 190, 194, 203, 257-58, 257. Palazzo Strozzi, Florence, 344-46, 345, 346, 573.634 420, 465, 623, 625 Calumny of Apelles, 383-84, 383, 473 334-36, 335, 336, 582, 584, 602 Benedictine Order, 167, 724 Old Sacristy, 14, 182, 188-89, 189, 194, 195, Camilla and the Centaur 377, 37 287, 319, 348, 416, 584 Bergamo, 425, 656 Lamentation over the Dead Christ with Sts. BERLINGHIERI, BERLINGHIERO, 63, 113 Jerome, Paul, and Peter, 384, 384, 473 Santa Maria degli Angeli, Florence, 192-93, Madonna of the Magnificat, 298, 376, 376 193, 306 Cross, 63, 63 BERLINGHIERI, BONAVENTURA, 63, 70 Mystic Nativity, 384-85, 385, 473 Santo Spirito, Florence, 89, 187, 190-91, 191, St. Francis with Scenes from His Life, San Portrait of a Man with a Medal of Cosimo de' 192, 482, 504, 504 Bruni, Lionardo, 54, 276, 289, 379 Francesco, Pescia, 63, 64, 113, 116, 135 Medici, 354, 381, 381, 497 Bernini, Gianlorenzo, 339, 612, 708 Primavera, 261, 358, 378-80, 379 brushwork, 635, 664 Louis XIV, 490 Punishment of Korah, Dathan, and Abiram, Bufalini, Maria, 617 fresco, Sistine Chapel, Vatican, Rome, 371, Berruguete, Alonso, 511 Bulgarini, Bartolommeo, 128 Berruguete, Pedro, 422 372, 374, 374, 410, 441, 517, 537, 538 BUONARROTI BERTOLDO DI GIOVANNI, 502 Sistine Chapel fresco, 538 See Michelangelo Buonarroti Venus and Mars, 377-78, 377 Commemorative Medal of the Pazzi BUONINSEGNA Conspiracy, with the Portrait of Lorenzo Botticelli, Simone, 382 See Duccio di Buoninsegna il Magnifico, 330, 331, 371 BOULOGNE Buontalenti, Bernardo, 394, 466 Betraval: See Giovanni Bologna (Giambologna; Jean Busketus, 79 (School of Florence), 36, 65, 65, 104 Boulogne) Bust of Matteo Palmieri (Antonio Rossellino), braccio, 724 (Simone Martini, workshop of), fresco, 138, 138 342, 342 Bibbiena, Cardinal, 564 BRAMANTE, DONATO (Donato di Pascuccio), Bust of Pietro Mellini (Benedetto da Maiano), Bicci di Lorenzo, 313 273, 346, 407, 421, 466, 511, 525, 526, 343, 343, 419 **527–35**, 555, 561, 564, 567, 606, 621, 623, Bird's-eye View of the Chiana Valley, Showing busts, portrait, 291 Arezzo, Cortona, Perugia, and Siena 656, 683, 720, 722 Buti, Lucrezia, 255 (Leonardo da Vinci), 248, 480, 480 Belvedere, Vatican, Rome, 36, 526, 533-34, 534 buttress, 725 Palazzo Caprini, Rome, 534-35, 534, 678, biretta, 724 Byzantine art, 59-62, 64, 65, 75, 170 Birth of the Virgin: 680, 721 Byzantinizing style, 67, 125, 429, 463 (Andrea del Sarto), fresco, 594, 595 Santa Maria delle Grazie, Milan, 528-29, 528, 529 decline of, 93 (Pietro Cavallini), mosaic, 76-77, 76, 158 Santa Maria presso San Satiro, Milan, 527, 527, (Domenico del Ghirlandaio), fresco, 395-96, 528, 528 396, 502, 594 St. Peter's, Vatican, Rome, design, 53, 54, 481. C (Pietro Lorenzetti), 128, 142, 143, 437 525, 528, 530, 531, 532, 532, 555, 582, (Andrea Orcagna), 158, 158 Birth of Venus (Sandro Botticelli), 380-81, 380. San Pietro in Montorio, Rome, Tempietto, 421, Cain Killing Abel (Titian), 647-48, 647, 652 381, 384, 517, 573, 634 481, 511, 529, 529, 530, 567, 683 Cajetan, Saint (Gaetano da Thiene), 569 Black Death, 155, 261 BRAMANTINO (Bartolomeo Suardi), 656-57 CALIARI The Blessed Agostino Novello and Four of His Adoration of the Magi, 656, 657 See Veronese, Paolo (Paolo Caliari) Miracles (Simone Martini), 134-35, 136 Brancacci, Pietro di Piuvichese, 231 Calumny of Apelles (Sandro Botticelli), 383-84, blind arcade, 724 Brancacci Chapel, Santa Maria del Carmine, 383, 473 "Blockhead" Captive (Michelangelo Buonarroti), Florence, 16, 229, 230-32, 230, 231, 385, Calvalcanti, Guido, 93 590-93, 593 566, 567 Calvary, 725 Boccaccio, 93 iconography, 230, 230 Camaldolite Order, 167, 192-93, 263, 725 Brazen Serpent (Michelangelo Buonarroti), 550, Bocchi, Francesco, 210 CAMBIO bole, 47, 724 551, 604, 613, 703 See Arnolfo di Cambio BOLOGNA Brescia, 170, 223, 631, 656, 658-60 Camilla and the Centaur (Sandro Botticelli), 377, 377 See Giovanni Bologna (Giambologna; Jean Bridget, Saint, 167-68 Campanile, Cathedral, Florence, 114-15, 114, 115, Boulogne) bronze, 52 158, 168, 214 Bologna, 537, 610 bronze casting, 52, 53 campanile, 725 San Petronio, Main Portal, 220, 220, 221, 221, BRONZINO, AGNOLO (Agnolo Tori), 598, Campi, Bernardino, 660-61 232, 504, 545 709-12, 718 Campidoglio, Rome (Michelangelo Buonarroti), Bon, Bartolomeo, 172 36, 699-700, 699, 700 Allegory with Venus and Cupid, 710, 711 BONAIUTI Bartolommeo Panciatichi, 710, 710 Campi family, 660 See Andrea da Firenze (Andrea Bonaiuti) Chapel of Eleonora da Toledo, Palazzo dei Priori CAMPIONE (Palazzo Vecchio), Florence, altarpiece and Bonaventura, Saint, 113, 116 See Bonino da Campione BONDONE frescoes, 27, 712, 712 campo, 725 See Giotto di Bondone Crossing of the Red Sea, fresco, Chapel of Camposanto, Pisa, 51, 149-50, 150-51, 173 BONINO DA CAMPIONE, 174 Eleonora da Toledo, Palazzo dei Priori Cantoria: Equestrian Monument to Bernabò Visconti, 174, (Palazzo Vecchio), Florence, 551, (Donatello), 279, 282-83, 282, 283 175, 177, 286 712, 713 (Luca della Robbia), 279-80, 279, 280, 294, Pietà, 709-10, 709 Funerary Monument of Cansignorio della 313, 327 Scala, 177, 177 Bruges, 38 cantoria, 725 Bono da Ferrara, 432 canvas, works on, 444 Bruges Madonna (Michelangelo Buonarroti), 508, BORDONE, PARIS, 655-56, 659 capital, 725 508, 553 A Fisherman Delivering the Ring, 656, 656 BRUNELLESCHI, FILIPPO, 168, 181, 183-95, capomaestro, 53, 725 Borgherini, Pierfrancesco, 598 199, 215-16, 241, 243, 249, 257, 274, 275, Capponi, Niccolò, 591 Borgia, Cesare, 385, 480, 495, 499, 571 339, 346, 420, 508, 582, 585, 684 Capponi family, 601 Borgia, Rodrigo (Alexander VI), 525 Cathedral, Florence, 36, 53, 90, 91, 164, 168, CAPRAROLA Borgia family, 525, 631 169, 184, 185, 185, 213-14, 213, 286, 294, See Cola da Caprarola bottega, 44-45, 724 294, 304, 309-10, 309 Caprarola, Villa Farnese, 720-21, 721, 722

CIONE Captive (Dying Slave) (Michelangelo Buonarroti), Cathedral, Prato, 260-61, 260, 261 Cathedral, Siena, 82, 83, 83, 85-86, 86, 125, 128, See Benci di Cione 504, 537, 552, 553, 553, 591 Cione, Jacopo di, 158 Captive (Rebellious Slave) (Michelangelo 413, 415 CIONE, NARDO DI, 159 Buonarroti), 537, 552, 553-54, 553, 591 façade, 84, 84, 126 Piccolomini Library, 18, 412-13, 412, 413, 414 Madonna and Child with Sts. Peter and John CARADOSSO, 525 the Evangelist, 48, 49, 159, 160 Medal of Julius II, 525 Cavalieri, Tommaso, 702 Strozzi Chapel, Santa Maria Novella, Florence, CAVALLINI, PIETRO (Pietro de' Cerroni), Carafa, Giovanni, 569 76-78.94 Caravaggio, 305, 448, 569, 718, 719, 722 Hell, 51, 159, 159, 362, 694 Care of the Sick (Domenico di Bartolo), fresco, Birth of the Virgin, mosaic, Santa Maria in Paradise, 51, 158, 159 Trastevere, Rome, 76-77, 76, 158 403, 404, 404 Cistercian Order, 88-89, 725 Last Judgment detail, fresco, Santa Cecilia in Carmelite Order, 230, 237, 725 Ciuffagni, Bernardo, statues, 205 Trastevere, Rome, 76, 77-78, 77, 119 Caro, Annibale, 661 classical art CAVALORI, MIRABELLO, 718-19 CARPACCIO, VITTORE (Scarpaza; Carpathius), See ancient art **457–61**, 631 Wool Factory, 718, 719 Cefalù, Sicily, Cathedral, 51, 59, 59 Claudian, 378 Arrival of the Ambassadors of Britain at the clausura, 725 CELLINI, BENVENUTO, 44, 704-7 Court of Brittany, 458, 459, 463 Clement VII, Pope (Giulio de' Medici), 564, 569, autobiography, 704 Departure of the Prince from Britain, His Perseus and Medusa, 38, 705-6, 705 582, 584-85, 588, 591, 691 Arrival in Brittany, and Departure of the Beclerestory, 725, 728 Portrait of Grandduke Cosimo de' Medici, trothed Couple for Rome, 457-58, 458, 463 closed door, 725 706-7, 706 Dream of St. Ursula, 458-59, 460 closed garden, 725 Saltcellar of King Francis I of France, 704, 704 Meditation on the Passion, 459-61, 461 Clovio, Giulio, 661 cenacolo, 725 Carracci, 722 CODUCCI Cennini, Cennino, 74, 81, 93, 100, 102, 117, 119, Carrara, 582 See Codussi, Mauro (or Coducci) 164, 275 cartellino, 725 CODUSSI (OR CODUCCI), MAURO, 463-65, 680 Il libro dell'arte (The Book of Art), 45–52 Carthusian Order, 725 Palazzo Loredan (Palazzo Vendramin-Calergi), Central Italy, Renaissance in, 399-423 cartoon (cartone), 47, 52, 725 Ceresara, Paride da, 443 Venice, 464-65, 464 caryatid, 725 San Zaccaria, Venice, façade, on a building by certosa, 725 Cascia di Regello, San Giovenale, 228, 228, Antonio Gambello, 463-64, 463 Certosa, Pavia (Giovanni Solari, with Guiniforte 238, 260 coffer, 725 Solari), 175, 466, 466-68, 467 casino, 725 COLA DA CAPRAROLA, 533 façade (Giovanni Antonio Amadeo), 466, 468 cassone, 355-57, 725 Santa Maria della Consolazione, Todi, 271, CASTAGNO, ANDREA DEL, 44, 212, 266, Cesena, Biagio da, 694 532-33, 533 chalice, 725 303-10, 313, 329-30, 333, 350, 353, 384, Colantonio, 447 chancel, 725 387, 391, 416, 425, 439 Collegiate Church, San Gimignano, 137, 137, Chapel of Nicholas V, Rome, 321 Cumaean Sibyl, 292, 306, 306 Chapel of the Cardinal of Portugal, San Miniato, 138, 138 David, 307-9, 307, 360 Colleoni, Bartolommeo, 369 Florence (Antonio Manetti), 339-42, 340, Death of the Virgin, 439 colonnade, 725 353-54, 364, 373 Famous Men and Women Cycle, computerized chapels, role of, 45 Colonna party, 584 reconstruction, 305-7, 305 colonnette, 725 chapter house, role of, 45, 725 Last Supper and Resurrection, Crucifixion, and colossal, 725 Charles V, Emperor, 584, 585, 606, 628, 631, Entombment, frescoes, Cenacolo, Sant' Columella, 378 636, 656 Apollonia, Florence, 302, 303-5, 303, 304, column, 725 Charles VIII of France, 383 391 492 engaged, 268 chasing, 725 Niccolò da Tolentino, fresco transferred to Commemorative Medal of the Pazzi Conspiracy Chastity of Joseph (Properzia de' Rossi), canvas, Cathedral, Florence, 309-10, 309 (Bertoldo di Giovanni), 330, 331, 371 Pippo Spano, 306, 306, 384 578, 579 Commentaries (Lorenzo Ghiberti), 201 cherub, 725 Resurrection, Crucifixion, Entombment, Communion of St. Catherine (Domenico chiaroscuro, 725 sinopia,50,50 Beccafumi), 607, 607 Chigi, Agostino, 571-72 Vision of St. Jerome, fresco, SS. Annunziata, Comnenian style, 60 Christ and St. Thomas (Andrea del Verrocchio), Florence, with Domenico Venziano?, 308, compagnia, 725 205, 367, 368, 368, 387 309, 309, 333, 362, 439 Company of the Magi, 371 Christ Giving the Keys to St. Peter (Perugino), Castello del Buonconsiglio, Trent, Eagle's Tower, fresco, 53, 398, 409-10, 409, 410, 441, composite order, 725 176-77, 176, 349, 473 compound pier, 725 511, 537, 538 Castiglione, Baldassare, 497, 563 Condivi, Ascanio, 554 Christ in Glory from the Ascension (Melozzo da Book of the Courtier, 562-63 condottiere, 726 Forlì), 416, 417 Castiglione Olona, Baptistery, 243, 243, 405 Confirmation of the Franciscan Rule by Pope cathedral, description/definition of, 52-53, 725 Christ Pantocrator, the Virgin Mary, Angels, Saints Honorius III (Domenico del Ghirlandaio), and Prophets, mosaic, Cathedral, Cathedral, Cefalù, Sicily, 51, 59, 59 Cefalù, Sicily, Italo-Byzantine, 51, 59, 59 fresco, 394, 394 Cathedral, Cremona, 619, 620 confraternity, 726 Cathedral, Florence, 36, 53, 90, 91, 164, 168, 169, Christ Treading on the Lion and the Basilisk, statue, Notre Dame, Amiens, France, French console, 726 184, 185, 185, 213-14, 213, 286, 294, 294, Constantine, Emperor, 118, 316 304, 309-10, 309 Gothic, 102, 104 Constantinople, 59-60, 170, 321, 329 Christus Mortuus, 725 Campanile, 114-15, 114, 115, 158, 168, fall of, 75 Christus Patiens, 60, 70, 725 214-15, 214, 215, 254, 333 Topkapi Palace, 445 Dome, 168, 181, 184-87, 184, 186, 267, 410, Christus Triumphans, 60, 725 contado, 726 Chrysolorus, Manuel, 36 482, 509 contrapposto, 208-9, 331, 726 lantern, 168, 185-86, 185 Church of the Trinity, Sopoćani, 78, 78 ciborium, 725 Convent of San Paolo, Parma, 610 North Sacristy, 280, 281, 330, 343-44, 344, 423 Camera di San Paolo, 21, 610-11, 610 CIMABUE (Cenni di Pepi), 59, 70-74, 75, 86, Cathedral, Milan, 175 Conversion of St. Paul (Michelangelo Buonarroti), 93, 94, 102, 125, 632 Cathedral, Montepulciano, Tomb of Bartolommeo Crucifix, 70-73, 72, 94 fresco, 690, 694-96, 695, 696 Aragazzi, 289, 289 cope, 726 Crucifixion, fresco, San Francesco, Upper Cathedral, Orvieto, 150, 151-53, 152, 153 COPPO DI MARCOVALDO, 67-69, 102, Church, Assisi, 73-74, 73, 75, 116-18 San Brizio Chapel, 53, 517-21, 518, 519, 520, Enthroned Madonna and Child with Angels and 120, 126 550, 554, 693 Crucifix, 66, 67, 67, 70, 73, 106 Prophets, 58, 70, 71, 108, 125 Cathedral, Parma, 614, 614, 615 Last Judgment, mosaic, Baptistery, Florence, cinquecento, 725 Cathedral, Pisa, 79 attrib., 68, 69, 107, 123, 694 Ciompi, revolt of the, 181 Baptistery Pulpit, 79-80, 79, 80, 81, 129, 238

Madonna and Child, 67-69, 67, 126 Cross No. 20 (School of Pisa), 45, 60-63, 61, 62, Day, Tomb of Giuliano de' Medici (Michelangelo corbel, 726 67, 70, 106 Buonarroti), 502, 585-86, 585, 587, 587, corbel table, 726 cross vault, 726 Corboli, Giorolamo (Jerome) dei, 309 Crowning with Thorns (Titian), 652, 652 Death of the Virgin (Andrea del Castagno), 439 Corinthian order, 268, 726 crucifix, 726 Deluge: cornice, 726 (Leonardo da Vinci), 500, 500 Crucifix Coronation of the Virgin: (Cimabue), 70-73, 72, 94 (Michelangelo Buonarroti), 526, 539, 543, 544, (Fra Angelico), fresco, 182, 254, 254 (Coppo di Marcovaldo), 66, 67, 67, 70, 73, 106 (Francesco di Giorgio), 406-7, 406 (Giotto di Bondone), 94-95, 94, 104 (Paolo Uccello), fresco, 233, 294-96, 295 (Gentile da Fabriano), from the Valle Romita (Michelangelo Buonarroti), attrib., 504, 504 Demons in Hell (Michelangelo Buonarroti), polyptych, 223, 224 Crucifixion, 726 694, 694 (Lorenzo Monaco), 164, 166, 167, 167, 223, Crucifixion dentils, 726 226, 402, 516 (Antonello da Messina), 448, 448 Departure of Aeneas Silvius Piccolomini for Basel, (Paolo Veneziano), 170-71, 171 (Cimabue), fresco, 73-74, 73, 75, 116-18 (Pintoricchio), 413, 414 (Jacopo Torriti), mosaic, 74, 75 (Duccio), 130, 131 Departure of the Prince from Britain, His Arrival (Antonio Vivarini), with Giovanni D'Alemagna, (Vincenzo Foppa), 465, 465 in Brittany, and Departure of the Betrothed 428, 429 (Giotto di Bondone), 104, 105 Couple for Rome (Vittore Carpaccio), Corpus Christi, 726 (Andrea Mantegna), 435, 437, 438, 465 457-58, 458, 463 Corpus Domini, 726 (Masaccio), from the Pisa polyptych, 238-39, Deposition, 726 CORREGGIO (Antonio Allegri), 416, 442-43, 239, 311 Deposition, Lamentation, and Entombment **610–16**, 621, 655, 722 (Michelangelo Buonarroti), 700, 700 (School of Pisa), 60-62, 62, 67, 106 Adoration of the Shepherds (Holy Night), (Tintoretto), 667-68, 667, 668 Descent from the Cross, 726 121, 612-13, 612 Crucifixion, mosaic, Monastery Church, Daphni, Descent from the Cross Assumption of the Virgin, fresco, Cathedral, Greece, Byzantine, 62, 62, 70 (Fra Angelico), frame and pinnacles by Lorenzo Parma, 614, 614, 615 Crucifixion of St. Peter: Monaco, 168, 246-47, 246, 247, 277, 298, Camera di San Paolo, Convent of San Paolo, (Masaccio), from the Pisa polyptych, 240, 240 313, 318 (Lorenzo Monaco), 246 Parma, frescoes, 21, 610-11, 610 (Michelangelo Buonarroti), fresco, 694-96, 695 Jupiter and Ganymede, 614-16, 616 Crucifixion with Saints (Perugino), 410-11, 411 (Rosso Fiorentino), 602-4, 603, 604 Iupiter and Io. 616, 616 cruciform, 726 Descent from the Cross, Lamentation and other Madonna and Child with Sts. Jerome and Mary Crusaders, 59-60, 143, 170 scenes from Christ's Passion (Pietro Magdalen, 611-12, 611 Cumaean Sibyl: Lorenzetti), frescoes, 141, 141 Vision of St. John the Evangelist, fresco, San (Andrea del Castagno), 292, 306, 306 Descent into Limbo, Descent from the Cross Giovanni Evangelista, Parma, 613-14, 613 (Michelangelo Buonarroti), 10-11, 503, 545, and Madonna with Two Saints (Pietro Cort, Cornelis, 649 546, 552 Lorenzetti), frescoes, 140, 141, 384 Cortona, Santa Maria del Calcinaio, 271, 407-8, Cupid Carving His Bow (Parmigianino), 619, 619 DESIDERIO DA SETTIGNANO, 182, 336-39, Cupid Pointing Out Psyche to the Three Graces 408, 533, 621 342, 501 COSIMO (Raphael), frescoes, with Giulio Romano, Head of a Child, attrib., 339, 339 See Piero di Cosimo 577, 577, 616, 628, 673 Madonna and Child, 338-39, 338 Cosimo I as Patron of Pisa (Pierino da Vinci), cupola, 726 Meeting of Christ and John the Baptist as 703, 703 cusping, 726 Youths, 338, 338 COSSA, FRANCESCO DEL. 471, 473 Tomb of Carlo Marsuppini, Santa Croce, frescoes, Hall of the Months, Palazzo Schifanoia, Florence, 336-38, 337 Ferrara, with Ercole de' Roberti, Cosmè Diamante, Fra, 260 D Tura, and others, 471, 472 diaphragm arch, 726 April, 19, 471, 472 diptych, 45, 726 St. John the Baptist, from the Griffoni DADDI, BERNARDO, 119-20, 155, 159 Discovery of the Body of St. Mark (Tintoretto), altarpiece, 471, 471 Madonna and Child Enthroned, Orsanmichele, 666, 667 COSTA, LORENZO, 442-43 Florence, 156-57, 157, 167 Discovery of the Wood of the True Cross and Meet-Garden of the Peaceful Arts, 444 Birth of the Virgin, 158, 158 ing of Solomon and the Queen of Sheba Council of Trent, 612 Triptych, Loggia del Bigallo, Florence, (Piero della Francesca), 317, 317, 419 Counter-Reformation, 648, 689, 693, 720 119-20, 119 disegno, 726 Court of Pan (Luca Signorelli), 517, 517 dalmatic, 726 di sotto in sù, 726 The Creation (Lorenzo Ghiberti), 220, 277, 277 Damned Consigned to Hell (Luca Signorelli), 520, Disputà (Disputation over the Sacrament) Creation of Adam: 521, 550 (Raphael), frescoes, and Three Cardinal (Michelangelo Buonarroti), 221, 526, 539, 542, Damned Soul Descending to Hell (Michelangelo Virtues: Fortitude, Prudence and Temper-546-47, 548 Buonarroti), 693, 693 ance, 521, 554, 555, 557, 558 (Andrea Pisano), 43, 122, 122 Danaë (Titian), 630, 648-49, 648 Distribution of the Goods of the Community and (Jacopo della Quercia), 220, 220, 232, 504 Dance of the Nudes (Antonio del Pollaiuolo), the Death of Ananais (Masaccio), fresco, Creation of Eve (Michelangelo Buonarroti), 539, 362, 362 236, 237 545, 547 Daniel (Nicola Pisano), 81, 81 doge, 726 Creation of Sun, Moon, and Plants (Michelangelo Dante, 93, 94, 100, 106, 406-7, 694 Doge's Palace, Venice, 445, 454, 670 Buonarroti), 311, 526, 539, 547-48, 549, DANTI, VINCENZO, 703 Hall of the Great Council, 670, 677, 677 550, 553 Moses and the Brazen Serpent, 703, 703 Dolce, Ludovico, 635, 636, 640, 702 Cremona, 425, 660 Daphni, Greece, Monastery Church, 62, 62, 70 Dolci, Carlo, 391 Cathedral, 619, 620 D'APULIA Dome, Cathedral, Florence, 168, 181, 184-87, See Pisano, Nicola (Nicola d'Apulia) CRIVELLI, CARLO, 461-63 184, 186, 267, 410, 482, 509 Madonna della Candeletta, 463, 463 dome, 726 Pietà, 462, 463 (Andrea del Castagno), 307-9, 307, 360 Domenichino, 566 crocketing, 726 (Donatello), 164, 182, 207-8, 207, 284-85, 285, Domenico da Pescia, Fra, 384 Cronaca, Il (Simone del Pollaiuolo), 344 307, 369, 378 DOMENICO DI BARTOLO, 303, 403-4 Cross (School of Florence), 36, 65, 65, 104 (Michelangelo Buonarroti), 20, 38, 207, 385, Care of the Sick, fresco, Pellegrinaio, Hospital Cross (Berlinghiero Berlinghieri), 63, 63 390, 508-9, 509, 510, 553, 587 of Santa Maria della Scala, Siena, 403, "Crossed-Leg" Captive (Michelangelo (Andrea del Verrocchio), 369, 369, 378 404, 404 Buonarroti), 590-93, 592 David and Goliath (Titian), 647-48, 647, 652 Madonna of Humility, 403, 403 Crossing of the Red Sea (Agnolo Bronzino), fresco, Dawn, Tomb of Lorenzo de' Medici (Michelangelo DOMENICO VENEZIANO, 182, 245, 256, 266, Buonarroti), 585–86, 585, 587, 588, 588, 551, 712, 713 **297–302**, 310, 313, 329, 339, 350, 351, Cross No. 15 (School of Pisa), 60, 60 705, 707 387, 409, 425

Eremitani Church, Padua, Ovetari Chapel, 432-33, Adoration of the Magi, 298, 298, 376 DUCCIO DI BUONINSEGNA, 83, 93, 125-30, Madonna and Child with Sts. Francis, John 401.402 433, 434, 434, 450 Madonna and Child (Rucellai Madonna), 70, erotica, 574, 710 the Baptist, Zenobius, and Lucy (St. Lucy altarpiece), 299-300, 299, 350 108, 125-26, 125 Este, Alfonso d', 641 Annunciation, 300-301, 300 Maestà, 126-30, 126, 127, 128, 310, 407 Este, Borso d', 471 St. John the Baptist in the Desert, 301, 301 Crucifixion, 130, 131 Este, Ercole d', 470 Este, Isabella d', 442-44, 495 Entry into Ierusalem, 130, 130, 143 Dome of the Rock, Jerusalem, 511 Dominican Order, 88, 155-58, 161, 171-72, 190, Nativity and Prophets Isaiah and Ezekiel, Este, Lionello d', 429, 468 Este, Niccolò d', 286, 468 246, 248, 726 129, 129 Este family, 321, 425, 468, 613 Dominici, Giovanni, 338 Temptation of Christ on the Mountain, 129, DONATELLO (Donato di Niccolò Bardi), 164, 129, 401 Etruscan art: 183, 188, 206-12, 214-17, 227, 232, 245, Duecento, 59, 59-74, 88-91, 726 sculpture, 313 266, 276, 279, 282-89, 309, 329, 331-36, sculpture, 79-88 temples, 348 366, 390, 399, 402, 405, 407, 425, 432, Duke of Athens, 155 eucharist, 726 434-37, 501, 502, 508, 708 Eugenius IV, Pope, 413, 466 duomo, 726 Dürer, Albrecht, 444, 450, 594, 598, 604 exedra, 726 Annunciation, Santa Croce, Florence, 258, 284, 284, 351, 382 Dusk, Tomb of Lorenzo de' Medici (Michelangelo Expulsion: Buonarroti), 585-86, 585, 587, 705 (Masaccio), fresco, 49, 234, 235, 235, 248, "Atys-Amorino", 283, 283 544, 545 Cantoria, 279, 282-83, 282, 283 David, 164, 182, 207-8, 207, 284-85, 285, 307, (Jacopo della Quercia), relief, 221, 221, 504, 545 (Jacopo della Quercia), relief, 219-20, 219, 235 369, 378 E Expulsion from the Garden (Cristoforo Equestrian Monument of Gattamelata, 36, 174, 286-87, 286, 287, 294, 370, 490 Mantegazza), 466, 467 Expulsion of Attila and Liberation of St. Peter from Feast of Herod, Baptismal Font, Baptistery, Siena, Early Christian architecture, 190, 530 Early Christian art, 76, 416 Prison (Raphael), frescoes, 554, 555, 558, 183, 215-16, 216, 399, 493 Jeremiah, Campanile, Cathedral, Florence, Ecce Homo with Angel (Moretto), 659, 660 559, 561, 650, 696 ex-voto, 726 removed, 214-15, 215 Edward III, King, 155 Eyck, Jan van, 211, 247, 327, 387, 447, 479 Judith and Holofernes, 52, 53, 209, 333-34, egg-and-dart, 726 English art, 631 Double Portrait (Arnolfini Betrotbal?), 617 334, 705 Miracle of the Believing Donkey, relief, entablature, 726 Enthroned Christ with Madonna and Saints Sant'Antonio, Padua, 116, 287-89, 288, 432 (Andrea Orcagna), 155-56, 156, 224 The Penitent Magdalen, 331–33, 332, 333 F Entbroned Madonna (Guido da Siena), 69-70, 69 St. Anthony of Padua Healing the Wrathful Son, Enthroned Madonna and Child (Masaccio), relief, Sant'Antonio, Padua, 287-89, 288, FABRIANO from the Pisa polyptych, 238, 260 432, 437, 707 See Gentile da Fabriano St. George, 15, 42, 198, 205, 206, 209-11, 210, Enthroned Madonna and Child with Angels 238, 333, 592 (Cosmè Tura), from the Roverella Fabriano, 329 altarpiece, 468-70, 469 Faith (Michelozzo di Bartolommeo), 289, 289 St. George and the Dragon, Orsanmichele, Flo-Entbroned Madonna and Child with Angels and Fall of Adam and Eve and Expulsion (Michelanrence, removed, 183, 211, 229, 276, Prophets (Cimabue), 58, 70, 71, 108, 125 gelo Buonarroti), 526, 539, 541, 542, 544 495.502.513 Fall of Icarus (Sebastiano del Piombo), 573, 573 Enthroned Madonna and Child with Saints San Lorenzo, Florence, reliefs Fall of the Giants (Perino del Vaga), 605-6, Lamentation, 334-36, 335 (San Zeno altarpiece) (Andrea Mantegna), Martydom of St. Lawrence, 334, 336, 336 324, 434-37, 435, 436, 437, 452 Fall of the Rebel Angels (first version) (Domenico Crucifixion, 435, 437, 438, 465 St. Louis of Toulouse, 367 Beccafumi), 607-8, 607, 691 St. Mark, Orsanmichele, Florence, 205, 208-9, Enthroned Madonna and Child with Saints Fall of the Rebel Angels (second version) 208, 209, 213, 254, 333, 432 (San Giobbe altarpiece) (Giovanni Bellini), (Domenico Beccafumi), 607-8, 608, 691 453-54, 454, 457, 459, 652 Zuccone (Habakkuk), Campanile, Cathedral, computerized reconstruction, 454 Famous Men and Women Cycle (Andrea del Florence, removed, 214-15, 214, 215, Castagno), 305-7, 305 Enthroned Madonna and Child with Sts. Peter, 254, 333 FANCELLI, LUCA, 274 Nicholas, Benedict, and Mark (Frari altar-Donati, Lucrezia, 369 Palazzo Pitti, Florence, 91, 274, 274 piece) (Giovanni Bellini), 452-53, 453, 652 DONATO Farnese, Alessandro, 623-24, 649 See Donatello (Donato di Niccolò Bardi) Enthroned Madonna with Saints (Ognissanti Farnese family, 721 Madonna) (Giotto di Bondone), 108-20, 109 Donato (artist in Siena), 82 Enthroned Madonna with Saints (San Zaccaria Fathers of the Church, 726 Doni, Angelo, 506-8 Feast in the House of Levi (Paolo Veronese), altarpiece) (Giovanni Bellini), 324, 450, Doni Madonna (Michelangelo Buonarroti), 298, 456, 457, 464 675 675 506, 507, 550, 551 Feast of Herod: Enthroned Madonna with Sts. Liberalis and Donna Velata (Veiled Woman) (Raphael), (Donatello), 183, 215-16, 216, 399, 493 Francis (Giorgione), 632, 632 562, 563 DONO (Fra Filippo Lippi), 260-61, 260 Ferdinand and Isabella of Spain, 529 (Jacopo Carucci da Pontormo), 600, 601, 709 See Uccello, Paolo (Paolo di Dono) Self-portrait, 601, 601 Ferdinand of Aragon, 419 donor, 726 Ferdinand of Naples, 463 (Titian), 644-45, 644 Doric order, 268, 726 Entry into Jerusalem (Duccio), 130, 130, 143 Ferrara, 170, 321, 425, 429, 468, 656 Dormition of the Virgin, fresco, Church of the equestrian monument, 286, 370-71, 490, 560 art, 468-73 Trinity, Sopoćani, Byzantine, 78, 78 Palazzo Schifanoia, 471 Equestrian Monument of Bartolommeo Colleoni DOSSI, DOSSO (Giovanni de Lutero), 657-58 Hall of the Months, 19, 471, 472 (Andrea del Verrocchio), 36, 174, 369-71, Melissa, 658, 658 Ferrara, School of, 631, 657 369, 371, 490 Dossi brothers, 657 Festival of Venus (Titian), 443, 641-43, 641 Double Portrait (Arnolfini Betrothal?) Equestrian Monument of Gattamelata Ficino, Marsilio, 330, 376, 378, 380-81 (Donatello), 36, 174, 286-87, 286, 287, (Jan van Eyck), 617 FIESOLE 294, 370, 490 drawing, role of, 46-47, 55 See Angelico, Fra (Giovanni da Fiesole; Drawing of the Belvedere Torso (Maarten van Equestrian Monument to Bernabò Visconti (Bonino da Campione), 174, 175, Guido di Pietro) Heemskerck), 36, 55, 526, 527, 702 177, 286 Fiesole, 37 Dream of St. Martin (Simone Martini), fresco, 133, Fighting Men (Raphael), study for relief sculpture Equestrian Monument to Marcus Aurelius 134, 158 in School of Athens, 558, 560-61 (ancient Roman art), 36, 36, 286, 699 Dream of St. Ursula (Vittore Carpaccio), 458-59, FILARETE, ANTONIO (Antonio Averlino), 269, Frasmo da Narni (Gattamelata), 286 460 350, 466 Erechtheum, Athens, 209

drum, 726

Ospedale Maggiore, Milan, 466 Palazzo Strozzi, 344-46, 345, 346, 420, 465, Plan of Sforzinda, 53, 274, 466, 466 623, 625 EII IPEPI Piazza della Signoria, 32-33, 38, 38, 394, 508, Fontana, Prospero, 719 See Botticelli, Sandro (Alessandro di Mariano 705, 708 Filipepi) Ponte Santa Trinita, 394, 707-8, 708 Crucifixion, 465, 465 FIORE SS. Annunziata, 168, 308, 309, 309, 333, 353, See Jacobello del Fiore 353, 362, 439, 491, 594, 594, 595, 598, FIORENTINO 598 602 602 439, 439 See Rosso Fiorentino (Giovanni Battista Sant'Apollonia, Cenacolo, 302, 303-5, 303, 304 391 492 di Jacopo) FORII Fioretti (Anonymous Life of St. Francis), 113 Santi Apostoli, 190 See Melozzo da Forlì Santa Croce, 54, 89, 89, 112, 164, 165, 172, Forli, 413 See Andrea da Firenze (Andrea Bonaiuti) 190, 258, 284, 284, 289-91, 290, 291, 316, San Biagio, 418 Firenze, Andrea da, 159-61, 168, 232 336-38, 337, 351, 382 A Fisherman Delivering the Ring (Paris Bordone), Bardi-Bardi di Vernio Chapel, 118, 118 656, 656 Bardi Chapel, 51, 110-13, 110, 111, 112, 113 706, 707 Flagellation: Baroncelli Chapel, 120, 121, 321 Pazzi Chapel, 193-95, 193, 194, 348 (Jacopo Bellini), drawing, 431-32, 431 (Francesco di Giorgio), 407, 407 Peruzzi Chapel, 110, 123 232, 284, 329 (Lorenzo Ghiberti), drawing, 203, 203 refectory, 72, 120-21, 121, 492 Rinuccini Chapel, 163, 163 (Lorenzo Ghiberti), 203, 203, 232, 277, 301 (Sebastiano del Piombo), 577-78, 577 Sant'Egidio, 387 FRANCESCA Flagellation of Christ (Piero della Francesca), 321, Santa Felicita, Capponi Chapel, 600, 601, 322, 407 601, 709 Flamboyant Gothic style, 463 San Lorenzo, 89, 178, 182, 187, 188, 188, 497, 515 Flight into Egypt (Gentile da Fabriano), 227, 190-92, 190, 194, 203, 257-58, 257. 227, 232 334-36, 335, 336, 582, 584, 602 Florence, 37, 38-40, 54, 55, 59, 65, 70, 94, 110, façade, 53, 54, 192, 582-83, 583, 622 Flagellation, 407, 407 155, 164, 181, 211, 212, 215, 245, 265, Laurentian Library 285-86, 298, 329-31, 382-83, 394, 399, Entrance Hall, 408, 588-90, 589, 696, 707 495, 499, 501, 509, 526, 582, 584-85, 598, Reading Room, 590, 590, 696 408, 533, 621 631, 691 Medici Chapel, 188, 502, 503, 584, 584. Baptistery, 54, 68, 69, 107, 122-23, 122, 187, 585-86, 585, 586, 587, 587, 588, 588, 592, 410, 694 648, 705, 707 38, 39 door competition, 199-201 Old Sacristy, 14, 182, 188-89, 189, 194, 195, Francia, Francesco, 442 East Doors, 17, 220, 276-78, 276, 277, 278, 287, 319, 348, 416, 584 279, 288, 300, 407 San Marco Monastery, 182, 196, 251, 251, North Doors, 164, 183, 201-3, 202, 203, 232, 252-54, 252, 253, 254, 276, 301, 569 276, 277, 301 library, 182, 196, 197, 248 South Doors, 123, 123, 167, 199, 201, 276 Santa Maria degli Angeli, 192-93, 193, 306 Cathedral, 36, 53, 90, 91, 164, 168, 169, 184, Santa Maria del Carmine, Brancacci Chapel, 16, 185, 185, 213-14, 213, 286, 294, 294, 304, 49, 229, 230-38, 231, 232, 233, 234, 235, French art, 64, 631 309-10, 309 236, 237, 243, 248, 298, 385, 544, 545, Campanile, 114-15, 114, 115, 158, 168, 566, 567 Mannerist, 604 214-15, 214, 215, 254, 333 iconography, 230, 230 Dome, 168, 181, 184-87, 184, 186, 267, 410, Santa Maria Novella, 56-57, 88-89, 88, frieze, 727 172, 240–43, 241, 264, 269–70, 269, 482, 509 lantern, 168, 185-86, 185 364, 395, 687 111-12, 111, 112 North Sacristy, 280, 281, 330, 343-44, Cappella Maggiore, 395-96, 396, 502, 594 344, 423 Chiostro Verde, 233, 294-96, 295 flood of November 4, 1966, 72 Spanish Chapel, 51, 161, 161, 162, 168 Strozzi Chapel, 51, 158, 159, 159, 362, 387, Loggia dei Lanzi, 38, 708, 709 388, 389-90, 389, 694 Loggia del Bigallo, 119-20, 119 G map, 38, 39 San Miniato, 187, 270 Ognissanti, Refectory, 391, 391, 492 Chapel of the Cardinal of Portugal, 339-42, Orsanmichele, 42, 42, 164, 183, 204-6, 204. 340, 341, 342, 353-54, 354, 355, 361, 206, 208-9, 208, 209, 211, 212, 212, 213, 364, 373 294, 390 228, 229, 232, 254, 276, 284, 329, 333, Santo Spirito, 89, 187, 190-91, 191, 192, 482, 432, 495, 502, 513 504, 504 iconography, 205, 205 Santa Trinita, Sassetti Chapel, 391, 392, 393, Tabernacle, 156-57, 157, 158, 158, 167 393, 394–95, 394, 395, 484, 506, 540 Ospedale degli Innocenti, 187-88, 187, 203, Uffizi, 54, 626, 715-16, 716 view of, 12, 181, 184 Palazzo Borgherini (Palazzo Rosselli del Turco), Villa La Gallina, 362, 362 Florence, School of, Cross, 65, 65 Palazzo dei Priori (Palazzo Vecchio), 90, 91, 196, Betrayal, 36, 65, 65, 104 120, 121, 321 394, 707, 716, 719 Florence: View with the Chain (Francesco di Chapel of Eleonora da Toledo, 27, 551, 712, Lorenzo Rosselli, attrib.), 38, 39 712, 713 Florentine Academy, 691 120-21, 121, 492 Sala dell'Udienza, 712, 713 Florentine art, 170, 245, 329-57, 410, 411, Palazzo Medici (Palazzo Medici-Riccardi), 180, 439,610 182, 195-97, 195, 196, 197, 268, 296, 346, architecture, 168-69, 273-74, 344-46 420, 465, 623 Early Trecento, 93-123 Chapel, 182, 349, 350 High Renaissance, 477-523 300, 407 Palazzo Pitti, 91, 274, 274, 707, 707 Mid-Trecento painting, 155-63 genius, 727 Palazzo Rucellai, 268-69, 268, 273, 289, painting, 65-69, 118-21, 223-43 Genoa, 37, 60, 170, 495 533, 535 sculpture, 122-23, 331-43

FONTANA, LAVINIA, 719-20 Self-Portrait at the Spinet, 719, 720 Fonte Gaia, Piazza del Campo, Siena, 217-18, 217 FOPPA, VINCENZO, 465 Foresbortened Christ (Andrea Mantegna), foreshortening, 100, 311, 317, 416, 439, 727 Forum of Trajan, Rome, 627 Fountain of Neptune (Bartolommeo Ammanati), Four Crowned Martyrs (Quattro Santi Coronati) (Nanni di Banco), 42, 205, 206, 212, 212, France, 383, 425, 465, 582, 631, 656 invasion of Italy, 495, 525, 561 See Piero della Francesca Francesco delle Opere (Perugino), 411, 412, FRANCESCO DI GIORGIO, 406-8, 621 Coronation of the Virgin, 406-7, 406 Santa Maria del Calcinaio, Cortona, with Antonio da Sangallo the Elder, 271, 407-8, FRANCESCO DI LORENZO ROSSELLI. attrib., Florence: View with the Chain, Franciscan Order, 88, 171-72, 190, 727 Francis I of France, 500, 526, 656, 704-5, 710 Francis of Assisi, Saint, 62, 63-64, 73, 113, 116 Franco-Flemish style, 297 Frederick II, Emperor, 79 Freiburg im Breisgau, Germany, Cathedral of, 114 Gothic, 83, 91, 108, 123 fresco painting, 49-52, 49, 444, 491, 610, 714, 727 Funeral of St. Francis (Giotto di Bondone), 51, Funerary Monument of Cansignorio della Scala (Bonino da Campione), 177, 177 GADDI, AGNOLO, 45-52, 93, 120, 164,

GADDI, AGNOLO, 45–52, 93, 120, 164, 294, 390

Legend of the True Cross, 164

Life Studies of Five Heads, attrib., 46, 47, 164

Triumph of Heraclius over Chosroes,
Santa Croce, Florence, 164, 165, 316

GADDI, TADDEO, 45, 93, 120–21, 155, 164, 168, 303, 304, 321

Annunciation to the Shepberds, fresco,
Baroncelli Chapel, Santa Croce, Florence, 120, 121, 321

Last Supper with the Tree of Life and Other Scenes, refectory, Santa Croce, Florence, 72, 120–21, 121, 492

Galatea (Raphael), 524, 573–74, 574, 594

Garden of the Peaceful Arts (Lorenzo Costa), 444

Gates of Paradise (Lorenzo Ghiberti), 17, 220, 276–78, 276, 277–78, 277, 278, 279, 288, 300, 407

genius, 727

Genoa, 37, 60, 170, 495

Palazzo del Principe, 605–6, 605, 691

GENTILE DA FABRIANO, 168, 176, 223-27, Crucifixion, 104, 105 Gothic art, 75, 245, 329, 399 architecture, 88-91, 181, 195, 206 228-29, 232, 297, 317, 321, 402, 413, 425, Inconstancy, 108, 108 cathedrals, 52-53, 79-80 Injustice, 108, 108 428, 429 Adoration of the Magi (Strozzi altarpiece), 222, Joachim Takes Refuge in the Wilderness, French, 83, 91, 108, 123 223-26, 225, 226, 239-40, 247, 298, 317, 99, 99, 129 German, 84 Justice, 108, 108 349, 425 painting, late, 164-68 Flight into Egypt, 227, 227, 232 Kiss of Judas, 104, 105 sculpture, 87 Nativity, 143, 168, 226, 226, 321, 613 Last Judgment, 51, 95, 97, 99, 106, 107, 107, in Tuscany and Northern Italy, 155-77 Coronation of the Virgin, from the Valle Romita 119,694 GOZZOLI, BENOZZO, 35, 50, 349-50, polyptych, 223, 224 Meeting at the Golden Gate, 100, 100 Procession of the Magi, Chapel, Palazzo Medici German art, 55 Nativity and Apparition to the Shepherds, (Palazzo Medici-Riccardi), Florence, 182, Gothic, 84 349, 350 gesso, 46, 727 Raising of Lazarus, 102, 103, 122 Graces, 378 Gesù, Rome (Vignola), 720 Bardi Chapel, Santa Croce, Florence Funeral of St. Francis, 51, 111-12, 111, 112 GRASSI Ghent, 38 Ghibellines, 94 St. Francis Undergoing the Test by Fire See Giovannino de' Grassi Great Schism, 223 GHIBERTI, LORENZO, 44, 76, 117, 122, 164, Before the Sultan, 51, 110-13, 110 182, 184, 199-206, 245, 266, 276-78, 279, Stigmatization of St. Francis, 51, Greek art, ancient, 76 329, 331, 339, 402, 405, 501, 708 112-13, 113 Greek Byzantine painters, 60, 75 Commentaries, 201 Campanile, Cathedral, Florence, 114-15, 114, Greek sculpture, ancient, 448 115, 158, 168, 214 grisaille, 727 Flagellation, drawing, 203, 203 Crucifix, 94-95, 94, 104 groin vault, 727 Gates of Paradise, East Doors, Baptistery, grotteschi, 390, 727 Florence, 17, 276-78, 276, 288, 300, 407 Enthroned Madonna with Saints (Ognissanti Madonna), 108-20, 109 Gubbio, 325, 422 The Creation, 220, 277, 277 Jacob and Esau, 277-78, 278, 407 influence of, 55, 88, 155, 167, 170, 173, 230, Gubbio, Oderisi da, 93 Guelphs, 42, 94, 181, 367 Self-Portrait, 278, 279 239, 401, 502 GUIDO DA SIENA, 69-70 Story of Abraham, 277, 277 influences on, 78, 126 Peruzzi Chapel, Santa Croce, Florence, 123 Enthroned Madonna, 69-70, 69 North Doors, Baptistery, Florence GIOVANE guilds, 42-45, 94, 660, 727 Annunciation, 164, 201-3, 203 Flagellation, 203, 203, 232, 277, 301 See Palma Giovane guilloche, 727 Sacrifice of Isaac, 183, 199-201, 200, 276, 277, 301 GIOVANNI BOLOGNA (Giambologna; Jean St. John the Baptist, Orsanmichele, Florence, Boulogne), 708 164, 204-6, 204, 206, 208, 228 Rape of the Sabine Woman, Loggia dei Lanzi, H St. Matthew, Orsanmichele, Florence, 42, 164, Florence, 38, 708, 709 205, 206, 206 Giovanni d'Alemagna, 428, 432 Ghirlandaio, Davide del, 390, 416 HAGESANDROS, ATHENODOROS, AND Giovanni d'Ambrogio, 184 POLYDOROS, Laocoön and His Sons, 36, GHIRLANDAIO, DOMENICO DEL (Domenico GIOVANNI DA MILANO, 163 55, 526, 526, 554, 643, 696, 702 Bigordi), 359, 372, 390-97, 410, 416, 444, Pietà, 154, 163, 163 Resurrection of Lazarus, Rinuccini Chapel, Hapsburg rulers, 631, 656 501 - 2Santa Croce, Florence, 163, 163 harpy, 727 Birth of the Virgin, Cappella Maggiore, Santa Maria Novella, Florence, 395-96, 396, Giovanni da Udine, 569, 585 Head of a Child (Desiderio da Settignano, attrib.), GIOVANNI DI PAOLO, 402 339, 339 502, 594 The Head of St. John the Baptist Handed to Last Supper, Refectory, Ognissanti, Florence, Madonna and Child in a Landscape (Madonna of Humility), 402, 402 Salome (Fra Filippo Lippi), 261, 261 391, 391, 492 St. John Entering the Wilderness, 402, 402 Head of the Apostle Matthew for Last Supper; Old Man with a Young Boy, 396, 397 Architectural Studies for Sforza Castle Sassetti Chapel, Santa Trinita, Florence, 391, GIOVANNINO DE' GRASSI, 175 Visconti Hours, 175-76, 175 (Leonardo da Vinci), 482, 483, 494 392, 393, 506, 540 Healing of the Lame Man (Raphael), 539, Giovio, Paolo, 601 Confirmation of the Franciscan Rule by Pope Honorius III, 394, 394 GIULIANO DA MAIANO, 343-46 565, 566 Healing of the Lame Man and the Raising of Studiolo of Frederico da Montefeltro, Palazzo Nativity and Adoration of the Shepherds, Tabitha (Masolino), 233-35, 233, 298 Ducale, Urbino, 321, 344, 422, 422, 423 394-95, 395, 484 Heemskerck, Maarten van, 527, 702, 702 Resurrection of the Notary's Son, 393, 393 GIULIO ROMANO, 560, 564, 566, 569, 571, Drawing of the Belvedere Torso, 36, 55, 574, 577, 581, 625, 626-28, 678 Sistine Chapel fresco, 538 The Gods on Mount Olympus and the Fall of the Giant order, 727 526, 527 Helena, Saint, 316 Giants, Sala dei Giganti, Palazzo del Te, gilding, 52, 727 Hell (Nardo di Cione), fresco, 51, 159, 159, Mantua, 606, 628, 629, 691 GIORGIO See Francesco di Giorgio Palazzo del Te, Mantua, 625, 626-28, 362, 694 Hellenistic, 727 627, 707 GIORGIONE (Zorzi da Castelfranco), 457, Henry II, Emperor, 156 **631–34**, 635, 636, 657, 667 Wedding Feast of Cupid and Psyche, Sala di Psiche, Palazzo del Te, Mantua, 628, 628 Hercules and Antaeus: Enthroned Madonna with Sts. Liberalis and (Antonio del Pollaiuolo), panel painting, glazes, 635-36, 727 Francis, 632, 632 Nativity and Adoration of the Shepherds The Gods on Mount Olympus and the 360-61, 360 (Antonio del Pollaiuolo), statue, 361, 361 Fall of the Giants (Giulio Romano), 606, (Allendale Nativity), 632, 632 Hercules and Hydra (Antonio del Pollaiuolo), Pastoral Scene (Fête Champêtre), or Titian, 634, 628, 629, 691 360, 360 GOES, HUGO VAN DER: 635 herm, 727 Adoration of the Shepherds (Portinari Sleeping Venus, finished by Titian, 634, 634, High Renaissance, 265, 411, 639 altarpiece), 327, 387, 387, 395 646-47 defined, 620-21 Golden Legend, 727 Tempestuous Landscape with the Soldier and end of, 581 the Gypsy, 633-34, 633 gold leaf, 47 Golgotha, 727 in Florence, 477-523 Giorgionesque manner, 657-59 in Rome, 500, 525-78, 610 Gombrich, Ernst, 376, 380 giornata, 50 history of art, practice of, 54, 581 GIOTTO DI BONDONE, 45, 49, 51, 55, 78, 90, gonfaloniere, 727 Hohenzollern, Barbara von, 439 Gonzaga, Federigo, 614, 626, 680 93-118, 120, 123, 126, 129-30, 155, 167, Holbein, 514 Gonzaga, Francesco, 442-44 168, 170, 173, 230, 239, 266, 304, 401, 502 Holy Roman Empire, 383, 399, 631 Gonzaga, Ludovico, 271, 437-39, 443 Arena Chapel, Padua, 95, 95-108, 95, 98, 116, Honorius III, Pope, 75 Gonzaga family, 425, 614 122, 167 Horace, 378 Annunciation, 101, 101, 168 gospel, 727

Horseman Trampling on Foe, study for an Jupiter and Io (Correggio), 616, 616 iconography, 316, 317 Equestrian Monument to Francesco Justice (Giotto di Bondone), 108, 108 Legnaia, Villa Carducci, originally, loggia, Sforza (Leonardo da Vinci), 490, Justice with Sts. Michael and Gabriel (Jacobello 305-7, 305 491, 499 del Fiore), 428, 428 Lenzi, Domenico, 240 bortus conclusus, 727 Justus of Ghent, 415, 422, 511 LEONARDO DA VINCI, 44, 217, 309, 330, Hospital of Santa Maria della Scala, Siena, 359, 366, 368, 371, 375, 406, 442-43, Pellegrinaio, 403, 404, 404 **477–501**, 502, 508, 511, 515, 517, 528, host, 727 562, 594, 598, 606, 610, 617, 621, 622, K house-towers, 37 656, 718 humanists, 37, 727 Adoration of the Magi, 375, 486-89, 487, 499 Hunting Scene (Piero di Cosimo), 522, 523 Kiss of Judas (Giotto di Bondone), 104, 105 Annunciation, 484-85, 484, 486, 498 Architectural Perspective and Background Figures for Adoration of the Magi, 486, 487 I L Battle of Anghiari, 499 copy after, 313, 499, 499, 510, 513, 560, icon, 727 Ladislaus of Naples, 182 561, 591 iconography, 727 Lamberti, Niccolò di Pietro, 205 Bird's-eye View of the Chiana Valley, Showing illusionism, 574, 620, 727 Lamentation, 728 Arezzo, Cortona, Perugia, and Siena, 248, impasto, 635, 728 Lamentation: 480, 480 impost block, 728 Deluge, 500, 500 (Andrea del Sarto), 596, 596, 601, 710 Inconstancy (Giotto di Bondone), 108, 108 (Donatello), 334-36, 335 Head of the Apostle Matthew for Last Supper; Ingres, 514, 566 Lamentation, St. Pantaleimon, Nerezi, Byzantine, Architectural Studies for Sforza Castle, Injustice (Giotto di Bondone), 108, 108 482, 483, 494 Innocent II, Pope, 60 Lamentation over the Dead Christ with Sts. Horseman Trampling on Foe, study for an Innocent III, Pope, 37 Jerome, Paul, and Peter (Sandro Botticelli), Equestrian Monument to Francesco Sforza, Innocent VIII, Pope, 441, 525 384, 384, 473 490, 491, 499 in situ, 728 landscape, 35, 100, 248, 298, 631-32 Last Supper, Santa Maria delle Grazie, Milan, intarsia, 343-44, 422-23, 728 51, 217, 391, 457, 491-95, 492, 493, Landucci, 368 International Gothic, 164, 223-24 lantern, 728 494, 554 intonaco, 50, 728 Laocoön and His Sons (Hagesandros, Athen-Madonna and Child with St. Anne, 495-97, 496, Invention of the True Cross and Recognition odoros, and Polydoros), 36, 55, 526, 526, 498, 513 of the True Cross (Piero della Francesca), 554, 643, 696, 702 cartoon for, 495, 506, 529 317, 318-19, 318, 419 Lapo (artist in Siena), 82 Madonna of the Rocks, 483, 488, 489-90, 490 Ionic order, 268, 728 Last Judgment, 728 Male Nude, 481, 481, 506 Isaac and Esau (Isaac Master), 75-76, 75 Last Judgment: Mona Lisa, 484, 497-99, 498, 515 ISAAC MASTER, 75, 77 (Coppo di Marcovaldo, attrib.), 68, 69, 107, Plans and Perspective Views of Domed Isaac and Esau, San Francesco, Upper Church, 123, 694 Churches, 53, 481, 482, 482, 528, 622 Assisi, 75-76, 75 (Giotto di Bondone), 51, 95, 97, 99, 106, 107, Portrait of Ginevra de' Benci, 485-86, 485. istoria, 728 107, 119, 694 486, 497 Italian art, basis of, 35-55 (Lorenzo Maitani), 151, 153, 153 Star-of-Bethlehem and Other Plants, 479, 479 Italian language, 37, 212 (Michelangelo Buonarroti), 364, 409, 502, 503, Storm Breaking over a Valley, 478, 478, 479 Italo-Byzantine style, 59-60, 70, 80-81, 86-87, 538, 691, 692, 693, 693, 694, 694, Studies of a Left Leg, Showing Bones and 126, 170 701,710 Tendons, 481, 481 Italy: (Nicola Pisano), 82, 83 Studies of Water, 482, 483 French invasion of, 495, 525, 561 Last Supper, 303 Studies of Water Movements, 482, 483 landscape of, 35 Last Supper: Study of composition of Last Supper, map, 34 (Domenico del Ghirlandaio), 391, 391, 492 491-92, 491 Southern, 37 (Leonardo da Vinci), 51, 217, 391, 457, 491-95, Study of Drapery, 484, 484 492, 493, 494, 494, 554 Study of the Head of the Angel for Madonna of (Pietro Lorenzetti), frescoes, 141, 142, 321, 670 the Rocks, 490, 490 (Tintoretto), 668-70, 669, 670-71, 670, Two Sheets of Battle Studies, 499, 500 674, 677 Vitruvian Man: Study of the Human Body, Last Supper and Resurrection, Crucifixion, 480, 480 Jacob and Esau (Lorenzo Ghiberti), 277-78, and Entombment (Andrea del Castagno), writings, 477-78, 479 278, 407 302, 303-5, 303, 304, Leopardi, Alessandro, 369-70 JACOBELLO DEL FIORE, 428 391, 492 Leo X, Pope (Giovanni de' Medici), 331, 500, 502, Justice with Sts. Michael and Gabriel, 526, 561, 563-64, 567, 571, 582, 586-87, Last Supper with the Tree of Life and Other 428, 428 Scenes (Taddeo Gaddi), 72, 120-21, 591, 601 Jacobus de Voragine, 96 121, 492 Liberation of the Companions of St. James Jacopo Strada (Titian), 651, 651 Lateran Palace, 530 (Jacopo Avanzo), fresco, 173, 173, 425 James, Cardinal Prince of Portugal, 339 Latin language, 265 Library, Vatican, Rome, 415 Jeremiab (Donatello), 214-15, 215 LAURANA, FRANCESCO, 419 Library of San Marco, Venice (Jacopo Sansovino), Jerusalem, Dome of the Rock, 511 Battista Sforza, 324, 419, 419 675, 680-81, 681, 683, 686 Joachim Takes Refuge in the Wilderness (Giotto di LAURANA, LUCIANO, 419 Libyan Sibyl (Michelangelo Buonarroti), 86, Bondone), 99, 99, 129 Palazzo Ducale, Urbino, 321, 419-21, 420, 511 550, 550 John Palaeologus, 319 View of an Ideal City, perhaps painted by Piero Lichtenstein, Georg von, 349 Joseph in Egypt (Jacopo Carucci da Pontormo), della Francesca, 53, 268, 272, 274, 348, Life Studies of Five Heads (Agnolo Gaddi, attrib.), 598, 599, 709 421, 421, 533 46, 47, 164 Judith and Holofernes (Donatello), 53, 209, Laurana brothers, 419-22, 511 light: 333-34, 334, 705 Laurentian Library, San Lorenzo, Florence, 408, effects of, 211, 339 bronze casting of, 52, 53 588-90, 589, 590, 696, 707 Leonardo's, 485 Julius II, Pope, 416, 525-27, 529, 535, 540, 542, League of Cambrai, 425, 631 medieval use of, 100 543, 545, 551, 558–59, 561, 571, 582, Legend of the True Cross: natural, 226-27 631,656 (Agnolo Gaddi), 164 night, 121 Jupiter and Ganymede (Correggio), (Piero della Francesca), frescoes, 313-21, 315, source of, 101 614-16, 616 317-21, 317, 318, 319, 320, 419, 490 Limbourg brothers, 176, 227, 297

lintel, 728 Madonna and Child with the Birth of the Virgin Basilica of the Santa Casa, Sacristy of St. Mark, LIPPI, FILIPPINO, 230, 237, 255, 359, 371, 418, 418, 419, 419 and the Meeting of Joachim and Anna **385-90**, 477, 489, 508 LOTTO, LORENZO, 557, 631, 654-55, 657 (Fra Filippo Lippi), 259-60, 259, 317 Strozzi Chapel, Santa Maria Novella, Florence, Annunciation, 654, 654 Madonna and Child with Two Angels (Fra Filippo frescoes, 387, 388 Lippi), 244, 258-59, 258, 260, 280, 317 Sacra Conversazione, 655, 655 St. Philip Exorcising the Demon in the Louis of Toulouse, Saint, 132 Madonna and Saints (San Marco altarpiece) (Fra Temple of Mars. 389-90, 389 Louis XII of France, 490-91, 500, 561, 656 Angelico), 182, 249, 249, 276, 379, 516 Vision of St. Bernard, 385-87, 386, 516, 522 Louis XIV (Gianlorenzo Bernini), 490 Beheading of Sts. Cosmas and Damian, 182, LIPPI, FRA FILIPPO, 182, 245-46, 254-63, 265, LUCA 251. 251 276, 317, 329, 355, 368, 371, 385, 425 See Robbia, Luca della Miracle of the Deacon Justinian, 158, 182, The Adoration of the Infant Jesus, 168, 262, Lucca, 37, 59, 110 250-51, 250 262, 349 Madonna della Candeletta (Carlo Crivelli), painting in, 63-64 Annunciation, San Lorenzo, Florence, 178, Lucretius, 378 463, 463 257-58, 257 Lucrezia, Madonna, 578 Madonna del Popolo (Federico Barocci), 722, 723 Feast of Herod, Cathedral, Prato, Madonna di San Biagio, Montepulciano (Antonio Ludolph of Saxony, 304 260-61, 260 Luke, Saint, 42 da Sangallo), 22, 271, 481, 582, 621-23, The Head of St. John the Baptist Handed to Sa-621, 622 Jome Cathedral Prato 261 261 See Dossi, Dosso (Giovanni de Lutero) Madonna of Humility (Domenico di Bartolo), Madonna and Child (Tarquinia Madonna), Luther, Martin, 564, 569 403, 403 255, 255 Lutherans, 586 Madonna of Humility with Donor Madonna and Child with Saints and Angels (Lionello d'Este?) (Jacopo Bellini), 429, (Barbadori altarpiece), 256-57, 256, 300 430, 451, 465 Madonna and Child with the Birth of the Virgin Madonna of Mercy, 728 M and the Meeting of Joachim and Anna, Madonna of the Cherubim (Jacopo Bellini), 259-60, 259, 317 429, 429 Madonna and Child with Two Angels, 244, Madonna of the Harpies (Andrea del Sarto), MACCHIETTI, GIROLAMO, 718-19 258-59, 258, 260, 280, 317 Baths at Pozzuoli, 718, 719 594-96, 595 LIPPO Machiavelli, 182, 495, 584 Madonna of the Magnificat (Sandro Botticelli), See Memmi, Lippo 298 376 376 machicolations, 728 litany, 728 Maddalena Strozzi Doni (Raphael), 411, 506, Madonna of the Meadows (Raphael), liturgy, 728 515, 515 513-14, 514 Livorno, 466 Madonna and Child, 45 Madonna of the Pesaro Family (Titian), 23, loggia, 728 Madonna and Child: 643-44, 643, 644, 675 Loggia dei Lanzi, Florence, 38, 708, 709 (Alesso Baldovinetti), 351-53, 352, 354 Madonna of the Rocks (Leonardo da Vinci), 483, Loggia del Bigallo, Florence, 119-20, 119 (Giovanni Bellini), 450-51, 450 488, 489-90, 490 Lombardo, Pietro, 172 Madonna of the Stairs (Michelangelo Buonarroti), (Coppo di Marcovaldo), 67-69, 67, 126 art, 465-66 502, 502, 586 (Desiderio da Settignano), 338-39, 338 LOMBARDO, TULLIO, 653-54 (Masolino), 229, 229 Madonna of the Victory (Andrea Mantegna), St. Anthony of Padua and the Miracle of the (Giovanni Pisano), 87, 87, 110 441-42, 441, 611 Miser's Heart, relief, Chapel of St. Anthony, (Nicola Pisano), 83, 83 Maestà: (Duccio di Buoninsegna), 126-30, 126, 127, 128, Santo, Padua, 653, 653 Madonna and Child (Gypsy Madonna) (Titian), Lombardo family, 463, 464, 680 129, 130, 131, 143, 310, 401, 407 636, 636 Lombardy, 37, 93, 425 Madonna and Child (Rucellai Madonna) (Duccio (Simone Martini), 130-31, 132 art of, 297 di Buoninsegna), 70, 108, 125-26, 125 maestà, 728 Madonna and Child (Tarquinia Madonna) London, 38 Maginnis, Hayden, 155 LORENZETTI, AMBROGIO, 132, 143-49, 155, (Fra Filippo Lippi), 255, 255 Mahomet II, Sultan, 445 MAIANO 161, 232, 402 Madonna and Child Enthroned (Bernardo Daddi), Allegory of Good Government, Sala della Pace, See Benedetto da Maiano; Giuliano da Maiano 156-57, 157, 167 Palazzo Pubblico, Siena Birth of the Virgin, 158, 158 Mainardi, Bastiano, 390 MAITANI, LORENZO, 150-53 Commune of Siena, 51, 145, 146 Madonna and Child in a Landscape (Madonna Effects of Good Government in the City and of Humility) (Giovanni di Paolo), 402, 402 Last Judgment, 151, 153, 153 Scenes from Genesis, marble, Cathedral, the Country, 51, 124, 145-49, 145, 146, Madonna and Child with Angels and St. Jerome 147, 148, 161, 173, 224 (Madonna of the Long Neck) Orvieto, 151-53, 152, 153 Presentation in the Temple, 128, 143-45, 144 Malatesta, Sigismondo, 266-67, 317, 321 (Parmigianino), 618-19, 618 LORENZETTI, PIETRO, **138–43**, 155, 321 Madonna and Child with Saints: Malatesta Temple (San Francesco), Rimini Birth of the Virgin, 128, 142, 143, 437 (Masaccio), panel, 228, 228, 238, 260 (Leonbattista Alberti), 266-67, 266, 267, 267, 317 Crucifixion, 117 (Piero della Francesca), 323, 323, 437, 453 Madonna and Child with Saints, Annunciation Madonna and Child with Saints, Annunciation design for, on medal by Matteo de' Pasti, 267, and Assumption, 138-39, 139 and Assumption (Pietro Lorenzetti), 267, 464, 527 Male Nude (Leonardo da Vinci), 481, 481, 506 San Francesco, Lower Church, Assisi, 138-39, 139 Descent from the Cross, Lamentation and Madonna and Child with Saints and Angels mandorla, 728 other scenes from Christ's Passion, MANETTI, ANTONIO, 339 (Barbadori altarpiece) (Fra Filippo Lippi), intarsia decoration, North Sacristy, Cathedral, 141, 141 256-57, 256, 300 Descent into Limbo, Descent from the Madonna and Child with St. Anne (Leonardo da Florence, with Giuliano da Maiano and Vinci), 495-97, 496, 498, 513 others, 330, 343-44, 344, 423 Cross and Madonna with Two Saints, 140, 141, 384 cartoon for, 495, 506, 529 San Miniato, Florence, Chapel of the Cardinal of Portugal, 339-42, 340, 353-54, 364, 373 Last Supper, 141, 142, 321, 670 Madonna and Child with Sts. Francis, John the Manetti, Giannozzo, 195, 243, 330 Lorenzetti brothers, 401 Baptist, Zenobius, and Lucy (St. Lucy LORENZO MONACO (Piero di Giovanni), altarpiece) (Domenico Veneziano), 299-300, maniera, 581, 582, 621, 691-22, 702, 728 299, 350 Mannerism, 551, 581-629, 671, 728 **164–68**, 205, 212, 226, 402, 516 Annunciation, 300-301, 300 Coronation of the Virgin, 164, 166, 167, defined, 620-21 223, 516 St. John the Baptist in the Desert, 301, 301 MANTEGAZZA, CRISTOFORO, 466 Nativity, 167, 167, 226, 402 Madonna and Child with Sts. Jerome and Mary Expulsion from the Garden, Certosa, Pavia, Descent from the Cross, 246 Magdalen (Correggio), 611-12, 611 466, 467 MANTEGNA, ANDREA, 44, 276, 415, 429, Six Kneeling Saints, study for Coronation of the Madonna and Child with Sts. Peter and John the 431, 432-44, 450, 468, 495, 574, 620, 656 Virgin, workshop of, 46, 46, 167 Evangelist (Nardo di Cione), 48, 49,

159, 160

Loreto, 418

Agony in the Garden, 437, 438, 451

Arrival of Cardinal Francesco Gonzaga. Camera picta, Palazzo Ducale, Mantua, 439-41, 440, 441, 613, 614 Enthroned Madonna and Child with Saints (San Zeno altarpiece), San Zeno, Verona, 324, 434-37, 435, 436, 437, 452 Crucifixion, 435, 437, 438, 465 Foreshortened Christ, 439, 439 Madonna of the Victory, 441-42, 441, 611 Ovetari Chapel, Eremitani Church, Padua, Baptism of Hermogenes, 432, 433 Martyrdom of St. James, 434, 434 St. James Before Herod Agrippa, 432, 433 Self-portrait, 432-33, 433 St. James Led to Execution, 434, 434, 450 Pallas Expelling the Vices from the Garden of Virtue, 444 Parnassus, 442, 442, 443 Mantua, 170, 425, 437-38, 626, 656 Palazzo del Te, 625, 626-28, 627, 707 Sala dei Giganti, 606, 628, 629, 691 Sala di Psiche, 628, 628 Palazzo Ducale, Camera picta, 439-41, 440, 441, 613, 614 Sant'Andrea, 270-72, 270, 271, 439, 527, 533, 686, 687, 720 San Sebastiano, 348 Man with the Glove (Titian), 645, 645 MARCOVALDO See Coppo di Marcovaldo Marriage at Cana (Paolo Veronese), 674, 674 Marriage of Alexander and Roxana (Sodoma), 574, 575 Marriage of St. Francis to Lady Poverty (Sassetta), from the back of the Sansepolcro altarpiece, 401, 401 Marriage of the Virgin (Raphael), 53, 511, 512 MARTINI See Simone Martini Martin V, Pope, 223 Martydom of St. Lawrence: (Donatello), 334, 336, 336 (Titian), 649-50, 649 Martyrdom of St. George (Altichiero), 173, 174 Martyrdom of St. James (Andrea Mantegna), 434, 434 Mary, Sister of Moses (Giovanni Pisano), 84-85, 84 MASACCIO (Maso di Ser Giovanni di Mone Cassai), 44, 49, 212, 226, 227-43, 245, 248, 254-55, 275, 276, 279, 298-99, 301, 310, 317, 390, 401, 403, 410, 416, 502, 545, 566 Brancacci Chapel, Santa Maria del Carmine, Florence Distribution of the Goods of the Community and the Death of Ananais, 236, 237 Expulsion, 49, 234, 235, 235, 248, 544, 545 Raising of the Son of Theophilus and the Enthronement of St. Peter, with Filippino Lippi, 236-38, 237, 567 St. Peter Baptizing the Neophytes, 232-33, 233, 243, 567 St. Peter Healing with His Shadow, 236, 236 Tribute Money, 230-32, 231, 232, 567 influence of, 245 Madonna and Child with Saints, panel, San Giovenale, Cascia di Regello, 228, 228, 238, 260

MASO DI BANCO, 118-19, 173 Sts. Paul and Julian, attrib., 51, 51, 118-19 St. Sylvester Sealing the Dragon's Mouth and Resuscitating Two Pagan Magicians, Bardi-Bardi di Vernio Chapel, Santa Croce, Florence, 118, 118 MASOLINO (Maso di Cristofano), 227, 227-43, 416 Baptistery, Castiglione Olona, fresco, 243, 243, 405 Brancacci Chapel, Santa Maria del Carmine, Florence Healing of the Lame Man and the Raising of Tabitha, 233-35, 233, 298 Temptation, 234, 235, 544 Madonna and Child, 229, 229 mass, 728 Massacre of the Innocents: (Matteo di Giovanni), 405, 405, 413 (Giovanni Pisano), 85-86, 86 (Nicola Pisano), 85-86, 86 Mass of Bolsena and Expulsion of Heliodorus (Raphael), 555, 558, 559-60, 560 MASTER OF THE ST. FRANCIS CYCLE, St. Francis Praying Before the Crucifix at San Damiano, San Francesco, Lower Church, Assisi, 45, 116, 116, 117 MASTER OF THE TRIUMPH OF DEATH, 149-50 The Three Living and the Three Dead. The Triumph of the Death, The Last Judgment and Hell, Camposanto, Pisa, possibly by Buffalmacco, 51, 149-50, 150-51, 173 Matilda, Countess of Tuscany, 59 MATTEO DI GIOVANNI, 312, 404-5 Massacre of the Innocents, 405, 405, 413 mazzocchio, 728 MAZZOLA See Parmigianino (Francesco Mazzola) Medal of Julius II (Caradosso), 525 Medici, Alessandro, 585 Medici, Cosimo de', 182, 191, 192, 195, 196, 245, 247, 248, 255, 285, 329-30, 349, 371, 704 Medici, Cosimo I de', 55, 691, 703, 710 Medici, Ferdinand I de', 466 Medici, Francesco I de', 708, 716 Medici, Giovanni de' (Pope Leo X), 330, 561, 563 Medici, Giovanni de' (son of Cosimo), 371 Medici, Giovanni di Bicci de', 182, 188 Medici, Giuliano, duke of Nemours, 331, 502, 582 Medici, Giuliano de', 330, 371, 378 Medici, Giulio de' (Pope Clement VII), 564, 567-69, 582, 588, 601 Medici, Lorenzo de', duke of Urbino, 582, 601 Medici, Lorenzo de' ("the Magnificent"), 182, 191, 282, 330, 344, 359, 365, 369, 371, 394, 502-3, 517, 582, 601 Medici, Lorenzo di Pierfrancesco de', 377, 378, 381, 521 Medici, Piero de', 50, 262 Medici, Piero de' (the Gouty), 182, 299, 330, 371 Medici, Piero de' (the Unlucky), 182-83, 291, 331, 383, 502, 503 Medici Chapel, San Lorenzo, Florence, 188, Medici family, 91, 182-83, 196, 245, 250, 329-31, 349, 355, 367, 371, 379, 381, 395, 506, 509, 569, 582, 584–85, 601 Medici gardens, 517 Medici Madonna (Michelangelo Buonarroti), 502, 503, 584, 586, *586*, 588, 592 Medici Tombs (Michelangelo Buonarroti), 502,

705. 707

564, 567-69, 568

Meeting at the Golden Gate (Giotto di Bondone), 100, 100 Meeting of Christ and John the Baptist as Youths (Desiderio da Settignano), 338, 338 Melissa (Dosso Dossi), 658, 658 MELOZZO DA FORLÌ, 273, 413-19, 495, 511, 574 Christ in Glory from the Ascension, 416, 417 fresco, Sacristy of St. Mark, Basilica of the Santa Casa, Loreto, 418, 418, 419, 419 Sixtus IV della Rovere, His Nephews, and Piatina, His Librarian, 273, 415–16, 415 Melzi, Francesco, 479 Memling, Hans, 410, 447 Memmi, Lippo, 134 mercanzia, mercatanzia, 728 MESSINA See Antonello da Messina MICHELANGELO BUONARROTI, 44, 45, 51, 53, 55, 113, 192, 229, 309, 364, 407, 416, 443, 477, 481, 495, 500, 501-11, 515, 517, 526, 530, **535–54**, 557–58, 560, 561–62, 577-78, 581, **582-93**, 594, 596, 598, 613, 619, 620, 621, 622, 623, 624-25, 631, 634, 648, 649, 660, 663, 671, 691-703, 708, 712, 715, 718, 720, 722 architecture, 53, 192, 407, 621, 623, 624-25, 720 Bacchus, 504, 505, 517 Battle of Cascina, 509 copied by Aristotile da Sangallo, 499, 503, 510, 511, 521, 535, 543, 591, 718 Battle of Lapiths and Centaurs, 476, 502-3, 503, 504, 510, 523 "Blockhead" Captive, 590-93, 593 Bruges Madonna, 508, 508, 553 Campidoglio, Rome, 36, 699-700, 699 Palazzo Nuovo, 700, 700 Captive (Dying Slave), 504, 537, 552, 553, 553, 591 Captive (Rebellious Slave), 537, 552, 553-54, 553, 591 Conversion of St. Paul, fresco, Pauline Chapel, Vatican, Rome, 690, 694-96, 695, 696 "Crossed-Leg" Captive, 590-93, 592 Crucifix, Santo Spirito, Florence, attrib., 504, 504 Crucifixion, drawing, 700, 700 Crucifixion of St. Peter, fresco, Pauline Chapel, Vatican, Rome, 694-96, 695 David, 20, 38, 207, 385, 390, 508-9, 509, 510, 553, 587 Doni Madonna, 298, 506, 507, 550, 551 funeral, 719 influence of, 515, 517, 557-58, 560, 561-62, 577-78, 581, 594, 596, 619, 620, 648, 663, 671, 708, 712, 715, 718, 722 influences on, 309, 416, 495, 622, 649 Madonna of the Stairs, 502, 502, 586 Medici Madonna, Medici Chapel, San Lorenzo, Florence, 502, 503, 584, 586, 586, 588, 592 Medici Tombs, Medici Chapel, San Lorenzo, Florence, 582 Tomb of Giuliano de' Medici Night and Day, 502, 585-86, 585, 587, 587, 648, 705 Tomb of Lorenzo de' Medici Dawn, 585-86, 585, 587, 588, 588, 705, 707 582, 585-86, 585, 587, 587, 588, 588, 648, Dusk, 585-86, 585, 587, 705 Moses, San Pietro in Vincoli, Rome, 374, 537, Medici Villa (now known as Villa Madama), Rome 545, 552-53, 552 Pietà, in Florence, 700, 701, 701 (Raphael), decorations by Giulio Romano, Giovanni da Udine, and Baldassare Peruzzi, Pietà, in Milan, intended for own tomb, 701-2, 701

Meditation on the Passion (Vittore Carpaccio),

459-61 461

Pisa polyptych, 238

Adoration of the Magi, 239-40, 239, 298, 317

Enthroned Madonna and Child, 238, 260

Trinity with Mary, John the Evangelist, and Two

Donors, fresco, Santa Maria Novella, Flo-

Crucifixion, 238-39, 239, 311

rence, 240-43, 241, 364

Maser, Villa Barbaro, 673, 673, 685, 685

Crucifixion of St. Peter, 240, 240

Nativity and Apparition to the Shepherds Pietà, in Vatican, 505-6, 505, 506, 618, 706 Miracle of the Believing Donkey (Donatello), relief, 116, 287-89, 288, 432 (Giotto di Bondone), 102, 102 Plan for Triangular Rare-Book Room of the Nativity and Prophets Isaiah and Ezekiel Miracle of the Deacon Justinian (Fra Angelico), Laurentian Library, 590, 590 (Duccio), 129, 129 158, 182, 250-51, 250 reliefs, 702-3 naturalism, 167, 247, 369, 413, 425, 601 Resurrection, 586, 587, 703 Misericordia altarpiece (Piero della nave, 728 San Lorenzo, Florence Francesca and others), 310-11, 311, Neoplatonists, 359, 376, 728 façade, 53, 54, 192, 582-83, 583, 622 399, 722 mitre, 728 Nerezi, St. Pantaleimon, 62, 63, 106 Laurentian Library Neri di Fioravante, 168 model (sculpture), 52 Entrance Hall, 408, 588-90, 589, model books, 430-31 Nero, 526 696, 707 Reading Room, 590, 590, 696 Netherlandish art, 137, 211, 387, 404, 410, 415, MONACO 457, 514 See Lorezo Monaco (Piero di Giovanni) Medici Chapel, 188, 502, 503, 584, 584, Niccolò da Tolentino, 296 585-86, 585, 586, 587, 587, 588, 588, 592, Mona Lisa (Leonardo da Vinci), 484, 497-99, Niccolò da Tolentino (Andrea del Castagno), 648, 705, 707 498, 515 Monastery Church, Daphni, Greece, 62, 62, 70 309-10, 309 St. Peter's, Vatican, Rome, 26, 54, 481, 530, Niccolò da Uzzano, 210 monstrance, 728 697, 697, 698, 698, 699, 699 Nicholas IV, Pope, 75 Montaigne, Michel de, 720 self-portrait, 693-94 Nicholas V, Pope, 265, 272, 329, 517, 530 Montefeltro, Federico da, 321-25, 413, 419, 422 Sistine Chapel, Vatican, Rome Night, Tomb of Giuliano de' Medici (Michelangelo ceiling frescoes, 372, 536, 537, 538, 539, 539, Montelupo, Baccio da, 594 Buonarroti), 502, 585-86, 585, 587, 587, 540-41, 544, 598, 601, 605, 613 Montepulciano, 623 648. 705 Cathedral, Tomb of Bartolommeo Aragazzi, Brazen Serpent, 550, 551, 604, 613, 703 289, 289 North Doors, Baptistery, Florence, 183, 201-2, Creation of Adam, 221, 526, 539, 542, 202, 276 Madonna di San Biagio, 22, 271, 481, 582, 546-47, 548 Northern European art, 136-37, 211-12, 227 621-23, 621, 622 Creation of Eve, 539, 545, 547 Northern Gothic, 93 Creation of Sun, Moon, and Plants, 311, Palazzo Tarugi, 623, 623 Northern Italian art, 170-77, 224, 425-74 526, 539, 547-48, 549, 550, 553 The Months, fresco, Eagle's Tower, Castello del Buonconsiglio, Trent, 176-77, 176, Gothic, 155-77 Cumaean Sibyl, 10-11, 503, 545, 546, 552 349, 473 Notre Dame, Amiens, France, 102, 104 Deluge, 526, 539, 543, 544, 712, 718 nude in art, 200-201, 221, 277, 284, 381, 504, MORETTO (Alesandro Bonvicino), Ecce Homo Fall of Adam and Eve and Expulsion, 526, 509, 547, 612, 647, 660, 693 with Angel, 659-60, 660 539, 541, 542, 544 Moses (Michelangelo Buonarroti), 374, 537, 545, Christian art, 550 Libyan Sibyl, 86, 550, 550 medieval, 81 552-53, 552 Prophet Isaiah, 543, 545, 551 number symbolism, 115 Moses and the Brazen Serpent (Vincenzo Danti), Separation of Light from Darkness, 539, nymphaeum, 728 548-49, 549, 613 703, 703 Moses Defending the Daughters of Jethro (Rosso Last Judgment, wall fresco, 364, 409, 502, Fiorentino), 604, 604 503, 538, 691, 692, 710 Moses Striking Water from the Rock (Tintoretto), Damned Soul Descending to Hell, 693, 693 O 668, 668 Demons in Hell, 694, 694 St. Bartholomew, 693, 693, 701 motifs, sharing of, 594 oculus, 728 mozzetta, 728 Sonnet with a caricature of the artist, 543, 543 Ognissanti, Florence, Refectory, 391, 391, 492 Study for Libyan Sibyl, 550, 551 mullion, 728 Mystical Marriage of St. Catherine (Paolo oil painting, 303, 447, 502, 728 Study for Sistine Ceiling, 537, 537 Old Man with a Young Boy (Domenico del Veronese), 675-77, 676 Tomb of Julius II project, 516, 535, 535, 551, Ghirlandaio), 396, 397 552, 552, 553, 561, 590, 591-92, 591, 702 Mystic Nativity (Sandro Botticelli), 384-85, Old Sacristy, San Lorenzo, Florence, 182, 188-89, 385, 473 completed, in San Pietro in Vincoli, Rome, 189, 194, 195, 287, 348, 416, 584 Mythological Scene (Piero di Cosimo), 374, 537, 545, 552-53, 552, 559, Olympian Theater, Vicenza (Andrea Palladio), 521-22, 522 694, 695 mythological subjects, 360, 376-81, 641-43 with Vincenzo Scamozzi, 688, 688, 689 Victory, 590-93, 591, 592, 703 opera del duomo, 728 MICHELOZZO DI BARTOLOMMEO, 186, 192, 195-96, 248, 252, 282 optical effects, 215 Oratory of Divine Love, 569, 596, 728 Faith, Tomb of Bartolommeo Aragazzi, N ORCAGNA, ANDREA (Andrea di Cione), Cathedral, Montepulciano, 289, 289 155-58, 168 Palazzo Medici (Palazzo Medici-Riccardi), Nailing of Christ to the Cross (Pordenone), 620, 620 Entbroned Christ with Madonna and Saints, Florence, 180, 182, 195-97, 195, 196, 197, 155-56, 156, 224 268, 296, 346, 420, 465, 623 NANNI DI BANCO, 164, **212–14**, 245, 284, 331 Orsanmichele, Florence, Tabernacle, 156-57, Assumption of the Virgin, Cathedral, Florence, San Marco monastery, library, 182, 196, 157, 158, 158, 167 164, 213-14, 213, 304 197, 248 order (monastic), 728 Four Crowned Martyrs (Quattro Santi Michiel, Marcantonio, 634 orders of architecture, 720 Coronati), Orsanmichele, Florence, 42, 205, Milan, 170, 174-76, 181-82, 212, 232, 329, 406, Orsanmichele, Florence, 42, 42, 164, 183, 204-6, 206, 212, 212, 232, 284, 329 425, 447, 465, 466, 489, 490-91, 656 204, 206, 208-9, 208, 209, 211, 212, 212, Naples, 212, 406 Cathedral, 175 213, 228, 229, 232, 254, 276, 284, 329, Napoleon, 170, 425 Ospedale Maggiore, 466 333, 432, 495, 502, 513 Santa Maria delle Grazie, 51, 217, 391, 457, Nativity, 80, 168 iconography, 205, 205 491-95, 492, 493, 494, 528-29, 528, 529, Nativity: Tabernacle, 156-57, 157, 158, 158, 167 (Alesso Baldovinetti), 168, 353, 353, 529, 554 491, 594 orthogonals, 729 Santa Maria presso San Satiro, 527, 527, (Jacopo Bellini), 168, 431, 431 Orvieto, 150 528, 528 (Gentile da Fabriano), 143, 168, 226, 226, Cathedral, 150, 151-53, 152, 153, 523 Milanese art, 656, 658 San Brizio Chapel, 53, 517-21, 518, 519, 520, 321, 613 Milanesi, Gaetano, 303 550, 554, 693 (Lorenzo Monaco), 167, 167, 226, 402 MILANO iconography, 517-21, 519 (Tintoretto), 668, 669 See Giovanni da Milano Ospedale degli Innocenti, Florence, 187-88, 187, Nativity and Adoration of the Shepherds miniatures, 661 (Domenico del Ghirlandaio), 394-95, 203, 237, 700 MINO DA FIESOLE, 291 Ospedale Maggiore, Milan (Filarete), 466 395, 484 Portrait of Piero de' Medici, 291, 291 ostrich eggs, 323-24 Nativity and Adoration of the Shepherds minorites, 728 Ottoman Empire, 425 (Allendale Nativity) (Giorgione), The Miracle of St. Michael on Mt. Gargano Ovid, 378 (Domenico Beccafumi), 608-10, 609 632, 632

P Palazzo Rucellai, Florence (Leonbattista Alberti Certosa, 175, 466, 466-68, 467 with Bernardo Rossellino), 268-69, 268, façade, 466, 468 Pacioli, Fra Luca, 371, 390 273, 289, 533, 535 Pazzi Chapel, Santa Croce, Florence, 193-95, 193. Pact of Judas (Simone Martini, workshop of), Palazzo Sacchetti, Rome, 712-14, 714 194, 348 137 137 Palazzo Schifanoia, Ferrara, 471 Pazzi conspiracy, 371 Padua, 45-46, 95, 170, 173, 285-89, 425, 654 Hall of the Months, 19, 471, 472 Pazzi family, 330 Arena Chapel, 51, 92, 95, 95-108, 95, 96, Palazzo Strozzi, Florence, 344-46, 345, 346, 420, Pearl Fishers (Alessandro Allori), 551, 718 97, 98, 99, 99, 100, 101, 102, 103, 105, 106, 465, 623, 625 Pellegrini, Margarita, 679 107, 108, 116, 119, 122, 129, 167, 168, Palazzo Tarugi, Montepulciano (Antonio da San-Pellegrini Chapel, San Bernardino, Verona gallo), 623, 623 (Michele Sanmicheli), 678-79, 679 iconography, 95, 96 Palazzo Valle-Capranica, Rome, ancient sculpture pendentive, 729 Eremitani Church, Ovetari Chapel, 432-33, 433, displayed in, 702, 702 The Penitent Magdalen (Donatello), 331-33, 434, 434, 450 Palazzo Venezia, Rome (Leonbattista Alberti), 272, 332, 333 Sant'Antonio, 116, 287-89, 288, 432, 272, 625 peristyle, 729 437, 707 Palladian motif, 729 Perseus and Andromeda (Giorgio Vasari), Chapel of St. Felix (formerly St. James), 173, Palladio, Andrea (Andrea di Pietro), 581, 673, 681, 54, 716-18, 717 Perseus and Medusa: San Giorgio, oratory, 173, 174 Basilica (Palazzo della Ragione), Vicenza, (Benvenuto Cellini), 38, 705-6, 705 Santo, Chapel of St. Anthony, 653, 653 682-83, 682 (Baldassare Peruzzi), 572-73, 572 Paduan school, 461 Olympian Theater, Vicenza, with Vincenzo perspective, 275-76, 278, 293, 304-5, 317, painting: Scamozzi, 688, 688, 689 365-66, 431-32, 495, 554 practice of, 45-52 Palazzo Chiericati, Vicenza, 683-84, 683 Albertian, 304, 432 vs. sculpture, 501 San Giorgio Maggiore, Venice, 25, 670, 686-87, one-point, 192, 215-16 writings on, 265, 275-76, 279 686, 687 scientific, 183 palaces: Villa Almerico (Villa Rotonda, Villa Capra), perspective construction (Leonbattista Alberti), Florentine, 344-46 Vicenza, 684, 684 275 275 Roman, 535 Villa Barbaro, Maser, 673, 685, 685 Perspective Study (Paolo Uccello), 293, 293 Venetian, 464-65 writings, 682 Perugia, 37, 82, 408-13 Palaeologan style, 78 Pallas Expelling the Vices from the Garden of PERUGINO (Pietro Vannucci), 359, 372, 409-11, palazzo, 195-96, 729 Virtue (Andrea Mantegna), 444 412, 442-43, 477, 511, 513, 526, 606 Palazzo Bevilacqua, Verona (Michele Sanmicheli), Palma Giovane, 652 Crucifixion with Saints, 410-11, 411 678, 678 palmettes, palmetto decoration, 729 Francesco delle Opere, 411, 412, 497, 515 Palazzo Borgherini (Palazzo Rosselli del Turco), Palmieri, Matteo, 342 Sistine Chapel, frescoes, 691 Florence, 598 panel painting, 46-49 Christ Giving the Keys to St. Peter, 53, 398, Palazzo Caprini, Rome (Donato Bramante), panels, 45, 46 409-10, 409, 410, 441, 511, 537, 538 534-35, 534, 678, 680, 721 Pantheon, Rome, 36, 185, 188, 267, 530 PERUZZI, BALDASSARE, 569, 571-73, 622, Palazzo Chiericati, Vicenza (Andrea Palladio), 625-26, 720 683-84, 683 See Giovanni di Paolo Palazzo Massimo alle Colonne, Rome, Palazzo dei Priori (Palazzo Vecchio), Florence, 90, PAOLO VENEZIANO, 170-71 626, 626 91, 196, 394, 707, 716, 719 Coronation of the Virgin, 170-71, 171 Villa Farnesina (originally Palazzo Chigi), papacy, 37, 74-75, 182, 330, 399, 495, 525, Chapel of Eleonora da Toledo, 27, 551, 712, Rome, 571-77, 571 712 713 584, 656 Sala delle Prospettive, 575 Sala dell'Udienza, 712, 713 Papal Palace and Cathedral, Pienza (Bernardo Sala di Galatea, 572, 572, 673 Palazzo della Cancelleria, Rome, 54, 268, 272, Rossellino), 273, 274, 399 Aquarius, 573, 573, 616 273, 533, 697, 715, 715 Paradise (Nardo di Cione), fresco, 51, 158, 159 Perseus and Medusa, 572-73, 572 Palazzo del Principe, Genoa, 605-6, 605, 691 Paris, 38 Pesaro, Jacopo, 644 Palazzo del Te, Mantua (Giulio Romano), 625, Parma, 656 Pescia, San Francesco, 63, 64, 113, 116, 135 626-28, 627, 707 Cathedral, 614, 614, 615 PESELLINO, FRANCESCO (Francesco di Ste-Sala dei Giganti, 606, 628, 629, 691 Convent of San Paolo, 610 fano), 355-57, The Triumphs of Love, Sala di Psiche, 628, 628 Camera di San Paolo, 21, 610-11, 610 Chastity, and Death, 355-56, 356-57 Palazzo Ducale, Mantua, Camera picta, 439-41, Sant'Antonio, 611 Pesello, Giuliano, 294 440, 441, 613, 614 San Giovanni Evangelista, 613-14, 613 Petrarch, 355-56, 486 Palazzo Ducale, Urbino (Luciano Laurana), PARMIGIANINO (Francesco Mazzola), 610, Petrucci, Pandolfo, 399 321, 344, 419-21, 420, 422, 422, 616-19, 621, 655 Petrus Christus, 387, 447 423, 511 Cupid Carving His Bow, 619, 619 Philip II, of Spain, 631, 649 Palazzo Farnese, Rome (Antonio da Sangallo), Madonna and Child with Angels and St. Jerome Philosophy (School of Athens) (Raphael), 625, 625 (Madonna of the Long Neck), 618-19, 618 frescoes, 554, 555, 555, 556, 558, 561, with Michelangelo, 571, 623-25, 624, 696-97, Self-Portrait in a Convex Mirror, 616-17, 617 573, 594 696, 720 Vision of St. Jerome, 617-18, 617 Philostratus, 641 Palazzo Loredan (Palazzo Vendramin-Calergi), Parnassus (Andrea Mantegna), 442, 442, 443 Piacenza, 561, 610 Venice (Mauro Codussi), 464-65, 464 Parthenon, 497 San Sisto, 561 Palazzo Massimo alle Colonne, Rome (Baldassare Passion of Christ, 729 Piacenza, Giovanna da, 611 Peruzzi), 626, 626 Pasti, Matteo de', 266, 267 piano nobile, 729 Palazzo Medici (Palazzo Medici-Riccardi), pastiglia, 729 piazza, 37-38, 729 Florence, 180, 182, 195-97, 195, 196, 197, Pastoral Scene (Fête Champêtre) (Giorgione), or Piazza del Campo, Siena, Fonte Gaia, 268, 296, 346, 420, 465, 623 Titian, 634, 635 217-18, 217 Chapel, 182, 349, 350 paten, 729 Piazza della Signoria, Florence, 32-33, 38, 38, 394, Palazzo Nuovo and Palazzo dei Conservatori. patron, definition of, 729 508, 705, 708 Campidoglio, Rome (Michelangelo Paul III, Pope, 624-25, 648, 691, 694 The Piazza of Florence Cathedral in 1754, with Buonarroti), 699, 700, 700 Paul III Farnese Directing the Continuance the Baptistery and Bell Tower (Giuseppe Palazzo Piccolomini, Pienza, 273 of St. Peter's (Giorgio Vasari), fresco, 54, Zocchi), 40, 40 Palazzo Pitti, Florence (Luca Fancelli?), 91, 274, 697, 715, 715 Piazza Pio II, Pienza (Bernardo Rossellino), 273, 274, 707, 707 Pauline Chapel, Vatican, Rome, 690, 694-96, 273, 399, 421 Palazzo Pubblico, Siena: 695, 696 Piccolomini, Aeneas Silvius (Pope Pius II), 399, 412 Paul IV, Pope, 569 Council Chamber, 130-31, 132 Piccolomini Library, Cathedral, Siena, 412-13, Sala della Pace, 51, 124, 145-49, 145, 146, 147, Pausanias, 680 412, 413 148, 161, 173, 224 Pavia, 425

Piedmont, 93

Hercules and Antaeus, panel, 360-61, 360 Baptistery Pulpit, 79-80, 79, 80, 81, 81, Pienza 289 399 421 Hercules and Antaeus, statue, 361, 361 Palazzo Piccolomini, 273 129, 238 Papal Palace and Cathedral, 273, 274, 399 painting in, 60-63 Hercules and Hydra, 360, 360 Piazza Pio II, 273, 273, 399, 421 Portrait of a Young Woman, 365, 365 Pisa, School of: St. Sebastian, with Piero del Pollaiuolo?, 362-64, Cross No. 15, 60, 60 pier, 729 Cross No. 20, 45, 60-63, 61, 70 363, 448, 482, 497 PIERINO DA VINCI, 703 Tomb of Pope Sixtus IV, 365, 366 Cosimo I as Patron of Pisa, 703, 703 Deposition, Lamentation, and Entombment, Pollajuolo, Piero del, 339, 360, 366 PIERO DELLA FRANCESCA, 164, 266, 299, 60-62, 62, 67, 106 PISANELLO, ANTONIO, 297, **425–28**, 468 310-27, 329, 359, 362, 364, 368, 371, 387, polychromy, 729 polyptych, 45, 729 St. George and the Princess, Pellegrini Chapel, 390, 399, 413, 421, 432, 468, 511, 517, Pompeiian murals, 714 581, 722 Sant'Anastasia, Verona, 425-27, 426 PONTE Adoration of the Child, 168, 322, 326, 327 Study of Hanged Men, 426, 427 Study of the Head of a Horse, 425, 426 See Bassano, Jacopo (Jacopo dal Ponte) Baptism of Christ, 312, 313 Ponte Santa Trinita, Florence (Bartolommeo Vision of St. Eustace, 427-28, 427 Battista Sforza and Frederico da Montefeltro, 324, 324, 325, 360, 419 PISANO, ANDREA, 122-23, 155, 158, 167, Ammanati), 394, 707-8, 708 PONTORMO, JACOPO CARUCCI DA, 50, Flagellation of Christ, 321, 322, 407 168, 284 Art of Architecture, 43, 44, 54, 122 581, 598, 621 Legend of the True Cross, Chapel, San Entombment, Capponi Chapel, Santa Felicita, Francesco, Arezzo, 313-21, 315 Art of Painting, 43, 43, 45, 48, 122 Florence, 600, 601, 709 Annunciation, 320-21, 320 Art of Sculpture, 43, 43, 52, 81, 122, 284 Battle of Constantine and Maxentius, 317, Baptistery, Florence, 54, 68, 69, 107, 122-23, Self-portrait, 601, 601 122, 187, 410, 694 Joseph in Egypt, 598, 599, 709 318, 319 San Lorenzo, Florence, frescoes, 602 Cathedral, Florence, Campanile, 114-15, 114, Battle of Heraclius and Chosroes, 317, Study for Deluge Fresco for San Lorenzo, 602 115, 158, 168, 214-15, 214, 215, 254, 333 319-20, 319, 490 Vertumnus and Pomona, Villa Medici, Poggio Creation of Adam, 43, 122, 122 Discovery of the Wood of the True Cross and a Caiano, 348, 580, 598-601, South Doors, Baptistery, Florence, Salome Pre-Meeting of Solomon and the Queen of senting the Baptist's Head to Herodias, 123, 599, 602 Sheba, 317, 317, 419 123, 167, 199, 201, 276 Visitation, SS. Annunziata, Florence, iconography, 316, 317 598 598 statues, 205 Invention of the True Cross and Recognition Pope Leo X with Cardinals Giulio de' Medici and of the True Cross, 317, 318-19, 318, 419 PISANO, GIOVANNI, 82, 83-88, 150, 164 Luigi de' Rossi (Raphael), 564, 564, 617 Cathedral, Siena, façade, 84, 84, 126 Vision of Constantine, 320, 321 Pope Paul III Farnese (Titian), 648, 648, 696 Madonna and Child with Saints, 323, 323, Madonna and Child, 87, 87, 110 Porcari, Stefano, 329 Mary, Sister of Moses, 84–85, 84 437, 453 PORDENONE (Giovanni Antonio de Sacchis), Misericordia altarpiece, and others, 310-11, Pulpit, Sant'Andrea, Pistoia, 85, 85 311, 399, 722 Massacre of the Innocents, 85-86, 86 619-20, 621 Nailing of Christ to the Cross, fresco, Cathedral, Sibvl 86, 87 Resurrection, 313, 314, 460 Cremona, 620, 620 Supporting Figure, 86, 87 Triumph of Federico da Montefeltro and PISANO, NICOLA (Nicolà d'Apulia), 79-88, porphyry, 729 Triumph of Battista, 324, 325, 326-27, 558 150, 164, 174, 409 PORTA writings, 327 See Bartolommeo, Fra (Baccio della Porta) PIERO DI COSIMO, 359, 508, 521-23, 594, 598 Baptistery Pulpit, Cathedral, Pisa, 79-80, 79, 80, 81, 81, 129, 238 porta clausa, 729 Hunting Scene, 522, 523 Pulpit, Cathedral, Siena, 82, 83, 125, 128 Portinari, Tommaso, 387 Mythological Scene, 521-22, 522 Portrait Medal of Cosimo de' Medici, Pater Portrait of Simonetta Vespucci(?), 521, 521 Last Judgment, 82, 83 Patriae (Commune of Florence), 182, Madonna and Child, 83, 83 pietà, 63, 729 183, 381 Massacre of the Innocents, 85-86, 86 Pietà. Portrait Medal of Isabella d'Este (Giancristoforo (Giovanni Bellini), 451-52, 452, 473 Pisano family, 94 Pisa polyptych (Masaccio), 238 Romano), 442, 443 (Agnolo Bronzino), 709-10, 709 Portrait of a Bearded Man (Self-Portrait?) Pistoia, 59 (Carlo Crivelli), 462, 463 (Titian), 636-39, 637 (Giovanni da Milano), 154, 163, 163 Sant'Andrea, 85, 85 Portrait of a Lady with Flowers (Andrea del Massacre of the Innocents, 85-86, 86 (Michelangelo Buonarroti) Verrocchio), 368-69, 369, 485-86 in Florence, 700, 701, 701 Sibvl. 86, 87 Portrait of a Man (Antonello da Messina), 448, 448 in Milan, intended for own tomb, 701-2, 701 Supporting Figure, 86, 87 Portrait of a Man with a Medal of Cosimo de' Pius II, Pope, 266, 273, 399, 412-13 in Vatican, 505-6, 505, 506, 618, 706 Medici (Sandro Botticelli), 354, 381, 381, (Titian), finished by Palma Giovane, 652, 653 Pius III, Pope, 412, 525 (Cosmè Tura), from the Roverella altarpiece, Pizzolo, Niccolò, 432 Portrait of a Turkish Boy (Gentile Bellini, attrib.), plague, 181-82, 329, 596 469, 470, 470 pietra forte, 729 Plan for Triangular Rare-Book Room of the Lau-445, 445 Portrait of a Woman in Mourning (Tintoretto), rentian Library (Michelangelo Buonarroti), pietra serena, 729 671 590, 590 Pietro da Novellara, Fra, 495 Plan of Sforzinda (Antonio Filarete), 53, 274, 466, 466 Portrait of a Young Woman: pigments, 48 Plans and Perspective Views of Domed Churches (Alesso Baldovinetti), 354-55, 355 pilaster, 729 (Antonio del Pollaiuolo), 365, 365 (Leonardo da Vinci), 53, 481, 482, 482, pinacoteca, 729 Portrait of Ginevra de' Benci (Leonardo da Vinci), 528, 622 pinnacle, 729 485-86, 485, 486, 497 PINTORICCHIO (Bernardino di Betto), 373, Platina (humanist), 416 Portrait of Grandduke Cosimo de' Medici Platonic Academy, 375, 729 412-13, 525 (Benvenuto Cellini), 706-7, 706 Plautilla, Sister, 578 The Allegory of Fortune, inlaid floor, Cathedral, Portrait of Piero de' Medici (Mino da Fiesole), 291, Pliny the Elder, 526, 660 Siena, 413, 415 291 Poggio a Caiano, Villa Medici, 346-48, 347, 580, Piccolomini Library, Cathedral, Siena, frescoes, Portrait of Simonetta Vespucci(?) (Piero di 18,412 598-601, 599, 602 Departure of Aeneas Silvius Piccolomini Poliziano, Angelo, 378, 380, 394 Cosimo), 521, 521 Portrait of Sultan Mahomet II (Gentile Bellini), POLLAIUOLO for Basel, 413, 414 322, 445, 445 See Cronaca, il (Simone del Pollaiuolo) pinxit, 729 Portrait of the Artist's Three Sisters with Their POLLAIUOLO, ANTONIO DEL, 44, 182, 309, PIOMBO 339, 340, 359-66, 371, 482, 517 Governess (Sofonisba Anguissola), 662, 662 See Sebastiano del Piombo portraiture, 63, 107, 133, 287, 354, 365, 416, 497, Apollo and Daphne, 364-65, 364 Pippo Spano (Andrea del Castagno), 306, 306, 384 514-15, 651 Battle of the Nudes, 361-62, 361 Pisa, 37, 59, 79, 110, 170 ancient, 343 Dance of the Nudes, Villa La Gallina, Florence, Camposanto, 51, 149-50, 150-51, 173 busts, 291 362, 362 Cathedral, 79

group, 662 Rape of Europa (Titian), 650-51, 650, 675 Resurrection, Crucifixion, Entombment (Andrea profile, 365 Rape of the Sabine Woman (Giovanni Bologna), del Castagno), 50, 50 pouncing, 729 38, 708, 709 Resurrection of Lazarus (Giovanni da Milano), Poussin, 514, 566 RAPHAEL (Raffaello Santi or Sanzio), 44, 407, fresco, 163, 163 Po Valley, 425 409, 410, 411, 416, 421, 477, 495, 497, Resurrection of the Dead (Luca Signorelli), 520, Prato, 59, 582 500, 511-15, 526, 534, 553, 554-78, 581, 521, 550, 554, 693 Cathedral, 260-61, 260, 261 594, 607, 610, 611, 619, 621, 622, 626, Resurrection of the Notary's Son (Domenico del Santa Maria delle Carceri, 271, 348, 348, 349, 678, 715, 719, 722 Ghirlandaio), frescoes, 393, 393 Angelo Doni, 411, 506, 515, 515 407, 481, 622 Riario, Raffaello, 272-73 ribbed vault, 730 Praxiteles, 443 architecture, 407, 622 Baldassare Castiglione, 497, 562-63, 563 predella, 45, 729 Riccobaldo (chronicler), 116-17 Presentation in the Temple (Ambrogio Lorenzetti), death of, 569 Ridolfi, Carlo, 663, 672 128, 143-45, 144 Donna Velata (Veiled Woman), 562, 563 rilievo schiacciato, 730 Presentation of the Virgin (Titian), 645-46, Fighting Men, study for relief sculpture in School Rimini, 266 645, 646 of Athens, 558, 560-61 Malatesta Temple (San Francesco), 116, 266-67, prie-dieu, 729 Healing of the Lame Man, 539, 565, 566 266, 267, 317 Primavera (Sandro Botticelli), 261, 358, influence of, 581, 594, 610, 619, 626, 678, 715, design for, on medal by Matteo de' Pasti, 267, 719, 722 267, 464, 527 378-80, 379 priori, 729 influences on, 409, 410, 411, 416, 421, 495, rinceau, 730 Procession of the Magi (Benozzo Gozzoli), fresco, 497, 553 Risen Christ (Vecchietta), 405-6, 406 182, 349, 350 Maddalena Strozzi Doni, 411, 506, 515, 515 ROBBIA, LUCA DELLA, 194, 196, 279-82, 339, Procession of the Relic of the True Cross (Gentile Madonna of the Meadows, 513-14, 514 340, 359 Marriage of the Virgin, 53, 511, 512 Cantoria, 279-80, 279, 294, 313, 327 Bellini), 444, 444 PROPERZIA DE' ROSSI, Chastity of Joseph, Medici Villa (now known as Villa Madama), Singing Boys, 280, 280 578, 579 Rome, decorations by Giulio Romano, Resurrection, North Sacristy, Cathedral, Prophet Isaiah (Michelangelo Buonarroti), 543, Giovanni da Udine, and Baldassare Peruzzi, Florence, 280, 281, 330 ROBERTI, ERCOLE DE', 471-73 545, 551 564, 567-69, 568 proto-Baroque, 616 Pope Leo X with Cardinals Giulio de' Medici St. John the Baptist, 473, 473 Psyche Received on Olympus (Raphael), fresco, and Luigi de' Rossi, 564, 564, 617 Robert of Anjou, 132 576, 577, 611, 628 St. George and the Dragon, 513, 513 ROBUSTI public works, and patriotism, 182 St. Paul Preaching in Athens, 539, 566-67, 567 See Tintoretto (Jacopo Robusti) Pucci, Antonio, 394 Sistine Chapel, Vatican, Rome, tapestries, 539, 565 Robusti, Domenico, 670 Robusti, Marietta, 664 Pucci family, 362 Sistine Madonna, 516, 561, 562, 610, 639 Pugliese, Francesco del, 522 Small Cowper Madonna, 323, 514, 514 Rococo, 416 punch work, 729 Stanze, Vatican, Rome, 601 Rodin, 339 Disputà (Disputation over the Sacrament), Punishment of Korah, Dathan, and Abiram Roger II of Sicily, 59 (Sandro Botticelli), fresco, 371, 372, 374, 554, 557 Romagna, 413, 631 374, 410, 441, 517, 537, 538 Roman architecture, 720-22 Three Cardinal Virtues: Fortitude, Prudence Punishment of the Gamblers (Andrea del Sarto), and Temperance, 521, 554, 555, 557, 558 Roman architecture, ancient, 52, 118, 183, 188, fresco, 594, 594 Expulsion of Attila and Liberation of St. Peter 196, 270-71, 272 putto, 729 from Prison, 554, 555, 558, 559, 561, Roman art, 411, 619 pyramidal composition, 489, 497, 632 650, 696 High Renaissance, 500, 525-78, 610 Pythagoras, 188 iconography, 554-61, 555 painting, 74-78 Mass of Bolsena and Expulsion of Heliodorus, Roman art, ancient, 80, 201, 212, 432 555, 558, 559-60, 560 portraiture, 343 Philosophy (School of Athens), 554, 555, 555, Roman Empire, 170 Q 556, 558, 561, 573, 594 Romanesque architecture, 60, 89, 143, 188 Romanesque painting, 65 Studies of the Madonna and Child, 513, 513 quatrefoil, 123, 167, 729 Transfiguration of Christ, 569, 570, 573, 577 Romanino of Brescia, 620 Quattrocento, 93, 181-97, 477, 729 Villa Farnesina (originally Palazzo Chigi), Rome, ROMANO Gothic style, 223 frescoes See Giulio Romano QUERCIA, JACOPO DELLA, 199, 217-21, 399, Galatea, Sala di Galatea, 524, 573-74, ROMANO, GIANCRISTOFORO, Portrait 406, 504-5 574, 594 Medal of Isabella d'Este, 442, 443 Fonte Gaia, Piazza del Campo, Siena, 217-18, 217 Loggia of Psyche, 576, 577, 611, 628 Rome: Expulsion, 219-20, 219, 235 Cupid Pointing Out Psyche to the Three ancient, 35-36 Rea Silvia or Public Charity 218, 219 Graces, with Giulio Romano, 577, 577, Basilica Emilia, 582, 622, 626 Campidoglio, 36, 699-700, 699 San Petronio, Bologna, Main Portal, 616, 628, 673 Creation of Adam, 220, 220, 232, 504 Psyche Received on Olympus, 576, 577, Palazzo dei Conservatori, 699 Expulsion, 221, 221, 504, 545 611, 628 Palazzo Nuovo, 700, 700 Temptation, 221, 221, 504 workshop of, 564-65 Forum of Trajan, 627 quoin, 729 Ravenna, 52, 267, 413 Gesù. 720 Rea Silvia or Public Charity (Jacopo della Medici Villa (now known as Villa Madama), Quercia), 218, 219 564, 567-69, 568 refectory, 729 Palazzo Caprini, 534-35, 534, 678, 680, 721 R Reformation, 608 Palazzo della Cancelleria, 54, 268, 272, 273, Reggio Emilia, San Prospero, 612 533, 697, 715, 715 radial architecture, 528 Reims Cathedral, 83-84, 114 Palazzo Farnese, 571, 623-25, 624, 625, RAFFAELLO relics, 271 696-97, 696, 720 See Raphael (Raffaello Santi or Sanzio) relief, 211, 729 Palazzo Massimo alle Colonne, 626, 626 Raimondi, Marcantonio, 560, 574, 578 Rembrandt, 563 Palazzo Sacchetti, 712-14, 714 Raising of Lazarus (Giotto di Bondone), 102, 103, republics, 582 Palazzo Valle-Capranica, 702, 702 122 Resurrection, 730 Palazzo Venezia, 272, 272, 625 Raising of the Son of Theophilus and the En-Pantheon, 36, 185, 188, 267, 530 Resurrection: thronement of St. Peter (Masaccio), fresco, (Michelangelo Buonarroti), 586, 587, 703 rebuilding of, 525 Sack of 1527, 584, 604 with Filippino Lippi, 236-38, 237, 567 (Piero della Francesca), 313, 314, 460 Rangone, Tommaso, 665 (Luca della Robbia), 280, 281, 330 San Giovanni in Laterano, 223

Santa Maria sopra Minerva, 387 San Pietro in Montorio Borgherini Chapel, 577-78, 577 Tempietto, 421, 481, 511, 529, 529, 530, 567, 683 San Pietro in Vincoli, 374, 537, 545, 552-53, 552, 554, 559, 694, 695 Santa Cecilia in Trastevere, 76, 77-78, 77, 119 Santa Maria in Trastevere, 76-77, 76, 158 Santa Maria Maggiore, 74, 75 Vatican. See Vatican, Rome Villa Farnesina (originally Palazzo Chigi), 571-77, 571 bedroom, 574, 575 Loggia of Psyche, 576, 577, 577, 611, 616, 628, 673 Sala delle Prospettive, 575 Sala di Galatea, 524, 572-74, 572, 573, 574, 594, 616, 673 rosary, 730 ROSSELLI, COSIMO, 372 Sistine Chapel frescoes, 538 ROSSELLINO, ANTONIO, 339-42, 361 Bust of Matteo Palmieri, 342, 342 Tomb of the Cardinal Prince of Portugal, Chapel of the Cardinal of Portugal, San Miniato, Florence, 341, 342, 342, 361 ROSSELLINO, BERNARDO, 193, 269, 273, 289-91, 339, 340, 342, 399, 530 Papal Palace and Cathedral, Pienza, 273, 274, 399 Piazza Pio II, Pienza, 273, 273, 399, 421 Tomb of Lionardo Bruni, Santa Croce, Florence, 54, 289-91, 290, 291, 336 Rossellino, Giovanni, 339 Rossellino family, 339, 501 Rossi, Luigi de', 564 ROSSI, PROPERZIA DE' See Properzia de' Rossi ROSSO FIORENTINO (Giovanni Battista di Jacopo), 581, 602-4, 621 Assumption of the Virgin, SS. Annunziata, Florence, 602, 602 Descent from the Cross, 602-4, 603, 604 Moses Defending the Daughters of Jethro, 604, 604 Rovere, Francesco Maria della, 591 Rovere, Girolamo Basso della, 418 Rovere, Giuliano della (Pope Julius II), 416, 525 Rovere, Guidobaldo II della, 646 Rovere, Marco Vigerio della, 537, 540, 544-45, 548-50 Rovere family, 416, 418, 542, 561 Roverella family, 469 Rubens, Peter Paul, 561, 612, 619 Rucellai, Giovanni, 268-69 Ruins of the Ancient Roman Theater of Marcellus, Rome (Giuliano da Sangallo), 36, 52, 272, 346, 346 Rule of the Antichrist (Luca Signorelli), 53, 519-21, 519 Ruskin, John, 99, 195, 390, 664 rustication, 54, 196, 268, 730

S

SACCHIS

See Pordenone (Giovanni Antonio de Sacchis)
Sacra Conversazione (Lorenzo Lotto), 655, 655
sacra conversazione, 730
Sacred and Profane Love (Titian), 640–41, 640
Sacrifice of Isaac:
(Filippo Brunelleschi), 199, 200
(Lorenzo Ghiberti), 183, 199–201, 200, 276, 277, 301

(Titian), 647–48, *647*, 652 sacristy, 730

Saint: Titles and buildings beginning with San, Sant', Santi, Santo, and SS. are alphabetized as if beginning with Saint.

Sant'Anastasia, Verona, Pellegrini Chapel, 425–27,

Sant'Andrea, Mantua (Leonbattista Alberti), 270–72, 270, 271, 271, 439, 527, 533, 686, 687, 720

Sant'Andrea, Pistoia, pulpit, 85, 85 Massacre of the Innocents, 85–86, 86 Sibyl, 86, 87 Supporting Figure, 86, 87

SS. Annunziata, Florence, 168, 308, 309, 309, 333, 353, 353, 362, 439, 491, 594, 594, 595, 598, 598, 602, 602

St. Anthony of Padua and the Miracle of the Miser's Heart (Tullio Lombardo), 653, 653

St. Antbony of Padua Healing the Wrathful Son (Donatello), 287–89, 288, 432, 437, 707

Sant'Antonio, Padua, 116, 287–89, 288, 432, 437, 707
Chapel of St. Felix (formerly St. James), 173, 173, 425

Sant'Antonio, Parma, 611

Sant'Apollonia, Florence, Cenacolo, *302*, 303–5, *303*, *304*, 391, 492

Santi Apostoli, Florence, 190

St. Bartbolomew (Michelangelo Buonarroti), 693, 693, 701

San Bernardino, Verona (Michele Sanmicheli), Pellegrini Chapel, 678–79, 679

San Biagio, Forli, 418

Santa Cecilia in Trastevere, Rome, 76, 77–78, 77, 119

St. Cecilia Master, 117-18

Santa Croce, Florence, 54, 89, 89, 112, 164, 165, 172, 190, 258, 284, 284, 289–91, 290, 291, 316, 336–38, 337, 351, 382

Bardi-Bardi di Vernio Chapel, 118, 118 Bardi Chapel, 51, 110–13, 110, 111, 112, 113 Baroncelli Chapel, 120, 121, 321

Pazzi Chapel, 193–95, 193, 194, 348

Peruzzi Chapel, 123

refectory, 72, 120-21, 121, 492

Rinuccini Chapel, 163, 163

Sant'Egidio, Florence, 387

Santa Felicita, Florence, Capponi Chapel, 600, 601, 601, 709

San Francesco, Arezzo, Chapel, 313–21, 315, 317, 318, 319, 320, 419, 490

iconography, 316, 317

San Francesco, Assisi, Lower Church, 45, 116, 116, 117, 139, 140, 141, 141, 142, 321, 384, 670

St. Martin Chapel, 133, 134, 158

San Francesco, Assisi, Upper Church, 73–74, 73, 75–76, 75, 116–18

San Francesco, Pescia, 63, 64, 113, 116, 135

St. Francis in Ecstasy:

(Giovanni Bellini), 454-57, 455

(Sassetta), from the back of the Sansepolcro altarpiece, 399–401, 400

St. Francis Praying Before the Crucifix at San Damiano (Master of the St. Francis Cycle), fresco, 45, 116, 117

St. Francis Undergoing the Test by Fire Before the Sultan (Giotto di Bondone), 51, 110–13, 110

St. Francis with Scenes from His Life (Bonaventura Berlinghieri), 63, 64, 113, 116, 135

St. George (Donatello), 15, 42, 198, 205, 206, 209–11, 210, 238, 333, 592

St. George and the Dragon:

(Donatello), 183, 211, 229, 276, 495, 502, 513 (Raphael), 513, 513

St. George and the Princess (Antonio Pisanello), 425–27, 426

San Gimignano, Collegiate Church, 137, 137, 138, 138

San Giorgio, Padua, oratory, 173, 174

San Giorgio Maggiore, Venice (Andrea Palladio), 25, 670-71, 670, 674, 677, 686-87, 686, 687

Santi Giovanni e Paolo, Venice, 172

San Giovanni Evangelista, Parma, 613–14, *613* San Giovanni in Laterano, Rome, 223

San Giovenale, Cascia di Regello, 228, 228, 238, 260

St. James Before Herod Agrippa (Andrea Mantegna), fresco, 432–33, 433

St. James Led to Execution (Andrea Mantegna), fresco, 434, 434, 450

St. Jerome (Alessandro Vittoria), 689, 689 St. Jerome in His Study (Antonello da Messina),

St. John Entering the Wilderness (Giovanni di Paolo), 402, 402

St. John the Baptist:

446, 447

(Francesco del Cossa), from the Griffoni altarpiece, 471, 471

(Lorenzo Ghiberti), 164, 204–6, *204*, *206*, 208, 228

(Ercole de' Roberti), 473, 473

St. John the Baptist in the Desert (Domenico Veneziano), 301, 301

San Lorenzo, Florence, 89, 178, 182, 187, 188, 188, 190–92, 190, 194, 203, 257–58, 257, 334–36, 335, 336, 582, 584, 602

façade (Giuliano da Sangallo), 53, 54, 192, 582–83, 583, 622

Laurentian Library

Entrance Hall, 408, 588–90, 589, 696, 707 Reading Room, 590, 590, 696

Medici Chapel, 188, 502, 503, 584, 584, 585–86, 585, 586, 587, 587, 588, 588, 592, 648, 705, 707

Old Sacristy, 14, 182, 188–89, 189, 194, 195, 287, 319, 348, 416, 584

St. Louis of Toulouse (Donatello), 367

St. Louis of Toulouse Crowning Robert of Anjou, King of Naples and Scenes from the Life of St. Louis (Simone Martini), 132–33, 133

San Marco, Venice, 170, 293, 452

San Marco Monastery, Florence, 182, 196, 251, 251, 252–54, 252, 253, 254, 276, 301, 569 library, 182, 196, 197, 248

Santa Maria degli Angeli, Florence, 192–93, 193, 306 Santa Maria del Calcinaio, Cortona (Francesco di Giorgio), with Antonio da Sangallo the Elder, 271, 407–8, 408, 533, 621

Santa Maria del Carmine, Florence, Brancacci Chapel, 16, 49, 229, 230–38, 230, 231, 232, 233, 234, 235, 236, 237, 243, 248, 298, 385, 544, 545, 566, 567

Santa Maria della Consolazione, Todi (Cola da Caprarola), 271, 532–33, 533

Santa Maria delle Carceri, Prato (Giuliano da Sangallo), 271, 348, *348*, *349*, 407, 481, 622

Santa Maria delle Grazie, Milan (Donato Bramante), 51, 217, 391, 457, 491–95, 492, 493, 494, 528–29, 528, 529, 554

Santa Maria Gloriosa dei Frari, Venice, 12, 23, 53, 172, 172, 635, 638, 639–40, 639, 643–44, 643, 644, 675

Sacristy, 452-53, 453, 652

Santa Maria in Trastevere, Rome, 76–77, 76, 158

Santa Maria Maggiore, Rome, 74, 75

Santa Maria Novella, Florence (Leonbattista Alberti), 56-57, 88-89, 88, 172, 240-43, 241, 264, 269-70, 269, 364, 395, 687

Chiostro Verde, 233, 294-96, 295 Cellini), 704, 704 Sala dell' Albergo, 667-68, 667, 668 SALVIATI, FRANCESCO, 509, 677, 712-14 Spanish Chapel, 51, 161, 161, 162, 168 Sala Grande, 24, 666, 667, 668-70, 668, 669 Strozzi Chapel, 51, 158, 159, 159, 362, 387, Palazzo Sacchetti, Rome, frescoes, 712-14, 714 Scuola di Sant'Orsola, Venice, 457 388, 389-90, 389, 694 Triumph of Camillus, fresco, Sala dell'Udienza, SEBASTIANO DEL PIOMBO, 562, 571, Santa Maria presso San Satiro, Milan (Donato Palazzo dei Priori (Palazzo Vecchio), Flo-573, 624 Bramante), 527, 527, 528, 528 rence, 712, 713 Fall of Icarus, fresco, Sala di Galatea, Villa Far-SANGALLO, ANTONIO DA, THE ELDER, Santa Maria sopra Minerva, Rome, 387 nesina (originally Palazzo Chigi), Rome, St. Mark (Donatello), 205, 208-9, 208, 209, 213, 346, 508, 621-23 573, 573 254, 333, 432 Madonna di San Biagio, Montepulciano, 22, Flagellation, fresco, Borgherini Chapel, San St. Mark Freeing a Christian Slave (Tintoretto), 271, 481, 582, 621-23, 621, 622 Pietro, Rome, 577-78, 577 551, 664-65, 664 Palazzo Tarugi, Montepulciano, 623, 623 second Renaissance style, 245-63 St. Matthew (Lorenzo Ghiberti), 42, 164, 205, SANGALLO, ANTONIO DA, THE YOUNGER, architecture and sculpture, 265-91 206, 206 346, **623–25**, 678, 720 painting, 293-327 San Miniato, Florence (Antonio Manetti), 187, 270 monumental architecture, 407 Self-Portrait: Chapel of the Cardinal of Portugal, 339-42, Palazzo Farnese, Rome, with Michelangelo, 571, (Sofonisba Anguissola), 661, 661 340, 341, 342, 353-54, 354, 355, 361, 623-25, 624, 625, 696-97, 696, 720 (Sandro Botticelli), 371, 373 (Lorenzo Ghiberti], 278, 279 St. Peter's, Vatican, Rome, 697, 697 St. Pantaleimon, Nerezi, 62, 63, 106 SANGALLO, GIULIANO DA, 344, 346-48, (Andrea Mantegna), 432-33, 433 Sts. Paul and Julian (Maso di Banco), attrib., 51, 392, 396, 418, 421, 508, 526, 543, (Pontormo), 601, 601 594, 621 Self-Portrait at the Spinet (Lavinia Fontana), 719, 720 St. Paul Preaching in Athens (Raphael), 539, Ruins of the Ancient Roman Theater of Self-Portrait in a Convex Mirror (Parmigianino), 566-67, 567 Marcellus, Rome, 36, 52, 272, 346, 346 616-17, 617 San Lorenzo, Florence, façade, 53, 582, St. Peter Baptizing the Neophytes (Masaccio), self-portraits, 617, 636, 661 fresco, 232-33, 233, 243, 567 583, 622 Separation of Light from Darkness (Michelangelo St. Peter Healing with His Shadow (Masaccio), Santa Maria delle Carceri, Prato, 271, 348, 348, Buonarroti), 539, 548-49, 549, 613 fresco, 236, 236 349, 407, 481, 622 seraph, 730 St. Peter's, Vatican, Rome (Bramante, Sangallo the Villa Medici, Poggio a Caiano, 346-48, 347, Seravezza, 582 Younger, Michelangelo), 26, 54, 273, 481, 598-601 Serbia, 62, 78 530, 532, 532, 564, 621, 623, 697, 697, SANMICHELI, MICHELE, 678-80 Serlio, Sebastiano, 720 698, 698, 699, 699, 720 Palazzo Bevilacqua, Verona, 678, 678 SETTIGNANO design (Donato Bramante), 54, 481, 528, 530, See Desiderio da Settignano San Bernardino, Verona, Pellegrini Chapel, 531, 532, 532, 697 engraving by B. Giuliari, 678-79, 679 Settignano, 501 drawing by Baldassare Peruzzi, 53, 54, 481, Sansovino, Andrea, 680 sexuality, 378, 616 528, 530, 531, 555, 697 SANSOVINO, JACOPO (Jacopo Tatti), 594, Sforza, Battista, 323-25, 419 on a medal by Caradosso, 481, 525, 528, 530, 656, 680 Sforza, Francesco, 465, 466, 490-91 Library of San Marco, Venice, 675, 680-81, 681, 531, 582 Sforza, Galeazzo Maria, 447, 465 San Petronio, Bologna, Main Portal, 220, 220, 683, 686 Sforza, Ludovico, 465, 466, 489, 528 221, 221, 232, 504, 545 Venus Anadyomene, 680, 680 Sforza family, 174, 425, 466, 528-29, 656 St. Philip Exorcising the Demon in the Temple of Zecca (Mint), Venice, 681, 681, 682, 707 sfumato, 497, 730 Mars (Filippino Lippi), fresco, 389-90, 389 sgraffito, 730 SANTI San Pietro in Montorio, Rome: See Raphael (Raffaello Santi or Sanzio) shaft, 730 Borgherini Chapel, 577-78, 577 Santi, Giovanni, 408, 413, 511 Shakespeare, 581 Tempietto, 421, 481, 511, 529, 529, 530, Santo, Padua, Chapel of St. Anthony, 653, 653 Sibyl (Giovanni Pisano), 86, 87 567, 683 SANZIO sibyls, 86, 730 San Pietro in Vincoli, Rome, 374, 537, 545, See Raphael (Raffaello Santi or Sanzio) Sicily, 59 552-53, 552, 554, 559, 694, 695 Saracens, 405 side aisle, 730 San Prospero, Reggio Emilia, 612 sarcophagi, Roman, 81, 362, 644 Siena, 37, 40, 59, 91, 93, 131, 155, 164, 181, St. Sebastian: 399-408 (Antonello da Messina), 448-50, 449, 454 See Andrea del Sarto aerial view of, 40, 41 (Antonio del Pollaiuolo with Piero del Pol-SASSETTA (Stefano di Giovanni), 399-401 Baptistery, Baptismal Font, 183, 215-16, 216, laiuolo?), 362-64, 363, 448, 482, 497 Marriage of St. Francis to Lady Poverty, 399, 493 San Sebastiano, Mantua (Leonbattista Alberti), 348 from the back of the Sansepolcro altarpiece, Cathedral, 82, 83, 83, 85-86, 86, 125, 128, San Sebastiano, Venice, 672, 673 401, 401 413, 415 San Sisto, Piacenza, 561 St. Francis in Ecstasy, from the back of the Sansefacade, 84, 84, 126 Santo Spirito, Florence, 89, 187, 190-91, 191, 192, polcro altarpiece, 399-401, 400 Piccolomini Library, 18, 412-13, 412, 413, 414 482, 504, 504 Sassetti, Francesco, 391-93, 394 Hospital of Santa Maria della Scala, Pellegrinaio, St. Sylvester Sealing the Dragon's Mouth and SAVOLDO, GIROLAMO, 659 403, 404, 404 Resuscitating Two Pagan Magicians (Maso Tobias and the Angel, 659, 659 Palazzo Pubblico di Banco), fresco, 118, 118 Savonarola, Girolamo, 183, 331, 382-83, Council Chamber, 130-31, 132 Santa Trinita, Florence, Sassetti Chapel, 391, 392, 384-85, 505 Sala della Pace, 51, 124, 145-49, 145, 146, 393, 393, 394-95, 394, 395, 484, 506, 540 Scala, Cansignorio della, 177 147, 148, 161, 173, 224 San Zaccaria, Venice, façade, Scala family, 286 Piazza del Campo, Fonte Gaia, 217-18, on a building by Antonio Gambello, Scamozzi, Vincenzo, 687-89 217 463-64, 463 Scenes from Genesis (Lorenzo Maitani), marble, Sienese art, 120, 610 San Zeno, Verona, 324, 434-37, 435, 436, 151-53, 152, 153 early Trecento, 125-53 437, 452 School of Athens (Philosophy) (Raphael), 555 painting, 69-70 Crucifixion, 435, 437, 438, 465 Scrovegni, Enrico, 95, 107 signatures, self-portraits as, 617 sala, 730 sculptors, 43 SIGNORELLI, LUCA, 359, 373, 517-21 Sala di Galatea, Villa Farnesina (originally Palazzo sculpture: Court of Pan. 517, 517 Chigi), Rome (Baldassare Peruzzi), 572, ancient, 556, 702-3 San Brizio Chapel, Cathedral, Orvieto, frescoes, 572, 673 vs. painting, 501 517-21, 518 Sala Grande, Scuola di San Rocco, Venice, 24, 667 practice of, 52 Damned Consigned to Hell, 520, 521, 550 Salome Presenting the Baptist's Head to Herodias, scuola, 730 iconography, 517-21, 519 (Andrea Pisano), 123, 123, 167, 199, Scuola di San Giovanni Evangelista, Venice, Resurrection of the Dead, 520, 521, 550, 201, 276 444-45 554, 693

Saltcellar of King Francis I of France (Benvenuto

Scuola di San Rocco, Venice, 667

Cappella Maggiore, 395-96, 396, 502, 594

spolvero, 47, 51-52, 730 taxation, 182, 232, 330 Sistine Chapel frescoes, 538 tempera painting, 46-49, 610, 730 Squarcione, Francesco, 432 signoria, 730 silverpoint, 730 S-shaped pose, 410 tempera panel, 46, 46 Tempestuous Landscape with the Soldier and the SIMONE MARTINI, 130-38, 401, 402, 403 stanza, 730 Stanza d'Eliodoro, Vatican, Rome, 554, 555, 558, Gypsy (Giorgione), 633-34, 633 Annunciation with Two Saints, with Lippo Tempietto, San Pietro in Montorio, Rome (Donato Memmi, 128, 134, 135 559-60, 559, 560, 561, 650, 696 Stanza della Segnatura, Vatican, Rome, 212, 521, Bramante), 421, 481, 511, 529, 529, 530, The Blessed Agostino Novello and Four of His 554, 555, 555, 556, 557, 558, 561, 573, 567, 683 Miracles, 134-35, 136 temple, 730 Dream of St. Martin, St. Martin Chapel, San 594,601 Star-of-Bethlehem and Other Plants (Leonardo da Temptation: Francesco, Lower Church, Assisi, 133, (Masolino), 234, 235, 544 Vinci), 479, 479 Maestà, fresco, Council Chamber, Palazzo stigmata, 730 (Jacopo della Quercia), 221, 221, 504 Stigmatization of St. Catherine (Domenico Becca-Temptation of Christ (Tintoretto), 668, 669 Pubblico, Siena, 130-31, 132 Temptation of Christ on the Mountain (Duccio), St. Louis of Toulouse Crowning Robert of Anjou, fumi), 606-7, 606 King of Naples and Scenes from the Life of Stigmatization of St. Francis (Giotto di Bondone), 129, 129, 401 terra-cotta, 730 51, 112-13, 113 St. Louis, 132-33, 133 terra verde, 730 storia, 730 Way to Calvary, 136, 136 terribile, 209 SIMONE MARTINI, WORKSHOP OF: Storm Breaking over a Valley (Leonardo da Vinci), Theatine Order, 569, 730 Betrayal, Collegiate Church, San Gimignano, 478, 478, 479 Story of Abraham (Lorenzo Ghiberti), 277, 277 Thomas à Kempis, 439 138, 138 stringcourse, 730 Thomas Aquinas, Saint, 155-56 Pact of Judas, Collegiate Church, San Three Cardinal Virtues: Fortitude, Prudence and Strozzi, Filippo, 344, 387 Gimignano, 137, 137 Strozzi, Maddalena, 506-8 Temperance, (Raphael), 521, 554, 555, Singing Boys (Luca della Robbia), 280, 280 Strozzi, Palla, 223-24, 246-47, 344 sinopia, 49-50, 730 The Three Living and the Three Dead, The Triumph Sir John Hawkwood (Paolo Uccello), 286, 294, Strozzi, Tommaso, 156 of Death, The Last Judgment and Hell (Mas-294. 309 Studies of a Left Leg, Showing Bones and Tendons (Leonardo da Vinci), 481, 481 ter of the Triumph of Death), Sistine Chapel, Vatican, Rome: possibly by Buffalmacco, 51, 149-50, Studies of the Madonna and Child (Raphael), (Michelangelo Buonarroti), frescoes, 10-11, 53, 150-51, 173 86, 221, 311, 364, 371, 372, 374, 374, 513, 513 Studies of Water (Leonardo da Vinci), 482, 483 tiara, 731 398, 409-10, 409, 410, 412, 416, 441, Studies of Water Movements (Leonardo da Vinci), tie-rod, 731 502, 503, 506, 511, 517, 526, 536, 537, Tintoretto, Domenico, 652 482, 483 538, 538-39, 539, 540-41, 541, 542, 542, TINTORETTO (Jacopo Robusti), 551, 619, 620, 543, 544, 544, 545, 545, 546-49, 546, studiolo, 730 Studiolo of Frederico da Montefeltro (Giuliano da 631, 663, 673 547, 548, 549, 550, 550, 551, 551, 552, 553, 565, 598, 601, 604, 605, 613, 691, Maiano), 321, 344, 422, 422, 423 Discovery of the Body of St. Mark, 666, 667 Last Supper, San Giorgio Maggiore, Venice, 692, 693, 693, 694, 694, 701, 703, 710, Study for a Bowman in the Capture of Zara (Tintoretto), 663, 663 670-71, 670, 674, 677 712, 718 (Perugino), frescoes, 53, 398, 409-10, 409, 410, Study for Deluge Fresco for San Lorenzo (Jacopo Portrait of a Woman in Mourning, 671 St. Mark Freeing a Christian Slave, 551, 441, 511, 537, 538, 691 Carucci da Pontormo), 602 Sistine Madonna (Raphael), 516, 561, 562, 610, 639 Study for Libyan Sibyl (Michelangelo Buonarroti), 664-65, 664 Scuola di San Rocco, Venice, 667 Six Kneeling Saints, study for Coronation of the 550, 551 Crucifixion, Sala dell' Albergo, 667-68, Virgin (Lorenzo Monaco, workshop of), 46, Study for Sistine Ceiling (Michelangelo Buonarroti), 537, 537 667, 668 46, 167 Last Supper, Sala Grande, 668-70, 669 Study of composition of Last Supper (Leonardo Sixtus IV, Pope, 330, 365, 371-72, 374, 409, Moses Striking Water from the Rock, Sala 415-16, 419, 441, 489, 517, 525, 537, 542 da Vinci), 491-92, 491 Study of Drapery (Leonardo da Vinci), 484, 484 Grande, 668, 668 Sixtus IV della Rovere, His Nephews, and Piatina, Nativity, Sala Grande, 668, 669 Study of Hanged Men (Antonio Pisanello), His Librarian (Melozzo da Forlì), 273, Sala Grande, 666, 667 415-16, 415 426, 427 Study of Nude after a Statuette by Michelangelo Temptation of Christ, Sala Grande, sketches, 47 668, 669 (Tintoretto), 671, 671 Sleeping Venus (Giorgione), finished by Titian, 634, Study for a Bowman in the Capture of Zara, 634, 646-47 Study of the Head of a Horse (Antonio Pisanello), 663, 663 Small Cowper Madonna (Raphael), 323, 425, 426 Study of the Head of the Angel for Madonna of Study of Nude after a Statuette by 514, 514 Michelangelo, 671, 671 the Rocks (Leonardo da Vinci), 490, 490 Soderini, Piero, 509, 547, 582 Transport of the Body of St. Mark, 665-67, 665 styolobate, 730 SODOMA (Giovanni Antonio Bazzi), 554, 555, TITIAN (Tiziano Vecellio), 44, 442, 457, 573, 571, 574 SUARDI 616, 619, 631, 634, 635-52, 655, 663, Marriage of Alexander and Roxana, See Bramantino (Bartolomeo Suardi) 665, 673 bedroom, Villa Farnesina Supporting Figure (Giovanni Pisano), 86, 87 Bacchanal of the Andrians, 443, 642, 643 Surrealism, 471 (originally Palazzo Chigi), Rome, Bacchus and Ariadne, 443, 642, 643 Sylvester, St., 118 574, 575 Cain Killing Abel, 647-48, 647, 652 soffit, 730 Symbolists, 390 Crowning with Thorns, 652, 652 SOLARI, GIOVANNI, 466 Danaë, 630, 648-49, 648 Certosa, Pavia, with Guiniforte Solari, 466, David and Goliath, 647-48, 647, 652 466-68, 467 T Entombment, 644-45, 644 Solari, Guiniforte, 466 Festival of Venus, 443, 641-43, 641 Solari family, 466 Sopoćani, Church of the Trinity, 78, 78 Tabernacle, Orsanmichele, Florence, 156-57, 157, Jacopo Strada, 651, 651 Madonna and Child (Gypsy Madonna), 158, 158, 167 Sopoćani, Serbia, 78 tabernacle, 730 636, 636 Spain, 383 tagliapietra, 52 Man with the Glove, 645, 645 Italian possessions, 525 Martydom of St. Lawrence, 649-50, 649 Talenti, Francesco, 168 spalliera, 730 Pietà, finished by Palma Giovane, 652, 653 Cathedral, Florence, Campanile, 114-15, 114, spandrel, 730 Pope Paul III Farnese, 648, 648, 696 115, 158, 168, 214-15, 214, 215, 254, 333 Spanish Chapel, Santa Maria Novella, Florence, Portrait of a Bearded Man (Self-Portrait?), Talenti, Jacopo, 168 636-39, 637 Talenti, Simone, 38, 168 Spinario, 201

Spoleto, 408

tapestries, 566

Rule of the Antichrist, 53, 519-21, 519

Presentation of the Virgin, 645-46, 645, 646 of Battista (Piero della Francesca), 324, 325, as artist, 390, 624, 647 Rape of Europa, 650-51, 650, 675 326-27, 558 Lives of the Most Eminent Painters, Sculptors, Sacred and Profane Love, 640-41, 640 Triumph of Heraclius over Chosroes (Agnolo and Architects, 54-55, 714 Sacrifice of Isaac, 647-48, 647, 652 Gaddi), 164, 165, 316 murals, 499 Santa Maria Gloriosa dei Frari, Venice Triumph of Mordecai (Paolo Veronese), 672, 673 Paul III Farnese Directing the Continuance of Assumption of the Virgin, 172, 635, 638, Triumph of the Church and Navicella (Andrea da St. Peter's, fresco, Palazzo della Cancelleria, 639-40, 639 Firenze), 51, 161, 162, 168 Rome, 54, 697, 715, 715 Perseus and Andromeda, 54, 716-18, 717 Madonna of the Pesaro Family, 23, 643-44, Triumph of Venice (Paolo Veronese), 677, 677 643, 644, 675 The Triumphs of Love, Chastity, and Death Uffizi, Florence, completed by Bernardo Venus of Urbino, 646, 646 (Francesco Pesellino), 355-56, 356-57 Buontalenti and Alfonso Parigi, 54, 626, Tito, Santi di, 718 Trivulzio, Giangiacomo, 500 715-16, 716 titulus, 731 trompe l'oeil, 731 Vatican, Rome: Tobias and the Angel (Girolamo Savoldo), TURA, COSMÈ, 468, 473 Basilica of St. Peter's (Old St. Peter's), 525, 530 659 659 Enthroned Madonna and Child with Angels, Belvedere, 36, 526, 533-34, 534, 721 from the Roverella altarpiece, 468-70, 469 Todi, Santa Maria della Consolazione, 271, Chapel of Nicholas V, 321 532-33, 533 Pietà, from the Roverella altarpiece, 469, Library, 415 Tomb of Carlo Marsuppini (Desiderio da 470, 470 Museums, 441 Settignano), 336-38, 337 Turks, 329 Pauline Chapel, 690, 694-96, 695, 696 Tomb of Filippo Strozzi, Strozzi Chapel, Santa Tuscan order, 268, 731 Raphael Stanze Maria Novella, Florence, 388 Tuscany, 408 iconography, 554-61, 555 Tomb of Giuliano de' Medici (Michelangelo Duecento art, 59-74 Stanza d'Eliodoro, 554, 555, 558, 559-60, Buonarroti), 502, 585-86, 585, 587, 587, Gothic art. 155-77 559, 560, 561, 650, 696 648. 705 sculpture, 199-221 Stanza della Segnatura, 521, 554, 555, 555, Tomb of Julius II project (Michelangelo Buonar-Two Sheets of Battle Studies (Leonardo da Vinci), 556, 557, 558, 561, 573, 594 roti), 516, 535, 535, 551, 552, 552, 553, 499, 500 St. Peter's, 26, 53, 54, 273, 481, 525, 528, 530, 561, 590, 591-92, 591, 702 531, 532, 532, 555, 564, 582, 621, 623, completed, 552, 559, 694, 695 697, 697, 698, 698, 699, 699, 720 Tomb of Lionardo Bruni (Bernardo Rossellino), Sistine Chapel, 10-11, 53, 86, 221, 311, 364, U 54, 289-91, 290, 291, 336 371, 372, 374, 374, 398, 409-10, 409, 410, Tomb of Lorenzo de' Medici (Michelangelo 412, 416, 441, 502, 503, 506, 511, 517, Buonarroti), 585-86, 585, 587, 588, 588, Uberti family, 91 526, 536, 537, 538, 538-39, 539, 539, 705, 707 UCCELLO, PAOLO (Paolo di Dono), 173, 182, 540-41, 541, 542, 542, 543, 544, 544, 545, Tomb of Pope Sixtus IV (Antonio del Pollaiuolo), 196, 266, 293-97, 310, 359, 390, 403, 416, 545, 546-49, 546, 547, 548, 549, 550, 550, 365, 366 425, 427, 437, 445, 511 551, 551, 552, 553, 565, 604, 613, 691, Tomb of the Cardinal Prince of Portugal (Antonio Battle of San Romano, 173, 196, 296-97, 296, 692, 693, 693, 694, 694, 701, 703, 710, Rossellino), 341, 342, 342, 361 297, 310, 319, 379, 403, 486 712, 718 tomb sculpture, 289-91 Deluge, fresco, Chiostro Verde, Santa Maria vault, 52-53, 731 tondo, 298, 506, 731 Novella, Florence, 233, 294-96, 295 VECCHIETTA (Lorenzo di Pietro), 405-6 Topkapi Palace, Constantinople, 445 Perspective Study, 293, 293 Risen Christ, 405-6, 406 TORI Sir John Hawkwood, Cathedral, Florence, 286, Vecellio, Orazio, 652 See Bronzino, Agnolo (Agnolo Tori) 294, 294, 309 velatura, 635-36 Tornabuoni, Giovanni, 395 UDINE Venetian art, 303, 425, 444-45, 447, 562, 569, Tornabuoni, Lucrezia, 262 See Giovanni da Udine 581, 619, **631–89**, 663, 702, 722 Torrigiani, Pietro, 502 Uffizi, Florence (Giorgio Vasari), completed by architecture, 463-65, 678-89 TORRITI, JACOPO, 75, 77 Bernardo Buontalenti and Alfonso Parigi, painting, 223, 428-29 Coronation of the Virgin, Santa Maria Maggiore, 54, 626, 715-16, 716 VENEZIANO Rome, 74, 75 ultramarine, 731 See Domenico Veneziano; Paolo Veneziano Toscanelli, Paolo del Pozzo, 325-26 Urban IV, Pope, 150 Venice, 37, 40, 75, 93, 170-72, 182, 223, Traini, Francesco, 149 Urbino, 321-27, 406, 407, 413-15, 419-22, 511, 329, 425, 457, 495, 631, 654, 656, 680 582, 591, 722 transept, 731 aerial view of, 40, 41, 170 Transfiguration (Fra Angelico), 182, 254, 254, 569 Palazzo Ducale, 321, 344, 419-21, 420, 422, Basilica of San Marco, 170, 293, 445, 452 Transfiguration of Christ: 422, 423, 511 Doge's Palace, 445, 454, 670 (Giovanni Bellini), 454, 455, 569 Uroš I, King, 78 Hall of the Great Council, 670, 677, 677 (Raphael), 569, 570, 573, 577 Library of San Marco, 675, 680-81, 681, 683, Transport of the Body of St. Mark (Tintoretto), 665-67, 665 Palazzo Loredan (Palazzo Vendramin-Calergi), V transversal, 731 464-65, 464 Traversari, Ambrogio, 193 San Giorgio Maggiore, 25, 670-71, 670, 674, travertine, 731 VAGA, PERINO DEL (Piero Bonaccorsi), 564, 677, 686-87, 686, 687, 687 Trecento, 93-163, 731 604-6, 621, 624 Santi Giovanni e Paolo, 172 Trent, 176-7 Santa Maria Gloriosa dei Frari, 12, 23, 53, 172, Adoration of the Child, 604-5, 605, Castello del Buonconsiglio, Eagle's Tower, Fall of the Giants, fresco, Palazzo del Principe, 172, 635, 638, 639-40, 639, 643-44, 643, 176–77, 176, 349, 473 Genoa, 605-6, 605, 691 644, 675 Treviso, 425 VANNUCCI Sacristy, 452-53, 453, 652 Tribute Money (Masaccio), fresco, 230-32, 231, See Perugino (Pietro Vannucci) San Sebastiano, 672, 673 232, 567 Varchi, Benedetto, 501 San Zaccaria, façade, 463-64, 463 triglyph, 731 varnish, 48-49 Scuola di San Giovanni Evangelista, 444-45 Trinity with Mary, John the Evangelist, VASARI, GIORGIO, 44, 47, 51, 54-55, 59, 70, Scuola di San Rocco, 667 and Two Donors (Masaccio), fresco, 240-43, 81, 93-94, 117, 126, 183, 195, 209, 215, Sala dell' Albergo, 667-68, 667, 668 241.364 217, 228, 254, 268, 282, 285, 293, 300, Sala Grande, 24, 666, 667, 668-70, 668, 669 triptych, 45, 731 303, 313, 327, 330, 364, 372, 378, 385, Scuola di Sant'Orsola, 457 Triptych (Bernardo Daddi), 119-20, 119 390, 409, 413, 482, 484, 491, 497, 501, Zecca (Mint), 681, 681, 682, 707 Trissino, Giangiorgio, 682 506, 509, 511, 517, 527, 535, 548, 554, Venus Anadyomene (Jacopo Sansovino), 680, 680 Triumph of Camillus (Francesco Salviati), 712, 578, 587, 593, 594, 598, 601, 602, 610, Venus and Mars (Sandro Botticelli), 377-78, 377 713 611, 616, 624, 625, 631, 635, 647, 649, Venus of Urbino (Titian), 646, 646 Triumph of Federico da Montefeltro and Triumph 651, 661, 702, 712, 714-16, 719 Vergerio, Pier Paolo, 44

Verona, 177, 286, 425, 432, 656, 678-80 Funerary Monument of Cansignorio della Scala, 177, 177 Palazzo Bevilacqua, 678, 678 Sant'Anastasia, Pellegrini Chapel, 425-27, 426 San Bernardino, 678–79, 679 San Zeno, 324, 434-37, 435, 436, 437, 438, 452, 465 VERONESE, PAOLO (Paolo Caliari), 631, 663, 672-77 Abundance, Fortitude, and Envy, Villa Barbaro, Maser, 673, 673, 685 Feast in the House of Levi, 675, 675 Hall of the Great Council, Doge's Palace, Venice, ceiling paintings, 670, 677, 677 Triumph of Venice, 677, 677 Marriage at Cana, 674, 674 Mystical Marriage of St. Catherine, 675-77, 676 Triumph of Mordecai, San Sebastiano, Venice, 672, 673 VERROCCHIO, ANDREA DEL (Andrea di Michele Cioni), 359, 366-71, 409, 410, 483, 708 Baptism of Christ, with Leonardo da Vinci, 366–67, 367, 484, 498 Christ and St. Thomas, 205, 367, 368, 368, 387 David, 369, 369, 378 Equestrian Monument of Bartolommeo Colleoni, 36, 174, 369-71, 369, 371, 490 Portrait of a Lady with Flowers, 368-69, 369, 485-86 Vertumnus and Pomona (Jacopo Carucci da Pontormo), fresco, 348, 580, 598-601, 599, 602 Vespasiano da Bisticci, 287 Vespucci family, 378 Vicenza, 425, 656, 682 Basilica (Palazzo della Ragione), 682-83, 682 Olympian Theater, 688, 688, 689 Palazzo Chiericati, 683-84, 683 Villa Almerico (Villa Rotonda, Villa Capra), 684, 684 vices, 731 Victory (Michelangelo Buonarroti), 590-93, 591, View of an Ideal City (Luciano Laurana, attrib.), perhaps painted by Piero della Francesca, 53, 268, 272, 274, 348, 421, 421, 533

VIGNOLA, GIACOMO DA (Jacopo Barozzi),

Vigevano, 466

720-21, 722

Gesù, Rome, 720 Villa Farnese, Caprarola, 720-21, 721, 722 Villa Almerico (Villa Rotonda, Villa Capra), Vicenza (Andrea Palladio), 684, 684 Villa Barbaro, Maser (Andrea Palladio), 673, 673, 685, 685 Villa Carducci, Legnaia, loggia, 305-7, 305 Villa Farnese, Caprarola (Giacomo da Vignola), 720-21, 721, 722 Villa Farnesina (originally Palazzo Chigi), Rome (Baldassare Peruzzi), 571-77, 571 bedroom, 574, 575 Loggia of Psyche, 576, 577, 577, 611, 616, 628, 673 Sala delle Prospettive, 575 Sala di Galatea, 524, 572-74, 572, 573, 574, 594, 616, 673 Villa La Gallina, Florence, 362, 362 Villa Medici, Poggio a Caiano (Giuliano da Sangallo), 346-48, 347, 580, 598-601, 599, 602 Villani, Filippo, 44 Villani, Giovanni, 93 VINCI See Leonardo da Vinci; Pierino da Vinci Virgin Annunciate (Antonello da Messina), 447-48, 447 Virgin Mary, 45 virtues, 731 Visconti, Bernabò, 174 Visconti, Filippo Maria, 182, 465, 499 Visconti, Giangaleazzo, 170, 174-75, 181-82, 199, 399, 466 Visconti family, 174, 425, 466, 490 Visconti Hours (Giovannino de' Grassi), 175-76, 175 Vision of Constantine (Piero della Francesca), 320, 321 Vision of St. Bernard: (Fra Bartolomeo), 387, 516, 516, 561-62 (Filippino Lippi), 385-87, 386, 516, 522 Vision of St. Eustace (Antonio Pisanello), 427-28, 427 Vision of St. Jerome: (Andrea del Castagno), fresco, with Domenico Venziano?, 308, 309, 309, 333, 362, 439 (Parmigianino), 617-18, 617

Vision of St. John the Evangelist (Correggio),

Visitation (Jacopo Carucci da Pontormo), fresco,

fresco, 613-14, 613

598, 598

wash, 731

Way to Calvary (Simone Martini), 136, 136

Wedding Feast of Cupid and Psycbe (Giulio Romano), fresco, 628, 628

Weyden, Rogier van der, 182, 327, 411, 447, 468

women:
artists, 578, 660, 719
manuscript illumination, 660
patrons, 121, 241, 262, 433, 442–44, 529, 595, 596, 610, 617, 618, 679
portraits of, and social conventions, 354–55, 365
role of, 379, 497, 647

Wool Factory (Mirabello Cavalori), 718, 719

Vitruvian Man: Study of the Human Body

Vitruvius, 196, 480-81, 680, 682, 685

VITTORIA, ALESSANDRO, 689

VIVARINI, ANTONIO, 428, 432

D'Alemagna, 428, 429

Voragine, Jacobus de, Golden Legend,

Vivarini family, 428-29, 457, 631

St. Jerome, 689, 689

Volterra, Daniele da, 693

385, 511

volgare, 731

volute, 731

Vulgate, 731

walls, 53-54

in church, 89

W

(Leonardo da Vinci), 480, 480

Coronation of the Virgin, with Giovanni

Z

Zappi, Giovan Paolo, 720
Zecca (Mint), Venice (Jacopo Sansovino), 681, 681, 682, 707
ZOCCHI, GIUSEPPE, The Piazza of Florence
Cathedral in 1754, with the Baptistery and
Bell Tower, 40, 40
Zuccari, Federico, 722
Zuccato (mosaicist), 636
Zuccone (Habakkuk) (Donatello), 214–15, 214, 215, 254, 333

CREDITS

The following captions identify and credit those illustrations appearing in the title page, part openers, and chapter openers.

- TITLE PAGE: LEONARDO DA VINCI. Architectural Drawing. c. 1489 or later. Paris, Institute of France: MS 'B'
- PAGES 10-11: MICHELANGELO. Cumaean Sibyl. 1510. Fresco. Sistine Ceiling, Vatican, Rome (see fig. 17.32)
- PAGES 32-33: Piazza della Signoria, with a view of the Uffizi and the Loggia della Signoria (dei Lanzi). Built 1376-c. 1381 under the supervision of BENCI DI CIONE and SIMONE TALENTI (see fig. 1.2)
- PAGES 56-57: Nave vaults, Sta. Maria Novella, Florence. Begun 1246 (see fig. 2.41)
 - PAGE 58: CIMABUE. Enthroned Madonna and Child with Angels and Prophets. c. 1280. Panel. Uffizi Gallery, Florence (see fig. 2.17)
 - PAGE 92: GIOTTO. Lamentation. Consecrated 1305. Fresco. Arena Chapel, Padua (see fig. 3.15)
 - PAGE 124: AMBROGIO LORENZETTI. Allegory of Good Government in the City and the Country. 1338–39. Fresco. Salla della Pace, Palazzo Pubblico, Siena (see figs. 4.28, 4.29)
 - PAGE 154: GIOVANNI DA MILANO. Pietà. 1365. Panel. Accademia, Florence (see fig. 5.10)
- PAGES 178-79: FRA FILIPPO LIPPI. Annunciation. c. 1440. Panel. S. Lorenzo, Florence (see fig. 9.15)
 - PAGE 180: MICHELOZZO DI BARTOLOMMEO (attributed to). Courtyard, Palazzo Medici, Florence. Begun 1446 (see fig. 6.19)
 - PAGE 198: DONATELLO. St. George. c. 1415-17. Marble. Museo Nazionale del Bargello, Florence (see fig. 7.16)
 - PAGE 222: GENTILE DA FABRIANO. Adoration of the Magi (Strozzi altarpiece). Dated May 1423. Panel. Uffizi Gallery, Florence (see fig. 8.2)
 - PAGE 244: FRA FILIPPO LIPPI. Madonna and Child with Two Angels. c. 1455 or mid-to-late 1460s(?). Panel. Uffizi Gallery, Florence (see fig. 9.16)
 - PAGE 264: LEONBATTISTA ALBERTI. Façade, Sta. Maria Novella, Florence. c. 1461-70 (see fig. 10.5)
 - PAGE 292: ANDREA DEL CASTAGNO. Cumaean Sibyl from a series of Famous Men and Women. 1448. Fresco. Uffizi Gallery, Florence (see fig. 11.16)
 - PAGE 328: ALESSO BALDOVINETTI. Annunciation. Before 1460. Panel. Uffizi Gallery, Florence (see fig. 12.31)
 - PAGE 358: SANDRO BOTTICELLI. Primavera. c. 1482(?). Panel. Uffizi Gallery, Florence (see fig. 13.25)
 - PAGE 398: PERUGINO. Christ Giving the Keys to St. Peter. 1481. Fresco. Sistine Chapel, Vatican, Rome (see fig. 14.14)
 - PAGE 424: GIOVANNI BELLINI. Agony in the Garden. c. 1465. Panel. National Gallery, London (see fig. 15.37)
- PAGES 474-75: DOMENICO BECCAFUMI. *The Appearance of St. Michael on the Castel Sant'Angelo.* c. 1528. Tempera on panel. Carnegie Museum of Art, Pittsburgh (see fig. 18.41)
 - PAGE 476: MICHELANGELO. Battle of the Lapiths and Centaurs. c. 1492. Marble. Casa Buonarroti, Florence (see fig. 16.32)
 - PAGE 524: RAPHAEL. Galatea. 1513. Fresco. Sala di Galatea, Villa Farnesina, Rome (see fig. 17.69)
 - PAGE 580: PONTORMO. *Vertumnus and Pomona*. Probably 1520–21. Fresco. Villa Medici, Poggio a Caiano (see fig. 18.27)
 - PAGE 630: TITIAN. Danaë. 1552-53(?). Canvas. Prado, Madrid (see fig. 19.25)
 - PAGE 690: MICHELANGELO. Conversion of St. Paul. 1542-45. Fresco. Pauline Chapel, Vatican, Rome (see fig. 20.7)

LITERARY CREDITS

- PAGES 336-37: Quotation extracted from Pope-Hennessy, John. Italian Renaissance Sculpture. London: Phaidon Press Ltd., © 1971.
 - PAGE 338: Quotation extracted from Reiss, Sheryl E., and David G. Wilkins, eds. Beyond Isabella: Secular Women Patrons of Art in Renaissance Italy. Vol. 54, Sixteenth Century Essays and Studies. Kirksville, Mo.: Truman State University Press, 2001.
- PAGES 469, 470-71: Quotations extracted from Cambell, Stephen J. Cosmè Tura of Ferrara: Style, Politics, and the Renaissance City, 1450-1495. New Haven: Yale University Press, 1997.
 - PAGE: 705: Quotation extracted from Cellini, Benvenuto. *The Autobiography of Benvenuto Cellini*. Translated by George Bull © 1956. Harmondsworth, Middlesex, Eng.: Penguin, 1956. Reproduced with permission of Penguin Books Ltd, pages 290–1.

The author and publisher wish to thank the libraries, museums, galleries, and private collectors named in the picture captions for permitting the reproduction of works of art in their collections and for supplying the necessary photographs. Photographs from other sources are gratefully acknowledged below.

AKG, London: 12.31, 15.38, 16.23, 16.24, 19.4, 20.26; AKG, London/Orsi Battaglini: 6.19, 13.35; AKG, London/Cameraphoto: 13, 19.30, 19.45, 19.52, 19.59, 19.75; AKG, London/Rabatti-Domingie: 8.5, $9.1,\ 11.5,\ 11.16,\ 11.34,\ 12.15,\ 12.33,\ 13.1,\ 13.15,\ 13.30,\ 16.34,\ 18.15,$ 18.20, 18.25, 19.20, 19.28, 20.49; Albertina/Bildarchiv, Österreichische Nationalbibliothek, Vienna: 7.7; Aragozzini, Milano: 17.8; Archives Photographiques, Paris: 17.19; Art Resource, New York: 1.5; Alinari/Art Resource, New York: 1.1, 1.6, 1.9, 1.10, 1.11, 1.13, 2.1, 2.4, 2.7, 2.14, 2.16, 2.21, 2.23, 2.28, 2.29, 2.30, 2.31, 2.32, 2.36, 2.37, 2.38, 2.39, 2.40, 2.41, 3.2, 3.5, 3.6, 3.7, 3.8, 3.9, 3.10, 3.11, 3.13, 3.14, 3.15, 3.16, 3.17, 3.18, 3.20, 3.25, 3.26, 3.33, 3.34, 4.1, 4.7, 4.11, 4.12, 4.14, 4.16, 4.31 right and left, 4.32, 4.33, 4.34, 5.4, 5.19, 5.20, 5.23, 5.24, 6.4, 6.9, 6.10, 6.14, 6.18, 7.3, 7.5, 7.6, 7.10, 7.11, 7.13, 7.18, 7.20, 7.21, 7.22, 7.23, 7.24, 7.27, 7.28, 7.29, 7.30, 8.11, 8.20, 8.25, 9.2, 9.7, 9.13, 10.2, 10.4, 10.5, 10.9, 10.13, 10.17, 10.19, 10.20, 10.28, 10.29, 10.30, 10.31, 10.32, 10.33, 10.34, 10.35, 10.37, 11.13, 11.23, 11.33, 11.35, 12.4, $12.6,\ 12.8,\ 12.10,\ 12.18,\ 12.21,\ 12.23,\ 12.26,\ 12.27,\ 12.29,\ 13.5,\ 13.8,$ $13.10,\,13.12,\,13.13,\,13.16,\,13.17,\,14.6,\,14.7,\,14.9,\,14.10,\,14.15,\,14.17,$ $14.24,\ 14.25,\ 14.26,\ 14.27,\ 15.5,\ 15.6,\ 15.11,\ 15.12,\ 15.13,\ 15.14,$ 15.15, 15.16, 15.18, 15.21, 15.25, 15.32, 15.51, 15.52, 15.54, 15.55, 15.58, 15.59, 16.19, 16.21, 16.29, 16.31, 16.38, 17.6, 17.16, 17.43, 17.50, 17.55, 17.57, 17.63, 17.66, 17.69, 17.70, 17.72, 17.74, 17.75, 17.76, 18.6, 18.8, 18.10, 18.16, 18.21, 18.22, 18.30, 18.34, 18.36, 18.49, 18.50, 18.57, 18.60, 18.61, 18.64, 18.68, 19.9, 19.18, 19.19, 19.21, 19.22, 19.23, 19.24, 19.31, 19.34, 19.47, 19.48, 19.56, 19.58, 19.60, 19.64, 19.72, 20.10, 20.14, 20.18, 20.19. 20.20, 20.27, 20.30, 20.31, 20.32, 20.33, 20.48; Nicolo Orsi Battaglini/Art Resource, New York: 8.4; Cameraphoto/Art Resource, New York: 12, 15.7, 15.46, 18.65, 19.15, 19.51; Foto Marburg/Art Resource, New York: 18.3; Giraudon/Art Resource, New York: 4.17, 14.2, 16.56, 17.1, 19.16.; © Photograph by Erich Lessing/Art Resource, New York: 1, 5.17, 11.22, 13.14, 13.22, 15.27, 15.44, 16.45, 17.54, 18.45, 19.6, 19.11, 20.24; Nimatallah/Art Resource, New York: 3, 6.3, 6.8,13.36, 18.17, 18.18, 18.17, 18.18; Réunion des Musées Nationaux/Art Resource, New York: 1.18,12.11, 12.32, 15.26, 16.17, 16.26, 16.27, 16.28, 17.44, 17.45, 17.56, 19.5, 19.17, 19.57; Scala/Art Resource, New York: 2, 4, 6, 7, 8, 9, $10,\ 1.2,\ 1.17,\ 2.8,\ 2.10,\ 2.11,\ 2.12,\ 2.13,\ 2.15,\ 2.17,\ 2.18,\ 2.19,\ 2.35,$ $2.43,\ 3.1,\ 3.4,\ 3.21,\ 3.22,\ 3.23,\ 3.24,\ 3.27,\ 3.28,\ 3.29,\ 3.30,\ 3.32,\ 4.18,$ 4.19, 4.27, 4.28, 4.29, 5.1, 5.3, 5.10, 5.11, 5.12, 6.11, 7.1, 7.2, 7.4, 7.15,7.16, 7.19, 8.10, 9.3, 9.15, 9.16, 9.17, 9.18, 10.15, 10.16, 10.18, 10.21, 10.22, 10.25, 10.38, 11.12, 11.32, 12.14, 12.25, 12.30, 13.3, 13.33, 13.34, 13.37, 13.39, 13.40, 14.13, 14.14, 14.18, 14.21, 14.22, 14.29, 14.30, 15.1, 15.24, 15.28, 15.49, 15.50, 15.56, 15.61, 16.4, 16.35, 16.36, 16.39, 16.40, 16.54, 16.55, 17.4, 18.19, 18.19, 18.27, 18.31, 18.37, 18.43, 18.70, 19.2, 19.25, 19.46, 19.49, 19.61, 19.62, 19.67, 20.6, 20.7, 20.8, 20.13, 20.25, 20.28, 20.29, 20.45; Santa Maria Gloriosa dei Frari, Venice, Italy/Bridgeman Art Library: 19.8, 19.14; Brancacci Chapel, Santa Maria del Carmine, Florence, Italy/Bridgeman Art Library: 5, 8.9; Church of the Madonna di San Biagio, Montepulciano, Italy/Bridgeman Art Library: 11, 18.58; Duomo, Florence, Italy/ Bridgeman Art Library: 6.2; Duomo, Prato, Italy/Bridgeman Art Library: 9.19; Fratelli Fabbri, Milan/Bridgeman Art Library: 14.11, 14.12; Galleria Borghese, Rome, Italy/Bridgeman Art Library CREDIT: Bridgeman Giraudon/Lauros: 19.10; Galleria degli Uffizi, Florence, Italy/Bridgeman Art Library: 2.9, 2.10, 18.55; Galleria dell' Accademia, Venice, Italy/Bridgeman Art Library: 19.43; Gesuiti, Venice, Italy/Bridgeman Art Library: 19.26; Kunsthistorisches Museum, Vienna, Austria/Bridgeman Art Library: 19.1; David Lees, Florence/Bridgeman Art Library: 19.73, 19.78, 19.79; Louvre, Paris, France (Peter Willi)/Bridgeman Art Library: 15.8; Ali Meyer/Bridgeman Art Library: 18.53; National Gallery, London, UK/Bridgeman Art Library: 8.22, 11.36, 13.24; Palazzo Pio II, Pienza, Italy/Bridgeman Art Library: 10.12; Palazzo Pitti, Florence, Italy/Bridgeman Art Library: 18.23; Palazzo Vecchio (Palazzo della Signoria) Florence, Italy/Bridgeman Art Library: 16, 20.35, 20.36, 20.37, 20.42, 20.43, 20.44; St. Sebastiano, Venice, Italy/Bridgeman Art Library: 19.55; San Pietro in Montorio, Rome, Italy/Bridgeman Art Library: 17.9; Scrovegni (Arena) Chapel, Padua, Italy/Bridgeman Art Library: 3.19; Venice, Italy (Sarah Quill)/Bridgeman Art Library: 14, 19.68, 19.77; Villa Rotonda, Vicenza, Italy (Merilyn Thorold)/Bridgeman Art Library: 19.71; Reproduced by courtesy of the Trustees of the British Library: 19.65; Cameraphoto, Venice: 15.39, 15.43; Canali Photobank, Italy: 2.3, 2.26, 2.33, 3.12, 4.2, 4.10, 4.13, 5.21, 7.17, 8.23, 8.27, 9.4, 9.1, 11.11, 13.18, 13.41, 15.17, 16.15, 17.22, 18.24, 18.28, 19.36, 19.81, 20.38, 20.39; Carnegie Museum of Art, Pittsburgh, Howard A. Noble Fund: 18.41, 18.42; Dr. Eugenio Cassin, Florence: 17.17; Castello Sforzesco, Milan: 1.14; © Yann Arthus-Bertrand/CORBIS: 1.7; © Elio Ciol/CORBIS: 4.22; Del Migliore, Ferdinando Leopoldo. Firenze, città nobilissima illustrata. 1684. Reprint, Bologna: Arnaldo Forni Editore, 1976: 6.17; Michel Desjardins, "Agence Top," Paris: 15.23; Encyclopedia of World Art. New York: McGraw Hill, 1967: 2.24; Fitzwilliam Museum, Cambridge, Eng.: 11.9; Foto Mayer, Vienna: 19.33; Fototeca di Architectura e Topograficie dell' Antica, Roma: 17.65; Fototeca Unione, Rome: 14.8, 17.71; Foto Grassi, Siena, courtesy Fototeca Unione, Rome: 2.34; The Frick Collection, New York, Copyright the Frick Collection: 4.9; Gabinetto dei Desegni e Stampe, Uffizi, Florence: 18.1; Gabinetto Fotografico della Soprintendenza alle Gallerie: 5.9, 16.33; Gabinetto Fotografico Nazionale, Florence: 2.2, 5.5, 6.20, 8.18, 8.19, 11.1, 11.19, 11.21, 12.34, 12.35, 14.28, 17.14; Gabinetto Fotografico Nazionale, Rome: 2.22, 7.14, 18.13, 18.33, 20.5, 20.15; Gabinetto Fotografico, Palazzo degli Uffizi: 17.18: Gabinetto Fotografico, Uffizi, Firenze: 18.29; Galleria Nazionale, Parma: 18.44; Stab. D. Anderson/Galleria Nazionale d'Arte Antica: 16.12, 17.67, 17.68; Lydia Gershey, Communigraph, New York: 1.16; Harry N. Abrams, Inc., New York: 1.4, 1.8, 4.24, 12.16, 12.17, 17.5, 17.7, 17.10; Hirmer Verlag, Munich: 7.8, 10.26, 17.2; Ikona/N. Orsi Battaglini, Firenze: 10.23; Ikona/R. Bencini, Firenze: 4.15, 7.12, 7.26, 8.2, 8.3, 9.6, 9.11, 9.12; Ikona/A. Brachetti, P. Zigrossi/The Vatican Museums: 20.1, 20.2, 20.3, 20.4; Ikona/Canali Photobank, Milano: 19.70; Ikona/Carfagna and Associated: 16.53; Ikona/Carfagna e Associati/Belei: 17.61; Ikona/A. de Luca, Roma: 20.9; Ikona/Rodolfo Fiorenza: 16.51; Ikona/Fototecnica, Vicenza: 19.69; Ikona/Gabinetto Fotografico Piazzale: 17.27; Ikona/F. Lensini, Siena: 7.25, 18.40; Ikona/Pinacoteca, Siena: 18.39; Ikona/Photo, Vincenzo Pizozzi, Rome: 18.62; Ikona/SBAS Arezzo: 11.24, 11.26, 11.27, 11.28, 11.29, 11.30, 11.31; Ikona/Paolo Tosi, Firenze: 3.31, 12.9; Ikona/Vasari, Roma: 10.10; Ikona Foto: P. Zigrossi/The Vatican Museums: 17.32, 17.39, 17.47, 17.48, 17.49,

17.52, 17.53; Institut de France, Paris: 16.7; Isabella Stewart Gardner Museum, Boston: 12.37, 19.27; Kaiser Friedrich Museum, Berlin: 16.50; Kunsthistorisches Museum, Vienna: 18.56, 19.63; Kupferstichkabinett, Staatliche Museen zu Berlin-Bildarchiv Preussischer Kulturbesitz, Foto Jörg P. Anders: 17.3; Laboratorio Ricerche Scientifiche, Pinacoteca di Brera, Milano: 19.44; The Louvre, Paris: 9.14, 15.2, 19.37; Lowry, Bates. Renaissance Architecture. New York: George Braziller, 1962: 18.67; Rollie McKenna, Stonington, Conn.: 10.6; Pepe Merisio, Bergamo: 20.47; The Metropolitan Museum of Art, New York, Bequest of W. Gedney Beatty, 1941: 17.11: The Metropolitan Museum of Art, New York, Theodore M. Davis Collection, Bequest of Theodore M. Davis, 1915 (39.95.28) Photograph © The Metropolitan Museum of Art, New York: 15.36; The Metropolitan Museum of Art, New York, purchase 1924, Joseph Pulitzer Bequest: 17.40; Museo Civico, Recanti: 19.32; Museo di San Marco dell'Angelico, Florence/Bridgeman Art Library: 9.9; Museo Nazionale di San Matteo Gabinetto Fotografico, Pisa: 2.27; Museo Storico Artistico, Rome: 13.9; Courtesy, Museum of Fine Arts, Boston. Reproduced with permission. © Museum of Fine Arts, Boston: 19.39; © National Gallery, London: 11.6, 15.20, 15.37, 18.26, 18.54, 20.34; © National Gallery of Art, Washington, D.C.: 12.13, 12.36; Samuel H. Kress Collection, Photograph © 2002 Board of Trustees, National Gallery of Art, Washington, D.C.: 1.15, 5.6, 5.16, 6.1, 18.35; Andrew W. Mellon Collection, Photograph © 2002 Board of Trustees, National Gallery of Art, Washington, D.C.: 4.8, 14.16, 19.66; Widener Collection, © 2002 National Gallery of Art, Washington, D.C.:

11.17; Nippon Television Network Corporation, Tokyo: 17.25, 17.26, 17.34, 17.35, 17.36, 17.37, 17.38, 17.41, 17.42; Takashi Okamura/Nippon Television Network Corporation, Tokyo: 15, 17.32, 20.12; Takashi Okamura/Shizuoka City, Japan: 4.21, 17.28, 17.29, 17.30, 17.31, 17.32, 17.33; Palazzo del Te, Mantua: 18.69; Philadelphia Museum of Art: 12.12; Pinacoteca, Lucca: 2.6; Pinacoteca, Siena: 18.38; Pinacoteca, Vatican, Rome: 18.32; Vincenzo Pizozzi, Roma: 20.16; Eric Pollitzer, New York: 17.20; Josephine Powell, Rome: 2.5; Quattrone, Florence: 4.25, 4.26, 4.30, 5.2, 5.8, 5.14, 8.6, 8.12, 8.13, 8.14, 8.15, 8.16, 8.17, 8.21, 8.26, 9.5, 10.24, 10.27, 10.36, 11.2, 11.3, 11.4, 11.15, 11.2, 12.3, 12.5, 12.7, 12.19, 12.20, 12.31, 13.2, 13.11, 13.19, 13.23, 13.25, 13.26, 13.27, 13.28, 13.29, 13.38, 13.42, 15.19, 15.22, 16.11, 16.18, 16.22, 16.25, 16.32, 16.37, 16.47, 16.48, 16.49, 18.2, 18.4, 18.5, 18.9, 18.11, 18.12, 20.23; Raffaeli, Armoni & Moretti: 5.22; Raffaello Bencini fotografo, Firenze: 11.8; Gerhard Reinhold, Berlin: 15.31; Rijksmuseum, Amsterdam: 20.21; Royal Library, Windsor, by permission of Her Majesty, Queen Elizabeth II: 16.1, 16.2, 16.3, 16.5, 16.6, 16.30; Il Soprintendente ai Beni Artistici e Storici di Venezia: 19.50; Walter Steinkopf, Berlin: 8.24, 9.20, 11.7, 15.62; Stickelmann, Bremen: 8.7; Studio Rapuzzi, Brescia: 19.38; Dusan Tasic, Belgrade: 2.25; John Bigelow Taylor, New York: 12.1, 12.2; Marvin Trachtenberg, New York: 6.6, 10.8; Nadir Tronci, Florence: 2.20; Uffizi Gallery, Florence: 5.13; The University of Oxford, Ashmolean Museum: 17.51; Vaghi, Parma: 18.46, 18.47, 18.48; Vatican Museums, Rome: 13.20, 17.39; Vincent, Berkeley, Calif.: 10.1; National Gallery, London, John Webb: 19.7